THE SCHER COLLECTION
of Commemorative Medals

THE SCHER COLLECTION
of Commemorative Medals

Edited by Stephen K. Scher

With the assistance of Aimee Ng

Essays by Christopher Eimer, Martin Hirsch, Mark Jones, Jan Pelsdonk,
Marie-Astrid Pelsdonk, Ulrich Pfisterer, and Stephen K. Scher

Entries by Walter Cupperi, Alessandra Di Croce, Arne Flaten, Emma Merkling,
Carolyn Miner, Aimee Ng, Marie-Astrid Pelsdonk, and Stephen K. Scher

Artist biographies by Emma Merkling, Stephen K. Scher, and Davide Stefanacci

The Frick Collection, New York
in association with D Giles Limited

g

Published by The Frick Collection
1 East 70th Street
New York, NY 10021
www.frick.org

Michaelyn Mitchell, Editor in Chief
Hilary Becker, Associate Editor

In association with GILES
An imprint of D Giles Limited
66 High Street,
Lewes, BN7 1XG
www.gilesltd.com

Designed by Caroline and Roger Hillier, The Old Chapel Graphic Design
Scher Collection medals photographed by Michael Bodycomb, Head of Photography and Digital Imaging, The Frick Collection
Typeset in Optima
Printed and bound in Slovenia

Front cover: Germain Pilon, *Henri II, King of France* (detail, no. 526)
Back cover: Unknown artist (Rome?), *Artemisia Gentileschi* (detail, no. 231)
Frontispiece: Mantuan School, *Jacoba Correggia* (detail, no. 36)
Page 10: Guillaume Dupré, *Anne of Austria* (detail of reverse, no. 543)
Page 12: Wouter Muller, *Admiral Maarten Harpertszoon Tromp* (detail, no. 750)
Page 24: Jacques Jonghelinck, *Don Fernando Álvarez de Toledo, Duke of Alba* (detail, no. 726)
Pages 28–29: Antonio di Puccio Pisano, called Pisanello, *Cecilia Gonzaga* (detail, no. 9)
Pages 160–61: Hans Reinhart the Elder, *Johann Friedrich I* (detail, no. 306)
Pages 280–81: Guillaume Dupré, *Francesco di Ferdinando de' Medici* (detail, no. 537)
Pages 416–17: After Pieter van Abeele, *Gertrude van Hooftman* (detail, no. 782)
Pages 486–87: Thomas Rawlins, *Sir William Parkhurst* (detail, no. 825)
Pages 512–13: Fyodor Alexeyev, *Peter the Great* (detail, no. 864)
Pages 536–37: Augustus Saint-Gaudens, *Robert Louis Stevenson* (detail, no. 879)
Page 550: Henri Eugène Nocq, *Jacqueline Cheruit* (detail, no. 706)
Page 631: Matthes Gebel, *Georg Hermann* (detail, no. 271)

Library of Congress Cataloging-in-Publication Data

Names: Scher, Stephen K., editor, writer of supplementary textual content. | Ng, Aimee, writer of supplementary textual content. | Eimer, Christopher, writer of supplementary textual content. | Frick Collection, issuing body.
Title: The Scher collection of commemorative medals / edited by Stephen K. Scher with the assistance of Aimee Ng ; essays by Christopher Eimer [and 6 others] ; entries by Walter Cupperi [and 7 others] ; artist biographies by Emma Merkling, Stephen K. Scher, and Davide Stefanacci.
Description: New York : The Frick Collection ; London : In association with D Giles Limited, [2019] | Includes bibliographical references and index.
Identifiers: LCCN 2018000157 | ISBN 9781907804878
Subjects: LCSH: Scher, Stephen K.--Art collections--Catalogs. | Scher, Janie Woo--Art collections--Catalogs. | Medals--Europe--Catalogs. | Medals--United States--Catalogs. | Medals--Mexico--Catalogs. | Portrait medallions--Catalogs. | Medals--Private collections--United States--Catalogs. | Frick Collection--Catalogs.
Classification: LCC CJ5512.U62 S34 2019 | DDC 737/.222--dc23 LC record available at https://lccn.loc.gov/2018000157

Contents

Director's Foreword

It is an honor and pleasure to publish this volume on the outstanding Stephen K. and Janie Woo Scher Collection. Impressive for both its breadth and depth, the Scher Collection is widely acknowledged as the greatest medal collection in private hands, and a significant portion of it has very generously come to the Frick as an initial and promised gift. This gift enhances the Frick's holdings immeasurably, beautifully complementing many of the museum's paintings, sculptures, enamels, and works on paper, and in keeping with founder Henry Clay Frick's abiding interest in portraiture. Moreover, it establishes the Frick as a center for the study of an art form long overdue for fresh examination.

As both a collector and one of the leading scholars in the field of medals, Steve Scher has had a long and deep connection with the Frick. For the exhibition *The Currency of Fame: Portrait Medals of the Renaissance*, an important examination of the subject held here and at the National Gallery in Washington in 1994, he was both a principal organizer and editor of its catalogue. This was followed three years later by a more specialized study of the history of medals in *The Proud Republic: Dutch Medals of the Golden Age*, a publication that accompanied an exhibition presented exclusively at the Frick. In 2017, Steve's collection was again featured at the Frick in the exhibition *The Pursuit of Immortality: Masterpieces from the Scher Collection of Portrait Medals*, with an accompanying publication by Aimee Ng, Associate Curator at the Frick. Steve's rigorous scholarship over the years has done much to establish medals—traditionally considered closer to numismatics than to fine art—as small-scale sculptures deserving of a prominent place in the history of art. His passion and authority, evident at the many seminars and lectures he has given at the Frick, have inspired multitudes of amateurs and students to take a lively interest in these works of art.

Steve has had cordial relations with several directors of the Frick, notably Charles Ryskamp and Anne Poulet, who initiated the discussions with him about his collection becoming a part of this museum. I first encountered him in a classroom at Brown University in 1971, when he taught a course on Flemish painting of the early Renaissance. Over the years, we have corresponded about scholarly matters, especially on the French Renaissance, when we both participated in a symposium on sculpture at the Louvre in 1990, and he gave a masterful talk on Germain Pilon's medals, one of which is in this volume. It gives me profound satisfaction that, in donating his collection to the Frick, Steve honors an enduring bond with the institution and its staff.

Appreciation also goes to Steve for his contribution to the shaping of this publication as volume editor and, in particular, for his engaging essay and careful review of all the entries. We are deeply grateful to the other contributors to the catalogue for their excellent texts: for their essays, Christopher Eimer, Martin Hirsch, Mark Jones, Jan Pelsdonk, Marie-Astrid Pelsdonk, and Ulrich Pfisterer; for their entries, Walter Cupperi, Alessandra Di Croce, Arne

Flaten, Emma Merkling, Carolyn Miner, Aimee Ng, and Marie-Astrid Pelsdonk; and for their artist biographies, Emma Merkling and Davide Stefanacci. In addition to contributing some of the entries, Associate Curator Aimee Ng played a vital role in the organization of this publication, masterfully guiding and shaping it along with Steve Scher.

Editor in Chief Michaelyn Mitchell edited the text and tirelessly and expertly marshalled the production of the book; she accomplished this with the essential assistance of Associate Editor Hilary Becker and editorial volunteer Serena Rattazzi. Also at the Frick, I would like to acknowledge Xavier F. Salomon, Peter Jay Sharp Chief Curator, for his support of our staff through several years of this project; Michael Bodycomb, Head of Photography and Digital Imaging, for his excellent photographs; current and past Curatorial Assistants Eloise Owens and Gemma McElroy, for support with innumerable administrative and research aspects of the project; Jeannette Sharpless, former Assistant Registrar, and Hannah Sisk, Registrar Assistant, for their meticulous attention to each of the 884 objects catalogued here; and Associate Conservator Julia Day, who looked after many aspects of conservation and examination of the medals. Others on the staff who contributed significantly to the realization of the project include Diane Farynyk, Allison Galea, Joseph Godla, Alison Lonshein, Gianna Puzzo, and Heidi Rosenau.

Many thanks go to Denise Allen, formerly Curator at the Frick and now Curator at the Metropolitan Museum of Art, for her critical role in the early stages of the project. Alessandra Di Croce also worked tirelessly on translating, reviewing, and often reworking hundreds of Latin inscriptions included in this catalogue. Our deep appreciation also goes to the wonderful team at D Giles, Ltd., our publishing partner.

Aimee Ng would like to thank Denise Allen, Colin B. Bailey, Marisa Bass, Hilary Becker, Peter Bell, Michael Bodycomb, Emma Capron, Walter Cupperi, Ibby Dalrymple, Julia Day, Alessandra Di Croce, Kelly Donahue-Wallace, Tom Eden, Christina Ferando, Nathan Flis, Daria Foner, Susan Grace Galassi, David Hill, Emma Holter, Margaret Iacono, Sophie Kerwin, Simon Lewis, Gemma McElroy, Diana Mellon, Michaelyn Mitchell, Virginia Napoleone, Alexander Noelle, Jenna Nugent, Eloise Owens, Jan Pelsdonk, Marie-Astrid Pelsdonk, Ulrich Pfisterer, Serena Rattazzi, Xavier F. Salomon, Stephen K. Scher, Jeannette Sharpless, Charlotte Vignon, Ian Wardropper, Hannah Williams, Nicholas Wise, Matthias Wivel, and Sara Wolfson.

Contributor Carolyn Miner gives heartfelt thanks to Ilaria Bernocchi for her essential input on many entries, and Walter Cupperi would like to give particular thanks to Matthias Barth, Jürg Fleischer, Rainer Grund, Joachim Kreutner, Hermann Maué, Wolfgang Steguweit, Hanns-Paul Ties, and Jürgen Wolf for their help.

Finally, we extend special thanks to the sponsors of the publication for their largesse. Steve Scher not only served as editor of the catalogue, leaving his scholarly stamp on every page, but he and his wife, Janie, also very generously supported its costs, and for that we are extremely grateful.

Ian Wardropper
Director, The Frick Collection

Acknowledgments

What a great pleasure it is at the conclusion of a massive and complicated project to have the opportunity of recognizing the extraordinary efforts, the special talents, the varied contributions, and the invaluable ideas and suggestions of an impressively large group of people. As part of such a satisfying task, however, I need to look back to a few relevant events in time that were the basis of my relationship with The Frick Collection. These are the events that led to the production of my first exhibition at the Frick, *The Currency of Fame*, when I received encouragement and support from both the then-director, Charles Ryskamp, and my old friend and the chief curator of the museum, the late and much lamented Edgar Munhall. For this invaluable involvement they are both owed my gratitude. In relation to the current exhibition and the catalogue of my collection, it was a subsequent director, Anne Poulet, also an old friend, who initially approached me with the idea of considering the Frick as a recipient of my collection, offering a proposal that placed the museum before me in an entirely new light. Finally, it was the current director, Ian Wardropper, who brought everything together in a way that put the project in concrete form, and who has been a calm (at least in my presence), sympathetic, and supportive colleague throughout all the necessary maneuvers, and who is the object of my most profound admiration and appreciation.

Then I must turn with awe and the highest praise and estimation to all those who, on an hourly, daily, monthly, even yearly basis, have enabled both this catalogue and the exhibition that accompanied it to reach fruition. Anyone who has engaged in such a project knows how the finished product, like an impressive facade, hides the complex mechanism of the building behind it. To change the image, as a kind of éminence grise, Xavier F. Salomon, Peter Jay Sharp Chief Curator, could always be counted upon to offer valuable suggestions. In the early stages, the then-curator of sculpture, Denise Allen, was a constant source of information and guidance and collaborated with me very closely as we launched the project. This task was then shouldered by the always high-spirited, brilliant, and astonishingly industrious Aimee Ng, who accompanied me shoulder to shoulder to the end with amazing forbearance and invaluable imagination. She was ably supported in administrative matters by Gemma McElroy and Eloise Owens.

The staff of the Frick forms a small but impressively productive machine at all levels and deserves my profoundest thanks. The editorial staff, headed by Editor in Chief Michaelyn Mitchell and aided by Associate Editor Hilary Becker and editorial volunteer Serena Rattazzi, were faced with the monumental task of editing a vast amount of material from multiple authors. They were there at every turn to guide and aid me. The quality of the photography was crucial to the effectiveness of the catalogue, and Michael Bodycomb, Head of Photography and Digital Imaging, was more than equal to the difficult task of reproducing accurately the different materials, types of relief, challengingly small scale,

and minute details encountered in medals. Keeping track of close to nine hundred objects, giving them an inventory identity, and ensuring their well-being was the responsibility of Jeannette Sharpless, former Assistant Registrar, whose efficiency and calm mastery of her job never ceased to amaze me. Other members of the Registrarial Department who contributed to the final product were Diane Farynyk and Allison Galea.

There are many others on the Frick staff who participated in valuable ways: Legal matters were handled by Alison Lonshein; publicity was in the capable hands of Heidi Rosenau and Alexis Light; conservation issues were the purview of Julia Day; and educational activities were organized by Rika Burnham. To all of them, and any others with whom I did not come in contact but who were involved, my deepest gratitude.

The distinguished scholars and experts, several of whom are old and close friends, who wrote the essays fall into a very special category. I was honored to have their invaluable thoughts and ideas as part of this book, and Christopher Eimer, Martin Hirsch, Mark Jones, Jan Pelsdonk, Marie-Astrid Pelsdonk, and Ulrich Pfisterer deserve my very special thanks. The enormous task of writing the entries fell to the capable hands of a diverse group of scholars including Walter Cupperi, Alessandra Di Croce (who also helped immeasurably with Latin translations), Arne Flaten, Emma Merkling, Carolyn Miner, Aimee Ng, and Marie-Astrid Pelsdonk. The accuracy of Spanish translations was checked by Carlos Riobó and Cristina Morales Segura, while those in Polish were scrutinized by Agnieszka Smolucha-Sladkowska; Nada Bayoud gave invaluable help with the Arabic text. I hope I will be forgiven if I have inadvertently neglected to include the names of anyone else who was part of this vast project. They, too, have earned my gratitude.

Finally, although I may have found the words to offer my feelings toward the entire team responsible for this book, the emotions I cherish for the person who has been the most important to me not only in my collecting but in all aspects of my life and career, and for whom I have a deep love and respect, are beyond adequate expression. Without the wisdom, concern, and constant guidance of my wife, Janie Woo, nothing I have done would have been possible. It is to her, therefore, that I dedicate this work.

Stephen K. Scher

Contributors

Walter Cupperi Research Fellow, Università degli studi Federico II, Naples

Alessandra Di Croce Lecturer for the Core Curriculum, Columbia University, New York

Christopher Eimer British medal specialist

Arne Flaten Director of the School of Art and Professor of Art History, Ball State University, Muncie, Indiana

Martin Hirsch Chief Curator, Staatliche Münzsammlung München (State Coin Collection Munich), and Lecturer, Ludwig Maximilian University, Munich

Mark Jones Chairman of the Pilgrim Trust, Hospitalfield and the Sarikhani Art Partnership; proprietor of the Golden Hare Bookshop; and one-time Director of the Victoria and Albert Museum, London

Emma Merkling Doctoral candidate, Courtauld Institute of Art, London

Carolyn Miner Independent art historian and curator of European sculpture, as well as President of Venetian Heritage

Aimee Ng Associate Curator, The Frick Collection

Jan Pelsdonk Curator of the Coin and Medal Collection, Teylers Museum, Haarlem, and Editor in Chief of *De Beeldenaar*

Marie-Astrid Pelsdonk General Secretary, International Art Medal Federation, and former Curator, Royal Coin Cabinet, Stockholm

Ulrich Pfisterer Professor of Art History, Ludwig Maximilian University, Munich, and Director, Zentralinstitut für Kunstgeschichte, Munich

Stephen K. Scher Art historian and one-time Chairman of the Art Department, Brown University, Providence

Davide Stefanacci Art historian

INTRODUCTION

Hunting the Wild Aftercast: Confessions of a Medal Collector

Stephen K. Scher

BEGINNINGS

I am frequently asked how and why I began collecting medals. Those of you who are inveterate collectors will understand when I confess that since childhood I have had the collector's disease. At the same time, I have always been fascinated by history and portraiture, and when one combines these interests, the results are inevitable and, referring to the disease, fatal, although the demise is a blissful one. It is this combination of passions that led me, under very particular circumstances, to begin collecting medals.

I had no idea of the existence of medals when, as an undergraduate, I read the Swiss historian Jacob Burckhardt's seminal book *The Civilization of the Renaissance in Italy*, first published in 1860.[1] Burckhardt was one of the first historians to describe the distinct form of individualism that has been traditionally considered a major characteristic of the Italian Renaissance, associated with a revival or re-examination of the cultures of classical antiquity, the growth of a new realism in the pictorial arts, and the use of innovative techniques for expressing these values and beliefs. In order to illustrate his point, Burckhardt focused attention on a number of the most prominent personalities of the Renaissance— personalities with whom, as a young man, I became fascinated.

So it was that during a trip to Europe as an undergraduate I found myself in the cradle of the Renaissance, Florence, wide-eyed, innocent, and voracious for knowledge and experience. While wandering along the banks of the Arno, I happened to notice the entrance to an antiquary's shop. With the courage of one who had nothing to lose—and, for that matter, nothing to spend—and in the hopes that I would not be bothering anyone but would, in fact, find some sympathy for a poor student, I entered the premises and asked if I might look around.

The hospitality I had been hoping for was forthcoming, and eventually the dealer brought out several objects he thought might interest me. One was a piece of Renaissance jewelry, the sort made of a mounted baroque pearl that is found quite commonly because it is so often forged. The other was a portrait medal, which I am almost certain was Matteo de' Pasti's superb medal of Sigismondo Malatesta (no. 12).

From that moment on, I was hooked. The evocation by this object of the very individuals described by Burckhardt was so strong that I felt it forged a spiritual link between me and those remarkable personalities of the Italian Renaissance. I was holding in my hand an object containing on its surface a portrait of one of the princes whose turbulent life had been so vividly described by the Swiss historian. Being on the strictest of student budgets, I could not purchase the piece, but, during the rest of the journey in Italy, I made it a point to visit the medal displays in as many museums as possible.

Subsequently, I went on to graduate school for advanced degrees in art history, followed by a career teaching the subject, primarily as a medievalist, and during most of that time did not have the means to collect seriously, although that did not deter me from purchasing art in a small way, usually paying in installments. I shall always be grateful to those understanding dealers whose sympathy for my passion made them tolerant of my impecunious state. I must confess that there were times when my parents helped or were persuaded to acquire an object for themselves, a ruse that fooled no one but left no one unhappy either.

It was while I was a graduate student at the Institute of Fine Arts in New York and taking a course titled Museum Training (now Curatorial Studies) that I finally purchased my first medal. One of the more delightful assignments given to the students was a competition in which each of us was tasked with purchasing a work of art—spending no more than $10 (this was 1957!). The faculty would then determine who had acquired the "best" object. Although I did not win, my career as a collector of medals had begun. Only afterward did I discover that what I had purchased was a later restitution of a papal medal. This was the first of many important lessons I learned as a fledgling collector and eventual connoisseur: always conduct thorough research before making a purchase.

My collecting of medals could begin in earnest only after I left the academic world in 1974 and took over the family chemical manufacturing business. As I learned more about medals and became familiar with the market—as represented in dealers' stock and auction catalogues—the collection grew, both chronologically, from about 1400 to the nineteenth century, and geographically, including Great Britain, Continental Europe, and the United States. This publication represents a personal collection, which is, perforce, idiosyncratic. The portrait medals obviously dominate, but since the medal was a useful instrument to commemorate a wide variety of subjects, most of these are also represented in the collection. Subject matter was not of particular concern to me. Rather, it was always the aesthetic aspect of the medal as a work of art that was the first and most important criterion in my selections.

In building the collection over a span of sixty years, I have had the opportunity to examine thousands of medals of all periods in museums, private collections, dealers' stock, and auction houses. There were always certain factors inherent in a medal that either enhanced or detracted from the aesthetic excellence to which I had been initially attracted. As a result, I established strict standards regarding the specific connoisseurial requirements for collecting medals. These included, among many other factors, excellence of design, the condition of a particular specimen, and, whether cast or struck, the quality of its fabrication.

Patina, whether applied or naturally acquired over time, was important to consider (particularly for bronze medals) in relation to the possible age of the medal. Sharpness of

detail and whether or not the piece had been tooled could not be ignored; and, in cast pieces, a comparison of dimensions (usually the overall diameter but preferably internal measurements) could indicate a later example in a succession of casts; while in struck medals, evidence of a cracked die or movement during striking, causing what is called "chattering," had to be avoided.

Rarely is there a fear of outright forgery, which is much more common with coins. With cast medals, copies were always being made, and only when they were treated to look older than they really were and then offered as original casts was there intent to deceive. Struck medals are more difficult to counterfeit since the process requires sophisticated machinery. Molds can be taken of a struck medal and a cast copy produced, but these are not too difficult to detect and are not necessarily meant to deceive. The desire to complete a series or own a particular medal never influences me if the specimen I am examining is mediocre, even if the type is extremely rare.

A BRIEF HISTORY

Although I have always considered medals as works of sculpture, it is important to remember that their roots are firmly established in the field of numismatics. To begin, it should be understood that a medal is not a coin, although there are commemorative coins that share the characteristics of medals. Coins are almost always struck, usually produced by or for a governing authority, and conform to specific weights and materials in their function as units of exchange and commerce. Medals are solely commemorative in nature, can be commissioned by anyone, may be struck or cast, and need not conform to any standards of size, weight, or material.

The widespread transmission of information by means of small, metallic objects has a very long history. In classical Greece, civic pride based on economic well-being and political and military strength was expressed in coinage of extraordinary beauty, occasionally marked by special issues in larger denominations commemorating a particular event—especially a military victory—such as the Syracusan and Athenian silver *decadrachms* (fig. 1). Such excellence of imagery was continued in the Hellenistic period, beginning with the coinage of Alexander the Great of Macedon and of the rulers who followed, introducing portraiture of outstanding quality, individuality, and sensitivity (fig. 2).

The inclusion of exact portraiture continued in Republican and Imperial Rome, gradually changing in character and accuracy toward the end of the imperial period,

Fig. 1 Euainetos, *decadrachm* of the head of Arethusa, surrounded by four dolphins (reverse), 405–400 BC
Syracuse, Sicily
Silver, 42.8 g
American Numismatic Society, New York (1997.9.64)

Fig. 2 *Tetradrachm* of Kingdom of Bactria, Antimachos I Theos (r. 171–160 BC)
Silver, 16.9 g
Scher Collection

Fig. 3 *Sestertius* of Servius Galba Caesar Augustus (24 BC–AD 69), with Este collector's mark (obverse), AD 69
Rome mint
Bronze, 26.4 g
Scher Collection

Fig. 4 *Solidus* of Constantius II, Roman Emperor (b. AD 317; r. AD 337–361), ca. AD 353
Rome mint
Gold, 4.5 g
The Metropolitan Museum of Art, New York; Gift of Darius Ogden Mills, 1904 (04.35.18)

leading to the more stylized and symbolic representation of the ruler on Byzantine coinage (figs. 3, 4). In the West, portraiture on coinage essentially disappeared except for the deliberate inclusion of a portrait all'antica, albeit idealized on the coinage of Emperor Frederick II (1194–1250) (fig. 5).

It was the revival of this particular manner of representing the individual in the ancient world that was among the extraordinary contributions made by the Italian Renaissance in the form of the portrait medal. As a mode of expression, it was completely original; within this form, the essence of the Renaissance was expressed to perfection, transmitting within a small, yet complex object the fierce pride and self-conscious dignity of Renaissance men and women. There is, in fact, a certain inevitability about the invention of the portrait medal, which seems to respond to a basic need not only within Renaissance culture but also timelessly and universally. As a means of virtually indestructible communication in multiple examples, the medal contains, in most cases, not only a portrait but also essential information about the subject.

It represents to an astonishing degree the union of a number of closely interconnected elements, namely, the growth of humanism with its intense interest in all phases of classical antiquity, in the course of which collectors encountered and acquired with enthusiasm such ancient artifacts as sculpture, gems, and coins; a revised concept of the dignity of man and his central place in the universe; the appearance of a new realism concurrent with an important change in the status of the artist; and the evolution of the portrait.

In a broader sense, humanism brought a changed attitude toward the dignity of man and a need to find corresponding sources in the ancient world from which these ideas

Fig. 5 *Augustalis* of Frederick II Hohenstaufen, Holy Roman Emperor (b. 1194; r. 1215–50), 1231–50
Gold, 5.28 g
Scher Collection

could be drawn. Self-awareness was a natural consequence of this belief in the concept of individual glory, or *fama*, which was the result of excellence, or *virtus*, and which led to a desire to celebrate one's particular accomplishments and talents and to inspire a passion for fame. The tangible manifestation of this desire appears most clearly in the biographical and descriptive literature of the time, as well as in portrait painting and sculpture, and, supremely, in the portrait medal, which was durable, could be reproduced in quantity, and could be widely distributed in the manner of ancient coins. Certainly, the medal has achieved its purpose in giving immortality to a large number of men and women who might otherwise have disappeared from the stage of history. It has celebrated their power and beauty, their successes and intellectual accomplishments, their family status and dynastic links, their personal skills, courage, hopes, and aspirations, their most valued attributes, the significant events in their lives (births, engagements, marriages, awards, deaths), their religious and philosophical beliefs. All of this was achieved through these small disks of metal, wood, or stone upon which is compressed—either explicitly or by the obscure language of symbol, allegory, or emblem—a wealth of information.

The most successful examples convey the skill of the artist in evoking such complexity within the confines of a tiny disk: the elegance of lettering, the sensitivity of portraiture, the masterful depiction of textures and substances, the pleasing and balanced composition, the richness of narrative. At its best, the medal embodies the basic values of the Renaissance man: purity of style, harmony, dignity, balance, the gravitas so important as a foundation of character.

As early as the late fourteenth century, the impulse to imitate the essentially commemorative nature of ancient coins, particularly Roman, existed in the north of Italy. The proto-humanist Francesco Petrarca (1304–1374) had been collecting Roman coins as evidence of an Italy whose ancient greatness he wished to revive. His influence was undoubtedly felt when Francesco II da Carrara, il Novello, the scion of the ruling family of Padua, liberated the city in 1390 from the occupying forces of Giangaleazzo Visconti of Milan and freed his father, who had been taken prisoner. To commemorate this event, two numismatic objects were struck in the form of the large Roman bronze coin, the *sestertius*, each bearing a portrait, all'antica, of the two Carraras (fig. 6). These precocious pieces had no immediate successors, although they must have attracted considerable attention since an example in lead of one of them makes an unlikely appearance in the inventories of the French royal prince Jean, the Duke of Berry (1340–1416), who, as collector and patron, played an indirect, though significant, role in the evolution of the medal.

In about 1400, the duke purchased several large gold pendants in jewel-encrusted mounts attached to chains for wearing, each representing a Roman emperor and other imperial family members. He subsequently ordered copies to be made in gold (but unmounted) of two of them: the famous medals of Constantine and Heraclius (nos. 504, 505). These were widely circulated and, until the early seventeenth century, considered to be ancient and therefore belonging within the entire known corpus of Roman coinage. As impressive artifacts portraying emperors associated with the life of Christ, they undoubtedly served as models for the Renaissance portrait medal, as did seals, whose format and size, along with their function as important indications of identity and social status, were adopted as another source (figs. 7, 8).

Fig. 6 Medal of Francesco II da Carrara, il Novello, Lord of Padua (1359–1406), dated June 19, 1390
Bronze, 35 mm
Münzkabinett, Staatliche Museen zu Berlin

Fig. 7 Seal of Jean de France,
Duke of Berry (1340–1416),
ca. 1400
Colored plaster copy, 89.4 mm
(without rim)
Scher Collection

Fig. 8 Niccolò di Forzore Spinelli
(called Niccolò Fiorentino), seal
of Charles the Bold, Duke of
Burgundy (1433–1477), ca. 1450
Colored plaster copy, 115.2 mm
Scher Collection

The true history of the Renaissance portrait medal, however, is generally thought to have begun in 1438 or 1439, with the celebrated painter Antonio di Puccio Pisano, called Pisanello (ca. 1395–1455), who also collected Roman coins. In order to commemorate the presence in Ferrara of the emperor of the eastern Roman Empire, John VIII Paleologus, Pisanello created what was certainly meant to represent the latest in the long line of imperial, commemorative numismatic objects. It was, instead, with great originality, a relatively large, cast, disk with a portrait of the emperor in contemporary dress on the obverse and a scene on the reverse showing him on horseback praying before a wayside crucifix (no. 1).

The effect of this extraordinary creation was immediate and widespread. Pisanello, in his mid-forties and well advanced in his career when he made his first medal, would proceed to produce at least twenty-three more, traveling to the north Italian principalities—Ferrara, Mantua, Milan, Rimini—and finally serving Alfonso of Aragon, the Magnanimous, in Naples before ending his career in Rome, where he died (nos. 2–11). Almost immediately, other artists began to craft medals for a wide variety of patrons in Italy, frequently moving from city to city, engaging in a range of activities besides making medals. We find sculptors, painters, die engravers, mint masters, jewelers, gem engravers, goldsmiths, architects, and pure amateurs all engaged in the production of medals.

Until the early sixteenth century and the introduction of the screw press—which replaced the striking of coins by hand—medals, unlike coins, were produced by the casting method, which consists of pouring molten metal into a mold. With the screw press, medals, as well as coins, were struck from dies by both government and private mints. In each case, the conditions and results varied considerably.

The desire for medals quickly spread from Italian examples to those from other European countries. The impulse to record one's features that was present in Italy, to establish one's unique presence, was an integral part of humanist philosophy further north as well and was expressed clearly by Maximilian I, Holy Roman Emperor (r. 1508–19): "The man who makes himself no memorial in life is forgotten with the tolling of his death bell."

Although Italian medals were known in Germany by the mid-fifteenth century, medals were not produced there until about fifty years later. Although one can speak of a German Renaissance in learning, literature, and the arts over a period of time beginning as early as the fourteenth century, the effect of such efforts on the visual arts varied greatly. With very few exceptions, the influence of the Italian Renaissance on architecture and sculpture was minimal and did not displace the dominant Gothic style throughout the sixteenth century, and perhaps not until the eighteenth century. In painting and the graphic arts, on the other hand, Germany produced a spectacular group of artists who worked during the first three decades of the sixteenth century, dominated by the figure of Albrecht Dürer, who traveled in Italy and was intimate with a circle of humanists. Not all of these artists drew upon classical or Italian models, and one must therefore use the term "German Renaissance" judiciously and recognize the distinctly northern character of that art.

In most aspects, German Renaissance medals are distinctly different from their Italian counterparts. Although cast, they are generally made from stone or wood models carved in fine detail with brilliant technique, in contrast to the more common use of wax or plaster for models in other countries. Yet despite their foundation in humanist thought,

German medals rarely display the same complex imagery and intellectual sophistication found in Italian medals. Only in rare cases does the reverse show anything other than a heraldic achievement. Instead, attention is focused on the portrait, which is usually uncompromisingly, even brutally, realistic (see, for example, no. 340).

The medallic art of the seventeenth and eighteenth centuries in Germany and Austria is represented in the collection by only a small number of examples. Commissioned by the rulers of the many principalities of what later became Germany, the medals (usually struck and in silver) are, for the most part, mediocre. Of particular note, however, is a large group by the German artist Sebastian Dadler (1586–1657), an extraordinary technician who recorded many of the events and people involved in the Thirty Years' War (1618–48), a devastating conflict that involved most of the European countries. With his ability to represent numerous tiny details within masterfully organized compositions, Dadler brought the large, struck medal to a new level of technical brilliance, producing an amazing chronicle not only of the war but also of other significant events of the period (see, for example, no. 381). Anton Franz Widemann (1724–1792) is the highly competent author of another large group of medals in the collection, recording the portraits and important events in the lives of members of the family of the Hapsburg Empress of the Holy Roman Empire, Maria Theresia (1717–1780) (see no. 452).

Although the collection possesses only a few examples, I was also particularly attracted to the medals of Franz Andreas Schega (1711–1787), who worked for the Bavarian court in Munich. These display a particularly animated Rococo style combined with excellent portraiture (nos. 444–448).

At the beginning of the sixteenth century, Lyon, with its large Italian colony, became a center of medallic production, issuing such impressive medals as that commemorating the visit to the city in 1500 (no. 507) of Louis XII and Anne of Brittany, which shows a mixture of Gothic and Renaissance elements, and, later, portraits of members of the city's Italian community (nos. 513, 515). It was not, however, until the last quarter of the sixteenth century that a truly significant figure appeared in France, the great Renaissance sculptor Germain Pilon (ca. 1525–1590). In 1577, Pilon produced a large and splendid medallion with the portrait of René de Birague, Chancellor of France (see fig. 20). Related to this triumph of portraiture and medallic art is a series of dramatic uniface portrait medallions of members of the house of Valois that has been attributed to Pilon (no. 526).[2]

The scale and quality of these pieces had an undoubted effect on the greatest of French medalists and indeed one of the greatest of all medalists anywhere, Guillaume Dupré (ca. 1579–1640). Dupré drew upon the accomplishments of the great sixteenth-century Italians to reach a peak of technical virtuosity about 1600 and bring to a close, until the nineteenth century, the entire tradition of the cast medal (nos. 532–550).

The flowering of the cast medal in France ends with Jean Warin (1606–1672), who also established the tradition of the endless, often tedious, series of royal struck medals institutionalized by Louis XIV. Warin's cast medals include a number of very impressive compositions, all in the manner of Dupré but giving nothing away in quality and perhaps even gaining a slight edge in sympathetic portraiture (nos. 575–584).

The revival of the cast medal initiated by Pierre-Jean David d'Angers (1788–1856), with his production of large medallions depicting five hundred prominent people of his

time (nos. 653–662), placed the medal squarely in the realm of sculpture and was followed by an era of significant contribution to the art of the medal by such important sculptors as Alexandre Charpentier (1856–1909), Jules-Clément Chaplain (1839–1909) (nos. 679–690), Louis-Oscar Roty (1846–1911) (nos. 691–695), and François-Joseph-Hubert Ponscarme (1827–1903) (nos. 674, 675). The best of these artists produced sensitively individualized portraits with imaginatively conceived and well-composed narrative scenes.

I was always particularly fascinated with the medallic art of the seventeenth-century Dutch Golden Age because of its highly original formal attributes and production methods. Medals of the Low Countries are represented in this collection by two distinct groups dating from the sixteenth and the seventeenth centuries. The first group was influenced strongly by Italian artists, some of whom—such as Leone Leoni (1509–1590) (nos. 164–171) and Jacopo Nizzola da Trezzo (1519–1589) (nos. 174–179)—worked for the same Hapsburg rulers who governed the Holy Roman Empire, including the Netherlands. The greatest among the Dutch artists working in this tradition was Jacques Jonghelinck (1530–1606), who had worked in Leoni's studio in Milan in 1552 (nos. 720–730). Both Steven van Herwijk (ca. 1530–1565/67) (nos. 715–717) and Conrad Bloc (ca. 1545–after 1602) (nos. 732–733) also produced admirable medals.

Beginning in the last third of the sixteenth century, the struggle for independence from Spain of the seven northern provinces of the Low Countries gave birth to an intense production of medals that chronicled every aspect of the conflict and its participants. The seven provinces, especially Holland and Zeeland, would achieve an international supremacy in naval power and build a vast commercial empire, accumulating enormous wealth and creating a rich culture that would be known as the Dutch Golden Age. The fabrication of medals during this period would become almost an obsession, with great leaders, famous soldiers and admirals, important events, satirical comments, even the mundane moments of everyday life recorded and widely circulated. Almost invariably the material was silver, and many of the medalists were silversmiths—among them, Johannes (or Jan) Lutma the Elder (ca. 1584–1669) (no. 743), Wouter Muller (1604–1673) (nos. 749–758), and Pieter van Abeele (1608–1684) (nos. 764–778)—leading to the development of a highly original and distinct method of production: the casting of two uniface silver shells that were then soldered together. High relief and facing or three-quarter portraits were also a distinct feature of Dutch medals, using painted portraits as their inspiration. Improved methods for striking also allowed for the issuing of large medals with a profusion of tiny details.

The appearance and evolution of the medal in England is represented in the collection by a small selection of examples from the sixteenth to the nineteenth centuries. In its earliest manifestations, medallic art in England was produced primarily by foreign artists—Netherlandish, French, and German—resident in England (no. 717), whereas in succeeding centuries it would become a domestic industry in the hands of the Simon brothers (no. 830) and the Wyon (no. 847) and Pingo families (nos. 840, 841, 844, 847, 848), to name only three of the most important. They produced a series of struck medals, often reaching impressive levels of technical brilliance and crisp purity of design.

Finally, emphasizing the idiosyncratic character of the collection represented by a diversity of artists and dates, there are medals from Russia and the Scandinavian countries,

primarily from the seventeenth and eighteenth centuries (nos. 852–872), as well as medals from Switzerland, Mexico, and the United States.

THE FUTURE OF THE MEDAL AND MEDALLIC STUDIES

Although this publication records the bulk of my collection, ending in the nineteenth century, I have not been unaware of the evolution of medallic art in the modern era and have, indeed, acquired pieces by contemporary artists. The medal has evolved in the same way as other aspects of the visual arts—with the introduction of new materials, forms, and means of visual communication—so that its traditional appearance and purpose have been profoundly transformed. If it has been our purpose to present the traditional medal as a form of sculpture, for some time now artists have been designating small works of sculpture as a type of medal, so that the definition of the form has become almost completely shattered. If the contemporary medal need not be made of metal, if it need not have two sides, if its shape is held to no traditional form, if a portrait is not expected, if indeed no inscriptions are required, then what is left to enable one to classify an object as a medal? Allowing for all the changes that have transformed the traditional components of a medal, the one constant among objects to which the term "medal" can be applied is that they be commemorative in some way—not an ideal definition but one that could serve for the time being.

In 1994, I organized the exhibition *The Currency of Fame: Portrait Medals of the Renaissance*, which included many of the finest examples of fifteenth- and sixteenth-century medallic art from Italy, Germany, France, the Netherlands, and England. Presented at three major museums, *The Currency of Fame* was intended to bring to the attention of both the scholar and the general public the special nature and beauty of these objects, their art-historical importance, and their singular complexity. The exhibition was accompanied by an illustrated catalogue containing introductory essays and detailed entries for each medal written by specialists including numismatists but also art historians and curators.[3] Placing such a bright and exclusive spotlight on the subject seemed to produce significant reactions in both the scholarly approach and the physical presentation of the medal. Medals have since been included as key components in exhibitions on portraiture, as significant examples of particular cultures in permanent and temporary museum installations, and as an important subject to be addressed in scholarly art-historical publications that are not exclusively devoted to numismatics.[4]

Yet despite the publication of such scholarly catalogues as Mark Jones's study of French medals in the British Museum,[5] Philip Attwood's extraordinary work on Italian medals of the sixteenth century in British collections,[6] the recent, impressive catalogue of the exhibition *Wettstreit in Erz: Porträtmedaillen der deutschen Renaissance* at the Münzsammlung in Munich, the stream of books about Pisanello, and the articles in the British Art Medal Society's journal *The Medal,* much remains to be done.

What is required, in fact, are more detailed studies: monographs on artists and works dealing in greater depth with specific periods or schools of medallic art and related to other aspects of art and cultural history. The interpretation of the often complex iconography of medals is a field unto itself, taking us into the mysteries of emblems and devices, symbols and allegories, behind which hide not only insights into the subject of the medal but also

the presence of other minds acting in an advisory capacity, revealing methods of thought particular to a given time and place. Questions of long-accepted yet controversial attributions need to be re-examined from an art-historical point of view. Finally, the contribution of the medal and all the information it compresses within its small surface must be included in an examination of the development and nature of portraiture. Certainly the medal is an ideal illustration of the dictum MULTUM IN PARVO (Much in Little).

Notes
1 J. Burckhardt 1951.
2 Scher 1993b.
3 Scher 1994.
4 See, for example, the catalogues for the following exhibitions, where medals played an important role: *Virtue and Beauty: Leonardo's Ginevra de' Benci and Renaissance Portraits of Women* (National Gallery of Art, Washington, 2001–2); *Renaissance Faces: Van Eyck to Titian* (National Gallery, London, 2008–9); and *The Renaissance Portrait from Donatello to Bellini* (The Metropolitan Museum of Art, New York, 2011). There has also been significant inclusion of medals in new installations in the Department of European Paintings and the Department of European Sculpture and Decorative Arts at the Metropolitan Museum of Art, and at the Yale Center for British Art, New Haven, and important displays of medals in the following exhibitions: *The Critique of Reason: Romantic Art, 1760–1860* (Yale University Art Gallery, New Haven, 2015) and the remarkable exhibition of German Renaissance medals *Wettstreit in Erz: Porträtmedaillen der deutschen Renaissance* (Staatliche Münzsammlung, Munich, 2013–14).
5 M. Jones 1982–88.
6 Attwood 2003.

Note to the Reader

Aimee Ng

ORGANIZATION

The entries in this volume are divided into geographic sections based on present-day borders, and each section (with the exception of the final one) is preceded by an essay pertaining to the history of medals of that region. Because of the evolution of national borders since the fifteenth century and the crossing of these borders by artists, patrons, sitters, and medals, such simple geographic divisions belie a much more complex history of the regions and their medals. In general, the sequence of entries within sections is determined by the birth dates or active dates of artists. The largest section, Italy, is subdivided into schools based on artistic centers. The medals of Germany and Austria are roughly divided into regions. The section on the Netherlands, whose present-day borders do not reflect the region in the sixteenth and seventeenth centuries, includes medals by artists who would be identified with present-day Belgium. Scandinavian countries are grouped together with Russia. The unusual grouping of the section with the medals of Switzerland, Mexico, and the United States represents the small but strong holdings of the Scher Collection in these areas.

In general, the entries are classified according to the nationality of the artist. The few significant exceptions include artists who worked primarily in a geographic area other than their region of birth, such as Simon de Passe (who was Dutch but worked primarily in England) and Giovanni Battista Nini (who was Italian but worked primarily in France). Their medals will be found in their primary place of work. In the case of unknown artists, regions or cultures of origin are suggested within parenthesis, and the medals are included in the most probable geographic section. This catalogue prioritizes the makers of medals over their subjects; thus the work of a single artist is grouped together and sequenced roughly chronologically, even if the artist traveled widely and worked in several European centers. One exception is the Napoleonic medals in the France section; the medals by a single artist, such as Bertrand Andrieu, are interspersed with the work of others in a chronological presentation of the commemorated events. Collaborations between artists (especially those of different geographic origins) have been dealt with on a case-by-case basis, though typically the medal appears in the section in which the commemorated person or event makes most sense. The index of artists at the end of this volume can assist with navigation.

DATING

It is extremely difficult to determine with certainty the production date of a medal, as it can be long after the creation of the first example, and commemorative dates inscribed on medals sometimes have little to do with the date of production. When a date appears on a medal, the entry will read, "Dated XXXX," though this does not denote that the medal was necessarily produced on that date. When a range of dates appears on a medal (for example,

the commemoration of a life span, centenary, or series of events), the medal is "dated" the latest of these dates, and, when possible or necessary, more precise information regarding the production date of the model or type is given. Chronograms (textual inscriptions in which certain Roman characters combine to give a date) are indicated with bolded text for the relevant characters.

DIMENSIONS AND MATERIALS

Dimensions of medals are given in millimeters and represent the external diameter unless otherwise noted. Measuring the internal dimensions, though a preferred method for comparison with other examples of a medal type, was not possible during this undertaking. The external dimensions given in each entry represent the largest external diameter consistently obtained when measuring circular medals at their widest perceptible point (which is, of course, imperceptible on examples nearing perfect geometry). Dimensions do not include loops or any additions to the edge of a medal unless otherwise indicated.

A small number of commemorative coins are included in the catalogue with the justification that, though they correspond to coin weights, they are very much like medals. Coin weights are recorded in grams, and the type of coin is given when known.

Technical analysis of all the medals included in the catalogue was not possible, though a number of them have been analyzed by XRF (X-ray fluorescence), and these examinations continue. "Copper alloy" is used to describe medals of bronze or brass that have not yet been analyzed.

DESCRIPTIONS AND IMAGES

Descriptions of medals are confined to their most distinctive features. Portraits without distinguishing attributes or dress are not described, leaving the illustration to suffice. Only the obverse description and image of uniface medals are included unless significant inscriptions or other marks appear on the back of the medal. Reverses of incuse reverse cast medals (with a relief on the obverse and a nearly exact negative hollowed on the reverse) are not illustrated. All medals in the catalogue section are, however, illustrated at actual size, unless, as in the case of the Augustus Saint-Gaudens medal of Robert Louis Stevenson, the medal is larger than this book. Reverses are illustrated to the right of obverses. The orientation of the reverse is always presented in the same orientation as the obverse, even if on the object itself the reverse is inverted or at a different angle to the obverse.

INSCRIPTIONS

Inscriptions are transcribed in uppercase letters without stops unless they are grammatically significant. The completion of abbreviated words is indicated by expanded text in lowercase letters within square brackets (for example, D[ei] G[ratia]). Where a symbol abbreviation appears on the medal's inscription, the symbol is not transcribed but is converted into the letters it represents and presented as uppercase letters within square brackets (for example, Q3 is transcribed as Q[UE]). Biblical passages are given using the King James Bible translation unless otherwise indicated. Greek characters are transcribed as they appear on the medal and translated into English without phonetic transcriptions or translation into modern Greek. Inscriptions in Cyrillic script, however, are translated into modern Russian

and English. Translations contained herein for the most part aim for faithfulness to the original in balance with clarity in English and with consideration of the medal's context.

LITERATURE AND COMMENTARY

Selected literature on each medal is included in the entries, with emphasis on major catalogues and recent scholarship, in which previous literature may be found. Literature on variants is indicated with "(var.)," and in the few cases in which the particular specimen treated here is published in previous scholarship, this is noted. Medals that appear to be unpublished are not given a field for literature. As in any collaboration among a number of authors, individual characteristics of each author introduce diversity to the treatment of the material; some authors deemed a wider range of bibliographic references essential. The commentary in each entry aims to present the basic purpose of the medal, when known; otherwise, a brief biographical account is given. The diversity of objects in this collection— and of their treatment in scholarship—is reflected in the varied length and character of the entries.

Depicted individuals may carry several titles, at times concurrently, and may be known by various names in multiple languages (for example, Marie de Medicis; Maria de' Medici). As much as is possible, the most popular versions of names are given, as well as the most relevant titles (and dates of reign or power) in the subject field of the commentary.

COATS OF ARMS AND PROVENANCE

Coats of arms are identified whenever possible. An ongoing project to blazon each coat of arms that appears on the medals will result in a future resource intended to accompany this catalogue; R. Theo Margelony, Associate Administrator in the Department of Medieval Art and the Cloisters, the Metropolitan Museum of Art, is preparing these. Establishing as fully as possible the provenance of the medals is also part of an ongoing project to continue to update technical information, changing attributions (especially of currently unattributed medals), and interpretation.

ITALY

ART AT ITS APEX

The Medals of Italy

Ulrich Pfisterer

The Italian medal reached its zenith as an artistic medium around the turn of the year 1560/61. Fifteen years earlier, Michelangelo had allegedly remarked, in relation to Alessandro Cesati's medal of Paul III, that art had reached its apex, and indeed its endpoint, and that one "could not see anything better."[1] In terms of the number of medals produced, there was also clearly an especially intense interest in medals in Italy from the 1550s on.[2] But now Il Divino himself, who had brought all the arts of *disegno* to perfection, received a portrait medal—a medal that, despite his otherwise critical regard for portraits, evidently satisfied him.[3] Michelangelo indeed appears to have been involved in its conception. Few other circumstances would explain the presence of his personal emblem on the reverse of the medal (no. 171). It shows a blind, heroic, half-naked pilgrim with a staff and a dog. The inscription surrounding the image quotes a verse from Psalm 51:13 (Vulgate 50:15), which bears the promise to redeem sins on the proper path.[4] If Michelangelo, as a young man, already had the audacity to compare himself to the Old Testament shepherd boy David in the monumental statue of 1501–4, now in old age he appears to recognize in himself the sins of the aged King David.[5] With a Christian gesture of submission by an artist anticipating death, the potential of the emblem is not yet exhausted: the pilgrim, decked in his antique nakedness in only a coat and accompanied by a dog, could, alongside the biblical interpretation, also evoke a pagan image of exemplary virtue implicitly compared to the ascetic Michelangelo: the philosopher Diogenes, the epitome of modest living, to whom the Cynics reportedly gave the nickname *kyon* (Greek: "dog"). After all, fifteenth-century Italy connected the concept of "pilgrimage" and the related adjective *pellegrino* to notions of the unknown, the surprising, and the new—all qualities that Michelangelo the artist prized.[6]

It is no coincidence that it was Leone Leoni's medal of Michelangelo (no. 171) that stirred the interest of Stephen K. Scher. Steve has not merely tried to assemble as many pieces or complete series (such as the papal medals) as possible. Rather, he seems to have approached medal acquisition with an interest in the artistic quality and the particular execution of each individual work—in a certain sense, he cultivated a Michelangelo-like perspective, an approach that strives toward an art of the medal in which one "could not

see anything better." It is against that backdrop that this introduction to the Italian medals breaks from the master narrative about the medal in Italy and focuses instead on the question of the artistic challenge of the medium and the medalist's (self)representational possibilities.

SOCIAL MEDIA

The Leoni medal testifies to Michelangelo's endeavor to secure his reputation for posterity. To that end, after the 1540s, his portrait played an increasing role. After 1545, Giulio Bonasone published multiple printed portraits of the master (Michelangelo's competitor Raphael had already received such a reproducible portrait from Bonasone about ten years earlier).[7]

Not only did the medal function as a conduit for self-promotion, it also reflected a growing interest in portraiture. People were increasingly dissatisfied with learning about the lives of famous historical men and women from texts alone: they also wanted images. Paolo Giovio, who began to collect portraits about 1512, quickly amassed about five hundred such works for a "musaeum" on Lake Como built between 1537 and 1543, which is regarded as the foremost example of the new demand for portraiture.[8] Collections of portraits nevertheless only became a "mass phenomenon" through the new reproductive media of print and medals. Admittedly, the printed portrait did not enjoy the same success or wide proliferation in sixteenth-century Italy as it did north of the Alps. In Italy, the medal was far more preferred as a portrait medium. This did not, however, diminish the success of the new genre of the illustrated book of lives, which combined printed portrait with biographical text.[9] Tellingly, a publication on the ancient caesars with pseudo-antique coin portraits, published by Andrea Fulvio with the title *Illustrium Imagines* (Rome, 1517), stands at the beginning of this genre. Yet historical works also increasingly attested, through their illustrations, to the power of coins and medals.

Compensatory medals, which served to fill the holes in a genealogical line or collection, began to appear after about 1500. Entire medal series that conveyed coherent historical narratives, or *histoires métalliques,* were produced in Florence and papal Bologna as early as the second half of the sixteenth century.[10] The popes recognized the potential for the new medium of the medal quite early and wielded it on every front: Paul II appears to have instituted the "indulgence penny." Sixtus IV issued the first architectural medals.[11] In the seventeenth century, the printed papal biographies received sophisticated illustrations with synoptic anthologies of medals, which presented, at a glance, something akin to the whole spectrum of papal architectural patronage (fig. 9).[12] The new contexts of collecting and seriality were in part responsible for this, for after the middle of the sixteenth century, a significant number of medals were produced with only one decorated side, as in medals by Pastorino de' Pastorini (no.102).

A wide spectrum of materials was employed in the production of medals; alongside gold and other metals, including lead, media as diverse as plaster, papier-mâché, and leather were also used. If one considers that in a collection of cast portraits, the materials and optical differences between contemporary medals, antique coins, works of goldsmithing, and glyptic portraits were equalized, then the reasons why the early modern period did not draw stark terminological distinctions between these categories makes more sense.[13] The diversity of materials also allowed for the medals to be employed in myriad contexts: from the representative "state gift" that might be worn on a chain, to inclusion in the *studiolo*

Fig. 9 Medals for the building projects of Pope Alexander VII. From Alfonso Chacón, *Vitae et res gestae pontificum Romanorum*, vol. 4, cols. 719–20 (Rome 1677)

of a scholar, to the devotional collection of a pious person, to the architectural medal, to the cheap embellishment of an everyday object. This is why Pietro Aretino, feigning indignation, complained in 1545 that his portrait medal, like those of Caesar and Alexander, now also appeared on comb boxes.[14] All in all, it is clear that while Jacob Burckhardt struck an important point with his characterization of the medal as the "currency of fame," when it comes to medals, far more than reputation mattered. As signs of social relationships, historical witnesses, decoration pieces, and demonstrative artistic objects, medals were the "social currency" of the early modern period—a social medium *avant la lettre*.[15]

To what extent Michelangelo already appreciated this is impossible to determine. The history of reception is, then, all the more informative. It was, after all, to medals, not engravings, that Vasari referred when he said that so many examples were produced that he had seen specimens in many places in Italy.[16] And while the printed Italian portrait types of Michelangelo proliferated outside of Italy only in the years around 1600,[17] Leoni's medal immediately provoked a reaction: indeed, in the very year of its production, 1561, Lambert Suavius printed a portrait of Michelangelo in the form of a medal—which is clearly based on Leoni's likeness of 1560–61—falsely listing, as does the medal, Michelangelo's age as "88" (fig. 10).[18] This print was likely accompanied by two other paper medals: one of Suavius's brother-in-law Lambert Lombard (fig. 11) and one of Dürer (fig. 12). Suavius does not merely present Lombard as a representative of the Netherlandish school of painters in relation to the two "stars" of the Italian and German schools, though a "face-off" does occur in the right-facing position of Lombard's portrait relative to the left-facing Michelangelo and Dürer. More important, what we see here is the earliest known printed series of artists' portraits, produced even before the appearance of those of Vasari (1568) and Lampsonius (1572). Ultimately, it is clear that the medal was appreciated as the ennobling portrait form *par excellence*—even in the case of "mere paper medals."[19]

ARTISTIC PROMOTION

Michelangelo received the Leoni medal as a gift from Leoni, who was a Milan-based goldsmith and sculptor. In the letter of March 14, 1561, that accompanied the gift, Leoni divulged his motivations: it was given "out of love," in honor of and in gratitude to Michelangelo, who served as an artistic model and mentor and who had also recommended Leoni for a papal commission.[20] In order to prove this visually to Michelangelo, Leoni had re-worked the silver medal especially carefully. Evidently, this was an absolute exception; Leoni otherwise had no scruples about admitting freely to those who commissioned his works that the medals were not perfect in terms of their execution.[21] In contrast to the medal that Leoni conveyed to the older artist as a token of *amicitia*, examples of the Michelangelo medal sent to Spain and Flanders and prominently marked with "LEO" he gave primarily "out of ambition." These objects served as tokens of Leoni's artistic generosity and talent and signaled his claim to be Michelangelo's successor in the field of sculpture.

Fig. 10 Lambert Suavius,
Paper Medal of Michelangelo Buonarroti, 1561
Engraving, 100 mm
British Museum, London

Fig. 11 Lambert Suavius,
Paper Medal of Lambert Lombard, not dated
Engraving, 98 mm
Université de Liège, Belgium;
Collections artistiques

Fig. 12 Lambert Suavius,
Paper Medal of Albrecht Dürer, not dated
Engraving, 97 mm
Université de Liège, Belgium;
Collections artistiques

The history of the medal in Italy can largely be understood in terms of artistic test-pieces and self-representation. This is true at the inception of the genre, for alongside the famous medals made for the Carraras in Padua and the two examples of Constantine and Heraclius in the collection of the Duke of Berry (nos. 504, 505), Lorenzo and Marco Sesto struck, at the beginning of their engagement with coins in Venice in 1393, two small pieces showing antique emperors' busts on one side and the personification of Venice on the other. The relevance of antique coins, which Italians began studying again in the age of Petrarch (at the very latest), is evident for all of these early specimens. Both pieces by the Sestos are signed, and the work by Marco is moreover marked with the family sign, the circle (*sesto*) (fig. 13). These medals were less about following antique models as precisely as possible than about staging a demonstrative performance of the artist's own abilities in comparison to the skill of ancient masters.[22]

The origins of the cast medal are controversial. Most researchers indicate Pisanello's medal of John VIII Paleologus (no. 1), produced in commemoration of the Council of Ferrara/Florence in 1438–39, as the beginning of the form. Nevertheless, it is possible that Pisanello already completed his first medal, for Filippo Maria Visconti, in Rome, in 1431–32, all the more so because a particularly fruitful context for the new forms of antique-style self-fashioning existed there.[23] It was no coincidence that at the same time (in connection with his appointment as *scriptor apostolicus*) Leon Battista Alberti executed his famous self-portrait plaquette. Alberti also experimented with a small pendant, which showed his image on both sides—one all'antica and one in contemporary dress—which likely functioned as a gift of friendship.[24] At the beginning of the 1440s, Filarete signed his bronze doors for old St. Peter's with a pseudo-medal and moreover appears from this time on to have produced medals all'antica, which—unlike the pieces of Pisanello—took antique *sestercii* as models.[25]

When Filarete made an actual self-portrait medal in 1460, he found himself in the company of the enigmatic Giovanni Boldù. Pisanello had, by this point, been immortalized in two medals that surprisingly stem not from the artist himself but from his students—there is no other explanation for the diminished quality and the stylistic departure of the works. There followed a full line of other artists' medals, which were in part executed by masters other than those they depicted: Lysippus, also known as Hermes Flavius de Bonis (1473), Candida (ca. 1470), the Bellinis (1480s–90s), Bramante (ca. 1506), Vittore Gambello (1508; no. 44), Valerio Belli (mid-16th century; no. 140), Andrea Riccio (1530s?), and others.[26] If the challenge of these works is often that the precise context of their creation is unknown, Alessandro Vittoria's medals—among which is a self-portrait medal with the likeness of his painter friend Bernardino India on the reverse—can at least be shown to have arisen as showpieces at the beginning of his career.[27]

Leone Leoni, meanwhile, produced medals for at least two and half decades.[28] From earlier pieces, such as the works for Pietro Aretino and Titian, it is possible to confirm that Leoni likewise strove for self-promotion. This is also present in the medals that Leoni allegedly produced as a token of gratitude to Andrea Doria after his release from the galleys in 1540–41. On the reverse of one version (no. 166), he seems to show his likeness surrounded by the shackles of the former prisoner. This surprising commemoration of the punishment can be explained in light of the new social position of the exceptional

artist: the "artist as criminal" stands, on the basis of his outstanding abilities, outside of the norm.[29] The medal of Baccio Bandinelli (no. 168) likewise belongs to this early period: that Bandinelli's quote of choice on the reverse of the medal should be CHANDOR ILLESVS (Unimpaired radiance), the former motto of Clement VII, is best explained by the fact that, in 1536, Bandinelli finally managed to wrest the commission for the epitaph of his former patron from his competitor Alfonso Lombardi. Bandinelli's artistic "radiance" countered all who stood in his way.[30]

As rich as this series of artist medals may be, Leoni's Michelangelo medal appears to have made an extraordinary impression on its 1561 debut. Not only was it the reason that Vasari also wanted his own portrait medal from Leoni; in Milan, other artists such as Girolamo Figino (1562; no. 120) and Giovanni Paolo Lomazzo (1561–62 [?] and 1562) added to this tradition of medals.

Artists were not the only ones who occupied themselves with the medium and its formal possibilities. Contact with coins and medals evidently had a decisive impact on the "education of the eye." Even if one only had the means to possess a modest collection, it was easy to compare the pieces and order them in a new way.[31] The combination of different coins and medals moreover allowed stylistic and qualitative differences to come to the fore. The fact that ever more effective imitations and indeed deliberate fakes of antique coins were put in circulation over the course of the sixteenth century—with Giovanni da Cavino as the most ingenious interpreter and Padua as the center of production— led to a new sharpness of critical assessment (fig. 14). These qualities, combined with the ubiquity of coins and medals on the writing desks of scholars, literary figures, and artists, made the objects among the most preferred subjects of literary, historical, and art-theoretical reflections: individuals investigated the *paragone* between coins and medals and painting, sculpture or text, as well as the evocative power of portraits, whose invention and composition were compared to those of emblems in terms of the interplay between their images and inscriptions.[32]

The interest in artists' portraits on Italian medals continued all the way up to the time of Antonio Canova (nos. 252 and 253), Italy's most important neoclassical artist. This is telling in another regard: between 1813 and 1818, Leopoldo Cicognara published his *Storia della Scultura dal suo risorgimento in Italia sino al secolo di Napoleone*, beginning with Donatello and ending with Canova. In this first-ever history of sculpture, medals are a component. A chapter is dedicated to medalists and gem-cutters, as was already the case in Vasari's 1568

Fig. 13 Marco Sesto, *Galba*, 1393
Bronze, 33 mm
American Numismatic Society, New York

Fig. 14 Giovanni da Cavino, *Faustina Junior*, early–mid-16th century
Bronze, 35 mm
National Gallery of Art, Washington; Kress Collection

Fig. 15 The historical development of sculpture as demonstrated by medals and gems. From Jean Baptiste Louis Georges Seroux d'Agincourt, *Histoire de l'art par les monumens, depuis sa décadence au IVe siècle jusqu'à son renouvellement au XVIe* vol. 4, pl. XLVIII (Paris 1810–23)

second edition of the *Vite*. Jean B.L.G. Seroux d'Agincourt's contemporaneous *Histoire de l'art par les monumens, depuis sa décadence au IVe siècle jusqu'à son renouvellement au XVIe* (1810–23) expanded on Cicognara's contribution with the first synoptic table of seventy-three coins, medals, and cut stones used to visualize the stylistic development of art from the time of Augustus to that of Leo X (fig. 15). With this work, the artistic pretensions of the medal from the Renaissance up to the early nineteenth century were regarded as a significant component of art history's collective horizons. Afterward, medals nevertheless increasingly disappeared from the narrative of the emerging discipline of art history and were, for two hundred years, more or less exclusively a subject of numismatic studies—and then only as objects of iconographic interest. A changed appreciation for these works has come about in the last two decades. The challenge remains this: to integrate medals of the early modern period into art history in the sense in which Michelangelo saw them—that is, as an "apex of art."

Notes

1 Vasari 1966–87, 4: 628; nevertheless, Vasari also writes in his *Life of Leone Leoni* (6: 201) that Leoni has moved from medals to "more important works."

2 On this phenomenon, see Attwood 2003, 1: 17; see also Hill 1930; Toderi and Vannel 2000; and Vannel and Toderi 2003–7.

3 Most recently, Attwood 2003, 1: 111–12, no. 61; A. Schumacher 2004, 169–94; Helas 2007; Fenichel 2016.

4 Because Paolo Giovio's treatment of *impresa* in *Dialogo delle imprese militari et amorose* first appeared in 1555 (Lyon 1559), it is not possible to speak of a concrete theory of the genre as already existing in 1560. Michelangelo's emblem would not have fulfilled Giovio's five fundamental rules for a good *imprese*. Giovio gives as a fourth criterion that the body should not be used under any circumstances.

5 I. Lavin 1993.

6 See, above all, Helas 2007; interestingly, it appears that the medals of the young Lomazzo (see below) show this nude with a knotted coat in the style of Cynical philosophers.

7 Steinmann 1913, 42–43, pls. 37–39; Emison 2004, 189–92.

8 Klinger 1998; Cannata 2014.

9 Cunnally 1999; Pelc 2002; Casini 2004.

10 C. Johnson 1976; R. Tuttle 1987; Kagan 1999.

11 On Paul II, see Pfisterer 2008, 240–44; on the popes in general, see Modesti 2002–4; Alteri 2004.

12 The model for this was the illuminated lives of antique Caesars from the later fifteenth century onward, whose coin impressions were imagined as a kind of "table of contents" of their deeds; on the seventeenth century, see Simonato 2008.

13 McCrory 1999.

14 Aretino 1957–60, 2: 234. See Syson and Thornton 2001; Collareta 2014.

15 Burckhardt speaks of the "Scheidemünze des Ruhmes" in the posthumously published *Beiträge zur Kunstgeschichte von Italien* (1898); see J. Burckhardt 2000, 361. See also Scher 1994.

16 Vasari 1966–87, 4: 101.

17 The two early northern portrait prints of Michelangelo do not reproduce printed Italian prototypes; see Léon Davent's *Portrait of Michelangelo Aged 23* and Reusner 1589, fol. R4ʳ. It was only with Leonard Gaultier's print from between 1600 and 1630, made after Martino Rota's reproduction of the *Last Judgment* with a portrait medallion of Michelangelo, that a print explicitly reproduced a graphic model from Italy.

18 On the symbolism of the age of eighty-eight, see Schumacher 2004; on Suavius and his prints, see Steinmann 1913, 52–53; Boon 1984, 185–87, nos. 75, 76, and 78. Unfortunately, Hollstein only describes another iteration of the print, where Michelangelo's age is given as "LXXI." For these copies of Michelangelo's, as well as Dürer's, paper medals by the Wierix family, see Van der Stock and Leesberg 2004, pt. 9, 232 (no. 2079) and pt. 10, 234 (no. R54). While partly based on the medal of Hans Schwarz (1519–20), the paper medal of Dürer also incorporates elements from the engraving of Melchior Lorck (1550). The next "paper medal" of Michelangelo in *Promptuaire des médalles des plus renommées personnes–Seconde Partie* (1577; 2nd ed., Lyon: Guillaume Rouillé, 1581, 211) differs substantially from Leoni's model.

19 Viljoen 2003, 203–26.

20 Gotti 1875, 1: 346: "Mando a V.S. [Michelangelo] . . . quatro medaglie de la vostra efiggie: le due sarano d'argento e l'arltre due di bronzo . . . Quella che è nel bossolo è tutta rinettata et la guarderà e conservarà per amor mio. L'altre tre ne farà ciò che gli parerà; perciochè, sendo ch'io per ambitione ne ho mandate in Spagna et in Fiandra, cosi per amore ne terò mandate a Roma et in altre parte. Dissi ambitione, per ciò che mi par haver troppo aquistato ad haver guadagnato la gratia di V. S. ch'io estimo molto" [*sic*] (I send Your Excellency [Michelangelo] . . . four medals with your portrait: two in silver, and the other two in bronze . . . The one in the small round box is perfectly finished and I beg you to look at it and keep it [as a token of] my love. With the other three you may do what seems best to you; similarly, I have sent [specimens] to Spain and Flanders out of ambition [for artistic recognition and fame], and have also sent others to Rome and elsewhere out of love [for you]. I said "ambition," because I have the feeling that I have reached too much [as an artist] by earning the grace [i.e., the graceful appreciation] of Your Excellency whom I esteem [so] much).

21 Attwood 1997, esp. 8.

22 Stahl and Waldman 1993–94.

23 In a letter of June 28, 1431, to the Visconti duke, Pisanello promised to finish the "bronze portrait" as soon as possible; the evidence for the identification of this image with the medal is discussed by Ruggero Rugolo in Puppi 1996, 138–43.

24 Pfisterer 2008, 316–18.

25 Spencer 1979; on the medals of his assistant, see Waldman 1992.

26 Hill 1912b.

27 K. H. Lanzoni 2010.

28 Cupperi 2006; Di Dio 2011.

29 On this topic, see Bredekamp 2008, 38–49; nevertheless, it must be emphasized that the identification of the prisoner as Leoni, which Eugène Plon (1887, 256–57) first suggested, cannot be proved with absolute certainty. See Cupperi 2006, 26–27.

30 See Hegener 2008, 222–42 and 421–25.

31 It is possible that already in the second half of the fifteenth century, different states and rulers of Italy consciously employed different and easily identifiable stylistic idioms in their medals; see Syson 2004. It appears that the worth of the Medici coins experienced an upswing as a result of their increased artistic quality; see Cole 2004.

32 See Scher 2000; Fontana 2009; Stahl 2009; Pfisterer 2013a. On the "education of the eye," see Syson and Thornton 2001.

PISANELLO

1

Antonio di Puccio Pisano, called Pisanello (ca. 1395–1455)
JOHN VIII PALEOLOGUS, EMPEROR OF BYZANTIUM
(b. 1392; r. 1425–48)
ca. 1438
Lead, cast; 104.1 mm
Scher Collection

Obverse: The emperor wearing a tall, conical hat with a high, upturned brim, pointed at front; spiral curls and pointed beard.
Inscription: + IωANNHC BACIΛEVC KAI AVTOKPATωP PωMAIωN O ΠAΛAIOΛOΓOC [Ioannis Paleologos, King and Emperor of the Romans].
Reverse: The emperor on horseback in hunting garb with a bow and quiver of arrows, halting to pray before a wayside cross; on the left, a page on horseback seen from behind, and rocks in the background.
Inscriptions: OPVS PISANI PICTO / RIS [The work of Pisano the painter]; EPΓON TON ΠICANOV ZωΓPAΦOV [Ergon Pisanou Zografou] [The work of Pisano the painter].
Literature: Hill 1930, 1: 7; 2: pl. 3, no. 19; Scher 1994, no. 4; Puppi 1996, no. 2; Cordellier 1996, 119; Pollard 2007, 1: no. 1.

Arguably the first true portrait medal, this was made to commemorate the 1438 visit of the Byzantine emperor John VIII Paleologus to Italy to seek reconciliation between the Orthodox and the Roman churches and to enlist aid against the Turks. Pisanello, court artist of Leonello d'Este when the Greek delegation traveled to Italy, created the portrait of the Byzantine emperor inspired by, but not in imitation of, Roman imperial portraits on coins; the idea may have been suggested by Leon Battista Alberti, who was also in Ferrara at the time (Scher 1994). The reverse represents the emperor interrupting one of his favorite activities (hunting) to pray at a cross, which alludes to the main purpose of his trip to Italy. ADC

2

Antonio di Puccio Pisano, called Pisanello (ca. 1395–1455)
FILIPPO MARIA VISCONTI, DUKE OF MILAN (1392–1447)
ca. 1441
Lead, cast; 101.2 mm
The Frick Collection; Gift of Stephen K. and Janie Woo Scher, 2016 (2016.2.113)

Obverse: Visconti wearing a soft bonnet with high, flat border.
Inscription: PHILIPPVS MARIA ANGLVS DVX MEDIOLANI ETCETERA PAPIE ANGLERIE QVE COMES AC GENVE DOMINVS [Filippo Maria Anglus, Duke of Milan et cetera, Count of Pavia and Angera, and Lord of Genoa].
Reverse: Visconti on horseback in full tournament armor, with crested helmet and lance, riding in a mountainous landscape; on the right, seen from behind, a page on horseback; between them, a second horseman also in tournament armor and with lance; in the background on the right, a building with a dome flanked by two towers and a colossal female statue (Fortitude?) holding a column.
Inscription: OPVS PISANI PICTORIS [The work of Pisano the painter].
Literature: Hill 1930, 1: 8; 2: pl. 4, no. 21; Cordellier 1996, 127; Pollard 2007, 1: nos. 2, 3.

1

2

Visconti devoted his reign to the expansion of the Milanese state. The extremely corpulent duke was shy about his appearance, and this medal and a drawing by Pisanello are the only two known contemporaneous portraits of him. The medal was probably issued in 1441, when the artist could have encountered Visconti in Milan. The appellative "Anglus" refers to a legendary ancestor, the grandson of Aeneas, from whom the Visconti claimed descendence. The reverse motif of the foreshortened horse seen from behind is a variant of the reverse of Pisanello's medal of John VIII Paleologus (no. 1) and is related to many drawings of the same subject. ADC

3

Antonio di Puccio Pisano, called Pisanello (ca. 1395–1455)
NICCOLÒ PICCININO (1386–1444)
ca. 1441
Lead, cast; 90.5 mm
Scher Collection

Obverse: Piccinino wearing armor and a *beretta alla capitanesca*, the red headgear of military leaders. Inscription: NICOLAVS PICININVS VICECOMES MARCHIO CAPITANEVS MAX[imus] AC MARS ALTER [Niccolò Piccinino Visconti, marquess, commander in chief, and a second Mars].

3

Reverse: The She-Griffin of Perugia suckling two infants. Inscriptions: BRACCIVS [Braccio]; PISANI P[ictoris] OPVS [The work of Pisano the painter]; N[icolaus] PICININVS [Niccolò Piccinino]; across the griffin's collar, fragmented, PERVSIA [Perugia].
Literature: Hill 1930, 1: 8; 2: pl. 4, no. 22; Cordellier 1996, 123; Puppi 1996, 160–62; Pollard 2007, 1: no. 4.

This medal celebrates Piccinino's fame as a condottiere and his adoption into the Visconti family; it was probably issued in 1441 (see no. 2). The two infants on the reverse represent Piccinino and his military mentor, the condottiere Braccio da Montone, being nurtured by the personification of their hometown, Perugia, a reference to the Roman she-wolf suckling Romulus and Remus. Piccinino was extremely short; hence his sobriquet (the tiny one). ADC

4

Antonio di Puccio Pisano, called Pisanello (ca. 1395–1455)
LEONELLO D'ESTE (1407–1450)
ca. 1445
Lead, cast; 69.5 mm
The Frick Collection; Gift of Stephen K. and Janie Woo Scher, 2016 (2016.2.112)

Obverse: Leonello wearing fish-scale armor over mail. Inscription: LEONELLVS MARCHIO ESTENSIS [Leonello, Marquess of Este]; olive branches between the words.
Reverse: Head with three infantile faces; on either side, a poleyn or knee armor suspended by a strap from an olive branch. Inscription: OPVS PISANI PICTORIS [The work of Pisano the painter].
Literature: Hill 1930, 1: 8–9; 2: pl. 5, no. 24; Cordellier 1996, 161, 262; Puppi 1996, 151–53; Pollard 2007, 1: no. 6.

Leonello, Marquess of Ferrara, was a cultivated humanist prince and a patron of Pisanello. The reverse alludes to his prudent and careful foreign policies toward the maintenance of peace. The three-faced infant's head probably signifies Prudence, the triple face indicating that the wisdom of the present comes from the experience of the past and the vision of the future. Prudence maintains Peace, symbolized by the armor suspended from the olive branches. The olive branches separating the words of the inscription on the obverse also allude to peace. ADC

5

Antonio di Puccio Pisano, called Pisanello (ca. 1395–1455)
LEONELLO D'ESTE (1407–1450)
ca. 1445
Copper alloy, cast; 68.9 mm
The Frick Collection; Gift of Stephen K. and Janie Woo Scher, 2016 (2016.2.111)

Obverse: Leonello wearing a doublet over mail. Inscription: LEONELLVS MARCHIO ESTENSIS [Leonello, Marquess of Este].
Reverse: Two men carrying baskets of olive branches while rain falls upon and extinguishes two vessels. Inscription: OPVS PISANI PICTORIS [The work of Pisano the painter].
Literature: Hill 1930, 1: 9; 2: pl. 5, no. 27; Cordellier 1996, 264; Pollard 2007, 1: no. 7.

Though the precise significance of the reverse allegory has been debated among scholars, the image seems to represent the blessings of Peace that resulted from Leonello's prudent governance. The old and young naked men symbolize the balance between thoughtful maturity and impetuous youth necessary to maintain peace, symbolized by the olive branches in the baskets. The two vessels are bombs with flames erupting from the sides and extinguished by the rain, a further allusion to peace. ADC

6

Antonio di Puccio Pisano, called Pisanello (ca. 1395–1455)
LEONELLO D'ESTE (1407–1450)
Dated 1444
Copper alloy, cast; 99 mm
Scher Collection

Obverse: Leonello wearing an embroidered *giornea* (tunic). Inscriptions: GE[ner] R[egis] AR[agonensis] [Son-in-law of the king of Aragon]; LEONELLVS MARCHIO ESTENSIS [Leonello, Marquess of Este]; D[ominus] FERRARIE REGII ET MVTINE [Lord of Ferrara, Reggio, and Modena].
Reverse: In a rocky landscape, a lion being taught to sing by Cupid; behind the lion's head, a pillar with an emblem of a billowing sail; beneath, the date M CCCC XLIIII [1444]; in the background on the

4

left, a bare tree with an eagle on a branch, its back to the viewer. Inscription: on the right in the field, OPVS PISANI PICTORIS [The work of Pisano the painter].
Literature: Hill 1930, 1: 10; 2: pl. 6, no. 32; Scher 1994, no. 5; Cordellier 1996, 272, 273; Puppi 1996, 157–58; Pollard 2007, 1: no. 10.

Leonello was trained in the traditional disciplines, as well as the martial arts. In 1444, he married Maria of Aragon, the illegitimate daughter of Alfonso V of Aragon (1396–1458), King of Naples and Sicily. The reverse alludes to the occasion: Cupid (Love) tames the lion (a pun on Leonello's name); the eagle is a charge on the Este coat of arms. The billowing sail on the pillar is one of Leonello's personal devices probably signifying the Latin motto "festina lente" (make haste slowly), while the pillar is an allusion to Fortitude. ADC

Antonio di Puccio Pisano, called Pisanello (ca. 1395–1455)
DOMENICO MALATESTA, CALLED MALATESTA NOVELLO
(b. 1418; Lord of Cesena 1429–65)
ca. 1445
Lead, cast; 84.9 mm
Scher Collection

Obverse: Domenico wearing a fur-lined *giornea*. Inscriptions: across the field, on either side of the bust, in two lines, MALATESTA NOVELLVS / CESENAE DOMINVS [Malatesta Novello, Lord of Cesena]; above, DVX EQUITVM PRAESTANS [illustrious leader of knights].
Reverse: In a rocky landscape, a figure in full armor kneels and embraces the foot of a crucifix; on the left, a foreshortened horse tied to a bare tree; on the right, a rock with a small bare tree on top. Inscription: OPVS PISANI PICTORIS [The work of Pisano the painter].
Literature: Hill 1930, 1: 10–11; 2: pl. 7, no. 35; Scher 1994, no. 6; Puppi 1996, 168; Cordellier 1996, 275; Pollard 2007, 1: no. 15.

7

Despite his pacific and studious nature, Domenico was a captain of the papal troops. This medal may commemorate the 1444 battle of Montolmo against the Milanese forces of Francesco Sforza: in danger of being caught by the enemy, Domenico vowed to build a hospital dedicated to the Holy Cross if he escaped. The reverse shows Domenico making his vow, which he fulfilled in 1452 by founding the hospital in Cesena. ADC

8

Antonio di Puccio Pisano, called Pisanello (ca. 1395–1455)
VITTORINO RAMBALDONI DA FELTRE (1378–1446)
ca. 1446
Copper alloy, cast; 66 mm
Scher Collection; Promised gift to The Frick Collection

Obverse: Vittorino wearing a *berretta* or bonnet and tunic with an undergarment showing. Inscription: VICTORINVS FELTRENSIS SVMMVS [Vittorino of Feltre, most distinguished . . . (inscription continues on reverse)].

Reverse: Pelican in Her Piety. Inscriptions: outer line, [rosette] MATHEMATICVS ET OMNIS HVMANITATIS PATER [. . . mathematician and father of all the humanities]; inner line, OPVS PISANI PICTORIS [The work of Pisano the painter].
Literature: Hill 1930, 1: 11; 2: pl. 8, no. 38; Scher 1994, no. 8; Cordellier 1996, 279; Puppi 1996, 173–74; Pollard 2007, 1: no. 18.

Vittorino da Feltre was a celebrated educator in the employ of the Gonzagas of Mantua, where he opened a school called La Giocosa, attended by the Gonzaga children, as well as by pupils from all over Italy. This medal was probably commissioned by Lodovico II Gonzaga around the time of Vittorino's death to celebrate his former teacher who dedicated his life to his students, as symbolized by the christological image of the pelican feeding her young with blood from her own breast. The flower at the beginning of the reverse inscription may be a sunflower, one of the Gonzaga family's emblems. ADC

8

9

9
Antonio di Puccio Pisano, called Pisanello (ca. 1395–1455)
CECILIA GONZAGA (1426–1451)
Dated 1447
Copper alloy, cast; 85.8 mm
Scher Collection

Obverse: Cecilia wearing an embroidered gown with pleated skirt and full sleeves, her hair tightly bound with a ribbon. Inscription: CICILIA VIRGO FILIA IOHANNIS FRANCISCI PRIMI MARCHIONIS MANTVE [The Virgin Cecilia, daughter of Gianfrancesco I Marquess of Mantua].
Reverse: In a rocky landscape, under a crescent moon, a half-naked young woman seated, with her left hand resting on the head of a unicorn; on the right, a stele with the Gonzaga emblem of a daisy or sunflower on top and the inscription: OPVS PISANI PICTORIS M CCCC XLVII [The work of Pisano the painter, 1447].
Literature: Hill 1930, 1: 11; 2: pl. 8, no. 37; Scher 1994, no. 7; Cordellier 1996, 285; Puppi 1996, 170–73; T. L. Jones 2005, 15–23; Pollard 2007, 1: no. 20; Centanni 2014, 129–52, 330.

The youngest daughter of Gianfrancesco Gonzaga, first Marquess of Mantua, was a gifted pupil of the humanist Vittorino da Feltre (see no. 8). Although the medal was produced two years after Cecilia entered the Clarissan convent of Santa Paola in Mantua, Pisanello portrays her in secular court dress, perhaps based on an earlier portrait. Her virginal status is indicated on the obverse (VIRGO) and figuratively represented on the reverse. Following medieval tradition, only a virgin could subdue the fierce unicorn, a symbol of Christ, which Pisanello represents as a goat, a symbol of knowledge that evokes Cecilia's intellectual accomplishments. Pisanello includes the crescent moon as a subtle all'antica reference to the virgin goddess Diana. ADC

10
Antonio di Puccio Pisano, called Pisanello (ca. 1395–1455)
ALFONSO V OF ARAGON, KING OF NAPLES AND SICILY
(b. 1396; r. 1442–58)
Dated 1449
Gilt copper alloy, cast; 109.9 mm
Scher Collection

Obverse: Alfonso in armor; on the left, a helmet with emblem of an open book surmounted by the sun; on the right, a crown and a date. Inscriptions: DIVVS ALPHONSVS REX / TRIVMPHATOR ET / PACIFICVS [The divine Alfonso, king, triumphator, and peacemaker]; M / CCCC XLVIIII [1449].
Reverse: An eagle standing on a tree branch above its prey; a deer, surrounded by lesser raptors. Inscriptions: LIBERALITAS / AVGVSTA [Royal generosity]; PISANI PICTORIS OPVS [The work of Pisano the painter].
Literature: Hill 1930, 1: 12; 2: pl. 9, no. 41; Syson 1994, 17, 19–22; Cordellier 1996, 300; Puppi 1996, 183; Pollard, 2007, 1: no. 21.

This medal celebrates Alfonso as soldier, humanist, and king. The book on the helmet was a typical *impresa* of Alfonso, who loved reading the ancient authors. The reverse composition is a traditional medieval allegory of royal liberality, as the eagle would allow the lesser birds to feed on its prey—in this case, Alfonso, the conqueror of Naples and the Two Sicilies, granting favors, lands, and titles to his most loyal followers. A study of an eagle by Pisanello (Louvre, Paris) may relate to the reverse. ADC

10

11

11

Unknown artist (Ferrara)

ANTONIO DI PUCCIO PISANO, CALLED PISANELLO

(ca. 1395–1455)

ca. 1450

Copper alloy, cast; 57.1 mm

The Frick Collection; Gift of Stephen K. and Janie Woo Scher, 2016

(2016.2.164)

Obverse: Pisanello in a tall cap and brocaded doublet. Inscription: PISANVS PICTOR [Pisano the painter].

Reverse: Within a laurel wreath, the initials of the seven Virtues. Inscription: F[ides] S[pes] K[aritas; *sic*] I[ustitia] P[rudentia] F[ortitudo] T[emperantia] [Faith, Hope, Charity, Justice, Prudence, Fortitude, Temperance].

Literature: Hill 1930, 1: 24; 2: pl. 20, no. 87; Scher 1994, no. 10; Cordellier 1996, 15–17; Pollard 2007, 1: no. 59.

Once thought to be a self-portrait produced at the height of Pisanello's career, this medal is now considered the product of a Ferrarese master, though no name has been suggested. ADC

MATTEO DE' PASTI

12

Matteo de' Pasti (1420–d. aft. 1467)

SIGISMONDO PANDOLFO MALATESTA (1417–1468)

Dated 1446

Copper alloy, cast; 83 mm

Scher Collection

Obverse: Sigismondo wearing a *giornea* over armor and mail. Inscription: SIGISMONDVS PANDVLFVS DE MALATESTIS S[anctæ] RO[manæ] ECLESIE C[apitaneus] GENERALIS [Sigismondo Pandolfo Malatesta, captain general of the Holy Roman Church].

Reverse: The castle of Rimini. Inscription: CASTELLVM SISMONDVM ARIMINENSE M CCCC XLVI [Castle Sismondo at Rimini, 1446].

Literature: Hill 1930, 1: 41; 2: pl. 33, no. 174; Glinsman 1997, 96, 98, 101; Pollard 2007, 1: no. 27; Pasini 2009, 30, 51, 86; Farina 2015, 39.

One of the most accomplished condottieri in Italy and captain general of the Church, Sigismondo, Lord of Rimini and Fano, built

12

13

a series of castles throughout his territories, most notably the Rocca Malatestiana in Rimini, the center of his court (begun in 1437). The reverse refers to the 1446 ceremonial inauguration of the Rocca, though this medal and the group of related medals that also bear the date were probably produced about 1450. Within the buildings' fabric, he buried several medals with the date 1446, the year he dedicated his new castle, consolidated his political power, and won Isotta degli Atti as his mistress. A reissue of this medal presents Sigismondo in armor (no. 13). The reverse design was copied by Piero della Francesca in the sacristy of the church of San Francesco in Rimini (also called the Tempio Malatestiano). ADC

13

Matteo de' Pasti (1420–d. aft. 1467)
SIGISMONDO PANDOLFO MALATESTA (1417–1468)
Dated 1446
Copper alloy, cast; 79.5 mm
Scher Collection

Obverse: Sigismondo wearing plate armor over mail. Inscription: SIGISMVNDVS PANDVLFVS MALATESTA PAN[dulfi] F[ilius] [Sigismondo Pandolfo Malatesta, son of Pandolfo].
Reverse: Castle of Rimini. Inscription: CASTELLVM SISMVNDVM ARIMINENSE M CCCC XLVI [Castle Sismondo at Rimini, 1446].

Literature: Hill 1930, 1: 42; 2: pl. 34, nos. 185 (obv.) and 184 (rev.); Scher 1994, no. 14; Glinsman 1997, 102; Pollard 2007, 1: no. 29; Pasini 2009, 56, 70, 104.

See the commentary for no. 12. The reverse is the first architectural reverse on a Renaissance medal, following a Roman tradition; it represents Sigismondo's military skills, the city of Rimini, and his *buon governo* (good governance). ADC

14

Matteo de' Pasti (1420–d. aft. 1467)
SIGISMONDO PANDOLFO MALATESTA (1417–1468)
Dated 1446
Copper alloy, cast; 42.6 mm
The Frick Collection; Gift of Stephen K. and Janie Woo Scher, 2016 (2016.2.116)

Obverse: Sigismondo wearing a surcoat over mail. Inscription: SIGISMONDVS P[andulfus] D[e] MALATESTIS S[anctæ] R[omanæ] EC[clesiæ] C[apitaneus] GENERALIS [Sigismondo Pandolfo Malatesta, captain general of the Holy Roman Church].
Reverse: Sigismondo's heraldic achievement with shield inscribed with the letters "SI"; the helmet with the elephant crest and mantling. Inscription: M CCCC XLVI [1446].
Literature: Hill 1930, 1: 39; 2: pl. 32, nos. 165 (obv.), 166 (rev.); Glinsman 1997, 102; Vannel and Toderi 2003–7, 1: nos. 63, 64 (var.); Pollard 2007, 1: no. 30 (var.); Pasini 2009, 28, 48, 60, 83.

See the commentary for no. 12. The interlaced letters "SI" on the reverse may refer to the first two letters of Sigismondo's name or to the initials of his name and that of his mistress Isotta degli Atti (about whom see nos. 16, 17). ADC

14

15

15

Matteo de' Pasti (1420–d. aft. 1467)

SIGISMONDO PANDOLFO MALATESTA (1417–1468)

Dated 1446

Copper alloy, cast; 80.7 mm

The Frick Collection; Gift of Stephen K. and Janie Woo Scher, 2016
(2016.2.114)

Obverse: Sigismondo wearing a surcoat over armor and mail.
Inscription: SIGISMVNDVS PANDVLFVS MALATESTA PAN[dulfi] F[ilius]
PONTIFICII EXER[citus] IMP[erator] [Sigismondo Pandolfo Malatesta, son
of Pandolfo, general of the papal army].

Reverse: Female figure seated on a throne formed by two elephants
and holding a broken column. Inscription: below the terrain,
M CCCC XLVI [1446].

Literature: Hill 1930, 1: 41–42; 2: pl. 34, no. 180; Glinsman 1997,
99; Pollard 2007, 1: no. 26; Pasini 2009, 54, 82.

See the commentary for no. 12. On the reverse, Fortitude, one
of the four cardinal virtues, is seated on a throne of elephants, a
Malatesta symbol and traditional allusion to force, magnanimity,
and prudence. From its condition (showing corrosion consistent
with being underground for a long time), it is probable that this is
a foundation medal. ADC

16

Matteo de' Pasti (1420–d. aft. 1467)

ISOTTA DEGLI ATTI OF RIMINI (1432/33–1474)

Dated 1446

Copper alloy, cast; 82.7 mm

Scher Collection

Obverse: Isotta wearing a *giornea* over a *gamurra* or *cotta*; hair piled
high in late-Gothic French or Flemish style, covered by a fine veil

16

17

fastened with a jewel on her plucked forehead. Inscription: ISOTE ARIMINENSI FORMA ET VIRTVTE ITALIE DECORI [To Isotta of Rimini, the ornament of Italy for beauty and virtue].

Reverse: The Malatesta elephant in a meadow. Inscription: OPVS MATHEI DE PASTIS V[eronensis] M CCCC XLVI [The work of Matteo de' Pasti of Verona, 1446].

Literature: Hill 1930, 1: 40; 2: pl. 32, no. 167; Scher 1994, no. 12; Glinsman 1997, 101, 103, 104; Pollard 2007, 1: no. 31; Pasini 2009, 30, 58, 83, 86, 87.

Isotta, the daughter of a Rimini merchant, attracted the attention of Sigismondo Malatesta, who, after making her his mistress and, later, wife, commissioned several medals of her. The elephant—one of the Malatesta devices, as well as a traditional symbol of strength and immortality—was also associated with chastity and piety, moral qualities meant to compliment the young woman. ADC

17

Matteo de' Pasti (1420–d. aft. 1467)
ISOTTA DEGLI ATTI OF RIMINI (1432/33–1474)
Dated 1446
Copper alloy, cast; 82.9 mm
The Frick Collection; Gift of Stephen K. and Janie Woo Scher, 2016
(2016.2.115)

Obverse: Isotta wearing a *giornea* over a *gamurra* or *cotta*, her hair bound up with crossing ribbons fastened with a jewel on top and falling in two pointed tresses behind. Inscription: D[ominæ] ISOTTAE ARIMINENSI [To the Lady Isotta of Rimini].

Reverse: The Malatesta elephant in a meadow. Inscription: M CCCC XLVI [1446].

Literature: Hill 1930, 1: 43; 2: pl. 35, no. 187; Scher 1994, no. 13; Glinsman 1997, 103, 104; Pollard 2007, 1: no. 33; Pasini 2009, 50, 51 (var.), 65 (var.), 83.

One of a group of medals of Isotta commissioned by Sigismondo Malatesta (see also no. 18), this example presents her as a courtly woman wearing a rich brocaded gown and elaborate hairstyle. ADC

18

Matteo de' Pasti (1420–d. aft. 1467)
ISOTTA DEGLI ATTI OF RIMINI (1432/33–1474)
ca. 1450
Copper alloy, cast; 41.4 mm
The Frick Collection; Gift of Stephen K. and Janie Woo Scher, 2016
(2016.2.117)

Obverse: Isotta wearing a *giornea* over a *gamurra* or *cotta*, her hair bound up with crossing ribbons fastened with a jewel on top, and falling in two pointed tresses behind. Inscription: D[ominæ] ISOTTAE ARIMINENSI [To the Lady Isotta of Rimini].

Reverse: Closed book. Inscription: E L E G I A E [Elegies].

Literature: Hill 1930, 1: 43; 2: pl. 35, no. 188; Vannel and Toderi 2003–7, 1: nos. 87–90; Pollard 2007, 1: no. 35.

See the commentary for no. 17. The reverse refers to the three volumes of thirty elegies in honor of Isotta commissioned by Sigismondo Malatesta in 1449–51, the *Liber Isottaeus*. ADC

18

19

SCHOOL OF FERRARA

19

Amadio Amadei, called Amadio da Milano (act. 1437–82; d. ca. 1483)

NICCOLÒ III D'ESTE (1383–1441)

ca. 1441
Copper alloy, cast; 53.9 mm
The Frick Collection; Gift of Stephen K. and Janie Woo Scher, 2016 (2016.2.124)

Obverse: Niccolò III d'Este. Inscription: NICOLAI MARCHIO ESTENSIS FER[rariæ] (incised) [Niccolò d'Este, Marquess of Ferrara].
Reverse: The Este shield of arms surrounded by floral branches. Inscription: N[icolai] M[archio] [Niccolò, Marquess].
Literature: Hill 1930, 1: 20; 2: pl. 17, no. 73; Pollard 2007, 1: no. 47.

A prestigious leader of early fourteenth-century Italy, Niccolò III d'Este, Marquess of Ferrara, was appointed captain general of the papal army against Milan in 1403. This medal is one of a group of five based on a portrait made before his death. Niccolò's severe haircut, well above the ears, was an archaic but still fashionable style. In 1431, King Charles VII of France allowed him to quarter the Este arms with the arms of France, distinguished by an indented border. ADC

20

Petrecino of Florence (act. 1460)

BORSO D'ESTE (1413–1471)

Dated 1460
Lead, cast; 94 mm
The Frick Collection; Gift of Stephen K. and Janie Woo Scher, 2016 (2016.2.120)

Obverse: Este wearing a *giornea*/surcoat over mail (?), the *berretta ducale* ornamented with a jewel, and a massive gem on his chest. Inscription: BORSIVS DVX MVTINE Z [ET] R[e]GII MARCHIO ESTENSIS RODIGII q[ue] COMES [Borso, Duke of Modena and Reggio, Marquess of Este, and Count of Rovigo].
Reverse: The sun shining down on a hexagonal baptismal font with its lid open, a bowl floating on the surface, in a rocky landscape with the sun above. Inscription: OPVS PETRECINI DE FLORE[n]TIA MCCCCLX [The work of Petrecino of Florence, 1460].

20

21

Literature: Hill 1930, 1: 26–27; 2: pl. 22, no. 96; Pollard 2007, 1: no. 55.

Unlike his half-brother Leonello (nos. 4, 5, 6), Borso d'Este, Marquess of Ferrara, the illegitimate son of Niccolò III (no. 20), had little interest in learning or the arts, concentrating his patronage instead on building his own image as an absolute ruler and strengthening the position of the Ferrarese state. The font (*il battesmo*), on the reverse, is one of many *impresas* developed for Borso, in this case meant to demonstrate his piety. ADC

21

Antonio Marescotti (act. 1444–62)
PAOLO ALBERTINI (ca. 1430–1475)
Dated 1462
Copper alloy, cast; 107.8 mm
Scher Collection

Obverse: Albertini wearing a hooded cassock. Inscription: M[onachus] PAVLVS VENETVS OR[dinis] S[er]VOR[um] MEMORIE FONS [Monk Paolo Veneto of the Servite Order, fountain of memory].
Reverse: Albertini meditating on a skull at his feet. Inscriptions: HOC VIRTVTIS OPVS [This is the work of virtue (Virgil, *Aeneid* X.469)]; in exergue, OPVS ANTHONII MARESCOTO DE FERRARIA M CCCC LXII [The work of Antonio Marescotti of Ferrara, 1462].
Literature: P. A. Gaetani 1761–63, 1: 73, pl. XI, no. 3; Heiss 1881– 92, 3: 31, pl. III, no. 8; Armand 1883–87, 1: 29, no. 6; Rizzini 1892, pt. 1, 7, no. 54; Museo Correr 1898, no. 40; J. Hirsch 1910, no. 171; Hill 1930, 1: 23; 2: pl. 19, no. 83; C. Johnson and Martini 1986–95, no. 307; Voltolina 1998, 1: 58, no. 41.

This exquisitely modeled medal recognizes the virtue of the Venetian Servite monk Paolo Albertini (also known as Paolo Veneto), a preacher, theologian, and diplomat and part of the Monastery of Santa Maria dei Servi. He became a doctor of theology in 1456. He was a Dante scholar also known for his knowledge of astrology. Here he contemplates death in a memento mori composition. CM

22

Sperandio di Bartolommeo Savelli (ca. 1425/28–d. aft. 1504)
BARTOLOMMEO PENDAGLIA (d. 1462)
ca. 1452–62
Copper alloy, cast; 85.2 mm
Scher Collection

Obverse: Pendaglia wearing a flat-topped hat or *mortier* and pleated robe with brocade pattern. Inscription: BARTHOLOMAEVS PENDALIA INSIGNE LIBERALITATIS ET MVNIFICENTIAE EXEMPLV[m] [Bartolommeo Pendaglia, emblem of liberality and model of munificence].
Reverse: A naked male figure seated on an all'antica cuirass and two shields (spoils of war), wearing around his neck and arms a thin scarf; holding a spear in his left hand and an orb in his right; his left foot resting on a sack from which coins escape. Inscriptions: CAESARIANA LIBERALITAS [The liberality of Caesar]; OPVS SPERANDEI [The work of Sperandio].
Literature: Hill 1930, 1: 91; 2: pl. 59, no. 356; Scher 1994, no. 23; Pollard 2007, 1: no. 78.

Perhaps the richest man in Ferrara in the mid-fifteenth century, Pendaglia was the administrator of the Este estates. On his wedding day, the emperor Frederick III gifted him with a knighthood and his bride Margherita Costabili with a pearl jewel. The figure on the reverse represents the emperor, his authority symbolized by the spoils and his liberality indicated by the coins spilling from the bag at his feet. Some scholars have suggested that the round object in his hand, being extended as a gift, could be a pearl, thus alluding to the gift to the bride. The medal may have been produced around the time of Pendaglia's knighthood and wedding (1452) or his death. ADC

22

23

23

Sperandio di Bartolommeo Savelli (ca. 1425/28–d. aft. 1504)
ERCOLE I D'ESTE (b. 1431)
ca. 1471
Lead, cast; 93.6 mm
The Frick Collection; Gift of Stephen K. and Janie Woo Scher, 2016
(2016.2.119)

Obverse: Ercole I d'Este wearing a tall cap with a flat top and a
chain with jeweled pendant over his figured robe. Inscription:
INVICTISSIMVS DIVVS HERCVLES FERRARIAE AC MVTINAE DVX SECVNDVS
[The most invincible divine Ercole, second Duke of Ferrara and
Mantua].
Reverse: Centered date palm on a rocky hill flanked by two small
leafless trees. Inscription: OPVS SPERANDEI [The work of Sperandio].
Literature: Bellini 1761, no. IX; Heraeus 1780, no. 7; Litta 1819, Este
no. 19; Heiss 1881–92, 4: 40, pl. V, no. 6; Armand 1883–87, 1: 68,
no. 20; Friedlaender 1882b, no. 41; Gruyer 1897, 1: 629–30; Foville
1910, no. 11; Hill 1930, 1: 93; 2: pl. 61, no. 364; Pollard 1984–85,
1: 208, no. 100; Boccolari 1987, 42; Vannel and Toderi 2003–7, no.
136.

This medal commemorates Ercole I d'Este, Marquess of Este and
Duke of Ferrara, who was an influential diplomatic and military
figure and patron of the arts. The medal may relate to notions of
Virtue as described and illustrated by Filarete in his treatise on
architecture of about 1464. In the treatise, both the palm of victory
and a fecund date tree relate to Virtue. Filarete further describes
Virtue at the top of a mountain above a cave, as the choice between
immediate pain (climbing the difficult path to virtue) that brings joy
and success as its reward and immediate pleasure (following the
broad path of temporal ease) that ultimately leads to misery. CM

24

Sperandio di Bartolommeo Savelli (ca. 1425/28–d. aft. 1504)
GALEAZZO MARESCOTTI DE' CALVI (1406–1502)
ca. 1478–80
Copper alloy, cast; 101.5 mm
Scher Collection; Promised gift to The Frick Collection

Obverse: Marescotti wearing a flat-topped hat, a chain mail collar,
and a pleated surcoat over armor. Inscription: OPTIMVS GALEAZIVS
MARESCOTVS DECALVIS BONONIEN[sis] EQVES AC SENATOR [The
excellent Galeazzo Marescotti de' Calvi, Bolognese knight and
senator].
Reverse: Marescotti dressed in a long loose robe with a fur collar,
seated at an angle, holding a book and surrounded by trophies
of war; in the background, a fortress atop a hill. Inscription: OPVS
SPERANDEI [The work of Sperandio].
Literature: P. A. Gaetani 1761–63, 1: 91, pl. XVIII, no. 1; Robinson
1856, no. 658; Freidlaender 1882b, no. 29; Armand 1883–87, 1:
70, no. 28; Heiss 1886, 6: no. 28; Rizzini 1892, pt. 1, 15, nos. 103,
104; Foville 1910, no. 26; Hill 1930, 1: 98; 2: 68, no. 382; *Medaglie
del Rinascimento* 1960, no. 61; Hill and Pollard 1967, no. 3; Panvini
Rosati 1968, no. 54; Forrer 1979–80, 5: 583; Pollard 1984–85, 1:
209, no. 106; Scher 1993a, 5, figs. 6–10.

A Bolognese nobleman and a supporter of Bologna's ruling
Bentivoglio family, Galeazzo Marescotti is shown here both in
military dress and as a humanist, having shed his armor and
holding a book. The fortress atop the hill in the background may
be a reference to the building in Varano (west of Bologna), from
which Marescotti freed Annibale I Bentivoglio in 1443. Marescotti
continued to fight on behalf of the family until 1501, when the
tyrannical Giovanni II Bentivoglio (see no. 25) accused some of
Marescotti's family members of conspiracy and murdered them in an
act of retribution. The tower may, as Heiss suggests, also reference

24

Uccellino, the Marescottis' castle where Galeazzo fled after the massacre. Giovanni's barbaric acts eventually led to the downfall of the Bentivoglio, as Pope Julius II expelled him from Bologna in 1506. Stylistically, the obverse relates to seated Hellenistic sculptures of the Muses that the artist either saw directly or through prints. The figures of Muses on Antonio del Pollaiuolo's (1431–1498) tomb of Sixtus IV (1493) in St. Peter's Basilica also follow this form. CM

25

Sperandio di Bartolommeo Savelli (ca. 1425/28–d. aft. 1504)
GIOVANNI II BENTIVOGLIO (1443–1508)
ca. 1485
Copper alloy, cast; 95.7 mm
The Frick Collection; Gift of Stephen K. and Janie Woo Scher, 2016
(2016.2.118)

25

26

Obverse: Bentivoglio wearing a round cap with brim and plate armor over chain mail. Inscription: IO[hannes] BENT[ivolius] II HANIB[ali] FILIVS EQVES AC COMES PATRIAE PRINCEPS AC LIBERTATIS COLVMEN [Giovanni II Bentivoglio, son of Annibale, knight and count, first of his country and supporter of liberty].

Reverse: Bentivoglio on horseback, in armor, with a sword and baton of command; his horse wearing elaborate barding with almost illegible coats of arms, probably of the Bentivoglio family; behind him, his squire on horseback wearing a helmet with elaborate crest and a lance. Inscription: OPVS S P ERANDEI [The work of Sperandio].

Literature: Hill 1930, 1: 100; 2: pl. 71, no. 391; Scher 1994, no. 24; Pollard 2007, 1: no. 96.

This medal (probably the last of Sperandio's three medals of the sitter) reflects the ambition of Bentivoglio, Lord of Bologna, to assert himself as the *signore* of Bologna and presents him as a powerful military leader during the period of his greatest authority. In November 1506, Bentivoglio was forced into exile. The reverse is a pastiche of Pisanello's medals of Gianfrancesco Gonzaga and Filippo Maria Visconti (no. 2). ADC

26

Unknown artist (Ferrara)

ERCOLE I D'ESTE (b. 1431; act. 1471–1505)

1502–3

Silver, struck; 24.3 mm, 9.6 g (*testone* coin)

Scher Collection

Obverse: D'Este with long hair to the nape of his neck, all'antica. Inscription: HERCVLES DVX FERRARIAE [Ercole, Duke of Ferrara].

Reverse: A draped man on a horse facing right.

Literature: Van Mieris 1732–35, 1: 289; Bellini 1761, 138, no. 3; *Trésor de numismatique* 1834–58, pl. XXXV, no. 2 (a version with FERRARIAE II); Armand 1883–87, 2: 44, no. 7 (a version with

FERRARIAE II); U. Rossi 1886, no. 43; *Corpus nummorum Italicorum* 1910–43, 10: pl. XXX, no. 10; Cott 1951, 205; Grierson 1959, 44; Hill and Pollard 1967, no. 657; Ravegnani Morosini 1984, 1: 131, no. 6; Manca 1989, pl. 12.

Ercole I d'Este, the second Duke of Ferrara, Modena, and Reggio, was famous for his patronage of the arts and his urban expansion of the city of Ferrara (Addizione Erculea). This coin, a *testone*, commemorates the equestrian monument he commissioned for the Piazza Nuova, the imposing square of the Addizione, which was never cast. It has also been suggested that the equestrian on the back is a copy of the lost cast for Leonardo da Vinci's statue of Francesco Sforza, acquired by Ercole. See also no. 23. CM

SCHOOL OF MANTUA

27

Bartolommeo di Virgilio Melioli (1448–1514)

FRANCESCO II GONZAGA (1466–1519)

ca. 1484

Copper alloy, cast; 70 mm

Scher Collection; Promised gift to The Frick Collection

Obverse: Gonzaga in parade armor, wearing a cap with upturned brim. Inscription: D[ominus] FRANCISCVS GON[zaga] D[omini] FRED[erici] III M[archionis] MANTVAE F[ilius] SPES PVB[lica] SALVSQ[ue] P[ublica] REDIVI[vas] [Lord Francesco Gonzaga, son of the Lord Frederico the third Marquess of Mantua, the renewed hope and good of the city].

Reverse: A female figure standing between water and fire, holding a wicker muzzle in one hand and a pole with grain stalks in the other. Inscriptions: ADOLESCENTIAE AVGVSTAE [To the sacred youth]; on a scroll on the muzzle, CAVTIVS [carefully]; in exergue, MELIOLVS DICAVIT [Melioli dedicated (it)].

Literature: Hill 1930, 1: 48; 2: pl. 36, no. 196; *Splendours of the Gonzaga* 1981, no. 84; Pollard 2007, 1: no. 107.

Francesco II Gonzaga, future husband of Isabella d'Este (see no. 31), is shown here at the age of about ten or twelve. On the reverse is the personification of Prudence, holding a muzzle, a Gonzaga device. ADC

27

28

Pier Jacopo di Antonio Alari Bonacolsi, called Antico (ca. 1460–1528)
GIANFRANCESCO GONZAGA DI RODIGO (b. 1443; Lord of Sabbioneta 1479–96)
ca. 1490
Copper alloy, cast with traces of gilding; 39.8 mm
The Frick Collection; Gift of Stephen K. and Janie Woo Scher, 2016 (2016.2.127)

Obverse: Gianfrancesco shown all'antica. Inscription: IOHANNES FRANCISCVS GONZ[aga] [Gianfrancesco Gonzaga].
Reverse: The figure of Fortune standing on a globe; on the left, a nude male tied to a tree; on the right, a female figure carrying a spear; on both sides, trophies symbolizing spoils of war. The shield next to the young man bears the Gonzaga device of the thunderbolt. Inscription: FOR[tunæ] VICTRICI [To victorious Fortune]; in exergue, ANTI[cus] [Antico].
Literature: Hill 1930, 1: 51; 2: pl. 38, no. 206; Scher 1994, no. 16; Pollard 2007, 1: no. 111.

The youngest son of Lodovico II Gonzaga, Gianfrancesco served as a condottiere for King Ferrante I of Naples. In 1479, he married the Neapolitan princess Antonia del Balzo (see no. 29), and they established their court in Bozzolo, near Mantua. This medal is the last of a series of eight made by Antico from about 1478–79 to 1486–90. Gianfrancesco is portrayed all'antica, while in earlier portraits he appears younger and in contemporary court attire. The reverse probably alludes to Gianfrancesco's military achievements. The male and female figures flanking Fortune are traditionally identified as Mars and Minerva (Hill 1930), but they could symbolize "military defeat" (the bound youth) and Victory (Scher 1994). ADC

29

Pier Jacopo di Antonio Alari Bonacolsi, called Antico (ca. 1460–1528)
ANTONIA DEL BALZO (1461–1538)
ca. 1500
Copper alloy, cast; 40.9 mm
Scher Collection; Promised gift to The Frick Collection

Obverse: Antonia wearing a gown and necklace, her hair bound up by a fillet in a simple net. Inscription: DIVA ANTONIA BAVTIA DE GONZ[aga] MAR[chionissa] [The divine Antonia del Balzo of the Gonzaga, Marchioness].
Reverse: A winged female figure standing on the prow of a broken-masted vessel drawn by two winged horses and a winged putto; in her right hand, a broken anchor; in her left hand, a sail. Inscriptions:

SVPEREST M[ihi] SPES [Only hope is left to me]; in exergue, ANTI[cus] [Antico]; on the vessel, MAI PIV [nevermore].
Literature: Hill 1930, 1: 52; 2: pl. 38, no. 212; Pollard 2007, 1: no. 112.

Antonia was the wife of Gianfrancesco Gonzaga (see no. 28). The reverse represents the futility of worldly hope and the yearning of the human soul for Christian salvation. Hope, the winged female figure associated here with the futility of worldly desires (the broken mast and anchor), is carried toward something higher by the winged horses symbolizing human aspiration to the divine. The motto "mai più" was often used by Antonia and her husband. ADC

30

Style of Antico
LUCA DE' ZUHARI (dates unknown)
ca. 1500
Copper alloy, cast; 40.1 mm
The Frick Collection; Gift of Stephen K. and Janie Woo Scher, 2016 (2016.2.128)

Obverse: The sitter wearing a high-necked robe and a conical cap. Inscription: LVCAS D[e] ZVHARIS PREPOSITVS PONPONESCHI [Luca de' Zuhari, provost of Pomponesco].
Reverse: Running figures of Victory and Mars; below, a panoply of arms. Inscription: VENER ET MARS VICTOR [Venus and the victorious Mars].
Literature: Hill 1930, 1: 53; 2: pl. 38, no. 217; Pollard 2007, 1: no. 116.

The reverse could allude to the beneficial astrological influence of the two planets (Venus and Mars). The word VENER is clearly a mistake for VENUS. Although the two running figures on the reverse have been traditionally identified as Mars and Venus, they could actually be interpreted as Mars and a winged genius or, most likely, Victory, though this would then make the translation of VENER questionable. Pomponesco is a town in Mantuan territory. ADC

31

Gian Cristoforo Romano (ca. 1465–1512)
ISABELLA D'ESTE (1474–1539)
ca. 1498
Copper alloy, cast; 39.2 mm
Scher Collection

Obverse: Isabella wearing a low-necked gown and a beaded necklace, her hair parted in two long tresses bound in the back with a ribbon. Inscription: ISABELLAE ESTEN[sis] MARCH[ionissæ] MA[ntuæ] DIVAE [(Portrait of) the divine Isabella d'Este, Marchioness of Mantua].
Literature: Hill 1930, 1: 55–56; 2: pl. 39, no. 221 (var.); Norris 1987, 134, 136; Vannel and Toderi 2003–7, 1: no. 1087 (var.); Pollard 2007, 1: no. 118 (var.).

Isabella d'Este, wife of Francesco II Gonzaga (see no. 27), was one of the most important women of the Italian Renaissance, a sophisticated patron and collector of the arts with a sharp political mind, often acting as regent during Francesco's absences from Mantua. Isabella commissioned a large number of portraits of herself in different media, which she often used as diplomatic gifts. The commission of this medal is well documented, first in 1495 and again in 1498, when the courtier Niccolò Correggio was asked to provide a motto for the medal, which was finally distributed. ADC

32

Gianfrancesco Enzola (act. 1455–78)
FRANCESCO I SFORZA (b. 1401; Duke of Milan 1450–66)
Dated 1456
Copper alloy, cast after a struck original; 42.2 mm
Scher Collection

Obverse: Francesco in armor. Inscriptions: FR[anciscus] SFORTIA VICECOMES M[edio]L[an]I DVX IIII BELLI PATER ET PACIS AVTOR MCCCCLVI [Francesco Sforza Visconti, fourth Duke of Milan, father of war and maker of peace, 1456]; across field, on either side of the portrait, V[otum] F[ecit] [A promise made]. The first stop of the inscription is in the shape of the Visconti *biscione* (a serpent with a child in its mouth).
Reverse: Seated greyhound leashed to a tree and touched by a hand descending from a cloud; a bridle tied to the tree lies on the ground. Inscription: IO[annis] FR[ancisci] ENZOLAE PARMENSIS OPVS [The work of Gianfrancesco Enzola of Parma].
Literature: Hill 1930, 1: 70; 2: pl. 45, no. 281; Vannel and Toderi 2003–7, 1: no. 101; Pollard 2007, 1: no. 135.

This portrait type is found much later in the *Sforziada* by Giovanni Simonetta (ca. 1490), suggesting that it became the official effigy of the Sforza. The letters "V.F" are found in other medals by Enzola and may come from Roman examples as a votive formula. The reverse

composition is an *impresa* of the duke that is also found in the *Sforziada,* where it is accompanied by the motto "quietum nemo me impune lacessat" (may none disturb my calm with impunity). As a leading condottiere, Francesco worked for, among others, Filippo Maria Visconti (no. 2), whose daughter, Bianca Maria, he married in 1441. In 1450, with the death of Filippo and after a period of unrest, Francesco became Duke of Milan. He was an effective ruler, and his court was a center of culture and learning. ADC

33

Gianfrancesco Enzola (act. 1455–78)
COSTANZO SFORZA (b. 1447; Lord of Pesaro 1473–83)
Dated 1475
Copper alloy, cast; 81.4 mm
Scher Collection

Obverse: Costanzo in armor. Inscription: CONSTANTIVS SFORTIA DE ARAGONIA DI[vi] ALEXAN[dri] SFOR[tiæ] FIL[ius] PISAVRENS[is] PRINCEPS ÆTATIS AN[nis] XXVII [Costanzo Sforza of Aragon, son of the divine Alessandro Sforza, Prince of Pesaro, aged 27].
Reverse: The castle of Pesaro, the Rocca Costanza. Inscriptions: INEXPVGNABILE CASTELLVM CONSTANTIVM PISAVRENSE SALVTI PVBLICAE M CCCC LXXV [The unconquerable Castle Costanzo of Pesaro, for the public good, 1475]; IO[annes] FR[anciscus] PARMEN[sis] [Gianfrancesco of Parma].
Literature: Hill 1930, 1: 73; 2: pl. 46, no. 294; Vannel and Toderi 2003–7, 1: nos. 109–11; Pollard 2007, 1: no. 140.

Designed by Luciano Laurana, the castle of Pesaro depicted on the reverse was begun in 1474 and was nearly completed at the time of Costanzo's death in 1483. Costanzo was granted the use of the name Aragon in 1473 by Ferdinand I, King of Naples, for whom he fought as a condottiere. ADC

34

Attributed to Galeazzo Mondella, called Moderno (1467–1528)
MADDALENA OF MANTUA (dates unknown)
Dated 1504
Copper alloy, cast; 46.1 mm
The Frick Collection; Gift of Stephen K. and Janie Woo Scher, 2016 (2016.2.129)

Obverse: Maddalena wearing a low-necked gown and a heavy necklace, her hair in a net in the back of the head, with two large bands of hair on the sides of the face. Inscription: MAGDALENA MANTVANA DIE XX NO[vembris] MCCCCIIII [Maddalena of Mantua on the twentieth day of November 1504].
Reverse: Two allegorical female figures running to the right, one looking back and carrying a balance beam in her right hand and an hourglass in the left. Inscriptions: BENE HANC CAPIAS ET CAPTAN [*sic* for M] TENETO [Catch her properly and, once caught, keep her]; between two leaf stops, an X, the significance of which is unclear.
Literature: Hill 1930, 1: 53; 2: pl. 38, no. 215; Lewis 1987, 86–87; Scher 1994, no. 18; Vannel and Toderi 2003–7, 1: no. 514; Pollard 2007, 1: no. 115.

Nothing is known about the sitter besides her name and origin, and the specificity of the date seems to relate to the temporal quality of the *impresa* on the reverse; it could be a sort of horoscope. The reverse has been interpreted alternately as the figure of Opportunity with the forelock of Fortune seizing Time. ADC

35

Mantuan School
LUCREZIA BORGIA (1480–1519)
ca. 1502
Copper alloy, cast; 60.3 mm
Scher Collection; Promised gift to The Frick Collection

Obverse: Lucrezia wearing an embroidered gown, her hair covered by a jeweled net with a fillet (or *ferronière*) around her forehead and a long braid behind. Inscription: LVC[r]ETIA ESTEN[sis] BORGIA DVC[i]SSA [Lucrezia Borgia of the Este, Duchess].
Literature: Hill 1930, 1: 58; 2: pl. 40, no. 231; Norris 1987, 138–39; Lawe 1990, 233–45; Pollard 2007, 1: no. 120.

This extremely rare medal depicts Lucrezia after her marriage to Alfonso d'Este, future Duke of Ferrara, in 1501, perhaps around the time of her arrival in Ferrara in 1502. The illegitimate daughter of the infamous Borgia pope Alexander VI, Lucrezia had been married twice before and was not immediately welcomed in Ferrara despite bringing an enormous dowry to the city. Over time, she established her image as a virtuous wife, mother, and duchess through a carefully orchestrated series of commissions of portraits of herself in paintings and medals. ADC

36

37

36

Mantuan School
JACOBA CORREGGIA (dates unknown)
Probably after 1505
Copper alloy, cast; 50.1 mm
Scher Collection

Obverse: Jacoba wearing a brocaded or embroidered gown with bodice, and two chains with pendants, her hair loosely arranged in a hairnet held by a jeweled fillet; on the left, a day lily, laurel sprig, and oak twig bound by a leather strap or *correggia*. Inscription: IACOBA CORRIGIA FORM[a]E AC MORVM DOMINA [Jacoba Correggia, mistress of beauty and manners].
Reverse: Blindfolded Cupid bound to a tree; on the left beside a stump, a broken quiver with arrows; on the right, a bow with a broken string. Inscriptions: CESSI. DEA MILITATI STAT [I (Cupid) have had to yield; the goddess stands victorious]; in the field, on both sides of Cupid, P[?] M[?].
Literature: Hill 1930, 1: 59; 2: pl. 40, no. 234; Lewis 1987, 88–89; Norris 1987, 139; Lawe 1990, 232–45; Scher 1994, no. 20; Pollard 2007, 1: no. 122.

Unusually, this medal presents together on the obverse the sitter's portrait and personal device of a lily (signifying purity), branch of laurel (chastity), and branch of oak (faith) bound together with a leather strap, or *correggia*, a pun on the sitter's family name. The reverse composition derives from a design by Niccolò Fiorentino, and the theme of Cupid tied to a tree (Amor bendato) is an allegory of chastity and appears on the reverse of a popular 1505 medal of Lucrezia Borgia (Hill 1930, no. 233), of which the reverse of this medal may be a simplified copy. The significance of the letters "P M" (which also appear on a medal for an otherwise unrecorded Mantuan woman, Maddalena Rossi) is unknown. Suggested interpretations include "Pulchritudo ac Mores" (Beauty and Virtue), "pulchra(e) Mantuana(e)" (pretty Mantuan[s]), and "pro meritis" (for her qualities). ADC

37

Unknown artist
P. OL OF MANTUA (dates unknown)
ca. 1500
Copper alloy, cast; 71.6 × 55.5 mm
Scher Collection

Obverse: The sitter wearing a tight cap and close-fitting tunic fastened with laces; molded frame. Inscription: P. OL. MN[Mantuanus?] [of Mantua].
Literature: *Trésor de numismatique* 1834–58, 2: pl. XXXIII; Armand 1883–87, 2: 101, no. 13; Foville 1908, no. 205; Hill 1930, 1: 67; 2: pl. 44, no. 264.

Neither the sitter nor the artist of this medal is known, and the inscription has yet to be deciphered. The sitter or artist may be Mantuan, as indicated by the "MN." The date is based on stylistic details of the portrait. CM

SCHOOL OF NAPLES

38

Unknown artist (Naples)
FERRANTE I OF ARAGON, KING OF NAPLES AND SICILY
(b. 1431; r. 1458–94)
ca. 1488–95
Silver, struck; 27 mm, 3.9 g (coin)
Scher Collection

Obverse: Ferrante, crowned. Inscriptions: FERRANDVS D[ux] C[alabriæ] R[ex] SICILIE I [Ferrante, Duke of Calabria, King of Sicily]; above the shoulder, T.
Reverse: The archangel Michael with a shield in one hand and a spear in the other, poised to kill the dragon at his feet. Inscription: IVSTA TVENDA [The right things must be defended].
Literature: Morbio sale 1882, no. 2305; *Corpus nummorum Italicorum* 1910–43, 19: pl. VI, no. 10.

38

This coin belongs to the so-called *Coronate dell'Angelo*, a series of coins and medals issued from about 1488 to 1495 to commemorate the melting of the silver effigy of St. Michael venerated on Mount Gargano in order to obtain precious metals to fund Ferrante's military campaigns. The motto on the reverse justifies his destruction of the effigy. St. Michael became the patron saint of Ferrante's Order of the Ermine. The duke was also known as Ferdinand I. CM

39

Adriano de' Maestri of Florence, called Adriano Fiorentino
(ca. 1450/60–1499)

FERDINAND II OF ARAGON, PRINCE OF CAPUA

(1467–1496)
ca. 1494
Copper alloy, cast; 73.6 mm
The Frick Collection; Gift of Stephen K. and Janie Woo Scher, 2016
(2016.2.136)

Obverse: Ferdinand with long hair and wearing a small *berretta*. Inscriptions: FERDINANDVS ALFONSI DVC[i] CALAB[riæ] F[ilius] FERD[inandi] REG[is] N[epos] DIVI ALFON[si] PRON[epos] ARAGONEVS [Ferdinand of Aragon, son of Alfonso, Duke of Calabria, grandson of King Ferdinand, great grandson of the divine Alfonso]; in the field, on either side of the portrait, CAPVE / PRINCEPS [Prince of Capua]; on edge of cap, W [rendered as two linked Vs].
Reverse: A seated, half-naked woman dressed in loose drapery, holding a cornucopia in her left hand and stalks of wheat in her right; in the field to the left, an eagle displayed. Inscriptions: PVBLICAE FELICITATIS SPES [Hope for public happiness]; at lower

center, below the chair, W [rendered as two linked Vs].
Literature: Hill 1930, 1: 84; 2: pl. 54, no. 336; Vannel and Toderi 2003–7, 1: no. 120 (var.); Pollard 2007, 1: no. 146.

The portrait shows Ferdinand with unusually long hair. On the reverse, an adoption from an ancient imperial coin of Nerva (Pollard 2007) symbolizes abundance and prosperity. The eagle represents the young heir to the throne. As firstborn of the heir apparent, Ferdinand bore the title "Prince of Capua" and became the penultimate Aragonese King of Naples in 1495. The medal was probably made before the death of Ferdinand's grandfather Ferdinand I in 1494, at which time Ferdinand became Duke of Calabria. ADC

40

Adriano de' Maestri of Florence, called Adriano Fiorentino
(ca. 1450/60–1499)

GIOVANNI GIOVIANO PONTANO (1426–1503)

ca. 1500
Copper alloy, cast; 84.5 mm
Scher Collection

Obverse: All'antica portrait of Pontano. Inscription: IOANNES IOVIANVS PONTANVS [Giovanni Gioviano Pontano].
Reverse: A female figure dressed in antique drapery holding a globe and lyre; on the right, a small bush. Inscription: VRANIA [Urania].
Literature: Hill 1930, 1: 85; 2: pl. 55, no. 340; Vannel and Toderi 2003–7, 1: nos. 121, 122; Pollard 2007, 1: no. 148.

Originally from Umbria, Giovanni Pontano was a humanist and writer active at the Aragonese court of Naples. He was royal secretary under King Alfonso I, tutor of Ferdinand II, and personal secretary of his mother Ippolita Sforza. Pontano became the leader of the Neapolitan Academy (called after him the Accademia Pontaniana). Urania, muse of Astronomy, represents a combination of astronomy and poetic inspiration, alluding to Pontano's astronomical poem "Urania." It is difficult to identify the small bush. ADC

39

40

Girolamo Santacroce (ca. 1502–1537)

JACOPO SANNAZARO (1456/58–1530)

ca. 1524

Copper alloy, cast; 36 mm

Scher Collection; Promised gift to The Frick Collection

Obverse: Sannazaro, laureate. Inscription: ACTIVS SYNCERVS [Sannazaro's pseudonym as a member of the Accademia Pontaniana, Naples].

Reverse: The Nativity: the Virgin and Joseph adoring the Child near a cave, four angels above, an ox and a donkey behind.

Literature: P. A. Gaetani 1761–63, 1: 191, pl. XLIII , no. 1; Cicogna 1824–53, 6: 414; Armand 1883–87, 2: 60, no. 10; 3: 53A; Rizzini 1892, pt. 1, 26, no. 166; Supino 1899, no. 162; Hill 1917, 100; Nicolini 1925, 48–50; Hill 1930, 1: 87–88; 2: pl. 57, no. 350; Börner 1997, no. 115; Pollard 1984–85, 1: 197, no. 93; Toderi and Vannel 2000, 2: 857, no. 2641; Vannel and Toderi 2003–7, 2: nos. 1425–34.

Isabella d'Este (1474–1539), the Marchioness of Mantua and one of the greatest patrons of the Italian Renaissance, commissioned this medal in 1519 to commemorate the Neapolitan humanist and poet Jacopo Sannazaro. Today, Sannazaro is recognized for his poem "Arcadia," but during his lifetime his "De partu Virginis" (On the Virgin Birth, composed in 1513, extensively rewritten from 1519–21, published in 1526) was considered his crowning achievement and

is referenced by the Nativity scene displayed on the reverse of this medal. The sacred poem is a blend of classical mythology and the Gospel, and because of it Sannazaro was called "the Christian Virgil." A medal by Santacroce of Sannazaro is mentioned in a letter of March 20, 1524, from Pietro Summonte (1463–1526) to Marcantonio Michiel (1484–1552), indicating that the medal was designed and cast before that date. CM

SCHOOL OF VENICE

Antonello Grifo della Moneta (act. 1454–84)

CRISTOFORO MORO (b. 1390; Doge of Venice 1462–71)

1462–71

Copper alloy, cast; 41.8 mm

Scher Collection; Promised gift to The Frick Collection

Obverse: Moro wearing the *corno ducale* and ample brocaded golden robe of the doges. Inscription: CRISTOFORVS MAVRO DVX [Cristoforo Moro, Doge].

Reverse inscription: In four lines within a decorative vegetable border with ribbons, RELIGIONIS / ET / IVSTICIAE / CVLTOR [Follower of religion and justice].

Literature: Hill 1930, 1: 108; 2: pl. 77, no. 411 (var.); Pollard 2007, 1: no. 157 (var.).

41

42

43

Religious and highly educated, Moro was a capable politician who tended to the less fortunate. Cardinal Bessarion dedicated his famous library to the city of Venice during Moro's reign as doge. The Venetian people, however, held Moro responsible for the Ottoman-Venetian War of 1463–79, and he died an unpopular leader. ADC

43

Giovanni di Pasqualino Boldù (act. ca. 1454–77)
CARACALLA (b. AD 188; Roman Emperor AD 211–217)
1466
Copper alloy, cast; 91.8 mm
Scher Collection

Obverse: The emperor as a boy, wearing a loose cloak and a laurel wreath. Inscription: ANTONINVS PIVS AVGVSTVS [Antoninus Pius Augustus].
Reverse: A naked youth seated in despair on a rock, facing a winged putto who leans on a skull and holds an inverted torch with his left hand.
Literature: Hill 1930, 1: 112, 2: pl. 80, no. 423; Schüssler 1998; Vannel and Toderi 2003–7, 1: no. 163; Pollard 2007, 1: no. 164 (var.).

This portrait type is generally believed to have been adapted in reverse from a Roman coin, probably minted in AD 199, featuring the future emperor (whose full name was Marcus Aurelius Severus Antoninus Augustus) as a boy. Schüssler (1998) proposed the identification of the emperor as Marcus Aurelius dressed, as a youth, in the philosopher's cloak. The winged putto with the skull and the inverted torch on the reverse is a classical funerary motif; the same imagery appears on the reverse of the artist's self-portrait medal dated 1458 (Pollard 2007, no. 163). Both obverse and reverse appear as marble medallions on the facade of the Certosa di Pavia. A variant with the same obverse and reverse includes the inscription IO SON FINE [I am the end] M CCCC LXVI [1466] (Pollard 2007, no. 164), providing the possible date of issue of this example. ADC

44

Vittore Gambello, called Camelio (1455/60–1537)
SELF-PORTRAIT
Dated 1508
Copper alloy, struck; 42 mm
The Frick Collection; Gift of Stephen K. and Janie Woo Scher, 2016
(2016.2.141)

Obverse inscription: VICTOR CAMELIVS SVI IPSIVS EFFIGIATOR MDVIII [Vittore Camelio, portrayer of himself, 1508].
Reverse: Naked men gathered around an altar with the remains of a sacrificed animal; two goats on the ground, one in front of the altar and the other to its left; on the left, a standing nude man seen from behind, an augur, lighting a torch from a lamp; next to him, another man leaning on a cippus with a child beside him; on the right, a man and a woman looking on. Inscriptions: FAVE FOR[tuna] [Favor Fortune]; in exergue, SACRIF[icio] [with a sacrifice].
Literature: Hill 1930, 1: 118; 2: pl. 84, no. 446; Pollard 2007, 1: no. 170; Zaccariotto 2010, 133n.5.

This self-portrait is inspired by ancient Roman coins. The scene on the reverse, an example of Camelio's vast repertory of all'antica images, does not seem to have a specific ancient prototype. The inscription is the invocation used by the augurs. The striking of the obverse shows chattering in the doubled lettering and, on both sides, the lack of a collar. ADC

44

45

45

Maffeo Olivieri (1484–1543/44)
ALTOBELLO AVEROLDO (ca. 1465–1531)
ca. 1517–21
Copper alloy, cast; 92.5 mm
Scher Collection

Obverse: The bishop wearing a biretta and a rochet. Inscription:
ALTOBELLVS AVEROLDVS BRIXIEN[sis] POLEN[sis] EP[iscopu]S VEN[etiæ]
LEG[a]T[u]S APOST[olicus] [Altobello Averoldo of Brescia, bishop of
Pola, apostolic legate at Venice].
Reverse: Two men unveiling a personification of Truth. Inscription:
VERITATI D[icatum] [Dedicated to truth].
Literature: Hill 1930, 1: 128; 2: pl. 90, no. 486; Scher 1994, no. 30;
Pollard 2007, 1: no. 183.

Averoldo, the illegitimate son of a prominent Brescian family, was
bishop of Pola in 1497 and apostolic legate twice (1517–21 and
1526–30). This medal was produced during his first tenure as papal
legate, as stated in the inscription of the obverse. The enigmatic
reverse seems to depict the unveiling of Truth in the form of a naked
female figure and could allude to two different events in 1518: the
committee (of which he was head) investigating witch burnings
in Valcamonica, near Brescia; or the successful banishment from
Brescia of a nobleman who, along with two companions, raped a
ten-year-old girl (the stepdaughter of a close relative). It has also
been suggested that the two men are veiling Truth rather than
stripping away her garment. ADC

46

Maffeo Olivieri (1484–1543/44)
AUGUSTO DA UDINE (act. first half of 16th century)
ca. 1519
Copper alloy, cast; 32 mm
Scher Collection

Obverse: Augusto with long hair, crowned with a laurel wreath.
Inscription: AVGVSTVS VATES [Augusto the poet].
Reverse: Standing nude female figure. Inscription: V R A N I A
[Urania].
Literature: Hill 1930, 1: 128; 2: pl. 90, no. 485; Vannel and Toderi
2003–7, 1: no. 536; Pollard 2007, 1: no. 182.

Agostino Geronimiano, also known as Augusto da Udine or Publio
Augusto Graziani, was a poet and astrologer, crowned with laurel
by Emperor Frederick III. He was still alive in 1519, when this
medal was probably produced. The portrait type appears on his
Odae (Venice, 1529). Urania, the muse of astronomy, alludes to his
astronomical studies. ADC

46

47

47

Attributed to Maffeo Olivieri (1484–1543/44)
MARCANTONIO CONTARINI (ca. 1485–1546)
Dated 1530
Copper alloy, cast; 62.7 mm
Scher Collection

Obverse: Contarini dressed in a tunic or gown. Inscriptions: M[arcus]
ANT[onius] CONTARENVS IVLIENS[is] PRESES; beneath truncation, MDXXX
[Marco Antonio Contarini, governor of Friuli; 1530].
Reverse: In the center, a naked female figure with her head turned
to the left, holding a spear with the point facing upward in her right
hand; at her right foot, a helmet; in her left hand, a horse head-
shaped shield adorned with the head of Medusa. Inscription: PACE
CONFECTA [Accomplished peace].
Literature: Cicogna 1824–53, 6: 308; Heiss 1881–92, 6: 191–92,
pl. XVI, no. 3; Armand 1883–87, 2: 174, no. 6; Bode 1904, 40; Hill
1930, 1: 128; 2: pl. 90, no. 484; Börner 1997, no. 186; Voltolina
1998, 1: 324, no. 277; Pollard 2007, no. 200, n. 3.

Contarini was elected Lieutenant of the Patria del Friuli in 1527;
in early 1530, when his mandate was about to end, the people of
Udine commissioned this medal to thank him for his service to the
city. On June 14, 1530, while laying the first stone of the Loggia
di San Giovanni in Piazza Contarena (now Piazza della Libertà),
in Udine, Contarini left two copies of the present medal in the
building. They were discovered during restoration work in 1881.
One remained there, and the other is now in the Museo Civico. As
indicated by her attributes, the figure on the reverse is very likely
Minerva, who was both the protector of peace and, like Contarini, of
the city. Bode initially attributed this medal to the group now given
to Maffeo Olivieri; however, as mentioned by Hill and Pollard, the
medal lacks the artist's characteristic stops and is of a later date than
the others. The authorship, as such, is not universally accepted. CM

48

Unknown artist (Venice)
GIOVANNI CORNARO (late 15th/16th century)
1507–14
Copper alloy, cast; 43.6 mm
Scher Collection; Promised gift to The Frick Collection

Obverse: Cornaro tonsured and wearing a cassock. Inscription:
IO[annes] CORNELIVS MONACOR[um] CASIN[ensium] COLVMEN
[Giovanni Cornelio, supporter of the monks of Montecassino].
Reverse: A shepherd carrying a sheep with a flock in front of a palm
tree with the Pelican in Her Piety. Inscription: PIETAS EVANGELICA
[Evangelical piety].
Literature: Rizzini 1892, pt. 1, 73, no. 495; Armand 1883–87, 2:
70, no. 5; Lanna sale 1911b, no. 123; Hill 1930, 1: 136; 2: pl. 96,
no. 527; Hill and Pollard 1967, no. 168; Pollard 1984–85, 1: 258,
no. 126; Börner 1997, no. 203; Voltolina 1998, 1: 207–8, no. 169;
Toderi and Vannel 2000, 1: 256, no. 707; Vannel and Toderi 2003–7,
1: no. 558; Pollard 2007, 1: no. 189.

This medal likely dates to the time when Cornaro (or Cornelio), a
Venetian Benedictine of the abbey of Praglia, was abbot of Santa
Giustina in Padua (1507–15). However, Pollard has suggested that
the cross at the beginning of the inscription on the obverse could
indicate that the medal was conceived to commemorate the abbot's
death. The image is of the Good Shepherd (Christ), with the symbol
of the Passion (the Pelican in Her Piety) in the background. CM

48

49

50

SCHOOL OF BOLOGNA

49

Francesco Francia (1450–1517)
FRANCESCO DEGLI ALIDOSI (ca. 1455–1511)
ca. 1508/10
Copper alloy, cast; 61.2 mm
Scher Collection

Obverse: Alidosi wearing a hooded cassock and *berretta*.
Inscription: FR[anciscus] ALIDOXIVS CAR[dinalis] PAPIEN[sis] BON[oniæ] ROMANDIOLAE Q[ue] C[ardinalis] LEGAT[us] [Francesco Alidosi, cardinal of Pavia, and cardinal legate of Bologna and Romagna].
Reverse: Jupiter with a thunderbolt in a chariot drawn by eagles; in exergue, the astrological signs of Pisces and Sagittarius. Inscription: HIS AVIBVS CVRRVQ[ue] CITO DVCERIS AD ASTRA [With these birds and chariot you will be quickly conducted to the heavens].
Literature: Hill 1930, 1: 156; 2: pl. 109, no. 610; Vannel and Toderi 2003–7, 1: nos. 645, 646; Pollard 2007, 1: no. 211.

Alidosi was ambassador and commander of the papal forces in the war against Venice and France. He became cardinal of Pavia in 1505, legate to Bologna and Romagna in 1508–9, and bishop of Bologna in 1510; so the medal must have been issued around this date. He was accused of conspiracy with the French by Francesco Maria della Rovere, Duke of Urbino and commander of the papal forces. Though Alidosi was protected by Pope Julius II, he was assassinated by the Sforza in 1511 in broad daylight in Ravenna. The reverse attributes the sitter's success to the influence of his planet, Jupiter, whose zodiacal signs appear in the exergue. As suggested by Carolyn Miner, the figure of Jupiter is probably based on the depiction of Odysseus in the Felix Gem (ca. A.D. 1–50; Ashmolean Museum, Oxford). ADC

50

Attributed to Francesco Francia (1450–1517)
GIOVANNI II BENTIVOGLIO (1443–1508)
Dated 1494
Copper alloy, struck; 28.1 mm
Scher Collection

Obverse: Bentivoglio wearing armor and a cap with border.
Inscription: IOANNES BENTIVOLVS II BONONIENSIS [Giovanni II Bentivoglio of Bologna].
Reverse inscription: In six lines, MA / XIMILIANI / IMPERATORIS / MVNVS / MCCCCLXXXX / IIII [Gift of the Emperor Maximilian, 1494].
Literature: Hill 1930, 1: 155; 2: pl. 108, no. 606; Pollard 2007, 1: no. 212.

This medal commemorates the right of coinage granted to Bentivoglio, Lord of Bologna, by the emperor in 1494. Bentivoglio ruled Bologna for forty-three years without an official title and in 1506 was expelled by the army of Pope Julius II. The attribution to Francia is made on the basis of Vasari's word, but no documentary evidence supports it. The portrait is related to a relief bust in San Giacomo Maggiore in Bologna; both the medal and relief may have been based on a previous portrait by Francia. ADC

51

After Francesco Francia (1450–1517)
BERNARDO DE' ROSSI (1468–1527; governor of Bologna 1519–23)
ca. 1519
Copper alloy, cast; 65.9 mm
The Frick Collection; Gift of Stephen K. and Janie Woo Scher, 2016 (2016.2.137)

Obverse: De' Rossi wearing a hooded cassock and *berretta*.
Inscription: BER[nardus] RV[beus] CO[mes] B[erceti] EP[iscopu]S TAR[visinus] LE[gatus] BO[noniæ] VIC[arius] GV[bernator] ET PRAE[fectus] [Bernardo Rossi, Count of Berceto, bishop of Treviso, legate of Bologna, vice-governor and prefect].
Reverse: Female figure in antique drapery holding a flower, standing in a chariot drawn by a dragon and an eagle; the wheels in flower form. Inscription: OB VIRTVTES IN FLAMINIAM RESTITVTAS [For the restitution of the virtues in Romagna].
Literature: Hill 1930, 1: 157; 2: pl. 110, no. 612; Vannel and Toderi 2003–7, 1: nos. 647–49; Pollard 2007, 1: nos. 209, 210.

Appointed bishop of Treviso in 1499, Bernardo de' Rossi was governor of Bologna between 1519 and 1523. The female figure, which may represent Peace, alludes to the repression of the

51

1519 disturbance in Ravenna when de' Rossi was legate there.
A portrait of de' Rossi by Lorenzo Lotto is in the Museo Nazionale di
Capodimonte in Naples. ADC

52

Girolamo Faccioli (act. ca. 1560; d. 1573)
POPE PIUS IV (b. 1499; r. 1559–65)
1561–65
Copper alloy, cast; 36.7 mm
Scher Collection; Promised gift to The Frick Collection

Obverse: Pius wearing a cope closed with a morse. Inscription: PIVS
IIII PONTIFEX MAXIMVS [Pope Pius IV].
Reverse: The goddess Annona holding a statuette of Justice and a
cornucopia, surrounded by crops and a wagon with bundles of
grain. Inscription: ANNONA PONT[ificis] [Pontifical Annona].
Literature: Bonanni 1699, 1: 290, no. 35; Venuti 1744, 121, no.
xxxv; Armand 1883–87, 3: 261; Patrignani 1951, 50; Bascapè 1967,
43; Toderi and Vannel 2000, 1: 434, no. 1294; Modesti 2002–4, 3:
no. 532.

Pope Pius IV (born Giovanni Angelo de' Medici di Marignano) is
known for reconvening and resolving the Council of Trent. This
extremely rare medal commemorates his *annona*, the control of
the provision and pricing of grain and other staples, for the city of
Bologna after the famine of 1560. A four-year plan was put in place
between 1561 and 1565; this is a cast of the medal that was likely
struck in Bologna by Faccioli in those years. CM

53

Unknown artist (possibly Bologna)
UNKNOWN MAN
1550–1600
Copper alloy, cast; 51.9 mm
Scher Collection

Obverse: Bust wearing a doublet with high collar and a ruff.
Inscription (fragmentary): PA[olus?] CRV[?].
Reverse: Mars and Mercury chained together, the chain held by
Amor. Inscription: VICTORE A SVMMO VINCI VICTORIA SVMMA EST
[To be defeated by the supreme winner is the greatest victory].
Literature: Toderi and Vannel 2000, 2: 901, no. 2818.

This is the only extant version of this medal. The inscription on the
reverse, which celebrates the power of love, comes from Achille
Bocchi's *Symbolicarum quaestionum . . . libri quinque* (A. Bocchi
1574, 161: "Pan victus a cupidine in lucta cadit," v. 11). The allegory,
however, is not easily deciphered. With both Alexandrine and
Petrarchan precedents, Mars could represent war and Mercury either
intellect or commerce. The profile on the obverse could therefore
be the portrait of a man involved in business or in the army, with a
passion for intellectual pursuits, or perhaps an author of love poems
or sonnets. The chains that bind all three figures probably have erotic
meaning. CM

52

53

54

SCHOOL OF MILAN

54
Antonio Abondio (1538–1591)
JACOPO NIZZOLA DA TREZZO (1519–1589)
Dated 1572
Copper alloy, cast; 69.6 mm
Scher Collection

Obverse: Trezzo wearing a cloak and *camicia* with ruffed collar.
Inscriptions: IACOBVS NIZOLLA DE TRIZZIA MDLXXII [Jacopo Nizzola
da Trezzo, 1572]; in the field behind the bust, AN[tonio] AB[ondio].
Reverse: Minerva and Vulcan representing wisdom and artistry;
Vulcan holding a hammer in his right hand and with a square, a
compass, and a plumb line (symbols of architecture) at his feet.
Inscription: ARTIBVS QVAESITA GLORIA [Fame acquired through the
arts].
Literature: Scher 1994, no. 60; Attwood 2003, no. 1125.

A medalist, jeweler, sculptor, and architect from Lombardy, Trezzo
was active in Spain from 1560. Most likely made during Abondio's
visit to Spain from June 1571 to March 1572, this medal celebrates
Trezzo's artistic achievements in Spain, especially as an architect
in the expansion of the Escorial (Vulcan, who was perhaps given
Trezzo's features, alludes to sculpture and medal making and is
surrounded by architectural tools). It is one of only three medals by
Abondio with a figurative scene of his invention on the reverse. ADC

55
Antonio Abondio (1538–1591)
ERNEST OF BAVARIA (1554–1612)
Dated 1572
Silver, cast; 40.3 mm
The Frick Collection; Gift of Stephen K. and Janie Woo Scher, 2016
(2016.2.145)

Obverse: Ernest wearing a biretta, a ruff, and a coat. Inscriptions:
ERNESTVS ADMI[nistrator] FRISING[æ] BAVARIAE DVX 1572 [Ernest, Duke
of Bavaria, administrator of Freising, 1572]; in exergue on bottom
left, AN[tonio] AB[ondio].
Reverse inscription: In field, OLEVM PECCATORIS NON IMPINGVABIT
CAPVT [The oil of the sinner will not anoint my head (Augustine,
Epistulae)].
Literature: Armand 1883–87, 1: no. 127; Dworschak 1958, 52;
Habich 1929–34, 2: pt. 2, no. 3369; Schulz 1988, 20, no. 6.3; Toderi
and Vannel 2000, 1: 166, no. 445; Cupperi et al. 2013, 250–51,
no. 161.

The son of Albert V, Duke of Bavaria, and Anna of Austria, Ernest
of Bavaria was Prince-Elector-Archbishop of Cologne and bishop
of Münster, Hildesheim, Freising, and Liège. He was called the
protector of Roman Catholicism in northwest Germany and was an
ardent supporter of the Counter-Reformation. CM

55

56

56

Antonio Abondio (1538–1591)
MARIA OF AUSTRIA, HOLY ROMAN EMPRESS (1528–1603)
Dated 1575
Lead alloy, cast; 58.2 mm
Scher Collection

Obverse: Maria in coif, cloak with fur collar, high-collared gown and ruff, wearing a necklace with a pendant. Inscriptions: MARIA IMPER[atrix] MDLXXV [Empress Maria, 1575]; behind the bust, AN[tonio] AB[ondio].
Literature: Scher 1994, no. 61a; Toderi and Vannel 2000, 1: 167, no. 453; Attwood 2003, no. 1134a; Pollard 2007, 1: no. 538 (var.).

Daughter of Emperor Charles V, Maria of Austria married her cousin Maximilian (future Emperor Maximilian II) and bore him sixteen children. Her portrait appears cast individually, as well as paired together with that of Maximilian II. These are the last of Abondio's medallic portraits of the imperial couple. ADC

57

Antonio Abondio (1538–1591)
COUNTESS PALATINE ELISABETH OF SIMMERN–SPONHEIM
(1540–1594)
Dated 1576
Silver, cast; 44.4 mm
Scher Collection

Obverse: Elisabeth wearing a gown, a ruff, a flat cap, a veil, a hairnet, and a jeweled collar with pendant. Inscriptions: ELISABETA DEI GRATIA DVCISSA SAXONIÆ [Elisabeth, by the grace of God, Duchess of Saxony]; in exergue, AN[tonio] AB[ondio].
Reverse: Coat of arms of Elisabeth. Inscriptions: HILF HIMLISCHER HERR HOCHSTER HORT [Help, O Celestial Lord, (thou) Highest Shelter]; below, 15 76.
Literature: Luckius 1620, 225; Tentzel 1705, 2: pl. 17, no. 3; Bergmann 1844–57, no. XIII; Armand 1883–87, 1: 272, no. 27; Fiala 1904, no. 44; Domanig 1907, no. 247; Habich 1929–34, 2: pt. 2, no. 3379; Dworschak 1958, no. 52; C. Johnson and Martini 1986–95, no. 689; Toderi and Vannel 2000, 1: 169, no. 464.

Elisabeth married Johann Friedrich II, Duke of Saxony, in 1558. The duke commissioned from Abondio a portrait medal of himself with his family's coat of arms (Attwood 2003, no. 1140) together with the present medal of his wife with her coat of arms. Both bear the date 1576, the year that Elisabeth's father, Frederick III, Elector Palatine, died. CM

58

Antonio Abondio (1538–1591)
RUDOLF II, HOLY ROMAN EMPEROR (b. 1552; r. 1576–1612)
ca. 1577
Silver, cast; 38 mm
Scher Collection

Obverse: Rudolf, laureate, wearing armor, a ruff, and a commander's sash fastened on the right shoulder. Inscription: RVDOLPHVS II ROM[anorum] IMP[erator] SEMP[er] AVG[ustus] [Rudolf II, Emperor of the Romans, Forever August].
Literature: Armand 1883–87, 1: 269, no. 8; Habich 1929–34, 1: pt. 2, no. 3418; Humphris 1993, no. 63.

Rudolf II was Holy Roman Emperor, King of Hungary and Croatia, King of Bohemia, and Archduke of Austria. Although he was a less than effective ruler, he was a defining patron of the arts and sciences. He cultivated northern mannerist artists and, in many ways, set the stage for the scientific revolution of the times. This uniface portrait of Rudolf II is a variant of a signed version by Abondio with an obverse bearing a slightly different inscription and a reverse of a spread eagle (Attwood 2003, no. 1147). There are other variants, including the same obverse with a reverse displaying the portrait of Ernest, Archduke of Austria. "Semper Augustus" (Forever August) was an official title given to the emperor. CM

57

58

59

59

Antonio Abondio (1538–1591)
APOLLONIO MENABENI (ca. 1540–ca. 1603)
Dated 1591
Copper alloy, cast; 50.3 mm
Scher Collection

Obverse: Menabeni wearing a doublet, a ruff, and a coat with a fur collar. Inscription: APOLLONIVS MENABENVS DOCT[or] PHYSICVS [Apollonio Menabeni, doctor].
Reverse: Androcles removing a thorn from a lion's paw in a rocky cave. Inscription: CVM EXVLTATIONE METET 1591 [(He) shall harvest with exultation, 1591].
Literature: P. A. Gaetani 1761–63, 1: 414–15, pl. XCIII, no. 4; Armand 1883–87, 2: 262, no. 1; Habich 1929–34, 1: pt. 2, no. 3394; Dworschak 1958, no. 53; Toderi and Vannel 2000, 1: 174, no. 485.

Apollonio Menabeni was a Milanese philosopher, poet, and physician to the King of Sweden. He wrote *Tractatus de magno animali . . .* in 1581 for the emperor Rudolf II. The reverse of this medal commemorates Menabeni's work as a doctor and naturalist with an illustration of a scene from the fifth book of Aulus Gellius's *Attic Nights*. It tells the story of Apion, who claimed to have witnessed the tribulations of the Roman slave Androcles, who escaped to a cave to discover it was the home of a wounded lion. Androcles removed the large thorn from the lion's paw and in return received a lion's loyalty. The depiction is reminiscent of scenes from the life of St. Jerome, which were popular at the time of the German Renaissance. Abondio was one of the few medalists to successfully marry the styles of Italian and German Renaissance art. CM

60

Anteo Lotello (act. ca. 1572–ca. 1578)
DON LUIS DE ZÚÑIGA Y REQUESENS (1528–1576)
1572–73
Silver, cast; 61.4 mm
The Frick Collection; Gift of Stephen K. and Janie Woo Scher, 2016 (2016.2.172)

Obverse: Zúñiga y Requesens wearing ornamental armor centered by a mask. Inscriptions: LVDVICVS RICASENIVS MAIOR CASTILLIE COMENDATARIVS [Luis de Requesens, Comendator Mayor of Castile]; signed above the shoulder, ANTEVS F[ecit] [Anteo made it].
Reverse: Galleys at the Battle of Lepanto, with an angel raising a sword appearing from the clouds. Inscription: FORTITVDINE AC CONSILIO [With fortitude and wisdom].
Literature: Van Loon 1723–31, 3: 216; Bolzenthal 1840, 161; Armand 1883–87, 1: 261; 3: 130; Supino 1899, no. 468; Rinaldis 1913, no. 349; Middeldorf 1977, fig. 2; Mateu y Llopis 1977, 36; Pollard 1984–85, 3: 1277, no. 742; C. Johnson and Martini 1986–95, nos. 715, 716; Pannuti 1996, no. 8.150; Börner 1997, no. 797; Toderi and Vannel 2000, 1: 85, no. 172; Attwood 2003, no. 130; Vannel and Toderi 2003–7, 1: no. 498.

Zúñiga y Requesens, a member of a prominent Catalan family, participated in the Battle of Lepanto in 1571 as the lieutenant general of Don Juan of Austria. He was then appointed viceroy of Milan by King Philip II and later succeeded Don Juan as governor of the Netherlands during the Dutch revolt. This medal celebrates an episode in the Battle of Lepanto, in which he avoided a shipwreck by countering more expert sailors' judgment and directing his auxiliary fleet toward Mallorca. CM

60

61

letters, the *docte princesse* of La Pléiade. This medal was made at the time of her death. The *impresa* on the reverse, which is also on her tomb in the Abbey of Hautecombe, is an homage to Margaret's numerous talents and achievements. CM

61

Anteo Lotello (act. ca. 1572–ca. 1578)
MARGARET OF VALOIS, DUCHESS OF SAVOY (1523–1574)
1574
Copper alloy, pierced, cast; 47.4 mm
Scher Collection; Promised gift to The Frick Collection

Obverse: Margaret wearing a French hood with a lower *billement* of pearls, in a dress with a high collar and ruff. Inscription: MARGARETA A FRANCIA EMAN[uelis] PHIL[iberti] ALLOB[rogum] DVCIS CONIVX [Margaret of France, wife of the Duke Emanuele Filiberto of Savoy].
Reverse: A sarcophagus with two sides inscribed and with four wreaths—olive branches (peace), oak branches (force), laurel branches (glory), and palm branches (victory); above the sarcophagus, a wreath of stars flanked by clouds; two olive branches lie in front. Inscriptions: on the sarcophagus, HIS SVMMAM MERVIT C[O]ELO [With these (crowns) she has deserved the highest (crown) in Heaven]; DIV POST FATA NITESCET [For a long time after death she will shine]; in exergue, traces of a signature, ANT[eus] FECIT [Anteo made it].
Literature: Wellenheim sale 1844, 147, no. 2515; Armand 1883–87, 3: 130, no. b; Marini 1914, 91, no. 13; Toderi and Vannel 2000, 1: 85, no. 175; Attwood 2003, no. 131 (var.).

Margaret of Valois, the daughter of the King of France, François I, became Duchess of Berry in 1549 and Duchess of Savoy after marrying Emanuele Filiberto of Savoy in 1559. Celebrated for her intelligence, taste, and refinement, she was a patron of the arts and

62

Anteo Lotello (act. ca. 1572–ca. 1578)
RENÉ DE BIRAGUE (1507–1583)
ca. 1578–83
Gilt copper alloy, cast; 67.5 mm
Scher Collection

Obverse: Birague wearing a hooded cassock and a biretta. Inscription: RENATVS CARD[inalis] BIRAGVS FRANCIÆ CANCEL[l]ARIVS [Cardinal René de Birague, Chancellor of France].
Reverse: The Lamb of God, with one hoof on a book, the other holding the papal cross, on a bed of grass. Inscriptions: RVBET AGNVS ARIS [The Lamb reddens on the altars]; ANTEO F[ecit] [Anteo made it].
Literature: M. Jones 1982, 1: no. 170 (var.).

René de Birague, also known as Renato Birago, belonged to a Milanese family that became French. He held important positions in Piedmont on behalf of the King of France, was close to Catherine de' Medici, and became chancellor in 1573. Birague began his ecclesiastical career after his wife died in 1572. He became bishop of Lodève in 1573 and cardinal in 1578. The motto of this medal is an anagram of Birague's name (Renatus Biragus). CM

63

Unidentified Milanese Medalist II
FRANCESCO D'ESTE (1516–1578)
Before 1544
Lead, cast; 67.8 mm
Scher Collection

Obverse: D'Este wearing a cuirass centered by a gorgon's head, lion-headed pauldrons, and a mantle over his shoulder. Inscription: FRANCISCVS ESTENSIS [Francesco d'Este].

62

63

Reverse: Two identical domed temples, one dedicated to Virtue and the other to Honor. Inscription: in exergue, PARI ANIMO [With equal spirit].
Literature: Keary 1881, no. 235; Armand 1883–87, 2: 148, no. 9; Boccolari 1987, no. 92; Rizzini 1892, pt. 1, 83, no. 563; Museo Correr 1898, no. 405; Humphris 1993, no. 60; Bellesia 1997, 40; Toderi and Vannel 2000, 1: 397, no. 1174; Attwood 2003, no. 100.

The son of Alfonso I, Duke of Ferrara, and Lucrezia Borgia, Francesco d'Este inherited Massa Lombarda upon his father's death in 1534 and became marquis ten years later. He was a general for Charles V, and, after the emperor's death, served in France. Attwood has convincingly attributed the work to the mid-sixteenth-century medalist now referred to as Unidentified Milanese Medalist II, based on similar open composition, lettering, and positioning of the busts found in three other medals. He believes the artist to be within the circle of Jacopo da Trezzo but possessing a superlative refinement (2003, no. 100) that places him above Trezzo and among the greatest medalists of the sixteenth century. The *impresa* and motto on the reverse are repeated in the Sala delle Imprese in Palazzo Marfisa d'Este in Ferrara and also belonged to Cardinal Ranuccio Farnese (1530–1565). CM

64

Unknown artist
GIAN GALEAZZO MARIA SFORZA, SIXTH DUKE OF MILAN (1469–1494) and **LUDOVICO MARIA SFORZA** (1452–1508)
1481–94
Silver, struck; 28.7 mm, 9.5 g (*testone* coin)
Scher Collection

Obverse: Gian Galeazzo in armor. Inscription: IO[annes] G[aleaz]Z[o] M[aria] SF[orza] VICECO[mes] DVX M[i]L[an]I S[e]X[tus] [Gian Galeazzo Maria Sforza Visconti, sixth duke of Milan].
Reverse: Ludovico in armor. Inscription: LVDOVICVS PATRVVS GVB[er]NANS [Ludovico, his uncle, being governor].
Literature: Pollard 2007, 2: no. 793.

Only seven years old when his father, Galeazzo Maria, was assassinated, Gian Galeazzo became Duke of Milan and reigned first with his mother Bona of Savoy and then with his uncle Ludovico (known as Ludovico il Moro) after 1481. His untimely death in 1494 was widely believed to have been caused by Ludovico himself. ADC

65

Unknown artist (Milan)
GALEAZZO MARIA SFORZA, FIFTH DUKE OF MILAN (1444–1476)
ca. 1466–1476
Silver, struck; 29 mm, 9.6 g (*testone* coin)
Scher Collection

Obverse: Galeazzo with hair to the nape of his neck, wearing mail beneath armor; to his right, a point inside a circle. Inscription: [head of Sant' Ambrogio stop] GALEAZ[zo] M[aria] SF[orza] VICECO[mes] DVX M[edio]L[an]I Q[u]I[n]T[us] [Galeazzo Maria Sforza Visconti, fifth duke of Milan].
Reverse: The Visconti coat of arms surmounted by a crowned helmet with a crest and a winged dragon devouring a man; on each side, two buckets hanging from two branches sprouting from the flames. Inscriptions: P[a]P[iæ] ANGLE[riæ] Q[ue] CO[mes] AC IANV[a]E D[ominus] [Count of Pavia and Angera and Lord of Genoa]; in the field, the initials G3 and M.

 64 65 66

Literature: *Corpus nummorum Italicorum* 1910–43, nos. 17, 177; Ravegnani Morosini 1984, 3: 248, no. 8; Crippa 1986, no. 6A; Varesi 1998–2011, 2101/2.

Galeazzo's reputation is that of a cruel and ruthless leader with many enemies. He was assassinated by high-ranking members of his court in 1476. The Visconti coat of arms shown on the reverse, referred to as the *biscione visconteo*, displays a snake devouring a human. Although its original meaning is unclear, the snake probably derives from the name Visconti, which sounds like *biscione* (meaning "viper"). Under the Viscontis' dominance as rulers of Milan and northern Italy in the fourteenth and fifteenth centuries, the coat of arms became a symbol for the city. When the Sforzas became dukes of Milan, they adopted the *biscione visconteo* (and a number of Visconti *imprese*) to symbolize political and dynastic continuity and their rightful claim to the duchy. CM

66
Unknown artist (Piedmont)
LUDOVICO II DI SALUZZO (1438–1504)
1475–1504
Silver, struck; 27.1 mm, 3.5 g (*cavalotto* coin)
Scher Collection

Obverse: Di Saluzzo wearing a cap and armor. Inscription: [cross] LVDOVICVS M[archio] SALVTIARUM [Ludovico, Marquess of Saluzzo].
Reverse: St. Constantius on a horse. Inscription: SANCTVS CONSTANTIVS.
Literature: Morbio sale 1882, no. 1201; *Corpus nummorum Italicorum* 1910–43, 2: pl. VI, no. 7a; Bernareggi 1954, 129, no. 24 (some var.); Hill and Pollard 1967, no. 643; Ravegnani Morosini 1984, 3: 103, no. 10.

Ludovico II di Saluzzo was Count of Carmagnola and Marquess of Saluzzo. He supported the King of France, Charles VIII, in the first Italian war (1494–96) and fought with him in the battle of Fornovo (1495). The coin associates Ludovico with St. Constantius, a converted Roman soldier who refused to fight the Gauls (French) and instead became a champion of the Christian faith. He went on to spread Christianity throughout the Piedmont and died a martyr. The coin, a *cavalotto*, shows the iconography of St. Constantius, which was also adopted by Ludovico's father, in a panegyric sermon written by the humanist Giacomo Falco. CM

67
Unknown artist (Casale Monferrato, Piedmont)
GUGLIELMO II PALAIOLOGOS (r. 1494–1518)
1494–1518
Silver, struck; 28.5 mm, 9.4 g (*mezzo-testone* coin)
Scher Collection

Obverse: Guglielmo wearing a cap. Inscription: GVLIELMVS MAR[chio] MONT[is] FER[rati] ETC[etera] [Gugliemo, Marquess of Monferrato, et cetera].
Reverse: The arms of the Palaiologi of Monferrato. Inscription: SACRI RO[mani] IMP[erii] PRINC[eps] VICA[rius] P[er]P[etuus] [Perpetual Prince Vicar of the Holy Roman Empire].
Literature: Wellenheim sale 1844, no. 2696; Promis 1858, 27; Morbio sale 1882, no. 1212; Armand 1883–87, 1: 101, no. 16; *Corpus nummorum Italicorum* 1910–43, 2: pl. VIII, no. 18; Ravegnani Morosini 1984, 3: 40, no. 11.

Guglielmo Palaiologos, who ruled as Guglielmo IX, was Marquess of Monferrato. On the reverse of this coin, the coat of arms is composed of quarters, displaying Byzantium; Jerusalem impaling Foix; Saxony impaling Bar; and Palaiologos above an escutcheon of Monferrato (all of which refer to the family's long history of allegiance to the empire). CM

68
Attributed to Cristoforo Foppa, called Caradosso (ca. 1452–1526/27)
GIAN GIACOMO TRIVULZIO (1441–1518)
Dated 1499
Copper alloy, cast; 45.6 × 46.6 mm
Scher Collection; Promised gift to The Frick Collection

Obverse: Trivulzio in armor and wearing a laurel crown; in the four corners of the plaquette, three Trivulzio shields of arms and the *ruota del sole*. Inscription: around the portrait, IO[annes] IACOBVS TRIVVL[tiu]S MAR[chio] VIG[evani] FRA[nciæ] MARESCAL[c]VS [Gian Giacomo Trivulzio, Marquess of Vigevano, Marshal of France].
Reverse inscription: In nine lines, 1499 / EXPVGNATA ALE / XANDRIA DELETO / EXERCITV LVDOVI / CVM SF[ortia] M[i]L[an]I DVC[em] / EXPELLIT REVER / SVM APVD NOVA / RIAM STERNIT / CAPIT [1499, having taken Alexandria, having destroyed the army, he expelled Ludovico Sforza, Duke of Milan, and (Ludovico) fleeing was defeated and captured near Novara].

67

68

69

Literature: Hill 1930, 1: 169–170; 2: pl. 115, no. 655; Vannel and Toderi 2003–7, 1: no. 407; Pollard 2007, 1: no. 217.

Trivulzio took Milan in 1499 on behalf of Louis XII of France, betraying Ludovico il Moro Sforza (see no. 64). Although Trivulzio led the French army against Venice (Agnadello, 1509) and the pope (Marignano, 1515), he lost the favor of the French king and died at Chartres in 1518. Lomazzo attributed this plaquette celebrating Trivulzio's victory to Caradosso, but its style is somewhat different from his other works (Pollard 2007). ADC

69
—
Attributed to Cristoforo Foppa, called Caradosso (ca. 1452–1526/27)
POPE JULIUS II (b. 1443; r. 1503–13)
Dated 1506
Copper alloy, cast; 52.1 mm
Scher Collection

Obverse: Julius wearing an embroidered cope with decorated orphrey and morse. Inscription: IVLIVS LIGVR PAPA SECVNDVS MCCCCVI [Pope Julius II of Liguria, 1506].
Reverse: View of St. Peter's, Rome. Inscriptions: TEMPLI PETRI INSTAVRACIO [The renewal of the Temple of St. Peter]; below, VATICANVS M[ons] [Mount Vatican].
Literature: Hill 1930, 1: 171; 2: pl. 115, no. 659; Pollard 2007, 1: no. 219; Zaccariotto 2014, 64–65.

Julius II (born Giuliano della Rovere) reestablished papal authority over the Church's states and resisted the French invasion in Italy.

A generous patron of the arts, he undertook the reconstruction of the crumbling old St. Peter's basilica, giving the commission for the design to Donato Bramante. Bramante's original idea was a Greek cross plan, with the elevation flanked by two bell towers, as seen on the reverse of the medal. Attributed to Caradosso by Vasari, the medal represents one among a group of twelve objects buried in the foundations of the new basilica on April 18, 1506. ADC

70
—
Attributed to Cristoforo Foppa, called Caradosso (ca. 1452–1526/27)
POPE JULIUS II (b. 1443; r. 1503–13)
Dated 1506
Copper alloy, cast; 58.4 mm
The Frick Collection; Gift of Stephen K. and Janie Woo Scher, 2016 (2016.2.139)

Obverse: The pope wearing a camauro (cap with ermine trim) and mozzetta (short cape) or a hooded cassock. Inscription: IVLIVS LIGVR PAPA SECVNDVS MCCCCCVI [Pope Julius II of Liguria, 1506].
Reverse: View of St. Peter's. Inscriptions: TEMPLI PETRI INSTAVRACIO [The renewal of the Temple of St. Peter]; below, VATICA[n]VS M[ons] [Mount Vatican].
Literature: Hill 1930, 1: 171; 2: pl. 115, nos. 659 (obv.), 660; Pollard 2007, 1: no. 220.

The medal is very similar to no. 69, although the pope is portrayed here wearing a camauro and mozzetta or a hooded cassock. It too was part of a group of twelve medals buried in the foundation of the new basilica on April 18, 1506. ADC

70

71

72

71

Attributed to Cristoforo Foppa, called Caradosso (ca. 1452–1526/27)
ENRICO BRUNI (ca. 1450–1509)
ca. 1507
Copper alloy, cast; 45.8 mm
Scher Collection; Promised gift to The Frick Collection

Obverse: Bruni dressed in a gown. Inscription: HENRICVS BRVNVS
PRESVI[ter] TARENTIN[us] PONT[ifici] A[lexandri] SECRET[arius] ET
T[h]ESAVR[ariu]S [*sic*. Enrico Bruni, Presbiter of Taranto secretary and
treasurer of Pope Alexander].
Reverse: An hourglass on uneven terrain. Inscription: NOSTRVM EST
VOLENTI SERVIT[ium] [We willingly serve].
Literature: Armand 1883–87, 3: 174; Hill 1923b, pl. D; Hill 1930, 1:
172; 2: pl. 116, no. 663; Scher 1994, 115, no. 33; Frapiccini 2013,
18.

This medal is one of a group of medals that share stylistic similarities
and relate to the foundation of St. Peter's. They include three
varieties of medals of Julius II, two of which are considered to be
foundation medals of St. Peter's: the present medal of Enrico Bruni,
Curial treasurer general, who, on April 16, 1507, laid the foundation
stones of three of the piers beneath the dome of St. Peter's; and a
medal of the architect Donato Bramante. Vasari attributed the medal
of Bramante to Caradosso, and it is this attribution that the other
medals, including the present one, have shared. Luke Syson (in Scher
1994) attributed the group to Bramante. The motto and hourglass
on the reverse follow the typology of medals commemorating
Renaissance humanists. CM

SCHOOL OF ROME

72

Cristoforo di Geremia (ca. 1430–1476)
LUDOVICO TREVISAN (1401–1465)
ca. 1440
Copper alloy, cast; 39.8 mm
Scher Collection; Promised gift to The Frick Collection

Obverse: Trevisan with tonsure. Inscription: L[udovicus]
AQVILEGIENSIVM PATRIARCA ECCLESIAM RESTITVIT [Ludovico, patriarch
of Aquileia, restored the Church].
Reverse: Triumphal procession all'antica. Inscriptions: ECCLESIA
RESTITVTA [The Church restored]; in exergue, EXALTO [To raise high].
Literature: Hill 1930, 1: 197–98; 2: pl. 127, no. 756; Pollard 2007,
1: no. 242.

Ludovico Trevisan began a successful ecclesiastical career when
he entered the household of Cardinal Condulmer, future Pope
Eugenius IV (1431–1447). Made bishop of Trau in 1435, archbishop
of Florence in 1537, and patriarch of Aquileia in 1439, Trevisan was
nominated *camerlengo* (chamberlain) and papal legate to Romagna
in 1440. In June of the same year, he led the papal troops to victory
against the Milanese at Anghiari and was created cardinal. He also
defeated the Ottomans in 1457. Since the inscription does not
mention his cardinalate, it is possible that the medal was produced
to commemorate the victory of Anghiari, shortly before Trevisan was
made cardinal (Pollard 2007). "Exalto" is Trevisan's personal motto.
ADC

73

Cristoforo di Geremia (ca. 1430–1476)
ALFONSO V OF ARAGON, KING OF NAPLES AND SICILY
(b. 1396; r. 1442–58)
ca. 1458
Copper alloy, cast; 74.7 mm
Scher Collection

Obverse: Bust of the king in decorated parade armor and cloak
placed on a crown; the armor ornamented with relief designs;
nereids riding on sea-centaurs and a Medusa mask. Inscription:
ALFONSVS REX REGIBVS IMPERANS ET BELLORVM VICTOR [King Alfonso,
commander of kings and victorious in wars].
Reverse: Alfonso seated on a throne, dressed as a Roman emperor
and holding a sword and a globe in his hands, is crowned by a
naked Mars and a winged Bellona. Inscriptions: VICTOREM REGNI
MARS ET BELLONA CORONANT [Mars and Bellona crown the victor
of the realm]; in exergue, CRISTOPHORVS HIERIMIA [Cristoforo di
Geremia].
Literature: Hill 1930, 1: 196; 2: pl. 127, no. 754; Scher 1994, no.
35; Pollard 2007, 1: no. 240.

One of the most important princes of his time, Alfonso of Aragon was
highly educated and a generous patron of the arts. For this medal,
Cristoforo di Geremia looked at Pisanello's medals of the king,
taking from him the detail of the bust on the crown to emphasize the
rank of the sitter. Although Hill (1930) suggested that the portrait is
posthumous, its lifelikeness suggests otherwise; the medal may have
been produced during his lifetime to celebrate his role as king. The
scene on the reverse echoes classical reliefs. Bellona is the goddess
of war. ADC

73

74

Cristoforo di Geremia (ca. 1430–1476)
GUILLAUME D'ESTOUTEVILLE (ca. 1412–1483)
After 1461
Copper alloy, cast; 46.6 mm
The Frick Collection; Gift of Stephen K. and Janie Woo Scher, 2016
(2016.2.134)

Obverse: Estouteville tonsured and wearing a pleated rochet (?).
Inscription: G[ulielmus] DESTOVTEVILLA EPIS[copus] OSTI[ensis]
CAR[dinalis] ROTHO[magensis] S[anctæ] R[omanæ] E[cclesiæ] CAM[erarius]
[Guillaume d'Estouteville, bishop of Ostia, cardinal of Rouen,
chamberlain of the Holy Roman Church].
Reverse: Shield of arms of Estouteville surmounted by cardinal's hat.
Literature: Hill 1930, 1: 198; 2: pl. 128, no. 757; Vannel and Toderi
2003–7, 1: no. 193; Pollard 2007, 1: no. 243.

This medal probably dates from after Estouteville became bishop
of Ostia in 1461. There is another medal portrait of the cardinal
by Guacialoti (ca. 1461) and a marble bust attributed to Mino da
Fiesole (Metropolitan Museum of Art, New York) most likely intended
for his funerary monument in the church of Sant'Agostino in Rome.
ADC

75

Cristoforo di Geremia (ca. 1430–1476)
CONSTANTINE THE GREAT (AD 274/88–337)
ca. 1468 (?)
Copper alloy, cast; 71.6 mm
The Frick Collection; Gift of Stephen K. and Janie Woo Scher, 2016
(2016.2.132)

Obverse: Constantine wearing a mantle over cuirass and an oak
leaf wreath. Inscription: CAESAR IMPERATOR PONT[ifex] P[ater] P[atriæ]
P[roconsul] ET SEMPER AVGVSTVS VIR [Caesar, emperor, priest, father of
his country, proconsul and forever august].
Reverse: The standing emperor holding a winged caduceus and
joining hands with the personification of Concordia, who holds
a cornucopia. Inscriptions: CONCORDIA AVG[usta] [The august
Concordia]; on caduceus, DIX[?]; in exergue, S[enatus] C[onsulto]
[by the order of the senate]; on the underside of the exergual line,
CHRISTOFORVS HIERIMIAE F[ecit] [Cristoforo di Geremia made it].
Literature: Hill 1930, 1: 197; 2: pl. 127, no. 755; Vannel and Toderi
2003–7, 1: nos. 186–88 (var.); Pollard 2007, 1: no. 241.

During the Renaissance, Emperor Constantine was looked upon as
a model of both imperial and papal leadership. The composition on
the reverse is based on an ancient prototype. Though the letters in
the caduceus have been interpreted by Pollard as PAX (peace), their
correct reading has yet to be determined. ADC

74

75

76

Cristoforo di Geremia (ca. 1430–1476)
PAOLO I DOTTI OF PADUA (mentioned in 1289)
1470s or late 1460s
Copper alloy, cast; 61.7 mm
Scher Collection

Obverse inscription: DOTTVS PATAVVS MILITIE PREFETVS PROPTER RES
BENE GESTAS [Dotti of Padua, prefect of the militia, for his success in
the war].
Reverse: Female nude figure, holding a staff and resting on a
column; on the ground, a shield, against the column. Inscription: in
exergue, CONSTANTIA [Constancy].
Literature: Hill 1930, 1: 198; 2: pl. 128, no. 758; Vannel and Toderi
2003–7, 1: nos. 194, 195; Pollard 2007, 1: no. 244.

The figure on the reverse is the personification of Constancy, one of
the most important Roman virtues. The medal was commissioned
by Paolo II Dotti to commemorate Paolo I Dotti, who was *praefectus
militiae* of Vicenza in 1289. The medal is convincingly attributed to
Cristoforo di Geremia on stylistic grounds (Pollard 2007). ADC

77

Attributed to Cristoforo di Geremia (ca. 1430–1476)
POPE PAUL II (b. 1417; r. 1464–71)
ca. 1469
Copper alloy, cast; 38.7 mm
The Frick Collection: Gift of Stephen K. and Janie Woo Scher, 2016
(2016.2.133)

Obverse: Paul tonsured and wearing a cope with an orphrey of
floral design and a morse. Inscription: PAVLVS II VENETVS PONT[ifex]
MAX[imus] [Pope Paul II, Venetian].
Reverse: Peter and Paul, nimbate, each seated before a palm tree
and flanking a flock of sheep facing the pontifical throne; the Agnus
Dei, nimbate, standing before the throne with a chalice beside him.
Inscription: in exergue, PABVLVM SALVTIS [Food of Salvation].
Literature: Bonanni 1699, 1: 71, no. 5; Juncker 1706, nos. 113–16;
Venuti 1744, 28, no. xiv; Armand 1883–87, 2: 33, no. 14; Museo
Correr 1898, no. 315; Fabriczy 1903b, no. 61; Martinori 1917–22,
4: no. 36; Hill 1930, 1: 199; 2: pl. 128, no. 760; Pollard 1984–85,
1: 1277, no. 162; C. Johnson and Martini 1986–95, no. 113; Börner
1997, no. 284; Modesti 2002–4, 1: no. 105; Vannel and Toderi
2003–7, 1: no. 197.

76

77

78

Pope Paul II (born Pietro Barbo) was against humanist learning during his papal reign, but he approved and encouraged the use of the printing press in the Papal States. Bonanni and then Hill postulate that this medal was likely issued in 1469 to commemorate a Maronite mission to Rome to consult the pope. The closest iconographical comparison, however, is to the fifth-century mosaic of the Triumphal Arch in Jerusalem from the Basilica of Santa Maria Maggiore in Rome and early Christian sarcophagi. Although the attribution to Cristoforo di Geremia cannot be certain, the medal fits stylistically into Cristoforo's oeuvre of papal medals, which were inspired by bronze coins of the Roman Empire and exhibit a contemporary artistic style favored by the Mantuan court. CM

78

Roman School, circle of Cristoforo di Geremia
ASCANIO MARIA SFORZA VISCONTI (1455–1505)
After 1492
Copper alloy, cast; 43.9 mm
The Frick Collection; Gift of Stephen K. and Janie Woo Scher, 2016 (2016.2.140)

Obverse: Sforza tonsured and in a cardinal's cloak with hood. Inscription: ASCANIVS MA[ria] CAR[dinalis] SFOR[za] VICECO[mes] S[anctæ] R[omanæ] E[cclesiæ] VICECANCE[llarius] [Cardinal Ascanio Maria Sforza Visconti, Vice Chancellor of the Holy Roman Church].
Reverse: A female figure, turned slightly to the right, wearing a three-quarter-length girdled tunic; in her right hand, a torch; in her left, incense to throw on the flaming altar; above, the arch of heaven discharges rays and flames. Inscriptions (incuse): on the altar beneath a swag, IDEM [Same]; SACER EST LOCVS ITE PROPHANI [The place is sacred, profane people go away].
Literature: Friedlaender 1882b, no. 182; Armand 1883–87, 2: 55, no. 8; Foville 1913, no. 547; Habich 1923–24, pl. 63, no. 7; Hill 1930, 1: 224; 2: pl. 139, no. 865; C. Johnson and Martini 1986–95, no. 642; Börner 1997, no. 334.

This medal recognizes the cardinal and diplomat Ascanio Sforza as vice chancellor of the Holy Roman Church, a role he assumed in 1492. The medal can therefore only have been cast after this date. This excludes Lysippus as the author of the medal, which was suggested by Foville. Certainly, the artist was working in Rome, and there are obvious comparisons with the medals of Cristoforo di Geremia, particularly the ancient-inspired style. This lends to an attribution to an artist in his circle. The inscription on the reverse is a quote from one of Juvenal's *Satires*. CM

79

Roman School
PIETRO BARBO (1417–1471)
Dated 1455
Copper alloy, cast; 33 mm
Scher Collection; Promised gift to The Frick Collection

Obverse: Pietro Barbo tonsured and wearing an embroidered cope. Inscription: PETRVS BARBVS VENETVS CARDINALIS S[ancti] MARCI [Pietro Barbo, Venetian, cardinal of St. Mark's].
Reverse: Shield with the arms of Barbo surmounted by the cardinal's hat. Inscription: HAS AEDES CONDIDIT ANNO CHRISTI M CCCCLV [He founded these buildings in the year of Christ 1455].
Literature: Hill 1930, 1: 191; 2: pl. 125, no. 737; Vannel and Toderi 2003–7, 1: nos. 167–70; Pollard 2007, 1: no. 233.

Pietro Barbo, the future Pope Paul II (r. 1464–71), was the offspring of a wealthy Venetian family and the nephew of Pope Eugenius IV. In 1451, he was made cardinal bishop of San Marco. Barbo was an enthusiastic humanist and antiquarian, an avid collector of antiquities, gems and coins in particular. In 1455, as cardinal of San Marco in Rome, he began the reconstruction of the church of San Marco and the adjoining Palazzo Venezia, still unfinished at the time of his death. Examples of this medal were buried, along with a different type, in the foundations of the palazzo. ADC

80

Emiliano Orfini da Foligno (act. 1461–84)
POPE PAUL II (b. 1417; r. 1464–71)
1466/67
Copper alloy, cast after original strike; 78.6 mm
Scher Collection; Promised gift to The Frick Collection

Obverse: The pope in public consistory. Inscription: SACRVM PVBLICVM APOSTOLICVM CONCISTORIVM PAVLVS VENETV[s] P[a]P[a] II [The sacred public apostolic consistory, Pope Paul II, Venetian]; at the bottom, the arms of the pope flanked by two guards.

79

80

Reverse: The Last Judgment; upper band, Christ in glory among angels, saints, sun, moon, and stars; middle band, doctors of the Church; lower band, in the center, an altar flanked by the Virgin Mary and the Baptist; on the left and right, the resurrection of the dead. Inscription: IVSTVS ES DOMINE ET RECTVM IVDICIVM TVVM MISERERE NOSTRI DO[mine] MISERERE NOSTRI [O God, just are you and your judgment is right, have mercy on us O God, have mercy on us (Psalms 118:137 and 122:3)].
Literature: Hill 1930, 1: 201–2; 2: pl. 129, no. 775; Vannel and Toderi 2003–7, 1: no. 218; Pollard 2007, 1: no. 245.

This medal depicting Pope Paul II (born Pietro Barbo, see no. 79) probably commemorates the consistory of December 1466 that condemned for heresy the Prince of Bohemia, or the consistory of the Holy Week of 1467 that confirmed the sentence. Unfortunately, the obverse inscription does not offer any clue to the specific occasion. The scene with the consistory on the obverse shows the influence of a miniature by Jean Fouquet in the *Heures d'Etienne Chevalier*, 1452–56 (Pollard 2007). Not originally a medal, this example is a cast of a struck gold donation piece of twenty ducats.
ADC

81

Lysippus the Younger, also known as Hermes Flavius de Bonis (ca. 1450/55–after 1526)
GIOVANNI ALVISE TOSCANI (ca. 1450–1478)
ca. 1473/74
Copper alloy, cast; 72.8 mm
Scher Collection

Obverse: Lysippus wearing a doublet and *berretta*. Inscription: IOHANNES ALOISIVS TVSCANVS ADVOCATVS [Giovanni Alvise Toscani, advocate].
Reverse inscription: In four lines in a laurel wreath, PREVENIT / AETATEM / INGENIVM / PRECOX [An early talent outstripped his age].
Literature: Hill 1930, 1: 209–10; 2: pl. 132, no. 812; Vannel and Toderi 2003–7, 1: no. 246; Pollard 2007, 1: no. 253; Pfisterer 2008, 396, no. A.6.

Giovanni Alvise Toscani was a lawyer and Latin poet from Milan. In 1468, he went to Rome, where he started his career at the Curia, becoming consistorial advocate (1473) and auditor general (1477). He was a close friend of Lysippus, who has been identified beyond doubt as a certain Hermes Flavius de Bonis (or in Italian, Ermete

81

Flavio de' Bonis), who made several medals of him. The elegant inscription on the reverse is probably based on Roman examples. The medal may have been made on the occasion of Toscani's nomination as Advocatus Consistorialis in 1473. ADC

82

Lysippus the Younger, also known as Hermes Flavius de Bonis (ca. 1450/55–after 1526)
GIOVANNI ALVISE TOSCANI (ca. 1450–1478)
ca. 1477
Copper alloy, cast; 34.2 mm
The Frick Collection; Gift of Stephen K. and Janie Woo Scher, 2016 (2016.2.121)

Obverse: Toscani, laureate, with close-fitting jacket. Inscription: IOANNES ALOISIVS TVSCANVS AVDITOR CAM[eræ] [Giovanni Alvise Toscani, Auditor of the (Apostolic) Chamber].
Reverse: Pallas Athena standing three-quarters to the left, wearing a long chiton and crested helmet and standing on a dolphin; in her right hand, a spear entwined with a serpent, and, on her left arm, a shield decorated with a star. Inscriptions: in field, L[ysippus] P[atavinus] [Lysippus of Padua]; in exergue, QUID NON PALLAS [What not, O Pallas?].
Literature: P. A. Gaetani 1761–63, 1: 95, pl. XIX, no. 6; Armand 1883–87, 2: 28, no. 14; Rizzini 1892, pt. 1, 67, no. 444; Supino 1899, no. 156; Hill 1930, 1: 209; 2: pl. 132, no. 808; Pollard 1984–85, 1: 336, no. 176; Vannel and Toderi 2003–7, 1: no. 239; Pfisterer 2008, 406–7, no. A.18.

Lysippus made six medals of Toscani, the humanist and consistorial advocate to Pope Sixtus IV, who became auditor in January 1477. The large number of designs of Toscani by Lysippus can be attributed to their close friendship. The image of Pallas Athena standing on a dolphin cannot be explained. As Lysippus was active during the reign of Pope Sixtus IV (r. 1471–84) and his earliest dated medal is from 1478, the present medal most likely dates to around this time. CM

83

Giovanni Filangieri Candida (ca. 1445/50–ca. 1498/99)
CHARLES THE BOLD, DUKE OF BURGUNDY (b. 1433; r. 1467–77)
ca. 1474
Copper alloy, cast; 38 mm
Scher Collection; Promised gift to The Frick Collection

Obverse: Charles, laureate, undraped. Inscription: DVX KAROLVS BVRGVNDVS [Charles, Duke of Burgundy].

Reverse: A ram couchant, facing right between two briquettes, each with flints darting sparks on the outer sides, all on a field *semé* with sparks. Inscriptions: IELAIEMPRINS BIENENAVIENGNE [Je l'ai emprins, bien en a viengne] [I have undertaken it, may good come of it]; on briquettes, VELLVS (right) AVREVM (left) [Golden Fleece].
Literature: Heraeus 1780, pl. 21, no. 2; Armand 1883–87, 2: 40, no. 1, 3: 167 no. b; Rizzini 1892, pt. 1, 70, no. 468; Supino 1899, no. 212; Bode 1904, 42; Tourneur 1919a, 257; Mann 1931, no. 338; Hill 1930, 1: 215; 2: pl. 134, no. 828; Hill 1931a, no. 223; Cott 1951, 176; Hill and Pollard 1967, no. 223; *Charles le Téméraire* 1977, no. 83; Pollard 2007, 1: no. 256.

This medal was most likely designed after the siege of Neuss in 1474. The ram is a reference to the Burgundian Order of the Golden Fleece, established by Charles's father in 1430, as was the order's motto inscribed on the briquettes. The inscription is the motto of Charles and his third wife, Margaret of York. Although they are unsigned and undocumented, this medal and three others of similar style (nos. 84–86) form a distinct group produced at the Burgundian court between 1472 and 1480 and are generally attributed to Candida. CM

84

Giovanni Filangieri Candida (ca. 1445/50–ca. 1498/99)
MAXIMILIAN I OF HAPSBURG, HOLY ROMAN EMPEROR (b. 1459; r. 1508–19) and **MARY, DUCHESS OF BURGUNDY** (1457–1482)
ca. 1477/79
Copper alloy, cast; 48 mm
Scher Collection

Obverse: Maximilian wearing a coat over a laced doublet with high collar and shoulder-length wavy hair with a myrtle or laurel wreath. Inscription: MAXIMILIANVS FR[ederici] CAES[aris] F[ilius] DVX AVSTR[iæ] BVRGVND[iæ] [Maximilian, son of the Emperor Frederick, Duke of Austria (and) Burgundy].
Reverse: Mary wearing a V-necked dress over an undergarment, her hair bound in a decorative chignon; behind her, on the left, two M's

85

interlaced and surmounted by a crown. Inscription: MARIA KAROLI F[ilia] DVX BVRGVNDIAE AVSTRIAE BRAB[antiæ] C[omitissa] FLAN[driæ] [Maria, daughter of Charles, Duchess of Burgundy, Austria, (and) Brabant, Countess of Flanders].
Literature: Hill 1930, 1: 126; 2: pl. 134, no. 831; Scher 1994, nos. 37, 37a; Pollard 2007, 1: no. 259; Winter (Heinz) 2009, no. 4.

This medal was made during the five-year period of Maximilian's first marriage to Mary of Burgundy. Although it is usually assumed that the medal was produced on the occasion of their wedding, it was probably made later. In a previous medal by Candida of the couple, they appear considerably younger, and Mary is represented as a young bride, with her hair loose (Hill 1930, no. 830). Here, Mary appears as a more mature woman and ruler; the ducal crown above their initials may even suggest a possible circumstance for its production. In 1479, Maximilian defeated the French troops at Guinegatte, sanctioning his role as ruling Duke of Burgundy through his marriage to Mary. If instead of being made of myrtle (symbol of conjugal happiness), Maximilian's wreath was made of laurel (symbol of military glory), it could be that this medal was produced on the occasion of his 1479 military victory. The presence of the ducal crown over the initials of their names, symbol of their royal power, could support this interpretation. See the commentary for no. 351. ADC

85

Giovanni Filangieri Candida (ca. 1445/50–ca. 1498/99)
CARDINAL GIULIANO DELLA ROVERE (1443–1513) and
CLEMENTE DELLA ROVERE (b. 1462; Bishop of Mende, 1483–1504)
ca. 1495
Copper alloy, cast with traces of gilding; 60.9 mm
The Frick Collection; Gift of Stephen K. and Janie Woo Scher, 2016 (2016.2.125)

Obverse: Giuliano wearing a collarless shirt and rochet. Inscription: IVLIANVS EP[iscopu]S OSTIEN[sis] CAR[dinalis] S[ancti] P[etri] AD VINCVLA [Giuliano, bishop of Ostia, cardinal of San Pietro in Vincoli].
Reverse: Clemente wearing a collarless shirt and rochet. Inscription: CLEMENS DE RVVERE EP[iscopu]S MIMATEN[sis] [Clemente della Rovere, bishop of Mende].
Literature: Hill 1930, 1: 218–19; 2: pl. 136, no. 843; Scher 1994, nos. 38, 38a; Pollard 2007, 1: no. 262.

In 1494, during the French invasion of Italy, Cardinal della Rovere, later Pope Julius II (r. 1503–13) was at the side of Charles VIII, hoping to depose the Borgia pope Alexander VI. The invasion, however, was halted when the pope formed an alliance with Venice, Milan, and Austria and defeated the French army in the battle of Fornovo (July 6, 1495). When Charles VIII returned to Lyon, Giuliano returned to Avignon (October 1495), where he met with Clemente della Rovere, a close relative and political ally who had guarded his interests while he was away. This is most likely the occasion on which this medal was commissioned. ADC

86

Giovanni Filangieri Candida (ca. 1445/50–ca. 1498/99)
ANTOINE OF BURGUNDY (ca. 1421–1504)
1472–80
Copper alloy, cast; 43.6 mm
The Frick Collection; Gift of Stephen K. and Janie Woo Scher, 2016 (2016.2.126)

Obverse: Antoine wearing a fillet with jewel. Inscription: ANTHONIVS B[astardus] DE BVRGVNDIA [Antoine, bastard of Burgundy].
Reverse: A barbican within a laurel wreath. Inscription: NVL / NE SI / FROTE [Let none touch it].
Literature: Hill 1930, 1: 215–16; 2: pl. 134, no. 829; Pollard 2007, 1: no. 258.

One of the alleged twenty-six bastard children of Duke Philip the Good of Burgundy (1419–1467), Antoine of Burgundy was a great collector of books and manuscripts. According to Pollard (2007), the reverse shows a barbican that formed, along with the motto, Antoine's device. This type of barbican was a device for throwing fire at besiegers from the walls of a fortification. ADC

86

87

87

Unknown artist (Rome)

JESUS CHRIST

ca. 1500

Copper alloy, cast; 92.3 mm

The Frick Collection; Gift of Stephen K. and Janie Woo Scher, 2016
(2016.2.135)

Obverse: Christ with cruciform halo. Inscription: IHS [Iesus] XPC
[Christus] SALVATOR MVNDI [Jesus Christ, savior of the world].

Reverse inscription: In six lines within a laurel wreath, TV ES /
CHRISTVS / FILIVS DEI VI / VI QVI IN HVNC / MVNDVM VE / NISTI [Thou
art the Christ, the son of the living God, who should come into the
world (John 11:27)].

Literature: Hill 1920a, 83; Hill 1930, 1: 232; 2: pl. 145, no. 901;
Pollard 2007, 1: no. 272.

This medal of Christ has a companion medal of St. Paul. Although
it is traditionally referred to as a Roman medal, produced between
1492 and 1500, similar images are only found in northern painting
and Florentine sculpture. Nevertheless, the juxtaposition of Christ
and St. Paul is a powerful symbol of the papal seat, so a Roman
provenance could be possible. The type of Christ on the medal is
believed to derive from the portraits of Christ and St. Paul engraved
on a precious emerald jewel, donated by the Turkish sultan Bajazet II
to Pope Innocent VIII in 1492 (Hill 1920a). ADC

88

Unknown artist (Rome)

GIULIANO II DE' MEDICI, DUKE OF NEMOURS

(1479–1516)

1513

Copper alloy, cast; 33.5 mm

Scher Collection; Promised gift to The Frick Collection

Obverse inscription: MAGNVS IVLIANVS MEDICES [The great Giuliano
de' Medici].

Reverse: Female figure dressed in antique drapery, seated on a
throne of shields and a cuirass, holding a figure of Victory in her right
hand. Inscriptions: in the field, on the left and right of the female
figure, C[onsensu] P[opuli] [With the agreement of the people]; in
exergue, ROMA [Rome].

Literature: Hill 1930, 1: 230; 2: pl. 141, nos. 887 (obv.), 885 (rev.);
Pollard 2007, 1: no. 277.

Giuliano, the third son of Lorenzo il Magnifico, went into exile
with his family in 1494, returned to Florence in 1512, and in 1515
married Philiberte of Savoy. This medal was produced for distribution
to the public on the occasion of Giuliano being admitted as a citizen
and patrician of Rome in 1513. The female figure all'antica on the
reverse is a personification of Rome. ADC

SCHOOL OF FLORENCE

89

Bertoldo di Giovanni (1420/30–1491)

FILIPPO DE' MEDICI (b. 1426; Archbishop of Pisa 1462–74)

1462–74

Copper alloy, cast; 55.6 mm

The Frick Collection; Gift of Stephen K. and Janie Woo Scher, 2016
(2016.2.123)

Obverse: Filippo tonsured and wearing a rochet, encircled by the
fimbriae or tassels of an archbishop's hat, around which is wrapped
a scroll; below, the Medici shield. Inscriptions: PHYLIPPVS DE MEDICIS
ARCHIEPISCHOPVS PISANVS [Filippo de' Medici, archbishop of Pisa];
on the scroll, VIRTVTE SVPERA [by superior virtue].

Reverse: Christ in a mandorla flanked by two symbols of the Passion,
the cross and column, and surrounded by trumpeting angels; below,

88

89

the resurrection of the dead framed by a semicircular-shaped frame supporting urns. Inscription: in three lines in exergue, ET IN CARNE MEA VIDEBO / DEVM SALVATOREM / MEVM [Yet in my flesh shall I see God my savior (Job 19:26)].

Literature: Hill 1930, 1: 240; 2: pl. 148, no. 914; Draper 1992, 82–86; Vannel and Toderi 2003–7, 1: nos. 304–6; Pollard 2007, 1: no. 284.

Filippo de' Medici, a distant cousin of Cosimo de' Medici the Elder, was archbishop of Pisa. The flower-like forms on the border of the obverse may represent tassels suspended from an archbishop's hat. The reverse composition of the Last Judgment is represented with the traditional iconography and, with the saved on the right of Christ and the damned on his left, presents the usual convention that Bertoldo's pupil Michelangelo would later adopt in his *Last Judgment*. Draper (1992) proposed a dating of the medal to Filippo's period in Rome in 1468–69, when he was positioning himself to be appointed cardinal. ADC

90

Bertoldo di Giovanni (1420/30–1491)
FREDERICK III, HOLY ROMAN EMPEROR
(b. 1415; r. 1452–93)
Dated 1469
Lead, cast; 55.4 mm
The Frick Collection; Gift of Stephen K. and Janie Woo Scher, 2016 (2016.2.122)

Obverse: The emperor wearing a brimmed fur hat and fur-collared robe. Inscription: FREDERIGVS TERCIVS ROMANORVM IMPERATOR SEMPER AVGVSTVS [Frederick III, Emperor of the Romans, Forever August].

Reverse: The emperor creating knights in the presence of the pope, cardinals, and foot soldiers on Ponte Sant'Angelo in Rome. A boat (not visible in this example) is below the bridge, from which a swag hangs supported by two putti; on the parapet, the imperial two-headed eagle separating the inscription: CXXII EqVITES CREA[vi]T KALEN[dis] IANVARI[is] MCCCCLXIX [He created 122 knights on the first of January, 1469].

Literature: Hill 1930, 1: 239; 2: pl. 148, no. 912; Draper 1992, 79–82; Scher 1994, no. 40; Pollard 2007, 1: no. 283.

This medal commemorates the creation of 122 knights of the Holy Roman Empire on New Year's Day 1469 in Rome, where the emperor had traveled to seek aid against the Turks. It may have been a personal gift of the Archbishop of Pisa, Filippo de' Medici, to the emperor. This is Bertoldo's only dated medal. Some early specimens have the misspelling of "senper" for "semper" in the reverse inscription, but later casts corrected the mistake (here, the word is spelled correctly). Given the fresh eyewitness character of the reverse, it is possible that Bertoldo—artist of the de' Medici family— witnessed the event as a member of the archbishop's retinue. ADC

90

91

91

Bertoldo di Giovanni (1420/30–1491)

THE PAZZI CONSPIRACY

1478

Copper alloy, cast; 65.6 mm

Scher Collection; Promised gift to The Frick Collection

Obverse: Colossal head of Lorenzo de' Medici set above an octagonal structure with columns supporting a cornice, each surmounted by a flaming torch (?); inside the structure, the choir of Florence cathedral, ecclesiastics and churchgoers attending mass, while a priest at the altar is about to elevate the host; in the center, a triangular lectern; outside the choir, in the foreground to the left, two men flee, while two conspirators approach the cloaked figure of Lorenzo, right of center, who is being attacked by two conspirators with swords; to the far right, Lorenzo fleeing into the choir, where, once again he is depicted in the center of the choir on his way to safety in the sacristy. Inscriptions: on both sides of the colossal head, LAVRENTIVS / MEDICES [Lorenzo de' Medici]; in the field, at the center of the structure, SALVS / PVBLICA [public good].

Reverse: The composition of the reverse mirrors that on the obverse with the colossal head of Giuliano de' Medici set above the same structure as obverse, the choir of Florence cathedral; in the foreground, in front of the choir, the murder of Giuliano, who lies on the ground surrounded by conspirators holding swords. Inscriptions: on both sides of the colossal head, IVLIANVS / MEDICES [Giuliano de'

Medici]; in the field, at the center of the structure, LVCTVS / PVBLICVS [public sorrow].

Literature: Hill 1930, 1: 240–41; 2: pl. 148, no. 915; Draper 1992, 86–95; Scher 1994, no. 41; Pollard 2007, 1: nos. 286, 287.

On Sunday, April 26, 1478, a faction led by members of the Pazzi family assaulted Lorenzo de' Medici and his brother Giuliano as they attended mass in the Florence cathedral. Giuliano was slain while Lorenzo escaped. The design of the medal, which commemorates this event, was likely created with the help of Angelo Poliziano, who wrote a detailed account of the conspiracy. The ultimate message of the medal is the relationship between the fate of Lorenzo and Giuliano and that of the city itself: death of Giuliano/public sorrow (*luctus publicus*); Lorenzo's miraculous escape/public good (*salus publica*). ADC

92

Niccolò di Forzore Spinelli, called Niccolò Fiorentino (1430–1514)

POPE INNOCENT VIII (b. 1432; r. 1484–92)

ca. 1485

Copper alloy, cast; 55 mm

The Frick Collection; Gift of Stephen K. and Janie Woo Scher, 2016 (2016.2.131)

92

93

Obverse: The pope tonsured wearing a cope and morse. Inscription: INNOCENTII IANVENSIS VIII PONT[ifex] MAX[imus] [Pope Innocent VIII of Genoa].

Reverse: Three female figures in antique drapery, the one on the left holding a sword and a scale and the other two a cornucopia in one hand and sheaves of wheat in the other. Inscription: IVSTITIA PAX COPIA [Justice, Peace, Abundance].

Literature: Hill 1930, 1: 248; 2: pl. 151, no. 928; Vannel and Toderi 2003–7, 1: no. 319; Pollard 2007, 1: no. 293.

With the personifications of Justice, Peace, and Abundance, the reverse of this medal of Pope Innocent VIII (born Giovanni Battista Cibo) could refer to the pope's rigorous sense of justice, for which he was so resented in Rome that he had to distribute wheat to appease the mob. Justice has an unusual attribute, the winged hat of Mercury, perhaps an allusion to the necessity of swift justice. ADC

93

Attributed to Niccolò di Forzore Spinelli, called Niccolò Fiorentino (1430–1514)

CHARLES VIII, KING OF FRANCE (b. 1470; r. 1483–98)

ca. 1495

Copper alloy, cast; 94.6 mm

Scher Collection

Obverse: The king, wearing a *berretta* with an upturned flap, a doublet with pleated front, and the collar of the Order of St. Michael. Inscription: KAROLVS OCTAVVS FRANCORVM IERVSALEN ET CICILIE REX [Charles VIII, King of the French, Jerusalem, and Sicily].

Reverse: A winged female figure wearing antique drapery holding a sword and a palm branch in her right hand, standing on a chariot pulled by two horses; on the flank of the chariot, the king's coat of arms; before the chariot, a female figure in antique drapery holding two olive branches in her hands and moving to the right. Inscription: VICTORIAM PAX SEQVETVR [Peace will follow Victory].

Literature: Hill 1930, 1: 251–52; pl. 153, no. 945; Vannel and Toderi 2003–7, 1: no. 324; Pollard 2007, 1: no. 298 (obv., uniface).

The French king took Naples in February 1495 by accord—without siege or battle—and was crowned there in May, acquiring new titles inscribed on this medal. The reverse composition, showing Victory in the chariot and Peace before her could be read as a clever pun on the common saying that peace follows victory, as in the case of Naples peace was obtained without any battle followed by victory, but through a political agreement reached on February 22, 1495. ADC

94

Attributed to Niccolò di Forzore Spinelli, called Niccolò Fiorentino (1430–1514)

SALVESTRO DI ANDREA CORBINELLI (d. 1557)

After 1500

Copper alloy, cast; 74.4 mm

Scher Collection

Obverse: Corbinelli wearing a cap with the edge turned up and a doublet. Inscription: SALVESTRO CHORBINEGLI.

Literature: Hill 1930, 1: 257; 2: pl. 158, no. 969.

This medal, formerly in the collection of Marchese Uberto Strozzi, is the only known cast. Hill identified the sitter as the Florentine nobleman Salvestro di Andrea Corbinelli from Florentine censuses and death records; however, not much more of Corbinelli is known. The attribution to Spinelli is based on similar medals signed by the artist. It is possible that this is either a trial cast or an unfinished medal. CM

94

95

Ercole I d'Este was a formidable politician and patron of the arts, and Ferrara became one of the leading cities in Europe during his rule. Minerva is the personification of wisdom or virtue. According to Pollard (2007), the medal was probably produced during the period of the first French invasion of Italy, the duke being a firm supporter of the French. ADC

95

Style of Niccolò di Forzore Spinelli, called Niccolò Fiorentino (1430–1514)
ERCOLE I D'ESTE, DUKE OF FERRARA, MODENA, AND REGGIO (1431–1505)
ca. 1494–95
Copper alloy, cast; 51.4 mm
The Frick Collection; Gift of Stephen K. and Janie Woo Scher, 2016 (2016.2.130)

Obverse: Ercole I d'Este wearing a cap and armor. Inscription: HERCVLES DVX FERA[riæ] MV[tinæ] ET[cetera] [Ercole, Duke of Ferrara, Modena, et cetera].
Reverse: Standing female figure in antique drapery, wearing a helmet, holding a spear, and placing her left hand on a shield bearing the head of Medusa. Inscription: MINERVA.
Literature: Hill 1930, 1: 257; 2: pl. 159, nos. 971a (obv.) and 971b (rev.); Pollard 2007, 1: no. 304.

96

Unknown artist (Florence)
GIROLAMO SAVONAROLA (1452–1498)
1492–94
Copper alloy, cast; 90.3 mm
Scher Collection

Obverse: Savonarola in Dominican habit, holding a crucifix. Inscription: HIERONYMVS SAVᵒ[narola] FER[rariensis] ORD[inis] PRE[dicatorum] VIR DOCTISSIMVS [Girolamo Savonarola of Ferrara, of the Order of Preachers, a most learned man].
Reverse: A vertical line bisects the field; on the right, a hand holding a dagger over a fortress; on the left, the dove of the Holy Spirit on a cloud above a city. Inscriptions: on the right, GLADIVS DOMINI SVP[er] TER[r]A[m] CITO ET VELOCITER [The sword of the Lord, quickly and

96

97

98

swiftly, over the earth]; on the left, SPIRITVS D[omi]NI SVP[er] TERRA[m] COPIOSE [e]T HABV[n]DA[n]T[er] [The spirit of the Lord, copiously and abundantly, over the earth].

Literature: Hill 1930, 1: 278; 2: pl. 180, no. 1079; Scher 1994, no. 47.

Girolamo Savonarola, the Dominican preacher known for his apocalyptic sermons and calls for Christian renewal, was executed in Florence in 1498. The various medals representing him, made in the last decade of the fifteenth century, present ten distinct types and can be divided into two groups: one with Savonarola's head completely covered by the hood and one with some hair showing over the forehead. The reverse of this medal is an illustration of Savonarola's vision on the evening of April 5, 1492, when he was seeking inspiration for his next day's sermon in the cathedral, and suddenly uttered the words "Ecce gladius Domini super terram cito et velociter." At eleven p.m. that night, the cathedral was struck by lightning, and the lantern of the cathedral was broken. The overall message of the reverse is straightforward: repent and enjoy the grace of God (the dove of the Holy Spirit) or do not repent and suffer his justice (the sword). ADC

97

Unknown artist
MATTHIAS CORVINUS, KING OF HUNGARY (b. 1443; r. 1458–90)
Late 15th century
Copper alloy, cast, 47.7 mm
Scher Collection

Obverse: Corvinus, laureate, loosely draped. Inscription: MATHIAS REX HUNGARIAE BOHEMIAE DALMAT[iæ] [Matthias, King of Hungary, Bohemia, and Dalmatia].
Literature: (all with reverse) Armand 1883–87, 2: 82, no. 9; Hill 1930, 1: 242–43; 2: pl. 149, no. 920; Cott 1951, no. 178; *Medaglie del Rinascimento* 1960, no. 127; Hill and Pollard 1967, 297; C. Johnson and Martini 1986–95, no. 32; Börner 1997, no. 362; Pollard 2007, 1: no. 337; Farbaky et al. 2008, no. 4.7.b (as attrib. to Tobias Wolff).

Corvinus, Matthias's nickname, derived from the raven on his shield. During his reign, he worked to reconstruct the Hungarian state after decades of feudal turmoil through financial, military, and judiciary initiatives. Matthias forged a close friendship with Lorenzo de' Medici, from 1469 until his death in 1490. He became one of the

most powerful figures in Europe and was a patron of the arts with a particular interest in Florentine manuscripts. This medal is the only extant version without a reverse. The type with the reverse and a pearled border on the obverse was previously attributed to Bertoldo, although that has been reconsidered (Pollard 2007, no. 337); the visit of the medalist Cristoforo Foppa to Matthias's court in 1489 also prompts speculation. The medal has recently been attributed to Tobias Wolff (act. second half of sixteenth century; see Winter in Farbaky et al. 2008). CM

ITALIAN HIGH RENAISSANCE AND LATER MEDALS
SCHOOL OF FLORENCE

98

Domenico di Polo de' Vetri (ca. 1480–ca. 1547)
ALESSANDRO DE' MEDICI, DUKE OF FLORENCE (b. 1510; r. 1532–37)
Dated 1534
Gilt copper alloy, struck; 37.8 mm
The Frick Collection; Gift of Stephen K. and Janie Woo Scher, 2016 (2016.2.155)

Obverse: Alessandro wearing armor. Inscription: ALEX[ander] M[edices] FLORENTIAE DVX PRIMVS [Alessandro de' Medici, first Duke of Florence].
Reverse: Peace, seated upon trophies of war; in her left hand, a cornucopia and a branch; in her right, a torch that she uses to light the trophies; in exergue, the sign of Mars and two stars. Inscription: FVNDATOR QVIETIS M D XXX IIII [The founder of peace 1534].
Literature: Heiss 1881–92, 2: 9, pl. I, no. 3; Armand 1983–87, 1: 151, no. 3; Plon 1884, no. 2; Rizzini 1892, pt. 1, 30, no. 198; Museo Correr 1898, no. 148; Supino 1899, no. 251; La Tour 1900, pl. XXXII, no. 1; Fabriczy 1904, pl. XXIX; Middeldorf and Goetz 1944, no. 137; Norris and Weber 1976, no. 26; Langedijk 1981–87, 1: 235, no. 34; Pollard 1984–85, 2: 650, no. 322; Fox 1988, no. 3; C. Johnson and Martini 1986–95, no. 1864; Börner 1997, no. 627; Toderi and Vannel 2000, 2: 468, no. 1381; Attwood 2003, no. 771.

Alessandro de' Medici is believed to have been the illegitimate son of Giulio de' Medici, who later became pope, and Simonetta da Collevecchio, a servant of African descent. This medal is part of a group of similar portrait medals and engraved gems by Domenico di Polo, who was Alessandro and Cosimo's court medalist. The figure of Peace on the reverse is a melange of two types of Roman coin iconography and was repeated on the reverse of a medal of Pope Leo X and a relief by Niccolò Tribolo of 1536. Alessandro's beard indicates that the present medal postdates the first portrait of this type, showing no facial hair, from 1534. CM

99

cighteen just after he became Duke of Tuscany in 1537 (he became Grand Duke of Tuscany in 1569). It follows earlier medals of the same type by Domenico but has been modified with the addition of a beard (indicating it is of a later date). The portrait type is discussed by Vasari in his *Lives* in reference to a medal with the same obverse but with a reverse with the sign of Capricorn. Attwood (2003) explains that the beard could have been added to the die, which might have been used over a period of time. CM

99

Domenico di Polo de' Vetri (ca. 1480–ca. 1547)
COSIMO I DE' MEDICI, DUKE OF TUSCANY (1519–1574)
Between 1537 and 1569
Copper alloy, struck; 35.3 mm
Scher Collection; Promised gift to The Frick Collection

Obverse: Cosimo wearing armor. Inscription: COSMVS MED[ices] II REI P[ublicæ] FLOR[entinæ] DVX [Cosimo de' Medici, second Duke of the Florentine Republic].
Reverse: Salus Publica draped and standing, a spear in her left hand, a bowl in her right; a snake eats out of the bowl. Inscription: SALVS PVBLICA [Public good].
Literature: P. A. Gaetani 1761–63, 1: 355, pl. LXXVIII, no. 8; Heiss 1881–92, 2: 15, pl. I, no. 9; Armand 1983–87, 1: 144, no. 3; Rizzini 1892, pt. 1, 30, no. 195; La Tour 1900, pl. XXXIII, no. 2; Rinaldis 1913, nos. 90–92; Habich 1922, pl. LXXXII; Álvarez–Ossorio 1950, no. 121; C. Johnson 1976, fig. 11; Langedijk 1981–87, 1: nos. 156 and 156c (rev.); Pollard 1984–85, 2: 658, no. 328; Fox 1988, no. 17; Pannuti 1996, no. 8.89; Toderi and Vannel 2000, 2: 471, no. 1392; Attwood 2003, no. 782.

This depiction of Cosimo is possibly after a 1537 drawing of him by Pontormo in the Uffizi that shows him in profile at the age of

100

After a medal by Francesco da Sangallo (1494–1576)
PAOLO GIOVIO (1483–1552)
Dated 1552, made 19th century
Copper alloy, cast; 91.4 mm
The Frick Collection; Gift of Stephen K. and Janie Woo Scher, 2016 (2016.2.174)

Obverse: Giovio wearing a furred coat and a cap. Inscription: PAVLVS IOVIVS COMENSIS EPISCOPVS NVCERINVS A[nno] D[omini] N[ostræ] S[alutis] M D LII [Paolo Giovio of Como, bishop of Nocera, in the year of our salvation 1552].
Reverse: Giovio standing, draped, wearing a cap, holding a large book in his left hand (possibly the folio edition of his *Historiae*); with his right hand, he pulls a naked man out of the grave. Inscription: NVNC DENIQVE VIVES [Now at last you will live].
Literature: P. A. Gaetani 1761–63, 1: 288, pl. LXII, no. 2; Duisburg 1862, no. XIX, 1; Heiss 1881–92, 8: 91, pl. XIV, no. 2; Friedlaender 1882b, 171, no. 6; Armand 1883–87, 1: 156; Rizzini 1892, pt. 1, 33, no. 208; Clausse 1902, 243–44; Forrer 1904–30, 5: 326; Hill and Bell 1913, no. 39; Rinaldis 1913, no. 97; Hill 1915, pl. 45; Hill 1923b, 36, no. 94; Holzmair 1937, no. 404; Middeldorf 1938, 138, no. 10; *Giorgio Vasari* 1981, 120, no. 17d; Pollard 1984–85, 2: 633–35, no. 309; Ferino-Pagden 1997, 175, no. II.21; Attwood 2003, no. 795b.

100

101

A writer, historian, and collector, Paolo Giovio, the bishop of Nocera, was one of the most influential intellectuals of his time. He is portrayed by Sangallo as a philosopher immersed in thought, with a long beard and a fur coat and cap. Giovio was a keen collector of portraits that he housed in his villa on Lake Como. He published two books on the lives of famous men and thus, true to the inscription and iconography on the medal's obverse, he "brought the dead back to life." CM

101

Pastorino de' Pastorini (ca. 1508–1592)
ALESSANDRO BONZAGNO (1488–1572) and **CECILIA BONZAGNO** (dates unknown)
Dated 1554
Copper alloy, cast; 50.2 mm
Scher Collection

Obverse: Alessandro Bonzagno wearing a coat with a fur collar. Inscription: ALEX[andrus] BONZAN[ius] A[nno] A[etatis] LXV 1553 [Alessandro Bonzagno, in his 65th year of age, 1553].
Reverse: Cecilia Bonzagno wearing a French hood with a veil falling to her shoulders, a gown and a chemise with a collar. Inscriptions: CICILIA CONS[ors] II ALEX[andri] B[onzanii] [Cecilia, second wife of Alessandro Bonzagno]; on truncation (incised), 1554.
Literature: Armand 1883–87, 3: 90, no. d; Heiss 1881–92, 8: 104, pl. VIII, no. 13; Börner 1997, no. 655 (Cecilia); Toderi and Vannel 2000, 2: 604, no. 1846.

Alessandro Bonzagno was a goldsmith from Reggio Emilia, and Cecilia was his second wife. The obverse medal was first conceived as uniface, and the reverse of 1554 also occurs alone; however, the two portraits were combined into one medal, as in the present example. CM

102

Pastorino de' Pastorini (ca. 1508–1592)
GIROLAMA SACRATI (ca. 1515–after 1573)
Dated 1555
Copper alloy, cast; 70.6 mm
Scher Collection; Promised gift to The Frick Collection

Obverse: Girolama wearing a low-cut square-neck dress with smocked chemise and standing collar; her hair bound up at the back and interlaced with pearls, with pearl-drop earrings. Inscriptions: HIERONIMA SACRATA M D LV [Girolama Sacrati, 1555]; on truncation (incised), P[astorino].
Literature: Attwood 2003, no. 520; Vannel and Toderi 2003–7, 1: no. 1046; Pollard 2007, 1: no. 375.

The Sacratis were an illustrious family from Ferrara. Girolama may have been the daughter of Aldobrandino Sacrati, ambassador of Duke Ercole II to Mantua and France. Presumably, she was born into the family, since if she had married a Sacrati, she would most likely have added to the Sacrati name her own family name (Mayr 1843, 102–3). ADC

102

103

Pastorino de' Pastorini (ca. 1508–1592)

FRANCESCO DE' MEDICI, GRAND DUKE OF TUSCANY

(b. 1541; r. 1574–87)

Dated 1560

Copper alloy, cast; 66.7 mm

The Frick Collection; Gift of Stephen K. and Janie Woo Scher, 2016
(2016.2.152)

Obverse: Francesco wearing decorated armor and a commander's
sash fastened on the right shoulder. Inscriptions: FRANCISCVS MEDICES
F[lorentiæ] PRINCEP[s] [Francesco de' Medici, Prince of Florence];
signed and dated on truncation (incised), 1560 P[astorino].
Literature: Heiss 1881–92, 2: 145, pl. XIII, no. 2; Armand 1883–87,
1: 202, no. 82; Kenner 1891, nos. 38, 39; R. F. Burckhardt 1917,
54, fig. 7; Álvarez–Ossorio 1950, no. 196; Garfagnini 1983, 3:
no. 357; Langedijk 1981–87, 2: 891, no. 92; Pollard 1984–85, 2:
692, no. 353; Börner 1997, no. 647; Toderi and Vannel 2000, 2:
623, no. 1947; Attwood 2003, no. 601; Vannel and Toderi 2003–7,
1: no. 1057.

Francesco de' Medici—whose daughter was Maria de' Medici,
wife of Henry IV of France—was a scholar and patron of the
arts, most notably of the mannerist sculptor Giambologna, also
called Giovanni da Bologna. He was also the first in his family to
move the Medici collection of pictures to the Uffizi. The obverse of
this medal was also cast with various reverses that do not belong
with it (Attwood 2003, no. 602). CM

104

Pastorino de' Pastorini (ca. 1508–1592)

MARGHERITA PALEOLOGO (1510–1566)

Dated 1561

Lead, cast; 67 mm

Scher Collection

Obverse: Paleologo, wearing a dress, robe, and veil. Inscriptions:
MARGARITA DVCISSA MANTVÆ [Margherita, Duchess of Mantua];
signed and dated on truncation (incised), 1561 P[astorino].
Literature: Armand 1883–87, 1: 198, no. 62; Heiss 1881–92, 2: 132,
pl. XI, no. 8; Kenner 1891, no. 48; Fabriczy 1904, pl. XXXI, no. 5;
Magnaguti 1921, no. 45; Magnaguti 1965, 9: 97, no. 37; *Splendours
of the Gonzaga* 1981, no. 145; M. Rossi 2000, 73, no. 68; Toderi
and Vannel 2000, 2: 626, no. 1959; Attwood 2003, no. 606.

In 1531, Margherita Paleologo, Marchioness of Monferrato, married
Duke Federico Gonzaga II, who died nine years later. In 1561,
Pastorino conceived portrait medals of her, of which the present
medal is an example, as well as medals of her son, Duke Guglielmo
I of Mantua (1538–1587), and her daughter-in-law, Eleanora of
Austria (1534–1594), to mark the occasion of their marriage
(Attwood 2003, no. 604). CM

105

Pastorino de' Pastorini (ca. 1508–1592)

LUDOVICA FELICINA ROSSI (ca. 1540–1592)

Dated 1572

Lead, cast; 52 mm

Scher Collection; Promised gift to The Frick Collection

Obverse: Ludovica Felicina, with braided hair with fillet, wearing an
earring, pearl necklace and gown with a ruffed collar. Inscriptions:
LVDOVICA FELICINA ROSCIA BONONIEN[sis] [Ludovica Felicina Rossi of
Bologna]; on truncation (incised), 1572.
Literature: Armand 1883–87, 1: 205, no. 103; Kenner 1891, no. 58;
Heiss 1881–92, 8: 154, pl. XIV, no. 9; Rosenheim sale 1923, 12,
no. 118; Oppenheimer sale 1936, no. 161; Börner 1997, no. 637;
Toderi and Vannel 2000, 2: 629, no. 1975.

Ludovica Felicina, the wife of Count Gian Galeazzo Rossi, was from
an old Bolognese family whose members held positions in both the
consiglio and the senate. This medal exists with two foreign reverses,
one of Hercules (Attwood 2003, no. 626) and another with Virtue
and Fortune (Armand 1883–87, 3: 92, no. bb). CM

105

106

107

106

Pastorino de' Pastorini (ca. 1508–1592)
AURELIA TOLOMEI (dates unknown)
Mid-16th century
Lead, cast; 36 mm
Scher Collection; Promised gift to The Frick Collection

Obverse: Tolomei, with hair in a braid, wearing a dress with a chemise and ruched collar. Inscriptions: D[omina] AVRELIA TOLOMEI [Lady Aurelia Tolomei]; on truncation (incised), P[astorino].
Literature: Armand 1883–87, 3: 87, no. aa; Heiss 1881–92, 8: 127, pl. XV, no. 15; Forrer 1909, 4: 418; Toderi and Vannel 2000, 2: 600, no. 1824.

Born into an old Sienese family, Aurelia Tolomei married Silvio Piccolomini, Lord of Sticciano. CM

107

Attributed to Pastorino de' Pastorini (ca. 1508–1592)
UNKNOWN WOMAN
1548–52
Lead, cast; 35.8 mm
Scher Collection; Promised gift to The Frick Collection

Obverse: Bust facing right, long hair braided and in a net, wearing a gown.
Literature: Toderi and Vannel 2000, 2: 593, no. 1777; Vannel and Toderi 2001, 87–94.

Although this medal (the only extant example) is unsigned and the sitter unidentified, the portrait style and raised border are commensurate with profile medals of women by Pastorino. It compares particularly well with an early portrait of Vittoria Farnese della Rovere (Attwood 2003, no. 473). CM

108

Giampaolo Poggini (1518–ca. 1582)
PHILIP II, KING OF SPAIN (b. 1527; r. 1556–98) and **ANNE OF AUSTRIA** (1549–1580)
1570
Silver, struck; 39 mm
The Frick Collection; Gift of Stephen K. and Janie Woo Scher, 2016 (2016.2.161)

Obverse: Philip wearing armor and a commander's sash fastened on the left shoulder. Inscription: PHILIPPVS HISPANIAR[um] ET NOVI ORBIS OCCIDVI REX [Philip, King of Spain and of the new western world].
Reverse: Bust facing right, wearing hair in a hairnet with pearls, a dress with a high collar, ruff, and pearl necklace. Inscriptions: ANNA AVSTRIACA PHILYPPI CATHOL[ici] [Anne of Austria, (wife) of Philip the Catholic]; below truncation, AET[atis] ZI [aged 21].
Literature: Van Loon 1723–31, 1: 2, 133; Armand 1883–87, 1: 240, no. 13; Löbbecke sale 1908, 11, no. 73; Álvarez-Ossorio 1950, no. 231; Panvini Rosati 1968, no. 190; Smolderen 1996, no. 74.

Philip II's four marriages were to Maria of Portugal (m. 1543–45), Queen Mary I of England (m. 1554–58), Elisabeth of Valois (m. 1559–68), and, finally, Anne of Austria (m. 1570–80), the daughter of his first cousin, the emperor Maximilian II. The last marriage was celebrated in 1570, and this medal was struck to mark the occasion. Philip and Anne's son became King Philip III. This medal combines two designs by Poggini, which can also be found separately. CM

108

109

Giampaolo Poggini (1518–ca. 1582)
PHILIP II, KING OF SPAIN (b. 1527; r. 1556–98) and
ELISABETH OF VALOIS (1545–1568)
ca. 1559
Silver, struck; 38.7 mm
Scher Collection

Obverse: Philip wearing armor and a commander's sash secured in a knot on the left shoulder. Inscriptions: PHILIPPVS II HISPAN[iarum] ET NOVI ORBIS OCCIDVI REX [Philip, King of Spain and of the new western world]; below truncation, I[oannes] PAVL[us] POG[ginus] F[ecit] [Giampaolo Poggini made it].
Reverse: Elisabeth, with hair in a hairnet and decorated with a diadem, wearing a gown with a high collar, a necklace centered with a pearl pendant, and an earring. Inscriptions: ISABELLA REGINA PHILIPPI II HISPAN[iarum] REGIS [Queen Isabella, (wife) of Philip II King of Spain]; below the bust: I[oannes] PAVL[us] POG[ginus] F[ecit] [Giampaolo Poggini made it].
Literature: Heiss 1881–92, 8: 36, no. 8, pl. II, nos. 10, 12; Armand 1883–87, 1: 239, no. 7; Betts 1894, 3, no. 5; Domanig 1896, no. 56 (illus. as 57); Museo Correr 1898, no. 231; Forrer 1909, 4: 634; García de la Fuente 1927, 88, no. 7; Wellens-de Donder 1959b, no. 66; Panvini Rosati 1968, no. 189; Pollard 1984–85, 2: 764, no. 405; Börner 1997, no. 686; Toderi and Vannel 2000, 2: 484, no. 1428; Attwood 2003, no. 1085; Vannel and Toderi 2003–7, 1: no. 728.

This medal commemorates the marriage of Philip to his third wife, Elisabeth, in 1559. A few months after the wedding, Philip and Elisabeth's father, the King of France, Henry II, signed the Peace of Cateau-Cambrésis. The marriage enabled an agreement between the two countries, marking the end of several decades of war over the control of Italy. CM

110

Giampaolo Poggini (1518–ca. 1582)
PHILIP II, KING OF SPAIN (b. 1527; r. 1556–98)
Dated 1559
Copper alloy, struck; 40.6 mm
Scher Collection; Promised gift to The Frick Collection

Obverse: Philip wearing armor and a commander's sash.
Inscriptions: PHILIPPVS HISPANIAR[um] ET NOVI ORBIS OCCIDVI REX [Philip, King of Spain and of the new western world]; beneath truncation, (I)[oannes] PAVL[us] POG[ginus] F[ecit] [Giampaolo Poggini made it].

Reverse: Peace, holding a cornucopia in her left hand and in her right hand a torch with which she sets trophies of war aflame before the temple of Janus. Inscriptions: PACE TERRA MARIQ[ue] COMPOSITA [Peace is brought on land and sea]; in exergue, MDLIX [1559].
Literature: Van Loon 1723–31, 1: 27; Pinchart 1870, 19, no. 2; Heiss 1881–92, 2: 36, no. 6, pl. II, no. 9; Armand 1883–87, 238, no. 5; Betts 1894, 2, no. 1; Brooke and Hill 1924, 98, no. 22, fig. 94; García de la Fuente 1927, 87, no. 5; Álvarez–Ossorio 1950, no. 227; Panvini Rosati 1968, no. 188; Panvini Rosati 1973, fig. 21; Gimeno Rúa 1976, fig. 16; Pollard 1984–85, 2: 762–64, nos. 404 and 404a; Brockhaus and Leinz 1994, no. 212; Börner 1997, no. 685; Pérez de Tudela Gabaldón 1998, 247–48, 271; *Felipe II* 1998, no. 67; Attwood 2003, no. 1082.

This medal commemorates the Peace of Cateau-Cambrésis of 1559, which marked the end of the sixty-five-year conflict between Spain and France for the control of Italy. Attwood (2003, no. 1082) has identified the Roman coin from which the legend and reverse are derived. CM

111

Giampaolo Poggini (1518–ca. 1582)
PHILIP II, KING OF SPAIN (b. 1527; r. 1556–98)
ca. 1560
Gilt copper alloy, cast; 40.9 mm
Scher Collection

Obverse: The king wearing armor, ruff, and a mantle fixed with a brooch on the left shoulder. Inscriptions: PHILIPPVS II HISPAN[iarum] ET NOVI ORBIS OCCIDVI REX [Philip II, King of Spain and of the new western world]; below truncation, I[oannes] PAVL[us] POG[ginus] F[ecit] [Giampaolo Poggini made it].
Reverse: A female figure wearing a cuirass (?) and antique drapery, her long hair falling loose in the back, moving to the left and holding in her hands a globe encircled by a band with the signs of the zodiac; on the left, three ships approach the shore; on the right, a group of natives and a llama carrying silver ingots. Inscriptions: RELIQVVM DATVRA [She will provide the rest]; in exergue, INDIA [India].
Literature: Scher 1994, no. 58; Attwood 2003, no. 1083; Vannel and Toderi 2003–7, 1: nos. 752, 753.

Poggini described this medal in a letter he wrote to his former patron the Duke of Florence in February 1562. The medal celebrates the great resources provided by the New World as evidenced by the

silver ingots borne by the llama and fully exploited by Spain since the middle of the century. The reverse represents a personification of India, that is, European conceptions of India as the New World (although the artist himself wrote that he preferred to identify her with "Fortune or Providence"; see Scher 1994). This is the earliest known medal to refer to South America. One of the women in the group on the right has her hands raised, an allusion to the christianization of the indigenous population, while the blank lower half of the globe suggests the presence of largely unexplored areas. ADC

112
Domenico Poggini (1520–1590)
PAOLO GIORDANO ORSINI (1541–1585) and **ISABELLA DE' MEDICI** (1542–1576)
Dated 1560
Gilt copper alloy, cast; 49.5 mm
Scher Collection

Obverse: Orsini wearing armor with a commander's sash fastened on the right shoulder. Inscriptions: PAVLVS IORDANVS VRSINVS [Paolo Giordano Orsini]; on truncation (incised), DP [artist's initials]; below, 1560.
Reverse: Isabella, with long hair braided and dressed with pearls, wearing a gown with a high collar, a mantle, a pearl necklace, and earring. Inscription: ISABELLA MEDICEA VRSINA [Isabella de' Medici Orsini].
Literature: Armand 1883–87, 3: 122, no. a; Heiss 1892, 1: pl. IV, no. 2; Rizzini 1892, pt. 1, 56, no. 368; Habich 1922, pl. LXXXI, no. 6; Langedijk 1981–87, 2: 1096, no. 63; Pollard 1984–85, 2: 352–53, no. 398; Börner 1997, no. 696; Toderi and Vannel 2000, 2: 492, no. 1456; Attwood 2003, no. 810.

Paolo Giordano Orsini was the first Duke of Bracciano, and Isabella was the daughter of Cosimo I de' Medici. Dated the year of their marriage, this medal was likely cast to celebrate their union. CM

113
Domenico Poggini (1520–1590)
NICCOLÒ TODINI (dates unknown)
1585–91
Copper alloy, cast; 45.7 mm
Scher Collection; Promised gift to The Frick Collection

Obverse: Todini wearing chiseled armor and a shirt with goffered ruff. Inscriptions: NICOL[aus] TODIN[us] ANC[onitanus] ARCIS S[ancti] ANG[eli] PREFECTVS [Niccolò Todini of Ancona, captain of Castel Sant'Angelo]; on truncation (incised), DP [artist's initials].
Reverse: View of Castel Sant'Angelo from across the Tiber.
Literature: Attwood 2003, no. 823; Vannel and Toderi 2003–7, 1: nos. 794, 795; Pollard 2007, 1: no. 392.

Pope Sixtus V appointed Niccolò Todini governor of Castel Sant'Angelo, Rome, in 1585. Married to a niece of the pope, Todini held the office until 1591. ADC

114
Attributed to Domenico Poggini (1520–1590)
HELEN OF TROY
ca. 1560–75
Copper alloy, cast; 48 mm
The Frick Collection; Gift of Stephen K. and Janie Woo Scher, 2016 (2016.2.151)

Obverse: Bust facing left, with long hair tied up in a fillet; wearing a chiton and an earring. Inscription: ΕΛΕΝΗ ΛΗΔΑΙΑ ΣΠΑΡΤΗΣ ΒΑΣΙΛΙΣΣΑ [Helen, daughter of Leda, Queen of Sparta].
Reverse: The Judgment of Paris; Paris sitting under a tree as he receives an apple from a flying Mercury holding his caduceus; Hera, Athena, and Aphrodite standing together as Eros aims his arrow at Paris; a dog resting at Paris's feet; in the background, the city of Troy; in the foreground, a reclining river god. Inscription: ΑΚΑΘΑΡΤΟΣ ΠΑΡΙΔΟΣ ΚΡΙΣΙΣ [The impure Judgment of Paris].

Literature: Hill 1917, 197–98, fig. D; Hill 1920–21, no. 156; Chigi sale 1975, no. 49; Norris and Weber 1976, no. 29; Pollard 1984–85, 2: 734, no. 386; Attwood 2003, no. 809.

As told by Homer, Helen of Troy, the daughter of Zeus and Leda, was Queen of Sparta and the wife of King Menelaus. Her abduction by Paris precipitated the Trojan War. Aphrodite had promised Helen to Paris if he chose her over Hera and Athena as the most beautiful of the three, which is why the Judgment of Paris is shown on the reverse. Stylistically, the portrait of Helen compares well with other portraits by Poggini, particularly his Lucrezia d'Este and Sibilla Lippi (Hill 1917). The reverse is commensurate with Poggini's work and his use of Greek letters. CM

114

115

Pietro Paolo Galeotti, called Romano (1520–1584), or Pietro Paolo Tomei, called Romano (ca. 1525–after 1567)
FRANCESCO TAVERNA (1488–1560)
Dated 1554
Copper alloy, cast; 57.6 mm
Scher Collection; Promised gift to The Frick Collection

Obverse: Taverna wearing a doublet and a cloak. Inscriptions: FRA[nciscus] TABERNA CO[mes] LANDR[iani] MAGN[us] CANC[ellarius] STA[tus] MEDIO[lanensis] AN[no] LXVI [Francesco Taverna, Count of Landriano, Grand Chancellor of the Milanese state, in his 66th year]; in the field to the right, P[ietro] P[aolo] R[omano].
Reverse: In a landscape with architectural ruins on the right (an obelisk and three columns with an entablature) and a cityscape on the left, a greyhound seated on the base of a column and looking at the constellation of Capricorn surrounded by clouds. Inscription: IN CONSTANTIA ET FIDE FELICITAS [In constancy and faith is happiness].
Literature: Scher 1994, no. 57; Attwood 2003, no. 837; Pollard 2007, 1: no. 411; Leydi and Zanuso 2015, no. 56.

The group of medals signed "PPR" have been traditionally identified with Galeotti, though Leydi and Zanuso (2015) convincingly proposed the identification of the artist as "Pier Paolo Tomei, detto Romano." Taverna, Count of Landriano, served as an ambassador for Francesco II Sforza on numerous occasions, and in 1533 he was named Grand Chancellor. The medal's reverse is an allegory

of stewardship, reflecting the count's faithful service to Milan. The greyhound is a symbol of faithfulness and also refers specifically to the Taverna family, whose coat of arms featured a greyhound staring up toward a star. In the medal, the star is replaced with the Capricorn constellation, a common symbol of happiness and imperial authority in the Renaissance, while the architectural ruins are probably an allusion to Rome, the imperial city and symbolic seat of power of the Holy Roman Emperor. The obelisk is a symbol of constancy. ADC

116

Pietro Paolo Galeotti, called Romano (1520–1584), or Pietro Paolo Tomei, called Romano (ca. 1525–after 1567)
JACOPO DE' MEDICI (1497–1555)
ca. 1555
Copper alloy, cast; 57.7 mm
Scher Collection

Obverse: Jacopo in armor with a grotesque mask and a commander's sash tied in a knot. Inscriptions: IA[cobus] MED[ices] MARCH[io] MELEG[nani] ET CÆS[aris] CAP[itaneus] G[e]N[er]ALIS ZC[et cetera] [Jacopo de' Medici, Marquess of Marignano, and captain general of the Emperor, et cetera]; P[ietro] P[aolo] R[omano].
Reverse: Pegasus striking with his hoof the rock of Mount Helicon, causing the Hippocrene spring to flow. Inscription: QVO ME FATA VOCANT [Whither Destiny summons me].
Literature: Armand 1883–87, 1: 232, no. 26; Hill and Pollard 1978, 87; Habich 1922, pl. XCVIII, no. 1; Álvarez–Ossorio 1950, no. 240;

115

116

Vermeule 1952, no. 10; Pollard 1984–85, 2: 772, no. 410; C. Johnson and Martini 1986–95, nos. 2059, 2060; Brockhaus and Leinz 1994, no. 221; Attwood 2003, no. 834; Pollard 2007, 1: no. 406, n.3; Leydi and Zanuso 2015, no. 44.

Jacopo de' Medici was Marquess of Marignano and a general of Charles V. Attwood explains that the reverse of this medal does not belong to the obverse but was conceived for the reverse of the medal of Marcantonio Magno (2003, no. 148) by an unknown artist and that they were put together at an early date. Pollard suggests that the reverse could be attributed to Leoni. The hooves of Pegasus striking a rock on Mount Helicon created the Hippocrene spring, and drinking the water was believed to bring about poetic inspiration. CM

117

Pietro Paolo Galeotti, called Romano (1520–1584), or Pietro Paolo Tomei, called Romano (ca. 1525–after 1567)

TOMMASO MARINI (OR MARINO), DUKE OF TERRANOVA (1475–1572)

ca. 1560–65

Copper alloy, cast; 52.9 mm

The Frick Collection; Gift of Stephen K. and Janie Woo Scher, 2016 (2016.2.146)

Obverse: Marini wearing a fur-lined *zimarra* (coat) over a doublet and ruff-collared shirt. Inscriptions: THOMAS MARINVS DVX TERRAENOVAE [Tommaso Marini, Duke of Terranova]; on truncation (incised), P[ietro] P[aolo] R[omano].

Reverse: Sun shining on a stormy sea. Inscription: NVNQVAM SICCABITVR ESTV [(The sea) shall never dry out].

Literature: Toderi and Vannel 2000, 2: 514, no. 1536; Attwood 2003, no. 842; Pollard 2007, 1: no. 405; 2: no. 825; Leydi and Zanuso 2015, no. 42.

A prominent merchant-banker originally from Genoa but active in Milan, Tommaso Marini was one of the most important financial supporters of the Spanish empire, as well as a key financial figure for the Roman Curia. In the 1560s—with the end of the Italian War and the reconciliation of the Hapsburgs and France (Peace of Cateau-Cambrésis, 1559) and the election of a new pope (Pius IV de' Medici)—Marini's fortunes changed dramatically. He was nevertheless able to purchase lands in southern Italy, among which was the duchy of Terranova (Calabria). This medal was probably produced to commemorate the acquisition of Terranova and the title of duke given to him by King Philip II of Spain. With the sun as the grace of God shining on the sea—a pun on the sitter's name (*mare*, Marini)—the reverse alludes to Marini's success and good fortune. ADC

117

118

118

Pietro Paolo Galeotti, called Romano (1520–1584) or Pietro Paolo Tomei, called Romano (ca. 1525–after 1567)
BIANCA PANSANA CARCANIA (dates unknown)
1560–65
Copper alloy, cast; 55.3 mm
Scher Collection

Obverse: The sitter wearing an elaborate *cioppa* or *vestito* over a gown with a ruffed collar, the hair bound up and interlaced with pearls. Inscriptions: BLANCA PANSANA CARCANIA [Bianca Pansana Carcania]; behind the sitter's shoulder, P[ietro] P[aolo] R[omano].
Reverse: In a stormy sea in which there are drowning figures and monsters, a circular island on which is a wall with three entrances enclosing a tall rock at the base of which kneels a suppliant figure; in the sky, rays of sunshine. Inscription: TE SINE NON POSSVM AD TE [Without you I cannot reach you].
Literature: Attwood 2003, no. 873; Vannel and Toderi 2003–7, 1: no. 819 (obv.); Pollard 2007, 1: no. 399; Leydi and Zanuso 2015, no. 13.

Nothing is known about the subject of this medal. The reverse represents the solid protection (the rock) offered by the Christian faith. ADC

119

Pietro Paolo Galeotti, called Romano (1520–1584) or Pietro Paolo Tomei, called Romano (ca. 1525–after 1567)
ANNIBALE ATTELLANI
ca. 1570
Copper alloy, cast; 44.6 mm
Scher Collection; Promised gift to The Frick Collection

Obverse: Attellani wearing armor. Inscriptions: ANNIBAL ATTELLAMIS ANN[o] XXVII [Annibale Attellani in the 27th year (of his office)]; P[ietro] P[aolo] R[omano].
Reverse: A drill on the point of a diamond ring, a townscape behind and to the right, a tree stump with one healthy branch to the left. Inscription: OMNIA CVM TEMPORE [Everything at its time].
Literature: Keary 1881, no. 178; Armand 1883–87, 1: 227, no. 2; C. Johnson and Martini 1986–95, no. 2002; Vannel and Toderi 2001, no. 1595; Attwood 2003, no. 870; Leydi and Zanuso 2015, no. 6.

Originally from southern Italy, the Attellanis were a family of courtiers and diplomats. In the fifteenth century, they settled in Milan in the service of Ludovico Sforza and the Sforza family. Although an emblem with a diamond and drill design reproduced by De Jonghe is similar to the design on the reverse of the present medal, the mottos designate different meanings. A tree shown cut down at the base with one branch regrown was a frequently used trope of the Medici family, signifying perpetual renewal. CM

120

Pietro Paolo Galeotti, called Romano (1520–1584)
GIROLAMO FIGINO (2nd half of 16th century)
Dated 1562
Copper alloy, cast; 37 mm
Scher Collection

Obverse: Figino wearing a loose drapery over the shoulders. Inscription: HIERONIMVS FIGINVS MDLXII [Girolamo Figino, 1562].
Reverse: Helmeted standing female figure with a shield and a spear; on the ground, musical instruments, an open book, and various architectural implements (T-square and compass). Inscription: OMNIS IN HOC SVM [In this I am all].
Literature: Attwood 2003, no. 852; Pollard 2007, 1: no. 400.

119

120

121

Figino was a renowned painter, musician, and singer, and his accomplishments are celebrated with a clever combination of words and images on the reverse of this medal. The female figure (Minerva) is the Roman goddess who protected the liberal arts. The medal is attributed to Galeotti on stylistic grounds but also because he made a medal of Giovanni Paolo Lomazzo (1538–1600), who praised Figino's artistic quality in his *Rime* (1587). ADC

121

Attributed to Pietro Paolo Galeotti, called Romano (1520–1584)
GIANFRANCESCO TRIVULZIO (1504–1573)
1543
Copper alloy, cast; 60.8 mm
Scher Collection

Obverse: Trivulzio in armor and a commander's sash. Inscriptions: IO[annes] FRAN[ciscus] TRI[vultius] MAR[chio] VIG[evani] CO[mes] MVSO[chi] AC VAL[lis] REN[ensis] ET STOSA[e] D[ominus] [Gianfrancesco Trivulzio, Marquess of Vigevano, Count of Mesocco, Lord of Rheinwald and Stoss]; on truncation, AET[atis] 39 [aged 39].
Reverse: A naked woman, the personification of Fortune, holding a billowing sail and standing on a dolphin upon a sea with drowning figures agitated by the four winds. Inscription: FVI SVM ET ERO [I was, I am, and I will be].
Literature: Scher 1994, no. 53; Toderi and Vannel 2000, 2: 506, no. 1502; Attwood 2003, no. 146; Pollard 2007, 1: no. 412.

Born into a noble Milanese family, Trivulzio served as a general in the French cavalry under King Francis I and later occupied a similar position in the papal army. Accused in 1533 of treason for poisoning Francesco II, the last Sforza Duke of Milan, Trivulzio was condemned to death. In 1543, when Emperor Charles V rescinded the death sentence, the medal was issued. Following new accusations a few years later (1550), Trivulzio was forced to flee Milan. Although the medal is traditionally attributed to Pietro Paolo Galeotti, it has also been given to a medalist in Leone Leoni's circle on stylistic grounds (Scher 1994). ADC

122

Attributed to Pietro Paolo Galeotti, called Romano (1520–1584)
ZENOBIA MAURUZI DA TOLENTINO (dates unknown)
ca. 1555–60
Copper alloy, cast; 59 mm
Scher Collection

Obverse: Mauruzi wearing a gown, a chemise, and a widow's veil. Inscription: DI[va] ZANOB[ia] TOLEN[tina] ALTERA PVLCR[a] HELENA [floral decoration] [The divine Zenobia da Tolentino, another beautiful Helen].
Literature: Toderi and Vannel 2000, 2: 509, no. 1511.

This portrait of Zenobia Mauruzi, the daughter of Count Ludovico da Tolentino, is the only extant medal of its type. The attribution of this unsigned medal to Pietro Paolo Galeotti has not been confirmed; however, it shares stylistic similarities with other signed medals, particularly that of Faustina Sforza. Additionally, the decorative branch at the end of the inscription was frequently used by Galeotti. CM

122

123

123

Unknown artist (probably Florence)
UNKNOWN WOMAN
Mid-16th century
Copper alloy, cast; 66.6 mm
Scher Collection

Obverse: Bust facing left, with hair in a net and decorated with jewels, wearing an ornamented dress with a high collar. Inscription: AENAS ICCIOAN[?] ALTERA PVLCR[a] HELE[na] [Aenas [?], another beautiful Helen].
Reverse: In a landscape, an eagle standing on a tree, its head raised toward the sun; a ribbon flowing behind. Inscription: written in ink, "Molson."
Literature: Armand 1883–87, 3: 276.

Neither the sitter nor the artist is known. Armand proposed Galeotti as the author, but this cannot be confirmed. CM

124

Unknown artist (Volterra)
ANDREA GHETTI DA VOLTERRA (ca. 1510–1593)
Dated 1570
Lead, cast; 64.3 mm
The Frick Collection

Obverse: Bust wearing a cassock; in the truncation, a pile of books. Inscription: F[rater] ANDREA VOLTERRA[nus] A[nno] A[etatis] LXV 1570 [Friar Andrea da Volterra, at age 65, 1570].
Literature: P. A. Gaetani 1761–63, 1: 345–46, pl. LXXV, no. 4; Armand 1883–87, 2: 201, no. 31; Heiss 1881–92, 8: 243, no. 32; Rizzini 1892, pt. 1, 92, no. 640; Toderi and Vannel 2000, 2: 573, no. 1725.

Andrea Ghetti da Volterra was a famous Augustinian friar and preacher who traveled throughout Italy. His theological positions were often viewed as unorthodox and too close to those of the Protestant reformers. The occasion for this medal is unknown, as is the reason for the strange inclusion of books in the truncation. CM

124

125

Unknown artist (Florence)
FRANCESCO LENZONI (1541–1594)
ca. 1580
Copper alloy, cast; 44.4 mm
Scher Collection; Promised gift to The Frick Collection

Obverse: Lenzoni wearing a doublet and a coat with a fur collar. Inscription: FRANC[iscus] LENZONIVS I[uris] C[onsultus] ET SENAT[or] FLOREN[tiæ] [Francesco Lenzoni, juriconsult and senator of Florence].
Reverse: Fortune standing on a pedestal and holding a sail; a wheel to the left of the pedestal. Inscription: PRVDENTIA RETENTA [Prudence maintained].
Literature: P. A. Gaetani 1761–63, 1: 425, pl. XCVI, no. 1; Armand 1883–87, 3: 248; Heiss 1881–92, 8: 190, pl. XVIII, no. 9; Rizzini 1892, pt. 1, 92, no. 639; Pollard 1984–85, 2: 924–27, no. 501; Börner 1997, no. 728; Toderi and Vannel 2000, 2: 549, no. 1648; Attwood 2003, no. 913; Vannel and Toderi 2003–7, 1: no. 989.

125

Francesco Lenzoni was a Florentine ambassador and senator who served on the secret council of Cosimo I, Grand Duke of Tuscany, and later under his successors, Francesco and Ferdinando. Lenzoni was sent on diplomatic missions to the courts of Rudolf II and Philip II. The coupling of Fortune and Prudence could allude to a medieval and Renaissance interpretation of Boethius's *Consolation of Philosophy*: Fortune embodied the temporal pleasures that good Christians must transcend through Prudence. This theme was further developed by Niccolò Machiavelli in *The Prince*. CM

ITALIAN HIGH RENAISSANCE AND LATER MEDALS
SCHOOL OF ROME

126

Gian Federico Bonzagni (1508–after 1586)
POPE PAUL III (b. 1468; r. 1534–49)
1548/49
Gilt copper alloy, cast; 36.1 mm
The Frick Collection; Gift of Stephen K. and Janie Woo Scher, 2016
(2016.2.144)

Obverse: Paul wearing a camauro and a hooded cassock.
Inscription: PAVLVS III PONT[ifex] OPT[imus] MAX[imus] AN[no] XVI [The excellent Pope Paul III in the sixteenth year (of his pontificate)].
Reverse: View of Frascati and the Villa Rufina. Inscriptions: RUFINA; in exergue, TVSCVLO REST[ituta] [Tuscolo restored].
Literature: Armand 1883–87, 2: 168, no. 19; Panvini Rosati 1968, no. 116; Pollard 1984–85, 2: 995, no. 530; C. Johnson and Martini 1986–95, no. 981; Börner 1997, no. 498; Toderi and Vannel 2000, 2: 663, no. 2068; Vannel and Toderi 2003–7, 1: no. 1120; Attwood 2003, no. 387.

Pope Paul III (born Alessandro Farnese) assumed the papal throne following the Sack of Rome (1527) and on the heels of the Protestant Reformation, when his keen diplomatic skills served him well. He was the last Renaissance pope and a great patron of the arts. This medal commemorates the pope's building projects in Frascati, including Villa Rufina. Alessandro Ruffini, Bishop of Melfi, started construction on the "Rufina" villa between 1548 and 1574, but the land and project were taken over by Bishop Alessandro Farnese. Farnese decided to complete the construction of the villa because he considered Frascati strategically located over Rome. The area was originally the ancient Roman city of Tusculum, and the town is built upon its ruins. Vannel and Toderi attribute this medal type to Alessandro Cesati. CM

127

Gian Federico Bonzagni (1508–after 1586)
CARDINAL FEDERICO CESI (1500–1565)
ca. 1557
Gilt copper alloy, cast; 34.6 mm
Scher Collection; Promised gift to The Frick Collection

Obverse: Cesi, with beard and tonsure, wearing a hooded cassock.
Inscriptions: FEDERICVS EP[iscopu]S PRENESTIN[us] S[anctæ] R[omanæ] E[cclesiæ] CARDIN[alis] CAESIVS [Federico Cesi, bishop of Palestrina, cardinal of the Holy Roman Church]; on truncation, F[edericus] P[armensis] [Federico of Parma].
Reverse: Standing figures of Justice and Clemency embracing, flanked by staffs. Inscription: IVSTITIA ET CLEMENTIA COMPLEXÆ SVNT SE [Justice and Clemency embrace each other].
Literature: Durand 1865, 245, no. 3; Armand 1883–87, 1: 221, no. 2; Rinaldis 1913, no. 185; Pollard 1984–85, 2: 1064, no. 592; C. Johnson and Martini 1986–95, no. 904; Attwood 2003, no. 960.

Born into a prominent Umbrian family, Cardinal Federico Cesi became the bishop of Palestrina in 1557, and this medal likely dates to about that time. A family member, the naturalist Federico Cesi, was an eminent scientist and the founder of the Accademia dei Lincei. The allegory on the reverse of the medal shows Cardinal Cesi as a man who balances Justice and Clemency. Indeed, according to contemporary sources, before turning to an ecclesiastical career, he was a skilled jurist like many other members of his family. CM

126

127

128

general. His pontificate was devoted to the reformation of the church and the strict reinforcement of the Tridentine decrees. The medal commemorates his major political success, the victorious Battle of Lepanto (October 7, 1571), showing on the reverse the defeat of the Turks in the Gulf of Lepanto, with its two forts. The Christian fleet, gathered around the personification of Faith, has on its side God the Father, who strikes the enemy with all His power. ADC

128

Gian Federico Bonzagni (1508–after 1586)
POPE PIUS V (b. 1504; r. 1566–72)
Dated 1571
Gilt copper alloy, struck; 37.3 mm
Scher Collection; Promised gift to The Frick Collection

Obverse: The pontiff wearing a *zucchetto* (cap) and hooded cassock. Inscriptions: PIVS V PONT[ifex] OPT[imus] MAX[imus] ANNO VI [The excellent Pope Pius V in the sixth year (of his pontificate)]; below truncation, F[edericus] P[armensis] [Federico of Parma].
Reverse: Naval battle scene, with galleys on the left and sinking ships on the right; above, God the Father in a cloud is striking with thunderbolts the fleet on the right, while in the center a female figure representing Faith holding a cross and a chalice stands on a ship; on the right, two forts guarding the entrance of the port. Inscription: DEXTERA TVA DOM[ine] PERCVSSIT INIMICVM 1571 [Your right hand, O God, smote the enemy, 1571].
Literature: Toderi and Vannel 2000, 2: 700, no. 2198; Attwood 2003, 388–89, fig. 84; Vannel and Toderi 2003–7, 1: nos. 199–201; Pollard 2007, 1: no. 428.

Pope Pius V was born into a humble family as Antonio Ghislieri and beginning in 1518 was called Michele Ghislieri. He became a Dominican monk at the age of fourteen and was later appointed inquisitor. In 1557, he was made cardinal and a year later inquisitor

129

Giovanni Antonio de' Rossi (1513–after 1575)
POPE MARCELLUS II (b. 1501; r. April 9, 1555–May 1, 1555)
1555
Lead, cast; 79.1 mm
Scher Collection; Promised gift to The Frick Collection

Obverse: The pontiff wearing a cope decorated with an orphrey showing the Evangelists and a morse with the Virgin and Child. Inscriptions: MARCELLVS II PONT[ifex] MAX[imus] [Pope Marcellus II]; below the truncation, IO[hannes] ANT[onius] RVB[eus] MEDIOL[anensis] [Giovanni Antonio de' Rossi of Milan].
Reverse: Female figure seated at a desk, reading a book and holding a rudder in her left hand; on the desk, a second book, closed; behind her, in the distance, a circular building.
Literature: Hill and Pollard 1967, no. 370; Attwood 2003, 130–31, fig. 32; Pollard 2007, 1: no. 422.

Marcello Cervini (the future Pope Marcellus II) was a respected papal diplomat, and, as Biliothecarius Sanctæ Romanæ Ecclesiæ (from 1550), he added more than five hundred codices to the library's collection. He was a member of the reforming party in the Church and upon his election prepared several measures of administrative reforms. Unfortunately, he fell ill and died just twenty-two days later. The figure on the reverse of the medal reads the Gospels; the rudder represents control of the world. ADC

129

The reverse shows a view of Troy, possibly taken from a book illustration, featuring an amalgam of fantastic and real monuments. The portrait does not appear to be based on an ancient type. ADC

130

Alessandro Cesati, called Il Grechetto (act. 1538–64)

DIDO, QUEEN OF CARTHAGE

Before 1564

Gilt copper alloy, cast after a struck original; 45.3 mm

Scher Collection; Promised gift to The Frick Collection

Obverse: Dido wearing elaborate hair adorned with a jeweled band and a (golden) laurel fillet. Inscription: ΔΙΔΩ ΒΑΣΙΛΙΣΣΑ [Queen Dido].

Reverse: Carthage with galleys in the harbor. Inscription: ΚΑΡΧΗΔΩΝ [Carthage].

Literature: Attwood 2003, no. 942; Vannel and Toderi 2003–7, 1: nos. 1136, 1137; Pollard 2007, 1: no. 419.

The view of Carthage is imaginary, possibly derived from a book illustration, but it incorporates some specific Roman monuments. Among others, the Pantheon is visible on the right and Trajan's Column on the left. ADC

131

Alessandro Cesati, called Il Grechetto (act. 1538–64)

PRIAM, KING OF TROY

Before 1564

Copper alloy, cast from an original strike; 37.8 mm

Scher Collection; Promised gift to The Frick Collection

Obverse: The legendary king of Troy. Inscription: ΠΡΙΑΜΟΣ ΒΑΣΙΛΕΥΣ [King Priam].

Reverse: Troy with galleys in the harbor. Inscriptions: ΤΡΟΙΑ [Troy]; on the citadel wall, second from the top, one can see, with some difficulty, the word Ilion (archaic name of the city of Troy) in Greek [ΙΛΙΟΝ].

Literature: Attwood 2003, no. 941; Vannel and Toderi 2003–7, 1: no. 1138; Pollard 2007, 1: no. 420.

132

Giovanni Vincenzo Melone (or Melon, act. 1571–89)

ALESSANDRO FARNESE (1520–1589)

Dated 1575

Copper alloy, cast; 44.7 mm

Scher Collection; Promised gift to The Frick Collection

Obverse: Farnese wearing a hooded cassock. Inscription: ALEXANDER CARD[inalis] FARN[ese] S[anctæ] R[omanæ] E[cclesiæ] VICECAN[cellarius] [Cardinal Alessandro Farnese, Vice Chancellor of the Holy Roman Church].

Reverse: The facade of the Chiesa del Gesù, Rome. Inscription: FECIT ANNO SAL[utis] MDLXXV ROMAE [He built in Rome in the year of (our) salvation 1575].

Literature: P. A. Gaetani 1761–63, 1: 407, pl. XCI, no. 7 (signed var.); Hauschild 1805, 2, no. 259 (signed var.); Durand 1865, 68, no. 3 (signed var.); Armand 1883–87, 1: 264, no. 3 (signed var.); Rizzini 1892, pt. 1, 57, no. 376 (signed var.); Supino 1899, no. 475 (signed var.); Forrer 1904–30, 4: 18; Rinaldis 1913, 110, nos. 364–67 (signed var.); Álvarez–Ossorio 1950, no. 284 (signed var.); Norris and Weber 1976, no. 61 (signed var.); Pialorsi 1982, 35, fig. 44 (signed var.); Whitman 1983, no. 18 (signed var.); Pollard 1984–85, 2: 1132–33, no. 654 (signed var.); Fornari Schianchi and Spinosa 1995, no. 259 (signed var.); Pannuti 1996, no. 8.96 (signed var.); Börner 1997, no. 940 (signed var.); Toderi and Vannel 1990, no. 34 (signed var.); Attwood 2003, no. 992.

The grandson of Pope Paul III and the son of the Duke of Parma, Alessandro Farnese became a cardinal in 1534 and Vice Chancellor of the Church in 1535. He was a great patron of the arts, and this medal celebrates his patronage of the building of the magnificent Chiesa del Gesù, the official church of the Society of Jesus in Rome and a symbol of the Counter-Reformation. The project began in 1561, when Farnese commissioned Jacopo Barozzi "Il Vignola" to design the church, but the construction actually began in 1568 and was completed by Giacomo della Porta. There are signed and unsigned types of this medal. This unsigned one differs from the others in the loop at the top. CM

133

134

133

Giovanni Vincenzo Melone (or Melon, act. 1571–89)
IÑIGO LÓPEZ DE MENDOZA Y MENDOZA (1512–1580)
Dated 1577
Copper alloy, cast, pierced; 49.2 mm
Scher Collection

Obverse: Mendoza wearing armor and a commander's sash.
Inscriptions: INICVS LOPES MENDOCIA MARC[hio] MONDE[jar] [Iñigo
López de Mendoza, Marquess of Mondejar]; signed beneath
truncation, IO[annes] V[incentius] MILON F[ecit] 1577 [Giovanni
Vincenzo Melon made it, 1577].
Reverse: Two armies confronting each other on a collapsing bridge,
one led by Mendoza on horseback, holding a baton.
Literature: Pinchart 1870, 31 (signed var.); Armand 1883–87, 1:
264, no. 4; 3: 126, no. b; Rizzini 1892, pt. 1, 57, no. 376; Álvarez–
Ossorio 1950, 198, no. 287 (signed var.) and no. 15 (signed var.);
Börner 1997, no. 941; Attwood 2003, no. 995 (signed var.).

Iñigo López de Mendoza y Mendoza, third Marquess of Mondejar
and fourth Count of Tendilla, was a Spanish nobleman, military
commander, diplomat, and politician in the service of King Philip II
of Spain. He also became the third and last captain of Granada. In
1555, he fought against the Turks in North Africa and in 1560 was
Spanish ambassador in Rome. He became viceroy of Valencia in
1572 and of Naples in 1575. There are two variants of this medal:
those with the inscription IP on the reverse and those, like the
present one, without. CM

134

Giovanni Vincenzo Melone (or Melon, act. 1571–89)
POPE GREGORY XIII (b. 1502; r. 1572–85)
1579
Copper alloy, cast; 46.6 mm
Scher Collection; Promised gift to The Frick Collection

Obverse: Gregory wearing a camauro and a hooded cassock, his
right hand in the act of blessing. Inscription: GREGORIVS XIII PONT[ifex]
MAX[imus] [Pope Gregory XIII].
Reverse: The dragon of the Buoncompagni (or Boncompagni) arms
between a caduceus and a cornucopia; an inscribed scroll extending
from the caduceus to the cornucopia. Inscription: VTR / VNQVE PRAES /
TAT [Each of them he supports].
Literature: Palazzi 1687–90, 4: 361; du Molinet 1679, 99, no. XXVI;

Bonanni 1699, 1: 330, no. 16; Venuti 1744, 152, no. xiii; Armand
1883–87, 1: 265, no. 8; Lincoln 1890, no. 730; Patrignani 1951, 59;
Pollard 1984–85, 2: 1130, no. 652; Toderi and Vannel 2000, 2: 731,
no. 2295; Vannel and Toderi 2003–7, 1: no. 1251; Modesti 2002–4,
3: no. 775.

Pope Gregory XIII (born Ugo Buoncompagni) is known for establish-
ing the Gregorian calendar, advancing the Counter-Reformation,
and establishing missions internationally. The reverse of the medal
shows Mercury's caduceus, which represents commerce, together
with the Cornucopia of Annona, which represents taxes. The medal
commemorates the administrative and economic merits of the pope.
CM

135

Bartolomeo Argenterio (act. 1576; d. 1591)
POPE GREGORY XIII (b. 1502; r. 1572–85)
1582
Copper alloy, cast; 58.5 mm
Scher Collection

Obverse: The pope wearing a camauro and *mozzetta*. Inscriptions:
SOCIETATIS IESV GENERALE COLLEGIVM EXSTRVXIT ET DOTAVIT [He built
and endowed the General College of the Society of Jesus]; below the
bust, in two lines, GREGORIVS XIII / AN[no] PON[tificatus] X [Gregory
XIII in the tenth year of his pontificate].
Reverse: A female figure seated on a throne and holding a cross;
kneeling on the floor, on both sides of the throne, female figures
offering to her attention various objects: a chalice, a globe, a
compass and polyhedron, and a book. Inscription: BONAS ARTES ALIT
ET VERAE RELIGIONI SVBIICIT GREGORIVS [Gregory promotes the good
arts and brings them under the sway of the true religion].
Literature: Toderi and Vannel 2000, 2: 752, no. 2351; Vannel and
Toderi 2003–7, 1: nos. 1289–91; Pollard 2007, 2: no. 818.

This medal was produced as a foundation medal for the Jesuit
College in Rome, founded by Gregory XIII (born Ugo
Buoncompagni). It was designed by the Florentine Bartolomeo
Ammannati (1511–1592) and made by Bartolomeo Argenterio
(supervisor of the mint in Rome in 1583). The personification
of Religion enthroned and surrounded by Theology, Astronomy,
Philosophy, and Poetry on the reverse celebrates the teaching of
Christian doctrine along with the Liberal Arts that was to take place
in the college. See the commentary for no. 134. ADC

135

136

Bernardino Passero (ca. 1540–1596)
POPE GREGORY XIII (b. 1502; r. 1572–85)
1582
Copper alloy, cast; 58.6 mm
Scher Collection; Promised gift to The Frick Collection

Obverse: Gregory, wearing a cope closed by a morse. Inscriptions: COLLEG[io] SOC[ietatis] IESV OMNIVM NATIONVM GRATIA FVNDATO DE RELIG[ionis] ET LIT[teris] OPT[imo] MER[ito] [The College of the Society of Jesus, founded for the sake of all nations, in religion and liberal education excellent … ?]; left, GREGORIVS XIII; right, AN[no] PON[tificatus] X [Gregory XIII in the tenth year of his pontificate].
Reverse: Abraham stands to the right, with his right hand directing numerous soldiers before him (from Genesis 14:14: Abraham goes to the rescue of Lot with 318 men). Inscriptions: VT ERVAT PRAEDAM CAPTIVORVM FRATRVM [To rescue the prey of the captive brothers]; in exergue, on truncation, ABRAHAM TRECENTOS / VERNACVLOS / EXPEDITOS NVMERAT [Abraham summons/calls out 300 trained men of his household].
Literature: Bonanni 1699, 1: 362, no. 56; *Trésor de numismatique* 1834–58, 6: pl. XVI, no. 6; Armand 1883–87, 3: 134, no. a; Rizzini 1892, pt. 1, 24, no. 146; C. Johnson and Martini 1986–95, no. 727; Norris and Weber 1976, no. 42; Toderi and Vannel 2000, 2: 755, no. 2356.

This medal, like no. 135, was made in 1582 to be placed in the foundations of the Jesuit College (see no. 135). On the reverse is a

scene from Genesis (14:14) that relates the story of Abraham, who, after being told that his brother had been taken captive, armed the 318 members of his household to rescue him. It is a biblical analogy for the large number of Jesuit missionaries the pope sent out of Rome in 1583. CM

ITALIAN HIGH RENAISSANCE AND LATER MEDALS SCHOOL OF THE VENETO

137

Unknown artist (Veneto)
VALERIO BELLI (ca. 1468–1546)
mid-16th century
Lead, cast; 48.6 mm
Scher Collection; Promised gift to The Frick Collection

Obverse inscription: VALERIVS BELLVS VICENTINVS [Valerio Belli of Vicenza].
Literature: Toderi and Vannel 2000, 1: 289, no. 827; Burns, Collareta, and Gasparotto 2000, no. 4; Attwood 2003, no. 415; Vannel and Toderi 2003–7, 1: no. 827; Pollard 2007, 1: no. 440.

This medal is one of two portraits formerly ascribed to Belli but challenged by Attwood, who finds them closer to the work of Danese Cattaneo. The portrait derives from a drawing in Rotterdam (Museum Boymans-van Beuningen), also used for Belli's effigy in Vasari's *Lives* (Pollard 2007). ADC

136

137

138

139

ITALIAN HIGH RENAISSANCE AND LATER MEDALS
SCHOOL OF PADUA

138

Valerio Belli (ca. 1468–1546)
BIAS OF PRIENE
ca. 1540
Copper alloy, cast from a struck original; 28.3 mm
Scher Collection; Promised gift to The Frick Collection

Obverse inscription: ΠΡΙΗΝΙΟΥ ΒΙΑΝΤΟΣ [Of Bias of Priene].
Reverse: Apollo holding a lyre in a central niche, a tripod in a niche on the left, an altar in the niche on the right. Inscription: ΜΟΝΩ ΤΡΙΠΟΔΟΣ ΑΞΙΩ [To the one who is worthy of the tripod].
Literature: Rowlands 1977, 90; Lawrence 1996, fig. 9; Burns, Collareta, and Gasparotto 2000, no. 235; Attwood 2003, no. 348.

Bias was one of the seven sages of ancient Greece, three of whom figure on medals by Valerio Belli (including Solon [no. 139] and Thales). They may be part of a larger group of eminent figures from ancient Greece conceived by Belli. The reverse shows the temple of Apollo at Delphi, where the sages inscribed aphorisms. Rubens created two drawings of Bias after Belli's medal (British Museum; 1858.0626.138). CM

139

Valerio Belli (ca. 1468–1546)
SOLON
Before 1546
Copper alloy, cast from a struck original; 30.4 mm
Scher Collection

Obverse: Solon, bearded and with hair to the nape of his neck. Inscription: ΣΟΛΟΝΟΣ ΣΟΦΟΥ [Of Solon the wise].
Reverse: A temple with a statue of Athena in the center. Inscription: ΚΟΙΝΟΝ ΑΘΗΝΩΝ [The Athenian State].
Literature: Rowlands 1977, 91; Attwood 2003, no. 346.

Solon was a noted statesman and one of the seven sages of ancient Greece, three of which figure on medals by Valerio Belli (including Bias [no. 138] and Thales). They may be part of a larger group conceived by Belli of eminent figures from ancient Greece. This medal type also exists with altars within each of the spaces that flank Athena. Rubens created a drawing of Solon after Belli's medal, together with a drawing of Belli's portrait of Lysander (British Museum; 1858.0626.140). CM

140

Valerio Belli (ca. 1468–1546)
HELEN OF TROY
Before 1546
Copper alloy, cast from a struck original; 28.9 mm
Scher Collection

Obverse: Bust facing right, with hair braided and secured upon the head, wearing a wreath and earrings. Inscription: ΕΛΕΝΗ ΒΑΣΙΛΙΣΣΑ [Queen Helen].
Reverse: Concordia seated, draped, holding a double cornucopia in her right hand. Inscription: ΟΜΟΝΟΙΑ ΕΛΛΗΝΩΝ [Concordia of the Greeks].
Literature: Hill 1931a, no. 387; Cott 1951, no. 187; Hill and Pollard 1967, no. 387; C. Johnson and Martini 1986–95, no. 782; Lawrence 1996, no. 29; Hoerschelmann 1991, fig. 8; Gasparotto 2000, no. 223; Toderi and Vannel 2000, 1: 295, no. 858; Pollard 2007, 1: no. 442.

The abduction by Paris of Helen of Troy, the daughter of Zeus and Leda, precipitated the Trojan War. The reverse of this medal, stylistically reminiscent of Concordia on Greek coins, alludes to the Greek states that joined forces in the Trojan War. This is one of the medals in Belli's series of Greek eminences. CM

140

141

142

143

141

Giovanni da Cavino (1500–1570)
MARCANTONIO CONTARINI (ca. 1485–1546)
Dated 1540
Copper alloy, struck, pierced and repaired; 39.2 mm
Scher Collection

Obverse: Contarini wearing a pleated gown. Inscription: M[arcus] ANTONIVS CONTARENVS [Marcantonio Contarini].
Reverse: The personification of Padua holding scales in her right hand and a cornucopia in her left, seated left on a suit of ancient armor and shields, her right foot resting on a helmet. Inscriptions: PATAVIVM [Padua]; in exergue, M D XL [1540].
Literature: Lawrence 1883, no. 88; Armand 1883–87; 1: 180, no. 11; Rizzini 1892, pt. 1, 40, no. 264; Gorini 1973, 117; Cessi 1969, no. 11; Gorini 1987, no. 50; C. Johnson and Martini 1986–95, no. 1163; Börner 1995, no. 26; Börner 1997, no. 886; Voltolina 1998, 1: 366, no. 317; Toderi and Vannel 2000, 1: 321, no. 939; Attwood 2003, no. 270.

A Paduan statesman from a prominent Venetian family, Marcantonio Contarini was called "il Filosofo" and was *podestà* of Vicenza from 1523 to 1524 and of Padua from 1539 to 1540, the occasion this medal commemorates. He was also an ambassador to Pope Paul III and the court of Charles V. An example of this medal was placed under the foundations of the loggia in Piazza Contarina, Udine. CM

142

Giovanni da Cavino (1500–1570)
MARCO MANTOVA BENAVIDES (1489–1582) and
GIAMPIETRO MANTOVA BENAVIDES (d. 1520)
ca. 1540
Copper alloy, struck; 36.3 mm
Scher Collection

Obverse: Marco Mantova Benavides wearing a mantle. Inscription: MARCUS MANT[ua] BONAVIT[us] PATAVIN[us] IVR[is] CON[sultus] [Marco Mantova Benavides of Padua, juriconsult].
Reverse: Giampietro Mantova Benavides wearing a gown with rope trim. Inscription: IO[annes] PET[rus] MAN[tua] BONAVI[tus] MEDICVS PATER [(His) father Giampietro Mantova Benavides, physician].
Literature: P. A. Gaetani 1761–63, 1: 377–78, pl. LXXXIV, no. 2; Duisburg 1869, no. XIV, no. 2; Lawrence 1883, nos. 83, 84; Armand 1883–87, 1: 179, no. 5; Magnaguti 1921, no. 221; Cessi 1969, no. 77; C. Johnson and Martini 1986–95, no. 1158; Börner 1995, no. 26; Börner 1997, no. 885; Voltolina 1998, 1: 461, no. 423; Toderi and Vannel 2000, 1: 321, no. 937.

Cavino was at the center of the artistic, humanist community in Padua, as was the noted Italian jurist, collector, and patron Marco Benavides. This community supported a self-consciously classicizing style in the 1540s, of which this medal—commemorating both Marco and his father, the celebrated physician Giampietro Benavides—is an example. The bust of Giampietro is based on an unattributed bronze now in the Ca' d'Oro in Venice. CM

143

Giovanni da Cavino (1500–1570)
TIBERIO DECIANI (1509–1582)
1549
Copper alloy, struck; 37.2 mm
The Frick Collection; Gift of Stephen K. and Janie Woo Scher, 2016 (2016.2.143)

Obverse: Deciani wearing a mantle pinned at the right shoulder. Inscription: TIBERIVS DECIANVS IVR[is] CON[sultus] VTINENSIS AN[no] XL [Tiberio Deciani, juriconsult of Udine, at the age of 40].
Reverse: Deciani wearing a gown and kneeling before a seated figure of Jurisprudence from whom he receives a codex of laws; Jurisprudence simultaneously being crowned with laurel by the standing figure of Peace, who holds a caduceus, and a figure of Justice, who holds a sword and scales; on the ground lies a helmet. Inscriptions: HONESTE VIVAS ALTERV[m] NON LÆDAS IVS SVV[m] CVIQ[ue] TRIBVAS [Live honestly, harm no one, give to each one his due by right of law (from *The Institutes of Justinian*, b.I, tit.I, 3–4: "Iuris praecepta sunt haec: honeste vivere, alterum non laedere, suum cuique tribuere")]; in exergue, IVRIS PRVDENCIA [Jurisprudence].
Literature: P. A. Gaetani 1761–63, 1: 377, pl. LXXXIV, no. 1; Keary 1881, no. 109; Lawrence 1883, no. 90; Armand 1883–87, 1: 180, no. 13; Ostermann 1888, no. 81; Rizzini 1892, pt. 1, 41, no. 266; Cessi 1969, no. 15; C. Johnson and Martini 1986–95, no. 1167; Gorini 1987, no. 50; Börner 1997, no. 888; Voltolina 1998, 1: 409–10, no. 361; Toderi and Vannel 2000, 1: 323, no. 946; Attwood 2003, no. 287a.

Deciani, a pupil of Marco Mantova Benavides (no. 142), became a professor of law at Padua in 1549, likely the occasion for the commissioning of this medal. CM

144

145

144

Giovanni da Cavino (1500–1570)

MARCANTONIO PASSERI (1491–1563)

ca. 1550

Silver, struck; 37.7 mm

Scher Collection

Obverse: Passeri wearing a doublet and a coat. Inscription: M[arcus] ANTONIUS PASSERVS PATAVIN[us] [Marcantonio Passeri, Paduan].

Reverse: A single figure formed by a male and female fused together, back to back, one of them walking on all fours. Inscription: PHILOSOPHIA COMI[t]E REGREDIMUR [With philosophy as our companion, we go back (in order to advance)].

Literature: P. A. Gaetani 1761–63, 1: 322–23, pl. LXIX, no. 3; Duisburg 1869, no. XXII; Lawrence 1883, no. 103; Armand 1883–87, 1: 184, no. 28; Rizzini 1892, pt. 1, 42, no. 274; Museo Correr 1898, no. 191; Hill 1920–21, no. 243; Cessi 1969, no. 29; Gorini 1973, no. 50; C. Johnson and Martini 1986–95, no. 1188; Börner 1997, no. 904; Voltolina 1998, 1: 466–67, no. 432; Toderi and Vannel 2000, 1: 328, no. 967; Attwood 2003, no. 289a.

Marcantonio Passeri, also known as Gènua, was a celebrated professor of philosophy and medicine. The reverse of this medal shows Plato's "spherical man" as described by Aristophanes in Plato's *Symposium*. The creature is a self-sufficient, perfect human, having male and female characteristics and genitals. The moral of the legend is that with the assistance of philosophy, humanity can return to a perfect state. The dating of the medal is based on the apparent age of Marcantonio (sixty) at the time of the portrait. CM

145

Giovanni da Cavino (1500–1570)

GIAMPAOLO ZUPONI (ca. 1460–1553)

ca. 1553

Copper alloy, struck; 37.4 mm

The Frick Collection; Gift of Stephen K. and Janie Woo Scher, 2016 (2016.2.142)

Obverse: Zuponi all'antica. Inscription: IO[annes] PAVLVS ZVPONVS PATAVINVS [Giampaolo Zuponi, Paduan].

Reverse: An eagle with open wings standing on an upturned amphora containing laurel. Inscription: VIRT[ute] AET[ate] CONS[ilio] [By Virtue, by Age, by Deliberation].

Literature: Lawrence 1883, no. 111; Armand 1883–87, 1: 185, no. 36; Molinier 1886, 1: no. 85; Rizzini 1892, pt. 1, 43, no. 281; Museo Correr 1898, no. 198; Cessi 1969, no. 45; C. Johnson and Martini 1986–95, no. 1207; Börner 1997, no. 911; Voltolina 1998, 1: 506–7, no. 479; Attwood 2003, no. 275; Toderi and Vannel 2000, 1: 326, no. 959.

This medal commemorates the long career of Giampaolo Zuponi as a notary in Padua, a position he held for seventy-two years. The iconography on the reverse—the overturned amphora with a laurel that no longer grows toward the sky—indicates that the medal was most likely struck after his death, at the age of ninety-two. CM

146

Ludovico Leoni (1542–1612)

SPERONE SPERONI (1500–1588)

After 1560

Lead tin alloy, cast; 67.9 mm

Scher Collection

Obverse: Speroni, with an academic cap, wearing a gown with a high collar, and a chain with a cross. Inscriptions: SPERON SPERONI; signed on truncation, LVD[ovico] L[eoni].

Literature: Armand 1883–87, 1: 252, no. 8; Attwood 2003, no. 304.

Sperone Speroni was a Paduan humanist and scholar who taught first logic and then philosophy at the University of Padua. He moved to Rome later in his career but returned to Padua to concentrate on his writing. His *Dialogo della retorica* (1542) was followed by discourses on a broad range of topics, including the nature of love, language, and ancient writings. The present medal, along with that listed in Armand and by Attwood, is a signed version. There are also other fine, unsigned versions. CM

146

147

Ludovico Leoni (1542–1612)

FRANCESCO MARIA BOURBON DEL MONTE (1549–1627)

ca. 1566

Lead, cast; 58.7 mm

The Frick Collection; Gift of Stephen K. and Janie Woo Scher, 2016
(2016.2.149)

Obverse: Del Monte wearing a doublet, a coat, and a ruff.
Inscription: FRANCISCVS MARIA CA[rdinalis] MARCH[io] MON[tis] AN[no]
XVII [Cardinal Francesco Maria, Marquess del Monte, at the age of
17].
Literature: Armand 1883–87, 3: 119, no. b; Hill 1920–21, no. 217.

Born into a patrician family of Tuscan descent, Francesco Maria del
Monte became a cardinal under Pope Sixtus V in 1588 and during
his career fostered a strong patronage of music and the visual arts.
He is noted for his early support of Caravaggio. This portrait was
modeled before he became cardinal, possibly when he was in the
service of Cardinal Ferdinando de' Medici, who encouraged the
pope to confer the title on Francesco. This medal is often with a
reverse of a volcano and the inscription SIDERA LAMBIT [(He) licks
the stars], from Virgil's description of a volcano in the *Aeneid*, III.574
("shooting out globes of flame, with monster tongues / That lick the
stars"). CM

148

Ludovico Leoni (1542–1612)

FRANCESCO LOMELLINI (first half of 16th century)

ca. 1568

Copper alloy, cast; 68.7 mm

Scher Collection; Promised gift to The Frick Collection

Obverse: Lomellini bearded with short hair, draped. Inscriptions:
FRAN[ciscus] LOMELLINVS DAVID[is] F[ilius] ET B[enedicti] CARD[inalis]
FR[ater] ÆT[atis] AN[no] LXV [Francesco Lomellini, son of Davide and
brother of the Cardinal Benedetto, aged 65]; signed on truncation,
LVD[ovico] L[eoni].

147

Reverse: An anvil resting on a base with a griffin in relief with
a banderole above inscribed DVRABO [I will endure]; in the
foreground, two picks and a coat of arms, set within a landscape of
trees, a river, a town, and mountains, a radiating sun above.
Literature: Armand 1883–87, 1: 251, no. 2; 3: 121, no. a; Keary
1881, no. 179; Greene 1913, 413–14; Hill 1923b, no. 125; Álvarez–
Ossorio 1950, no. 247; Börner 1997, no. 917; Attwood 2003, no.
312; Toderi and Vannel 2000, 1: 333, no. 980.

The Genoese nobleman Francesco Lomellini was the son of Davide
and the brother of Angelo and of Cardinal Benedetto Lomellini
(b. 1517). The reverse is an allegory of Fortitude confronted by the
blows of Fate. The motto and anvil upon a tree trunk (but without
the surrounding scene) was also used by another Genoese, Cardinal
Innocenzo Cibo (1491–1550), nephew of Pope Innocent VIII, who
was made a cardinal by Pope Leo X in 1513. His *impresa* was
published by Girolamo Ruscelli in *Imprese illustri* of 1566 (p. 39). CM

148

149

150

149

AN GO (act. ca. 1568)
TEODORA COSMICO (dates unknown)
Dated 1568
Lead, cast; 64.2 × 47.5 mm
Scher Collection

Obverse: Teodora Cosmico, with long hair tied up and a veil, wearing a loose gown and a necklace of pearls. Inscriptions: TEODORAE COSMICAE MDLXVIII [(Image) of Teodora Cosmico, 1568]; signed on truncation, AN GO.
Literature: Armand 1883–87, 1: 253; Lanna sale 1911b, no. 231; Bange 1922, no. 264; Habich 1922, pl. C, no. 3; F. Rossi 1974, 111; Börner 1997, no. 928; Toderi and Vannel 2000, 1: 337, no. 997.

This medal is the only known work ascribed to the unidentified artist AN GO, based on the signature. Toderi and Vannel believe the artist to be Paduan from the name of the Paduan woman depicted. CM

ITALIAN HIGH RENAISSANCE AND LATER MEDALS SCHOOL OF VENICE

150

Andrea Spinelli (1508–1572)
ANTONIO DA MULA (ca. 1460–after 1539)
Dated 1538
Gilt copper alloy, struck; 40.4 mm
Scher Collection; Promised gift to The Frick Collection

Obverse: Antonio Da Mula wearing a *roba* or *vestito*. Inscription: ANT[onius] MVLA DVX CRETÆ X VIR III CONS[iliarius] IIII [Antonio Da Mula, Duke of Crete, member of the Council of Ten for the third time and councilor for the fourth time].
Reverse: Two standing male figures, dressed in togas and shaking hands. Inscriptions: CONCORDIA FRATRVM 1538 [Brotherly concord, 1538]; in exergue, AND[rea] SPIN[elli] / F[ecit] [Andrea Spinelli made it].
Literature: Attwood 2003, no. 208; Pollard 2007, 1: nos. 471, 472.

Antonio Da Mula served in various Venetian offices until his appointment as governor of Candia (1536) and Crete (1538). In June 1538, Mula organized, along with Captain Marcantonio Trevisan (b. ca. 1475; Doge of Venice 1553–54), the defense of Crete against the Turkish pirate Barbarossa. It is commonly accepted that the reverse of the medal showing Da Mula and Trevisan shaking hands refers to their concord on this occasion. ADC

151

Danese Cattaneo (ca. 1509–1572)
GIOVANNI DE' MEDICI DELLE BANDE NERE (1498–1526)
ca. 1546
Copper alloy, cast; 58 mm
The Frick Collection; Gift of Stephen K. and Janie Woo Scher, 2016 (2016.2.148)

Obverse: Giovanni wearing a commander's shawl over armor and a shirt with a frilled collar. Inscription: GIOVANNI DE MEDICI.

151

Reverse: Thunderbolt issuing from a cloud. Inscription: FOLGORE DI GVERRA [The thunderbolt of war].
Literature: Attwood 2003, no. 215; Vannel and Toderi 2003–7, 1: no. 541; Pollard 2007, 1: no. 484.

Giovanni delle Bande Nere was one of the most celebrated papal generals of his time. He entered the service of Pope Leo X de' Medici in 1516 and adopted black stripes ("bande nere") as his personal device following the pope's death in 1521. He died at the age of twenty-eight from septicemia caused by the amputation of a leg badly wounded in the battle of Governolo (November 25, 1526). He was assisted until the very end by his close friend Pietro Aretino, who commissioned this medal. Although the original medal is not known, in 1546 Aretino commissioned copies to be sent to Cosimo de' Medici, as he himself writes in a letter to Cosimo of April 1546 (Pollard 2007). The heroic appellative "thunderbolt of war" comes from Virgil and other Roman sources. ADC

152

Danese Cattaneo (ca. 1509–1572)
TRIFONE GABRIEL (ca. 1470–1549)
ca. 1549
Copper alloy, cast; 44.3 mm
Scher Collection; Promised gift to The Frick Collection

Obverse inscription: TRYPHON GABRIEL [Trifone Gabriel].
Reverse: A woman loosely draped in a gown washing her hands in a waterfall. Inscription: INNOCEN[tibu]S MANIB[us] ET MVNDO CORDE [With innocent hands and a pure heart (Psalm 23:4–6)].
Literature: P. A. Gaetani 1761, 1: 194–95, pl. XLIII, no. 5; Heiss 1881–92, 6: 188, pl. XIII, no. 3; Armand 1883–87, 2: 126, no. 10; Rizzini 1892, pt. 1, 80, no. 548; Museo Correr 1898, no. 370; Foville 1913–14, 79, pl. VIII, no. 10; Rinaldis 1913, no. 796; Álvarez–Ossorio 1950, no. 378; Voltolina 1998, 1: 414–15, no. 366; Attwood 2003, no. 218.

A Venetian poet and scholar born into one of the city's patrician families, Trifone Gabriel was widely recognized for his work on Petrarch. Attwood mentions letters from Aretino to Cattaneo about Trifone, sent in June and July of 1548 and after the scholar's death in 1549. CM

153

Danese Cattaneo (ca. 1509–1572)
ELISABETTA QUERINI (d. 1559)
ca. 1550
Copper alloy, cast; 42.8 mm
Scher Collection

Obverse: Elisabetta dressed all'antica with braided hair. Inscription: ELISABETTAE QVIRINAE [(Image of) Elisabetta Querini].
Reverse: The three Graces.
Literature: Attwood 2003, no. 227; Pollard 2007, 1: no. 482.

Elisabetta Querini, daughter of the Venetian Francesco Querini, was a celebrated beauty and learned woman of her time. She married Lorenzo Massolo in 1512 and was widowed in 1556. They were patrons of Titian and commissioned from him a portrait of Elisabetta (ca. 1534, now lost) and the *Martyrdom of St. Lawrence* in the Gesuiti in Venice. ADC

154

Probably Danese Cattaneo (ca. 1509–1572)?
PIETRO BEMBO (1470–1547)
ca. 1547
Copper alloy, cast; 56.3 mm
Scher Collection

Obverse: Bembo wearing a hooded cassock. Inscription: PETRI BEMBI CAR[dinalis] [(Portrait of) Cardinal Pietro Bembo].
Reverse: Pegasus creating the Hippocrene spring on Mount Helicon.
Literature: Scher 1994, no. 64; Attwood 2003, no. 217; Pollard 2007, 1: no. 562; Beltramini et al. 2013, no. 6.13.

Pietro Bembo is one of the most significant poets of the Renaissance. His major work, *Prose della volgar lingua*, appeared in 1524 and promoted the use of standardized Italian. Nominated official historiographer of the Venetian Republic, he was made cardinal in 1539. On the reverse of the medal is a symbol of poetic inspiration: Pegasus creating the Hippocrene spring on Mount Helicon, home of the Muses. Although the medal has often been attributed to Benvenuto Cellini (who wrote about producing a medal for Bembo), the attribution of this medal to Cattaneo is now generally accepted. ADC

154

155

Alessandro Vittoria (1525–1608)
PIETRO ARETINO (1492–1556)
ca. 1550
Copper alloy, cast; 56.8 mm
The Frick Collection; Gift of Stephen K. and Janie Woo Scher, 2016
(2016.2.154)

Obverse: Aretino wearing a fur-collared *vestito* and a chain.
Inscriptions: DIVVS PETRVS ARETINVS [The divine Pietro Aretino];
below the shoulder, AV [artist's initials].
Reverse: Aretino all'antica, seated on a throne and holding a book,
being paid tribute by four men all dressed in antique manner, the
principal figure wearing armor all'antica. Inscription: I PRINCIPI
TRIBVTATI DAI POPOLI IL SERVO LORO TRIBVTANO [The princes, having
received tribute from the people, pay tribute to their servant].
Literature: Scher 1994, no. 70; Attwood 2003, no. 231; Waddington
2004, 78–82.

The satirist Pietro Aretino was one of the most famous writers of the
Renaissance. In 1524, the circulation of his erotic sonnets based
on Giulio Romano's pornographic engravings forced him to escape
Rome, and he settled in Venice (1527). This medal shows Aretino
at the age of sixty, wearing the chain given to him by Francis I. The
reverse, with the princes of the world paying tribute to Aretino, was
obviously meant to flatter him. Aretino liked Vittoria's design but not
the quality of the cast (Scher 1994). See the commentary for the next
entry (no. 156). ADC

156

Attributed to Antonio Vicentino (act. 1523/24–1545)
PIETRO ARETINO (1492–1556)
ca. 1542
Copper alloy, cast; 60.7 mm
Scher Collection

Obverse: Aretino wearing a gold chain and an elegant *vestito* over
a doublet. Inscription: DIVVS PETRVS ARETINVS [The divine Pietro
Aretino].
Reverse: A naked woman seated on a rock, her right foot on the
thigh of a crouching satyr, pointing toward him while looking up to a
female figure on a cloud. She is crowned with a wreath by a woman
in antique drapery standing behind her. Inscription: VERITAS ODIVM
PARIT [Truth engenders hate].
Literature: Scher 1989b, 4–11; Woods-Marsden 1994; Attwood
2003, no. 407; Vannel and Toderi 2003–7, 1: nos. 569, 570, 572,
571 (var.); Pollard 2007, 1: no. 561.

The portrait of Aretino (see also no. 155) showing the golden chain
given to him by Francis I conforms to the type seen in Titian's portrait
of Aretino in The Frick Collection. The reverse shows Truth (the
naked woman on the rock) and Hate (the satyr), and behind Truth
Victory, illustrating the sentence from the *Andria* by Terentius: "Truth
engenders Hate." It refers to Aretino's profession as a satirist. Attwood
disputes the attribution to Vicentino and considers the medal an
unattributed medal from the Veneto. ADC

155

156

157

Martino Pasqualigo (ca. 1524–1580)
DANIELE CENTURIONE (second half of 16th century)
Mid-16th century
Copper alloy, cast; 43.9 mm
Scher Collection

Obverse: Centurione wearing a doublet and a ruff. Inscriptions: DANIELE CENTVRIONE; signed, MART[inus] S[culptor] PASQ[ualigus] F[ecit] [Martino Pasqualigo, sculptor, made it].
Reverse: A bay tree with a branch sprouting from its trunk, flanked by two saplings. Inscription: SEMPER INTACTA [Always intact].
Literature: Hill 1923c, 47, no. L; Bernhart 1925–26, 73; Eden 1988, fig. 8: Humphris 1993, no. 53; Toderi and Vannel 2000, 1: 66, no. 115; Attwood 2003, no. 299.

Daniele Centurione was a Genoese patrician and businessman who lived in Naples and Puglia. The *impresa* on the reverse of this medal is inspired by a Petrarchan theme: the laurel tree (the plant consecrated by Apollo), which remains intact after being struck by lightning, a symbol of virtue resisting adversity. This medal type is the only known work by Martino Pasqualigo. Before the discovery of the present medal, the attribution of the medal type was unknown as the signatures on the examples in the British Museum and Berlin were unclear. On this medal, Pasqualigo's signature, MART S PASQ, is unmistakable. CM

158

Matteo della Fede, called Matteo Pagano (act. 1543–62)
TOMMASO RANGONE (1493–1577)
Dated 1562
Gilt copper alloy, cast; 39.4 mm
Scher Collection

Obverse inscriptions: THOM[as] PHILOL[ogus] RAVEN[natis] PHYS[icus] EQ[ues] GVARD[ianus] D[ominus] MAR[ci] MAG[ister] [Master Tommaso Philologus of Ravenna, physician and knight, guardian of San Marco]; in the field, on the left, 1562.
Reverse: An eagle gently placing a baby over the breasts of a nude reclining woman, surrounded by a circle of stars; below, a bush of lilies with three little birds flying among the flowers. Inscription: A IOVE ET SORORE GENITA [Born of Jove and his sister].
Literature: Attwood 2003, no. 236 (var.); Vannel and Toderi 2003–7, 1: no. 555; Pollard 2007, 1: no. 481 (var.).

Born Tommaso Giannozzi in Ravenna, Tommaso Rangone was later adopted by Count Guido Rangone. In 1528, he settled in Venice, where he was a successful physician and generous patron of the arts. The reverse represents the legendary creation of the Milky Way: Jupiter wished to give immortality to Hercules, his son by Alcmene, by having him fed by Juno. The infant fed with such vigor that some of Juno's milk spilled out, creating the Milky Way in the sky and lily flowers on earth. Pollard suggests that the "adoption" of Hercules by Juno may allude to the sitter's adoption by Count Rangone. Attwood attributes the medal to an unidentified Venetian artist. ADC

157

158

159

159

Unknown artist (Venice)
GIOVAN FRANCESCO PEVERONE (ca. 1509–1559)
Dated 1550
Copper alloy, cast; 51.1 mm
Scher Collection

Obverse: Peverone wearing a chain and a coat over a shirt.
Inscriptions: IO[annes] FRANC[iscus] PEVERONVS (Giovan Francesco
Peverone); on truncation, 1550.
Reverse: A hand pointing. Inscription: incomplete, [Ann]A PEVERONA
(Anna Peverone).
Literature: Tiraboschi 1832, VII–2, 524; Promis 1873, 712–13;
Municipio di Cuneo 1873, 17; Armand 1883–87, 2: 173, no. 2;
Rizzini 1892, pt. 1, 88, no. 614; Foville 1913–14, 78–79; Toderi and
Vannel 2000, 1: 104, no. 242; Sereno 2002, 33n.1.

Peverone was a cartographer and the author of treatises on
mathematics (printed in Lyon in 1548), as well as councilor and
mayor of Cuneo. The event commemorated here is unknown, but the
medal was reproduced on the frontispiece of Peverone's treatises.
The hand pointing down on the reverse might be a reference to
Peverone's studies of cartography, geometry, and earth sciences.
Anna, his sister, who is mentioned in the inscription, was his sole
heir. CM

160

Unknown artist (Venice)
GIROLAMO PRIULI (b. 1486; Doge of Venice, 1559–67)
Dated 1561
Copper alloy, cast; 61.8 mm
Scher Collection

Obverse: Priuli wearing a doge's robe and cornetto. Inscription:
HIE[ronimus] PRIOL[us] VENE[tiæ] DVX III AN[no] Æ[tatis] LXXV [Girolamo
Priuli, in his third year as Doge of Venice, at the age of 75].
Reverse: The personification of Venice, draped and crowned, seated
and holding in her right hand a palm branch and in her left a scepter,
a galley behind her. Inscriptions: AN[no] SAL[utis] M D L XI DV[x] LXXXVI
UR[be] CON[dita] M C X LI [In the year of (our) salvation 1561, the
86th doge, the year 1,141 from the foundation of the city]; within,
ADRIA[tici] REGI[na] MARIS [Queen of the Adriatic Sea].
Literature: P. A. Gaetani 1761–63, 1: 345, pl. LXXV, no. 1; Heiss
1881–92, 6: 162, pl. XII, no. 1; Armand 1883–87, 2: 224, no. 2;
Rizzini 1892, pt. 1, 97, no. 684; Museo Correr 1898, no. 465;
Voltolina 1998, 1: 544–45, no. 517; Attwood 2003, no. 437.

Girolamo Priuli was born into a noble Venetian family. His reign as
doge was marked by a peaceful period in Venetian history. Attwood
points out that the use of Venetian and Christian dates on this medal
is remarkable. It must have been driven by Priuli himself as he also
used it on his *oselle* (tokens issued by Venetian doges), as did the two
following doges. This portrait is contemporary with that of the doge
painted by Jacopo Tintoretto (now in the Accademia, Venice) and
paid for on December 23, 1560. CM

160

161

161

Unknown artist (Veneto)

CORNELIO MUSSO (1511–1574)

Dated 1562

Copper alloy, cast; 60.3 mm

Scher Collection; Promised gift to The Frick Collection

Obverse: Musso wearing a hooded cassock. Inscription: CORNELIVS MVSSVS EP[iscop]VS BOTVNT[inus] [Cornelio Musso, bishop of Bitonto].

Reverse: Two cornucopia tied with a ribbon. Inscriptions: INGENIO ET LINGVA [With acumen and speech]; M [D] LXII [1562].

Literature: Toderi and Vannel 2000, 1: 110, no. 272; Attwood 2003, no. 441.

Musso, a Franciscan monk, was appointed bishop of Bitonto, Puglia, in 1547 and participated in the Council of Trent. See the commentary for no. 162. ADC

162

Unknown artist (Veneto)

CORNELIO MUSSO (1511–1574)

ca. 1562

Copper alloy, cast; 57.9 mm

Scher Collection

Obverse: Musso wearing a hooded cassock. Inscription: CORNELIVS MVSSVS EP[iscop]VS BITVNT[inus] [Cornelio Musso, bishop of Bitonto].

Reverse: Unicorn dipping its horn into a river from which flee two snakes, in a landscape with trees, figures and animals, and a shepherd (Musso) tending his flock; below, two cornucopias flanking a coat of arms. Inscription: SIC VIRVS A SACRIS [Thus is poison from the holy (springs removed)].

Literature: Toderi and Vannel 2000, 1: 111, no. 279; Attwood 2003, no. 443; Pollard 2007, 1: no. 571.

See no. 161. The reverse, which illustrates the fable that the horn of a unicorn can remove venomous creatures from water, is a reference to Musso's pastoral care and incessant work against the vices of the church. ADC

163

Unknown artist (Verona)

PIETRO PAOLO MAFFEI (dates unknown)

Second half of 16th century

Copper alloy, cast; 55.8 mm

Scher Collection

Obverse: Maffei wearing a doublet, a coat, and a ruff. Inscription: P[etrus] PAVLVS MAFEVS IVRISC[onsultus] [Pietro Paolo Maffei, juriconsult].

162

163

164

Reverse: A laurel tree flanked by two lions. Inscription: EREXIT AD ÆTERA VIRTUS [Virtue raised him to the stars (Virgil, *Aeneid* VI.130: "evexit ad aethera virtus")].

Literature: P. A. Gaetani 1761–63, 2: 58, pl. CXII, no. 7; Hill 1911, fig. k; Hill 1920–21, no. 170; Habich 1929–34, 1: pt. 1, no. 486; Nussbaum 1934, no. 2004; Dworschak 1958, no. 50; Schulz 1988, no. 3.4; Voltolina 1998, 1: 32–33, no. 17; Attwood 2003, no. 188.

The inscription on the reverse of this medal has the same meaning as that spoken by the Cumaean Sibyl in Virgil's *Aeneid* (VI.130), as well as the quote "Ita et virtus" from Typotius's *Ippolita Scaldasole*. The imagery on the reverse likewise shows that the laurel tree flourishes between two lions just as virtue flourishes between tyrants. The latter motto was adopted by Lorenzo II de' Medici, Duke of Urbino (1492–1519), and both the image and motto appear on a portrait medal of the duke by Antonio Selvi (1679–1753) (Vannel and Toderi 1987, no. 269). The present medal was previously attributed to Antonio Abondio by Dworschak. CM

ITALIAN HIGH RENAISSANCE AND LATER MEDALS SCHOOL OF MILAN

164

Leone Leoni (1509–1590)
PIETRO ARETINO (1492–1556)
Dated 1537, made ca. 1550
Copper alloy, cast; 36.7 mm
The Frick Collection; Gift of Stephen K. and Janie Woo Scher, 2016 (2016.2.158)

Obverse: Aretino wearing drapery fastened on the right shoulder. Inscription: DIVVS P[etrus] ARRETINVS FLAGELLVM PRINCIPVM [The divine Pietro Aretino, the Scourge of Princes].

Reverse: A laurel wreath surrounding the inscription. Inscriptions: centered, VERITAS ODIUM PARIT [Truth engenders hate (Terentius, *Andria*, act I, sc. I, v. 68)]; on the top center, 1537.

Literature: P. A. Gaetani 1761–63, 1: 291, pl. LXIII, no. 2; Armand 1883–87, 1: 162, no. 3, 3: 65, no. f; Casati 1884, 46; Plon 1887, 253, pl. XXIX, no. 10; Rizzini 1892, pt. 1, 35, no. 223; Museo Correr 1898, no. 159; Supino 1899, no. 288; Rinaldis 1913, no. 99; Venturi 1901–40, 10: 3, 415, fig. 333; Álvarez–Ossorio 1950, 102; Aretino 1957–60, 3: I, 230; *Medaglie del Rinascimento* 1960, no. 169;

Pollard 1984–85, 3: 1128, no. 716; Scher 1989b, fig. 9; Waddington 1989b, fig. 1; Cano Cuesta 1994, no. 25; C. Johnson and Martini 1986–95, nos. 2209, 2210; Börner 1997, no. 734; Voltolina 1998, 1: 342–43, no. 294; Toderi and Vannel 2000, 1: 41, no. 21; Attwood 2003, no. 1; Waddington 2004, 75–8.

Aretino's sharp tongue and his parodies of eminent figures earned him the title on the obverse, which is first recorded in the third edition of *Orlando Furioso* (1532) by Ludovico Ariosto. Leoni and Aretino were friends; early on, Aretino even served to advance Leone's career. Valerio published a list of the books authored by Aretino, where he used the present medal as a frontispiece. CM

165

Leone Leoni (1509–1590)
ANDREA DORIA (1466–1560)
ca. 1541
Copper alloy, cast probably after an original strike; 41.5 mm
The Frick Collection: Gift of Stephen K. and Janie Woo Scher, 2016 (2016.2.157)

Obverse: Andrea Doria wearing all'antica armor, decorated with a mask, with a mantle secured on his right shoulder by a brooch, and a chain with the emblem of the Order of the Golden Fleece; behind his right shoulder, the trident of Neptune. Inscription: ANDREAS DORIA P[ater] P[atriæ] [Andrea Doria, father of his country].

Reverse: A galley and a small boat with two men on board in the middle of the sea; on the left, a fisherman on a rock.

Literature: Attwood 2003, no. 5; Vannel and Toderi 2003–7, 1: nos. 424, 425, 426 (obv.), 427; Pollard 2007, 1: no. 490.

165

166

Obverse: Doria in all'antica armor ornamented with a mask and a mantle secured on his shoulder by a brooch; around his neck, the emblem of the Order of the Golden Fleece; to the left, behind his head, the trident of Neptune. Inscription: ANDREAS DORIA P[ater] P[atriæ] [Andrea Doria, father of his country].

Reverse: Leoni surrounded by a border of manacles and chains; on the left, a galley, and below, a hammer, an opened fetter-lock, and a grappling iron.

Literature: Scher 1994, no. 50; Attwood 2003, no. 6; Pollard 2007, 1: no. 489.

See no. 165. ADC

This medal celebrates Leoni's release from the papal galleys in 1541, where he had been sent following an assault on the goldsmith Pellegrino di Leuti, jeweler of Pope Paul III. Leoni was released after a few months due to the intervention of Andrea Doria, admiral and ruler of Genoa. On March 23, 1541, Leoni announced his freedom in a letter to Pietro Aretino and from their correspondence we know that shortly afterward Leoni produced a portrait of his patron and savior. Andrea Doria is portrayed all'antica and the title *Pater Patriæ* also comes from Roman examples. The galley on the reverse alludes to Leoni's punishment and the small boat depicts his release from the galley. The obverse portrait is identical to that of the other medal issued for the same occasion (see no. 166). A drawing for the obverse is in the collection of the Morgan Library and Museum in New York. ADC

166

Leone Leoni (1509–1590)
ANDREA DORIA (1466–1560) and **SELF-PORTRAIT OF LEONE LEONI**
ca. 1541
Copper alloy, cast; 43.4 mm
Scher Collection

167

Leone Leoni (1509–1590)
MARTIN DE HANNA (1475–1553)
1544/46
Copper alloy, cast; 68.5 mm
Scher Collection; Promised gift to The Frick Collection

Obverse: De Hanna wearing a *cioppa* or *vestito* over a *camicia*. Inscription: MARTINV[s] DE HANNA [Martin de Hanna].

Reverse: A standing female figure wearing antique drapery looking upward, her arms raised toward rays of light from a cloud. Inscription: SPES MEA IN DEO EST [My hope is in God].

Literature: Scher 1994, no. 49; Attwood 2003, no. 11; Pollard 2007, 1: no. 491.

One of the wealthiest Flemish merchants in Venice, Martin de Hanna was a generous patron of the arts. Titian most likely introduced him to Leoni during the latter's stay in Venice in 1544. It is possible, however, that the medal was produced two years later, on the occasion of Leoni's second trip to Venice (1546). The figure on the reverse is, as clarified by the inscription, the personification of Hope. ADC

167

168

169

168

Leone Leoni (1509–1590)
BACCIO BANDINELLI (1493–1560)
ca. 1547
Copper alloy, cast; 37 mm
Scher Collection; Promised gift to The Frick Collection

Obverse: Baccio Bandinelli all'antica. Inscription: BACIVS
BAN[dinellus] SCVLP[tor] FLO[rentinus] [Baccio Bandinelli, Florentine
sculptor].
Reverse inscription: in two lines in a laurel wreath, CHANDOR /
ILLESVS [Unimpaired radiance].
Literature: Attwood 2003, no. 19; Vannel and Toderi 2003–7, 1: nos.
453–55; Pollard 2007, 1: no. 499.

A prominent Florentine sculptor and rival to Michelangelo, Baccio
Bandinelli designed this medal himself (as recorded in his own
Memorie), but the struck originals are signed by Leoni. The reverse
inscription may have been taken from the motto of Pope Clement VII.
ADC

169

Leone Leoni (1509–1590)
CHARLES V, HOLY ROMAN EMPEROR (1500–1558;
r. 1516–56)
ca. 1547
Copper alloy, cast; 51.4 mm
The Frick Collection; Gift of Stephen K. and Janie Woo Scher, 2016
(2016.2.159)

Obverse: Charles wearing a shirt, a coat, and a cap. Inscription:
(I)MP[eratore] CAES[are] CAROLO V CHRIST[ianæ] REI P[ublicæ]
INSTAVRAT[ore] AVG[usto] [To the August Emperor Caesar Charles V,
restorer of the Christian republic].
Reverse: A draped female figure of Salus Publica, standing, holding
a spear in her left hand and a *patera* in her right, which she offers to
the snake of Aesculapius at an altar decorated with two masks; an
architectural structure with a statue in a niche in the background.
Inscription: SALVS PVBLICA [Public good].
Literature: Van Mieris 1732–35, 2: 340; Armand 1883–87, 181, no.
6; Rizzini 1892, pt. 1, 34, no. 219; Museo Correr 1898, no. 400;
Rinaldis 1913, nos. 798, 799; Bernhart 1919, no. 181; Álvarez-

Ossorio 1950, no. 150; Hill and Pollard 1967, 96; Humphris 1993,
no. 35; C. Johnson and Martini 1986–95, no. 2221; Cano Cuesta
1994, no. 32; Rodríguez G. de Ceballos 1994, fig. 8; Börner 1997,
no. 740; Checa Cremades 1998, no. 5; Toderi and Vannel 2000, 1:
45, no. 38; Cupperi 2002, 49–50; Attwood 2003, no. 21.

Charles V was King of Spain (as Charles I) and Archduke of Austria
(as Charles I from 1519 to 1521). He inherited a Spanish and
Hapsburg empire that extended across Europe and into Spanish
territories in the Americas, Grenada, and the West Indies. The
Spanish branch of the Hapsburg dynasty began with his accession
to the throne. With the spread of Protestantism, pressure from
the Ottomans and French, and an unsympathetic pope, he faced
difficulties holding the empire together. Faced with mounting
pressure, he abdicated his rule of the Netherlands and Spain to his
son Philip II and the title of emperor to his brother Ferdinand II. The
inscription on the obverse and the imagery on the reverse may refer
to Charles's victory over the German Protestants in 1547, which
corresponds to the dating of the medal before the large imperial
medals of 1549. The two columns allude to his customary badge and
represent the Gates of Gibraltar and the world beyond. CM

170

Leone Leoni (1509–1590)
FERRANTE GONZAGA (1507–1557)
1555/56
Lead, cast; 71.8 mm
The Frick Collection; Gift of Stephen K. and Janie Woo Scher, 2016
(2016.2.160)

Obverse: Gonzaga wearing armor and the Order of the Golden
Fleece and a commander's sash. Inscription: FER[dinandus (Ferrante)]
GONZ[aga] PRÆF[ectus] GAL[liæ] CISAL[pinæ] TRIB[unus] MAX[imus]
LEGG[ionum] CAROLI V CAES[aris] AVG[usti] [Ferrante Gonzaga, prefect
of Gallia Cisalpina, supreme commander of the army of Emperor
Charles V].
Literature: R. F. Burckhardt 1917, no. 57, fig. 10; Attwood 2003,
no. 50.

Ferrante Gonzaga was a Knight of the Order of the Golden
Fleece (from 1531). He was Duke of Ariano (1532–57), Count of
Guastalla (1539–57), viceroy of Sicily (1535–46), and governor

170

of Milan (1546–55). As governor, he was accused of corruption and misappropriation of funds. He challenged the claims in a trial in Brussels and was acquitted, but he lost his post in Milan and returned to Mantua. The obverse of this medal was originally conceived with a reverse showing Hercules and the giants (see Börner 1997, no. 747) and with the inscription TV NE CEDE MALIS (you do not yield to evil), which refers to the accusations and trial. In 1564, Ferrante's son Cesare commissioned an over-life-size bronze from Leoni titled *Triumph of Ferrante Gonzaga over Envy*, which still stands in Piazza Roma, Guastalla. CM

Reverse: Blind man in the guise of a pilgrim with staff, rosary, and water flask, led by a dog in a rocky landscape. Inscription: DOCEBO INIQVOS V[ias] T[uas] ET IMPII AD TE CONVER[tentur] [Vulgate] [Then will I teach transgressors Thy ways; and sinners shall be converted unto Thee (Psalm 51:13)].
Literature: Scher 1994, no. 52; Attwood 2003, no. 61; Pollard 2007, 1: no. 500; Fenichel 2016.

As Emily Fenichel contends and as once mentioned by Vasari, this medal should be considered a collaboration between Leoni, the fabricator, and the great sculptor Michelangelo, the latter being the source of the complex imagery and personal meaning. The medal is the deeply moving statement of a great artist nearing the end of his life. On the obverse, Michelangelo presents himself as a kind of priest, the full implications of which are expounded on the reverse, where he is depicted as a blind pilgrim led by Fides (Faith, Fido, the dog). The entire image is an *impresa* in which the inscription (Michelangelo's motto) is a promise that through his art the artist, once cleansed of sin at the end of his pilgrimage, will be able to "teach transgressors Thy ways; and sinners shall be converted unto Thee." The wax model from life that Leoni carved in Rome was cast in Milan, and four examples (two in silver, two in bronze) were sent to the revered master on March 14, 1561, accompanied by the following note: "The medal which is in the box is chased and finished. I pray you to keep it for love of me and do with the other as you please. If it is ambition that has inspired me to send examples to Spain and Flanders, it is affection for you that has inspired me to send some to Rome and elsewhere." ADC, SKS

171

Leone Leoni (1509–1590)
MICHELANGELO (1475–1564)
1560
Copper alloy, cast; 58.3 mm
Scher Collection

Obverse: Michelangelo wearing a cassock. Inscriptions: MICHAELANGELVS BONARROTVS FLOR[entinus] AET[ati]S ANN[o] 88 [Michelangelo Buonarroti of Florence, aged 88]; on truncation, LEO[ni].

172

Milanese School (attributed to Leone Leoni)
GIROLAMO CARDANO (1501–1576)
ca. 1550
Copper alloy, cast; 50.6 mm
The Frick Collection; Gift of Stephen K. and Janie Woo Scher, 2016 (2016.2.156)

Obverse: Cardano wearing an outer cloak over a *camicia*. Inscription: HIER[onymus] CARDANVS ÆTATIS AN[no] XLVIIII [Girolamo Cardano, aged 49].

171

172

Reverse: A procession of people approaching a vine in a rocky landscape; in the background, a man and a boy walking toward a house. Inscription: ONEIPON [Dream].

Literature: Attwood 2003, no. 97; Vannel and Toderi 2003–7, 1: no. 443–45; Pollard 2007, 1: no. 497.

Born in Pavia, Girolamo Cardano was a physician, mathematician, philosopher, and astrologer. Jailed for heresy, he was later released under the protection of Pope Pius V. As a mathematician, he made major contributions to algebra and hydrodynamics; as a physician, he was the first to be interested in the study of dreams. The reverse of this medal depicts one of his own dreams, as Cardano described it (the entire dream is described in Attwood). The medal is attributed to Leone Leoni on stylistic grounds, and the illegible marks on the truncation could be read as LEO, a form of signature used elsewhere by Leoni. ADC

173

Pompeo Leoni (ca. 1533–1608)
HONORATO JUAN TRISTULL (1507–1566)
ca. 1556
Copper alloy, cast; 66.5 mm
Scher Collection

Obverse: Tristull wearing a doublet and a coat with a fur collar. Inscriptions: HONORATVS IOANNIVS CAROLI HISPP[aniensis] PRINC[ipis] MAGISTER [Honorato Juan, preceptor of Charles, Prince of Spain]; on truncation (incised), AET[atis] S[uæ] XLIX [aged 49].

Reverse: A standing woman, loosely dressed, wearing a veil, part of which she holds in her mouth, a serpent and a lyre at her feet, standing next to a pedestal with the inscription, SPE[s] FINIS [Hope for the end].

Literature: Armand 1883–87, 250, no. 7; Plon 1887, 324; García y López 1905, 153, no. 10; Caruana y Reig 1937, 60, no. 41; Álvarez-Ossorio 1950, 74; Amorós 1958, 26, fig. 63; Mateu y Llopis 1975, 69; Cano Cuesta 1994, no. 50; Rodríguez de Ceballos 1994, 83–84; *Felipe II* 1998, no. 319; Toderi and Vannel 2000, 1: 68, no. 120; Almagro-Gorbea, Pérez Alcorta, and Moneo 2005, no. 1556.

Born in Valencia, Honorato Juan Tristull was a noted Spanish humanist and teacher of the future Philip II of Spain (1527–1598) and his son Carlos, Prince of Asturias (1545–1568). About the time this medal was conceived, Honorato decided to pursue an ecclesiastical career. In 1564, he was made bishop of Osma, as well as master of the mint of Valencia. The serpent is an attribute of Prudence. The standing figure holding her veil in her teeth signifies discretion. CM

173

174

174

Jacopo Nizzola da Trezzo (1519–1589)
GIANELLO DELLA TORRE (1500–1585)
ca. 1550
Copper alloy, cast; 79.7 mm
Scher Collection

Obverse: Gianello della Torre wearing a doublet and cloak.
Inscription: IANELLVS TVRRIAN[us] CREMON[ensis] HOROLOG[iarius]
ARCHITECT[us] [Gianello della Torre of Cremona, clockmaker and
architect].
Reverse: A female figure in antique drapery at the center of a
fountain, holding on her head a basin with two animal spouts from
which water pours forth; a group of seven men of different ages,
all dressed in classical garments, surround the fountain; two men
carrying a ruler and a compass, while the others are either drinking
from the fountain or collecting the water. Inscription: VIRTVS; in
exergue, NVNQ[uam] DEFICIT [Virtue never fails].
Literature: Scher 1994, no. 55; Attwood 2003, no. 91; Pollard 2007,
1: no. 501.

Gianello della Torre was a noted engineer and architect in the
service of emperors Charles V and Philip II. The reverse of the medal
shows the Fountain of Knowledge from which several men drink.
The medal is of excellent artistic quality and must be the product
of one of the great Milanese medalists of the mid-sixteenth century.
The medal is generally dated to about 1550, when both Leone Leoni
and Jacopo da Trezzo were in Milan. Based on stylistic grounds,
however, the author of the medal is most likely Trezzo. ADC

175

Jacopo Nizzola da Trezzo (1519–1589)
ISABELLA DI CAPUA, PRINCESS OF MOLFETTA (1509–1559)
ca. 1550
Copper alloy, cast; 70.6 mm
Scher Collection

Obverse: Isabella in a *giornea* over a *cotta*, with puffed sleeves, with
a veil on the back of her head and a jeweled diadem. She also wears
a pearl necklace with a large pearl pendant, and pearl-drop earrings.

175

176

Inscriptions: ISABELLA CAPVA PRINC[eps] MALFICT[i] FERDIN[andi] GONZ[agæ] VXOR [Isabella Capua, Princess of Molfetta, wife of Ferdinand Gonzaga]; below the bust, IAC[obus] TREZ[z]O [Jacopo da Trezzo].
Reverse: Isabella as a veiled Vestal praying at a burning altar upon which she is making an offering. Inscription: CASTE ET SVPPLICITER [Chastely and humbly].
Literature: Attwood 2003, no. 65; Pollard 2007, 1: no. 502 (var.).

Known for her beauty and moral virtues, Isabella di Capua married Ferrante Gonzaga (see no. 170) in 1534. The medal was probably made in Milan between 1546 and 1555, during Isabella's stay in the city when Ferrante was the governor of Milan. There is a variant of the medal with the altar bearing the image of a shining sun and the word NVBIFVGO (cloud chaser), an appellative of Apollo to whom Isabella is sacrificing for the protection of her house. ADC

176

Jacopo Nizzola da Trezzo (1519–1589)
IPPOLITA GONZAGA (1535–1563)
1552
Copper alloy, cast; 68.8 mm
Scher Collection; Promised gift to The Frick Collection

Obverse: Ippolita dressed all'antica wearing pearl-drop earrings and a necklace with pendant and a row of pearls; her hair elaborately braided, bound up, and interlaced with pearls (frenello). Inscriptions: HIPPOLYTA GONZAGA FERDINANDI FIL[ia] AN[no] XVII [Ippolita Gonzaga, daughter of Ferdinando, aged 17]; below the bust, IAC[obus] TREZ[zo] [Jacopo da Trezzo].
Reverse: Aurora, holding a torch and scattering flowers, rides across the sky in a chariot pulled by Pegasus; beside the chariot, a cockerel stands on the clouds; below, a bird's-eye view of a landscape with a town, a river with a boat, a forest, and mountains in the distance. Inscription: VIRTVTIS FORMÆQ[ue] PRÆVIA [Preeminent in virtue and beauty].
Literature: Attwood 2003, no. 71; Vannel and Toderi 2003–7, 1: nos. 462, 463; Pollard 2007, 1: no. 503.

Ippolita Gonzaga, daughter of Ferrante Gonzaga and Isabella di Capua (see nos. 170 and 175), was celebrated for her beauty and erudition. This portrait is loosely based on a 1551 medal of Ippolita by Leone Leoni. The reverse, praised by Lomazzo, suggests that just as the beautiful Aurora (dawn) precedes the splendor of the day, so Ippolita's young beauty will only become ever more magnificent with maturity. According to Pollard, the composition copies a cameo by Trezzo recorded in 1550 in the collection of Maximilian II (today in the Kunsthistorisches Museum, Vienna). ADC

177

Jacopo Nizzola da Trezzo (1519–1589)
MARIA OF AUSTRIA (1528–1603)
ca. 1552
Copper alloy, cast; 65.3 mm
The Frick Collection; Gift of Stephen K. and Janie Woo Scher, 2016 (2016.2.153)

Obverse: Maria, with long hair in a veiled coif and dressed with a diadem and pearls, wearing a collared dress, earrings, and a necklace. Inscription: MARIA AVSTR[iaca] REG[ina] BOEM[iæ] CAROLI V IMP[eratoris] FI[lia] [Maria of Austria, Queen of Bohemia, daughter of the Emperor Charles V].
Reverse: A draped woman, holding three branches in her right hand and a crown in her left, tramples upon trophies of war below. Inscription: CONSOCIATIO RERVM DOMINA [Union, mistress of things].
Literature: Van Mieris 1732–35, 3: 271; Armand 1883–87, 2: 237, no. 6; Rizzini 1892, pt. 1, nos. 348, 703; Domanig 1893, no. 52; Rinaldis 1913, no. 685; Greene 1913, 417; J. Babelon 1927a, 215, no. VI; Pollard 1984–85, 3: 1269, no. 738; Landolt and Ackermann 1991, no. 70; Waldman 1991, fig. 9; C. Johnson and Martini 1986–95, nos. 2296, 2297; Waldman 1994, 59–60; Cano Cuesta 1994, fig 3; Pannuti 1996, no. 8.109; Börner 1997, no. 769; Toderi and Vannel 2000, 1: 70, no. 126; Attwood 2003, no. 76.

In 1548, Maria of Austria, the daughter of Charles V, married her cousin, the future King of Bohemia (from 1549) and Emperor Maximilian II (from 1564). This medal likely commemorates the union of the two branches of the imperial family through Maria's

177

marriage. The figure on the reverse is copied from a figure type on a Roman relief of *Maidens Decorating a Candelabrum* (1st century BC–1st century AD; Musée du Louvre, Paris). The reverse relief was formerly attributed to both Pompeo and Leone Leoni; however, the medal type is more commensurate with the oeuvre of Jacopo da Trezzo (Attwood 2003, no. 76). CM

178

Jacopo Nizzola da Trezzo (1519–1589)
PHILIP II, KING OF SPAIN (b. 1527; r. 1556–98)
1555
Copper alloy, cast; 69.3 mm
Scher Collection

Obverse: Philip wearing armor, a sash tied around his right arm. Inscriptions: PHILIPPUS REX PRINC[eps] HISP[aniæ] ÆT[atis] S[uæ] AN[no] XXVIII [Philip, King (of Naples and Sicily), Prince of Spain, aged 28]; below, IAC[opo] TREZZO F[ecit] [Jacopo da Trezzo made it].
Reverse: Apollo riding a chariot drawn by four horses in the sky over a coastal landscape, including rocky outcrops and a castle; to the left, a tree stump sprouting one new branch. Inscription: IAM ILLVSTRABIT OMNIA [Now (he) will illuminate everything].

Literature: Luckius 1620, 185; Van Loon 1732–37, 1: 4; Pinchart 1868, 16, no. 2; South Kensington Museum 1868, 26; Herrera 1882, 21, no. 2; Armand 1883–87, 1: 241, no. 2; Rizzini 1892, pt. 1, 51, no. 338; Domanig 1907, no. 54; Rinaldis 1913, no. 302; Farquhar 1907, 120–21; Forrer 1904–30, 6: 136; J. Babelon 1913, 312; Habich 1922, pl. XCIV, no. I; García de la Fuente 1927, 76; Álvarez-Ossorio 1950, no. 268; Wellens-de Donder 1959b, nos. 67, 68; Panvini Rosati 1968, no. 178; V. Johnson 1975a, fig. 3; Northumberland sale 1981, no. 429; Pollard 1984–85, 3: 1243, no. 723; M. Jones 1982–88, 2: 88, fig. 29; Waldman 1991, fig. 7; Humphris 1993, no. 42; Pannuti 1996, no. 8.115; Börner 1997, no. 773; Scher 1997, no. 3; Pérez de Tudela Gabaldón 1998, no. 270; Checa Cremades 1998, no. 14; Toderi and Vannel 2000, 1: 62, no. 99; Attwood 2003, no. 85; Trusted 2007, 81, pl. 127.

Designed by Trezzo as one of a pair with a medal of Philip's wife (no. 179), this medal was conceived the year before Philip became King of Spain and shortly after his marriage to Mary Tudor, Queen of England (Attwood 2003, no. 80). Trezzo entered the service of Philip II about 1553–54. Attwood explains that the subject on the reverse is a celebration of the transfer of power from Charles V to Philip, when the father abdicated on October 25, 1555. CM

178

179

179

Jacopo Nizzola da Trezzo (1519–1589)
MARY TUDOR, QUEEN OF ENGLAND AND IRELAND
(b. 1516; r. 1553–58)
1555
Copper alloy, cast; 67.5 mm
Scher Collection

Obverse: Mary wearing a brocaded gown, a French hood with veil over a coif, and a brooch with pendant pearl suspended at her breast. Inscriptions: MARIA I REG[ina] ANGL[iæ] FRANC[iæ] ET HIB[erniæ] FIDEI DEFENSATRIX [Mary I, Queen of England, France and Ireland, defender of the faith]; in the field, on the left, a punch of a crowned "C," an eighteenth-century French tax stamp.
Reverse: A personification of Peace wearing antique drapery and a radiate crown, seated on a throne; in her right hand, olive and palm branches, and in her left hand a flaming torch with which she sets fire to a pile of arms and armor; below the throne, a cube with a relief of two clasping hands and scales; on the left, a group of suppliants battered by a hail storm; on the right, other figures and a small circular temple with columns; above right, sunbeams; below, a river. Inscription: CECIS VISVS TIMIDIS QVIES [Sight to the blind, tranquility to the fearful].
Literature: Scher 1994, no. 54; Attwood 2003, no. 80; Pollard 2007, 1: no. 504; Campbell et al. 2008, no. 96.

Probably commissioned in 1554 shortly after Philip and Mary's wedding, along with a medal of Philip II of Spain (no. 178), this is

one of Trezzo's most spectacular medals. It may derive from Mary's court portrait by Anthonis Mor (Museo del Prado, Madrid). The jewel is possibly the diamond pendant with pearl that Philip sent to her shortly before their wedding. The reverse symbolizes the peace brought to England under Mary with symbols of stability (cube), unity (clasping hands), and justice (scales), as well as the divine blessing (symbolized by the radiating sun) obtained through the reconciliation with Rome in contrast to the unrest and conflict of the past represented behind the figure of Peace. Other known examples include the artist's signature below the bust. ADC

180

Attributed to Annibale Fontana (1540–1587)
GIOVANNI BATTISTA CASTALDI (1493–after 1565)
ca. 1562
Copper alloy, cast; 44.5 mm
Scher Collection; Promised gift to The Frick Collection

Obverse: Castaldi in ornamented armor. Inscriptions: IO[annes] BA[ptista] CAS[taldus] CAR[oli] V CAES[aris] FER[dinandi] RO[manorum] REG[is] ET BOE[miæ] RE[gis] EXERGIT[us] [*sic*] DVX [Giovanni Battista Castaldi, general of the army of Emperor Charles V (and) of Ferdinand, King of the Romans and King of Bohemia]; below the bust, ANIB (ANNIB[ale]).
Reverse: A reclining naked female figure, holding a crown in her left hand and a sceptre in her right hand; on the left, a trophy of Turkish arms; in the background, a bird's-eye view of a landscape, with town, forest, and mountains in the distance; below, a reclining naked river god resting on an urn from which flows a river. Inscriptions: TRANSILVANIA CAPTA [Transylvania captured]; below, among the waves of the river, MAVRVSCIVS [Mures].
Literature: Attwood 2003, no. 103; Vannel and Toderi 2003–7, 1: no. 496; Pollard 2007, 1: no. 511.

A general under Charles V, Castaldi, Count of Piadena and Cassano, took several Transylvanian fortresses from the Turks, including the town of Lipova on the river Mures, in 1551. Only a year later, however, the Turks returned and retook the entire region. The medal celebrates the 1551 victorious campaign in Transylvania: the female

180

figure is most likely a personification of Transylvania, and the male figure is the personification of the river Mures that runs through the region. According to Attwood, the medal was produced before the military reverse of 1552 and thus cannot be attributed to Annibale Fontana (born in 1540). Pollard, however, suggests that the medal is one of a group of three medals commemorating Castaldi's military career, attributable to Fontana and issued after the peace between the sultan and the emperor (1562). ADC

has been variously attributed to an artist known as Annibale, as well as Annibale Fontana. Armand and Attwood, however, have distinguished the three artists, with the present medal being the only type attributed to ANN. There are signed and unsigned versions of this type, as well as some with a different reverse. The reverse can also be found with Leone Leoni's obverse of Ferdinand Francesco d'Avalos (C. Johnson and Martini 1986–95, no. 1938) on a medal of Titian and on a restitution of Gabrinus Fondulus (Attwood 2003, no. 108). CM

181

ANN
CARDINAL CRISTOFORO MADRUZZO (1512–1578)
1557
Copper alloy, cast; 60.8 mm
The Frick Collection; Gift of Stephen K. and Janie Woo Scher, 2016 (2016.2.150)

Obverse: Madruzzo wearing a *biretta*, a doublet, and coat. Inscriptions: CHRIST[ophorus] MADRV[ccius] CARDIN[alis] EPIS[copus] ET PRIN[ceps] TRIDEN[tinus] ET BRIX[inensis] [Cardinal Cristoforo Madruzzo, Bishop and Prince of Trent and Brixen]; beneath truncation, ANN[ibal?].
Reverse: A priest all'antica, standing at an altar, holding, in his left hand, a patera over a flame making a sacrifice, and with his right, the left arm of a man dressed in classical armor sitting on a rock, a reclining river god in the foreground. Inscriptions: STATVS MEDIOL[ani] RESTITVTORI OPTIMO [The state of Milan to (its) excellent rebuilder]; at the bottom, SECVRITAS PADI [The security of the Po].
Literature: Bergmann 1844–57, 17, no. 3; Armand 1883–87, 1: 177, no. 1; C. Johnson and Martini 1986–95, nos. 708, 711; Humphris 1993, no. 54.

Cristoforo Madruzzo was Prince Bishop of Trent (1539), cardinal and bishop of Brixen (1543), and governor of Milan (1556–57). This medal may mark his involvement in the expulsion of the Jews from Milan under the direction of Philip II in 1557. Based on the inscription, the medal was most likely conceived while Madruzzo was governor. He played an important role as the secretary to the Council of Trent (1545–63). Titian painted a portrait of him in 1552, which is now in the Museu de Arte in São Paulo. The medal

182

Milanese School
FAUSTINA ROMANA (1519–1544)
Mid-16th century
Copper alloy, cast; 49.3 mm
Scher Collection

Obverse: Faustina wearing a gown and a cloak, jeweled hairnet on her braided hair, a string of pearls, and pearl-drop earrings. Inscription: FAVSTINA RO[mana] O[mnium] P[ulcherrima] [Faustina Romana (the Roman), most beautiful of all (women)].
Reverse: Leda and the swan. Inscription: SI IOVI QVID HOMINI [If such to Jupiter, what to a mere mortal].
Literature: Attwood 2003, no. 189; Pollard 2007, 1: no. 567 (as Antonio Abondio).

183

Although the suggestion that the sitter for the medal was a courtesan has been widely accepted, the woman can be identified as Faustina Lucia Mancini, the daughter of a Roman family of old nobility. Little is known of her life beyond her birth in 1519, marriage to the condottiere Pietro Paolo Attavanti in 1538, and death in childbirth in 1544. One of the most admired women in Rome for her beauty and virtue, she was celebrated by several poets, among them, Annibale Caro, Clovio, and Antonio Filarete. Faustina entered the circle of Cardinal Alessandro Farnese, who loved to surround himself with beautiful and learned women. She was the muse of the literary academy "dello Sdegno" founded in Rome in 1541 under the patronage of Cardinal Farnese. Upon her untimely death, the scholars of the Farnese circle composed a collection of sonnets. The reverse shows Leda and the swan, a common theme related to love. ADC

183
Milanese School
CARLO VISCONTI (1523–1565)
ca. 1550
Copper alloy, cast; 69.3 mm
Scher Collection; Promised gift to The Frick Collection

Obverse: Visconti wearing armor with Gorgon heads on the besagews and lions' heads for pauldrons; around his neck, a chain with a medallion bearing a portrait. Inscription: CAROLVS VICECOMES [Carlo Visconti].
Reverse: Stalk of branching coral. Inscription: COR ALIT [The heart sustains].
Literature: Scher in Marincola, Poulet, and Scher 1986, 94; Scher 1994, no. 59; Attwood 2003, no. 101; Pollard 2007, 1: no. 583.

A member of a prominent Milanese family, Visconti was given the cardinal's hat in 1565. His appearance in armor is probably due to his relationship with the great Milanese armorer, Negroli. The reverse shows a coral, traditionally regarded as an amulet against the evil eye, and the motto "Cor alit," which includes a pun on the representation of coral and an anagram of the name Carlo. It was Visconti who delivered to Michelangelo examples of Leone Leoni's

portrait medal of the great artist (no. 171): "I am sending to your lordship, by the favour of Lord Carlo Visconti, a great man in this city [Milan], and beloved by his Holiness [Pope Pius IV], four medals of your portrait: two in silver, and two in bronze." SKS

184
Milanese School
FERRANTE LOFFREDO (d. 1573)
Mid-16th century
Wax on glass; 100.2 mm (including wooden case)
Scher Collection

Obverse: Loffredo in Roman-style parade armor, with commander's sash knotted on the left shoulder; below the bust, stylized acanthus *rinceaux* overlapping in the center and framing a mask. Inscription: FERD[inandus] LOFFREDVS MARCH[io] TRIVICI [Ferdinando (Ferrante) Loffredo, Marquess of Trevico].
Reverse: On a large platform, Loffredo in Roman-style armor and cape on the left; in the center, Emperor Charles V, also in cloak and ancient-style armor, and a laurel wreath, as well as a female figure dressed in a light, billowing dress belted at the waist, her hair bound up with a fillet, on the right. She is walking toward the left of the field and carrying a lance that she is presumably going to offer to Loffredo at the behest of the emperor; below the platform, decorative *rinceaux* with serpentine heads facing in the center. Inscription: DIVI Q[uinti] CARO[li] CÆS[ari] VERITAS [To the divine Emperor Charles V, Truth].
Literature: Scher 1994, no. 56.

This model was no doubt produced before the abdication in 1556 of Charles V, who is represented here in his imperial capacity, and after Loffredo was made Marquess of Trevico in 1548. The reverse shows the conferring of a military title or appointment, referring perhaps to Loffredo's appointment as governor of Magna Grecia by Charles V. Based on stylistic observations, the medal has been tentatively associated with the work of Pietro Paolo Galeotti (Scher 1994). However, Loffredo's medal also appears to have several traits in common with a group of medals produced by the so-called Milanese School. ADC

184

185

Milanese School
FERRANTE LOFFREDO (d. 1573)
Mid-16th century
Copper alloy, cast; 69.7 mm
Scher Collection

Literature: Scher 1994, no. 56a; Attwood 2003, no. 155.

See the commentary for no. 184. ADC

186

Unknown artist (Lombardy)
GIOVANNI BATTISTA CASTALDO (1493–ca. 1565)
ca. 1551
Copper alloy, cast; 51.2 mm
Scher Collection; Promised gift to The Frick Collection

Obverse: Castaldo wearing drapery fixed on the right shoulder.
Inscription: IOAN[nes] BAPT[ista] CASTALDVS DVX BELLI MAX[imus]
[Giovanni Battista Castaldo, captain general].
Reverse: Castaldo wearing classical armor, holding a baton in his left
hand, and raising a personification of Dacia (Hungary) from a trophy
of arms. Inscription: SVBACTÆ DACIÆ RESTITVTORI OPTIMO [To the
excellent restitutor of subjugated Dacia].

185

186

187

Literature: Van Mieris 1732–35, 3: 276; Armand 1883–87, 163, no. 4; 72, no. r; 227, no. c; Plon 1887, 273, pl. XXXIV, nos. 4, 5; Lanna sale 1911b, no. 165; Mann 1931, no. S 352; C. Johnson and Martini 1986–95, no. 2229; Toderi and Vannel 2000, 1: 56, no. 82; Attwood 2003, no. 171.

Castaldo was a military captain who fought in the battle of Pavia (1525), the Sack of Rome (1527), and the battle of Mühlberg (1547). The reverse refers to the campaign against the Turks in Hungary, which Castaldo led from 1550. The fighting began in 1551, which is how Van Mieris dated the medal. Attwood (2003) discusses a former attribution to Leone Leoni, based on a letter of 1555, which is without stylistic or documentary merit. CM

187

Unknown artist (Lombardy)
MARIA OF ARAGON (after 1503–1568)
Mid-16th century
Copper alloy, cast; 48.5 mm
Scher Collection

Obverse: Maria, with hair braided and wrapped in a hairnet and crowned with a diadem, wearing a dress with an open chemise and ruched collar and an earring, a crown in the field to the left. Inscription: D[iva] MARIA ARAGONIA [The divine Maria of Aragon].
Literature: Armand 1883–87, 2: 163, no. 2; Rizzini 1892, pt. 1, 87, nos. 604, 605; Museo Correr 1898, no. 393; Habich 1922, pl. XCVII, no. 5; Álvarez-Ossorio 1950, no. 163; Pollard 1984–85, 3: 1402–3, no. 810; Humphris 1993, no. 32; Attwood 2003, no. 142.

Maria of Aragon was the illegitimate daughter of Count Ferdinand di Castella and the wife of Alfonso II d'Avalos, who was the Marquis of Vasto, captain general to Charles V, and governor of Milan. After

her husband's death, she acted as governor in his stead. This medal shares similarities with those by Leone Leoni, who made medals of Alfonso while he worked for him from 1542 to 1545. Maria also commissioned Leoni to model a posthumous statue of Alfonso in 1546. The portrait on the obverse of this medal shares similarities with the portrait on the obverse of another unattributed medal (Pollard 2007, no. 560). CM

188

Milanese School
PIETRO PIANTANIDA (dates unknown)
ca. 1562
Copper alloy, cast; 49.7 mm
Scher Collection

Obverse: Piantanida wearing a commander's sash and decorated parade armor with pauldrons in the form of grotesque lion masks. Inscription: CAP[itaneus] PET[rus] PLANTANIDA AET[atis] AN[nis] XXXVI [Captain Pietro Piantanida, aged 36].
Reverse: Standing female figure holding a chalice in her left hand while pointing to heaven with her right. Inscription: DVM SPIRITVS HOS REGET ARTVS [As long as the spirit directs these limbs (Virgil, *Aeneid* IV.336)].
Literature: Attwood 2003, no. 98; Vannel and Toderi 2003–7, 1: no. 524; Pollard 2007, 1: no. 485.

According to Luigi Piantanida (1807), who claims the sitter as his ancestor, Pietro Piantanida was a Milanese captain and naval commander under Charles V. The composition on the reverse, with the personification of Faith combined with the inscription, is a clear profession of his having faith until the day he dies. The medal has been variously attributed to Cellini, Antonio Abondio, and a follower of Abondio (Pollard 2007). ADC, AN

188

189

189

Unknown artist (Lombardy)
FRANCESCO GIUSANI (d. 1608)
Dated 1566
Copper alloy, cast; 56.3 mm
Scher Collection; Promised gift to The Frick Collection

Obverse: Giusani wearing armor and a commander's sash.
Inscription: FRANCISCUS GIUSANUS APEL[latus] TAPPA 1566 [Francesco Giusani, called Tappa, 1566].
Reverse: A lightly draped and veiled female figure, holding a sword in her right hand and a compass in her left, standing amid trophies of war. Inscription: CUM PONDERE ET MENSURA [With balance and proportion].
Literature: P. A. Gaetani 1761–63, 1: 276–77, pl. LX, no. 5; Armand 1883–87, 2: 204, no. 4; Rizzini 1892, pt. 1, 93, no. 650; Mann 1931, no. S 356; C. Johnson and Martini 1986–95, no. 2018; Humphris 1993, no. 64; Börner 1997, no. 678; Toderi and Vannel 2000, 2: 519, no. 1560; Attwood 2003, no. 187.

Giusani was governor of Cremona and a Milanese jurist. The reverse of this medal is likely an allegory of Justice. The unusual attribute of the compass cannot be explained; the sword, trophies of war, and the inscription, however, are all commensurate with the designation. Several scholars have attributed this unsigned medal to Pietro Paolo Galeotti (1520–1584). There are similarities in typography, design, and numbers, but, as argued by Attwood, Galeotti was working in

Florence in 1566 when this medal was modeled; thus it is more likely the work of someone within his circle. CM

190

Unknown artist (Milan)
JUAN DE MOLINA SAGREDO (dates unknown)
Third quarter of 16th century
Copper alloy, cast; 56.9 mm
Scher Collection

Obverse: Sagredo wearing armor with a lion's head pauldron and bearing the emblem of a military order, possibly the Order of Monreal. Inscription: DON IVAN DE MOLINA SAGREDO [Don Juan de Molina Sagredo].
Reverse: An angel bearing a laurel wreath descending upon a recumbent skeleton; faintly, at the center of the field, the same cross-like form worn by the sitter on the obverse. Inscription: LA VIDA ME ENOIA POR QVERERME I LA MVERTE HVYE POR NO DESPER[...] [Life annoys me by loving me, and death flees, so as not . . . (to awaken me?)].
Literature: Toderi and Vannel 2000, 1: 116, no. 306 (this specimen).

This is the only extant medal of this type. Nothing is known of the sitter or the artist. Stylistically, however, the work is commensurate with the Milanese School. CM

190

191

191

Unknown artist (Milan)
CARLO D'ARAGONA TAGLIAVIA (1520–1599)
1585–99
Copper alloy, cast; 54.3 × 42.3 mm
Scher Collection

Obverse: Tagliavia, wearing armor, a ruff, and the badge of the
Order of the Golden Fleece. Inscription: CAROLVS ARAGONIA DVX
TERRÆNOVE [Carlo d'Aragona, Duke of Terranova].
Reverse: A palm tree with a rock hanging from one of its branches.
Inscription: EO MAGIS ERIGOR [The more I elevate myself].
Literature: F. M. E. Gaetani 1754, 20; Toderi and Vannel 2000, 1:
116, no. 309.

One of the most influential figures in sixteenth-century Sicily, Carlo
d'Aragona Tagliavia, Prince of Castelvetrano and Duke of Terranova,
occupied prestigious positions not only in Italy but also in Madrid
at the court of Philip II, gaining the sobriquet "Magnum Siculum"
(the Great Sicilian). He was *Gran conestabile* of the Kingdom of
Sicily, governor of Milan and Catalunya, councilor of Philip II, and
even regent of the Spanish monarchy until Philip III was of age. In
1585, Carlo obtained the Order of the Golden Fleece, the occasion
that this medal likely commemorates. The *impresa* on the reverse is
related to the heraldic shield of the paternal side of Carlos's family,
the Tagliavias, whose symbol is the palm tree. The symbolism of the
Tagliavia family tree with a weight attached refers to the palm tree's
demonstrable elasticity in growing upward, despite being weighed
down by a rock. It is therefore analogous to Carlos's piety lifting
him to noble heights of virtue (in receiving the Order of the Golden
Fleece) despite forces trying to depress and hamper him. CM

192

Unknown artist (Lombardy)
CARLO BORROMEO (1538–1584)
ca. 1600
Copper alloy, cast; 52.8 mm
Scher Collection

Obverse: Borromeo wearing a hooded cassock and a biretta.
Inscription: CAR[olus] BORROMEVS CARD[inalis] ARCHIEP[iscopus]
MEDI[olani] [Cardinal Carlo Borromeo, archbishop of Milan].

Reverse: A lamb on an altar with a cloud issuing rays from above
right. Inscription: SOLA GAVDET HVMILITATE DEVS [God rejoices for
solitary humility].
Literature: Bidelli 1626, 276; P. A. Gaetani 1761–63, 1: 379–80,
pl. LXXXV, no. 2; Armand 1883–87, 2: 263, no. 5; Rizzini 1892, pt.
1, 58, no. 380; La Tour 1893, 273–78, pl. VI, no. 3; Museo Correr
1898, no. 477; Lanna sale 1911b, no. 262; Álvarez-Ossorio 1950,
no. 330; Pollard 1984–85, 3: 1416, no. 821; Börner 1997, no. 974;
Vannel and Toderi 1998, no. 46; Attwood 2003, no. 199.

Carlo Borromeo was archbishop of Milan, Cardinal-Priest of the Title
of St. Prassede, papal secretary of state under Pius IV, and one of the
chief figures of the Counter-Reformation. He was born in the castle
of Arona, near Lake Maggiore, and died in Milan. His emblem is the
word *humilitas* crowned, which is on his shield and reflected in the
inscription on the reverse of this medal. He was often represented
in art in his cardinal's robes, as here. There are three types of the
present medal, which are discussed by Attwood: those with a "B"
before the legend on the obverse (dating to 1601–10), those with
an "S" before the legend on the obverse (dating to after 1610), and
those with only the inscription. CM

ITALIAN HIGH RENAISSANCE AND LATER MEDALS
SCHOOL OF REGGIO EMILIA

193

Alfonso Ruspagiari (1521–1576)
PORTRAIT OF A WOMAN AND AN ONLOOKER
ca. 1550
Lead, cast; 69.6 mm
Scher Collection

Obverse: Three-quarter bust of a woman, the truncation bound by
a narrow, rigid girdle with a grotesque mask in the center, around
which is intertwined loose drapery; wearing a ribbon with a pendant
with her hair bound up with pearls (*frenello*) and a veil; both
arms truncated just below the shoulder in imitation of an ancient
sculptured bust; in the right margin, the face of what is almost
certainly an older man with a collar barely visible at the base of
the neck; the scrolled frame cast as an integral part of the medal.
Inscription: on truncation of the right arm, AR [artist's initials].
Literature: Scher 1994, no. 73; Attwood 2003, no. 646 (with
extensive discussion of the possible meaning of the image); Pollard
2007, 1: no. 519.

This intriguing medal is one of the masterpieces of the Reggio-
Emilian School and one of the most compelling images of the
Renaissance. Although suggestive of a vanitas subject, the probable
gender of the face in the margin (an identification suggested by
Attwood and seconded by Pollard) would argue against such a
theory. The bust is certainly meant to represent an ideal of female
beauty, but the presence of the admirer looking in complicates
the overall meaning. The iconography of this extraordinary medal
remains a mystery. SKS

192

193

194

Bombarda (probably Giambattista Cambi, d. 1582[?])
GABRIELE FIAMMA (b. 1533; Abbot General of the Augustinian Congregation 1578–85)
1578
Copper alloy, cast; 82.3 mm
The Frick Collection; Gift of Stephen K. and Janie Woo Scher, 2016 (2016.2.162)

Obverse: Gabriele Fiamma wearing a pleated surplice with a skull in the field to the side of the left shoulder. Inscription: MEMINISSE IVVABIT [It will be helpful to remember].

Reverse: Inscribed record of Fiamma's life and works. Inscription in 24 lines: GABRIEL FLAMMA / VENETIIS ORIVN[dus] PAT[re] IO[annis] FR[ancisco] I[ure] V[troque] DOC[tore] / ET EQV[ues] MAT[re] VICENTIA DIEDA PATRITII GEN[eratus] / ADHVC PVER POLIT[i]ORIB LITERIS EGREGIE NAVA / VIT OPERAM TRESDECIM NATVS ANNOS CANONI / CORVM REGVLARIVM ORDINEM INGRESSVS PH / ILOSOFIAE ATQV[e] THEOLOGIAE STVDIA MIRVM IN MOD / VM EST AMPLEXATVS IN IPSO ÆTATIS FLORE AD ILLV / STRISSIMAS ITAL CIVITATES CONCIONES DIV HABVI / T QVIBVS DIVINAM PRISCORVM PATRVM ELOQVENTIAM / AEMVLATVS NON PARVAM NOMINIIS GLORIAM EST ASS / ECVTVS IN TRACTANDIS REBVS SVMMA DEXTERITATE VSVS / EST EAQVE PROCERVM POTENTVMQVE OMNIVM QVIBVSCV / M EGIT ANIMOS MIRE SIBI DEVINXIT HAEC INGENII SVI / MONVMENTA EDIDIT SERMONVM TOMOS III CON / CIONVM QVAS IN TEMPLIS HABV[i]T TOMOS III / DIVINORVM CARMINVM CVM EXPLANATIONI / BVS TOMOS II SIMILIVM LIBROS VI / MINORVM OPERVM TOMVM I EPISTOLA / RVM TOMVM I MOLITVR NVNC DIC / TIONARIVM THEOLOGICVM ATQVE / DE CHRISTO PRAESIGNATO NON / CONTEMNENDA COMMENT / ARIA ANNVM AGIT / [X]LV [Gabriele Fiamma, of Venetian origin, born of Giovanni Francesco, doctor of both laws and a knight, and of Vincenza Dieda of noble family, even as a boy produced work of highly accomplished learning; at the age of thirteen he entered the order of Regular Canons; he embraced the studies of philosophy and theology in an extraordinary way; in the very bloom of life, for a long time he gave discourses in the most illustrious Italian cities, in which,

194

195

Gabriele Fiamma was a Venetian preacher, author of religious works, and bishop of Chioggia from 1584. The medal is clearly for posterity, as indicated by the obverse legend (Aeneas's remark to his men that their present trials may be helpful for the future and perhaps even pleasant to look at: Virgil, *Aeneid* I.203) and the skull (a memento mori rather unusual on sixteenth-century Italian medals). On the reverse is a record of Fiamma's life works. ADC

195

Gian Antonio Signoretti (act. ca. 1540–1602)
GIULIA PRATONIERI (dates unknown)
Lead, cast; 68.3 mm
Late 16th century
The Frick Collection; Gift of Stephen K. and Janie Woo Scher, 2016
(2016.2.173)

Obverse: Giulia Pratonieri all'antica, adorned with straps, a pearl necklace, pearl earrings, and an elaborate helmet over braided hair with pearls (*frenello*), holding arrows under her left arm. Inscriptions: IVLIA PRATONER[ia] [Giulia Pratonieri]; at bottom, on bracket, S[ignoretti].
Literature: Attwood 2003, no. 653; Vannel and Toderi 2003–7, 1: no. 630; Pollard 2007, 1: no. 522.

Nothing is known of Giulia Pratonieri except that she was a member of the Pratonieri family from Reggio Emilia, where their family palazzo still exists. She is probably shown as Diana (arrows) although the helmet seems to indicate Athena, perhaps an allusion to Giulia as patroness of the arts (Attwood 2003). ADC

rivaling the divine eloquence of our ancient forefathers, he gained not a little glory; in handling matters he used the greatest dexterity, and by this bound to himself in an extraordinary way the minds of all the powerful leaders with whom he dealt. He has published these memorials to his abilities: three volumes of sermons, three volumes of discourses given in churches, two volumes of divine poems with explanations, six books of similar material, one volume of minor works, one volume of letters. He is now working on a theological dictionary and on a commentary that should not be disdained on the prophecies of the coming of Christ. He is in his forty-fifth year].
Literature: Voltolina 1998, 1: no. 639; Toderi and Vannel 2000, 1: 417, no. 1255; Attwood 2003, no. 684; Pollard 2007, 2: no. 837.

196

UNDESIGNATED ITALIAN

196
Unknown artist
CALIGULA (b. AD 12; r. AD 37–41)
Probably 16th century
Lead, cast; 104.5 mm
The Frick Collection; Gift of Stephen K. and Janie Woo Scher, 2016
(2016.2.216)

Obverse: Caligula wearing armor. Inscription: IIII CAIVS CAESAR AVG[ustus] [Caius Caesar, Fourth Emperor].

The infamous Roman emperor called Caligula is here represented in a slightly modernized fashion. The medal does not try to imitate original Roman coins (Cohen 1859, pl. IX; Flaten 2012, no. 24) but instead adopts some markedly sixteenth-century stylistic devices: the modern border, the straightforward style of the inscription, and the frontal positioning of the bust. CM

197
Master F.V. (act. 16th century)
DON DUARTE, DUKE OF GUIMARÃES (1541–1576)
Mid 16th century
Lead, cast; 67.6 mm
Scher Collection

Obverse: Half-length bust of Don Duarte, wearing armor, ruff, and commander's sash, holding a baton and a helmet. Inscriptions: EDVARDVS EDVARDI ET ISABELÆ INFANTV[sic] FILIVS [Duarte, son of Duarte and the Infanta Isabella]; signed below the baton, F.V.
Literature: Armand 1883–87, 3: 99 (with reverse by Bombarda); Rinaldis 1913, 64, no. I. 149 (a different reverse); Pannuti 1996, no. 8.114 (a different reverse); Attwood 2003, no. 655 (with the reverse of a medal of Giulia Pratonieri).

This medal portrays Don Duarte, fifth Duke of Guimarães and constable of Portugal. He was the son of Don Duarte and the Infanta Isabella of Braganza and the nephew of King Manuel I of Portugal. The medal is often found with variant reverses by other artists, including Bombarda and Giovanni Battista Nicolucci. CM

198
MARTINO SA, probably Martino da Savona (act. late 16th century)
GIROLAMO DE' FRANCHI CONESTAGGIO (ca. 1530–1618)
Dated 1590
Copper alloy, cast; 57 × 43.1 mm
Scher Collection

Obverse: Conestaggio wearing armor and a ruff. Inscriptions: HIERONIMVS CONESTAGIVS MDXC [Girolamo Conestaggio, 1590]; signed on truncation, MART[ini] SA[onensis] OP[us] [the work of Martino da Savona?].
Reverse: A crossed sword and pen; border formed of four raised scrolls.
Literature: *Trésor de numismatique* 1834–58, 8: pl. XXXIX, no. 1; Armand 1883–87, 1: 299; Rizzini 1892, pt. 1, 61–62, no. 404; Hill 1923c, 47; Toderi and Vannel 2000, 1: 374, no. 1113; Attwood 2003, no. 764.

A Genoese nobleman, merchant, poet, and writer, Girolamo Conestaggio (also known as Conestaggi) served under Cardinal Alessandro Sforza and later founded the Accademia dei Confusi. He lived in Flanders and Portugal, where he published some of his works, among them, *Rime* (1618) and two historical works, *Dell'unione del regno di Portogallo alla corona di Castiglia* (1585) and *Delle guerre della Germania inferiore* (1614). CM

199

199

Girolamo Paladino (1647–1689)
POPE SIXTUS IV (b. 1414; r. 1471–84)
Late 17th century
Copper alloy, struck, restitution medal; cracked reverse die; 43.9 mm
Scher Collection; Promised gift to The Frick Collection

Obverse: Sixtus wearing a mitre and cope and a morse bearing the della Rovere arms. Inscription: SIXTVS IIII PONT[ifex] MAX[imus] [Pope Sixtus IV].
Reverse: The holy door of St. Peter's, with the entrance bricked shut and centered by a small cross. Inscriptions: CONSTITVIT EVM DOMINVM DOMVS SVAE [He made him lord of his home (Psalm 104:21)]; in exergue, ROMA.
Literature: Mazio 1884, no. 24; Lincoln 1890, no. 396; Berni 1950, no. 14; Patrignani 1951, 23; Modesti 2002–4, 1: no. 151.

Born Francesco della Rovere, Pope Sixtus IV became pope in 1471. During his reign, he established the Vatican archives, built the Sistine Chapel, supported Renaissance artists in Rome, and annulled the Council of Constance. The Porta Sancta or Holy Door of St. Peter's in Rome, bricked from the inside, is only opened every twenty-five years by the pope. Pope Sixtus IV opened the door in 1475 so that pilgrims could pass through into the presence of God. Paladino made restitutions of papal medals, in this case a medal of Sixtus IV by Andrea Guacialotti (1435–1495; Hill 1930, no. 751), although with a different reverse. CM

200

Giovanni Martino Hamerani (1646–1705)
LIVIO ODESCALCHI (1658–1713)
Dated 1677
Silver, struck; 25.9 mm
Scher Collection

Obverse: Odescalchi all'antica with long hair. Inscriptions: LIVIVS ODESCALCVS INN[ocentii] XI NEP[os] [Livio Odescalchi, nephew of Pope Innocent XI]; signed on truncation, I[oannes] H[ameranus] F[ecit] [Giovanni Hamerani made it]; beneath the bust, 1677.
Reverse: A pomegranate. Inscription: INTRINSECVS LATET [What is inside is concealed; *Canticus Canticorum*, 4.1].
Literature: P. A. Gaetani 1761–63, 2: 223–24, pl. CLV, no. 2; Morbio sale 1882, no. 4409; Hutten-Czapski 1871–1916, no. 4799; Rizzini 1892, pt. 1, 136, no. 944; Noè 1989, 83; C. Johnson 1990, 1: 168; Clifford sale 1996, no. 258; Börner 1997, no. 1232.

Prince Livio Odescalchi was Duke of Ceri and Bracciano. Although he was the nephew of Pope Innocent XI, his *cursus honorum* only commenced after his uncle's death. This medal was made one year after his uncle became pope and is paired with another with the same obverse but a reverse bearing the profile of Odescalchi's sister Giovanna. The pomegranate and the motto allude to the concealed position that Odescalchi and his sister had at the papal court. CM

201

Giovanni Martino Hamerani (1646–1705)
LUIS MANUEL FERNANDEZ DE PORTOCARRERO
(1629–1709)
Dated 1678
Silver, struck; 45.6 mm
The Frick Collection; Gift of Stephen K. and Janie Woo Scher, 2016 (2016.2.165)

Obverse: Portocarrero in a biretta over a *zucchetto* and hooded cassock. Inscriptions: outer circle, LVDOV[icus] CARD[inalis] PORTOCARRERO PROT[onotarius] HISP[aniæ] ARCH[iepiscopus] TOLET[anus] HISP[aniæ] PRIMAS A CONS[iliis] STAT[us]; inner circle, PROREX ET CAP[itaneus] GEN[eralis] SICIL[iæ] TEN[ens] GEN[eralis] MARIS ORATOR EXTR[aordinarius] AD INNOC[entium] XI [Cardinal Luis de Portocarrero, protonotary of Spain, archbishop of Toledo, primate of Spain, councilor of state, viceroy and captain general of Sicily, general of the sea, extraordinary orator for Innocent XI]; on truncation, IO[annes] HAMERANVS F[ecit] A[nno]; below truncation, MDCLXXVIII [Giovanni Hamerani made it in the year 1678].
Reverse: A composite monument featuring the winged figure of Victory blowing one trumpet and holding another in her right hand, standing on a short and ornamented pillar placed, in turn, on a taller pedestal decorated with floral festoons; on the top of the pedestal, surrounding the pillar, the four cardinal virtues—Justice with sword

200

201

202

and scales, Temperance with bridle and reins, Prudence with mirror, and Fortitude in armor with a spear; on the front of the pedestal, an inscription in five lines; the monument, surrounded by cannons, munitions, a soldier, and an anchor, stands in front of a gulf; on the right, a bastion with the coat of arms of the Portocarrero and behind the fortified walls a galleon with the flag of Spain; in the distance, a small boat, and a mountain landscape; in the sky, on the left, four cherubs holding a cardinal's regalia—hat, mitre, crozier, and cross. Inscription: on the altar, in five lines, HAC / DVCE / CVNCTA / PLA / CENT [With this leader all things please].

Literature: Morbio sale 1882, no. 4113; Lincoln 1890, nos. 2487, 2488; Rizzini 1892, pt. 1, 137, no. 951; Wurzbach-Tannenberg 1943, 2: no. 7631; Norris and Weber 1976, no. 110; C. Johnson 1990, 1: no. 169; Börner 1997, no. 1236; Klauss 2000, 1: no. 705; Vannel and Toderi 2003–7, 2: nos. 659–62; Pollard 2007, 2: no. 847.

The medal celebrates the retaking of Messina after the revolt against Spain, begun in 1674 with the help of the French, who defeated the Spanish the following year. In 1678, however, Spain and France signed a peace treaty at Nijmegen, and the French left the city, which was rapidly reoccupied by the Spanish army. The city was sacked, the leaders of the revolt who had not fled were executed, Messina was deprived of all political and economic privileges, and its university was closed. ADC

Giovanni Martino Hamerani (1646–1705)
LIVIO ODESCALCHI (1658–1713)
Dated 1689
Copper alloy, struck; 64 mm
Scher Collection; Promised gift to The Frick Collection

Obverse: Odescalchi wearing armor with a grotesque lion's face on the chest, lace jabot, and a commander's sash. Inscriptions: LIVIVS ODESC[alcus] S[anctæ] R[omanæ] E[cclesiæ] G[eneralis] [Livio Odescalchi, general of the Holy Roman Church]; on truncation, HAMERANVS 1689.
Reverse: A sun rising over the globe showing the map of Italy. Inscription: NON NOVVS SED NOVITER [Not new, but in a new way].
Literature: P. A. Gaetani 1761–63, 2: 226–27, pl. CLV, no. 3; Morbio sale 1882, no. 4410; Hutten-Czapski 1871–1916, no. 4800; Rizzini

1892, pt. 1, 136–37, no. 945; Lepke 1913, 9, no. 62; Panvini Rosati 1968, no. 225; *Vernon Hall Collection* 1978, no. 160; V. Johnson 1979, no. 16; Pialorsi 1982, pt. 2, fig. 25; Roethlisberger 1985, 9; Noè 1989, 85–86, 94 (no. 5); Toderi and Vannel 1990, no. 40; Mirnik 1994, no. 3; Börner 1997, no. 1251; Toderi and Vannel 2000, no. 75; Klauss 2000, 1: nos. 1013, 1014; Vannel and Toderi 2003–7, 2: 705; Flaten 2012, no. 65.

This medal of Prince Livio Odescalchi, Duke of Ceri and Bracciano, was made by Hamerani on the occasion of the nomination of Odescalchi to the position of general of the Holy Roman Church in 1689, the same year Leopold I made him prince of the Holy Roman Empire. Although he was the nephew of Pope Innocent XI, his *cursus honorum* only commenced after his uncle's death. The motto on the reverse demonstrates that the family glory of the Odescalchi is being renewed by the rise of a new member. CM

Giovanni Martino Hamerani (1646–1705)
POPE INNOCENT XI (b. 1611; r. 1676–89)
Dated 1679
Silver, struck; 48.9 mm
Scher Collection; Promised gift to The Frick Collection

Obverse: Innocent wearing the papal tiara and a cope decorated with Odescalchi emblems: a sable eagle and a lion passant gules. Inscriptions: INNOCEN[tius] XI PONT[ifex] MAX[imus] [Pope Innocent XI]; signed beneath truncation, IO[annes] HAMERANVS [Giovanni Hamerani].
Reverse: Peace as a young woman kneeling and laureate, a lamb sitting next to her; she offers a vase with frankincense to an angel seated on a cloud, who holds an olive branch; in the background, a landscape with ancient ruins, an obelisk, and a temple. Inscriptions: FECIT PACEM SVPER TERRAM [He brought peace on earth]; date (incuse) on the altar, 1679.
Literature: Bonanni 1699, 2: 746, no. 15; Venuti 1744, 301, no. xxxiv; Mazio 1824, no. 335; Morbio sale 1882, no. 3856; Lincoln 1890, no. 1428; Martinori 1917–22, 16: no. 95; Bartolotti 1967, E. 679; *Sculpture in Miniature* 1969, no. 262; Whitman 1983, no. 125; Börner 1997, no. 1238; Klauss 2000, 1: no. 523; Vannel and Toderi 2003–7, 2: no. 666.

203

204

Trained as a lawyer, Pope Innocent XI (born Benedetto Odescalchi) adopted reforms of the Roman Curia and returned the papal treasury to solvency. This medal celebrates the diplomatic role of the papacy in the long but successful peace negotiations between France, Holland, Spain, and Germany, which were sealed on February 5, 1679, with the Peace of Nijmegen. This brought to a close the Franco-Dutch War (1672–78) between France and Spain (and their allies) for the control of the Dutch territories, which Louis XIV claimed on behalf of his wife, the daughter of the king of Spain. CM

204

Giovanni Martino Hamerani (1646–1705)
POPE INNOCENT XI (b. 1611; r. 1676–89)
1689
Copper alloy, struck; 36.5 mm
Scher Collection; Promised gift to The Frick Collection

Obverse: Innocent wearing a *mozzetta* and an orphrey adorned with a cross. Inscriptions: INNOC[entius] XI PONT[ifex] MAX[imus] A[nno] XIII [Pope Innocent XI in the thirteenth year (of his pontificate)]; beneath truncation, IO[annes] HAMERANVS [Giovanni Hamerani].
Reverse: Fortitude seated on Roman ruins, holding a section of a column in one hand and caressing a lion with the other; next to her a shield with a winged thunderbolt of Zeus. Inscription: FORTITVDO MEA DOMINE [My strength, O Lord (Psalm 118:14)].
Literature: Bonanni 1699, 2: 761, no. 13 (variant of the rev. inscription with DOMINUS); Venuti 1744, 302, no. xxxix; Mazio 1824, no. 350; Morbio sale 1882, no. 3856; Lincoln 1890, no. 1477; Bartolotti 1967, E. 689; Wurzbach-Tannenberg 1978, no. 3858; Whitman 1983, 132; Toderi and Vannel 1990, no. 137; Clifford sale 1996, no. 206; Börner 1997, no. 1253; Voltolina 1998, 2: no. 1081; Klauss 2000, 1: no. 546; Vannel and Toderi 2003–7, 2: 697.

This is the last of Innocent XI's annual medals, issued shortly before his death in 1689. The final year of his pontificate was a particularly turbulent one, requiring great fortitude amid the fractures among the Catholic monarchs, the depositions of King James II of England and VII of Scotland during the Glorious Revolution, and the constant Turkish threat. CM

205

Giovanni Martino Hamerani (1646–1705)
CHRISTINA, QUEEN OF SWEDEN (1626–1689; r. 1632–54)
1681
Silver, struck; 36.5 mm
Scher Collection

Obverse: Christina, her hair braided and bound up in back.
Inscriptions: REGINA CHRISTINA [Queen Christina]; on truncation, I[oannes] H[amerani] F[ecit] [Giovanni Hamerani made it].
Reverse: Victory, holding a palm branch in her left hand, and resting her right foot on a globe, holds a quill pen in her right hand, having just completed the inscription on a shield hanging from a palm tree. Inscription: G[loria] D[eo] / MAX / IMA [Greatest Glory to God].
Literature: P. A. Gaetani 1761–63, 2: pl. CXXXIV, no. 1; Rizzini 1892, pt. 1, 137, no. 948; Rasmusson 1966, no. 777; Börner 1997, no. 1256; Klauss 2000, 1: no. 1815; Vannel and Toderi 2003–7, 2: nos. 672, 673; Pollard 2007, 2: no. 848; Flaten 2012, no. 64.

One of the most learned women of the century, Christina—the only surviving legitimate child of Gustavus II Adolphus—attracted scholars and artists to her court. In 1554, she abdicated, converted to Roman Catholicism, and moved to Rome, where she became a prominent supporter of the city's cultural life. This medal belongs to a group of medals originally planned by the queen as a sort of *histoire métallique* of her life, commemorating important events and celebrating her virtues. It was known as the *Gloria Deo* series because of the letters "DG" on each medal. Only a few were actually produced in Rome between 1675 and 1685. ADC

206

Ermenegildo Hamerani (1683–1756)
POPE CLEMENT XI (b. 1649; r. 1700–21)
ca. 1707–10
Gilt copper alloy, struck; 44.3 mm
Scher Collection

205

Obverse: Clement wearing a camauro, hooded cassock, and orphrey, the latter bearing one of the charges from the Albani coat of arms. Inscriptions: CLEMENS XI PONT[ifex] MAX[imus] [Pope Clement XI]; signed on truncation, HERMEN[egildus] HAMERANVS [Ermenegildo Hamerani].

Reverse: St. Luke painting a portrait of the Virgin, with his symbol, an ox, behind the easel. Inscription: in exergue, HAMERANO F[ecit] [Hamerani made it].

Literature: Venuti 1744, 340, no. xli; Lincoln 1890, no. 1602; Panvini Rosati 1968, no. 230; *Sculpture in Miniature* 1969, no. 266; Börner 1997, no. 1292 (obv.) and 1309 (rev.); Klauss 2000, 1: no. 597; Vannel and Toderi 2003–7, 3: no. 609 (version with complete inscription by E. Hamerani and date).

Pope Clement XI (born Giovanni Francesco Albani) was passionate about the classics, science, and archaeology and also a great patron of the Vatican library. The present medal is a smaller and later version of the Prize Medal of the Academy of St. Luke struck by Ermenegildo Hamerani in 1707. The academy, of which the pope was patron and protector, was an association of artists operating in Rome and included such eminent members as Gian Lorenzo Bernini, Pietro da Cortona, and Charles Le Brun. CM

207

Ottone Hamerani (1694–1761)

PRINCESS MARIA CLEMENTINA SOBIESKA (1702–1735)

Dated 1719

Silver, struck; 47.8 mm

Scher Collection; Promised gift to The Frick Collection

Obverse: Princess Maria Clementina Sobieska wearing a low-cut dress, a string of pearls around her neck and in her elaborately arranged hair, and an ermine-lined mantle. Inscriptions: CLEMENTINA M[agnæ] BRITAN[niæ] FR[anciæ] ET HIB[erniæ] REGINA [Clementina, Queen of Great Britain, France and Ireland]; below the portrait, along the raised border, OTTO HAMERANI F[ecit] [Ottone Hamerani made it].

Reverse: A woman riding an elaborately decorated chariot pulled by two horses; in the background on the left, a view of Rome with classical monuments; on the right, the rising sun; in the far distance, a ship at sea. Inscriptions: FORTVNAM CAVSAMQVE SEQVOR [I follow his fortune and his cause]; in exergue, in two lines, DECEPTIS CVSTODIBVS / MDCCXIX [with the guardians deceived, 1719].

Literature: Hawkins 1885, 2: 444, no. 49; *Sculpture in Miniature* 1969, no. 96; Clifford sale 1996, no. 505; Börner 1997, no. 1334; Pollard 2007, 2: no. 850; Eimer 2010, no. 484.

Princess Maria Clementina Sobieska, granddaughter of the Polish King John III Sobieski and one of the richest heiresses in Europe, was betrothed to Prince James Francis Edward Stuart. In an attempt by King George I to prevent the marriage that would have strengthened the position of the Jacobite pretender, she was detained by Emperor Charles VI in Innsbruck Castle. However, the guards were eventually deceived, and the princess escaped to Bologna, where she was married to James Stuart by proxy on September 3, 1719. The medal commemorates this event. ADC

208

Ottone Hamerani (1694–1761)

JAMES FRANCIS EDWARD STUART (1688–1766) and **MARIA CLEMENTINA SOBIESKA** (1702–1735)

Dated 1720

Silver, struck; 41.3 mm

The Frick Collection; Gift of Stephen K. and Janie Woo Scher, 2016 (2016.2.166)

Obverse: Jugate busts, Stuart with a wig and wearing armor with a commander's sash, Sobieska with long hair, wearing a diadem. Inscriptions: IACOB[us] III R[ex] CLEMENTINA R[egina] [King James III and Queen Clementina]; signed on truncation, HAMERAN[i].

Reverse: A personification of Providence with a child in her arms, leaning against a column and pointing toward a globe with Ireland, Scotland, and England. Inscriptions: PROVIDENTIA OBSTETRIX [Providence the midwife]; in exergue, CAROLO PRINC[ipe] VALLIAE / NAT[o] DIE VLTIMA / A[nno] MDCCXX [To Charles, Prince of Wales, born on the last day of the year 1720].

Literature: Hutten-Czapski 1871–1916, no. 5961 (var.); Hawkins 1885, 2: nos. 452, 460; Börner 1997, no. 1335.

209

Charles Edward Stuart, known as the Young Pretender, was the last direct male descendant of the royal Stuart line and the instigator of the unsuccessful Jacobite uprising (1745). He was the first son of the Old Pretender, James Francis Edward, and Maria Clementina Sobieska. The star in the field indicates his royal origin. He and his younger brother Henry Benedict, future Cardinal of York, were born in Rome, where their father had been given a residence by Pope Clement XI. This medal asserts the legitimacy of the Jacobite succession by presenting the two last legitimate Stuarts. ADC

James Edward Stuart, known as the Old Pretender, was the son of the deposed Catholic monarch James II and a claimant to the thrones of England and Scotland as James III of England and James VIII of Scotland. He married Maria Clementina Sobieska, a granddaughter of the king of Poland, in 1719. This medal commemorates the birth of their son Charles Edward, called the Young Pretender, and the allegory on the reverse shows Providence revealing to the newborn his future kingdom on the globe. Neither James nor his son Charles became king. CM

17TH CENTURY

210

Rutilio Gaci (or Caci; ca. 1570–1634)
PHILIP III, KING OF SPAIN (b. 1578; r. 1598–1621) and
MARGARET OF AUSTRIA (1584–1611)
Dated 1609
Gilt copper alloy, cast; 51.9 mm
Scher Collection

Obverse: Philip wearing armor, a ruff, a commander's sash, and a chain with the Order of the Golden Fleece. Inscription: PHILIPPVS III HISPANIAR[um] REX [Philip III, King of Spain].
Reverse: Margaret, her hair adorned with jewels, wearing a richly embroidered dress with large ruff and a string of pearls. Inscription: MARG[arita] AVST[riæ] HISP[aniarum] REG[ina] A[nno] MDCIX [Margaret of Austria, Queen of Spain, 1609].
Literature: Domanig 1896, 62; Forrer 1904–30, 5: 278 (signed var.); Löbbecke sale 1908, no. 153; Hill 1920b, 148; Cano Cuesta 2005, no. 17 (signed var.).

209

Ottone Hamerani (1694–1761)
PRINCE CHARLES STUART (1720–1788) and
PRINCE HENRY STUART (b. 1725; Cardinal of York 1747–1807)
Dated 1720
Copper alloy, struck; 41.7 mm
Scher Collection; Promised gift to The Frick Collection

Obverse: Prince Charles wearing an ermine-lined mantle and armor with lion head pauldrons; in the field, on the right, a star. Inscription: MICAT INTER OMNES [He shines in the midst of all].
Reverse: Prince Henry wearing an ornamented cuirass and a sash, long hair tied back with a ribbon. Inscriptions: ALTER AB ILLO [The next after him]; on truncation, H[amerani].
Edge inscription: DIE XXXI DECEMBER MDCCXX EXTVLIT OS SACRVM COELO [On 31 December 1720 he raised his sacred face to the sky (latter part of the inscription, Virgil, *Aeneid* VIII.591)].
Literature: Hawkins 1885, 2: 492, no. 34; Börner 1997, no. 1340; Pollard 2007, 2: no. 851; Guthrie 2009, 24–27; Eimer 2010, no. 521.

Philip III was King of Spain and of Portugal (as Philip II). His reign was marked by peace in western Europe, although history views him as an ineffectual ruler. He is remembered for spending excessive amounts on his own entertainment and neglecting his country's increasing fiscal problems. He married his cousin, the Archduchess Margaret of Austria, in 1599, and Rutilio Gaci made a commemorative medal for their marriage. The present medal was conceived after the ratification of the Twelve Years' Truce (1609–21), between the Spanish Hapsburgs and the Dutch Republic and was given, together with a thick gold chain, by Archduke Albert to representatives from each of the provinces that signed the treaty. The present medal differs from a variant that is signed; unlike the other medals of its type, it has a loop. CM

210

211

211

After a medal by Rutilio Gaci (or Caci; ca. 1570–1634)
PHILIP IV, KING OF SPAIN (b. 1605; r. 1621–65)
After 1621
Copper alloy, cast; 43.1 mm
Scher Collection; Promised gift to The Frick Collection

Obverse: Philip wearing armor with a lion's head pauldron, a seraph on the chest, the Order of the Golden Fleece, and a commander's sash. Inscriptions: PHILIPPVS IIII HISPANIARVM REX [Philip IV, King of Spain]; signed beneath the truncation, MA[?] SP[?] F[ecit] [MA(?) SP(?) made it].
Reverse: Apollo, holding an olive branch and riding a chariot drawn by four horses in the sky over clouds and the upper section of a globe. Inscription: LVSTRAT ET FOVET [He shines and warms].
Literature: Van Loon 1732–37, 2: 133; Forrer 1904–30, 5: 279; Pollard 1984–85, 3: 1358, no. 792.

Philip IV was King of Spain and Portugal (as Philip III) during the decline of Spain as a world power. He fought to maintain Spain's prominence during the Thirty Years' War (1618–48) and is remembered for his cultivated patronage of the arts, most notably of Diego Velázquez. This medal is a copy of a medal by Rutilio Gaci conceived to commemorate Philip IV's ascension to the throne in 1621. The inscription on the reverse alludes to Philip as the provider of light and prosperity to his kingdom. One of Philip IV's celebratory surnames, consistent with the "four" in his royal title, was Quarto Planeta (the Fourth Planet), which, according to the Ptolemaic scheme of the universe, means Apollo, the Sun. Gaci adapted the design on the reverse from Jacopo da Trezzo's medal of King Philip II (no. 178) for his medal of King Philip IV. The present medal varies from Gaci's in the lion's head on the pauldron, the placement of the composition on the reverse, and, most noticeably, the unidentified signature, MA SP F. CM

212

Gaspare Mola (ca. 1580–1640)
COSIMO II DE' MEDICI, GRAND DUKE OF TUSCANY
(b. 1590; r. 1609–21) and **MARIA MADDALENA OF AUSTRIA**
(1587–1631)
After 1608
Silver, cast; 39.4 × 33.2 mm
Scher Collection

Obverse: Cosimo wearing armor, a ruff, and a commander's sash.
Inscriptions: COSMVS II MAGNVS DVX ETRVR[iæ] IIII [Cosimo II, fourth Duke of Tuscany]; signed beneath truncation, GASP[are] MOL[a].
Reverse: Maria Maddalena wearing a decorated dress and large lace collar. Inscription: M[aria] MAGD[alena] ARCH[iducissa] AVSTR[iæ] ET MED[ices] D[ucissa] ETRVR[iæ] [Maria Maddalena, Archduchess of Austria and Medici Duchess of Tuscany].
Literature: Heiss 1881–92, 2: 250, no. 3, pl. XXIII, no. 6; Supino 1899, no. 599; Langedijk 1981–87, 2: 578, no. 104; Pollard 1984–85, 2: 861, no. 463.

This medal commemorates the marriage of Cosimo II de' Medici, fourth Grand Duke of Tuscany, to Maria Maddalena of Austria in 1608. It was also the year that Gaspare Mola signed his first medal while in the employ of the Medici as mint master. In 1609 and 1610, he was the die-cutter for the silver coins and the medals of merit bestowed on those chosen by the grand duke. CM

213

Gaspare Mola (ca. 1580–1640)
COSIMO II DE' MEDICI, GRAND DUKE OF TUSCANY
(b. 1590; r. 1609–21) and **MARIA MADDALENA OF AUSTRIA**
(1587–1631)
Dated 1618
Silver, struck; 40 mm
Scher Collection; Promised gift to The Frick Collection

Obverse: Cosimo II wearing armor, a high collar and a commander's sash. Inscriptions: COSMVS II MAG[nus] DVX ETRVRIAE IIII [Cosimo II, fourth Grand Duke of Tuscany]; in the field, to the right of the bust, 1618; on truncation, G[aspare] MOL[a].
Reverse: Maria Maddalena wearing a high ruff, long pearl necklace, and pearl-drop earrings; her hair elaborately braided and coiled. Inscriptions: MAR[iæ] MAGDALENÆ ARCH[iducissæ] AVST[riæ] M[agnæ] D[ucissæ] ETR[uriæ] [(The image of) Maria Maddalena, Archduchess of Austria and Grand Duchess of Tuscany]; on the left, below the collar: GM [artist's initials]; on the right, below the collar, 1618.
Literature: Vannel and Toderi 2003–7, 2: no. 74; Pollard 2007, 2: no. 834.

The couple married in 1608. Cosimo's father had arranged the match to please Spain, whose queen was Maria Maddalena's sister, Margaret of Austria. They enjoyed a happy marriage and had eight children. ADC

214

Gasparo Morone Mola (d. 1669)
VINCENZO II GONZAGA (1594–1627)
1627
Gilt copper alloy, struck; 44.8 mm
Scher Collection; Promised gift to The Frick Collection

Obverse: Gonzaga wearing armor, a ruff, and a chain with the pendant of the Order of the Most Holy Blood of Jesus. Inscriptions: VINCEN[tius] II D[ominus] G[onzaga] DVX MANT[uæ] VII ET M[ontis] F[errati] V [Lord Vincenzo II Gonzaga, seventh Duke of Mantua and fifth Duke of Monferrato]; signed beneath bust, G[asparo] MORONE.
Reverse: A hound with a large collar standing on a bed of grass. Inscription: FERIS TANTVM INFENSVS [Hostile only to wild beasts].
Literature: Wellenheim sale 1844, no. 3477; Rizzini 1892, pt. 1, 116, no. 820; Forrer 1904–30, 4: 156; Magnaguti 1965, no. 80; Panvini Rosati 1968, no. 220; *Salton Collection* 1969, no. 49; Norris and Weber 1976, 89; Balbi de Caro 1995, V 71; Börner 1997, no. 1107; M. Rossi 2000, no. 199; Vannel and Toderi 2003–7, 2: nos. 386, 387.

Vincenzo Gonzaga succeeded his brother Ferdinando to become the seventh Duke of Mantua and fifth Duke of Monferrato in 1626. Although he was nominated to be a cardinal by Pope Paul V, he declined in order to marry Isabella Gonzaga di Novellara. His unpopular rule of the dukedom lasted little more than a year; he died in December 1627. CM

215

Gasparo Morone Mola (d. 1669)
POPE URBAN VIII (b. 1568; r. 1623–44)
1643
Gilt copper alloy, struck; 45.5 mm
Scher Collection

Obverse: Urban wearing a cope decorated with a figure of the Virgin of the Apocalypse on a crescent moon. Inscriptions: VRBANVS VIII PONT[ifex] MAX[imus] A[nno] XX [Pope Urban VIII in the twentieth year (of his pontificate)]; beneath truncation, GM [artist's initials].
Reverse: A view of the Aurelian Wall of Rome with the new bastioned fortifications to the left side of Porta San Pancrazio. Inscription: ADDITIS VRBI PROPVGNACVLIS [For the fortifications added to the city].
Literature: Billaine 1679, 169, no. XXXIV; Bonanni 1699, 1: 585, no. 13; Venuti 1744, 242, no. lxiv; Mazio 1824, 61, no. 218; Traunfellner sale 1841, 114, no. 71.

Pope Urban VIII (born Maffeo Barberini) used his political and military adeptness to expand the papal territory, particularly during the Thirty Years' War (1618–48). He is also recognized as a great patron of the arts. This medal celebrates the strengthening of the Roman fortifications with the addition of four bastions near Porta San Pancrazio. CM

Reverse: A rose with three blossoms. Inscriptions: GRATIA OBVIA VLTIO QVESITA [Grace is evident, punishment is ready (for those who deserve it)]; at bottom, TRAVANVS.

Literature: P. A. Gaetani 1761–63, 2: 95, pl. CXXII, no. 1; Ieracus 1828, pl. 63, no. 3; Heiss 1881–92, 2: 253, pl. XXXIII, no. 11; Morbio sale 1882, no. 1634 (a variant of the inscription on the obverse); Rizzini 1892, pt. 1, 119, no. 835; Forrer 1904–30, 6: 130; Delitala 1973, 47, pl. 49; V. Johnson 1975b, 11, fig. 1; Norris and Weber 1976, no. 100; Wurzbach-Tannenberg 1978, no. 2088; V. Johnson 1979, 91, fig. 93; Langedijk 1981–87, 2: 810, no. 90; Vannel and Toderi 1987, 226 and fig. 3; *Middeldorf Collection* 1995, no. 34; Börner 1997, no. 1183; Klauss 2000, 1: no. 1007; Vannel and Toderi 2001, no. 95; Flaten 2012, no. 54.

Ferdinando II de' Medici, son of Cosimo II de' Medici and Maria Maddalena of Austria, became Grand Duke of Tuscany in 1628 and married Vittoria della Rovere. The motto of this medal—which was devised by Francesco Rondinelli, the grand duke's librarian—admonishes Ferdinando's enemies, whom the grand duke, however clement, was ready to punish harshly if they threatened him. CM

216

Gioacchino Francesco Travani (act. ca. 1634–75)
POPE ALEXANDER VII (b. 1599; r. 1655–67)
Dated 1662
Copper alloy, cast; 71.8 mm
Scher Collection

Obverse: Alexander wearing a cope and the papal tiara. Inscriptions: ALEXANDER VII PONT[ifex] MAX[imus] ANNO MDCLXII [Pope Alexander VII, 1662]; beneath truncation, GFT [artist's initials].
Reverse: The design for the facade of Santa Maria in Campitelli, Rome. Inscription: QVÆ VOVI REDDAM PRO SALVTE DOMINO [I will repay whatever I have vowed to the Lord, because of my salvation (Jonah 2:10)].
Literature: Du Molinet 1679, 188, no. xxiii; Venuti 1744, 263, no. xvii; *Trésor de numismatique* 1834–58, 6: pl. XXXIII, no. 2 (incorrectly identifies the church as Santa Maria della Pace); Forrer 1904–30, 6: 130; Whitman 1983, no. 95 (this version mentioned); Toderi and Vannel 1990, no. 125; Vannel and Toderi 2003–7, 2: no. 509; Benedetti 2012, fig. 5, 207n. 28.

Pope Alexander VII (born Fabio Chigi) was a key figure in the creation of the grand urban and architectural presentation of Baroque Rome. His commissions included the renovation of churches, the restoration of ancient buildings, the construction of private villas, and the improvement of public squares and infrastructures. All these campaigns were extensively recorded in medals. Alexander's taste for the grandiose found the perfect counterpart in the genius of Bernini, Rainaldi, and Borromini. This medal records the design for the facade of Santa Maria in Campitelli by Carlo Rainaldi, which was eventually modified. CM

217

Gioacchino Francesco Travani (act. ca. 1634–75)
FERDINANDO II DE' MEDICI, GRAND DUKE OF TUSCANY (1610–1670)
Dated 1666
Silver, struck; 48 mm
Scher Collection; Promised gift to The Frick Collection

Obverse: Ferdinando in armor and cloak. Inscriptions: FERDINANDVS II MAG[nus] DVX ETRVRIÆ [Ferdinando II, Grand Duke of Tuscany]; signed beneath truncation, I[oachinus] F[ranciscus] T[ravani] 1666.

218

Style of Gioacchino Francesco Travani (act. ca. 1634–75)
POPE ALEXANDER VII (b. 1599; r. 1655–67)
Dated 1661
Copper alloy, cast; 101.9 mm
Scher Collection

Obverse: Alexander wearing the papal tiara and a cope with jeweled morse and embroidered with a saint holding a chalice and a sword (possibly St. Paul). Inscriptions: ALEX[ander] VII PONT[ifex] MAX[imus] A[nno] VII [Pope Alexander VII in the seventh year (of his pontificate)]; dated beneath truncation, 1661.

219

Pope Alexander VII (born Fabio Chigi) was a generous patron of the arts credited with creating the grand look of Baroque Rome. This medal is after a design by Gioacchino Francesco Travani, who worked from a portrait by Alexander VII's favorite artist, Gian Lorenzo Bernini. The portrait was cast and copied many times over. The present portrait was likely taken from the obverse of the foundation medal of St. Peter, where St. Peter is embroidered on the pope's cope. On the present medal, however, it is an unidentified saint, probably St. Paul. Additionally, this medal incorrectly lists the seventh year of Alexander VII's pontificate as 1661, not 1662. CM

219
Francesco Bertinetti (d. after 1706)
MICHEL LE TELLIER (1603–1685)
Dated 1678
Copper alloy, cast; 133.7 mm
Scher Collection; Promised gift to The Frick Collection

Obverse: Le Tellier wearing the uniform of Keeper of the Seals, including the *calotte*, with the cross of the Order of the Holy Spirit. Inscriptions: MICHA[el] LE TELLIER FR[anciæ] CANCELLARIVS 1678 [Michel Le Tellier, Chancellor of France, 1678]; on truncation (incuse), BERTINET.
Literature: Forrer 1904–32, 7: 74; Rouhette and Tuzio 2008, 166.

The French statesman Michel Le Tellier, Marquess of Barbezieux, was Chancellor and Keeper of the Seals (1677) under Louis XIV. This medal, which commemorates his nomination to the post, follows the style and format of the one made by Bertinetti for Louis XIV in the same year. CM

220
Francesco Bertinetti (d. after 1706)
LOUIS XIV, KING OF FRANCE (b. 1638; r. 1643–1715)
Dated 1678
Copper alloy, cast; 133.3 mm
Scher Collection; Promised gift to The Frick Collection

Obverse: Louis, laureate, wearing a large peruke, commander's sash, and armor all'antica with lion pauldron. Inscriptions: BENEDIC[e] D[omi]NE POPVLVM BENEVOLVM QVEM AVDIVISTI PROPTER ME IN AMARITVDINE MEA [Bless O Lord the benevolent people that you have heard (through their prayer) close to me during my hard times]; on truncation (incuse), BERTINET.
Reverse: Louis as the Sun resting on clouds from which radiate sunbeams and from which fall branches of laurel upon a landscape with lions and the Hydra. Inscriptions: on a banderole above the profile of the king, ORTVS EST SOL, and on a central banderole, ET CONGREGATI SUNT PS[almus] 103 [The Sun has risen, and they are

220

gathered together, Psalm 103 (King James Bible, Psalm 104: 22)]; below the landscape, a third scroll with PROBAVERVNT ET VIDERVNT [They have proved (me) and saw (my work); Psalm 94:9]; around the border, VIDETE OPERA D[omi]NI QVÆ POSVIT PRODIGIA SVPER TERRA AVFERENS BELLA PS[almus] 45 1678 BERTINET M[odellavit] ET SCULP[sit] [Behold the work of God, which brought prodigies on the earth and ended the wars, Psalm 45 (King James Bible, Psalm 46: 8–9); 1678 Bertinetti modeled and sculpted it].
Literature: Porée 1891, 16; Vermeylen 1902, 343–54, pl. VII; Rondot 1904, 300–301; Forrer 1904–32, 1: 176; J. Babelon 1941, 59; Jacquiot 1970, 253–61.

This medal celebrates Louis XIV's victory in the Dutch War (1672–78), with an allegory of the Sun King bringing peace and order to his territory (Psalm 46, King James Bible). The animals and the Hydra on the reverse are a faithful interpretation of verses from Psalm 103 (104, King James Bible), in which the glory of God is celebrated through the harmonious existence of all creatures on earth. This is also echoed in Psalm 94 (95, King James Bible), which is meant to be read as a demonstration of the king's resilience when faced with adversity. Porée mentions ten versions of this medal. CM

221

Giovanni Battista Guglielmada (act. 1665–88; d. 1689)
CHRISTINA, QUEEN OF SWEDEN (1626–1689; r. 1632–54)
ca. 1680
Copper alloy, struck; 61.4 mm
The Frick Collection; Gift of Stephen K. and Janie Woo Scher, 2016 (2016.2.167)

Obverse: Christina, hair tied up and adorned with pearls, wearing a gown and an ermine mantle secured on her right shoulder with a brooch. Inscription: REGINA CHRISTINA [Queen Christina].
Reverse: The globe. Inscriptions: NE MI BISOGNA NE MI BASTA [I do not need it, and it is not enough for me], G[loria] D[eo] [Glory to God].
Literature: Hildebrand 1874, 1: 316, no. 112; Bildt 1908, 114, no. iv; fig. 69; Ballico 1983, pl. 26e (rev.).

A highly educated and cultured monarch, Queen Christina of Sweden was an extraordinary patron of the arts. She commissioned a series of medals that would compose an *Histoire métallique* to rival that of Louis XIV of France. The first medals were cast by Massimiliano Soldani-Benzi in 1680, and the work was later continued by Guglielmada, Giovanni Hamerani, and other medalists. This medal belongs to the so-called *Gloria Deo* series, as identified by the initials on the reverse. CM

222

Giovanni Battista Guglielmada (act. 1665–88; d. 1689)
FERDINANDO CARLO GONZAGA (1652–1708)
Dated 1686
Copper alloy, cast; 42.2 mm
Scher Collection; Promised gift to The Frick Collection

Obverse: Gonzaga with a long wig, dressed in decorative armor and lace cravat, and wearing the Order of the Holy Blood of Christ. Inscriptions: FERD[inandus] CAR[olus] D[e] G[onzaga] DVX MANT[uæ] MONTISF[errati] CAROLIV[illæ] GVAST[allæ] ETC [Ferdinando Carlo di Gonzaga, Duke of Mantua and Monferrato, of Charleville and Guastalla, et cetera]; on truncation, G[uglielmada] F[ecit] 1686 [Guglielmada made it, 1686].
Reverse: A radiating sun with a human face with three signs of the zodiac—Leo, Virgo, and Libra. Inscription: CERTISSIMA SIGNA SEQVENTVR [Clear signs follow (the sun); Virgil, *Georgics* I.439].
Literature: Wellenheim sale 1844, no. 3502; Wurzbach-Tannenberg 1943, no. 2108; Magnaguti 1965, no. 98; C. Johnson 1990, 1: 245, no. 154; Börner 1997, no. 1211A; M. Rossi 2000, 8: no. 251.

The reverse of this rare medal of the tenth Duke of Mantua shows a view of the sun and zodiac that is based loosely on contemporary illustrations of the Copernican theory of the solar system. The sun

223

became the symbol of the reign of Louis XIV, a close ally of the duke. The Gonzaga family, which ruled the prosperous city of Mantua from the fourteenth century, met the end of its reign under the duke, who was ousted from his city in 1708 and died in exile. CM

Christina was Queen of Sweden until 1654, when she had to abdicate because of her conversion to Catholicism. A woman of considerable energy, intelligence, and culture, she moved to Rome to the court of Pope Alexander VII and became a great patron of the arts. Her larger-than-life personality is the subject of the reverse of this medal with the myth of the bird of paradise, which, having no legs, always flew over the earth, thus perpetually remaining a heavenly body. This medal has been variously attributed to Soldani-Benzi and Guglielmada, who executed a number of designs of Queen Christina after Soldani-Benzi's designs. CM

223

Giovanni Battista Guglielmada (act. 1665–88; d. 1689)
CHRISTINA, QUEEN OF SWEDEN (1626–1689; r. 1632–54)
ca. 1681
Copper alloy, cast; 61.8 mm
Scher Collection; Promised gift to The Frick Collection

Obverse: Christina, laureate, wearing a gown secured on her left shoulder by a brooch decorated with a sun. Inscription: REGINA CHRISTINA [Queen Christina].
Reverse: A bird of paradise flying over the sea. Inscription: MI NIHIL IN TERRIS [The world is not enough for me].
Literature: P. A. Gaetani 1761–63, 2: 145–46, pl. CXXXV, no. 1; Hildebrand 1874–75, 1: 316, no. 111; Rizzini 1892, pt. 1, 120, no. 842; Bildt 1908, 105, no. 2, pl. 56; Ballico 1983, pl. 22b.

224

Massimiliano Soldani-Benzi (1656–1740)
FRANCESCO REDI (1626–1697)
Dated 1684
Copper alloy, cast; 86.8 mm
The Frick Collection: Gift of Stephen K. and Janie Woo Scher, 2016 (2016.2.169)

Obverse inscriptions: FRANCISCVS REDI PATRITIVS ARETINVS [Francesco Redi, patrician of Arezzo]; below the bust, M[assimiliano] SOLD[ani] 1684.

224

225

Reverse: To the left, a seated female figure, Eternity, dressed in flowing robes, her head covered, handing a laurel crown to Minerva with her right hand; her left leg over her right with the foot resting on a globe, she indicates the temple in the background; Minerva kneeling on the head of the personification of Time, who falls backward onto the ground; behind, two columns supporting an entablature with an inscription partly obscured, on which is a snake with its tail in its mouth (*ouroboros*); all set in front of a rocky landscape. Inscriptions: AERE PEREMNIVS [More lasting than bronze; from "Exegi monumentum aere perennius" (I have made a monument more lasting than bronze), Horace, *Odes*, 3: 30]; on the entablature, AETERNITATI [To eternity]; in exergue, M[assimiliano] S[oldani] F[ecit] 1684 [Massimiliano Soldani made it, 1684].
Literature: Vannel and Toderi 1987, no. 38; Vannel and Toderi 2003–7, 2: nos. 183, 184; Pollard 2007, 1: no. 854 (var.).

In addition to being chief physician to the Medicean grand dukes Ferdinando II and Cosimo III and a zoologist, Francesco Redi was renowned as a poet and philosopher. The reverse reflects the idea that poetry and literature have the power to defeat time and last forever, as visualized by Minerva trampling upon Time and by the personification of Eternity pointing to the *ouroboros*, another symbol of eternity, and further declared by the quote from Horace. ADC

225

Massimiliano Soldani-Benzi (1656–1740)
GIUSEPPE AVERANI (1662–1738)
Dated 1721
Copper alloy, cast; 86.9 mm
Scher Collection; Promised gift to The Frick Collection

Obverse: Averani wearing a long wig. Inscription: IOSEPHVS AVERANIVS FLOR[entinus] [Giuseppe Averani, Florentine].
Reverse: A temple on Mount Parnassus with the herm of Themis, goddess of divine law and order, in the center, flanked by statues of Abundance and Dike (Justice); on the pediment, a relief with

a reclining figure; to the right, three Muses—(from left to right) Euterpe (music), Clio (history), and Urania (astronomy); above in the background, Pegasus striking the rock on Mount Helicon. Inscriptions: THEMIS PARNASSIA [Themis of Mount Parnassus]; in exergue, 1721.
Literature: "Inventario . . . Riccardi" 1752, 372, no. 39; P. A. Gaetani 1761–63, 2: 310, pl. CLXXVI, no. 1; Rizzini 1892, pt. 1, 208, no. 1321; V. Johnson 1979, 142; Vannel and Toderi 1987, no. 67; *Middeldorf Collection* 1995, no. 39; Börner 1997, no. 1511; Vannel and Toderi 1998, no. 119; Klauss 2000, 1: no. 1070; Vannel and Toderi 2003–7, 2: no. 237; Flaten 2012, no. 96.

This medal was dedicated to the renowned Florentine jurist, writer, and poet Giuseppe Averani by his students at the University of Pisa. Averani was an instructor of law to Grand Duke Gian Gastone de' Medici, and in 1685 he was made a professor in Pisa by Cosimo III. The allegory on the reverse refers to Averani as a man dedicated primarily to the study and practice of the law (the spatial primacy of the Temple) and blessed by the Muses with a fine intellect. CM

226

Massimiliano Soldani-Benzi (1656–1740)
ANTONIO MANOEL DE VILHENA (b. 1663; Grand Master of the Order of St. John 1722–36)
Dated 1729
Copper alloy, cast; 97.3 mm
Scher Collection; Promised gift to The Frick Collection

Obverse: De Vilhena, with a long wig, wearing armor with a lion's head pauldron, the Cross of the Knights of Malta on the cuirass, and a commander's sash. Inscriptions: F[rater] D[on] AN[tonius] MANOEL DE VILHENA M[agister] M[elitæ] [Brother Don Antonio Manoel de Vilhena, Master of Malta]; below the truncation, MDCCXXIX [1729].
Reverse: A draped personification of Religion sitting on an altar decorated with papal regalia hands the arms of victory to a Roman soldier who stands on Turkish trophies of war; to the right, two

226

cherubs, a cross, a chalice, a thurible, and a book; behind the soldier, a prancing lion. Inscription: INSIGNIS GLORIA FACTI [The Glory of the noble deed (is recorded); Virgil, *Aeneid* XII.322].
Literature: Morbio sale 1882, no. 4508; Furse 1885, 351; Forrer 1904–30, 5: 567; Schembri 1908, 209, no. 7; Lankheit 1962, 161; *Ultimi Medici* 1974, no. 96; Bascapè 1975, fig. 25; V. Johnson 1979, 141; Vannel and Toderi 1987, no. 69; Vannel and Toderi 2003–7, 2: no. 244.

Prince Antonio Manoel de Vilhena, Grand Master of the Sovereign Military Order of Malta, defeated the Turkish fleet multiple times during his reign. As a token of the great regard in which Pope Benedict XIII held de Vilhena, he presented him with the Stock and

Pilier, an honor bestowed on the likes of Philip II of Spain. This gift is the subject of the allegory on the reverse of this medal designed by Anton Francesco Gori. The lion is the heraldic symbol of de Vilhena's family arms. CM

227

Massimiliano Soldani-Benzi (1656–1740)
GIUSEPPE CARRILLO DE ALBORNOZ Y MONTIEL
(1671–1747)
Dated 1735
Copper alloy, cast; 91.5 mm
Scher Collection

227

228

Obverse: Carrillo de Albornoz, with a long wig, wearing armor, a mantle, and the Order of the Golden Fleece on a chain. Inscriptions: IOS[eph] CARILLO DE ALBORNOZ DVX DE MONTEMAR [Giuseppe Carrillo de Albornoz, Duke of Montemar]; below truncation, AN[no] MDCCXXXV [year 1735].

Reverse: Winged Victory holding the crown of Spain and the crown of the Kingdom of the Two Sicilies in her right hand, the crown of Milan in her left, and standing on trophies of war with the arms of Naples, Palermo, and the Turks. Inscription: RECVPERATIS [For the recovered (kingdoms)].

Literature: "Inventario . . . Riccardi" 1752, 374, no. 47; Vives 1916, no. 16; Siciliano 1956, no. 100; V. Johnson 1979, 142; Vannel and Toderi 1987, no. 73; Vannel and Toderi 2003–7, 2: no. 249; Di Rauso 2008.

Giuseppe Carrillo de Albornoz, Duke of Montemar, was captain general of the army of the king of Spain. As part of the War of the Polish Succession (1732–38), he reconquered the Kingdom of the Two Sicilies (Sicily and Naples) from Austrian domination in 1734 for the Spanish king, Philip V. After defeating the Austrian troops at Bitonto, in Puglia, Carrillo de Albornoz was made Commander of Castelnuovo di Napoli and Duke of Bitonto. CM

228

Unknown artist (Ferrara)
OTTAVIO TASSONI ESTENSE (ca. 1547–1609)
Dated 1606, made 1608
Copper alloy, cast; 53.8 mm
Scher Collection; Promised gift to The Frick Collection

Obverse: Estense wearing a doublet decorated with a cross patriarchal *moline* (a cross with bifurcated ends) and the Este eagle. Inscriptions: [cross of the Knights Templar] COME[s] OCT[avius] TASSONVS ESTEN[sis] COM[mendator] S[ancti] SP[iritu]S 1606 [Count Ottavio Tassoni Estense, Commendatore of Santo Spirito, 1606].

Reverse: The castle of Roccarespampani. Inscription: ARCE ANTIQVA LABENTE NOVAM EXTRVXIT [The old fortress being about to fall, he built up a new one].

Literature: Rizzini 1892, pt. 1, 112, no. 788; Supino 1899, no. 629; Lanna sale 1911b, no. 392; Norris and Weber 1976, no. 194; Pollard 1984–85, 3: 1483, no. 874; Vannel and Toderi 2003–7, 2: no. 48.

Ottavio Tassoni Estense was an officer of the Banco di Santo Spirito founded by Pope Paul V in 1605. The cross on Ottavio's chest is either the emblem of the bank or the cross of a Papal Supreme Order of Christ, related to the original Knights Templar. The medieval Knights Templar were bankers, as well as soldiers, and this medal could refer to the founding of the bank. It could also refer to the commencement of the project to restore the castle of Roccarespampani (Viterbo), shown on the reverse. The original building was probably built in the eleventh century on a pre-existing site. The estate changed owners many times and was in a state of extreme neglect until Count Ottavio Tassoni Estense commissioned the construction of the current building. According to an inscription *in situ*, the castle was completed in 1608. The medal, presenting the final facade of the building, was therefore completed about 1608 but is dated to the inception of the project. SKS

229

Unknown artist (Sicily?)
BONAVENTURA OTTAVIO SECUSIO (1558–1618)
ca. 1618
Copper alloy, cast; 55.5 mm
Scher Collection

Obverse: Secusio wearing a hooded cassock. Inscription: F[rater] BON[aventura] SECVSIVS PATRIARCHA CONSTANTINOPOLITANVS [Fra Bonaventura Secusio, Patriarch of Constantinople].

Reverse: Clockwise, St. Francis in a double circle, two mitres, a papal tiara, two other mitres; in the center, two crowned olive branches placed across each other. Inscriptions: clockwise from St. Francis, SI[ciliæ] MI[nisterius] G[enerali]S; AR[chiepiscopus] M[essanæ]; EP[iscopus] P[actari]; C[anonicus] S[ancti] PE[tri]; EP[iscopus] CA[taniæ]; PA[triarcha] CO[nstantinopolitanus], PAX [Minister General (of the Franciscan Minors) in Sicily; archbishop of Messina; bishop of Patti; Canon of St. Peter; bishop of Catania; Patriarch of Constantinople; Peace].

Fra Bonaventura Secusio, a member of the Franciscan Minors Observants, was a prelate and diplomat from Caltagirone in Sicily. This medal, probably cast after his death, commemorates his many offices, as well as his important diplomatic contribution to reaching peace agreements, including the Treaty of Vervins (1598) between France and Spain and the Treaty of Lyon (1601) between France and

229

Savoy as represented by the crowned olive branches. The portrait on the obverse is probably modeled on Secusio's funerary monument in the cathedral of Catania. CM

230

Unknown artist (possibly Prague)
FERDINAND II, HOLY ROMAN EMPEROR (b. 1578; r. 1619–37) and **ELEONORA GONZAGA** (1598–1655)
1622
Silver, cast; 56.4 mm
Scher Collection

Obverse: Ferdinand wearing armor, a commander's sash, a ruff, and a pendant with the Order of the Golden Fleece. Inscription: FERDIN[andus] II DEI GRA[tia] RO[manorum] IMP[erator] SEM[per] AVGVS[tus] GER[maniæ] HVN[gariæ] BOHE[miæ] REX [Ferdinand II, by the grace of God Roman Emperor Forever August, King of Germany, Hungary, and Bohemia].
Reverse: Gonzaga wearing a richly embroidered dress, with a lace collar, two pearl necklaces, and a bejeweled diadem. Inscription: ELEONORA IMP[eratrix] GERM[aniæ] HVNG[ariæ] BOHEM[iæ] REGIN[a] MANT[uæ] DVCISSA [Eleonora Empress, Queen of Germany, Hungary, and Bohemia, Duchess of Mantua].
Literature: Magnaguti 1965, no. 174; *Gonzaga* 1996–2002, 5: 64.

This medal was most likely conceived to commemorate the marriage of Ferdinand II to Eleonora Gonzaga, the youngest daughter of Vincenzo I, the Duke of Mantua. Magnaguti attributes the medal to an artist working in Prague. "Semper Augustus" (Forever August) was an official title given to the emperor. CM

231

Unknown artist (Rome?)
ARTEMISIA GENTILESCHI (1593–ca. 1652)
ca. 1627
Copper alloy, cast; 53.5 mm
Scher Collection

Obverse: Gentileschi with long hair pulled back in a ribbon, wearing a dress, a mantle, and a pearl necklace. Inscription: ARTHEMISIA GENTILESCA PICTRIX CELEBRIS [Artemisia Gentileschi, the celebrated painter].
Literature: Börner 1997, no. 1864; Bissell 1999, fig. 99; Christiansen and Mann 2001, 418; Locker 2015, 20 (this example).

The daughter of the painter Orazio Gentileschi, Artemisia was a follower of Caravaggio and a successful painter in her own right. The portrait on this rare medal is possibly adapted from an engraving by Jérôme David (ca. 1627) after a now-lost self-portrait. CM

230

231

232

18TH CENTURY

232

Giovacchino Fortini (1670–1736)
FRANCESCO RICCARDI (1648–1719)
Dated 1715
Gilt copper alloy, cast; 87.4 mm
Scher Collection; Promised gift to The Frick Collection

Obverse: Riccardi with a large peruke, wearing a loose cloak.
Inscriptions: F[ranciscus] MARCHIO RICCARDI R[egni] C[onsultor] COS[mi]
M[agni] D[ucis] ETR[uriæ] A[c] CONS[ul] ET SVM[mus] AVLE PREF[ectus]
[Marquess Francesco Riccardi, councilor to Cosimo Grand Duke of
Tuscany, consul and *Maggiordomo Maggiore* (Grand Majordomo)];
on truncation, G[iovacchino] F[ortini] F[ecit] MDCCXV [Giovacchino
Fortini made it, 1715].
Reverse: The Medici-Riccardi palazzo with a draped, winged figure
holding a crown and a key above; the draped figures of Charity,
holding two babies, and Abundance, holding a double cornucopia
and a compass, sitting to either side. Inscription: EGENTIVM VOTIS [For
the prayers of the poor].
Literature: "Inventario . . . Riccardi" 1752, 372, no. 38; Morbio sale
1882, no. 4460; Lankheit 1962, 219n.154; *Sculpture in Miniature*
1969, no. 303; *Ultimi Medici* 1974, 84–85, no. 46; Norris and
Weber 1976, no. 150; V. Johnson 1975a, 39 and 68; Meloni Trkulja
1980, 39, no. VI, 7; Vannel and Toderi 1987, no. 86; Danielson
1990, 284–85, no. 8; *Middeldorf Collection* 1995, no. 42; Börner
1997, no. 1527; Vannel and Toderi 2003–7, 3: nos. 185–89; Bellesi
and Visonà 2008, no. 58; Flaten 2012, no. 96.

Marquess Francesco Riccardi was a state advisor to Cosimo III de'
Medici (1642–1723), as well as his *maggiordomo maggiore*. One
of the richest and most prominent Florentine families, the Riccardis
purchased the historic Medici palazzo in Via Larga in 1659. This
medal commemorates the completion of the renovation in 1715,

and the reverse offers a clear view of the Riccardi additions to the
building (the facade and the stables). The winged figure holds a
crown, symbol of Riccardi's title of marquess, which he was granted
in 1715, and a key, the heraldic symbol of the family and a reference
to Francesco's position as *maggiordomo maggiore*. The allegory and
the inscription suggest that the Riccardis, by commissioning the
building, contributed to the wealth of the city. CM

233

Giovacchino Fortini (1670–1736)
COSIMO III DE' MEDICI, GRAND DUKE OF TUSCANY
(b. 1642; r. 1670–1723)
Dated 1720
Gilt copper alloy, cast; 84.9 mm
The Frick Collection; Gift of Stephen K. and Janie Woo Scher, 2016
(2016.2.163)

Obverse: Cosimo wearing a fur-lined commander's sash and armor
with a lion's head pauldron. Inscriptions: COSMVS III ETRVSCORVM REX
[Cosimo III, Sovereign of the Tuscans]; on truncation, G[iovacchino]
FORTINI 1720.
Reverse: The personification of Religion to the left with a cross, a
flame, and a book; the personification of Potestas (judicial power
under Roman law) with a scepter leaning against a column; and the
personification of Virtue, winged, holding a cornucopia. Inscription:
TRANQVILLITAS PVBLICA [Public Tranquility].
Literature: "Inventario . . . Riccardi" 1752, 374, no. 49; V. Johnson
1975a, 68; V. Johnson 1979, 143; Langedijk 1981–87, 1: 635–36,
nos. 113 and 113a (rev.); Vannel and Toderi 1987, no. 90; Börner
1997, no. 1530; Vannel and Toderi 2003–7, 3: no. 200.

Cosimo III de' Medici, son of Cosimo II and Vittoria della Rovere,
succeeded his father as Grand Duke of Tuscany in 1670. He ruled for
fifty-three years, the longest period in the history of the grand duchy,

233

and married Marguerite-Louise d'Orléans, niece of Louis XIII of France. He was very devout, inclined more toward a contemplative life than a political one; his reign saw the decline of Tuscany as a political power. CM

234

Giovanni Battista Pozzo (ca. 1670–1752)
PHILIPP VON STOSCH (1691–1757)
Dated 1717
Copper alloy, cast; 82.3 mm
Scher Collection; Promised gift to The Frick Collection

Obverse: Stosch, all'antica, a mantle draped over his left shoulder. Inscriptions: PHILIP[pus] STOSCHIVS A[nno] ÆT[atis] XXVI MDCCXVII [Philipp von Stosch, aged 26, 1717]; signed on truncation, I[oannes]

POZZO F[ecit] ROMÆ [Giovanni Pozzo made it, in Rome].
Reverse inscription: MORIBVS ANTIQVIS [Following the ancient customs].
Literature: P. A. Gaetani 1761–63, 2: 379, pl. CXCIII, no. 2; Durand 1865, 194, no. 1; Forrer 1904–30, 4: 681; Toderi and Vannel 1990, no. 43; Börner 1997, no. 1403; Vannel and Toderi 2003–7, 3: no. 589.

A Prussian connoisseur and antiquarian admired throughout Europe, Baron Philipp von Stosch had a collection of carved gems and medals purported to have been superior to that of the king of France, as well as a library of rare manuscripts coveted by the pope. This medal may celebrate Stosch's appointment as royal antiquarian to the Elector of Saxony in 1717, a post he held briefly while attempting to begin a diplomatic career for the elector. CM

234

236

235

Obverse: Charles with a long peruke, wearing a commander's sash and a doublet with a high collar. Inscriptions: CAROLVS III HISPANIARVM REX [Charles III, King of Spain]; on truncation, JOS[eph] HORT[olanus].

Reverse: Personifications of Justice and Peace embracing each other before a landscape; Justice holding scales in her right hand and Peace a laurel branch in her left hand; in the left corner, a putto writing on the cover of a closed book; above, a putto holding a crown; in exergue, a rocky landscape. Inscription: IVSTITIA ET PAX OSCULANTVR SE [Justice and Peace kiss each other; from Psalm 85:10].

Literature: Van Loon 1732–37, 4: 404; Forrer 1979–80, 4: 333; C. Johnson 1990, 2: 582, no. 418; Toderi and Vannel 1990, no. 64; Flaten 2012, no. 67.

Charles, son of Emperor Leopold I and Princess Eleonor Magdalene of Neuburg, was a pretender to the throne of Spain with the name Charles III (1703–11) but renounced it to become Holy Roman Emperor as Charles VI in 1711. This medal was struck about 1703 to commemorate Charles's claim to the Spanish throne. CM

235

Girolamo Ticciati (1671–1744)
ANTONIO MAGLIABECHI (1633–1714)
ca. 1704
Lead, cast; 101.4 mm
The Frick Collection; Gift of Stephen K. and Janie Woo Scher, 2016
(2016.2.171)

Obverse: Magliabechi with long, unkempt hair to the nape of the neck, wearing a gown, collar, and mantle. Inscription: ANTONIVS MAGLIABECHIVS [Antonio Magliabechi].
Literature: Vannel and Toderi 2003–7, 3: no. 171 (same obv. but different rev.).

At the age of forty and after a career as a goldsmith, Magliabechi became a self-taught scholar and librarian to Cosimo II de' Medici (1642–1723). He was a passionate reader and the center of intellectual life in Florence. According to one of his surviving letters, Ticciati conceived this medal in 1704 without Magliabechi's permission or sitting for the artist (*alla macchia*). Magliabechi categorically refused to be portrayed, even at the risk of openly challenging the grand duke's request. This portrait is all the more interesting for Ticciati's recording of Magliabechi's expressive physiognomy despite the absent model. This medal is usually cast with an open book and the inscription OMNIBVS OMNIA (Everything to everyone) on the reverse. CM

237

Giuseppe Ortolani (ca. 1674–1734)
ANTONIO OTTOBONI (1646–1720)
1690–1720
Copper alloy, struck; 73 mm
Scher Collection

Obverse: Ottoboni with a long peruke, wearing a lace cravat, armor and commander's sash. Inscriptions: ANTONIVS OTTHOBON[us] CAP[itaneus] GEN[eralis] S[anctæ] R[omanæ] E[cclesiæ] [Antonio Ottoboni, captain general of the Holy Roman Church]; signed below the bust, GIOS[eph] ORTOL[anus] F[ecit] [Giuseppe Ortolani made it].
Reverse: The Capitoline She-Wolf, representing Rome, and the Lion of St. Mark, representing Venice, pulling a celestial chariot over water and two fortified cities; Religion sits on the chariot holding a cross between the personifications of the sleeping figure of Security to her right and Victory to her left; the chariot guided by Prudence with Terror at her side wielding a sword in her right hand, a snake wound around her left, while the enemies of Religion are crushed beneath the chariot's wheels. Inscription: CIVITATES IMPIORVM DESTRVET D[omi]N[u]S ET LATOS FACIET TERM[in]OS FIDEI [The Lord will destroy the cities of the impious and will extend the borders of Faith].

236

Giuseppe Ortolani (ca. 1674–1734)
CHARLES VI, HOLY ROMAN EMPEROR (b. 1685; r. 1711–40)
ca. 1703
Gilt copper alloy, struck; 48.8 mm
Scher Collection; Promised gift to The Frick Collection

237

Literature: P. A. Gaetani 1761–63, 2: 248, pl. CLXI, no. 1; Morbio sale 1882, no. 4418; Rizzini 1892, pt. 1, 142, no. 968; Forrer 1904–30, 3: 332–33; Vannel and Toderi 1987, 26, fig. 19; C. Johnson 1990, 2: 585, no. 421; Toderi and Vannel 1990, no. 56; Börner 1997, no. 1380; Voltolina 1998, 2: no. 1084; Vannel and Toderi 2003–7, 2: no. 850; Olszewski 2004, 48–49.

Antonio Ottoboni, the nephew of Pope Alexander VIII (1610–1691), was appointed captain general of the papal army in 1689. This medal was most likely made about 1690 to celebrate the victory of the pope and the Republic of Venice against the Turks. It therefore may be a pendant to another medal also conceived by Ortolani for the pope on the occasion of the celebration (Olszewski 2004, fig. 23). CM

238

Antonio Francesco Selvi (1679–1753)
MARIA SALVIATI (1499–1543)
ca. 1740
Copper alloy, cast; 86.4 mm
The Frick Collection; Gift of Stephen K. and Janie Woo Scher, 2016 (2016.2.170)

Obverse: Salviati wearing a veil, drop earrings, and a simple gown with a brooch. Inscription: MARIA SALVIATI MEDICES [Maria Salviati de' Medici].
Reverse: An eagle tearing at a diamond ring. Inscription: IAMAIS AVTRE [Never another].
Literature: Morbio sale 1882, no. 4382; Delitala 1973, fig. 38; V. Johnson 1975b, no. 39; Langedijk 1981–87, 2: 1264, no. 87; Vannel and Toderi 1987, no. 289; Vannel and Toderi 2003–7, 3: no. 415.

Maria Salviati, wife of Giovanni delle Bande Nere and mother of Duke Cosimo I de' Medici, was widowed in 1526, when her husband, captain of the papal army, died from an infected wound. Although still young, she maintained the role of faithful widow. She is usually represented in a simple dark dress, without jewels, and wearing a white veil. The *diamante impresa* on the reverse, which belongs to the traditional Medici imagery, is usually associated with the motto "Semper" (Always). Here, the opposite notion "Jamais" (Never) asserts Maria's proverbial resoluteness and strength. This medal type belongs to the *Serie Medicea* by Selvi, a series of retrospective portraits of the entire Medici line. CM

238

239

<div>

239

Antonio Francesco Selvi (1679–1753)
MADDALENA DE LA TOUR D'AUVERGNE (ca. 1500–1519)
ca. 1740
Copper alloy, cast; 86.5 mm
Scher Collection; Promised gift to The Frick Collection

Obverse: Maddalena with hair in a coif, wearing an earring, a pearl necklace, a dress, a lace shawl, and a pendant with a cross. Inscription: MAGDALENA DE BONONIA VXOR LAVREN[tii] MED[icis] DVCIS VRBINI [Maddalena of Boulogne, wife of Lorenzo de' Medici, Duke of Urbino].
Reverse: Three lily plants growing among other flowers. Inscription: AMAT SVBLIMIA CANDOR [Integrity loves eminent things].
Literature: Hill 1930, 1: 284; 2: pl. 29, no. 1110 (later restitution); V. Johnson 1975b, no. 24; Langedijk 1981–87, 2: 1218, no. 81; Vannel and Toderi 1987, no. 270; Börner 1997, no. 1665; Vannel and Toderi 2003–7, 3: no. 398.

Maddalena, Duchess of Urbino, was the daughter of Jean III de La Tour, Count of Auvergne, Lauraguais, and Boulogne. She married Duke Lorenzo de' Medici in 1518 and died in 1519, after giving birth to their only child, Catherine de' Medici, the future queen of France. The lilies, a symbol of purity, are traditionally associated with the iconography of the Virgin Mary and the Annunciation, thus possibly drawing a parallel between the birth of the Child and that of Maddalena's daughter, Catherine (SUBLIMIA). This is another in the retrospective *Serie Medicea*. CM

</div>

<div>

240

Antonio Francesco Selvi (1679–1753)
ELEONORA OF TOLEDO, DUCHESS OF FLORENCE
(1522–1562)
ca. 1740
Copper alloy, cast; 84.8 mm
Scher Collection; Promised gift to The Frick Collection

Obverse: Eleonora with hair up, wearing an embroidered *cuffia*, an earring and a pearl necklace, a gown, and an over-gown. Inscription: ELEONORA TOLETANA FLOR[entiæ] DVCISSA [Eleonora of Toledo, Duchess of Florence].
Reverse: A peahen protecting her chicks under her wings. Inscription: CVM PVDORE LÆTA FOECVNDITAS [Fecundity is joyful when accompanied by chastity].
Literature: V. Johnson 1975a, 73, no. 41; Langedijk 1981–87, 1: 35, no. 31; Pollard 1984–85, 2: 745, no. 392; Vannel and Toderi 1987, no. 291; Börner 1997, no. 1681; Vannel and Toderi 2003–7, 3: no. 417.

Eleonora was the wife of Cosimo I de' Medici, with whom she had eleven children. Her fertility and her role as the matriarch of the newly flourishing Medici dynasty were important aspects of her public profile. The motto on the reverse of this medal was chosen by Cosimo I himself. The medal was inspired by one conceived by Domenico Poggini in 1551, and the *impresa*, devised by Paolo Giovio, masterfully marries references to royal magnificence (the peahen is consort to the peacock, symbol of Juno, mother of the gods) and marital decorum. This is another in the retrospective *Serie Medicea*. CM

</div>

240

241

Antonio Francesco Selvi (1679–1753)

MARCO ANTONIO ZUCCHI (1696–1764)

Dated 1750

Copper alloy, cast; 89.1 mm

Scher Collection; Promised gift to The Frick Collection

Obverse: Zucchi wearing a *zucchetto* and a hooded cassock.
Inscriptions: D[ominus] M[arcus] ANT[onius] ZVCCHIVS ABBAS
VERON[ensis] VISIT[ator] GEN[eralis] CONGR[egationis] OLIVET[anæ]
[Marco Antonio Zucchi, Veronese abbott, Visitor General of the
Olivetan Congregation]; on truncation, A[ntonius] SELVIVS.
Reverse: Zucchi kneeling in front of God, who points toward a
mountain with four springs in the background. Inscriptions: EGO
IN ORE TVO [(*lit*: I will be in your mouth) I will help you find the

words; Exodus 4.12]; below, in exergue, PLAVDENTIBVS FLORENTINIS /
A[ntonius] F[ranciscus] GORIVS DEDIC[ans] AN[no] / IVB[ilare] CIƆ IƆ CC L
[From the acclaiming people of Florence, dedicated by Antonio
Francesco Gori in the year of the Jubilee 1750].

Literature: P. A. Gaetani 1761–63, 2: 411, pl. CCI, no. 3; Rizzini
1892, pt. 1, 179, no. 1172; Panvini Rosati 1968, no. 251; V. Johnson
1979, 146; Vannel and Toderi 1987, no. 216; Börner 1997, no.
1611; Voltolina 1998, 3: no. 1507; Flaten 2012, no. 116.

The Olivetan monk Marco Antonio Zucchi was famous for his ability
to improvise in verse, a talent evident in his preaching. The scholar
Antonio Francesco Gori, a numismatics expert, commissioned this
medal to celebrate the presentation of Zucchi in Florence in 1750,
where his ability as an impromptu poet was acknowledged with
great acclaim. CM

241

242

242

Antonio Lazari (first half of 18th century)
LAURA MARIA CATERINA BASSI VERATTI (1711–1778)
Dated 1732
Silver, struck; 70 mm
Scher Collection

Obverse: Bassi, laureate, wearing an earring, a dress, and an ermine cape fastened with a brooch. Inscriptions: LAVRA MAR[ia] CATH[erina] BASSI BON[oniensis] PHIL[osophiæ] DOCT[rix] COLLEG[ii] LECT[rix] PVB[lica]; continued in the field, INST[ituti] SCIEN[tiarum] SOC[ia] AN[no] XX MDCCXXXII [Laura Maria Caterina Bassi of Bologna, Doctor of Philosophy, Member of the Public College, Member of the Institute of Sciences, in her twentieth year, 1732].

Reverse: The standing figures of Minerva and a female figure representing Bassi flanking an owl resting on a globe; Minerva hands the lamp of knowledge to Bassi, who holds an open book in her left hand and a crown of laurel in her right. Inscriptions: SOLI CVI FAS VIDISSE MINERVAM [To the only one who was allowed to see Minerva]; in exergue, ANT[onius] LAZARI FEC[it] [Antonio Lazari made it].

Literature: Köhler 1729–50, 9: 56; P. A. Gaetani 1761–63, 2: 413, pl. CCII, no. 2; Gualandi 1842, 65; Morbio sale 1882, no. 4186; Rizzini 1892, pt. 1, 165, no. 1103; Forrer 1904–30, 3: 350; C. Johnson 1973, 30–34; Norris and Weber 1976, no. 170; C. Johnson 1990, 2: no. 403; Börner 1997, no. 1405a; Vannel and Toderi 2003–7, 3: no. 123.

A physicist and academic, Laura Bassi Veratti was the first woman to earn a university chair in a scientific subject, a professorship in physics at a European university, and an official teaching position at a university in Europe. She was awarded a doctorate from the University of Bologna in 1732, the third woman to achieve this distinction. She was the second woman to obtain a doctoral degree in philosophy and the first to lecture in history. Shortly after her defense to obtain her degree from the University of Bologna—made in front of a panel of academics, ecclesiastic officials, magistrates, and a large audience—she was made professor of philosophy at the university. This medal was struck to commemorate Bassi's first classes. Her research centered on electricity and Newtonian physics. CM

243

244

243

Giuseppe Broccetti (1684–1733)
FAUSTINA BORDONI (ca. 1700–1781)
Dated 1723
Copper alloy, cast; 86.1 mm
Scher Collection

Obverse: Bordoni with long hair tied with a ribbon, wearing a dress adorned with a double strand of pearls and a mantle. Inscriptions: FAVSTINA BORDONI; beneath bust, IOS[eph] BROCCETTI.
Reverse: Ulysses and his companions being charmed by the singing of a Siren. Inscriptions: QVIS TAM FERREVS VT TENEAT SE [Who is so steeled, that he can restrain himself (Juvenal, *Satires* I.32)]; in exergue, MDCCXXIII [1723].
Literature: Andorfer and Epstein 1907, no. 356; Niggl 1965, no. 380; C. Johnson 1975, 120; Vannel and Toderi 1987, no. 108; Voltolina 1998, 3: no. 1421; Avery 2000, fig. 4; Vannel and Toderi 2003–7, 3: no. 244.

Faustina Bordoni was a Venetian mezzosoprano who attained success not only in Italy but also in Vienna, Dresden, and England, where she was one of Handel's prima donnas. This medal commemorates Bordoni's performance at the Teatro della Pergola

in Florence in 1723. The reverse alludes to the sobriquet "New Siren," which the singer earned after a particularly successful performance of Pollarolo's *Ariodante* at the Teatro di San Giovanni Crisostomo in Venice in 1716. CM

244

Agostino Franchi (act. 1738–50s)
GIACOMO SORANZO (1686–1761)
Dated 1750
Copper alloy, struck; 45.1 mm
Scher Collection

Obverse: Soranzo wearing a large peruke. Inscriptions: IACOB[us] SVPERANTIVS SEN[ator] AMPLISS[imus] PATR[iæ] AMANTISS[imus] [Giacomo Soranzo, eminent senator and lover of (his) country]; signed on truncation, AF [artist's initials].
Reverse: A circular temple with personifications of Death (left), Time (right), and Fame (above); on the ground in front of the temple, books and medals. Inscriptions: CONGERIT EFFIG[ies] RES GESTAS SCRIPTA VIROR[um] INNVM[erabilium] IN LIBR[is] NVMM[orum] [He collects in numismatic books the portraits, historical accounts, and writings of innumerable men]; in exergue, DOMVS SVPERANTIA / 1750 [The house of Soranzo, 1750].
Literature: P. A. Gaetani 1761–63, 2: 384, pl. CXCIV, no. 5; Rizzini 1892, pt. 1, 180, no. 1177; Voltolina 1998, 3: 202, no. 1498.

The Venetian senator Giacomo Soranzo was an important bibliophile, whose collection of almost sixty thousand books included Antonio Vivaldi's autograph scores and notes. His collection brought him such recognition that, according to the allegory on the reverse, Soranzo's home became a Temple of Fame, a place where he would survive death and the passing of time. The allegory can also be interpreted as a reference to Soranzo's collection as a monument to antiquity. CM

245

246

245

Filippo Balugani (1734–1780)

GIACOMO GRADENIGO (1721–1796)

Dated 1777

Silver gilt, struck; 66.7 mm

Scher Collection

Obverse: Gradenigo, with hair clubbed and tied with a ribbon, wearing a jacket, a jabot, and a mantle. Inscriptions: IACOBO GRADONICO PROCONSVLI PATRI SVO [To the Proconsul Giacomo Gradenigo, his patron]; signed on the bottom of the bust, F[ilippo] BALVGANI.

Reverse: A male allegorical figure wearing a corn measure as a crown and a cloak and holding a cornucopia spilling coins; to the right, two standards, one with the Lion of St. Mark; to the left, three standards, one with the Lion of St. Mark with a sword and the arms of Gradenigo, the second with a double-headed eagle, possibly representing Albania. Inscriptions: GENIVS OBSEQVENS EXERCITVS ILLYRII [The propitious Genius of the army of the Illyrians]; in exergue, A[nno] S[alutis] MDCCLXXVII / SVI PROCONSVLATVS / TERTIO

[In the year 1777, the third of his proconsulate].

Literature: Forrer 1904–30, 1: 120; Majer 1929, 9; Noè 1984, 80–81 and 104, no. 23; Voltolina 1998, 3: no. 1625.

This medal celebrates the admirable work of Gradenigo as Provveditore Generale in Dalmatia and Albania, which at the time were part of the republic of Venice. Originally from Grad and with a long history of dedication to the security of the border territories of the Republic, the Gradenigos were one of the most important Venetian families. The figure on the reverse of this medal has been interpreted variously: Voltolina calls the figure a Tyche, who was a goddess of the prosperity of a city. The figure is wearing a *moggio* or corn measure as a crown and carries a cornucopia, a symbol of prosperity. The inscription, however, would seem to support the identification of the figure as the genius of the Albanian army and thus is an elaborate allegory of military stability and prosperity. Gradenigo inherited a richly documented catalogue of Italian medals from his brother Giovanni Agostino, a scholar. He, however, personally completed collecting the section on Venice. CM

247

Antonio Pazzaglia (ca. 1736–1815)
ABBONDIO REZZONICO (1742–1810)
Dated 1766
Copper alloy, struck; 62.5 mm
Scher Collection

Obverse: Rezzonico wearing a senator's robe. Inscriptions: ABVNDIVS REZZONICO SENATOR VRBIS [Abbondio Rezzonico, senator of the city]; signed below the bust, PAZZAGLIA.
Reverse: The personification of Rome seated above military trophies. Inscriptions: CLEMENTIS XIII P[ontificis] M[aximi] PATRVI ANNO VIII [In the eighth year of his uncle Pope Clement XIII's pontificate]; in exergue, MDCCLXVI [1766].
Literature: Museo Correr 1898, no. 87; Forrer 1904–30, 4: 440; Patrignani 1947, 21; Voltolina 1998, 3: 319, no. 1579; Klauss 2000, no. 1106; Flaten 2012, no. 128.

This medal celebrates the nomination of Abbondio Rezzonico, a member of a prominent Venetian family, to the prestigious office of senator of Rome in 1766. His nomination had been strongly backed by his uncle, Pope Clement XIII, and was celebrated with the commissioning of the present medal and of a portrait by Pompeo Batoni and his workshop (ca. 1765, The Walters Art Museum, Baltimore). CM

Giovanni Zanobio Weber (ca. 1737–ca. 1806)
INNOCENZO BUONAMICI (1691–1775)
Dated 1775
Copper alloy, cast, partially gilt; 85.8 mm
Scher Collection; Promised gift to The Frick Collection

Obverse: Buonamici wearing a *zucchetto* and a *mozzetta*. Inscriptions: CAN[onicus] INNOC[entius] BONAMICVS I[uris] V[trisque] D[octor] THEOL[ogus] AC POENITENT[iarius] ECCL[esiæ] CATH[olicæ]

PRATEN[sis] NVMISM[atum] ET VETVSTAT[um] CVLTOR EXIMIVS [Canon Innocenzo Buonamici, Doctor of both Laws, theologian and *penitenziere* of the Catholic church of Prato, fine connoisseur of coins and antiques]; on truncation, I[oannes] Z[anobius] VEBER.
Reverse: The standing goddess Minerva, draped, wearing a helmet, and holding a spear, surrounded by rocks upon which grow stalks of corn. Inscriptions: EX VIRTVTE FERTILITAS ET IN SCIENTIA REPLEBVNTVR CELLARIA [From virtue (derives) fertility, and with knowledge the pantries will be filled]; in exergue, MDCCLXXV [1775].
Literature: Vannel and Toderi 1987, no. 416.

Innocenzo Buonamici was a Pratese prelate, scholar, and collector. His collection of more than five hundred medals is described in *Musei bonamiciani pratensis brevis descriptio* (1748). CM

Giovanni Zanobio Weber (ca. 1737– ca. 1808)
MARIA MADDALENA MORELLI (1727–1800)
Dated 1776
Gilt copper alloy, cast; 79.9 mm
Scher Collection

Obverse: Morelli, laureate, wearing a low-cut gown with lace trim. Inscriptions: M[aria] MAGD[alena] MORELLI FERNANDEZ PISTOR[iensis] IN ARCAD[ia] CORILLA OLYMP[ica] [Maria Maddalena Morelli Fernandez of Pistoia, in Arcadia [called] "Corilla Olimpica"]; beneath the bust, IN CAPITOLIO CORONATA PRID[ie] KAL[endas] SEPT[embres] MDCCLXXVI [crowned on the Campidoglio on 31 August 1776].
Reverse: Warriors in feather headdresses and loincloths throwing arrows at the sun are hit by them as they fall back down. Inscriptions: QVI MALEDICVNT DIEI [(Let them curse it) that curse the day (who are ready to raise up the Leviathan); Job 3:8]; signed in exergue (incuse), I[oannes] V[eber].
Literature: Forrer 1904–30, 6: 404; C. Johnson 1973, 35–37; Norris and Weber 1976, no. 161; Vannel and Toderi 1987, no. 422.

248

A celebrated poet and improviser, Morelli was a member of the Arcadia with the name Corilla Olimpica and was awarded the highest poetic honor when she was crowned on the Campidoglio in Rome in 1776. One of the celebratory sonnets dedicated to her for the event describes the strange scene reproduced on the reverse: an allegory of "primitive" peoples who, envying the light of the sun, representing culture and wisdom, foolishly shoot arrows at it. Any insult thrown in jealousy is quick to turn against the sender, like the arrows falling back down. The message served as a warning to Morelli's enemies. CM

249

Girolamo Vassallo (1771–1819) and Franz Joseph Salwirk (1762–1820)
NAPOLEON BONAPARTE (1769–1821)
Dated 1797
Silver, struck; 47.7 mm
The Frick Collection; Gift of Stephen K. and Janie Woo Scher, 2016 (2016.2.168)

Obverse: Napoleon, with hair to the nape of his neck, partly tied in a pigtail, dressed in uniform. Inscriptions: ALL'ITALICO [To the Italian]; on truncation, H[ieronymus] VASSALLO F[ecit] [Girolamo Vassallo made it].
Reverse: The personifications of Peace, the French République, and Insubria (Milan) with a child and crops next to her feet, standing; République puts the Phrygian cap on Insubria's head. Inscriptions: L'INSUBRIA LIBERA [Insubria liberated]; on truncation, IX LUGLIO / MDCCLXXXXVII [9 July 1797]; I[oseph] S[alwirk] F[ecit] [Joseph Salwirk made it].
Literature: *Vite e ritratti* 1812–20, 1: no. viii; Millin 1819, 7, no. 17; Brockett sale 1823, no. 763; Hennin 1826, no. 793, pl. 79; Brasseux aîné 1840, 35; Julius sale 1932, no. 556.

This medal commemorates Napoleon's success in the military campaign in Italy (1794–97) and the annexation of Lombardy into the Cispadane Republic, thus forming the Cisalpine Republic on July 9, 1797. The newly constituted Cisalpine Republic extended from the Alps to Bologna and Rimini and was governed by a directory on the French model, until the formation of the Kingdom of Italy in 1861. CM

250

Luigi Manfredini (1771–1840)
GIACOMO CARRARA (1714–1796)
Dated 1796
Silver, struck; 46.1 mm
Scher Collection; Promised gift to The Frick Collection

Obverse: Carrara, hair clubbed with a ribbon. Inscriptions: IACOBVS CARRARA COMES INSTITVTOR ACADEMIAE BERGOM[ensis] AN[no] M DCC LXXXXVI [Count Giacomo Carrara, founder of the Accademia of Bergamo, 1796]; beneath truncation, L[uigi] MANFREDINI F[ecit] [Luigi Manfredini made it].
Reverse: A garland of oak leaves. Inscriptions: MINOR NE SIT FVTVRVS LABOR [May future labors be equally proficuous]; in the center, BENE MERENTI [to the well-deserving].
Literature: Voltolina 1998, 3: 566–67, no. 1779.

Count Giacomo Carrara was a patron of the arts and one of the most important art collectors in Italy during his lifetime. His rich collection of paintings was initially displayed in his family home, open to the public, but later moved to a purpose-built building, which also hosted a school of painting. Count Giacomo bequeathed not only his collection but all of his patrimony to the city of Bergamo to bring the project of the Accademia Carrara to completion. The Accademia has been continuously enriched by new acquisitions ever since. CM

251

Attributed to Petronio Tadolini (1727–1813) and Luigi Manfredini (1771–1840)
ENEA SILVIO MONTECUCCOLI CAPRARA (1631–1701)
ca. 1799
Copper alloy, struck; 67.2 mm
Scher Collection; Promised gift to The Frick Collection

Obverse: Montecuccoli, long hair clubbed with a ribbon, wearing a jacket with the cross of the Order of St. Stephen and a Maltese cross. Inscriptions: ÆNEAS MONTECVC[coli] CAPRARA AVSTRIAC[is] AGMINIB[us] PRÆFECT[us] PONTIFICII EXERCITVS DVX [Enea Montecuccoli Caprara, prefect of the Austrian troops, commander in chief of the papal army].
Reverse: The draped figure of Rome seated on trophies of war, in her left hand the cross of St. Stephen, in her right, the *palladium*.

251

Inscriptions: VIRES RESTITVIT [He restored the strengths]; in exergue, ROMAE [(Made) in Rome].

Literature: Morbio sale 1882, no. 4399; *Napoléon et son temps* 1914, no. 228; Norris and Weber 1976, no. 196; R. Martini and Turricchia 1999, 550–60.

Enea Caprara, born in Bologna, was commander in chief of the papal army during the Nine Years' War (1688–97) and held other important military positions in the Austrian army under Charles V, Duke of Lorraine. This medal was made posthumously, during the Austro-Russian occupation of Italy (1799–1800), and has been attributed to two different Bolognese medalists working in Rome: Petronio Tadolini (obv.) and Luigi Manfredini (rev.). CM

252

Giovanni Hamerani (1763–1846)
ANTONIO CANOVA (1757–1822)
Dated 1795, made 1805
Silver, struck; 54.5 mm
Scher Collection

Obverse inscriptions: ANTONIVS CANOVA SCVLPTOR [Sculptor Antonio Canova]; signed on truncation, GM [artist's initials].

Reverse: A sculpture of Psyche holding an oil lamp with her name inscribed on the pedestal. Inscriptions: HIERONYMVS IVLIANVS EQVES AMICO [Cavaliere Girolamo Zulian to his friend]; in exergue, MDCCXCV [1795].

Literature: Wurzbach-Tannenberg 1943, 1: no. 1194; C. Johnson 1981, 24–26; C. Johnson 1990, 2: no. 347; Voltolina 1998, 3: no. 1763.

Canova was one of the greatest artists of the neoclassical period. As a token of his gratitude to his friend Girolamo Zulian, the Venetian ambassador in Rome, he modeled a sculpture of Psyche. Zulian had helped Canova during his stay in the city and commissioned this medal from Hamerani to celebrate the gift. A series of unfortunate events, however, occurred following Zulian's death, and the statue was eventually sold to Napoleon. Only three silver and several copper medals of this type were struck in 1805 from Hamerani's model by Giannantonio Selva, making this medal one of the three rare examples. The medal has in the past been erroneously attributed to Giovanni's brother Gioacchino (see, for example, C. Johnson 1981). CM

252

253

19TH CENTURY

253

Francesco Putinati (1775–ca. 1853)
ANTONIO CANOVA (1757–1822)
ca. 1823
Copper alloy, struck; 34.1 mm
Scher Collection

Obverse inscriptions: ANTONIO CANOVA; on truncation, PVTINATI.
Reverse: A serpent biting its tail (*ouroboros*), Hermes's winged hat (*petasos*) above, and the head of Minerva below. Inscription: AL SECOLO DECIMO NONO [To the nineteenth century].
Literature: Bianchi 1881, 152; Corsi 1891, no. 5250 (with PUTINATI F.); Rizzini 1892, pt. 2, 162, nos. 213–16; Forrer 1904–30, 4: 711; Eidlitz 1927, no. 209; *Sculpture in Miniature* 1969, no. 319; Camozzi–Vertova 1970, no. 340 [with PUTINATI F.]; Norris and Weber 1976, no. 221 (with PUTINATI F.); C. Johnson 1981, 40, fig. 30 (with PUTINATI F.); R. Martini and Turricchia 1999, no. 2016; Klauss 2000, nos. 1117, 1118; Flaten 2012, no. 194 (with PUTINATI F.).

The sculptor Antonio Canova is considered one of the greatest artists of his time. This medal was made shortly after his death in 1822. The profile portrait on the obverse is classically modeled and was probably copied by Putinati from the artist's self-portrait in Possagno (Tempio Canoviano). The *ouroboros* and the inscription on the reverse allude to Canova's eternal fame. CM

254

Giuseppe Malavasi (d. 1855)
MARIA BEATRICE VITTORIA GIUSEPPINA OF SAVOY, DUCHESS OF MODENA AND REGGIO (1792–1840)
Dated 1840
Copper alloy, cast; 81.4 mm
Scher Collection

Obverse: Maria Beatrice Vittoria with hair tied up and wearing a diadem, a gown, two strings of pearls, and a pendant with a cross; under the bust, two olive branches intertwined with roses. Inscriptions: MARIA BEATRIX VICTORIA SABAVD[a] ATEST[ina] ARC[hiducissa] AVST[riaca] DVC[issa] M[utinæ] R[eggii] M[irandolæ] M[assæ] C[arrariæ] &[et cetera] [Maria Beatrice Vittoria of Savoy and Este, Archduchess of Austria, Duchess of Modena, Reggio, Mirandola and Massa Carrara, et cetera]; beneath the bust, MDCCCXXXX [1840].
Reverse: A woman kneeling down in prayer in a room with two servants. Inscriptions: in exergue, NVNQVAM LAETATA NISI IN TE / DOMINE DEVS [Never joyful unless in you, O Lord (Esther XIV:18)]; on the border of the room's floor (incuse), left, G[?] G[?]; right, L[?] M[?].
Literature: Comandini 1900–42, 3: 905; Boccolari 1987, no. 244.

Maria Beatrice Vittoria was the daughter of Vittorio Emanuele I of Savoy, King of Sardinia, and Maria Theresia, Archduchess of Austria-Este. She was married to Francesco IV, Duke of Modena. This medal was conceived by Malavasi to commemorate her early death from a heart condition in 1840. CM

255

Ignazio Bianchi (act. 1848–69)
POPE PIUS IX (b. 1792; r. 1846–78)
Dated 1854
Copper alloy, struck; 82.1 mm
Scher Collection

254

158 ITALY

255

Obverse: Pius wearing a *zucchetto* and papal *mozzetta* with an orphrey decorated with an allegorical figure of faith. Inscriptions: PIVS IX PONT[ifex] MAX[imus] [Pope Pius IX]; beneath the bust, I[gnatius] BIANCHI F[ecit] [Ignazio Bianchi made it].

Reverse: The interior of the Basilica of St. Paul Outside the Walls in Rome, with a view of the central nave and the *baldacchino* by Luigi Poletti (now destroyed), with Arnolfo di Cambio's *ciborio*. Inscriptions: PIVS IX P[ontifex] M[aximus] BASILICAM PAVLI APOST[oli] AB INCENDIO REFECTAM SOLEMNI RITV CONSECRAVIT IV ID[as] DEC[embris] MDCCCLIV [Pope Pius IX consecrated the Basilica of San Paolo Apostolo, restored after the fire, with a solemn rite on the 4th day of the Ides of December, 1854]; signed in exergue, I[gnatius] BIANCHI F[ecit]; AL[oisius] POLETTI ARCH[itectus] INV[enit] [Ignazio Bianchi made it; Luigi Poletti, architect, designed it].

Literature: Mazio 1884, no. 780; Forrer 1904–30, 1: 184; Martinori 1917–22, 22: no. 138; Patrignani 1947, 81; Bartolotti 1971, no. 6; Norris and Weber 1976, no. 216; Bartolotti 1988, 136, IX.25/a (as by Giuseppe Bianchi).

Pope Pius IX (born Giovanni Maria Mastai Ferretti) is the longest reigning pope in the history of the Roman Catholic Church. This medal celebrates his re-consecration of the Basilica of St. Paul Outside the Walls on September 10, 1854. The basilica, one of the most important for the Catholic Church, is the second largest papal basilica after St. Peter's. Destroyed in a fire in 1823, the building was rebuilt during the nineteenth century following the designs of architect Luigi Poletti (1792–1869). CM

A HANDY MIRROR FOR PRINCES AND CITIZENS

The Rise and Dissemination of Medals in Germany

Martin Hirsch

During the sixteenth century, the German designation for those who produced medals was typically *conterfetter*, a term that could be understood to mean "portraitist."[1] It took a surprisingly long time for the word *medailleur* to appear in historical documents. In Italy, in a letter of 1559, *medaglista* could mean the man who produces medals or simply an expert or collector in this medium.[2] Its meaning was closer to that of an artist's title in the later use of the word under Pope Sixtus V (1585–1590), whose privileges speak of *medallari*.[3] In Germany, not until the appearance of printed portraits of masters like Raimund Faltz from 1704 (fig. 16) and Peter Paul Werner (ca. 1740) do we find the term *medailleur*;[4] furthermore, the designation *medailleur* is mentioned in Johann Gröning's *Historia numismatico-critica* of 1705.[5] Gröning and Johann Christoph Gatterer after him are among the German researchers whose treatises established a theory of medals.[6] The texts not only explained the value of studying medals but also introduced rules for their production to instruct both artists and collectors. On the other hand, little distinction seems to have been made between medals and coins in general speech. Therefore, it is still possible to read in the chapter on the die-cutter's art in Paul von Stetten's 1779 history of the arts in Augsburg that the designation *medailleur* is a new term for those formerly called die-cutters or embossers.[7]

THE BEGINNINGS OF THE ART OF THE MEDAL

Initially commissioned by princes, medals in Germany first appeared after 1500. Over the course of the sixteenth century, orders from the public led to them being produced in greater numbers. The surviving body of sixteenth-century medals encompasses almost forty-six hundred individual works, and, accounting for copies, the total number of examples can be estimated to be at least twenty-five thousand to thirty thousand.[8] Thus, already in the first century of its existence, the medal was one of the most important mediums for portraits in Germany.

It is difficult to assess how Italian medals influenced the German medal in the sixteenth century. If one takes as the touchstone the medal of the scholar Johannes Stabius, created sometime before 1518 (no. 265), numerous similarities can be discerned.[9] The

design speaks to a tradition cultivated in Italy, in which poets were celebrated with the honorific title *poeta laureatus*. Stabius's medal, conceived as a work of praise for a poet, shows the heritage of the humanistic culture of Italy. The medal of the court historiographer of Emperor Maximilian I appears also to have followed Italian tendencies in that it began as a wax model. This is suggested by the fluid modeling, evident, for instance, in the drapery. The use of wax models occurs multiple times in the Nuremberg workshop of the Vischer family but remains the exception in Germany, where stone or wood models were generally preferred. The Stabius medal, with its beautiful bronze patina, would fit well in a collection of Italian medals. With its finely modeled nose and eyes, it probably originated in preparatory drawings by Dürer, who had traveled in Italy. On the other hand, the medal also displays certain "un-Italian" characteristics, such as the exaggerated size of the bust. The artist moreover emphasizes the many individual hairs and long locks of the beard, and the ribbons of the poet's crown flutter in agitation. All these qualities originate in the medals of Germany, not Italy.

Ideas about the "origins" of German medals tend not to take into account the degree to which the conditions for medal production differed from region to region in the many parts of the country. Friedrich Hagenauer and Christoph Weiditz, two of the best artists of the first generation of medalists, appear to have come from a family of sculptors from the Upper Rhine that was ruined by the diminishing number of church commissions during the Reformation and thus re-oriented itself around new artistic tasks.[10] To trace the influences on their art, one should look more to the family workshop than to Italy. Evidence for this comes in the form of Niklas Hagenauer's carved portrait of Jean d'Orliac (fig. 17), a kneeling patron figure in the central section of the Isenheim Altarpiece, which has been described as a "precursor to the material and theretofore somewhat dry medal portrait" by Niklas's presumed son, Friedrich Hagenauer (fig. 18).[11] One could say that Hagenauer availed himself of a medium that originated in Italy, but his artistic style grew from a workshop of the Upper Rhine. Local impulses also nourished the art of the medal. This was not only due to the distinct characteristics of portraiture in Italy and Germany; the even greater difference lay in the fact that in sixteenth-century Germany, the reverse sides of medals seldom displayed emblems or inscriptions. The medal was regarded in Germany primarily as a portrait medium and was less often used as an emblematic object.

In the early years of the art of the medal, we can recognize approaches that will not continue with the rise of the cast medal in the later history of the genre. Between 1504 and 1519, Maximilian I von Hapsburg ordered impressions from his technologically and

Fig. 18 Friedrich Hagenauer,
*Relief Portrait of Philipps von
der Pfalz*, 1525–27
Limewood, 58.5 × 41.3 cm
Staatliche Museen,
Skulpturensammlung, Berlin

artistically advanced mint in Tirol to be used as gifts. Because they, in many respects, do not follow the model of coins, they are to be regarded as medals (no. 258).[12] These large and costly struck objects are nevertheless technically different from the newly introduced *taler*. Another early aspect of the art of the medal is represented by three medals made in the Nuremberg workshop of the Vischer family by Peter Vischer the Younger and his brother Hermann sometime after 1507. Their manner of modeling and representation align themselves with the Italian art of medal production,[13] but they did not make a lasting impression. It was another ten years before Hans Schwarz created a series of medals for a number of participants in the Augsburg Reichstag of 1518. Together with medals completed shortly before in Augsburg and afterward in Nuremberg and for the 1521 Reichstag in Worms, this group represents the first big wave of medal production in Germany. The Reichstag medals of 1518, in particular, have been repeatedly identified as the beginnings of medallic art in Germany, and the importance of the Reichstag as an appropriate place for the distribution of medals has been frequently underscored.[14] Meetings of the Reichstag offered especially good possibilities for generating commissions, and it was indeed during these conferences that a great number of the portraits of the early modern period were created. There is evidence that various masters traveled to the Reichstag, for instance, Matthes Gebel, who traveled to meetings in Speyer in 1529 and in Augsburg in 1530.[15]

Another important year for the development of the medal in Germany is 1525, when Christoph Weiditz and Friedrich Hagenauer began their careers in Augsburg and Munich,

respectively. Between 1525 and 1527, there also emerged in Nuremberg a group of medals that still lack definitive attribution (see nos. 261–264). From 1525 on, the production of medals continued, and similar patterns of manufacture emerged, in which artists typically cast medals after models prepared in stone or wood. Augsburg and Nuremberg became the most important centers of production: workshops in Saxony followed. Cities such as Strasbourg, Heidelberg, Munich, and Vienna meanwhile yielded a smaller number of medals. There is little evidence of centers of medal production in northern Germany during the sixteenth century.[16] Saxony and the Erzgebirge played an exceptional role, and while medalists in Augsburg and Nuremberg depended on commissions, the medalists in the Erzgebirge independently made medals that courted collectors and commemorated religious holidays.[17] The medals also depicted many other images in addition to portraits, ranging from religious to ancient subjects, as well as mythological images that refer to recent events such as the Battle of Mühlberg (April 24, 1547). The medals also functioned as a form of propaganda in the clash between Protestants and Catholics, largely promoting the views of Luther through satirical images of the Catholic clergy.[18]

As in Italy, the production of medals in Germany did not count among the crafts regulated by the artisanal guilds. Master medalists rather appear to have pursued independent training and could work on commission for princely patrons or practice in the cities. In some cities, records of conflicts between medalists and the guilds survive. Friedrich Hagenauer and Christoph Weiditz of Augsburg had to negotiate with the local sculptors' and goldsmiths' guilds in 1530 and 1538.[19] In 1534, Matthes Gebel of Nuremberg was forced to cast his medals or portraits according to the rules of the goldsmiths.[20] In 1547, Leipzig medalist Hans Reinhart even had to retroactively complete training as a goldsmith.[21] His Trinity medal of 1544 (no. 310) attests to his ambition to connect the art of the goldsmith to that of the medalist. The production of medals was intimately connected with the current economic climate. Only in exceptional cases were workshops passed from the older to the younger generation, for example, in the Maler and Abondio families. Matthes Gebel, who created about three hundred fifty medals in Nuremberg over nearly thirty years, between 1526 and 1555, and is certainly the most productive German medalist of the Renaissance, presents a notable instance of continuity (see nos. 270–284).[22]

The ability to create multiple casts or impressions of a medal made it possible to disseminate the works, whether within family, society, or in the context of diplomacy. Commission statistics are known in some cases. In 1533, the Nuremberger Christoph Scheurl ordered five examples of a medal that shows him and his wife Katharina, as well as two casts of a medal five years older than the previous example that depicts Christoph's brother.[23] Evidently, the model or mold was kept so that later orders were possible. Meanwhile, about one hundred fifty medals were created in 1519 for Frederick the Wise, Elector of Saxony, which he distributed at the Reichstag in Frankfurt in the same year. This was the Reichstag to which Frederick traveled in the hope of being elected king of Germany.[24] The vote nevertheless went to Charles V, for whom more than two hundred fifty different medals were created throughout his lifetime, compositions that were in turn allowed to be reproduced (no. 309).[25] A comparison of these statistics suggests that the scale of medal production approximates the relative influence and power of those who commissioned the works.

MEANS OF DISSEMINATION

Medals were used in the context of political events and also to commemorate the ceremonial entry of the emperor in some cities, as attested to by the Nuremberg medal from 1527 dedicated to Charles V.[26] Medals were even used as hostile political gifts. It was in this spirit that Emperor Maximilian I ordered gold and silver medals to be sent to the council of the belligerent Venetian Republic on the eve of the great Venetian War (1508–16). With this gift, we can even observe the appropriate gradation of materials—gold was used for the doge and silver for the members of the Signoria.[27] Of course, the gift of a medal more typically involved a positive instance of recognition or friendship. Individual medals that bore a particular meaning for their owners were outfitted with loops and worn on chains, a practice that gave rise during the later sixteenth century to courtly *Gnadenpfennige*, which were outfitted with costly gold plating.[28] There is also evidence of the mutual exchange of medals between learned figures such as Willibald Pirckheimer (1471–1531) and Erasmus of Rotterdam.[29] Goblets decorated with medals of individual family members, such as the lidded bowl of the Pfinzing[30] at the Germanisches Nationalmuseum in Nuremberg, provide evidence that medals were also used as monuments to family history. Cardinal Albrecht of Brandenburg selected a medal to decorate the lid of his sarcophagus,[31] a case in which the medium no longer functions solely as a messenger among contemporaries but is dedicated to preserving Albrecht's eternal memory (no. 263).

During the sixteenth century, medal collecting took place in princely, bourgeois, and learned circles and was predominantly associated with the accumulation of antique coins.[32] Some sources, such as records of the collections of the princes and aristocrats of Tettnang am Bodensee,[33] Neuburg an der Donau,[34] Munich,[35] and Saxony,[36] attest to the collection of medals. As in the early history of coin collecting, it has been observed that humanists began collecting medals before aristocrats did.[37] We can point to the learned burgher circles of Basel,[38] Nuremberg,[39] and Augsburg[40] as examples. The Augsburg scholar and imperial advisor Conrad Peutinger (1465–1547) (no. 256) is known to have possessed modern medals.[41] The fact that the evidentiary qualities of medals were appreciated in a manner similar to those of antique coins comes to the fore in a letter to a member of the clergy that Peutinger composed in 1509. In it, he informs the addressee that a portrait of Pope Julius II was badly painted because the facial qualities departed from those of coins and medals depicting him.[42]

The inventory produced fifty years after Peutinger's death gives only a vague indication of how early medal collections looked. Peutinger stored his medals not in large cabinets but in multiple small casks, bags, tureens, and boxes. The inventory summarily lists objects like a "cast penny" or a "cast" and is arranged according to metal. Some medals in Peutinger's possession were identified by name, including those with portraits of the emperor Charles V and Erasmus of Rotterdam.[43] Furniture made specifically for storing coins seems to have been rare. Pirckheimer's inventory of possessions nevertheless mentions an ark with more than one hundred compartments.[44] In the Augsburg house of Octavian Secundus Fugger (1549–1600), there is evidence of medals that were collected by succeeding generations of the Fugger family, including Italian medals of the fifteenth century, papal medals, and casts after medals of the Hapsburgs and Wittelsbachs.[45] From the 1560s on, collections of medals in furniture specifically created for that purpose occur more frequently.[46] In 1588,

Fig. 19 Coin cabinet of Basilius
Amerbach with medal in
open shelf showing Erasmus
of Rotterdam, ca. 1578–81
Historisches Museum, Basel

Octavian Secundus Fugger ordered an Augsburg furniture-maker to create a "writing desk"
with more than sixteen hundred compartments, and he kept many of his modern medals
in chests and drawers specifically outfitted for that purpose.[47] The most famous surviving
coin cabinet is the closet of Basilius Amerbach at the Historisches Museum in Basel. In the
center of one tray, the impression of a medal of Erasmus of Rotterdam is still recognizable,
indicating that it was a particularly treasured object (fig. 19).[48] It is therefore likely that in
many cases a "medal was never alone"[49] but rather was viewed and judged in comparison
to other medals. The step from stashing medals in small containers to keeping them in
furniture specifically designed for that use can be pragmatically explained as a result of the
need to store an ever-growing number of objects. We can additionally recognize attempts
to create an ordering system and even the wish to preserve a precious collection in an
appropriate, and indeed representative, cabinet.

DEVELOPMENTS AFTER 1600

In tracing the creation of medals after the year 1600, certain gaps become evident in the first half of the seventeenth century. It has been rightly observed that the medallic art, because of the effects of the Thirty Years' War (1618–48), experienced something of a slump during that period.[50] Most notable is the interruption triggered by the decline of the bourgeoisie as commissioners of medals. As a result, the German medal was reduced to being an object solely for the princely patrons. Hardly any medalist could maintain the productivity of the medalists of the sixteenth century, whose oeuvre sometimes included two or three hundred works. The dominance of the princely medal at this time offers a possible explanation for the eclipsing of the cast medal by the struck or embossed medal. Aristocrats seem to have found the striking technique more convenient because they could employ it in the context of their mints and therefore strike larger numbers of medals. Sebastian Dadler (nos. 376–395), who was employed at the electoral court of Dresden between 1623 and 1632, can be regarded as the most important exponent of this procedure in the first half of the century. His pictorial inventions, above all in medals commemorating events, dominate heretofore unexplored realms. Sweeping landscapes, cityscapes, and even fantastic scenes occur in his work (no. 387). That he is to be regarded as a major master is not only the judgment of modern researchers.[51] Already in the medal literature of the eighteenth century, Dadler's reputation had reached surprising heights. In his text on the famous medalists and coin-masters, Johann Ludwig Ammon wrote that Dadler was "a very artful medalist" whose works "are regarded as rare cabinet pieces."[52] His life was nevertheless difficult, as he was forced to seek work in various cities.

Dadler's record of commissions offers rich insights into his status as an artist.[53] His work was not limited to the production of medals, and he is therefore considered not a medalist but rather a goldsmith, as well as an artist. One can read in the documents that Dadler would create "beautiful, artful things" for the elector, including chased works in silver and gold. He would "model" and "depict" and indeed do all else entailed in his "learned art." He was additionally required to evaluate and appraise the worth of works by other artists and artisans.[54]

That a medalist's daily work would encompass a variety of tasks was a widespread phenomenon. Christoph Weiditz, for example, was simultaneously active as a goldsmith and a sculptor of small-scale works.[55] Sometimes, the medalist was called upon by his patron for judgments in questions of art, which recalls similar cases among Italian medalists.[56] Documents from the later sixteenth century indicate how much princes valued the activities of the medalist. Emperor Rudolf II wooed Antonio Abondio to his court in Prague in the 1570s. The late seventeenth-century art writer Joachim von Sandrart, who described the great German medal collections,[57] praised Abondio's skills in wax modeling.[58] Rudolf II also allowed unauthorized persons to create copies of medals by Valentin Maler in 1588,[59] and the Saxon Elector Christian I ordered the same Valentin Maler to teach an apprentice "image-making, the art of depicting, and seal and iron-cutting"—further evidence of the princely appreciation for medalists.[60] It is likely that Maler's talent for creating portrait medals with three-quarter profiles caught Christian's attention, as this type of medal had become fashionable during that period. Some masters became sought-after artists who simultaneously attracted the interest of many different courts.

In the seventeenth century, we can also observe how Augsburg and Nuremberg medalists such as Philipp Heinrich Müller and Georg Hautsch created medals with imperial themes, such as dynastic events or military victories. They did not, however, make these medals for the imperial court but rather acted as freelance artists, peddling their inventions to publishers such as Georg Friedrich Nürnberger and Caspar Gottlieb Lauffer, who procured the designs for both the imperial court and a broader customer base.[61] The productive Christian Wermuth assumed an active entrepreneurial role. With his famous 1698 sales list, he was probably the first medalist in Europe who offered his works to large numbers of customers.[62] His medals could be purchased at the Leipzig trade fair or through agents in different cities in Germany, as well as in distant centers such as Breslau or Amsterdam.

In these decades, we see the emergence of an international style. For the first time in the history of the genre, it is not always possible to determine at first glance if a medal is German, Italian, or French. Artists such as Ehrenreich Hannibal and Johann Carl Hedlinger, who were active across international borders and formed schools at different courts, also promoted the tendency to internationalization. This phenomenon was additionally supported by the continuing development of striking technologies, which created a certain uniformity among medals. It is also evident that the medals of King Louis XIV of France[63] offered Europe a point of reference for medalists across the continent.[64]

After 1700, burghers again emerged as the more prominent patrons. The medal served as one of the most important media for representing sovereignty at the great courts in Vienna[65] and now also Berlin.[66] The emperors Joseph I and Charles VI ordered Carl Gustav Heraeus to maintain and describe the Viennese medal collection, which resulted in the medals becoming more widely known as a monument to the imperial house. In the later eighteenth century, Anton Franz Widemann would become a chronicler of the Hapsburg monarchy.[67] This master, who came from Bohemia and was active between 1769 and 1778 as the main engraver at the imperial mint in Vienna, created few war medals but rather a great number of wedding medals, including one for Marie Antoinette (no. 457). The work shows the Hapsburg political program pursued under the empress Maria Theresia, whereby Hapsburg power in Europe was consolidated through strategic dynastic marriages. The approximately one dozen wedding medals by Widemann reflect the importance of family ties at court (see, for example, no. 450). During the eighteenth century, masters such as Johann Carl Hedlinger[68] and Franz Andreas Schega also developed the art of the medal portrait in other courts, creating scintillating effects in the Baroque portrait bust (no. 445).[69] A larger range of medals than ever before now represented academies and other institutions. The technology of the struck medal dominated well into the nineteenth century, when it was overshadowed in part by the example of French medals and in part as a result of the rediscovery of the beauty of Renaissance medals, which brought the cast medal to prominence again.

Notes

1 For instance, the Nuremberg chronicler Johann Neudörffer calls Hans Schwarz "the best portraitist" of his time; see Wolfgang and Lochner 1875, 124.
2 See Pfisterer 2017, 138–39.
3 In his *privilegium Pontificis*, Sixtus V extended the right to produce medals with his image to certain *medallari*; see Alteri 2004, 94. Similar designations are encountered more often in Italy during the seventeenth century, for instance, *medagliaro* and *medaglieri* in Rome about 1619; see Simonato 2008, 72, 94. In older Italian art literature—for instance, in the work of Giorgio Vasari—the professional title of medalist is nevertheless absent; see Attwood 2003, 15.
4 Steguweit 2015, esp. 416–17.
5 Gröning 1705, 90.
6 Gatterer 1767. Michel Pastoureau composed a critical methodology for the study of medals; see Pastoureau 1988. On the development of early research on medals, see Pfisterer 2008, 129–203; for research in Germany, see esp. 191–93.
7 Stetten 1779, 498.
8 On the estimation of these statistics, see Grotemeyer 1957, 14; Maué 2000, 3. The basis for all research on the sixteenth century is Habich 1929–34. In the Staatliche Münzsammlung, Munich, there is additionally a corpus of about 1,000 plaster casts and a catalogue card index by Habich on German portrait medals of the Renaissance that could not be attributed to any master. Habich declined to publish this information. Additional research includes Trusted 1990; Scher 1994, 201–303; J. C. Smith 1994; Volz and Jokisch 2008; Cupperi et al. 2013.
9 Cupperi et al. 2013, 202, no. 101.
10 M. Hirsch 2013b, 49–50.
11 Habich 1929–34, 2: 1, pl. CIX.
12 Winter (Heinz) 2009, 13.
13 Cupperi et al. 2013, 154–55, no. 59.
14 Maué 2000, 3; Kranz 2013, 187.
15 Cupperi et al. 2013, 324.
16 Cupperi 2013.
17 Maué 2013, 72–74.
18 Katz 1932.
19 On Hagenauer, see Cupperi et al. 2013, 325, 335.
20 Habich 1929–34, 1: 2, 140.
21 Cupperi et al. 2013, 330–31.
22 Habich 1929–34, 1: 2, 140.
23 Maué 1986, 107.
24 Grotemeyer 1970, 155.
25 Grotemeyer 1957, 13.
26 Cupperi et al. 2013, 201–2, no. 100.
27 Egg 1971, 39, 156, no. 12; Cupperi et al. 2013, 136, no. 40.
28 Börner 1971.
29 Mende 1983, 30; J. C. Smith 1994, 323.
30 Cupperi et al. 2013, 142–43, no. 51a.
31 M. Hirsch 2013a, 129.
32 Pfisterer 2013b, esp. 298.
33 On the art room of Count Ulrich von Montfort, see ibid., 298.
34 Kirch 2017, 107–19.
35 Diemer 2008; M. Hirsch 2013b, 56.
36 On Degenhardt Pfeffinger, see Westphal 2012; Cupperi et al. 2013, 302–3, no. 218.
37 Maué 1982, 199.
38 Matzke 2013.
39 Maué 1982, 199; see also Maué 1994.
40 The earliest evidence of this phenomenon in Germany are the casts after Pisanello sent to Augsburg in 1459; see Kranz 2004, esp. 302.
41 Ibid., 305–6.
42 Konrad Peutinger, letter to Abbot Johann Mayer von Ummendorf von Weissenhorn. See König 1914, 67, 115; Cupperi et al. 2013, 101.
43 Kranz 2004, 305.
44 Maué 1982, 199.
45 Kranz 2004, 308.
46 Kaiser Maximilian II had cabinets for antique coins at his disposal; see Sauerländer 2008, 355–56. Coin cabinets from Archduke Ferdinand von Tirol, which are mentioned in the 1596 inventory of Schloss Ambras, still survive; see Maué 1982, 200. The Nuremberger Johann Michael Dilherr possessed a coin cabinet datable to about 1570/80; see Maué 1982, 200, no. 305, ill. p. 187; Pfisterer 2013b, 298.
47 Kranz 2004, 311.
48 Ackermann 1992, 55.
49 Pastoureau 1988, 247.
50 Arnold 2000, 15.
51 Maué 2000, 43.
52 Quoted in Maué 2008, 9. See Ammon 1778, 19, no. 33.
53 Maué 2008, 16, no. 188.
54 Ibid., 16.
55 Cupperi et al. 2013, 334–35.
56 We know, for example, that Gaspare Mola served as an art agent. See Bertolotti 1877a, esp. 298, 310.
57 Maué 1982, 201.
58 M. Hirsch 2013b, 47.
59 Cupperi et al. 2013, 328.
60 Ibid.
61 Winter (Heinz) 2009, 21–22.
62 Wohlfahrt 1992, 26.
63 Ziegler 2010.
64 Johann David Köhler stresses the significance of the Royal Academy in Paris for medal design; see Köhler 1745, XXII–XXV. On French medals as models for those of Emperor Charles VI and the coin and antiquities expert Carl Gustav Heraeus, see Winter (Heinz) 2009, 23–24. On this topic in general, see Loskoutoff 2016.
65 Loskoutoff 2016, 24–31.
66 Steguweit and Kluge 2008.
67 Winter (Heinz) 2009, 26.
68 Felder 1978.
69 Grotemeyer 1971.

256

257

256

Hans Schwarz (ca. 1492–after 1527)
CONRAD PEUTINGER (1465–1547)
ca. 1517–18
Lead, cast; 83.1 mm
The Frick Collection; Gift of Stephen K. and Janie Woo Scher, 2016
(2016.2.98)

Obverse: Peutinger all'antica. Inscription: CHVONRADI PEVTINGER
IVRIS CONSVLTI AETAT[is] LII [(Image of) Conrad Peutinger, lawyer, aged
52].
Literature: Habich 1929–34, 1: pt. 1, no. 111; Pollard 2007, 2: no.
683; Cupperi et al. 2013, 100, no. 4.

Peutinger, one of the most important German humanists, was in
contact with Giovanni Pico della Mirandola and Pomponius Letus.
This medal, produced in Augsburg, was Schwarz's earliest work and
led to commissions for twenty-five additional medals. ADC

257

Hans Schwarz (ca. 1492–after 1527)
MARTIN TUCHER (1460–1528)
1519
Copper alloy, cast; 56.3 mm
Scher Collection

Obverse: Bust with hairnet and hat. Inscription: MARTINVS TVECHE LIX
IAR ALT [Martin Tucher, aged 59].
Literature: Will 1764–67, 3: 161; Erman 1884, 22; Habich 1906, 60;
Lanna sale 1911b, no. 912; Habich 1929–34, 1: pt. 1, no. 161 (table
23, fig. 3 for this variant); Kastenholz 2006, 48, no. 50b.

Schwarz's medallic portrait of Martin Tucher, a patrician of
Nuremberg, is preserved in a wood version (Staatliche Museen,
Münzkabinett, Berlin; with a later label dating it to 1519) and in two
metal types. According to Kastenholz, the latter could be aftercasts of

a lost medal replicated with significant epigraphic changes. In fact,
the example reproduced by Will in 1766 has an obverse inscription,
SIC VOLVITVR AETAS, that is missing in the present version. A
manuscript note by Schwarz referring to the sitter ("Martein Tucher
LIX Iar alt. / [1]519") can be read on the reverse of a drawing that
the sculptor made in Nuremberg (Staatsbibliothek, Bamberg, inv.
no. IA50: Kastenholz 2006, no. 153). However, it is unclear if this
inscription can be referred to a lost preparatory drawing for Tucher's
medal or whether the latter was made on a specific occasion. WaC

258

Benedikt Burkhart (act. 1496–1508)
MAXIMILIAN I OF HAPSBURG, HOLY ROMAN EMPEROR
(b. 1459; r. 1508–19)
Dated 1505
Silver, struck; 44.8 mm, 36.9 g (*Schauguldiner* coin)
Scher Collection

Obverse: Bust with royal crown, armor, sword, and scepter.
Inscription: MAXIMILIANVS DEI GRA[tia] ROMANOR[um] REX SEMPER
AVGVSTVS [Maximilian, by the grace of God, King of the Romans,
Forever August].
Reverse: Coat of arms of Maximilian as King of the Romans,
surrounded by the collar of the Order of the Golden Fleece and
the coats of arms of Hungary, Burgundy, Jerusalem, and Austria.
Inscriptions: XRIA [Christianorum] REGNOR[um] REX HERS[cher?] Q[ue?]
ARCHIDVX AVSTR[ia]E PLVRIMAR[um]Q[ue] EVROP[æ] PROVICIAR[um]
P[ri]N[cep]S DVX ET D[ominus] [King and Sovereign of the Christian
Kingdoms, Archduke of Austria, and Prince, Duke, and Lord of
several provinces of Europe]; in the field, 1505.
Literature: Egg 1971, no. 2 (var.); Moser and Tursky 1977, 1: fig. 78;
Winter (Heinz) 2009, no. 8; Hall sale 2010, no. 2412.

Double *Schauguldiner* were coins of high nominal value issued from
1504 onward. Their name comes from their resemblance to the silver
coins called *Guldiner*; yet, unlike the latter, *Schauguldiner* were
only occasionally multiples of ordinary coins as far as their weight is
concerned. Moreover, their coinage was considered an extraordinary
activity and was not registered in the ordinary account books of
the mint. These circumstances suggest that double *Schauguldiner*
like the present one were not intended as a means of payment but

258

259

rather as precious portraits that Maximilian could use in different ways, including donation and hoarding. Their large size facilitated the depiction of fine portraits and complex coats of arms such as the ones represented here. Later *Schauguldiner* were struck on specific occasions that were referred to through their inscriptions and imagery; the present type, however, cannot be traced to a particular event. WAC

received the dies and had further specimens struck. Although the surviving specimens correspond to the weight of one or two "gulden Grosschen," they were not meant to be used as common currency. According to Georg Burkhardt Spalatin's *Life of Frederick the Wise*, the duke distributed such "outstanding portrait gold and silver coins within and without the Imperial Diets," as well as "to learned men, also outside the country" (1851, 32). WAC

259

Ulrich Ursenthaler (1482–1562)
FRIEDRICH III OF WETTIN, CALLED THE WISE (b. 1493;
Prince Elector of Saxony 1486–1525)
1512
Silver, struck; 47.9 mm, 28.8 g (one-*Gulden* coin)
Scher Collection

Obverse: Friedrich with hairnet; the inscription is punctuated by two shields bearing the coats of arms of Saxony (respectively, with electoral swords and with rue) and another two with the coat of arms of Meissen and Thüringen (with lion reversed). Inscriptions: FRID[ericus] DVX SAX[oniæ] ELECT[or] IMPER[ialis]QVE LOCVM TENE[n]S GENERA[lis] [Friedrich, Duke of Saxony, Elector and Imperial Lieutenant General]; on the cuirass, I[e]H[su]S MARIA [Jesus, Mary].
Reverse: Single-headed eagle with Austrian-Burgundian arms on the breast. Inscription: MAXIMILIANVS ROMANORVM REX SEMPER AVGVST[us] [Maximilian, King of the Romans, Forever August].
Literature: Tentzel 1714, *Ern.*, table 3, no. I; Domanig 1907, 8, no. 34; Lanna sale 1911b, nos. 848, 849; Habich 1929–34, 1: pt. 2, fig. 80; Bernhart 1934a, 260, fig. 3; Grotemeyer 1970, no. 5; J. S. Davenport 1979, no. 9699; Meister & Sonntag 2004, no. 2411.

On August 8, 1507, Friedrich III assumed the rule of the German territories of the empire on behalf of Maximilian I, who planned to travel to Italy. The concession of the title of Imperial Lieutenant General, which Friedrich retained, was commemorated through several emissions. In 1508, Lucas Cranach the Elder (ca. 1472–1553) carved a stone model to which all the cast and struck circular portraits made on this occasion had to conform. The dies for the present type were commissioned from Ulrich Ursenthaler, "die-engraver of his Imperial Majesty in Innsbruck," in 1512 (R. Bruck 1903, 328). The emperor paid for the die-cutting and ordered several "Pfennige" in gold and silver for himself, which were struck in Hall (Tirol: Schönherr 1884, nos. 1062 and 1065). Subsequently, Friedrich

260

Ulrich Ursenthaler (1482–1562)
CARDINAL MATTHÄUS LANG VON WELLENBURG
(1469–1540; Prince-Archbishop of Salzburg from 1519)
Dated 1521
Silver, struck; 47.5 mm, 54.5 g (two-*Guldiner* coin)
Scher Collection

Obverse: Bust with mozzetta and biretta; circular inscription punctuated through shields with the coats of arms of Salzburg, Gurk, and the Lang family. Inscriptions: MATHEVS CARD[inalis] ARCHIEP[iscopu]S SALZBVRG[ensis] AC EP[iscop]VS GVRCEN[sis] [Matthäus, cardinal, archbishop of Salzburg, and bishop of Gurk]; in the field, MD XX I [1521]; in the truncation of the bust, four punched stars; punched in the field above the head, Z.
Reverse: St. Radegund (Radiana) of Wellenburg assaulted by wolves; at her feet an overturned bucket, brush, and comb; in the background, Wellenburg Castle (near Augsburg). Inscription: ORA PRO NOBIS DEVM SANCTA VIRGO RADIANA [Pray to God for us, Saint Radegund Virgin].
Literature: Hinterstoisser sale 1926, no. 35; Bernhart and Roll 1929–30, 1: no. 561; Probszt 1975, no. 194; Zöttl 2014, 49, type 1, no. 185.

According to legend, St. Radegund (or Radiana) cared for the poor and sick in a local hospital and on her return home one day was attacked by wolves and severely injured. Three days later, she died in Wellenburg Castle and was buried near the hospital. A chapel was erected on the burial site and designated a pilgrimage destination in about 1450. Cardinal Lang commissioned a Gothic church in about 1520 and the following year had this commemorative coin struck. In 1521, the cardinal commissioned a woodcut from Hans Burgkmaier (1473–1531) that is closely related in style and composition to that of the coin reverse, showing a scene of the saint being attacked by two wolves (Bartsch 1978, 31; Hollstein 1954–2014, 4: 268). SKS

260

261

261

Unknown artist (Nuremberg)
FRIEDRICH VII BEHAIM (1491–1533)
Dated 1526
Solnhofen stone; 40 mm
Scher Collection

Obverse: Friedrich wearing a hairnet, pleated shirt, and smock.
Inscription: FRIDERICH PEHAIM ALT XXXV IAR [Friedrich Behaim, at
35 years].
Reverse: Collector's stickers; incised, AD [monogram of Albrecht
Dürer] 1526.
Literature: Habich 1929–34, 1: pt. 2, no. 936.

Friedrich VII Behaim von Schwarzbach was, in 1518, an alderman,
burgomaster, and war councilor in Nuremberg. He was involved in
religious questions as indicated in the description on the reverse of
the reduced version of this medal (no. 262). The incised monogram
of Albrecht Dürer on the reverse of the medal was probably added
later to suggest falsely that he was the author. AF, SKS

262

Unknown artist (Nuremberg)
FRIEDRICH VII BEHAIM (1491–1533)
Dated 1526
Copper alloy, cast; 21.5 mm
Scher Collection

Obverse: Friedrich wearing a hairnet and pleated shirt. Inscription:
FRIDERICH BEHAIM ZV NVRMBERG ALT XXXV [Friedrich Behaim of
Nuremberg, at 35 years].
Reverse: Behaim coat of arms and helmet. Inscription: GOT DIE ER
AVCH SEINER LER M D XXVI [Honor to God and his teachings, 1526].
Literature: Habich 1929–34, 1: pt. 2, no. 942.

This is a reduced version made from a smaller variant of the stone
model in no. 261. AF, SKS

262

263

Unknown artist (Nuremberg)
CARDINAL ALBRECHT (b. 1490; Archbishop of Mainz and
Elector 1514–45)
Dated 1526
Silver, cast; 44 mm
Scher Collection; Promised gift to The Frick Collection

Obverse: The cardinal wearing a biretta, damask coat, and soft shirt
forming several folds around his neck. Inscription: DOMINVS MIHI
ADIVTOR QVEM TIMEBO ANN[o] AETAT[is] XXXVII [The Lord is on my
side, whom shall I fear? (Psalms 118:6; 27:1) in his 37th year of age].
Reverse: Arms of the cardinal hanging from a cross on top of which
is a cardinal's hat; behind the shield, a crossed sword and crozier.
Inscription: ALBERT CARD[inalis] MOG[untiaci] ARCHIEP[iscopus]
MAGD[eburgensis] HALB[erstadiensis] ADM[inistrator] MARCH[io]
BRAND[enburgensis] ZC [et cetera] M D XXVI [Cardinal Albrecht,
archbishop of Mainz, administrator of Magdeburg and Halberstadt,
Margrave of Brandenburg, et cetera, 1526].
Literature: Habich 1929–34, 1: pt. 2, no. 923; Scher 1994, no. 108
(var.); Maué 2005.

This medal is one of the two known smaller variants of a larger
uniface portrait medal (Germanisches Nationalmuseum, Nuremberg)
that may have been produced as a model after which smaller
versions were cast in larger quantities. The humanist Cardinal
Albrecht, Margrave of Brandenburg, emulated Italian Renaissance
princes and patronized the leading German artists of his time. ADC

263

264

Unknown artist (Nuremberg)
CHRISTOF FÜRER (1479–1537)
Dated 1526
Copper alloy, cast; 39 mm
Scher Collection

Obverse: Fürer wearing a large plumed hat and armor. Inscription: CRISTOF FVRER ALT XXXXVII [Christof Fürer, 47 years old].
Reverse: The arms of Fürer surmounted by a helmet with cascading plume. Inscription: NVRMBERGISCHER HAVBTMAN IM ANDERN ZVG GEIN WIRTTENBERG M D XXVI [Nuremberger captain goes to Württemberg on a different march, 1526].
Literature: Habich 1929–34, 1: pt. 2, no. 928.

Christof Fürer of Haimendorf descended from one of Nuremberg's oldest patrician families, first mentioned in 1295. He was a merchant in copper mining, a Nuremberg councilor, and founder of the Saigerhandelskartell (1534), an association of exchange houses concerned primarily with the segregation of metals and the smelting processes. He fought as a member of the Nuremberg militia in the war of the Swabian League against Duke Ulrich von Württemberg in 1519. AF, SKS

265

Unknown artist (Nuremberg)
JOHANNES STABIUS (1462–1522)
ca. 1517
Copper alloy, cast; 72.3 mm
Scher Collection

Obverse: Stabius wearing a laurel wreath on his head and a cloak with a wide collar. Inscription: IOHANNES STABIVS POETA LAVREATVS ET HISTORIOGRAPHVS [Johannes Stabius, poet laureate, and writer of history].
Literature: Habich 1929–34, 1: pt. 1, no. 318; Scher 1994, no. 86; Cupperi et al. 2013, 202, no. 101.

In 1502, the humanist Johannes Stöbere, who later took the Latinized name Stabius, became a poet laureate in the "Collegium poetarum et mathematicorum," established in Vienna by Emperor Maximilian I, and in 1503 was appointed court historian. The death of Maximilian in 1519 and Charles V's disinterest in Stabius's work marked the end of his career. This is the only authentic portrait of the humanist and was most likely designed by Albrecht Dürer when they were both in Nuremberg to collaborate on the *Triumphal Arch* series of

woodcuts. A possible author of the medal is Hans Schwarz, who was in Nuremberg in 1519–20 and from whom Dürer had commissioned his own portrait medal. ADC

266

Unknown artist (Nuremberg)
MAGDALENA WELZER ROEMERIN (1505–1582)
Dated 1582
Silver, cast; 39.7 mm
Scher Collection

Obverse: Magdalena with long hair pulled back in a braid, wearing a wide hat with badge, chemise with high collar, chain, and pendant cross. Inscription: MAGDALENA GEORG ROEMERIN ÆTATIS SVÆ 20 ANNO 1525 [Magdalena, (wife of) Georg Roemerin, aged 20, in the year 1525].
Reverse: An angel supporting with the right hand the arms of Römer and with the left the arms of Welser. Inscription: MADALENA G[e]ORG RO[e]MERIN GEB WELSERIN OB[iit] 20 APR[ilis] A[nn]° 1582 [Magdalena, (wife of) Georg Roemerin, born Welser, died 20 April 1582].
Literature: Imhof 1780–82, 2: 882, no. 16; Löbbecke sale 1908, 42, no. 341; Habich 1929–34, 2: pt. 1, no. 2532.

This medal commemorates the marriage of Magdalena Welser to Georg Roemerin in 1525 in Nuremberg, as well as Magdalena's death in 1582. Georg was from Mansfeld, studied in Leipzig, and worked as an assessor in Nuremberg. The medal combines an earlier obverse with a later reverse. AF, SKS

267

Unknown artist (Nuremberg)
PETER KIENER (b. 1544)
Dated 1596, made 1595
Silver, cast; 52.9 × 39.2 mm
Scher Collection

Obverse: Kiener with vest and ruff. Inscription: PETTER KIENNER Æ[tatis] SVÆ 46 A[nno] [15]90 [Peter Kiener, aged 46, in the year 1590].
Reverse inscription: MDXCVI / Den Ersten Tag / Januarij Verehrt / Peter Kiener seiner / liebe(n) Schweister Anna / Michel Mußerhard / in disen Schilling zu / einem Glückhsee / ligen Neuem / Jhare [On 1 January 1596, Peter Kiener expresses his devotion to his dear sister Anna, wife of Michael Musserhard, through this medal, with best wishes for a happy new year].
Literature: Domanig 1907, 74.

This medal portraying Kiener in 1590 was made in that year or shortly afterward. Its style, the formula to express age and date, and the frontal orientation of the bust can be traced to an artist trained in Nuremberg. In 1595, the pre-existing obverse was combined with a new reverse with dedication in order to be presented to Kiener's sister Anna on the first day of 1596. WaC

268

Unknown artist (Nuremberg)
KONRAD REUTER (1477–1540)
Dated 1527
Copper alloy, cast; 39.5 mm
Scher Collection; Promised gift to The Frick Collection

Obverse: Reuter wearing a biretta and habit. Inscription: CONRADVS ABBAS M[onasteri] CÆSARIENSIS ÆTATIS SVÆ ANNO L [Conrad, abbot of the monastery at Kaisersheim, aged 50].
Reverse: The arms of Reuter and crozier. Inscription: INSIGNIA EIVSDEM IN DOMINO CONFIDO M DXXVII [His motto: I trust in God. 1527].
Literature: Domanig 1907, 15, no. 72; Habich 1929–34, 1: pt. 2, no. 952; Trusted 1990, no. 131.

Abbot of the Cistercian monastery at Kaisersheim from 1509 to 1540, Reuter was a distinguished scholar of law, theology, poetry, and music. AF

269

Unknown artist (Nuremberg)
JOHANN GEUDER (1496–1557)
ca. 1526
Solnhofen stone, 41.1 mm
Scher Collection

Obverse inscription: IOANNES GEVDER AETATIS SVAE AN[no] XXX [Johann Geuder, aged 30].
Literature: Will 1764–67, 159, no. 2; Imhof 1780–82, 2: 338, no. 3; Habich 1929–34, 1: pt. 2, no. 941; Trusted 1990, no. 129 (reduced and reversed).

This stone would have been used as the model for creating a mold from which a medal would have been cast. A reduced variant of this medal in silver with traces of mercury gilt is in no. 270. Johann Geuder, the eldest son of Martin Geuder (1455–1532), was senior Bürgermeister of Nuremberg in 1545. AF

270

Matthes Gebel (ca. 1500–1574)
JOHANN GEUDER (1496–1557)
Dated 1526
Silver with traces of mercury gilt, cast; 28.3 mm
Scher Collection

Obverse inscription: IOANNES GEVDER AE TATIS SVAE AN[no] XXX [Johann Geuder, aged 30].
Reverse: Ancient-style armor with bow, arrows, sword, ax, helmet, and escutcheon with the arms of Geuder. Inscription: RECTE AGENDO NE TIMEAS M D XXVI [While acting justly, do not fear, 1526].
Literature: Habich 1929–34, 1: pt. 2, no. 943.

On Geuder, see no. 269, which is a variant of the obverse of this medal. AF

271

Matthes Gebel (ca. 1500–1574)
GEORG HERMANN (1491–1552)
Dated 1527
Copper alloy, cast; 46.5 mm
Scher Collection; Promised gift to The Frick Collection

Obverse: Hermann wearing a wide-brimmed hat and a fur-collared mantle. Inscription: GEORGIVS HERMAN ÆTATIS SVÆ XXXVI [Georg Hermann, aged 36].
Reverse: Shield with Hermann's arms, and helm and crest resting on a suit of armor and a shield to the left. Inscriptions: EXPLORANT ADVERSA VIROS ET PERDVCIT AD ARDVA VIRTVS [Adversity tries men, but virtue leads to (the accomplishment of) difficult things]; M D XXVII [1527].
Literature: Habich 1929–34, 1: pt. 2, no. 964.

Hermann was an employee of and related by marriage to the Fuggers, a leading banking family based in Augsburg. This is one of several medals of Hermann produced by Gebel with various obverse and reverse combinations. ADC

272

Matthes Gebel (ca. 1500–1574)
GEORG HERMANN (1491–1552)
Dated 1529
Copper alloy, cast; 38.5 mm
Scher Collection

Obverse: Hermann wearing a hairnet. Inscription: GEORGIVS HERMAN ÆTATIS SVÆ AN[no] XXXVIII [Georg Hermann, aged 38].
Reverse: Shield with Hermann's arms, and helm and crest resting on a suit of armor. Inscription: SOLI DEO CONFIDE M D XXIX [Have trust in God alone, 1529].
Literature: Habich 1929–34, 1: pt. 2, no. 1003; Pollard 2007, 2: no. 721 (var.).

On Hermann, see the commentary for no. 271. ADC

273

Matthes Gebel (ca. 1500–1574)
ALBRECHT DÜRER (1471–1528)
Dated 1528
Copper alloy, cast; 39 mm
Scher Collection

Obverse: Dürer wearing a high-necked shirt and doublet (*Wams*). Inscription: IMAGO ALBERTI DVRERI AETATIS SVAE LVI [Portrait of Albrecht Dürer aged 56].
Reverse: Laurel wreath surrounding inscription. Inscription: BE[atis] MA[nibus] / OBDORMIVIT / IN XPO [Christo] / VI IDVS / APRILIS M D / XXVIII / VI[xit?] C[um?] VI[rtute, or: virtute clara vixit] [To the blessed Manes (of Dürer). He passed away in Christ on 8 April 1528. He lived with (spotless) virtue].

Literature: Van Mieris 1732–35, 2: 294; Imhof 1780–82, 2: no. 31; Habich 1929–34, 1: pt. 2, no. 968; Mende 1983, no. 34; Maué 1986, no. 226; Trusted 1990, no. 36; Volz 2013, no. 86.

This medal commemorates Dürer's death (which occurred on April 6, not April 8, as stated on the reverse) and is dedicated to his "Manes"—the name by which the ancient Romans designated the souls of the dead as gods of the underworld. Gebel matched this new reverse with the obverse he had modeled for his Dürer medal of 1527 (Habich 1929–34, 1: pt. 2, no. 959). The latter is documented as his work in a letter from Andreas Rüttel to Willibald Pirckheimer (Mende 1983, 211). WaC

274
Matthes Gebel (ca. 1500–1574)
CHRISTOPH KRESS VON KRESSENSTEIN (1484–1535)
Dated 1526, made ca. 1530
Copper alloy, cast; 39.4 mm
Scher Collection

Obverse: Von Kressenstein wearing a pleated shirt with ornamented collar. Inscription: CRISTOF KRES XXXXII IAR ALT [Christoph Kress, 42 years old].
Reverse: The Kress family arms with helmet and crest resting on a suit of armor. Inscription: CRISTOFF KRES VOM KRESENSTAIN M D XXVI [Christoph Kress von Kressenstein, 1526].
Literature: Habich 1929–34, 1: pt. 2, no. 957; Pollard 2007, 2: no. 717; Scher 1994, no. 109.

The reverse is unquestionably the work of Matthes Gebel, but the obverse with the portrait and the name "Kress" is typical of the style of the Nuremberg workshop active about 1525–27. Although the date on the reverse is 1526, Kress was not elevated to nobility and given permission to use the appellative "von Kressenstein" until July 1530, on the occasion of which he commissioned a reverse depicting the new coat of arms and family name with the 1526 date. ADC

275
Matthes Gebel (ca. 1500–1574)
GEORG VON LOXAN (ca. 1491–ca. 1551)
1530
Lead, cast; 45.9 mm
The Frick Collection; Gift of Stephen K. and Janie Woo Scher, 2016 (2016.2.65)

Obverse: Von Loxan wearing a flat cap, pleated shirt, chain, and outer cloak. Inscription: GEORGIVS LOXANVS SILESIVS EQVES [Georg von Loxan, Silesian knight].
Reverse: A panoply of arms and armor including a shield bearing the arms of Loxan. Inscription: ARMA VIRVMQ[ue] VIDES OPERAE EST COGNOSCERE VT[sic for I]RUN[sic for M]Q[ue] [See the arms and the man, it is worth knowing them both].
Literature: Domanig 1907, 17, no. 91 (as by Peter Flötner); Habich 1929–34, 1: pt. 2, no. 1020; Cupperi et al. 2013, 191, no. 90.

Georg von Loxan, a Silesian knight, was married to Katherina von Loxan (see no. 282). According to Domanig, he was secretary to King Ferdinand I; German Vice-Chancellor to the Augsburg Diets of 1530, 1547, and 1548; and the Imperial Captain of Regensburg 1543–48; and died in 1551. The reverse inscription derives from Virgil (*Aeneid* I.1). Another medal of von Loxan is dated 1523 and gives his age as thirty-two (Domanig 1907, no. 51). AF

276
Matthes Gebel (ca. 1500–1574)
ULPIAN MOSER and **APOLLONIA SCHWERZIN** (dates unknown)
Dated 1530
Gilt copper alloy, cast; 36.9 mm
Scher Collection; Promised gift to The Frick Collection

Obverse: Jugate busts; Ulpian, with mid-length hair and beard, wearing a pleated shirt with high collar; Apollonia wearing a fillet, high collar, and chain. Inscription: VLPIANVS MOSER APOLONIA SCHWERZIN VXOR [Ulpian Moser (and) wife Apollonia Schwerzin].
Reverse: Arms of Moser and helmet with crest. Inscription: INSIGNIA EIVSDEM ANNO M DXXX [His arms, in the year 1530].
Literature: Habich 1929–34, 1: pt. 2, no. 1039.

The Mosers were an old family with roots in various parts of Germany. Ulpian Moser appears in the service of Emperor Charles V. AF, SKS

277

Matthes Gebel (ca. 1500–1574)
MICHAEL HESS (b. 1497)
Dated 1530
Copper alloy, cast; 34.2 mm
Scher Collection; Promised gift to The Frick Collection

Obverse: Hess wearing a cloak all'antica fastened at the shoulder. Inscription: MICH[ael] HESSII PHI[sicus] ÆTA[tis] XXXIII [Michael Hess, physician, aged 33].
Reverse: Fortuna, balanced on an orb, holding up shield with arms of Hess and armillary sphere to hand extending from clouds; helmet to left. Inscription: SVPERIS CEDITE FATA M D XXX [Fate, yield to the superior Gods, 1530].
Literature: Duisburg 1862, 98, pl. CCLXVI, no. 1; Habich 1929–34, 1: pt. 2, no. 1037.

Hess was a surgeon from Nuremberg. A second medal of him, uniface and showing him with a full beard, was made in 1543 when he was forty-six years old (Imhof 1780–82, 2: 779, no. 20). AF

278

Matthes Gebel (ca. 1500–1574)
LORENZ TRUCHSESS VON POMERSFELDEN (1473–1543)
Dated 1530
Silver, cast; 41.7 mm
The Frick Collection; Gift of Stephen K. and Janie Woo Scher, 2016 (2016.2.66)

Obverse: Von Pomersfelden wearing a hat and fur-collared embroidered coat. Inscriptions: outer line, LAVRENT[ius] TRVCHSES A BOMERSFELDEN DECANVS EC[c]L[es]I[a]E; inner line, MAGVNT[inæ] M D XXX [Lorenz Truchsess von Pomersfelden, dean of the church of Mainz, 1530].
Reverse: Hourglass on an inscribed plaque. Inscriptions: PERICVLVM IN FALSIS FRATRIBVS [Danger in false brothers]; in the field, above the

hourglass, MICHI HODIE CRAS TIBI [Today it is me, tomorrow it is you]; on the tablet, in four lines, CONFVNDANTVR / SVPERBI QVIA / INIVSTE INIQVITATEM / FECERVNT IN ME [Let the proud be ashamed, for they dealt perversely with me without cause (Psalm 118:78)]; beneath the tablet, two heraldic shields; to the right, Truchsess von Pomersfelden; to the left, illegible.
Literature: Habich 1929–34, 1: pt. 2, no. 1025; Pollard 2007, 2: no. 725.

Lorenz Truchsess von Pomersfelden was dean of the cathedral of Mainz and became canon of Würzburg in 1528. ADC

279

Matthes Gebel (ca. 1500–1574)
HEINRICH RIBISCH (1485–1544), **GEORG HERMANN** (1491–1552) and **KONRAD MAIER** (1493–1565)
Dated 1531
Silver, cast; 39 mm
Scher Collection

Obverse: Jugate portraits of the sitters, each wearing shirts with ornamented collars and chains. Inscription: HEN[rich] RIBISCH DOCTOR GEOR[g] HERMAN CVNRA[d] MAIR [Heinrich Ribisch, doctor; Georg Hermann; Konrad Maier].
Reverse: The Ribisch, Hermann, and Maier coats of arms. Inscription: QVAM IVCVNDVM HABITARE FRATRES IN VNVM M D XXXI [How pleasant it is for brethren to dwell together in unity (abbreviated from Psalm 133:1), 1531].
Literature: Habich 1929–34, 1: pt. 2, no. 1061; Scher 1994, no. 110; Cupperi et al. 2013, 207, no. 109.

Ribisch, Hermann, and Maier were business partners in the service of the Fuggers, a leading banking family in Augsburg. Hermann, related to the Fuggers by marriage, was a medal enthusiast and the likely commissioner of this "friendship medal" (Scher 1994). ADC

280

Matthes Gebel (ca. 1500–1574)
JOHANN FRIEDRICH I (1503–1554; Elector of Saxony 1532–47)
ca. 1532
Silver, cast; 45.4 mm
The Frick Collection; Gift of Stephen K. and Janie Woo Scher, 2016 (2016.2.67)

280

281

Obverse: Johann Friedrich wearing a pleated shirt, several chains around his neck, and an embroidered mantle (barely visible). Inscription: IO[annes] FR[idericus] I IO[annis] I RO[mani] IMP[erii] ELECT[oris] PRIMOG[enitus] D[ux] SAX[oniæ] [Johann Friedrich I, firstborn of Johann I Elector of the Roman Empire, Duke of Saxony].
Reverse: Johann's coat of arms. Inscription: SPES MEA IN DEO EST [My hope is in God].
Literature: Tentzel 1699, 12; Habich 1929–34, 1: pt. 2, no. 1080; Pollard 2007, 2: no. 726.

Johann Friedrich became Elector of Saxony in 1532, an event perhaps celebrated by this medal. While it is unusual that the title of elector is referred to the father of the sitter rather than to the sitter himself, it could be a way to commemorate the recently deceased father Johann I Elector of Saxony (d. August 16, 1532) from whom Johann Friedrich had inherited the electoral title. Johann Friedrich was a champion of the Lutheran religion and led the forces of the Schmalkaldic League against the Holy Roman Emperor, Charles V, at the Battle of Mühlberg in 1547, where he was defeated and imprisoned until 1552. See the commentaries for nos. 294, 306, and 326. ADC

281

Matthes Gebel (ca. 1500–1574)
LORENZ STAIBER (1486–1539) and **SUSANNA EINHÖRING** or **STIEBARIN** (dates unknown)
Dated 1535
Silver, cast; 43.6 mm
Scher Collection

282

Obverse: Staiber wearing a hairnet and a pleated shirt with embroidered collar; around his neck, two chains, one composed of linked "S" letters with a Tudor rose pendant awarded to him by Henry VIII of England. Inscriptions: LAVREN[tius] STAVBERVS EQ[ues] AVR[atus] AC ANGL[iæ] ET FRANC[iæ] REGIS ORATOR [Lorenz Staiber, Knight of the Golden Spur, royal speaker of the King of England and France]; on truncation, L [50; Staiber's age].
Reverse: Susanna wearing a hat pinned to her hairnet, a pleated shirt with embroidered collar, two chains, and a shorter necklace with a floral pendant. Inscription: ICH ANYM GOT ZV HILFF M D XXXV [I urge God to help, 1535].
Literature: Habich 1929–34, 1: pt. 2, no. 1120; Pollard 2007, 2: no. 727.

Staiber was a patrician of Nuremberg, city councilor, writer, and orator and active as an agent of Henry VIII. His first wife, Magdalena, died in 1526. The woman on the reverse is probably his second wife, Susanna Einhöring or Stiebarin (Glockner 1963–64, 223). This medal is one of only two extant. ADC

282

Matthes Gebel (ca. 1500–1574)
KATHERINA VON LOXAN (1516–1580)
Dated 1535
Silver, cast; 38.9 mm
The Frick Collection; Gift of Stephen K. and Janie Woo Scher, 2016 (2016.2.64)

Obverse: Katherina with hairnet, wearing a flat hat, high collar, and chain. Inscription: CHATERINA VON LOXAV GEBORNE ADLERIN XIX IAR ALT [Katherina von Loxan, born Adlerin, 19 years old].
Reverse: The arms of Adler. Inscription: MEIN TROST ZV GOT MICH NIE V[er]LASEN HOT M D XXXV [My trust in God has never left me, 1535].
Literature: Domanig 1907, 18, no. 109; Habich 1929–34, 1: pt. 2, no. 1114.

Celebrated as one of the most beautiful women of her era, Katherina (neé Adler) was the aunt of Philippine Welser, the clandestine wife of Archduke Ferdinand of Tyrol, and one of only two witnesses to her secret wedding in 1557. This medal possibly celebrates her marriage to Georg von Loxan (no. 275). AF, SKS

283

Matthes Gebel (ca. 1500–1574)
GEORG SCHILLING (b. 1501)
Dated 1539
Silver, cast; 36.9 mm
Scher Collection; Promised gift to The Frick Collection

Obverse: Schilling wearing a shirt and chain under an embroidered jacket. Inscription: SPES MEA IN DEO SALVTARI MEO [My hope (is) in God my Savior].
Reverse: Arms of the Schilling family. Inscription: GEORGIVS SCHILLINK ETATIS SVÆ XXXVIII MD XXXIX [Georg Schilling, aged 38, 1539].
Literature: Habich 1929–34, 1: pt. 2, no. 1173.

Georg Schilling was a Nuremberg patrician. AF

284

Matthes Gebel (ca. 1500–1574)
GEORG SCHENK (b. 1515)
Dated 1541
Silver, cast; 36.6 mm
Scher Collection; Promised gift to The Frick Collection

Obverse: Schenk wearing a jerkin with high-collared shirt. Inscription: IORG SCHENCK XXVI IAR ALT [Georg Schenk, 26 years old].
Reverse: The arms of Schenk. Inscription: ALLEIN WAS GOTWILL

MDXXXXI [Only what God wills, 1541].
Literature: Habich 1929–34, 1: pt. 2, no. 1804; Peus 1975.

In a commentary for a medal with a Jörg Schenk on the reverse, Habich discusses other identities with this name. It is possible this is the same person as on this medal. AF, SKS

285

Friedrich Hagenauer (act. 1525–after 1546)
KATHARINA HECHSTETTER-NEUMANN (1510–ca. 1550?)
Dated 1528
Lead; cast, 63 mm
Scher Collection

Obverse: Katharina with hair in braids under a figured hairnet, wearing a blouse with high collar, chain necklace, and bodice. Inscriptions: KATHARINA NEVMANIN VXOR AMEROSII HECHSTETER ETATIS ANNO XVIII; to either side of bust, M D / XXVIII [Katharina Neumann, wife of Ambrose Hechstetter, aged 18, 1528]. FH [artist's initials].
Reverse inscription: In five lines, AMVLVS / AVREVS IN MANIBVS / SVIS / MVLIER VENVSTA ET / MOROSA [A golden ring in her hands. A beautiful and capricious wife].
Literature: Volz 1992–93, 249–50.

Katharina Neumann was the wife of the wealthy Augsburg merchant Ambrose Hechstetter. Hagenauer also made medals for various members of Katharina's extended family. AF, SKS

286

286

Friedrich Hagenauer (act. 1525–after 1546)
MATTHAEUS SCHWARZ (1497–ca. 1574)
1530
Wood in two pieces, 44.1 mm (obv.), 43.6 mm (rev.)
Scher Collection

Obverse: Schwarz facing right, wearing a hat and shirt with high collar; the numbers *3* and *4* lightly incised on either side of the bust.
Reverse: Shield of arms with helmet and crest.
Literature: Habich 1929–34, 1: pt. 1, no. 546.

This is the wood model for the medal of Schwarz. The reverses of those medals also include a circumferential inscription not seen here: TVA FIAT VOLVNTAS (May your will be done). Schwarz, a cousin of the medalist Hans Schwarz, was a merchant and accountant from Augsburg who worked for Jakob Fugger and his family. He is remembered for his illustrated catalogue of the different types of clothing he wore for several decades, the *Klaidungsbüchlein* or *Trachtenbuch*. AF, SKS

287

Friedrich Hagenauer (act. 1525–after 1546)
PHILIPP MELANCHTHON (1497–1560)
Dated 1543
Silver, cast; 38.2 mm
The Frick Collection; Gift of Stephen K. and Janie Woo Scher, 2016
(2016.2.101)

Obverse: Melanchthon wearing a jacket and a collared shirt.
Inscriptions: PHILIPPVS MELAN[ch]THON ANNO ÆTATIS SVÆ XLVII [Philipp Melanchthon, aged 47]; in the field, to the left, FH [artist's initials].
Reverse inscription: In five lines, PSAL[m] 36 / SVBDITVS ESTO / DEO ET ORA EVM / ANNO / M D XXXXIII [Psalm 36: Rest in the Lord, and wait patiently for him (Psalm 37:6); in the year 1543].
Literature: Habich 1929–34, 1: pt. 1, no. 651; Hill and Pollard 1967, no. 593; Scher 1994, no. 99a (var.); Pollard 2007, 2: no. 708 (var.); Cupperi et al. 2013, 234, no. 147a–e.

After Martin Luther, Philipp Melanchthon was the most important Protestant reformer in Germany. His *Loci Communes rerum theologicarum seu hypotyposes theologicae* (1521) is the first systematic theology of Protestantism, and his *Augsburg Confessions*, composed at the Diet of Augsburg (1530), summarizes the articles

of faith for the Protestant church. A second portrait (the wood model for which is at the Staatliche Museen, Berlin), also created by Hagenauer in 1543, shows Melanchthon wearing a biretta. ADC

288

Hans Daucher (ca. 1485–1538)
LUDWIG II, KING OF HUNGARY AND BOHEMIA (b. 1506; r. 1516–26) and **STEFAN SCHLICK** (1487–1526)
Dated 1526
Copper alloy, cast; 60.4 mm
Scher Collection

Obverse: Ludwig wearing a flat cap and cloak with fur collar; around his neck, the Order of the Golden Fleece. Inscription: LVDOWIG V[on] GO[ttes] GN[aden] KOENIG IN VNG[arn] V[nd] BO[ehmen] A[nno] 1526 [Ludwig, by the grace of God, King of Hungary and Bohemia, 1526].
Reverse: Schlick wearing a flat cap over a hairnet, a richly pleated shirt and a cloak with double collar. Inscription: HERR STEFFAN SCHLICK GRAF ZV BASSAN[o] HER ZV WEISKIRCHEN ELBO[gen] V[nd] SCHLACREN[werth] [Lord Stefan Schlick, Count of Bassano, Lord of Weiskirchen, Elbogen, and Schlackenwerth].
Literature: Habich 1929–34, 1: pt. 1, no. 79; Scher 1994, no. 80a.

This medal, combining the portrait of the king (after the stone model now in the Museum of Fine Arts, Boston) and Schlick, Count of Bassano and Weiskirchen, commemorates their deaths at the Battle of Mohács on August 29, 1526, when the Turks destroyed the king's army. See also nos. 313 and 356. ADC

289

Christoph Weiditz (ca. 1500–1559)
GEORG OF WETTIN, CALLED THE BEARDED (b. 1471; Duke of the Albertine dominions of Saxony 1500–39)
Dated 1537
Silver, cast; 43.2 mm
The Frick Collection; Gift of Stephen K. and Janie Woo Scher, 2016
(2016.2.82)

Obverse: Bust with *Wams* (doublet). Inscription: SEMPER LAVS EIVS IN ORE MEO ANNO ÆTATIS LXV [The praise (of God) is always in my mouth (Psalm 34:2); 65th year of age].
Reverse: Coat of arms of the House of Wettin. Inscription: GEORGIVS DEI GRACIA DVX SAXONIE ANNO MDXXXVII [Georg, by the grace of God, Duke of Saxony, in the year 1537].

288

Literature: Tentzel 1714, *Alb.*, table 3, no. 7; Merseburger sale 1894, no. 600; Domanig 1907, 17, no. 94 (as by Peter Flötner); P. Grotemeyer in Thieme and Becker 1907–50, 35: 268 (as by Christoph Weiditz); Löbbecke sale 1908, no. 357 (as by Master of the Rosette); Habich 1929–34, 2: pt. 1, no. 1848 (as Master of the Group of the Cardinal Albert); E. Bünz in *Glaube & Macht* 2004, no. 166 (as style of Hans Schwarz); Cupperi et al. 2013, 260, no. 171.

Shortly before the publication of Tentzel's *Saxonia numismatica* (1705), a silver specimen of this medal was found in the steeples of St. Thomas Church in Leipzig, which had been rebuilt in 1537 (Gretzschel and Mai 1993, 9). Other silver specimens were circulated, instead of being buried, so the medal must not have been issued for this specific occasion. Tentzel, for example, thought that it may have been distributed during the Schmalkaldic Bundestag of 1537. WaC

290

Christoph Weiditz (ca.1500–1559)
PHILIP OF WITTELSBACH (1503–1548; Count Palatine of the Rhine, Duke of Palatinate-Neuburg 1535–41)
Dated 1541
Silver, cast; 54.3 mm
Scher Collection

Obverse: Philip with collar of the Order of the Golden Fleece. Inscription: TE AMO VT PROPRIAM ANIMAM AN[no] M D XLI [I love you as my own soul; in the year 1541].
Reverse: Philip's coat of arms, surrounded by the collar of the Order of the Golden Fleece. Inscriptions: S[iegel] PHILIPS VON GOTS GNADEN PFALCZGRAF B[ei] REIN HERCZOG I[n] NIDERN V[ND] OBERN BAIRN [The seal of Philip, by the grace of God, Count Palatine of the Rhine, Duke in Lower and Upper Bavaria]; in the field, NICHTS VNVERSVCHT / 1535 [nothing unattempted, 1535].
Literature: Hauschild 1805, no. 1495; P. Grotemeyer in Thieme and Becker 1907–50, 35: 268 (as by Christoph Weiditz); Lanna sale 1911b, no. 830; Vogel sale 1924, no. 124; Habich 1929–34, 1: pt. 2, no. 1840 (as by "Gruppe des Georg Fugger"); Stemper 1997, 96, no. 92; Volz and Jokisch 2008, no. 22; Peus 2013, no. 1670.

On April 4, 1541, Philip of Wittelsbach ceded his dominions to his brother Otto Henry to mark the payment of his debts and an appanage (a grant made by a sovereign to a dependent member of the royal family) of 5,000 florins. This medal, possibly commissioned at the Diet of Regensburg, was certainly made for this occasion. The reverse, however, is cast after an impression of Philip's seal, which was engraved with the date of his ducal accession, 1535. Stemper considers the motto "I love you as my own soul" an expression of Philip's gratitude toward Otto Henry, but the latter is neither named nor portrayed in the medal. This medal can therefore be seen as Otto's homage to Philip and justification of his own gesture before the personalities who received the medal. In this case, Philip would be the dedicatee rather than the patron of the medal. WaC

289

290

291

Hans Bolsterer (act. 1540; d. 1573)
WENZEL JAMNITZER (1507/8–1585)
Dated 1552
Silver, cast; 39.3 mm
Scher Collection

Obverse: Jamnitzer with long beard, wearing a coat with collar.
Inscriptions: WENCZEL IAMNICZER XLIIII IAR ALT IM MDLII [Wenzel Jamnitzer, 44 years old in 1552]; on truncation, flanking the artist's mark, HB [artist's initials].
Reverse inscription: In nine lines, DER / ENGEL DES / HERREN LE / GERT SICH VMB / DIE HER SO IN / FVRCHTEN VND / HILFT IN AVS / ALLER NOT / PS XXXIII [The angel of the Lord encamps around those that fear him, and assists them in need; Psalm 33].
Literature: Habich 1929–34, 1: pt. 2, no. 1793; Forrer 1979–80, 2: 358.

Born in Nuremberg, Jamnitzer was among the best-known goldsmiths of his era. He was court goldsmith to several Holy Roman emperors, including Charles V, Ferdinand I, Maximilian II, and Rudolf II. In 1552, the year this medal was made, he was named master of the city mint at Nuremberg. The text on the reverse states that it derives from Psalm 33, but in the King James and Lutheran Bibles it is Psalm 34:7. AF

292

Hans Bolsterer (act. 1540; d. 1573)
WOLF MUNZER (1524–1577)
Dated 1567
Silver, cast; 41.1 mm
Scher Collection; Promised gift to The Frick Collection

Obverse: Munzer wearing armor and a chain with cross pendant.
Inscription: WOLF MVNTZER VON BABENBERG RITER [Wolf Munzer of Babenberg, knight].
Reverse: Female figure, holding with the left hand a shield with the arms of Munzer and a helmet with crest on a plinth with right arm; in the background, a flagpole with the arms of Jerusalem.
Inscriptions: GOT GIBT GVT GLVCK [God gives good luck]; in exergue, M D LXVII [1567]; on plinth, V V V [?].
Literature: Imhof 1780–82, 2: 844, no. 25; Lanna sale 1911b, no. 1006; Habich 1929–34, 1: pt. 2, no. 1803.

Munzer, a nobleman from Nuremberg, made a pilgrimage to the Holy Land in 1556 but was held captive by the Turks until 1559, when he was able to return to Nuremberg. A full-size portrait by Nicolas Neufchatel from the same year survives in the city. AF

293

Ludwig Neufahrer (ca. 1500/5–1563)
LUDWIG X OF BAYERN-LANDSHUT (1495–1545)
ca. 1535
Silver, cast; 40.6 mm
Scher Collection

Obverse: Ludwig with long beard, wearing a flattened hat and coat with fur collar. Inscription: LVDOVICVS COMES PALATINVS RHENI VTRIVS QVE BAVARIE DVX [Ludwig, Count Palatine of the Rhine, Duke of Bavaria].
Reverse: Two helmets with crests resting on the arms of the Rhine Palatinate and Bavaria. Inscription: SI DEVS NOBISCVM QVIS CONTRA NOS [If God is with us, who is against us].
Literature: Lanna sale 1911b, no. 806; Habich 1929–34, 1: pt. 2, no. 1325; Probszt 1960, 85, no. 7; Cupperi et al. 2013, 247, no. 156.

Ludwig X and his older brother, William IV, co-ruled as dukes of Bavaria from 1516 until Ludwig's death. The popular inscription on the reverse is from Romans 8:31. AF

295

296

294

Ludwig Neufahrer (ca. 1500/5–1563)
JOHANN FRIEDRICH I (1503–1554; Elector of Saxony 1532–47)
Dated 1547
Silver, cast; 33.6 mm
Scher Collection

Obverse: Johann Friedrich wearing a high-necked pleated shirt and chain. Inscription: IOANNES FRIDERICVS DVX ELECTOR SAXONIAE D M XLVII [Johann Friedrich, Duke and Elector of Saxony, 1547].
Reverse: Armored figure wearing a helmet and holding in the right hand the arms of Saxony and in the left those of the Imperial Archmarshal. Inscription: PRO VERO E[t] RELIGIONE ET LIBERTA[te] GERMA[niæ] [For the true religion and freedom of Germany].
Literature: Habich 1929–34, 1: pt. 2, no. 1400; Probszt 1960, 95, no. 80.

Also known as John the Magnanimous, Johann Friedrich was Elector of Saxony and head of the Protestant Confederation of Germany. This medal was made in the same year he was wounded and defeated at the Battle of Mühlberg and imprisoned until 1552. See nos. 280, 306, and 326. AF

295

Attributed to Ludwig Neufahrer (ca. 1500/5–1563)
FRANCIS I, KING OF FRANCE (b. 1494; r. 1515–47)
ca. 1537
Silver, cast; 44 mm
Scher Collection; Promised gift to The Frick Collection

Obverse: Francis in feathered cap and embroidered shirt and jacket. Inscription: FRANCISCVS I FRANCORVM REX C[hristianissimus] 43 [Francis I, most Christian King of the French, 43 (sitter's age)].
Reverse: Salamander in flames inside a laurel wreath; above, a crown. Inscriptions: DISCVTIT H[an]C FLA[m]MA[m] FRA[n]CISC[us] ROBORE ME[n]TIS O[m]NIA P[er]VI[n]CIT RERV[m] IM[m]ERSABILIS V[n]DIS [Francis destroys this flame, with the power of the spirit he conquers all, in the waves of events he is unsinkable]; below the salamander, LN [artist's initials].
Literature: Habich 1929–34, 1: pt. 2, no. 1397; Scher 1994, no. 116; Pollard 2007, 2: no. 732.

The salamander, the device of King Francis I, is usually associated with the motto "Nutrisco et extinguo" (I nourish [the good] and extinguish [the bad]). The portrait is based on that of a larger uniface medal modeled, in turn, after a 1537 painting by François Clouet. The attribution to Neufahrer, first made by Forrer, is debatable since the medalist never signed his work in this manner and seems to have only created profile portraits. Why Neufahrer, a medalist working in Austria for the Hapsburgs, would produce a portrait of the Hapsburg enemy king of France is also unclear. However, King Francis was widely admired as a Renaissance prince and generous patron of the arts and was also depicted by other German medalists. ADC

296

Christoph Fueszl the Elder (d. 1561)
MARIA OF HAPSBURG, also known as **MARIA OF HUNGARY** (1505–1558; Queen Consort of Hungary and Bohemia 1522–26, Governor of the Hapsburg Netherlands 1531–56)
Dated 1526, made ca. 1530–31
Silver, cast; 44.9 mm
Scher Collection

Obverse: Maria wearing a hat, hairnet, and chain with pendant; coats of arms of Hungary and Bohemia held by pages. Inscription: on a cartouche, MARIE HVNGAR[iæ] BOHEM[iæ] / EQVÆ REGINÆ IAM / PRO CESARAE [scil. Caesare] CAROL[o] / V° [Quinto] IN FLANDRIS / EFFIGIES [Portrait of Maria, equitable Queen of Hungary and Bohemia, now in Flanders on behalf of Charles V the Caesar].
Reverse: Louis II, crowned, in armor and on horseback, attacked by the Ottoman cavalry and artillery. Inscription: LVDO[vicus] HVNG[ariæ] BOEM[iæ] [et]C REX / AN[n]V[m] AGENS XX IN TVRCAS / APVD MOHAZ CVM PAR / VA SVORVM MANV PV / GNA[n]S HONESTE / OBYT M D XXVI [Louis, King of Hungary, Bohemia, et cetera, died with honor at age 20 in 1526 while fighting against the Turks with a small maniple of his soldiers near Mohács].
Literature: Donebauer sale 1889, no. 985; Huszár and Procopius 1932, no. 16; J. Kerkhoff in *Maria van Hongarije* 1993, no. 51.7.

The reverse commemorates the death of Maria's husband at the Battle of Mohács in 1526. The medal must have been issued in 1530 or shortly afterward because the obverse mentions her appointment as governor of the Netherlands as a recent event. WaC

297

298

297

Christoph Fueszl the Elder (d. 1561)
LUDWIG II, KING OF HUNGARY, BOHEMIA, AND CROATIA (b. 1506; r. 1516–26) and **MARIA OF HAPSBURG**, also known as **MARIA OF HUNGARY** (1505–1558; Queen Consort of Hungary and Bohemia 1522–26, Governor of the Hapsburg Netherlands 1531–56)
Dated 1526, made ca. 1530–31
Silver, cast; 42.9 mm
The Frick Collection; Gift of Stephen K. and Janie Woo Scher, 2016 (2016.2.109)

Obverse: Louis, with hat and collar of the Order of the Golden Fleece, facing Maria, wearing a hairnet, hat, and necklace; background with floral motif. Inscription: LVDO[vici] VNGAR[iæ] BOHE[miæ]QVE / REGIS ET MARIÆ RE / GINÆ DVLCISS[imæ] Co[n]IV / GIS AC PRO CES[are] / IN FLAN[dris] [(Portrait of) Louis, King of Hungary and Bohemia, and Queen Maria, his very lovely wife, who has gone to Flanders on behalf of the Caesar (Charles V)].
Reverse: Same as no. 296.
Literature: Domanig 1896, no. 24 (as by Hans Reinhart the Elder); Löbbecke sale 1908, no. 458; Lanna sale 1911b, no. 660; Huszár and Procopius 1932, no. 15; V. Héri in *Matthias Corvinus* 1982, no. 536; J. Kerkhoff in *Maria van Hongarije* 1993, no. 51.8; Astarte 2001, no. 133; H. Winter in *Kaiser Ferdinand I* 2003, no. V.5.

The reverse of this medal commemorates the death of Maria's husband at the Battle of Mohács in 1526. The obverse mentions her appointment as governor of the Netherlands (1531–56). It is not clear whether the medal was made on a specific occasion or simply varied a previous type by Fueszl, which instead refers explicitly to Maria's appointment as a recent event (see no. 296). waC

298

After Johann Wilhelm Reifenstein (or Reyffenstein) (b. ca. 1520)
MARTIN LUTHER (1483–1546)
1546
Silver, cast; 38 mm
Scher Collection; Promised gift to The Frick Collection

Obverse: Bust with academic gown. Inscription: D[ominus] MARTINVS LVTHER / AN[n]O ÆT[atis] S[uæ] LXIII [Dom Martin Luther, aged 63].
Reverse inscription: IN SILEN / TIO ET SPE / ERIT FORTI / TVDO VESTRA / ESAIAE / XXX [In quietness and in confidence lies your strength: Isaiah 30 (Isaiah 30:15)].
Literature: Juncker 1706, 210; van Mieris 1732–35, 3: 134–35, no. 1; Merzbacher 1900, no. 213 (as restitution of the seventeenth century); Ficker 1924, 72–73; Löbbecke sale 1925, no. 147 (as by Jakob Stampfer); Habich 1929–34, 2: pt. 1, no. 2237 and fig. 320, and pt. 2, no. 3337; Ficker 1934, no. 435; Grün 2012, no. 3453.

This rare medal indicates Luther's age at the year of his death, which may be the event the medal commemorates. The portrait was copied from a medal of 1543 ascribed to the dilettante Johann Wilhelm Reifenstein, a jurist who lived in Luther's house in Wittenberg. The basis for this attribution is a letter of July 17, 1543, to Georg Römer, in which Reifenstein claimed to have personally "sculpted a likeness of the very illustrious Dr. Martin Luther, because those circulated among the people clearly do not portray him at all from life or hardly render his features." Additionally, Reifenstein promised to send a cast example of his work as soon as he found the "powder" to mold it (Ficker 1924, 71, translations of the author). Yet, the association between the letter and the medal of 1537 remains conjectural because scholarship has identified only putative drawings by Reifenstein and no other medal. Moreover, the differences between the medal of 1543 and the present one are significant enough to leave open the possibility that the later type was copied or molded from the earlier one by another artist. waC

299

299

Joachim Deschler (ca. 1500/5–1571)
FRANZ VON SICKINGEN (1481–1523)
Dated 1521
Silver gilt, cast; 37.1 mm
Scher Collection; Promised gift to The Frick Collection

300

Obverse: Sickingen wearing a hat, cloak, and chain. Inscription: FRANCISCVS VON SICKING 1521 [Franz von Sickingen, 1521].
Reverse: The arms of Sickingen. Inscription: FRANCISCVS VON SICKINGEN KAISER KARL DES V RATH CHAMERER VND HAVBTMAN [Franz von Sickingen, council chamberlain and captain of Emperor Charles V].
Literature: Habich 1929–34, 1: pt. 2, no. 1666.

Franz von Sickingen fought for the emperor Maximilian I in 1508 and became a wealthy and powerful landowner and soldier. In 1518, he took part in the war carried on by the Swabian League against Ulrich, Duke of Württemberg. His military presence was important in support of the election of Charles V as Holy Roman Emperor, for which service he was made imperial chamberlain and councilor. He became a supporter of the Reformation and intimate with Ulrich von Hutten, offering his castles as a refuge for the reformers, including Martin Luther. He was also interested in science and supported men of learning. AF, SKS

300
Joachim Deschler (ca. 1500/5–1571)
HIERONYMUS PAUMGARTNER (1497–1565)
Dated 1553
Tin alloy, cast; 66.6 mm
Scher Collection

301

Obverse: Paumgartner wearing a pleated doublet over a pleated shirt. Inscriptions: HIERONYMUS PAVMGARTNER ANNO ÆTATIS 56 [Hieronymus Paumgartner, aged 56]; on truncation, 1553; I[oachim] D[eschler].
Reverse: Arms of Paumgartner. Inscription: IN VMBRA ALARVM TVARVM SPERABO DONEC TRANSEAT INIQVITAS [I put my trust under the shadow of your wings until injustice has departed].
Literature: Habich 1929–34, 1: pt. 2, no. 1611; Scher 1994, no. 119; Pollard 2007, 2: no. 734.

Paumgartner, who was from a highly influential Nuremberg family, was named Oberster Hauptman (Chief Councilor) of Nuremberg in 1553, the year of the medal that was possibly produced to celebrate this event. ADC

301
Joachim Deschler (ca. 1500/5–1571)
FELICITAS MAIRIN (b. 1521)
Dated 1553
Silver, cast; 42.7 mm
Scher Collection

Obverse: Felicitas wearing a coif and jacket with frilled collar. Inscription: FELICITAS MAIRIN ÆTAT[is] SVÆ XXXII A[nno] D[omini] M D LIII [Felicitas Mairin, aged 32, in the year of the Lord 1553].
Reverse: Probably the Kötzler arms of Felicitas Mair, née Kötzler. Inscription: CASTA PVDICITIÆ LAVS MIHI SOLA PLACET [Only a chaste praise for modesty pleases me].
Literature: Habich 1929–34, 1: pt. 2, no. 1605.

Known for her piety and virtue, Felicitas was the daughter of Augsburg court clerk Franz Kötzler. She married Paul Hector Mair about 1537. Her married name in the inscription is in the feminine form, Mairin. The arms for Kötzler on the reverse have not been found in standard German heraldic registers, but presumably these are Felicitas's family arms since Kötzler was her maiden name. SKS

302

Joachim Deschler (ca. 1500/5–1571)
PAUL HECTOR MAIR (1517–1579)
Dated 1553
Silver, cast; 43.1 mm
Scher Collection

Obverse: Mair with forked beard and buttoned coat. Inscription: PAVLVS HECTOR MAIR ANNO [D] M LIII [Paul Hector Mair, in the year 1553].
Reverse: The arms of Mair. Inscription: NOBILITAT[em] VIRTV[ti]S ILLAM MENS APPETAT VNAM [The mind strives for that one virtue that ennobles].
Literature: Habich 1929–34, 1: pt. 2, no. 1604.

Mair was administrator of the Augsburg treasury and the author of a history of the town. He incurred significant expenses in building a collection of works of art, luxury goods, curiosities, and coins and medals; in 1579, he was convicted of embezzling from the city and hanged. Habich records a "D" in the obverse inscription before the "M" as it appears in the example that he illustrates and indicates the error; the correct address should be MDLIII, the "D" in this specimen being effaced. Although there are a number of arms for Mair in German heraldic registers, the one on the reverse is not included with this spelling. SKS

303

Joachim Deschler (ca. 1500/5–1571)
SEBALD KRAUS (b. 1514)
Dated 1569
Silver, cast; 38.2 mm
The Frick Collection; Gift of Stephen K. and Janie Woo Scher, 2016 (2016.2.84)

Obverse: Kraus with long beard, wearing a brocaded coat and frilled collar. Inscriptions: SEBALDVS K[r]AUS ÆTA[tis] SVÆ 55; below bust (incised), 156[9] [Sebald Kraus, aged 55, 1569].
Reverse: The arms of Kraus. Inscription: TREV[e?] IN ALLEN LAS M[i]RS GEFALLEN 1569 [Let faithfulness in all respects please me, 1569].
Literature: *Trésor de numismatique* 1834–58, 8: 46, no. 9; Habich 1929–34, 1: pt. 2, no. 1658.

Sebald Kraus was from Nuremberg, and either his son or grandson was a lawyer in Nuremberg, who died in 1630. AF

304

Joachim Deschler (ca. 1500/5–1571)
GEORG (1508/9–1574) and **ANNA PRANDSTETTER** (d. 1568)
Dated 1563
Silver, cast; 47.6 mm
Scher Collection; Promised gift to The Frick Collection

Obverse: Georg, wearing a brocaded doublet and chains and holding with his right hand an hourglass surmounted by a skull and Anna, wearing a bodice with high collar and holding a book with her left hand. Inscription: GEORGEN PRANTSTETTERS RO[manischer] KHAY[serlicher] M[agestä]T RATT VND ANNA SINER HAVSFRAVEN [Georg Prandstetter, Roman imperial majesty, with the council, and Anna, his (house)wife].
Reverse: The arms of Georg (left) and Anna (right). Inscription: BILDTNVS VND WAPPEN ANNO 1563 [Portrait and coat of arms, in the year 1563].
Literature: Domanig 1907, 29–30, no. 185; Habich 1929–34, 1: pt. 2, no. 1720.

Georg Prandstetter held various offices in Vienna, including municipal judge and mayor. In 1559, he was raised to the nobility by Emperor Ferdinand I. Anna was his second wife. Domanig (1907) misreads the date and inscription as 1568. AF, SKS

306

305

Hans Reinhart the Elder (ca. 1510–1581)
MAXIMILIAN I OF HAPSBURG, HOLY ROMAN EMPEROR
(b. 1459; r. 1508–19)
Dated 1502, made ca. 1540
Silver, cast; 36.2 × 32.9 mm
Scher Collection; Promised gift to The Frick Collection

Obverse: Maximilian wearing a cap and coat with fur collar, and a chain with the Order of the Golden Fleece.
Reverse: Shield of Maximilian. Inscription: MAX[imilianus] I IMP[erator] / M D II [Emperor Maximilian I, 1502].
Literature: Habich 1929–34, 2: pt. 1, no. 1925.

This medal is dated 1502, but this date cannot be associated with its design or casting since the artist would not have been alive (or at least old enough) to cast it at that time. Habich dates it to 1540. AF, SKS

306

Hans Reinhart the Elder (ca. 1510–1581)
JOHANN FRIEDRICH I (1503–1554; Elector of Saxony 1532–47)
Dated 1535
Silver, cast; 65.7 mm
Scher Collection

Obverse: Johann Friedrich wearing a pleated shirt under a fur cloak, holding the electoral sword and hat. Inscriptions: IOANN[e]S FRIDERICVS ELECTOR DVX SAXONI[a]E FIERI FECIT ETATIS SVÆ 32 [Johann Friedrich, Duke Elector of Saxony had this made at the age of 32]; embroidered on the shirt collar, REN ALS IN EREN [Alles in Ehren kann niemand wehren (There is no defense against an honorable man)]; in the field beneath his right hand, HR [artist's initials].
Reverse: Coat of arms with three helms and crests. Inscription: SPES MEA IN DEO EST ANNO NOSTRI SALVATORIS M D X X X V [My hope is in God; in the year of our Savior 1535].
Literature: Habich 1929–34, 2: pt. 1, no. 1935; Pollard 2007, 2: no. 741; Scher 1994, no. 126; Cupperi et al. 2013, 262, no. 175.

Johann Friedrich was called the "Magnanimous" for his dignity and strength during trials that included imprisonment and being stripped of his title and territories by the forces of his enemy Maurice, Duke of Saxony. Johann Friedrich was a loyal supporter of Martin Luther and the Lutheran faith. The portrait is based on painted and woodcut portraits by Lucas Cranach the Elder. The medal has been described as possibly marking a birthday. See nos. 280, 294, and 326. ADC

307

Hans Reinhart the Elder (ca. 1510–1581)
ADAM AND EVE and **THE CRUCIFIXION**
Dated 1536
Silver gilt, cast; 67 mm
Scher Collection; Promised gift to The Frick Collection

Obverse: Adam and Eve under the Tree of Knowledge surrounded by animals, including a unicorn; to the left, the Creation of Eve and the coat of arms of Saxony; to the right, the Expulsion from Paradise and the coat of arms of the Duke of Saxony. Inscriptions: ET SICVT IN ADAM OMNES MORIVNTVR ITA ET IN CHRISTVM OMNES VIVIFICABVNTVR VNVSQVISQVE IN ORDINE SVO [For as in Adam all die, even so in Christ shall all be made alive, every man in his own order (1 Corinthians 15:22)]; on banderole below, IOANN[e]S FRIDERICVS ELECTOR DVX SAXONI[a]E FIERI FECIT [Johann Friedrich, Duke Elector of Saxony had this made].
Reverse: The Crucifixion with soldiers; the Church of the Holy Sepulcher (?) to the left, the Resurrection to the right. Inscriptions: VT MOSES EREXIT SERPE[n]TE[m] ITA CHR[istu]S IN CRVCE EXALTATVS ET RESVSCITATVS CAPVT SERPE[n]TIS CO[n]TRIVIT VT SALVARET CREDE[n]TES [As Moses lifted up the serpent in the wilderness, even so must the Son of man be lifted up. That whosoever believeth in Him should not perish, but have eternal life]; banderole below, SPES MEA IN DEO EST [My hope is in God]; in banderole at top of cross, I[esus] N[azarenus] R[ex] I[udæorum] [Jesus of Nazareth, King of the Jews]; below cross, HR [artist's initials] 1536.
Literature: Habich 1929–34, 2: pt. 1, no. 1968; *Salton Collection* 1969, no. 95; Trusted 1990, no. 140; Cupperi et al. 2013, 263–64, no. 178.

The reverse inscription derives from John 3:14. Medals such as this with religious subjects were made to be sold on the open market. AF

307

Hans Reinhart the Elder (ca. 1510–1581)
FERDINAND I OF HAPSBURG (b. 1503; King of Bohemia and
Hungary 1526–64; King of Croatia 1527–64; King of the Romans,
1531–58; Holy Roman Emperor 1558–64)
Dated 1539
Silver, cast; 66.6 mm
Scher Collection

Obverse: Ferdinand, wearing a broad-brimmed hat and the Order
of the Golden Fleece, with a scroll in his left hand. Inscription:
FERDINANDVS DEI GRACIA ROMAN[orum] [H]VNGARI[a]E ET BO[h]EMI[a]
E REX ANNO SAL[utis] M D XXXVIIII ÆTATIS SVÆ XXXVII [Ferdinand, by the
grace of God, King of the Romans, Hungary, and Bohemia, in the
year of salvation 1539, aged 37].
Reverse: An eagle from which hangs a shield of arms with Bohemia,
Hungary, Austria, and Castile, and the collar of the Order of the
Golden Fleece. Inscriptions: FERDINANDVS REX [King Ferdinand]; to
the right, between talons, HR [artist's initials].
Literature: Habich 1929–34, 2: pt. 1, no. 1934; Trusted 1990, no.
147.

Ferdinand I, brother of Charles V, was Holy Roman Emperor from
1558, King of Bohemia and Hungary from 1526, and King of Croatia
from 1527. On the scroll, the letters "ER" and "KE" are faintly
visible. AF, SKS

Hans Reinhart the Elder (ca. 1510–1581)
CHARLES V OF HAPSBURG, HOLY ROMAN EMPEROR
(1500–1558; r. 1519–56)
Dated 1544
Silver, cast; 75 mm
Scher Collection

Obverse: Charles wearing a flat cap, pleated shirt and decorated
cloak with the collar of the Order of the Golden Fleece, the
globe and scepter in his hands. Inscription: CAROLVS V DEI GRATIA
ROMAN[orum] IMPERATOR SEMPER AVGVSTVS REX HIS[paniæ] ANNO
SAL[vatoris] M D XLIIII ÆTATIS SVAE XLIIII [Charles V, by the grace of
God, Emperor of the Romans, Forever August, King of Spain, in the
year of the Savior 1544, aged 44].
Reverse: Shield of arms of Charles V hanging from the neck of the
double-headed imperial eagle, as well as the Order of the Golden
Fleece; above, a crown; flanking the arms, the crowned Pillars of
Hercules. Inscriptions: below, in perspective on the ground, HR
[artist's initials]; in the field, behind the pillars of Hercules, PLVS
OVLTRE [Still further].
Literature: Habich 1929–34, 2: pt. 1, no. 1927; Scher 1994,
no. 125; Pollard 2007, 2: no. 740 (var.); Winter (Heinz) 2009,
no. 21a–b (var.).

308

309

In a version of this medal dated 1537, the emperor appears younger. Reinhart seems to have reworked the earlier model to update the portrait years later. Neither medal appears to commemorate a specific event. Charles V was ruler of both the Spanish Empire from 1518 and Holy Roman Empire from 1519, as well as of the Hapsburg Netherlands from 1506. Eventually, the territories under his control covered vast domains, including the Spanish colonies in the Americas and Asia. It is this empire, not the British, that was the first to be called "the empire on which the sun never sets." ADC

310

Hans Reinhart the Elder (ca. 1510–1581)

TRINITY MEDAL

Dated 1544

Silver, cast; 102.8 mm

Scher Collection

Obverse: God the Father enthroned, crowned, and wearing an embroidered cope; in his hands, the orb and scepter, the signs of His regal authority over the Universe; against His knees, the Crucifix, above which is the dove of the Holy Spirit; the Trinity flanked by two angels in adoration, and above each one four cherubs' heads; on either side, clouds. Inscriptions: PROPTER SCELVS POPVLI MEI PERCVSSI

310

EVM ESAIÆ LIII [He was stricken to death for my people's transgression 53 (Isaiah 53:8)]; engraved on the platform, flanking the foot of the Cross, HR [artist's initials].

Reverse: Two angels supporting a tablet with the arms of Saxony. Inscriptions: on the border, REGNANTE MAVRITIO D[ei] G[ratia] DVCE SAXONIÆ ZC [et cetera] GROSSVM HVNC LIPSIÆ H[ans] R[einhart] CVDEBAT AN[n]O M D XLIIII MENSE IANV[arii] [In the reign of Maurice, by the grace of God, Duke of Saxony, et cetera, Hans Reinhart cast this medal in Leipzig in the month of January, 1544]; on the tablet, in twenty-two lines, HÆC EST / FIDES CATHOLICA, / VT VNVM DEVM IN TRINI=TATE, ET TRINITATEM, IN / VNITATE, VENEREMVR / ALIA EST PERSONA PATRIS, / ALIA FILII, ALIA SPIRITVS / SANCTI SED PATRIS ET FI=LII ET SPIRITVS SANCTI, V=NA EST DIVINITAS, ÆQVA=LIS GLORIA, COETERNA / MAIESTAS / O VENERA[n]DA VNITAS, O / ADORANDA TRINITAS, PER / TE SVMVS CREATI, VERA / AETERNITAS, PER TE SV=MVS REDEMPTI SUMMA TV / CHARITAS, TE ADORAMVS / OMNIPOTENS, TIBI / CANIMVS, TIBI / LAVS ET GLO=RIA [The Catholic faith is this: that we worship one God in Trinity and Trinity in Unity; there is one person of the Father, another of the Son, and another of the Holy Ghost. But the Godhead of the Father, and of the Son, and of the Holy Ghost is all one; the Glory equal, the majesty coeternal; O venerable Unity; O worshipful Trinity; by You we were created, You true Eternity; by You we were redeemed; You greatest Love. We worship You, all-powerful One; we exalt You. To You, praise and honor].

Literature: Habich 1929–34, 2: pt. 1, no. 1962; Scher 1994, no. 127; Steguweit 2012; Cupperi et al. 2013, 265, no. 179.

This medal, possibly produced in support of efforts at reconciliation between the new Protestant Church and the Church of Rome, may have been commissioned by Maurice, Duke of Saxony, whose arms appear on the reverse. The text up to the word MAIESTAS is taken from the Athanasian Creed, a statement of Catholic belief centered on the Holy Trinity (a doctrine accepted by Protestants). The second part is from the hymn *Benedicta sit semper Sancta Trinitas* (Victoria and Albert Museum, online database of medals). ADC

312

Hans Reinhart the Elder (ca. 1510–1581)
CHARLES V OF HAPSBURG, HOLY ROMAN EMPEROR
(1500–1558; r. 1519–56)
Dated 1547
Silver, cast; 45.8 × 37.9 mm (without loop)
Scher Collection; Promised gift to The Frick Collection

Obverse: Charles, bearded, wearing a hat, coat, collar and the Order of the Golden Fleece. Inscriptions: CARO LVS V [Charles V]; below, HR [artist's initials].

Reverse: The Crucifixion superimposed over a double-headed eagle. Inscriptions: above, MI=SERERE / MEI DEVS / 1547 [God have mercy on me, 1547]; in banderole, PLVS [u]LTRA [Still further]; in banderole at top of cross, I[esus] N[azarenus] R[ex] I[udæorum] [Jesus of Nazareth, King of the Jews].

Literature: Habich 1929–34, 2: pt. 1, no. 1928; Trusted 1990, no. 148.

This medal presumably commemorates the Schmalkaldic War (1546–47) and perhaps, more specifically, Charles V's victory at the Battle of Mühlberg (1547). AF

Hieronymus Magdeburger (d. 1540)
FERDINAND I OF HAPSBURG (b. 1503; King of Bohemia and Hungary 1526–64; King of Croatia 1527–64; King of the Romans, 1531–58; Holy Roman Emperor 1558–64)
Dated 1529
Silver, struck; 44.9 mm
Scher Collection

Obverse: Ferdinand wearing a hat and the collar of the Order of the Golden Fleece. Inscription: outer line, FERDINANDVS DEI GRACIA HVNGARIÆ BOEMIÆ ETC REX; inner line, ANNO DOMINI M D XXIX ETATIS SVÆ XXV [Ferdinand, by the grace of God, King of Hungary, Bohemia, et cetera, in the year of the Lord 1529, at the age of 25].

Reverse: Five shields with the arms of (clockwise, starting from above left) Austria, Bohemia, Dalmatia, Croatia, and (at the center) Austria with Castile on a cross of flowers. Inscription: outer line, DA MICHI VIRTVTEM CONTRA HOSTES TVOS DOMINE; inner line, QVIA TV ADIVTOR MEVS ES [Give me strength against your enemies (a quote from the antiphon *Ave Regina Caelorum*, sung in the Liturgy of the Hours), my Lord, because you are my supporter].

Literature: Herrgott 1752–53, 2: table 1, fig. 9; Löbbecke sale 1908, no. 425; Katz 1932, no. 36; Frankfurter Münzhandlung 1992, no. 361; Meister & Sonntag 2004, no. 1226.

This medal's allusion to the "enemies" of God is usually interpreted as a reference to the Ottoman troops approaching the southeastern borders of Ferdinand's dominions in 1529. Struck in Saxony and based on a portrait by Hans Daucher of 1523 (Habich 1929–34, 1: pt. 1, no. 64), this type can hardly have been issued on Ferdinand's own initiative. More likely, it was made for local patrons or for the market and expressed the widespread hope that the new ruler could stop the advance of the Turkish army toward central Europe. WaC

313

Obverse inscriptions: To either side of St. Paul, S[anctus] P[aulus] [Saint Paul]; below, 1531.

Reverse: Chalice with three rising vapors. Inscriptions: DATE DEO QVAE SVNT DE[i] [Render unto God that which is God's]; on either side of the chalice, ORATIO [Speech].

Literature: Lanna sale 1911b, no. 1432; Katz 1932, no. 90.

The reverse inscription derives from Matthew 22:21, wherein Jesus instructs his disciples to "render unto Caesar that which is Caesar's, and unto God that which is God's." AF

313

Hieronymus Magdeburger (d. 1540)
STEFAN SCHLICK (1487–1526)
Dated 1526
Silver, struck; 43.6 mm
Scher Collection

Obverse: Schlick wearing a hairnet under a wide hat with hat badge, pleated shirt with high collar, chain and cloak. Inscriptions: outer line, DOMINVS STEPHANVS SLICK COMES DE PASSAVN[o] ET C[etera] [Lord Stefan Schlick, Count of Bassano, et cetera]; inner line, ANNO DOMINI M D XXVI ETATIS SVE XXXX [In the year of the Lord 1526, aged 40].
Reverse: Arms of Schlick. Inscription: CONTRA TVRCAM OPPETIIT PRO PATRIA PVGNANDO [He persisted while fighting for his country against the Turk].
Literature: Katz 1932, no. 33.

Born in what is now the Czech Republic, Stefan Schlick, Count of Bassano and Weiskirchen, founded the rich silver mining town of St. Joachimstal on the southern slopes of the Ore Mountains and issued coinage as *Joachimstalers* beginning in 1520. (The term *thaler*, derived from *Joachimstalers*, is the ancestor of the American word *dollar*.) Stefan Schlick and his brother, Count Lorenzo Schlick, were among those fighting at Mohács, Hungary, following King Louis II of Bohemia as part of Charles V's war against Suleiman and the Muslims. Stefan died on the battlefield, while Lorenzo died later from wounds inflicted there. This *thaler*-like medal commemorates Stefan Schlick's death. A monument erected in 1924 in Jáchymov, in the modern Czech Republic, declares him as the city's benefactor. See also nos. 288 and 356. AF

314

Hieronymus Magdeburger (d. 1540)
ST. PAUL
Dated 1531
Silver, cast; 21.6 mm
Scher Collection

315

Hieronymus Magdeburger (d. 1540)
ERASMUS OF ROTTERDAM (1466/69–1536)
Dated 1531
Silver, cast; 32.4 mm
The Frick Collection; Gift of Stephen K. and Janie Woo Scher, 2016 (2016.2.71)

Obverse: Erasmus with academic biretta. Inscriptions: along the edge, IMAGO AD VIVA[m] EFFIGIE[m] EXPRESSA 1531 [Likeness portrayed from life, 1531]; in the field, ER[asmus] RO[tterdamus].
Reverse: Herm with the Roman god Terminus, protector of boundaries. Inscriptions: MORS VLTIMA LINEA RERVM [Death is the final goal of things]; in the field, CONCEDO / NVLLI [I yield to no one]; on the herm, TERMINVS [the god Terminus].
Literature: Habich 1916, 124; Tourneur 1920, 151, no. 4; Habich 1923–24, 121; Habich 1929–34, 2: pt. 1, no. 1893 (var.); Katz 1932, no. 45 (var.).

The likeness and some of the inscriptions are based on a previous medal, made by Quentin Matsys (d. 1530) upon request of Erasmus and modeled from life in 1519 (Smolderen 2009, 15–16). Therefore, the date 1531 must refer to the die engraving for this second medal rather than to the original portrait. Erasmus's device and motto, represented in his own seal (Historisches Museum, Basel; 1893.365) and in Matsys's medal, were also reproduced in this later type. In a letter to Henry Botteus of March 29, 1528 (Tourneur 1920, 140), the Netherlandish humanist shows himself aware of the circulation of such unauthorized medals. As he explains in his *Epistola apologetica de termini sui inscriptione "Concedo nulli"* (August 1, 1528), the motto refers to a herm of Terminus that could not be removed from the Capitoline Hill in Rome (Livy, 1, 55). Therefore it is Terminus, god of boundaries, the one who "does not yield to anyone." The reverse quotation from Horace (*Epistles* I: 16.79) must also be understood as an allusion to Erasmus's approaching death. WAC

314

315

316

Hieronymus Magdeburger (d. 1540) and School
MARTIN LUTHER (1483–1546)
ca. 1533
Silver, cast; 41.5 mm
The Frick Collection; Gift of Stephen K. and Janie Woo Scher, 2016
(2016.2.92)

Obverse: Martin Luther, wearing a cap and doctoral robes.
Inscriptions: OS ET SAPIECIA[m] DABO VOBIS CVI NO POTER[un]T
CO[n]T[ra]DICERE ZC[et cetera] [I will give you a mouth and wisdom
which none will be able to contradict]; in the field, to the left and
right of the sitter, in two lines: MA[rtinus] LVT[herus] / EC[cle]S[iæ]
WIT[tembergensis]; in the field, above the sitter, LV[cas] ZI [Martin
Luther, (doctor of) the Church of Wittenberg: Luke 21].
Reverse: Stylized rose in the center of which is a heart with a cross.
Inscription: IN SILENCIO ET SPE ERIT FORTITVDO VESTRA ESA[ias] 30 [In
silence and in hope shall your strength be: Isaiah 30:15].
Literature: Habich 1929–34, 2: pt. 1, no. 1895.

This medal of the leader of Protestant reform bears on the reverse
Luther's seal and personal symbol, also known as a Luther rose.
Habich (1929–34) suggested a date of about 1533. SKS

317

Attributed to Balduin Drentwett (1545–1627)
MICHAEL LEONHARD MAIER (b. 1520)
Dated 1580
Silver, cast; 41.6 mm
Scher Collection; Promised gift to The Frick Collection

Obverse inscription: MICHAEL LEONHARDº MAIER A[nn]º D[omin]I 1580
Æ[tatis] LX [Michael Leonhard Maier, in the year of the Lord 1580,
aged 60].
Reverse: Skull and bones.
Literature: Habich 1929–34, 2: pt. 1, no. 2950.

This and the following medal are among a large group attributed
to Drentwett by Habich based on a signed plaquette. The reverse
is concave, and the skull is on a removable threaded shaft. This is
clearly a memento mori and perhaps refers to the death of Maier,
possibly the Michael Maier who was Bürgermeister of Augsburg and
who died in 1596. AF, SKS

318

Attributed to Balduin Drentwett (1545–1627)
JAKOB IHENISCH (1540–1615)
Dated 1599
Silver, cast; 34.2 mm
Scher Collection; Promised gift to The Frick Collection

Obverse inscription: IACOB IHENISCH Æ[tatis] LIX A[nn]º 99 [Jacob
Ihenisch, aged 59, in the year 1599].
Reverse: Ihenisch's shield of arms.
Literature: Habich 1929–34, 2: pt. 1, no. 3009.

Jakob Ihenisch was a doctor living in Augsburg. AF

319

Valentin Maler (ca. 1540–1603)
KATHERINA GOSWEIN (1514–1571)
Dated 1568
Lead, cast; 31.4 mm
Scher Collection; Promised gift to The Frick Collection

Obverse inscription: KATERINA N[eckl]ES GOSWEININ ALT LIIII IAR
[Katherina Neckles Goswein, 54 years old].
Reverse: The arms of, left, Goswein; right, Tucher. Inscription: GOT IST
ALLEIN MEIN TROST MDLXVIII [God alone is my solace, 1568].
Literature: Imhof 1780–82, 2: 763, no. 18; Rolas du Rosey sale
1863, 2776; Löbbecke sale 1925, 102; Habich 1929–34, 2: pt. 1,
no. 2416.

320

321

Katherina was the daughter of Pankranz Tucher and wife of the Nuremberg merchant Nicklaus Goswein, whom she married in 1534. AF

Valentin Maler (ca. 1540–1603)
JULIUS ECHTER VON MESPELBRUNN (1545–1617)
ca. 1575
Silver gilt, cast; 31.7 mm
Scher Collection; Promised gift to The Frick Collection

Obverse inscription: IVLIVS D[ei] G[ratia] EP[i]S[copus] WIRTZBVRG[ensis] [Julius, by the grace of God, bishop of Würzburg].
Reverse: Quartered shield with the arms of Franconia, Mespelbrunn, and Würzburg. Inscription: ET FRA[n]CIÆ ORIENT[alis] DUX [and Duke of Eastern France].
Literature: Löbbecke sale 1925, 11, no. 110; Habich 1929–34, 2: pt. 1, no. 2502.

Echter was a Prince-Bishop of Würzburg, an office to which he was appointed before being ordained as a priest, in 1573. In 1582, he re-founded the University of Würzburg, which became a model of Counter-Reformation, especially Jesuit, institutions in Germany. He built or renovated some three hundred churches in his territories over the course of his lifetime. AF

Valentin Maler (ca. 1540–1603)
JAKOB MUFFEL (1509–1569)
Dated 1569
Lead, cast; 55.9 mm
Scher Collection

Obverse: Muffel wearing a collared shirt, doublet, and chain.
Inscriptions: IACOB MVFFEL V[on] EKENHAID ÆTA[tis] LIX ANNO MDLXIX [Jakob Muffel of Ekenhaid, aged 59, 1569]; on truncation (incuse), M[aler].
Literature: Habich 1929–34, 2: pt. 1, no. 2421; Pollard 2007, 2: no. 745.

A patrician of Nuremberg, Muffel became senior mayor in 1557. ADC

Valentin Maler (ca. 1540–1603)
GABRIEL NÜTZEL (1514–1576)
Dated 1569
Lead (polychromed), cast; 54.7 mm
The Frick Collection; Gift of Stephen K. and Janie Woo Scher, 2016 (2016.2.74)

Obverse: Nützel wearing a doublet, ruff, and chain. Inscription: GABRIEL NVTZEL DER ELTER ÆTAT[is] LV 1569 [Gabriel Nützel the Elder, 55 years old, 1569].
Literature: Will 1764–67, 378, no. 3; Imhof 1780–82, 2: 597, no. 2; Löbbecke sale 1925, 10, no. 107; Habich 1929–34, 2: pt. 1, no. 2422.

First noted in 1272, the Nützels of Sündersbühl were among the oldest patrician families of Nuremberg. Gabriel Nützel was a councilor and diplomat involved in the economic negotiations among Augsburg, Nuremberg, Strasbourg, and Ulm. This medal is also found with a reverse depicting the Nützel arms, a helmet and three lilies. AF

322

323

323

Valentin Maler (ca. 1540–1603)

PHILIP ROEMER (d. 1593)

Dated 1576

Silver, cast; 38.1 mm

The Frick Collection; Gift of Stephen K. and Janie Woo Scher, 2016 (2016.2.73)

Obverse inscription: PHILIP ROEMER ANNO MDLXXVI [Philip Roemer, 1576].

Reverse: Arms of Roemer. Inscription: ICH LAS GOT WALTEN [I let God rule].

Literature: Will 1764–67, 4: 250, no. 6; Imhof 1780–82, 2: 832, no. 18; Rolas du Rosey sale 1863, no. 3282; Lanna sale 1911b, no. 1059 (obv.); Habich 1929–34, 2: pt. 1, no. 2508.

In 1580, Roemer was a member of the greater Nuremberg council. AF, SKS

324

Valentin Maler (ca. 1540–1603)

GEORG SCHRÖTL VON SCHRÖTENSTEIN (d. before 1626; councilor to Rudolf II in Prague, *Kammer- und Buchhalter* of Lower Austria)

Last decade of 16th century or beginning of 17th century

Silver, struck; 43.2 mm

Scher Collection; Promised gift to The Frick Collection

Obverse: Schrötl wearing a high-necked doublet with a large collar. Inscription: GEORG SCHRÖTL V[on] SCHRÖTENSTAIN.

Reverse: Schrötl's coat of arms. Inscription: RÖM[ischen] KAI[sers]

AVCH DER ZV HVNG[arn] VND BÖ[hmen] KÖ[niglichen] MAT[thiæ] RATH [councilor of Matthias, Roman Emperor and King of Hungary and Bohemia].

Literature: Domanig 1907, 100, no. 624; Habich 1929–34, 2: pt. 1, no. 2620.

"Made from life" in 1610, according to its legend, an engraving by Aegidius Sadeler portrays Schrötl with similar features and slightly different coat of arms (Hollstein 1954–2014, 21: 71, no. 325). Instead, in a *Klippe* (lozenge-shaped medal) dated 1582, the sitter looks younger (Lanna sale 1911b, no. 1253; Löbbecke sale 1908, no. 555). Therefore, the dating of the present medal should be closer to 1610 than to 1582. It is not possible to establish if the medal was struck on a specific occasion. WAC

325

Wolf Milicz (act. 1533–46)

CHARLES V OF HAPSBURG, HOLY ROMAN EMPEROR

(1500–1558; r. 1519–56)

Date unknown

Silver gilt, struck; 30.6 mm

The Frick Collection; Gift of Stephen K. and Janie Woo Scher, 2016 (2016.2.68)

Obverse: Charles wearing a hat and a cloak over a pleated shirt. Inscription: CAROLVS ROMANORV[m] IN[*sic* for M]PERAT[or] [Charles, Emperor of the Romans].

Reverse: The double-headed imperial eagle. Inscription: AQVILA EL[e]CTA IVSTE O[mn]IA VINC[it] [Justly chosen eagle conquers all].

Literature: Lanna sale 1911b, no. 623; Bernhart 1919, no. 140; Katz 1932, no. 287. SKS

324

325

326

326

Wolf Milicz (act. 1533–46)

JOHANN FRIEDRICH I (1503–1554; Elector of Saxony 1532–47)

Dated 1536

Silver, cast; 44.7 mm

The Frick Collection; Gift of Stephen K. and Janie Woo Scher, 2016 (2016.2.69)

Obverse: Johann Friedrich wearing a fur-collared mantle and gold chain. Inscription: CONTRAFRAITWRA [contrafactura] IOAN[nis] FRIDERICI ELECTORIS DVCIS SAXONIAE MDXXXVI [Portrait of Johann Friedrich, Duke Elector of Saxony, 1536].

Reverse: Battle scene with three mounted knights in armor with crested helms (Meissen, left; Electoral Saxony, center; Thuringia, right) in battle with one foot soldier, two slain and one wounded in the foreground. Inscription: NON FRVSTRA GLADIVM GESTAT NAM DEI MINISTER EST VLTOR AD IR[am] [They (the government) take the sword in vain, for it is a minister of God as an avenger].

Literature: Erbstein sale 1908, no. 272; Katz 1932, no. 270; Tentzel 1982, 3: pl. 9, no. 1; Merseburger sale 1984, no. 544.

This medal was commissioned by Karl Theodor, Elector of Bavaria (1724–1799), to celebrate Johann Friedrich the Magnanimous, Elector of Saxony. Head of the Protestant Schmalkaldic League, Johann Friedrich continued to be venerated almost as a martyr of Protestantism for several centuries. See nos. 280, 294, and 306. SKS

327

Wolf Milicz (act. 1533–46)

FERDINAND I OF HAPSBURG (b. 1503; King of Bohemia and Hungary 1526–64; King of Croatia 1527–64; King of the Romans, 1531–58; Holy Roman Emperor 1558–64) and **ANNE OF BOHEMIA AND HUNGARY, QUEEN OF THE ROMANS** (1503–47)

Dated 1537

Silver, struck; 46.8 mm

Scher Collection; Promised gift to The Frick Collection

Obverse: Ferdinand wearing a broad hat, pleated shirt, wide-collared cloak, and the badge of the Order of the Golden Fleece. Inscription: FERDINA[n]DVS ROMANORVM HVNGARIAE BOHEMIAE REX MDXXXVII [Ferdinand, King of the Romans, Hungary and Bohemia, 1537].

Reverse: Anne wearing a broad hat and a pleated blouse under a brocaded gown. Inscription: ANNA REGINA HVNGARIAE CONIVNX FERDINANDI MDXXXVII [Anne, Queen of Hungary, wife of Ferdinand, 1537].

Literature: Katz 1932, no. 273.

Ferdinand was King of Bohemia and Hungary from 1526 and became Holy Roman Emperor in 1558. The key issues of his reign were the conflict with the Ottoman Empire and the Protestant Reformation. He married Anne of Bohemia and Hungary in May of 1521. SKS

327

328

328

Nickel Milicz (act. ca. 1539–before 1575)
CHARLES V OF HAPSBURG, HOLY ROMAN EMPEROR
(1500–1558; r. 1519–56) and **FERDINAND I OF HAPSBURG**
(b. 1503; King of Bohemia and Hungary 1526–64; King of Croatia
1527–64; King of the Romans, 1531–58; Holy Roman Emperor
1558–64)
Dated 1547
Silver, cast; 59 mm
Scher Collection; Promised gift to The Frick Collection

Obverse: Charles V (left, with doublet) and Ferdinand I (right,
with mantle) wearing hats and collars of the Order of the Golden
Fleece; in the exergue and in the spandrel between the arches in
the background, harpies holding shields with the Austrian and
the Castilian coats of arms. Inscription: LVMI[na] ET ORA CAROLI
V IMPERATOREIS [*sic*] G[e]R[mania]E FERDINA[n]DVS D[ei] G[ratia]
ROMANO[rum] BOE[miæ] HVNG[ariæ] Z[et cetera] REX [Eyes and face of
Charles V, by the grace of God, Emperor of Germany; Ferdinand, by
the grace of God, King of the Romans, of Bohemia and Hungary, et
cetera].
Reverse: The battlefield of Mühlberg on April 24, 1547; on the right,
the Imperial troops crossing the Elbe by the burg of Mühlberg; in
the middle, the imperial cavalry and infantry surprising the troops of
the Schmalkaldic League in their tents; on the left, Charles V's forces
putting the rebels to flight and Johann Friedrich kneeling before the
emperor. Inscription: CAPTIVITAS IOANIS FRIDERICI / DVCIS SAXONIAE
M D XLVII [Imprisonment of Johann Friedrich, Duke of Saxony, 1547].
Literature: Tentzel 1714, *Ern.*, table 13, no. 5; Herrgott 1752–53, 1:
table 23, fig. 47; Domanig 1907, 35, no. 227; Löbbecke sale 1908,
no. 417; Lanna sale 1911b, no. 647; Bernhart 1919, no. 135; Braun
1921–22, 132; Habich 1929–34, 2: pt. 1, no. 1909; Katz 1932, no.
313; G. Bruck 1963–64, 27–29; H. Winter in *Kaiser Ferdinand I*
2003, 443, no. VI.16; Wallenstein 2012, fig. 97.

This medal refers to a seminal episode in the conflict between the
Hapsburgs and the Schmalkaldic League: Johann Friedrich I, Elector
of Saxony (1503–1554) and a member of the league, surrendered
to Charles V during the Battle of Mühlberg and was imprisoned.
The author of this medal worked in the town of St. Joachimsthal,
which passed from the Schlick to the Hapsburg dominions as a
consequence of this defeat. This circumstance may explain why the
artist cast a medal representing the new rulers either for local patrons

or for the market. The representation of the battlefield is based on a
woodcut published in 1547 by Virgilius Solis the Elder (Herzogliches
Museum, Gotha), which was also freely copied in Luis de Ávila y
Zúñiga's *Commentariorum de bello Germanico* (Antwerp 1550,
114). WAC

329

Nickel Milicz (act ca. 1539–before 1575)
CHARLES V OF HAPSBURG, HOLY ROMAN EMPEROR
(1500–1558; r. 1519–56) and **FERDINAND I OF HAPSBURG**
(b. 1503; King of Bohemia and Hungary 1526–64; King of Croatia
1527–64; King of the Romans, 1531–58; Holy Roman Emperor
1558–64)
After 1531
Silver, cast; 57.5 mm
The Frick Collection; Gift of Stephen K. and Janie Woo Scher, 2016
(2016.2.70)

Obverse: Charles wearing armor and the collar of the Order of the
Golden Fleece and holding a scroll in the right hand and a sword in
the left; in the background, a balustrade and two columns embraced
by two putti bearing shields with coats of arms (Austria and the
double-headed eagle of the Holy Roman Empire). Inscription:
PROGENIES DIVVM QVINTVS SIC CAROLVS ILLE IMPERI CAESAR LVMINA ET
ORA [The famous Charles V, descendant of gods, Caesar, eyes and
face of the Empire].
Reverse: Ferdinand wearing armor and the collar of the Order
of the Golden Fleece and holding a scroll; in the background, a
balustrade and two columns embraced by two putti bearing shields
with coats of arms of Bohemia and Austria. Inscription: FERDINANDVS
D[ei] G[ratia] ROMA[norum] HVNGA[riæ] BOEMINI[æ] [*sic*] INFANS
HISPANIAR[um] ARCHIDVX AVST[riæ] REX [Ferdinand, by the grace of
God, King of the Romans, Hungary, and Bohemia, Prince of Spain,
Archduke of Austria].
Literature: Herrgott 1752–53, 2: 38; Lanna sale 1911b, no. 646;
Bernhart 1919, 137; Katz 1926, 103; Habich 1929–34, 2: pt. 1,
no. 1908; Katz 1932, no. 333; R. Grund in *Glaube & Macht* 2004,
no. 319.

The legend of the obverse is an unrecognized fragment of an elegiac
couplet, transcribed with omissions that make its wording difficult
to understand. Its complete text ("progenies Divum Quintus sic

329

Carolus ille / imperii Caesar lumina et ora tulit" [the famous Charles V, descendant of gods, Caesar, bore the eyes and face of the Empire]) appears in Barthel Beham's engraved likeness of Charles V (1531: Bartsch 1978, no. 60). The print had been used as a model for an earlier medal of the emperor by Wolf Milicz, Nickel's father (Katz 1932, no. 280). There is therefore little doubt that it belonged to the repertory of engravings used by the Milicz family to make their medals of illustrious contemporaries. This medal must have been made in St. Joachimsthal (now Jáchymov, Czech Republic), where Nickel was a coin engraver, without any contact with the sitters. It may have been made for the market and not to commemorate a specific event. wac

330

Nickel Milicz, workshop (act. ca. 1545–68)

CHARLES V OF HAPSBURG, HOLY ROMAN EMPEROR (1500–1558; r. 1519–56) and **FERDINAND I OF HAPSBURG** (b. 1503; King of Bohemia and Hungary 1526–64; King of Croatia 1527–64; King of the Romans, 1531–58; Holy Roman Emperor 1558–64)

Dated 1550

Silver, struck; 60 mm

Scher Collection

Obverse: Charles wearing armor and the badge of the Order of the Golden Fleece. Inscription: PROGENIES DIVVM QVINTVS SIC CAROLVS ILLE IMPERII CAESAR LVMINA AET[atis] SVAE L [Charles V, descendant of gods, Caesar and eyes of the Empire, aged 50].

Reverse: Ferdinand wearing armor and the badge of the Order of the Golden Fleece. Inscription: FERDINANDVS D[ei] G[ratia] ROMANOR[um] HVNGARI[æ] BOEMINI [sic] INFANS HISPA[niæ] ARC[hidux] AVS[triæ] REX 1550 [Ferdinand, by the grace of God, King of the Romans, of Hungary and Bohemia, Prince of Spain, Archduke of Austria, 1550]. **Literature**: Habich 1929–34, 1: pt. 2, no. 1616; Katz 1932, no. 318.

This medal was struck in a variety of examples to celebrate Charles V's fiftieth birthday. On the obverse, *LUMINA* refers to part of the inscription (LUMINA ET ORA TULIT [bore the eyes and face [of the empire]) on the 1531 portrait engraving of Charles. sks

331

Peter Dell the Elder (1490–1552)

WILLIBALD VON REDWITZ (1493–1544)

Dated 1536

Copper alloy, cast; 113.6 mm

Scher Collection; Promised gift to The Frick Collection

Obverse: Von Redwitz wearing a hat, a pleated shirt, a rich cloak, and a chain, and holding a rosary in his hands; in the background, a suspended tapestry with floral motifs, above which is a scroll. Inscriptions: on the scroll, AN GOT NICHTS [Before God, nothing]; CONTERFE H WILBALDEN V REDWIZ THVMHERN Z BAMBERG VITZDOM Z WOLFSPERG CZ SEINES ALTERS XLIII IARN [The image of Willibald von Redwitz, canon of Bamberg and the diocese of Wolfsburg, at the age of 43].

330

331

200 GERMANY and AUSTRIA

332

333

Reverse: Von Redwitz arms within a floral wreath. Inscription: BEI REGIERVNG DES HOHWIRDIGEN FVRSTEN VND H H WEIGANDEN BISCHOVE ZV BAMBPG DES GESLEHTS AVCH V[on] REDWIZ A[nno] 1536 [Under the reign of the noble prince and his relative Weigand, also von Redwitz, bishop of Bamberg, in the year 1536].
Literature: Habich 1929–34, 1: pt. 1, no. 888; Pollard 2007, 2: no. 716.

Willibald von Redwitz was a cousin of Weigand von Redwitz, the Catholic bishop of Bamberg, to whom the reverse refers. SKS

332
Raphael Ranghieri (act. ca. 1567–1587)
ULRICH II MOLITOR (ca. 1526–1584)
Dated 1581
Silver, cast; 52.7 mm
The Frick Collection; Gift of Stephen K. and Janie Woo Scher, 2016 (2016.2.91)

Obverse inscription: VDALRICVS ABBAS MONASTERII SA[cræ] CRVCIS Æ[tatis] S[uæ] LV 1581 [Ulrich, abbot of the monastery of Heiligenkreuz, aged 55, 1581].
Reverse: Arms of the abbey of Heiligenkreuz and of the Müller family (Ulrich was the son of Joseph and Clementia Müller). Inscription: GLORIATIO N[ost]RA IN CRVCE CHRI[sti] [Our praise is in the cross of Christ]; RR [artist's initials].
Literature: Domanig 1907, 41, no. 255; Habich 1929–34, 2: pt. 2, no. 3473.

Ulrich II Molitor was abbot of the Cistercian monastery of Heiligenkreuz, in lower Austria, from 1558 to 1584. He joined the order in 1548, became prior and then abbot in 1558. He was sufficiently famous to be known as a second founder of the monastery. A specimen of this medal was found in the foundations of the church built in 1584. AF, SKS

333
Raphael Ranghieri (act. ca. 1567–1587) and Peter Ranghieri (d. 1624)
MICHAEL and **URSULA STARZER** (doc. 1563–1587)
ca. 1570
Silver, cast; 34.9 mm
Scher Collection; Promised gift to The Frick Collection

Obverse inscription: MICHAEL STARZER ANNO ÆTA[tis] SV[æ] 41 [Michael Starzer, aged 41].
Reverse: Ursula Starzer with flat cap and hair braided at rear, with ruff and three chains. Inscription: VRSVLA STARZERIN GEBORNE STAMPIN E 18 [Ursula Starzer, born Stampin, aged 18].
Literature: Habich 1929–34, 2: pt. 2, no. 3487.

A member of the Viennese middle class, Michael Starzer is recorded in the property book of 1563–87 as the owner of a house. AF, SKS

334
Raphael Ranghieri (act. ca. 1567–1587) and Peter Ranghieri (d. 1624)
JOHANN III VON TRAUTSON (ca. 1507–1595)
Dated 1589
Silver, cast; 29.6 mm
Scher Collection

Obverse inscription: IOANNES TRAVTHSON LIB[er] BARO E[t] Z[etera] S[acræ] C[aesareæ] M[aiestatis] INT[imus] PRIM[us] CON[silarius] [Johann Trautson, free baron, et cetera, first-ranked close councilor of his sacred imperial majesty].
Reverse: Trautson arms. Inscriptions: ÆTATIS SV[a]E 79 [Aged 79]; on either side of the arms, 1589.
Literature: Habich 1929–34, 2: pt. 2, no. 3480.

A distinguished statesman and nobleman, Trautson had substantial properties in Germany and Austria and served three Austrian emperors. AF, SKS

334

335

335

Hanns Lautensack (ca. 1520–1564/66)
GEORG KHOTLER (b. 1535) and his wife **MARTHA KNORR**
(b. ca. 1538)
Third quarter of 16th century
Silver, cast; 34.3 mm
Scher Collection

Obverse: Georg Khotler with doublet and hat before a curtain.
Reverse: Martha Knorr with dress and cap before a curtain.
Literature: Volz 1981–82, no. 7; Morton & Eden 2003, no. 857.

The identification of Khotler, a watchmaker in Vienna, rests on comparison with a medal with legend and date (1563) made by the same artist (Habich 1929–34, 1: pt. 2, no. 1719). None of these medals, however, can be traced back to a specific occasion. WaC

336

Unknown artist
ALBRECHT V, DUKE OF BAVARIA (1528–1579) and
ANNA, ARCHDUCHESS OF AUSTRIA (1528–1590)
ca. 1576
Silver, struck; 80.9 mm
Scher Collection

Obverse: Albrecht in full, decorated armor, wearing the Order of the Golden Fleece; beside him, Anna in a dress with ruff and a close cap; in front, the combined arms of the Rhine Palatinate,

Bavaria, and Austria. Inscription: ALBERTVS D[ei] G[ratia] COM[es] PAL[atinus] RHE[ni] VTRIVS[que] BAVA[riæ] DVX ANNA AB AVS[tria] D[uc]I[s] FERD[inandi] I CÆ[saris] AVG[usti] PII FEL[icis] FIL[ia] [H]ÆC [Albrecht, by the grace of God, Count of the Rhine Palatinate, and Duke of Bavaria, (and) Duchess Anna of Austria, daughter of the Duke Ferdinand I Caesar Augustus, the pious and happy, here].
Reverse: Two lions standing upon cliffs framing a distant city view and holding up a shield of arms of the Rhine Palatinate and Duke of Bavaria and the Order of the Golden Fleece; bordered by 34 municipal shields. Inscription: SI DEVS NOBISCVM QVIS CONTRA NOS [If God be with us, who can be against us?].
Literature: Habich 1929–34, 2: pt. 2, no. 3185; Cupperi et al. 2013, 253–54, no. 165 (obv. only, as by Gruppe München).

This medal celebrating Albrecht V, Duke of Bavaria, and Archduchess Anna of Austria, who married in 1546, was perhaps intended to glorify the areas under Albrecht's domain three years before his death. The reverse inscription derives from Romans 8:31. AF

337

Unknown artist
WILHELM V, DUKE OF BAVARIA (1548–1626) and
RENÉE OF LORRAINE (1544–1602)
Dated 1585
Copper alloy, cast; 77.1 mm
The Frick Collection; Gift of Stephen K. and Janie Woo Scher, 2016
(2016.2.106)

Obverse: Wilhelm in full armor wearing the Order of the Golden Fleece and, facing him, Renée in full dress with ruff, gable hood and a jeweled pendant; above, with radiant frame containing a cross, the Jesuit monogram IHS [Iehsus] and nails of the Crucifixion. Inscriptions: BENEFAC DOMINE BONIS ET RECTIS CORDE PSALM CXXIV [Do well, O Lord, unto those that are good and true of heart: Psalm 124 (Psalm 125:4)]; in exergue, impaled arms of Bavaria and Lorraine, and in three lines, COR UNUM ET / ANIMA UNA / 15 85 [one heart and one soul, 1585].

336

337

Reverse inscription: In thirteen lines, IHS / GVILHELMVS / V D[ei] G[ratia] COM[es] PALAT[inus] / RHE[ni] VTRIVSQ[ue] BAVA[riæ] / DVX ET RENATA LOTAR[ingiensis] / EIVS CONIVNX / HOC SOCIETATIS IESV / TEMPL[um] ATQ[ue] COL[legium] PROSVA / IN CATHOL[icam] RELIG[ionem] ET ORDI[nem] / ILLVM PIE A FVNDA[verunt] EX=TRVX[erunt] AC DOTA[ve] R[unt] AN[no] SA[lutis] / HVM[anæ] M D LXXXV / MONACHII [Jesus. Wilhelm V, by the grace of God, Count of the Rhine Palatinate, and Duke of Bavaria, and Renée of Lorraine his wife founded, built, and endowed this church and college of the Society of Jesus, piously moved by their devotion toward the Catholic religion and that order, in Munich in the year of human salvation 1585].

Literature: Habich 1929–34, 2: pt. 2, 463, no. 3191; Trusted 1990, no. 77; Cupperi et al. 2013, 254–55, no. 166 (as by Gruppe München).

This medal commemorates the founding of St. Michael's Church in Munich, the largest Renaissance church north of the Alps, in 1585. This was also the year Wilhelm was awarded the Order of the Golden Fleece. AF

338

Mattaeus Carl (ca. 1550–1609)
UNKNOWN MAN
Dated 1584
Silver, cast; 36.3 mm
Scher Collection

Obverse: Male bust wearing a jerkin and ruff. Inscriptions: I C V V S [?] Æ[tatis] XXXIIII [aged 34]; on truncation at left, MC [artist's initials].
Reverse: Fortuna stands on a sphere in the water and holds a banner. Inscription: FATA TRAHENTIA SEQVAR 1584 [I will follow the will of fate, 1584].
Literature: Habich 1929–34, 2: pt. 1, no. 2658.

The sitter, who was apparently born in 1550, remains unidentified, as do the initials in the obverse inscription. AF

339

Mattaeus Carl (ca. 1550–1609)
PAUL PFINZING (1554–1599) and **SABINA** (b. 1564)
Dated 1592
Lead, cast; 42 mm
Scher Collection; Promised gift to The Frick Collection

Obverse: Pfinzing wearing a jerkin and ruff. Inscription: PAVLVS PFINTZING ZV HENFFENFELD ÆTA[tis] SV[æ] 38 A[nn]°[15]92 [Paul Pfinzing of Henfenfeld, aged 38, in the year (15)92].
Reverse: Sabina with hair in a long braid, wearing a flat hat, high-collared dress, and ruff. Inscription: SABINA PAVLVS PFINTZINGIN ÆTATIS SVÆ 28 A[nn]° 1592 [Sabina Paul Pfinzing, aged 28, in the year 1592].
Literature: Habich 1929–34, 2: pt. 1, no. 2672.

338

339

Paul Pfinzing was from a patrician Nuremberg family, the Pfinzing von Henfenfeld. He was known for his work in cartography, especially the *Pfinzing Atlas* (1594), and for having developed instruments for cartographic work, including a pedometer and tachometer. Sabina was from the Lindner family; they were married in 1585 and had three children. AF

340

340
Master of the Ottheinrich of the Palatinate Group (act. 1551–59)
OTTHEINRICH, COUNT OF THE RHENISH PALATINATE
(b. 1502; Duke of Lower and Upper Bavaria 1502–59, Prince Elector of the Palatinate 1556–59)
Dated 1558
Silver gilt, cast; 44.5 mm
Scher Collection

Obverse: Ottheinrich wearing a flat cap with badge, a pleated shirt, vest, and decorated coat. Inscription: OTTO HENRICVS D[ei] G[ratia] COMES PALATINVS RHENI ELECTOR ÆTATIS LVI [Ottheinrich, by the grace of God, Count of the Rhenish Palatinate, Elector, aged 56]; a spray of flowers precedes the inscription.
Reverse: Ottheinrich's coat of arms: right, Palatinate of the Rhine; center, Arch-Steward of the Holy Roman Empire; left, Bavaria. Inscription: IN DOMINO CONFIDO ANNO SALVTIS M D LVIII CVM TEMPORE [I trust in the Lord; in the year of our salvation 1558; all in good time].
Literature: Habich 1929–34, 1: pt. 2, no. 1706; Scher 1994, no. 121; Thiel 2014, 279–306, 473–74.

One of the first acts of Ottheinrich as Prince Elector was to reintroduce the Reformation in the Palatinate. With the help of Melanchthon, he gave the University of Heidelberg a new constitution, making it one of the leading humanistic universities in the empire. A prominent art collector and patron, Ottheinrich commissioned about thirty portrait medals of himself from the best German medalists. This medal belongs to a group of sixteen made from 1551 to 1559, published by Habich under the heading "Otto-Heinrich of the Palatinate Group," which are among the finest medals produced in Germany at that time but for which there is no agreement on authorship. Scholars have linked the medals to the alabaster bust of the sitter (Louvre, Paris), recently attributed to Dietrich Schro (act. ca. 1542/44–1572/73). ADC

341
Hans Wild (act. from 1561)
MARCUS KUENE (1537–1564)
Dated 1561
Silver, cast; 32 mm
Scher Collection

341

Obverse inscriptions: MARC[us] KVENE IASCHKE GENANT AETAT[is] XXV [Marcus Kuene, called Jaschke, at the age of 25]; on the truncation of the bust (incised), HW [artist's initials] 1561.
Literature: Vossberg 1844, 229, table 9, fig. 2; Vossberg 1852, no. 488; Rolas du Rosey sale 1863, no. 2873; Habich 1929–34, 2: pt. 2: no. 3229.

Marcus Kuene, the son of an amber dealer in Danzig, was portrayed twice at the age of twenty-five, first in this circular medal and then in an oval one dated "1562" (Habich 1929–34, 2: pt. 2, no. 3230). It is unclear whether these likenesses were modeled in connection with any specific events. WaC

342
Lucas Richter (act. 1557; d. ca. 1590)
FERDINAND I OF HAPSBURG (b. 1503; King of Bohemia and Hungary 1526–64; King of Croatia 1527–64; King of the Romans, 1531–58; Holy Roman Emperor 1558–64), **MAXIMILIAN II OF HAPSBURG, HOLY ROMAN EMPEROR** (b. 1527; r. 1564–76) and **MARIA OF AUSTRIA, PRINCESS OF SPAIN** (1528–1603)
Dated 1563
Silver, struck; 35.1 mm
Scher Collection; Promised gift to The Frick Collection

Obverse: Ferdinand with parade armor and collar of the Order of the Golden Fleece. Inscription: FER[dinandus] D[ei] G[ratia] EL[ectus] RO[manus] IM[perator] S[acrus] AV[gustus] GE[rmanicus] HV[ngariæ] BO[hemiæ] R[ex] 1563 [Ferdinand, by the grace of God, elected Holy Roman Emperor Augustus of the German nation, King of Hungary and Bohemia, 1563].
Reverse: Jugate portraits of Maximilian, wearing a crown, parade armor, and the collar of the Order of the Golden Fleece, and his wife Maria. Inscription: MAXIMILIAN D[ei] G[ratia] RO[manorum] HVN[gariæ] BO[hemiæ] REX 1563 [Maximilian, by the grace of God, King of the Romans, of Hungary, and Bohemia, 1563].

342

343

344

Literature: Herrgott 1752–53, 2: table 9, no. 32; Löbbecke sale 1908, no. 545; Lanna sale 1911b, no. 689; Huszár and Procopius 1932, no. 45; Westfälische Auktionsgesellschaft 1998a, no. 5; Hall sale 2010, nos. 2021, 2022.

The portrait on the obverse copies Leone Leoni's medal of Ferdinand with subtle modifications (1551: Toderi and Vannel 2000, 1: no. 78); the reverse closely follows Lorenz Rosenbaum's medal of Maximilian and Maria of Hapsburg (after 1551: Habich 1929–34, 1: pt. 2, no. 1489), which is based on two previous portraits made from life by Leoni and Jacopo Nizzola da Trezzo (Toderi and Vannel 2000, 1: nos. 126, 127). As a consequence, the year 1563 inscribed on the two faces must refer to an event or to the die-engraving. Herrgott suggested that the medal could have been made for Maximilian's coronation as king of Hungary in 1563. WaC

343
Dietrich Schro (act. ca. 1542/44–1572/73)
PHILIP VON STOCKHEIM (1504–1564)
Dated 1550
Silver, cast, with traces of a loop for suspension; 33.9 mm
The Frick Collection; Gift of Stephen K. and Janie Woo Scher, 2016
(2016.2.104)

Obverse inscription: P[h]I[lippus] V[on] STOCKHEIM VICZSTHVM ZU MAINCZS AET[atis] 44 [Philip von Stockheim, fiduciary in Mainz, aged 44].
Reverse: Stockheim family coat of arms. Inscription: NOCH DEM DAS EWIG[e] LEBEN AN[n]O 1550 [To him the eternal life in the future, year 1550].
Literature: Greene sale 1898, no. 110; Habich 1914–15, 77, no. 12; Habich 1929–34, 1: pt. 2, no. 1694; Peus 2007, no. 2343; Thiel 2014, no. I.6.

Von Stockheim was the canon of the Cathedral of Mainz and fiduciary of Archbishop Albert of Brandenburg. The making of this medal cannot be traced to any specific occasion. WaC

344
Severin Brachmann (act. 1564–90)
ADAM MYSLÍK VON HYRŠOV (1520–1581; Knight of the Kingdom of Bohemia from 1553, Councilor in the Oberstburggrafenamt of Prague from 1570) and **PRUDENTIA MYSLÍK** (b. 1525)
Dated 1573
Silver, cast; 33.5 mm
Scher Collection

Obverse: Adam with ruff and chain. Inscriptions: ADAM MYSLIK [ET] HYRSSOWA AETA[tis] 53 [Adam Myslík von Hyršov, at the age of 53]; in relief on truncation of bust, 1573 SV [Severin Brachmann].
Reverse: Prudentia with a complex headdress. Inscriptions: PRVDENCZY MYSLIKOWA ET DOVBRAWY [Prudentia Myslík (born) von Doubrava]; on the truncation, AETA[tis] 48 [at the age of 48].
Literature: *Trésor de numismatique* 1834–58, 8: pl. VII, no. 10; Donebauer sale 1889, no. 3614 (rev.); Lanna sale 1911b, nos. 1038 (obv.) and 1039 (rev.); Habich 1929–34, 2: pt. 2, nos. 3288 (obv.) and 3289 (rev.).

This medal of von Hyršov and his wife combines the obverses of two much more common types and is likely an early, high-quality hybrid. The circumstances in which the two portraits were made are unknown. WaC

345
Monogrammist DS (act. 1560–69)
JOHANN FRIEDRICH II OF WETTIN (1529–1595; Duke of Saxony 1554–67)
After 1554
Silver, cast and struck; 47.1 mm
Scher Collection

Obverse: Bust with fur-collared cloak, hat, and chains. Inscription: DEI G[ratia] IOH[annes] FRI[dericus] SEC[undus] DVX SAX[oniæ] COMES PRO[vincialis] TVRINGIÆ ET M[archio/argravius] MISNIE [Johann Friedrich II, by the grace of God, Duke of Saxony, Landgrave of Thuringia, and Margrave of Meissen].
Reverse: Johann Friedrich's coat of arms. Inscription: ALLEIN EVANGELIVM IST O[h]NE VERLVST [Only the Gospel causes no loss].
Literature: Tentzel 1714, *Ern.*, table 16, no. 1; Löbbecke sale 1908, no. 589; Lanna sale 1911b, no. 880; Habich 1916, 126; Katz 1932, no. 539; Trusted 1990, no. 175 (obv.).

345

346

347

348

Tentzel traces the issue of this medal back to the so-called Grumbach Feud (1563–67), an unsuccessful plot through which Johann Friedrich II attempted to seize the title of elector from his cousin Augustus of Saxony by inciting an uprising against him. Regardless, the medal was certainly issued after 1554 because it mentions Johann Friedrich's ducal title. WaC

346
Unknown artist (southern Germany)
MARQUART ROSENBERGER (1480–1536)
First half of 16th century
Lead, cast; 46.2 mm
The Frick Collection; Gift of Stephen K. and Janie Woo Scher, 2016 (2016.2.99)

Obverse: Bust with fur coat and hat.
Literature: Habich 1916, 11 (as by master of Marquart Rosenberger); Habich 1929–34, 1: pt. 1, no. 289 (as by Hans Schwarz); Kastenholz 2006, 376; Cupperi et al. 2013, 151, no. 55a (as by Hans Schwarz).

The identification of the subject, a citizen of Nuremberg and Master of the Mint in Schwabach, rests on comparison with a medal bearing a very similar portrait and dated to 1536 (Habich 1929–34, 1: pt. 2, no. 1456). Neither type, however, can be traced to a specific occasion. WaC

347
Unknown artist
CHARLES V OF HAPSBURG, HOLY ROMAN EMPEROR
(b. 1500; r. 1520–58)
After 1541
Nutwood (two pieces); 47.4 mm
Scher Collection

Obverse: Charles with hat and collar of the Order of the Golden Fleece.

This gaming piece carefully copies a medal modeled in Regensburg or Nuremberg in 1541, possibly from life. The latter is attributed to a southern German medalist called "Master of the Georg Fugger" (Habich 1929–34, 1: pt. 2, no. 1837). On the function of gaming pieces, see no. 348. WaC

348
Unknown artist
FEMALE FIGURE
16th century
Nutwood; 47.5 mm
Scher Collection

Obverse: Female bust with hat, hair ribbon, and necklace with pendant.

This object can be considered a gaming piece because of the height and width of its frame, the lack of reverse and inscriptions, and the depiction of a likeness. This type of object is common in luxury examples made in the sixteenth century and could form complex iconographic series, usually articulated in two sets of twelve to fifteen pieces. The latter were used for games such as draughts, puff, and tric trac and required a board, which was often decorated with battle scenes, mythological motifs, or animals. WaC

349
Unknown artist (Germany)
MARGARET OF HAPSBURG, called **MARGARET OF AUSTRIA** (b. 1480; Governor of the Low Countries 1507–15 and 1517–30)
16th century
Boxwood (relief) and nutwood (frame); 62.6 mm
Scher Collection

Obverse: Bust in widow's dress with arms crossed.
Reverse: Label: MA [. . .] IAC COLLECTION 1529 I[?].
Literature: Habich 1929–34, 1: pt. 1, 106 and pl. 93, fig. 10 (after Konrad Meit).

349

Gaming pieces portraying members of ruling houses were not meant to simply commemorate their sitters; they enabled the two playing teams to identify with real factions of the European political arena (see no. 348). Therefore, they could copy much older likenesses and depict personalities who were already dead. For this reason, although the portrait model can be approximately dated to the first quarter of the sixteenth century, the gaming piece might be later. WaC

the biscuit. Such virtuosity can hardly be found in sixteenth-century hafnerware. Finally, although stove tiles with portraits of rulers were quite popular in sixteenth-century central Europe, they were usually provided with rich frames (Franz 1969, 11–12, 85–86, and fig. 184). It is therefore possible that this piece was made after Maximilian's lifetime. WaC

350

Unknown artist

MAXIMILIAN I OF HAPSBURG, HOLY ROMAN EMPEROR
(b. 1459; r. 1508–19)
Date unknown
Hafnerware (fired, glazed), with double hollow in the reverse;
53.4 mm
Scher Collection

Obverse: Maximilian with hat, ermine mantle, and collar of the Order of the Golden Fleece.

Though meant to represent Maximilian in his late years, the likeness on this medal differs significantly from his portraits of the period in the form of the nose and the unusual flow of the hair (e.g., the *Schauguldiner* of 1518; Egg 1971, no. 33). Additionally, the painting technique employed for the textiles pursues sophisticated effects of transparency and nuance and partially spares the original color of

351

Unknown artist

MAXIMILIAN I OF HAPSBURG, HOLY ROMAN EMPEROR
(b. 1459; r. 1508–19) and **MARY, DUCHESS OF BURGUNDY**
(1457–1482)
Dated 1479, made 1511–18
Silver, struck; 42.5 mm, 13.5 g (*Schautaler* coin)
Scher Collection; Promised gift to The Frick Collection

Obverse: Maximilian with long hair and crowned with a wreath. Inscriptions: MAXIMILIAN[us] MAGNANIM[us] ARCHIDVX AVSTRI[a]E BVRGVND[iæ] [Maximilian the Magnanimous, Archduke of Austria, and Burgundy]; in field, [a]ETA TIS 19 [aged 19].
Reverse: Mary with hair bound back. Inscriptions: MARIA KAROLI FILIA HERES BVRGVND[iæ] BRAB[antiæ] CONIVGES [Mary, daughter of Charles, heiress of Burgundy and Brabant, married]; in field, [a]ETAT IS 20 [aged 20].
Literature: Voglhuber 1971, no. 3; Bachtell 1974, no. 2; Moser and Tursky 1977, fig. 83; Winter (Heinz) 2009, no. 5a–b.

350

351

352

This coin, a *Schautaler*, is modeled after one of two medals by Giovanni Candida depicting Maximilian and his first wife (see no. 84); the other medal (Hill 1930, no. 830) celebrates their marriage in 1477, showing Maximilian and Mary as a younger couple. They had been married for only five years when Mary died in a hunting accident. This portrait type served as Maximilian's official portrait for twenty-five years, with several versions of struck coins based on the image. The year 1479 is considered by some scholars to be a mistake for the year of their marriage. However, 1479 was the year the archduke defeated the French troops at Guinegatte, thus sanctioning his role as the ruling duke of Burgundy; it is possible that a new medal was commissioned to commemorate this specific event. See also no. 84. ADC

352

Unknown artist
MAXIMILIAN I OF HAPSBURG, HOLY ROMAN EMPEROR
(b. 1459; r. 1508–19)
Dated 1478, made after 1519
Copper alloy, cast; 93.4 mm
The Frick Collection; Gift of Stephen K. and Janie Woo Scher, 2016
(2016.2.77)

Obverse: Maximilian with long hair and headband. Inscription:
MAXIMILIANVS DVX AVSTRIE BVRGVND[ieque] [Maximilian, Duke of Austria and Burgundy].
Reverse: The insignia of the Order of the Golden Fleece (a ram's skin hanging from a firesteel shaped like the "B" of "Burgundy") in a field semé of firesteels, flints, and flames. Inscription: IE LAY EMPRINT MCCCCLXXVIII [I undertook it, 1478].
Literature: Herrgott 1752–53, 1: table 10, fig. 9; Trampitsch sale 1988, no. 575; Astarte 2001, no. 134; Winter (Heinz) 2013, no. 80.

This rare medal commemorates Maximilian I's installation as Master of the Order of the Golden Fleece in 1478 yet differs significantly from the medals cast during Maximilian's lifetime in layout, modeling, and lettering. Recent scholarship therefore tends to consider the present type a restitution of uncertain dating, based on Candida's medals of about 1477 (Winter (Heinz) 2013, nos. 22, 23). The reverse motto was the device of the Order of the Golden Fleece under Charles the Bold. WaC

353

Unknown artist
LUDWIG II, KING OF HUNGARY, BOHEMIA, AND CROATIA (b. 1506; r. 1516–26) and **MARIA OF HAPSBURG,** also known as **MARIA OF HUNGARY** (1505–1558; Queen Consort of Hungary and Bohemia 1522–26, Governor of the Hapsburg Netherlands 1531–56)
Dated 1526
Silver, struck; 40.6 mm
The Frick Collection; Gift of Stephen K. and Janie Woo Scher, 2016
(2016.2.80)

353

354

355

Obverse: Ludwig wearing a large-brimmed hat, a pleated chemise with embroidered collar, a fur-collared mantle, and the Order of the Golden Fleece. Inscriptions: LVDOVIC[us] [H]VNGA[riæ] E[t]C[etera] REX CONTRA TVRCA[s] PVGNANDO OCCVBVIT [Ludwig, King of Hungary, et cetera, died fighting against the Turks]; in the field, 1526 / [a]ETATIS SV[a]E 30 [1526, aged 30].
Reverse: Maria wearing a pleated chemise with embroidered collar, hat, chain, and hairnet. Inscription: MARIA REGINA E[t] C[etera] QVOS DEVS CONIVNXIT HOMO NO[n] SE[paret] [Maria, Queen, et cetera; those God has joined, no man shall part].
Literature: Horsky sale 1910, no. 728; Pollard 2007, 2: no. 754.

Ludwig II died in the Battle of Mohács against the Turks at the age of twenty (the inscription erroneously says thirty). After the death of her husband, Maria ruled Hungary as regent for her brother, Ferdinand I, and later became governor of the Hapsburg Netherlands. This medal has also been attributed to Michael Hohenauer. ADC

354
Unknown artist (southern Germany)
JOHANNES COCHLÄUS (Johannes Dobeneck, 1479–1552)
ca. 1525–52
Copper alloy, cast; 47 mm
Scher Collection; Promised gift to The Frick Collection

Obverse: Cochläus wearing an academic gown and low hat with turned-up brim. Inscription: I[ohannes] C[ochlaeus].
Literature: Habich 1929–34, 1: pt. 1, no. 745.

On the basis of the form of the hat, which was typical of German professors (Hargreaves-Mawdsley 1963, 150), Georg Habich suggested that the sitter could be a humanist. The initials that flank the sitter and comparison with the engraved portraits published in Reusner (1587, fol. K8) and Boissard and De Bry (1669, fol. H3) allow here for the identification of this academic as the theologian Johannes Cochläus, one of the fiercest German opponents of Martin Luther on the Catholic side (Grimm 1957). A protégé of the humanist Willibald Pirckheimer and councilor to Cardinal Albert of Brandenburg, Cochläus had good relations with significant patrons of medallic art. As canon of the cathedral in Meissen (1525–39) and then in Breslau/Wrocław (1539–52), he also took part in religious meetings and imperial diets in several southern German cities. He may have encountered his now unidentified portraitist during one of these stays. WaC

355
Unknown artist
MARIA JAKOBÄA OF BADEN, DUCHESS OF BAYERN (1507–1580)
Dated 1560
Silver, cast; 39.2 mm
Scher Collection

Obverse: Maria Jakobäa with brocaded robe and hairnet. Inscription: IACOBA COMIT[issa] PAL[atinatus] RHE[ni] DV[cissa] BAVAR[iæ] MAR[gravia/chionissa] BADE[nsis] [Jakobäa, Countess Palatine of the Rhine, Duchess of Bavaria, Margravine of Baden].
Reverse: Ducal coat of arms of Baden-Sponheim. Inscription: ANNO M D LX [In the year 1560].
Literature: Beierlein 1897–1901, pt. 1, no. 277; *Sammlung … Otto Bally* 1896–1911, 1: no. 1118; Habich 1929–34, 2: pt. 2, no. 3207; Wielandt and Zeitz 1980, no. 12; Meister & Sonntag 2004, no. 1787.

The making of this medal of Maria Jakobäa, daughter of Philip I of Baden and wife of William IV of Wittelsbach, cannot be traced to any specific occasion. WaC

356
After the monogrammist Œ (act. ca. 1530–41)
JOHANN FRIEDRICH I OF WETTIN, called **THE MAGNANIMOUS** (b. 1503; Elector of Saxony 1547–54) and **STEFAN SCHLICK** (1487–1526)
Dated 1532
Silver, struck; 30.8 mm
Scher Collection

356

357

358

Obverse inscriptions: IOAN[nes] FRIDERICVS DEI GRA[tia] ELECTOR ET DVX SAXONIAE [Johann Friedrich, by the grace of God, Elector and Duke of Saxony]; in the field, 15 32 / Œ.
Reverse: Bust of Schlick, wearing a mantle, chains, hairnet, and hat with badge. Inscriptions: STEFAN SLICK COMES DE PASSAVN ALTER 40 [Stefan Schlick, Count of Bassano, at the age of 40]; in the field, Œ.
Literature: Habich 1929–34, 2: pt. 1, nos. 1913 (obv.) and 1910 (rev.); Katz 1932, nos. 174 (obv.) and 177 (rev.).

The layout of the inscriptions, the format of the two portraits, and the truncation of the busts do not match, and both likenesses are known separately in more common types. Moreover, the association of the portrait of Johann Friedrich and Schlick, Count of Bassano and Weiskirchen, as seen in this medal, is extremely rare. This piece can be considered a hybrid of two preexisting types and may not have been struck for a specific occasion. Nevertheless, the dies for the two faces, incised by the same unidentified monogrammist, have been combined in a fine way, respecting the standard vertical orientation of the axis. See also nos. 288 and 313. WaC

This medal is based on a similar type struck by Wolf Milicz in 1537 (Katz 1932, no. 271). A copyist added the monogram WS / SW and slightly modified the coat of arms, possibly through partial molding and remodeling (as suggested by the fact that this type survives only in cast specimens). The inscriptions were borrowed from a medal issued by Hieronymus Magdeburger in 1532 (Katz 1932, no. 46, transcribes them wrongly, but their wording is identical). The lettering of the present medal led Katz to conclude that it was made in Milicz's or Magdeburger's workshops and to understand the monogram as the mark of an unidentified sixteenth-century artist. Yet the monogram is documented only in a variant of the present type (Katz 1932, no. 527c) and its prominent position is unusual for sixteenth-century authorial marks, as Stephen K. Scher suggests. Either the medal is the work of a dilettante who ignored the conventions of medallic art and worked in this field only accidentally, as supposed by Katz, or the monogram has a different meaning. Unlikely commissioned by Charles or his entourage (especially if made in Saxony, as suggested by Georg Habich), this rare medal should be considered a later edition combining features of previous types, possibly for a specific owner and purpose. WaC

357

Unknown artist
CHARLES V OF HAPSBURG, HOLY ROMAN EMPEROR
(b. 1500; r. 1520–58)
Dated 1541
Silver, cast; 43.4 mm
Scher Collection; Promised gift to The Frick Collection

Obverse: Charles with hat, collar of the Order of the Golden Fleece, and gloves in his right hand. Inscription: TECVM REGNA DEVS PARTITVS VT IMPERET ASTRIS [hexameter: God has shared his kingdoms with you so that his particular dominion is the sky].
Reverse: Imperial coat of arms crowned with the imperial crown and surrounded by the collar of the Order of the Golden Fleece; at both sides, Charles's device, the columns of Hercules crowned with the imperial crown (left) and a lower one (right). Inscriptions: ILLE REGENDA TIBI SIC SOLA CVNCTA DEDIT 1541 [pentameter: As a consequence, (God) gave you all earthly lands to rule, 1541]; above, shield with the monogram: WS / SW.
Literature: Löbbecke sale 1908, no. 581; Bernhart 1919, no. 130; Habich 1929–34, 2: pt. 1, no. 1999; Katz 1932, no. 527b.

358

Unknown artist (Germany)
ELISABETH, DUCHESS OF BRUNSWICK-CALENBERG
(1510–1558)
Dated 1544
Silver gilt, cast; 41.3 mm
Scher Collection

Obverse: Elisabeth wearing a widow's bonnet and cap. Inscription: in the field to the left and right of the sitter, 15 / 44 [date].
Reverse: The Brandenburg coat of arms. Inscriptions: ELISABET[a] MAR[chionissa] PRI[ncipissa] BRVN[suicensis] E[t] LVNE[burgensis] [Elisabeth, Marchioness (and) Princess of Brunswick and Lüneburg]; 34 [sitter's age].
Literature: Brockmann 1994, no. 20; Scher 1994, no. 137 (var.).

Elisabeth, daughter of the Elector of Brandenburg Joachim I and wife of Duke Erich the Elder, was widowed in 1540, at which point she ruled as guardian of her twelve-year-old son Erich and introduced Protestant reform to her territories. This medal is paired with one depicting her late husband. In 1545, a version of Elisabeth's medal was struck and bears that date, which may commemorate the year her son assumed power. ADC

359

360

359

Unknown artist (Germany)

JOHANN FRIEDRICH I OF WETTIN, called **THE MAGNANIMOUS** (b. 1503; Elector of Saxony 1547–54) and his grandfather **FRIEDRICH III OF WETTIN**, called **THE WISE** (b. 1463; Elector of Saxony 1486–1525)

After 1547

Silver, cast from a struck specimen; 32.6 mm

Scher Collection

Obverse: Johann Friedrich I with fur coat; coats of arms of the House of Wettin punctuating the inscription. Inscription: IOHAN FRIDE[rich] DVX SAXONIE [Johann Friedrich, Duke of Saxony].
Reverse: Friedrich III with fur coat and hairnet. Inscription: FRIDERICH DVX SAXONIE [Frederick, Duke of Saxony].
Literature: Tentzel 1714, *Ern.*, table 4, no. 5; Vogel sale 1928, no. 5947; Katz 1932, no. 32.

As observed by Tentzel, the representation of the electoral swords in one of the coats of arms in the obverse demonstrates that this medal was made after 1547, though the exact circumstances of its issue are unknown. WAC

360

Unknown artist (Germany)

HANS EBNER VON ESCHENBACH THE ELDER (patrician of Nuremberg; Knight of the Holy Roman Empire from 1550; d. 1553)

Probably before 1553

Lead, cast; 49.4 mm

The Frick Collection; Gift of Stephen K. and Janie Woo Scher, 2016 (2016.2.97)

Obverse inscription: HANNS EBNER SENIOR Æ[tatis] SVÆ 61 IAR [Hans Ebner the Elder, at the age of 61 years].
Literature: Lanna sale 1911b, no. 1159; Habich 1929–34, 1: pt. 1, no. 158 (as by Hans Schwarz); Kastenholz 2006, 373 (as anonymous).

The making of this medal cannot be traced to any specific occasion. In specimens with a reverse (for example, Staatliche Münzsammlung, Munich), the Ebners' coat of arms is depicted. WAC

361

362

363

361

Unknown artist
CHARLES V OF HAPSBURG, HOLY ROMAN EMPEROR
(b. 1500; r. 1519–56) and **PHILIP II, KING OF SPAIN** (b. 1527;
r. 1556–98)
Before 1556
Copper alloy, cast; 99.7 mm
Scher Collection

Obverse: Charles, laureate, in armor all'antica and knotted cloak
with the Order of the Golden Fleece. Inscription: IMP[erator] CAES[ar]
CAROLVS V AVG[ustus] [Emperor Caesar Charles V Augustus].
Reverse: Philip, in full body armor on horseback holding a mace.
Inscription: PHILIPVS AVSTR[iæ] CAROLI V CAES[aris] F[ilius] [Philip of
Austria, son of Emperor Charles V].
Literature: Scher 1994, no. 156.

The figures of Emperor Charles and his son Philip show a rather
heavy-handed modeling, while the obverse is loosely based on a
portrait of Charles V by the Milanese Leone Leoni. The medal may
have been made in the Netherlands, sometime before the abdication
of Charles V (January 16, 1556). ADC

362

Monogrammist I.M. (Isaak Melper?)
BARTHOLOMÄUS SCHOWINGER THE ELDER (1500–1585)
Dated 1561
Silver, cast; 39.2 mm
Scher Collection; Promised gift to The Frick Collection

Obverse inscriptions: BARTT[o]L[o]ME[us] SCHOWINGER; on the
truncation (incised), I[?] M[?].
Reverse: Schowinger's coat of arms. Inscription: LAVDA ANIMA MEA
DOMINVM 1561 [My soul praises the Lord, 1561].
Literature: Haller 1780, 157, no. 271; Forrer 1904–30, 3: 75;
Habich 1929–34, 1: pt. 2, no. 1552; Peus 2013, no. 1293.

The sitter has been identified with Bartholomäus Schowinger the
Elder, a patrician of St. Gallen. WaC

363

Unknown artist (Austria)
FERDINAND I OF HAPSBURG (b. 1503; King of Bohemia and
Hungary 1526–64; King of Croatia 1527–64; King of the Romans,
1531–58; Holy Roman Emperor 1588–64)
Dated 1561
Silver, cast; 48.6 × 40.9 mm
The Frick Collection; Gift of Stephen K. and Janie Woo Scher, 2016
(2016.2.78)

Obverse: Ferdinand wearing the collar of the Order of the Golden
Fleece, gloves in his right hand and a letter in the left; background
punched with arabesques. Inscriptions: FERDINANDVS D[ivina]
FAV[ente] CLE[mentia] EL[ectus] RO[manus] IMP[erator] SEMP[er] AVC
[scil. Augustus] AC GER[maniæ] HVNG[ariæ] BOHE[miæ] REX ETC[etera]
[Ferdinand, elected with the favor of Roman Emperor Forever
August of the clemency of God, and King of Germany, Hungary, and
Bohemia, et cetera]; engraved in the letter, 15 / 61.
Reverse: The greater coat of arms of Ferdinand I (I and II quarter, III
and IV quarter reversed) held by Victories, crowned by the Imperial
crown held by two putti, and surrounded by his collar as Master of
the Order of the Golden Fleece.
Literature: Herrgott 1752–53, 2: table 3, fig. 26; Horsky sale 1910,
no. 911 (this specimen); Habich 1929–34, 1: pt. 2, no. 1716; Winter
(Heinz) 2009, no. 29; Cupperi et al. 2013, 218–19, no. 125 (as by
Joachim Deschler).

This portrait exists in two variants with the same date and almost
identical reverses but slightly different obverses and inscriptions:
a version in stone (Domanig 1896, no. 79) attributed to Joachim
Deschler (1500–1571); and this version in metal, characterized by
Ferdinand's more ascetic features and made by a different hand. If
the stone relief was made first, as assumed by Habich and Winter,
the author of the medal did not simply mold its portrait but also
modified his wax model freehand. The existence of two different
versions inscribed "1561" suggests that this date refers to the
making of the portrait model rather than to the casting of the medal.
Herrgott interprets the reverse as an allusion to the confirmation of
Ferdinand's imperial title in 1558. WaC

364

365

364

Unknown artist (Netherlands)

MATTHIAS II OF HAPSBURG (b. 1557; Governor of the Low
Countries 1578–81; Holy Roman Emperor 1612–19)

Dated 1579

Lead, cast; 36.9 mm

The Frick Collection; Gift of Stephen K. and Janie Woo Scher, 2016
(2016.2.76)

Obverse: Matthias wearing armor, mantle, and ruff. Inscriptions:
MATTHIAS D[ei] G[ratia] ARCHI[dux] AVST[riæ] D[ux] BVRG[undiæ] CO[mes]
TY[rolis] GVBER[nator] CAP[itanus] G[ene]R[a]L[is] BEL[gi] [Matthias, by
the grace of God, Archduke of Austria, Duke of Burgundy, Count
of Tirol, Governor and Lieutenant General of the Netherlands]; on
truncation (incised), 1579.

Reverse: Perseus, with winged sandals and the shield made by
Athena, fights against a sea monster to liberate Andromeda in chains.
Inscription: AMAT VICTORIA CVRAM [Victory loves to be cared for.
Catullus, *Carmen* 62.16].

Literature: Van Loon 1723–37, 1: 247, no. 3; Herrgott 1752–53,
2: table 15, fig. 6; Armand 1883–87, 2: 276, no. 2; Löbbecke sale
1908, no. 556; Horsky sale 1910, no. 1408; Smolderen 1996,
no. 823.

This medal was cast in the Netherlands a year after Matthias's
appointment as governor of the Hapsburg dominions (1578). In
this capacity, he unsuccessfully attempted to restablish peace in
the conflict between his uncle, Philip II of Spain, and the seven
rebellious provinces of the Northern Netherlands. The medal
presents Matthias as a new Perseus coming to liberate the Low
Countries. Its reverse is based on a previous one cast by Jacques
Jonghelinck in 1578 (Smolderen 1996, no. 92). The two types
demonstrate quite different styles, yet the author of the present
medal shows awareness of Jonghelinck's and Giampaolo Poggini's
Netherlandish works and is likely to have been active in the same
area. WaC

365

Unknown artist

GREGOR SENNER (b. 1536)

Dated 1580

Silver, cast; 34.6 mm

Scher Collection; Promised gift to The Frick Collection

Obverse inscription: GREGORIVS SENNER AET[atis] 44 AN[n]O 80
[Gregor Senner, aged 44, in the year 1580].

Reverse: Baptism of Christ with God the Father sending the Holy
Spirit in the form of a dove, and the coat of arms of the Senner
family. Inscription: DIS IST MEIN GELIBTER SON DEN SOLT IR HERN
[This is my beloved Son (Matthew 3:17), you shall honor him].

Literature: Löbbecke sale 1908, no. 329; Lanna sale 1911b, no.
1256; Mueller-Lebanon sale 1925, no. 34; Meister & Sonntag 2004,
no. 2318; Peus 2013, no. 1649.

Senner was a patrician of Nuremberg. WaC

366

Unknown artist

CHRISTOPH PUTZ VON KIRCHAMEG (b. 1554)

Dated 1584

Silver, struck; 39.2 mm

Scher Collection; Promised gift to The Frick Collection

Obverse: Von Kirchameg wearing a doublet and ruff. Inscriptions:
CHRISTOPH PVTZ V[on] KIRCHAMEGG Z[u] S[agritz] V[nd] P[ilzelstaetten] 84
[Christoph Putz von Kirchameg zu Sagritz und Pilzelstätten, 1584];
ÆTA[tis] SVÆ / 30 [aged 30].

Literature: Pollard 2007, 2: no. 756.

Von Kirchameg was the mint master of the Kingdom of Bohemia in
Prague from 1590. ADC

366

367

367

Hans Daucher? (ca. 1485–1538)?

YOUNG WOMAN

Dated 1514

Solnhofen stone mounted in a wooden frame, with traces of a loop for suspension; 84.3 mm (150 mm including frame)

Scher Collection

Obverse: Bust with *goller* (traditional jacket) and hat. Inscription: 1514.

Literature: Brentano sale 1822, no. 65 (as terracotta); Felix sale 1895, no. 297; Habich 1929–34, 1: pt. 1: no. 15; pt. 2: LX; Bernhart 1934a, table A, fig. 4; M. Jones 1979a, fig. 79; Mende 1983, no. 61.

This piece was first believed to be a work by Albrecht Dürer portraying his wife Agnes (Brentano, 1822) and then considered the pendant of an unidentified male portrait by the same hand, also dated 1514 and engraved in Solnhofen stone (Coin Cabinet, Stockholm: Mende 1983, no. 58, as "Hans Daucher?"). Yet, the latter is slightly smaller (76 to 81 mm) and facing left, like the present one, while pendant portraits of couples usually face each other. Scholars agree on the dating of this work to 1514 or slightly later, but there is no conclusive evidence as to the genre of the image, the circumstances of its carving, or the identity of the sitter. WAC

368

This medal was commissioned by Catherine Schlick (d. 1617), wife of Melchior von Redern, after the siege of Grosswardein (now Oradea, Romania), a fortress her husband had successfully defended from the Ottomans in 1598. In recognition of this achievement, Melchior received the title of baron (mentioned in the inscription) on May 16, 1599. WAC

368

Gerard Hendrik (Heinrik) the Younger (act. ca. 1587; d. ca. 1616)
MELCHIOR, BARON OF REDERN, LORD OF FRIEDLAND (FRÝDLANT) (1555–1600; commander of the Hapsburg troops from 1580)
Dated 1598, made probably 1599 or soon after
Silver, cast; 52.2 × 41.5 mm
Scher Collection; Promised gift to The Frick Collection

Obverse: Bust with ruff and armor. Inscription: MELCHIOR VON REDERN FRYHERR [Melchior von Redern, baron].
Reverse inscription: ANNO 1598 / DEN 28 SEPT[ember] IST / MEIN LIEBSTER / HERR SAMBT 2000 / MAN IN DER VESTVNG / G[roß]WARDEIN VON 130000 / TVRCKEN VND TATTERN / BELEGERT VND DVRCH GOT / TES HVLF WIDERVMB DEN / 3 NOVEMB[er] ERLEDIGET / WORDEN GOTT / SEY LOB [My beloved Lord was besieged in the fortress of Grosswardein together with two thousand men by a hundred thirty thousand Turks and Tartars on 28 September 1598, and he was liberated again through God's help on 3 November, God be praised].
Literature: Kundmann 1738, 76; Domanig 1892, 93–94; Löbbecke sale 1908, no. 558 (anon. master act. 1550–1600); Habich 1929–34, 2: pt. 1, no. 2897; Rauch 2014, no. 1900.

369

Heinrich Rappost the Younger (d. 1616)
FREDERICK ULRICH OF GUELPH (b. 1591; Duke of Brunswick-Lüneburg, Prince of Wolfenbüttel 1613–34)
Dated 1615
Silver, struck; 72.3 mm
Scher Collection

Obverse: Portrait in armor with baton in the right hand and helm lying on a table under his left hand. Inscription: FRIDERICVS VLRICVS D[ei] G[ratia] DVX BRVNS[uicensis] E[t] L[uneburgensis] [Frederick Ulrich, by the grace of God, Duke of Brunswick and Lüneburg].
Reverse: The rays emanating from the name יהוה [Hebrew for Jehovah] strike an oak tree and break off its top; in the background, the city of Brunswick. Inscriptions: FLECTERIS AN FRANGERIS 1615 [You will bend yourself or you will break, 1615]; HR [artist's initials].
Literature: Praun 1747, no. 242; Fiala 1906, no. 773; Brockmann 1985–87, 1: no. 137a; Leschhorn 2010, 197 and fig. 210; Hall sale 2010, no. 2492.

On July 22, 1615, Frederick Ulrich laid siege to the city of Brunswick, which refused to recognize him as duke. This medal, the reverse of which refers to Frederick's hostile purposes, must have been issued before he acceded to the city's requests by signing the Peace of Steterburg (December 21). WAC

369

370

371

370

Georg Holdermann (1585–1629)

PHILIPP SCHERL (ca. 1553–1615)

Dated 1615

Silver, cast; 37.2 mm

The Frick Collection; Gift of Stephen K. and Janie Woo Scher, 2016 (2016.2.105)

Obverse inscription: PHILIPPS SCHERL ÆTA[tis] SVÆ 62 [Philipp Scherl, at 62 years of age].

Reverse: Coat of arms of the Scherl family. Inscription: VERSCHID[en] DEN 28 IANVARI ANNO 1615 [Died on 28 January 1615].

Literature: Imhof 1780–82, 2: 899, no. 18; Erman 1884, 63; Lanna sale 1911b, no. 1103 (this specimen?); Habich 1929–34, 2: pt. 1, no. 2786; Westfälische Auktionsgesellschaft 1998a, no. 88; Meister & Sonntag 2004, no. 2322.

This medal commemorates the death of Philipp Scherl, a merchant in Nuremberg, in 1615. WaC

371

Christian Maler (1578–1652)

MATTHIAS II (1557–1619) and **EMPRESS ANNA OF TYROL** (1585–1618)

Dated 1613

Silver gilt, struck; 39.8 mm

Scher Collection; Promised gift to The Frick Collection

Obverse: Matthias, laureate, in armor with lion pauldrons and wearing the Order of the Golden Fleece; Anna in upswept coiffure and high stiff lace collar. Inscription: MATTH[ias] ROM[anus] IMP[erator] CAES[ar] ET ANNA AVSTR[iaca] AVG[usta] [Matthias, Roman Emperor and Caesar, and the August Anna of Austria].

Reverse: Matthias on horseback under a canopy held by four courtiers. Inscriptions: ZVR GEDECHTNIS K[aisers] M[atthias] EINRI[e]IT[en]S, VND; in exergue, in four lines, REIG[sic for C]HSTAGS ZV REGE=NSPVRG ANNO 1613 / DEN 4 AVG C[um] P[rivilegio] / C[hristian] M[aler] [In memory of the entrance on horseback of Emperor Matthias

to the Diet of Regensburg, in the year 1613, 4 August; with privilege. Christian Maler].

Literature: K. H. von Lang 1825, 3: 10; Riechmann 1921, no. 233; *Münzen- und Medaillen Auktion* 1961–62, 205.

Shortly after Matthias became emperor in 1612, he faced growing religious tensions in Germany and sought to address them by assuming an attitude of moderation and attempting to reconcile the contending religious parties at the diet of Regensburg in 1613, an attempt that proved futile. AF

372

Christian Maler (1578–1652)

FRIEDRICH VON DER PFALZ (1596–1632) and **ELIZABETH STUART** (1596–1662)

Dated 1619

Silver, cast; 41.7 × 34.9 mm

Scher Collection; Promised gift to The Frick Collection

Obverse: Friedrich wearing decorative armor with lion pauldrons, ruff, and Order of the Garter; Elizabeth wearing a diadem, lace collar, and pendant. Inscription: FRIDERICVS ET ELISABETHA D[ei] G[ratia] R[ex] R[egina] BOHEMIÆ [Friedrich and Elizabeth, by the grace of God, King and Queen of Bohemia].

Reverse: Inside a small oval, five hands extending from clouds holding up a crown below a radiant inscription: יהוה [Hebrew for Jehovah]; surrounded by inscription: DANTE DEO ET ORDINVM CONCORDIA [If God allows it, concord of the orders]. Inscription: across larger oval, in eleven lines, FRIDERI[cus] / D[ei] G[ratia] COM[es] PALAT[inus] / RHENI S[acri] R[omani] I[mperii] ELEC[tor] / DVX BAV[ariæ] CORON[atus] / ET CRE[atus] IN REG[em] / BOHE[miæ] MARCH[ionem] / MORA[viæ] DVCEM / SIL[esiæ] ET MARCH[ionem] / VTR[iusque] LVSAT[iæ] / ANNO CIƆ IƆ CXIX / DIE IV NOVEM[bris] [Friedrich, by the grace of God, Count Palatine of the Rhine, Elector of the Holy Roman Empire, Duke of Bavaria, crowned and created King of Bohemia, Marquess of Moravia, Duke of Silesia, and Marquess of both Lusatias, in the year 1619 on 4 November].

372

373

Literature: Cochran-Patrick 1884, 40, no. 4; Stemper 1997, 161, no. 162.

Friedrich V was elector of the Rhine Palatinate and briefly ruled as King of Bohemia as Friedrich I (sometimes called the Winter King); this medal was made on his coronation in 1619. Another version of the medal includes only the portrait of Friedrich with the same reverse. Elizabeth was the daughter of James VI of Scotland (James I of England), the successor to Elizabeth I of England. AF

373

Johann Jacob Kornmann (d. 1649)
PAOLO GIORDANO II ORSINI (1591–1656)
Dated 1621
Copper alloy, struck; 31.4 mm
Scher Collection; Promised gift to The Frick Collection

Obverse: Orsini all'antica. Inscriptions: PAVL[us] IORD[anus] II D[ei] G[ratia] ANG[uillaræ] C[omes] BRACC[iani] DVX S[acri] R[omani] I[mperii] P[rinceps] [Paolo Giordano II, by the grace of God, Count of Anguillara, Duke of Bracciano, Prince of the Holy Roman Empire]; on truncation, 1621.

Reverse: Athena with a helmet, lance, and shield; in the background, Neptune riding on the sea. Inscription: VT VTRVNQVE TEMPVS [So that each time].
Literature: P. A. Gaetani 1761–63, 2: 51–52, pl. XCI, no. 1; Vannel and Toderi 2003–7, 2: no. 327.

In 1615, Orsini became Duke of Bracciano and head of the Orsini family. He was an effective and enlightened ruler, bringing key industries to his duchy. He was also a passionate patron of the arts, commissioning architecture, supporting musicians, and collecting musical instruments. Orsini built an important art collection and patronized many artists, among them, Jacques Callot and Simon Vouet, and commissioned his own portrait in many media. At the end of his life, his duchy suffered serious economic decline. He probably died of the plague. SKS

374

Johann Jacob Kornmann (d. 1649)
FILIPPO PIROVANI (d. 1643)
Dated 1641
Copper alloy, cast; 88.9 mm
The Frick Collection; Gift of Stephen K. and Janie Woo Scher, 2016 (2016.2.100)

374

Obverse inscriptions: PHILIPPVS PIROVANVS S[acræ] ROTÆ ROMANÆ DECANVS [Filippo Pirovani, dean of the Holy Roman Rota]; OPVS CORMANI 1641 [Work of Kornmann, 1641].
Reverse: A warship sailing on a choppy sea. Inscriptions: SALVS NOSTRA A DOMINO [Our salvation (comes) from the Lord]; in the lower left field, among the waves, COR[manus] [Kornmann].
Literature: P. A. Gaetani 1761–63, 2: 25, pl. CVI, no. 1; Vannel and Toderi 2003–7, 2: no. 336.

Filippo Pirovani was a jurist and dean of the Apostolic Tribunal of the Roman Rota, which is the highest appellate tribunal of the Roman Catholic Church. sks

375

Hans Georg Perro (act. from ca. 1629)
JOHANN BAPTIST VERDA (1582–1648; Count of Werdenberg from 1630, First Chancellor for Upper and Lower Austria)
Dated 1630
Silver, struck; 48.5 mm
Scher Collection; Promised gift to The Frick Collection

Obverse: Verda with mantle on the left shoulder and medallion on the breast. Inscriptions: IO[hannes] BAP[tista] F[rei]H[err] VVERDENBERG H[err] Z[u] G[rafenegg] [Johann Baptist, Baron of Werdenberg, Lord of Grafenegg]; on truncation of shoulder, 1630.
Reverse: A shining six-pointed star, enclosed within the ring formed by a snake biting its own tail (*ouroboros*) resting on a field of grass. Inscription: FATO SAPIENTIA MAIOR [Wisdom matters more than destiny].
Literature: Domanig 1907, table XXVIII, fig. 260; Bergmann 1844–57, 2: no. 86; Probszt 1928, no. 41; Habich 1929–34, 2: pt. 2, no. 3539.

This medal, made before Verda's appointment as Count of Werdenberg and Namiest (November 1630), was possibly struck in preparation for a diplomatic mission to Memmingen that he undertook in September 1630 on behalf of the emperor. The *impresa* may be an allusion to destiny, which was influenced by

the stars, depending on their cyclical movement and continuous change, here represented through the *ouroboros*. Valerianus (1556, 103) describes it as a symbol of the *machina mundi*. wac

376

Sebastian Dadler (1586–1657)
GUSTAVUS II ADOLPHUS, KING OF SWEDEN (b. 1594; r. 1611–32)
Dated 1621, made 1641
Silver, struck; 60.2 mm
Scher Collection

Obverse: Gustavus, in armor, holding a baton on horseback moving to the right and turning to face front with an encampment of troops and the city of Riga in the background; two putti in clouds hold a crown above his head. Inscriptions: GUSTAVUS ADOLPHUS MAGNUS DEI GRATIS SUECOR[um] GOTHOR[um] ET VANDALOR[um] REX AUGUSTUS [Gustavus Adolphus the Great, by the grace of God, August King of the Swedes, Goths, and Vandals]; in exergue, SD [artist's initials].
Reverse: In the background, the city of Riga surmounted by two putti holding a crown and lions supporting the shield of Riga; in left foreground, Gustavus marshals his troops while on the right a battle ensues. Inscriptions: RIGA **DE**VI**C**TA **VI**CTORIA **V**ENIT AB A**X**E **L**A**V**RV **V**BI G**V**STA**VI** **C**IN**XI**T RA**DI**ANTE **C**AP**ILL**OS [When Riga was conquered, there descended from the North the goddess of victory who crowned Gustavus's head with the spiral laurel wreath], chronogram for 1621; in exergue, H[einrich] W[ulff].
Literature: Hildebrand 1874, 105, no. 8; Więcek 1962, no. 108; Forrer 1979–80, 1: 496; McKeown 2001, 19–20; Maué 2008, no. 45.

This medal commemorates the Siege of Riga (Latvia) in 1621, as the beginning of Gustavus Adolphus's campaign against Poland. The reverse inscription is a chronogram for the date. The initials on the reverse, H W, are those of Heinrich Wulff, who was mint master at Riga from 1625 to 1659. Maué states that the medal was produced in 1641 to commemorate the events of 1621. af, sks

375

376

377

Sebastian Dadler (1586–1657)

GUSTAVUS II ADOLPHUS, KING OF SWEDEN (b. 1594; r. 1611–32)

Dated 1631

Silver, struck; 56.6 mm

Scher Collection; Promised gift to The Frick Collection

Obverse: Gustavus wearing a commander's sash and large collar beneath which armor is visible, within an auricular frame with a putto's head at top. Inscriptions: GUST[avus] ADOLPH[us] D[ei] G[ratia] SUEC[orum] GOT[horum] VA[n]D[alorum] R[ex] M[agnus] PRI[n]C[eps] FI[n] LA[n]D[iæ] DUX E[s]THO[niæ] ET CARELIÆ I[n]GRIÆ D[ominus] [Gustavus Adolphus, by the grace of God, great King of the Swedes, Goths, and Vandals, Prince of Finland, Duke of Estonia and Karelia, and Lord of Ingria]; within the frame at the bottom, 1631 SD [artist's initials].

Reverse: Gustavus as the Christian soldier "Miles Christianus" in armor all'antica with sword and a cross-decorated shield, standing on vanquished humans and beasts; in the background, rays and

lightning bolts. Inscription: right, outer line, MILES EGO CHRISTI CHR[ist]O DUCE STERNO TYRANNOS; right, inner line, HÆRETICOS SIMUL ET CALCO MEIS PEDIBUS; left, outer line, PARCERE CHRISTICOLIS, ME DEBELLARE FEROCES; left, inner line, PAPICOLAS, CHRIST[us] DUX ME[us] EN ANIMAT [I, a soldier of Christ, with Christ as my commander, scatter tyrants and at the same time trample heretics under my feet. Christ my commander inspires me to spare the Christians and to vanquish the arrogant Papists]. The line "parcere christicolis me debellare feroces" is adapted from Virgil's *Aeneid* (VI.853): "parcere subiectis et debellare superbos."

Literature: Hildebrand 1874, 132, no. 57; Więcek 1962, no. 74; McKeown 2001, 10–12; Maué 2008, 29.

Gustavus II Adolphus (see no. 376) transformed Sweden from a regional power to one of major European influence through a relentless series of military battles from 1611 until his death in battle. This medal presents him as a Christian soldier defending the faith, following an established medieval tradition. AF, SKS

377

378

378

Sebastian Dadler (1586–1657)

THE BATTLE OF BREITENFELD

Dated 1631

Silver, struck; 65.5 mm

Scher Collection; Promised gift to The Frick Collection

Obverse: Before a city view of Leipzig, three female figures clasping their right hands in amity: to the left, Justice holding a sword in her left hand; in the center, Fortitude holding antique arms in her right hand and supporting a crowned column with her left arm; to the right, Piety holding a laurel branch; on the left, above, a hand emerging from a cloud. Inscriptions: above in radiant burst, יהוה [Hebrew for Jehovah]; IVSTITIA ET PIETAS CONSTANS ANIMVSQVE TRIUMPHANT [Justice, steadfast piety and courage triumph]; below in a cartouche: GOT MIT UNS [God with us]; below cartouche inscription, SD [artist's initials].

Reverse: Surrounded by seven stars, an angel with sword descending from the clouds over the battlefield of Breitenfeld. Inscription: AVXILIANTE DEO PRESSIS VICTORIA VENIT AN[no] MDCXXXI VII

SEPT[embris] [With God's help victory came to the hard-pressed, 7 September 1631].

Literature: Hildebrand 1874, 117, no. 28; Więcek 1962, no. 72; McKeown 2001, 9–10; Maué 2008, 71, no. 28.

This medal was struck by Saxon Elector Johann Georg I to commemorate the allied Swedish and Saxon troops' victory over the imperial army at Breitenfeld, near Leipzig. It was the first Protestant victory of the Thirty Years' War (1618–48) and established Gustavus II Adophus as a great tactical leader since it was his countermaneuver that saved the day. AF, SKS

379

Sebastian Dadler (1586–1657)

GUSTAVUS II ADOLPHUS, KING OF SWEDEN (b. 1594; r. 1611–32)

Dated 1634

Silver, struck; 78.9 mm

The Frick Collection; Gift of Stephen K. and Janie Woo Scher, 2016 (2016.2.85)

379

Obverse: The body of the deceased king, crowned and in full armor, lying on the battlefield of Lützen; in the background, Swedish troops pursuing the fleeing Imperialists; two cherubs carrying his soul to heaven symbolized by the word יהוה [Hebrew for Jehovah] emanating rays of light; in the path of the king's soul, radiating from above, the words EUGE SERVE FIDELIS [Well done, faithful servant]; in the sky above the king and the battlefield, clouds with cherubs; one cherub, just above the troops leaving the battlefield, holds a sword and a scroll with the words VEL MORTUUM FUGIUNT [Even when (he is) dead, they flee him]. Inscriptions: GUSTAVUS ADOLPHUS MAGNUS DEI GRATIA SUECOR[um] GOTHOR[um] ET VANDALOR[um] REX AUGUSTUS [Gustavus Adolphus the Great, by the grace of God, August King of the Swedes, Goths, and Vandals]; in exergue, in three lines, NATUS 9 DEC[embris] ANNO 1594 / GLORIOSE MORTUUS 6 / NOV[embris] AN[n]O 1632 [born 9th of December in the year 1594, gloriously deceased 6th of November in the year 1632].

Reverse: Triumph of the king: Gustavus, represented as a skeleton, holding a book and a sword, is seated on a triumphal chariot pulled by three winged horses crushing several demons (in particular is visible the Hydra); Religion and Fortitude, attributes in hand (respectively, a book and flamboyant heart, and a column), crown the king with laurel. Inscriptions: in the field, above, in two lines, ET VITA ET MORTE / TRIUMPHO [I triumph in both life and death]; DUX GLORIOS[us] PRINC[eps] PIUS HEROS INVICT[us] VICTOR INCOMPARAB[ilis] TRIUMPH[ator] FELIX & GERM[aniæ] LIBERATOR A[nno] 1634 [The glorious general, pious prince, unbeaten hero, incomparable victor, happily triumphant and liberator of Germany in the year 1634]; on wheel, SD [artist's initials].

Literature: Hildebrand 1874, 192, no. 188; Więcek 1962, no. 89; Pollard 2007, 2: no. 914; McKeown 2001, 14–19; Maué 2008, 77–78, no. 35.

This medal commemorating the anniversary of the victory at the Battle of Lützen (November 6, 1632), was commissioned on the occasion of the king's state funeral in Sweden in 1634. The battle was one of the most important Protestant victories of the Thirty Years' War (1618–48), but the death of Gustavus Adolphus led to a serious loss of direction for the Protestant cause. ADC

380

Sebastian Dadler (1586–1657)
CHRISTINA, QUEEN OF SWEDEN (1626–1689; r. 1632–54)
1642–44
Silver, struck; 49.1 mm
Scher Collection; Promised gift to The Frick Collection

380

Obverse: Christina wearing a crown, earrings, pearl necklace, dress in heavy brocade and lace. Inscription: CHRISTINA D[ei] G[ratia] SUEC[orum] GOTH[orum] VAND[alorum]Q[ue] DES[ignata] REGINA [Christina, by the grace of God, appointed queen of the Swedes, Goths, and Vandals].

Reverse: Phoenix rising from its ashes on an island. Inscription: PHOENIX PHOENICIS GUSTAVI E[t] FUNER[ata] E[t] NATA [A phoenix born from the ashes of Gustavus's phoenix].

Literature: Hildebrand 1874, 253–54, no. 1; Więcek 1962, no. 83; Maué 2008, 107, no. 60.

The only surviving legitimate child of King Gustavus II Adolphus, Queen Christina of Sweden abdicated her throne in 1654 at the age of twenty-eight, converted to Catholicism, and moved to Rome, where she became a leader in cultural and intellectual society. The medal expresses the hope that Christina will continue the work of her fallen father. AF, SKS

381

Sebastian Dadler (1586–1657)
CHRISTINA, QUEEN OF SWEDEN (1626–1689; r. 1632–54)
Dated 1644
Silver, struck; 82.5 mm
Scher Collection

Obverse: Christina flanked by the members of the Royal Council on her right (from the center: Peter Brahe, Jakob Pontusson de la Gardie, Carl Carlsson Gyllehielm, Axel Oxenstierna, and Gabriel Bengtson Oxenstierna) and by the representatives of the four Estates on her left (from the center: Henrik Claesson Fleming, Archbishop Laurentius Paulinus Gothius, Jacob Grundel, and Erik Matsson); on Christina's right, the councilors holding her regalia (crown, sword, scepter, globe, and keys); at the queen's feet, her coat of arms; in the foreground at bottom, a group of courtiers observing the scene. Inscription: IMPERIVM PROLES GVSTAVI MAXIMA MAGNI, SVSCIPIT: INNVMMERIS VIVAT CHRISTINA TRIVMPHIS [two hexameters: the magnificent daughter of Gustavus the Great assumes power; may Christina live through innumerable triumphs].

Reverse: The battle between the Swedish and Danish fleets by the island of Fehmarn (Baltic Sea). Inscription: AVGVSTÆ PRENDIT DVM SCEPTRA POTENTIA LAVRO CINGIT SACRATVM BALTICA PVGNA CAPVT 1644 [While she takes her powerful office as Augusta, a battle on the Baltic Sea crowns her blessed head with laurel, 1644].

Literature: *Cimeliarchium* 1709, 124; Hildebrand 1874, 264–65, no. 16; Więcek 1962, no. 116; N. Rasmusson 1966, 306; Maué 2008, no. 61; Wallenstein 2012, fig. 125.

This medal, possibly struck in Gdańsk, celebrates two events that took place in 1644: Christina's coronation as queen of Sweden on her eighteenth birthday (December 8) and the victory that her ships achieved at the island of Fehmarn against the Danish fleet. WaC

381

382
Sebastian Dadler (1586–1657)

**LADISLAUS IV VASA, KING OF POLAND AND GRAND
DUKE OF LITHUANIA** (b. 1595; r. 1632–48)

Dated 1636

Silver, struck; 79.4 mm

Scher Collection

Obverse: Three Muscovite commanders (among them, Mikhail
Borisovich Schein, d. 1634) prostrate before the mounted figure
of King Ladislaus (center) and his commander Hetman Christoph
Radziwiłł (1585–1640); in the background, the Russian army,
surrounded by Polish troops, surrendering by placing flags on the
ground; in the distance, the tents of the Russian camp and the
walled city of Smolensk. Inscriptions: DEI OPT[imi] MAX[imi] AVSPICIO
INVICT[i] VLADISLAI IV POL[oniæ] SVECIÆQ[ue] REG[is] ARMIS VICTRIC[ibus]
SMOLENSCV[m] OBSIDIONE LIBERATV[m] MOSCI SVBIVGATI SIGNA DVCES

PROSTRATI [Smolensk was liberated from the siege, the Muscovites
were subdued, their commanders and insignia laid low under the
auspices of God, the best and the supreme entity, and through the
victorious weapons of Ladislaus IV, undefeated King of Poland and
Sweden]; in the field at the bottom: SD [artist's initials].

Reverse: Turkish delegates (bringing olive branches) and Swedish
representatives (holding olive branches and taking their hats off)
kneeling down before King Ladislaus and his army; an angel
crowning the king with laurel and bringing him the palm of victory.
Inscriptions: ET BELLO ET PACE COLENDVS [He shall be honored in
peace and in war]; TVRCÆ PACEM FERENTES ET SVECI [Turkish and
Swedish (commanders) bringing the peace]; in the field at the
bottom, 1636.

Literature: Hutten-Czapski 1871–1916, no. 1766; Hildebrand 1874,
256, no. 6; Domanig 1907, 52, no. 330; Więcek 1962, no. 98; Stahr
1990, 117–19, fig. 75; Maué 2008, no. 38.

382

383

This medal refers to Ladislaus's military achievements: the capitulation of the Russian army besieging Smolensk in 1634; the peace with the Ottomans, defeated near Kamieniec Podolski in the same year; and the armistice between Ladislaus of Poland and Christina of Sweden in 1635. wac

383

Sebastian Dadler (1586–1657)

LADISLAUS IV VASA, KING OF POLAND AND GRAND DUKE OF LITHUANIA (b. 1595; r. 1632–48) and **CECILIA RENATA OF HAPSBURG** (b. 1611; Archduchess of Austria, Queen of Poland 1637–44)
1637
Silver, struck; 67.9 mm
Scher Collection; Promised gift to The Frick Collection

Obverse: Ladislaus, with the collar of the Order of the Golden Fleece, and Cecilia Renata, wearing a small crown, clasping hands; the dove of the Holy Ghost descending through the clouds, where cherubs sing, play music, and hold laurel wreaths, palm leaves, and olive branches above the couple. Inscriptions: outer line [in elegiac distich], VLADISLAUS IV POL[oniæ] SVEC[iæ]Q[ue] REX, ET CÆCILIA RENATA ARCHIDUX AUSTR[iæ] SPONSI AUGUSTISSIMI; inner line [in elegiac distich], HUNC GENUIT BOREAS HÆC NOMEN DUCIT AB AUSTRO. REGIBUS HIS MUNDI PLAUDIT UTRUMQUE LATUS [Ladislaus IV, King of Poland and Sweden, and Cecilia Renata, Archduchess of Austria, very august spouses; the former was born by Boreas, the latter takes her name from Auster; both sides of the world acclaim these rulers]; below the table, SD [artist's initials].

Reverse: Mars (with sword) and Minerva/Bellona (with spear), holding the royal crown of Poland, above two hearts bearing the coats of arms of Poland and Austria and burning with love; divine rays of light descending from clouds. Inscription: ASPICE QUAM FAUSTO COEANT IN FOEDERA NEXU. SARMATA LIBERTAS AUSTRIACUM IMPERIUM. DI RERUM DOMINI FACIANT PLACIDEQUE DIUQUE. GAUDEAT UT TANTIS ISTUD ET ILLA BONIS [Look how auspicious is the tie through which they gather to form an alliance; Polish freedom, Austrian Empire; may the gods, rulers of the world, allow both of them to enjoy all these favorable circumstances in peace and for a long time].

Literature: Domanig 1896, no. 185; Chelminski sale 1904, no. 566; Hutten-Czapski 1871–1916, no. 1778; Więcek 1962, no. 102; Stahr 1990, 138–39, fig. 87; Maué 2008, no. 40; Hall sale 2010, no. 2584.

This medal celebrates the royal wedding of Ladislaus IV Vasa and Cecilia Renata of Hapsburg (1637). Maué identifies on the reverse the male figure with Poland and the female figure with the Austrian empire. wac

384

Sebastian Dadler (1586–1657)

LADISLAUS IV VASA, KING OF POLAND AND GRAND DUKE OF LITHUANIA (b. 1595; r. 1632–48) and **LUDOVICA MARIA GONZAGA-NEVERS, QUEEN OF POLAND** (b. 1611; r. 1645–67)
1645–48
Silver, struck; 49.8 mm
Scher Collection

Obverse: Ladislaus in armor with collar of the Order of the Golden Fleece. Inscription: VLADISLAUS IV D[ei] G[ratia] REX POL[oniæ] ET SUEC[iæ] M[agnus] D[ux] LIT[huaniæ] RUS[siæ] PR[ussiæ] [Ladislaus IV, by the grace of God, King of Poland and Sweden, Grand Duke of Lithuania, Russia, and Prussia].
Reverse: Ludovica with crown, earrings, necklace, and chain. Inscription: LVDOVICA MARIA CONZ[aga] D[ei] G[ratia] REG[ina]

384

385

POL[oniæ] ET SVE[ciæ] M[agna] D[ucissa] L[ithuaniæ] RVS[siæ] PRVS[siæ] NATA PRIN[cipissa] MANT[uæ] MONT[is] FER[rati] NIV[ersi] [Ludovica Maria Gonzaga, by the grace of God, Queen of Poland and Sweden, Grand Duchess of Lithuania, Russia, and Prussia, born Princess of Mantua, Monferrato, and Nevers].

Literature: *Museum … Milano-Viscontianum* 1786, no. 724 (with slightly different or wrongly transcribed inscription in the obverse); Hutten-Czapski 1871–1916, nos. 1879, 1880; Riechmann 1921, no. 283; Więcek 1962, no. 119; Maué 2008, no. 62.

This medal commemorates the union between Ladislaus and his second wife, Ludovica (born Maria Luisa Gonzaga-Nevers), and was struck sometime between their proxy marriage in 1645 and his death in 1648. waC

385

Sebastian Dadler (1586–1657)
GEORG WILHELM, ELECTOR OF BRANDENBURG (1595–1640) and his son **FRIEDRICH WILHELM** (1620–1688)
Dated 1639
Silver, struck; 72.4 mm
Scher Collection

Obverse: Two figures in armor standing in front of a table bearing the electoral hat and a scepter; the elector wearing a commander's sash and holding a commander's baton in his right hand; at their feet, helmets and gauntlets. Inscriptions: outer line, NUMEN QVOD STUPEAT VEL PRISCA GEORGIUS ÆTAS ET MIREMUR ADHUC HOS RHENUS ET ODERA NEC NON; inner line, SANGVINIS ET BRENNI SPES FRIDERICUS HABENT BREGELA SI FAMULIS NOSTER ADORET AQVIS [Georg and Friedrich, the hope of the Brandenburg blood, before whom even the ancient age is astounded and we here still marvel, when the Rhine, Oder, and even our Bregela reveres these men with attendant waters].

Reverse: The personification of Prussia, amid broken weapons, holding an olive branch in her right hand; on her lap, a cornucopia and open book; on the broken cannons, the initials S[ebastian] D[adler] and the date 1639; behind her, a bird's-eye view of the Prussian coast with the cities of Konigsberg and Fischhausen and the fortifications of Pillau; in the fields, farmers at work. Inscription: TALIS EGO AUREOLAM TRANQVILLA BORUSSIA PACEM RARO DIVORUM MUNERE NACTA COLOR [So will I, the pacified Prussia, be honored, for I have attained a golden peace as a splendid gift from heaven].

Literature: Więcek 1962, no. 106; Maué 2008, 89–90, no. 44.

This medal marks the presence of the elector and his son in Königsberg to celebrate the establishment of peace with Gustavus Adolphus of Sweden, who was married to Friedrich Wilhelm's sister, during the Thirty Years' War (1618–48). AF, SKS

386

387

386

Sebastian Dadler (1586–1657)
WILLIAM II, PRINCE OF ORANGE (1626–1650) and **MARY HENRIETTA STUART, PRINCESS ROYAL** (1631–1660)
Dated 1641
Silver, struck; 63.3 mm
Scher Collection

Obverse: William and Mary joining hands under the radiant dove of the Holy Spirit; putti crowning both figures with myrtle wreaths; in the background, view of The Hague. Inscriptions: behind female, in four lines, ALBIONUM GENUIT REX ME / SUMMUSQUE MONARCHA / CAROLUS, ET SPONSAM / ME IUBET ESSE TUAM [Charles, King of Britain and a most mighty monarch, is my father, and commands me to be your bride]; behind male, in four lines, PRINCEPS ME HENRICUS / GENUIT FORTISSIMUS HEROS / NASSOVIAE ET SPONSUM / MEIUBET ESSE TUAM [*sic* for TUM] [Prince Henry, the most valiant hero of Nassau, is my father, and commands me to be your bridegroom]; in exergue, in three lines, LONDINI DESPONSATI WIL=HELM ET MARIA AN[n]O / MDCXLI [William and Mary betrothed at London in 1641].
Reverse: William as Pallas Athena, left, attended by Victory, trampling on Bellona, the goddess of war, before a pile of weapons and military gear; he receives an olive branch from Mary as Peace, who approaches on a cloud accompanied by Cupid and Ceres, goddess of plenty. Inscriptions: BELLONAM PRINCEPS PALLAS PEDIBUS TERIT ET PAX FLORET ET ALMA CERES CONFERT SACRO ALITE FRUGES [Princely Pallas tramples Bellona under foot; Peace flourishes and abundance delivering Ceres, brings fruits through the sacred bird]; in exergue, NOVI IMPERY AUSPICIO / BONO [for the happy presage of a new empire].
Literature: Hawkins 1885, 1: 288, no. 101; Maué 2008, 96, no. 49.

This medal records the marriage, one of convenience, of William of Orange and Mary, eldest daughter of Charles I of England. Charles was seeking help from the Dutch in his conflict with Parliament, a conflict that ended with his execution. A duplicate of this medal was struck by Johann Blum, Dadler's presumed pupil (no. 397). AF, SKS

387

Sebastian Dadler (1586–1657)
FREDERICK HENRY, PRINCE OF ORANGE (1584–1647) **IN TRIUMPH** and **ARRIVAL OF PRINCESS MARY OF ENGLAND** (1631–1660) **IN THE NETHERLANDS**
Dated 1648
Silver gilt, struck; 73.5 mm
Scher Collection

Obverse: Frederick Henry, laureate and enthroned, wearing classical armor and the badge of an order suspended from his neck; in his right hand, a sword; in his left hand, the shields of the seven United Provinces suspended from a cord with tassels; behind him on a balustrade, his personal arms; at his feet, two prone figures with broken swords; in the background, a mounted commander leading cavalry toward a fortified city, with ships in the distance; in the middle ground at left, two elegantly dressed men with a dog at their feet. Inscriptions: LIBERTAS PATRIÆ ME DEFENSORE, TRIUMPHAT, INSIDIATA NIHIL VIS INIMICA NOCET [The liberty of my country triumphs under my protection, the insidious violence of my enemies injures me not]; in exergue (engraved), BELGICUM PACATUM [The Netherlands pacified].
Reverse: Between two columns, Prince William, with his hat in his left hand, grasping with his right the right hand of Princess Mary, who holds a rose; perched on the columns, the lion rampant of Belgium holds in the right paw a sword and in the left seven arrows (representing the United Provinces), and against its chest a lance with the Dutch Liberty hat at its point; above, the name יהוה [Hebrew for Jehovah], below which are clouds emitting rays and two putti dispensing from upended cornucopias riches and honors; a wattle fence (supported at intervals by decorated obelisks on square bases) enclosing a populated landscape including, to the left of the central columns, the figure of Love embracing children and, at right, Mars seated; ships sail beyond. Inscriptions: QUO TE MARS ET AMOR VOCAT INTRA DIVA VIRETUM FRUCTUM HIC LIBERTAS TE GENITRICE FERET [Enter, divine creature, the bower where Mars and Love invite you; here, under your patronage, Liberty shall produce her fruit]; on bases of pillars flanking central figures, SD [artist's initials]; in exergue

388

(engraved), AN[n]O 1648 [*sic*] 20/30 JANU[arius] [in the year 1648, 20/30 January].

Literature: Van Loon 1732–37, 2: 257; Więcek 1962, no. 107; Scher 1997, no. 16; Maué 2008, 93–96, nos. 47 (var.), 48.

This medal celebrates the rule of Frederick Henry as Stadtholder of the Netherlands and the 1642 arrival in the Netherlands of Princess Mary of England as the bride of Prince William of Orange; the two married in England in 1641. A variant omits the exergue inscriptions (Maué 2008, no. 47). The date of 1648 that appears on this type was misinterpreted by Więcek (1962) as "1640." At Münster on January 30, 1648, peace was achieved between Spain and the United Provinces; the medal may have been reissued or altered with the exergue inscriptions at this point to reassert the marriage and authority of the House of Orange. The wattle fence, the *hollandse tuin*, is often used to symbolize the United Provinces as a secure enclosure within which prosperity flourishes. AN

388

Sebastian Dadler (1586–1657)
END OF THE SIEGE OF AMSTERDAM, NOVEMBER 14, 1650
Dated 1650
Silver, struck; 77 mm
Scher Collection; Promised gift to The Frick Collection

Obverse: A horse springing to the left over the Amstel River with a setting sun and a view of Amsterdam in the background; the horse wearing a saddle blanket decorated with a sun and an open document hung with seals embroidered with the inscription UNIO and RELIGIO, beneath which the word SIMULANT [Unity and Religion resemble each other]. Inscriptions: CRIMINE AB UNO DISCE OMNEIS MDCL XXX IULII [By a single offense, know them all, 30 July 1650]; in exergue, QUIA BELLA VETABAT [Because he was against the war].
Reverse: Zeus in clouds with lightning bolts and the Fall of Phaeton above a funeral procession issuing from the Buitenhof in The Hague; above Zeus, the arms of The Hague. Inscriptions: MAGNIS EXCIDIT AUSIS MDCL VI NOVEMBRIS [He fell in a great enterprise, 6 November 1650]; at the end of the wall to the right, SD [artist's initials].
Literature: Więcek 1962, no. 133; Maué 2008, 123–24, no. 76.

As a result of the terms of the Peace of Münster (1648), ending the Eighty Years' War (1568–1648) with Spain, the Stadtholder William II of Orange challenged the province of Holland. This led to an armed confrontation before the gates of Amsterdam, which was settled peaceably; William II succumbed to smallpox the same year. This medal commemorates both the incident with Amsterdam and the death of William. The obverse inscription is from Virgil's *Aeneid* (II.65–66; II.84). The reverse inscription is a partial passage from Ovid's *Metamorphoses* (II.327), where the author describes Phaeton's grave. AF

389

Sebastian Dadler (1586–1657)
ARMAND JEAN DU PLESSIS, DUKE OF RICHELIEU
(1585–1642)
ca. 1642
Silver, struck; 55.5 × 45.9 mm
Scher Collection

Obverse: Armand wearing cardinal's robes and the Order of the Holy Spirit. Inscription: ARMANVS IOAN[nes] CARD[inalis] DE RICHELIEV [Armand Jean, Cardinal of Richelieu].
Reverse: People gathering about an obelisk entwined with laurel vines to which are attached the arms of the Plessis family surmounted by a cardinal's hat; an angel with trumpet emerging

389

390

from clouds and grasping the summit of the obelisk. Inscription: to the left, in two lines, CEST VIIEG[?] QVI EST LE PERE / DELLA IVSTE GLOIRE; to the right, in two lines, MERITE BIEN VNE ETERNEL=LE MEMOIRE [It is (?), who is the father of just glory, who well deserves an eternal memory].
Literature: Więcek 1962, no. 115; Maué 2008, 97–98, no. 50.

Maué believes this medal commemorates Cardinal Richelieu's death. Armand was made cardinal in 1622 and Duke of Richelieu in 1631. The reverse inscription includes a jumbled French word that cannot be deciphered. AF

390

Sebastian Dadler (1586–1657)
FERDINAND III, HOLY ROMAN EMPEROR (b. 1608; r. 1637–57)
Dated 1649
Silver, struck; 77.6 mm
The Frick Collection; Gift of Stephen K. and Janie Woo Scher, 2016 (2016.2.86)

Obverse: Ferdinand on a rearing steed, wearing armor all'antica, crowned with laurel, and bearing in his right hand a commander's baton; in the background, massed troops and a view of Vienna. Inscriptions: DER GROSE FERDINAND3 EUROPÆNS ZIER, ZIEHT SEINER VOLCKER RUH DEM KRIGE FUR [The great Ferdinand III, Europe's adornment, advances his people calmly into war]; below horse, Seba[stian] Datt[ler].
Reverse: Above a view of Nuremberg, a crowned eagle holding a scepter and sword in clouds; three putti in clouds holding a palm branch, trumpet, and laurel branch; two angels holding a chain with ten shields: above left, France; above right, Vasa Dynasty of Sweden; below, left to right: Trier, Cologne, Mainz, Hesse, Quarterly Palatinate of the Rhine and Bavaria, Saxony, Brandenburg, Southern or Catholic Netherlands. Inscriptions: DURCH DIESER GOTTER FRIED UND EINIKEIT IST ALLE CHRISTE WELT SEHR HOCH ERFREUT [Through

the peace and unity of these gods is the entire Christian world very highly gladdened]; in exergue, in two lines, FRIEDGEMACHT / MDCIL [Peace established 1649]; below, SD [artist's initials].
Literature: Więcek 1962, no. 129; Maué 2008, 118–19, no. 71.

Ferdinand III negotiated the end of the Thirty Years' War (1618–48) with the Peace of Westphalia, a series of peace treaties between May and October of 1648: the Peace of Münster between Spain and the Netherlands ending the Eighty Years' War (1568–1648); the Treaty of Osnabrück between the Holy Roman Empire and Sweden; and the Treaty of Münster between the Holy Roman Empire and France in 1648. The reverse commemorates the 1649 *Exekutionstag*, an event that settled questions of demobilization and withdrawal of troops. The figure of Ferdinand III on horseback is based on a 1629 print of Ferdinand II by Aegidius Sadeler. AF, AN

391

Sebastian Dadler (1586–1657)
PEACE OF WESTMINSTER
Dated 1654
Silver, struck; 60.6 mm
The Frick Collection; Gift of Stephen K. and Janie Woo Scher, 2016 (2016.2.87)

Obverse: Figures of Britannia and Holland seated and facing each other, supporting a hat representing Liberty; a harp on the lap of one, and a lion, holding in his forepaws a bundle of arrows representing the Seven Provinces of the Netherlands, seated at the feet of the other; in the foreground, flowers and two trees flanking the composition. Inscriptions: MENTIBUS UNITIS PRISCUS PROCUL ABSIT AMAROR PILEA NE SUBITO PARTA CRUORE RUANT [May the former bitterness depart from their united minds, lest the caps of Liberty, obtained by their blood, should suddenly fall down]; in exergue, in two lines, CONCL[usus] XV/XXV D APRIL / A[nn]° M DCLIV [concluded 15/25 April 1654].

391

Reverse: A British warship on the left and a Dutch warship on the right sailing side by side in a calm sea, the British boarding the Dutch ship and shaking hands. Inscriptions: left, LUXURIAT GEMINO NEXU / TRANQVILLA SALO RES; right, EXCIPIT UNANIMES / TOTIUS ORBIS AMOR [Commerce, tranquilized by a double alliance, flourishes on the sea, and the amity of the whole world welcomes the reconciled]; on the stern of each ship, SD [artist's initials].

Literature: Van Loon 1732–37, 2: 373; Więcek 1962, no. 149; Pollard 2007, 2: no. 761, Maué 2008, 130, no. 81.

This medal commemorates the end of the first Anglo-Dutch War (1652–54) on April 15, 1654, by which the Navigation Acts were recognized, guaranteeing freedom of movement to the naval and merchant ships of both nations and ending the commercial rivalry between Holland and England. The medal is part of a series of medals depicting contemporary events by Dadler. ADC

392

Sebastian Dadler (1586–1657)

HAMBURG

Dated 1636

Silver, struck; 79.2 mm

Scher Collection

Obverse: A colossus of Mercury in armor all'antica and winged helmet and boots, the arms of the city of Hamburg on the cuirass, straddling Hamburg harbor, the right foot on the prow of a ship, the left on a promontory, beside each foot a cornucopia, holding in his right hand the caduceus and stalks of wheat and in the left an olive branch; on the left, a female figure holding an oar and standing in the bow of a ship that supports a globe of the heavens and on the right a female figure holding a spade in the right hand and a sheaf of wheat in the left with sacks, barrels, and flowers in front; at the top, a hand descending from heaven and touching the head of Mercury. Inscriptions: right, outer line, MERCURII QUID IMAGO NOTAT : COMMERCIA : QUINAM; right, inner line, IPSI ADSTANT IUNCTUS SEDULITATE LABOR; below, outer line, COELO EXERTA MAN[us] DO[min]I EST BENEDICTIO : QUÆ SI; below, inner line, ACCEDIT NOBIS OMNIA FAUSTA FLUUNT; left, outer line, HOC SCEPTRU[m] AGUIGERU[m] HOC GE[m]INO BONA COPIA COR[n]U; left, inner line, HOC OLEÆ SIGNAT FRONS ET ARISTA TIBI [What does the image of Mercury signify? Commerce. And who stands at his side? Industry joined with work. The hand of the Lord thrust from the sky is a blessing: if it comes our way, all blessed things flow to us. This is what the serpentine scepter, the good double horn-of-plenty, the olive branch and ear of grain signify]; above in radiant clouds, BENEDICTIO DOMINI DITAT [The blessing of God enriches].

Reverse: Bird's-eye view of Hamburg; on the left, ALSTER [Lake

392

Alster] with the date 1636 beneath; to the right, ELBE [the Elbe River]. Inscriptions: above, DA PACEM DOMINE IN DIEBUS NOSTRIS [Give peace in our days, O Lord]; in banderole below, LIBERTATEM QVAM PEPERERE MAIORES STUDEAT SERVARE POSTERITAS [Let posterity work to preserve the freedom that the elders acquired].
Literature: Więcek 1962, no. 99; McKeown 2004, 51–54; Maué 2008, 82–84, no. 39.

This medal celebrating Hamburg as a prosperous center of commerce and productivity, both on land and sea, associates the city with the Colossus of Rhodes. AF

Sebastian Dadler (1586–1657)
LOVE CONQUERS ALL
ca. 1629
Silver, struck; 44 mm
The Frick Collection; Gift of Stephen K. and Janie Woo Scher, 2016 (2016.2.89)

Obverse: A courtly couple holding hands beneath a radiant dove of the Holy Spirit; emerging from the clouds, two hands holding laurel crowns. Inscription: MANVS MANVM LAVAT [One hand washes the other].
Reverse: A bridled lion; on his back, Cupid, holding his bow and arrows in his right hand, his left holding the reins while being embraced and kissed by a young maiden holding a crown. Inscriptions: AMOR VINCIT OMNIA [Love conquers all]; on a stone in the field below the lion, SD [artist's initials]; in exergue, a burning heart in front of crossed branches of palm and oak.
Literature: Więcek 1962, no. 48; Maué 2008, 174–75, no. 154. AF

Sebastian Dadler (1586–1657)
MARRIAGE MEDAL AND LÜBECK
Dated 1657
Silver, struck; 67.4 mm
The Frick Collection; Gift of Stephen K. and Janie Woo Scher, 2016 (2016.2.88)

Obverse: Beneath a radiant sun with the eye of God and two wind gods blowing from clouds, a walled city (Lübeck) and winged female holding two shields, the Holy Roman imperial arms and those of Lübeck. Inscriptions: O GOTT LAS DEINEM SCHUTZ ALLEIN DISE EDLE STATT BEFOHLEN SEIN [O God, let this noble city be ordered to your protection]; on the center sun ray, a banderole with the word LVBEC [Lübeck].
Reverse: A couple joining hands before a clergyman officiating; above, a putto pouring holy water between two hands descending in blessing from clouds; at the right side, palm frond, bees, and hive; to the left, the Pelican in Her Piety and an olive branch; at their feet, two doves. Inscriptions: DES ALLERHŒCHSTEN GNADENHAND GESEGNE KRÆFFTIG UNSERN STAND [May the merciful hand of the Most High mightily bless our position]; in exergue, 16 SD 57 [artist's initials flanked by date, 1657].
Literature: Więcek 1962, no. 152; Maué 2008, 133–34, no. 85.

There seems to be little connection between the obverse and reverse of this medal. AF, SKS

Attributed to Sebastian Dadler (1586–1657)
LOVE AND MARRIAGE
ca. 1650
Silver, struck; 53.8 mm
Scher Collection

394

395

Obverse: A hen with chicks between two palm trees; in exergue, a rose. Inscription: EINE KLUCK HENNE LIBET IHRE KUCHLEIN SEHR [A fortunate hen loves its chicks very much].

Reverse: An elegant couple kissing; in the foreground, a table with food and drink and two doves, one of them recumbent. Inscription: ICH LIEBE MEINE LIEBSTE NOCH VIEL MEHR [I love my dearest still much more].

Literature: Künker sale 2005, no. 5365.

Although this medal is unsigned, it is usually attributed to Dadler. Certainly the style, especially of the reverse figures, is that of the master. Medals such as this, referring to subjects of ordinary life, were commonly produced for sale to a general public, often with a moral message. On the reverse, the dove on the left appears to be either dead, which would be puzzling, or, as a female, submitting to the male dove. SKS

396

Johann Blum (ca. 1599–after 1668)
MARRIAGE MEDAL
Dated 1640
Silver, struck; 68.2 mm
Scher Collection

Obverse: Female figure, draped, facing a male figure holding a hat; Amor in radiant clouds between them holding laurel wreaths above their heads; above clouds, the name יהוה [Hebrew for Jehovah]; lower center, two cuddling doves. Inscriptions: DAS DISE SEI DIE LIBSTE MEIN DES WOLLF GOTT MEIN ZEUGESEIN [That this woman is my most beloved, let God be my witness]; inner ring, EN DEXTRA FIDESQUE DUM SPIRITUS HOS REGIT ARTUS [Here (is my) right (hand) and my fidelity as long as life animates these limbs].

Reverse: Two female figures, one holding a baby and the other holding a censer and book/box with flaming heart, pull a *biga* with a seated male figure holding a cross and palm frond; a hand emerging from clouds with a crown. Inscriptions: GLAUBE LIEB VND GOTTSELIGKEIT ERBEN DIE CRON DER HERRLIGKEIT [Faith, love and God's blessing inherit the crown of splendor]; in center, FIDES TRIUMPHANS [Faith triumphant]; in exergue, MDCXL I[oannis] Blum Fe[cit] [1640 Johann Blum made it].

Literature: Jungk 1875, 387, no. 7.

The Latin component of the obverse inscription comes from Virgil's *Aeneid*. The first part is from IV.597; the second part from IV.336. AF

396

397

397

Johann Blum (ca. 1599–after 1668)

WILLIAM II, PRINCE OF ORANGE (1626–1650) and **MARY HENRIETTA STUART, PRINCESS ROYAL** (1631–1660)

Dated 1641

Silver, struck; 72.8 mm

Scher Collection

Obverse: William and Mary joining hands and receiving laurel wreaths from angels; above, the dove of the Holy Ghost blesses the couple from a burst of sun rays; in the background, cavaliers welcoming the arrival of a cortege into a town crossed by a river (London?). Inscriptions: left, ALBIONUM GENUIT / REX ME SUMMUSQUE / MONARCHA CAROLUS, / ET SPONSAM ME JUBET / ESSE TUAM; right, PRINCEPS ME HENRICUS / GENUIT FORTISSIMUS / HEROS NASSOVIAE, ET / SPONSUM ME JUBET ESSE TUUM; in exergue, LONDINI DESPONSATI WILHELM ET MARIA / AN[n]O 1641 12 MAI [(Mary): "Charles, King of Britain and supreme monarch, begot me, and he commands me to be your bride"; (William): "Prince Henry, very valiant hero of Nassau, begot me, and he commands me to be your bridegroom"; William and Mary, betrothed (but actually married) in London on 12 May 1641].

Reverse: Minerva, flanked by a winged figure holding a sword and embodying her rule (a Victory?), tramples underfoot Bellona, the goddess of war, who is surrounded by implements of war; Bellona receiving an olive branch from Peace, who descends from a cloud accompanied by Cupid, holding a sheaf of seven arrows possibly representing the seven provinces of the northern Netherlands, and Ceres, who holds a cornucopia filled with fruits and flowers. Inscriptions: BELLONAM PRINCEPS / PALLAS PEDIBUS TERIT, ET PAX FLO / RET, ET ALMA CERES CONFERT SACRO ALITE / FRUGES [Minerva, who is the ruler, tramples Bellona under foot; Peace flourishes and Ceres, the goddess who nourishes, brings fruits through the sacred bird (possibly referring to the winged god *par excellence*, Amor)]; in exergue, NOVII IMPERII AUSPICIO / BONO [with the happy auspice of a new rule]; J[ohann] BLUM FE[cit] [Johann Blum made it].

Literature: Van Loon 1723–37, 2: 258, no. I; Hawkins 1885, 1: 287, no. 100; Domanig 1907, 105, no. 667; Forrer 1904–3, 1: 96; Lanna sale 1911b, no. 487; Scher 1997, no. 15; Eimer 2010, no. 137.

This medal commemorates the marriage in London of William and Mary Henrietta, eldest daughter of Charles I Stuart, on May 12, 1641, and not their betrothal (as stated in some of the literature). WaC

398

Johann Blum (ca. 1599–after 1668)

MARRIAGE MEDAL

Dated 1646

Silver, struck; 42.7 mm

Scher Collection

Obverse: Man with mustache and goatee, left, wearing a coat and collar with left hand on open book and right hand holding the right hand of a woman, right, wearing a dress and necklace and holding a fan in left hand. Inscriptions: GOTT HATS GEFÜGT DAS VNS GENÜGT [God has brought us together, that is sufficient]; in open book, ES IST NICHT GUTT, DAS DER MENSCH ALLEIN [sei]. Gen 2 [It is not good for man to be alone: Genesis 2:18]; beside the book, a bunch of grapes.

Reverse: Winged Amor, with a bow and arrow in the right hand and reins in the left hand, riding a lion. Inscriptions: AMOR VINCIT OMNIA [Love conquers all]; in exergue, 1646 I[oannis] B[lum].

Literature: Kahane 1928, 144.

Medals such as these were produced for general consumption and marked significant events such as betrothal or marriage. The bunch of grapes is often used to symbolize charity or, more likely in this case, fertility or abundance. The reverse shows love harnessing the ferocity of the lion. AF

398

399

399

Johann Höhn the Elder (1607–1693)

MARRIAGE MEDAL

ca. 1636
Silver, struck; 69 mm
Scher Collection

Obverse: The dove of the Holy Spirit in radiant sun over two hands clasping a flower and flanked by date palms from which dates fall; in the background, the walled city of Danzig; below, in the foreground, a marriage ring enclosing two doves; rosette outer border, alternating rosettes and clasped hands inner border. Inscription: PALMA VELUT PALMAM CEV CASTA COLUMBA COLUMBU[m] SIC VERO CONIUX CONIUGE[m] AMORE COLA[t] [Just as the palm with the palm, or the chaste dove with her companion, so let the spouse honor her spouse with true love].

Reverse: A man, holding a spade, and a woman, holding a spindle, both in casual attire and holding up a small altar with two burning hearts, above which a hand descends from heaven holding a bow; both figures chained together at the arms and legs with a naked child between, his hands on their thighs, his right foot on the lower chain. Inscriptions: CONIUGIUM FOECUNDA[n]T AMOR LABOR ATQ[ue] SECUNDAT: DITAT IDEM COELO GRATIA LAPSA DEI [Love and labor make marriage fertile and prosperous; the Grace of God falling down from heaven enriches the same]; on shovel, IH [artist's initials].

Literature: Hutten-Czapski 1871–1916, no. 9866; Więcek 1962, no. 101 (var.); Maué 2008, 172–73, nos. 151, 152.

The references listed above refer to variants by Sebastian Dadler alone and in collaboration with Johann Höhn. This example has only the initials of Höhn, although this version usually has the initials of Dadler on the obverse. All of the medals are virtually identical. AF, SKS

400

Johann Höhn the Elder (1607–1693)

MARRIAGE MEDAL, DANZIG

ca. 1650
Silver, struck; 48.9 mm
Scher Collection

Obverse: Female figure, left, holding hand of male figure, right, amid radiant cloudburst with the dove of the Holy Spirit; three putti hover, two with crowns and fronds, and a third pouring water on central altar. Inscription: VIRI DILIGITE UXORES VESTRAS SICUT & CHRIST[us] DILEXIT ECCLES[iam] [Husbands, love your wives just as Christ loved the church]; to either side of altar, IH [artist's initials].

Reverse: Hands extending from clouds on either side holding a heart superimposed over intersecting laurel branches; above, a radiant circle with IHS [Jesus]; below, a walled cityscape. Inscription: SICUT ECCLESIA SE SUBYCIT CHRISTO ITA & UXORES SUIS VIRIS [Just as the church subjects itself to Christ so also wives subject themselves to their husbands].

Literature: Hutten-Czapski 1871–1916, no. 2532.

A rectangular plaque made of horn survives at the British Museum (iOA.4587) for the reverse composition, perhaps used as a mold for impressions in straw or paper. The obverse inscription is from Ephesians 5:25; the reverse inscription is from Ephesians 5:24. AF, SKS

400

401

401

Johann Höhn the Elder (1607–1693)

LADISLAUS IV VASA, KING OF POLAND AND GRAND DUKE OF LITHUANIA (b. 1595; r. 1632–48) and **LUDOVICA MARIA GONZAGA-NEVERS, QUEEN OF POLAND** (b. 1611; r. 1645–67)

Dated 1646

Silver gilt, struck; 57.3 mm

Scher Collection

Obverse: Ladislaus and Ludovica Maria, wearing the royal insignia, joining their hands in front of a baldachin decorated with heraldic eagles and rue branches (motifs stemming from the coat of arms of the branch Gonzaga-Nevers and the House of Wettin, respectively); Ladislaus, in his role of peacekeeper, trampling weapons and pieces of armor; the ground strewn with flowers. Inscriptions: around the edge [in elegiac distich], SISTE GRADU[m] BELLONA IUBET NUNC IUNO QUIETEM EN FACIAM TIBI SIT DULCIS AMORE QUIES [Stop your path, Bellona! Juno (the goddess of marriage) now commands to keep peace. O, may I act so that you enjoy peace through love]; above the exergue on the right, I[ohann] H[öhn] .

Reverse: The name יהוה [Hebrew for Jehovah] in the sky and the dove of the Holy Ghost descending to bless the coat of arms of Gdańsk. Inscriptions: VLADISLAO IV POLONIÆ AC SUECIÆ REGI ET LUDOVICÆ MARIÆ MANTUANÆ SPONSIS [To Ladislaus IV, King of Poland and Sweden, and Ludovica Maria of Mantua, married]; in the field [in two elegiac distichs], FATA POLO VENIUNT; HOMI / NUM

SUNT VOTA: IEHOVA / TU DEVOTA IUVA; TU / SACRA PACTA FOVE. / SINT EA FAUSTA NOVIS / CONSORTIB[us] HIS[que] SUB ALIS / PAX REGNUM POPULUS / FLOREAT ET / GEDANUM. / M DC XLVI. / 10. MART[ii] [Destinies descend from the divine will, to men pertain vows; Jehovah, please support what has been consecrated, foster the sacred bonds! May they be felicitous for the new spouses and may peace, their kingdom, their people, and the city of Danzig flourish under these wings. 10 March 1646].

Literature: A. J. Martini 1646, fol. Q4r; *Trésor de numismatique* 1834–58, 8: pl. XLV, no. 4; Hutten-Czapski 1871–1916, no. 1859; Stahr 1990, 144–45, fig. 93.

This medal, struck in Gdańsk, celebrates the marriage of Ladislaus and his second wife, Ludovica, held in Warsaw on March 10, 1646, after a marriage by proxy (see no. 384). Gold specimens of this medal and of a smaller one were presented to the princess by the city of Danzig on March 13, 1646. WAC

402

Johann Höhn the Elder (1607–1693) and Sebastian Dadler (1586–1657)

THE BLESSINGS OF PEACE

ca. 1642

Silver, struck; 58.8 mm

The Frick Collection; Gift of Stephen K. and Janie Woo Scher, 2016 (2016.2.90)

402

403

Obverse: Justice, to the left, crowned with five stars and holding a sword entwined with ribbons, embracing and kissing Peace, to the right, holding a caduceus, palm and laurel branches, flowers and corn. Inscriptions: PAX CUM IUSTITIA FORA TEMPLA ET RURA CORONAT [Peace, along with Justice, allows commerce, religion, and agriculture to flourish]; on tablets, PROXI[m]O DEO [With God close (to us)]; on lower edge of tablets, I[ohann] H[öhn], S[ebastian] D[adler].
Reverse: In front of a walled cityscape, Piety, to the left, holding an olive branch, extends a hand to Faith, at the right, wearing a star diadem and holding a scepter with radiant sun. Inscriptions: FELIX TERRA FIDES PIETATI UBI IUNCTA TRIUMPHAT [Happy is the land where faith joined with piety triumphs]; above in radiant oval, יהוה [Hebrew for Jehovah].
Literature: Van Loon 1723–31, 2: 304; Schulman (Jacob) 1912, 103; Więcek 1962, no. 94; Maué 2008, 100–101, nos. 52, 53.

The obverse image is based on Psalm 85, 10: Mercy and Truth are met together; Righteousness and Peace have kissed each other. There is no indication in the inscriptions which peace is being celebrated. It was once thought to be the Peace of Westphalia in 1648, but this is not possible since Johann Höhn and Sebastian Dadler were not together at that time. The medal is now believed to have been commissioned by the Polish king Wladislaw IV, whose medal by Dadler dated 1642 has the same view of Danzig (Gdansk) on the reverse (Maué 2008, 99–100, no. 51). SKS

403

Johann Höhn the Elder (1607–1693)
PEACE OF OLIVA
Dated 1660
Silver, struck; 74.2 mm
Scher Collection

Obverse: A dove bringing an olive branch to Oliva Abbey; two angels holding an olive branch, a palm branch, and a festoon with four hearts—one for each of the rulers who signed the Peace of Oliva. Inscription: PACIS OLIVENSIS ANNO MIƆCLX III MAII AD GEDANUM IN PRUSSIA CONCLUSÆ MONUMENTUM [Commemorative piece for the Peace of Oliva, concluded at Danzig in Prussia on 3 May 1660].

Reverse: A female figure prays under an olive tree, while the name יהוה [Hebrew for Jehovah] appears in the sky above the sun and the moon; in the background, the activities made possible through peace on the land and on the sea. Inscriptions [in elegiac distich]: PECTORA QUO REGUM, COEUNT QUO VULNERA SECLI, EN FELIX OLEUM PACIS OLIVA DEDIT [See! The blessed Oliva, where the hearts of the kings and the wounds of the century come together, has yielded the oil of peace!]; on a ship, I[ohann] H[öhn].
Literature: Hutten-Czapski 1871–1916, no. 2149; Forrer 1904–30, 2: 522; Schulman (Jacob) 1912, no. 238.

This medal, made in Gdańsk, commemorates the Peace of Oliva, signed by the Holy Roman Emperor, the Elector of Brandenburg, and the rulers of Prussia and Sweden on April 23, 1660, ending the Second Northern War (1655–60) between Sweden, the Polish-Lithuanian Commonwealth, Russia, Brandenburg-Prussia, Denmark, Transylvania, Austria, the Netherlands, and the Crimean Khanate. WAC

404

Johann Höhn the Elder (1607–1693)
FRIEDRICH WILHELM DER GROSSE (1620–1688)
1673/75
Silver, struck; 43.5 mm
Scher Collection

Obverse: Friedrich Wilhelm wearing a cravat and mantle over armor. Inscriptions: FRID[ericus] WILH[elmus] D[ei] G[ratia] M[ar]E[schallus]

404

405

406

& EL[ector] BR[andenburgicus] SUP[remus] DOM[inus] DUX PRUSS[iæ] [Friedrich Wilhelm, by the grace of God, marshal and elector of Brandenburg, supreme lord, Duke of Prussia]; below bust, the cipher JH [artist's initials].

Reverse: An eagle in a nest with four eaglets on a rocky cliff overlooking turbulent water, looking toward a radiant sun. Inscription: MEI NON DEGENERANT [My offspring do not degenerate]. **Literature**: Forrer 1979–80, 2: 520–23; H. Schumacher 2007, 24–25, no. 1A/B.

Friedrich Wilhelm ("the Great Elector") was Elector of Brandenburg and Duke of Prussia from 1640 until his death. According to Schumacher, the medal commemorates the birth of either Prince Karl Philip (1673–1695) or Princess Dorothea (1675–1676). AF

405

Possibly Johann Höhn the Elder (1607–1693)
BOGUSLAW (1620–1669) and **ANNA MARIA** (1640–1667)
RADZIWILL OF POLAND
1665
Silver, struck; 48.8 mm
Scher Collection

Obverse: Boguslaw Radziwill wearing armor with a draped mantle. Inscription: BOGUSLAUS D[ei] G[ratia] DUX RADZIWILL [Boguslaw, by the grace of God, Duke of Radziwill].
Reverse: Anna Maria Radziwill wearing a dress and a draped mantle held with a pearl brooch, pearl earrings, and a pearl necklace, her hair tied up in the back with a string of pearls. Inscription: ANNA MARIA D[ei] G[ratia] DUCISSA RADZIVVILIA [Anna Maria, by the grace of God, Duchess of Radziwill].
Literature: Thieme and Becker 1907–50, 17: 201.

This is a wedding medal for Boguslaw Radziwill, a princely magnate and member of the Polish-Lithuanian nobility, and his cousin, Anna Maria Radziwill. They were married on November 24, 1665, after a year of courtship. MAP

406

Balthasar Lauch (act. 1669–85)
PHILIP WEBER (1588–after 1650)
Dated 1645
Silver, cast; 49.5 × 39.4 mm
Scher Collection; Promised gift to The Frick Collection

Obverse: Weber wearing an ecclesiastical robe and ruff. Inscriptions: M[agister] PHILIPVS WEBER AUGUST[æ] ECCLES[iæ] PATRIÆ PASTOR ÆT[atis] 57 [Master Philip Weber of Augsburg, pastor of the city's church, aged 57]; in the field, above the sitter, 1645.
Literature: Domanig 1907, 51, no. 320.

Weber was senior pastor at the Lutheran church of St. Anna in Augsburg. AF

407

Balthasar Lauch (act. 1669–85)
MARTIN GEIER (1614–1680)
After 1665
Silver, struck; 44.2 × 36.9 mm
The Frick Collection; Gift of Stephen K. and Janie Woo Scher, 2016 (2016.2.81)

Obverse: Geier wearing either academic or ecclesiastical robes. Inscription: MART[inus] GEIER S[acræ] TH[eologiæ] D[octor] EL[ectoris] SAX[oniæ] CONSIL[iarius] ECCL[esiasticus] ET CON[cilii] AVL[ici] PRIM[arius] [Martin Geier, reverend doctor of sacred theology, ecclesiastical councilor of the Elector of Saxony, and president of the court council].
Reverse: A lamb looking up to a radiant sun; within sun: יהוה [Hebrew for Jehovah]. Inscriptions: to either side of lamb, MITES GAVDEBVNT MATTH V V 5 [The meek will rejoice: Matthew 5:5] SELIG SIND DIE SANFFT MUTHIGEN [Blessed are the gently courageous]; below lamb (incised), BL [artist's initials].
Literature: Löbbecke sale 1908, no. 693; Lanna sale 1911b, no. 1127.

Martin Geier was a Lutheran theologian at the court of Dresden. AF

407

408

409

408

Balthasar Lauch (act. 1669–85)

JOHANN GEORGE III OF SAXONY (1647–1691)

Dated 1669

Silver, cast; 46.1 × 39 mm

Scher Collection

Obverse inscriptions: IOH[annes] GEORG[ius] III D[ei] G[ratia] D[ux] SAX[oniæ] I[uliæ] C[liviæ] E[t] M[ontium] PR[inceps] ELECT[or] [Johann George III, by the grace of God, Duke of Saxony, Jülich, Cleves, and Berg, Prince Elector]; on truncation (incised), BL [artist's initials].

Reverse: Over a distant landscape, a hand emerging from clouds at the left and holding a banner. Inscription: on the banner, יהוה IEHOVA VEXILLVM MEVM 1669 [Yahweh. Jehovah (is) my banner, 1669].

Literature: Tentzel 1705, 57 or 631; Merseburger sale 1894, no. 1222; Löbbecke sale 1908, 690.

This medal was made when Johann George III was twenty-two years old. Upon his father's death in 1680, he succeeded him as Elector of Saxony. The reverse inscription was a favorite of Johann George and appears on other medals and award *thalers* (dollars). AF

409

Balthasar Lauch (act. 1669–85)

JOHANN GEORG II OF WETTIN (b. 1613; Elector of Saxony 1656–80)

Dated 1669

Silver, cast; 47.8 × 39.5 mm

Scher Collection

Obverse: Johann Georg in armor with the sash of the Order of the Garter on the left shoulder. Inscription: IOH[annes] GEORG[ius] II D[ei] G[ratia] D[ux] SAX[oniæ] I[ulaci] C[leviæ] E[t] M[ontis] AR[chimarescallus] E[t] ELECT[or] [Johann Georg II, by the grace of God, Duke of Saxony, Jülich, Cleves, and Berg, Arch-Marshal and Elector].

Reverse: Johann Georg's coat of arms. Inscription: 1669 / BL [artist's initials].

Literature: Tentzel 1714, *Alb.*, table 57, no. 2; J. Erbstein and A. Erbstein 1888–96, 3: no. 950; Merseburger sale 1894, no. 1180; Forrer 1904–30, 3: 312; Westfälische Auktionsgesellschaft 1998a, no. 104.

On April 13, 1669, Johann Georg II received the insignia of the Order of the Garter from Wilhelm von Schwan, envoy of Charles II, the King of England. According to Tentzel, this *Gnadenpfennig* refers to this occasion. WaC

410

Balthasar Lauch (act. 1669–85)

VALENTIN ALBERTI (1635–1697)

Dated 1683

Silver, cast; 47.3 × 39 mm

Scher Collection

Obverse: Alberti in an ecclesiastical collar and buttoned robe. Inscription: D[octor] VAL[entin] ALBERTI P[rofessor] P[ublicus] A[cademiæ] ÆTAT[is] XLVIII [Doctor Valentin Alberti, university professor, aged 48].

Reverse: In a garden, a matronly personification of Theology/Religion sitting with an open book in her lap, reaching for a flower offered to her by a young personification of Philosophy; behind them, a rose bush and the Tree of Knowledge. Inscriptions: UTILE THEOLOGIÆ DOMINIUM IUCUNDUM PHILOSOPHIÆ MINISTERIVM [The useful is the realm of theology, [while] the pleasant is the task of philosophy]; in exergue, M DC L XXXIII [1683]; BL [artist's initials].

Literature: "Sitzungsberichte der Numismatischen Gesellschaft zu Berlin" 1898, 5.

A Lutheran theologian and scholar, Alberti was renowned for his strong defense of Lutheran orthodoxy and opposition to Pietism and Roman Catholicism. In 1683, he published the *Interesse Præcipuarum Religionum Christianarum*. "Professor Publicus Academiæ" is an academic title. EM

410

411

412

411

Johann Engelhart (d. 1713)
IMRE THÖKÖLY (EMERICH TÖKÖLI) (1657–1705)
ca. 1684
Silver, struck; 45 × 39.8 mm
Scher Collection

Obverse: Thököly with mustache and long hair, wearing a cloak with decorative fasteners over a breastplate. Inscriptions: EMERIC TOCKEL HUNGAROR[um] REBELL[ium] CAPUT [Imre Thököly, head of the Hungarian rebels]; below bust, E[ngelhart] F[ecit] [Engelhart made it].
Reverse: On a high cliff, a crown; an upside-down male figure falling with eagle above and lion (?) below. Inscriptions: RETRO CADIT AUDAX [The arrogant one falls back]; at lower left, E[ngelhart].
Literature: Resch 1901, no. 83.

Thököly had an active but checkered career as a Hungarian statesman and patriot. Raised a Lutheran, in 1670 he fled to Transylvania from Upper Hungary, which was torn by the conflict between the Catholics of the Holy Roman Empire under Leopold I (1640–1705) and the Protestants. There he rallied the Magyar refugees to rebel against the empire. To aid in the ensuing war that began in 1679, he enlisted the help of the Turks, who recognized him as Prince of Upper Hungary and offered him the title of king, which he refused. Elected Prince of Transylvania in 1690 by the Hungarian Diet, he ended his days in the Turkish city of Galata. The reverse of this medal—with the figure in Hungarian uniform plummeting from a crowned mountain—seems not to be a celebration of Thököly but rather propaganda from an imperial

source referring to his defeat as a rebel and the denial of a royal crown. This is certainly indicated by the reverse inscription. AF, SKS

412

Johann Engelhart (d. 1713)
IMRE THÖKÖLY (EMERICH TÖKÖLI) (1657–1705)
ca. 1690
Silver, struck; 45 × 39.7 mm
Scher Collection; Promised gift to The Frick Collection

Obverse: Thököly wearing a cloak with decorative fasteners over an embroidered shirt. Inscriptions: EMERIC TOCKEL HUNGAROR[um] REBELL[ium] CAPUT [Imre Thököly, head of the Hungarian rebels]; below bust, E[ngelhart] F[ecit] [Engelhart made it].
Reverse: On a high cliff, a crown; a male figure falling with eagle above and lion below. Inscriptions: RETRO CADIT AUDAX [The arrogant one falls back]; at lower left, E[ngelhart].
Literature: Resch 1901, no. 85; Wormser 1914, no. 94.

See the commentary for no. 411. AF, SKS

413

Heinrich Bonhorst (act. 1669–95; d. 1711)
SATURN
1686
Silver, struck; 65.1 mm
The Frick Collection; Gift of Stephen K. and Janie Woo Scher, 2016 (2016.2.207)

413

414

Obverse: A bearded figure with a wooden leg holding two cornucopias on his shoulders, one filled with coins and medals and the other with silver ingots, in a landscape showing a silver mine and processing plant; on the god's hip, the astrological sign for Saturn (♄). Inscription: SIC VENIUNT [So they come].

Reverse: Winged figure with a wooden leg and the astrological sign for Saturn (♄) on his hip, pouring coins out of a cornucopia and into a well, with a male and two female peacocks in front of a palace on the left, a large house in the center, and on the right, soldiers, a fort with cannons firing, and a church. Inscription: SIC ABEUNT [So they go].

Literature: Brockmann 1985–87, 2: 739; Müseler 1983, 1: no. 10.4.3/1.

This medal shows, on the obverse, the production of riches through the mining and processing of ore in the German region of Harz and, on the reverse, the squandering of riches to purchase palaces, fine homes, and luxury goods and to finance the costs of war. The figure on both sides is a conflation of Saturn, associated with wealth and plenty, and Pluto, ruler over the treasures contained within the earth, whose attribute was a cornucopia of abundance. In modern parlance, the message of the medal is "easy come, easy go." SKS

414

Heinrich Bonhorst (act. 1669–95; d. 1711)
FORTUNA AND MINING
ca. 1698
Silver, struck; 66 mm

Obverse: Fortuna standing with a sail on a wheel in the sea; in the background, a mountainous coastline and a ship. Inscription: on the sail, FRONTE CAPILLATA EST [The forehead is hairy].

Reverse: In the foreground, a mining operation; to the left, a tree around which is curled a cornucopia spilling raw silver ingots; in the background, a building with molten silver in crucibles; to the right, a tree around which curls another cornucopia out of which coins spill; behind, a water mill that may be a mint. Inscriptions: AUREA HERCINIÆ STERILITAS [The golden barrenness of the Hercynia]; in exergue, DITESCIT AB IMO [He grows rich from below]; HB [artist's initials].

Literature: Brockmann 1985–87, 2: no. 736.

The inscription on the obverse derives from a passage often attributed to Cato the Elder but is probably associated with a much later author, perhaps Dionysius Cato: "Fronte capillata, post est occasio calva" (Hairy in front, opportunity is bald behind). The personification of Opportunity or Fortune on the obverse essentially completes the inscription. The Hercynian Forest (including the Black Forest on its western end) was a vast, densely wooded area that extended east from the Rhine River and was well known to ancient writers. It was also home to various mythological creatures mentioned by, among others, Caesar. AF, SKS

415

Johann Buchheim (1624–1683)
MARRIAGE MEDAL
1653–83
Silver, struck; 59.9 mm
Scher Collection; Promised gift to The Frick Collection

Obverse: A man and a woman in wedding garb pledge their troth over an altar in front of which a small dog, representing Fidelity, faces the viewer. A putto descending from heaven pours water over their hands, while above, in clouds from which spread rays of light, the dove of the Holy Spirit is displayed; at each side of the clouds, two arms descend holding wreaths above the heads of the married couple; to the left of the man, the Pelican in Her Piety in a tree, beneath which is a spade signifying labor; to the right of the woman, a beehive, referring to industry and two birds in a tree indicating love. Inscriptions: LEGITIMO THALAMI QUI DEXTRAS FOEDERE IUNGUNT HOS DEUS OMNIMODA PROSPERITATE BEAT [The Lord will bless with all prosperity those who join their hands in proper marriage]; in exergue, I[ohann] B[uchheim].

Reverse: In the foreground, a family—an older man and woman, a teenage boy and girl, and two small children, all with hands clasped in prayer—standing on either side of a table loaded with food; behind the table, a grapevine, on whose trunk is tied a palm and laurel branch; above on either side of a sunburst containing the name יהוה [Hebrew for Jehovah], two hands appearing from clouds,

415

one pouring water on the grapevine from a vessel and the other hand scattering fruit and flowers. Inscriptions: PROLE TORUM VICTU MENSAM, VELAMINE CORP[us] ATQ[ue] OPERIT DRACHMAE GRANDINE TECTA DOM[inus] [The Lord blesses the (conjugal) bed with children, the table with food, the body with clothing, and the roof of the house with a hail of money]; ECCE SIC BENEDICETUR VIR QUI TIMET IEHOVAM [Behold the man who fears God is thus blessed]; in exergue, PRECE ET LABORE [With prayer and work]; I[ohann] B[uchheim].
Literature: Forrer 1979–80, 1: 305–6.

Several "stock" marriage medals were produced in the seventeenth century by such medalists as Johann Buchheim and Sebastian Dadler (who often worked with another German medalist, Johann Höhn) and, like this example, showed the basis of a successful marriage on the obverse and the abundant fruits of that marriage on the reverse. This medal appears to be modeled after a medal by Dadler (Maué 2008, 144–45, no. 102). ADC

416

Johann Christoph Reteke (act. 1664–1720)
HAMBURG SATIRICAL MEDAL
17th century
Silver, struck; 43.9 × 40.2 mm
Scher Collection

Obverse: A dandy wearing a wide hat with plume, holding spectacles and a glove in his gloved right hand and covering his face with the left hand. Inscription: NICHT DURCH BRILLEN [Not through eyeglasses].

Reverse: A headless and bare-breasted woman wearing a long dress and pearl necklace, holding a fan with her right hand and the train of her dress in the left. Inscription: DER REST IST GUTT [The rest is good].
Literature: *Katalog . . . aus dem Nachlass Professor C. Fieweger* 1885, 102; Kahane 1928, 29; Holzmair 1937, 4764.

This medal is a satirical comment on the follies of wealthy dandies and prostitutes. See the commentary for no. 417. AF, SKS

417

Johann Christoph Reteke (act. 1664–1720)
HAMBURG SATIRICAL MEDAL
17th century
Silver, struck; 40 mm
Scher Collection

Obverse: A dandy wearing a wide hat with plume and holding glasses in the left hand and covering the face with the right hand. Inscription: NICHT DURCH BRILLEN [Not through eyeglasses].
Reverse: A headless woman wearing a long dress and pearl necklace and holding a closed fan with the right hand. Inscription: DER REST IST GUTT [The rest is good].
Literature: *Katalog … aus dem Nachlass Professor C. Fieweger* 1885, 102; Kahane 1928, 29; Holzmair 1937, 4764.

This medal is the companion to no. 416, with identical inscriptions. The figures and poses are slightly different—notably, the female is no longer bare-breasted—but the overall intent is similar. The treatment of the inscription and figures, however, is quite different. AF, SKS

416

417

418

418

Attributed to Georg Hautsch (1664–ca. 1745) and Philipp Heinrich Müller (1654–1719)

MARCANTONIO GIUSTINIAN (1616–1688; Doge of the Republic of Venice from 1684)

Dated 1687

Silver, struck; 72 × 57 mm

Scher Collection

Obverse: The doge, surrounded by three *Procuratori di San Marco*, receives two subdued Ottoman commanders, Mustafa Pasha and his brother Hassan. Inscription: PARCERE SUBIECTIS ET DEBELLARE SUPERBOS [*Aeneid* VI.853] / SCIT NOBILIS IRA LEONIS [The noble rage of the Lion (of Venice) knows how to spare the conquered, and subdue the proud].

Reverse: The Lion of St. Mark rampant, grasping a dolphin, carrying a flower wreath, holding a sword entwined with a laurel branch, and treading on a bow and an arrow, both broken. Inscriptions: EX UTROQUE VICTOR [Winner on land and offshore]; on the edge, SERENISSIMI LEONIS ALATI SOLO SALOQUE TURCARUM VICTORIS TRIUMPHALE FLORILEGIUM, 1687 [collection of triumphs achieved by the very serene winged lion (of Venice), winner over the Turks on land and in the open sea, 1687].

Literature: Lauffer 1742, 9; Rizzini 1892, no. 1068; Julius sale 1958, no. 323; Toderi and Vannel 1990, no. 54; Maué 1997, no. 8; Voltolina 1998, 2: no. 1054.

Following the Venetian victories against the Turks in Morea in the summer of 1686, the Ottoman commander Mustafa Pasha, his brother Hassan, and their families escaped to Venice. This medal celebrates this Venetian triumph by emphasizing the clemency demonstrated by Doge Marcantonio Giustinian toward the refugees in August 1687. The medal is listed by Caspar Gottlieb Lauffer, master at the mint of Nuremberg, in a catalogue of medals that he claimed to be ready to strike upon request because he owned their dies (Lauffer 1742). WAC

419

Philipp Heinrich Müller (1654–1719)

LEOPOLD I (1640–1705)

1688

Silver, struck; 58.2 mm

Scher Collection; Promised gift to The Frick Collection

419

420

Obverse: Leopold, laureate, wearing a wig, armor, commander's sash, and chain with the Order of the Golden Fleece, surrounded by foliage and ten shields. Inscription: on truncation, PHM [artist's initials].

Reverse: Joseph, Leopold's eldest son, seated on a throne, surrounded by a lion and panoplies of war, offering a scepter wrapped in laurel to a kneeling man holding a shield with the arms of Hungary Ancient and Modern. Inscriptions: on banderole, IL PIV BEL GRADO [The most beautiful honor]; in small letters on the right side, P[hilipp] H[einrich] M[üller] F[ecit] [Philipp Heinrich Müller made it]; on stairs, 1688 NANDOR ALBA SVPERATA / 1687 OSSEK EXPVGNATVM / 1686 BVDA RECVPERATA / 1685 STRIGONIVM CAPTVM / 1684 VICTORIA PROSECVTA / 1683 VIENNA LIBERATA [1688 Belgrade conquered / 1687 Ossek cleansed / 1686 Buda recovered / 1685 Esztergom captured / 1684 Victoria in sight / 1683 Vienna liberated]; in exergue, in three lines, DE ALBA GRÆCA SVPERATA / D[ie] XVI SEPT[embris] A[nno] MDCLXXXIIX / GRATVLATVR / S[enatus] P[opulus] Q[ue] A[ugusburgensis] [After conquering Belgrade on the 16th day of September in the year 1688 he is thanked by the Senate and the people of Augsburg].

Literature: Montenuovo sale 1885, no. 1090; Julius sale 1958, no. 357.

This medal commemorating the taking of Belgrade was made for Emperor Leopold I as thanks from Augsburg; in 1686, the League of Augsburg was formed by Leopold and the imperial princes to uphold the terms of the treaties of Westphalia and Nijmegen. The reverse depicts a personification of Hungary paying homage to Leopold's eldest son, Joseph I, who was crowned hereditary King of Hungary at the Hungarian Diet in Bratislava (formerly Pressburg) in 1687. Imre Thököly (see nos. 411, 412) clashed with Leopold and the imperial forces on a great many occasions. Thököly supported the Turks in the Battle of Vienna in 1683 and, after a decisive loss, attempted to reconcile with Leopold with the provision that Leopold restore Protestant liberties in Hungary and name him prince; those terms were denied. AF

420

Philipp Heinrich Müller (1654–1719)
FRIEDRICH SCHOMBERG (ca. 1615–1690)
Silver, struck; 49.5 mm
Dated 1690
Scher Collection; Promised gift to The Frick Collection

Obverse: Schomberg wearing armor. Inscriptions: FRIDERICUS MARESCHALCUS SCHOMBERG & [Marshal Friedrich Schomberg]; on the truncation, PHM [artist's initials].

Reverse: Schomberg as Mars grasping a tree with his right hand, while his left rests upon a shield ornamented with the Christian monogram XP; planting his club, like Hercules, which takes root and flourishes as an olive tree; on the ground, a coronet and sack with money; a snake biting at his shield in vain; behind him, a pyramid, against which rests a laurel branch bearing the shields of France, Germany, Scotland, Spain, and Ireland, the scenes of his career. Inscriptions: PLANTAVIT UBIQUE FERACEM [He has planted a fruitful club everywhere]; in exergue, CONTINVATIS TRIVMPHIS / OBDVRATA IN DEVM FIDE / IN HIBER MILITANTI / 1690 [To him who served in Ireland with continued success and with enduring trust in God, 1690]; on the edge, SUBIT IRA, CADENTEM VLCISCI PATRIAM, ET SCELERATAS SVMERE POENAS [Then in my bosom rose a blaze of wrath; I thought I should avenge my dying country, and with horrid deed pay crime for crime (*Aeneid* II.575)].

Literature: Van Loon 1732–37, 4: no. 9 (var.); Forrer 1979–80, 4: 198.

This medal commemorates the death of Friedrich Schomberg, first Duke of Schomberg, in the Battle of the Boyne (July 1, 1690), where William III of England defeated the deposed King James II of England, father of William's wife, Mary II. Schomberg was William's second in command. SKS

421

Philipp Heinrich Müller (1654–1719)
JOHANN HEINRICH HORBIUS (1645–1695)
Dated 1695
Copper alloy, struck; 44.4 mm
The Frick Collection; Gift of Stephen K. and Janie Woo Scher, 2016 (2016.2.108)

Obverse: Horbius wearing a skullcap, ruff, and ecclesiastical gown. Inscriptions: IOH[annes] HENRIC[us] HORBIVS PAST[or] Ad DIV[um] NICOL[aum] HAMB[urgenses] [Johann Heinrich Horbius, pastor at Saint Nicholas in Hamburg]; in a cartouche framed by two winged putto heads, in three lines, NAT[us] 1645 D[ie] XI IUN[ii] DENAT[us] 1695 D[ie] 26 IAN[uarii] ÆTAT[is] 49 AN[norum] 7 MENS[ium] [Born 1645, June 11; died 1695, 26 January; aged 49 years, 7 months]; PHM [artist's initials].

421

422

Reverse: Scene of a shipwreck on rocks during a storm with a figure climbing the rocks and being welcomed into heaven by two arms emerging from clouds, the right clasping the left hand of the figure, the left offering a crown of salvation. Inscriptions: EVOLAT AD COELOS UNDARUM TURBINE FESSUS [He ascends to heaven exhausted by a storm of waves].
Edge inscription: FELIX IVSTA FIDES QVEM SIC SVPER ÆTHERA VEXIT [Happy the one whose faith takes him to heaven; chronogram, 1695].
Literature: Forrer 1979–80, 4: 198.

This medal commemorates the death of Johann Heinrich Horbius, a prominent Pietist pastor and the brother-in-law of Philipp Jakob Spener, one of the leaders of the movement blossoming in the second half of the seventeenth century in Germany. In 1684, Horbius was elected chief pastor of the church of St. Nicholas in Hamburg, but his election was met with great opposition. He was ferociously criticized for sharing Philipp Spener's idea on the education of the theologians. In 1693, he was finally forced to resign. ADC

422

Philipp Heinrich Müller (1654–1719)
JOSEPH I OF HAPSBURG, HOLY ROMAN EMPEROR
(b. 1678; r. 1705–11) and **PRINCESS WILHELMINA AMALIA**
(1673–1742)
Dated 1699
Silver, struck; 45.5 mm
Scher Collection; Promised gift to The Frick Collection

Obverse: Joseph and Wilhelmina facing each other, the emperor wearing the badge of the Order of the Golden Fleece and commander's sash over armor; the princess with hair bound back and bejeweled. Inscriptions: NIL VIGET QVICQVAM SIMILE AVT SECVNDVM [Nor flourishes anyone similar or even second (from Horace, *Carmina* 11: 17–18: *Vnde nil maivs generatvr ipso nec viget qvicqvam simile avt secvndvm*)]; in exergue, in four lines, IOSEPHVS ET / WILHELMIA AMALIA / D[ei] G[ratia] ROM[anorum] REX ET / REGINA [Joseph and Wilhelmina Amalia, by the grace of God, King and Queen of the Romans]; PHM [artist's initials].
Reverse: A Cupid holding two crowns descending toward Venus, who advances from the right. Inscriptions: DVPLICEM CYTHEREA CORONAM DONAT [Cytherea bestows the double crown]; in exergue, MDCXCVIIII [1699]; PHM [artist's initials].
Literature: Forrer 1979–80, 4: 201; Pollard 2007, 2: no. 920.

This medal celebrates Joseph and Wilhelmina's marriage on February 24, 1699. Venus was also known as Cytherea, after Cythera, one of her main cult sites in Greece. ADC

423

Philipp Heinrich Müller (1654–1719)
CARL III WILHELM OF BADEN-DURLACH (1679–1738)
Dated 1709
Silver, struck; 44.4 mm
Scher Collection; Promised gift to The Frick Collection

Obverse: Carl Wilhelm wearing a wig, armor, and commander's sash. Inscriptions: CAROL[us] GVILIELM[us] D[ei] G[ratia] MARCH[io] BADEN DVRL[ach] ET HOCHB[erg] [Carl Wilhelm, by the grace of God, Marquess of Baden-Durlach, and Hochberg]; beneath bust, PHM [artist's initials].
Reverse: A lion with two tails and wearing a crown stands amid various broken elements of war. Inscriptions: AVDACEM FORTVNA CORONAT [Fortune crowns the bold]; in exergue, MDCCVIIII [1709].
Literature: Wielandt and Zeitz 1980, 100.

Carl III Wilhelm was Margrave of Baden-Durlach from 1709, the year this medal was made, until his death. He was a very successful military commander, attaining the rank of field marshal after fighting in many battles in the War of the Spanish Succession (1701–15), including the Battle of Blenheim (August 13, 1704). Also a passionate gardener and planner, he founded the city of Karlsruhe, where, in 1715, he laid the foundation stone of Karlsruhe Castle, from which he ruled his territories with great ability. AF, SKS

423

424

Georg Pfründt (1603–1663)

KARL I LUDWIG OF WITTELSBACH (b. 1617; Elector Palatine 1649–80)

Dated 1661

Silver, cast; 72.7 mm

The Frick Collection; Gift of Stephen K. and Janie Woo Scher, 2016 (2016.2.72)

Obverse: Karl Ludwig wearing armor, cravat, and Order of the Garter and holding a baton in his right hand and resting his left arm on a table with an elaborate tablecloth with his helmet and electoral hat. Inscription: CAR[olus] LUD[ovicus] D[ei] G[ratia] COM[es] PAL[atinus] RHEN[i] ELECT[or] B[avariæ] D[ux] [Karl Ludwig, by the grace of God, Count Palatine of the Rhine, Duke Elector of Bavaria].

Reverse: The city of Heidelberg; in banderole above, DOMINVS PROVIDEBIT [The Lord will provide]; in exergue, two rampant lions holding the arms of the Palatinate with 1661 to either side. Inscription: around crest, HONI SOIT QVI MAL Y PENSE [Shame on him who thinks evil of it].

Literature: Stemper 1997, 228, no. 217.

This medal relates to the restoration of Heidelberg after the depredations of the Thirty Years' War (1618–48). The upper inscription on the reverse (DOMINVS PROVIDEBIT), derived from Genesis 22:8, was the motto of the electors. The lower text surrounding the Palatine coat of arms was the traditional motto of the Order of the Garter. The tablecloth includes a mirror monogram CL (Carl Ludwig). AF

425

Georg Pfründt (1603–1663)

KARL I LUDWIG OF WITTELSBACH (b. 1617; Elector Palatine 1649–80)

Mid-17th century

Silver, lightly gilded, cast; 39.9 × 32.5 mm

Scher Collection

Obverse: Karl Ludwig wearing a collar, armor, and commander's sash tied at the shoulder. Inscription: CAR[olus] LVD[ovicus] D[ei] G[ratia] COM[es] PALATINVS RH[eni] S[acri] R[omani] I[mperii] AR[chidapifer] ET EL[ector] BAV[ariæ] DVX [Karl Ludwig, by the grace of God, Count Palatine of the Rhine, Arch-Steward of the Holy Roman Empire, and Duke Elector of Bavaria].

Reverse: The ruins of Heidelberg Castle. Inscription: DOMINVS PROVIDEBIT [The Lord will provide].

Literature: Lanna sale 1911b, no. 843; Exter 1988, 1: 125; Stemper 1997, 222, no. 212.

Karl Ludwig was restored as elector of the Lower Palatinate by the Peace of Westminster (1648), ending the Thirty Years' War (1618–48). He returned to his devastated capital, Heidelberg, in 1649 and spent the years of his reign rebuilding both the city and his domain, which is the subject of this medal. AF

425

426

426

Johann Linck (act. 1659–1711)

KARL I LUDWIG OF WITTELSBACH (b. 1617; Elector Palatine
1649–80)

Dated 1665

Copper alloy, cast; 55.4 mm

Scher Collection

Obverse: Karl Ludwig with armor and baton, his helm and electoral
hat on a table. Inscriptions: CAR[olus] LVD[ovicus] D[ei] G[ratia] COM[es]
PAL[atinus] RHEN[i] ELECT[or] B[avariæ] D[ux] 1665 [Karl Ludwig, by the
grace of God, Count Palatine of the Rhine, Elector, Duke of Bavaria,
1665]; in the field below right arm, I[ohannes] L[inck].

Reverse: Three dogs, a squirrel, a weasel, a snake, and a frog trying
to catch Pegasus, who flies away amid clouds; in the background,
Mount Helicon. Inscription: PRAESTENT MODO SVMMA QVIETEM [May
the most crucial issues matter more than quietness].

Literature: Exter 1759–75, 1: table 79, no. 142; M. Bachmayer and
P.-H. Martin in *Barock in Baden-Württemberg* 1981, 1: no. J50;
Stemper 1997, 237, no. 228; Peus 2004, no. 2383.

Karl Ludwig was in contention with Charles III of Lorraine for the
control of the fortresses of Landstuhl and Falkenstein in the years

1665–69. In March 1669, he presented this medal to several princes,
aristocrats, and army officers who had supported him in this conflict.
For example, "a chain [. . . and] a medal of Electoral Palatinate
struck in gold for half Dukaten and half Goldgulden with (the image
of) Pegasus" were given "to Captain Dolne for the message he
successfully brought because of the Landstuhl issue" (Huffschmid
1916, cols. 85–87, here col. 85). WAC

427

Friedrich Kleinert (1633–1714)

JOSEPH I OF HAPSBURG, HOLY ROMAN EMPEROR
(b. 1678; r. 1705–11)

Dated 1687

Silver, struck; 76.4 × 61.1 mm

Scher Collection

Obverse: Joseph, wearing the Collar of the Order of the Golden
Fleece, receiving the Hungarian crown from the hand of God.
Inscription: IOSEPHUS DER ERSTE KÖNIG IN UNGARN MDCLXXXVII
[Joseph I, King of Hungary, 1687].

Reverse: Allegory of Joseph's reign—a pomegranate tree, with two
coats of arms, Austria (left) and Hungary (right), and the crown of

427

428

Hungary watered by the two main Austro-Hungarian rivers, the Danube and the Drave; in the background, a landscape with cities of the Austrian-Hungarian dominions. Inscriptions: IOSEPH WIRD WACHSEN / WIE AN EINER QUELLE. I[m] BUCH MOSE IN 49 [Joseph will grow up as if he were by a spring, as written in the Book of Moses, chapter 49 (the citation refers to Genesis 49:22: "Joseph is the offshoot of a fruitful tree, a fruitful tree by a spring, whose branches extend over the wall")]: on the trunk, IOSEPH; in the field, WIEN PRESBVRG OFFEN DONAW DRAW ESSEK [Vienna, Bratislava, Buda, Danube, Drave, Osijek].

Edge inscriptions: AUSTRIA EXTENDETUR IN ORBEM UNIVERSUM [Austria extends over the whole universe]; ÖSTERREICH VOLL ALLER EHREN IST [Austria enjoys all honors]; in a cartouche, F[riedrich] K[leinert].

Literature: Lauffer 1742, 10; Wellenheim sale 1844, no. 7406; Forrer 1904–30, 2: 326; Horsky sale 1910, no. 2384; Wallenstein 2012, fig. 104 (as by Martin Brunner); Telesko 2017–18, 41, fig. 7.

This medal commemorates Joseph's coronation as King of Hungary on December 9, 1687. Caspar Gottlieb Lauffer, master at the mint of Nuremberg, included it in a catalogue of medals that he claimed to be ready to strike upon request (Lauffer 1742) because he owned their dies. This mention, however, is not evidence that Lauffer had engraved it himself, as conjectured by Forrer, because the introduction of his catalogue credits several artists with the making of the dies (fol. 3v). WaC

428

Rudolf Bornemann (1650–1711)
ERNEST AUGUST OF HANOVER (1629–1698; Bishop of Osnabrück from 1662, Prince of Calenberg and Duke of Brunswick-Lüneburg from 1679, Elector of Hanover from 1692)
Dated 1680
Silver, struck; 63.8 mm
Scher Collection

Obverse: Ernest with armor and peruke. Inscription: ERNESTUS AUGUSTUS D[ei] G[ratia] EPISCOP[us] OSNABR[ugensis] DUX BRUNS[vicensis] ET LUN[eburgensis] [Ernest August, by the grace of God, bishop of Osnabrück and Duke of Brunswick-Lüneburg].
Reverse: The hand of Divine Providence guiding the wheel of Osnabrück with a rope; other symbols (a straight palm tree, a stable ship under a gust of wind, and a solid rock in the stormy sea) referring to the firmness of Ernest's rule; the clouds, the storm, and the personifications of Wind and Sun representing the diverse conditions that Ernest's government resisted. Inscriptions: VARIIS IN MOTIBUS EADEM [It remains the same under different impulses]; in exergue, M DC LXXX [1680].
Literature: Fiala 1906, no. 2250; Brockmann 1985–87, 2: no. 692.

According to Brockmann, this medal may have been issued to celebrate Ernest's installation as Duke of Hanover after the death of his brother Johann Friedrich (1679). WaC

429

Martin Heinrich Omeis (or Ohmeiss) (1651–1703)
JOHANN GEORG II OF WETTIN (b. 1613; Elector of Saxony 1656–80)
Dated 1677
Silver, struck; 55.3 × 48.2mm
Scher Collection

429

430

431

Obverse: Johann Georg with peruke, armor, marshal's baton, and ermine mantle. Inscription: IOAN[nes] GEORG[ius] II D[ei] G[ratia] DUX SAX[oniæ] I[ulaci] C[leviæ] & MONT[is] ELECT[or] [Johann Georg II, by the grace of God, Duke of Saxony, Jülich, Cleves, and Berg, Elector].

Reverse: Two swords (insignia of the elector as Arch-Marshal, also depicted in the Albertine Wettin coat of arms) and two palms between branches of rue (another element of the Wettin coat of arms); above, the electoral hat and shining clouds surrounding the name יהוה [Hebrew for Jehovah]. Inscriptions: VI NUMINIS PACE VIREBO [Through the powerful intervention of God I will flourish in peace]; in the field, 1677 and O[meis?].

Literature: Tentzel 1714, *Alb.*, table 60, no. 1; Merseburger sale 1894, no. 1185; J. Erbstein and A. Erbstein 1888–96, 3: no. 956; Popken sale 2014, no. 280.

This medal refers to Saxony's neutrality in the Franco-Dutch War (1672–78). WaC

431

Johann Georg Breuer (d. ca. 1695)

AUGUST FREDERICK OF GUELPH, HEREDITARY PRINCE OF BRUNSWICK-LÜNEBURG (1657–1676)

Dated 1676

Silver, struck; 55.5 mm

Scher Collection; Promised gift to The Frick Collection

Obverse: August Frederick with all'antica parade armor and peruke. Inscriptions: AVG[ustus] FRIDERIC[us] D[ux] BRVNS[vicensis] ET LVN[eburgensis] [August Frederick, Duke of Brunswick-Lüneburg]; on truncation of shoulder, BREVER.

Reverse: The personification of Germany kneeling before the Holy Roman Emperor, under whose rule it has returned, while Charity and Mars cremate August Frederick's body, saluted by Fame's trumpets; above the funeral pyre, a ducal crown, laurel wreath, and smoke. Inscriptions: ODOR AD POSTEROS [His scent/repute will reach posterity]; in exergue, OCCVB[uit] AD EREPTAM GALLIS / PHILIPSBVRG / M DC LXXVI [he fell near Philippsburg, seized from the French occupation, 1676]; the figures depicted are identified by the inscriptions (from the left), MAIESTAS IMPERII, GERMANIA, CHARITAS, and MARS [the Majesty of the Empire, Germany, Charity, and Mars].

Literature: Fiala 1906, no. 1211; Brockmann 1985–87, 1: no. 266a; Leschhorn 2010, 250, fig. 281.

This medal commemorates August Frederick's death as a consequence of the wounds he received at the Siege of Philippsburg in 1671, during the Franco-Dutch War (1672–78). WaC

430

Carlo Giuseppe Plura? (1655–1737)

JOSEPH I OF HAPSBURG, HOLY ROMAN EMPEROR

(b. 1678; r. 1705–11)

1690–1705

Copper alloy, cast; 65.8 mm

Scher Collection

Obverse: Joseph wearing a richly decorated buttoned jacket beneath an embroidered cape with the Order of the Golden Fleece. Inscription: IOSEPH[us] PRIMVS HVN[gariæ] ET ROM[anorum] REX [Joseph I, King of Hungary and of the Romans].

Literature: Argelati 1750–59, 3: 39, no. 12 (probably; not illustrated); *Fach-Katalog der Musikhistorischen Abtheilung* 1892, 6, no. 54.

Joseph, son of Emperor Leopold I, ascended to the Austrian throne during the War of Spanish Succession (1701–14). Despite his successful reorganization of Austria's finances, and the many victories won by his exceptional military commander Prince Eugene of Savoy, Joseph was unsuccessful in his attempts to retain the Spanish throne for the Hapsburgs. EM

432

Unknown artist

JOHANN GEORG I OF WETTIN (b. 1585; Elector of Saxony 1611–56)

After 1611

Silver, struck (?); 38.3 × 30.1 mm

The Frick Collection; Gift of Stephen K. and Janie Woo Scher, 2016 (2016.2.75)

432

433

Obverse inscription: D[ei] G[ratia] IOH[annes] GEOR[gius] DVX SAX[oniæ] IVL[aci] CLE[viæ] ET MONT[is] [Johann Georg, by the grace of God, Duke of Saxony, Jülich, Cleves, and Berg].
Reverse: Coat of arms of the Albertine Wettin. Inscription: ARCHIMAR[e]S[callus] ET ELECTOR SACRI ROMANI IMPERI [Arch-Marshal and Elector of the Holy Roman Empire].
Literature: Tentzel 1714, *Alb.*, table 33, no. 3; Leberecht sale 1833–35, 3: no. 14248; Merseburger sale 1894, no. 849.

According to Tentzel, this undated medal is unlikely to have been issued for a specific event. Such pieces may have been made in advance for Johann Georg I and his wife to present as gifts on various occasions. wac

433
Unknown artist
ST. ELIZABETH OF HUNGARY (1207–1231; Hungarian Princess of the House of Árpád and widow of Landgrave Hermann of Thuringia)
Before 1622
Silver, struck; 50.4 mm
Scher Collection

Obverse: Elizabeth with veil and crown. Inscription: ELISABETA FILIA ANDR[eæ] REG[is] UNGAR[iæ] OBIIT MARB[urgi] AN[no] MDDXXXI [Elizabeth, daughter of King Andrew of Hungary, died in Marburg in 1231].
Reverse: The church of St. Elizabeth in Marburg, formerly the burial place of her body. Inscription: DISPERSIT DEDIT PAUP[eribus] : IUST[itia] EIUS MANET IN SECUL[um] SECULI [She has distributed, she has given to the poor; his (in this context, Elizabeth/her) justice remains from age to age (Psalm 111:9)].
Literature: Tentzel 1714, *Ern.*, fol. c, recto of the *Vorrede*; Köhler 1729–50, 6: 138, no. 4; Bernhart 1921–22, no. 21; Klein 1976, no. B21; Winter (Heinz) 2011, no. 17/2; Wallenstein 2012, no. 163; Steguweit 2017, no. 10.

This medal belongs to a group of about twenty-five struck types known as "Prager Judenmedaillen" because of their attribution to an anonymous Jewish goldsmith active in the Bohemian capital (Tentzel 1697, fol. A2v; Köhler 1729–50, 1: 90). Allegedly, the medalist sold them as portraits made during the lifetime of the personalities they represented—chiefly, sovereigns who ruled in

the period spanning from the twelfth century to 1622 or shortly afterward (Bernhart 1921–22, no. 13). The medalist also employed "old Gothic capital letters" and layouts commonly adopted in seals to support his fraudulent claim (Köhler 1729–50, 1: 427). Yet, Tentzel and Köhler recognized the medals as restitutions, and Tentzel argued their early modern dating on the basis of material, technical, and linguistic remarks (Köhler 1729–50, 1: 90; 6: 140). The historical existence of the Jewish master, however, appears doubtful to current scholars. Moreover, the Judenmedaillen, which have different diameters, should not be considered as parts of one series but rather as the uniform outcome of a workshop possibly active at the beginning of the seventeenth century, if not a few decades before. The present type was described in an inventory of Prince Ernest of Wettin (1601–1675) drawn in Weimar in 1622 (Steguweit 2017). This circumstance, together with elements such as the drapery of Elizabeth's veil, indicate that the medal was struck before that date. Köhler and Tentzel suggested that these restitutions were forgeries intended for the market. Yet, the circumstances and the purposes for which they were made remain unknown. wac

434
Unknown artist
SOPHIA OF HOHENZOLLERN (b. 1568; Electress of Saxony 1582–1622)
Dated 1622
Silver, cast; 38.3 × 29.3 mm
Scher Collection

Obverse: Sophia wearing a widow's cap, ruff, robe, and pearl necklaces; the pendant formed by Sophia's initial "S" intertwined with that of her husband "C[hristianus]." Inscription: D[ei] G[ratia] SOPHIA NAT[a] MAR[gravia/chionissa] BRAN[denburgi] DVC[issa]

434

SAX[oniæ] ET E[lectrix] [Sophia, by the grace of God, born Margravine of Brandenburg, Duchess and Electress of Saxony].

Reverse: Head of a cherub. Inscriptions: on the edge, SEREN[issimus] D[ominus] D[ominus] IOH[annes] GEORG[ius] ELECT[or] SAX[oniæ] IN MATR[em] CHARISS[imam] [The very serene Lord, Herr John George, Elector of Saxony, in honor of his dearest mother]; in the field, NAT[am] 6 Jun[ii] / 15 68 / MOR[tam] 7 Dec[embris] / 1622 [born on 6 June 1568, died on 7 December 1622]; in exergue, PIETAS [devotion (toward parents)].

Literature: Tentzel 1714, *Alb.*, table 22, no. 9; Renesse-Breidbach 1836, 2: no. 18695; J. Erbstein and A. Erbstein 1888–96, 1: no. 420; Merseburger sale 1894, no. 774; Hess 1929, no. 1768; Brockmann 1994, no. 74.

This medal was commissioned by Sophia's second son, John George I (1585–1656), Elector of Saxony from 1611, to express his filial devotion. wac

436

Unknown artist (Germany)

LOVE AND HONOR

Dated 1698

Silver, struck; 46 mm

Scher Collection

Obverse: Fortuna standing upon a winged globe, holding a burning heart in her left hand and a sail catching the wind in her right. Inscription: WER DAS GLÜCK HAT GEWINNET DER IUNGEER HERTZ [Who has the luck wins the heart of the spinster].

Reverse: God joins together in marriage the hands of a young man and woman and blesses them. Inscriptions: QUOS DEUS CONIUNXIT HOMO NON SEPARET [What . . . God hath joined together, let not man put asunder (Mark 10:9)]; in exergue, EIN TVGENDSAM WEIB IST / EINE EDLE GABE VND WIRD / DEM GEGEBBEN DER / GOTT FÜRCHTET [A good wife is a good portion, which shall be given in the portion of them that fear the Lord (Ecclesiasticus 26:3)]; 1698.

Literature: Kahane 1928, 42, no. 190.

This medal celebrates the virtues of love and honor. Such allegorical medals were often made for newlyweds or to be handed out at weddings. Fortuna, unstable and blown by the wings of chance, is represented in the traditional manner and relates to the reverse of the medal in meaning. EM

435

Unknown artist ("F")

CHARLES I, KING OF GREAT BRITAIN AND IRELAND

(b. 1600; r. 1625–49)

ca. 1649

Silver, struck; 46.7 mm

The Frick Collection; Gift of Stephen K. and Janie Woo Scher, 2016 (2016.2.04)

Obverse: Charles, in armor, wearing drapery embroidered with roses. Inscriptions: innermost, CARL I V[on] G[ottes] G[naden] KÖNIG VON ENGEL[and] SCHOTT[land] UND IRRLAND [Charles I, by the grace of God, King of England, Scotland, and Ireland]; outermost, LEYDEN GOTT UND OBRIGKEIT [God and the Sovereign Power suffer]; under bust, F(?).

Reverse: A seven-headed monster, rampant, towering over the head, crown, and scepter of Charles. Inscription: BEY DES PÖFELS MACHT UND STREIT [By the mob's might and strife].

Literature: Hawkins 1885, 1: 352, no. 210; Eimer 2010, no. 163.

This medal mourns the death of the monarch and denounces the civil unrest leading to his execution. Charles, under whose reign civil war broke out, was executed as a tyrant, traitor, and public enemy. EM

437

Unknown artist

MEMBER OF THE RIETER VON KORNBURG FAMILY

(patrician of Nuremberg; likely died in 1637)

Dated 1631 (medal); dated 1637 (mounting)

Silver with traces of gilding, cast (medal); partially gilt silver (mounting and suspension chains, probably the original ones). The medal is welded to the mounting through a separate silver fillet; 39.6 × 33.6 mm (framed 50.8 × 49.7 mm, with loop at top 59.8 mm)

Scher Collection

Obverse: Sitter with ruff and neck chain.

Reverse: Coat of arms of the Rieter von Kornburg family. Inscription: FIDE SED CVI FIDE 1631 [With trust, but be careful of whom you trust, 1631]; on cover of mounting, + ANNO 1637 / D[ie] 28 MAR[tii] R[equiescat] I[n] P[ace] [Died on 20 March 1637. May he rest in peace].

437

Literature: Lanna sale 1911a, nos. 175, 443; Lanna sale 1911b, no. 1282; Löbbecke sale 1925, no. 318 (this specimen).

A portrait medal cast in 1631 (or shortly afterward) was placed in a mounting with cover and suspension chains in 1637. The absence of inscriptions on the obverse of the medal may indicate that it was initially meant to be inserted in such mountings. The inscription engraved on the cover in 1637 can be found in all the silver specimens preserved, although their frames slightly differ from each other. The date seems to refer to the sitter's death, but unfortunately the genealogy of the Rieter von Kornburgs published by Biedermann (1748a, tables 69–83) records no member of the family having died on March 20, 1637. In its current mounting, when the jewel is worn at the neck, its viewers can see the heraldic reverse of the medal but not its obverse. The portrait can be seen only if the jewel is turned and the cover is open. Yet, a photo of 1925 illustrates this very specimen mounted with the obverse facing the viewer and the reverse closed in the mounting. Therefore, the original orientation of the medal with respect to the mounting remains uncertain. wac

Obverse: Eleanor enthroned with the imperial insignia (crown, scepter, globe). Inscription: LEONORA FILIA EDUARDI REG[is] PORTUGALI FRID[erici] III IMPER[atoris] UXOR [Eleanor, daughter of Edward, King of Portugal, and wife of Emperor Frederick III].
Reverse: A rose. Inscription: UT ROSA FLORES SPLENDORE CORUSCO PRÆFULGET / SIC LEONORA VIRTUTUM AMATO CHORO PRÆSTAT [As a rose surpasses in brilliance the other flowers by her vibrant radiance, so Eleanor excels in the choir of virtues, which she loves].
Literature: Köhler 1729–50, 1: 1729, 89–90; Bernhart 1921–22, no. 7; Klein 1976, no. B7; Winter (Heinz) 2011, no. 7; Steguweit 2017, no. 3.

This medal refers to the marriage of the Portuguese infanta and Frederick III of Hapsburg (1415–1493), celebrated in 1452. Its obverse, however, is based either on a gold sovereign of 1553 portraying Mary Tudor or on its reproduction in Luckius (1620, 165). Therefore, the medal must be considered a restitution. For further details on the group of the so called "Prager Judenmedaillen," to which this type belongs, see the commentary for no. 433. wac

438

Unknown artist
ELEANOR OF AVIZ, HOLY ROMAN EMPRESS (1434–1467)
17th century (?)
Copper alloy, cast; 50.1 mm
Scher Collection

438

439

439

Unknown artist

ANSELM FRANZ VON INGELHEIM (b. 1634; Archbishop of
Mainz 1679–95)

Dated 1686

Silver, cast; 74.1 mm

Scher Collection

Obverse: Anselm with ermine mantle; below, his coat of arms
crowned by the electoral hat and a processional cross; the shield
is flanked by palm branches, a crozier on the viewer's right and a
sword on the viewer's left. Inscription: ANSELM[us] FRANC[us] D[ei]
G[ratia] ARCHIEP[iscopus] MOG[untinus] S[acri] R[omani] I[mperii] P[rimas]
GERM[aniæ] ARCHIC[ancellarius] PRIN[ceps] ELECTOR [Anselm Franz, by
the grace of God, archbishop of Mainz, Primate of the Holy Roman
Empire, Arch-Chancellor of Germany, and Prince Elector].

Reverse: Crowned imperial eagle with scepter, sword, and the coat
of arms of Austria on its breast and the arms of the eight electors on
its wings. Inscriptions: SUNT NOSTRI PARS CORPORIS IPSI A[ureæ] B[ullæ]
Tit[ulus] 24 [They are part of our body, Golden Bull, article 24]; in the
field at the bottom, 1686.

Literature: *Münzsammlung des . . . Johann Michael von Stubenrauch*
1803, no. 54; Leberecht sale 1833–35, 2: no. 7017 (var.).

The motto on the reverse is a quote from the Golden Bull (1356),
the constitutional act that codified the governance of the Holy
Roman Empire. Article 24 punished felonies against the electors and
described them as "part of the body" of the imperial person (*Bulla
aurea* 1660, 67). The medal can be traced back to the Imperial Diet
held in Regensburg in 1686, which Anselm chaired in his capacity as
arch-chancellor of Germany. wac

440

Johann Georg Seidlitz (act. from 1699)

JOSEPH I OF HAPSBURG, HOLY ROMAN EMPEROR
(b. 1678; r. 1705–11)

1699

Silver, struck; 58.5 mm

The Frick Collection; Gift of Stephen K. and Janie Woo Scher, 2016
(2016.2.110)

Obverse: Bust in cuirass, peruke, sash, and collar of the Order of
the Golden Fleece. Inscription: IOSEPHUS I D[ei] G[ratia] ROM[anorum]
GER[maniæ] HUNG[ariæ] ETC[etera] REX ARCH[idux] AUST[riæ] [Joseph I,
by the grace of God, King of the Romans, Germany, Hungary, et
cetera, Archduke of Austria].

Reverse: Two burning hearts with mingled flames, flanked by a pair

440

441

442

of wings above a globe showing the Holy Roman Empire. Inscriptions: JVNXIT AMOR [Love joined them]; on the hearts, J[oseph] A[malie].
Literature: Domanig 1896, no. 228; Forrer 1904–30, 5: 467.

This medal celebrates Joseph I's marriage to Wilhelmina Amalia of Brunswick-Lüneburg (1673–1742) in 1699. WaC

441
Christian Wermuth (1661–1739)
SATIRICAL MEDAL ON THE ACTIVITY OF THE IMPERIAL COMMISSION IN HAMBURG
ca. 1708; certainly before 1714
Silver, struck; 26 mm
Scher Collection

Obverse: Hand offering six coins. Inscription: KOMSTU MIR ALSO [If you really come to me this way . . . (namely, if you are ready to pay for a favor)].
Reverse: Open hand blinding the sight of an officer. Inscription: SO KOMME ICH DIR SO [. . . then I come to you this way (that is, ready to close an eye)].
Literature: Wermuth 1714, 6, no. 7; Gaedechens 1850–76, 2: no. 25; Wohlfahrt 1992, no. 55.100 (var.); Ruffert 2009, no. 7086.

This medal makes fun of the corruption of the imperial commission sent to Hamburg in 1708 to quell a conflict between the city council and the community. A variant of this type is mentioned in the catalogue of his oeuvre that Christian Wermuth published in 1714 (unfortunately, without declaring the occasion for which its dies were originally engraved). It is therefore possible that this type was also struck by Wermuth, his workshop, or his descendants. WaC

442
Georg Wilhelm Vestner (1677–1740)
CHARLES VI OF HAPSBURG, HOLY ROMAN EMPEROR
(b. 1635; r. 1711–40)
Dated 1711
Silver, struck; 37.7 mm
Scher Collection

Obverse: Charles wearing a mantle and Imperial crown. Inscription: CAROLVS VI ROMANORVM IMPERATOR [Charles VI, Emperor of the Romans].
Reverse: The earth with southwestern Europe, northern Africa, and their main rivers. Inscriptions: CONSTANTIA ET FORTITVDINE [With perseverance and fortitude]; in exergue, CORONAT[us] FRANCOF[orti] / MDCCXI [crowned in Frankfurt, 1711].

Literature: Van Loon 1732–37, 5: 198, no. 2; Lochner 1737–44, *Vorrede* n.d., no. 2; Will 1764–67, 1: 128, no. 4; Forrer 1979–80, 6: 254.

The regalia on the obverse and the inscription on the reverse refer to Charles's coronation as Holy Roman Emperor in Frankfurt am Main (December 22, 1711). WaC

443
Georg Wilhelm Vestner (1677–1740)
GEORGE I OF HANOVER, KING OF GREAT BRITAIN AND IRELAND (b. 1660; r. 1714–27)
Dated 1714
Silver, struck; 44.1 mm
Scher Collection; Promised gift to The Frick Collection

Obverse: George with laurel wreath and peruke. Inscriptions: GEORG[ius] LVD[ovicus] D[ei] G[ratia] M[agnæ] BRIT[anniæ] FR[anciæ] ET HIB[erniæ] REX DVX B[runsvicensis] & L[uneburgensis] S[acri] R[omani] I[mperii] ELEC[tor] [George Louis, by the grace of God, King of Great Britain, France, and Ireland, Duke of Brunswick and Lüneburg, Elector of the Holy Roman Empire]; a star, the mark of Georg Wilhelm Vestner, under the bust.
Reverse: A Hanoverian horse leaping from Hanover to Britain in a cartographic depiction of northwestern Europe. Inscriptions: ACCEDENS DIGNVS DIVISOS ORBE BRITANNOS [hexameter: Deservedly reaching the British people, who are separated from the world; chronogram, 1714; the hemistich "divisos orbe Britannos" is a quote from Virgil's *Bucolics*, Ecl. I.67]; in exergue, VNVS NON SVFFICIT / ORBIS [one world (that is, the European continent) is not sufficient].
Literature: Van Mieris 1732–35, 2: 422, no. 5; Lochner 1737–44, 145–46; Hawkins 1885, 2: 422, no. 5; Murdoch sale 1904, 2: no. 503; Eimer 2010, no. 465.

This medal was issued to celebrate the accession of George I as King of Great Britain and Ireland. WaC

443

444

444

Franz Andreas Schega (1711–1787)
MAXIMILIAN III JOSEPH (1727–1777) and **MARIA ANNA SOPHIA OF SAXONY** (1728–1797)
Dated 1747
Silver, struck; 41.5 mm
Scher Collection; Promised gift to The Frick Collection

Obverse: Maximilian wearing a wig and cuirass with the sash and star of the Order of the Black Eagle; Maria Anna wearing a low bodice. Inscriptions: D[ei] G[ratia] MAX[imilianus] IOS[ephus] U[triusque] B[avariæ] & P[alatinatus] S[uperioris] D[ux] C[omes] P[alatinus] R[heni] S[acri] R[omani] I[mperii] A[rchidapifer] & ELL[ector] & M[aria] AN[na] R[egia] P[rincipissa] P[olonia] & S[axoniæ] [By the grace of God, Maximilian Joseph, Duke of Bavaria and the Upper Palatine, Count Palatine of the Rhine, Arch-Steward and Elector of the Holy Roman Empire, and Queen Maria Anna, royal princess of Poland and Saxony]; below bust, F[ranz] A[ndreas] SCHEGA F[ecit] [Franz Andreas Schega made it].
Reverse: Sun rising left over landscape with castle and two rainbows. Inscriptions: DESIGNANT AMBO SERENUM [Both represent the serene]; in exergue, in three lines, BAVARIA DUPLICI CON=NUBIO FELIX / MDCCXLVII [Bavaria happy with the double union, 1747]; above exergue to left, FAS [artist's initials].
Literature: Merseburger sale 1894, no. 1842; Grotemeyer 1971, no. 19.

This medal was made to commemorate the marriage of Maximilian III Joseph, Prince Elector of the Holy Roman Empire and Duke of Bavaria from 1745 until his death, and Maria Anna Sophia, daughter of King Augustus III of Poland. AF

445

Franz Andreas Schega (1711–1787)
MAXIMILIAN III JOSEPH (1727–1777) and **MARIA ANNA SOPHIA OF SAXONY** (1728–1797)
ca. 1747
Silver, struck; 61.9 mm
Scher Collection; Promised gift to The Frick Collection

Obverse: Maximilian with clubbed hair and cuirass with the sash and cross pendant of the Order of the Black Eagle, and the Order of the Golden Fleece. Inscriptions: D[ei] G[ratia] MAXIMILIANUS IOSEPHUS ELECTOR BAVARIAE [By the grace of God, Maximilian Joseph, Elector of Bavaria]; below, F[ranz] A[ndreas] SCHEGA F[ecit] [Franz Andreas Schega made it].
Reverse: Maria Anna wearing earrings, strands of pearls woven throughout her hair, and a bodice with a sash and the star of an order, possibly the Order of the Starry Cross or the Order of the Black Eagle, pinned on her breast. Inscriptions: D[ei] G[ratia] MARIA ANNA ELECTR[ix] BAV[ariæ] NATA REG[ia] PR[incipissa] POL[oniæ] ET SAX[oniæ] [By the grace of God, Maria Anna, Electress of Bavaria, born royal princess of Poland and Saxony]; below bust, F[ranz] A[ndreas] SCHEGA F[ecit] [Franz Andreas Schega made it].
Literature: Merseburger sale 1894, no. 1840.

Same as no. 444. AF

446

Franz Andreas Schega (1711–1787)
MAXIMILIAN III JOSEPH (1727–1777) and **MARIA ANNA SOPHIA OF SAXONY** (1728–1797)
Dated 1747
Silver, struck; 34.5 mm
The Frick Collection; Gift of Stephen K. and Janie Woo Scher, 2016 (2016.2.215)

Obverse: Jugate busts of Maximilian and Maria Anna, the former with long wig, wearing a commander's sash with the star of an order and the collar of the Golden Fleece, the latter wearing a diadem. Inscriptions: D[ei] G[ratia] MAX[imilianus] IOS[ephus] U[triusque] B[avariæ] & P[alatinatus] S[uperioris] D[ux] [C(omes) P(alatinus)] R[heni]

445

446

447

S[acri] R[omani] I[mperii] A[rchidapifer] & ELL[ector] & MAR[ia] AN[na] R[egia] P[rincipissa] P[oloniæ] & S[axoniæ] [Maximilian Joseph, by the grace of God, Duke of Bavaria and Upper Palatine, Count Palatine of the Rhine, Arch-Steward and Elector of the Holy Roman Empire, and Maria Anna, royal princess of Poland and Saxony]; below truncation, FAS [artist's initials].

Reverse: Kneeling woman, wearing an ermine mantle, looking up toward a radiant triangle probably containing the eye of God in front of a pyramid. Inscriptions: BENEDICAT VOS OMNIPOTENS BENEDICTIONIBUS CŒLI DESUPER $_{GEN}$ C $_{49}$ V $_{25}$ [And by the Almighty who shall bless you with blessings from heaven above. Genesis 49:25]; on stele, in nine lines, DA / VIVAT / BAVARIA / IVNCTA / SAXONIAE / ITA / PRECAMVR /STATVS / BOIARIAE [Allow Bavaria to live next to Saxony. So we beg for the states of Bavaria; chronogram, 1747]; in exergue, SCHEGA F[ecit] [Schega made it].

Literature: Merseburger sale 1894, 1842; Grotemeyer 1971, no. 19.

This medal commemorates the marriage of Maximilian III Joseph, Elector of Bavaria, to Maria Anna Sophia of Saxony in 1747. A progressive and enlightened ruler, Maximilian was also a supporter of the arts and one of Mozart's (1756–1791) patrons. He fought in the War of the Austrian Succession (1740–48) and the Seven Years' War (1754–63). The inscription on the stele is a chronogram for the date of the medal. Maria Anna was the daughter of King Augustus III of Poland. AF

447

Franz Andreas Schega (1711–1787)
FRIEDRICH CHRISTIAN VON SAXONY (1722–1763)
Dated 1763
Silver, struck; 61.5 mm
The Frick Collection; Gift of Stephen K. and Janie Woo Scher, 2016 (2016.2.83)

Obverse: Friedrich Christian wearing a wig, ermine stole clasped at the front with gem brooch, and sash with the cross of the Order of the Black Eagle. Inscriptions: FRIDERIC[us] CHRIST[ianus] D[ei] G[ratia] PR[inceps] REG[ius] POL[oniæ] & LITH[uaniæ] DUX SAX[oniæ] & EL[ector] [Friedrich Christian, by the grace of God, Prince of Poland and Lithuania, Duke and Elector of Saxony]; on truncation, F[ranz]

A[ndreas] SCHEGA F[ecit] [Franz Andreas Schega made it].

Reverse: A Roman tempietto surmounted by an eagle and surrounded by clouds; inside, a winged Victory carries a palm frond and crowns an all'antica bust of Augustus III with a ring of seven stars. Inscriptions: PIIS MANIBUS AUG[usti] III MAGNANIMI [To the blessed remains of Augustus III the Magnanimous]; in exergue, OBIIT V OCTOBRIS / MDCCLXIII [died 5 October 1763].

Literature: Grotemeyer 1971, no. 78.

This medal may have been commissioned by Friedrich Christian on the occasion of the death of his father, Augustus III, King of Poland (1696–1763). Augustus died on October 5, 1763, and Friedrich Christian succeeded him but died of smallpox on December 17, 1763, thus bearing the title for only seventy-four days. AF

448

Franz Andreas Schega (1711–1787)
MARIA JOSEPHA VON BAYERN (1739–1767)
Dated 1765
Silver, struck; 45.9 mm
Scher Collection

Obverse: Maria Josepha wearing a diadem, earrings, strands of pearls woven throughout her hair, bodice, and ermine stole closed at the shoulder by a brooch. Inscriptions: IOSEPHA ROM[anorum] REGINA [Josepha, Queen of the Romans]; below bust, F[ranz] A[ndreas] SCHEGA F[ecit] [Franz Andreas Schega made it].

448

449

450

Reverse: Winged Victory, center, holding a torch and laurel crown with the left hand and with the right hand placing arms of Bavaria on a pyramidal monument on which hang the arms of Austria impaling Lorraine, entwined with flowered garlands. Inscriptions: CONNUBIUM AUGUSTUM [August marriage]; in exergue, in five lines, CÆSARIS FILIA CÆSARIS FILIO / ROM[anorum] REGI IVNCTA / FRATRE PROCVRATORE / MONACHII D[ie] 13 IAN[uarii] / 1765 [The daughter of the Caesar is joined to the son of Caesar, King of the Romans, with her brother as proxy, in Munich on the 13th day of January 1765].
Literature: Beierlein 1897–1901, pt. 2, 335, no. 2245.

This medal commemorates the marriage by proxy of Maria Josepha, Princess of Bavaria and Bohemia, to Joseph (later that year, Emperor Joseph II) of Austria. She died two years later of smallpox. AF

449

Anton Franz Widemann (1724–1792)
GERHARD VON SWIETEN (1700–1772)
Dated 1756
Silver, struck; 49.1 mm
Scher Collection; Promised gift to The Frick Collection

Obverse: Von Swieten wearing a wig, jacket, cape, and cravat. Inscriptions: GER[hardus] L[iber] B[aro] V[on] SWIETEN S[acræ] C[aesareæ] R[omanæ] M[aiestatis] A[postolicæ] CON[silarius] ARCH[iducissæ] CO[mes] BIB[liothecæ] PR[aefectus] [Gerhard, free Baron of Swieten, councilor of his Holy and Apostolic Caesarean Roman majesty, companion of the archduchess, prefect of the library]; below truncation, A[nton] WIDE[mann] 1756.
Reverse: Apollo seated, beneath a laurel tree, with open book on knee and staff of Asclepius in left hand; beside him, a lyre; in front, a chemical furnace; behind him, a pedestal with a vase containing an aloe plant and prickly pear. Inscriptions: DOCET ET SANAT [He teaches and he heals]; in exergue, in two lines, MED[icus] VIENN[am] / EMEND[at] [The doctor restores/heals Vienna].
Literature: Horsky sale 1910, no. 7677; *Münzen und Medaillen . . . Heldenzeitalters* 1987, 486–87, no. 550.

Beginning in 1745, Gerhard von Swieten, who was born in Leiden, was both personal physician and librarian to Empress Maria Theresia. AF

450

Anton Franz Widemann (1724–1792)
ARCHDUKE JOSEPH II (1741–1790) and **ISABELLA OF BOURBON-PARMA** (1741–1763)
Dated 1760
Silver, struck; 38.9 mm
Scher Collection; Promised gift to The Frick Collection

Obverse: Joseph, wearing clubbed hair and pendant with Order of the Golden Fleece, and Isabella, with veil and brocaded dress with pearls. Inscriptions: IOSEPH[us] A[rchidux] A[ustriæ] ELISAB[etta] BOVRB[ona] PHILIP[pi] HISP[aniæ] INF[antis] FILIA [Joseph, Archduke of Austria (and) Isabella Bourbon, daughter of Philip, Prince of Spain]; below truncation, A[nton] WIDEMAN.
Reverse: Hymen, the god of weddings, standing to the right of the altar making a sacrifice with the left hand and holding up entwined laurel crowns with the right hand. Inscriptions: FELIX CONNVBIVM [Happy Marriage]; in exergue, in two lines, CELEBRAT[us] VINDOB[anæ] / VI OCT MDCCLX [Celebrated at Vienna 6 October 1760].
Literature: Montenuovo sale 1885, no. 3115; Winter (Heinz) 2009, no. 113.

This medal commemorates the wedding of Archduke Joseph II, heir to the Hapsburg monarchy, and Isabella of Bourbon-Parma, daughter of Prince Philip, Duke of Parma. The marriage was initially arranged by proxy until October 6, 1760, when, at the age of eighteen, she traveled to Austria for the official ceremony. AF

451

Anton Franz Widemann (1724–1792)
ARCHDUKE FERDINAND KARL OF AUSTRIA-ESTE (1754–1806)
ca. 1760
Silver, struck; 45 mm
The Frick Collection; Gift of Stephen K. and Janie Woo Scher, 2016 (2016.2.96)

Obverse inscriptions: FERDINANDVS ARCHID[ux] AVSTR[iæ] [Ferdinand, Archduke of Austria]; below truncation, A[nton] WIDEMAN.
Reverse: Sword entwined with laurel upon an open book resting upon a globe; above, Eye of Providence, set in a radiant triangle amid clouds. Inscription: PRO FIDE ET LEGE [For Faith and Law].

451

Literature: Julius sale 1932, no. 2544; *Münzen und Medaillen . . . Heldenzeitalters* 1987, 274, no. 384. Winter (Heinz) 2009, no. 107.

Archduke Ferdinand Karl was the son of Holy Roman Emperor Francis I and Maria Theresia of Austria. This medal may have been made in 1761, or slightly later, to establish Ferdinand Karl as a worthy heir to the duchy of Modena after his older brother Peter Leopold (1747–1792) became heir to the grand duchy of Tuscany. AF, SKS

452

Anton Franz Widemann (1724–1792)
FRANCIS I (1708–1765) and **MARIA THERESIA OF HAPSBURG, HOLY ROMAN EMPRESS** (b. 1717; r. 1745–80)
Dated 1763
Silver, struck; 46.3 mm
Scher Collection; Promised gift to The Frick Collection

Obverse: Francis in armor and fur-lined cloak with the Order of the Golden Fleece; Maria Theresia wearing a diadem and brocaded bodice with pearls. Inscriptions: FRANCISCVS M[aria] THERESIA AVGG[usti] [August Francis and Maria Theresia]; below truncation, A[nton] WIDEMAN.
Reverse: Minerva standing to the right of the altar and holding a cornucopia with the left arm offers the caduceus of Hermes to the altar, from which depend the arms of Austria, shield and spear at her feet. Inscriptions: MINERVAE PACIFICAE [To the peaceful Minerva]; in exergue, in two lines, DIE XV FEBR[uarii] / MDCCLXIII [On the 15th day of February 1763].

Literature: *Münzen und Medaillen . . . Heldenzeitalters* 1987, 408–9, no. 496; Winter (Heinz) 2009, no. 92a; Haag 2017–18, 18–19.

This medal commemorates the Peace of Hubertusburg, signed on February 15, 1763, which, along with the Treaty of Paris, marked the end of the Seven Years' War (1756–63). AF

453

Anton Franz Widemann (1724–1792)
FRANCIS I (1708–1765), **MARIA THERESIA OF HAPSBURG, HOLY ROMAN EMPRESS** (b. 1717; r. 1745–80), **JOSEPH II** (1741–1790) and **MARIA JOSEPHA** (1751–1767)
Dated 1765
Silver, struck; 46.8 mm
Scher Collection; Promised gift to The Frick Collection

Obverse: Francis I (laureate, in armor and fur-lined cloak with the Order of the Golden Fleece), Maria Theresia (draped), Joseph II (laureate, in armor with the Order of the Golden Fleece), and Maria Josepha. Inscriptions: FRANCISC[us] I M[aria] THERES[ia] IOSEP[hus] II M[aria] IOSEPHA AVGGGG[usti] [The august Francis I, Maria Theresia, Joseph II and Maria Josepha]; below truncation, A[nton] WIDEMAN.
Reverse: Triple-bayed triumphal arch with roundel portraits of Francis I, Maria Theresia, Leopold and Maria Josepha, surmounted by an imperial double-headed eagle flanked by seated statues of Piety and Justice; in the background, an urban scene. Inscriptions: ADVENTVS AVG GGG[ustorum] OENIPONTVM [The arrival of the most noble ones to Innsbruck]; in exergue, in three lines, D[ie] XVIVL MDCCLXV / AD NVPT[um] LEOP[oldi] A[rchiduci] A[ustriæ] / CELEBRAND[um] [on July 15, 1765, to celebrate the wedding of Leopold, Archduke of Austria].
Literature: Montenuovo sale 1885, no. 1942; Beierlein 1897–1901, pt. 2, no. 2253; Julius sale 1932, no. 1899; *Münzen und Medaillen . . . Heldenzeitalters* 1987, 500–501, no. 560; Winter (Heinz) 2009, no. 95; Haag 2017–18, 18, 20.

This medal, the last medal issued for Francis I during his lifetime, commemorates the arrival of the imperial couple to Innsbruck for the marriage of Archduke Leopold and Maria Josepha of Spain. Francis died three days after his arrival in Innsbruck. AF

452

453

454

455

454

Anton Franz Widemann (1724–1792)

ARCHDUCHESS MARIA ANNA OF AUSTRIA (1738–1789)

Dated 1766

Silver, struck; 42.9 mm

The Frick Collection; Gift of Stephen K. and Janie Woo Scher, 2016 (2016.2.95)

Obverse: Maria Anna facing right, wearing a cloak with fur collar on which is pinned the medal of an order, probably the Order of the Starry Cross. Inscriptions: M[aria] ANNA AVSTRIACA [Maria Anna of Austria]; below truncation, A[nton] WIDEMAN.

Reverse: The Imperial and Royal Convent for Noble Ladies in Prague. Inscriptions: REG[ium] COLLEG[ium] PRAG[ensis] A MAR[ia] THER[esia] AVG[usta] CONDITI [sic] [The royal college founded in Prague by the august Maria Theresia]; in exergue, in three lines, PRIMA ANTISTES / INAVGVRATA / II FEB[ruarii] MDCCLXVI [Consecrated first abbess, 2 February 1766].

Literature: *Münzen und Medaillen . . . Heldenzeitalters* 1987, 266, no. 375; Haag 2017–18, 24.

Archduchess Maria Anna of Austria was the eldest surviving daughter of Maria Theresia and Francis I. In 1766, she was made abbess of the Imperial and Royal Convent for Noble Ladies in Prague with a promise of 80,000 florins annually, which this medal commemorates. AF

455

Anton Franz Widemann (1724–1792)

MARIA THERESIA OF HAPSBURG, HOLY ROMAN EMPRESS (b. 1717; r. 1745–80)

Dated 1767

Silver, struck; 46.9 mm

The Frick Collection; Gift of Stephen K. and Janie Woo Scher, 2016 (2016.2.94)

Obverse inscriptions: M[aria] THERESIA D[ei] G[ratia] ROM[ana] IMP[eratrix] GER[maniæ] HUNG[ariæ] & BOH[emiæ] RE[gina] A[rchiducissa] A[ustriæ] [Maria Theresia, by the grace of God, Roman Empress, Queen of Germany, Hungary and Bohemia, Archduchess of Austria]; below truncation, A[nton] WIDEMAN.

Reverse: Kneeling figure at right swinging a smoking censor before an altar. Inscriptions: DEO CONSERVATORI AUGUSTAE [To God, protector of the empress]; on lower border of altar, A[nton]

W[ideman]; in exergue, in three lines, OB REDDITAM PATRIÆ / MATREM 22 IVLII / MDCCLXVII [For the mother's return to her country, 22 July 1767].

Literature: Montenuovo sale 1885, no. 1976; Probszt 1964, pl. CXCVII; Flaten 2012, no. 287; Haag 2017–18, 47–48.

Maria Theresia, the daughter of Emperor Charles VI, married Francis Stephen, Duke of Lorraine. This medal commemorates Maria Theresia's recovery from smallpox in 1767. AF

456

Anton Franz Widemann (1724–1792) and Peter Kaiserswerth (act. 1765–93)

ARCHDUCHESS MARIA AMALIA (1746–1804)

Dated 1769

Silver, struck; 43.1 mm

The Frick Collection; Gift of Stephen K. and Janie Woo Scher, 2016 (2016.2.93)

Obverse inscriptions: M[aria] AMALIA AVSTR[iæ] FERDINANDO BORBON[io] PARM[æ] DVCI NVPTA [Maria Amalia of Austria, married to Duke Ferdinand Bourbon-Parma]; below truncation, A[nton] WIDEMAN.

Reverse: Hymen, the god of marriage, with a torch approaches a palm tree from the left with the shields of the Hapsburg-Lothringen (Lorraine) and Spain/Bourbon-Parma; to the right, a reclining river god with an oar, resting his left arm on an overturned urn with the inscription PADVS on the rim, representing the Po river. Inscriptions: FELICI NEXV [To the happy bond]; in exergue, in four lines, NVPTIÆ CELEBRATÆ VINDOB[anæ] / PROCVRATORE FERDINANDO / ARCH[iduce] AVST[riæ] XXVII IUNII / MDCCLXIX [For the marriage celebrated at Vienna by proxy [to] Ferdinand, Archduke of Austria, 27 June 1769]; on the ground to the left, the initials P[eter] K[aiserwerth].

456

Literature: Montenuovo sale 1885, no. 1998, 215; Julius sale 1932, no. 2585; *Münzen und Medaillen . . . Heldenzeitalters* 1987, 270, no. 379; Horsky sale 1910, no. 3304.

This medal commemorates the marriage of Archduchess Maria Amalia of Austria, fourth daughter of Empress Maria Theresia, to Ferdinand of Bourbon, Duke of Parma. As a grandson of King Philip V of Spain, Ferdinand was also *infante* of Spain; hence the Spanish arms on the reverse. AF

457

Anton Franz Widemann (1724–1792) and Peter Kaiserswerth (act. 1765–93)
MARIE ANTOINETTE (1755–1793)
Dated 1770
Silver, struck; 43.8 mm
Scher Collection

Obverse: Marie Antoinette facing right, wearing a fur-lined cloak tied at the bust with a brooch. Inscriptions: M[aria] ANTONIA ARC[hiducissa] AVST[riæ] LUDOVIC[o] FRANCIÆ DELPHIN[o] SPONSA [Marie Antoinette, Archduchess of Austria, betrothed to Louis, Dauphin of France]; below truncation, A[nton] WIDEMAN.
Reverse: Flaming altar at center; to the right, Abundance facing left, cradling two cornucopias in her left arm and pouring an offering with her right; to the left, Hymen, the god of marriage, holding aloft two laurel crowns with his left hand and offering a flaming torch to the altar with his right. Inscriptions: CONCORDIA NOVO SANGVINIS NEXV FIRMATA [Harmony strengthened by a new tie of blood]; in exergue, NVPT[us] CELEBR[atus] VIEN[næ] PROCVR[atore] / FERDINAND[o] A[rchiduci] A[ustriæ] XIX APR[ilis] / MDCCLXX [Marriage celebrated at Vienna with Ferdinand, Archduke of Austria, acting as proxy, 19 April 1770]; on the ground to the left of the altar, K[aiserswerth].
Literature: *Münzen und Medaillen . . . Heldenzeitalters* 1987, 274, no. 385; Haag 2017–18, 24–25.

This medal was made to commemorate the marriage of Marie Antoinette—fifteenth child of Francis I, Holy Roman Emperor, and Empress Maria Theresia—to Louis, Dauphin of France. Four years later, Louis ascended the throne as Louis XVI, King of France, and she became Queen of France and Navarre. Both were guillotined in 1793 during the Reign of Terror. AF

458

Anton Franz Widemann (1724–1792)
FERENC, COUNT ZICHY (b. 1700)
Dated 1774
Silver, cast; 46.8 mm
Scher Collection; Promised gift to The Frick Collection

Obverse: Ferenc with pectoral cross and collar of the Royal Order of St. Stephen; the rings of the collar represent the Hungarian Crown of St. Stephen and the monograms "M[aria] T[heresia]" and "S[anctus] S[tephanus]," the founder and the patron of the order, respectively. Inscriptions: FRANC[iscus] COMES ZICHY EPISC[opus] IAVRIN[ensis] [Ferenc, Count Zichy, bishop of Győr/Raab]; on truncation, A[nton] WIDEMAN.
Reverse: A table with loaves of bread and a ewer. Inscriptions: PRIMITIAE SECVNDAE [Primices (best-quality fruits) that bring favor]; in exergue, IAVRINI XV AVG[usti] / MDCCLXXIV [in Győr/Raab, 15 August 1774].
Literature: Traunfellner sale 1841, no. 543; Horsky sale 1910, no. 4819; Nudelman 2013, no. 363.

This medal celebrates the re-consecration on August 15, 1774, of the Cathedral of Our Lady of Győr/Raab in Hungary, a building that Ferenc Zichy, bishop of Győr/Raab, had extensively renovated and richly refurbished in the previous years. On the same day, he also received from Empress Maria Theresia of Hapsburg the collar of the Royal Order of St. Stephen depicted here (*Syllabus* 1822, 89). WAC

459

Georg Hautsch (1664–ca. 1745)
PAUL ALBRECHT RIETER OF KORNBURG (1634–1704)
Dated 1693
Copper alloy, struck; 43.2 × 39.3 mm
Scher Collection; Promised gift to The Frick Collection

Obverse: Paul Albrecht Rieter wearing armor and a large cravat. Inscriptions: PAVL ALBRECHT RIETER A KORNBVRG A[nno] 1693 [Paul Albrecht Rieter of Kornburg, 1693]; to the right, below truncation, G[eorg] HAVTSCH.
Reverse: Above a view of the walled city of Kornburg, the Rieter arms. Inscription: CONTEMNIT TV=TA PROCELLAS [Secure, she defies storms].
Literature: Will 1764–67, 3: 368; Imhof 1780–82, 2: 653; Löbbecke sale 1908, no. 635; Sonntag 1989, no. 1835.

459

In 1659, Paul Albrecht Rieter of Kornburg was Bürgermeister and Councilor of Nuremberg. The reverse inscription derives from Paulo Giovio's *Dialogo dell'Imprese militari et amorose* (1574). AF, SKS

460

Georg Hautsch (1664–ca. 1745)
PRINCE EUGENE OF SAVOY (1663–1736)
Dated 1704
Silver, struck; 37.1 mm
Scher Collection; Promised gift to The Frick Collection

Obverse: Eugene wearing a wig, armor, lace cravat, and Order of the Golden Fleece. Inscriptions: EVGENIVS FRANC[iscus] DVX SAB[audiæ] CÆS[arei] EXER[citus] GENER[alis] COMM[endans] [Eugene Francis, Duke of Savoy, commander general of the Imperial army]; on truncation, six-pointed star [artist's mark].
Reverse: An angel with flaming sword vanquishing the army of Sennacherib amid tents. Inscriptions: GENII VIRTVTE BONI II REG 19 [By virtue of the good angel: II Kings 19]; in exergue, GALLIS BAVARISQ[ue] CÆSIS / TALLARDO CUM X MILI / AD HOCHSTAD CAPT[o] / 1704 [The French and the Bavarians slain, Tallard with 10,000 (soldiers) taken at Hochstädt, 1704].
Edge inscription: GLORIA AD TIBISCVM HVNGARIÆ PARTA, RENOVATVR AD DANVBIVM GERMANIÆ [The glory, acquired on the Theiss in Hungary, is renewed on the Danube in Germany].
Literature: Hawkins 1885, 2: 258–59, no. 53; *Garrett Collection* 1985, no. 1241.

This medal commemorates the victory at Blenheim, also called the Battle of Hochstädt, in the War of the Spanish Succession (1701–14). The edge inscription refers to the victory over the Turks at Zenta in 1697. AF, SKS

461

Georg Hautsch (1664–ca. 1745)
JOHN CHURCHILL, DUKE OF MARLBOROUGH
(1650–1722)
Dated 1704
Silver, struck; 37.1 mm
Scher Collection; Promised gift to The Frick Collection

Obverse: Churchill wearing a wig, armor, and commander's sash. Inscriptions: IOH[annes] D[ux] MARLEBVRG ANG[liæ] EXER[citus] CAPIT[aneus] GENER[alis] [John, Duke of Marlborough, commander in chief of the English army]; below truncation, H[autsch] [artist's mark].
Reverse: Mars seated to the right, leaning on a shield, directing a soldier who is vanquishing his enemies. Inscriptions: MIRATVR TELIS AEMVLA TELA SVIS [He marvels at the weapons that rival his own]; in exergue, in four lines, OB GALLOS ET BAVAROS / DEVICTOS TALLARDO / DVC AD HOCHSTAD / CAPTO 1704 [On the defeat of the French and Bavarians, Tallard, their general, having been captured at Hochstädt, 1704); in shield, MARS VLTOR [Mars the Avenger].
Edge inscription: FORTVNÆ OBSEQVENTI DVCIS FORTISSIMI POST PRIMITIAS SCHELLENBERGICAS [To Fortune, obedient to the most valiant General after the first fruits of Schellenberg].
Literature: Hawkins 1885, 2: 256–57, no. 50.

The title Duke of Marlborough was created by Queen Anne in 1702 for John Churchill. This medal commemorates Churchill's victory at Blenheim, also called the Battle of Hochstädt, in the War of the Spanish Succession (1701–14). AF

462

Georg Hautsch (1664–ca. 1745)
JOHN CHURCHILL, DUKE OF MARLBOROUGH
(1650–1722)
Dated 1706
Silver, struck; 37.2 mm
The Frick Collection; Gift of Stephen K. and Janie Woo Scher, 2016 (2016.2.103)

Obverse: John Churchill in armor with peruke and collar of the Order of the Garter. Inscriptions: IOH[annes] D[ei] G[ratia] S[acri] R[omani] I[mperii] PR[imas] D[ux] MARL[eburgensis] EXERC[itus] ANGL[ici] C[apitanus] G[eneralis] [John, by the grace of God, Primate of the Holy Roman Empire, Duke of Marlborough, General of the English army]; under the bust, a six-pointed star [artist's mark].
Reverse: Mars carrying war trophies and holding shields with the coats of arms of Brabant, Flanders, and Antwerp; on the ground,

460

461

462

defeated soldiers. Inscription: PRETIVM NON VILE LABORVM [Non-worthless prize of his labors]; in exergue, GALLIS ACIE DEVICTIS BRA / BANTIA FLANDR[iæ] ET ANT / WERP XV DIER[um] SP[atio] / EREPT[æ] 1706 [After routing the French troops in the open battlefield, he seized Brabant, Flanders, and Antwerp from Spanish control in the space of 15 days, 1706]; on the edge, MARTE FEROX ET VINCI NESCIVS ARMIS VIRG[ilius?] [hexametric fragment: Fierce in war and invincible when armed, Virgil (actually Ovid, *Ex ponto* II.9.45)].
Literature: Stübel 1706, 513; Leberecht sale 1833–35, 2: no. 9761; Hawkins 1885, 2: 287, no. 95; Eimer 2010, no. 420.

In 1704, the Dutch, English, and Danish troops guided by the Duke of Marlborough defeated the allied French, Bavarian, and Spanish forces on the fields of Blenheim (1704). The medal celebrates this episode of the War of the Spanish Succession (1701–14). WaC

463

Conrad Heinrich Küchler (act. 1763–1821)
LOUIS XVI (1754–1793) and **MARIE ANTOINETTE** (1755–1793)
Dated 1793
Copper alloy, struck; 47.9 mm
The Frick Collection; Gift of Stephen K. and Janie Woo Scher, 2016 (2016.2.37)

Obverse: Jugate portraits of Louis XIV and Marie Antoinette. Inscriptions: LUD[ovicus] XVI D[ei] G[ratia] FR[anciæ] ET NAV[arræ] REX MAR[ia] ANT[onia] AUSTR[iaca] REG[ina] [Louis XVI, by the grace of God, King of France and Navarre, Queen Marie Antoinette of Austria]; on truncation, C[onrad] H[einrich] K[üchler]; below truncation, FATI INIQUI [Of unfair fate].
Reverse: Louis saying farewell to his family, his two young children, Louis Charles and Marie-Thérèse Charlotte, kneeling before him, and his wife Marie Antoinette resting her head on his arm; behind them,

a female figure weeping; in the background, a crowded Place de la Révolution (today Place de la Concorde), with the guillotine at its center. Inscriptions: on banderole, AN EST DOLOR PAR DOLORI NOSTRO [See if there be any sorrow like unto my sorrow (Lamentations 1:12)]; in exergue, in four lines, NATUS XXIII AUG[usti] MDCCLIV / SUCC[essit] X MAY [*sic* for MAII] MDCCLXXIV / DECOLL[atus] XXI JAN[uarii] / MDCCXCIII [Born 23 August 1754; succeeded 10 May 1774; decapitated 21 January 1793]; C[onrad] H[einrich] KUCHLER FEC[it] [Conrad Heinrich Küchler made it].
Literature: Hennin 1970, pl. 44, no. 163; Pollard 2007, 2: no. 931 (var.).

This medal depicting Louis XVI's farewell to his family before his execution (January 1793) was produced to commemorate his death. Struck in England at the Soho Mint, the medal was meant to exploit the popular feelings against the French Revolution. In March 1793, Conrad Heinrich Küchler came to work in England and began to produce medals related to the French Revolution for the British public, who were both fascinated and horrified by the event. ADC

464

Conrad Heinrich Küchler (act. 1763–1821)
MARIE ANTOINETTE (1755–1793)
Dated 1793
Copper, struck; 48 mm
The Frick Collection; Gift of Stephen K. and Janie Woo Scher, 2016 (2016.2.38)

Obverse: Marie Antoinette, her hair in the *toque* style and decorated with strings of pearls, lace ribbons, and a tiara, with curls framing her face and wearing tear-drop pearl earrings, a low-cut dress worn off the shoulder embroidered with tear-drop pearls, and an ermine-lined mantle with fleurs-de-lis fastened with strings of pearls. Inscriptions: MARIA ANTON[ia] AUSTR[iaca] FR[anciæ] ET NAV[arræ] REGINA [Marie Antoinette of Austria, Queen of France and Navarre]; below, NAT[a] 2 NOV[embris] 1755 NUP[ta] 16 MAY 1770 COR[onata] 11 JUN[ii] 1775 [Born on 2 November 1755; married on 16 May 1770; crowned on 11 June 1775].
Reverse: Queen Marie Antoinette being led to the guillotine, seated in a cart with hands tied behind her back as guards follow and a child with a hat in his hand dances in front of it; in the background, a crowded Place de la Révolution (today Place de la Concorde) with the guillotine at its center. Inscriptions: on banderole, ALTERA VENIT

463

464

465

VICTIMA [abbreviated for "EN ALTERA VENIT VICTIMA NOBILIOR" (*Pharsalia,* Book X, 385–86): Another (nobler) victim comes]; in exergue, in two lines, within a rope oval border, XVI OCT[obris] / MDCCXCIII [16 October 1793].
Literature: Hennin 1970, pl. 52 , no. 533; Pollard 2007, 2: no. 931 (var.).

This medal, struck in England at the Soho Mint, commemorates the execution of Marie Antoinette (see nos. 457 and 463). The reverse depiction resembles Jacques-Louis David's famous drawing, from life, of the event (Musée du Louvre, Paris). ADC

Obverse: Jugate busts of George, hair short on top and long in the back, wearing a soft lace collar and a medal suspended from a ribbon, with the star of an order on his chest, and Caroline, who wears a fanciful tiara (plumed). Inscriptions: GEORGE PRINCE OF WALES ET CAROLINE PRINC[ess]; on truncation, CHK [artist's initials].
Reverse: A pair of oak branches, crossed. Inscriptions: FROGMORE / MAY 19.TH / 1795; beneath, SOHO [Soho Mint?].
Literature: L. Brown 1980–95, 1: no. 401.

This medal was struck to commemorate George and Caroline's visit to Frogmore, a royal country retreat in the Home Park of Windsor Castle, on the birthday of Queen Charlotte, George's mother. EM

465

Conrad Heinrich Küchler (act. 1763–1821)
GEORGE, PRINCE OF WALES (b. 1762; King of the United Kingdom 1820–30) and **CAROLINE, PRINCESS OF WALES** (b. 1768; Queen of the United Kingdom 1820–21)
Dated 1795
Silver, struck; 47.9 mm
Scher Collection

466

Bernhard Perger (act. ca. 1769–98)
PRINCESS LIVIA AB AURIA CARAPHA (dates unknown)
Dated 1778
Copper alloy, struck; 73.8 mm
The Frick Collection; Gift of Stephen K. and Janie Woo Scher, 2016 (2016.2.102)

Obverse: Livia with hair styled high and draped. Inscriptions: LIVIA AB AVRIA KARAPHA S[acri] R[omani] I[mperii] ET AMPHISSIENSIVM PRINC[ipissa] [Livia Doria Carafa, princess of the Holy Roman Empire

466

and Roccella]; RAPTA IV KAL[endas] FEB[ruarias] / CIƆIƆCCLXXVIII AN[no] N[atali] XXXIIII [carried away on the 4th day to the Kalends of February 1778, in the 37th year after her birth]; on the truncation of the bust, B[ernhard] P[erger] F[ecit] [Bernhard Perger made it].

Reverse: Death represented as a veiled woman standing with her left hand on the shoulder of a seated woman, and with her right pointing to a bird in flight toward three stars and, at the top, a triangle containing the Eye of God; the seated woman dropping coins to a woman with two children and with her left arm embracing a child standing between her legs; the child (perhaps Hymen, representing conjugal love) holding small objects, possibly including two hearts; at the seated woman's feet, a lyre, a torch, and a yoke [or an unstrung bow?] (symbols of conjugal love and harmonious marriage). Inscriptions: DILEXIT [He loved]; on the side of a rock, lower right, B[ernhard] P[erger] F[ecit] [Bernhard Perger made it]; in exergue, CONIVGALIS MONVMENTVM / AMORIS [A monument of conjugal love].

Literature: Forrer 1979–80, 4: 451–52.

Livia died in childbirth at the age of thirty-four. By then, she had had several children, only two of whom survived. Her husband, the Prince of Roccella, commissioned this medal to commemorate her untimely death. The allegorical reverse is interpreted in a volume of prose and poetry written in Livia's honor, in which the three stars represent the princess's deceased daughters. The eagle refers to the family's coat of arms and symbolizes the strength with which the princess educated her children; the act of dispensing coins emphasizes her charity (Bodoni 1784–85, 234). The ancient name of Roccella Ionica, on the southern shore of the toe of Italy, was Amphissa; thus the word used in the inscription. ADC

Mathias Koegler (?)

UNIDENTIFIED MAN

Dated 1778
Alabaster; 79.2 mm
The Frick Collection; Gift of Stephen K. and Janie Woo Scher, 2016 (2016.2.214)

Obverse: Bust with gown and peruke. Inscription: on truncation of bust, KŒGLER F[ecit] 1778 [Koegler made it, 1778].
Reverse inscription: ÆTATIS 25 / 1778 [aged 25, 1778]; label, MALLETT 2.

The portraitist might be the sculptor Mathias Koegler, admitted as a member of the Academy of Fine Arts in Vienna in 1772 (Weinkopf 1875, 12, 24). His low relief with the *Good Samaritan*, once preserved in the same institution, was lost before the beginning of the twentieth century (Thieme and Becker 1907–50, 7: 115). Comparison with his statues of *Patriotism* and *Merit* (1779–1880; see Pötzl-Malíková 1969) for the facade of the Primate's Palace of Bratislava reveals interesting similarities in the form of the eyes and in the drapery (Pötzl-Malíková 2009, figs. 5, 7). Yet, the photographs on which this observation relies are not appropriate for connoisseurship, and a serious attribution to Mathias Koegler would require a re-assessment of his oeuvre. The sculpture of another eighteenth-century Viennese artist named Kögler, Tobias Kögler, on the other hand, does not offer significant elements for comparison. WaC

467

468

468

Karl Ernst Riesing (act. until ca. 1795)
FRANCIS LOUIS, BARON OF ERTHAL (b. 1730; Bishop-Prince
of Würzburg and Bamberg 1779–95)
Dated 1782
Silver, struck; 56.9 mm
Scher Collection; Promised gift to The Frick Collection

Obverse: Francis Louis with peruke, pectoral cross, and ermine
mantle. Inscriptions: FRANC[iscus] LUDOV[icus] D[ei] G[ratia] EP[iscopus]
BAMB[ergensis] ET WIRC[eburgensis] S[acri] R[omani] I[mperii] PR[imas]
FR[anconiæ] OR[ientalis] DUX [Francis Louis, by the grace of God,
bishop of Bamberg and Würzburg, Primate of the Holy Roman
Empire, Duke of Eastern Franconia]; RIESING F[ecit] [Riesing made it].
Reverse: Coats of arms of the families whose members had occupied
Würzburg's episcopal seat from 1617 to 1782 (clockwise, starting
from the sword: Egloffstein, Echter, Aschhausen, Ehrenberg,
Hatzfeld, Schönborn, Rosenbach, Dernbach, Wernau, Guttenberg,
Greifenklau-Vollraths, Schönborn, Hutten-Stolzenberg, Schönborn,
Ingelheim, Hutten-Stolzenberg, Seinsheim, and Erthal) crowned
with princely hat, sword, and crozier. Inscription: ACADEMIA /
WIRCEBURGENSIS / A IOANNE I CONDITA / A IULIO INSTAURATA / A
XV SUCCESORIB[us] AUCTA / SACRUM SÆCULARE II / IUBENTE IULII /
AB NEPOTE / IV KAL[endas] AUGUSTI / MDCCLXXXII / CELEBRAT [The
University of Würzburg, founded by Johannes I (von Egloffstein,
bishop from 1400 to 1411), re-opened by Julius (Echter von
Mespelbrunn, bishop from 1573 to 1617), enlarged by their 15
successors, celebrates its second blessed centennial under the rule
of a descendant of Julius on 28 July 1782].
Literature: Laverrenz 1885–87, 1: no. 43; K. Helmschrott and R.
Helmschrott 1977, no. 869.

This medal was issued on the second centennial of the University of
Würzburg. The representatives of other academic institutions who
attended the ceremonies for the jubilee received silver versions of
the medal, while gold specimens were reserved for the rulers of their
homelands. The families of the previous bishops of Würzburg (whose
coats of arms can be seen in the reverse) received gold examples.
WaC

469

Daniel Friedrich Loos (1735–1819)
FRIEDRICH WILHELM II OF PRUSSIA (1744–1797)
Dated 1786
Silver, struck; 42.3 mm
Scher Collection; Promised gift to The Frick Collection

Obverse: Friedrich Wilhelm facing left, with clubbed hair, armor,
ermine cape, and ribbon of an order. Inscriptions: FRIDERICUS
WILH[helmus] REX BORUSS[iæ] PATER PATRIAE [Friedrich Wilhelm,
King of Prussia, father of his country]; below truncation, LOOS.
Reverse: Minerva wearing a helmet and holding with the left arm
a spear and shield decorated with the Gorgoneion and pointing to
symbols of the arts at the base of a laurel tree. Inscriptions: ARTIBUS
UMBRAM / HOSTIBUS TERROREM [Protection for the arts; terror for the
enemies]; in exergue, in three lines, REGNUM ADEPTUS / D[ie] XVII
AUGUSTI / MDCCLXXXVI [Enthroned 17 August 1786].
Literature: Reimmann 1892, no. 8267; J. Hamburger 1908, no.
1251; Forrer 1979–80, 3: 461–65.

This medal commemorates King Friedrich Wilhelm II of Prussia's
accession to the throne in 1786. An ardent supporter of the arts,
Friedrich is remembered for the construction of the Brandenburg
Gate in Berlin. AF

469

470

470

Daniel Friedrich Loos (1735–1819)
CONJUGAL HAPPINESS
Dated 1812
Silver, struck; 41.5 mm
Scher Collection

Obverse: Two parrots sharing a branch with exotic foliage and fruit. Inscriptions: in exergue, DEIN [Yours]; to left above exergue line, LOOS.
Reverse: A serpent biting its tail. Inscriptions: AUF EWIG[keit?] [To eternity]; surrounded by, incised: V C E B [presumably the initials of Bezanson]; J J C [presumably the initials of Cabanes].
Edge inscription: BEZANSON CABANES MARIÉS LE 20 JUIN 1812 [Bezanson Cabanes married 20 June 1812].
Literature: Forrer 1979–80, 3: 463; Sommer 1981, B67.

The snake biting its tail, a symbol of eternity spanning eastern and western cultures from ancient to modern times, is known as an ouroboros. The engraved letters are probably the initials of the couple for whom the medal was intended. AF

471

Leonhard Posch? (1750–1831)
ELISABETH WILHELMINE LOUISE OF WÜRTTEMBERG
(b. Princess of Württemberg 1767; Archduchess of Austria 1788–90)
1782–85
Silver, cast, with traces of partial gilding, mounted in a frame in plaster and wood; 116.1 mm (including frame)
Scher Collection

Obverse: Elisabeth bearing a coiffure with ribbons and feathers and wearing a pendant with a male portrait (possibly her father or her future husband Francis Joseph). Inscription: ELISABETH WILHELMINE LOUISE PRINCESSE DE WURTEMBERG [Elisabeth Wilhelmine Louise, Princess of Württemberg].
Literature: UBS 2001, no. 1376; Klein and Raff 2003, no. 67 (unique piece?).

Elisabeth looks younger here than in her marriage medal of 1788 by Johann Nepomuk Wirt (Klein and Raff 1995, no. 65a). This suggests dating this portrait to shortly after her arrival in Vienna in 1782. For its pendant, see no. 472. WaC

472

Leonhard Posch? (1750–1831)
FRANCIS JOSEPH CHARLES OF HAPSBURG-LORRAINE
(b. 1768; Holy Roman Emperor 1792–1806, Emperor of Austria 1804–35)
1784–85
Silver, cast, with traces of partial gilding, mounted in a frame in plaster and wood; 116.2 mm (including frame)
Scher Collection

Obverse: Francis Joseph with clubbed hair and collar of the Order of the Golden Fleece. Inscription: FRANCOIS JOSEPH GRAND PRINCE DE TOSCANE [Francis Joseph, Grand Prince of Tuscany].
Literature: UBS 2001, no. 1376; Klein and Raff 2003, no. 67 (unique piece?).

Francis Joseph looks younger than in the medal celebrating his marriage in 1788 (Klein and Raff 1995, no. 65a), which suggests dating it to the preceding years. However, the medal should have been modeled after 1784, when Francis reached Vienna to complete his education as future successor of his uncle, Emperor Joseph II (1741–1790), and could sit for his portraitist—possibly the Tirolean sculptor Leonhard Posch, active in Vienna from 1775 to 1803 (as suggested by Klein and Raff). In 1790, after this successful test, Posch modeled a series of twenty-two plaster portraits of Leopold II's relatives, including a likeness of Francis Joseph (Historisches Museum der Stadt, Vienna). If dating and attribution are correct, this portrait and its pendant (no. 471) must be considered among the earliest medallions of this artist. WaC

473

Georg Christian Waechter (1729–ca. 1789)
VOLTAIRE (1694–1778)
Dated 1770
Copper alloy, struck; 59.1 mm
The Frick Collection; Gift of Stephen K. and Janie Woo Scher, 2016 (2016.2.30)

Obverse: Voltaire wearing a jacket, a shirt with frills, and a mantle draped on the left shoulder. Inscriptions: VOLTAIRE NÉ LE XX FEVRIER M DC XCIV [Voltaire, born 20 February 1694]; G[eorg] C[hristian] WAECHTER F[ecit] [Georg Christian Waechter made it].
Reverse: Within a border of foliage and flowers and in front of a sunburst, an altar with several objects on top: two classical theatrical masks, a lyre, a quill pen, a telescope, a laurel wreath, a trumpet, a globe, musical sheets, two books (one with the title "La Henriade"), and rose festoons. Inscriptions: on the altar, in five lines, TIRÉ / D'APRÈS NATURE / AU CHÂTEAU / DE FERNEY / G[eorg] C[hristian] WÆCHTER [Taken from life at the chateau of Ferney; Georg Christian Waechter]; in exergue, in two lines, GRAVÉ / M DCCLXX [Engraved 1770].
Literature: Forrer 1979–80, 6: 338–39; Pollard 2007, 2: no. 929.

With various arts and science emblems, the altar of fame celebrates the many aspects of Voltaire's career as writer, poet, dramatist, philosopher, and historian. One of the main protagonists of the

471

472

473

Enlightenment, Voltaire conducted an incessant campaign against tyranny and religious fanaticism. In "La Henriade," his epic poem in ten cantos published in 1723 and celebrating the life of Henry IV of Navarre, Voltaire discusses the evil of religious and civil war. ADC

474
Unknown artist
MARIA THERESIA OF HAPSBURG, HOLY ROMAN EMPRESS
(b. 1717; r. 1745–80)
ca. 1745–55
Iron, cast; 94.4 mm
Scher Collection; Promised gift to The Frick Collection

Obverse inscription: MARIA THERESIA ROM[ana] IMPERAT[rix] HUN[gariæ] BOHE[miæ] REGINA ARC[hiducissa] AVSTRIA[e] [Maria Theresia, Roman Empress, Queen of Hungary and Bohemia, Archduchess of Austria].
Literature: Winter (Heinrich) 1999, no. 1024.

The circumstances in which this unusual and rare iron medal was made are unknown. WaC

475
Anton Guillemard (1747–1812) and Franz Stuckhart (1781–1857)
WOLFGANG AMADEUS MOZART (1756–1791)
Dated 1791, made 1803–5
Silver, struck; 37.1 mm
Scher Collection

Obverse inscriptions: WOLFGANG GOTTLIEB MOZART GEB[oren] 1756 GEST[orben] 1791 [Wolfgang Gottlieb (that is, Amadeus) Mozart, born 1756, died 1791]; on truncation, A[nton] GUILLEMARD F[ecit] [Anton Guillemard made it].
Reverse: The Muse Eutherpe with a lyre and a winged putto, perhaps the genius of Music, with a salpinx. Inscriptions: HERRSCHER DER SEELEN DURCH MELODISCHE DENKKRAFT [Lord of souls through the power of his melodic imagination]; on the upper edge of the exergue, F[ranz] STUCKHART F[ecit] [Franz Stuckhart made it].
Literature: *Annalen der Literatur* 1803–12, 7: cols. 231–33; Wurzbach 1856–91, 6: 30; Engl 1906, no. 26; Forrer 1904–30, 4: 706; Horsky sale 1910, no. 7493; Niggl 1965, no. 1373.

The making of this medal was announced in the *Kunstnachrichten* of the periodical *Annalen der Literatur und Kunst in den österreichischen Staaten* (May 1805) as a collaborative work by Anton Guillemard, former medalist of Louis XVI and chief coin engraver in the mint of Prague from 1796, and Franz Stuckhart, employed at the same mint from 1799 to 1806. The medal is part of a set of commemorative medals conceived for the market. According to the *Kunstnachrichten*, a silver specimen like the present one cost 2 florins and 30 crowns, while struck specimens in copper were 30 crowns. WaC

474

475

476

477

476

Johann Nepomuk Wirt (or Würth) (1753–1811)

MARIA LUDOVICA OF AUSTRIA-ESTE, EMPRESS OF AUSTRIA (b. 1787; r. 1808–16)

1808

Silver, struck; 49.2 mm

Scher Collection; Promised gift to The Frick Collection

Obverse inscriptions: MARIA LVDOVICA AVG[usta] A[rchiducissa] A[ustriæ] FRANCISCI AVST[riæ] IMP[eratoris] [Maria Ludovica Augusta, Archduchess of Austria, wife of Francis, Emperor of Austria]; beneath the truncation, I[ohannes] N[epomucenus] WIRT F[ecit] [Johann Nepomuk Wirt made it].
Reverse: A lily. Inscription: RECTE ET CANDIDE [With rectitude and candor; but also referring to the straight form and white color of the lily].
Literature: Arneth 1839, no. 493; Montenuovo sale 1885, no. 2358; Domanig 1896, no. 346; Horsky sale 1910, no. 3400; Westfälische Auktionsgesellschaft 1998a, no. 237; Winter (Heinz) 2009, no. 142.

This medal was made on the occasion of the coronation of Maria Ludovica, wife of Francis I of Hapsburg-Lorraine, which took place in Bratislava on September 7, 1808. wac

477

Leopold Heuberger (1786–1839)

FRANCIS I OF HAPSBURG-LORRAINE, EMPEROR OF AUSTRIA (b. 1768; r. 1804–35), **ALEXANDER I ROMANOV, CZAR OF RUSSIA** (b. 1777; r. 1801–35), and **FREDERICK WILLIAM III OF HOHENZOLLERN, KING OF PRUSSIA** (b. 1770; r. 1797–1840)

1815 or slightly later

Copper alloy, cast; 66 mm

Scher Collection

Obverse: Jugate busts of Francis I (with collar of the Order of the Golden Fleece), Alexander I (with collar of the Order of St. George), and Frederick William III (with collar of the Order of the Red Eagle). Inscriptions: FRANZ I ALEXANDER I F[riedrich] WILHELM III [Francis I,

Alexander I, Frederick William III]; under the busts, L[eopold] HEUBERGER F[ecit] [Leopold Heuberger made it].
Literature: Julius sale 1959, no. 3105 and table 45, w.n.; Hall sale 2010, no. 1197; M. Hirsch 2012, 532.

The medal celebrates the Holy Alliance signed by Austria, Russia, and Prussia in Paris after the defeat of Napoleon Bonaparte on September 26, 1815. wac

478

Johann Baptist Harnisch (1778–1826)

CHARLES LOUIS JOHN JOSEPH LAWRENCE OF HAPSBURG-LORRAINE, ARCHDUKE OF AUSTRIA (b. 1771; Duke of Teschen 1791–1847)

Dated 1809

Silver, struck; 76 mm

Scher Collection

Obverse: Charles, riding a horse and accompanied by two officers, receiving a canteen from one of the Ulanen (a cavalry regiment of the Austro-Hungarian army); in the background, a village and its church on fire. Inscription: along the edge, I[ohannes] HARNISCH F[ecit] [Johann Harnisch made it].
Reverse inscription: CARL DER SIEGER / VON ASPARN / TRANK AN DIESEM AUF EWIG / RUHMVOLLEN TAG / AUS DIESER FELDFLASCHE / EIN HEILIGES DENKMAHL / BLEIBT DIESELBE FÜR SEIN / DURCH SEINEN NAHMEN / BEGLÜCKTES / UHLANEN REGIMENT / DEN XXIIN MAY / MDCCCIX [Charles, the victor of Aspern, drank from this canteen on this day, which will be eternally celebrated; this canteen remains a sacred monument for his regiment of Ulanen, blessed by luck through his name on 22 May 1809].
Literature: Wellenheim sale 1844, no. 8422; Montenuovo sale 1885, no. 2363; Domanig 1907, 66, no. 433; Julius sale 1959, no. 2099; Westfälische Auktionsgesellschaft 1998a, no. 238.

This medal celebrates the Victory of Aspern, near Vienna, which allowed the Austrian troops to temporarily stop Napoleon Bonaparte's advancement toward the Austrian capital in 1809. wac

478

479

Johann Baptist Harnisch (1778–1826)
CAROLINE AUGUSTA OF WITTELSBACH, EMPRESS OF AUSTRIA (1792–1873; r. 1816–35)
Dated 1819
Pewter, cast; 50 mm
Scher Collection; Promised gift to The Frick Collection

Obverse: Bust with diadem, lace dress, and shawl. Inscriptions: CAROLINA AVGVSTA FRANCISCI AVGVSTI [Caroline Augusta, wife of Francis August]; below the bust, J[ohann] HARNISCH F[ecit] [Johann Harnisch made it].
Reverse inscription: ADSPICIT ABSENTES / PRAESENTI NUMINE / GENTES / ET DEXTRAM MISERIS / ET BLANDA JUVAMINA / PRAEBET / MDCCCXIX [She considers disadvantaged people with prompt authority and offers her right hand and gentle aid to the poor ones, 1819].
Literature: Arneth 1839, no. 519; Montenuovo sale 1885, no. 2486; Forrer 1904–30, 2: 429.

Caroline Augusta built her public image as a Catholic ruler through an impressive record of charitable initiatives—in the areas of education, public health, and social assistance—in Vienna, Salzburg, and elsewhere (Leo Santifaller/Eva Obermayer-Marnach, in *Österreichisches biographisches Lexikon* 1954–, 3: 245; Rath

1993). This medal was issued to commemorate the empress's visits to hospitals, cloisters, and hospices (e.g., in Klagenfurt and in Naples) on her trip to Rome in 1819 (for a chronicle of her travel, see Wolfsgruber 1893, 99–102). WAC

480

Anton Scharff (1845–1903)
VIENNESE LAUNDRY MAID
1903
Silver, cast; 42.7mm
Scher Collection

Obverse: Woman with a kerchief on her hair. Inscriptions: on the field, A[nton] S[charff]; on truncation of bust (incised), SCHARFF 1876.
Literature: Domanig 1895, 43; Loehr 1904, no. 37; Forrer 1904–30, 5: 360.

According to August, Ritter von Loehr, this medal was cast on behalf of the Austrian Society for the Promotion of the Medallic Art in 1903. The figure is based on a wax model of 126 mm modeled in 1876, which was also used to make another plaquette (126 mm), a pendant (25 mm), and a pin (15 mm). WAC

479

480

481

481

Anton Scharff (1845–1903)
STEPHAN (ISTVÁN) DELHAËS (1843/48–1901)
Dated 1887
Copper alloy, cast; 133.8 mm
Scher Collection

Obverse inscriptions: S[tephan] DELHAES; on truncation, A[nton] SCHARFF / 1887.
Literature: Domanig 1895, 48; Loehr 1899, 22, no. 241; Loehr 1904, no. 141; Forrer 1904–30, 5: 354; S. Schmidt 1983, no. 372.

Born in Budapest, the painter István Delhaës studied and lived in Vienna, where this medallion, the purpose of which is unknown, was made. He worked as restorer for the gallery of the Princes Lichtenstein and collected paintings, medals, antiquities, and graphic works (K. Lyka in Thieme and Becker 1907–50, 9: 20). WAC

482

Anton Scharff (1845–1903)
EUGEN FELIX (1826–1906)
Dated 1890
Copper alloy, cast (three pearls cast together with frame and medal, and loop for suspension); 60.1 × 45.8 mm
Scher Collection

Obverse: Eugen in historical costume, with ruff and a chain with a medal as pendant. Inscriptions: E[ugen] F[elix]; incised, AS [artist's initials].
Reverse: Behind a coat of arms, a male figure (a jester?) embracing and kissing the personification of Painting. Inscriptions: 17 FEB[ruary] 1890; on the scroll, KÜNSTLER [Artist].
Literature: Domanig 1895, 44; Loehr 1904, no. 192; Forrer 1904–30, 5: 367; Hauser 2006, 2: no. 4792.

The date on the reverse refers to the *Gschnasfest*, a yearly costume party given by Viennese artists during carnival. The making of facetious medals was customary on this occasion. The *Gschnasmedaille* of 1890 (that is, the medal sold at the party that year) portrays Eugen Felix, a painter and chairman, from 1886 to 1890, of the Artists' Union of Vienna, which organized the party. WAC

482

483

Anton Scharff (1845–1903)

KARL ADOLF, BARON OF BACHOFEN VON ECHT

(1830–1922)

Dated 1890

Copper alloy, cast together with the frame and four projections at top, bottom, left, and right; 65.2 × 51.6 mm

Scher Collection

Obverse: Karl Adolf in sixteenth-century costume, wearing a ribbon with a medal as pendant. Inscription: A[dolf] B[achofen] V[on] E[cht] / ÆT[atis]: LX [Adolf Bachofen von Echt, aged 60].

Reverse: Allegorical figure in contemporary dress holding a flower or a branch and the coat of arms of the sitter. Inscriptions: above,

MDCCCLXL [*sic*]; in the scroll, RESPICE FINEM [1890, look at the end].

Literature: Domanig 1895, 25, 47; Loehr 1899, 23, no. 183; Loehr 1904, no. 183; Forrer 1904–30, 5: 366; S. Schmidt 1983, no. 63; Hauser 2006, 2: no. 7178.

The industrial magnate Karl Adolf Bachofen von Echt, an art collector and member of the Numismatic Society of Vienna, was one of Anton Scharff's main patrons. Beginning in 1883, Bachofen commissioned portraits of himself and several members of his family from the Viennese die-engraver and director of the Graveur-Akademie. Bachofen also co-sponsored the first monograph on the artist (Domanig 1895, 7). It is unknown whether this medal was requested for a specific occasion. wac

483

484

Anton Scharff (1845–1903)
JOHANN STRAUSS (1825–1899)
Dated 1894
Copper alloy, cast; 59.3 mm
Scher Collection

Obverse inscriptions: JOHANN STRAUSS; in the field, GEB[oren] 1825 [born 1825]; beneath the bust, A. SCHARFF [with A and S interlaced].
Reverse: Palm and olive branches behind a bat, musical instruments, and a theatrical mask; in the background, ballroom with dancing couples. Inscriptions: ZUR FEIER SEINES 50 JÆHRIGEN KÜNSTLERISCHEN WIRKENS [To celebrate his fifty-year artistic activity]; on the ribbon bound around the violin, 15. OKTOBER; in exergue, 1894.
Literature: Domanig 1895, 24; Loehr 1899, 25, no. 250; Loehr 1904, no. 250; Forrer 1904–30, 5: 369; Niggl 1965, no. 1954.

Intended to celebrate the composer Johann Strauss's fifty years of activity, this medal was requested by Nicolaus Dumba (1830–1900), a member of several art promotion committees in Vienna. During his career, Scharff made other medals representing musicians (Brahms, Wagner) and monuments dedicated to musicians (Beethoven, Mozart) for the same patron. wac

485

Anton Scharff (1845–1903)
SAMUEL PUTNAM AVERY (1822–1904)
Dated 1897
Copper alloy, cast; 65.4 mm
Scher Collection

Obverse: Avery with suit, vest, and tie. Inscriptions: MART[ii] XVII MDCCCXCVII SAMVEL P[utnam] AVERY [Samuel Putnam Avery, 17 March 1897]; in the field at left, AET[atis] S[uæ] LXXV [at the age of 75]; at right, A[nton] SCHARFF.
Reverse: The personification of the Graphic Arts (keeping an album of prints with Albrecht Dürer's monogram beside her chair) admiring a small model of Benvenuto Cellini's *Perseus* in her hand; in the background, a library furnished with a vase, a shield, and a Venus. Inscription: ARTIVM STVDIOSO / AMICI [To a dedicated friend of the arts].
Literature: Loehr 1899, 26, no. 282; Loehr 1904, no. 282; Forrer 1904–30, 5: 370.

On March 17, 1897, the seventy-fifth birthday of the engraver, art dealer, and collector Samuel P. Avery, seventy-five New Yorkers presented him with a gold medal in recognition of his service (De Vinne 1905, 74). The work had been modeled by Anton Scharff. This

485

486

specimen and those in silver and copper alloy preserved in several American museums (among them, the Metropolitan Museum of Art, New York, and Museum of Fine Arts, Boston) are likely based on the same model; the gold specimen presented to Avery has not been located. WAC

486

Henri-François Brandt (1789–1845)
FRIEDRICH CARL NICOLAUS OF HOHENZOLLERN, PRINCE OF PRUSSIA (1828–1885)
Dated 1828
Copper alloy, struck; 41.2 mm
Scher Collection

Obverse: Friedrich as a baby. Inscriptions: FRIEDRICI I CARL NICOLAUS PRINZ VON PREUSSEN [Friedrich Carl Nicolaus, Prince of Prussia]; in the truncation of the shoulder, BRANDT F[ecit] [Brandt made it].
Reverse: Putto holding a *tabula anseata* (tablet with dovetail handles). Inscription: GEBOREN / D[en] 20 MÄRZ / 1828 [born on 20 March 1828].
Literature: Bolzenthal 1834, no. 76; Leberecht sale 1833–35, 3: no. 11830; Weyl 1876–77, no. 2454; UBS 2006, no. 2230.

This medal was issued on the birth of Prince Friedrich, nephew of Wilhelm Friedrich Ludwig of Prussia (1797–1888; emperor from 1871). The prince pursued a successful military career, participating in several of Prussia's wars, including the Franco-Prussian War (1870–71). WAC

487

Abraham Abramson (1754–1811)
LOUISE AUGUSTA WILHELMINE AMALIE ZU MECKLENBURG-STRELITZ, QUEEN OF PRUSSIA (b. 1776; r. 1797–1810)
Dated 1810
Silver, struck; 45.4 mm
Scher Collection

Obverse: Louise with high-waisted tunic dress. Inscriptions: LUISE PREUSSENS SCHMUCK [Louise, ornament of Prussia]; under the bust, ABRAMSON.
Reverse: Six-pointed star shining over a pyramid (possibly alluding to Louise Augusta's funeral monument). Inscriptions: ACH! IST FÜR UNS DAHIN [Alas! We have lost her]; GEST[orben] ZU HOHENZIERITZ / D[en] 19 IUL[i] 1810 / IM 35 IAHRE [Died in Hohenzieritz on 19 July 1810, at 35].
Literature: Leberecht sale 1833–35, 3: no. 11743; Weyl 1876–77, no. 2436; Forrer 1904–30, 1: 18.

Louise was the wife of Frederick William III of Hohenzollern and the mother of Emperor Wilhelm I. This medal was issued on her death in 1810. WAC

487

488

Thomas Crawford, a New Yorker, trained as a sculptor under Bertel Thorvaldsen and lived in Rome from 1835. Among his major works are a bronze equestrian statue of George Washington in Richmond, Virginia (1852–54) and several works for the United States Capitol in Washington, D.C. (1854–56). According to Gale, this medal may have been modeled during Voigt's stay in Rome in 1853 because the medalist is mentioned in a letter from the sculptor to his wife dated July 7, 1853. WaC

488

Heinrich Kautsch (1859–1943)
FRANZ JOSEPH OTTO OF HAPSBURG (1912–2011;
Crown Prince of Austria-Hungary 1916–18)
1916
Copper alloy, cast; 77.7 × 77.8 mm
Scher Collection

Obverse: Otto as a child in a sailor suit. Inscriptions: in the field, FRANCISCUS / JOSEPHUS / OTTO; on truncation of shoulder (incised), H[einrich] KAUTSCH; in exergue, NATUS DIE XX NOV[embris] / MDCCCCXII [born on 20 November 1912].
Reverse: Crowned coat of arms of Hapsburg-Lorraine. Inscription: FLAGRANTE TERRARUM ORBE 1914–1916 [While the world is in flames, 1914–1916].
Literature: Winter (Heinrich) 1999, no. 1030; Hauser 2006, no. 574.

This medal may have been made on Otto's fourth birthday. The eldest son of Emperor Charles I of Austria, Otto was the head of the House of Hapsburg-Lorraine from 1922 to 2007, but he never acceded to his father's throne. WaC

489

Karl Friedrich Voigt (1800–1874)
THOMAS GIBSON CRAWFORD (1814–1857)
Dated 1853
Copper alloy, cast, with traces of a loop for suspension on the back; 87.5 mm
Scher Collection

Obverse inscriptions: T[homas] CRAWFORD SCULPTOR; in exergue, C[arl] VOIGT 1853.
Literature: Forrer 1904–30, 6: 305–8 (on Voigt); Gale 1964, 105.

489

490

491

490

Lauer Die-Sinking Establishment, Nuremberg (possibly Wolfgang Lauer, act. for the company from 1883)
VICTORIA OF HOHENZOLLERN (1866–1929; Princess of Prussia 1890–1916)
Dated 1893
Silver gilt, struck; 50.2 mm
Scher Collection

Obverse inscription: PROTECTORIN PRINCESSIN ADOLF ZU SCHAUMBURG LIPPE [Princess Adolf zu Schaumburg-Lippe, supporter (of the event)].
Reverse: Coats of arms of the German Empire (yet, with eagle facing right) and of Cologne, and view of the city within cartouche. Inscriptions: AUSSTELLUNG FÜR KOCHKUNST ARMEEVERPFLEGUNG VOLKSERNÄHR[un]G U[nd] VERW[andte] FÄCHER; in the field, 1893; below on a cloth swag, KÖLN [Exhibition for culinary art, meal-provisioning for the army, feeding of people, and related fields, 1893, Cologne]; in exergue, LAUER NÜRNBERG; on edge, unintelligible mark, incised, 0,990.
Literature: Forrer 1904–30, 3: 624; Weiler 1977–79, 3: no. 239; Weiler 1970–81, 2: no. 2963.

The medal refers to Victoria's support of the *Exhibition for Culinary Art* held in Cologne between October and November 1893 (*Ausstellung für Kochkunst* 1893). This type of philanthropic activity was not uncommon among princesses of the German empire. WAC

491

Lauer Die-Sinking Establishment, Nuremberg (?)
VICTORIA OF HOHENZOLLERN (1866–1929; Princess of Prussia 1890–1916)
ca. 1893
Silver-plated copper, cast from a circular model; 45.4 × 36.7 mm (irregular rectangle, measured from point of sleeves)
Scher Collection

Obverse: Victoria wearing a dress with lace collar; coat of arms of the Princes zu Schaumburg-Lippe. Inscription: K[önigliche] H[öhe] PR[in]Z[essi]N ADOLF Z[u] SCHAUMB[urg] LIPPE [Her Royal Highness Princess Adolf zu Schaumburg-Lippe].
Literature: Forrer 1904–30, 3: 324; M. Jones 1979a, fig. 365.

As evidenced by the dimensions of the figure and the traces of junction in the background, this plaquette was cast from the same circular model made to cast Victoria's medal (no. 490). The casting of this oblong version cannot be traced back to any specific occasion. WAC

492

Maximilian Dasio (1865–1954)
VANITAS
Dated 1905
Silver, struck; 50.2 mm
Scher Collection

492

493

Obverse: A genius holding a mirror up to Vanitas, who fixes her hair leaning on a plinth. Inscriptions: VANI=TAS [Vanity]; in exergue, DASIO P[i]CT[or] FEC[it] MDCCCCV [The painter Dasio made it, 1905].
Reverse: A sphinx holding a sphere under the left paw. Inscriptions: in exergue, D[asio]; along the border, HITL; punched on the edge, C[arl] POLLATH.
Literature: Bernhart 1917, no. 55; I. S. Weber 1985, no. 158; I. S. Weber 1989, 84; Westfälische Auktionsgesellschaft 1998b, no. 2296.

In 1925, this medal was listed as "Vanitas" in the sale catalogue of the Coining Establishment "Carl Poellath" in Schrobenhausen (Bavaria). WAC

Ludwig Gies (1887–1966)
MAX BERNHART (b. 1883)
Dated 1916
Copper alloy, cast; 66 mm
Scher Collection

Obverse inscription: MAX BERNHART 1916.
Reverse: An owl with a pen in its beak opens a sack of coins that fall to the feet of a statuette representing Venus pudica. Inscriptions: MENS INSPIRAT MOLEM [The mind infuses life into matter]; in exergue, GIES L[udwig].
Literature: Bernhart 1917, no. 114; S. Schmidt 1983, no. 174; Ernsting 1995, no. MVZ.142; Hauck & Aufhäuser 2000, no. 1742.

494

Bernhart was director of the Staatliche Münzsammlung of Munich (1932–49, see no. 495). The motto may refer to intellect in its ability to breathe new life into the relics of the past through interpretation. The imagery on the reverse can be explained with regard to the sitter's profession: the owl (sacred to Minerva, the goddess of knowledge) could represent Bernhart as discoverer of hoards, keeper of treasures, and scholar unveiling their significance through his writing (the owl's pen); the coins and the statuette could refer to Bernhart's academic interests in the field of numismatics, classical, and antiquarian studies. He wrote an essay on the representations of Venus on ancient Greek coins two decades after the issue of this medal (*Aphrodite auf griechischen Münzen*, Munich 1935). wac

494

Hans Schwegerle (1882–1950)
GEORG HABICH (1868–1932)
Dated 1918
Copper alloy, cast; 94.3 mm
Scher Collection

Obverse inscriptions: GEORG HABICH ÆTATIS SVÆ L MCMXVIII [Georg Habich, aged 50, 1918]; below bust, H[ans] SCHWEGERLE 18.
Reverse: A naked athlete holding a hawk in his right hand; the bird (whose German name is "Habicht") alludes to the surname of the sitter. Inscription: punched on the edge, C[arl] POELLATH SCHROBINHAUSEN.
Literature: S. Schmidt 1983, no. 618; Hasselmann 2000, no. 155; Hauck & Aufhäuser 2000, no. 1759.

This medal celebrated the fiftieth birthday of the medal scholar Georg Habich, who was director of the Staatliche Münzsammlung of Munich (1907–32) and president of the Bavarian Numismatic Society. It was commissioned and cast in twenty-five specimens by the Coining Establishment "Carl Poellath" in Schrobenhausen, Bavaria, to be sold to the members of the Bavarian Numismatic Society. A struck version of 50 mm and another in the form of a plaquette were also made on the same occasion. The latter was presented to Habich. The faint artist's signature and date were incised on the wax model and appear on each specimen. wac

Joseph Bernhart (1883–1967)
MAX BERNHART (b. 1883)
Dated 1943
Silver, cast; 52.4 × 45 mm
Scher Collection

Obverse inscription: On truncation of head (incised), I[oseph] BERNHART.
Reverse: Ancient Greek Gorgonian mask. Inscription: MAX / BERNHART / MONACENSIS / ÆT[atis] SVÆ LX / A[NN]o MCMXLIII [Max Bernhart, citizen of Munich, at the age of 60, 1943].
Literature: S. Schmidt 1983, no. 173; Hauck & Aufhäuser 2000, no. 1725; Westfälische Auktionsgesellschaft 2012, no. 2632.

Max Bernhart, director of the Staatliche Münzsammlung in Munich from 1932 to 1949, published extensively on Greek and Roman coinage, sixteenth-century and modern medals, and plaquettes. This medal was made to celebrate his birthday. wac

Joseph Bernhart (1883–1967)
GEORG HABICH (1868–1932)
Dated 1931
Silver, cast; 45.7 mm
Scher Collection
Obverse inscriptions: GEORG HABICH AETATIS SVAE LXIII [Georg Habich, aged 63]; on the truncation of the head, I[oseph] B[ernhart].
Reverse inscription: HOMO / HOMINI / LVPVS / ANNO / MCMXXXI [Every man behaves like a wolf toward the other men; (made) in the year 1931].
Literature: Gebhart 1932, no. 94; S. Schmidt 1983, no. 611; Hauck & Aufhäuser 2000, no. 1692.

Habich was director of the Staatliche Münzsammlung of Munich beginning in 1907. This medal was made in his last years but cannot be traced to any specific event. His portrait was cast from a positive model in lithographic or Solnhofen stone recorded among the artist's holdings in 1932. Bernhart usually engraved such models from photographic prints of the same size and then adjusted them from life, molded them, and personally cast them in metal. Finally, he patinated their surfaces chemically. wac

497

Joseph Bernhart (1883–1967)
HERMANN HEINRICH BUCHENAU OF MUNICH
(1862–1931)
Dated 1922
Silver, cast; 32 mm
Scher Collection

Obverse: Buchenau in a suit with bow tie. Inscriptions: DR HERM[ann] HEINR[ich] BVCHENAV MVENCHEN MCMXXII [Dr. Hermann Heinrich Buchenau, Munich, 1922]; on truncation, I[oseph] B[ernhart].
Reverse: A helm and a shield with a bird. Inscription: GEBOREN / ZV BREMEN / 20 APRIL / MDCCCLXII [Born in Bremen on 20 April 1862].
Literature: Gebhart 1932, no. 11a; S. Schmidt 1983, no. 271; Hauck & Aufhäuser 2000, no. 1644.

This medal was made on the sixtieth birthday of Hermann Heinrich Buchenau, a professor of medieval studies and numismatics in Munich. A stone model for this portrait is mentioned by Gebhart (1932). The lettering of the medal imitates the inscriptions of Matthes Bebel (ca. 1500–1574). waC

498

Joseph Bernhart (1883–1967)
MAXIMILIAN DASIO (1865–1965)
Dated 1926
Silver, cast; 36.1 mm
Scher Collection

Obverse inscriptions: MAXIMILIANVS DASIO PICTOR MONACENSIS AET[atis] S[uae] LXII [Maximilian Dasio, painter of Munich, at the age of 62]; beneath the bust, I[oseph] B[ernhart].
Reverse: Cactus flourishing. Inscription: SEMPER SPINOSVS RARO FLORESCENS A[nno] D[omini] MCMXXVI [Always thorny, seldom in flower, in the year of the Lord 1926].
Literature: Gebhart 1932, no. 32; I. S. Weber 1985, no. 300; Hauck & Aufhäuser 2000, no. 1667.

Based on a documented stone model, this medal was made on the sixty-second birthday of Dasio, who was a medalist and professor at the School for Applied Arts in Munich (see no. 492). waC

499

Joseph Bernhart (1883–1967)
KARL GARZAROLLI-THURNLACKH (1894–1964)
Dated 1928
Copper alloy, cast; 39.4 mm
Scher Collection

Obverse inscriptions: CAROLVS GARZAROLLI DE THVRNLACKH DOCT[or] PHIL[osophiae] [Karl Garzarolli-Thurnlackh, Ph.D.]; on the truncation of the head, JB [artist's initials].
Reverse: Coat of arms. Inscriptions: COLL[ectionis] PICT[oricae] ET CHALCOGR[aphicae] STYRIÆ PRÆFECTVS [Curator of the collection of paintings and prints of Styria]; in the field, MCMXXVIII [1928].
Literature: Gebhard 1932, no. 71; Hauck & Aufhäuser 2000, no. 1687.

Garzarolli-Thurnlackh was an art historian at the Universalmuseum Johanneum of Graz, Austria, from 1919 to 1946. waC

500

500

Joseph Bernhart (1883–1967)

ERNST LIEBERMANN (1869–1960)

Dated 1936

Lithographic stone; 58.4 mm

Scher Collection

Obverse inscriptions: PROF[essor] ERNST LIEBERMANN MALER IN MVENCHEN ÆT[atis] 67 A[nn]° 1936 [Professor Ernst Liebermann, painter in Munich, aged 67, in the year 1936]; on truncation, I[oseph] B[ernhart].

Reverse inscription: Incised, OPVS IOSEPHI / BERNHART / MONACENSIS [Work of Joseph Bernhart, of Munich].

Literature: Hauck & Aufhäuser 2000, no. 1716.

Liebermann was a painter and illustrator active in Munich from 1897. The circumstances in which this medal was carved are unknown. Apparently, no version in metal was made from it. wac

501

Bruno Eyermann (1888–1961)

FERRARA PARTY AT THE ROYAL ACADEMY FOR GRAPHIC ARTS AND BOOK INDUSTRY OF LEIPZIG

Dated 1912

Copper alloy, struck; 50.3 mm

Scher Collection

Obverse: Female head attired in the fashion of the second half of the fifteenth century and drawn after models of the same period. Inscriptions: FEST A[m] HOFE V[on] FERRARA K[öni]GL[iche] AKADEMIE F[ür] GRAPH[ische] K[unst] U[nd] B[uchgewerbe] [Party at the Court of Ferrara, Royal Academy for Graphic Arts and Book Industry]; in the field, EYERMANN.

Reverse: Coat of arms of the Este family of Ferrara. Inscription: LEIPZIG 1912.

Literature: Coch 1993, 42, 45, fig. 18; Winter (Heinrich) 1996, no. 1484.

This medal was made for a costume party organized by the Royal Academy for Graphic Arts and Book Industry of Leipzig during the carnival in 1912. Its issue in 250 specimens was authorized by the Ministry of Internal Affairs, and the Royal Academy commissioned it from Glaser und Sohn in January–February 1912. wac

501

Franz Kounitzky (1880–1928)

EMIL GEORG CONRAD, KNIGHT OF SAUER (1862–1942)

1905

Copper alloy, cast; 170 mm

Scher Collection

Obverse inscriptions: EMIL SAUER; on truncation of shoulder, F[ranz] KOUNITZKY.

Edge inscription: FK [artist's initials].

Literature: Forrer 1904–30, 7: 514; Andorfer and Epstein 1907, no. 789; Niggl 1965, no. 1763.

Kounitzky made medals of several musicians, and Emil Georg Conrad was a pianist and composer. According to Andorfer and Epstein, writing at the time and in the city in which Kounitzky was active, Vienna, this medal appeared during the preparation of their book in 1905. WAC

Martin Schausz (dates unknown)

VICTORIA-LOUISE ADELHEID MATHILDE CHARLOTTE, DUCHESS OF BRUNSWICK-LÜNEBURG AND PRINCESS OF HANOVER, GREAT BRITAIN, AND IRELAND (1892–1980)

Dated 1915

Copper alloy, cast; 106 mm

Scher Collection

Obverse inscriptions: VICTORIA-LUISE; in the field, 1915; under the bust, MARTIN SCHAUSZ.

Reverse: Victoria with her two children, surrounded by cherubs. Inscriptions: SCHAUSZ; punched on edge, D[eutsche] S[chaumünze] 43 7[?].

Literature: Brockmann 1985–87, 1: no. 587.

502

This medal was issued to celebrate the birth in 1915 of Victoria-Louise's second child, George William. The punch on the edge demonstrates that the work was commissioned by the Berliner Club "Freunde der deutschen Schaumünze" (Friends of the German Medal), who raised money through the sale of such medals and employed it to support disabled veterans. Victoria-Louise was a great-granddaughter of Queen Victoria through her father. WAC

503

FRANCE

"PROOF STONES OF HISTORY"

The Medal in France, 1400–1900

Mark Jones

A native tradition of medal-making developed quite late in France, not until the second half of the sixteenth century, more than a century after its emergence in Italy. This was not, however, because France and Italy were geographically or culturally separate (in fact, they were in constant contact) or because medals were unknown in France. The Duke of Berry, uncle of and regent for Charles VI, acquired a lead impression of the earliest known modern medal, which was made to commemorate Francesco I da Carrara in the 1390s,[1] and he purchased medals of Constantine and Heraclius from the Florentine merchant Antonio Mancini in Bourges in November 1402.[2] It is possible that the impulse for their creation, like that for the medal of John VIII Paleologus made by Pisanello (no. 1) more than thirty years later, was the visit of a Roman—or, as we would say, Byzantine—emperor, Manuel II Paleologus, to Paris in 1400–1402. Made using goldsmiths' techniques, in precious metal surrounded with jewels, these medals combined exquisite luxury with piety, in the fashion of the court of France.

The 1450s saw a series of medals in the form of large coin-like objects produced to celebrate victory over the English at the end of the Hundred Years' War (no. 506).[3] They were made in gold and silver and are said to have been presented as rewards to those who took part in the successful campaign to drive the English out of France. Italian medals and medalists came to France in the latter part of the fifteenth century. Pietro da Milano worked at the court of that great patron of the arts René d'Anjou from 1461 to 1463, making medals of Margaret of Anjou and Ferry II of Lorraine when René was in Bar-le-Duc in 1463. So too did Francesco Laurana, who left Naples about 1460 and who made portraits of Louis XI, as well as of René and various figures at his court. The portrait of François I as a boy in 1504, with its fiery salamander reverse, and of his mother and sister, Louise of Savoy and Marguerite of Angoulême,[4] have been attributed to Giovanni Candida,[5] who was at the French court from about 1480 (nos. 510 and 511); and Benvenuto Cellini made a medal of the king during his first stay in France in 1537.[6] But when the French turned to medal-making, even in a city like Lyon with its large Italian population, their approach was very different from that adopted in Italy.

The surviving examples of the medal of Louis XII and Anne of Brittany, commissioned by the town council of Lyon in 1500,[7] with bold profile portraits of the king and queen, like those of Philibert of Savoy and Margaret of Austria,[8] do at first glance look like Italian medals. But those that survive are predominantly nineteenth-century copies of carefully patinated bronze, made with Italian medals in mind (nos. 507 and 508). The lost originals were goldsmiths' work, beautifully chased in gold and given to Anne and Margaret on their respective entries to Lyon in 1500 and Bourg-en-Bresse in 1502. The difference is yet more evident in the smaller struck medals of Charles VIII and Anne, made for her earlier visit in 1494: a hundred gold pieces presented in a golden cup held by a golden lion. These are true portraits, but the identity and status of the sitters are asserted as much through heraldry, titulature, and emblems of royalty as through likeness. And the medals are very clearly substituting for, or rather elevating, what is essentially a monetary gift.[9] Jacques Gauvain, a goldsmith working in Lyon from 1515 to 1547, is known to have made a medal for Queen Eléonore's visit in 1533,[10] and Regnault Danet, a Parisian goldsmith, made bronze medals for François I in 1529.[11] But these isolated examples do not seem to have generated more widespread demand for medallic portraiture.

Why are there so few French medals in the fifteenth and sixteenth centuries? And why are they so different from Italian medals in appearance and function? Portraits were regarded with suspicion in late medieval Europe: they reeked of vanity, a deadly sin.[12] It is for this reason that so many early portraits were conceived as memento mori. Contemplation of mortality was the recommended prophylactic for the sin of vanity.[13] Moreover, those near the summit of late medieval society owed their status, at least formally, not to wealth or individual talent but to family. Promotion of the individual was something to be disguised with invented pedigrees, not advertised and celebrated. Portraiture only worked for those outside the formal hierarchy—bankers, merchants, and artists—who needed to subvert the traditional hierarchy in order to assert their status. For this reason, portraiture, and therefore medals, flourished among the newly rich in the banking and mercantile centers in northern Italy, the Low Countries, and southern Germany but not among those in France and England, whose prestige—dependent on inherited status derived from the ownership of land, excelling at the arts of war, and resolutely avoiding involvement in trade or commerce—was already high.

The adoption of mechanical presses in the mid-sixteenth century reinforced the role of medals as a ceremonial version of money—having a precise intrinsic value but untainted by the marketplace—bearing royal portraits and celebrating royal events.[14] Versions of the medal of Charles IX by Guillaume Martin were struck in gold to a weight of ten *écus*[15] to serve as presents for the followers of the Duke of Alva at his meeting with Charles and his mother, the Regent Catherine de' Medici.[16] The sculptor Germain Pilon, chosen to make the models for royal portraits on the coinage in 1572,[17] modeled a large portrait medallion of René de Birague in 1577 (see fig. 20)[18] and may also have been responsible for a series of cast medallions of the Valois rulers, including a slightly melancholy portrait of the late king, Henry II.[19] Jacopo Primavera made a number of cast portrait medals in the late 1570s and early 1580s, but it was not until Guillaume Dupré began work at the end of the sixteenth century that portrait medals really found a maker and a market to rival those in Italy and the Low Countries.

Fig. 20 Germain Pilon,
René de Birague, 1577
Gilt bronze, cast, 164 mm
Bibliothèque Nationale de
France, Paris

Dupré was the pupil and, from 1600, son-in-law of Barthélemy Prieur, who had himself been Germain Pilon's pupil and who, like Pilon, modeled wax portraits for coinage.[20] Traveling with the court to Lyon in 1600, Dupré must have seen the work of artists such as Leone Leoni, Pastorino, da Trezzo, and Jonghelinck, whose art greatly influenced his own. The birth of an heir to Henri IV and Marie de' Medici in 1601 demanded celebration and commemoration. Dupré rose to the challenge with a medal representing Henri as Mars and Marie as Minerva with their child between them (no. 532).[21] So pleased was the king that he frequently visited Dupré to see the work in progress,[22] ordered it to be cast in gold and silver, and gave him a patent protecting him from imitators when it was finished.[23] Dupré went on to portray most of the leading figures in early seventeenth-century France. Finely modeled, elegantly composed, and cast with unequaled finesse, Dupré's medals are among the finest made in the seventeenth century. In 1612–13, Dupré traveled in Italy, creating a series of impressive portrait medallions of Italian princes, including Marcantonio Memmo, doge of Venice, Francesco de' Medici (fig. 21), and Cosimo II de' Medici and his mother, Christine of Lorraine. Back in France, in 1615, Dupré made a superb medal of Marie de' Medici as regent (no. 541), showing her as Cybele, guiding the ship of state through a stormy sea. Filling the fictive space of the medal, the vigorously modeled composition is executed with masterly skill. The greatest of Dupré's French portraits, the medallion of Pierre Jeannin (no. 542),[24] made in 1618, shows the incorruptible statesman in his robes of office, proud of his role in guiding Marie de' Medici through the difficult years of the regency. The harmonious classicism of Dupré's figure of Justice for the reverse of his portrait of Louis XIII (no. 546), known as Louis the Just, and the brilliant depiction of the Maréchal de Toiras in exile at the court of Savoy (no. 550)—with a sun burning through the clouds that eclipsed him after his rift with Richelieu—illustrate the range of Dupré's talent.

Dupré held a number of official positions. In addition to his role as one of the king's sculptors, he was commissioner general of the French artillery, responsible for casting cannons at the arsenal in Paris and elsewhere, and controller general of puncheons at the mint, responsible for modeling portraits for coins and struck medals. His colleague there, the Engraver General Nicolas Briot—like Dupré, a Protestant—made a charming medal for the reconstruction of Pont Saint Michel in 1617. But Briot's attempt to mechanize the coinage failed; in 1625, he left for Britain, where he became an engraver at the London

mint and master of the Scottish mint. His best medal, depicting Charles I, celebrates British dominion over the seas (no. 566).

Briot's much more able successor at the Paris mint was Jean Warin, who started his career with flattering portraits of Cardinal Richelieu (nos. 578 and 579), which won him a pardon for the capital crime of coin forgery. The medals are astonishing in their *lèse majesté*, asserting Richelieu's sole responsibility for guiding France through difficult times, chaining Fortune to her chariot on one medal and lauding the extraordinary force and reach of his intellect with the legend MENS SIDERA VOLVIT (the mind makes the stars revolve) on another.[25] Unlike Briot, Warin was a great artist. His large cast medal of Anne of Austria and Louis XIV (no. 581), made in gold to be placed under the foundation stone of the Val-de-Grâce, bears a touching representation of the young king in his mother's arms.[26] But Warin was far from sentimental: he undertook a complete reform of the coinage, producing pieces of such beauty that they were collected as though they were ancient medals,[27] and he schemed with utter ruthlessness to gain complete control of the mechanical mint. Once he had achieved this, he went on to establish a monopoly of medallic production, demonstrating the desirability of struck medals through his extraordinary technical mastery and his brilliant portraits of the young king (no. 584). At the same time, he argued that since medal presses could be used to strike false coins (something he knew all about), the state had to monopolize their use. His younger brother Claude, who had been sent to Lyon by Jean in 1647 after fourteen years in England,[28] found a ready market for large cast medals there, and his medallions of noblewomen like Madeleine de Créquy (no. 589)[29] and bourgeois like Mathieu Chappuis (no. 587) are competently modeled and cast. But after Claude's death, independent creation of cast medals in France virtually ceased. Medallic portraits, like coin portraits, came to be seen as the prerogative of the ruler.

Jean Warin was a talented sculptor, regarded by contemporaries as the French rival to Bernini: his bust of Louis XIV, produced in response to Bernini's, was accorded a place of honor on the ambassadors' staircase at Versailles.[30] It was to Warin that Jean-Baptiste Colbert turned when he initiated the "Medallic History" of Louis's reign in 1662, and it was Warin who produced the first medals celebrating the triumphs of the young king, as well as the medal bearing the famous image of Louis as the sun (no. 583), warming the world with his beneficent rays under the motto "not unequal to many," meaning that Louis was capable of ruling many realms.

Medallic production during Louis's reign, from 1661 to 1715, was given over almost entirely to glorification of the king and the record of his achievements. A special academy, known initially as the Little Academy and later as the Academy of Medals and Inscriptions—which included among its members the leading historians, writers, and antiquarians of the day, including Jean Racine, Boileau and Charles Perrault—supervised the representation of the regime. The members contributed to the program, provided the inscriptions for Charles Le Brun's great scheme of decorative painting for Louis's palace at Versailles, and oversaw the erection of triumphal arches, like the Porte Saint-Denis, as well as the creation of historic records in other media, including tapestries and prints. But from the mid-1680s on, they concentrated increasingly on documenting the history of Louis's reign in medals,

Fig. 21 Guillaume Dupré, *Francesco de' Medici*, 1613
Cast silver, 92.5 mm
British Museum, London

devoting the years 1694–1702 entirely to this task. The medal became the official medium through which the king and his minister hoped to communicate their version of events to posterity. Carefully composed, modeled, and engraved with commendable skill by medalists like Jean Mauger, Michel Molart (no. 600), and Charles-Jean-François Cheron— whose portraits of Charles Le Brun are a rare exception to the rule that only the king's head was to grace medals (no. 596)—and published in the grandest of folio volumes, the medals certainly had an impact on contemporaries. Louis XIV, like the academicians who served him, believed that their medallic history would survive as an unchallengeable record of the grandeur and glory of his reign. But though contemporaries were sufficiently impressed to imitate the French example and strike medals in riposte, they were also skeptical. "Medals were formerly the proof stones of history," wrote a Dutch contemporary in 1701, "but they have become false and flattering."[31]

The eighteenth century began with a medallic history of Louis XV, a continuation and imitation of that of his great-grandfather, which gradually lost momentum and was never published as a whole. Perhaps neither the king nor the academy could convince themselves that the new reign was worth a sustained campaign of commemoration. Jean Duvivier, whose medal of the regent demonstrates his skills in composition (no. 611), engraving, and portraiture, dominated French medal-making for more than fifty years along with his son Benjamin. In eighteenth-century France, as elsewhere in Europe, medals took on new functions—for example, as prizes—and also resumed their role as portraits of individuals other than the ruler. The American War of Independence provided new opportunities in the 1780s. Benjamin Franklin, as the American ambassador in Paris, initiated a series of medals that both honored revolutionary heroes and commemorated their great deeds. Franklin himself came up with the idea of depicting America as the infant Hercules strangling serpents, representing the British armies defeated at York and Saratoga, under the protection of France;[32] and, working with the architect Alexandre-Théodore Brogniart, he commissioned the medal commemorating these victories (no. 617) from Augustin Dupré and organized its distribution.[33] Dupré's fiery figure of American Liberty on the other side of the medal was borrowed a few years later by André Galle for his very first medal, celebrating Republican Liberty, in 1792.

The French Revolution saw the resurgence of popular medals quickly and cheaply made to comment on the latest excitement. Some, like Bertrand Andrieu's *Siege of the Bastille* and *The Arrival of the King in Paris* were created by experienced medalists, but there was also an outpouring of medals made in the heat of the moment, in tin or pewter, and sold in the same way as popular prints. Augustin de Robespierre's youthful enthusiasm is vigorously conveyed in the ephemeral medal that records his moment of fame before he was guillotined in 1794. But Napoleon Bonaparte, as First Consul and then Emperor Napoleon, reasserted order as authoritarian rulers so often do, by looking back to antiquity. When still in his late twenties, commanding the French army in Italy, Napoleon commissioned a series of five medals designed by the great neoclassical painter Andrea Appiani to celebrate and promote his victories.[34] Determined to rival and outstrip Louis XIV's medallic histories, he commissioned the "Classe d'histoire et de littérature ancienne" within the Imperial Institute, the successor of the Academy of Inscriptions, to undertake the task. At the same time, Vivant Denon—who had accompanied Bonaparte to Egypt and

was appointed director of the Louvre and cultural dictator under the emperor—used his immense energy to produce an instant medallic history of the empire. Working under the emperor, who personally approved every medal, even when on campaign, Denon himself proposed the subject matter, the inscriptions, and often the composition. He employed the best available artists—Antoine-Denis Chaudet, Pierre Lafitte, Pierre Paul Prud'hon, Alexandre-Evariste Fragonard, and others—to provide the drawings and gifted engravers like Bertrand Andrieu, Nicolas Brenet, and Jean-Pierre Droz to produce a remarkably fine series of neoclassical medals.[35]

Napoleon was portrayed as the purest of classical heroes, rivaling and outdoing the emperor Augustus. André Galle's medal for the Battle of Friedland, after a drawing by Charles Meynier,[36] for example, shows Napoleon as a naked warrior, sheathing his sword, the heaped corpses of slain enemies at his feet (no. 642). The great bulk of the mountain, personified as a brooding giant, head wreathed with clouds, fills the reverse of the medal engraved by Brenet for the École des Mines du Mont Blanc (no. 640), almost to bursting.[37] Brenet's poignant medal of February 1814 (no. 645), showing the imperial eagle unbowed in the face of his enemies, was struck without a collar, in direct imitation of ancient coins, giving the impression that his subject had already become a hero from the distant past.

David d'Angers, who began his "Gallery of Contemporaries" in 1827,[38] was a romantic sculptor who valued self-expression rather than neoclassical restraint. As can be seen from the vigorous modeling of his portrait of Pierre-René Choudieu (no. 660), David believed not in careful composition and the painstaking translation of a finished drawing into engraved steel but rather in the direct translation of his impressions into wax cast directly into bronze, retaining every mark of the sculptor's struggle to capture the essence of the subject. He used medals to make his friends and contemporaries heroic, brilliantly capturing the romantic intensity of composers like Gaspare Spontini and writers like Théophile Gautier and Mélanie Waldor. If his medals promise immortality, it is immortality not for a serene, idealized, eternal image but for the moment of contact between sculptor and a sitter, identified not by a classical inscription but by a scrawled signature or a name crudely carved into the wax. David was a radical, a revolutionary, who saw the image of a new society in the features of his contemporaries.

Jules-Clément Chaplain (1839–1909) was, by contrast, a figure of unimpeachable respectability, who won the Prix de Rome and went on to win medals at the official salon, be elected to the Academy of Fine Arts, and be promoted to commander of the Legion of Honor.[39] When still in Rome, he modeled a vigorous portrait of Napoleon III (no. 679) for the Universal Exhibition of 1867, and, after his return to France, he became the preferred official medalist of the republic. His portraits are immaculately composed, with hair and clothes beautifully realized, seeming almost to have a life of their own. But the beholder's eye is always drawn back to the features of the sitter, who is typically in profile, classical, almost monumental, but imbued with the force of personality, with the essence of the individual. Sarah Gustave-Simon (no. 683) and Princess Maria Gorchakov Sturdza (no. 684), clearly fashionable, are represented with great seriousness. The actress Jeanne Julia Bartet (no. 687) clutches a tragic mask, while the architect Charles Garnier (no. 685), seen with disheveled hair and upturned lapel, as though rushing from one job to another, has paused to focus on some grand idea.

Louis-Oscar Roty (1846–1911) was more seductive and more pictorial in his approach to medal-making than his great contemporary Chaplain.[40] Both artists modeled on a large scale and then used a reducing machine (or three-dimensional pantograph) to create much smaller dies from which to strike the medal. This meant they were aware of the medal or plaquette in two formats, as a relatively large cast relief made in a small edition and as a small struck piece that could be produced in hundreds or thousands. Both of them loved silver with a matte finish (too often subsequently ruined by polishing or cleaning), and Roty was particularly skilled in using this effect to create an enveloping atmosphere that united the field or background with the modeled figures. His great memorial medal (no. 694) for the assassinated president Sadi Carnot induces a remarkable sense of melancholy as veiled figures carry a coffin through the mist to the Pantheon. In another medal, the wild-haired centenarian scientist Michel-Eugène Chevreul (no. 693), famous for his work on color contrasts, is shown seated, pen and paper at the ready, while receiving the grateful thanks of French youth. Roty handles spatial recession in very low relief with exceptional skill, and his masterly inscriptions, influenced by the example of Pisanello, are a lesson in the contribution that elegant lettering can make to a composition. Quite different, but equally touching, is the portrait Roty made of his "dearest wife [Marie Boulanger] … so that she would be ever before his eyes, ever young and happy" (no. 691).[41]

Paris was a magnet for artists from all over Europe at the end of the nineteenth century, and French medalists, as in the seventeenth century, had a dominant influence on the work of their colleagues elsewhere in Europe and in the United States. Perhaps the most widely influential of the generation, after Chaplain and Roty, was Alexandre Charpentier (1856–1909).[42] Trained as a medalist under Hubert Ponscarme, he was a founding member of the arts group Les Cinq and an inventive and wide-ranging designer who worked on furniture, ceramics, and large-scale sculpture, as well as medals. His faun peering out of a door handle is both playful and slightly unsettling; we know somehow that his chess player, intent on her game, is in a darkened room with a single source of light. His touching medal of a young mother feeding her baby boy hints at a social realist strand, which is more evident in his portrayal of stonemasons at work, *Tailleurs de pierre – Maçons* (Musée d'Orsay, Paris). Marie-Alexandre-Lucien Coudray (1864–1932) was one of a generation of medalists whose work was fashionable about 1900 but which came to seem dated in the aftermath of World War I. His medal of Orpheus, made for the Universal Exhibition of 1900 (no. 704), was hugely successful, taken as a souvenir and kept in homes all over the world, recalling a moment when medals, once the preserve of monarchs, had become an enormously popular form of art.

Notes

1 Hill 1930, 1: no. 1; M. Jones 1987, 57.
2 M. Jones 1979b; Scher 1994, 32–37, nos. 1, 2.
3 Mazerolle 1902–4, 2: nos. 1–9; M. Jones 1982–88, 1: nos. 8–11.
4 Scher 1994, 138.
5 Hill 1930, 1: 211–12 and no. 484.
6 Attwood 2003, no. 768.
7 M. Jones 1982–88, 1: no. 15.
8 M. Jones 1982–88, 1: no. 16; Scher 1994, no. 141.
9 Margaret's medal weighed 140 Savoyard gold ducats. Ibid.
10 M. Jones 1982–88, 49; Scher 1994, 142.
11 Mazerolle 1902–4, 1: no. 13; M. Jones 1982–88, 1: 52.
12 Bloomfield 1952.
13 M. Jones 2016.
14 M. Jones 1982–88, 1: 9.
15 A gold coin valued at three *livres,* the *écu* was central to the French monetary system.
16 M. Jones 1982–88, 1: no. 83.
17 Ibid., 128.
18 M. Jones 1982–88, 1: no. 121; Scher 1994, no. 144.
19 Mazerolle 1902–4, 2: nos. 232–40; M. Jones 1982–88, 1: nos. 114–20.
20 M. Jones 1982–88, 2: 44n.16.
21 Ibid., 58–61, no. 15.
22 Ibid., 37.
23 M. Jones 1982–88, 2: 59; Scher 1994, no. 146.
24 M. Jones 1982–88, 2: no. 50; Scher 1994, no. 149.
25 M. Jones 1982–88, 2: 187.
26 Ibid., 208.
27 Charles Perrault, quoted in Mazerolle 1932, 28.
28 M. Jones 1982–88, 2: 259.
29 Ibid., 307.
30 De Chantelou 1981, passim.
31 M. Jones 1982, 117; M. Jones 2015; Wellington 2015; M. Jones in Loskoutoff 2016.
32 *Papers of Benjamin Franklin* 2001, 644.
33 Margolis 2015, 195ff; *Papers of Benjamin Franklin* 2006, 128; J. W. Adams and Bentley 2007, esp. 183ff.
34 Griffiths 1990b.
35 Griffiths 1990a.
36 Ibid., 27.
37 Inspired by the figure of the Apennine Colossus by Giambologna at the Villa di Pratolino.
38 Reinis 1999, xvii.
39 Maier 2010, 145–61.
40 Ibid., 162–79.
41 This is the inscription on the medal.
42 Maier 2010, 206–10.

504

Literature: M. Jones 1979b; M. Jones 1982–88, 1: nos. 1, 2, 3 (var.), 4 (var.); Scher 1994, nos. 1, 1a; Scher in Evans 2004, no. 323a; Pollard 2007, 2: 597; T. L. Jones 2010.

504

Unknown artist
CONSTANTINE THE GREAT, EMPEROR OF ROME (b. 285; r. 307–37)
1402/13
Copper alloy, cast; 93.2 mm
Scher Collection

Obverse: Constantine, bearded and crowned, on horseback, wearing a long outer robe that falls in many folds, with a V-shaped collar and half-length sleeves with long hanging ends in the back; on the emperor's breast on a pleated shirt or undergarment, a large cross. Inscriptions: CONSTANTINVS IN XP[ist]O DEO FIDELIS IMPERATOR ET MODERATOR ROMANORVM ET SEMPER AVGVSTVS [Constantine, faithful in Christ God, leader and ruler of the Romans, forever august]; in the field, below, Z 34.

Reverse: A large fountain composed of a basin of water and inside a smaller basin containing a tall plant with long leaves and flowered stalks; on the rim of the smaller basin, a relief of a child holding two serpents by their tails; emerging from the plant, a large cross, topped with four birds' heads, from which water gushes; at the base of the outer basin, an arched opening with a lion above; the foot of the cross visible through the opening, with a serpent around it; two seated female figures flanking the fountain, one old and clothed, the other young and partially naked, her left leg extended and her foot resting on a small, elongated animal; beside each woman, a perch with a bird of prey. Inscriptions: MIHI ABSIT GLORIARI NISI IN CRVCE DOMINI NOSTRI I[e]HV XP[ist]I [God forbid that I should glory in anything save in the Cross of our Lord Jesus Christ (Galatians 6:14)]; in the field, on the left and right side of the plant in the fountain, just below the arm of the cross, Z 3 5.

This medal, along with the following one, is among the most important sources for the portrait medals that emerged in Italy in the fifteenth century, the history of which is complex and not fully understood. The two medals appear to derive from a set of eight gold discs recorded in the collection of Jean de France, Duke of Berry (1340–1416). These discs, the originals of which do not survive, bore reliefs related to Roman emperors on both sides and were mounted in jeweled frames to be worn around the neck. The duke commissioned copies of the discs to be made in gold depicting Constantine and Heraclius. These were not subsequently mounted or embellished with jewels. The present examples are among many made of these initial copies in various materials since the fourteenth century. Their style suggests a Franco-Flemish artist, though the originals may have been Italian. Based on style, Scher (1994) attributes them to Michelet Saulmon (act. 1375–1416), the duke's court painter. Both medals are related to the history of the True Cross. There is no consensus regarding the iconography of the reverse of the present medal. Mark Jones (1979) argues that the two female figures on the reverse are Sarah and Hagar, the mothers of Abraham's sons Isaac and Ishmael. The reverse is an elaborate allegory of the True Cross and the Fountain of Life. It was Constantine's mother, Helena, who discovered the True Cross in the location where it had been buried. ADC

505

505

Unknown artist

HERACLIUS I, EMPEROR OF BYZANTIUM (b. ca. 575;
r. 610–41)

1402/13

Copper alloy, cast; 98.9 mm

Scher Collection

Obverse: Heraclius with his face in profile, looking up toward light
rays; his bust faces three-quarters to the right and rests on a crescent
moon. He wears a pleated cloak and crown composed of circlets
with points resembling fleurs-de-lis, two rows of large leaves, and a
conical center that appears to be made of cloth. Inscriptions: around
the edge, ΗΡΑΚΛΕΙΟC ΕΝ Χ[ΡΙCΤ]Ω ΤΩ Θ[Ε]Ω ΠΙCΤΟC ΒΑCΙ[ΛΕΥC] ΚΑΙ
ΑΥΤΟ[ΚΡΑΤΩΡ] ΡΩ[ΜΑΙΩΝ] ΝΙΚΙΤΗC ΚΑΙ ΑΘΛΟΘΕΤΗC ΑΕΙ ΑΥΓΟΥCΤΟC
[Heraclius, faithful in Christ God, king and emperor of the Romans,
victorious and triumphant, forever august]; in the field, to the left
behind his head, ΑΠΟΛΙΝΙC [?]; in the field, in front of him, ILLVMINA
UVL / TVM TVVM DEU[s] [Cause thy face to shine, O God (Psalm
66:2)]; on the crescent moon, SVPER TENEBRAS NOSTRAS MILLITABOR /
IN GENTIBVS [Upon our darkness I shall make war among the
heathens].

Reverse: Heraclius crowned and wearing a pleated cloak over an
undergarment in a cart drawn by three horses with harnesses made
of bands decorated with high raised knots; a groom holding a
whip, his face turned toward the rear; the cart covered with heavy
drapery and the emperor seated in the front on a draped throne and
holding a cross in his left hand; above, four lamps hang from a pole
across the field. Inscriptions: around the edge, SVP ER ASPIDEM ET
BAXILISCVM AMBVLAVIT ET CONCVLCAVIT LEONEM ET DRACONEM [He
has trodden on the asp and the basilisk and trampled on the lion
and the dragon (adapted from Psalm 90:13)]; across the field, ΛΟΞΑ
ΕΝ ΥΨΙC[ΤΟ]ΙC Χ[ΡΙCΤ]Ω ΤΟ Θ[Ε]Ω ΟΤΙ ΔΙΕΡΡΗΞΕ CΙΔΗΡΑC ΠΥΛΑC ΚΑΙ
ΕΛΕΥΘΕΡΩCΕΝ ΑΓΙΑΝ ΒΑCΙ[ΛΕΩC] ΗΡΑΚΛΕΙΟΥ [Glory to God in the
highest, because he has broken the iron gates and freed the Holy
Cross, during the reign of Heraclius].

Literature: M. Jones 1982–88, 1: nos. 5, 6 (var.), 7; Scher 1994,
no. 2; Evans 2004, no. 3238; Pollard 2007, 2: no. 598; T. L. Jones
2010.

See no. 504 and the essays by Scher and Pfisterer in this publication.
On the obverse, the inscription ΑΠΟΛΙΝΙC is meaningless and may
indicate a mistake or ignorance of Greek on the part of the author
or maker. Hill (1910a) proposes its reading as ΑΠΟΛΕΙ ΠΕΙC (apolipis,
or thou art waning). This medal celebrates the recovery of the True
Cross by Heraclius during his defeat of the Persians and his return of
the cross to Jerusalem. ADC

506

506

Unknown artist
CHARLES VII, KING OF FRANCE (b. 1403; r. 1422–61)
Dated 1455
Silver, struck; 62 mm
Scher Collection

Obverse: Charles, crowned and wearing, over armor, a surcoat with three fleurs-de-lis, visor closed and brandishing a sword, riding a horse in a fleur-de-lis-adorned caparison. Inscriptions: outermost, FERRO PACEM QVESITAM IVSTICIA MAGNA CONSERVAS XPO[CHRISTO] DEVOTVS MILITES; middle, DISCIPLINA COHERCENS IN EVVM REGNES HOS INSIGNES PERAGENS; innermost, ACTVS TEMPORA DE LICTERIS HIC ET RETRO RESPICE SIES [After having conquered peace with the sword you maintain it through your great justice, soldier devout to Christ. May you reign forever, preserving order and bringing to their conclusion these eminent deeds. If you want to know the period in which this medal was made, look at the numbers in the word HIC and back to the beginning of this present and last verse]; chronogram, 1455.

Reverse: A shield, crowned, bearing the arms of France Modern, and flanked by two flowering rose branches. Inscriptions: outermost, GLORIA PAX TIBI SIT REX KAROLE LAVS Q3[que] PERHENIVS REGNVM FRANCORV[m]; middle, TANTO DISCRIMINE LABENS HOSTILI RABIE VICTA VIRTVTE; innermost, REFORMANS XPI[CHRISTI] CONSILIO LEGIS ET AVXILIO [Glory, peace and eternal praise to you King Charles; when the king of France was running into such great danger, having defeated the rage of the enemy with your courage, you reestablished order with the counsel of Christ and the aid of the law].

Literature: M. Jones 1982–88, 1: nos. 11 (obv.), 8 (rev. as obv.).

Created to celebrate the expulsion of the English from France in 1453 and the subsequent end of the Hundred Years' War (1337–1453), this medal honors the French king, who, after the war, favored a conciliatory policy, pardoning many towns that had sided with the English. Various combinations of obverses and reverses exist. EM

507

Nicolas Leclerc (act. 1487–1507) and Jean de Saint-Priest (act. 1490–1516)
LOUIS XII, KING OF FRANCE (b. 1462; r. 1498–1515) and **ANNE OF BRITTANY** (1476–1514)
Dated 1499
Copper alloy, cast; 114.4 mm
Scher Collection

Obverse: Louis wearing his crown over a cap and the collar of the Order of St. Michael; in the field, fleurs-de-lis; in the margin, below the bust, the gardant lion of the city of Lyon. Inscription: FELICE LVDOVICO REGNA[n]TE DVODECIMO CESARE ALTERO GAVDET OMNIS NACIO [In the blessed reign of Louis XII, a second Caesar, the entire nation rejoices].

Reverse: Anne wearing a square-cut gown with a string of pearls and a double necklace with a pendant; over her hair, a veil and the crown; in the field, fleurs-de-lis on the left and ermine tails from the arms of Brittany on the right; in the margin, below the bust, the gardant lion of the city of Lyon. Inscription: LVGDVN[ensi] RE PUBLICA GAVDE[n]TE BIS ANNA REGNANTE BENIGNE SIC FVI CONFLATA 1499 [The commune of Lyon rejoicing twice in the reign of good Queen Anne, I was cast. 1499].

Literature: M. Jones 1982–88, 1: no. 15; Scher 1994, no. 140; Pollard 2007, 2: nos. 600 (var.), 601.

In 1499, Louis XII married Anne of Brittany, widow of Charles VIII. This medal (the collective work of a group of local artists influenced by Italian medalists) was commissioned by the city of Lyon on March 18 of that year. An example cast in gold was presented to the royal couple on their visit to Lyon in March 1500, and a specimen in copper was made for the town hall. ADC

507

508

509

508

Jean Marende (act. ca. 1502)
PHILIBERT II, "THE FAIR," EIGHTH DUKE OF SAVOY
(1480–1504) and **MARGARET OF AUSTRIA** (1480–1530)
ca. 1502
Copper alloy, cast; 103.7 mm
Scher Collection

Obverse: Philibert and Margaret behind a rustic fence; Margaret
wearing a square-cut gown, two strings of pearls, and a veil; in
the field, a pattern of marguerites and Savoy knots. Inscription:
PHILIBERTVS DVX SABAVDI[a]E VIII MARGVA[rita] MAXI[miliani] CAE[saris]
AVG[usti] FI[lia] D[ucissa] SA[baudiæ] [Philibert, Eighth Duke of Savoy,
Margaret, daughter of Maximilian, Caesar Augustus, Duchess of
Savoy].
Reverse: Shield with coat of arms of Austria impaling Savoy.
Inscriptions: GLORIA IN ALTISSIMIS DEO ET IN TERRA PAX HOMINIBVS
BVRGVS [Glory to God in the highest, and on earth peace to men.
Bourg (text derived from Luke 2:14)]; in the field, to the right and
left of the shield, F[ortitudo] E[ius] R[egnum] T[enit] [his courage
maintained the kingdom].
Literature: M. Jones 1982–88, 1: no. 16; Scher 1994, no. 141;
Pollard 2007, 2: nos. 602, 603.

This medal was made in two stages: a trial proof featuring fleurs-de-
lis around Margaret and a final model with marguerites and Savoy
knots. The young couple is portrayed in the enclosed garden (*hortus
conclusus*) of Christian and chivalric tradition, a symbol of pure love
appropriate to newlyweds. The marguerites are a pun on Margaret's
name, while the heraldic Savoy knots double as symbolic love knots.
A specimen in gold was presented to Margaret when she entered
Bourg-en-Bresse as Duchess of Savoy, on August 2, 1502. ADC

509

Unknown artist
PIERRE BRIÇONNET (d. 1509)
Dated 1503
Lead, cast; 68.6 mm
Scher Collection; Promised gift to The Frick Collection

Obverse: Briçonnet wearing a cap with an upturned brim, a doublet,
and a gown with pleated sleeves, as well as a chain or livery collar
around his neck. Inscriptions: PETRVS BRICONNET MILES FRANCIE
GENERALIS [Pierre Briçonnet, knight (of the Order of St. Michael) and
general of France]; MCCCCIII [1503].
Reverse: The Briçonnet coat of arms.
Literature: *Trésor de numismatique* 1834–58, 14: pl. LI, no. 3; Hill
1930, no. 847 (this specimen).

Briçonnet, Lord of Praville and Cormes, was notary and secretary to
Charles VIII of France in 1490 before becoming General of Finance
in Languedoc (1493–96). He was also mayor of Tours in 1496. This
example was reportedly recovered from the River Seine in Paris. EM

510

French School, after Giovanni Candida (ca. 1445/50–ca. 1498/99)
FRANÇOIS, DUKE OF VALOIS (1494–1547)
Dated 1504
Copper alloy, cast; 67.1 mm
Scher Collection

Obverse inscription: FRANCOIS DVC DE VALOIS COMTE DANGOLESME
AV X AN D[e] S[on] EA[ge] [François, Duke of Valois, Count of
Angoulême, at 10 years of his age].
Reverse: Salamander in flames. Inscription: NOTRISCO AL BVONO
STINGO EL REO MCCCCIIII [I feed upon the good fire and extinguish
the bad, 1504].
Literature: Hill and Pollard 1967, no. 232; Pollard 2007, 2: no. 606.

This medal commemorating the duke's tenth birthday was
commissioned by his mother, Louise of Savoy, as a companion to a
medal depicting Louise and her daughter, Marguerite of Angoulême
(no. 511). The medals belong to a group of early sixteenth-century
medals of the French court long associated with the Italian Giovanni
Candida, whose medals served as a model from which French
medalists developed a local style. This is the first appearance of the
salamander emblem that Francis would use as king of France, which
he was crowned as in 1515. ADC

510

511

French School, after Giovanni Candida (ca. 1445/50–ca. 1498/99)
LOUISE OF SAVOY (1476–1531) and **MARGUERITE OF ANGOULÊME** (1492–1549)
ca. 1504–12
Copper alloy, cast; 68.7 mm
Scher Collection

Obverse: Louise wearing a widow's veil. Inscription: LOYSE DVCHESSE DEVALOIS COMTESSE DANGOLESME [Louise, Duchess of Valois, Countess of Angoulême].
Reverse: Marguerite wearing a *coiffe à templette* under a *chaperon*. Inscription: MARGVERITE FILLE DE CHARLES COMTE DANGOLESME [Marguerite, daughter of Charles, Count of Angoulême].
Literature: Hill 1930, no. 852; Scher 1994, no. 138.

Louise, wife of Charles d'Orléans, Count of Angoulême (1459–1496), was the mother of Marguerite and François of Angoulême (future King Francis I). This medal is contemporaneous with a 1504 medal of Francis issued for his tenth birthday (see no. 510); together, they may have been issued to assert Francis's claim to the throne at a time when Louis XII was gravely ill and without a direct heir. The king, however, recovered and lived until 1515. ADC

512

Unknown artist
MARGUERITE DE FOIX (1473–1536)
Dated 1516
Silver, struck; 43.6 mm, 39.2 g (*tallero* coin)
Scher Collection

Obverse: Marguerite wearing a widow's veil. Inscription: MARGARITA DE FVXO MARCHIONISA SALVCIAR[um] T[utrix et] C[uratrix] 1516 [Marguerite de Foix, Marchioness of Saluzzo, protector (and) guardian, 1516].
Reverse: A jousting shield with the arms of Saluzzo impaled by Béarn and Foix hanging from a barren and uprooted tree on which a dove perches. Inscription: DEVS PROTECTOR ET REFVGIVM MEVM I IC [God is my protector and my refuge … (?)].
Literature: Scher 1994, no. 34.

This medallic coin (*tallero*) was made for Marguerite, Marchioness of Saluzzo and wife of Ludovico II di Saluzzo, at a coin weight (forty *grossi*) but was probably never meant to circulate as currency. Marguerite is presented as a widow and regent, a position she held from Ludovico's death in 1504, when her eldest son was only nine years old, until 1521. The barren tree alludes to the death

511

512

of Ludovico, the bird perhaps to life after death. Though several interpretations have been proposed for the letters "I IC" in the reverse inscription (which also appear on Ludovico's coins from 1503), their meaning remains a mystery. ADC

513

Jacques Gauvain (before 1501–after 1547)
BARTOLOMEO PANCIATICHI (1468–1533)
Dated 1517
Copper alloy, cast; 45.4 mm
Scher Collection

Obverse inscription: BARTHOLOMEVS PANCIATIC[us] CIVIS
FLORE[n]TI[nus] [Bartolomeo Panciatichi, citizen of Florence].
Reverse: Arms of Panciatichi. Inscriptions: HANC CAPELLA[m]
FVNDAVIT AN[n]O D[omi]NI M DXVII [He founded this chapel in the
year of the Lord 1517]; in the field, to the left and right of the
heraldic shield, L[eo] X [Leo X].
Literature: Hill and Pollard 1967, no. 533; Pollard 2007, 2: no. 612.

Originally from Pistoia, Panciatichi owned a Florentine trade
company based in Lyon. This is the foundation medal for a chapel in
the church of the Jacobins in Lyon, where a specimen of the medal
was recovered. The coat of arms on the reverse features a ball with
the French fleur-de-lis and the letters "L" and "X" to commemorate
Pope Leo X, who granted the family arms on the occasion of his
entrance into Florence in 1515. ADC

514

Jacques Gauvain (before 1501–after 1547)
ANTOINE, DUKE OF LORRAINE AND BAR (1489–1544)
and **RENÉE DE BOURBON** (1494–1539)
1521–25
Silver, struck; 40 mm
Scher Collection

Obverse: Antoine wearing a hairnet and hat ornamented with a
badge bearing the letter "A." Inscription: [cross of Lorraine] ANTHONIVS
D[ei] G[ratia] LOTHO[rum] ET Ba[rri] DUX [Antoine, by the grace of God,
Duke of Lorraine and Bar].
Reverse: Renée wearing a coif. Inscription: RENATA DE BORBO[n]IA
LOTHO[rum] ET BA[rri] DUCISSA [Renée de Bourbon, Duchess of
Lorraine and Bar].
Literature: M. Jones 1982–88, 1: no. 29; Scher 1994, no. 142;
Pollard 2007, 2: no. 610.

Raised at the court of Louis XII, Antoine married Renée de Bourbon
in 1515. He was close to the Duke of Angoulême, the future
Francis I, King of France, and after 1521 wore a beard (as seen here)
following Francis's fashion. Eventually, Antoine and his son broke
their allegiance to the French king to support Francis's principal
enemy, Holy Roman Emperor Charles V. ADC

513

514

515

515

Unknown artist

TOMMASO GUADAGNI (1454–1533)

Dated 1523

Copper alloy, cast; 100.1 mm

The Frick Collection; Gift of Stephen K. and Janie Woo Scher, 2016
(2016.2.18)

Obverse inscription: DE GVADAGNIS CI[vis] FLO[rentinus] [Guadagni, citizen of Florence].

Reverse inscription: In the field, in twelve lines, NOBILIS / THOMAS DE / GVADAGNIS CIVIS / FLOR[entinus] CONSILIARI=VS ATQ[ue] ORDINARIVS / MAGISTER DOMVS CH=RISTIANISSIMI FRAN=CISCI P[rimi] GALLOR[um] R[egi] AC / DV[m] MEDIO HA[n]C CAPPE[llam] / FACIE[n]DAM CVRAVIT / AN[no] D[omini] M D XX / III [The noble Tommaso Guadagni, citizen of Florence, councilor and majordomo of the most Christian King of the French, Francis I, while seeing through the construction of this chapel, in the year of the Lord 1523].

Literature: Pollard 2007, 2: no. 613 (var.).

Guadagni, an important Florentine banker in Lyon, became councilor and majordomo to Francis I in 1523, the same year the medal was issued to commemorate the foundation of his family chapel in the church of the Jacobins in Lyon. ADC

516

Regnault Danet (act. ca. 1529–38)

PIERRE BRIÇONNET (d. 1509) and **ANNE COMPAING**
(dates unknown)

ca. 1530

Copper alloy, cast; 34.7 mm

The Frick Collection; Gift of Stephen K. and Janie Woo Scher, 2016
(2016.2.35)

Obverse inscription: TAIRE OV BIEN DIRE [Say nothing or speak well].
Reverse inscription: SANS VARIER [Without change].
Literature: Hill and Pollard 1967, no. 540; Pollard 2007, 2: no. 618.

Briçonnet was the General of Finance of Languedoc (1493–96) and mayor of Tours in 1496. The legends surrounding his portrait and that of his wife are a prescription for married life (see also no. 509). ADC

516

517

517

Unknown artist
CHARLES III, DUKE OF LORRAINE (1543–1608)
ca. 1545
Copper alloy, cast; 36 mm
The Frick Collection; Gift of Stephen K. and Janie Woo Scher, 2016
(2016.2.16)

Obverse: The young Charles, wearing a soft collar, a chain around
his neck, a rich doublet with puffed and slashed sleeves and fur
collar, with a pair of gloves in his hand, and the hilt of a sword
showing. Inscription: KAROLI D[ei] G[ratia] LOTOR[ingiæ] BAR[ri] GEL[riæ]
DVX [Charles, by the grace of God, Duke of Lorraine, Bar, and
Guelders/Gelderland].
Reverse: The Lorraine coat of arms, with ducal crown, supported
by four genies; laurel leaves as border. Inscription: ANDVRER POVR
RECOVVRIRE [Endure in order to recover].
Literature: Mazerolle 1902–4, 2: no. 400.

Charles became a duke in 1545, at a very young age, and was
encouraged to maintain strong connections with the French despite
Lorraine having upheld, for half a century, a policy of autonomy and
neutrality in relations with both France and Germany. Though he
married one of the daughters of Henri II, King of France, he gradually
distanced himself from his French upbringing. He is remembered for
his promotion of economic development and financial and judicial
reforms. EM

518

Alexandre Olivier (1527–before 1607) and/or Pierre Regnier
(ca. 1577–after 1640)
DIANE DE POITIERS, DUCHESS OF VALENTINOIS
(1499–1566)
ca. 1548 (obverse design); ca. 1602 (reverse design); a later striking
Gilt copper alloy, struck; 52.7 mm
The Frick Collection; Gift of Stephen K. and Janie Woo Scher, 2016
(2016.2.63)

Obverse: Diane wearing a French hood and a gown with a plain
bodice and puffed sleeves. Inscription: DIANA DVX VALENTINORVM
CLARISSIMA [Diane, most celebrated Duchess of Valentinois].
Reverse: Juno, her peacock beside her, watering a lily with her breast
milk; the lily placed in a vase resting behind the legs of a recumbent
female figure (probably Prosperity or Abundance) leaning on a
cornucopia; above, the sun shining through the clouds; in exergue, a
laurel and palm branch joined. Inscription: ORITVR ET LACTE VIRESCIT
[He is born and milk makes him strong].
Literature: M. Jones 1982–88, 1: no. 235.

This medal is what is termed a "mule," that is, a medal composed of
the obverse of one medal with the reverse of another, in this case a
medal of Henri II (see M. Jones 1982–88, 1: no. 190). Diane was the
longstanding mistress of Henri II of France; she respected his wife
Catherine de' Medici's role as mother of the heirs to the throne and
is said to have taken an active interest in the royal couple's family,
even nursing Catherine to health when she was ill. The reverse has
no connection with Diane but was associated with a medal of Henri
II and refers to him and to the queen Catherine de' Medici, depicted
as Juno, who, through her offspring, is watering the lily of France
with her breast milk, thus leading to the Prosperity represented by
the reclining figure with the cornucopia. SKS

518

519

519

Unknown artist

Possibly **CATHERINE DE' MEDICI** (1519–1589; Queen Consort of France 1547–59, Queen Regent of France 1560–74)

ca. 1559

Copper alloy, cast; 77.3 mm

The Frick Collection; Gift of Stephen K. and Janie Woo Scher, 2016 (2016.2.15)

Obverse: The sitter wearing a French hood and contemporary dress.
Literature: M. Jones 1982–88, 1: no. 116.

Jones identifies the sitter as Catherine de' Medici as a widow, though without confirmation: the subject is not wearing a widow's headgear but rather a French hood. EM

520

Etienne Delaune (ca. 1518–ca. 1583)

HENRI II, KING OF FRANCE (b. 1519; r. 1547–59)

Dated 1552

Gilt copper alloy, cast; 54.1 mm

Scher Collection; Promised gift to The Frick Collection

Obverse: Henri wearing a laurel wreath, decorated armor, ruff, and the Order of St. Michael. Inscription: HENRICVS II GALLIARVM REX INVICTISS[imus] P[ater] P[atriæ] [Henri II, most invincible King of the French, father of his country].

Reverse inscription: In a laurel wreath, in nine lines, RESTITVTA / REP[ublica] SENENSI / LIBERATIS OBSID[ione] / MEDIOMAT[ricis] PARMA / MIRAND[ola] SANDAMI[ano] / ET RECEPTO / HEDINIO / ORBIS CONSENSV / 1552 [The republic of Siena restored; Metz, Parma, Mirandola and San Damiano delivered from siege and Hesdin retaken, with the approval of the world, 1552].

Literature: M. Jones 1982–88, 1: no. 66; Pollard 2007, 2: no. 620.

One of several variants (see no. 521), this medal refers to successes of Henri II against the Holy Roman Empire in Italy and France in 1552, though it may have been produced at a later date. It and its variants appear to be modeled or cast after an original (probably struck) medal bearing the date 1552 on the reverse. ADC

520

521

522

521

Etienne Delaune (ca. 1518–ca. 1583)
HENRI II, KING OF FRANCE (b. 1519; r. 1547–59)
After 1552
Gilt copper alloy, cast; 53 mm
The Frick Collection; Gift of Stephen K. and Janie Woo Scher, 2016
(2016.2.31)

Obverse: Henri wearing a laurel wreath and decorated armor, ruff, and the Order of St. Michael. Inscription: HENRICVS II FRANCOR[um] REX INVICTISS[imus] P[ater] P[atriæ] [Henri II, most invincible King of the French, father of his country].
Reverse: Personifications of Victory, Abundance, and Fame riding a triumphal cart pulled by four horses. Inscriptions: TE COPIA LAVRO ET FAMA BEARVNT; in the field, below the cart, NV[m]I[n]A [The gods have blessed you with plenty, victory and fame].
Literature: M. Jones 1982–88, 1: no. 69; Pollard 2007, 2: no. 619.

See the commentary for no. 520. ADC

522

Attributed to Etienne Delaune (ca. 1518–ca. 1583)
HENRI II, KING OF FRANCE (b. 1519; r. 1547–59)
Dated 1551
Silver, struck; 34.7 mm
Scher Collection; Promised gift to The Frick Collection

Obverse inscription: HENRICVS II D[ei] G[ratia] FRAN[corum] REX [Henri II, by the grace of God, King of the French].
Reverse: Fame, standing on a globe, blowing one trumpet and holding another. Inscription: SVA CIRCVIT ORBE FAMA 1551 [His fame encircles the globe, 1551].
Literature: M. Jones 1982–88, 1: no. 60.

The inscribed date coincides with Henri II's announcement of the Edict of Châteaubriant, which formed part of his program of persecuting French Protestants through censorship, draconian judicial and other sanctions, and burnings at the stake. EM

523

Attributed to Etienne Delaune (ca. 1518–ca. 1583)
HENRI II, KING OF FRANCE (b. 1519; r. 1547–59)
ca. 1552
Copper alloy, cast; 54.7 mm
Scher Collection; Promised gift to The Frick Collection

Obverse: Henri, laureate, and in classical dress (armor and a commander's sash, clasped on the right shoulder). Inscription: HENRICVS II GALLIARVM REX INVICTISS[imus] P[ater] P[atriæ] [Henri II, most invincible King of the French, father of his country].
Reverse: Two generals, each with an army behind him, shaking hands as Victory flies overhead.
Literature: M. Jones 1982–88, 1: no. 72.

523

Henri allied himself with Protestant German princes as part of his Italian Wars against their common enemy, Charles V, the Holy Roman Emperor. The reverse depicting generals shaking hands may celebrate this alliance, formalized by the 1552 Treaty of Chambord or the much older one between France and the Ottoman Empire (which Henri also approached in 1552, when he needed greater manpower to fight Charles). EM

524

After Marc Béchot (1520–1557)
HENRI II, KING OF FRANCE (b. 1519; r. 1547–59)
Dated 1522
Copper alloy, cast; 59.4 mm
Scher Collection

Obverse: Henri in ornately decorated armor, a laurel wreath, and the livery collar and badge of the Order of St. Michael. Inscription: HENRICVS II REX CHRISTIANISSIMVS [Henri II, most Christian king].
Reverse: A pileus-like hat between two swords. Inscriptions: above, in two lines, LIBER / TAS [Liberty]; below, in five lines, VINDEX /

ITALICÆ ET / GERMANICÆ / LIBERTATIS / 1522 [avenger of liberty in Italy and Germany, 1522].
Literature: Mazerolle 1902–4, 2: no. 91.

This medal celebrates Henri's renewal of the Italian Wars against Charles V. These wars had begun under Henri's father, Francis I, and ranged far beyond France and Italy in a struggle for supremacy across Europe. The "Liberty cap" and two swords on the reverse refer to Brutus's "Ides of March" *denarii*, which bear the image of a pair of daggers flanking a pileus. That Henri chose to identify himself with a man who violently overthrew a self-proclaimed emperor resonates with his own claim to have been a liberating force in the battle against the Holy Roman Emperor. EM

525

Unknown artist
HENRI II, KING OF FRANCE (b. 1519; r. 1547–59)
Dated 155[2(?)]
Copper alloy, cast; 83.7 mm
Scher Collection

Obverse: Henri, in a flat, plumed cap, wearing embossed armor with a tall gorget, a small ruff, and a medal suspended from his neck by a ribbon. Inscriptions (incuse): HENRICVS II GALLIARVM REX INVICTISS[imus] P[ater] P[atriæ] [Henri II, most invincible King of the French, father of his country]; 155[2(?)]
Literature: Mazerolle 1902–4, 2: no. 331.

A casting flaw appears to have obscured the last digit of the date, which refers to the decade of Henri's Italian Wars (1551–59). EM

526

Germain Pilon (ca. 1525–1590)
HENRI II, KING OF FRANCE (b. 1519; r. 1547–59)
Dated 1559; made ca. 1575
Copper alloy, cast; 163.6 mm
Scher Collection

Obverse: Henri wearing a soft hat decorated with pearls and ostrich feathers on the left side, an embroidered high-collared shirt with an elaborate double necklace made of beads of gold filigree, and pearl earrings. Inscription: HENRICVS II GALLIAR[um] REX CHRISTIANISS[imus] P[ater] P[atriæ] 1559 [Henri II, most Christian King of the French, father of his country, 1559].
Literature: M. Jones 1982–88, 1: no. 114; Scher 1993b, 144–53; Scher 1994, no. 145.

Based on drawings and painted portraits by François Clouet (ca. 1510–1572), this medallion belongs to a series depicting the last members of the House of Valois, possibly commissioned by Henri's widow, Catherine de' Medici, about 1575. The 1559 date probably refers to the king's death on June 30 of that year from wounds sustained at a tournament celebrating the Peace of Cateau-Cambrésis and the wedding of his daughter Elisabeth of Valois to Philip II of Spain. ADC

526

527

528

527

Unknown artist
JEANNE D'ALBRET, QUEEN OF NAVARRE (b. 1528; r. 1555–72)
Dated 1564
Silver, struck; 29.4 mm, 9.4 g (coin)
Scher Collection

Obverse: Jeanne, hair pinned under an attifet (a type of hood), wearing a bodice with a high-necked collar and a small ruff. Inscriptions: IOA[n]NA DEI G[ratia] REG[ina] NAVAR[ræ] D[omina] B[earni] [Jeanne, by the grace of God, Queen of Navarre and Lady of Béarn]; P[?]; below the bust, a cow-shaped mark of the mint of Pau.
Reverse: Crowned arms of Jeanne; on either side, a crowned "I" for Jeanne. Inscription: GRATIA DEI SVM ID QVOD SVM 1564 [By the grace of God I am what I am, 1564].
Literature: Poey d'Avant 1858–62, 2: no. 3440.

In her time, Jeanne was one of the most powerful and formidable champions of the Huguenot cause. In 1564, she uncovered and foiled the conspiratorial plans of her enemies, notably Philip II of Spain and Pope Pius IV, to invade Lower Navarre and have her abducted and delivered to the Inquisition to be tried as a heretic. After Jeanne's death, her title passed to her son, who, as Henri IV of France, would continue to protect Protestant interests and bring a new unity and prosperity to a nation ravaged by religious wars. EM

528

Antoine Brucher (act. 1554; d. 1568)
HENRI II, KING OF FRANCE (b. 1519; r. 1547–59),
CATHERINE DE' MEDICI (1519–1589; Queen Consort of France 1547–59, Queen Regent of France 1560–74), and **CHARLES IX, KING OF FRANCE** (b. 1550; r. 1560–74)
Dated 1566
Silver, struck; 38.9 mm
Scher Collection; Promised gift to The Frick Collection

Obverse: Henri, laureate, and in armor and a commander's sash, knotted on the shoulder, facing Catherine, in a plain French hood and widow's veil, wearing a high-necked bodice, trimmed at the collar and open in front. Inscription: HENRICVS II GALLOR[um] REX INVICTIS[simus] ET CATHARINA EIVS VXOR [Henri II, most invincible King of the French, and Catherine, his wife].
Reverse: Charles, laureate, and in armor, a commander's sash, and the medal of the Order of St. Michael suspended from a ribbon.

Inscriptions: CAROLVS IX GALLOR[um] REX EORVM FILLIVS [Charles IX, King of the French; their son]; 1566.
Literature: M. Jones 1982–88, 1: no. 94.

In 1566, Charles IX concluded his grand tour of France, an event organized by Catherine, who was notorious for the influence she had over her son (despite no longer technically being his regent). Most infamously, Catherine seems to have impelled Charles—who, like his father and brothers, ruled during the bloody Catholic-Protestant civil wars—to give the orders for the St. Bartholomew's Day massacre, in which thousands of Huguenots were murdered over a three-day period. EM

529

After Guillaume Martin (ca. 1520–ca. 1590)
CATHERINE DE' MEDICI (1519–1589; Queen Consort of France 1547–59, Queen Regent of France 1560–74), **FRANÇOIS II, KING OF FRANCE** (b. 1544; r. 1559–60), **CHARLES IX, KING OF FRANCE** (b. 1550; r. 1560–74) and **HENRI III** (b. 1551; King of Poland 1573–75; King of France 1574–89)
ca. 1574
Gilt copper alloy, struck; 54.8 mm
The Frick Collection; Gift of Stephen K. and Janie Woo Scher, 2016 (2016.2.51)

Obverse: Catherine, in a widow's hood and veil, wearing a high-necked bodice with a small ruff. Inscription: CATHAR[ina] HEN[rici] II VXOR FRAN[cisci] II CAROL[i] IX ET HEN[rici] III REG[um] GALL[iæ] MATER PIISS[ima] [Catherine, wife of Henri II, most pious mother of François II, Charles IX, and Henri III, Kings of France].
Reverse: Henri III (top), François II (bottom left), and Charles IX (bottom right), all laureate. Inscription: FRANCISC[us] II CAROL[us] IX REGES GALL[iæ] HENRIC[us] III GALL[iæ] ET POL[oniæ] REX [François II, Charles IX, Kings of France; Henri III, King of France and Poland].
Literature: Mazerolle 1902–4, 2: no. 124; M. Jones 1982–88, 1: no. 85.

Catherine held little real power during her husband's reign. After his death, however, she wielded considerable political influence as queen regent for her first two sons, when each was in power. Though she was never regent for her third son, Henri III, she influenced him in her capacity as queen mother. Her sons were the last three kings of the Valois dynasty. EM

529

530

Unknown artist

CATHERINE DE BOURBON, DUCHESS OF BAR (1558–1604)

Dated 1599

Copper alloy, cast; 52.1 × 41.3 mm

Scher Collection

Obverse inscriptions: CATH[erine] DE BOVRBON DVCHESSE DE BAR [Catherine de Bourbon, Duchess of Bar]; 1599.

Reverse: The three Graces, two holding flowers. Inscription: OV QVATR OV VNE [Either four or one].

Literature: Mazerolle 1902–4, 2: no. 405.

Catherine married Henri, Duke of Bar, later Duke of Lorraine, in 1599. The marriage is said to have been unhappy: by the time her brother, Henri IV of France, finally allowed her to marry, she was in her forties and unable to bear children. The king had also promised the duke that his Calvinist sister would convert to Catholicism, but Catherine, an avid writer of religious poetry, refused. The wedding was annulled a few years before her death. The Princess of Bourbon cultivated a life of the mind, and this medal presents her as a classical figure or a sort of fourth Grace, an embodiment of all the qualities of the three Graces. EM

531

Danfrie family

HENRI IV, KING OF FRANCE (b. 1553; r. 1589–1610)

Dated 1604

Silver gilt, struck; 44.5 mm

Scher Collection; Promised gift to The Frick Collection

Obverse: Henri, bearded and laureate, wearing a soft collar, armor with a tall gorget, a commander's sash knotted at the shoulder, and the Order of the Holy Spirit suspended from a ribbon. Inscriptions: HENRICVS IIII FRANC[iæ] ET NAVA[rræ] REX [Henri IV, King of France and Navarre]; DANFR[ie].

Reverse: Minerva, dressed in armor, holding a lance in her right hand and leaning with her left on a shield emblazoned with fleurs-de-lis, standing upon an ornate pedestal (inscribed PALLADIVM) before urban scenes in a mountainous landscape. Inscriptions: MEA ME SIC GALLIA SOSPES [To me, my France that I have saved (erected this statue)]; in exergue, 1604.

Literature: Mazerolle 1902–4, 2: no. 28.

This medal, which may refer to the birth of the Dauphin, relates to medals by Guillaume Dupré showing Marie de' Medici as Minerva celebrating the arrival of an heir as saving the nation. The inscription PALLADIVM refers to the Trojan statue of Pallas Athena stolen by Odysseus and brought to Rome, where it was carefully preserved. EM

530

531

532

Guillaume Dupré (ca. 1579–1640)
HENRI IV, KING OF FRANCE (b. 1553; r. 1589–1610), and
MARIE DE' MEDICI (1575–1642; Queen Consort of France
1600–10, Queen Regent of France 1610–14)
Dated 1603
Silver, cast; 66.9 mm
The Frick Collection: Gift of Stephen K. and Janie Woo Scher, 2016
(2016.2.06)

Obverse: Jugate busts of Henri in highly decorated armor with a sash
and the Cross of the Order of the Holy Spirit on a ribbon around his
neck and Marie wearing a high lace collar and elaborately coiffed
hair with a rose-shaped jewel. Inscriptions: HENR[icus] IIII R[ex]
CHRIST[ianissimus] MARIA AVGVSTA [The most Christian King Henri IV;
Marie, august queen]; below truncation, G[uillaume] DVPRE F[ecit]
[Guillaume Dupré made it]; on truncation, 1603.
Reverse: The couple as Mars and Minerva with the dauphin as a
naked boy between; the king wearing a Roman cuirass and an
ancient sword at his waist; the queen in antique drapery with
ornamented breastplate and plumed helmet; the dauphin holding his
father's helmet and resting his right foot on the head of a dolphin,
behind which is a shield and a spear; above, an eagle with a crown
in its beak. Inscriptions: PROPAGO IMPERI [royal offering]; in exergue,
1603.
Literature: M. Jones 1982–88, 2: no. 15; Scher 1994, nos. 146 (var.),
146a (var.); Pollard 2007, 2: no. 637.

This medal commemorates the second birthday of the Dauphin of
France, the future Louis XIII. The reverse composition and legend
are based on a Roman coin of Plautilla, wife of Caracalla (ca. AD
202). The king was so pleased with Dupré's medal that he gave him a
ten-year monopoly on the images to be replicated and sold as many
times as he liked. ADC

533

Guillaume Dupré (ca. 1579–1640)
HENRI IV, KING OF FRANCE (b. 1553; r. 1589–1610)
Dated 1606
Copper alloy, cast; 136.4 mm (including frame)
Scher Collection

Obverse: Henri, bearded and laureate, wearing ornately decorated
armor with lion-headed pauldrons, a soft collar, a cape, and the
Order of the Holy Spirit suspended from a ribbon. Inscriptions:
HENRICVS IIII D[ei] G[ratia] FRANCOROM ET NAVAR[r]Æ REX [Henri IV, by
the grace of God, King of the French and of Navarre]; on truncation,
1606.
Literature: M. Jones 1982–88, 2: no. 20.

Henri IV's government revived the French economy through
promotion of international commerce and trade and brought unity
and peace to a nation ravaged by religious civil wars. Henri famously
converted to Roman Catholicism in order to reunify France, while
simultaneously guaranteeing the Huguenots their civil and legal
rights to religious freedom through his promulgation of the Edict of
Nantes. EM

534

Guillaume Dupré (ca. 1579–1640)
JEAN-LOUIS DE NOGARET DE LA VALETTE (1554–1642)
Dated 1607
Copper alloy, cast; 55.3 mm
Scher Collection

Obverse: Valette wearing a cuirass and gorget decorated with a
grotesque head on the front and a commander's sash. Inscriptions:
I[ean] L[ouis] A LAVALETA D[ux] ESPERN[onis] P[ar] ET TOT[ius] GAL[liæ]
PEDIT[atus] PRÆF[ectus] [Jean-Louis de la Valette, Duke of Épernon,
peer and general of the infantry of all of France]; G[uillaume] DVPRE
F[ecit] 1607 [Guillaume Dupré made it, 1607].

533

Reverse: A lion in the foreground, his left paw slightly raised to protect the flower below, growling at a half-naked old woman on the right, with a torch in her right hand; on the left, a fox emerging from woods. Inscription: INTACTVS VTRINQVE [Untouched from either side].
Literature: M. Jones 1982–88, 2: no. 22; Pollard 2007, 2: no. 639.

Valette, general of the French infantry in 1585 and admiral of France in 1587, was a favorite of Henri III. This medal probably commemorates a successful diplomatic mission to Metz and Strasbourg in 1605–7. The allegory on the reverse shows the French royal lion protecting a beautiful flower from Deceit (the fox) and Discord (the old woman). ADC

534

536

Reverse: Fame sounding one trumpet and holding another.
Inscriptions: ÆTERNA FAMA [Eternal fame]; D[u]P[ré].
Literature: M. Jones 1982–88, 2: no. 17.

This medal commemorates the death of Isabella Andreini, the leading lady of the Gelosi, the most famous of the early commedia dell'arte troupes. Andreini's genius, beauty, and talent attracted the patronage of such powerful figures as Charles Emmanuel I of Savoy and Henri IV of France. Andreini was also a philosopher, academician, linguist, poet, and theater critic; her formidable legacy lives on in the commedia dell'arte stock character Isabella, named in her honor. EM

535

Guillaume Dupré (ca. 1579–1640)
MARCANTONIO MEMMO (b. 1536)
Dated 1612
Lead, cast; 89.8 mm
Scher Collection; Promised gift to The Frick Collection

Obverse: Memmo wearing a richly brocaded gown with oblong buttons and the *corno*. Inscriptions: MARCVS ANTONIVS MEMMO DVX VENETIARVM [Marcantoinio Memmo, Doge of Venice]; below truncation, G[uillaume] DVPRÈ [*sic*] F[ecit] 1612 [Guillaume Dupré made it, 1612].
Literature: M. Jones 1982–88, 2: no. 37; Scher 1994, no. 147.

This medal was probably executed in Venice shortly after Memmo's election as doge on July 24, 1612. No record of the commission has been found, but Dupré was in Mantua working on a medal of Duke Francesco IV at the time and may have been called from there to Venice to congratulate the newly elected doge. ADC

537

Guillaume Dupré (ca. 1579–1640)
FRANCESCO DI FERDINANDO DE' MEDICI (1594–1614)
Dated 1613
Copper alloy, cast; 93.7 mm
Scher Collection

537

536

Guillaume Dupré (ca. 1579–1640)
ISABELLA ANDREINI (1562–1604)
Dated 1604
Copper alloy, cast; 41.6 mm
The Frick Collection; Gift of Stephen K. and Janie Woo Scher, 2016 (2016.2.05)

Obverse: Andreini, hair curled in front, piled high above her forehead, and braided into a chignon at the back, wearing a lace *reticella* collar, a pearl necklace, pearl tear-drop earrings, and a richly decorated bodice, open in front. Inscriptions: ISABELLA ANDREINI C[ompagnia dei] G[elosi] [Isabella Andreini, the Gelosi Company]; monogram, D[u]P[ré]; on truncation, 1604.

Obverse: Francesco, with short and wavy hair, wearing a plain, standing collar and armor with a gorget and a grotesque mask on the chest, with a commander's sash over his left shoulder. Inscriptions: D[ivus] PRINCEPS FRANCISCVS MEDICES [Divine Prince Francesco de' Medici]; on truncation, G[uillaume] D[u] P[ré] 1613.
Literature: M. Jones 1982–88, 2: no. 43.

While in Florence—almost certainly at the behest of Marie de' Medici, queen regent of France and a cousin of the sitter—Dupré created medals of Francesco (son of Ferdinando, Grand Duke of Tuscany) and other members of the Medici family, including his brother, Cosimo II (see no. 538). Francesco's military dress speaks to his role as commander of the Tuscan soldiers sent, in 1613, to aid a recently occupied Mantua and to his military aspirations, which were cut short by his death a year later. EM

538

Guillaume Dupré (ca. 1579–1640)
COSIMO II DE' MEDICI, GRAND DUKE OF TUSCANY
(b. 1590; r. 1609–21)
Dated 1613
Copper alloy, cast; 93.1 mm
Scher Collection

Obverse: Cosimo, with short hair swept back, wearing a millstone ruff, the badge of the Order of the Holy Spirit suspended from a ribbon, and ceremonial armor with a commander's sash, gorget, and ornate decoration. Inscriptions: COSMVS II MAGN[us] DVX ETRVRIÆ IIII [Cosimo II, the fourth Grand Duke of Tuscany]; beneath truncation, G[uillaume] D[u] P[ré] 1613.
Literature: M. Jones 1982–88, 2: no. 42.

The young grand duke's decorated parade armor recalls the great military leaders of antiquity, unlike the contemporary armor in which Dupré chose to represent his brother Francesco (no. 537), a commander actively involved in military matters. EM

539

Guillaume Dupré (ca. 1579–1640)
MARIA MADDALENA OF AUSTRIA (1587–1631)
Dated 1613
Copper alloy, cast; 92.6 mm
Scher Collection

Obverse: Maria Maddalena in court dress with a high lace ruff open to the front, hair curled in the front and elaborately arranged in braids in the back and with a jeweled brooch on the side, pearl tear-drop earrings, a pearl necklace, and a longer necklace with pendant. Inscriptions: MAR[iæ] MAGDALENÆ ARCH[iducissæ] AVSTR[iæ] MAG[næ] D[ucissæ] ETR[uriæ] [(Image of) Maria Maddalena, Archduchess of Austria, Grand Duchess of Tuscany]; below truncation, G[uillaume] D[u]P[ré] 1613.
Literature: M. Jones 1982–88, 2: no. 44 (obv.); Pollard 2007, 2: no. 643.

In 1608, Maria Maddalena, the daughter of Archduke Karl II of Inner Austria and sister of Emperor Ferdinand II, married the son of Ferdinando I de' Medici, Cosimo, who became Grand Duke of Tuscany as Cosimo II the following year. This medal is one of a group of portraits of members of the Medici house made by the artist during his visit to Florence. ADC

538

539

540

540

Guillaume Dupré (ca. 1579–1640)

CHRISTINE OF LORRAINE, GRAND DUCHESS OF TUSCANY (1565–1636)

1613

Copper alloy, cast; 93 mm

Scher Collection

Obverse: Christine wearing a widow's veil with a laced cap and a garment with a V-shaped collar. Inscription: CHRISTIANA PRINC[ipissa] LOTH[eringæ] MAG[na] DVX HETRVR[iæ] [Christine, Princess of Lorraine, Grand Duchess of Tuscany].
Literature: M. Jones 1982–88, 2: no. 45; Scher 1994, no. 148.

Christine married Ferdinando I de' Medici, Grand Duke of Tuscany, in 1589, was widowed in 1609, and, when her son Duke Cosimo II died in 1621, became regent for her then ten-year-old grandson Ferdinando. ADC

541

Guillaume Dupré (ca. 1579–1640)

MARIE DE' MEDICI (1575–1642; Queen Consort of France 1600–1610, Queen Regent of France 1610–14)

Dated 1615

Copper alloy, cast; 62.8 mm

Scher Collection; Promised gift to The Frick Collection

Obverse: Marie wearing a court dress with a large fan-shaped collar adorned in the front with a floral brooch and a pendant jeweled cross, her hair piled up in the back and curled in the front and a heart-shaped widow's cap, pearl tear-drop earrings, and a pearl necklace. Inscriptions: MARIA AVG[usta] GALLIÆ ET NAVAR[r]Æ REGINA [Marie, August Queen of France and Navarre]; G[uillaume] DVPRE 1615.
Reverse: Marie as Cybele steering a ship during a storm; on board, a group of six nudes, three men and three women; in the sky, two male heads emerging from the clouds, blowing wind. Inscription:

541

SERVANDO DEA FACTA DEOS [In protecting the gods she became a goddess].
Literature: M. Jones 1982–88, 2: no. 48; Pollard 2007, 2: no. 645.

After the assassination of Henri IV, the queen consort became regent for her son Louis XIII. In 1615, she issued a decree that strengthened her position, the occasion for which this medal may have been produced. The reverse illustrates one of her responsibilities as queen regent to preserve the safety of the state: as Cybele (the goddess venerated as tutelary deity of Rome), she steers the "ship of state" during a violent storm. Dupré produced six medals of Marie during her widowhood. ADC

Guillaume Dupré (ca. 1579–1640)
PIERRE JEANNIN (1540–1622)
Dated 1618
Copper alloy, cast; 187.5 mm
Scher Collection

Obverse: Jeannin wearing a robe with brocaded sleeve over a shirt with falling collar. Inscriptions: PETRVS IEANNIN REG[is] CHRIST[ianissimi] A SECR[etis] CONS[iliarius] ET SAC[ri] ÆRA[rii] PRÆF[ectus] [Pierre Jeannin, member of the private council of the most Christian King, superintendent of finances]; below truncation, G[uillaume] DVPRE F[ecit] 1618 [Guillaume Dupré made it, 1618].

542

543

Literature: M. Jones 1982–88, 2: no. 50 (var.); Scher 1994, no. 149 (var.); Pollard 2007, 2: no. 646 (var.).

Jeannin was Superintendent of Finances under Henri IV and Louis XIII (the latter, in 1617, restored him to this post, from which he had been temporarily ousted). This medal belongs to the second of two known types; possibly a reworking of the first type, the second is distinguished by subtle changes to the costume, including the addition of a brocade pattern to the robe and a different number of buttons on the shirt. AN

543
Guillaume Dupré (ca. 1579–1640)
LOUIS XIII, KING OF FRANCE (b. 1601; r. 1610–43) and
ANNE OF AUSTRIA (1601–1666; Queen Consort of France 1615–43, Queen Regent of France 1643–51)
Dated 1623
Copper alloy, cast; 59.7 mm
Scher Collection; Promised gift to The Frick Collection

Obverse: Louis XIII wearing a full ruff, armor, and commander's sash. Inscriptions: LVDOVIC[us] XIII D[ei] G[ratia] FRANCOR[um] ET NAVAR[r]Æ REX [Louis XIII, by the grace of God, King of the French and of Navarre]; below truncation, G[uillaume] DVPRE; on truncation (incised), 1623.
Reverse: Anne, her hair adorned with a diadem, wearing a high lace ruff open in front, pearl tear-drop earrings and matching pearl necklace, a gown with slashed sleeves and low neckline trimmed with lace, held in front with a star-shaped brooch, and a rose pinned to her left shoulder. Inscriptions: ANNA AVGVS[ta] GALLIÆ ET NAVAR[r]Æ REGINA [Anne, August Queen of France and Navarre]; G[uillaume] DVPRE F[ecit] 1620 [Guillaume Dupré made it, 1620].
Literature: M. Jones 1982–88, 2: no. 52 (var.); Pollard 2007, 2: no. 648 (var.).

Married in 1615 at the age of fourteen, the king did not approach his wife's bed until 1619. Finally, in 1638, after several miscarriages, Anne gave birth to the heir, the future Louis XIV. The disparity of dates on the obverse and reverse is an unresolved question. ADC

544
Guillaume Dupré (ca. 1579–1640)
ANNE OF AUSTRIA (1601–1666; Queen Consort of France 1615–43, Queen Regent of France 1643–51)
Dated 1620
Copper alloy, cast; 60.1 mm
Scher Collection; Promised gift to The Frick Collection

Obverse: Anne, her hair adorned with a diadem, wearing a high lace ruff open in front, pearl tear-drop earrings and matching pearl necklace, a gown with slashed sleeves and low neckline trimmed with lace, held in front with a star-shaped brooch, and a rose pinned to her left shoulder. Inscriptions: ANNA AVGVS[ta] GALLIÆ ET NAVAR[r]Æ REGINA [Anne, August Queen of France and Navarre]; beneath truncation, G[uillaume] DVPRE F[ecit] 1620 [Guillaume Dupré made it, 1620].
Literature: M. Jones 1982–88, 2: no. 54.

Anne and Louis XIII consummated their marriage in 1619, and Anne recovered from an illness in early 1620. EM

544

545

545

Guillaume Dupré (ca. 1579–1640)
CHARLES DE VALOIS (1573–1650)
Dated 1620
Copper alloy, cast; 45.4 mm
The Frick Collection; Gift of Stephen K. and Janie Woo Scher, 2016
(2016.2.09)

Obverse: Valois wearing armor, ruff, and commander's sash.
Inscriptions: CARO[lus] B[astardus] VALESIVS CAROLI NONI FILIVS
[Charles, bastard of Valois, son of Charles IX]; on truncation
(incised), 1620.
Reverse: A phoenix rising from ashes. Inscription: RARA CINERE RARVS
[A rare (man) from rare ashes].
Literature: M. Jones 1982–88, 2: no. 55; Pollard 2007, 2: no. 877.

In 1606, Valois was stripped of all his possessions and sentenced
to life imprisonment for his involvement in a conspiracy against
Henri IV. He was liberated in 1616 by Marie de' Medici. The reverse
imagery and legend could allude to this event and (with Charles
as the last remaining heir of the Valois family) the consequent
continuation of the Valois line. It could also allude to the "rebirth"
of Charles to a new life of respect and privilege. Jones suggests the
medal celebrates Louis XIII's 1620 gift to Valois of the duchy of
Angoulême and the county of Ponthieu. ADC

546

Guillaume Dupré (ca. 1579–1640)
LOUIS XIII, KING OF FRANCE (b. 1601; r. 1610–43)
Dated 1623
Copper alloy, cast; 62.4 mm
Scher Collection; Promised gift to The Frick Collection

Obverse: Louis in decorated armor, layered ruff, and commander's
sash. Inscriptions: LVDOVIC[us] XIII D[ei] G[ratia] FRANCOR[um] ET
NAVAR[r]Æ REX [Louis XIII, by the grace of God, King of the French
and of Navarre]; below truncation: G[uillaume] DVPRE; on truncation
(incised), 1623.
Reverse: Personification of Justice seated on an armchair with
armrests decorated with lions' heads, cradling a sword in her right
arm and a scale with her left hand. Inscriptions: VT GENTES TOLLAT
QVE PREMAT QVE [So that he may raise up and humble nations]; in
exergue, 1623.
Literature: M. Jones 1982–88, 2: no. 58; Pollard 2007, 2: no. 647.

Under the regency of his mother, Marie de' Medici, Louis became
king in 1610. Although the medal bears the date 1623, the portrait
type must date from 1620, when the king was beardless. The reverse
of the medal, featuring the personification of Justice and a scale,
illustrates the king's title, "Le Juste," and his zodiac sign, Libra. ADC

547

Guillaume Dupré (ca. 1579–1640)
FRANÇOIS DE BONNE, DUKE OF LESDIGUIÈRES
(1543–1626)
Dated 1623
Copper alloy, cast; 49.1 mm
Scher Collection; Gift of Stephen K. and Janie Woo Scher, 2016
(2016.2.07)

546

547

Obverse: De Bonne, hair short and curled, wearing the cross of the Order of the Holy Spirit suspended from a ribbon, a double-layered ruff over armor, with lion-headed pauldrons and a commander's sash. Inscriptions: FRAN[ciscus] A BONA D[ux] DESDIGVIERES P[ar] ET COMESTABILIS [François de Bonne, Duke of Lesdiguières, peer and constable]; below truncation, 1623.
Reverse: Crowned arms of Lesdiguières, encircled by the collars of the Order of the Holy Spirit and the Order of St. Michael. Inscription: GRADIENDO ROBORE FLORET [Growing in strength, he flowers].
Literature: M. Jones 1982–88, 2: no. 56.

This medal was made shortly after Lesdiguières, once a leader of Huguenot resistance forces, converted to Catholicism. Already a duke and peer of France, he was made constable and awarded the Order of the Holy Spirit, the medal and collar of which are displayed on obverse and reverse. In 1617, he married his longtime mistress Marie de Vignon (no. 569). EM

548

Guillaume Dupré (ca. 1579–1640)
MARIE DE' MEDICI (1575–1642; Queen Consort of France 1600–10, Queen Regent of France 1610–14)
Dated 1624
Copper alloy, cast; 101.9 mm
Scher Collection; Promised gift to The Frick Collection

Obverse: Marie wearing a court dress with a large open ruff, a floral brooch and pendant cross, her hair piled up in the back and curled on the front and a heart-shaped widow's cap, pearl tear-drop earrings, and a pearl necklace. Inscriptions: in retrograde, MARIA AVGVSTA GALLIÆ ET NAVAR[r]Æ REGINA [Marie, August Queen of France and Navarre]; below truncation, G[uillaume] DVPRE F[ecit] 1624 [Guillaume Dupré made it, 1624].
Literature: M. Jones 1982–88, 2: no. 59; Pollard 2007, 2: no. 649.

In April 1624, the queen secured her position at court when her son Louis XIII was persuaded to admit to his council her confidant and adviser, Cardinal Richelieu. The inscription that can only be read in a mirror may allude to her power as a reflection of the king's. ADC

548

549

549

Guillaume Dupré (ca. 1579–1640)
MARIE DE' MEDICI (1575–1642; Queen Consort of France
1600–10, Queen Regent of France 1610–14)
ca. 1625
Copper alloy, cast; 52.5 mm
The Frick Collection; Gift of Stephen K. and Janie Woo Scher, 2016
(2016.2.11)

Obverse: Marie wearing a court dress with a large open ruff, a
floral brooch and pendant cross, her hair piled up in the back and
curled on the front and a heart-shaped widow's cap, pearl tear-drop
earrings, and a pearl necklace. Inscriptions: in retrograde, MARIA
AVG[usta] GALL[iæ] ET NAVAR[ræ] REGIN[a] [Marie, August Queen of
France and Navarre]; G[uillaume] DVPRE F[ecit] [Guillaume Dupré
made it].
Reverse: Marie as Cybele with her lion, holding a globe and scepter
and wearing a mural crown, accompanied by her family in the guise
of Olympic gods; above, a chariot pulled by two lions on a cloud.
Inscription: in exergue, LÆTA DEVM PARTV [Happy in the birth of the
gods].
Literature: M. Jones 1982–88, 2: no. 61; Pollard 2007, 2: no. 650.

Presenting Marie and her family in the guise of deities—from left
to right, Louis XIII as Jupiter, Henrietta Maria as Amphitrite, Marie
as Cybele, Christine as Diana, Elisabeth as Juno, and Gaston as
Hercules—this medal celebrates Marie's role as the leading figure in
the royal family and her important position at court. Other examples
of the medal include the date 1624 on the obverse truncation. The
medal's date is likely 1625, when Henrietta Maria married Charles I
of England by proxy. This explains why she is shown as Amphitrite,
wife of Poseidon, the ruler of the sea. ADC

550

Guillaume Dupré (ca. 1579–1640)
JEAN DU CAYLAR DE SAINT-BONNET (1585–1636)
Dated 1634
Copper alloy, cast; 59.3 mm
The Frick Collection; Gift of Stephen K. and Janie Woo Scher, 2016
(2016.2.08)

Obverse: Du Caylar de Saint-Bonnet wearing armor, an ample lace
collar, a commander's sash, and the cross of the Order of the Holy
Spirit. Inscriptions: LE MARESCHAL DE TOYRAS [The marshal of Toiras];
GVIL[laume] DVPRE F[ecit] 1634 [Guillaume Dupré made it, 1634].
Reverse: The sun shining through clouds over a landscape with
a fortress and the sea in the background. Inscription: ADVERSA
CORONANT [Adversities crown him].
Literature: M. Jones 1982–88, 2: no. 67; Pollard 2007, 2: no. 652.

A successful military commander appointed marshal of France
in December 1630, Du Caylar de Saint-Bonnet, Maréchal de
Toiras, was in exile in Turin at the Savoy court (after a quarrel with
Richelieu) when this medal was produced. In 1636, he was named
lieutenant of the Savoy troops but shortly afterward was killed in
action. The image of the sun shining through menacing clouds is a
metaphor for his endurance in the face of adversity. ADC

550

551

551

Guillaume Dupré (ca. 1579–1640); cast by Johann Balthasar Keller (1638–1702)

FRANCESCO IV GONZAGA, DUKE OF MANTUA

(1586–1612)

Dated 1612, made in 1654

Copper alloy, cast; 158.8 mm

The Frick Collection; Gift of Stephen K. and Janie Woo Scher, 2016 (2016.2.12)

Obverse: Francesco wearing armor and a large ruff and the Order of the Precious Blood of Our Savior. Inscriptions: FRAN[ciscus] IIII D[ei] G[ratia] DVX MANT[uæ] V MONT[is] FER[rati] III AN[no] I ÆT[atis] XXVI [Francesco IV, by the grace of God, fifth duke of Mantua, third duke of Monferrato, in the first year of the reign, aged 26]; below truncation, G[uillaume] DVPRE F[ecit] 1612 [Guillaume Dupré made it, 1612].

Reverse inscription: J[ohann] B[althasar] Keller 1654.

Literature: M. Jones 1982–88, 2: no. 36; Pollard 2007, 2: no. 642.

The eldest son of Duke Vincenzo Gonzaga and Eleonora de' Medici (sister of Marie de' Medici, Queen Regent of France) became duke upon his father's death in February 1612 but died from smallpox only a few months later. Dupré was likely invited to Mantua because of his acquaintance with Eleonora's sister. This medal, possibly made to celebrate Francesco's marriage to Princess Margherita of Savoy, bears the signature of Johann Balthasar Keller, a member of the celebrated family of founders who took over Dupré's foundry in Paris after the latter's death. ADC

552

After Guillaume Dupré (ca. 1579–1640)

MICHEL DE BEAUCLERC (d. ca. 1643)

ca. 1643

Copper alloy, cast; 58.4 × 50 mm

Scher Collection; Promised gift to The Frick Collection

551

Obverse: De Beauclerc, hair curled, wearing a soft, double-layered ruff, and a doublet, with a commander's sash. Inscriptions (fragmentary): [Mi]C[h]Æ[l] [d]E BEAVCLE[r]C [a]NN[o] ÆTATIS SVEE[SUÆ (*sic*)] 26 [Michel de Beauclerc, aged 26]; beneath truncation, G[uillaume] D[upré] F[ecit] [Guillaume Dupré made it].
Reverse: Fortune, draped and standing on a sphere removing one of Icarus's wings as Daedalus places them on his son's shoulders. Inscription: FRANGIT SOES INV[i]DA PENNAS [Jealous fate snatches his wings from him].
Literature: Mazerolle 1902–4, 2: no. 698.

This medal was probably made to mark the death of de Beauclerc, who, in 1629, married Marguerite d'Estampes and was councilor of state, provost, and master of ceremonies for Louis XIII. The reverse imagery seems to symbolize a man whose life was snatched from him before his time. This is a flawed cast with the loss of some of the obverse inscription letters. A close variant (see Mazerolle 1902–4, 2: no. 697) does not include De Beauclerc's age on the obverse. EM

552

553

Guillaume Dupré (ca. 1579–1640) and Leone Leoni (1509–1590)

HENRI IV, KING OF FRANCE (b. 1553; r. 1589–1610)

Dated 1600

Copper alloy, cast; 67.4 mm

Scher Collection; Promised gift to The Frick Collection

Obverse: Henri, laureate, wearing ornately decorated armor, a commander's sash, with a soft collar emerging from the gorget, and the cross of the Order of the Holy Spirit suspended from a ribbon. Inscriptions: HENRIC[us] IIII D[ei] G[ratia] FRANC[iæ] ET NAVAR[ræ] REX

[Henri IV, by the grace of God, King of France and Navarre]; on truncation, 1600; beneath truncation, G[uillaume] DVPRE.

Reverse: Ippolita Gonzaga as Diana, in her roles as virginal huntress and goddess of the moon (she holds trumpet and spear, striding through a wild landscape lit by the moon and stars, accompanied by three hounds) and as Hecate, goddess of the underworld (behind her stand the gates of hell, into which Pluto drags Proserpina, and from which Cerberus emerges, spewing flames). Inscription: PAR VBIQ[ue] POTESTAS [Her power is everywhere equal].

Literature: Mazerolle 1902–4, 2: no. 626; Scher 1994, no. 51a.

554

The reverse of this medal is taken from Leone Leoni's medal of Ippolita Gonzaga, which celebrates some of the virtues for which this extraordinary woman was known, in particular, piety and fortitude, especially in the face of bereavement. This combination of mismatched obverse and reverse is called a mule, in this instance having no explanation. EM

554

Guillaume (ca. 1579–1640) and Abraham Dupré (1604–1647)
VICTOR AMADEUS I (1587–1637; titular King of Cyprus; Duke of Savoy 1630–37) and **CHRISTINE OF FRANCE** (1606–1663; titular Queen of Cyprus; Duchess of Savoy 1630–37; Regent of Savoy 1637–48)
Dated 1636
Copper alloy, cast; 104 mm
The Frick Collection; Gift of Stephen K. and Janie Woo Scher, 2016 (2016.2.14)

Obverse: Amadeus, with a lovelock at his left, wearing a broad lace collar and ornate armor. Inscriptions: VICTOR AMEDEVS DVX SAB[audiæ] PRINC[eps] PED[emonti] REX CIPR[i] [Victor Amadeus, Duke of Savoy, Prince of Piedmont, King of Cyprus]; below truncation, G[uillaume] DVPRE F[ecit] 1636 [Guillaume Dupré made it, 1636].
Reverse: Christine, hair tightly curled beneath a crown, wearing earrings, a pearl necklace, a broad standing lace collar (open in front), a jeweled brooch pinned to an ermine mantle embroidered with fleurs-de-lis, and a heavily brocaded dress. Inscriptions: CHRISTI[n]A A[?] FRANCIA DVC[iss]A SAB[audiæ] REG[ina] CYPRI [Christine of France, Duchess of Savoy, Queen of Cyprus]. Beneath the CHR of CHRISTINA: AB[raham] DVPRE.
Literature: Umberto di Savoia 1980, 134, 138, no. 8; M. Jones 1982–88, 2: no. 71; Smolderen 1990.

Christine, sister of King Louis XIII of France, married Victor Amadeus in 1619. In 1630, when Amadeus succeeded his father as Duke of Savoy, the duchy was embroiled in the War of the Mantuan Succession (1628–31)—part of the Thirty Years' War (1618–38)—and under occupation by France. Through his connection to the French throne and negotiation of the Treaty of Cherasco (1631), however, the young duke managed to reclaim Savoy. Abraham Dupré had accompanied his father Guillaume to Savoy in 1633, to help him make cannons, and remained there until late 1637. Presumably, the Duke and Duchess of Savoy originally commissioned their medallic portraits from Guillaume and then ordered more from Abraham after his father returned to Paris, resulting in different combinations of obverse and reverse, each side signed by its maker, as in this medal. EM

555

After Guillaume Dupré (ca. 1579–1640)
HENRI IV, KING OF FRANCE (b. 1553; r. 1589–1610)
17th century
Copper alloy, cast; 101.8 mm
Scher Collection; Promised gift to The Frick Collection

Obverse: Henri wearing an embroidered doublet, a ruff, and a cape embroidered with the Order of the Holy Spirit. Inscription: HANRICVS IIII D[ei] G[ratia] FRANCOROM ET NAVAR[ræ] REX [Henri IV, by the grace of God, King of the French and of Navarre].
Literature: M. Jones 1982–88, 2: no. 21; Pollard 2007, 2: no. 638.

For reasons given by Jones that the spelling, stops, pose, and costume are atypical of Dupré and his period, this medal may be a later fabrication or by another contemporaneous artist. SKS

555

556

557

556

Unknown artist ("G.P.")
PHILIPPE DESPORTES (1546–ca. 1610)
Late 16th–early 17th century
Copper alloy, cast; 49.9 mm
Scher Collection; Promised gift to The Frick Collection

Obverse: Desportes wearing a high-necked jerkin with a standing collar, as well as drapery knotted at the shoulder. Inscriptions: PH[ilippe] DES PORTES; on truncation, G.P.
Literature: M. Jones 1982–88, 1: no. 163.

This medal commemorates the poet Philippe Desportes, whose simple, elegant style, modeled after that of Italian poets like Petrarch, influenced the Elizabethan sonnet writers. Desportes was Henri III's secretary before the monarch's accession to the throne and quickly became the foremost court poet. EM

557

Unknown artist
MARIE DE' MEDICI (1575–1642; Queen Consort of France 1600–10, Queen Regent of France 1610–14)
Dated 1614
Copper alloy, cast; 43.7 mm
The Frick Collection; Gift of Stephen K. and Janie Woo Scher, 2016 (2016.2.48)

Obverse: Marie, in a bongrace and widow's veil, wearing a plain standing collar, a ruched shirt, a plain bodice, and an over-gown. Inscription: MARIA MEDICEA FRANC[iæ] [et] NAVARR[æ] R[egina] REGENS [Marie de' Medici, Queen Regent of France and Navarre].

Reverse: A semi-naked woman, her hand resting on a shield bearing the arms of France and Navarre, reclining in the foreground; standing before her, a magistrate, soldier, and a bishop. Inscriptions: CVNCTORVM VOTIS CLERIQ[ue] [E]QUITVMQ[ue] PATRVMQVE [By the wish of all, the Clergy, the Nobility and the Magistrature]; in exergue, GALLIA STABILITA / 1614 [France stabilized, 1614].
Literature: Mazerolle 1902–4, 2: no. 799; M. Jones 1982–88, 2: no. 333.

This medal marks the 1614 meeting of the Estates General, the consultative French assembly comprising representatives of the clergy, the nobility, and the people (or Third Estate), demanded by those opposed to the rule of Marie de' Medici (regent for Louis XIII). Marie neutralized the threat by ensuring that almost half the deputies elected to the Third Estate were royal officials who would not jeopardize her authority, and the meeting ended without solution. The legend on the reverse mirrors this strategy of cooptation in its assertion that Marie reigns as regent "by the wish of all," notwithstanding that the 1614 meeting was called precisely to contest that assertion. EM

558

Pierre Regnier (ca. 1577–after 1640)
MARIE DE' MEDICI (1575–1642; Queen Consort of France 1600–10, Queen Regent of France 1610–14)
Dated 1613
Silver, struck; 52.7 mm
The Frick Collection; Gift of Stephen K. and Janie Woo Scher, 2016 (2016.2.32)

558

559

Obverse: Marie, crowned, hair braided into a knot, wearing a high and ornate lace collar, open in front, with a mantle embroidered with fleurs-de-lis, and a pearl earring and necklace. Inscription: MARIA AVGVSTA MED[icea] FR[anciæ] REG[ina] MODERATRIX [Marie de' Medici, August Queen Regent of France].

Reverse: Marie as Juno, breasts bare, with crown and scepter (topped with a fleur-de-lis), seated beside her peacock on a rainbow above a town and body of water. Inscription: DAT PACCATVM [*sic*] OMNIBVS ÆTHER 1613 [The heavens give a peaceful country to everyone, 1613].

Literature: Mazerolle 1902–4, 2: no. 562; M. Jones 1982–88, 2: no. 90.

After the assassination of Henri IV in 1610, Marie de' Medici was made regent for their son, Louis XIII. Likened to Juno on this medal, she is cast as queen of the gods. The reverse was combined with other obverses; see, for example, the medal by Nicolas Briot (no. 564). EM

559
Pierre Regnier (ca. 1577–after 1640)
CHARLES D'ALBERT, DUKE OF LUYNES (1578–1621)
Dated 1621
Silver, struck; 56.2 mm
Scher Collection; Promised gift to The Frick Collection

Obverse: Luynes, with curled hair and a goatee, wearing a ruff, ornately decorated armor with pauldrons formed of grotesque faces, a commander's sash pinned at the shoulder, and the order of the Holy Spirit suspended from a ribbon. Inscriptions: CH[arles] D['] ALBERT DVC D[e] LVYNES PAIR ET CON[n]EST[able] D[e] FR[ance] [Charles d'Albert, Duke of Luynes, peer and constable of France]; 1621.

Reverse: A gauntlet-clad hand emerges from the clouds, grasping a sword about which a laurel branch and palm branch are entwined; below, a town in a hilly setting overlooking a plain of trees and shrubs. Inscriptions: QVO ME IVRA VOCANT ET REGIS GLORIA [Wherever the laws and the glory of the King call me]; on a scroll, 1621.

Literature: M. Jones 1982–88, 2: no. 92.

A controversial statesman known for being the favorite of young Louis XIII, Luynes was instrumental in helping Louis reclaim the French throne from his mother, Marie de' Medici, who acted as regent and continued to rule for three years after his majority. Shortly after Louis's ascension, he made Luynes a duke and peer and in 1621 appointed him constable of France despite his lack of military competence. After the death of the French chancellor later that year, the monarch also gave Luynes the seals of France, an honor bestowed upon the state's highest-ranking judicial officer (hence the reference to laws on the medal's reverse). EM

560
Pierre Regnier (ca. 1577–after 1640)
LOUIS XIII, KING OF FRANCE (b. 1601; r. 1610–43)
Dated 1624
Copper alloy, cast copy of a struck medal; 32.5 mm
Scher Collection; Promised gift to The Frick Collection

Obverse: Louis, laureate, hair curled and with a lovelock at his left, wearing plain armor. Inscriptions: LVD[ovicus] XIII D[ei] G[ratia] FRANCORVM ET NAVAR[r]Æ REX [Louis XIII, by the grace of God, King of the French and of Navarre]; below truncation, 1624.

Reverse: The new Palais du Louvre. Inscription: POSCEBANT HANC FATA MANVM [The future required this work].

Literature: M. Jones 1982–88, 2: no. 95; Pollard 2007, 2: no. 655.

This medal was used as a foundation deposit for an extension to the Louvre (known as the Pavillon de l'Horloge) begun in July 1624 and completed in 1639–40. Other scholars have interpreted the reverse inscription as "We have put our hand to this work." SKS

560

561

562

561

Pierre Regnier (ca. 1577–after 1640)
LOUIS XIII, KING OF FRANCE (b. 1601; r. 1610–43)
Dated 1628
Copper alloy, struck; 38.2 mm
Scher Collection; Promised gift to The Frick Collection

Obverse: Louis, laureate, with beard and mustache, hair curled and with a lovelock at his left, wearing plain armor. Inscription: LVDOVIC[us] XIII D[ei] G[ratia] FRANCORVM ET NAVAR[r]Æ REX [Louis XIII, by the grace of God, King of the French and of Navarre].
Reverse: A full-rigged ship of the line (part of the Arms of Paris), flying a flag emblazoned with France Modern; in chief, a field of fleurs-de-lis. Inscription: DE LA 3[troisième] P[révô]TE DE M[onsieu]RE N[icolas] DEBAILLEVL PRESID[en]T AV PARLEM[ent] 1628 [In the third provostship of Mr. Nicolas de Bailleul, president of the *parlement*, 1628].
Literature: M. Jones 1982–88, 2: no. 111.

Nicolas de Bailleul (1506–1652), chief magistrate (*président à mortier*) of the *parlement* of Paris in 1627, was first elected provost of merchants (chief officer in the municipal government) of Paris about 1621. This medal celebrates his third and final term. The image of the ship refers specifically to Paris and also recalls the mercantile trade to which de Bailleul's title alludes. The portrait of Louis is the same as that on other medals (see no. 560), with a beard and mustache added. EM

562

Unknown artist
LOUIS XIII, KING OF FRANCE (b. 1601; r. 1610–43)
Dated 1624
Gilt copper alloy, cast; 57.6 mm
The Frick Collection; Gift of Stephen K. and Janie Woo Scher, 2016 (2016.2.17)

Obverse: Louis, laureate, hair short and curled, with a lovelock on his left, wearing a ruff and ornate armor draped with a commander's sash. Inscriptions: LVDOVICVS XIII D[ei] G[ratia] FRANCORVM ET NAVAR[r]Æ REX [Louis XIII, by the grace of God, King of the French and of Navarre]; below the bust, OB AQVAS DEDVCTAS [For having brought the waters]; on truncation, 1624.

Reverse: A warship. Inscription: ABSQVE TVIS STARET INANIS AQVIS [Without you, we would have been without water].
Literature: Mazerolle 1902–4, 2: no. 692.

This medal celebrates Louis's role in the construction of the aqueduct of Arcueil, which began in 1613, when the king and his mother laid its foundation stone. Built beside the ruins of a Roman aqueduct, the colossal structure supplied Paris with spring water. The galleon on the reverse, probably an extension of the medal's watery theme, brings to mind the Arms of Paris. EM

563

Nicolas Briot (ca. 1579–1646)
LOUIS XIII, KING OF FRANCE (b. 1601; r. 1610–43)
Dated 1610
Silver, struck; 41.8 mm
The Frick Collection; Gift of Stephen K. and Janie Woo Scher, 2016 (2016.2.27)

Obverse: The young Louis, crowned, wearing a small lace ruff, an ermine surcoat over armor, and an ermine-lined sash (pinned at the shoulders and also decorated with fleurs-de-lis), and the collar of the Order of the Holy Spirit. Inscription: LVDO[vicus] XIII D[ei] G[ratia] FR[anciæ] ET NA[varræ] REX CHRISTIANISSIMVS [Louis XIII, by the grace of God, most Christian King of France and Navarre].
Reverse: A hand emerging from clouds holding *la sainte ampoule* (the holy ampulla) above some vegetation. Inscription: FRANCIS DATA MVNERA COELI 17 OCTOBRIS 1610 [The French were given a gift from Heaven, 17 October, 1610].
Literature: M. Jones 1982–88, 2: no. 114.

563

This medal was struck to celebrate the consecration of Louis XIII as king of France. A religious ritual intended to reinforce the divine right of the kings of France by giving their rule Christian legitimacy, consecration was carried out during the coronation service at Reims Cathedral. The holy ampulla is the vessel containing the oil used for anointing French kings. EM

564

Nicolas Briot (ca. 1579–1646) (obv.) and Pierre Regnier (ca. 1577–after 1640) (rev.)

LOUIS XIII, KING OF FRANCE (b. 1601; r. 1610–43)

Dated 1613

Silver, struck; 53.2 mm

Scher Collection; Promised gift to The Frick Collection

Obverse: The young Louis, laureate, and wearing a lace ruff (floral in style), embellished armor with pauldrons formed of grotesque faces, a commander's sash knotted at the shoulder, and the Order of the Holy Spirit suspended from a ribbon. Inscriptions: LVDO[vicus] XIII D[ei] G[ratia] FR[anciæ] ET NAVAR[ræ] REX CHRIS[tianissimus] [Louis XIII, by the grace of God, most Christian King of France and Navarre]; 1613.

Reverse: Same as no. 558.

Literature: M. Jones 1982–88, 2: no. 118.

Marie de' Medici ensured that Louis had little political influence during her tenure and indeed continued to rule for three years after his majority. This medal is an example of the complex use of dies; obverse and reverse dies were often combined, restored, recut, or reproduced at a later date. EM

565

Nicolas Briot (ca. 1579–1646)

LOUIS XIII, KING OF FRANCE (b. 1601; r. 1610–43)

Dated 1617

Silver, struck; 52.5 mm

The Frick Collection; Gift of Stephen K. and Janie Woo Scher, 2016 (2016.2.28)

Obverse: The young Louis, laureate, wearing a lace ruff (floral in style), embellished armor with pauldrons formed of grotesque faces, a commander's sash knotted at the shoulder, and the Order of the Holy Spirit suspended from a ribbon. Inscriptions: LVDO[vicus] XIII D[ei] G[ratia] FR[anciæ] ET NAVAR[ræ] REX CHRIS[tianissimus] 1617 [Louis XIII, by the grace of God, most Christian King of France and Navarre, 1617].

Reverse: The Pont Saint-Michel, Paris, in choppy waters and under cloudy skies. Inscriptions: EVERTIT ET ÆQVAT XXI SEPTEMBR[is] [He demolishes and levels, 21 September]; on a scroll, 1617.

Literature: M. Jones 1982–88, 2: no. 120.

This medal was struck to commemorate the rebuilding of the Pont Saint-Michel after the old wooden construction had been wrecked by ice floes the year before. Louis was responsible for laying the foundation stone for the straighter and more robust replacement structure, today considered one of the finest examples of Renaissance bridge architecture. EM

566

566

Nicolas Briot (ca. 1579–1646)

CHARLES I, KING OF GREAT BRITAIN AND IRELAND

(b. 1600; r. 1625–49)

1630

Silver, cast; 61.1 mm

Scher Collection; Promised gift to The Frick Collection

Obverse: Charles, hair short and curled, with a lovelock at his left, wearing a cartwheel ruff, armor, a cloak embroidered with the cyphers of the king and queen, and the Order of the Garter suspended from a ribbon. Inscriptions: CAROLVS I D[ei] G[ratia] MAG[næ] BRITAN[n]IÆ FRAN[ciæ] ET HIB[erniæ] REX [Charles I, by the grace of God, King of Great Britain, France, and Ireland]; N[icolas] BRIOT.

Reverse: A war galleon, square sails full, moving away from the shore. Inscription: NEC META MIHI QVÆ TERMINVS ORBI [There are no limits for me, than those of the world].

Literature: Hawkins 1885, 1: 256, no. 41; M. Jones 1982–88, 2: no. 144; Eimer 2010, no. 118 a/b.

This medal was issued in assertion of Charles's claim to dominion of the seas. In the 1630s, Charles—without Parliament's consent—imposed a tax that allowed for a greater naval presence in the seas separating England from the Continent. The ship represented is the *Sovereign of the Seas*, the only three-decker commissioned by Charles I (in 1634), enormously expensive and heavily armed. In the tradition of English monarchs, Charles called himself King of France even though he did not rule France. EM

567

Nicolas-Gabriel Jacquet (act. 1601–26)

POMPONNE DE BELLIÈVRE (1529–1607)

Dated 1601

Silver, cast; 54.5 mm

The Frick Collection; Gift of Stephen K. and Janie Woo Scher, 2016 (2016.2.29)

Obverse: De Bellièvre wearing a ruff and embroidered coat. Inscriptions: [laurel branch] POMPONIVS DE BELIEVRE FRANCIÆ CANCEL[larius] ÆT[atis] 71 [Pomponne de Bellièvre, chancellor of France, aged 71]; N[icolas] G[abriel] I[acquet] F[ecit] 1601 [Nicolas-Gabriel Jacquet made it, 1601].

Reverse: Altar with flames flanked by the personifications of Justice and Piety, the latter making a libation on the altar. Inscriptions: COLIT HANC RIGIDE MODERATVR ET ISTAM [He cultivates one and strictly administers the other]; in exergue, PIE[tas] ÆQ[uitas] / PVB[lica] [piety and public justice].

Literature: M. Jones 1982–88, 1: no. 205; Pollard 2007, 2: no. 658.

De Bellièvre served as councilor of state in 1570, superintendent of finances in 1575, and chancellor of France in 1599. The reverse composition, derived from coins of Antoninus Pius, presents personifications of piety and justice, two virtues necessary for a high-ranking public official. ADC

567

568

568

Nicolas-Gabriel Jacquet (act. 1601–26)
OMER TALON (1538–1618) and **SUZANNE CHOART DE BUZENVAL** (1545–1643)
1626
Copper alloy, cast; 42 mm
Scher Collection

Obverse: Talon, bearded and wearing a soft collar and a magistrate's robe over a buttoned jerkin. Inscriptions: AVDOMARVS TALEVS IN [s]VPR[ema] PAR[isiensi] CVRIA PATR[onus] [Omer Talon, advocate in the Paris *parlement*]; below the bust, 16 19.
Reverse: Choart de Buzenval, in a bongrace (a type of hood), wearing a partlet over a ribbed bodice, a large standing collar, and large, winged sleeves. Inscriptions: SVSANNA CHOART AVDOMARI TALEI [Suzanne Choart, (wife of) Omer Talon]; CIƆIƆCXXVI [1626].
Literature: *Trésor de numismatique* 1834–58, 14: pl. LXIV, no. 4; Mazerolle 1902–4, 2: no. 723.

This medal is a mule, its obverse coming from a 1619 medal of Talon and its reverse from a 1626 medal of Choart de Buzenval,

his wife (both by Jacquet). Talon was an advocate at the Paris *parlement* (where he would ultimately become *avocat général*), a councilor at the Council of State, and a master of *requêtes du palais* (a deputy or assistant to the chancellor of France) under Marguerite de Valois. SKS

569

Jacob Richier (ca. 1586–ca. 1640)
MARIE DE VIGNON (1576–1657)
Dated 1613
Copper alloy, cast; 109.8 mm
Scher Collection

Obverse: Marie in pearl tear-drop earrings, a pearl necklace, and a floral brooch and wearing a dress with partlet, elaborate shoulders, slashed sleeves, and a standing lace collar; her hair elaborately piled up and ornamented with floral elements emerging from a headband. Inscriptions: MARIE DE VIGNON MARQVISE DE TREFFORT [Marie de Vignon, Marquise de Treffort]; below truncation, I[acob] R[ichier] F[ecit] 1613 [Jacob Richier made it, 1613].
Literature: M. Jones 1982–88, 2: no. 87; Scher 1994, no. 151.

Born to Grenoble bourgeoisie, Marie de Vignon, Marquise of Treffort, was famous for her beauty. In 1591, she became the mistress of François de Bonne, Duke of Lesdiguières and governor of Grenoble (no. 547). In 1617, after the deaths of their spouses—Lesdiguières's wife in 1608 and Marie's husband, murdered, in 1613—the pair married. This medal was probably produced a year after Lesdiguières commissioned from Richier the tomb for his first wife (1612) and is his only signed work. ADC

569

570

Unknown artist
MICHEL DE L'HÔPITAL (1505/6–1573)
Early 17th century
Silver, struck; 38.2 mm
Scher Collection; Promised gift to The Frick Collection

Obverse inscription: M[ichael] OSP[italis] FRAN[ciæ] CANCEL[larius]
[Michel de l'Hôpital, chancellor of France].
Reverse: Lightning striking a tower in the sea. Inscription: IMPAVIDVM
FERIENT RVINAE [Without fear he will bear destruction (Horace, *Odes*
3: 3.8)].
Literature: M. Jones 1982–88, 1: no. 244; Pollard 2007, 2: no. 635.

This medal belongs to a group of eleven medals of sixteenth-
century sitters struck in the early seventeenth century. As chancellor
of France (1560–68), de l'Hôpital pursued a policy of religious
tolerance and sought national unity; his refusal to take sides cost
him his office. The tower was part of his coat of arms, and the legend
from Horace, which also appears on his full-length portrait by
Giovanni Battista Moroni (Pinacoteca Ambrosiana, Milan), was his
personal motto. The reverse alludes to his fortitude under attack. ADC

571

Abraham Dupré (1604–1647)
JACQUES BOYCEAU (1562–1633/38)
Dated 1624
Copper alloy, cast; 71.3 mm
The Frick Collection; Gift of Stephen K. and Janie Woo Scher, 2016
(2016.2.13)

Obverse: Boyceau wearing a layered ruff and a doublet embroidered
with flowers. Inscriptions: IACQVES BOICEAV S[eigneu]R DE LA
BARRAVDERIE [Jacques Boyceau, Lord of Barauderie]; AB[raham]
DVPRE F[ecit] 1624 [Abraham Dupré made it, 1624].
Reverse: Wooded landscape with six silkworms in the foreground
and a town in the background, on the left; in the sky, six silk moths.
Inscription: NATVS HVMI POST OPVS ASTRA PETO [Born of the earth,
after my work I reach for the stars].
Literature: M. Jones 1982–88, 2: no. 72; Pollard 2007, 2: no. 654.

This first medal by Abraham Dupré commemorates the *Intendant
des Jardins* under Louis XIII, whose treatise on gardening, the *Traité
du jardinage*, was published posthumously, in 1638. Boyceau was
also godfather to Abraham's brother Jacques. The reverse has been
interpreted as an allusion to the human condition—born on earth
but aspiring to a superior spiritual dimension—and to Boyceau's own
achievements in life. The city in the background has been identified
as La Rochelle, a Huguenot center, which would be appropriate to
the sitter's faith. ADC

571

572

572

Abraham Dupré (1604–1647)
UNKNOWN WOMAN
Dated 1624
Copper alloy, cast; 125.7 mm
Scher Collection

Obverse: A woman, hair braided and decorated with a *frenello* (a string of pearls entwined around twists of real and false hair and a silk veil), wearing a double strand of pearls, pearl earrings, an embroidered, very low-cut gown with ribbons on the shoulders, and a gauzy mantle. Inscription: AB[raham] DVPRE F[ecit] 1624 [Abraham Dupré made it, 1624].
Literature: Mazerolle 1902–4, 2: no. 713. EM

573

Abraham Dupré (1604–1647) after Guillaume Dupré, (ca. 1579–1640)
HENRI DE MALEYSSIC (act. 1617–51)
Dated 1635
Copper alloy, cast; 106.8 mm
Scher Collection; Promised gift to The Frick Collection

Obverse: De Maleyssic, hair curled, wearing an elaborate lace collar over armor, with a commander's sash across his chest. Inscriptions: H[enri] DE MALEYSSYC PINEROLII GVBERNATOR [Henri de Maleyssic, governor of Pinerolo]; A[braham] DVPRÉ F[ecit] 1635 [Abraham Dupré made it, 1635].
Reverse: The gates of Pinerolo styled as a triumphal arch, with a dog peering through the open gate and a view of the citadel and its gate in the exergue. Inscription: FIDA FORTITVDINE [With loyal bravery].
Literature: M. Jones 1982–88, 2: no. 73.

In 1630, de Maleyssic, a captain in the Regiment of Guards, took part in the siege and conquest of Pinerolo with an army personally commanded by Cardinal Richelieu (Louis XIII's chief minister). By the time this medal was made, de Maleyssic had been governor of Pinerolo for two years, and plans, as apparently displayed in Dupré's imagery, were being made to rebuild the town gates. A view of one of the original gates is shown in the reverse exergue, and the main image of the triumphal arch-like gate seems to be a model for the planned renovation. The little dog peering through the gate could signify the loyalty indicated in the inscription. Although this medal is signed by Abraham Dupré, he has copied exactly the medal produced by his father, Guillaume (M. Jones 1982–88, 2: no. 69). EM

573

574

Unknown artist
NICOLAS CHEVALIER (1562–1630)
Dated 1630
Gilt copper alloy, cast; 53 mm
Scher Collection

Obverse: Nicolas Chevalier, bearded and with short hair, wearing a plain stiff collar and magistrate's robes. Inscription: NIC[olas] CHEVALIER SVBSID[iarii] PAR[isii] P[rimus] PRÆS[idens] ET ANNÆ R[eginæ] CANCELL[arius] [Nicolas Chevalier, first president of the Court of Aids of Paris, and chancellor to the Queen].

Reverse: Justice, with a sword in one hand and scales in the other, standing atop an altar embellished with swags and rams' heads, at which a female figure (Prosperity or France) holding a cornucopia (and at whose feet is a lamb) makes an offering from a *patera*; beside the altar, a square support with a covered vessel. Inscriptions: FOECVNDAT CVLTA COLENTEM [The worship of the devout creates prosperity]; in exergue, above a pair of crossed palms, M DC XXX [1630].

Literature: Mazerolle 1902–4, 2: no. 858 (obv. only).

This medal was probably made to commemorate Chevalier's death. EM

575

Jean Warin (1606–1672)
LOUIS XIII, KING OF FRANCE (b. 1601; r. 1610–43)
Dated 1629
Copper alloy, struck; 40.4 mm
Scher Collection; Promised gift to The Frick Collection

Obverse: Louis, hair short and curled, with a lovelock at his left, wearing a soft, layered ruff, ornate armor (with grotesque face pauldrons), and the order of the Holy Spirit suspended from a ribbon. Inscriptions: LVDOVICVS XIII FRANCORVM ET [NAVAR[r]Æ REX [Louis XIII, King of the French and of Navarre]; 1629.

Reverse: Louis in the guise of Hercules, naked, laureate, wielding a club and wearing the skin of the Nemean lion, towering over troops of soldiers on a mountain; in the background, the town of La Rochelle, its harbor's entry blocked by a naval fleet. Inscriptions: NON MARE NON MONTES FAMAM SED TERMINAT ORBIS [Not the sea nor the mountains, but only the world limits his fame]; in exergue, W [artist's signature].

Literature: M. Jones 1982–88, 2: no. 179.

In 1628, at the height of religious tensions in France, Louis captured La Rochelle, the Huguenots' last military stronghold (the siege of which is illustrated on the medal's reverse), finally allowing him to attend to the increasingly urgent Mantuan succession crisis. The duchy had recently been inherited by a French subject, and this succession was contested by the Duke of Savoy, the King of Spain, and the Holy Roman Emperor, who laid siege to various parts of Mantua in protest. En route to Savoy, Louis found his path blocked by belligerents at the Pas de Suze. This medal also celebrates Louis's successful forcing of the pass. EM

576

576

Jean Warin (1606–1672)
ANTOINE COËFFIER, CALLED RUZÉ (1581–1632)
Dated 1629
Copper alloy, cast; 65.4 mm
Scher Collection

Obverse: Ruzé wearing a lace collar, elaborate armor with a lion's head pauldron, and a ribbon with the cross of the Order of the Holy Spirit. Inscription: A[ntoine] RVZE M[arquis] DEFFIAT ET D[e] LONIVMEAV SVR[intendan]T DES FINANCES [Antoine Ruzé, Marquis of Éffiat and Longjumeau, superintendent of finances].
Reverse: Atlas transferring the weight of the world to Hercules, who has laid down his club; Atlas wearing a mantle whose end flows between his legs; Hercules wearing the lion's skin, the tail and one paw flowing above his right shoulder and the head on the ground; in the background, a rocky landscape. Inscriptions: QVIDQVID EST IVSSVM LEVE EST [Whatever is ordered (to me) is easy (Seneca, *Hercules Oetaeus* 1.59)]; in exergue, 1629.
Literature: M. Jones 1982–88, 2: no. 180; Scher 1994, no. 152; Pollard 2007, 2: no. 660.

Ruzé, Marquis of Éffiat, had a successful career under the protection of Cardinal Richelieu. In 1626, he was appointed superintendent of finances; in 1629, joint commander of the French army; and in

1631, marshal of France, a post he assumed only shortly before his death in 1632. The episode of Hercules temporarily relieving Atlas is a reference to Ruzé's readiness to accept the burden of the affairs of the state. A signed specimen in the British Museum confirms the attribution (first made on stylistic grounds) to Warin. ADC

577

Jean Warin (1606–1672)
JULES, CARDINAL MAZARIN (b. 1602; First Minister of France 1642–61)
ca. 1630
Copper alloy, cast after a struck original; 50.9 mm
The Frick Collection; Gift of Stephen K. and Janie Woo Scher, 2016 (2016.2.20)

Obverse: Mazarin, hair long and wavy, wearing a *calotte* (also called a *zucchetto*), a soft collar, and a hooded cassock; at the top edge, a suspension loop, with a casting flaw beneath it. Inscriptions: IVLIVS CARDINALIS MAZARINVS [Jules, Cardinal Mazarin]; on truncation, VARIN [Warin].
Reverse: In the central middle ground, a soldier on horseback, holding a hat outstretched before him, riding between two facing armies; in the background, the citadel of Casale

577

578

Monferrato; casting flaws throughout the field. Inscription: NVNC ORBI SERVIRE LABOR [Now (his) work (is) to serve the world].
Literature: M. Jones 1982–88, 2: no. 212.

This medal commemorates Mazarin's legendary act of valor during the crisis of Mantuan succession, a peripheral conflict during the Thirty Years' War between France and Spain (1618–48). In 1630, the two armies were preparing for battle at Casale Monferrato (visible on the reverse), which Spain held under siege. As the French army advanced, Mazarin, then a papal legate, dramatically rode his horse between the two armies crying, "Peace! Peace!" Though the Spanish lifted their siege and Mazarin negotiated a treaty that settled the issue of Mantuan succession, a final resolution was not reached; France would continue to do battle with Spain throughout the Thirty Years' War. EM

holding a circle of drapery in her hands) chained to the rear of the chariot; a winged Victory flying above and about to crown France with a laurel wreath. Inscriptions: TANDEM VICTA SEQVOR [Conquered at last, I follow]; in exergue, I[ean] WARIN / 1630.
Literature: M. Jones 1982–88, 2: no. 182; Scher 1994, no. 153; Pollard 2007, 2: no. 661.

From 1624 until his death, Richelieu was the effective head of the government in France. This medal may have been produced on the occasion of the "Day of Dupes" (November 10, 1630), when the king refused to oust the cardinal from his offices, though it is not clear whether Richelieu himself commissioned it or Warin made it to attract the cardinal's benevolence. Richelieu must have appreciated the medal since a few years later, in 1634, he interceded for the medalist when he was accused of forgery. ADC

578

Jean Warin (1606–1672)
ARMAND-JEAN DU PLESSIS, CARDINAL RICHELIEU
(1585–1642)
Dated 1630
Copper alloy, cast; 76.4 mm
Scher Collection

Obverse: Richelieu wearing a biretta and cardinal's robes.
Inscription: ARMANDVS IOANNES CARDINALIS DE RICHELIEV [Armand-Jean, Cardinal Richelieu].
Reverse: Female representation of France in classical drapery on a richly decorated chariot, holding a sword in her right hand and a palm branch in her left; the chariot, drawn by four horses, driven by Fame (a nude, winged woman blowing a horn from which hang the arms of Richelieu), with Fortune (also a nude, winged female figure

579

Jean Warin (1606–1672)
ARMAND-JEAN DU PLESSIS, CARDINAL RICHELIEU
(1585–1642)
Dated 1631
Silver, struck; 51.6 mm
The Frick Collection; Gift of Stephen K. and Janie Woo Scher, 2016
(2016.2.21)

Obverse: Richelieu wearing a biretta and cardinal's robes.
Inscriptions: ARMANVS IOAN[nes] CARD[inalis] DE RICHELIEV [Armand-Jean, Cardinal Richelieu]; below truncation, I[ean] WARIN.
Reverse: A genius guides the revolution of the planets around the world. Inscriptions: MENS SIDERA VOLVIT [(His) mind makes the stars revolve]; in exergue, 1631.
Literature: M. Jones 1982–88, 2: no. 187; Pollard 2007, 2: no. 662.

579

Warin may have made this medal with the intention of gaining Richelieu's support when he was accused of forgery (see no. 578). The astrological composition has been interpreted as a celebration of Richelieu concerning himself with only the most important matters and as representing the Renaissance belief that men, through wisdom and knowledge, can control the negative effects of the stars. His first name (Armandus) is misspelled on the obverse. ADC

580

Jean Warin (1606–1672)
LOUIS XIV, KING OF FRANCE (b. 1638; r. 1643–1715), and
ANNE OF AUSTRIA (1601–1666; Queen Consort of France
1615–43, Queen Regent of France 1643–51)
Dated 1643
Silver, struck; 56.9 mm
The Frick Collection; Gift of Stephen K. and Janie Woo Scher, 2016
(2016.2.22)

Obverse: The young Louis, laureate and with wavy hair, wearing the Order of the Holy Spirit and armor all'antica with a commander's sash pinned at the shoulder. Inscriptions: LVDOVICVS XIIII D[ei] G[ratia] FR[anciæ] ET NAV[arræ] REX [Louis XIV, by the grace of God, King of France and Navarre]; below truncation, WARIN 1643.
Reverse: Anne, hair pinned beneath a widow's hood and veil, wearing a plain collar and a simple gown. Inscriptions: ANNA D[ei] G[ratia] FR[anciæ] ET NAV[arræ] REG[ina] [Anne, by the grace of God, Queen of France and Navarre]; on truncation, WARIN.

Literature: Mazerolle 1932, 1: no. 14; M. Jones 1982–88, 2: no. 200.

After the deaths of Louis XIII and his first minister, Cardinal Richelieu, the young Louis XIV was declared king of France with his mother, Anne, as regent. Louis XIII treated his wife Anne coolly throughout their marriage and, through a provision in his will, attempted to prevent her from being his son's sole regent. Shortly after her husband's death, Anne had the will annulled and was declared regent, making Cardinal Mazarin, with whom she was close, her first minister. EM

581

Jean Warin (1606–1672)
ANNE OF AUSTRIA (1601–1666; Queen Consort of France
1615–43, Queen Regent of France 1643–51) and
LOUIS XIV, KING OF FRANCE (b. 1638; r. 1643–1715)
Dated 1638, made 1645
Copper alloy, cast; 97.5 mm
Scher Collection

Obverse: Anne wearing a widow's hood that is combined with a cloak, embracing her seven-year-old son Louis XIV, who wears a lace collar, doublet, and sash and plays with a fastening of her dress. Inscription: ANNA D[ei] G[ratia] FR[anciæ] ET NAV[arræ] RE[gina] RE[gnans] R[egia] MATER LVD[ovici] XIV D[ei] G[ratia] FR[anciæ] ET NAV[arræ] REG[is] CHR[istianissimi] [Anne, by the grace of God, Queen

580

581

Regent of France and Navarre, royal mother of Louis XIV, by the grace of God, most Christian King of France and Navarre].
Reverse: The facade of the church of the Val-de-Grâce as originally planned by François Mansart, with two porticos and a dome topped by a cupola and a cross, and stairs leading up to the doors of the church. Inscriptions: OB GRATIAM DIV DESIDERATI REGII ET SECVNDI PARTVS [In thanks for the longed-for and happy issue of the King]; QVINTO CAL[endæ] SEPT[embris] 1638 [5 September 1638].
Literature: M. Jones 1982–88, 2: no. 208; Scher 1994, no. 154.

On September 5, 1638, after more than twenty years of marriage to Louis XIII without producing an heir, Anne of Austria gave birth to the future Louis XIV. This medal was made to commemorate the laying of the foundation stone of the Benedictine church of Val-de-Grâce on April 1, 1645, in fulfillment of the queen's vow to build a church and convent if she had a son. The reverse of the medal provides the only record of the original plan made by Mansart for the facade of the church. An example in gold was placed in the foundation. ADC

Obverse: Marie-Thérèse, hair half-braided in a chignon, with loose strands falling over her shoulders and curling at the temples, wearing a pearl necklace, pearl tear-drop earrings, a richly draped gown, pinned at the shoulder, and a bust with bejeweled brooches. Inscription: MAR[ia] THER[esa] D[ei] G[ratia] FR[anciæ] ET NAV[arræ] REG[ina] [Marie-Thérèse, by the grace of God, Queen of France and Navarre].
Reverse: A rainbow amid clouds, above a field. Inscriptions: IN FŒDERA VENI [I agreed to this marriage]; in exergue, 1662.
Literature: M. Jones 1982–88, 2: no. 229.

Originally struck shortly after Marie-Thérèse's marriage to Louis XIV of France, this medal celebrates the arrival of the young queen, who as a member of the House of Hapsburg was also Archduchess of Austria, from her native Spain. The rainbow on the reverse, combined with the legend announcing her allegiance to France, implies that her arrival brought peace, hope, and serenity. EM

582

Jean Warin (1606–1672)
MARIE-THÉRÈSE OF AUSTRIA (b. 1638; Queen Consort of France and Navarre 1660–83)
Dated 1662
Copper alloy, cast from a struck medal; 37.5 mm
Scher Collection; Promised gift to The Frick Collection

582

583

Jean Warin (1606–1672)

LOUIS XIV, KING OF FRANCE (b. 1638; r. 1643–1715)

Dated 1671

Copper alloy, struck; 51.7 mm

The Frick Collection; Gift of Stephen K. and Janie Woo Scher, 2016
(2016.2.23)

Obverse: Louis wearing armor, the ribbon of an order across his
chest, and a lace cravat. Inscription: LUD[ovicus] XIIII D[ei] G[ratia]
FR[anciæ] ET NAV[arræ] REX [Louis XIV, by the grace of God, King of
France and Navarre].

Reverse: The sun, with a face and curly hair, surrounded by rays,
shining upon a globe of the Earth amid clouds. Inscription: NEC
PLVRIBVS IMPAR 1671 [Not unequal to many, 1671].

Literature: Mazerolle 1932, 1: no. 56; M. Jones 2015, 168–69.

By the time this medal was made, Louis XIV had adopted the sun as
a primary symbol of his rule. In his memoirs, he describes attributes
and powers of the sun that he associates with a great monarch. In
doing so, he recalls classical antiquity and gods like Apollo (alluded
to on this medal by the Olympian motto of the reverse) and positions
himself at the center of the physical universe. The symbolic power
of the Sun King also has Christian resonances, establishing Louis as
an intermediary between the human and divine, able to bring great
benefits to his subjects and illuminate the whole world. In Louis's
own words, "I would be just as capable of ruling still other empires
as would the sun of illuminating still other worlds with its rays." This
is the meaning of the motto on the medal's reverse and also explains
his territorial aggressions. EM

584

Jean Warin (1606–1672)

LOUIS XIV, KING OF FRANCE (b. 1638; r. 1643–1715)

Dated 1663

Silver, struck; 55.8 mm

The Frick Collection; Gift of Stephen K. and Janie Woo Scher, 2016
(2016.2.24)

Obverse: Louis, hair long and curled, in classical armor with a
commander's sash pinned at the shoulder. Inscription: LVD[ovicus]
XIIII D[ei] G[ratia] FR[anciæ] ET NAV[arræ] REX [Louis XIV, by the grace of
God, King of France and Navarre].

Reverse: Louis, crowned and wearing an ermine mantle and the
livery collars of the orders of the Holy Spirit and St. Michael, resting
his right hand on an altar before an open Bible and a crucifix as if
to swear an oath, and, with his left hand, holding the hand of the
dauphin (also crowned and in an ermine robe, wearing the livery
collar of the Order of the Holy Spirit); on the other side of the altar,
the ambassadors of the Swiss cantons, one of whom also appears
about to take an oath. Inscriptions: NVLLA DIES SVB ME NATOQVE
HÆC FOEDERA RVMPET [On no day, during my reign and that of my
son, will this alliance be broken]; in exergue, FOEDERE HELVETICO /
INSTAVRATO / MDCLXIII [At the time that the alliance with the Swiss
was renewed, 1663].

Literature: *Trésor de numismatique* 1834–58, 16: pl. IX, no. 1;
Mazerolle 1932, 1: no. 42; Jacquiot 1970, no. 122; M. Jones
1982–88, 2: 233.

This medal—the first composed by the fledgling Petite Académie (in collaboration with master medalist Jean Warin)—was made to commemorate France's renewal of its alliance with the Swiss. The reverse references the moment that the French king and the Swiss ambassadors, sent to France to ratify the treaty, took their oaths of mutual loyalty in the choir of Notre-Dame Cathedral. As was customary, Louis distributed gold medals like this to each of the ambassadors. EM

585

Attributed to Jean Warin (1606–1672)
PIERRE SÉGUIER (b. 1588)
ca. 1635–50
Copper alloy, cast; 83.6 mm
Scher Collection; Promised gift to The Frick Collection

Obverse: Séguier, hair short and curled, wearing a stiff collar, a skullcap (calotte), and a cassock (simarre). Inscription: PETRVS SEGVIERIVS FRANCIÆ CANCELLARIVS [Pierre Séguier, chancellor of France].
Literature: *Trésor de numismatique* 1834–58, 14: pl. LXVIII, no. 5.

Pierre Séguier was chancellor of France during the Fronde, the series of civil conflicts between 1648 and 1653 that were the culmination of a campaign by Louis XIII's chief minister, Cardinal Richelieu, to weaken the power of France's judicial bodies (*parlements*) as counterweights to the monarchy. Though Séguier had served in the Paris *parlement* for nearly a decade, in 1633 he became keeper of the seals, making him one of the most hated figures of the rebel frondeurs; his dismissal from that post was one of the concessions granted to them in 1650 (although he was reappointed in 1651). EM

586

Unknown artist
CÉSAR, DUKE OF VENDÔME (1594–1665)
ca. 1650
Copper alloy, cast; 63.7 mm
Scher Collection

Obverse: César, hair long, wearing a soft collar, ornate armor (with grotesque face pauldrons), a commander's sash, and the Order of the Holy Spirit suspended from a ribbon. Inscription: CESAR DVC DE VANDOSME PAIR GRAND MAISTRE CHEF [César, Duke of Vendôme; peer, Grand Master, leader].
Literature: Mazerolle 1902–4, 2: no. 783.

César, the legitimized son of King Henri IV of France and his mistress, Gabrielle d'Estrées, was at the heart of several aristocratic rebellions and conspiracies during the reign of his half-brother, Louis XIII, and was implicated in the assassination attempt on Cardinal Richelieu. By the time this medal was made, however, Louis and Richelieu were dead, César's son had married the niece of Cardinal Mazarin, Richelieu's successor, and the duke—pacified by his appointment in 1650 as governor of Burgundy and *grand maître, chef et surintendant général de la navigation et du commerce de France* (1650–65)—had served the crown during the Fronde. It is the latter title—invented, ironically, by Richelieu for himself—that César bears on this medal. However, only half of the full legend is visible on this particular specimen, which is missing the reverse that is present on other versions. EM

585

586

587

588

587

Claude Warin (ca. 1612–1654)

MATHIEU CHAPPUIS (ca. 1615–1678; Councilor to the King, Présidial Court of Lyon 1651–52; Secretary to the King, House and Crown of France 1657)

Dated 1651

Copper alloy, struck; 104.7 mm

The Frick Collection; Gift of Stephen K. and Janie Woo Scher, 2016 (2016.2.25)

Obverse: Chappuis, hair curled beneath a calotte, wearing magistrate's robes. Inscriptions: MATTHÆVS CHAPPVIS IN CVRIA LVGDVNENSI CONS[iliarius] [Mathieu Chappuis, counsel to the tribunal of Lyon]; below truncation, WARIN 1651.

Literature: Rondot 1888, no. 25; Tricou 1958, no. 62.

This medal was modeled by Warin at the same time as those of the members of the Lyon Consulate of 1651. In 1651, Chappuis, lord and baron of Corgenon, was made councilor to the king (*conseiller du roi*) at the judicial tribunal of Lyon. EM

588

Claude Warin (ca. 1612–1654)

CAMILLE DE NEUFVILLE (1606–1693)

Dated 1651

Copper alloy, cast; 105 mm

The Frick Collection; Gift of Stephen K. and Janie Woo Scher, 2016 (2016.2.26)

Obverse: Camille, wearing a soft collar with tassels over a jerkin. Inscriptions: CAM[ille] DENEVFVILLE ABB[as] ATHAN[acum] PROREX LVGDVNENSIS [Camille de Neufville, abbot of Ainay, governor of the Lyonnais]; below truncation, Warin 1651.

Literature: Rondot 1888, no. 15; Tricou 1958, no. 62; M. Jones 1982–88, 2: no. 309.

This medal, along with those of Madeleine de Créquy (no. 589) and Nicolas de Neufville (Camille's sister-in-law and brother), was commissioned by the consulate of Lyon, to which both brothers had belonged. Silver versions were given to the brothers, and a bronze version was given to their *chargé d'affaires* in Paris. Camille, abbot of Ainay, became governor of Lyon in 1645, only a couple of years after his older brother had given up the post to better perform his duties as first marshal of France. In 1654, the abbot was promoted to archbishop of Lyon. EM

589

Claude Warin (ca. 1612–1654)

MADELEINE DE CRÉQUY (ca. 1609–1675)

Dated 1651

Copper alloy, cast; 103.1 mm

Scher Collection

Obverse: De Créquy, hair bound in a caul, with loose ringlets falling over her ears, wearing drapery, décolletage exposed. Inscriptions: MAGDELENE DE CREQVY MARESCHALE DE FRANCE [Madeleine de Créquy, marshal of France]; below truncation, WARIN 1651.

Literature: Rondot 1888, no. 12; Tricou 1958, no. 83; M. Jones 1982–88, 2: no. 307.

589

590

See the commentary for no. 588. De Créquy was the granddaughter of the great Duke of Lesdiguières, constable of France (see no. 547). In 1646, her husband was named marshal of France, thus her designation to *maréschale* in the feminine. EM

590

Claude Warin (ca. 1612–1654)
PORTRAIT OF A WOMAN
First half of 17th century
Copper alloy, cast; 97 mm
Scher Collection; Promised gift to The Frick Collection

Obverse: The sitter, hair worn in ringlets and a braided caul, wearing a pearl necklace and a low-cut gown, draped and knotted at the shoulder. Inscription: below truncation, VARIN. EM

591

Unknown artist
RAOUL DE ROSTAING (14th century)
Dated 1324, made ca. 1652
Copper alloy, cast; 63.6 mm
The Frick Collection; Gift of Stephen K. and Janie Woo Scher, 2016 (2016.2.41)

Obverse: Bust of Rostaing, mounted on a pedestal, bearded and with short, wavy hair, wearing classical armor and drapery, knotted at the shoulder above a grotesque mask. Inscription: RAOVL DE ROSTAING BARON ET CAPITAINE ALLEMAND 1324 [Raoul de Rostaing, German baron and captain, 1324].
Reverse: Raoul de Rostaing, in classical armor and accompanied by troops bearing a standard, leaning on his shield (emblazoned with a wheel from the arms of the Rostaings) and offering his sword to

591

592

France personified. Inscription: FRANCE IE SERAY POVR VOVS ENVERS TOVS ET CONTRE TOVS [France, I will be there for you, in the face of all opposition].
Literature: M. Jones 1982–88, 2: no. 341.

Probably commissioned by Charles, marquis de Rostaing (1572–1660), godson of Charles IX and councilor to the throne, this medal celebrates Raoul de Rostaing, ostensibly one of the first of the marquis's ancestors to have settled in France. A German baron and captain said to have brought his men-at-arms to serve Charles IV (apparently following the example of an even earlier ancestor who served Emperor Charlemagne), Raoul does not actually appear in the Rostaing genealogy. On the medal's reverse, Raoul pledges his allegiance to France, a nation that, in turn, promises to protect him. EM

592

Unknown artist
CHARLES DE L'AUBESPINE (1580–1653)
Dated 1653
Copper alloy, cast; 92 mm
Scher Collection; Promised gift to The Frick Collection

Obverse: Châteauneuf, bearded, wearing a calotte and simarre, with the Order of the Holy Spirit suspended from a ribbon and the star of the Order pinned to his gown. Inscriptions: CAROLVS DE LAVBESPINE CVST[os] SIGILLI GALLIÆ MARC[hio] DE CHASTEAVNEVF [Charles de l'Aubespine, Guardian of the Seal of France, Marquis of Châteauneuf]; 1653.

Reverse: Justice, with breasts bare, sitting on a throne decorated in bas-relief, one hand holding scales and the other resting on a large medallic portrait of Charles de l'Aubespine; beside her, a genius holding a book and a bow; by her feet, a dog, a crown, a sword, and some sort of vessel; behind her, soldiers with standards and Mercury and a female figure holding a round disk flying above; facing Justice, the Temple of Glory, before which Fame sounds a trumpet and a woman kneels. Inscription: HOC MONIMENTVM DABIT NOMEN ÆTERNVM [This monument will give him eternal fame].
Literature: *Trésor de numismatique* 1834–58, 14: pl. LXV, no. 1.

This medal was made to commemorate the death of de l'Aubespine, Marquis of Châteauneuf, abbot of Préaux, who led the frondeurs during the 1649 "revolt of the judges," a rebellion against the royal administration. After incurring the suspicions of Cardinal Richelieu, Châteauneuf was removed from office and imprisoned in 1633. He was a key figure in such conspiracies as the 1643 *cabale des importants* assassination plot against Cardinal Mazarin. In 1650, as a concession granted to the frondeurs, the seals of France and the powers of chancellor were returned to Châteauneuf. EM

593

593
Unknown artist
LOUIS HESSELIN (ca. 1600–1662)
1662
Copper alloy, cast; 63 mm
Scher Collection; Promised gift to The Frick Collection

Obverse: Hesselin, all'antica, with lovelock at his left. Inscriptions:
L[udo]V[i]C[us] HESSELIN REG[is] A CONS[ilio] ET OECON[omus] AC
ÆRAR[ii] DOMEST[ici] PRÆFERT[PRÆFECTUS] [Louis Hesselin, councilor
to the King and *maître de la Chambre aux deniers*].
Reverse: Laurel wreath framing a flying rocket. Inscription: SVPEREST
DVM VITA MOVETVR [Life progresses while it moves].
Literature: Mazerolle 1902–4, 2: no. 869.

This medal marks the death of Hesselin, a wealthy collector who
was Louis XIV's *surintendant des plaisirs du roy*. Responsible for

organizing fêtes, ballets, and other extravagant affairs for the king
and his guests, Hesselin was known for his love of luxury and
overindulgence: indeed, he died after consuming, on a bet, nearly
three hundred half-ripe walnuts (a delicacy). The imagery on the
medal's reverse speaks of a socially ambitious man who wished to
climb high and who lived life to the fullest. EM

594
Charles-Jean-François Chéron (1635–1698)
POPE CLEMENT IX (b. 1600; r. 1667–69)
1669
Copper alloy, struck; 98.1 mm
Scher Collection

Obverse: Clement, bearded, wearing a cassock, a soft collar, a fur-
lined cap, and a stole bearing the Rospigliosi diamond. Inscriptions:

594

595

CLEMENS IX PONT[ifex] MAX[imus] AN[no] III [Pope Clement IX, in the third year (of his pontificate)]; on truncation, F[rançois] CHERON.
Reverse: A she-wolf suckling Romulus and Remus, beside a reclining river god who holds a cornucopia, on the banks of the river Tiber before the Sant'Angelo Bridge; on the river, a man in a boat; above, Fame sounding a trumpet in the right hand and holding another trumpet in the left. Inscriptions: ÆLIO PONTE EXORNATO [When the Aelian bridge was embellished]; on inner rim (incuse), F[rançois] CHERON.
Literature: Whitman 1983, no. 112.

This medal was created to celebrate Pope Clement IX's restoration of the Sant'Angelo Bridge, originally built by Hadrian. Its imagery suggests continuity between classical and Christian Rome: the bridge's name is given in its Hadrianic form, and the figures of the she-wolf and river god allude to early Rome; yet Fame appears more angelic than ancient, and the bridge is replete with Christian adornments. Clement, born Giulio Rospigliosi, is remembered for his policies of conciliation, particularly where religious strife was concerned. EM

595

Charles-Jean-François Chéron (1635–1698)
JACQUES TROIS-DAMES (mid- to late 17th century)
Dated 1674
Copper alloy, cast; 67 mm
Scher Collection; Promised gift to The Frick Collection

Obverse: Trois-Dames, in a periwig and magistrate's robes. Inscriptions: IAC[opo] TROIS=DAMES ÆDIL[is] PAR[is] 1674 [Jacques Trois-Dames, municipal officer, Paris, 1674]; on truncation, F[rançois] C[héron].

This medal commemorates the year Trois-Dames was an alderman in the Paris Hôtel de Ville (the city's primary municipal building). EM

596

Charles-Jean-François Chéron (1635–1698)
CHARLES LE BRUN (1619–1690)
ca. 1681
Copper alloy, cast; 71.1 mm
The Frick Collection; Gift of Stephen K. and Janie Woo Scher, 2016 (2016.2.19)

596

597

Obverse inscriptions: CAR[olus] LE BRVN EQ[ues] I^{VS}[PRIMUS] REGIS PICTOR ACAD[emiæ] CANCEL[larius] [Charles Le Brun, *chevalier*, first painter to the King, director of the Academy]; on truncation, F[rançois] CHERON.

Reverse: A personification of Design, naked and draped, with wings on her head, standing with one foot on a pedestal while inscribing a stone slab; on the floor in front of her, a patterned rug, an antique ewer, paintbrushes, and a palette; in the right background, a compass, measuring stick, and slabs of stone showing architectural plans and elevations; behind her on the ground, architect's tools (a compass, a T-square, a book, and rolls of paper), a pedestal supporting an urn, and a stand with the classical bust of a bearded man. Inscription: ARTIVM MATER DIAGRAPHE [The science of drawing is the mother of the arts].

Literature: *Trésor de numismatique* 1834–58, 16: pl. XXIX, no. 6; Rondot 1888, pl. XXXIV, no. 1; Forrer 1979–80, 1: 420.

Charles Le Brun, first painter to Louis XIV, had enormous influence over French artistic production in the latter half of the seventeenth century. During his tenure (beginning in 1663) as director of the Royal Academy of Painting and Sculpture in Paris—which he helped to found—a quarrel broke out over the relative merits of design and color. This medal positions Le Brun, a student of Nicolas Poussin, as a supporter of the supremacy of design, which was said to appeal to the intellect (as opposed to the eye alone). On Le Brun's recommendation, Chéron was also invited to work under Louis XIV and was received at the academy in 1679. EM

597

Unknown artist

LOUIS XIV, KING OF FRANCE (b. 1638; r. 1643–1715)

1672

Copper alloy, struck; 83 mm

The Frick Collection; Gift of Stephen K. and Janie Woo Scher, 2016 (2016.2.44)

Obverse: Louis, in a periwig, lace cravat, commander's sash, and armor, draped. Inscription: LVDOVICVS MAGNVS FRAN[ciæ] ET NAV[arræ] REX P[ater] P[atriæ] [Louis the Great, King of France and Navarre, father of his country].

Reverse: Paris personified, seated on a base with a relief showing two male nudes wrestling and dressed in the classical style, her right hand holding a cornucopia, her left resting on a shield bearing the arms of Paris. Inscriptions: FELICITAS PVBLICA [Public happiness]; in exergue, LVTETIA [(Latin name for) Paris].

Literature: Jacquiot 1970, no. 226 (var.).

The die for the obverse was broken, and a faithful reduced copy (59 mm) was made by Jean Dollin (act. 1680–1717), who was probably not the original artist. The medal was probably offered to the king in 1672 as a token of loyalty and affection from the citizens of Paris, which was ironic since Louis had little love for his capital city. SKS

598

Unknown artist

HENRI DE LA TOUR D'AUVERGNE (1611–1675)

Dated 1675

Copper alloy, cast; 71.6 mm

Scher Collection

Obverse: Turenne, in a periwig, wearing a cravat tied into a bow, and ornately decorated armor with the ribbon of an order across his chest. Inscriptions: HEN[ri] DE LA TOVR DAVV[ergne] PR[inceps] VICE[comitem] DE TVRENNE [Henri de la Tour d'Auvergne, prince, Viscount of Turenne]; EX IDEA 1675 [From an idea (of) 1675].

This medal—the idea for which, as the inscription states, dates from 1675—was probably made to mark the death of Turenne, Viscount of Turenne and one of the great military leaders of his time. Commander of the Royal French army during the Dutch War (1672–78) and the civil strife of the Fronde, among other conflicts,

598

599

Turenne is remembered as a great tactician and strategist. Despite his Protestant faith, in 1660 he was offered the prestigious title of marshal-general of France; when he died, he was laid to rest at Saint-Denis, burial ground of the kings of France. EM

his baroque paintings, which decorated the Tuileries, the Louvre, Versailles, and the apartments of Jules Mazarin. It may be a self-portrait. EM

599

Attributed to Noël Coypel (1628–1707)
NOËL COYPEL (1628–1707)
1672–76
Copper alloy, cast; 67.3 mm
Scher Collection

Obverse: Coypel in a periwig and academician's robe with lace or embroidery trim. Inscription: N[o]A[l] COYPEL RECT[or] ACADE[miæ] REG[iæ] ROMÆ [Noël Coypel, director of the Royal Academy, Rome].
Literature: Forrer 1979–80, 1: 467.

Coypel was director of the French Academy in Rome (1672–76) and later of the Royal Academy in Paris (1695–1707). A student of Poussin and a favorite of Louis XIV, he is known primarily for

600

Jérôme Roussel (1663–1713) and Michel Molart (1641–1713)
LOUIS XIV, KING OF FRANCE (b. 1638; r. 1643–1715)
Dated 1672, made after 1678
Copper alloy (partial gilt), struck; 69.9 mm
The Frick Collection; Gift of Stephen K. and Janie Woo Scher, 2016 (2016.2.39)

Obverse: Louis, laureate, with peruke, wearing armor all'antica emblazoned with fleurs-de-lis, a commander's sash pinned at the shoulder. Inscriptions: LVDOVICVS MAGNVS REX CHRISTIANISSIMVS [Louis the Great, most Christian king]; below the bust, R[oussel].
Reverse: A tree trunk, atop which rests a mural crown bearing the inscription VRB[es] XL CAP[tæ] [Forty towns captured] and over which is draped a lion skin (from the arms of Holland) pierced by seven arrows, representing the seven provinces of the Netherlands; at the

600

601

base of the tree, a weeping personification of Holland, before whom lies a bull, tied to the tree, and behind whom is a boat, with net and anchor. Inscriptions: VLTOR [star stop] REGVM [Avenger of kings]; in exergue, BATAVIA DEBELLATA / M DC LXXII [The Netherlands subdued, 1672]; MOLART F[ecit] [Molart made it].
Literature: *Catalogue des Poinçons, Coins, et Médailles* 1833, no. 177; Musée de Toulouse 1865, 1319; Rondot 1904, pl. XXXVI, no. 1; Jacquiot 1970, no. 7; Forrer 1979–80, 4: 117–20; 5: 253–58.

Although dated 1672, this medal is a later copy by two artists— Roussel (with a different portrait of Louis for the obverse) and Molart (with an exact copy of the reverse)—of a medal by Jean Mauger (ca. 1648–1722) produced to mark the end of the Dutch War (1622–78) in which a coalition of European powers, including France, Sweden, and England, successfully invaded and defeated the forces of the Netherlands. The Treaties of Westminster (1674) and Nijmegen (1678–79) concluded the war. The medal celebrates the victories of the allied kings, especially Louis. The reverse is based on a drawing by Sébastien Le Clerc (1637–1714). SKS

601
Michel Molart (1641–1713)
LOUIS DE BOUCHERAT (1616–1699)
Dated 1685
Copper alloy, struck; 75.6 mm
Scher Collection; Promised gift to The Frick Collection

Obverse: Boucherat, wearing a calotte and magistrate's robes. Inscriptions: LVDOVICVS DE BOVCHERAT FRANCIÆ CANCELLARIVS [Louis de Boucherat, chancellor of France]; MOLART F[ecit] [Molart made it].
Reverse: Justice (holding a set of scales, with a sword tucked into her belt) and Beneficence (holding a cornucopia) personified, both laureate and in classical robes; between them, they hold the fleurs-de-lis-emblazoned box containing the seals of France. Inscriptions: IVSTITIAE COMES BENEFICENTIA [Beneficence (is the) companion of Justice]; in exergue, M D C LXXXV [1685].

Literature: *Trésor de numismatique* 1834–58, 16: pl. XXIV, no. 5; Forrer 1979–80, 4: 119.

This medal was made to commemorate Boucherat's appointment as chancellor and keeper of the seals of France in 1685. He is remembered for signing Louis XIV's Revocation of the Edict of Nantes of the same year, which stripped French Protestants of their religious and civil liberties. EM

602
Thomas Bernard (1650–1713)
CHARLES LE BRUN (1619–1690)
Dated 1684
Copper alloy, struck; 55.4 mm
Scher Collection; Promised gift to The Frick Collection

Obverse: Le Brun, wearing a pleated shirt with an embroidered collar (pinned with a brooch), and a crowned medal of an order, tied with a bow. Inscriptions: CAR[olus] LE BRVN EQVES PRIM[us] PICTOR REGIS [Charles Le Brun, *chevalier*, first painter to the King]; MDC L XXXIV [1684]; beneath truncation, T[homas] BERNARD.
Reverse: On a pedestal, draped with a patterned rug or tapestry, paintbrushes and a palette, alongside a sculpture fragment; on the floor, a shield, a vase, books, an Ionic column capital, a compass and other tools for measuring, a mallet, a chisel, and a scroll with a drawing on it. Inscription: HÆ TIBI ERVNT ARTES [These shall be your arts (Virgil, *Aeneid* VI.852)].
Literature: *Trésor de numismatique* 1834–58, 16: pl. XXIV, no. 2; Rondot 1888, pl. XXXIII, no. 3.

As well as being a master painter, Charles Le Brun was responsible for the interiors of many of the royal palaces. It is thus fitting that he is here figured as master over all arts, both fine and applied—he is surrounded by the tools of measurement, as well as those of the *beaux-arts* (like paintbrushes). The Latin word *artes* (of the reverse inscription from Virgil's *Aeneid*) alludes at once to the fine arts and all other kinds of industry. See also no. 596. EM

602

603

Thomas Bernard (1650–1713)
LOUIS-FRANÇOIS LEFÈVRE DE CAUMARTIN (1624–1687)
ca. 1687
Copper alloy, struck; 81.2 mm
Scher Collection

Obverse: Caumartin, wearing a lace cravat, square collar, and buttoned jerkin beneath magistrate's robes. Inscriptions: LVD[ovicus] FRAN[ciscus] LE FEVRE DE CAVMARTIN EQVES COMES CONSISTORIANVS [Louis-François de Caumartin, knight, councilor of State]; on truncation, BERNARD F[ecit] [Bernard made it].
Reverse: A ruined building, covered in ivy, before a tomb supporting the scales of justice. Inscriptions: ÆQVI VINDEX CERTVS AMICIS [Advocate of the just, loyal to friends]; in exergue, in three lines, OPTIMO PARENTI LVD[ovicus] / VRB[anus] LIBEL[larum] SVPL[icationum] MAG[ister] / F[aciendum] C[uravit] [Louis-Urbain, master of requests, had this medal made (in memory of) his excellent father].
Literature: *Trésor de numismatique* 1834–58, 16: pl. XXXIV, no. 7.

This medal was commissioned after Louis-François de Caumartin's death by his son, Louis-Urbain. Louis-François, grandson of Louis Lefèvre (Louis XIII's keeper of the seals), was in turn a councilor in the Paris *parlement*, an *intendant* (provincial commissioner/ representative of the throne) in Champagne, and a councilor of state.
EM

604

Thomas Bernard (1650–1713)
ANTOINE COYSEVOX (1640–1720)
Dated 1711
Gilt copper alloy, struck; 61.4 mm
Scher Collection; Promised gift to The Frick Collection

Obverse: Coysevox, in a periwig tied with a ribbon, wearing an unbuttoned chemise beneath a jacket with large buttons and embroidered lapels. Inscription: ANT[oine] COYZEVOX SCULP[teur] ORD[inaire] D[u] R[oi] A[ncien] DIR[ecteur] ET RECT[eur] EN L[']ACAD[émie]

603

604

R[oyale] AET[atis] 70 [Antoine Coysevox, regular sculptor to the King, former director and rector at the Royal Academy, aged 70].
Reverse: The personification of Sculpture seated, raising a hammer to strike the chisel she is using to sculpt a bust of Louis XIV; on the floor, a capital, tools of measurement, a palette and paintbrushes, books, and a sculptural fragment resembling the Belvedere torso.
Inscriptions: MENS ADDITA SAXO [A soul given to stone]; in exergue, in two lines, M DCCXI / T[homas] B[ernard] F[ecit] [1711, Thomas Bernard made it].
Literature: Tricou 1958, no. 118.

This medal seems to commemorate Coysevox's relationship with Louis XIV. While working for the Bâtiments du Roi, Coysevox had been involved in the decoration projects of a number of Louis XIV's residences, including Versailles. He became director of the Académie in 1702. Coysevox's sculpted portraits were popular in Louis XIV's court. He designed a medal of Louis XIV, which was executed by Le Blanc and Duvivier. EM

605

Jean Cavalier? (act. 1684; d. 1699)
Possibly **SIR ROBERT JACKSON** (ca. 1585–1645)
Late 17th–early 18th century
Ivory; 78.3 mm
Scher Collection

Obverse: The sitter, in a periwig, embroidered collar, lace-trimmed cravat and drapery, over a chemise with short, lace-trimmed sleeves.
Inscription: ROBERTVS IACKSON.

Sir Robert Jackson was an alderman and M.P. for Berwick-upon-Tweed in five successive parliaments (1605, 1608, 1616, 1627, 1640). He was knighted in 1616 or 1617 by James VI. Mark Jones (correspondence, 2017) proposes other Robert Jacksons as the medal's subject: Robert Lowick, known as Robert Jackson, a Jacobite executed in 1694; or the Robert Jackson who was British minister to Sweden, 1709–17. Jones also suggests Michel Molart (1641–1713), who was an ivory carver, as well as a medalist, as the possible artist. EM

605

606

Ferdinand de Saint-Urbain (1658–1738)
PHILIP V, KING OF SPAIN (b. 1683; r. 1700–January 1724,
September 1724–46)
1700
Gilt copper alloy, struck; 49 mm
The Frick Collection; Gift of Stephen K. and Janie Woo Scher, 2016
(2016.2.52)

Obverse: Philip, in a periwig and a robe trimmed with ermine.
Inscriptions: PHILIPPVS V HISPANIARVM REX [Philip V, King of Spain];
F[erdinand] S[ancti] VRBANI [Ferdinand de Saint-Urbain].
Reverse: Neptune, trident in hand and crowned, standing on a
shell in the sea, before an aerial map of Sicily and southern Italy;
above him, the shining sun and a personification of one of the
winds blowing away clouds. Inscription: SIC CVNCTVS PELAGI CECIDIT
FRAGOR VIR[gilius] AE[neis] I [Thus, the crash of the sea subsides: Virgil,
Aeneid I].
Literature: Norris and Weber 1976, no. 121.

This medal was probably struck to celebrate the accession of Philip V
to the throne. After Charles II (the last Hapsburg king of Spain) died
without issue, the War of Spanish Succession (1701–14) broke out
between England, France, and the Dutch Republic over the rights
to succession. Charles had bequeathed his territories to Philip (a
grandson of Louis XIV of France), who, by the end of the war had
managed to retain the crown and was the founder of the Bourbon
dynasty in Spain. EM

607

Ferdinand de Saint-Urbain (1658–1738)
POPE ALEXANDER VIII (b. 1610; r. 1689–91)
Dated 1700
Copper alloy, struck; 64.4 mm
The Frick Collection; Gift of Stephen K. and Janie Woo Scher, 2016
(2016.2.53)

Obverse: Alexander, in a camauro (papal cap) trimmed with ermine,
wearing a cowl, a soft collar, and an embroidered orphrey featuring
the Virgin and Child. Inscription: ALEXANDER VIII OTTHOBONVS
VENETVS PONT[ifex] MAX[imus] [Pope Alexander VIII Ottoboni,
Venetian].
Reverse: Alexander VIII's tomb, with the seated pontiff, blessing and
flanked by two allegorical figures, Religion on the left and Prudence
on the right, and the inscription ALEX[ander] VIII PONT[ifex] MAX[imus],
all upon a pedestal (featuring a tableau of the Canonization of Five
Saints) and contained within a niche framed by two columns and
a pediment upon which is a relief of an angel supporting the papal
arms); in the foreground, a group of people, including the patron
(Ottoboni) and architect (San Martino), stand beside the monument;
in exergue, the arms of the cardinal (bisecting the inscription S[aint]
V[rbain]) and the inscription COM[es] CAROLVS H[enricus] S[ancti]
MARTIN[i] INVEN[it] [Count Carlo Enrico di San Martino conceived
it]. Inscription: PETRVS CARD[inalis] OTTHOBONVS S[anctæ] R[omanæ]
E[cclesiæ] VICECANCE[llarius] PATRVO MAG[no] BENEMERENTI POSVIT
MDCC [Pietro Ottoboni, cardinal and vice chancellor of the Holy
Roman Church, erected to his noble and deserving uncle, 1700].
Literature: Whitman 1983, no. 137; Olszewski 2004, 36.

This medal celebrates the creation of the tomb of Alexander VIII
(born Pietro Ottoboni) in St. Peter's, Rome, commissioned by his
great-nephew Cardinal Pietro Ottoboni and inspired by Bernini's
monument to Urban VIII. A sophisticated patron of the arts who
benefited greatly from the nepotism of Alexander's papacy, Ottoboni
chose both the tomb's designer (Carlo Enrico di San Martino) and
its sculptor (Angelo de' Rossi). Though he evidently wished the
monument to be ready by the Jubilee or "Holy Year" of 1700, it
would not be finished for another twenty-five years; as a result, the
depiction on the medal does not reflect its final form. EM

608

Ferdinand de Saint-Urbain (1658–1738)
POPE CLEMENT XI (b. 1649; r. 1700–21)
1702
Copper alloy, struck; 52.4 mm
Scher Collection; Promised gift to The Frick Collection

Obverse: Clement wearing a camauro trimmed with ermine, a cowl, a soft collar, and an embroidered orphrey featuring stars and vegetal motifs. Inscriptions: CLEMENS XI PONT[ifex] MAX[imus] A[nno] II [Pope Clement XI, in the second year (of his pontificate)]; beneath truncation, S[ancti] VRBANI OP[us] [The work of Saint-Urbain].

Reverse: Catholic Doctrine, radiant and sitting on a throne above the clouds, wearing loose robes with a sun symbol on her chest, pointing her scepter at the Eye of Providence with one hand, and holding a book with the other. Inscriptions: LVCET IN VVLTV EIVS [(A man's wisdom) maketh his face to shine (Ecclesiastes 8:11)]; S V [artist's signature].
Literature: Vannel and Toderi 2003–7, 2: no. 826.

This medal seems to celebrate the position of Clement XI (born Giovanni Francesco Albani) as upholder of the doctrine of the Catholic Church (although the female personification on the reverse has also been identified as Benevolence, Wisdom, Religion,

609

and Mercy). The early years of Clement, who is remembered as combative and indecisive, were defined by the War of Spanish Succession (1701–14). His initial recognition of Philip V (grandson of Louis XIV) as king of Spain angered the Holy Roman Emperor Leopold I, whose son invaded the Papal States a few years later, forcing Clement to transfer his allegiance to Charles VI (the invader's brother). This was personally humiliating for the pope and also highlighted the vulnerability and political impotence of the papacy. EM

610

609

Charles-Claude Dubut (ca. 1657–1742)
POPE CLEMENT XI (b. 1649; r. 1700–21)
1707
Copper alloy, cast; 127.4 mm
The Frick Collection; Gift of Stephen K. and Janie Woo Scher, 2016
(2016.2.60)

Obverse: Clement, in a papal tiara and lappets decorated with a cross and floral and vegetal motifs, wearing a similarly decorated papal mantle featuring St. Peter and pinned in front with a bejeweled morse. Inscriptions: CLEMENS XI PONT[ifex] MAX[imus] AN[no] VII [Pope Clement XI, in the seventh year (of his pontificate)]; beneath truncation, C[harles-Claude] DVBVT F[ecit] [Charles-Claude Dubut made it].

On Clement XI, see the commentary for no. 608. EM

610

Unknown artist
SATIRICAL MEDAL
1709
Silver, struck; 31.7 mm
Scher Collection

Obverse: Two cavaliers, the first offering the second his snuffbox as the second flicks the nose of the first. Inscription: FAITES VOUS CELA POUR M'AFFRONTER? [Do you do that to insult me?].
Reverse: A man with a lantern in one hand and a staff in his

other hand searching for something on the ground or in a stream, illuminated by sunrays. Inscription: JE CHERCHE DU COURAGE POUR MON MAISTRE [I am searching for courage for my master].
Literature: *American Journal of Numismatics* 1899; Schulman (Jacob) 1912, no. 422.

The only source that connects this extremely rare satirical medal with any historical event is the Schulman catalogue of the Le Maistre Collection, *Pax In Nummis*, where the medal is dated 1709 and associated with the failed peace negotiations at The Hague during the War of the Spanish Succession (1701–14) but with no explanation of the imagery. France was staggering from a series of military defeats, close to bankruptcy, and threatened by famine, and Louis XIV (1638–1715) was desperate for peace. At The Hague, however, he was presented with impossible conditions from the allies and rejected their terms. It is possible that the figure offering the snuffbox on the obverse represents Louis who offers peace but is insulted by the allies, with the sun on the reverse referring to Louis (the Sun King) shining upon a figure searching for peace. EM, SKS

611

Jean Duvivier (1687–1761)
LOUIS HENRI DE BOURBON (1692–1740)
Dated 1724
Silver, struck; 59.7 mm
Scher Collection; Promised gift to The Frick Collection

Obverse: Louis Henri in a periwig tied with a ribbon, wearing a silk cravat, a chemise, drapery, and a coat with gilded buttonholes and flower-shaped buttons, with the Order of the Holy Spirit pinned to his chest and the Order of the Golden Fleece suspended from

611

612

a ribbon around his neck. Inscriptions: LUD[ovicus] HEN[ricus] DUX BORBONIUS PR[imus] REG[ni] ADMINISTER [Louis Henri, Duke of Bourbon, First Minister]; on truncation, DU VIVIER F[ecit] [Duvivier made it].

Reverse: A female figure (Peace), in a laurel wreath and classical dress and holding an olive branch, points an inverted torch toward a helmet, shield, and other armor on the ground at her feet; another female figure (Abundance) in classical dress and flowers in her hair, looks at the first and holds her in an embrace with one arm and a

cornucopia in her other. Inscriptions: ORDO FIDESQUE PERENNANT [Order and good faith are durable]; DU VIVIER F[ecit] [Duvivier made it]; in exergue, M DCC XXIV [1724].

Literature: *Trésor de numismatique* 1834–58, 16: pl. XLIII, no. 1.

This medal was made shortly after Louis Henri, a grandson of Louis XIV, was appointed prime minister to the young Louis XV. He was ultimately ousted by the more politically adept Cardinal Fleury (the king's tutor), who exiled Louis Henri to his estates at Chantilly. EM

Giovanni Battista Nini (1717–1786)

CHARLES-RENÉ PÉAN (1712–1786)

Dated 1768

Terracotta, cast; 196.9 mm (including frame)

The Frick Collection; Gift of Stephen K. and Janie Woo Scher, 2016
(2016.2.175)

Obverse: Bust facing left, wearing a coat with fur collar and chemise;
on truncation, arms of two swordsmen under crown with swords
pointed downward. Inscriptions: CHARLES RENE PEAN SEIGNEUR DE
MOSNAC; on truncation (incuse), J[oannes] NINI F[ecit] 1768 [Giovanni
Nini made it, 1768].

Literature: Villers 1862, no. 18; Lami 1910–11, 2: 189; *Louis XV*
1975, no. 924; Storelli 1896, no. 29; Cerboni Baiardi and Sibille
2001, no. 69.

Charles-René Péan, Lord of Mosnac, was *maître de la chambre des
comptes* and squire. In the fine modeling of the terracotta, especially
in areas such as the fur collar or the hair, the Nini portrait gives an
impression of luxury, befitting an accomplished middle-aged man
who has attained a solid government position. CM

Giovanni Battista Nini (1717–1786)

**SUZANNE-ELISABETH-FRANÇOISE DE JARENTE
D'ORGEVAL, MADAME GRIMOD DE LA REYNIÈRE**

(1733–1815)

Dated 1769

Terracotta, cast; 165 mm

Scher Collection

613

614

Obverse: Bust facing right, wearing a simple dress all'antica; on the folds of the dress, behind the shoulder, two coats of arms. Inscriptions: SUZANNE JARENTE DE LA REYNIERE 1769; on truncation (incuse), J[oannes] NINI F[ecit] 1769 [Giovanni Nini made it, 1769].
Literature: Villers 1862, no. 20; Storelli 1896, no. 34; Lami 1910–11, 2: 190; Cerboni Baiardi and Sibille 2001, no. 71; Sibille 2002, 12; Bailey 2002, 211.

Suzanne de Jarente, a descendant of an old and prestigious family, was the wife of the rich bourgeois Laurent Grimod de La Reynière, *fermier général* and an art collector. Suzanne cultivated a sophisticated group of artists and intellectuals in her palace on the Champs-Élysées. Although incarcerated during the revolution, she survived the Terror. CM

614
Giovanni Battista Nini (1717–1786)
JACQUES-DONATIEN LERAY DE CHAUMONT (1725–1803)
Dated 1771
Terracotta, cast; 164 mm
Scher Collection; Promised gift to The Frick Collection

Obverse: De Chaumont wearing a shirt and a jabot; on the truncation, the Leray de Chaumont coat of arms. Inscriptions: J[acques] D[onatien] LERAY DE CHAUMONT INTENDANT DES INVAL[ides] [Jacques-Donatien Leray de Chaumont, governor of Les Invalides]; on truncation, J[oannes] B[aptista] NINI F[ecit] 1771 [Giovanni Battista Nini made it, 1771].
Literature: Villers 1862, no. 28; Storelli 1896, no. 51; Lami 1910–11, 2: 191; Schaeper 1995, 123; Cerboni Baiardi and Sibille 2001, no. 80; Sibille 2002, 11.

Leray de Chaumont was a French entrepreneur and manufacturer who amassed a great fortune. He enjoyed a close friendship with Louis XVI and served in the court of Versailles as *intendant des Invalides*. An early supporter of the American War of Independence, Leray de Chaumont befriended Benjamin Franklin (no. 615), providing him with a place to live in Paris and facilitating the negotiations of the American delegation with the king. Leray de Chaumont commissioned this medallion from Nini in 1771. The result so pleased him that he invited Nini to live and and work in his chateau. Leray de Chaumont signed a contract with the artist to manage the business side of his production of terracotta portrait medallions of French aristocrats and intellectuals. CM

615

Giovanni Battista Nini (1717–1786)
BENJAMIN FRANKLIN (1706–1790)
Dated 1777
Terracotta, cast; 115.4 mm
Scher Collection

Obverse: Franklin wearing a fur cap, coat, vest, shirt, and jabot.
Inscriptions: B[enjamin] FRANKLIN AMERICAIN [Benjamin Franklin, American]; signed on truncation, NINI 1777 [incuse], with a shield emblazoned with a bolt of lightning striking an iron bar held by a hand and surmounted by a crown.

Literature: Villers 1862, no. 43; Storelli 1896, no. 61; Lami 1910–11, 2: 192; Sellers 1962, 103–5, 343–47; Schaeper 1995, 128–31; Cerboni Baiardi and Sibille 2001, no. 94; Sibille 2002, 14; Margolis 2015.

This medallion of the early American statesman and polymath Benjamin Franklin was produced by Nini after he had established a successful workshop in the chateau of his patron Jacques-Donatien Leray de Chaumont (see no. 614), an important figure in the French and American revolutions. Leray de Chaumont was also instrumental in popularizing the figure of Franklin in France. The extraordinary quality of the portrait has caused many scholars to conclude that Franklin must have visited Leray de Chaumont to model for Nini. According to a letter from Franklin to Thomas Walpole, however, the artist never met him and worked solely from a drawing done by Walpole's son. Nini added the fur cap from a portrait of Rousseau by Allan Ramsay (1713–1784). The small shield below Franklin's left shoulder containing a lightning bolt is a reference to Franklin's invention of the lightning rod and discovery of electricity. CM

615

616

616

Unknown artist

UNKNOWN MAN

Late 18th century

Wax on glass; h. 36 mm

Scher Collection; Promised gift to The Frick Collection

This is probably a model for an as yet unidentified medal. EM

617

Augustin Dupré (1748–1833) and Claude Michel, called Clodion (1738–1814)

LIBERTAS AMERICANA

Dated 1781, made 1783

Silver, struck; 47.5 mm

Scher Collection

Obverse: Liberty, her long hair blowing in the wind; behind her, the Phrygian cap of freedom (on a pole). Inscriptions: LIBERTAS AMERICANA [American freedom]; on truncation, DUPRE; in exergue, 4 JUIL[let] 1776 [4 July 1776].

Reverse: The infant Hercules, on a shield covered in bedclothes, strangling two snakes; behind him, Minerva, in a breastplate and plumed helmet, using her fleurs-de-lis-emblazoned shield to fend

off an attacking lion. Inscriptions: NON SINE DIIS ANIMOSUS INFANS [Not without the (favor of the) gods is the infant courageous (from Horace's *Carmina*: Book 3, "Ode to Calliope")]; DUPRE F[ecit] [Dupré made it]; in exergue, in two lines, 17 OCT[obre] 1777 [17 October 1777] / 19 [Octobre] 1781 [19 October 1781].

Literature: Trogan and Sorel 2000, 17–22; J. W. Adams and Bentley 2007, 184; Margolis 2015, 14 and *in passim*.

Conceived and financed by Benjamin Franklin, American ambassador to France, this medal pays homage to the pivotal role of the French during America's War of Independence. Gold specimens were sent to the French king and queen and silver ones given to French ministers and the president of the Continental Congress; a limited number of silver and larger number of bronze examples were also distributed. The dates on the medal's reverse refer to the Franco-American victories at Saratoga and Yorktown, respectively, and the imagery presents the personification of France protecting America, the fledgling demi-god Hercules, from the English lion. Although the reverse is signed by Dupré, the attribution is complicated by the possible collaboration in the design by Esprit-Antoine Gibelin (J. W. Adams and Bentley 2007, 184) and Clodion (Poulet and Scherf 1992, 204–7; supported by Margolis 2015; refuted by Trogan and Sorel 2000, 17–22). EM

618

Augustin Dupré (1748–1833)

LOUIS XVI, KING OF FRANCE (1754–1793; r. 1774–92)

Dated 1786

Copper alloy, struck; 69.3 mm

The Frick Collection; Gift of Stephen K. and Janie Woo Scher, 2016 (2016.2.45)

Obverse: Louis, wearing a lace cravat, a jacket with brocaded borders, the sash of an order passing under a shoulder strap, and an outer robe decorated with fleurs-de-lis and lined with ermine, pinned at the chest. Inscriptions: LOUIS XVI ROI ET FRERE BIENFAISANT [Louis XVI, beneficent king and brother]; DUPRÉ.

617

618

Reverse: Louis XVI's brother (the Count of Provence), handing a medal made of gold from the mines of Allemont to the king (to whose chest is pinned the Order of the Holy Spirit, and from whose sash hangs the badge of another order), a crown and scepter resting behind him on a pedestal draped in fleurs-de-lis-emblazoned cloth; in the distance, men working the mines. Inscriptions: HOMMAGE DE TENDRESSE ET DE RECONNOISSANCE [Tribute of fondness and gratitude]; DUPRÉ F[ecit] [Dupré made it]; in exergue, in three lines, PRÉMICES DE L'OR TIRÉ DES MINES D'ALLEMONT [Commencement of the excavation of gold from the mines of Allemont] / OFFERTES AU ROI PAR MONSIEUR [Offered to the King by *Monsieur* (the Count of Provence)] / M DCCL XXXVI [1786].
Literature: *Catalogue des Poinçons, Coins, et Médailles* 1833, 299, no. 60; *Trésor de numismatique* 1834–58, 16: pl. LVI, no. 3; Müseler 1983, 18, no. 19.

Some ten years before the creation of this medal, Louis XVI granted the mines of Chalances, Allemont, and La Gardette to his brother, the Count of Provence (the future Louis XVIII). The mines predominantly produced silver (and some lead), but gold veins were discovered in 1779. This medal commemorates the first excavation of that gold. EM

619

Anton Guillemard (1747–1812)
NICOLÒ VENIER (b. 1743) and **ELEONORA BENTIVOGLIO** (dates unknown)
Dated 1786
Copper alloy, struck; 41.7 mm
The Frick Collection; Gift of Stephen K. and Janie Woo Scher, 2016 (2016.2.55)

Obverse: Venier, hair clubbed and tied with a ribbon. Inscriptions: NICOLAO VENERIO PRAEF[ecto] BERGOMI [To Nicolò Venier, captain of Bergamo]; CIVES BERG[omates] MDCCLXXXVI [The citizens of Bergamo, 1786]; on truncation, A[nton] G[uillemard] F[ecit] [Anton Guillemard made it].
Reverse: Bentivoglio, hair drawn back and braided, tied with a fillet, and decorated with feathers, wearing loose drapery pinned at the shoulder with a jeweled brooch. Inscription: ELEONORAE BENTIVOLAE CONIVGI [To his wife, Eleonora Bentivoglio].
Literature: Voltolina 1998, 3: 832–33, no. 1697.

Presented by the people of Bergamo to Nicolò in recognition of his service as captain of Bergamo (1784–86), this medal also celebrates his wife, Eleonora. Nicolò later served the Republic of Bergamo as ambassador to Russia. EM

619

620

620

Anton Guillemard (1747–1812)
PATTARO MARCHESE BUZZACCARINI (b. 1737) and
ELENA SAGREDO (dates unknown)
ca. 1791
Copper alloy, struck; 42.2 mm
The Frick Collection; Gift of Stephen K. and Janie Woo Scher, 2016
(2016.2.54)

Obverse: Pattaro Buzzaccarini, hair clubbed and tied in back with a ribbon, wearing armor and a cravat. Inscriptions: PATTARO BUZZACARENO CAP[itaneo] BERG[omi] [To Pattaro Buzzaccarini, captain of Bergamo]; EQUESTRIS ORDO [The Order of Knights]; on truncation, A[nton] G[uillemard] F[ecit] [Anton Guillemard made it].
Reverse: Elena Sagredo, hair drawn back from the temples, loose but ending in a braid tied up with a ribbon. Inscriptions: HELENÆ SAGREDO CONIVGI [To his wife Elena Sagredo]; DUPPLEX GLORIA [double glory]; on truncation, A[nton] G[uillemard] F[ecit] [Anton Guillemard made it].
Literature: Voltolina 1998, 3: no. 1732.

Among the expressions of esteem and recognition presented by the citizens of Bergamo to Pattaro, his wife, and his sons at the close of his captaincy of Bergamo (1790–91) were a dedicatory book and two medals (of which this is one), commissioned by the Order of

Knights of the city. Elena descended from a noble Venetian family, while Buzzaccarini was elevated to Venetian nobility in 1782, after their marriage, with the inscription of his name in the *Libro d'oro*. EM

621

Unknown artist
MEETING OF THE ESTATES GENERAL
Dated 1789
Lead tin alloy, cast; 77.2 mm
Scher Collection; Promised gift to The Frick Collection

Obverse: Louis XVI, in full regalia and a plumed hat, seated on a throne in the Hall of the Estates General; behind him, his *chiffre* (royal monogram/symbol) on a fleurs-de-lis backdrop; to his right, the representatives of the clergy and, to his left, the representatives of the nobility, before whom a minister sits, reading from a sheet of paper; in the foreground, the members of the Third Estate, seated in two rows; between the king and the Third Estate, *fleurons* and a shield with the arms, France Modern. Inscription: in exergue, in three lines, ETATS GENERAUX TENUS / A VERSAILLES / LE 5 MAI 1789 [Estates General held at Versailles on 5 May 1789].
Literature: *Trésor de numismatique* 1834–58, 17: pl. II, no. 7; Julius sale 1932, no. 3.

This medal commemorates the first meeting since 1614 of the Estates General, the consultative French assembly comprising representatives of the clergy, the nobility, and the people (or Third Estate). At the outset of the French Revolution and in the face of widespread popular unrest, Louis XVI, having failed to convince the *parlements* and a specially convened Assembly of Notables to approve the fiscal reforms necessary to save France from bankruptcy, was forced to summon the Estates General. The result would prove disastrous for the king, with the Third Estate (which boasted double the deputies of either the nobility or the clergy) ultimately declaring itself the National Assembly. EM

621

622

623

622

Bertrand Andrieu (1761–1822)
SIEGE OF THE BASTILLE
Dated 1789
Lead tin alloy, cast; 80 mm
Scher Collection; Promised gift to The Frick Collection

Obverse: A crowd of armed citizens and members of the National Guard, surrounded by cannons and barrels of ammunition, firing at the Bastille, from whose ramparts armed figures return fire. Inscriptions: SIEGE DE LA BASTILLE [Siege of the Bastille]; below the border/truncation, to the right, ANDRIEU F[ecit] [Andrieu made it]; to the right, NO. 1; in exergue, in three lines, PRISE PAR LES CITOYENS DE / LA VILLE DE PARIS / LE 14 J[UILL]ET 1789 [Taken by the citizens of the City of Paris, 14 July 1789].
Literature: Hennin 1826, no. 22, pl. 3; Julius sale 1932, no. 13.

This medal commemorates the storming of the Bastille by a crowd of Parisians, a symbolic attack on the ancien régime that marked the beginning of the French Revolution. It is one of Andrieu's first major successes and the first in what he intended to be a medallic series celebrating the most remarkable events of the revolution. During this period, medals, which could be issued quickly and in great numbers, were used to disseminate revolutionary ideals. Indeed, since medal production had previously been the purview of the Royal Mint, the mere act of producing pro-revolutionary medals was a declaration of freedom and defiance. EM

623

Bertrand Andrieu (1761–1822)
THE ARRIVAL OF THE KING IN PARIS
Dated 1789
Lead and tin, cast; 85.8 mm
Scher Collection; Promised gift to The Frick Collection

Obverse: Louis XVI and his family arriving in Paris by carriage, surrounded by a throng of men and women (some of whom stand on toppled slabs of stone) and guards, passing the Place Louis XV with the equestrian statue of Louis XV. Inscriptions: ARRIVEE DU ROI A PARIS [Arrival of the king in Paris]; in exergue, in two lines, LE 6 OCTOBRE / 1789 [6 October 1789].
Literature: Hennin 1826, no. 62, pl. 8; Julius sale 1932, no. 54.

The National Assembly's Declaration of the Rights of Man and of the Citizen in the early days of the French Revolution was small consolation for the poor of Paris, who remained hungry and destitute. On October 5, in protest of the high price of bread, some seven thousand Parisian women armed themselves and marched on Versailles, storming the National Assembly and royal apartments. Their demand that Louis return to Paris and live among his people was met the following day when, after the intervention of the National Guard, the royal family acquiesced. This medal commemorating the arrival of the king in Paris is the second and final episode in Andrieu's medallic series celebrating the events of the revolution. EM

624

624

Unknown artist
PEACE TO THE COTTAGES
Dated 1792
Lead, cast; 86.9 mm
Scher Collection; Promised gift to The Frick Collection

Obverse: A beehive on a bench (upon which is written PAIX AUX CHAUMIERES [Peace to the cottages]) standing beneath a tree and before a field of wheat; little birds hopping on the grass in the foreground and the sun radiating light. Inscription: in exergue, in two lines, REPUBLIQUE FRANÇAISE / 1792 [French Republic, 1792].
Literature: Hennin 1826, no. 392, pl. 38; Julius sale 1932, no. 228; M. Jones 1977, 10.

This medal bears the date of a year of strong anti-monarchical sentiment: Louis XVI was put on trial, the monarchy was officially abolished, and the republic was established. New reforms were introduced, benefiting poor peasants at the expense of wealthy landlords and emigrés. The medal credits the French Republic with bringing "peace to the cottages," but the inscription is incomplete. It is taken from the contemporary saying "guerre aux châteaux et paix aux chaumières" (war against castles and peace toward cottages), sometimes attributed to Jacobin writer Nicolas Chamfort (who suggested it as a motto for the soldiers of the Republic). EM

625

André Galle (1761–1844)
FRENCH FREEDOM
Dated 1792
Copper alloy, struck; 39 mm
Scher Collection

Obverse: Liberty, hair blowing in the wind; behind her, the Phrygian cap of Liberty (on a pole). Inscriptions: LIBERTE FRANÇOISE [*sic*] [French liberty]; L'AN I DE LA R[épublique] F[rançaise] [Year 1 of the French Republic]; on truncation, [André] GALLE.
Reverse inscription: In ten lines surrounded by an oak wreath, À LA / CONVENTION / NATIONALE, / PAR LES / ARTISTES REUNIS / DE LYON / PUR MÉTAL / DE CLOCHE / FRAPPE EN / MDCCXCII [To the National Convention, by the united artists of Lyon / pure bell metal / struck in 1792].
Literature: Hennin 1826, no. 387.

In 1792—the same year Dupré's famous *Libertas Americana* medal (no. 617) was adapted for the first federal coins in the United States—a group of artists from Lyon united to create new coinage for revolutionary France (which was experiencing a shortage in small change) from the large quantity of metal rendered from church bells melted during the revolution. The group made and presented this trial piece, a clear homage to *Libertas Americana*, to the National Convention. Despite four separate decrees from the government, their project would never come to fruition. The design, however, propelled Galle to fame. EM

625

626

626

Unknown artist
MARIE ANTOINETTE (1755–1793; Queen Consort of France
1774–92)
Dated 1793
Lead, cast; 71.7 mm
Scher Collection; Promised gift to The Frick Collection

Obverse: Marie Antoinette, hair worn in the *toque* style and
decorated with feathers, in a simple trimmed bodice and drapery.
Inscription: MARIE ANTOINETTE REINE DE FRANCE [Marie Antoinette,
Queen of France]; DECAPITEE LE 16 8ᴮᴿᴱ 1793 [Decapitated 16 October
1793].

This medal was cast to commemorate the guillotining of Marie
Antoinette. Popular hatred of the queen peaked in 1792, when
the French Republic declared war on Austria, whose king (Marie
Antoinette's brother) had made a declaration in support of the
monarchy—a monarchy that would be abolished in France later
that year. A foreigner and lavish spender even in times of economic
crisis, Marie Antoinette had always been despised, but it was her
opposition to reform and active enmity toward the revolutionaries
that made her their main target. This medal may have been produced
as propaganda in other countries as a horrified reaction to the
execution of the queen. EM

627

Unknown artist
MARIE-JEANNE ROLAND (also known as Jeanne Manon Roland)
(1754–1793)
Dated 1793
Copper alloy, cast; 68.3 mm
Scher Collection

Obverse: Roland with full, flowing hair beneath a loose turban,
wearing a silky chemise and an overcoat. Inscription (incuse): in
three lines, Mᵐᵉ / Roland / 1793 [Madame Roland, 1793].

This medal was probably made to mark the death of the formidable
Madame Roland, whose salon during the French Revolution was an
important meeting place for the moderate Girondins. The influence
of Roland on the policies of the Girondins, as well as on the political
activities and career of her husband (Jean-Marie Roland), is well
documented. She was arrested by radical Montagnards during the
Reign of Terror and the popular insurrections of 1793 (in which
the Girondins were expelled from the convention) and sent to the
guillotine, where she is said to have cried, "O Liberty, what crimes
are committed in thy name!" EM

627

628

from favor in 1791, after declaring martial law at the behest of the Marquis de Lafayette. This allowed the National Guard to open fire on demonstrators who had gathered in the Champ de Mars to sign a Jacobin petition calling for the deposition of Louis XVI. Bailly retired to Nantes but was executed by guillotine during the Reign of Terror. The obverse image comes from a 1789 medal celebrating Bailly's election as mayor of Paris. EM

628

Benjamin Duvivier (1730–1819)
JEAN-SYLVAIN BAILLY (1736–1793)
Dated 1793
Copper alloy, struck; 42.5 mm
Scher Collection; Promised gift to The Frick Collection

Obverse: Bailly in a periwig, cravat, and jacket. Inscription: J[ean] SILVAIN BAILLY NE A PARIS LE XV SEPT[embre] MDCCXXXVI [Jean-Sylvain Bailly, born in Paris on 15 September 1736].
Reverse inscription: In twelve lines, ASTRONOME, / AUTHEUR DE L'HISTOIRE / DE L'ASTRONOMIE, / MEMBRE DES TROIS ACADÉMIES / FRANÇAISE, DES BELLES LETTRES / ET DES SCIENCES, PRÉSIDENT DE L'ASSEMBLEE / NATIONALE LE 17 JUIN, / ÉLU 1ER MAIRE DE PARIS / LE 15 JUILLET 1789 / ET HÉLAS [image of an axe] . . . / 11 NOV 1793 [Astronomer; author of *A History of Astronomy*; member of three Academies (the *Académie Française*, the *Académie des inscriptions et belles-lettres*, and the *Académie des sciences*); president of the National Assembly, 17 July; elected first mayor of Paris on 15 July 1789; and, alas, [beheaded on] 11 November 1793].
Literature: Hennin 1826, no. 551, pl. 54; Julius sale 1932, no. 361.

This medal was struck to commemorate the execution of Jean-Sylvain Bailly, an astronomer and statesman under whose leadership the Tennis Court Oath took place. Bailly was elected president of the Third Estate in 1789 and mayor of Paris shortly thereafter. He fell

629

Unknown artist
JEAN-SYLVAIN BAILLY (1736–1793)
Dated 1793
Tin, probably cast; 78 mm
Scher Collection

Obverse: Bailly, wearing a periwig, cravat, frilled shirt front, and jacket with large buttons; in the foreground, a Phrygian cap on an altar against which is unrolled a scroll with indistinct letters, and branches of oak and palm above a pile of indistinct objects and spears; behind him to the left, the scene of the execution, the present Place de la Concorde with the present Hôtel Crillon or Ministère de la Marine in the background, complete with scaffold, guillotine, crowd of spectators, and the tumbril to remove the body; to the far right in front of Bailly, a flag. Inscriptions: outer line, J[ean] S[ylvain] BAILLY PROCLAME LA LOI MARTIALE POUR LA IERE FOIS AU CHAMP DE MARS CONTRE LES 2000 FACTIEUX QUI SY ETAIENT RENDUS; inner line, POUR SIGNER LEUR PETITION SUR LAUTEL DE LA PATRIE IL Y FUT DECAPITE LE 12 NIVOSE 93 [Jean-Sylvain Bailly proclaims martial law for the first time in the Champ de Mars against the 2,000 rebels who had gathered there to sign their petition. He was beheaded on the altar of the homeland on 12 Nivôse 1793 (1st of January in the Gregorian calendar)].
Literature: Julius sale 1932, no. 366.

On Bailly, see the commentary for no. 628. EM

629

630

630

Unknown artist
JEAN-PAUL MARAT (1743–1793)
Dated 1793
Copper alloy, cast; 67.2 mm
Scher Collection; Promised gift to The Frick Collection

Obverse: Marat, in a robe and head towel. Inscription (incuse): MARAT TUE EN 1793 [Marat, killed in 1793].
Literature: Julius sale 1932, no. 302 (var.).

This medal commemorates the death of Jean-Paul Marat, the Jacobin hailed as a martyr for the people after his assassination by Charlotte Corday, a supporter of the Girondins. A prominent radical member of the National Convention and strong proponent of the abolition of the monarchy, Marat often came into conflict with the moderate Girondins, who saw him as a dangerous demagogue and whom he, in turn, saw as anti-republican. Corday, who held Marat responsible for the insurgency of 1793 that led to the fall of the Girondins, murdered him in his bath after having been admitted to his home under the pretense of possessing compromising information about the moderates. EM

631

Unknown artist
AUGUSTIN DE ROBESPIERRE (1763–1794)
ca. 1793
Lead, cast in two pieces; obverse, 54.2 × 45.9 mm; reverse, 54 × 45.6 mm
Scher Collection

Obverse: Augustin, hair in long pigtail, wearing a high cravat and a military coat with epaulettes, a ribbon tied around his arm. Inscription: ROBESPIERRE JEUNE REPRÉSENTANT DU PEUPLE [Robespierre the Younger, the People's representative].
Reverse: A fasces topped with a Phrygian cap. Inscriptions: in the field, to the left and right of the fasces, R[épublique] F[rançaise] [French Republic]; HONNEUR AUX DÉFENSEURS DE LA PATRIE [Honor to the defenders of the nation]; below, in two lines, ROBESPIERRE JEUNE / AU CAMP DEVANT TOULON [Robespierre the Younger at the camp before Toulon].
Literature: Hennin 1826, no. 549, pl. 54; Julius sale 1932, no. 357.

A radical Jacobin statesman elected to the National Convention in 1792 (and the younger brother of the famous Maximilien de Robespierre), Augustin is remembered for his organizational skill and his advancement of the young Napoleon Bonaparte's career. While commissioner on the Riviera, Augustin witnessed firsthand the crucial role played by Napoleon, then a mere artillery officer, in the defeat of the British at the Siege of Toulon. Augustin wrote to his brother, declaring the young soldier "worthy of rising merit," then promoted Napoleon to head of the newly rebuilt Army of Italy. This medal celebrates Augustin's role in the events at Toulon, particularly, as suggested by the fasces (a symbol of magisterial authority) on the reverse, in his capacity as a civilian commissioner, a position that granted him supreme authority over both military and civil officials. He was guillotined along with his brother, Maximilien, on July 28, 1794. EM

631

632

633

632

Alexis Joseph Depaulis (ca. 1792–1867)
LOUIS XVII (b. 1785; titular King of France 1793–95)
Dated 1795, made 19th century
Silver, struck; 13.1 mm
The Frick Collection; Gift of Stephen K. and Janie Woo Scher, 2016
(2016.2.42)

Obverse inscriptions: LOUIS XVII ROI DE FRANCE [Louis XVII, King of France]; DEPAULIS F[ecit] [Depaulis made it].
Reverse inscription: In five lines framed by a laurel wreath, NÉ / EN 1785 / IL PÉRIT / LE 8 JUIN / 1795 [Born in 1785, he perished 8 June 1795].
Literature: Julius sale 1932, no. 456.

This medal commemorates the death of the son of Louis XVI and Marie Antoinette, who had been declared king by exiled French nobility after the execution of his father by revolutionaries. Louis XVII was kept alive for his value as a pawn in the republic's negotiations with Austria and Prussia, with whom France was at war. However, his health deteriorated rapidly due to the harsh conditions of his imprisonment, and he soon died of tuberculosis. EM

633

Raymond Gayrard (1777–1858) and Romain-Vincent Jeuffroy (1749–1826)
NAPOLEON BONAPARTE (1769–1821; First Consul 1799–1804, Emperor of France 1804–14/15)
Dated 1796, designed in 1813 by Louis Lafitte (1770–1828)
Copper alloy, struck; 40.5 mm
Scher Collection; Promised gift to The Frick Collection

Obverse: Napoleon, hair long and clubbed, wearing a silk cravat and a military jacket, the collar and trim embroidered with oak branches. Inscription: GAYRARD F[ecit] [Gayrard made it].
Reverse: Victory flying over a globe showing Italy, holding a sword in her right hand and a laurel wreath and palm branches in her left. Inscriptions: JEUFFROY F[ecit] [Jeuffroy made it]; DENON DIR[exit] [Denon directed it]; in exergue, in two lines, BATAILLE DE MONTENOTTE / MDCCXCVI [Battle of Montenotte, 1796].
Literature: Hennin 1826, no. 731; Julius sale 1932, no. 490; Voltolina 1998, 3: no. 1785.

This medal celebrates France's victory, under the command of General Bonaparte, over the Austrians and Sardinians at the Battle of Montenotte (April 12, 1796) during the revolutionary wars. The victory was particularly impressive considering that Napoleon had been in charge of the Army of Italy (one of the five republican armies) for less than a month, that his army was severely outnumbered and outgunned by the enemy, and that this was the young general's first campaign as a commander. The medal is one of the many designed, commissioned, and/or overseen by Dominique Vivant, Baron Denon (1747–1825) (whose name appears on the reverse) for his medallic history of Napoleon's reign. In his capacity as director of the *Monnaie des médailles*, Denon was responsible for all coins and medals struck in commemoration of Napoleon. The reverse is after a design by Louis Lafitte. EM

634

634

Bertrand Andrieu (1761–1822)
NAPOLEON BONAPARTE (1769–1821; First Consul 1799–1804,
Emperor of France 1804–14/15)
Dated 1800
Lead alloy, cast; 68.3 mm
Scher Collection

Obverse: Napoleon on horseback, wearing military uniform, a
bicorne hat, and a commander's cape, riding through a rocky
outcrop, his right hand raised and brandishing bolts of lightning;
reeded border. Inscriptions: ANDRIEU F[ecit] [Andrieu made it]; in
exergue, PASSAGE DU G[rand] S[aint] BERNARD / LE XXV FLOREAL / AN VIII
[The Great St. Bernard Pass, 25 Floréal, Year 8 (May 15, 1800)].
Literature: *Trésor de numismatique* 1834–58, 17: pl. LXXVI, no. 7;
Bramsen 1977, no. 35.

In 1799, after his successful coup d'état against the Directory,
Napoleon became First Consul of France. Eager to legitimize his
sweeping new powers with a grand military success, he crossed
the Alps with his Reserve Army, hoping to take the Austrian forces
in Italy by surprise. In May, Napoleon and his forty thousand men
accomplished this by way of the Great St. Bernard Pass, a feat that
became the stuff of legend almost immediately. This dramatization
of the event, based on the painting by Jacques-Louis David (known
in five versions), depicts Napoleon as godlike and substitutes a horse
for the mule on which he had in fact made the journey. EM

635

Bertrand Andrieu (1761–1822)
HORTENSE OF HOLLAND (1783–1837; Queen Consort of
Holland 1806–10)
Dated 1808
Porcelain; 23.6 mm
Scher Collection

Obverse: Hortense, hair braided and pinned up, a myrtle wreath
in her hair. Inscriptions: ΟΡΤΗΣΙΑ ΒΑΣΙΛΙΣΣΑ [Queen Hortense];
AN[drieu].
Literature: Julius sale 1932, no. 1969; Bramsen 1977, 1: no. 767;
L. Zeitz and J. Zeitz 2003, no. 141.

The purpose of this medal in porcelain, apparently unique and
unrecorded, is unknown, though metal variations are accompanied
by a reverse commemorating a visit to the Paris mint (a visit that did
not, in fact, take place). Hortense, daughter of Empress Josephine
and stepdaughter of Napoleon, had three sons with Louis Bonaparte
(the emperor's younger brother, whom he made King of Holland
in 1806), the youngest of whom was the future Napoleon III. A
Bonapartist and favorite of the emperor, Hortense was banished
from France in 1815 for her support of Napoleon, for whom she had
provided refuge after his defeat at Waterloo. She is also remembered
for her memoirs. EM

636

Bertrand Andrieu (1761–1822)
LOUIS ANTOINE DE BOURBON, DUKE OF ANGOULÊME
(1775–1844)
Dated 1815
Copper alloy, struck; 41 mm
Scher Collection

Obverse inscriptions: LOUIS ANTOINE DUC D'ANGOULEME [Louis
Antoine, Duke of Angoulême]; on truncation, ANDRIEU F[ecit]
[Andrieu made it].
Reverse: A throne decorated with winged lions stands before a table
(covered in a fleur-de-lis tablecloth) that supports the *urne électorale*,
an inkpot and quill, paper, and a bell. Inscriptions: S[on] A[ltesse]
R[oyale] PRÉSIDE LE COLLEGE ELECTORAL DE LA GIRONDE [His Royal
Highness chairs the Electoral College of the Gironde]; ANDRIEU DE
BORDEAUX FECIT [Andrieu of Bordeaux made it]; in exergue, AOUT
MDCCCXV VOTÉ PAR LE C[ollège] E[lectoral] [August 1815, voted (on) by
the Electoral College].
Literature: Évrard de Fayolle 1902, 303, no. 54.

Angoulême, eldest son of the future Charles X and nephew of Louis
XVIII, was the last dauphin of France. Exiled in 1789, he returned
to Paris in 1814, becoming a key figure in the restoration of the
Bourbon monarchy. After Napoleon's brief return to power during the
Hundred Days, France once more found itself politically unstable,
and the nation was gripped by a "White Terror" during which
reactionary Catholic "ultra-royalists" attempted to purge France of
traitors to the monarchy, especially Protestants and *fédérés*. Louis
XVIII was eager to elect a new Chamber of Deputies, and in August
1815 Angoulême was made president of the Electoral College in the
department of the Gironde. This medal celebrates the results of the
election, a sweeping victory (partially due to electoral intimidation)
for the royalists. EM

635

636

637

638

637

Bertrand Andrieu (1761–1822)

ÉLISA BONAPARTE (1777–1820; Princess of Piombino 1805–14, Duchess of Lucca 1806–14, Grand Duchess of Tuscany 1809–14)

1808–13

Copper alloy, struck; 22.4 mm

Scher Collection; Promised gift to The Frick Collection

Obverse inscription: ΕΛΙΣΑ ΣΕΒΑΣΤΟΥ ΑΔΕΛΦΗ [Élisa, sister of the Emperor]; AN[drieu].

Reverse inscription: In six lines, S[on] A[ltesse] I[mpériale] / LA PRINCESSE ELISA / GRANDE DUCHESSE / DE TOSCANE / VISITE LA MONNAIE / DES MÉDAILLES [Her Imperial Highness Princess Élisa, Grand Duchess of Tuscany, visits the (Paris) mint].

Literature: Millin 1819, 2: no. 292; *Trésor de numismatique* 1834–58, 18: pl. XXVIII, no. 8; Julius sale 1932, no. 1973; Bramsen 1977, no. 776; L. Zeitz and J. Zeitz 2003, no. 138.

Designed to evoke ancient Greek coinage, this medal was issued by the Paris mint alongside a number of others featuring the portraits of the Bonaparte women (including Marie-Louise, Caroline, and Hortense), though the event it appears to commemorate probably never took place. The headstrong and capable Élisa, Napoleon's only sister to hold political power, was an impressive and talented administrator, and the principalities of Piombino and Lucca prospered under her rule. She had less autonomy in the duchy of Tuscany, where she was effectively Napoleon's viceroy and bound to carry out the demands of his administration. EM

638

Nicolas Guy Antoine Brenet (1773–1846)

QUEEN CAROLINE (1782–1839; Grand Duchess of Berg and Cleves 1806, Titular Queen of Sicily and Naples 1808–15)

Dated 1808

Silver, struck; 22.8 mm

Scher Collection; Promised gift to The Frick Collection

Obverse: Caroline, wearing a diadem, pendant earrings, and a pearl necklace, and flanked by a myrtle branch and a rose. Inscriptions: ΒΑΣΙΛΙΣΣΑ ΚΑΡΟΛΙΝΗ [Queen Caroline]; BP (Greek, BR[enet]).

Reverse: A bull with the head of a man being crowned with a laurel wreath by Victory. Inscriptions: ΑΠΗ [1808]; ΔΕΝ[on] [Denon]; in exergue, ΝΕΟΠΟΛΙΤΩΝ [(Vasilissa) Neopoliton] [(Queen of) the Neapolitans].

Literature: Julius sale 1932, no. 1980; Bramsen 1977, 1: no. 772; L. Zeitz and J. Zeitz 2003, no. 140.

This medal was made shortly after Caroline Bonaparte, Napoleon's youngest and dearest sister, ascended to the Neapolitan throne alongside her husband, Joachim Murat, one of Napoleon's finest generals. Many of the Bonapartes considered Napoleon's appointment of Murat as king an affront, feeling Caroline ought to have been made sole regent. In reality, Caroline did become the "dominant party" of their rule, due in part to Murat's lack of political skill. She was once described by Talleyrand as having "the head of Cromwell on the shoulders of a beautiful woman." Brenet clearly modeled this medal after the *didrachmas* of Neapolis: the reverses of medal and coin are almost identical (bar the artist's signature), and though the medal's obverse bears the likeness of Caroline, the queen is styled as the nymph Parthenope (whose bust adorns the coins). EM

639

Nicolas Guy Antoine Brenet (1773–1846) after a drawing by Antoine-Denis Chaudet (1763–1810)

NAPOLEON BONAPARTE (1769–1821; First Consul 1799–1804, Emperor of France 1804–14/15)

1803

Silver, struck; 33.4 mm, struck on a planchet previously struck for another medal

The Frick Collection; Gift of Stephen K. and Janie Woo Scher, 2016 (2016.2.36)

Obverse: Napoleon, hair short and close-cropped in the style of a Roman emperor. Inscriptions: DENON DIREXIT [Denon directed it]; beneath truncation, BRENET.

Reverse: A personification of Fortune, beneath a guiding star, seated on a ship whose wind-filled sail she directs with her left hand, while her right is holding the tiller. Inscriptions: A LA FORTUNE CONSERVATRICE [To Fortune the Preserver]; BRENET; in exergue, in two lines, L'AN 4 DE / BONAPARTE [Year 4 of Bonaparte].

Literature: Millin 1819, pl. XVI, no. 72; L. Zeitz and J. Zeitz 2003, no. 30.

Struck during France's preparations for war with Britain, this medal celebrates Fortune (who had certainly favored Napoleon thus far) and implores her to continue watching over France and its emperor. It is fitting that the obverse recalls Roman portraits of Augustus, for the reverse (after a drawing by Antoine-Denis Chaudet) echoes Horace's odes to Fortune in which the poet asks Fortune to protect

639

640

the emperor Augustus during his expedition to Britain—an entreaty suited to Napoleon's own venture. This specimen is particularly unusual in that it appears to have been struck on a planchet that had already been partially struck from a different die: faint lettering is visible under the text on the reverse (specifically, DENON DIREXIT can be seen in exergue, the letters "MAN" beneath the word CONSERVATRICE, and further lettering beneath LA FORTUNE). EM

640

Bertrand Andrieu (1761–1822) and Nicolas Guy Antoine Brenet (1773–1846)

NAPOLEON BONAPARTE (1769–1821; First Consul 1799–1804, Emperor of France 1804–14/15)

1805

Silver, struck; 40 mm

Scher Collection

Obverse inscriptions: NAPOLEON EMPEREUR [Napoleon, Emperor]; beneath truncation, in two lines, DENON DIR[exit] [Denon directed it]; ANDRIEU F[ecit] [Andrieu made it].

Reverse: A gigantic personification of Mont Blanc, styled as an ancient god of nature, his head touching the clouds and his beard transformed into a waterfall (through which a fish swims); his right hand, from which flows water with a fish, resting on a rocky outcrop within which two miners work (one chiseling the rock, the other carting it away); the left hand, from which water also flows with a fish, resting upon his thigh; in the foreground, a river. Inscriptions: in exergue, in two lines, ECOLE DES MINES DU / MONT BLANC [School of

the Mines of Mont Blanc]; on truncation, BRENET F[ecit] [Brenet made it]; DENON D[irexit] [Denon directed it].

Literature: *Trésor de numismatique* 1834–58, 18: pl. VIII, no. 9; Julius sale 1932, no. 1496; Bramsen 1977, 1: no. 471; Baladda 2003; L. Zeitz and J. Zeitz 2003, no. 34.

This medal commemorates the founding of a school for mining engineers (École des Mines) in the French *département* (administrative division) of Mont Blanc. The first École des Mines had been established in 1783 by the Ministry of Public Works in Paris to train men for the Corps of Mining Engineers *(Corps des Ingénieurs des Mines)* but was closed by the convention in 1802 and replaced with schools situated in the mining areas (including Mont Blanc), with the aim of developing mining research by training scientists in the field. The figure on the reverse evokes that of Giambologna's *Appennino*, a colossal personification of the mountain range, in the garden of the Villa Medici in Pratolino. EM

641

André Galle (1761–1844) and Nicolas Guy Antoine Brenet (1773–1846)

NAPOLEON BONAPARTE (1769–1821; First Consul 1799–1804, Emperor of France 1804–14/15) and **JOACHIM MURAT** (1767–1815; Military Governor of Paris from 1804, Grand Duke of Berg and Cleves 1806, Titular King of Sicily and Naples 1808–15)

Dated 1805

Silver, struck; 67.6 mm

Scher Collection; Promised gift to The Frick Collection

641

Obverse: Two mayors of Paris, one holding a scroll containing the thanks of the city, bow before Napoleon, who rests one hand on the hilt of his sword and holds a branch of laurel with the other, wearing armor with eagle-emblazoned greaves, a sash, a commander's cape, and a laurel wreath; behind him, Murat, in similar armor (though with a more ornately decorated breastplate and lion pauldrons) and also wearing a sash, holding a scroll; before them, a small, half-naked nymph leans on an urn upon which is engraved: SCHOENBRUNN. Inscriptions: PANNONIA SVBACTA [Austria subdued]; below the exergue line, to the left, GALLE F[ecit] [Galle made it]; in exergue, in four lines, AEDILES PARIS IMP[erator] NEAPOLIONI A VICTORIA / REDVCI IN SVBVRBANO CAESARVM / GRATES AGVNT / PR[idiè] ID[us] DECEMBR[is] MDCCCV [The mayors of Paris present their thanks to Napoleon, returned victorious in the mansion of the Emperors, the day before the Ides of December (December 11), 1805].
Reverse: Fame, winged and trumpeting, holding an open scroll reading IMP[erator] / VRBI / SVAE [The emperor in his city]; at her feet, standards (one emblazoned with an eagle) and various military paraphernalia. Inscriptions: DE GERMANIS [About the Germans]; BRENET F[ecit] [Brenet made it]; in exergue, in four lines, PRIMITIAE BELLI ARMA ET SIGNA MILITARIA / E MANVBIIS VERTINGENS / CIVITATI DONATA / VI ID[us] OCT[obris] MDCCCV [The first fruits of war, guns and flags, from the spoils at Wertingen, offered to the city (of Paris) six days before the Ides of October (October 10), 1805].
Literature: *Trésors de numismatique* 1834–58, pl. X, no. 2; Julius sale 1932, no. 1459; Bramsen 1977, no. 453.

After his army's victory over the Austrians at Wertingen—a battle that marked the beginning of a campaign that culminated in the famous Battle of Austerlitz and the withdrawal of Austria from the Third Coalition—Napoleon established himself in the Viennese palace of Schönbrunn. There he wrote to the mayors of Paris informing them that, as a token of his gratitude toward Murat, military governor of Paris and commander of the troops at Wertingen, the city was to receive some of the spoils of the battle. A deputation of the mayors of Paris went to Napoleon to thank him on behalf of the city—an event commemorated by this medal, manufactured at the city's expense. The reverse is after a design by François Frédéric Lemot (1772–1827). EM

642

Bertrand Andrieu (1761–1822) and André Galle (1761–1844) after Antoine-Denis Chaudet (1763–1810)
NAPOLEON BONAPARTE (1769–1821; First Consul 1799–1804, Emperor of France 1804–14/15)
Dated 1807
Silver, struck; 40.3 mm
The Frick Collection; Gift of Stephen K. and Janie Woo Scher, 2016 (2016.2.34)

Obverse: Napoleon, hair short and close-cropped, laureate. Inscriptions: NAPOLEON EMP[ereur] ET ROI [Napoleon, Emperor and King]; on truncation, ANDRIEU F[ecit] [Andrieu made it]; beneath truncation, DENON DIR[exit] [Denon directed it].
Reverse: Napoleon as Mars, sheathing his sword; he towers over a pile of corpses and is flanked by the inverted torch (a symbol

642

of death) and an olive tree (a symbol of peace). Inscriptions: GALLE F[ecit] [Galle made it]; in exergue, in two lines, BATAILLE DE FRIEDLAND / XIV JUIN MDCCCVII [Battle of Friedland, 14 June 1807].
Literature: Julius sale 1932, no. 1736; Bramsen 1977, 1: no. 632; L. Zeitz and J. Zeitz 2003, no. 84.

This medal commemorates the defeat of Russian forces at Friedland by Napoleon's Grand Army, a victory that led to the Treaty of Tilsit, effectively ending the War of the Fourth Coalition (October 1806–July 1807). During the battle, half of the Russian army had been forced to retreat to the village of Friedland, where Napoleon's men slaughtered them at close quarters. More than twenty thousand Russians were killed. The reverse is after a design by Antoine-Denis Chaudet. EM

643

Jean-Pierre Droz (1746–1823) and Nicolas Guy Antoine Brenet (1773–1846)
NAPOLEON BONAPARTE (1769–1821; First Consul 1799–1804, Emperor of France 1804–14/15)
Dated 1806, made 1807
Silver, struck; 40.5 mm
Scher Collection; Promised gift to The Frick Collection

Obverse: Napoleon, hair short and close-cropped, laureate. Inscriptions: NAPOLEON EMP[ereur] ET ROI [Napoleon, Emperor and King]; on truncation, DROZ FECIT [Droz made it]; beneath truncation, DENON DIR[exi]^T [Denon directed it]; M DCCCVI [1806].
Reverse: Winged Victory, writing on her shield (which she balances on a pedestal): XIV JUIN / MARINGO / FRIEDLAND [14 June: Marengo; Friedland]; beside her, a laurel or olive branch. Inscription: in exergue, BRENET F[ecit] DENON D[irexit] [Brenet made it; Denon directed it].

643

Literature: Julius sale 1932, no. 1742; Bramsen 1977, 1: no. 633; L. Zeitz and J. Zeitz 2003, no. 85 (var.).

This medal, though dated 1806 on the obverse, commemorates the French victory over Russia at the Battle of Friedland (which ended the War of the Fourth Coalition, 1806–7), and emphasizes that the victory took place on the seventh anniversary of Napoleon's triumph over Austria at the Battle of Marengo (June 14, 1800). The emperor himself considered the date auspicious and is said to have reminded his troops of the anniversary as he moved among them in high spirits before the battle. The trope of Victory inscribing military triumphs on a shield harks back to imagery on Roman coins and triumphal columns and here is based on a drawing by Charles Meynier (1768–1832). EM

644

Bertrand Andrieu (1761–1822) and Nicolas Guy Antoine Brenet (1773–1846)
NAPOLEON BONAPARTE (1769–1821; First Consul 1799–1804, Emperor of France 1804–14/15)
Dated 1807, struck in 1808
Silver, struck; 40.5 mm
The Frick Collection; Gift of Stephen K. and Janie Woo Scher, 2016 (2016.2.33)

Obverse: Napoleon, hair short and close-cropped, laureate. Inscriptions: NAPOLEON EMP[ereur] ET ROI [Napoleon, Emperor and King]; beneath truncation, ANDRIEU F[ecit] [Andrieu made it]; DENON DIR[exi]^T [Denon directed it].
Reverse: A long-haired Naiad, probably a personification of the Vistula, naked and reclining her head, leaning on a rock beside a river, holding an oar, placed in the water flowing from a fissure in a rock; behind her, a standard topped with an eagle and the letter "N" [Napoleon]. Inscriptions: DENON D[irexit] [Denon directed it]; BRENET F[ecit] [Brenet made it]; in exergue, in three lines, SIGNIS VLTRA VISTVLAM / CONSTITVTIS / MDCCCVII [Ensigns raised beyond the Vistula, 1807].
Literature: *Trésors de numismatique* 1834–58, pl. XIX, no. 1; Julius sale 1932, no. 1713; L. Zeitz and J. Zeitz 2003, no. 80.

After Napoleon's defeat of the Prussians at the Battle of Jena (October 14, 1806), the Prussian king, Frederick William III, fled east to Königsberg (today, Kaliningrad). The French advanced swiftly in the same direction, taking with ease all fortresses in their path. This medal commemorates the arrival of the French army at the Vistula, on whose banks they triumphantly planted their imperial standards. The reverse was designed by Antoine-Denis Chaudet (1763–1810). EM

645

Bertrand Andrieu (1761–1822) and Nicolas Guy Antoine Brenet (1773–1846)
NAPOLEON BONAPARTE (1769–1821; First Consul 1799–1804, Emperor of France 1804–14/15)
Dated 1814
Silver, struck; 40.6 mm
Scher Collection

Obverse: Napoleon, laureate. Inscriptions: NAPOLEON EMP[ereur] ET ROI [Napoleon, Emperor and King]; on truncation, ANDRIEU F[ecit] [Andrieu made it].
Reverse: The imperial eagle perched on a stylized bolt of lightning, crowned with a star and flanked by a pair of fish (representing Pisces, the zodiac sign for February) on one side and a naked Victory, winged and carrying a laurel wreath, on the other. Inscription: FEVRIER MDCCCXIV [February, 1814].
Literature: Julius sale 1932, no. 2836; Bramsen 1977, 1: no. 1348; L. Zeitz and J. Zeitz 2003, no. 135.

By January 1814, a few months after the Battle of Leipzig (which had devastated Napoleon's Grand Army), France was facing allied attacks on all fronts. During the Six Days' Campaign of early February, the emperor's strategic skills secured the French some victories, as celebrated by this medal. These efforts would not, however, prove enough to win the War of the Sixth Coalition (1812–14). The reverse closely recalls the eagles on the coins of Ptolemy I, II, and III of Egypt. The star, however, appears to be Brenet's addition and might refer to the guiding star of Napoleon (see no. 639). This medal has been struck without a collar, perhaps in imitation of a Hellenistic *tetradrachm*. EM

644

645

646

on March 31, 1814, with the Allies (Austria, Prussia, Russia, and Britain), who wished to restore Bourbon rule. A provisional government was created on April 1 with Talleyrand at its head. When the news reached Napoleon, he threatened to march on Paris, but his marshals rebelled, and he was forced to comply with the Allies' wishes. On April 11, the same day the senate called Louis XVIII to the throne, a dejected Bonaparte signed an unconditional abdication. He would attempt suicide the following day. EM

646

Bertrand Andrieu (1761–1822) and Nicolas Guy Antoine Brenet (1773–1846)
NAPOLEON BONAPARTE (1769–1821; First Consul 1799–1804, Emperor of France 1804–14/15)
Dated 1814
Copper alloy, struck; 40.4 mm
Scher Collection

See no. 645. EM

647

Bertrand Andrieu (1761–1822) and Nicolas Guy Antoine Brenet (1773–1846)
NAPOLEON BONAPARTE (1769–1821; First Consul 1799–1804, Emperor of France 1804–14/15)
Dated 1814
Silver, struck; 41 mm
Scher Collection

Obverse inscriptions: NAPOLEON; on truncation, ANDRIEU F[ecit] [Andrieu made it].
Reverse: Napoleon, holding back a Fury (wrapped in a snake), who tries to stop him, and signing an open scroll (beside an inkpot) on a table. Inscriptions: BRENET F[ecit] [Brenet made it]; in exergue, L'EMPEREUR NAPOLEON ABDIQUE / XI AVRIL MDCCCXIV [Emperor Napoleon abdicates 11 April 1814]; DENON D[irexit] [Denon directed it].
Literature: *Trésors de numismatique* 1834–58, pl. LXI, no. 5; Julius sale 1932, no. 2888.

Weary of war and looking to avoid the subjugation of their nation, members of the French government met (without Napoleon)

648

Bertrand Andrieu (1761–1822) and Nicolas Guy Antoine Brenet (1773–1846)
MARIE LOUISE (1791–1847; Empress of France 1810–14/15; Duchess of Parma, Piacenza, and Guastalla 1814–47)
Dated 1813
Copper alloy, struck; 22.8 mm
Scher Collection

Obverse: Marie Louise wearing a simple diadem, her wavy hair tied in a chignon. Inscription: below truncation, ANDRIEU F[ecit] [Andrieu made it].
Reverse: The monogram M[arie]L[ouise], positioned in the center of a sunburst, shining down upon a screw press decorated with two figures (the one to the left indistinct; the one to the right, Victory) flanking the letter "N" [Napoleon] surrounded by branches. Inscriptions: BRENET F[ecit] [Brenet made it]; DENON D[irexit] [Denon directed it]; in exergue, in four lines, L'IMPERATRICE MARIE LOUISE / A HONORÉ DE SA PRESENCE / LA M[onnaie] DES MÉDAILLES / MDCCCXIII [Empress Marie Louise graced the (Paris) mint with her presence, 1813].
Literature: *Trésors de numismatique* 1834–58, pl. LVIII, no. 1; Julius sale 1932, no. 2751; Bramsen 1977, 1: no. 1303; L. Zeitz and J. Zeitz 2003, no. 137.

This medal has as its subject a visit of Marie Louise, Napoleon's second wife, to the Paris mint—a visit that did not, in fact, take place. An Austrian archduchess and eldest daughter of Emperor Francis I, Marie Louise served as regent for Napoleon in Paris during the Russian campaign. After Napoleon's abdication in 1814, she moved to Vienna with their son, and, after she refused to join him in exile, the couple grew estranged. That same year, the Congress of Vienna granted her full sovereignty over the duchies of Parma, Piacenza, and Guastalla, which she ruled until her death. EM

647

648

649

649

Romain-Vincent Jeuffroy (1749–1826)

BREACH OF THE TREATY OF AMIENS and **OCCUPATION OF HANOVER**

Dated 1803, made 1804

Copper alloy, struck; 41 mm

Scher Collection; Promised gift to The Frick Collection

Obverse: The English leopard, tearing apart a scroll with its teeth and claws. Inscriptions: LE TRAITÉ D'AMIENS ROMPU PAR L'ANGLETERRE EN MAI DE L'AN 1803 [The Treaty of Amiens, broken by England in May of the year 1803]; in exergue, in two lines, DENON DIREXIT [Denon directed it] / JEUFFROY FECIT [Jeuffroy made it].

Reverse: Victory, winged and holding a laurel wreath, on a horse (a symbol of Hanover). Inscriptions: L'HANOVRE OCCUPÉ PAR L'ARMÉE FRANÇAISE EN JUIN DE L'AN 1803 [Hanover occupied by the French army in June of the year 1803]; in exergue, in three lines, FRAPPÉE AVEC L'ARGENT DES / MINES D'HANOVRE L'AN / 4 DE BONAPARTE [Struck with silver from the mines of Hanover in Year 4 of (the government of) Bonaparte].

Literature: *Trésors de numismatique* 1834–58, pl. XCIV, no. 7; Julius sale 1932, no. 1166; L. Zeitz and J. Zeitz 2003, no. 27.

In 1802, Britain and France signed the Treaty of Amiens, bringing peace to Europe for the first time in a decade. Though it is technically true that England was to blame for the breaking of the truce, both nations were in fact at fault for their refusal to relinquish power, with France repeatedly violating the spirit, if not the letter, of the treaty. In May, 1803, Britain once more declared war on France, and French forces seized Hanover, a continental (and thus vulnerable) territory ruled in personal union by the British King George III, whose family was originally from Hanover. The medal, the reverse of which is after a design by Antoine-Denis Chaudet (1763–1810), was struck in silver and bronze. EM

650

Unknown artist (Zirotti?)

NAPOLEON BONAPARTE (1769–1821; First Consul 1799–1804, Emperor of France 1804–14/15)

Dated 1801

Copper alloy, struck; 38.5 mm

The Frick Collection; Gift of Stephen K. and Janie Woo Scher, 2016 (2016.2.43)

Obverse: Napoleon, hair in a pigtail with a ribbon, wearing a silk cravat and a buttoned overcoat with brocaded collar and lapels. Inscriptions: BONAPARTE; on truncation, Z.

Reverse inscriptions: In seven lines, framed by an oak branch and palm branch tied into a wreath, SAGESSE / DANS / LES CONSEILS / ET COURAGE / DANS / LES COMBATS [Wisdom in governing and bravery in battle]; MDCCCI [1801].

Literature: Julius sale 1932, no. 916; Bramsen 1977, no. 114.

This medal may have been struck to celebrate the Treaty of Lunéville between France and Austria (signed on February 9, 1801), which, along with the Treaty of Amiens (March 27, 1802), brought an end to the Second Coalition. Austria was forced to sign the treaty after losing the battles of Marengo (June 14, 1800) and Hohenlinden (December 3, 1800) (to Bonaparte and Moreau, respectively). Bramsen (1977) notes that a medal of this description was struck in Birmingham, England (by Kempson and Kindon), in which case it may commemorate peace with Britain. EM

650

651

652

651

Jean Philippe Guy Le Gentil, Comte de Paroy (act. ca. 1808–14)
JOACHIM MURAT (JOACHIM NAPOLEON) (1767–1815;
Military Governor of Paris from 1804, Grand Duke of Berg and
Cleves 1806, Titular King of Sicily and Naples 1808–15)
Dated 1809
Gilt copper alloy, struck; 62.8 mm
Scher Collection

Obverse: Murat, wearing a cravat, a sash, and a high-collared,
embroidered waistcoat, to which is pinned the star of the Legion of
Honor (Grand-Aigle), all beneath a frock coat embroidered with bees
(one of Napoleon's emblems), to which is pinned another star of the
Legion of Honor (Grand-Croix. Inscriptions: JOACHIM NAPOLEON
ROI DE NAPLES ET DE SICILE [Joachim Napoleon, King of Naples and
Sicily]; 1809.
Literature: *Trésors de numismatique* 1834–58, pl. XXXV, no. 2; Julius
sale 1932, no. 2173; Bramsen 1977, 1: no. 894; Forrer 1979–80, 4:
393–94.

In 1808, Napoleon issued an edict declaring Joachim Murat, one of
his finest generals, king of Naples and Sicily (though Ferdinand III
continued to rule Sicily under British protection) after transferring his
brother Joseph, the previous king, to the Spanish throne. Murat, the
husband of Bonaparte's youngest sister Caroline (see no. 638), took
the name "Joachim Napoleon" upon ascension to the throne. Murat
was responsible for a number of important reforms during his reign,
including the introduction of the Napoleonic Code (or Code Civil).
EM

652

Jean-Pierre Droz (1746–1823)
**CHARLES-MAURICE DE TALLEYRAND-PÉRIGORD, PRINCE
DE BÉNÉVENT** (1754–1838; Bishop of Autun 1788–91; Minister of
Foreign Affairs 1797–99, 1799–1807, 1814–15; Grand Chamberlain
1804–14; Prime Minister of France 1815)
ca. 1815
Copper alloy, struck; 39 mm
The Frick Collection; Gift of Stephen K. and Janie Woo Scher, 2016
(2016.2.61)

Obverse: Talleyrand, in a short periwig tied in back with a ribbon,
wearing a lace cravat and an embroidered jacket with high collar.
Inscription: M[auri]CE TALLEYRAND DE PÉRIGORD PRINCE DE BENEVENT;
DROZ F[ecit] [Droz made it].
Literature: Julius sale 1932, no. 3292; Forrer 1979–80, 1: 618–28.

Talleyrand, a clergyman and statesman, managed to maintain various
offices (mostly diplomatic) at the highest levels of French government
during the ancien régime, French Revolution, Napoleonic Empire,
and first and second restorations of the monarchy. In 1806–7, he
received two of the highest honorific titles of the empire, as well as
the title Prince de Bénévent. As the Napoleonic Wars drew to a close
and it became clear that France was under threat of subjugation,
Talleyrand negotiated with allied forces to orchestrate the Bourbon
restoration and abdication of Napoleon and was made head of the
provisional government that oversaw the transition. He would go on
to become the first prime minister of France under King Louis XVIII.
EM

653

Pierre-Jean David d'Angers (1788–1856)
JOSEPHINE BONAPARTE (1763–1814; Empress Consort of
France 1804–10; Queen Consort of Italy 1805–10)
ca. 1832
Gilt copper alloy, cast; 177.8 mm
Scher Collection; Promised gift to The Frick Collection

Obverse: Josephine, hair braided around head and held in place
with a fillet, wearing a tiara of oak leaves and acorns, a comb or
tiara edged with pearls, a pendant earring, a pearl necklace, and a
delicate, high-standing lace collar. Inscriptions (incuse): LAPAGERIE
BONAPARTE; DAVID.
Literature: Reinis 1999, no. 57.

D'Angers began his *Galérie des Contemporains*—a series of
about five hundred medallions commemorating individuals of
contemporary French history—in 1827, though he made medals as
early as 1815. Josephine (born Tascher de la Pagerie) was the first
wife of Napoleon, whom d'Angers also portrayed in a medallion,
dated 1832 (with which date this medal of Josephine is associated).
Although the artist criticized the practice of posthumous portraiture,
he created this medal after Josephine's death with no obvious single
source; it was probably based on a number of earlier portraits. AN

653

654

655

654

Pierre-Jean David d'Angers (1788–1856)
JEAN-BAPTISTE, COUNT JOURDAN (1762–1833)
Dated 1828
Copper alloy, cast; 124.6 mm
The Frick Collection; Gift of Stephen K. and Janie Woo Scher, 2016
(2016.2.59)

Obverse inscriptions (incuse): MARECHAL JOURDAN [Marshal
Jourdan]; beneath truncation, DAVID 1828.
Reverse inscription: 256.
Literature: Reinis 1999, no. 239.

A hero of the revolutionary wars, Jourdan rose to the positions of
division general (1793) and commander of the Army of Moselle
(1794). Despite his opposition to the coup of 1799, and perhaps as a
gesture to the republican old guard, Napoleon made him a marshal
in 1804 but denied him an active role in his campaigns. During
the second restoration, Jourdan was made head of the Army of the
Rhine, given a title, and made a peer of France. He is also known
for the Jourdan Law, instituted in 1798, which made military service
compulsory for all able-bodied men over the age of twenty. EM

655

Pierre-Jean David d'Angers (1788–1856)
JEAN-VICTOR SCHNETZ (1787–1870)
Dated 1828
Plaster; 123.7 mm (without loop)
Scher Collection

Obverse inscriptions (incuse): VICTOR SHNETZ; beneath truncation,
DAVID 1828.
Literature: Reinis 1999, no. 430 (var.).

Schnetz, who studied under Jacques-Louis David, Jean-Baptiste
Regnault, and Antoine-Jean Gros, was an idiosyncratic artist who
served two terms as director of the French Academy in Rome
(1841–46, 1853–66). A history painter by training, he was encouraged
by d'Angers to pursue religious subjects but also painted scenes of
the Napoleonic Wars and dabbled in genre painting. Schnetz was
elected to the Académie des Beaux-Arts in 1837 and sent to Rome
to take up the position of director (no. 677), succeeding Ingres. The
bronze medal for which this plaster probably served as a model has
the additional inscription PICTOR (painter) on the obverse. EM

656

Pierre-Jean David d'Angers (1788–1856)
ANNE-LOUISE SWANTON BELLOC (1796–1881)
Dated 1830
Lead, cast; 140.7 mm
Scher Collection

Obverse inscriptions (incuse): LOUISE SW[anton]-BELLOC; beneath truncation, DAVID 1830.
Literature: Reinis 1999, no. 451.

Swanton Belloc, a French writer of Irish extraction, was a prolific author and the translator into French of a number of modern English works of literature (including those by Harriet Beecher Stowe, Maria Edgeworth, Charles Dickens, and Lord Byron), often being the first to do so. In her twenties, she was awarded a gold medal by the Institut de France for her literary accomplishments. Swanton Belloc was a proponent of women's education and founded a circulating library with this end in mind. She was married to the French painter Jean-Hilaire Belloc. EM

657

657

Pierre-Jean David d'Angers (1788–1856)

BERNARD-FRANÇOIS, MARQUIS OF CHAUVELIN

(1766–1832)

Dated 1830

Lead alloy, cast; 122.3 mm

The Frick Collection; Gift of Stephen K. and Janie Woo Scher, 2016

(2016.2.58)

Obverse inscriptions (incuse): CHAUVELIN; beneath truncation, DAVID 1830.

Literature: Reinis 1999, no. 101.

A diplomat and politician known for his oratorical skills and liberal views, Chauvelin was a nobleman who had been *intendant* to Louis XVI in 1789 but welcomed the revolution. He occupied various important political posts up until the second restoration, including ambassador to London, prefect of the *département* of Lys, *intendant-general* of Catalonia, councilor of state, and member of the Chamber of Deputies. EM

658

658

Pierre-Jean David d'Angers (1788–1856)
GASPARE LUIGI PACIFICO SPONTINI (1779–1851)
Dated 1830
Copper alloy, cast; 139.2 mm
The Frick Collection; Gift of Stephen K. and Janie Woo Scher, 2016
(2016.2.56)

Obverse inscriptions: SPONTINI; beneath truncation, DAVID 1830.
Literature: Niggl 1965, no. 1921; Reinis 1999, no. 446; Daniels and
Baloga sale 2002, no. 180; Davids sale 2005, no. 265.

The Italian Spontini, an Empire-style opera composer best
remembered for his *La Vestale* of 1807, spent most of his career
working for royalty in Paris and Berlin. In 1805, he was made
chamber composer to Empress Josephine; after her death in 1814,
he accepted an invitation to become court composer to the newly
restored Louis XVIII. In 1820, King Frederick William III of Prussia
appointed Spontini, whom he had long admired, chief Kapellmeister
and general director of music of the Berlin Court Opera, where the
Italian would remain until after the king's death in 1840. EM

659

659

Pierre-Jean David d'Angers (1788–1856)

ACHILLE ROCHE (1801–1834)

Dated 1831

Copper alloy, cast; 140.3 mm

The Frick Collection; Gift of Stephen K. and Janie Woo Scher, 2016 (2016.2.57)

Obverse inscriptions (incuse): ACHILE ROCHE; beneath truncation, DAVID 1831.

Literature: Reinis 1999, no. 405.

A French writer, publicist, and revolutionary, Roche is perhaps best remembered for his *Histoire de la Révolution française* (1825). He wrote a number of political novels and was jailed in 1829 for several months after praising the Reign of Terror in his introduction to the memoirs of René Lavasseur, a former Montagnard. A member of the Jacobin Club, Roche founded the journal *Mouvement* and, after its confiscation, became an editor at the *Tribune*. EM

660

660

Pierre-Jean David d'Angers (1788–1856)
PIERRE-RENÉ CHOUDIEU (1761–1838)
1832
Wax on slate; 142.5 × 125.6 mm
Scher Collection

Obverse inscriptions: CHOUDIEU; on truncation, DAVID.
Literature: Reinis 1999, no. 107.

The medallion cast from this model would have been made shortly after Choudieu, a Republican prosecutor and politician, returned to France for the first time since the fall of Napoleon (having been exiled during the Restoration for supporting the execution of Louis XVI). Choudieu had once before been driven out of France: during the revolution, he had acted as deputy to the Legislative Assembly and National Convention but was accused of involvement in the April 1, 1795, insurrection and forced to flee the nation. In his diary, David d'Angers wrote: "Poor and in exile, Choudieu preferred to be a foreman in a printing house rather than accept aid from his former colleagues of the Convention." EM

661

661

Pierre-Jean David d'Angers (1788–1856)
MÉLANIE WALDOR (1796–1871)
Dated 1835
Copper alloy, cast; 165.1 mm
Scher Collection

Obverse: Waldor, hair braided into a chignon at the back with loose ringlets in front, wearing a knotted kerchief and a shawl. Inscriptions (incuse): M[élanie] WALDOR; DAVID, 1835.
Literature: Reinis 1999, no. 481.

Born into a literary family, Waldor was a French poet, novelist, and dramatist. For some time, she was involved in an extramarital affair with Alexandre Dumas the Elder. By the time this medal was cast, the affair had ended, marking the beginning of her most productive period. In 1835, Waldor published *Poésie du Cœur*, one of her magna opera. EM

662

662

Pierre-Jean David d'Angers (1788–1856)

THÉOPHILE GAUTIER (1811–1872)

Dated 1845

Copper alloy, cast; 189 mm

Scher Collection; Promised gift to The Frick Collection

Obverse inscriptions: (incuse): THEOPHILE GAUTIER; DAVID, 1845.

Reverse: Foundry mark of Louis Richard.

Literature: Reinis 1999, no. 191.

A novelist, journalist, essayist, poet, and critic, Gautier was venerated by the most prominent literary figures of his generation. By the time this medal was made, he had become an advocate of art for art's sake, celebrating beauty over conventional morality. Despite the author's reputation in literary and artistic circles, David d'Angers considered Gautier an egotist with "a profound lack of concern for others" who was prone to "feign[ing] beliefs he [did] not truly hold."

EM

662

663

663

Possibly by Pierre-Jean David d'Angers (1788–1856)

JEAN ÉTIENNE EQUOI (dates unknown)

Dated 1829

Copper alloy, cast; 102.6 mm

Scher Collection

Obverse inscriptions (incuse): JEAN ETIENNE EQUOI; on truncation, 1829.

Reverse: RICHARD FRÈRES [foundry mark, incuse]. EM

664

Louis Marie Joseph Richard (1791–1879)

SELF-PORTRAIT

Dated 1816

Copper alloy, cast; 78.4 mm (irregular)

Scher Collection

Obverse: Richard in a high collar, silk cravat, and overcoat.

Inscription: on truncation, 1816.

Reverse: RICHARD FRÈRES [foundry mark].

The renowned sculptor and medallist David d'Angers once referred to Richard, a friend who cast most of the artist's medallions, as "the

664

665

finest founder in all of Europe" (Reinis 2007, 122). The Parisian Richard entered the Réunion des Fabricants in 1818 and became its delegate in 1841. From 1826, he worked with the chaser Édouard Quesnel, leaving in 1836 to form Richard, Eck et Durand. Bronze casts bearing only Richard's name, like this example, are rare. EM

in "inexpensive but beautiful" cast-iron mourning jewelry of a type that had become immensely popular at the end of the Napoleonic era. Jean-Jacques was considered the "eldest and best" in this area, in which the medal—commemorative by nature—played an important role (Lebon 2008, 125, 127). EM

665

Jean-Jacques Richard (1792–1865)
JUSTIN LIBERTÉ
Dated 182(?)9
Copper alloy, cast; 93.9 mm
Scher Collection

Obverse inscriptions (incuse): At left, JUSTIN LIBERTÉ; at right, RICHARD FONDEUR [foundry mark]; on truncation, J[ean] J[acques] RICHARD 182(?)9.
Reverse: RICHARD FRÈRES [foundry mark, incuse].
Literature: Daniels and Baloga sale 2002, no. 185.

The identity of this sitter is unknown. Jean-Jacques Richard, like his more famous brother Louis Richard, was a French founder. He developed a number of alloys and founding techniques that enjoyed great success among his peers and for much of his career specialized

666

Joseph Eugène Dubois (1795–1863)
CLÉMENCE ISAURE (dates unknown)
Dated 1819
Silver, struck; 35.7 mm
Scher Collection

Obverse: Isaure wearing a fillet, a veil, and drapery (pinned in front) up to her chin; in the field, a lyre. Inscriptions: CLEMEN[tina] ISAURA LUD[orum] FLORAL[ium] RESTAURATRIX [Clémence Isaure, restorer of the Floral Games]; EUGENE DUBOIS F[ecit] [Eugène Dubois made it].
Reverse: A bouquet of wild flowers (including pansies, hyacinths, and lilies). Inscriptions: HIS IDEM SEMPER HONOS [Through (these flowers) always the same honor]; M DCCC XIX [1819].
Literature: Forrer 1979–80, 1: 638.

The legendary Clémence Isaure is often credited with either instituting (in 1324) or reviving and formalizing (in the late fifteenth century) the floral games at Toulouse, though her actual existence is debatable. Poets from all over France would assemble at Toulouse each May to compete in these games for literary prizes, chief among these, a violet in gold. Particularly worthy prizewinners were granted degrees of "Doctor *en gaye science*" by the Acadèmia dels Jòcs Florals (which Clémence Isaure is also imagined to have founded). The tradition was revived under the Restoration, and at the games of 1819, a young Victor Hugo won two prizes and admission to the Academy of Toulouse. EM

666

667

667

Joseph Eugène Dubois (1795–1863)
UNKNOWN ("PORTRAIT OF A MAN")
ca. 1820
Copper alloy, cast; 118.1 mm
Scher Collection; Promised gift to The Frick Collection

Obverse inscription (incuse): on truncation, E[ugène] DUBOIS.
Literature: Forrer 1979–80, 1: 638. EM

668

Jacques-Édouard Gatteaux (1788–1881)
NICOLAS-MARIE GATTEAUX (1751–1832)
Dated 1832
Copper alloy, struck; 49.9 mm
Scher Collection; Promised gift to The Frick Collection

Obverse inscriptions: NIC[ol]AS MARIE GATTEAUX; beneath truncation,
E[douard] GATTEAUX.
Reverse inscription: In five lines, À / MON PÈRE / GRAVEUR DE
MÉDAILLES / NÉ À PARIS EN 1751 / MORT EN 1832 [To my father, medal
engraver; born in Paris in 1751, died in 1832].
Literature: Forrer 1979–80, 2: 207, 210.

668

669

This medal commemorates the death of the artist's father, who was also a medalist. At the time the medal was made, Jacques-Édouard, following in his father's footsteps, held the position of *médailleur du roi* (medalist to the king). A number of Nicolas-Marie's pupils besides his own son would go on to become celebrated medalists, including Bertrand Andrieu and Nicolas Guy Antoine Brenet. EM

669

Jacques-Édouard Gatteaux (1788–1881) and Jean-Jacques Barre (1793–1855)
CHARLES X, KING OF FRANCE (1757–1836; r. 1824–30)
Dated 1825
Silver, struck; 68 mm
The Frick Collection; Gift of Stephen K. and Janie Woo Scher, 2016 (2016.2.46)

Obverse: Charles, crowned, with a lace cravat, ermine robe (over fleur-de-lis-patterned cloth), and the livery collar and medal of the Order of the Holy Spirit. Inscriptions: CAROLUS X REX CHRISTIANISSIMUS [Charles X, most Christian king]; on truncation, E[douard] GATTEAUX.
Reverse: Charles in a fleur-de-lis-embroidered coronation robe kneeling on a cushion before a bishop, who anoints him with holy oil; surrounding the pair, statesmen, military men, and members of the clergy. Inscriptions: REX CAROLUS COELESTI OLEO UNCTUS [King Charles anointed with the holy oil]; in exergue, in six lines, ADSTANTIBUS FRANCIAE PARIBUS / REGIONUMQUE DELECTIS SUMMIS LEGUM / ADMINISTRIS EXERCIT PROCERIBUS / GENTIUM EXTERAR LEGATIS / REMIS XXIX MAII / MDCCCXXV [In the presence of peers of France, deputies of the *départements*, ministers, generals and foreign ambassadors in Reims, 29 May 1825]; to the left, BARRE F[eci]ᵀ XV DIEB[us?] [Barre made it in 15 days (?)]; to the right, DE PUYMAURIN N[umismatique de] P[aris].
Literature: Norris and Weber 1976, no. 302; Forrer 1904–30, 2: 207.

This medal celebrates the coronation of Charles X (brother of Louis XVI and Louis XVIII) with a reverse of the consecration, a religious ritual during which the king of France is anointed at Reims Cathedral with oil from the holy ampulla. Charles became increasingly unpopular during his reign for his ultra-royalism and reactionary policies, which impinged upon personal liberties and limited freedom of press. He was forced to abdicate in 1830 during the July Revolution, sparked by his regressive ordinances of that month. It is fitting that this medal, struck for a king whose reign epitomized the failure of the Bourbons to reconcile their perceived monarchical rights with the democratic ideals of the French people, depicts a ritual that had once functioned to reinforce the Divine Right of the kings of France. EM

670

Jean-Jacques Barre (1793–1855)
CLEMENTINA GRASSILLI (1795–1848)
Dated 1828
Lead, cast; 119.6 mm
Scher Collection

Obverse: Grassilli, hair braided in a chignon and held in place with a comb, with curls framing her face, wearing an earring, two strands of pearls, and a low-cut dress worn off the shoulder (her décolletage covered with a fichu). Inscriptions: CLEMENTINA GRASSILLI [incuse]; beneath truncation, BARRE 1828.
Literature: Forrer 1979–80, 1: 127–31.

The daughter of Bolognese painter and engraver Mauro Gandolfi, Clementina was a musician and watercolorist. She was elected to the Accademia delle Belle Arti in 1837. She married Giuseppe Grassilli, a printer, in 1815. EM

670

671

Jean-Jacques Barre (1793–1855)
LOUIS PHILIPPE I, KING OF FRANCE (1773–1850;
r. 1830–48) and **FERDINAND PHILIPPE, DUKE OF ORLÉANS**
(1810–1842)
Dated 1842
Copper alloy, struck; 27 mm
The Frick Collection; Gift of Stephen K. and Janie Woo Scher, 2016
(2016.2.213)

Obverse: Louis Philippe in a wreath of laurel and oak leaves.
Inscriptions: LOUIS PHILIPPE I ROI DES FRANCAIS [Louis Philippe I,
King of the French]; beneath truncation, BARRE.
Reverse: Ferdinand Philippe in military costume seated on a
horse, holding the reins in his left hand and a sword in his right.

Inscriptions: L'ARMEE AU DUC D'ORLÉANS PRINCE ROYAL [(From) the
army to the Duke of Orléans, Crown Prince]; on the border of
truncation, BARRE D'APRES MAROCHETTI [(Jean-Jacques) Barre, after
(Carlo) Marochetti]; in exergue, M DCCC XLII [1842].
Literature: *Bulletins de la Société Archéologique de l'Orléanais* 1859,
173; Verly 1860, no. 1003; Gibert 1882, 564, no. 1899.

This medal commemorates the death of Ferdinand Philippe, Duke of
Orléans and son of Louis Philippe I of France. Ferdinand Philippe,
whose military exploits in Algeria earned him a reputation as a
brilliant soldier, died after falling from an open carriage. The reverse
imagery is drawn from Carlo Marochetti's equestrian statue of the
duke, begun in 1842 and erected two years later in the Place du
Gouvernement, Algiers. EM

671

672

672

Jean-François-Antoine Bovy (1795–1877)

FRANÇOIS-AUGUSTE-RENÉ, VISCOUNT OF CHATEAUBRIAND (1768–1848)

Mid-19th century

Patinated plaster, 177.8 mm (not including frame)

Scher Collection

Obverse: Chateaubriand, hair short and curly, wearing a greatcoat, a double-breasted jacket, and a shirt with a soft collar and knotted cravat. Inscriptions: F[rançois] A[uguste] VICOMTE DE CHATEAUBRIAND [François-Auguste, Viscount of Chateaubriand]; in the field, to the left of the portrait, A[ntoine] BOVY; to the right, D'APRÈS [*sic*] GIRODET [After Girodet].

Literature: Forrer 1979–80, 1: 246.

A key literary figure in the romantic movement in France, Chateaubriand is primarily remembered for his memoirs. He was a statesman, as well as an author, and served as an envoy of state under both Napoleon and (after being made a viscount and peer) the Bourbon monarchy, later being appointed minister of foreign affairs. The portrait is after an oil painting by Anne-Louis Girodet (National Museum of Versailles and the Trianons). EM

673

673

Antoine-Augustin Préault (1809–1879)
ALPHONSE LOUIS DAVID (1798–after 1849)
ca. 1838
Copper alloy, cast; 196.9 mm
Scher Collection

Obverse inscription (incuse): ALPHONSE DAVID.
Literature: Blühm 1997, no. 39.

David, a student of Anne-Louis Girodet, was a painter and
lithographer. Nothing is known of his relationship with Préault. EM

674

675

674

François-Joseph-Hubert Ponscarme (1827–1903)
GUDIN THE YOUNGER (GUDIN FILS)
1852
Copper alloy, cast; 38.1 mm
Scher Collection

Obverse inscription: In the field to the left, SOUVENIR D'AMITIÉ DE PONSCARME [A token of the friendship of Ponscarme].
Literature: Forrer 1979–80, 4: 658.

This medal is one of a number of portraits of the Gudin family made by Ponscarme in 1852. EM

675

François-Joseph-Hubert Ponscarme (1827–1903)
COMMANDANT PONSCARME (dates unknown)
1858
Copper alloy, cast; 44.9 × 40.9 mm
Scher Collection

Obverse inscription (incuse): On truncation, PONSCARME.

The subject of this medal is the artist's brother. EM

676

François-Joseph-Hubert Ponscarme (1827–1903)
PORTRAIT OF A MAN
Second half of 19th century
Wax on slate; 70.3 × 55 mm
Scher Collection

677

Henri-Michel-Antoine Chapu (1833–1891)
JEAN-VICTOR SCHNETZ (1787–1870)
Dated 1861
Copper alloy, cast; 135.1 mm
Scher Collection; Promised gift to The Frick Collection

Obverse inscriptions: V[ictor] SCHNETZ DIRECTEUR DE L'ACAD[é]mie DE FRANCE A ROME [incuse] [Victor Schnetz, director of the French Academy in Rome]; H[enri] CHAPU, [illegible word: Paris?] ROME 1861 [incuse].
Literature: Forrer 1979–80, 1: 406.

This medal was created and cast at the French Academy in Villa Medici, Rome. On Schnetz, see no. 655. EM

676

677

678

Adolphe Rivet (1855–1925)
MIGNON
ca. 1866–70
Copper alloy, cast; 124.3 mm
Scher Collection

Obverse inscriptions: MIGNON; A[dolphe] RIVET.
Literature: Forrer 1979–80, 5: 135.

The creation of this medal roughly coincides with the first
performance of Ambroise Thomas's *Mignon*, at the Opéra Comique
in 1866. The opera, which made Thomas one of the foremost French
composers, was based on Goethe's novel *Wilhelm Meisters Lehrjahre*
and became enormously popular across the Continent. Its titular
character, the mysterious child Mignon, is the subject of the medal.
Based on the date of the medal, the portrait could depict either
Célestine Galli-Marié or Christina Nilsson, the first two interpreters
of the role. EM

679

Jules-Clément Chaplain (1839–1909)
NAPOLEON III (1808–1873; President of the Second Republic of
France 1848–52, Emperor of France 1852–70)
1867
Copper alloy (silvered), cast; 78.5 mm
Scher Collection

Obverse: Napoleon III, laureate, in a jacket with oak leaf-
embroidered collar and starred epaulettes, wearing a medal
pinned to his chest, as well as a sash and bee-emblazoned drapery.
Inscriptions: NAPOLEON III EMPEREUR [Napoleon III, Emperor];
beneath truncation, CHAPLAIN.
Literature: Goldenberg 1967, no. 43; Daniels and Baloga sale 2002,
no. 193.

678

This medal was made for the Exposition Universelle of 1867. Napoleon III, nephew of Napoleon Bonaparte, was the first French president to be elected by direct popular vote, having won his 1848 election by a landslide. He brought prosperity and relative stability to France under his authoritarian rule, but his popularity fluctuated greatly throughout his reign. By 1869, it had become clear to him that a change in regime was inevitable, and he abdicated a year later, partly as a result of France's disastrous defeat in the Franco-Prussian War (1870–71). The bees on the drapery in the portrait recall the heraldic golden bees associated with Bonaparte. EM

679

680

Left column

680

Jules-Clément Chaplain (1839–1909)

LÉON GAMBETTA (1838–1882)

Dated 1882

Silver, cast; 69.4 mm

Scher Collection

Obverse: Gambetta, in a dress shirt with wing-tipped collar, cravat, waistcoat, and jacket. Inscriptions: LEON GAMBETTA 2 AVRIL 1838 31 DECEMBRE 1882 [Leon Gambetta, 2 April 1838, 31 December 1882]; on truncation, J[ules] C[lément] CHAPLAIN.

Reverse: Two forks of lightning behind an old oak that leans on an altar or tombstone around which its roots have grown; on its face, a fasces, flanked by the letters R[épublique] and F[rançaise]. Inscriptions: QVO JVSSA POPVLI [For any command of the people]; in exergue, MDCCCLXXXII [1882].

Literature: Mazerolle 1897a, no. 24; American Numismatic Society 1911, 53, no. 28; Goldenberg 1967, no. 49; Daniels and Baloga sale 2002, no. 193.

This medal was made to commemorate the death of Gambetta, a republican statesman and lawyer who was instrumental in transforming France into a parliamentary republic. A passionate proponent of modern democracy, Gambetta was elected to the Legislative Assembly in 1869 and National Assembly in 1871 and held a number of important offices, most notably those of president of the Chamber of Deputies (1876–81) and Prime Minister of France (1881–82). He also served as Minister of the Interior during the Franco-Prussian War (1870–71). EM

681

Jules-Clément Chaplain (1839–1909)

JEAN-LÉON GÉRÔME (1824–1904)

Dated 1885

Copper alloy, cast; 101.9 mm

Scher Collection

Right column

Obverse inscriptions: JEAN LEON GEROME PEINTRE [Jean-Léon Gérôme, painter]; ETATIS SVÆ LX [aged 60]; MDCCCLXXXV [1885]; beneath truncation, J[ules] C[lément] CHAPLAIN.

Reverse: The personification of Painting, naked and laureate, sitting on a bench before an easel and working on a canvas; behind her, references to Gérôme's most famous works, including a gladiator's helmet from *Pollice Verso*, a sphinx from *Bonaparte before the Sphinx*, and the Blue Mosque. Inscription: in exergue, PITTVRA [Painting].

Literature: Mazerolle 1897a, no. 60; American Numismatic Society 1911, 52, no. 24; Forrer 1979–80, 1: 411–14; 7: 176–78; Baxter 1987, 17, no. 7; Daniels and Baloga sale 2002, no. 199; *Fauver Collections* 2006, no. 381.

A successful painter and academician, Gérôme benefited greatly from the mechanical reproduction and mass redistribution of his work. One of only four French artists to be awarded a medal of honor at the 1867 Exposition Universelle, he held a professorship at the École des Beaux-Arts, where he became one of the nineteenth century's most influential art teachers, instructing thousands of students. Gérôme was also a member of the Institut de France from 1865 and a *grand officier* of the Legion of Honor from 1898 (an unusual distinction for an artist). This medal belongs to Chaplain's series of about twenty portraits of prominent contemporary artists and architects, considered by some to be "his crowning achievement as a medalist" (*Fauver Collections* 2006, 74). EM

682

Jules-Clément Chaplain (1839–1909)

THE PERSONIFICATION OF PAINTING

1885

Copper alloy, cast; 101.1 mm

The Frick Collection; Gift of Stephen K. and Janie Woo Scher, 2016 (2016.2.50)

This image usually appears as the reverse of the portrait medal of Jean-Léon Gérôme (as in no. 681). EM

681

682

683

683

Jules-Clément Chaplain (1839–1909)
SARAH GUSTAVE-SIMON (dates unknown)
Dated 1889
Gilt galvanotype; 121.9 mm
Scher Collection

Obverse: Gustave-Simon, hair in a chignon and pinned beneath a hat decorated with feathers, wearing a high-necked blouse over which is a fur-trimmed cloak with leg-of-mutton sleeves; around her neck, a ribbon from which hangs a medal, also by Chaplain, with a portrait of her daughter, Marguerite. Inscriptions: SARAH; J[ules] C[lément] CHAPLAIN 1889.
Literature: Jones 1979a, 121, no. 315; Daniels and Baloga sale 2002, no. 192; Collin du Boccage sale 2017, no. 201.

This medallion, one of Chaplain's masterpieces, was commissioned by Sarah Gustave-Simon's husband, Dr. Gustave-Simon (1848–1928), who gave up medicine and became a prominent writer and journalist. He was the son of Jules Simon (1814–1896), a writer, statesman, and philosopher, as well as prime minister from December 1876 to May 1877. Sarah was the daughter of the Paris banker Mardochée Sourdis and was married in February 1879, with Victor Hugo, a close friend of her husband's, as a witness. SKS

684

Jules-Clément Chaplain (1839–1909)
PRINCESS MARIA GORCHAKOV STURDZA (b. ca. 1848)
Dated 1895
Gilt copper alloy, cast; 96.1 × 76.8 mm
Scher Collection

Obverse: Sturdza, hair tied in a chignon and pinned with feathers, wearing a pearl necklace, a boa, and a low-cut gown decorated in front with a bow. Inscriptions: PRINCESSE MARIE GORTCHACOW STOURDZA; in the field, to the right, J[ules] C[lément] CHAPLAIN 1895.
Reverse: A villa surrounded by trees on a cliff facing the sea. Inscriptions: VILLA SYRACUSE; SORENTE [Sorrento].
Literature: Mazerolle 1897a, no. 106; Goldenberg 1967, no. 112; Forrer 1979–80, 1: 404; Daniels and Baloga sale 2002, no. 189.

Maria Sturdza was the daughter of Prince Mihail Sturdza, conservative ruler of Moldavia (r. 1834–49). She married Prince Konstantin Alexandrovich Gorchakov (son of the famous Russian politician Prince Alexander Mikhailovich Gorchakov) in 1868 but in 1886 began divorce proceedings against him. Though she was ultimately successful in her appeal to the Patriarchate of Constantinople, her high social standing (and that of her husband) meant she was faced with great opposition from the Russian government throughout the proceedings. The Sorrento villa on the reverse appears to have been one of her homes. EM

684

685

Jules-Clément Chaplain (1839–1909)
CHARLES GARNIER (1825–1898)
Dated 1895
Copper alloy, cast; 68.1 mm
Scher Collection

Obverse inscriptions: CHARLES GARNIER; in the field, to the left, ÆTATIS SVÆ LXX [aged 70]; on truncation, J[ules] C[lément] CHAPLAIN [incuse].

Reverse: A bouquet of flowers and palm branches tied with a ribbon. Inscription: in thirteen lines, A / CHARLES GARNIER / ARCHITECTE / MEMBRE DE L'INSTITUT / PRESIDENT / DE LA SOCIETE CENTRALE / DES ARCHITECTES FRANÇAIS / EN SOUVENIR / DE SON ELEVATION A

LA DIGNITÉ / DE GRAND-OFFICIER / DE LA LEGION D'HONNEUR / SES CONFRERES / SES ADMIRATEURS / 1895 [To Charles Garnier, architect, member of the Institute, president of the Central Society of Architects of France; in commemoration of his elevation to the dignity of *grand officier* of the Legion of Honor; (from) his colleagues (and) his admirers, 1895].

Literature: Mazerolle 1897a, no. 109; Goldenberg 1967, no. 66; Forrer 1979–80, 1: 403; Daniels and Baloga sale 2002, no. 193.

Garnier is most famous for his creation and design of the Paris Opéra, a masterpiece of Second Empire style. This medal, commissioned by the Société Centrale, was made to celebrate Garnier's elevation to the position of *grand officier* of the Legion of Honor. EM

685

686

687

686

Jules-Clément Chaplain (1839–1909)
PAUL DUBOIS (1829–1905)
1897
Copper alloy, cast; 98.5 mm
Scher Collection; Promised gift to The Frick Collection

Obverse inscriptions: PAUL DUBOIS STATUAIRE [Paul Dubois, sculptor];
MEMBRE DE L'INSTITUT [Member of the Institut]; on truncation, J[ules]
C[lément] CHAPLAIN.
Literature: American Numismatic Society 1911, 53, no. 38; Forrer
1979–80, 1: 404.

One of the foremost French Italianate sculptors of his time, Dubois
was twenty-six when he first entered a sculptor's studio. Early in his
career, he traveled around Italy, where he developed an enduring
interest in early Renaissance sculpture. In 1896, some years after his
appointment as director of the École des Beaux-Arts in 1878, Dubois
was awarded the *grand croix* of the Legion of Honor. EM

687

Jules-Clément Chaplain (1839–1909)
JEANNE JULIA BARTET (1854–1941)
Dated 1900
Silvered galvanotype; 133.1 × 101 mm
Scher Collection

Obverse: Bartet, hair in a chignon, wearing a low-cut, embroidered
gown trimmed with lace, with leg-of-mutton sleeves; in her right
hand, a libretto, and in her left, a tragic mask; behind her, a laurel
tree. Inscriptions: in the field above, to the right, in five lines,
SOPHOCLE / RACINE / MARIVAUX / MUSSET / DUMAS FILS [Sophocles /
Racine / Marivaux / Musset / Dumas the Younger]; in the field below,
to the left, J[ules] C[lément] CHAPLAIN 1900; in exergue, in two lines,
JEANNE JULIA BARTET / DE LA COMEDIE FRANCAISE [Jeanne Julia Bartet
of the Comédie Française].
Literature: Forrer 1979–80, 1: 404; Daniels and Baloga sale 2002,
no. 189.

Bartet was a successful actor and member of the Comédie Française
from 1879 until her retirement in 1919. She was most celebrated
for her portrayal of Marivaux's Silvia (from *Le Jeu de l'amour
et du hazard*) and her performances in Racine's *Bérénice* and
Andromaque, as referenced in the list of dramatists on the obverse.
EM

688

Jules-Clément Chaplain (1839–1909)
JULES CLARETIE (1840–1913)
Dated 1905
Copper alloy, cast; 104.4 × 80.2 mm
Scher Collection

688

Obverse: A woman in a gown with leg-of-mutton sleeves, a high neck, and a skirt decorated with flowers standing beside a column, behind which is a laurel tree and upon which are two theatrical masks, one of them the mask of comedy, a portrait possibly of Claretie; in her right hand, a bouquet of flowers. Inscriptions: A JULES CLARETIE EN SOUVENIR DU 20ME ANNIVERSAIRE DE SON ADMINISTRATION [To Jules Claretie, in commemoration of the 20th anniversary of his administration]; LES SOCIETAIRES ET LES PENSIONNAIRES DE LA COMEDIE FRANÇAISE [The sociétaires and pensionnaires of the Comédie Française]; 1885–1905.
Literature: Daniels and Baloga sale 2002, no. 187.

This plaquette was cast in honor of the dramatist, novelist, journalist, and critic Jules Claretie to commemorate the twentieth anniversary of his position at the Comédie Française (1885–1905), the complex affairs of which he handled as manager with great skill. EM

Literature: American Numismatic Society 1911, 52, no. 17; Goldenberg 1967, no. 99.

Usually accompanied by an obverse portrait (dated 1905) of world-famous surgeon and gynecologist Samuel Jean Pozzi (1846–1918), this medal, which was probably commissioned by his many friends and admirers to celebrate the twentieth anniversary of his professorship, refers to his highly influential and internationally acclaimed textbook *Traité de gynécologie clinique et opératoire* (1890). A student of renowned neurologist Paul Broca, the handsome and charismatic Pozzi contributed greatly to the development of modern gynecological surgery. Dr. Pozzi is the subject of a famous portrait by John Singer Sargent in the Hammer Museum, Los Angeles. EM

689

Jules-Clément Chaplain (1839–1909)
TREATISE ON GYNECOLOGY
1905
Copper alloy (silvered), cast; 98.9 mm
The Frick Collection; Gift of Stephen K. and Janie Woo Scher, 2016 (2016.2.49)

Obverse: A frightened woman, naked, on a hospital bed beside a table supporting medical instruments clings to Science, who protects her from Death. Inscription: TRAITE DE GYNECOLOGIE [Treatise on Gynecology].

690

Jules-Clément Chaplain (1839–1909)
THE PERSONIFICATION OF MUSIC
1889
Copper alloy, cast; 100.4 mm
Scher Collection

Obverse: Music, her hair braided down her back, wearing a daisy crown and fanciful dress, sits at a Gothic Revival organ, her foot resting on a stool; she holds a quill and rests her hands on an opera score inscribed FAUST OPERA CINQ AC[tes] [incuse] [*Faust*, opera (in) five acts]; to the right, a laurel tree, overlaid with the inscription DRAMES LYRIQVES MESSES ORATORIOS SYMPHONIES [Dramas, librettos, masses, oratorios, and symphonies].

691

Literature: Mazerolle 1897a, no. 76; Forrer 1979–80, 1: 403; Daniels and Baloga sale 2002, no. 187; Maier 2010, 149, no. 69.

This medal is usually accompanied by an obverse portrait of Charles Gounod (1818–1893), composer of the grand opera *Faust*, featuring a libretto by Jules Barbier and Michel Carré loosely based on Goethe's play. *Faust* made its debut in Paris on March 19, 1859, and remains Gounod's most famous work. The musical forms and texts listed on the medal—dramas, librettos, etc.—are those favored by the composer, and the floral crown worn by the figure of Music is possibly a reference to the main character of Gounod's *Faust*: the French for "daisy" is *marguerite*. EM

691

Louis-Oscar Roty (1846–1911)
MARIE AUGUSTINE ROTY (dates unknown)
1880
Copper alloy, cast; 146.3 × 106.4 mm
Scher Collection

Obverse inscription (incuse): MARIE AVGVSTINE ROTY; TVVM CARISSIMA CONJVX VVLTVM ÆRE FIXI VT TE SEMPER ANTE OCVLOS HABEAM JVVENEM SEMPER ET FELICEM [My dearest wife, I have fixed your face in brass so that I shall have you ever before my eyes, ever young and happy].
Literature: Mazerolle 1897b, no. 90; American Numismatic Society 1911, 270, no. 69; Daniels and Baloga sale 2002, no. 200; Maier 2010, 164, no. 89.

Roty made this medal for his wife two years after their marriage. EM

692

693

692

Louis-Oscar Roty (1846–1911)
PAUL BEURDELEY (1841–1905)
Dated 1885
Copper alloy, cast; 69.7 × 52.4 mm (with loop)
Scher Collection

Obverse: Beurdeley in magistrate's robes. Inscriptions: PAVL
BEVRDELEY AVOCAT A LA COVR DE PARIS [Paul Beurdeley, advocate at
the Paris Court]; MDCCCLXXX V [1885]; L[ouis-Oscar] ROTY X[bre] [incuse]
[Louis-Oscar Roty, October].
Literature: Mazerolle 1897b, no. 99.

A French statesman with a doctorate in juridical science, Paul
Beurdeley was a lawyer at the Paris Court of Appeals and would
go on to serve as mayor of the city's eighth *arrondissement* (1888–
1905). EM

693

Louis-Oscar Roty (1846–1911)
MICHEL-EUGÈNE CHEVREUL (1786–1889)
Dated 1886
Copper alloy, cast; 68 mm
Scher Collection

Obverse inscriptions: MICHEL EVGENE CHEVREVL MEMBRE DE
L'ACADEMIE DES SCIENCES [Michel Eugène Chevreul, member of the
Académie des Sciences]; O[scar] Roty.
Reverse: Youth personified offering her laurels to Chevreul, who sits
writing in a chair (positioned above a pile of books draped with an
unfurled scroll of parchment); in the background, a table supporting
some scientific equipment. Inscriptions: LA JEVNESSE FRANCAISE AV
DOYEN DES ETVDIANTS [(From) the youth of France to the doyen of
students]; 31 AOVT 1786 31 AOVT 1886 [31 August 1786 (to) 31 August
1886]; in exergue, O[scar] ROTY.
Literature: Mazerolle 1897b, no. 12; American Numismatic Society
1910, no. 2619; Daniels and Baloga sale 2002, no. 200; Maier
2010, 167, no. 93.

This medal was made to celebrate the centenary of Chevreul, a
celebrated French chemist remembered for, among other things,
his treatise on the laws of the contrast of colors, which had a great
influence on the Impressionist movement and became the standard
color manual for nineteenth-century artists and designers. Chevreul
was elected to the Académie des Sciences in 1826 and offered a
position as professor of chemistry at the Muséum national d'Histoire
naturelle in 1830. His centenary was a national celebration,
attended by more than two thousand international delegates. The
medal's reverse affectionately dubs Chevreul the "doyen of students,"
an equivocal term repeated in the centenary ceremony: "You are
the doyen [most venerable] of all the world's scholars," the speaker
remarked, "but in greeting you today I speak above all to the
doyen [eldest] student, since this is a title of which you seem fond"
(*Célébration du centenaire* 1886, 10–12). Bronze versions of the
medal were given to each subscriber who had donated money to the
committee in charge of producing the medal. EM

694

694

Louis-Oscar Roty (1846–1911)
FUNERAL OF SADI CARNOT (1837–1894)
Dated 1894
Silver, struck; 80.6 × 57.4 mm
Scher Collection

Obverse: The personification of France standing at the deathbed of Carnot, surrounded by funeral wreaths, holding a laurel (?) branch; above, landscape with the Basilique Notre-Dame de Fourvière in Lyon. Inscriptions: upper right, XXIV JUIN MDCCC / XCIV [24 June 1894]; below, across, DANS LE DEUIL DE LA PATRIE [in the grief of the nation].
Reverse: The coffin of Carnot with several wreaths on top carried to the Panthéon by veiled female figures. Inscriptions: lower right, SADI CARNOT / PRESIDENT / DE LA / REPUBLIQUE / FRANÇAISE [Sadi Carnot, president of the French Republic]; upper right corner: 1ER JUILLET [1 July]; lower right corner, O[scar] ROTY.
Literature: Baxter 1987, 26, no. 35; Pollard 2007, 2: no. 898; Maier 2010, 172, no. 101.

This medal commemorates the death of Sadi Carnot, president of the French Republic (1887–94), who was stabbed by the Italian anarchist Sante Caserio during a speech in Lyon on June 24, 1894. Carnot died the following day and was honored with an elaborate funeral on July 1, 1894. EM

695

Louis-Oscar Roty (1846–1911)
MARIE LAURENT (1825–1904)
Dated 1901
Silver, struck; 40.9 mm
Scher Collection

Obverse inscriptions: MARIE LAURENT; in the field, to the left, O[scar] Roty.
Reverse: A woman's head, draped, beneath which is a laurel branch wrapped in a ribbon reading MAI MDCCCCI [May 1901]. Inscriptions: in the field, in eleven lines, A / MARIE LAURENT / DOYENNE DES ARTISTES DRAMATIQUES / FONDATRICE DE L'ORPHELINAT DES ARTS / CHEVALIER DE LA LEGION D'HONNEUR / CETTE MEDAILLE A ETE OFFERTE COMME / UN HOMMAGE DE LEUR PROFOND / RESPECT DANS LA REPRESENTATION / EXTRAORDINAIRE DONNEE AU / THEATRE NATIONAL DE L'OPERA / PAR SES COLLEGUES SES ADMIRATEURS [To Marie Laurent, doyenne of the dramatic artists, founder of the Arts Orphanage, dame of the Legion of Honor. This medal was offered as a tribute of their deep respect for her extraordinary performance. Presented at the Paris Opera by her colleagues (and) admirers]; around border, KLYTEMNESTRA LA SACHETTE LA MERE MOAN MARFA LA FLECHARDE JACK SCHEPPARD LA POISSARDE LA TIREUSE DE CARTES [Clytemnestra (from *Les Érinnyes*), the Recluse (from *Notre-Dame de Paris*), the mother Moan (from *Pêcheur d'Islande*), Marfa (from *Michael Strogoff*), Flecharde (from *Quatrevingt-treize*), *Jack Sheppard*, *La Poissarde*, *La Tireuse des cartes*].
Literature: American Numismatic Society 1911, 270, no. 57; Daniels and Baloga sale 2002, no. 200.

695

The celebrated French actress Marie Laurent is also remembered for her philanthropy and dedication to women's causes. Most notably, she founded the Orphelinat des Arts in 1880 for the orphaned daughters of actors, musicians, writers, painters, and sculptors. The reverse lists a number of the plays in which Laurent performed, as well as characters she portrayed. Laurent was a recipient of the Legion of Honor. EM

696

Paul Jean-Baptiste Gasq (1860–1944)
JEAN-CLÉMENT-CYR DEGUERGUE (1863–1935)
Dated 1887
Terracotta; 222.3 mm (without frame)
Scher Collection

Obverse inscriptions (incuse): A MONSIEUR DEGUERGUE SOUVENIR TRES SYMPATHIQUE [To Mr. Deguergue; very fond memory]; P[aul] GASQ [18]87.

The nature of the relationship between the medalist and his subject is unknown. Deguergue, a painter from Nevers who studied under Édouard Pail and Gustave Mohler, was a founding member and secretary of the Société Artistique of Nièvre. In 1902, he would be made an *officier d'académie*, an acknowledgment of his contribution to the enrichment of France's cultural heritage. EM

696

A
Monsieur
Deguergue
souvenir
très
sympathique

T. Gaudez 87.

696
actual
size

697

698

699

697

Eugène Adolphe Crocquefer (b. probably 1854; act. ca. 1886–ca. 1895)

MARTHE CÉCILE CROCQUEFER (b. 1887)

Dated 1889

Copper alloy, cast; 49.9 mm

Scher Collection

Obverse inscriptions: MARTHE CÉCILE CROCQUEFER; 1887; 1889.
Literature: Forrer 1979–80, 1: 470–71.

The subject is probably the artist's daughter. EM

698

Jean-Désiré Ringel d'Illzach (1849–1916)

NATHANIEL HAWTHORNE (1804–1864)

Dated 1892

Copper alloy, cast; 176.3 cm

Scher Collection

Obverse: Hawthorne, flanked by his homestead (accompanied by the date of his birth, JULY 4, 1804) and a tombstone (inscribed HAWTHORN[e]; accompanied by the date of his death: MAY 18, 1864) and a quill pen; above him, the letter "A" (a reference to *The Scarlet Letter*), radiant and entwined with leaves; beneath him, the seal of the Grolier Club with the arms of Jean Grolier inscribed GROLIER CLUB; NEW YORK 1892 (?). Inscriptions: NATHANIEL HAWTHORNE; RINGEL D ILLZACH; MED[ailleu]R MDCCCXCII [1892].
Literature: Storer 1923, 255, no. 1956; *Fauver Collections* 2006, no. 382a.

Made in honor of the American writer Nathaniel Hawthorne, best known for *The Scarlet Letter* (1850), this medal was commissioned and issued by the Grolier Club (a New York literary society founded in honor of bibliophile Jean Grolier de Servières [1479–1565]) as part of a series honoring celebrated American writers (see also no. 881). EM

699

Alphonse-Eugène Lechevrel (1848–1924)

ANTONIN LOUIS LIARD (1860–1940)

Dated 1892

Silver, cast; 79.9 × 55.7 mm

Scher Collection

Obverse: Liard, in a cap and smock; beneath him, a palm branch, founders' tools and a forge. Inscriptions (incuse): upper left, MDCCCXCII [1892]; upper right, A NOTRE FONDEVR [To our founder]; [By] A[lphonse-Eugène] LECHEVREL; in the field, to the right, AEL [monogram]; in the field, to the left, ÆTATIS SVÆ XXXIII [aged 33]; in exergue, on the banner to the right, ARS [Art]; on the foreground plaque, in three lines [inverted], A[ntonin] LIARD / FONDEVR / EN MÉDAILLES [Antonin Liard, founder of medals]; in exergue, on the smoke to the left rising from a crucible, [Charles Jean Marie?] DEGEORGE (?) / J[ules-Clément] CHAPLAIN / O[scar] ROTY / D[aniel] DVPVIS / L[ouis-Alexandre] BOTTEE.
Literature: Goldenberg 1967, no. 509.

This plaquette was made in honor of French founder Antonin Liard, grandson of Louis Richard (friend and preferred founder of David d'Angers) (no. 664). He was considered one of the best medal casters of the time. The names featured in the rising smoke belong to the prominent medalists for whom Liard probably worked and who dedicated this medal to him. EM

700

700

Jean-Antoine Injalbert (1845–1933)
ALFRED-LOUIS-OLIVIER LEGRAND DES CLOIZEAUX
(1817–1897)
Dated 1893
Copper alloy, cast; 169.9 mm
Scher Collection

Obverse: Des Cloizeaux, in a jacket bearing the button of an order (possibly the Legion of Honor) in his lapel, and overcoat. Inscriptions (incuse): 1893; on truncation, A[ntoine] INJALBERT.

This medallion may have been made to commemorate Des Cloizeaux's retirement from his position as mineralogical specialist at the Musée National d'Histoire Naturelle in Paris. Previously, he had been professor of mineralogy at the École Normale Supérieure, where he conducted groundbreaking research into polarization and the optical properties of the crystals of minerals. In 1886, he received the prestigious Wollaston medal from the Geological Society of London, the highest accolade the society bestows, recognizing the influence his work had had on the field. EM

701

701

Ferdinand Gilbault (1837–1926)

JULES-EMMANUEL VALADON (1826–1900)

Dated 1894

Copper alloy, cast; 183 × 145 mm

Scher Collection

Obverse: Valadon in a cravat and jacket with the ribbon of the Legion of Honor on his lapel. Inscriptions: beside paintbrushes and a palette, JULES VALADON; on truncation, F[erdinand] GILBAULT 1894.

Valadon was a French painter who attended the École des Beaux-Arts, exhibited at the Salon, and was decorated with the Legion of Honor in 1893. EM

702

703

702

Henri Auguste Jules Patey (1855–1930)
MOZAFFAR AD-DĪN SHĀH QAJAR, SHAH OF PERSIA
(b. 1852; r. 1896–1907)
Dated 1900
Silver, struck; 36.6 mm
Scher Collection

Obverse: Mozaffar ad-Dīn Shāh Qajar wearing a decorated military
tunic with epaulettes and a baldric, as well as regal headwear (a
tarboosh?). Inscriptions: السلطان الأعظم والخاقان الأفخم [Al-Sultan al-Aʿzam
waʾl-Khaqan al-Afkham Muzaffar al-Din Shah Qajar] [Arabic for
The Great Sultan the Most Prestigious Mozaffar od-Dīn Shah Qajar];
A[uguste] PATEY.
Reverse: Framed by a wreath of oak and laurel branches tied with
a ribbon, a lion holds a scimitar, standing before a sunburst with a
human face in the center, whose central rays pass through the crown
above. Inscription: [Arabic: sana 1318].
Literature: Jones sale 2011, no. 1505.

This medal was made in France during one of Mozaffar ad-Dīn's
visits to Europe between 1900 and 1905. In 1906, as a result of
excessive personal spending and large loans from foreign powers,
he was forced, by popular revolts, to acknowledge the need for
a constitutional monarchy and the formation of a representative
assembly. Once formed, this assembly drafted a Belgian-modeled
constitution that the shah signed a week before his death. The year
1318 is the Muslim date for the Gregorian calendar date of 1900. EM

703

Henri Alfred Auguste Dubois (1859–1943)
ALPHÉE DUBOIS (1831–1905)
1883–1900
Silver, cast; 59 mm
Scher Collection

Obverse: Dubois, in a plain collar, cravat, and jacket with the ribbon
of the Legion of Honor on the lapel. Inscriptions: ALPHEE-DUBOIS
Gᴿ[aveur] EN MEDAILLES [Alphée Dubois, medal engraver]; in the field,
to the left, H[enri] DVBOIS.
Literature: Flaten 2012, 148, 152.

Alphée Dubois, the father of the artist, was himself a prominent and
prolific medalist (and one of Henri's tutors), as well as a sculptor.
After studying at the École des Beaux-Arts under Jean-Jacques Barre
and Francisque Duret, Alphée won the Prix de Rome (1855) and was
made a knight of the Legion of Honor (1883). In 1900, he was one
of the jurors at the Exposition Universelle. This medal was displayed
at the Exhibition of Modern Medals in Frankfurt (1900), along with a
number of Henri's other works. EM

704

Marie-Alexandre-Lucien Coudray (1864–1932)
ORPHEUS
1893–1899
Copper alloy, cast; 213 mm
Scher Collection

Obverse: An androgynous Orpheus, laureate, holding a lute; in the
background, a laurel tree. Inscription (incuse): L[ucien] COUDRAY.
Literature: Forrer 1979–80, 1: 463–64; Maier 2010, 270, no. 223.

This medallion, a small struck version of which won a silver prize
at the 1900 Exposition Universelle, is one of the most exemplary
French medals in the Art Nouveau style. Orpheus, the subject of
several of Coudray's medals, is shown at a moment of emotional
intensity, the slight twist to his shoulder perhaps alluding to the
moment in which the poet, having turned to look at Eurydice,
realizes he has lost his lover forever. Coudray, trained by Thomas,
Allouard and Ponscarme at the École des Beaux-Arts, also won the
1893 Prix de Rome for a medal of Orpheus. EM

704

FRANCE 409

705

705

Henri Eugène Nocq (1868–1942)
ANATOLE FRANCE (1844–1924)
Dated 1902
Copper alloy, cast (two shells soldered together); 58.2 mm
Scher Collection

Obverse inscriptions: ANATOLE FRANCE; N[ocq]H[enri] [monogram]
MCMII [1902].
Reverse: A sword hanging from a patriarchal cross, a wicker dummy,
and a fleur-de-lis.
Literature: Maier 2010, 261, no. 217 (var.).

Anatole France was a man of letters known for his urbane wit and
cynicism. In 1896, he was elected to the Académie Française, and
in 1921 he won the Nobel Prize for Literature. The objects on the
reverse are references to a number of his literary works, including *Le
Lys rouge* (*The Red Lily*) of 1894, *Le Mannequin d'osier* (*The Wicker
Work Woman*) of 1897, and *L'Anneau d'améthyste* (*The Amethyst
Ring*) of 1899. EM

706

Henri Eugène Nocq (1868–1942)
JACQUELINE CHERUIT (dates unknown)
Late 19th or early 20th century
Copper alloy, struck; 50.2 mm
Scher Collection

Obverse inscriptions: JACQUELINE CHERUIT A Æ[tatis] S[uæ] 4
[Jacqueline Cheruit, at the age of 4]; in the field, to the left, HN
[artist's initials].
Literature: American Numismatic Society 1911, 221, no. 11. EM

707

Unknown artist (Defer?)
JEANNE AND ALICE
Dated [19]02
Copper alloy, cast; 133.9 mm
Scher Collection

Obverse: Jugate busts of two young girls. Inscriptions: JEANNE; ALICE;
on the truncation, DEFER 02.

Because of the inscription DEFER, this medal has been attributed to
Félicie Tiger, née Defer(t) (1820–1890), though her life dates and the
date on the medal do not correspond. AN

706

707

708

Jean Marie Delpech (b. 1866)
PORTRAIT OF A MAN
Dated 1905
Silver, cast; 80.6 mm
Scher Collection

Obverse inscription: In the field to the right, J[ean] DELPECH 1905. EM

708

709

709

Victor Joseph Jean Ambroise Ségoffin (1867–1925)
JOAQUÍN MARIA ALBARRÁN Y DOMINGUEZ (1860–1912)
Dated 1907
Copper alloy, cast; 88.7 mm
Scher Collection

Obverse inscriptions (incuse): J[oaquín] ALBARRAN; in the field, to the right, A[mbroise] J[oseph Jean] V[ic]TOR SÉGOFFIN [sic] 1907.

Joaquín Albarrán was a celebrated Cuban urologist, histologist, and bacteriologist who had a significant impact on medicine at the time. After receiving his medical training in Spain, he moved to Paris to further his studies. In 1906, he became director of the Department of Urology at the renowned Hôpital Necker in Paris. This medal was probably made in celebration of his receipt of the Legion of Honor in 1907. In 1912, the year of his death, Albarrán was nominated for the Nobel Prize in medicine. EM

710

710

Henry Dropsy (1885–1969)
MA MÈRE (My Mother)
1913
Copper alloy, cast; 99 mm
Scher Collection

Obverse: The sitter in a high-necked lace or embroidery gown and her hair pinned up, wearing a *pince-nez*. Inscription (incuse): HENRY DROPSY.
Literature: Pradel 1963, no. 31 (not ill.).

The medal's date and title appear in the catalogue of the exhibition of Dropsy's work at the Monnaie de Paris in 1964. AN

711

711

Maurice Delannoy (1885–1972)
ADOLPHE-FÉLIX-SYLVESTRE ÉBOUÉ (1884–1944)
Dated 1944
Copper alloy, cast; 68 mm
Scher Collection

Obverse: Éboué in military uniform, with the Legion of Honor and Order of Liberation pinned to his chest. Inscriptions: FELIX EBOUE 1884 1944 GOUVERNEUR GENERAL DE L'AFRIQUE EQUATORIALE FRANÇAIS [Félix Éboué, 1884–1944, governor-general of French Equatorial Africa]; in the field, to the left, M[aurice] DELANNOY [incuse].
Reverse: A map of Nigeria, Cameroon, Chad, and Sudan, inscribed: NIGERIA; CAMEROUN [Cameroon]; LERE; TCHAD [Chad]; MAO; BOL; FORT-LAMY; BONGOR; MASSENIA; BOKORO; MELFI; BILTINE; ABECHE; AMTIMAM; SOUDAN ANGLO-EG[yp]T[ien] [Anglo-Egyptian Sudan] [incuse]; all beneath the bust of an African woman wearing three necklaces, her hair braided at the back and pulled into a chignon at the forehead. Inscription: in the field, in five lines, "PAR SA RESOLUTION LE TCHAD A / DONNE LE SIGNAL DU REDRESSEMENT / A

L'EMPIRE FRANÇAIS TOUT ENTIER" / GENERAL DE GAULLE / 26 AOUT 1940 [By his (Éboué's) resolve, Chad gave the signal of recovery to the entire French Empire – General de Gaulle, August 26, 1940].

This medal was probably made to mark the death in 1944 of Félix Éboué, a colonial administrator born in French Guiana, who was the first black man to achieve the highest rank in the French colonial administration. After France's defeat by Germany in 1940, the Vichy government ordered the colonies to cease hostilities with their Axis enemies. Éboué, then governor of Chad, played a pivotal role in rejecting this armistice and rallying French Equatorial Africa behind Charles de Gaulle and his Free French forces on August 26. In recognition of his support, he was named governor-general of French Equatorial Africa (the largest French territory under de Gaulle's control). Éboué was an anti-assimilationist and a powerful voice for reform in French colonial Africa, but his dedication to the enforcement of colonial rule left him with the mixed legacy of a colonial collaborator. In 1949, he became the first black person to be buried in France's Panthéon in Paris. EM

712

712

Daniel G. Flourat (1928–1968)

THE MENDERS OF ALTEA, ALICANTE PROVINCE, SPAIN

ca. 1965

Copper alloy, cast; 100.9 mm

Scher Collection

Obverse: Two seated women, their faces obscured by large, broad-brimmed hats, mend nets on a beach. Inscription: D[aniel] FLOURAT. **Reverse**: The port and town of Altea. Inscriptions: ALTEA; ALICANTE; D[aniel] FLOURAT.

Altea is a small port in the province of Alicante, Spain. EM

THE
NETHERLANDS

PERSPECTIVES IN METAL

A History of Medals in the Low Countries

Jan Pelsdonk

This essay provides a general historical context for the development of medallic art in the Low Countries—the northwestern coast of Europe made up of the Netherlands, Belgium, Luxembourg, and the northern part of France (fig. 22). The richness and variety of these medals are well represented in the Scher Collection, both with common and rare examples.

RENAISSANCE

Originating in Renaissance Italy and made by famous Italian artists including Antonio di Puccio Pisano (called Pisanello, ca. 1395–1455) and Matteo de' Pasti (1420–d. after 1467) (nos. 1–10 and 12–18), medallic art reached the Low Countries at the end of the fifteenth century. There, medal-making had an excellent start with the extraordinary medal of the humanist Desiderius Erasmus (ca. 1466–1536) (fig. 23; a copy, smaller in size) by Quenten Metsys (ca. 1466–1530).[1] The medalist Jacques Jonghelinck (1530–1606) immortalized in metal many important people, among them, Holy Roman Emperor Charles V (1500–1558) and King Philip II of Spain (1527–1598) (no. 720). For a short time, medallic art seems to have influenced coin design, as can be seen in Giampaolo Poggini's (1518–1582) coins of Philip II; but, for the most part, coin design remained unchanged while the medal evolved as an art form with its own characteristics.

MULTIPLE FUNCTIONS

Medals were produced in the Low Countries for various purposes. Older than Renaissance medals are what are commonly referred to as tokens, the often poorly designed numismatic objects made for daily use. The appearance and purpose of these tokens changed little after the introduction of medals for collectors (fig. 24)

Also produced from the thirteenth century through the beginning of the seventeenth century were numerous objects referred to as counter or reckoning tokens. These had no function as currency but were used in the calculation of accounts. Usually produced in brass or copper, only a handful of them can be attributed to known medalists. With designs in very low relief, they are closely related to coins. During the Eighty Years' War (1568–

Fig. 22 The lion of the Low
Countries, on a map of the
Northern and Southern
Netherlands (detail), by Claes
Janszoon Visscher, 1609
Hand-colored paper,
502 × 627 mm
Atlas Van Stolk, Rotterdam

Fig. 23 Quenten Metsys,
*Desiderius Erasmus of
Rotterdam*, 1519
Silver, 103 mm
Fitzwilliam Museum, Cambridge

Fig. 24 Unknown artist, *Proof of Paid Taxes for the Beacons along the Zuiderzee*, 1714
Lead, 27 mm
Teylers Museum, Haarlem, The Netherlands

Fig. 25 Johannes Looff, *Middelburg Schoolmasters' Guild*, 1628
Brass, 40 mm
Teylers Museum, Haarlem, The Netherlands

1648), tokens assumed an interesting new function as propaganda. Many important events in the struggle for freedom in the Low Countries were immortalized on these medals.

Other medals produced for everyday use in the Low Countries are guild medals and those for *vroedschappen* (town councils). Often similar in design to medals for collectors, they were used, for instance, to show that the bearer was a guild member and sometimes were designed by famous medalists, such as Johannes Looff (act. 1623–48; d. 1651) (fig. 25).

Because important people and collectors commissioned medals, their quality is generally high. In the Low Countries, several mints were active, and they also produced many struck medals, such as those of Gerard van Bylaer (or Bijlaer) (ca. 1540–1617) and Willem van Bylaer (or Bijlaer) (act. ca. 1580–1635), both working at the mint of Holland in the town of Dordrecht (nos. 734 and 736).

GOLDEN AGE

Medals had initially been intended primarily for wealthy clients. During the Eighty Years' War, however, a new group of medals was produced for a wide market, and medal collectors began to emerge. There were, of course, still official orders for medals, but the volume of "free work" increased. The fall of Antwerp to the Spanish in 1585 was an important event for medallic art. Many wealthy people moved from Antwerp to Amsterdam, and the small town was transformed almost overnight into one of the leading cities of Europe. Thus began in the Northern Netherlands the period of great prosperity known as the Golden Age, which extends roughly to the Treaty of Utrecht in 1713.

The government did not restrict the production of medals, and this helped bring medallic art to great heights. Medalists competed with each other and were not afraid to enlist third-party assistance from outside their own discipline. The great Dutch poet Joost van den Vondel (1587–1679) (no. 787), for instance, wrote several poems for medals or their accompanying pamphlets (no. 796).[2] Medalists also adapted a variety of techniques: in addition to casting, some medals were struck like coins. About 1650 in Amsterdam, the first screw presses came into use (fig. 26), several decades earlier than in coin production. Medals produced with a press are distinguished by their high-quality finish. An early and famous example is the one by Juriaen Pool I (1618–1669) issued on the completion of the town hall in Amsterdam in 1655 (nos. 784 and 785). Other medalists, such as Pieter van Abeele (1608–1684), produced medals using the silversmith's methods—hammering the design of the obverse and reverse on two silver plates (shells) and then soldering the plates together, leaving a hollow space in between (no. 773). Once created, these so-called plaquettes were often used to cast multiple specimens, to reduce the reproduction time.

Fig. 26 Screw press on a medal (detail), by Martinus Holtzhey Sr., 1729
Silver, 44 mm
Teylers Museum, Haarlem, The Netherlands
Holtzhey likely depicted his own press.

By casting the shells and soldering them together, less precious metal was needed. Some medals were engraved or produced in other materials, such as whalebone or ivory. Artists were less interested in creating medals as standard, round, and flat pieces of precious metal with image and text. They wanted to produce and reproduce interesting and easy-to-sell objects. Therefore they also tried different precious materials to attract buyers.

In the Low Countries, many family medals were produced. These commemorated personal events such as birth, graduation, marriage, and death. Noteworthy is the medal by Jan de Vos (ca. 1578–after 1619) from 1614 (no. 738), with its allegory of death: the obverse depicts the bust of a young woman, the reverse a skeleton in the same pose. The medal is here set into a silver cup and combined with coins and other medals.

MELTED DOWN

Most of the first Netherlandish medals of the sixteenth century were produced in bronze, but before long silver and gold were used to create objects of higher value for special occasions or important persons. During the Golden Age, Amsterdam burgomasters, for instance, ordered a series of special-occasion medals that were produced in pure gold for the first recipients. The medalist often kept the dies so that more medals could be produced on demand for collectors, but these were mostly produced in cheaper materials such as silver or bronze, like the previously mentioned medals by Pool issued on the completion of the town hall in Amsterdam in 1655. This was also true of medals for private occasions. For instance, a gold medal might be produced for a newlywed couple and several cheaper silver copies for the wedding guests.

Among the most important Dutch medals were the gold "ambassador's medals" issued by the States General as special awards (fig. 27). For instance, foreign ambassadors or generals successful in battle might receive such a medal—far more than half a kilogram in pure gold—on a long, heavy gold chain. It was a very valuable gift. For centuries, the value of the metal was in the end regarded as more significant than the craftsmanship or the importance of the medal itself. In fact, some of the ambassador's medals were sold almost

Fig. 27 Medal of Honor from the
States General, dies by Nicolaas
van Swinderen, issued in 1781
Gold, 91 mm
Teylers Museum, Haarlem,
The Netherlands

immediately after the award to the local goldsmith, who in turn sold the medal back to the
States General so it could be re-used.[3] As several painted portraits show, however, many
were proud to keep the medal once received. Later generations regarded the object more
practically and often sold it. Nowadays, there are hardly any gold medals because most of
them were melted down for their bullion value. Of the more than 1,230 gold medals and
chains issued by the States General, only a handful still exist.[4]

Although less often, even silver was considered valuable enough to be melted down.
Until late in the nineteenth century, it was common to sell a medal for barely more than
its metal value. A letter from Andries Schoemaker (1660–1735) to his son Gerard provides
an interesting insight.[5] Schoemaker—a major collector in his day—not only bought medals
from medalists and collectors, and at auction, but also found them in silversmiths' shops,
where they were waiting to be melted and could be bought for just a little more than the
silver value. Interestingly, even collectors appeared to disregard the historical value of the
original objects. Schoemaker, in the same letter, writes that he found out "hoe groot een
somme gelts dat daar door bij mij ledig lach" (what a big sum of money was lying useless
at my home). Before selling his whole collection at an auction, he simply had cast copies
of every medal made in copper: that satisfied his interest. Many copies were produced
decades after the fabrication of the original dies. Since, in most cases, it is not possible
to determine the exact moment of production, the date on the medal is generally used by
collectors.

SATIRICAL MEDALS

The government had no role in the fabrication of medals they did not issue, and this could be problematic with satirical or political medals. Jan Smeltzing (1656–1693), for instance, produced a medal on which Louis XIV is portrayed in a singularly unflattering manner (fig. 28). The subject is peace between France and Algiers and the donation of Avignon to the pope.[6] Louis is depicted being purged by both the pope (with an enema syringe) and the Bey of Algiers (with a vomit bowl). Apparently this medal was tolerated, but mocking the local government was more hazardous. Smeltzing was banned from his hometown, Leiden, after making a medal about the Costerman Riot, an anti-tax uprising in Rotterdam in 1690.[7] He defended himself by saying that he did not intend to inflame the situation but only wanted to capture the historical event. During his exile, he lived in Amsterdam; only after a couple of years—and after making a medal in favor of the Leiden city council—was he allowed to return.

Of course, satirical medals tell us a lot about the opinions of the creator. A 1696 medal by the German medalist Christian Wermuth portrayed Jean Bart as "the biggest of the French pirates," while an anonymous Dutch artist immortalized the Dutch privateer Piet Hein—in more or less the same line of work as Bart, but sailing for another government— after the conquest of the Spanish silver fleet in 1628, mentioning his "virtue" (fig. 29).[8] The

Fig. 28 Jan Smeltzing, *Peace between France and Algiers and Donation of Avignon to the Pope* (detail), 1689
Silver, 50 mm
Teylers Museum, Haarlem, The Netherlands

Fig. 29 Unknown artist, *Capture of the Silver Fleet by Piet Hein in 1628*, 1629
Silver, 48 mm
Teylers Museum, Haarlem, The Netherlands
The obverse celebrates the privateer's virtue (*deugt*); the reverse shows the capture of the fleet.

most famous—or infamous—example of a medal with far-reaching political consequences is the one Christoffel Adolfszoon (ca. 1631–1680) created in 1667 to commemorate the Peace of Breda at the end of the Second Anglo-Dutch War (1665–67) (no. 789).[9] The English king was not at all pleased, and this controversial medal is actually mentioned in the declaration of the Third Anglo-Dutch War (1672–74).[10]

DATING AND DESCRIBING

It is not always clear when and by whom a medal was created. As soon as the dies were ready, they could be used to produce more struck medals. When they could, medalists kept the dies in stock for future use, so it is seldom possible to determine the exact date of production. There are also medals that recall events long past. An anonymous artist, for example, made a medal about the beheading of Johan van Oldenbarnevelt (1547–1619) (no. 797),[11] which shows the 1619 event but not the year of creation, as is so often the case. Anyone who uses only the old publications of Gerard van Loon (of which French and Dutch versions exist, with different locations of the illustrations) misses almost three hundred years of research.[12] Both versions are suitable for general reference, but newer publications are indispensable for details. Van Loon wrote a history of the Dutch Republic in which he referenced all the medals known to him—a remarkably complete overview— but with no mention of medals as art; he included them only where they best suited his story. Jan Smeltzing, the possible creator of the medal about Van Oldenbarnevelt, was born in 1656, which means the medal could not have been produced much earlier than 1675. Further study shows that the copy in the collection of Teylers Museum (Haarlem, the Netherlands) was made on a screw press. This is visible in both the smooth surface and the edge, as, during production, a small collar is used to create an attractive, even edge.[13] This method of production started in the Northern Netherlands in the second half of the seventeenth century.

CREATOR OR PRODUCER

Not only is the date of production often unclear, but so is the identity of the medalist. Especially with satirical and political medals, the authors were often cautious and omitted their signature. An example is a medal about the 1672 murder of the De Witt brothers (no. 793). Society was, at that time, highly polarized. By admitting to making this medal, an artist would have placed himself in the camp of the De Witt brothers, possibly leading to jail, exile, or at the very least fewer orders for medals from the Orange-favoring camp.

Even medals bearing signatures may be regarded with some skepticism. Nicolas Chevalier (act. ca. 1677–1720), for instance, bought in 1693 for 400 carolus guilders a screw press, finished medals, and dies from the widow of Jan Smeltzing.[14] Chevalier used the dies to continue production and to combine this with his own work so that the old dies still bear the signature of the original creator. After his death in 1720, Chevalier's tools and dies were auctioned in Amsterdam, and therefore the re-use could continue.[15]

An interesting case is the above-mentioned medal about the Amsterdam town hall by Juriaen Pool (nos. 784 and 785). Research has revealed that Pool was indeed the engraver of the dies, but he worked for Simon Andrieszoon Valckenaer (1609–1672), an Amsterdam silversmith.[16] Some of these medals show a tiny stamp on the rim—a falcon with a rope around its neck—which means that it was Valckenaer who had received the exclusive right to produce this medal (the right was granted on December 17, 1655, by the Amsterdam City Council).[17] These medals were created with a screw press. It is highly unlikely that Valckenaer owned one, as this is the only medal attributed to him. It also seems that even Juriaen Pool did not possess this machine: when he and his wife died suddenly in 1669 (their children ended up in the city's orphanage), no screw press was found in his household. Because of the risk of counterfeit coins, a screw press could not be installed without permission from the city government. Valckenaer probably paid to use the screw press of another medalist to produce his medals. Christoffel Adolfszoon is known to have had a screw press;[18] he may have been the only medalist in Amsterdam to own one. Of Johannes Lutma it is known that he visited the London mint in 1668 to obtain more information about screw presses; it is uncertain if he had one himself.

DUTCH OR NOT?

The place of production of many medals is unknown because of the constant traveling and migration of artists, the absence of signatures, and the practice of copying the work of other medalists. An example of the latter is a medal about the forced opening of the Sound between Denmark and Sweden. It was important for the Dutch to be able to sail this route to reach the Baltic area, one of their three major trade regions (with the Levant and East India). When this route was blocked because of the Fourth Nordic War (1655–60) between Sweden and Poland, Dutch warships cleared the path with a sea battle near the Danish castle of Kronenborg in 1658. To commemorate this event, medals were produced by both Juriaen Pool in Amsterdam and Jeremias Hercules (ca. 1623–1689) in Copenhagen (figs. 30 and 31). The reader will have to guess which medal is a copy and which the original; it has not been possible thus far to attribute the original design.

NEW ROADS

In the early eighteenth century, about the time of the Treaty of Utrecht in 1713, Dutch trading power declined steeply. This is also reflected in medallic art. Craftsmanship was overtaken by "standard" medals, mainly struck, with an image on the obverse and text on the reverse.

Only about the year 1900—under the influence of the Art Nouveau movement—was medallic art revived. Renewed attention to the medal as artistic expression was fueled by the Belgian-Dutch Society of the Friends of the Art Medal (1900–14), among others.

Figs. 30 and 31 *Opening of the Sound after the Sea Battle of Kronenborg*, by Juriaen Pool (left) and Jeremias Hercules (right), 1658
Silver, 46 mm
Teylers Museum, Haarlem, The Netherlands
Both obverses show the name or initials of the engraver on a piece of wood on the bottom right. The reverse of Pool's medal shows a poem, likely by Van den Vondel.[19]

With the outbreak of World War I, the association ceased to exist, but in short order an important group of medalists designed a series of medals influenced by the popular Art Nouveau movement. One of the leading figures was Christiaan van der Hoef (1875–1933) (nos. 812–815). Later, medal art reflected the Art Deco style.

After World War II, medallic art in the Netherlands follows two currents. The first preserves the traditional medal—in general, round with image and text, obverse and reverse. The second focuses on innovation and abstraction, and uses different shapes and materials. These two currents survive—along with a third group of less interesting medals for everyday use—to the present day. The story of medals continues.

Notes
1 Smolderen 2009, 15, 27.
2 Voigtmann 2012.
3 Sanders 2013, 259.
4 Ibid., 433.
5 Letter from Andries Schoemaker to his son Gerard, April 11, 1728, as dedicatory in "De Stichtse klyne Chronieke" (1605) by Cortgeen van der Gouwen, Het Utrechts Archief, VE 5, 1–8; Pelsdonk 2012, 55, 61.
6 Van Loon 1723–31, 3: 458; Van der Meer 1991, 352.
7 Van der Meer 1975, 4–5.
8 Van Loon 1723–31, 4: 173; Van Loon 1723–31, 2: 173, no. 4.
9 Van Loon 1723–31, 2: 555, no. 1.
10 *His Majesties Declaration* 1672; Scharloo 2012, 37.
11 Van Loon 1723–31, 2: 109, no. 3.
12 Van Loon 1723–31.
13 Van der Beek 2011, 8–10.
14 Van der Meer 2007, 65.
15 Luijt 2013, 113.
16 Pelsdonk 2013.
17 Van Dillen 1974, 642: Keurboek M fol. 257v, no. 1340, Amsterdam City Archive.
18 Jacobi 1982, 152–53.
19 Scholten 1938, 172.

713

714

713

Unknown artist (The Netherlands)
POPE ADRIAN VI (b. 1459; r. 1522–23)
Dated 1523; possibily a later cast after a sixteenth-century medal
Lead, cast; 82.4 mm (not including wooden frame)
Scher Collection; Promised gift to The Frick Collection

Obverse: The pope wearing a decorated cope with a large morse showing an indistinct subject, flanked by shields of his arms (right) and those of Utrecht (left). Inscription: M[ester] ADRIÆN VAN GOD GHEKOREN PAVS VA[n] ROMEN TVTRECHT GHEBOREN [Adrian called by God, Pope of Rome, born in Utrecht].
Reverse inscriptions: INVICTA VIRTVTE RESVRGET [His insuperable moral purity will make him rise again]; in the field, HADRIANVS VI / HEIC SITVS EST QVI NIHIL SIBI / INFELICIVS IN VITA DVXIT / QVAM QVOD IMPERARET [Here is shown Adrian VI who considered nothing more sorrowful in (his) life than to rule]; in exergue, OBII[t]: BONIS FLEBILIS OCCIDIT / 14 SEP 1523 [He died mourned by many good men, 14 September 1523] [Horace, *Odes*, 1: 24].
Literature: Pollard 2007, 2: no. 766.

Adrian, the only Dutch pope, distinguished himself at the University of Louvain and later became the tutor of Charles V. During his brief papacy, he showed little interest in the arts. He was buried in St. Peter's, but in 1533 his body was moved to Rome's German national church, Santa Maria dell'Anima. Two other examples of this medal (National Gallery of Art, Washington, and Victoria and Albert Museum, London) do not bear inscriptions on the reverse. In the reverse inscription of this example, the lines in the field are from the pope's funerary inscription in St. Peter's, and the line in the exergue comes from an ode by Horace found in other funerary contexts. ADC

714

Attributed to Jan Symons (act. 1552–69)
CHRISTOPHE VOLKMAR (b. 1522)
Dated 1553
Silver, cast; 57.5 mm
Scher Collection

Obverse: Volkmar wearing a doublet. Inscriptions: CRISTOF VOLCKMAR SEIN ALTERS XXXI [Christophe Volkmar, his age 31]; on truncation, 1553.
Reverse: Volkmar's coat of arms with helmet and Pelican in Her Piety crest.
Literature: Simonis 1900, 54–55; Hill 1915, 129–30; Smolderen 1996, 190n.624, 208, 218.

Volkmar established a powerful colony at Antwerp that was involved in German commerce. Smolderen (1996) does not support Hill's attribution (1915) to Jonghelinck. SKS

715

Steven van Herwijk (ca. 1530–1565/67)
GEORGE VAN EGMOND (1504–1559)
Dated 1558
Silver, cast; 144.5 mm
Scher Collection

Obverse: Van Egmond holding his gloves and wearing a ring, a Canterbury cap, a small ruff under a buttoned jerkin, and a cloak with hanging sleeves, trimmed with ermine. Inscriptions: D[ominus] GEORG[ius] DEGMOND EP[iscopu]S TRAIECT[ensis] A[nn]° 1558 ÆT[atis] SV[a]E 54 [Lord George van Egmond, bishop of Utrecht, in the year 1558, aged 54]; between his hands, STE[ven] H[erwijk] FEC[it] [Steven van Herwijk made it].
Literature: Scher 1994, no. 166; Smolderen 2009, 35.

715

716

Van Egmond, bishop of Utrecht (1535), commissioned this medal shortly before his death. A pious man remembered for his patronage of the arts and reform-minded humanist philosophy, Van Egmond was unsuccessful in combatting Calvinism. He was made a Knight of the Order of the Golden Fleece by Emperor Charles V, a distant relative who had helped advance his career. EM

716

Steven van Herwijk (ca. 1530–1565/67)
GEORGE VAN EGMOND (1504–1559)
Dated 1558
Bronze, cast; 68.6 mm
The Frick Collection; Gift of Stephen K. and Janie Woo Scher, 2016 (2016.2.192)

Obverse: Van Egmond wearing a richly decorated cope and morse. Inscription: D[ominus] GEORG[ius] DEGMOND EP[iscopu]S TRA[jectum] ÆT[atis] S[uæ] 54 1558 [Lord George van Egmond, bishop of Utrecht, aged 54, 1558].
Reverse: Two hands descending from clouds and scattering coins onto a hilly landscape with trees, architectural ruins, and a church on the left in the background. Inscriptions: PIETATEM EXERCE [Practice piety]; signed at the bottom of the hill, on a small rectangular cartouche, STE[ven] H[erwijk] F[ecit] [Steven van Herwijk made it].
Literature: Simonis 1900, 193, pl. 20, no. 1; Scher 1994, 369–70.

For a biography of Van Egmond, bishop of Utrecht (1535), who probably commissioned this medal of himself in the same year as the previous medal, see the commentary for no. 715. The images embroidered on his cope show Christ as Good Shepherd in the large central panel, with God the Father above and St. Peter below. A standing Christ holding the cross is shown on the morse. The reverse pays homage to the bounty that descends from God. ADC

717

Steven van Herwijk (ca. 1530–1565/67)
ELIZABETH BROOK (1526–1565)
Dated 1562
Silver, cast; 40.6 mm
Scher Collection

Obverse: Elizabeth Brook wearing a French hood, a brocade gown with puffed sleeves, a ruffed collar, and a necklace. Inscription: EL[i]ZABET[h] MARQVI[onissa] NORTHAMPTON [Elizabeth, Marchioness of Northampton].
Reverse: Personification of Faith holding a book and supporting the cross against her body. Inscription: SOLA TVTA FIDES A[nn]° 1562 [Only faith (is) safe, 1562].
Literature: Hawkins 1885, 1: 104, no. 29; Simonis 1900, 5, pl. 25; Eimer 1987, 31, no. 43.

Elizabeth Brook, Marchioness of Northampton, was the second daughter of Lord Cobham and second wife of William Parr, Marquess of Northampton. Parr was one of Henry VIII's associates and brother of Catherine Parr, Henry's sixth and last wife. The allegorical figure on the reverse refers to her devotion. SKS

718

Attributed to Steven van Herwijk (ca. 1530–1565/67)
SIGISMUND II AUGUSTUS, KING OF POLAND (b. 1520; r. 1548–72) and **CATHERINE HAPSBURG** (b. 1533; Queen Consort of Poland 1553–72)
Dated 1561
Silver, cast; 80.8 mm
Scher Collection

Obverse: Sigismund in armor with a light sash draped around his shoulders and pinned in front. Inscription: SIGISMVND AVGVSTVS D[ei] G[ratia] REX POLONIÆ A[nn]° 1561 [Sigismund Augustus, by the grace of God, King of Poland, 1561].
Reverse: Catherine, in a bejeweled, cap, her hair pinned beneath cauls, wearing a small ruff, a necklace with an elaborate pendant, and a richly embroidered stole over a decorated bodice, with large, lavish sleeves, decorated with pearls. Inscription: CATHARINA D[ei] G[ratia] REGINA POLONIÆ [Catherine, by the grace of God, Queen of Poland].
Literature: Simonis 1904, 206–7, pl. XXIV, nos. 1, 2; Hutten-Czapski 1957, 1: no. 514; Smolderen 2009, 35, figs. 95, 96.

Sigismund II expanded the Kingdom of Poland by legally unifying it with Livonia and the Duchy of Lithuania. His marriage to Catherine, his third wife (and a sister of his first), is said to have been unhappy, with Sigismund trying and failing to obtain a divorce from the pope. Like his other marriages, it was childless. EM

717

718

719

P. Alexander (ca. 1520–1578)

JAN BAPTIST HOUWAERT (1533–1599)

Dated 1578

Copper alloy, cast; 64.3 mm

Scher Collection

Obverse: Houwaert wearing armor with a ruff and a commander's sash. Inscriptions: IEHAN[nes] BAPTISTA HOVWAERT ÆT[atis] 45 1578; on truncation, BRUXELLENSIS [Jan Baptist Houwaert of Brussels, aged 45, 1578]; below the shoulder, ALEXANDER P F[ecit] [Alexander P. made it].

Reverse: A spade, a quill pen, and a compass encircled by a laurel wreath flanked by an eagle and a cornucopia; below a dividing line, a tortoise and a beggar's bowl. Inscription: HOVDT MIDDEL=MATE [Maintain the middle ground].

Literature: Van Loon 1732–37, 1: 240–41; Forrer 1979–80, 1: 37; Smolderen 2009, 44.

This medal was likely produced in Antwerp, where Alexander worked, to commemorate the entrance of Mathias of Hapsburg into Brussels, for which Houwaert organized a ceremony. Brussels-born Houwaert was an advocate, Master of the Royal Chamber of Accounts (Chambre des Comptes), soldier, historian, and poet whose literary work was held in great esteem. While preserving the appearance of a good Catholic, he was most likely a Lutheran and was arrested on suspicion of heresy by the Duke of Alba. After a year in prison, he renounced the Lutheran faith to escape death, which did not prevent him from rejoining the supporters of William I of Orange, the main leader of the Dutch revolt against Spain. The reverse elements signify that one obtains the crown of eternal glory with both the works of the hand and the mind, maintaining a balance between the sky (eagle) and the earth (tortoise), between abundance and poverty. The inscription is part of a phrase—[To arrive at happiness] Fear Heaven, Maintain the Average or the Middle ground—that may refer to preserving his position between the two contending forces in the Netherlands, the Hapsburgs and the forces for Dutch independence. ADC, SKS

719

720

Jacques Jonghelinck (1530–1606)
EMPEROR CHARLES V (1500–1558; r. 1516–56) and
PHILIP II, KING OF SPAIN (b. 1527; r. 1556–98)
Dated 1557?
Copper alloy, cast; 35.3 mm
Scher Collection; Promised gift to The Frick Collection

Obverse: Charles, laureate, wearing armor and the emblem of
the Order of the Golden Fleece. Inscriptions: IMP[erator] CAES[ar]
CAROLVS V AVG[ustus] [Emperor Caesar Charles V Augustus]; on
truncation, 1557[?].
Reverse: Philip wearing armor and a commander's sash. Inscription:
PHILIPPVS HISPANIAR[um] ET NOVI ORBIS OCCIDVI REX [Philip, King of
Spain and of the new western world].
Literature: Smolderen 1996, 222–23 (var.), no. 10.

The date inscribed on this example is not clearly legible. It has
been suggested that the medal was originally issued in 1555 on the
occasion of the abdication of Charles V in favor of his son Philip
(Van Mieris 1732–35, 3: 378). However, Smolderen argues that
there is insufficient information to make this claim since none of the
known variants of the medals bear the date. The *terminus post quem*
for the medal should be 1556, when Philip became king of Spain.
Many bear the date 1557; Smolderen suggests these were perhaps
distributed as a reward to the participants in the Battle of St. Quentin
(August 10, 1557), during the Franco-Spanish War (1551–59). ADC

721

Jacques Jonghelinck (1530–1606)
LUCAS MUNICH (1490/91–1563)
Dated 1559
Copper alloy, cast; 68.1 mm
Scher Collection

Obverse: Munich wearing a cope richly decorated with orphreys.
Inscriptions: LVCAS M[unich] ABBAS S[ancti] BAVONIS GANDENSIS
ÆT[atis] LXVI [Lucas Munich, abbot of St. Bavo in Ghent, aged 66];
on truncation, 1559 [incuse].
Literature: Smolderen 1996, 239–42, no. 21.

This medal was made on the occasion of the establishment of the
twenty-third general chapter of the Order of the Golden Fleece in
July and August 1559 in the church of St. Bavo, in Ghent, where
Munich was a monk at the abbey and became abbot in 1535. SKS

722

Jacques Jonghelinck (1530–1606)
ANTHONY VAN STRAELEN (1521–1568)
Dated 1565
Silver, cast; 53.3 mm
Scher Collection

Obverse: Van Straelen dressed in a coat with wide lapels.
Inscriptions: ANTONII ASTRALE D[omin]VS DE MERXEM ET DAMBRVGGE
[Anthony van Straelen, Lord of Merxem and Dambrugge]; on
truncation, ET[atis] XLIIII 1565 [aged 43, 1565].
Reverse: Naked figure of Fortune standing atop a globe set on a
scallop shell amid waves and holding a spar and billowing sail.
Inscription: VIRTVTE ET CONSTANCIA [With valor and steadfastness].
Literature: Scher 1994, no. 161; Smolderen 1996, 264–66, no. 42.

Highly respected for his financial skills, Van Straelen served as an
alderman, treasurer, and burgomaster in his native city of Antwerp.
The reverse motif, a common representation of Fortune blown by the
winds of chance, is used to symbolize the role of the burgomaster
of a large harbor city. Under the Duke of Alba, Van Straelen was
tortured and executed. ADC

722

723

Jacques Jonghelinck (1530–1606)
PHILIPPE DE MONTMORENCY, COUNT OF HORN
(ca. 1518–1568)
Dated 1565
Lead, cast; 67.1 mm
The Frick Collection; Gift of Stephen K. and Janie Woo Scher, 2016
(2016.2.181)

Obverse: The Count of Horn wearing armor, a commander's sash, and the Order of the Golden Fleece. Inscriptions: PH[i]L[ipp]VS BARO DE MONTMORENCY COMES DE HORN ADMIRALLVS ZC[etera] [Philippe, Baron de Montmorency, Count of Horn, admiral, et cetera]; on truncation, 1565.
Literature: Smolderen 1996, 270–71, no. 46.

Born in Flanders, Philippe de Montmorency began his career as a page and then chamberlain at the court of Charles V. In 1556, he was made Knight of the Golden Fleece and became Stadtholder of Guelders and Zutphen and Admiral of Flanders. Between 1559 and 1561, he was in Spain with Philip II, but upon his return to the Netherlands, he aligned himself with the Count of Egmont and the Prince of Orange against Cardinal de Granvelle and the Inquisition. In the following years, Montmorency continued to resist the introduction of the Spanish Inquisition in the Dutch territories. Upon the arrival of the Duke of Alba in the Netherlands, Montmorency and the Count of Egmont were tried for high treason. Montmorency was executed in Brussels on June 5, 1568. ADC

724

Jacques Jonghelinck (1530–1606)
MARGARET OF AUSTRIA, DUCHESS OF PARMA
(1522–1586)
Dated 1567
Silver, cast; 56.6 mm
Scher Collection

Obverse: Margaret wearing a veiled headdress, a gown with slashed and puffed sleeves, and a necklace with a cross pendant. Inscriptions: MARGARETA DE AVSTRIA D[ucissa] P[armæ] ET P[lacentiæ] GERMANIÆ INFERIORIS GVB[ernatrix] [Margaret of Austria, Duchess of Parma and Piacenza, governor general of the Low Countries]; on truncation, ÆT[atis] 45 [aged 45].
Reverse: Standing on a rock before a turbulent sea, an allegorical female figure in cuirass, crowned with laurel and holding a sword in her right hand and palm and olive branches in her left; in the foreground on the right, a tree, and a church behind it; in the background, a ship approaching a fortified city; personifications of the four winds in the sky. Inscriptions: FAVENTE DEO [With God's favor]; at the bottom of the rock, 1567.
Literature: Scher 1994, no. 158; Smolderen 1996, 287–89, no. 56; Scher 1997, no. 5.

The female figure holding the symbols of war and peace on the reverse symbolizes Margaret's militant resistance to insurrection and heresy, as well as her efforts to introduce orthodoxy and peace in her realm. ADC

725

Jacques Jonghelinck (1530–1606)
VIGLIUS VAN AYTTA DE ZUICHEM (1507–1577)
Dated 1568
Silver, cast; 55.8 mm
Scher Collection; Promised gift to The Frick Collection

Obverse: Aytta de Zuichem wearing a furred cloak and a biretta over a tight cap with flaps. Inscriptions: VIGLIVS PRÆP[ositus] S[ancti] BAV[onis] PRÆS[es] SECR[eti] CON[silii] R[egiæ] MA[jestatis] ET CANC[ellarius] ORD[inis] AV[rei] VEL[leris] [Viglius, provost of St. Bavo, president of his royal majesty's Privy Council, and Chancellor of the Order of the Golden Fleece]; on truncation, ÆT[atis] LXII [aged 62]; engraved at the bottom, 1568.

723

724

Reverse: The arms of Ghent quartered with those of Aytta de Zuichem topped by a miter and a crozier, from which hangs a cloth. Inscription: VITA MORTALIVM VIGILIA [The life of mortals is but a night watch].
Literature: Smolderen 1996, 298–99, no. 65; Scher 1997, no. 7.

Holding positions of great importance in the government of the Spanish Netherlands under Charles V and Philip II, Aytta de Zuichem entered the church after his wife's death. As a native of Friesland, he was one of those officials from the provinces that the Hapsburgs placed in central positions to gain the loyalty of peripheral regions, while also undermining the power of the local nobility. ADC

726

Jacques Jonghelinck (1530–1606)
DON FERNANDO ÁLVAREZ DE TOLEDO, DUKE OF ALBA
(1507–1582)
Dated 1571
Silver, cast; 40 mm
The Frick Collection; Gift of Stephen K. and Janie Woo Scher, 1994
(1994.2.100)

Obverse: Alba wearing a cuirass, sash, ruff, and the emblem of the Order of the Golden Fleece. Inscription: FE[or FF]RDIN[andus] TOLET[anus] ALBÆ DVX BELG[ii] PRÆF[ectus] [Ferdinand de Toledo, Duke of Alba, governor general of Belgium]; on truncation, 1571.
Reverse: A burning candle on a base supported by a lion, recumbent with paws crossed, flanked by two cranes, that on the left holding a stone in its raised right claw. Inscriptions: DEO ET REGI; engraved in exergue, VITÆ VSVS [The purpose of life (is service) to God and the King].
Literature: Van Loon 1732–37, 1: 134, no. 1; Luc Smolderen in Scher 1994, no. 163; Scher 1997, no. 6; S. Galassi in The Frick Collection 2003, 444–47; Smolderen 1996, 315–16, no. 77.

Jonghelinck produced three portraits of Alba, all bearing the date 1571: a bronze bust (The Frick Collection), a now-lost full-size bronze statue, and this medal. On the reverse, the lion (representing Might) supports a burning candle, probably an allusion to the duke's life consumed by his devotion to God and to the Holy Roman Emperor (Alba served both Charles V and Philip II). The crane at left represents Vigilance, according to a belief that the bird carried a stone to avoid sleeping; if it fell asleep and dropped the stone, it would awaken. AN

725 726

727

727
Jacques Jonghelinck (1530–1606)
HANNIBAL DE HOHENEMS (1530–1587)
Dated 1575
Gold, cast; 40.8 mm
Scher Collection

Obverse: Hohenems wearing armor, a ruff, and a commander's sash. Inscriptions: IACOBUS HANIBAL COMES IN ALTAEMPS [Jacob Hannibal, Count of Hohenems]; on truncation, 1575.
Reverse: A full-rigged ship sailing in a rough sea with a giant at the helm. Inscription: SALVA DOMINE VIGILANTES [Save (us), Lord, while awake].
Literature: Smolderen 1996, 328–29, no. 86.

Hohenems was nephew of Pope Pius IV and brother-in-law of St. Carlo Borromeo, having married his sister Ortensia (1550–1578) in 1565. This medal commemorates his vigilance and authority in controlling the Calvinist uprising at Antwerp on December 13, 1574. His motto, inscribed on the reverse, is taken from the Canticle of Simeon, Luke 2:29–32. SKS

728
Jacques Jonghelinck (1530–1606)
CHRISTOPHE D'ASSONVILLE
(ca. 1528–1607)
Dated 1559
Silver, cast; 50.5 mm
Scher Collection

Obverse: Assonville wearing a wide-collared cloak and a ruff. Inscriptions: CHRISTOPH[orus] AB ASSONVILLA REG[is] CA[t]HOL[ici] [sic] CONS[ultor/consiliarius (Van Loon)]: [Christophe d'Assonville, adviser of the Catholic King]; engraved on truncation, ÆT[atis] XLVIII [aged 48].
Reverse: Mercury, seated in a landscape, pointing with his caduceus to the road that leads to Terminus, the Roman god of boundaries; along the path, three men who represent the stages of life—youth, middle age, and old age. Inscriptions: ĔΡ[Π]ΟΥ ΘΕΩ [sic] [Follow God]; engraved on a rock at the bottom, 1559.
Literature: Van Loon 1732–37, 1: 268; Smolderen 1996, 308–9, no. 72.

Christophe d'Assonville, Lord of Hauteville, became Philip II's private councilor in 1559. He was deeply loyal to the Spanish crown but committed to finding common ground between the position of the Spanish king and the Dutch ruling class. There are two other variants of this medal: one, of higher quality and bearing the date 1569, has a slightly different reverse (with only the youngest traveler following the path); another bears the date 1579. The reverse allegory is the all'antica representation of his personal motto "Suivez Dieu!" (Follow God). ADC

729
Jacques Jonghelinck (1530–1606)
ALESSANDRO FARNESE, DUKE OF PARMA (1545–1592)
Dated 1585
Gilt bronze, cast; 45.9 mm
The Frick Collection; Gift of Stephen K. and Janie Woo Scher, 2016 (2016.2.180)

Obverse: Farnese wearing armor, ruff, commander's sash, and the Order of the Golden Fleece. Inscriptions: ALEXANDER FARNES[e] PAR[mæ] PLA[centiæ] DVX BELG[icarum] DVM GVB[ernator] [Alessandro Farnese, Duke of Parma and Piacenza, and governor of the Spanish Netherlands]; Aet[atis] 40 [aged 40].
Reverse: In the foreground, Farnese, in a tent, waking up to a satyr who seems to show him a view, just outside his tent, of the harbor of Antwerp, with the curve of the Scheldt river and a pontoon bridge built during the siege. Inscriptions: CONCIPE CERTAS SPES 1585 [Conceive sure hopes, 1585]; below, ΣΑΤΥΡΟΣ [satyr].
Literature: Van Loon 1732–37, 1: 350; Smolderen 1996, 352–53, no. 98.

728

729

730

The scene recalls Alexander the Great's vision during the siege of Tyre, when he dreamt of a satyr who appeared to be mocking him while dancing on a shield. When he asked his most trusted seer, Aristander, to explain the dream, the seer said that it was a good omen for the capture of the city. The word "satyr" could be interpreted to mean "sa tyr" (Tyre is yours) while the shield alluded to the capture. Alexander conquered Tyre by building a causeway of massive stones and earth—just like the pontoon bridge built by Farnese clearly visible in the medal. ADC

730

Jacques Jonghelinck (1530–1606)
JUSTUS LIPSIUS (1547–1606)
Dated 1601
Silver, cast; 45 mm
Scher Collection

Obverse: Lipsius wearing a ruff and fur-collared coat. Inscriptions: IVSTVS LIPSIVS AET[atis] LI [Justus Lipsius, aged 51]; on truncation, 1601.
Reverse: The head of Roma, as taken from Roman Republican coins, wearing a winged helmet surrounded by an augur's staff, a fasces, and two clasped hands (Concord). Inscription: MORIBVS ANTIQVIS RES STAT ROMANA VIRISQVE [It is by its ancient customs and its great men that Rome survives (from Quintus Ennius, *Annales*)].
Literature: Smolderen 1996, 371–74, no. 109.

Justus Lipsius was considered the prince of the humanists in the Low Countries. From 1568 to 1570, he was in Rome as Cardinal de Granvelle's private secretary. Under the Duke of Alba's government of the Low Countries, he fled to Vienna, then became a professor at the University of Jena, having embraced the Protestant faith. In 1578, Lipsius was appointed professor of history and law at the newly created Calvinist University of Leiden. In 1591, he reconciled with Catholicism and resigned. Forgiven by the king and given a certificate of orthodoxy, he took a professorship at the University of Louvain in 1592. In the last years of his life, he was given prestigious appointments, in particular, privy councilor and historiographer of King Philip II. The array of elements on the reverse of the medal refers to ancient Rome, and the two clasped hands below (Concord) represent the peace and harmony of the Pax Romana. Ennius's line, a gloss to the figurative elements, was Lipsius's personal motto. ADC

731

Attributed to Jacques Jonghelinck (1530–1606)
GILLIS HOOFTMAN (1521–1581)
Dated 1580
Silver, cast; 60.8 mm
Scher Collection

Obverse: Hooftman wearing a coat with upturned collar and a ruff. Inscription: GILLIS HOOFTMAN ÆT[atis] LIX AN[no] M D LXXX [Gillis Hooftman, aged 59, 1580].
Literature: Smolderen 1968, 108–9, pl. 20 (var.); Forrer 1979–80, 7: 488 (var.); Smolderen 1996, 432; De Dompierre de Chaufepié 1903–6, 1: no. 326 (obv.).

Hooftman was a wealthy banker and merchant and a member of the city council of Antwerp. He was also a patron of the arts, supporting, among others, the geographer Abraham Ortelius, the painter Marten de Vos, and the mathematician Michiel Coigniet. ADC

731

732

Conrad Bloc (ca. 1545–after 1602)
WILLIAM I, PRINCE OF ORANGE AND COUNT OF NASSAU (1533–1584) and **CHARLOTTE DE BOURBON** (1548–1581)
Dated 1580
Silver, cast; 30.1 mm
Scher Collection

732

733

Obverse: William wearing armor, a ruff, and a commander's sash. Inscriptions: GVILEL[mus] D[ei] G[ratia] PR[inceps] AVRAICÆ CO[mes] NASSAV A[nno] 1580 [William, by the grace of God, Prince of Orange, Count of Nassau, 1580]; below the shoulder, C[onrad] B[loc] F[ecit] [Conrad Bloc made it].
Reverse: Charlotte wearing a ruff, jeweled fret, and a brocaded gown. Inscription: CHARLOTTE DE BOVRBON PR[incesse] DAVRENGE [Charlotte de Bourbon, Princess of Orange].
Literature: Scher 1994, no. 170 (var.); Scher 1997, no. 10; Pollard 2007, 2: no. 776.

William of Orange, who married the princess in 1575, was the key figure in the revolt of the Netherlands against Spain. The wealthiest nobleman in the Low Countries and a distinguished statesman, he was also a man of great culture. Bloc's medal is the only contemporary image of Prince William in metal; there are several copies executed with slightly different details. Initially a personal gift to courtiers for services, the medal was later used for propaganda purposes. ADC

733

Conrad Bloc (ca. 1545–after 1602)
CARDINAL ARCHDUKE ALBERT OF AUSTRIA (1559–1621)
Dated 1596
Silver, cast; 37.8 mm
Scher Collection; Promised gift to The Frick Collection

Obverse: Albert, tonsured and wearing a mozzetta. Inscriptions: ALBERTVS D[ei] G[ratia] S[anctæ] R[omanæ] E[cclesiæ] CAR[dinalis] ARC[hiepiscopus] TOL[etanus] ARCHID[ux] AVS[triæ] [Albert, by the grace of God, cardinal of the Holy Roman Church, archbishop of Toledo, archduke of Austria]; below truncation, CONR[ad] BLOC F[ecit] [Conrad Bloc made it].
Reverse: Plans of the fortresses of Calais, Ardres, and Hulst. Inscriptions: VENI VIDI VICIT / DEVS / 1596 [I came, I saw, God conquered, 1596]; CALES [Calais]; ARDERS [Ardres]; HVLST [Hulst].
Literature: Van Loon 1732–37, 1: 466.

This medal commemorates the conquest of three cities in France and Flanders during the Eighty Years' War for independence between Spain and the United Provinces of the Netherlands (1568–1648). Albert of Austria was the son of the Holy Roman Emperor Maximilian II and nephew of Philip II of Spain (his mother was Maria of Spain, daughter of Charles V and sister of Philip II). He was appointed archbishop and cardinal of Toledo in 1577, although he mainly served the Spanish crown as a diplomat and soldier.

From 1581 to 1595, Albert was viceroy of Portugal; in 1596, he was sent to Brussels as governor general of the Hapsburg Netherlands, tasked with restoring Spain's military power in the region. His first victorious campaign saw the capture of Calais and Ardres from the French and Hulst from the Dutch. In 1598, he received joint sovereignty of the Low Countries. In April 1599, after having been released from holy orders by the pope, Albert married Philip's daughter Isabella. In 1607, after many years of fighting, he arranged an armistice with the United Provinces, which resulted in the Twelve Years' Truce, a turning point in the process of the official recognition of the independent Dutch Republic. ADC

734

Gerard van Bylaer (or Bijlaer) (ca. 1540–1617), produced at the Holland Mint at Dordrecht after the original medal of Conrad Bloc
MAURICE, PRINCE OF ORANGE (1567–1625)
Dated 1602
Silver, struck; 34.8 mm
The Frick Collection; Gift of Stephen K. and Janie Woo Scher, 2016 (2016.2.190)

Obverse: Maurice wearing armor, a ruff, and a commander's sash tied at the shoulder. Inscriptions: MAVRITIVS PR[inceps] AVR[aicæ] CO[mes] NASS[aviae] CAT[timeliboci] MARC[hio] VER[æ] ET VLIS[singæ] [Maurice, Prince of Orange, Count of Nassau, of Katzenelenbogen, Marquis of Veere and of Vlissingen]; G V B F[ecit] [Gerard van Bylaer made it]; on truncation, ÆT[atis] 34 [aged 34].
Reverse: An orange tree emerging from a tree stump and surrounded by two laurel branches. Inscription: TANDEM FIT SVRCVLVS ARBOR ANNO 1602 [The sapling finally becomes a tree, 1602].
Literature: Van Loon 1732–37, 1: 553–54.

Maurice was the second son of William of Orange, the Silent, who was assassinated by a Catholic fanatic in 1584; hence the presence of the tree stump with an orange tree growing out of it. SKS

734

735

735

Gerard van Bylaer (or Bijlaer) (ca. 1540–1617)
QUEEN ELIZABETH SUPPORTS THE PROTESTANTS IN THE UNITED PROVINCES
Dated 1587
Silver, cast; 52.4 mm
The Frick Collection; Gift of Stephen K. and Janie Woo Scher, 2016 (2016.2.194)

Obverse: Queen Elizabeth holding the scepter and the orb and seated on her throne with the Beast of the Apocalypse under her feet; to her right, a courtier (the Earl of Leicester?) holding the royal mantle; naked children as suppliants kneel around the throne and hold shields of arms representing the states of Guelders, Holland, Zeeland, Utrecht, and Friesland. Inscriptions: DEO OPT[imo] MAX[imo] LAVS ET HONOR IN O[mn]E ÆVVM QVOD . . . [Praise and glory to the mighty and benevolent God that . . .]; in exergue, 1587.
Reverse: The name הוהי [Hebrew for Jehovah] in a shining cloud; the pope, accompanied by monks and other members of the clergy, falling from heaven along with chalices, reliquaries, and hosts. Inscription: QVEM DEVS CONFICIET SPIRITV ORIS SVI [Whom the Lord shall consume with the spirit of his mouth (2 Thessalonians 2:8)].
Literature: Van Loon 1732–37, 1: 369–70; Hawkins 1885, 1: 139–40, no. 99; Eimer 2010, no. 53.

This medal commemorates the British support for the Dutch Revolt against the Roman Catholic rule of King Philip II of Spain. It may specifically allude to the offer of sovereignty over the Netherlands

to Elizabeth I presented by the Frisian Clergy (Van Loon 1732–37, 1: 369). Elizabeth sent the Earl of Leicester to the Netherlands as Lord Regent in 1585. Having rapidly lost the public support due to his radical religious views and poor command skills, Leicester (no. 816) returned to England in 1586, going back to the Netherlands in 1587 and ultimately returning to England in failure in the same year. According to Van Loon, the obverse inscription should be completed with "the queen has kindly accepted our offer," an overt statement withheld. ADC

736

Willem van Bylaer (or Bijlaer) (act. ca. 1580–1635)
SYNOD OF DORDRECHT
Dated 1619
Silver, struck; 59.2 mm
The Frick Collection; Gift of Stephen K. and Janie Woo Scher, 2016 (2016.2.196)

Obverse: A representation of the Assembly Hall. Inscriptions: ASSERTA RELIGIONE [Religion having been established]; on the entrance wall, 1619.
Reverse: A temple on top of a mountain illuminated with a celestial light emanating from the word הוהי [Hebrew for Jehovah]; pilgrims climbing toward the temple; the personifications of the four winds blowing on the mountain. Inscription: ERVNT VT MONS SION CIƆ IƆ CXIX [They (who trust in the Lord) shall be like Mount Zion, 1619] [Psalm 125:1].

736

Literature: Van Loon 1732–37, 2: 105; Hawkins 1885, 1: 223, no. 78; Eimer 1987, 37, no. 99.

The Synod of Dordrecht (November 19, 1618–May 29, 1619) addressed the issue of remonstrants (followers of Jacobus Arminius in disagreement with Calvin in particular on the question of free will and predestination) and counter-remonstrants. The Synod declared the victory of Calvinism and reestablished the unity of the Church. It was also decided to translate the Bible into Dutch (the translation was completed in 1635 and authorized in 1637). It became known as the State Bible, as it had been paid for by the states. This commemorative medal was produced in gold for the foreign delegates and in silver for the domestic delegates. ADC

737

Attributed to Paulus Willemsz. van Vianen (1570–1614)
RUDOLF II, HOLY ROMAN EMPEROR (b. 1552; r. 1576–1612)
ca. 1604
Silver, cast; 41.4 × 33 mm
The Frick Collection; Gift of Stephen K. and Janie Woo Scher, 2016 (2016.2.193)

Obverse: Rudolf, laureate, wearing armor, ruff collar, commander's sash, and the Order of the Golden Fleece. Inscription: RVDOLPHVS II ROM[anorum] IMP[erator] AVG[ustus] REX HVNG[ariæ] BO[h]E[miæ] [Rudolf II, August Emperor of the Romans, King of Hungary (and) Bohemia].
Reverse: The zodiac sign of the constellation Capricorn, represented as a beast half goat and half fish rising above the earth; above, a star and the imperial eagle. Inscription: FVLGET CÆS[aris] ASTRVM [The emperor's star shines].
Literature: Habich 1929–34, 2: pt. 2, no. 3553; pl. CCCXXIX, fig. 4; Scher 1994, no. 136.

In Greek mythology, Capricorn fought on the side of Zeus, crushing the Titans who attempted to storm Mt. Olympus, a parallel to Rudolf's struggle against his numerous adversaries. It was also his astrological sign. The composition on the reverse is a celebration of the emperor's power and supremacy. sks

Above, cup inset with *Allegory of Vanitas* (no. 738); below, interior view of cup.

737

738

738

Jan de Vos (ca. 1578–after 1619)

ALLEGORY OF VANITAS

Dated 1614

Silver, cast; 57 × 44 mm

Scher Collection

Obverse: The sitter, hair elaborately pinned up beneath a diadem, wearing pearl tear-drop earrings, a necklace ending in a pearl pendant that hangs between her bare breasts, a cape, and a gown pinned with a sunburst brooch. Inscriptions: NE GLORIERIS IN CRASTINVM [incuse] [Do not boast of the morrow (Proverbs 27:1)]; on truncation, [1]6↓14 [1614, Jan (de) Vos (monogram)].

Reverse: A skeleton, with a toad on its head and a snake winding between its ribs, wearing drapery, pinned in front with a death's head. Inscription (incuse): MEMOR ESTO QVONIAM MORS NON TARDAT [Be mindful that Death does not delay].

Literature: Scher 1994, no. 134.

With its memento mori inscription and vanitas imagery, this medal serves as a reminder of the vanity of earthly life and the inevitability of death. The woman on the obverse, bejeweled and elaborately dressed, embodies the vanity of the flesh. When the medal is flipped over, she "transforms" into a skeleton; the brooch between her breasts now a death's head, her elaborate coiffure replaced by a toad (another symbol of death). This specimen was mounted in a Münzbecher (a vessel primarily inset with coins) at a later date. EM

739

Attributed to Jan de Vos (ca. 1578–after 1619)

JOSEPH KÖNIG (1535–1602) and **SABINA MAIR** (1538–1603)

Dated 1603

Silver, cast; 55.6 × 47.7 mm

Scher Collection

Obverse: Three-quarter view of König, bearded and wearing a ruff, doublet, and fur-collared cloak. Inscription: IOSEPH KÖNIG CONS[iliator] CAMP[odunum] NA[tus] ANNO 1535 MORT[us] 160Z [Joseph König, Bürgermeister of Kempten, born 1535, died 1602].

Reverse: Three-quarter view of König's wife, Sabina, born Mair, wearing a hood, ruff, and fur-collared cloak. Inscription: SABINA

MAIRIN NATA ANNO 1538 MORTVA 1603 [Sabina Mair, born 1538, died 1603].

Literature: Domanig 1907, no. 703; Lanna sale 1911b, no. 478 (this specimen); Habich 1929–34, 2: pt. 1, no. 3064.

König was bürgermeister of the imperial city of Kempten from 1592 until his death in 1602. He owned a large property near the town hall. For stylistic reasons, this very rare unsigned medal was originally attributed to the sculptor and silversmith Paulus van Vianen. The current attribution was made by Georg Habich based on a stylistic comparison with one of de Vos's signed medals (Habich 1929–34, 2: pt. 1, no. 3071). ADC

740

Adriaen Rottermont (1579–1652)

MAURICE, PRINCE OF ORANGE (1567–1625)

Dated 1615(?)

Silver, cast; 55.5 × 45 mm

The Frick Collection; Gift of Stephen K. and Janie Woo Scher, 2016 (2016.2.195)

Obverse: Maurice wearing armor, ruff, and commander's sash over one shoulder. Inscriptions: in the outer line, MAVRITIVS AVR[aicæ] PRINC[eps] COM[es] NASS[aviæ]; in the inner line, ET MV[rsiæ] MAR[chio] VE[ræ] FL[issingaeque] EQ[ues] OR[dinis] PERISCELIDIS [Maurice, Prince of Orange, Count of Nassau and Meurs, Marquess of Veere and Flushing, Knight of the Order of the Garter]; dated to left beneath the bust, 1615[?].

Reverse: Armorial shield of Prince Maurice within the Garter, crown above. Inscription: HONY SOIT QVI MAL Y PENSE [Shame to him who thinks evil of it].

Literature: Van Loon 1732–37, 2: 87–88; Scher 1997, no. 11.

Prince Maurice was elected a Knight of the Garter on December 19, 1612, with a ceremony at The Hague. This medal was issued on the anniversary of this event. Maurice became Stadtholder of Holland and Zeeland upon the death of his father in 1584 and of the remaining provinces of the Northern Netherlands in 1590 and 1620. As both a commander and a theoretician, he was one of the most important innovators of military art. His victories led to the twelve-year truce with Spain in 1609. SKS

739

740

741

741

Aert Verbeeck the Younger (1579–1653)

FRIEDRICK HENRY, PRINCE OF ORANGE (1584–1647)

Dated 1632

Silver, struck; 56.2 mm

The Frick Collection; Gift of Stephen K. and Janie Woo Scher, 2016
(2016.2.189)

Obverse: Friedrick Henry wearing armor, the sash of an order,
and lace collar. Inscriptions: [perhaps an orange blossom] in the
outer circle, AVSPIC[iis] POTENT[issimorum] BELG[ii] ORDD[inum]
ARMIS ET INDVSTR[ia] INVICT[issimi]; in the inner circle, PRINC[ipis]
ARAVS[ionis] FR[ederici] HENR[ici] E[t] S[ociorum] I[psius] LIB[erata]
MOSA LIMB[urgoque] RECEPT[a] A DEO ILL[ustris] VICT[oria] [Under
the auspices of the most potent States of Holland, by the arms and
diligence of the most invincible Friedrick Henry, Prince of Orange,
and of his allies, Maastricht delivered and Limburg retaken: an
illustrious victory given by God].

Reverse: Plan of the city and fortifications of Maastricht, with forces
besieging and crossing the Maas. Inscriptions: TRAIECT[um] AD
MOSA[m] 1632; in exergue, RECEPT[a] [Maastricht retaken, 1632].

Literature: Van Loon 1732–37, 2: 202–3; De Dompierre de
Chaufepié 1903–6, 1: no. 631; Scher 1997, no. 14.

Friedrick Henry was able to recapture several important strongholds
and chase the Spanish army from the Dutch territory. This medal
commemorates the surrender of Pappenheim, the enemy commander
of the Spanish armies, to Friedrick Henry's forces on August 22,
1632, and the subsequent surrender of Maastricht. SKS

742

Jan van Bylaer (or Bijlaer) (act. 1622–46)

MAURICE, PRINCE OF ORANGE (1567–1625)

Dated 1624

Silver, struck; 67.2 mm

Scher Collection; Promised gift to The Frick Collection

Obverse: Maurice wearing armor, ruff, and commander's sash,
surrounded by the arms of the seven United Provinces. Inscriptions:
MAURITIUS D[ei] G[ratia] PRINCEPS AURIACÆ, COM[es] NASS[aviæ]
ETC. PROV[inciarum] CONFŒ[deratarum] GUB[ernator] [Maurice, by
the grace of God, Prince of Orange, Count of Nassau, et cetera,
governor of the United Provinces]; on truncation, J[an] V[an] BYLAER;
on banderoles beneath the arms of each of the United Provinces,
clockwise, GELRIA [Guelders]; HOLLAN [Holland]; ZEELAN [Zeeland];
TRAIEC [Utrecht]; FRISIA [Frisia]; TRANSI[sulania] [Overijssel]; GROENI
[Groningen].

Reverse: Armorial shield of Prince Maurice within the Garter in
an auricular frame, crown above; all enclosed within two laurel
branches. Inscriptions: HONI SOIT QVI MAL Y PENSE [Shame to him
who thinks evil of it]; in a banderole at the bottom, IE MAINTIENDRAY

742

[I will maintain it]; below the banderole, CUM PRIVIL[egio] 1624 [with privilege, 1624].

Literature: Van Loon 1732–37, 2: 155; Hawkins 1885, 1: 231, no. 91.

This medal may have been produced to honor Maurice of Orange as Grand Admiral on the occasion of two naval victories over the Spanish in Peru and Brazil. SKS

743
Johannes (or Jan) Lutma the Elder (ca. 1584–1669)
THE PEACE OF MÜNSTER
Dated 1648
Silver gilt, two cast shells soldered together; 71.8 mm
Scher Collection

Obverse: Hercules and Minerva standing on either side of a pile of weapons and armor; between them, two branches, oak and olive, are tied together; in Minerva's right hand, seven arrows representing the seven provinces of the Netherlands; above, heavenly rays emanating from the name יהוה [Hebrew for Jehovah]; two cherubs supporting a banderole bearing the inscription PAX VNA TRIVMPHIS INNVMERIS POTIOR [A single peace is preferable to innumerable victories] [Silius Italicus (Bell), *Punica* XI, 593.4]. In the center of the field, two other cherubs hold a smaller banderole with the

inscription OB CIVES SERVATOS [For having saved the citizens].

Reverse: A cloth hangs in an auricular frame with openings that contain putti, and at the bottom, various fruits; at the top, the arms of Amsterdam beneath a crown. Inscription: in twelve lines, EXTINCTO / TERRA MARIQVE / PVBL[ico] BEL[lorum] INCENDIO / PER LXXX ANNOS CONTNVA[to] / CVM TRIB[us]. PHILIP[is] HISP[aniæ] REG[ibus] / TANDEMQ[ue] ODIIS VTRIMQ[ue] SVBLAT[is] / ET ASSERTA PATRIÆ LIBERTATE / PACIS NOM[ine] ET OMINE ÆTERN[ae] / LÆTI LVBENTESQVE / S[enatus] P[opulus]Q[ue] AMSTEL[o]DAM[ensis] / CIƆIƆCXLVIII / S[enatus] C[onsulto] [Having extinguished—by land and sea—the public flame of wars, which had endured for eighty years under three Philips, kings of Spain; and having at last abolished hatred on both sides, and restored the freedom of the homeland; as a token and in the name of eternal peace, the joyful and rejoicing Senate and People of Amsterdam (dedicated this medal) in the year 1648. By resolve of the Senate].

Literature: Van Loon 1732–37, 2: 300; De Dompierre de Chaufepié 1903–6, 1: no. 726; Frederiks 1943, 33, no. 13; Scher 1997, nos. 31, 34; Pelsdonk and Plomp 2012, 18–19, fig. 12 (var.).

This medal commemorates the Peace of Münster, which concluded the Eighty Years' War (1566–1648) and established the independence from Spain of the United Provinces, symbolized by the arrows in Minerva's right hand. The treaty was part of the Peace of Westphalia, which concluded the Thirty Years' War (1618–48). SKS

745

746

744

Adrian Waterloos (1600–1684)

FUNERAL OF ARCHDUKE ALBERT OF AUSTRIA (1559–1621)

Dated 1622

Silver, struck; 54.3 mm

The Frick Collection; Gift of Stephen K. and Janie Woo Scher, 2016 (2016.2.191)

Obverse: The coffin of Archduke Albert of Austria, covered with a canopy being carried during the funeral procession. Inscription: in exergue, M DC XXII XII MARTI [12 March 1622].

Reverse: A hand emerging from a cloud holding a sword entwined with an olive branch; on a banderole, the inscription PVLCHRVM CLARESCERE VTROQVE [It is noble to become famous in both (war and peace)]. Inscription: AVGVSTO FVNERI ALB[erti] PII BELG[arum] PRINC[ipis] VMBRACVLVM TVLIT SENAT[us] BRVX[ellensis] [The senate of Brussels carried the canopy in the solemn funeral of Albert the Pious, Prince of the Netherlands].

Literature: Van Loon 1732–37, 2: 140; Forrer 1979–80, 6: 382.

This medal commemorates the funeral of Archduke Albert on March 12, 1622, with, on the reverse, the emblem and the device of the archduke that refer to his accomplishments in both war and peace. SKS

745

Adrian Waterloos (1600–1684)

PHILIP IV OF SPAIN (1605–1665)

Dated 1631

Silver, cast; 30.8 mm

Scher Collection; Promised gift to The Frick Collection

Obverse: Philip IV in armor, wearing the Order of the Golden Fleece. Inscription: PHILIP[pus] IIII HISP[aniarum] INDIAR[um] ᵒ[ue] REX CATHOLICVS 00 IƆ C XXXI. [Philip IV, Catholic King of Spain and of the Indies, 1631].

Reverse: Samson killing the lion he encountered on his way to Timnah. Inscriptions: DVLCIA SIC MERVIT [Thus he has deserved the sweets]; at the bottom, A[drian]WA[terloos]F[ecit] [Adrian Waterloos made it].

Literature: Van Loon 1732–37, 2: 192–93 (var.).

The Dutch-Portuguese War (1602–63) was the result of Dutch efforts to establish dominant market positions in South America and the Far East. The Brazilian trade in sugar was particularly lucrative, and on September 12, 1631, at the sea battle of Albrolhos off the coast of Brazil a combined Spanish and Portuguese fleet defeated the Dutch,

thus ensuring eventual Portuguese dominance of the sugar market. On the reverse of this medal, the Spanish/Portuguese king, Philip IV, is shown in the guise of Samson, who, on his way to Timnah to marry a Philistine woman, was attacked by a lion, here representing the Netherlands, which he killed with his bare hands. A few days later, Samson noticed that bees had nested and made honey in the lion's carcass (Judges 14:5–9), here referring to the survival of the Portuguese sugar trade. ADC

746

Adrian Waterloos (1600–1684)

JOHN OF AUSTRIA THE YOUNGER (1629–1679)

Dated 1656

Silver, cast; 45.9 mm

Scher Collection

Obverse: John wearing armor, a commander's sash, a wide flat collar, and a medal with a Maltese Cross hung around his neck. Inscription: IOANNES AVSTRIACVS PH[i]LI[ppi] IV HISP[aniæ] R[egis] F[ilius] BEL[gii] G[ubernator] [John of Austria, son of Philip IV, King of Spain, governor of the Spanish Netherlands].

Reverse: God the Father in papal tiara holding a decorated cross and placed inside a Gothic architectural structure within an oak wreath; above, a triple crown and a richly decorated mantle, symbolizing divine protection. Inscriptions: **MI**RA**CVL**OSO FESTO A**D**OREA [Glory on the miraculous solemnity]; chronogram, 1656; below the Gothic architecture, A[drian] WA[terloos] F[ecit] [Adrian Waterloos made it].

Literature: Griffet 1770, 86–87; Forrer 1979–80, 6: 384; Smolderen 2009, 71–73.

The image on the reverse represents the Shrine of St. Gudule in Brussels, with the reliquary containing the miraculous Sacrament, the holy host that remained intact, though bleeding, following the attack by a Jew in the fourteenth century (an episode that led to one of the many anti-Semitic events in medieval Europe). The shrine of the sacred host became a powerful symbol of Catholic identity in the Spanish Netherlands. In 1656, John, the illegitimate son of Philip IV of Spain, was appointed governor of the Spanish Netherlands, at the time in revolt against Spain. On June 15 of that year—the day of the solemn celebration of the miraculous host in Brussels—John of Austria attacked the city of Valenciennes and retook it from the rebels. Convinced that his great victory had been granted by the divine intervention of the holy Host, he commissioned this medal to commemorate the event. ADC

747

747

Johannes Looff (act. 1623–48; d. 1651)

PRELIMINARIES TO THE PEACE OF MÜNSTER

Dated 1647

Silver, struck; 63.9 mm

The Frick Collection; Gift of Stephen K. and Janie Woo Scher, 2016 (2016.2.206)

Obverse: A warship bearing the arms of Zeeland, the United Provinces, the Prince of Orange, and those of the Council of Admiralty. Inscription: TIMIDE AC PRUDENTER [With tact and prudence].

Reverse inscription: Framed by swags of flowers and fruit, in twelve lines, DUM BELLU[m] OCTUAGENARIUM IN / BELGIO STUDIO PACIS SUBITO / DEFERVESCIT IPSUMQ[ue] PACIS / NEGOTIUM MONASTERII CIRCA / COM[m]ODA FÆDERATORU[m] ADHUC / FLUCTUAT; ORDINES ZELANDIÆ / TAM SUSPENSIS REBUS AC SOLLI = CITIS CONSILIIS IN PERPETUUM / MONUMENTU[m] HOC NUMISMA / CUDI JUSSERUNT XII DECEMB[ris] / M DC XLVII / J[ohannes] Looff F[ecit] [While the Eighty Years' War in the Netherlands suddenly subsided as the result of the inclination toward peace, the negotiations for the peace at Münster stalled on the question of the advantages of the allies; the States of Zeeland, being so uncertain about the (state of the) affairs and so agitated by the consultations, have struck this medal as an eternal monument, 12 December 1647. Johannes Looff made it.].

Literature: Van Loon 1732–37, 2: 295–96; Schulman (Jacob) 1912, no. 88.

The Peace of Münster was a series of treaties signed in 1648 that ended the Eighty Years' War (1568–1648) between Spain and the Dutch Republic and resulted in the independence of the latter. The negotiations were difficult, with Spain asked to ratify several concessions, both political and commercial, to the newly independent Dutch Republic. The motto "with tact and prudence" refers to persuading Spain to accept the terms. ADC

748

Dirck van Rijswijck (1596–1679) after a design by Jan Lievens (1607–1674)

ADMIRAL MAARTEN HARPERTSZOON TROMP (1597–1653)

Dated 1653

Silver, cast with a suspension ring; 56 mm

Scher Collection; Promised gift to The Frick Collection

Obverse: Tromp wearing a mantle and armor with a lion's-head pauldron, a medallion (order of St. Michael) hanging from a ribbon and bearing the arms of Tromp; a fish head in waves between the signatures. Inscriptions: MARTINUS HERPERTI TROMPIUS EQUES ET THALASSIAR[cha] HOLLANDIAE XX AN[nis] [Maarten Harpertszoon Tromp, knight, admiral of Holland for twenty years]; in the field to the right, AET[atis] LV [aged 55]; signed beneath the bust, left, I[an] L[ievens] DEL[ineavit]; right, D[irck] V[an] RISWICK F[ecit] [Jan Lievens designed it; Dirck van Rijswijck made it].

748

749

Reverse: A naval battle with a ship sinking in flames on the right. Inscriptions: VICTOR HOSTIUM FORTITER PRO PATRIA PUGNANS OCCUBUIT 10 AUG[usti] AN[n]O DOM[ini] CIƆIƆCL[III] [Conqueror of his enemies, he died fighting bravely for his country, 10 August in the year of the Lord 1653]; D[irck] V[an] R[ijswijck].
Literature: Van Loon 1732–37, 2: 364, 366; De Dompierre de Chaufepié 1903–6, 1: no. 814; Scher 1997, no. 25.

Tromp was one of the most important naval commanders in the Netherlands, and his death, in the Battle of Ter Heijde (July 31, 1653) during the First Anglo-Dutch War (1652–54), was a cause for national mourning. He was honored with a state funeral and a number of commemorative medals. This medal is a collaboration between a well-known painter (Lievens) and a lesser-known medalist (Van Rijswijck). The admiral's face seems to be derived from his official portrait painted by Jan Lievens (1640–53; Rijksmuseum, Amsterdam). ADC

749
Wouter Muller (1604–1673)
ADMIRAL MAARTEN HARPERTSZOON TROMP (1597–1653)
Dated 1653
Silver, two cast shells soldered together; 70.6 mm
Scher Collection

Obverse: Tromp wearing a plain collar, gorget, doublet, and badge of the Order of St. Michael on a ribbon, flanked by two palm branches, banners, clouds, and cannons; above, two putti (genii of Fame) hold a crown over his head formed by the prows of ships. Inscription: on a banderole, MYN HERT EN HAND WAS VOOR HET LANDT [My heart and hand were for the country].
Reverse: A naval battle. Inscription: WAAROM DOET MULLER TROMP DOOR KUNST VAN GOUT EN SILVER LEEVEN: OM DAT HY D YSER EEW DOOR KRYGSDEUGD HEFT VERDREVEN DEN 10 AUG[ustus] 1653 [Why does Muller bring Tromp to life through the art of gold and silver? Because his military heroism drove out the age of iron, on 10 August 1653].

Literature: Van Loon 1732–37, 2: 376, 3; Frederiks 1943, 41, nos. 1, 1a; Scher 1997, no. 24.

On the admiral, see the commentary for no. 748. This medal, featuring a high-relief portrait derived from an engraving, is one of the most impressive of the numerous medals commemorating his death. ADC

750
Wouter Muller (1604–1673)
ADMIRAL MAARTEN HARPERTSZOON TROMP (1597–1653)
Dated 1653
Silver, two cast shells soldered together; 75 mm
Scher Collection; Promised gift to The Frick Collection

Obverse: Tromp, framed by palm fronds and wearing a plain collar, gorget, and buttoned doublet, with the Order of St. Michael suspended from a ribbon; above him, two trumpeting genii hold a crown (made of the prows of ships) above his head; on either side of him, banners and weapons, including smoking cannons. Inscription: on a banderole, MYN HERT EN HANDT WAS VOOR HET LANDT [My heart and hand were for the country].
Reverse: The scene of a naval battle, engulfed in smoke; in the foreground, a sinking ship, behind which are two other ships (one flying the Dutch flag; the other, the English flag). Inscription: WAAROM DOET MULLER TROMP DOOR KUNST VAN GOUT EN SILVER LEEVEN: OM DAT HY DYSER EEW DOOR KRYGSDEUGD HEEFT VERDREVEN. OBYT DEN 10 AUG[ustus] 1653 [Why does Muller bring Tromp to life through the art of gold and silver? Because his military heroism drove out the age of iron. Died 10 August 1653].
Literature: Van Loon 1732–37: 365 (var.); Frederiks 1943, 41, nos. 1, 1a (var.); Bemolt van Loghum Slaterus 1981, no. 99; Scher 1997, nos. 24 (var.), 28 (var.).

On the admiral, see the commentary for no. 748. EM

750

751

Wouter Muller (1604–1673)
OLIVER CROMWELL (1599–1658) and **MASANIELLO
(TOMMASO ANIELLO D'AMALFI)** (ca. 1623–1647)
Dated 1658
Silver, two cast chased shells soldered together; 72 mm
Scher Collection; Promised gift to The Frick Collection

Obverse: Cromwell wearing a flat collar over armor, flanked by
two soldiers in classical armor who lean on shields and hold
a laurel wreath over his head; stippled field. Inscription: on a
scrolled cartouche, OLIVAR CROMWEL PROTECTOR V~[an] ENGEL[and]
SCHOTL[and] YRLAN[d] 1658 [Oliver Cromwell, protector of England,
Scotland, and Ireland, 1658].
Reverse: Masaniello, wearing a shirt with open collar, between two
fishermen leaning on shields and holding a crown over his head;
stippled field. Inscription: on a scrolled cartouche, MAS' ANIELLO
VISSCH[e]R EN CONINCK V~[an] NAPELS 1647 [Masaniello, fisherman
and king of Naples, 1647].

Literature: Frederiks 1943, 43, no. 6; Scher 1997, no. 26; Eimer
2010, no. 198.

Attributed by Frederiks to Muller on stylistic grounds, this medal
commemorates two figures perceived as courageous leaders against
tyranny. Cromwell's role in overturning the monarchy in England is
well known. Masaniello, the son of a fisherman and a housekeeper,
became the leader of the popular revolt in Naples against Spanish
rule and unjust taxes. Following the initially successful revolt,
Masaniello was assassinated by people from his own political
faction. ADC

752

Wouter Muller (1604–1673)
MEMENTO MORI FOR MICHIEL VAN PEENE (1659–1665)
Dated 1665
Silver, cast; 63.9 × 56.1 mm
Scher Collection

751

752

Obverse: Laureate skull and crossbones topped by an hourglass with bird and bat wings, before a pair of crossed scythes; beneath the skull, a cartouche flanked by two genii (one holding an inverted torch, the other blowing bubbles) above a recumbent corpse. Inscriptions: on banderole, DIE IN MY GELOOFT SAL LEVEN AL WAER HŸ OOCK GESTORVEN [He that believeth in me, though he were dead, yet shall he live (John 11:25)]; on the cartouche, Ps[alm] 39.6 / GHY HEBT MIJNE DAGEN / EEN HAND BREET GESTELT [Psalm 39:6 / Thou hast made my days (as) an handbreadth].

Reverse: A skeleton, crowned with laurels, holding a scythe in one hand and a flaming torch in the other; before him, a cartouche, flanked by genii carrying torches (one of which is inverted) and bearing the inscription MICHIEL VAN PEENE GEBOREN DEN 1 MAERT A[nn]° 1659 GESTORVE DEN 8 DECEMB[er] A[nn]° 1665 [incuse] [Michiel van Peene, born 1 March 1659, died 8 December 1665].

Literature: Frederiks 1943, 49 (var.), no. 19; Bemolt van Loghum Slaterus 1981, no. 179.

Memento mori medals were made in great numbers in the Netherlands. Cast from stock models and later engraved with the specifics of the deceased, the medals were made for distribution among friends and family at funerals. The imagery, both grim and hopeful, is replete with symbols of time and serves as a reminder of the transience of life and inevitability of death. Some symbols are familiar to the modern eye (skeletons, hourglasses, scythes); others, less so (the inverted torch of death, transient bubbles, the laurels of Fame, the birdwing for life [day] and batwing for death [night]). To the Calvinist mind, memento mori stressed the importance of putting one's faith in the heavenly and eternal rather than the earthly and ephemeral. EM

753

Wouter Muller (1604–1673)

ADMIRAL CORNELIS TROMP (1629–1691)

Dated 1666

Silver, two cast chased shells soldered together; 77.3 mm

Scher Collection; Promised gift to The Frick Collection

753

Obverse: Tromp wearing a lace cravat, doublet, and broad ribbon of office across the breast with panoplies of war on either side; two infant Tritons blowing the horn of Fame and holding a laurel wreath. The field is stippled. Inscriptions (incuse): on a banderole beneath the bust, CORNELIS TROMP LUYT[enant] ADMIRAAL V[an] HOLL[and] [Cornelis Tromp, lieutenant-admiral of Holland]; SOO BEELDT MEN TROMP HIER AF, DES AMSTELS ADMIRAAL, HE STEECKT DE ZEE IN BRANDT, GELYCK EEN BLIXEMSTRAAL. A[nno] 1666 [Thus we portray Tromp, admiral of Holland; he ignites the sea like a lightning bolt. In the year 1666].

Reverse: Naval battle with ship sinking in foreground. Inscription: HIER STRYCKT HET BRITISCH GEWELT VOOR NEDERLANT DE VLAGH, DE ZEE HEEFT NOIT GEWAEGHT VAN ZUILK EEN ZWAEREN SLAGH [Here the English forces strike their flag to the Dutch; never did the sea resound with such a tremendous conflict].

Literature: Scher 1997, no. 28.

Son of Maarten Tromp (see the commentary for no. 748), Cornelis Tromp was a naval hero who distinguished himself during the second and third Anglo-Dutch Wars (1665–67 and 1672–74, respectively). This medal refers to the Four Days' Battle of June 1–4, 1666, a resounding victory for the Dutch. SKS

754

Wouter Muller (1604–1673)
FREDERICK WILLIAM (1620–1688)
Dated 1666
Silver, two cast shells soldered together; 86.1 mm
Scher Collection

Obverse: Two warriors in antique armor holding a crown of laurel over Frederick William, who wears a plain collar over an ermine robe. Inscriptions (incuse): HIER STAAT KEUR BRANDENBURG'S LANTS TROUWSTE BONTGENOOT DIE DOOR SYN STAALE VUIST DE GOUDE VREE BESLOOT [Here is the Elector of Brandenburg, the truest ally of the States, who by his iron fist concluded a golden peace]; in cartouche, KEUR VORST VAN BRANDENBURG 1666 [Elector of Brandenburg, 1666].

Reverse: Peace personified wraps an olive branch around the standards of Holland and the city of Münster (each topped with a hat of Liberty), which are being carried by personifications of these places, each dressed in a breastplate and helmet; Holland holding seven arrows that represent the seven provinces of the republic and its lion tethered to a leash, and Münster holding a shield bearing the arms of its bishop, with a British harp and thistle at her feet. Inscription: LAAT NU DEN BITTREN BRIT OP MUNSTERS VREE VRY SCHELDEN DOOR KUNST KROONT MULLER HIER HET PUIK DER OORLOGS HELDEN [Let the angry English rail freely at the peace with Münster; by his art Muller here crowns the best of heroes].

Literature: Van Loon 1732–37, 2: 520; Hawkins 1885, 1: 515, no. 160; Frederiks 1943, 44, nos. 7, 7a; Brockmann 1994, 131–33, no. 207.

In 1666, during the Second Anglo-Dutch War (1665–67), the republic paid Frederick William of Brandenburg, Elector of Brandenburg—(the "Great Elector" who laid the foundations for the future Prussian monarchy) to mediate a peace—by force, if necessary—with the bishop of Münster, a subsidized ally of England. This medal celebrates the conclusion of the peace in April 1666. The reverse image, or some iteration thereof, was used a number of times in the seventeenth century for various purposes (see, for example, no. 757). According to Hawkins, Münster should here be understood as trampling the British emblems of the harp and thistle. EM

754

755

755

Wouter Muller (1604–1673)

MICHIEL ADRIAANSZOON DE RUYTER (1607–1676;
Lieutenant-Admiral of Holland 1665–76)
Dated 1666
Silver, two cast shells soldered together; 79.1 mm
Scher Collection

Obverse: De Ruyter, in a plain collar and jerkin, flanked by
panoplies of war and wearing the Danish Order of the Elephant
suspended from a ribbon; two mermaids hold a crown (made of
the prows of ships) above his head. Inscriptions (incuse): on scroll
beneath bust, M[ichiel] A[driaanszoon] D[e]RUYTER LUYT[enant]
ADMIRAAL GEN[eraal] [Michiel Adriaanszoon de Ruyter, lieutenant-
admiral, general]; DE RUYTER DIE DEN BRIT SYN MOET GETEUGELT
HEEFT, ALDUS DOOR MULLERS HANT INT GOUT EN SILUER LEEFT A[nn]°

MDCLXVI DEN XIII JUNY [De Ruyter, who reined in the British courage,
lives through Muller's hand in gold and silver; 13 June 1666].
Reverse: The scene of a naval battle, engulfed in smoke; in the
foreground, a sinking ship, behind which are two other ships (one
flying the Dutch flag; the other, the British flag). Inscription (incuse):
HIER STRYCKT HET BRITSCH GEWELT VOOR NEDERLANT DE VLAGH. DE
ZEE HEEFT NOIT GEWAEGHT VAN ZULK EEN ZWAEREN SLAGH [Here
the English forces strike their flag to the Dutch; never did the sea
resound with such a tremendous conflict].
Literature: Van Loon 1732–37, 2: 528; Frederiks 1943, 45, nos. 8,
8a; Scher 1997, no. 28.

This medal celebrates the pivotal role of Lieutenant-Admiral De
Ruyter in the resounding Dutch victory over the British at the Four
Days' Battle (part of the Second Anglo-Dutch War, 1665–67). De
Ruyter is considered one of the greatest admirals in Dutch history

756

and was instrumental in preventing the invasion of the republic during the Third Anglo-Dutch War (1672–74). His importance was recognized throughout Europe even during his lifetime: he was granted both Danish and Spanish titles of nobility, and France's naval minister called him "the greatest commander who has ever been to sea." EM

This medal celebrates the peace treaty of July 31, 1667, signed at Breda Castle by England, the Dutch Republic, and France and Denmark (the republic's allies). The treaty brought an end to the Second Anglo-Dutch War (1665–67). EM

756
Wouter Muller (1604–1673)
THE PEACE OF BREDA
Dated 1667
Silver, cast; 81.4 mm
The Frick Collection; Gift of Stephen K. and Janie Woo Scher, 2016 (2016.2.203)

Obverse: Above the castle of Breda (beside a river with a number of boats and birds floating on it) flies Fame surrounded by putti, sounding a trumpet and holding a banderole reading SOLI DEO GLORIA [incuse] [To God alone the glory]. Inscription: HET OUD BREDAAS KASTEEL, DOOR MULLERS VOND EN WERK, VERTOONT VAN BINNEN EEN GEWENSTE VREEDE KERK [incuse] [Old Breda's Castle, by the ingenuity and art of Muller, exhibits within it a wished-for Temple of Peace].
Reverse: A large warship, sails full of wind, accompanied by Tritons (sounding seashells) and Fame (sounding a trumpet); the ship's flags and sails emblazoned with symbols and arms of England, the Dutch Republic, France, Ireland, and Denmark. Inscriptions: HIER ZEIILT HET VREDESCHIP OP 'T ZILUER IN DE ZEE, MET BLIIDE WIMPELS, VAN EEN VIER GEKNOOPTE VREE [incuse] [Here sails the ship of Peace on the silvery sea, and bears the happy pennants of a quadruple peace]; in exergue, A[nn]° 1667 [In the year 1667].
Literature: Van Loon 1732–37, 2: 538–39; Hawkins 1885, 1: 531–32, no. 180; Schulman (Jacob) 1912, no. 263; Frederiks 1943, 48, nos. 17, 17a.

757
Wouter Muller (1604–1673)
MARRIAGE AND PEACE OF WESTMINSTER
1654
Silver, two cast shells soldered together; 91 mm
Scher Collection

Obverse: The groom, hat in hand, and bride, bathed in rays of sunlight and holding hands over a burning heart; in the background, a fountain, a tree, and a building. Inscriptions: IN DEN ECHTEN BANT MET LIEFD EN TROUW KROONT GODT DOOR ZEGEN MAN EN VROUW [In matrimony with love and faith, God crowns with blessing husband and wife]; engraved in a cartouche, GTMI SARG FRIV [?].
Reverse: Peace personified, wrapping an olive branch around the standards of Holland and England (each topped with a hat of Liberty), which are being carried by personifications of these nations, each wearing a breastplate and helmet; the former holding seven arrows representing the seven provinces of the Republic and the lion of Holland tethered to a leash, and the latter a shield bearing the English arms, with a harp and thistle at her feet. Inscription: HIER BINT DE HEIL'GE VREE DEN BRIT EN BATAVIER DE WERELT EER 'T VERBONT EN VREEZ' ER KRYGSBANIER [Here holy peace binds the Briton and the Dutchman; the world respects their alliance and fears their standards].
Literature: Hawkins 1885, 1: 567–68, no. 234; Frederiks 1943, 47, no. 15 (var.).

757

758

Each side of this medal was designed separately and joined with other sides for different purposes, the obverse generally used for marriages. It subsequently formed the reverse of a medal of Frederick William, Elector of Brandenburg (1666) (see the commentary for no. 754). An example of the present combination in the Bibliothèque Royale, Brussels, has the initials of William III of Orange (1650–1702) and Mary Stuart (1662–1694) in the cartouche at the bottom of the obverse, which has led to the false assumption that the medal was originally intended to celebrate their marriage in 1677, impossible given the date of death of the artist. This is an example of the interchangeability of obverse and reverse shells in Dutch medals and their continuing use long after they were originally created. The meaning of the inscription on the obverse cartouche is unknown. EM

758

Wouter Muller (1604–1673)
SILVER WEDDING OF JAN VAN TARELINK (1661–1729)
AND MAREGRETA WITTE (1661–1735)
Dated 1682, made 1707
Silver, two cast shells soldered together; 76.9 mm
The Frick Collection; Gift of Stephen K. and Janie Woo Scher, 2016
(2016.2.202)

Obverse: In the foreground, a cock and hen with chicks appear before the Genius of Time (with scythe and hourglass), who grasps a branch of a sapling with both hands; in the middle ground, a man plowing a field before a palm tree (with a crown and scepter in its branches) and a grapevine-entwined staff, beyond which a sailboat moves across a river and a man crosses a bridge; in the background, a walled city, above which clouds part to reveal the name הוהי [Hebrew for Jehovah] flanked by symbols of the sun and moon; from the clouds emerges the hand of God grasping a chain that binds the palm tree and staff with a padlock. Inscription (incuse): SOO BLOEYT DE TROU ALS MAN EN VROU HAER PLICHT BETRACHTEN EN OP GODT WAGHTEN [Thus fidelity/marriage blossoms, as man and wife perform their duty and attend to God].

Reverse inscriptions (incuse): ZOO LANGH DE PLANT NAT'ENTE GROEIJT / ZOO LANGH DE HEN HAAR KIEKENS BROEIJT / ZOO LANGH DE PLOEGH DOOR D'AARDE RIJDT / ZOO LANGH HET SCHIP DE BAAREN SNIJDT / ZOO LANGE BLOEIJD OOK TAARLINKS STAM / INT KOOP-GEZEGEND AMSTERDAM / ZIJN EGAAS WYNRANK HEEST GEDAAN / DAT NEGEN LOOTEN VOOR HEM STAAN / DOGH VAN ZIJN DUYFJENS ZIJN ER VYF / GEVLOGEN UŸT DIT AARDS BEDRIJF / TOT KROON EN SCHEPTERS HEERLIJKHEIJDT / GEKETENT AAN DE ZALIGHEIJT / ALS HIER OOK T' GLAS TEN EIJNDE GAAT / EN ALS DE DOOT ZIJN SIKKEL SLAAT / DAN ZAL GEEN ZON NOGH MANESCHIJN / MAAR GODE AL IN ALLE ZIJN [As long as a plant grows after grafting, / as long as a hen breeds her chicks, / as long as a plow cuts the earth, / as long as the ship cuts through the waves, / so long will the Tarelink clan flourish in the trade-blessed Amsterdam. / His partner's vine has made / nine offspring stand before him, / but of his little doves, five have / flown away from earthly business, / to become crown and creator's glory, / chained to salvation. / If here also the glass is almost empty, / and Death is striking his sickle, / there will no longer be sun or moonshine, / but only God in everyone]; TER GEDAGHTENIS VAN DE SILVER BRUYLOFT VAN IAN VAN TARELINK EN MAREGRETA WITTE GETROUDT DEN 23 YUNY 1682 [In memory of the silver anniversary of Jan van Tarelink and Maregreta Witte; married 23 June 1682].
Literature: Frederiks 1943, 49, no. 18c (var.); Bemolt van Loghum Slaterus 1981, no. 649.

On this stock medal, which was produced from the design of the artist after his death, the complicated allegory of fidelity and conjugal happiness celebrates the silver (twenty-fifth) wedding anniversary of the couple. Jan van Tarelink was an affluent tradesman (dealing in grains and involved in the whaling industry) who became the director of the Groenlandsche Visscherij (Greenland Fisheries) in 1683. EM

759

759

After Wouter Muller (1604–1673), probably by Cornelis Coutrier (before 1730–1749)

SILVER WEDDING OF JOHANNIS DE WAAL AND GERBREGHIE VALKES (dates unknown)

Dated 1718

Silver, two cast shells soldered together; 69 mm

Scher Collection

Obverse: In the foreground, a rooster with hen and chicks beside a scythe and agricultural tools (including a spade and plow), behind which appears Cupid with arrows and a lion (of the Dutch Republic) looking at two people (seated on a cart) who, hands clasped, face each another while stepping on a skull; in the middle ground, a man working the field before a chapel, outside which a mother and two children, as well as a figure with a cross and Bible, sit; in the background, behind an obelisk, a town; and in the sky, above a dove with an olive branch and genius emptying a cornucopia, the hand of God emerges from the clouds (flanked by symbols of the sun and moon), holding a key and a padlock hanging from a chain connected by two strands to a flowering palm tree.

Reverse: Flowering vine. Inscriptions (incuse): SOO BLOEYT DE TROU, ALS MAN EN VROU, HAER PLIGT BETRAGHTEN, EN OP GODT WAGTEN [Thus fidelity/marriage blossoms, as man and wife perform their duty and attend to God]; TER GEDAGTENIS / VAN JOHANNIS DE WAAL / MET GERBREGHIE VALKES / GETROUT DEN 13 MEY 1693 / EN GEDAGHTIG DEN 13 MOY 1718 / WAARDE KINDERE, NEEMT DIT GESCHENK / VAN DEESE PENING EN GEDENCK / DAT ÚWER OUDER TROU VERBONT / [a]NN[o] 25 JAARE STONT [In memory of Johannis de Waal, married to Gerbreghie Valkes on 13 May 1693, and remembered on 13 May 1718. Valued children, take the gift of this medal and remember your parents' faithful bond, which held for 25 years].

Edge inscription: B [?] [as in no. 760].

Literature: Bemolt van Loghum Slaterus 1981, no. 734. EM

760

After Wouter Muller (1604–1673)

MEMENTO MORI FOR CORNELIUS NUCK (1637–1717)

Dated 1717

Silver, cast; 73.8 × 67.2 mm

Scher Collection

760

761

Obverse: Two flying genii, one clothed and one naked, sounding horns, each holding a ribbon ending in a tassel and a banner with the inscription CHRISTUS IS U LEVEN, STERVEN IS U GEWIN [Christ is your life and death is your gain (Philippians 1:21)] [incuse]; below, a corpse wrapped in a shroud and resting, head supported by a bolster, on a tomb. Inscription: on a cartouche flanked by two contorted skeletons, SALIGH SYN DE DOODEN DIE IN DEN HEERE STERVEN VAN MIAEN: JA SEYT DE GEEST OP DAT SŸ RUSTEN MOGHEN VAN HAREN ARBEYT. APOCALIPSIS C14V13 [Blessed are the dead who die in the Lord henceforth. "Yea," says the Spirit, "that they may rest from their labors." Revelations 14:13] [incuse].
Reverse: Within a border of bones, upon which rests a winged (bat and bird wings) hourglass, are the laureate arms of Cornelius Nuck [incuse], beneath which is inscribed CORNELI[u]S NUCK (on a banner); NATUS 18 MAART 1637 [Cornelius Nuck; born 18 March 1637] [incuse]; the arms flanked by two skeletons, one holding a scythe and one an inverted torch, who stand upon wings (bat and bird wings) framing the inscription, DENATUS 2 JAN[uari] 1717 [died 2 January 1717] [incuse].
Edge inscription: B [?] [as in no. 759].
Literature: Bemolt van Loghum Slaterus 1981, no. 725.

See the commentary for no. 752. EM

762

After Wouter Muller (1604–1673)
MEMENTO MORI FOR JACOBUS VLEMMINCX (d. 1699)
Dated 1699
Silver, two cast shells soldered together; 62.6 × 54.9 mm
Scher Collection; Promised gift to The Frick Collection

Obverse: A man in a robe lying peacefully in a field near a tree, his hands clasped over a cross on his chest; above him, a genius holding out a laurel wreath and palm fronds; the background is hilly with some buildings in the distance.
Reverse: A skeleton, crowned with laurels, holding a scythe in one hand and a flaming torch in the other; before him, a cartouche, flanked by genii carrying torches (one of which is inverted) and bearing the inscription (incuse), BIDT VOOR DE ZIEL VAN DEN E[erwaarde] P[r][iester] IACOBUS VLEMINCX S[ocietatis] I[esu] OBIIT 26 AUGUSTI 1699 [Pray for the soul of (the) honorable priest Jacobus

Vlemmincx, Society of Jesus, died 26 August 1699]; beneath this, a death's head as part of an auricular panel.
Literature: Bemolt van Loghum Slaterus 1981, no. 580; Pelsdonk and Plomp 2012, 122 (var.).

See the commentary for no. 752. EM

762

After Wouter Muller (1604–1673)
MEMENTO MORI FOR MARIA HENRICA (1731–1734) and
JOHANNES PETRUS VAN BRIENEN (1734–1734)
Dated 1734
Silver, two cast shells soldered together; 73.3 × 66.4 mm
Scher Collection

Obverse: Two flying genii, naked, pointing toward the clouds, above which is inscribed יהוה [Hebrew for Jehovah] and from which rays of sunlight stream; below, a woman crowned with laurels and wrapped in a shroud, her eyes closed and head supported by a roll of cloth, reclines upon a sarcophagus, fronted by a cartouche flanked by genii. Inscriptions: TER GEDAGTENISSE VAN MARIA HENRICA VAN BRIENEN GEBOOREN DEN 13 OCTOBER 1731 EN JOANNIS PETRUS VAN BRIENEN GEBOOREN DEN 6 JUNY 1734 BEYDE GESTORVEN DEN 3 AUG[us]T[u]S 1734 [In memory of Maria Henrica van Brienen, born 13 October 1731, and Johannes Petrus van Brienen, born 6 June 1734; both died 3 August 1734]; on the banner, [He]T'LEVEN IS MIJ CRISTUS ENDE HET STERV[en] IS MIJN GEWIN [For to me to live is Christ, and to die is gain (Philippians 1:21)].
Reverse: A naked child blowing bubbles, seated on a cartouche framed by bones; the plaque flanked by two skeletons with wispy hair, one carrying a scythe, the other holding an inverted torch, standing upon a bird's wing and a bat's wing, respectively. Inscriptions: between the bird's and bat's wings, GEDENK TE STERVEN [Memento Mori]; on the cartouches, OP EENEN DAG VOERT THANS / DE DOOD / TWEE TEDRE ZIELEN IN / DEN SCHOOT / VAN ABRAHAM DOOR / GODTS BEHAAGE / OM HUN DE HEILKROON / OP TE DRAAGE / MARIA EN JOANNIS / TRÊ[d]EN / TEN HEMEL IN VOL / ZALIG HEEN [One day death carries two tender souls to the lap of Abraham, God willing, to bequeath to them the crown of salvation. Maria and Johannes enter heaven in total bliss].

762

Literature

Literature: Frederiks 1943, 50, no. 20 (var.); Bemolt van Loghum Slaterus 1981, no. 868; Scher 1997, no. 43 (var.); Pelsdonk and Plomp 2012, 45–46, fig. 36 (obv.).

See the commentary for no. 752. EM

763

Attributed in part to Wouter Muller (1604–1673)

EGBERT MEEUWSZOON KORTENAER (1604–1665)

Dated 1665

Silver, two cast shells soldered together; 83.2 mm

Scher Collection

Obverse: Kortenaer wearing a cravat and embossed bandolier. Inscriptions: EGB[ert] M[eus]Z KORTENAAR L[uytenant] ADM[iraal] V[an] HOLL[and] EN W[est] F[risiæ] [Egbert Meusz Kortenaer, lieutenant-

admiral of Holland and West Friesland]; OB[iit] 13 IVN[ius] A[nn]° 1665 [died 13 June 1665].

Reverse: Four naval commanders, in brimmed hats and cloaks, seated around a table before an Ionic colonnade interspersed with swords. Inscription: RIDDER MARTEN HARPERTSEN TROMP, PIETER PIETERSEN HEYN, IACOB HEEMSKERCK, IAN VAN GALEN [Knight Maarten Harpertszoon Tromp, Pieter Pietersen Hein, Jacob van Heemskerk, and Jan van Galen].

Literature: Van Loon 1732–37, 2: 360; De Dompierre de Chaufepié 1903–6, 1: no. 945 (early 19th-century copy).

Kortenaer is honored here in the year he was made lieutenant-admiral and died in battle. He commanded squadrons of the Dutch navy during both the First and Second Anglo-Dutch Wars (1652–54 and 1665–67, respectively). After Maarten Tromp's death (1653), Kortenaer successfully took command of the admiral's squadron. His heroic feats during the Battle of the Sound (November 8, 1658)

763

764

earned him a vice-admiralty (1659) and a knighthood from Frederick III of Denmark. Kortenaer was fatally wounded during the Battle of Lowestoft (June 13, 1665). The reverse of this medal, which celebrates four of the republic's greatest maritime heroes during the Dutch Golden Age, is copied from the reverse of a medal of William I of Orange, the Silent, by Wouter Muller, but it is paired here with an obverse based on a painted portrait of Kortenaer by Bartholomeus van der Helst dated 1660 (Rijksmuseum, Amsterdam). Other than the reference with illustration of another example of this medal in the Koninklijk Kabinet that appears to be given a date of 1854, there are no other recorded examples (De Dompierre de Chaufepié, no. 945). This medal is probably a later fabrication with a nineteenth-century obverse and a reverse by Muller. sks

764

Pieter van Abeele (1608–1684)
MAURICE OF ORANGE (1567–1625)
1622
Silver, two cast silver shells soldered together; 65 mm
The Frick Collection; Gift of Stephen K. and Janie Woo Scher, 2016
(2016.2.199)

Obverse: Maurice wearing armor, a commander's sash, and a ruff. Inscriptions: MAVRITIO D[ei] G[ratia] PRINC[ipi] AVRAI[cæ] COM[iti] NASS[aviæ] E[t]C[etera] [To Maurice, by the grace of God, Prince of Orange, Count of Nassau, et cetera]; P[ieter] V[an] A[beele] F[ecit] [Pieter van Abeele made it].

Reverse: Maurice, on a rearing horse, holding a baton, with a townscape in the distance. Inscription: MAVRICI[i] AVXILIVM PRÆSTANS VICTORIA BERGIS [The aid of Maurice procures a great victory in Bergen].

Literature: Van Loon 1732–37, 2: 149–50; Frederiks 1943, 8, nos. 6, 6a.

This medal celebrates Maurice, who with the Dutch army in 1622 lifted the Spanish siege of Bergen op Zoom during the Eighty Years' War (1568–1648). sks

765

Pieter van Abeele (1608–1684)
FRIEDRICK HENRY, PRINCE OF ORANGE (1584–1647)
1647
Silver, two cast shells soldered together; 67.2 mm
Scher Collection; Promised gift to The Frick Collection

765

766

Obverse: Friedrick Henry wearing a flat lace collar, commander's sash, and armor decorated with the badge of the Order of the Garter. Inscriptions: FRID[ericus] HENRICVS D[ei] G[ratia] PRINC[eps] AVRAI[cæ] COM[es] NASS[aviæ] E[t]ᶜ[etera] [Frederick Henry, by the grace of God, Prince of Orange, Count of Nassau, et cetera]; P[ieter] ABEELE F[ecit] [Pieter van Abeele made it].

Reverse: An olive branch crossing a laurel branch in the middle of a circle formed by instruments of war, and the arms of (clockwise) Groenlo [Grol], Bois-le-Duc, Wezel; Maastricht, Rheinberg [Rijnberk], Breda, [?], Hulst; all within a laurel wreath. Inscription: VLTIMVS ANTE OMNES DE PARTA PACE TRIVMPHVS [The supreme triumph is the one by which peace is procured].

Literature: Van Loon 1732–37, 2: 288; Frederiks 1943, 8, no. 7.

Peace with France had been the central achievement of Friedrick Henry's foreign policy, but in his later years he sacrificed the alliance to press for peace with Spain. On January 8, 1647, Spain and the Dutch signed a preliminary treaty, paving the way for the official peace treaty signed a year later, after Friedrick Henry's death. According to Van Loon, this medal was produced to honor the prince on the occasion of the provisional peace. The arms on the reverse represent places he conquered. The reverse inscription, the coats-of-arms, and most of the decorative elements are incuse. ADC

766

Pieter van Abeele (1608–1684)

WILLIAM II, PRINCE OF ORANGE (1626–1650) and
DOWAGER PRINCESS MARY OF ENGLAND (1631–1660)
1650
Silver, two cast chased shells soldered together; 64.5 mm
Scher Collection

Obverse: William wearing armor, a commander's sash, and the badge of the Order of the Garter on a ribbon; the field is decorated with tracery of orange branches. Inscriptions: WILHELMVS II D[ei] G[ratia] PRINC[eps] AVRAICÆ COM[es] NASS[aviæ] E[t]c[etera] [William II, by the grace of God, Prince of Orange, Count of Nassau, et cetera]; signed below the shoulder, PVA [artist's initials].

Reverse: Mary wearing a low-cut dress, a string of pearls around her neck, and pearl-drop earrings; her hair elaborately arranged with bands of diamonds and pearls; the field decorated with tracery of roses and thistles. Inscription: MARIA D[ei] G[ratia] PRINCEPS M[agnæ] BRIT[anniæ] AVRANT[iæ] DOTARIA ETC[etera] [Mary, by the grace of God, Princess of Great Britain, Dowager of Orange, et cetera]; PABEELE F[ecit] [Pieter van Abeele made it].

Literature: Van Loon 1732–37, 2: 340; Hawkins 1885, 1: 393–94, no. 17; Scher 1997, nos. 17, 17a; Eimer 2010, no. 182.

This medal was made as a memorial to William upon his death from smallpox in 1650. ADC

767

Pieter van Abeele (1608–1684)
ADMIRAL MAARTEN HARPERTSZOON TROMP (1597–1653)
Dated 1653
Silver, two cast shells soldered together; 68.8 mm
The Frick Collection; Gift of Stephen K. and Janie Woo Scher, 2016 (2016.2.198)

Obverse: Tromp wearing a plain collar, gorget, buttoned doublet, and badge of the Order of St. Michael on a ribbon; the field decorated with stylized vines, crowns, and harp; laurel wreath as border. Inscriptions: MART[en] HERP[ertszoon] TROMP R[idder] L[uytenant] ADM[iraal] V[an] HOLL[and] E[n] WESTV[riesland] A[nn]° 1653 [Maarten Harpertszoon Tromp, knight, lieutenant-admiral of Holland and West Friesland, 1653]; on truncation, P[ieter] A[beele] F[ecit] [Pieter van Abeele made it].

Reverse: Tromp coat of arms in front of two anchors with griffon supporters, each surmounted by an escutcheon charged with a rose. The griffons stand on stylized waves that frame the scene of the sea battle in which the Admiral perished. Inscription: OBYT Æ[tatis] 56 [Died aged 56].

Literature: Van Loon 1732–37, 2: 364–65; Frederiks 1943, 7, nos. 3, 3a.

On the admiral, see the commentary for no. 748. SKS

767

768

Pieter van Abeele (1608–1684)

WILLIAM III, PRINCE OF ORANGE (1650–1702) and
PRINCESS MARY OF ENGLAND (1631–1660)

Dated 1654

Silver, two cast shells soldered together; 64.9 mm

Scher Collection

Obverse: Mary wearing a low-cut dress, a string of pearls around her neck, and pearl-drop earrings; her hair elaborately arranged with bands of diamonds and pearls; the field decorated with incised tracery of roses and thistles. Inscriptions: MARIA D[ei] G[ratia] PRINCEPS M[agnæ] BRIT[anniæ] AVRANT[iæ] DOTARIA ETC[etera] [Mary, by the grace of God, Princess of Great Britain, Dowager of Orange, et cetera]; P[ieter] V[an] ABEELE F[ecit] [Pieter van Abeele made it].

Reverse: William wearing a lace-trimmed cap with two bows and a beret with feathers, surrounded by a fruit wreath. Inscriptions: on a banner beneath the bust, WILHELMVS III D[ei] G[ratia] / PRINC[eps] ARAVS[ionis] ETC[etera] [William III, by the grace of God, Prince of Orange, et cetera]; AN[no] 1654 [the year 1654]; in the field behind the bust, P[ieter] V[an] A[beele] F[ecit] [monogram; Pieter van Abeele made it].

Literature: Hawkins 1885, 1: 417–18, no. 55; Eimer 1987, 46, no. 192.

This medal represents the regency of Princess Mary over her son, William. Both portraits were combined with other obverses and reverses. SKS

769

Pieter van Abeele (1608–1684)

WILLIAM III, PRINCE OF ORANGE (1650–1702)

Dated 1654

Silver, two cast shells soldered together; 65 mm

Scher Collection; Promised gift to The Frick Collection

Obverse: William wearing a lace-trimmed cap with two bows and a beret with feathers, surrounded by a fruit wreath. Inscriptions: on a banner beneath the bust, WILHELMVS III D[ei] G[ratia] / PRINC[eps] ARAVS[ionis] ETC[etera] [William III, by the grace of God, Prince of Orange, et cetera]; AN[no] 1654 [the year 1654]; P[ieter] V[an] A[beele] F[ecit] [monogram; Pieter van Abeele made it].

Reverse: Minerva with a Gorgoneion shield and holding a lance with an owl at her feet; her right hand pointing toward a sunburst with the word יהוה [Hebrew for Jehovah]; before her, the child William wearing classical dress and a laurel wreath and holding a baton of command; in the background, The Hague; a laurel wreath with a flower at the top enclosing the whole composition. Inscriptions:

768

769

TIME DEVM [Fear God]; beside the shield, P[ieter] V[an] AB[eele] F[ecit] [Pieter van Abeele made it].

Literature: Van Loon 1732–37, 2: 376–77; Frederiks 1943, 6–7, nos. 1e, 2c; Scher 1997, no. 18a.

This medal represents the education of the prince by his mother in the guise of Minerva as the Dutch State. As suggested by Van Loon, the medal may commemorate the election of the young William III as Stadtholder in 1654 (deferred to 1657) in response to Cromwell's Act of Seclusion, which debarred members of the House of Orange from the highest offices in the Netherlands. ADC

770

Pieter van Abeele (1608–1684)

COMPLETION OF THE AMSTERDAM EXCHANGE IN 1611

Dated 1655

Silver, cast; 77 mm

Scher Collection; Promised gift to The Frick Collection

Obverse: Amsterdam personified, wearing an imperial crown and holding a palm branch in her right hand and the arms of the city in her left, sits on a throne composed of two lions; on her right, Athena as Valor and/or Wisdom, and on her left, Hermes, god of commerce; all on a bridge above merchandise of various kinds. Inscriptions: D'EERWAARDE DEUGT HAAR RECHTER ARM BESCHUT DE COOPMANSCHAP HAAR SLINKER ONDERSTUT [Honorable Virtue protects her right arm; Commerce supports her left]; on a parcel (incuse) P[ieter] V[an] A[beele] F[ecit] [monogram; Pieter van Abeele made it].

Reverse: Ships, including a warship firing its cannons, on a river before Amsterdam, watched over by a reclining river god (a rudder in one hand and an urn, from which water flows, in the other); above, Fame sounds two trumpets, and the sun's rays illuminate all. Inscription: VIER BURGEMEESTERS EEL EN VROOM VAN STAM REGEERDENT VOLCK EN SCHEEPRYK AMSTERDAM [Four burgomasters of distinguished and virtuous families govern Amsterdam, rich in citizens and vessels].

Edge inscription: JOHAN HUYDE-KOOPER RIDDER, HEER VAN MARSEVEEN. CORNELI[s] DE GRAEF, VRŸ–HEER VAN ZUYT–POLS–BROECK. JAN VAN DE POL. HENDRICK DIRCKS SPIEGEL. A[nn]° 1655 [Knight Johan Huydekoper, Lord of Maarseveen, Cornelis de Graef, Lord of Zuid-Polsbroek, Jan van de Pol (and) Hendrick Dircks Spiegel (names of the Amsterdam burgomasters), 1655]

770

771

Literature: Van Loon 1732–37, 2: 80; Frederiks 1943, 15, nos. 27, 27a.

The construction of the Amsterdam Exchange—considered the oldest stock exchange in the world—began in 1608 with the building of a bridge over the Rokin Canal (a tributary to the Amstel River). This medal was probably reissued for the inauguration of the Amsterdam town hall in 1655, the date given in the edge inscription. EM

771

Pieter van Abeele (1608–1684)
JAN WOLFERT VAN BREDERODE (1599–1655)
Dated 1655
Silver, two cast shells soldered together; 67.4 mm
Scher Collection

Obverse: Brederode wearing armor and flat collar with the Danish Order of the Elephant hanging from a ribbon. Inscriptions: IOH[annes] WOLFERDVS D[ominus] D[e] BRED[erode] COM[es] NAT[us] EX COM[itibus] HOLL[andiæ] DOM[inus] S[upremus] D[e] V[iana] A[meyda] VICE C[omes] H[ereditarius] T[rajecti] CONF[ederati] BEL[gii] IN C[ampo] MARSCH[allus] G[eneralis] [John Wolfert; Lord of Brederode; Count born of the Counts of Holland; Sovereign Lord of Vianen and Ameda; hereditary Viscount of Utrecht; general field marshal of the United Provinces]; on truncation, P[ieter] V[an] A[beele] F[ecit] [monogram; Pieter van Abeele made it].

Reverse: Brederode badge (the head of a wild boar over two crossed, burning laurel branches with flames in the field). Inscription: ETSI MORTUUS VRIT CI⊃ CICLV [Although dead, it stirs flames, 1655].

Literature: Frederiks 1943, 8, nos. 8, 8a.

This medal commemorates the death of Brederode, a member of a distinguished Dutch family and an important military leader who became a field marshal in 1642. SKS

772

773

772

Pieter van Abeele (1608–1684)

AWARDING OF AMSTERDAM CITY ARMS AND CROWN BY WILLIAM IV (b. 1307; Count of Holland, Hainaut and Zeeland, 1337–45) **AND MAXIMILIAN I** (1459–1519; King of the Romans 1493–1519; Archduke of Austria 1493–1519; Holy Roman Emperor 1508–19)

ca. 1655

Silver, two cast shells soldered together; 82.3 mm

The Frick Collection; Gift of Stephen K. and Janie Woo Scher, 2016 (2016.2.201)

Obverse: William, seated on a throne and surrounded by guards with pikes, points to a scroll bearing the Arms of Amsterdam [incuse] held by the Herald-at-Arms, before whom is a dog; a city magistrate, surrounded by others, bowing slightly, hat in hand; in the background, an arched portico (upon which is the ancient seal of the city. Inscriptions: on pedestal beneath throne, P[ieter] V[an] ABEELE F[ecit] [incuse] [Pieter van Abeele made it]; in exergue, COM[es] WILH[elmus] HOC INSIGNE / AMSTELODAMO DONO / 13DEDIT42 [Count William donated these arms to Amsterdam (in the year) 1342].

Reverse: Maximilian, in armor and open robes, wearing the collar of the Order of the Golden Fleece, his left hand holding his gloves and resting on a sword, holds out the Imperial Crown to the magistrates of Amsterdam, a representative of whom stands before him, bowing slightly and holding the Arms of Amsterdam beneath the crown; between them, a dog descending the stairs away from the emperor, behind whom are guards with pikes, courtiers, and a child, all in front of a portico. Inscription: in exergue, CÆS[ar] MAX[imilianus] CORONAM IMP[erialem] / DONAVIT AMSTELO / 14DAMO88 [Emperor Maximilian gave Amsterdam the imperial crown (in the year) 1488].

Literature: Van Loon 1732–37, 1: 250; Frederiks 1943, 16–17, nos. 28, 28a.

This medal, possibly made in conjunction with the opening of a new town hall in Amsterdam in 1655, commemorates two events in the creation of the arms of Amsterdam. In 1342, after coming under the control of William IV (also known as William II, Count of Hainaut; William IV, ruler of Avesnes and Holland; and William III, ruler of

Zeeland), Amsterdam was first given a coat of arms (as seen on the obverse); and in 1489, as a token of thanks for the city's support during the struggle for the Duchy of Burgundy, Maximilian I granted Amsterdam the right to add his imperial crown to the shield (on the reverse). EM

773

Pieter van Abeele (1608–1684)

MARRIAGE AND FIDELITY

ca. 1655

Silver, two cast shells soldered together; 65.6 mm

Scher Collection

Obverse: Juno, crowned, seated, and accompanied by two peacocks; in one hand, she holds a scepter; in the other, a crown from which a wedding ring is suspended by a ribbon. Inscriptions: IK KROON OPRECHTE LIEFD ALTOOS MET MYNEN TROURING EINDELOOS [I always crown sincere love with my wedding ring, forever]; P[ieter] V[an]A[beele].

Reverse: Venus, holding a burning heart in her left hand, sits beside two swans before a burning altar, to which Cupid, leaning on her left knee, points. Inscription: EEN HART DAT REINE LIEFDE DRAAGT IS D OFFRHANT DIE MY BEHAAGT [A heart that contains pure love is the offering that pleases me].

Literature: Frederiks 1943, 17, nos. 30, 30a.

Stock medals like this would have been distributed at the celebration of an engagement or a marriage. EM

774

Pieter van Abeele (1608–1684)

MARRIAGE AND CHARITY

ca. 1656–57

Silver, two cast shells soldered together; 84.6 mm

The Frick Collection; Gift of Stephen K. and Janie Woo Scher, 2016 (2016.2.197)

774

Obverse: A man and woman holding hands; between them, a dove descending with an olive branch in its beak; field bordered by a wreath of fruit. Inscription: HET HUWELYCK IS GODDELYCK VAN AART WANNEER MEN TSAAM VYT REINE LIEFDE PAART [Marriage is divine in nature when people join together out of pure love].

Reverse: Charity personified, nursing one child and flanked by two others bathed in sunlight (one holds a dove tethered to a string); field bordered by a wreath of flowers. Inscription: OPRECHTE LIEFDE TUSSCHEN MAN EN VROUW DUURT EEWIGLYK WEL ZALIG IS DE TROUW [Sincere love between man and woman endures eternally; most blessed is Fidelity].

Literature: Frederiks 1943, 18, nos. 32, 32a. EM

775

Pieter van Abeele (1608–1684)

CHARLES X GUSTAV, KING OF SWEDEN (b. 1622; r. 1654–60)

Dated 1658

Silver, two cast shells soldered together; 65.6 mm

Scher Collection

Obverse: Charles wearing armor with a flat collar and commander's sash. Inscriptions: CAROLUS GUSTAV[us] D[ei] G[ratia] SVEC[orum] GOTH[orum] VANDALOR[um] Q[ue] REX [Charles Gustav, by the grace of God, King of the Swedes, the Goths, and the Vandals]; on truncation, PVA [artist's initials].

Reverse: Charles on horseback and carrying a baton; in the distance, the city of Roskilde. Inscriptions: INVIA VIRTUTI NULLA EST VIA AN[n]° 1658 [No road is impassable for valor (Ovid), 1658]; in field below horse, ROOSCHIL [Roskilde].

Literature: Van Loon 1732–37, 2: 424–25; Hildebrand 1874, 351, no. 30; De Dompierre de Chaufepié 1903–6, 1: no. 870; Frederiks 1943, 9, nos. 10, 10a; Scher 1997, nos. 19, 19a.

This medal commemorates Charles's victory over the Danes and the subsequent Treaty of Roskilde, which ended the Second Northern War (1655–60). SKS

775

776

776

Pieter van Abeele (1608–1684)

CHARLES II (b. 1630; King of Scotland 1649–51; King of England, Scotland, and Ireland 1660–85)

Dated 1660

Silver, two cast shells soldered together; 68.5 mm

The Frick Collection; Gift of Stephen K. and Janie Woo Scher, 2016 (2016.2.200)

Obverse: Charles wearing armor, a large neck cloth with bow, and the Order of the Garter. Inscription: CAROLUS II D[ei] G[ratia] MAGNÆ BRIT[anniæ] FRA[nciæ] ET HIB[erniæ] REX [Charles II, by the grace of God, King of Great Britain, France, and Ireland].

Reverse: Fleet under sail; above, Fame flying with a trumpet and scroll with the inscription SOLI DEO GLORIA [To God alone the glory]; below, on a shell, S[yne] M[ajesteyt] IS UIT HOLLANT VAN SCHEVELING AFGEVAREN NAER FYN CONINCRYKEN A[nn]° 1660 JUNI 2 [His Majesty departed from Holland by Scheveningen to his own kingdom in the year 1660, June 2]; IN NOMINE MEO EXALTABITUR CORNU EIUS PSAL[mo] 89 [In my name shall his horn be exalted; Psalm 89:24].

Literature: Frederiks 1943, 10–11, nos. 13b, 16b; Scher 1997, nos. 20, 20a.

After a long exile, Charles II was proclaimed King of England on May 8, 1660. The reverse shows the English fleet departing from Scheveningen with Charles returning to England. Some examples of the medal are signed PVA; thus the entire group is attributed to Pieter van Abeele. SKS

777

Pieter van Abeele (1608–1684)

JULES, CARDINAL MAZARIN (1602–1661)

Dated 1660

Silver, two cast shells soldered together; 69 mm

Scher Collection

Obverse: Mazarin wearing a flat collar over a cardinal's mozzetta and skullcap. Inscriptions: IVLIVS S[anc]t[æ] ROM[anæ] EC[c]L[esiæ] CARD[inalis] MAZARINVS [Jules Mazarin, Cardinal of the Holy Roman Church]; on truncation, P[ieter] V[an] A[beele] F[ecit] [monogram; Pieter van Abeele made it].

Reverse: Doric temple on high podium; on the tympanum, the double-faced head of Janus; behind it, crossed keys. Inscriptions: QVI POSVIT FINES SVOS PACEM PSA[lmo] [1]47 [He maketh peace in thy

777

778

borders; Psalm 147:14]; on entablature, GAL[liæ] M[onarchia] P[acata] [The monarchy of France pacified]; at the bottom, beneath the temple, D[eo] I[ulius] EQVES DED[icavit] [The knight Jules has dedicated this to God]; in the field, ANNO 1660 [the year 1660].
Literature: Van Loon 1732–37, 2: 441; Frederiks 1943, 11, no. 18; Scher 1997, no. 27.

This medal refers to Cardinal Mazarin's diplomatic role in the Treaty of the Pyrenees of 1659, ending the war between France and Spain that was a continuation of the Thirty Years' War (1618–48). The closed Temple of Janus on the reverse refers to the ancient Roman custom of shutting its doors to signify a state of peace. Cardinal Jules Raymond Mazarin, born Giulio Raimondo Mazzarino in Pescina in the Kingdom of Naples, was educated in Rome by the Jesuits and in the 1630s entered the service of Cardinal Richelieu and King Louis XIII. He became a naturalized Frenchman in 1639 and in 1641 was made cardinal. Following the death of Richelieu and Louis XIII, Mazarin established a strong relationship with Queen Anne, regent for the young Louis XIV. A man of intelligence, charm, and diplomatic ability, he amassed a considerable fortune and became a great collector and patron of the arts. ADC

778

Pieter van Abeele (1608–1684)
CHARLES II (b. 1630; King of Scotland 1649–51; King of England, Scotland, and Ireland 1660–85) and **WILLIAM III OF ORANGE** (b. 1650; Stadtholder of the United Provinces of the Netherlands 1672–1702; King of England, Scotland, and Ireland 1689–1702)
1661
Silver, two cast shells soldered together; 70.3 mm
Scher Collection

Obverse: Charles, wearing a doublet with a flat collar and a medal suspended from a ribbon. Inscription: CAROLVS D[ei] II [Charles II].
Reverse: William on horseback wearing a wide-brimmed hat with a feather and holding a baton; a townscape and water in the background. Inscription: WILHELMVS III D[ei] G[ratia] PRINC[eps] AVRAICÆ COM[es] NASS[aviæ] E[t]c[etera] [William III, by the grace of God, Prince of Orange, Count of Nassau, et cetera].
Literature: Hawkins 1885, 1: 471–72, no. 74; Frederiks 1943, 12, nos. 20, 20d.

This medal, along with two others, was likely made during Charles's residence in Holland. Given the youthful appearance of William,

779

780

it was probably issued to celebrate the awarding of the Order of the Garter to William by Charles. The inscription on the obverse is missing the "G": Carolus Dei Gratia II [Charles II, by the grace of God]. SKS

779

Attributed to Pieter van Abeele (1608–1684)
SIEGE OF AMSTERDAM BY WILLIAM II OF ORANGE
Dated 1650
Silver, cast; 67.2 mm
Scher Collection; Promised gift to The Frick Collection

Obverse: In the foreground, the Amstel River with two boatloads of soldiers; other vessels in the middle ground; in the background, the city of Amsterdam; above, the arms of the city in luminous clouds, a hand holds a heart. Inscription on two banderoles: ONS HER TEN HANDT IS VOOR HET LANDT [Our hand and heart are for the country].
Reverse inscriptions: Inside an olive wreath, GODT / HEEFT ONS / BEWAERT [God kept us]; all around, in script, ZŸN HOOGHEŸT WILHEM PRINS VAN ORANGÉ HEFT DE STADT AMSTELDAM BELEEGERT DEN 30 JULŸ, ENDE WEEDEROM AFGETROCKEN DEN 4 AÚGÚSTŸ 1650 [His Highness William Prince of Orange laid siege to Amsterdam on 30 July and lifted it on 4 August 1650].
Literature: Van Loon 1732–37, 2: 332–33.

Following the Treaty of Münster and the end of the Eighty Years' War (1568–1648), the military power of the Stadtholder was to be drastically diminished, something William II was not eager to accept. Moreover, he wanted to defend the interests of his wife's family, the Stuarts, against Cromwell and demanded more military action. This led to a dispute with the States of Holland, and Amsterdam in particular, which had no interest in breaking the peace. William's response was to besiege the city of Amsterdam. A few months later (November 1650), he died of smallpox; the general confusion paved the way to de Witt's long leadership (ended by his brutal assassination in 1672; nos. 792, 793). ADC

780

Attributed to Pieter van Abeele (1608–1684)
MARRIAGE AND PROSPERITY
ca. 1655
Silver, two cast shells soldered together; 76.5 mm
Scher Collection

Obverse: Wearing fanciful classical dress and joined together by a chain from which hangs a heart, a seated couple bathed in sunlight tramples three snakes underfoot; in the background, a grapevine trained on two posts and a flowering plant. Inscription: DAAR TWEE TROUW HARTEN SYN IN EEN SIET MEN DE HAAT EN TWIST VERTREEN [Where two faithful hearts are one, hate and strife are trampled].
Reverse: Prosperity personified, seated and wearing a loose gown and fruited crown, holding in one hand a *tazza* bearing a pomegranate and an almond branch in the other; before her, a cornucopia with a bird perched on its tip and behind, an aloe plant. Inscription: DE EENDRACHT VAN HET HUWELYCK BAART WINST VAN D' AART EN T'HEMEL RYCK [The harmony of marriage produces gains on earth and in the heavenly kingdom].
Literature: Frederiks 1943, 19, nos. 35, 35a; Scher 1997, no. 42.

The reverse of this medal, a stock medal that would have been distributed at the celebration of an engagement or a marriage, emphasizes fertility and faith. EM

781

Attributed to Pieter van Abeele (1608–1684)
CHARLES X GUSTAV, KING OF SWEDEN (b. 1622; r. 1654–60)
Dated 1660
Silver, cast; 65.4 × 54.7 mm
Scher Collection

Obverse: Charles X Gustav in civilian clothes, standing by Öresund (the strait forming the borders between Denmark and Sweden); on the left, the city of Helsingör (Denmark); on the right, the castle of

781

Kronoborg. Inscription: CAROLUS GUSTAV[us] REX OBIIT 1660 [King Charles Gustav, died 1660].
Literature: Hildebrand 1874, 362, no. 53; Frederiks 1943, 11, no. 19.

This medal commemorating the death of the Swedish king has been attributed to Van Abeele on stylistic grounds, and archival records show that the medalist had connections in Stockholm. It is not known who commissioned the medal. ADC

782

After Pieter van Abeele (1608–1684)
GERTRUDE VAN HOOFTMAN (1609–1658)
Dated 1658
Silver, cast; two shells soldered together; 72 mm
Scher Collection

Obverse: Hooftman wearing a brocade gown with large flat collar, a double strand of pearls, pearl-drop earrings, and a tight cap. Inscriptions: GEERTRVYDT HOOFTMAN ÆT[atis] 48 AN[n]° 1658 [Gertrude Hooftman, aged 48, 1658]; under bust (incuse) P[ieter]

V[an] A[beele] F[ecit] [monogram; Pieter van Abeele made it].
Reverse: Five coats of arms suspended from ribbons. Inscriptions: on a banderole below the largest coat of arms in the center, OBIIT 22 MAIJ 1658 [Died 22 May 1658]; on the other smaller banderoles below each of the four smaller coats of arms (clockwise, starting from the top left), HOOFTMAN; VAN CÜELEN; HEYMANS; MESSINGH.
Literature: Frederiks 1943, 9, nos. 11, 11a.

The central and larger coat of arms is that of the Hooftman family, replicated in a smaller size as the first of the two coats of arms on the left, with the family name engraved on the banderole. ADC

783

Juriaen Pool I (1618–1669)
ADMIRAL MAARTEN HARPERTSZOON TROMP (1597–1653)
Dated 1653
Silver, struck; 67.8 mm
Scher Collection

Obverse: Tromp wearing a plain collar, metal gorget, buttoned doublet, and a medal of his arms suspended from a ribbon.

782

Inscriptions: MARTEN HARPERTƷEN TROMP RIDDER [Maarten Harpertszoon Tromp, knight]; I[uriaen] Pool.

Reverse: Two warships (one flying an English flag; the other, a Dutch one) abreast of one another, cannons blazing and engulfing them in smoke; in the foreground, a sinking ship. Inscription: LIEVTENANT ADMIRAAL VAN HOLLAND VOOR HET VAADERLAND GESNEVVELT DEN 10 AVGVSTI ANNO 1653 [Lieutenant-Admiral of Holland, died for the fatherland on 10 August 1653].

Literature: Van Loon 1732–37, 2: 365; Hawkins 1885, 1: 308, no. 33; De Dompierre de Chaufepié 1903–6, 1: no. 811; Forrer 1979–80, 4: 665–66; Bemolt van Loghum Slaterus 1981, no. 98; Koldeweij 2014, no. 1.

On the admiral, see the commentary for no. 748. EM

784

Juriaen Pool I (1618–1669)

INAUGURATION OF THE NEW TOWN HALL, AMSTERDAM

Dated 1655

Silver, struck; 71 mm

Scher Collection

Obverse: Mercury, god of commerce, flies above the new town hall holding the caduceus and a hat signifying Liberty; to the right, the Nieuwe Kerk; Amphion seated in the foreground and arms of Amsterdam atop; in the middle ground, a crowd of onlookers. Inscriptions: on the cap in Mercury's left hand, OMNIBVS IDEM [The same for all (Virgil's *Aeneid*, X.112)]; on the Ionic capital at Amphion's feet, GP [artist's initials]; on the stone block in the foreground, the names of four burgomasters of 1655—HVIDECOPER [Johan Huydecoper], GRAEF [Cornelis de Graeff], POLL [Johan van de Poll], SPIEGEL [Hendrik Dirkszoon Spiegel]—and two treasurers—COSS AED TVLP [Nicolaas Tulp], DRONKEL [Cornelis van Dronkelaar]; MDCLV [1655]; FUIT HÆC SAPIENTIA QUONDAM [There was once wisdom (Horace, *Ars Poetica*, v. 396)].

Reverse: The legendary hero Jason holding the Golden Fleece aboard the ship *Argo* depicted as a fantastical galley with a view of Amsterdam in the background and the ancient arms of the city at the top. Inscriptions: on the poop deck of a small boat towed by the ship, GPS [Juriaen Pool, Sculptor]; PELAGUS QUANTOS APERIMUS IN USUS! [For what great purposes have we opened (for use) the sea (Valerius Flaccus, *Argonautica*, I, v. 169)].

Literature: Van Loon 1732–37, 2: 387; Scher 1997, no. 36. (var.); Pelsdonk 2013, 111–18 (var.); Koldeweij 2014, no. 5 (var.).

785

Pool here compares Amsterdam (represented by the new town hall) with the glories of antiquity. On the obverse, the presence of Amphion—the semi-divine builder of Thebes—connects Amsterdam and Thebes with its supernatural origins. On the reverse, Jason and his successful expedition to recover the Golden Fleece and the quotation from the Roman poet Valerius Flaccus allude to the commercial and maritime power of Amsterdam. This is one of several variants of the medal. On what is believed to be the first die, Pool hid his initials on the *Argo*; on this example, the letters "GPS" appear on the small boat to the left of the *Argo*. Silversmith Simon Andrieszoon Valckenaer, who held the rights to produce the medal, ordered the dies of this medal and of no. 785. SKS

785

Juriaen Pool I (1618–1669)

INAUGURATION OF THE NEW TOWN HALL, AMSTERDAM

Dated 1659

Silver gilt, struck; 70.2 mm

The Frick Collection; Gift of Stephen K. and Janie Woo Scher, 2016 (2016.2.205)

Obverse inscriptions: Same as no. 784.

Reverse: In the foreground, an enclosed garden with a seated woman, the personification of the city of Amsterdam, wearing an imperial crown, holding in her left hand the shield with the acronym SPQA (Senatus Populusque Amstelodamensis) and in her right hand an olive branch; flanking the woman, two lions holding three coats of arms each in their paws; attached to the fence of the enclosed garden, the two coats of arms of Amsterdam, the old and the new, and in between a cartouche with the inscription SALVTEM ET CIVES SERVARE POTENS [Powerful enough to preserve the public good and the citizens]; all around the medal, thirty-six coats of arms; behind the personification of Amsterdam, ships sail in a calm sea; further in the background, a view of the city; above, the name הוהי [Hebrew for Jehovah] radiating sunbeams, and cherubs blowing trumpets and holding banderoles. Inscription: below cartouche, G. POOLL.

Edge inscription: CORN[elis] DE GRAEF IOAN HVYDECOPER HEN[d]R[ik] THEOD[oor] SPIEGEL SIMON AB HOORN CO[n]S[ul]S. CORN[elis] WITS[e] N NICOL[aas] TVLP ÆDIL[es] MDCLIX [Cornelis de Graeff, Johan Huydecoper, Hendrik Dirkszoon Spiegel (and) Simon of Hoorn, consuls. Cornelis Janszoon Witsen (and) Nicolaas Pieterszoon Tulp, aldermen, 1659].

786

Literature: Van Loon 1732–37, 2: 387–88; Scher 1997, no. 36 (obv.); Pelsdonk and Plomp 2012, 44, fig. 32; Koldeweij 2014, no. 7.

On the obverse, see the commentary for no. 784. According to Van Loon, the six coats of arms held by the lions belong to the four burgomasters and two treasurers listed on the obverse of the medal, while the thirty-six coats of arms around the medal belong to the thirty-six burgomasters of the city, including the six men named on the obverse. ADC

786

Johannes (or Jan) Lutma the Younger (1624–1685/89)
THE PEACE OF BREDA
Dated 1667
Silver, struck; 70.6 mm
Scher Collection; Promised gift to The Frick Collection

Obverse: In the foreground, a lion standing on implements of war: two cannons, a helmet, a shield, and an arquebus; in the background, warships scattered over the sea. Inscriptions: chronogram, 1667; SIC FINES NOSTROS, LEGES TVTAMVR, ET VNDAS [Thus we defend our frontiers, our laws, and our seas]; LEO BATAVUS [the Dutch lion]; in cipher, behind the lion's right rear leg, OAL [artist's signature].
Reverse inscription: At the top the arms of Amsterdam, in nineteen lines, DEO AVSPICE / ASSERTIS / NON MINORE ANIMO / QVAM SVCCESSV / AVITIS PATRIÆ LEGIBVS / ADVERSVS TRES POTENTISSIMOS / HISPANIARVM REGES / COACTIS DEINDE SEMEL ITERVMQ[ue] / CONTRA VICINOS BRITANNOS / ARMA SVMERE BATAVIS / POST PACEM EGREGIA VIRTVTE / BELLO PARTAM / ATQVE REDVCTA GENERIS / HVMANI COMMERCIA / CONSVLES SENATVSQVE / AMSTELODAMENSIS / MONVMENTVM HOC / CIƆ IƆ C LXVII / F[ieri] C[urarunt] [Having been reasserted with God's auspices the ancient laws of the country, without much courage as well as success against three most powerful kings of Spain, the Dutch were forced to take up arms again against their neighbors the Britons, and after they obtained peace again through their extraordinary military valor, and reestablished commerce among the nations, the Council and Senate of Amsterdam had this medal made in 1667].

Literature: Hawkins 1885, 1: 529–30, no. 177; De Dompierre de Chaufepié 1903–6, 1: no. 984; Frederiks 1943, 40, no. 30/z and 30a/z; Scher 1997, no. 37; Pelsdonk and Plomp 2012, 26, fig. 20.

This is one of nine medals celebrating the Treaty of Breda of July 21, 1667, which ended the Second Anglo-Dutch War (1665–67). The terms of the treaty—signed after an attack that saw the Dutch arriving within twenty miles of London following the destruction of the British fleet at Chatham (the "Medway Disaster")—were only slightly favorable to the Dutch. They, for instance, agreed to give up New Amsterdam (New York), which had been taken by the British in August 1664, in exchange for Surinam, which they had captured that year. ADC

787

Attributed to Johannes (or Jan) Lutma the Younger (1624–1685/89)
JOOST VAN DEN VONDEL (1587–1679)
Dated 1679
Silver, two cast shells soldered together; 61 mm
The Frick Collection; Gift of Stephen K. and Janie Woo Scher, 2016 (2016.2.204)

Obverse: Van den Vondel draped, surrounded by a laurel wreath wrapped in a ribbon upon which is inscribed (incuse) JOOST VAN DEN VONDEL; GEST[orven] 5 FEB[ruarius] 1679 [died 5 February 1679].
Reverse: A singing swan with outstretched wings, enclosed within a ribbon-bound laurel wreath. Inscription: SLANTS OUTSTE EN GROOISTE POEET / GEB[oren] 17 NOV[ember] 1587 [The oldest and greatest poet of the land, born 17 November 1587].
Literature: Van Loon 1732–37, 3: 264–65; Frederiks 1943, 37–38, no. 21; Scher 1997, nos. 30, 30a; Pelsdonk and Plomp 2012, 47, fig. 37.

Made to commemorate the death of Joost van den Vondel—considered the greatest poet and playwright in Dutch history—this medal appears to have been distributed to the fourteen poets who carried his coffin at his funeral. Van den Vondel is probably best remembered for his play *Lucifer* (1654), a Christian tragedy based on the Greek model. Frederiks made the tentative attribution to Lutma the Younger. EM

787

788

788

Christoffel Adolfszoon (ca. 1631–1680)
ADMIRAL MICHIEL DE RUYTER (1607–1676)
1666 or 1676
Silver, struck; 69.6 mm
Scher Collection

Obverse: De Ruyter wearing armor, a commander's sash, a cravat, and the collar and badge of the Order of St. Michael. Inscriptions: on the outer line, MICHAEL DE RVITER PROVINCIARVM CONFOEDERAT[arum]; on the inner line, BELGIC[arum] ARCHITHA= LASSVS DVX ET EQVES [Michiel de Ruyter, high admiral of the United Provinces of Holland, general and knight]; C[hristoffel] AD[olfszoon] F[ecit] [Christoffel Adolfszoon made it].
Reverse: A naval battle with a burning ship in the foreground. Inscription: in exergue, PUGNANDO [With fighting].
Literature: Van Loon 1732–37, 3: 176; Scher 1997, no. 29.

Michiel de Ruyter had a key role in the Anglo-Dutch Wars (1653–74). This medal may have been struck to commemorate naval engagements against the English in 1666 (Hawkins 1885),

de Ruyter's death during an engagement with the Spanish fleet off Syracuse in Sicily in 1676 (Van Loon), or his successful attack, in June 1667, on the English naval station at Chatham on the Medway near the mouth of the Thames. He was honored with an elaborate state funeral (March 18, 1676) and a monumental tomb. SKS

789

Christoffel Adolfszoon (ca. 1631–1680)
THE PEACE OF BREDA
Dated 1667
Silver, struck; 71.4 mm
Scher Collection

Obverse: Female personification of the Seven United Provinces wearing a helmet, breastplate over a loose talaric chiton and high-laced sandals, and holding a scepter with an eye of Justice in her right hand; in her left hand, a lance to which are tied seven arrows representing the seven provinces of the Netherlands; on either side of her, a lion and a lamb standing on the naked gorgon-headed female figure of Envy who holds a heart and a snake in her hands;

789

790

behind her, warships at sea, two burning on the left (an allusion to the defeat of the British fleet at Chatham); in the background, the castle of Breda. Inscriptions: MITIS ET FORTIS [Gentle and strong]; in exergue, PROCUL HINC MALA BESTIA / IUN[ii] REGNIS! 22 / 1667 C[hristoffel] A[dolfszoon] [Go away from these states, you vicious beast! 22 June 1667. Christoffel Adolfszoon].

Reverse: Female personification of Peace or Concordia, with long flowing hair and wearing a loose talaric chiton off the right shoulder and an oak-wreath crown, supporting a cornucopia and a caduceus with her left arm, holding a sword with a laurel (or olive) wreath on its tip, and standing on a broken sword, a helmet, a crown, and a moneybag; in the background, merchant ships at sea; on the top, a hand holding two suspended coats of arms: Great Britain on the left and the Netherlands on the right; hanging to either side, two festoons of fruits and flowers. Inscriptions: on the long banderole passing from left to right, IRATO BELLUM / PLACATO NUMINE PAX EST [war from an angry divinity, peace from one appeased]; in exergue, REDIIT CONCORDIA MATER / IUL[ii] 31 BREDÆ A[nn]° 1667 [Maternal Concord has returned at Breda, 31 July 1667], followed by the shield of Breda.

Edge inscription: NUMISMA POSTERITATI SACRUM BELGA BRITANOQUE RECONCILIATIS CUM PRIVIL[egio] ORDIN[um] HOLLAND[iae] ET WEST[frisiae] [Medal for posterity commemorating the appeasement of the Netherlands and Britain. With copyright granted by the States of Holland and West Friesland].

Literature: Van Loon 1732–37, 2: 535; Hawkins 1885, 1: 528–29, no. 176; Schulman (Jacob) 1912, no. 257; Scher 1997, no. 38; Scharloo 2012.

This is one of nine medals celebrating the Treaty of Breda of July 21, 1667, which brought an end to the Second Anglo-Dutch War (1665–67). The representation of burning British warships, along with other more personal references to the British king Charles II (for instance, the epithet "mala bestia" often used against Charles by his enemies), incited the king's anger, and he ordered the dies to be destroyed. The Provincial States of Holland destroyed the dies but also rewarded Adolfszoon with a large monetary compensation. ADC

790

Arent Janszoon Smeltzing (1639–1710)
THE ALCHEMIST
Dated 1666
Silver, struck; 56.7 mm
Scher Collection

Obverse: An alchemist seated in front of a fireplace with a cat on his right side: behind him, to the right, an alembic on the athanor (the furnace that provided constant and uniform heat for alchemic transformations); in the background, a curtain draped on a wall with a mirror with an auricular frame, a shelf with several vessels, and the bottom left corner of a window; hanging from the ceiling, a six-branched chandelier; within the inscription, four coats of arms of four burgomasters of Leiden: Guillaume Paats; Jean Meerman; Herman Schuyl, son of Jean; Remi van Sanen. Inscriptions: OPERÆ PRO ARIS ET FOCIS PRÆSTITÆ RED HOSTIMENTVM [The right compensation for the work done for the religion and the country]; beneath the floor, A[rent] [Janszoon] S[meltzing].

Reverse: In the field, inscription in seven lines; above, two cherubs holding the crowned coat of arms of Leiden; below, a banderole with the inscription A[nn]° 1666 [the year 1666]; at the bottom, the profile of a city (Leiden). Inscriptions: ARGENTVM EX FVMO, NON ARS, SED OBSEQVIVM FECIT [Not the art, but the obedience made money from smoke]; in the field, WT ROOCK DE GROOTSTE YDELHEYT / DĒ ALCHYMIST GEEN LOOT KAN TRECKEN / MAER YVER EN GEHOOR SAEMHEYT / DOET ROOK TOT GOUT EN SILVER STRECKĒ / DAER YDER AENSPANT MET DEN RAEDT / IS ROOCK EEN GOUTMYN VOOR / DEN STAEDT [From smoke, sign of the greatest vanity, the alchemist cannot produce lead, but zeal and obedience know how to derive from smoke gold and silver. When each subject joins with the ruler, smoke becomes a goldmine for the State].

Literature: Van Loon 1732–37, 2: 516.

Produced by the city of Leiden, this medal is about the new taxes on fireplaces, the so-called "haardstedengeld." According to Van Loon, the medal was produced in 1666 for the four burgomasters of the city, who, in 1665, had worked with great honesty and zeal—but for little pay—as tax inspectors. ADC

791

791

Roelof Hensbergen (act. 1665–77)

WILLIAM III OF ORANGE (b. 1650; Stadtholder of the United Provinces of the Netherlands 1672–1702; King of England, Scotland, and Ireland 1689–1702)

ca. 1677

Silver, two cast shells soldered together; 70.5 mm

Scher Collection

Obverse: William wearing armor, lace cravat, commander's sash across the breast, and the badge of the Order of the Garter on a ribbon. Inscription: WILHELMVS III D[ei] G[ratia] PRINC[eps] AVRAICÆ COM[es] NASS[aviæ] E[t]c[etera] [William III, by the grace of God, Prince of Orange, Count of Nassau, et cetera]; signed before the inscription in cipher, R[oelof] H[ensbergen].

Reverse: The arms of William, crowned above and encircled by the Garter, on which is the inscription HONI SOIT QUI MAL Y PENSE [Shame to him who thinks evil of it].

Literature: De Dompierre de Chaufepié 1903–6, 1: no. 1243; Scher 1997, no. 21.

This medal probably commemorates the marriage of William of Orange, on November 4, 1677, to his cousin Princess Mary Stuart, the eldest daughter of James, Duke of York and later King James II. The union was seen to mark the end of the long period of war between England and the Netherlands (1652–74). ADC

792

Pierre Aury (1622–1692)

CORNELIUS DE WITT (1623–1672) and **JOHAN DE WITT** (1625–1672)

Dated 1672

Silver, struck; 71.6 mm

Scher Collection; Promised gift to The Frick Collection

Obverse: Facing portraits of Cornelius at left, wearing armor, a lace collar, and a general's sash, and his brother Johan at right, wearing the robes of a councilor. Inscriptions: IOHANNES DE WITT NAT[us] A[nno] 1625 CORNELIVS DE WITT NAT[us] A[nno] 1623 [Johan de Witt, born in (the year) 1625; Cornelius de Witt, born in (the year) 1623]; below, the arms of de Witt; below Cornelius's and Johan's shoulders, respectively, AVRY FEC[it] [Aury made it]; behind the heads of Cornelius and Johan, INTEGER VITÆ SCELERISQVE PVRVS [Irreproachable in his conduct and free from crime (Horace, *Odes* 22)]; on the banderole at the bottom, HIC ARMIS MAXIMVS ILLE TOGA [one was great in war, the other in civil life].

Reverse: A lion-like monster with a serpent's tail and the heads of nine different beasts attacks and devours the bodies of Johan and Cornelius de Witt within a frame of thorn branches; entwined around the branches is a ribbon inscribed MENS AGITAT MOLEM ET MAGNO SE CORPORE MISCET [A mind that moves the mass and connects (all parts of) the mighty body (Virgil, *Aeneid* VI.724)]. Inscriptions: NUNC REDEUNT ANIMIS INGENTIA CONSULIS ACTA ET FORMIDATI SCEPTRIS ORACLA MINISTRI [Now the great deeds of the consul and the memorable speeches of the minister feared (even) by the kings come back to mind]; in exergue, NOB**ILE** PAR FRATR**VM** SÆ**VO** FVROR ORE TR**VCID**AT XX AVGVSTI [This noble pair of brothers was put to death by an inhuman frenzy, 20 August 1672]; chronogram; at the lower left of the field, AVRY F[ecit] [Aury made it].

Literature: Scher 1997, no. 39; Pollard 2007, 2: no. 937.

This medal commemorates the assassination of the de Witt brothers in The Hague on August 20, 1672. Johan de Witt was elected councilor pensionary of Holland in 1653, and for more than two decades, following the death of William II and the absence of a Stadtholder, he maintained stability in the Netherlands. While the Dutch fleet was enormously powerful, the Dutch army was less so and was easily defeated by the French. As a result, most of the Dutch territory was invaded, and the people called for William III to take leadership, blaming de Witt for the disaster. In July 1672, de Witt's brother, Cornelius, was arrested on accusations of a complot against William III and taken to prison in The Hague. While Johan was visiting his brother in prison, an organized mob broke into the building, dragged the two brothers outside, and murdered them. Their bodies were mutilated, hung, and publicly exhibited, as recorded in a painting attributed to Jan de Baen (Rijksmuseum, Amsterdam). ADC

792

793

Unknown artist

CORNELIUS DE WITT (1623–1672) and **JOHAN DE WITT**
(1625–1672)

Dated 1672

Silver, cast; 50.9 mm

The Frick Collection; Gift of Stephen K. and Janie Woo Scher, 2016
(2016.2.187)

Obverse: Jugate portrait of the de Witt brothers. Inscription:
IOH[annes] ET CORNE[lius] DE WIT[t] [Johan and Cornelius de Witt].
Reverse: A frame enclosing the mutilated corpses of the de Witt
brothers tied to a torture device. The frame is flanked by two putti
holding inverted torches; below, a skull, crossbones and palm
branches; above, an hourglass with a bird wing on the left and bat
wing on the right. Inscription: at the bottom of the frame, AUG[usti] 20
A[nn]° 1672 [August 20, 1672].
Literature: Van Loon 1732–37, 3: 84–85.

The reverse of this medal depicts the bodies of the brothers at the
base of a *strappado*, a torture device. The inverted torches held
by the putti are symbols of death. The hourglass with bird and bat
wings refers to day (life) and night (death), respectively. See the
commentary for no. 792. sks

794

Jacob van Dishoecke (1650–1723)

THE PEACE OF NIJMEGEN

Dated 1678

Silver, cast; 68.3 mm

Scher Collection; Promised gift to The Frick Collection

Obverse: Personification of the United Provinces as Liberty,
holding a lance with a hat of Liberty on its tip and the seven arrows
representing the seven provinces of the Netherlands tied to its shaft;
Liberty seated between Prudence on the left, with an olive branch
and cornucopia, and Peace on the right with a mirror and serpent;
beneath Liberty, the Dutch lion; beside Prudence, the arms of
Amsterdam. Inscription: LIBERTAS PACIS SOBOLES, PRVDENTIÆ ALVMNA
[Liberty, daughter of Peace, nourished by Prudence].
Reverse: The shields of France and the United Provinces tied with a
chain and swags of olive branches below a shining sun and above
the city of Nijmegen. Inscriptions: OCCIDIT AD RHENVM NASCITVR AD
VAHALIM [Killed on the Rhine, reborn on the shores of Waal (Vahal)];
in exergue, CIƆIƆC.LXXVIII [1678].
Literature: Van Loon 1732–37, 3: 233–34; Schulman (Jacob) 1912,
no. 292.

The Peace of Nijmegen with the French King Louis XIV brought the
Franco-Dutch War (1672–78) to an end. sks

793

794

795

Jacob van Dishoecke (1650–1723)
THE PEACE OF NIJMEGEN
Dated 1678
Silver, struck; 71.7 mm
Scher Collection; Promised gift to The Frick Collection

Obverse: At the top, arms of the city in front of a banderole; in the background, a view of the city of Nijmegen on the Waal River, with the fortress of Knostenbourg visible on the left; in the foreground, envoys to the peace conference meeting. Inscriptions: in exergue, I[acob] V[an] D[ishoecke] F[ecit] [Jacob van Dishoecke made it]; on the banderole, FIRMATA NEOMAGI PAX 1678 [Peace confirmed at Nijmegen, 1678].

Reverse: A laurel-crowned female figure representing Peace standing on a pile of implements of war, holding a snake biting its tail (an *ouroboros*, symbol of eternity) in one hand and a palm branch in the other; suspended from ribbons held by both hands are the arms of the nations involved in the peace treaties: the Holy Roman Empire, France, Spain, the United Provinces, Sweden, Denmark, and possibly Münster; at the top, the sun. Inscriptions: PACATUS SOLIS

VIRTUTIBVS ORBIS [Peace rendered to the world by the influence of the sun]; I[acob] V[an] DISHOUKE F[ecit] [Jacob van Dishoecke made it].
Literature: Van Loon 1732–37, 3: 257–58; Schulman (Jacob) 1912, no. 305; Scher 1997, no. 40.

See also no. 794. SKS

796

Attributed to Jan Smeltzing (1656–1693)
JOHAN VAN OLDENBARNEVELT (1547–1619)
Probably 1670s
Silver, struck; 48.8 mm
Scher Collection; Promised gift to The Frick Collection

Obverse: Van Oldenbarnevelt, bearded, in a lace ruff and fur-trimmed robe, worn over a doublet. Inscription: JOHAN VAN OLDENBARNEVELT.
Reverse: A pair of entwined palm branches above and another pair of entwined leafy laurel or oak branches (tied with a ribbon) below.

795

796

Inscription: DEES VADER VAN ONS VADERLAND, / BEZEGELDE, MET EIGE HAND, / 'S LANDS VRYHEIT TWE EN VEERTIG JARE / EN STORF STANDVASTIG VOOR 'T GEMEEN / DOEN HEM DE STROT WIERT AFGESNEEN / DOOR'T MOORDMES, VAN SYN MOORDENARÊ [This father of our fatherland, worked, for forty-two years, to seal the liberty of our nation by his own hand, and died without hesitation for the people, his throat severed by his murderers' barbaric knife].
Literature: Van Loon 1732–37, 2: 109–10.

This medal, which is not contemporaneous with its subject, commemorates the death of Van Oldenbarnevelt on May 13, 1619. A devoted follower of the House of Orange and a key figure in the struggle for the independence of the Northern Netherlands from Spain, Van Oldenbarnevelt held the highest offices in the United Provinces for thirty-two years (including Chief Minister of Holland from 1586), holding the Union together through many crises. Although his influence was fundamental in the election of Maurice of Nassau as Stadtholder in 1585, eventually their opposing positions on a number of key issues led to Van Oldenbarnevelt and his

followers being falsely accused of treason and executed. The reverse bears verses from a poem by Joost van den Vondel (1587–1679). See the commentary for no. 787. ADC

797

Unknown artist
JOHAN VAN OLDENBARNEVELT (1547–1619)
Late 17th century or later
Silver, cast; 94.4 × 73.7 mm
The Frick Collection; Gift of Stephen K. and Janie Woo Scher, 2016
(2016.2.186)

Obverse: Van Oldenbarnevelt wearing a large ruff and a furred robe over a doublet.
Literature: Scher 1997, no. 23 (var.).

This medal, a variant of no. 796, may have been produced as late as the nineteenth century. ADC

797

798

798

Unknown artist

LOUIS XIV AND THE WAR OF THE REUNIONS (1683–84)
Dated 1684
Silver, struck; 59.5 mm
The Frick Collection; Gift of Stephen K. and Janie Woo Scher, 2016
(2016.2.208)

Obverse: Louis XIV, King of France, wearing a crown and an ermine-lined cape, standing on a hillock and holding a sword piercing an orb of the world; in the background, a seascape with, on the left, the bombardment from the sea of a city labeled GENUA (Genoa) and, on the right, a fortified city flying a French flag and labeled LUXEMBURG (Luxembourg). Inscription: QUOD LIBET, LICET [I do what pleases me].
Reverse: Emerging from a curtain decorated with fleurs-de-lis, a child's arm holding a sword encircled by an olive branch. Inscription: ELIGE [Choose].

During the brutal War of the Reunions (1683–84) between France and Spain and its allies, Louis XIV ordered a punishing naval bombardment of Genoa, a city friendly to Spain, and a siege of Luxembourg, which threatened Louis's northern borders and which he claimed as belonging to France. The war was concluded by the Truce of Ratisbon (August 15, 1684). The obverse of this medal shows a satirical image of an imperious Louis XIV asserting both his displeasure and his territorial ambitions by holding a sword that is piercing an orb, while he is flanked by images of the aggressions he has ordered. The equally satirical reverse alludes to the king's offers of peace on his terms, that is, at the point of a sword. ADC

799

Attributed to Nicolas Chevalier (act. ca. 1677–1720)
WILLIAM III OF ORANGE (b. 1650; Stadtholder of the United Provinces of the Netherlands 1672–1702; King of England, Scotland, and Ireland 1689–1702) and **MARY II, QUEEN OF ENGLAND, SCOTLAND, AND IRELAND** (b. 1662; r. 1689–94)
1677
Silver, struck; 41.9 mm
The Frick Collection; Gift of Stephen K. and Janie Woo Scher, 2016
(2016.2.62)

Obverse: William wearing a lace cravat, armor, and the star of an order suspended from a ribbon. Inscription: GVILH[elmus] III D[ei] G[ratia] PRIN[ceps] AVR[aicæ] HOL[landiæ] ET WES[tfrisiæ] GV[bernator] [William III, by the grace of God, Prince of Orange, governor of Holland and West Friesland].
Reverse: Mary, hair gathered loosely into a chignon and woven with pearls, ringlets framing her face and falling onto her neck, wearing a pearl necklace and loose, silky gown pinned in front with a floral brooch. Inscription: MARIA D[ei] G[ratia] AVR[aicæ] PRIN[cipissa] NAT[a] DE IORC[ensis] [Mary, by the grace of God, Princess of Orange, born (Princess) of York].
Literature: Hawkins 1885, 1: 568–69, no. 235; Van Loon 1732–37, 3: 221–22, no. 1; Eimer 2010, no. 256.

This medal was probably struck to celebrate the 1677 marriage of William, Prince of Orange, and Mary, daughter of the future James II of England. It was hoped that their union would bring an end to the hostilities between their two nations (three wars had been fought, mostly due to commercial rivalry, since 1652). In 1689, after the so-called Glorious Revolution, William and Mary were crowned King and Queen of England and ruled jointly. EM

799

800

800

Unknown artist

WILLIAM III OF ORANGE (b. 1650; Stadtholder of the United
Provinces of the Netherlands 1672–1702; King of England, Scotland,
and Ireland 1689–1702) and **MARY II, QUEEN OF ENGLAND,
SCOTLAND, AND IRELAND** (b. 1662; r. 1689–94)
Dated 1689
Silver, two cast shells soldered together; 62.7 mm
Scher Collection; Promised gift to The Frick Collection

Obverse: William and Mary seated and crowned, each wearing
their coronation robes and holding a scepter and orb. Inscription:
GVILHELMVS ET MARIA REX ET REGINA CORON[ati] APR[ilis] 11/21 1689
[William and Mary, King and Queen, crowned April 11/21, 1689].
Reverse: The captain Bernard Muikens, his lieutenant John
Althusius, and his ensign Sylvester Van Tongeren of the City Guard
of Amsterdam holding lances and a banner; above, the arms of
Amsterdam. Inscription: TER GEDAGTNIS DAT OP DE DACH DER
KRONING DE WAGHT HAD D[e] COMP[agnie] VAN D[en] H[eer] B[ernard]
MVIKENS [In remembrance that on the day of the coronation the
guard was kept by the company of Mister Bernard Muikens].
Literature: Van Loon 1732–37, 3: 390–91; Scher 1997, nos. 22, 22a.

This medal commemorates the coronation of William III and Mary II
as king and queen of England in Amsterdam and the services of the
guard company of Bernard Muikens, which preserved order in the
city during the festivities. SKS

801

801

Nicolaas van Swinderen (1705–1760)
WILLIAM IV OF ORANGE-NASSAU (b. 1711; Stadtholder of the
United Provinces of the Netherlands 1747–50)
Dated 1747
Silver gilt, struck; 37.9 mm
Scher Collection; Promised gift to The Frick Collection

Obverse: Bust with peruke, uniform, and mantle. Inscriptions:
WILH[elmus] CAR[olus] HENR[icus] FRISO PRINC[eps] NASS[oviæ] ET
AR[ausii] [William Charles Henry Friso, Prince of Nassau, and
Orange]; N[icolaas] V[an] S[winderen] F[ecit] [Nicolaas van Swinderen
made it].
Reverse: The Dutch Republic Lion raising a sword and holding
a book lying on a pedestal together with an orange branch—an
allusion to the House of Orange and the military support it received
from Great Britain, the motto of whose highest order of chivalry, the
Order of the Garter, is inscribed on the pedestal; behind, the rising
sun and a spear entwined by an orange branch and surmounted
by the Liberty cap. Inscriptions: GLADIVS DOMINI ET GEDEONIS [The
sword of the Lord and of Gideon (Judges 7:20)]; on the plinth,
HONY SOIT QVI MAL Y PENSE [Shame to him who thinks evil of it];
in exergue, HOLLANDIÆ / PROCLAM[atus] GVBERN[ator] / 3 MAII 1747
[Proclaimed governor of Holland, 3 May 1747].
Literature: *Beschrijving van Nederlandsche historie-penningen*
1822–69, 3: table 23, no. 227; Hawkins 1885, 2: 639, no. 317;
Eimer 2010, no. 615.

This medal commemorates William IV's installation as governor of
the United Provinces of the Netherlands on May 3, 1747. The motto
GLADIVS DOMINI ET GEDEONIS compares him with Gideon, sent
by God to liberate Israel. WAC

801

802

802

Johann George Holtzhey (1729–1808)
FUNERAL OF STADTHOLDER WILLIAM IV (1711–1751)
Dated 1752
Silver, struck; 49.7 mm
The Frick Collection; Gift of Stephen K. and Janie Woo Scher, 2016
(2016.2.184)

Obverse: William, a circle of stars over his head, in armor under a jacket, wearing the Order of the Garter and an ermine-lined cloak. Inscriptions: W[ilhelmus] C[arolus] H[enricus] FRISO D[ei] G[ratia] PR[inceps] AR[ausiæ] NASS[aviæ] TOT[ius] BELG[ii] LIB[eri] GVB[ernator] HÆRED[itarius] [William Charles Henry Friso, by the grace of God, Prince of Orange and Nassau, hereditary Stadtholder of all free Netherlands]; below bust, I[ohann] G[eorge] HOLTZHEY FECIT [Johann George Holtzhey made it].
Reverse: Stadtholder William IV represented as Hercules in a chariot on the clouds rising toward heaven; below, the funeral procession with Delft in the background. Inscriptions: AVGVSTA GRAVITATE VERENDVS [Revered for his august greatness (Ovid, *Metamorphoses* IX,270)]; in exergue, IVSTIS PERACTIS IMMORT[alis] PR[inceps] / DIE 4 FEBR[uarii] MDCCLII [A prince immortal for his right deeds, 4 February 1752].
Literature: De Dompierre de Chaufepié 1903–6, 2: no. 2972; Pollard 2007, 2: no. 939 (with different reverse).

This medal commemorates the funeral of William IV of Orange held in Delft on February 4, 1752. ADC

803

Johann George Holtzhey (1729–1808)
WILLIAM V, PRINCE OF ORANGE (1748–1806) and
FREDERIKA SOPHIA WILHELMINA (1751–1820)
Dated 1767
Silver, struck; 45 mm
The Frick Collection; Gift of Stephen K. and Janie Woo Scher, 2016
(2016.2.183)

Obverse: William and Wilhelmina in profile, facing each other. Inscription: WILH[elmus] V D[ei] G[ratia] PR[inceps] ARAVS[iæ] ETC[etera] FRED[erika] SOPH[ia] WILH[elmina] D[ei] G[ratia] PR[incipissa] REG[ia] BORVSS[iæ] ETC[etera] [William V, by the grace of God, Prince of Orange, et cetera, and Frederika Sophia Wilhelmina, by the grace of God, Princess Royal of Prussia, et cetera].
Reverse: In the foreground, a flaming altar over which, to the right, hovers a winged putto holding a torch in the left hand; from behind the altar to the left, a lion clutching seven arrows that represent the seven provinces of the Netherlands; behind the altar, two shields of arms, that of the House of Orange on the left and Prussia to the right; above the altar, a crowned eagle with outstretched wings holding in each claw a laurel wreath and scepter; at the top, the eye of God emitting rays of light. Inscriptions: FAVSTO OMINE [A good omen]; in exergue, MDCCLXVII [1767]; on the altar, CEL[ebratum] BEROL[ini] / IV OCT[obris] [celebrated in Berlin, 4 October]; below the altar, I[ohann] G[eorge] HOLTZHEY FEC[it] [Johann George Holtzhey made it].
Literature: *Beschrijving van Nederlandsche historie-penningen* 1822–69, 5: 447–48, no. 405, pl. 36; De Dompierre de Chaufepié 1903–6, 2: no. 3167.

This medal commemorates the marriage of William V to Princess Wilhelmina of Prussia in Berlin, on October 4, 1767. SKS

803

804

805

804

Johann George Holtzhey (1729–1808)
WILLIAM V, PRINCE OF ORANGE (1748–1806) and
FREDERIKA SOPHIA WILHELMINA (1751–1820)
Dated 1770
Silver, struck; 33.9 mm
Scher Collection; Promised gift to The Frick Collection

Obverse: Jugate portraits of William and Wilhelmina. Inscriptions:
WILH[elmus] V ET F[rederika] S[ophia] WILH[elmina] D[ei] G[ratia] AR[ausiæ]
ET NASS[aviæ] PRINC[ipes] ETC[etera] [William V and Frederika Sophia
Wilhelmina, by the grace of God, Prince and Princess of Orange and
Nassau, et cetera]; I[ohann] G[eorge] HOLTZHEY FEC[it] [Johann George
Holtzhey made it].
Reverse: Winged figure crowned with flowers sitting on a cloud,
on which rests a torch, surrounded by flowers and holding a baby.
Inscription: DEI BENEFICIO NATA XXVIII NOV[embris] MDCCLXX [Born
with the favor of God on 28 November 1770].
Literature: De Dompierre de Chaufepié 1903–6, 2: no. 3215.

This medal celebrates the birth of the hereditary Princess of Orange,
Louise (1770–1819). ADC

805

Johann George Holtzhey (1729–1808)
BARON JOHAN DERK VAN DER CAPELLEN TOT DEN POL
(1741–1784)
Dated 1782
Silver, struck; 49.4 mm
Scher Collection; Promised gift to The Frick Collection

Obverse: Van der Capellen, hair clubbed with a ribbon, in a shirt
with a tall, soft collar, an embroidered waistcoat trimmed with
lace, and a plain, buttoned coat. Inscriptions: JOH[an] DERK VAN
DER CAPELLEN TOT DEN POL BESCH[reven] IN DE RIDD[erschap] VAN
OVER-YSSEL [Johan Derk van der Capellen tot den Pol, member of the
knighthood of Overijssel]; on truncation, I[ohann] G[eorge] HOLTZHEY
F[ecit] [Johann George Holtzhey made it].
Reverse: A hat, representing freedom, rays of sunlight streaming from
it, above the crowned arms of Van der Capellen flanked by two palm
branches and two oak branches, entwined; below, a cornucopia and
some agricultural tools (including a scythe, a rake, and a spade), with
a vine curling around them. Inscription: DIE NŸVRE LANDMAN JUICHT, /
ZYN VRYHEID IS HERSTELD! / CAPELLEN ZEGEPRAALT / OP BAATZUCHT

EN GEWELD! / D[en] 1 NOV[ember] A[nn]° 1782 [The industrious farmer
cheers / his freedom is restored! / Capellen has triumphed / over
selfishness and violence! 1 November 1782].
Literature: *Beschrijving van Nederlandsche historie-penningen*
1822–69, 8: 181, no. 579, pl. 56; De Dompierre de Chaufepié
1903–6, 2: no. 3403.

A patriot and progressive politician, Van der Capellen was an early
supporter of the American Revolution, a position so unpopular
at the time that it lost him his seat in the States General and his
position as deputy and regent within his own province (Overijssel).
On November 1, 1782, after the Dutch nation's belated recognition
of the American Republic, representatives of the States General
readmitted Van der Capellen. Shortly thereafter, he played a pivotal
role in abolishing in Overijssel the Drostediensten, an outdated
feudalist mandate requiring farmers to perform labor services for
their Drost (or landlord) twice yearly (a mandate that had recently
been revived by the Drost of Twente). This medal was made as a
gesture of thanks from the inhabitants of Twente. EM

806

Johann George Holtzhey (1729–1808)
FREDERICK II, KING OF PRUSSIA (b. 1712; r. 1740–86)
Dated 1786
Silver, struck; 45.3 mm
Scher Collection

Obverse: Frederick, hair clubbed with a ribbon, wearing a lavishly
decorated tricorne, an embroidered coat to which is pinned the
Order of the Black Eagle, a chemise with a soft embroidered collar,
a lace cravat, and a sash across his chest. Inscriptions: FRID[ericus]
INCOMPARABILIS DEI GRATIA REX BORVSS[iæ] ETC[etera] [Frederick the

806

Incomparable, by the grace of God, King of Prussia, et cetera]; on truncation, I[ohann] G[eorge] H[oltzhey].

Reverse: An eagle soaring, amid rays of sunlight, toward a crown of stars; beneath, a crowned urn (inscribed PHILOSOPH[e] [Philosopher]) emitting incense fumes sits upon a pedestal that bears the legend DE SANS-SOUCI [of Sanssouci]; to its right, flags, cannons, a classical plumed helmet and breastplate, Hercules's club and the skin of the Nemean lion, assorted weapons, and a lance topped with a laurel wreath and figurine of Victory, within which is inscribed XIII [13]; to the urn's left, an open book that reads CODEX FRIDE-RI-CIANUS [Frederician Codex] and is crowned with a laurel wreath, the medal of an order (suspended from a ribbon), a fasces, a scepter topped with the Hand of Justice inset with an eye, the scales and sword of Justice, and a pile of books upon which rest a burning lamp and Apollo's lyre. Inscriptions: RESTABAT ALIUD NIHIL [There remained nothing more (to do)]; in exergue, NATUS XXIV JAN[uarii] MDCCXII / DENATUS XVII AUGUST[i] / MDCCLXXXVI [born 24 January 1712, died 17 August 1786].

Literature: De Dompierre de Chaufepié 1903–6, 2: no. 3486; Olding 2003, no. 753.

This medal was made to mark the death of Frederick the Great, an exceptional military strategist under whose rule Prussia became Europe's foremost military power. A champion of Enlightenment ideals, the monarch had a penchant for French culture and entertained such figures as Voltaire at Sanssouci, his summer palace in Potsdam. The reverse celebrates both aspects of his persona, with contemporary and classical military articles placed to the right of the urn and items to its left celebrating Frederick's intellectual pursuits (including what is probably his first book, *Oeuvres du Philosophe de Sans Souci*). The number XIII circumscribed by the wreath may refer to the number of Prussian victories during the Seven Years' War. EM

807

Johann George Holtzhey (1729–1808)
CORNELIA BIERENS (1690–1792)
Dated 1790
Silver, struck; 44.7 mm
The Frick Collection; Gift of Stephen K. and Janie Woo Scher, 2016
(2016.2.182)

Obverse: Bierens wearing an ermine-lined coat and flowered cap. Inscriptions: IK HEB EEN EEUW VOLBRACHT, EN WAGT DE ZALIGHEID [I have completed a century and wait for salvation]; I[ohann] G[eorge]

H[oltzhey] F[ecit] [Johann George Holtzhey made it].

Reverse: A curtain hanging from a mantel topped by an oil lamp and an hourglass with two wings, that of a bird to the left (life and day) and a bat on the right (death and night) with a serpent eating its tail (*ouroboros*), all symbols of eternity; the *ouroboros*, encircling the Roman numeral C (100), with a sunburst behind, resting on a palm and laurel branch (again, eternity), beneath which is the date MDCCXC (1790). Inscription: on the curtain, CORNELIA BIERENS GEBOOREN 29 DEC MDCXC DOGTER VAN ANTHONY BIERENS EN KUNIRA VAN HOOGMAADE [Cornelia Bierens, born 29 December 1690, daughter of Anthony Bierens and Kunira van Hoogmaade].

Literature: Bemolt van Loghum Slaterus 1981, no. 1460.

This medal was struck to commemorate the one hundredth birthday of Bierens, who was born in Amsterdam, the daughter of Anthony Bierens (1653–1738) and Kunira (or Cunera, modern) van Hoogmaade (1658–1741). She died two years later, unmarried, in Loenen aan de Vecht. SKS

808

Eise Andeles (1731–1766)
MARIE-LOUISE OF HESSE-KASSEL (1688–1765)
Dated 1765
Silver, cast; 44.5 mm
Scher Collection

Obverse: Marie-Louise wearing a chemise with a furred cloak and headscarf. Inscription: MARIA LUD[ovica] D[ei] G[ratia] PR[incipissa] AUR[aicæ] NASS[aviæ] NAT[a] PR[incipissa] HASS[iæ] CASS[el] [Marie-Louise, by the grace of God, Princess of Orange (and) Nassau, born Princess of Hesse-Kassel].

Reverse: A skull flanked by two branches of laurel placed at the center of two crossing palm branches on top of a sarcophagus; against the front of the sarcophagus, two cherubs holding a coat of arms; in the background, a townscape (possibly Leeuwarden). Inscriptions: VIVIT POST FUNERA VIRTUS [Virtue survives death]; on the lower left in the foreground, A [artist's signature]; in exergue, NAT[a] 7 FE[bruarii] 1688 D[e]NAT[a] / 9 AP[rilis] 1765 [born 7 February 1688, died 9 April 1765].

Literature: Forrer 1979–80, 1: 50.

This medal commemorates the death of Marie-Louise, wife of John William Friso, Prince of Orange, and mother of William IV of Orange. ADC

809

809

Unknown artist
PIETER TJEBBES DREYER (1755–1770)
Dated 1770
Silver, struck; 60.2 mm
Scher Collection; Promised gift to The Frick Collection

Obverse: On a pedestal decorated with a leafy garland, a draped bust of a skeleton, crowned with laurels, stands between rows of poplar trees; a scythe, an inverted torch, and an anchor lean on the monument, which is surrounded by scattered leaves and a solitary rose, and behind which the final leafy branch falls from a withered tree.
Reverse inscription: DE HOOP VAN DREYERSSTAM, / ONTYDIG NÊERGESLAGEN, / EER T'LIEFLYKST VAN DE DAGEN / DER JEUGD ZYN BLOEIBEKWAM, / ERINNERT TEEDRE VRINDEN, / DOOR DEES GEDAGHTENIS, / DIE DROEF, MAAR STREELENDE IS, / HOE ZY DIEN TELG BEMINDEN [The hope of the Dreyer family, struck down before the loveliest period of his youth came to blossom. Dear friends are reminded by this memorial which is sad but comforting how they [the family] love their child].
Edge inscription: TER GEDACH-TENISSE VAN PIETER TJEBBES DREYER, GEB[oren] XXIV FEB[ruarius] MDCCLV OVER[leden] IX APR[il] MDCCLXX [In memory of Pieter Tjebbes Dreyer, born 24 February 1755, passed away 9 April 1770].
Literature: De Dompierre de Chaufepié 1903–6, 2: no. 3227; Bemolt van Loghum Slaterus 1981, no. 1258.

This medal was made to commemorate the death of Pieter Dreyer, who died at fifteen. The legend echoes the imagery of the obverse: the solitary leafless tree, losing its final branch as it stands before its ever-leafy brothers, cut down in its bloom; the single, fallen rose; and the testament to Death, imagined as a victorious commander. EM

810

Unknown artist
BEHEADING OF LOUIS XVI, KING OF FRANCE (1754–1793; r. 1774–92)
Dated 1793
Lead tin alloy, cast; 44.9 mm
The Frick Collection; Gift of Stephen K. and Janie Woo Scher, 2016 (2016.2.188)

Obverse inscriptions: DER DOOD VON LUDWIG XVI KONIG VON FRANKREICH [The death of Louis XVI, King of France]; on truncation, CIM [thought to be the artist's initials].
Reverse: The headless corpse of Louis XVI, blood from his neck gushing into a bucket, lies under a guillotine; one man holds up the king's head; in the background, a man reading from the Bible and a man leading a tumbril. Inscription: in exergue, 1793.
Literature: *Trésor de numismatique* 1834–58, pl. XLI, no. 10; Hennin 1826, pl. 45, no. 466.

The beheading of Louis XVI in Paris on January 21, 1793, shocked much of Europe and inspired the production of propaganda such as this medal. According to the languages represented in the inscription, it may have been cast in the Netherlands or Germany. EM

810

811

811

Jacques Wiener (1815–1899)

CONSECRATION OF THE CATHEDRAL OF ST. ISAAC, SAINT PETERSBURG

Dated 1858

Copper alloy, struck; 59.6 mm

Scher Collection

Obverse: Exterior view of St. Isaac Cathedral in Saint Petersburg, designed by the French architect Auguste Ricard de Montferrand and built between 1818 and 1858. Inscriptions: СОБОРЪ СВ ИСААКІЯ ДАЛМАТСКАГО ВЪ С ПЕТЕРБУРГѢ [Cathedral of St. Isaac of Dalmatia in Saint Petersburg]; in exergue, ÉGLISE Sᵀ ISAAC À Sᵀ PETERBOURG BATIE PAR PIERRE LE GRAND 1717–1727 / INCENDIÉE 1735. POSE DE LA 1ᴱ PIERRE DE L'ÉGLISE ACTUELLE PAR ALEXANDRE I 1819 / CONSACRÉE PAR ALEXANDRE II 1858. R[icard] / DE MONFERRAND ARCH[itectus] / JACQUES WIENER F[ecit] [Church of St. Isaac in Saint Petersburg, built by Peter the Great 1717–1727. Burned 1735. Laying of the first stone of the current church by Alexander I, 1819. Consecrated by Alexander II, 1858. Ricard de Montferrand, architect. Jacques Wiener made it].

Reverse: Interior view of St. Isaac Cathedral. Inscription: in exergue, J[acques] WIENER F[ecit] 1858 [Jacques Wiener made it, 1858].

Literature: Bouhy 1883, no. 20; Witte 1912, nos. 161 and 162; Thieme and Becker 1907–50, 36: 535.

Part of the artist's series produced in the Royal Mint of Brussels about remarkable European religious buildings, this medal was made to commemorate the consecration on May 30 (June 11), 1858, of St. Isaac's, a new cathedral of the Russian Orthodox Church in Saint Petersburg. Held on the feast day of St. Isaac of Dalmatia, the ceremony attracted the emperor Alexander II and members of his family. The church, designed by the French architect Auguste Montferrand, had been under construction for forty years. There had been three earlier churches on the site: the first, a small wooden structure erected in 1710 by decree of Peter the Great; the second, a small stone building designed by the architect Georg Johann Mattarnovy; and the third designed initially by the architect Antonio Rinaldi and finished by Vincenzo Brenna, the court architect of Emperor Paul I. MAP

812

Christiaan Johannes van der Hoef (1875–1933)

LAND AND SEA (1900–1914)

1913

Silver, struck; 65.1 mm

Scher Collection

812

813

Obverse: Five young women holding hands, flowers and chaplets in their loose hair, their skirts forming the individual petals of a large tulip; in the background, four rows of tulip fields. Inscriptions: HET BLOEIENDE WIJDE LAND [The blossoming, wide land]; NEDERLANDSCH BELGISCHE [*sic*] VER[eeniging] VAN VRIENDEN VAN DE MEDAILLE [Dutch-Belgian Society of the Friends of the Art Medal].

Reverse: A water nymph, bare-chested and scaled around the hips, holding aloft a seashell from which stylized water drips, joining the equally stylized waves of the sea below and rising up on either side. Inscription: VAN DE ZEE HET ONMEET LIJK GEWEMEL [From the sea, the immeasurable tumult].

Literature: Jintes and Pol-Tyszkiewicz 1994, no. 13.

This medal, commissioned by the Dutch-Belgian Society of the Friends of the Art Medal, was Van der Hoef's first original design. The legend comes from a poem by Adriaan Roland Holst. EM

813

Christiaan Johannes van der Hoef (1875–1933)
NETHERLANDS: 100 YEARS INDEPENDENT I
Dated 1913
Copper alloy, struck; 70.4 mm
Scher Collection

Obverse: An angel with large wings wearing a diaphanous gown, framed by roses, holding an ornate, curling banner bearing the legend ONAFHANKELIJKHEID [independence] and, on either end, the dates 1813 and 1913.

Reverse: Neptune, bearded and holding a trident, wearing robes with a trident motif, and Mercury, in a winged helmet and a robe with a caduceus motif, holding a globe in his right hand and a caduceus in his left, standing in a seashell-like carriage drawn by three seahorses with webbed feet, moving through layers of stylized waves. Inscriptions: DE ZEE IS VRIJ [The sea is free]; DE KOOPHANDEL HERLEEFT [The trade, revived]; between heads of the two figures, CJH [artist's initials].

Literature: Jintes and Pol-Tyszkiewicz 1994, no. 14.

This medal, one of Van der Hoef's earliest, was struck to celebrate the one hundredth anniversary of Dutch independence from the French Empire and subsequent formation of the Kingdom of the Netherlands. The quote on the reverse comes from the 1813 proclamation returning power to the new king of the Netherlands, William I, who is remembered for his revival of the nation's economy. A smaller version of this medal (29 mm) was distributed to schoolchildren. EM

814

814

Christiaan Johannes van der Hoef (1875–1933)
NETHERLANDS: 100 YEARS INDEPENDENT II
Dated 1913
Copper alloy, struck; 70.4 mm
Scher Collection

Obverse: An angel with large wings wearing a diaphanous gown, framed by roses, holding an ornate, curling banner bearing the legend ONAFHANKELIJKHEID [independence] and, on either end, the dates 1813 and 1913.

Reverse: The Dutch Maiden (the Netherlands' national personification) in a plumed helmet, an embroidered gown bearing the Arms of the Kingdom of the Netherlands, and a cloak, pinned in front with a bejeweled brooch, sitting on a throne with lion statuettes as armrests; in her right hand, an olive branch; in her left, a Bible;

behind her, the eleven female personifications of the provinces of the Netherlands, each wearing a helmet with an appropriate heraldic crest and her province's arms emblazoned on her gown; the Maiden is flanked by two female figures: one, to her left, in West Indian dress, holding a bowl of fruit and resting her arm on the Arms of the West Indies; the other in Malay dress, holding some flowers and resting her arm on the Arms of the East Indies. Inscriptions: NEDERLAND EN ORANJE [The Netherlands and (the House of) Orange]; [flanked by lions and separated by leaf stops] 1813; BEGEER UTRECHT [Begeer, Utrecht]; 1913.
Literature: Jintes and Pol-Tyszkiewicz 1994, no. 15.

See the commentary for no. 813. The inclusion of the East and West Indies on the reverse seems to acknowledge the historical primacy of Dutch long-distance trade. The Begeer family of Utrecht founded a firm specializing in silverwork and medals. EM

815

815

Christiaan Johannes van der Hoef (1875–1933)
GIJSBERTI HODENPIJL FUND OF DELFT, I
Dated 1914
Copper alloy, struck; 59.8 mm
Scher Collection

Obverse: Two women in flowing, stylized robes (one with an embroidered bodice), their hair in chignons strung with pearls, facing one another, offering roses to a benedictory angel who stands on an altar decorated with an image of the Oude Kerk, Delft, as well as the date 1913 and the monogram T[echnische] H[ogeschool] [Technical College]. Inscription: GIJSBERTI HODENPIJLFONDS [Gijsberti Hodenpijl Fund].

Reverse: Border of holly branches, leaves, and berries. Inscription: OP 8 JANUARI 1914 TOEGEKEND AAN N RODENBURG WEGENS DE RESTAURATIE VAN HET HUIS DE HANDBOOG [Awarded to N. Rodenburg on 8 January 1914, due to the restoration of Handboog House]. **Literature**: Jintes and Pol-Tyszkiewicz 1994, no. 20.

Van der Hoef made the obverse of this medal for the Gijsberti Hodenpijl Fund, established in 1913 for the arts and sciences of the Technical College of Delft. A new die for the reverse was made for each recipient. The medal appears to have been awarded to N. Rodenburg, the architect who oversaw the restoration of De Handboog, a historic house (built ca. 1500) in Delft. EM

ENGLAND

ILLUSTRATING AN ISLAND NATION

The Medals of Britain

Christopher Eimer

Unlike in Italy a century earlier with Pisanello and his studio, early medal making in England during the 1540s did not have the benefit of either a great native artist or workshops in which to cast medals successfully. Instead, it has more modest origins among the makers of struck, low-relief coinage at the Royal Mint, located in the Tower of London.[1] From these makers' hands came medals struck to commemorate Henry VIII as head of the church in 1545[2] and the coronation of Edward VI in 1547.[3] Both medals are believed to be the work of the mint's chief engraver, Henry Basse, and are characterized by designs and lettering in low relief.

It is largely with these methods, rather than with casting, that medal making in England developed, though more slowly than it had on the Continent. Cast medals were, however, occasionally made; among them are a group of personal portraits produced in the early reign of Elizabeth I by Steven van Herwijk (ca. 1530–1565/67)[4] and, by an unknown hand, a portrait of Robert Dudley (1532/33–1588; first Earl of Leicester and a close associate of the queen) dated 1587 (no. 816) and possibly made for distribution to friends. Dudley's countenance has been described as conveying an "air of ineffectual complacency."[5]

The reign of James I saw a number of well-made medals of small diameter and low relief, including those for the king's coronation in 1603, considered the first official coronation issue (no. 817), and a companion piece of Queen Anne (no. 818), which are among those that may be attributable to the mint's chief engraver Charles Anthony (act. 1599–1615).[6] The celebrated miniaturist and goldsmith Nicholas Hilliard (ca. 1547–1619) worked for the courts of Elizabeth I and James I and is associated with two splendid oval medals that mark the defeat of the Spanish Armada in 1588,[7] as well as a fine medal commemorating the peace with Spain in 1604, versions of which were also cast (no. 819).

In the early seventeenth century, Simon de Passe (1595–1647) produced distinctive oval medals of superb workmanship, carrying both single and group portraits of Tudor and Stuart royalty.[8] Mostly in silver and on shallow flans, or metal blanks, they project a remarkable sense of three-dimensionality, in a manner that recalls the painted miniature, and include portraits of Queen Anne (no. 820), Charles, Prince of Wales (no. 821), and James I (no. 822).

Yet to be attributed is a 1618 double portrait medal of Nicholas and Dorothy Wadham, founders of the eponymous college at Oxford, which is made up of two plates joined at their edge (no. 824). From the same period is a beautifully worked cast-silver "ark badge" of James I that appears to be a naval award, possibly from the hand of Nicholas Hilliard or his workshop (no. 823).

For an engraver like Nicolas Briot (ca. 1579–1646), who had come over from Paris and obtained a position at the Royal Mint in 1625, medal making provided a supplementary income to the primary work of coinage production.[9] The skills and experience gained by the frequent execution of such medals had the benefit of ensuring greater precision in the cutting of coinage dies—a necessary component in the ongoing battle against forgery.

Thomas Rawlins (1620–1670) produced both cast and struck medals, as did Briot, and is associated with the cast English Civil War badges of the 1640s and the similarly made memorials for members of the Stuart royal family, including Henrietta Maria (no. 826), the delightful portrait medal of Charles I (no. 827), and that of Charles II (no. 828).[10] Rawlins's rare medal of Sir William Parkhurst, Warden of the Mint, includes, alongside the artist's signature, mention of Oxford, where Charles I moved from London during the civil war (no. 825).

The finely detailed cast medals by the brothers Thomas and Abraham Simon (1618–1665; 1617–1692) are akin to the work of a miniaturist painter. Dating from the mid-1640s onward, they represent a gallery of contemporary sitters and include an exquisitely modeled portrait of Dorcas Brabazon (no. 830).[11]

Technological advances for the striking of medals were slow to arrive in England. Even in the 1640s and 1650s—a century after the first struck medals had been made—those of large diameter and high relief commemorating events associated with England, such as royal marriages, naval conflicts, and peace treaties, were still being struck on the Continent by Dutch and German medalists.[12]

The restoration of the monarchy in 1660 brought the return of Charles II from Holland with a retinue that included die engravers with superior mechanical capabilities, which now facilitated the striking of larger, high-relief medals in London. Principal among these engravers were Jan Roettiers and George Bower. Jan Roettiers (1631–1703), a native of Antwerp and member of a large dynasty of engravers, found favor as chief engraver at the Royal Mint and executed the new milled coinage of Charles II in 1662. He subsequently acquired a patent enabling him to "frame and engrave the designs and effigies" of medals.[13] Among his many medals is one commemorating the peace treaty of Breda in 1667 (no. 831), which was available from goldsmiths and booksellers in the City of London and was famously referred to by Samuel Pepys, who recorded in his diary a visit to his goldsmith in February 1667. Pepys wrote that he was able to "observe the King's new medal, where in little there is Mrs Stuart's face as well done as ever I saw anything in my whole life." Serving as the model for Roettiers's seated figure of Britannia was Mrs. Frances Stuart, Charles II's mistress, who later became Duchess of Richmond.[14]

The medallic work of George Bower (d. ca. 1689), whose origins have yet to be established, extends from the restoration of Charles II in the 1660s to the late 1680s and includes medals on the arrival in London of the Moroccan and Bantamese ambassadors

Fig. 32 George Bower,
*Moroccan and Bantamese
Ambassadors in London*, 1682
Silver, 40 mm
Private collection

(fig. 32), the first non-British subjects to be depicted on a medal,[15] and the recovery of Spanish treasure, with the conjoined portraits of James II and Queen Mary (no. 832).

Norbert Roettiers (1665–1727), the son of Jan, produced medals for the exiled Jacobite family beginning in the late 1690s.[16] Before this, his work for the Stuarts and for William and Mary included a small group of uniface portraits on thin oval plates of silver, the rendition of Charles I being a particularly impressive example (no. 829). With the resurgence of the Stuart family, the arrival and accession of William and Mary to the English throne in 1689, and the success of the Jacobites, royalty would continue, over the centuries, to constitute the principal subject matter. Medals did, however, gradually embrace wider themes, which occasionally caught the attention of a political observer or satirist.[17]

Medals of topical interest were commissioned by jewelers and goldsmiths and sold through retail outlets and by the mint engravers themselves. The prices for silver medals, advertised as having been "engraved and coined" at the mint, suggest a select circle of buyers rather than volume business.[18] A Royal Warrant under the initiative of Isaac Newton, who had been made Master of the Mint in 1699, secured the continuing right of engravers to indulge in private trade in medals.[19]

Arriving from Germany in the late 1690s, John Croker (b. Johann Crocker, 1670–1741) secured the position of chief engraver at the mint, where he was to cut coinage and medal dies for more than thirty years. His work includes the medal commemorating the much celebrated union with Scotland in 1707, with a reverse by his co-engraver Samuel Bull (no. 834). A printed list issued by Croker in 1718 itemizes the occasions for which a medal could be purchased, with options for prices, metals, and sizes.[20] In addition to marking events during the reign of Queen Anne, Croker's medals celebrate the accession of George I in 1714, which was also commemorated by medalists in Germany. His imposing medal of George II and Queen Caroline, from 1732, with their children paraded on the reverse side, is a splendid affirmation of the royal house of Hanover[21] and an emphatic rebuttal to the ongoing Jacobite claims of succession (fig. 33). The exiled family themselves used the medal as an instrument of propaganda.[22]

The public's growing enthusiasm for medals in the late seventeenth century resulted in the making of cheap, and likely illicit, cast copies of struck medals.[23] By the late 1730s, a greater requirement at the mint for precision-made coinage tools and dies had reduced the number of medals that its engravers could make, enabling a more broad-based medal-making industry to develop. In London, Thomas Pingo (1692–1776) and his sons, John and Lewis, and John Kirk (ca. 1724–ca. 1778) and his family established themselves as private medal makers. The collective output of these two families accounts for a significant proportion of attributable medals produced in Britain during the eighteenth century.[24]

Fig. 33 John Croker, *George II and the Royal Family*, 1732
Silver, 69 mm
Private collection

Admiral Vernon's capture of Porto Bello in 1739 typifies an event that would particularly grip the public imagination, causing the wholesale production of cheaply made and largely unsigned medals.[25] Medals were now also being made by people in related metal trades, such as button makers, and in other locations with a metal manufacturing base, such as Dublin, Birmingham, Sheffield, and Edinburgh.[26] Meeting demand at all levels of the market for events of public interest, the industry was in some instances less an art than a business, with many medals inferior in design and manufacture.[27]

The Society of Arts in London was sufficiently moved by this development to introduce, during the 1750s, monetary and medallic prizes for the improvement of the medallic art.[28] To this end, it also sponsored a series of medals commemorating the Seven Years' War that had taken place from 1756 to 1763, most of them based on designs prepared by the artist James "Athenian" Stuart.[29]

The collecting of medals was seen as a laudable pursuit by a broad range of cognoscenti that included royalty, nobility, antiquarians, members of the clergy, and other professional classes. Among the most prominent collectors in the eighteenth century were Sir Hans Sloane (1660–1753), the eminent physician, and the anatomist William Hunter (1718–1783), whose respective bequests helped to form the nucleus of the British Museum and the Hunterian Museum in Glasgow. This growth of interest is also reflected in the publication in London of *Numismata, a Discourse of Medals*, by the diarist John Evelyn in 1697, which constitutes the first catalogue listing of medals relating to Britain.

The official medals for the coronation of George III in 1761 were engraved by Johann Lorenz Natter (1705–1763) and include that of the king's consort Queen Charlotte (no. 838).[30] Thomas Pingo engraved a widely distributed medal of William Pitt the Elder, commemorating the Repeal of the Stamp Act in 1766 (no. 837); he can also be firmly linked to an unsigned medal made in 1750 of Charles Edward Stuart, the Jacobite Pretender to the throne (no. 836). However, another unsigned medal, of William Beckford, Lord Mayor of London, offers no apparent clue as to the medalist (no. 839).

Thomas Snelling, the principal London coin dealer of his day, was commemorated by three different medalists on his death in 1773. This is an indication of both how revered he was among the profession and how the genre itself had evolved.[31] The Whig antiquary

Fig. 34 Rambert Dumarest,
*Matthew Boulton and the
Medallic Scale*, 1798
Bronze, 43 mm
Private collection

Thomas Hollis, an admirer of the medallic art, provides a rare insight into such activity in London at the time, noting that the Pinchbecks—who, like Snelling, had retail premises—counted both the fourth Duke of Devonshire and the Earl Temple of Stowe as clients for medals.[32] It was a period that saw the making of copies of rare sixteenth- and seventeenth-century medals that most collectors were unlikely to possess as original specimens.[33]

The latter part of the eighteenth century heralds the ascent of Birmingham as a center of medal making that would come to rival London. As the powerhouse of the Industrial Revolution, the city became known as the "workshop of the world," and at its forefront, as a producer of coinage and medals, was Matthew Boulton (1728–1809), whose medallic scale (fig. 34) illustrates the benefits of steam-powered machinery.[34] In the 1790s, Boulton's engagement of Conrad Heinrich Küchler, a northern European die engraver (act. 1763–1821), led to a series of finely engraved medals celebrating events of the period.[35] The series includes a medal commemorating a birthday visit to Queen Charlotte by her son George, Prince of Wales, and his wife, Princess Caroline, in 1795 (no. 465).

The much welcomed Peace of Paris in 1814, marking the end of hostilities with Napoleonic France, is commemorated by a variety of medals. Noteworthy among them is the splendid joint work of large size by J. Barber (act. 1809–42) and Thomas Wyon Jr. (1792–1817), with its depiction of Britannia supporting the fallen figure of Europa on the reverse (no. 841). Thomas Wyon Jr. was also responsible for an equally fine medal commemorating the centenary of the Hanoverian accession (no. 844). Both of these may have been commissioned by the royal goldsmiths Rundell Bridge and Rundell and offered for sale at their retail premises.[36]

Medallic compositions were frequently inspired by the work of contemporary artists and sculptors: Thomas Wyon Jr.'s depiction of Britannia and Europa was based on a work by the history painter Henry Howard; a medal by Thomas's father, Thomas Wyon Sr. (1767–1830), marking the unexpected death of Princess Charlotte in 1817, was based on her bust by the sculptor Peter Turnerelli (no. 844). This very sad occasion elicited many medals, including one by the Birmingham medalists Thomas Webb (act. 1797–1822) and George Mills (1792–1824) (no. 843).[37]

In a risky financial venture of 1820 that almost bankrupted its promoter, James Mudie, the British campaigns against Napoleon over the previous twenty years were recorded on a series of forty medals by both British and French medalists. The series includes a medal of the Duke of Cambridge by Thomas Webb and Jean Jacques Barre (1793–1855) (no. 842).[38]

The return of Queen Caroline to England in 1820, after a period of residence overseas, was marked by many medals, including one by Peter Kempson, a Birmingham die sinker

and button maker (act. ca. 1798–ca. 1844) (no. 845).[39] At the time, the popular imagination was quite taken by Lord Byron: a medal by Alfred Joseph Stothard (1793–1864), made on the death of the poet in 1824, fittingly refers in its Greek inscription to a reputation that would remain "imperishable forever" (no. 846).

Catering to increasing demand from publishers wishing to reach a wider market at the other end of the scale, medals were now being struck in a softish alloy of lead, tin, and zinc, commonly referred to as "white metal." Requiring less technical expertise than those struck in harder metals, such as bronze or silver, and priced accordingly, they were ideal for serving the still-growing demand for cheap souvenirs of current events, be they the opening of the Liverpool-Manchester railway in 1830, the death of the Duke of Wellington in 1852, or the numerous other such occasions that proved popular or newsworthy.[40]

With highly specialist skills and experience commonly passed on from one family member and generation to the next, the profession of engraver at the mint was frequently dynastic, and the same was true of those engaged in affiliated work. The Wyon family represents the most prominent die-engraving dynasty of the nineteenth century, with several generations occupying positions at the Royal Mint.[41] Well-made medals in bronze or silver, often of large diameter and high relief, are the family's hallmark, and among its most prominent members is William Wyon (1795–1851), whose portrait of Queen Victoria (fig. 35) was used on the first postage stamp issued in Britain.[42] A little earlier, Wyon's charming portrait of Princess Victoria had commemorated the attainment of her majority in 1837, a year before her official coronation (no. 847).

The Great Exhibition of 1851, held at the location commonly referred to as the Crystal Palace, was hugely influential as a universal showcase of artistic, technological, and scientific achievement, of which the awarding of official prize medals—engraved by William Wyon and his son Leonard Charles (1826–1891)—formed an integral part.[43] Over the next fifty years, it spawned large numbers of local exhibitions throughout Britain, in which prize medals were to play an increasing role.[44] Such medals were also being awarded by the newly established governmental departments of art, science, and education and by the many societies being created for purposes of learning and social discourse.[45]

The number of medals celebrating Queen Victoria's reign reflects the growing popularity of the royal family, who would be the subject of an increasingly large number of medals made in Britain during the nineteenth century. This trend peaked during the queen's

Fig. 35 William Wyon, *Visit of Queen Victoria to the City of London*, 1837
Bronze, 55 mm
Private collection

diamond jubilee in 1897, for which a distinctive medal featuring portraits of both the young and old sovereign (no. 848) was made by the Royal Mint engraver George William de Saulles (1862–1903).

The success of the genre was, however, at the expense of its individual character, as the designs of many medals became more generic. The Society of Medallists was established in the 1880s to revive the cast medal and introduce more aesthetically pleasing designs to the medium.[46] Theodore Spicer-Simson (1871–1959) produced a large gallery of such medallic portraits, including eminent writers and artists, all of them superbly rendered; among their number are Ella Mielziner (no. 850), James Stephens (no. 851), and George Frederick Watts (no. 849). This genre catered to a less populist and more elite segment of the market, which diminished in size after World War I, possibly due to the growing popularity of photography, which offered an immediate means of capturing a subject.

Over the next century, medals have continued to be produced by the Royal Mint and by independent medalists and private mints.[47] However, with the more recent evolution of the medallic form, or "sculpture in miniature"—as seen, for example, in the contemporary work being sponsored by the British Art Medal Society and sister societies elsewhere in the world—it is today no easier to identify exclusive characteristics, or enduring features, in the medals being produced in England than it was in previous centuries.[48]

Notes

1 The mint gained its royal appellation in 1816 and is referred to in the text as either the mint or the Royal Mint. For further information, see Challis 1992.
2 Hawkins 1885, 1: 47, no. 44; Eimer 2010, no. 26.
3 Hawkins 1885, 1: 53, no. 1; Eimer 2010, no. 28.
4 Hawkins 1885, 1: 103, nos. 28–30; 105, nos. 32–36; 113, no. 42; Eimer 2010, nos. 42–46.
5 Hill and Pollard 1978, 150.
6 Charles Anthony was the son of the mint engraver Derick Anthony, who died in 1599.
7 Hawkins 1885, 1: 154, nos. 129, 130; Eimer 2010, nos. 61a, 61b.
8 Hawkins 1885, pls. XVI (nos. 1–9), XVII (no. 5), and XVIII (no. 6).
9 H. Symonds 1913, 364–65; letters patent of December 16, 1628, enabling Nicolas Briot to make medals "representing the king's or his consort's effigies" or those "marking worthy successes." Briot worked with both cast and struck medals. See Hawkins 1885, 1: 243, no. 10; 249, nos. 23–27; 253, no. 33; 255, nos. 38, 39; 265, no. 60; 267, nos. 64, 65; Eimer 2010, nos. 106, 110–13, 123, 126, 127.
10 Thomas Rawlins worked with both cast and struck medals; see Hawkins 1885, 1: 292, nos. 108, 109, 295, no. 113; see also Eimer 2010, nos. 134, 139–40, 142, 166–73, 204–8.
11 Thomas Simon worked with both cast and struck medals. See Hawkins 1885, 1: 282, nos. 90–94; 321, no. 157; 324, nos. 161, 162; 390, nos. 12–14; 409, no. 45; 433, no. 82; 472, no. 76; see also Eimer 2010, nos. 134, 148, 150–52, 179, 181, 188, 189, 202, 221.
12 See Hawkins 1885, 1: 284, nos. 95, 96; 287, no. 100; 290, no. 105; 403, no. 33; 415, no. 52; Eimer 2010, nos. 135, 137, 138, 187, 191.
13 H. Symonds 1913, 376.
14 Hawkins 1885, 1: 535, no. 186; Eimer 2010, no. 241. For Jan Roettiers's other medals, see Hawkins 1885, 1: 457, no. 48; 460, nos. 53, 54; 503, no. 139; 504, nos. 141–43; see also Eimer 2010, nos. 211, 212, 214, 228–31.
15 Hawkins 1885, 1: 584, no. 260; Eimer 2010, no. 262. For George Bower's other medals, see Hawkins 1885, 1: 458, no. 50; 459, no. 52; 480, no. 90; 491, no. 115; 577, nos. 247, 248; 578, no. 250; 579, no. 252; see also Eimer 2010, nos. 213, 216, 222, 223, 257–60.
16 See Hawkins 1885, 2: 192, nos. 500–4; 201, nos. 515, 516; 204, nos. 519, 520; 313, no. 134; 314, no. 136; 453, no. 61; Eimer 2010, nos. 373–77, 379–82, 427, 460a, 487.
17 The poet John Dryden famously described George Bower's medal for the acquittal from treason of the Earl of Shaftesbury in 1681 (Hawkins 1885, 1: 583, no. 259; Eimer 2010, no. 261) as having one side "fill'd with Title and with Face; And, lest the King shou'd want a regal Place; on the reverse, a Tow'r the Town surveys; O'er which our mounting sun his beam displays" (extracts from *The Medall: A Satyre against Sedition*, 1682).
18 Bryden 1991; Griffiths 1989.
19 Eimer 1989, 20; PRO (Public Record Office) MINT 3/18.
20 Eimer 1989, 23, fig. 10.
21 Hawkins 1885, 2: 500, no. 47; Eimer 2010, no. 528.
22 Woolf 1988.
23 See Eimer 2010, nos. 56, 124, 191, 223, 262, 307, 308, 310–12.
24 Eimer 1998, app. 9, 35.
25 J. W. Adams and Chao 2010; see also Hawkins 1885, 2: 530, nos. 92–181; Eimer 2010, nos. 547–54.
26 Eimer 1998, app. 9, 36, table 1.
27 Ibid., 37, table 2.
28 Hawkins 1885, 2: 684, no. 401; Eimer 2010, no. 648; see also Eimer 1998, 9.
29 Hawkins 1885, 2: 683, no. 400; 686, no. 405; 691, no. 405; 705, no. 439; 711, no. 448; Eimer 2010, nos. 655, 658, 661, 673, 680; see also Eimer 1998, 11–12, 14–15, 30.
30 Coronation of George III by Lorenz Natter: L. Brown 1980–95, 1: nos. 22, 23; Eimer 2010, no. 694.
31 L. Brown 1980–95, 1: nos. 178–80; Eimer 2010, no. 749.
32 Diary of Thomas Hollis, September 8, 1762, Houghton Library, Harvard University; and Stowe Papers, March 11, 1762, box 164 (4c). Huntingdon Library, San Marino, CA, A/Cs.
33 Eimer 2010, no. 28 (note), and p. 15.
34 L. Brown 1980–95, 1: no. 462; Eimer 2010, no. 901.
35 Pollard 1970.
36 Hartop 2005, 37, fig. 30.
37 L. Brown 1980–95, 1: nos. 936–50.
38 Ibid., no. 1057; Eimer 2010, no. 1136.
39 L. Brown 1980–95, 1: nos. 1021–29.
40 Liverpool-Manchester Railway: ibid., nos. 1458–59; Eimer 2010, nos. 1223–24. Duke of Wellington: L. Brown 1980–95, 2: nos. 2474–87; Eimer 1994, 137–80; Eimer 2010, nos. 1468–70.
41 Forrer 1904–30, 6: nos. 571–687, 8: nos. 291–303.
42 L. Brown 1980–95, 2: no. 1775; Eimer 2010, no. 1304.
43 L. Brown 1980–95, 2: nos. 2461–65; Eimer 2010, nos. 1455–59.
44 See Eimer 2010, no. 1455 (note).
45 See ibid., no. 1511 (note).
46 The Society of Medallists was largely formed under the aegis of the French medalist Alphonse Legros, and its earlier production includes his portrait of the philosopher and economist John Stuart Mill and Edward Poynter's medal of the actress Lily Langtry. See L. Brown 1980–95, 2: nos. 3067, 3120; Eimer 2010, nos. 1624, 1692. For a broader treatment of the subject, see Attwood 1992, 3, 5, 12.
47 See Eimer 2010, nos. 2160, 2183, 2186, 2197 (Royal Mint); see also nos. 2168, 2174, 2178, 2182 (Thomas Fattorini Ltd.), and nos. 2201–4, 2211, 2221, 2222 (Bigbury Mint).
48 Since its foundation in 1982, the British Art Medal Society has commissioned annual medallic work from artists across various genres. It publishes *The Medal*, biannually, in spring and autumn, and organizes an annual lecture series and various associated projects.

816

816

Unknown artist
ROBERT DUDLEY, EARL OF LEICESTER (1532/33–1588)
Dated 1587
Silver, cast; 46.7 mm
The Frick Collection; Gift of Stephen K. and Janie Woo Scher, 2016
(2016.2.185)

Obverse: Robert Dudley, in a flat collar and richly decorated armor, wearing a soft cap with a bejeweled brim, adorned with feathers. Inscription: ROBE[rtus] CO[mes] LEIC[estriæ] ET IN BELG[io] GVBER[nator] 1587 [Robert, Earl of Leicester, and governor in the Netherlands, 1587].
Reverse: A dog walking before a flock of sheep and turning his head to look back at them. Inscriptions: NON GREGEM SED INGRATOS [Not the flock, but the ungrateful]; in the field at right, in two lines, INVITVS / DESERO [I leave unwillingly].
Literature: Van Loon 1732–37, 1: 375; Hawkins 1885, 1: 140–41, no. 100; Eimer 2010, no. 54.

The Earl of Leicester, a favorite of Elizabeth I of England and infamously arrogant, was recalled from his post as governor of the United Provinces for behaving poorly, enacting policies that ran contrary to the instructions of the queen, and arousing suspicion and frustration in the Dutch, who complained to Elizabeth of his conduct. Leicester, embittered, produced this medal, which he distributed among his friends; it is unclear whether it was made in the Low Countries or in England, following his return. EM

817

Possibly by Charles Anthony (act. 1599–1615)
JAMES I, KING OF GREAT BRITAIN AND IRELAND (b. 1566; r. 1603–25)
1603
Silver, struck; 28.5 mm
Scher Collection

Obverse: James wearing a laurel wreath, a lace collar, armor (with lion-headed pauldrons and a gorget), and a commander's sash knotted on the shoulder. Inscription: IAC[obus] I BRIT[anniæ] CÆ[sar] AVG[ustus] HÆ[res] CÆSARVM CÆ[sar] D[ono] D[edit] [James I, Caesar Augustus of Britain, Caesar the heir of the Caesars, gave it (the medal) as a gift].
Reverse: A lion, gardant, crowned and holding a sheaf of wheat and a beacon. Inscription: ECCE PHAOS POPVLIQ[ue] SALVS [Behold the beacon and safety of the people].
Literature: Hawkins 1885, 1: 191, no. 11; Eimer 2010, no. 80a.

This medal showing James styled as a Roman emperor was made for distribution at James's coronation as king of Great Britain and Ireland and is the first to be issued for such a purpose. He was king of Scotland as James VI from 1567 until his death, ruling from 1603 over the sovereign states of Scotland, England, and Ireland. EM

818

Possibly by Charles Anthony (act. 1599–1615)
QUEEN ANNE (b. 1574; Queen Consort of Scotland 1589–1619; Queen Consort of Great Britain and Ireland 1603–19)
ca. 1604
Silver, struck; 28.7 mm
Scher Collection

Obverse: Anne, with hair bejeweled and piled high above her forehead, wearing a high and ornate lace collar, a pearl necklace with pendant, and pearl earrings. Inscriptions: outer line, ANNA D[ei] G[ratia] REGINA MAG[næ] BRIT[anniæ] FR[anciæ] ET HIB[erniæ] [Anne, by the grace of God, Queen of Great Britain, France, and Ireland]; inner line, right, FILIA & SOROR; inner line, left, REGV[m] DANIÆ [daughter and sister of kings of Denmark].
Reverse: Anne's armorial shield, crowned. Inscription: ASTVTIA FALLAX TVTIOR INNOCENTIA [Cunning is fallacious; innocence is safer].
Literature: Hawkins 1885, 1: 192, no. 12; Eimer 2010, no. 81.

In 1589, Princess Anne of Denmark married James VI of Scotland and became Queen Consort of Great Britain and Ireland in 1603, when he was crowned James I. AN

819

Attributed to Nicholas Hilliard (ca. 1547–1619)
JAMES I, KING OF GREAT BRITAIN AND IRELAND (b. 1566; r. 1603–25)
Dated 1604
Silver, cast; 34.2 mm
Scher Collection

817

818

819

Obverse: James wearing a wide-brimmed hat (crowned, plumed, and supporting a jewel) and a slashed doublet with lace collar and wide shoulder-wings. Inscription: IACOBVS D[ei] G[ratia] ANG[liæ] SCO[tiæ] FR[anciæ] ET HIB[erniæ] REX [James, by the grace of God, King of England, Scotland, France, and Ireland].

Reverse: Peace, holding a palm branch and cornucopia, facing Religion, holding a beacon and a cross. Inscriptions: HINC PAX COPIA CLARAQ[ue] RELIGIO [Henceforth peace, plenty, and pure religion]; in exergue, A[nn]° 1604 [In the year 1604].

Literature: Hawkins 1885, 1: 193, nos. 14, 15; Eimer 2010, no. 84b.

This medal commemorates the end of the war between England and Spain as negotiated in 1604 by James. In addition to being king of Scotland and, from 1603, king of Great Britain and Ireland, he called himself king of France in the tradition of English monarchs, though he did not rule France. EM

820

Simon de Passe (1595–1647)
QUEEN ANNE (b. 1574; Queen Consort of Scotland 1589–1619; Queen Consort of Great Britain and Ireland 1603–19)
ca. 1616
Silver, engraved (?); 56.9 x 45.5 mm (including gold frame)
Scher Collection; Promised gift to The Frick Collection

Obverse: Anne, crowned, with jewels in her hair, wearing a stiff lace collar, pearl earrings, a pearl necklace with pendant, and a gown with a low neckline. Inscriptions: above, flanking a crown, A[nna] R[egina] [Queen Anne]; below, Anna D[ei] G[ratia] Mag[næ] Britt[anniæ]

Fr[anciæ] & Hyb[erniæ] Regina [Anne, by the grace of God, Queen of Great Britain, France, and Ireland]; on left side, PS [Simon de Passe]; on right side, FE[cit] [Made by].

Reverse: Anne's armorial shield, crowned, with Wild Men as supporters. Inscriptions: ANNA DEI GRATIA MAGNÆ BRITANNIÆ FRANCIÆ ET HYBERNIÆ REGINA [Anne, by the grace of God, Queen of Great Britain, France, and Ireland]; beneath shield, LA MIA GRANDEZZA DAL ECCELSO [My greatness is from on high].

Literature: Hawkins 1885, 1: 215, no. 63.

This medal is one of a series by de Passe of the royal family and court of James I. It is unclear whether the series was intended to mark a specific occasion. The process for producing these medals is still not entirely understood. EM

821

Simon de Passe (1595–1647)
CHARLES, PRINCE OF WALES (b. 1600; King of Great Britain and Ireland 1625–49)
Dated 1616
Silver, engraved (?); 55.8 x 43.1 mm
Scher Collection

Obverse: The young prince, hair worn short, in a lace ruff and armor, with a sash across his chest, beneath which is visible the medal of the Order of the Garter suspended from a ribbon. Inscription: CAROLUS PRINCEPS WALLIÆ [Charles, Prince of Wales].

Reverse: Charles's armorial shield (crowned), framed by the Garter, upon which is inscribed the motto of the Order of the Garter: HONY SOIT QVI MAL Y PENSE [Shame to him who thinks evil of it]; on external border, ILLUSTRISS[imus] ET POTEN[tissimus] P_R[inceps] CAROLUS PRINCEPS WALLIÆ DUX CORN[wallis] YOR[k?] LT[?] ALB[aniæ/any?] ET_c[etera] [The most illustrious and potent Prince Charles, Prince of Wales, Duke of Cornwall, York, and Albany, et cetera]; ANNO D[omini] 1616 [In the year of the Lord 1616]; SI[mon] PASSE F[ecit] [Simon de Passe made it]

Literature: Hawkins 1885, 1: 216, no. 66.

Charles was invested as prince of Wales (and thus as a knight of the Garter) in 1616, and this medal, which prominently displays his new title on both sides, probably commemorated the occasion. EM

820

821

822

823

822

Simon de Passe (1595–1647)

JAMES I, KING OF GREAT BRITAIN AND IRELAND (b. 1566; r. 1603–25)

ca. 1616 or 1625

Silver, engraved (?); 60.4 x 49 mm

Scher Collection

Obverse: James wearing a wide-brimmed hat, elaborate hat-badge, lace ruff, and the collar of the Order of the Garter (worn over his doublet and ermine robe).

Reverse: The Royal Arms, framed by the Garter, with helmet, crest, and lion and unicorn supporters. Inscriptions: IACOBVS DEI GRATIA MAGNÆ BRITANNIÆ FRANCIÆ ET HYBERNIÆ REX [James, by the grace of God, King of Great Britain, France, and Ireland]; on garter, HONI SOIT QVI MAL Y PENSE [Shame to him who thinks evil of it]; BEATI PACIFICI [Blessed are those who seek peace].

Literature: Hawkins 1885, 1: 215, no. 62.

This medal is one of a series by de Passe of the royal family and court of James I. It is unclear if the series was intended to mark a specific occasion. EM

823

Unknown artist, possibly workshop of Nicholas Hilliard (ca. 1547–1619)

JAMES I, KING OF GREAT BRITAIN AND IRELAND (b. 1566; r. 1603–25)

ca. 1620

Silver, cast; 49.4 x 42.5 mm

Scher Collection

Obverse: James wearing a plumed hat with bejeweled hat-badge, a lace collar, and a richly embellished doublet and cloak, with the badge of the Order of the Garter suspended from a ribbon. Inscription: IACOBVS D[ei] G[ratia] MAG[næ] BRITA[nniæ] FR[anciæ] ET HI[berniæ] REX [James, by the grace of God, King of Great Britain, France, and Ireland].

Reverse: The Ark, smoke issuing from its chimney, in choppy waters, with the sun's rays streaming through clouds. Inscription: STET SALVVS IN VNDIS [May it stand safe amid the waves].

Literature: Hawkins 1885, 1: 233, no. 96; Eimer 2010, no. 101a.

Though the purpose of this medal is unclear, its reverse imagery seems symbolic of the state of England following the turmoil of the Reformation, and it may have been made as a gift for favored individuals in James's court (although it is also possible that it was a general form of naval award). EM

824

Unknown artist

NICHOLAS (1532–1609) and **DOROTHY WADHAM** (1534–1618)

1618

Silver, repoussé; 54 x 45.5 mm

Scher Collection

Obverse: Nicholas, framed by a narrow wreath and four skulls (above, below, and flanking), wearing a falling ruff and plain doublet with set-in sleeves. Inscription: WHEN CHRIST WHO IS OVR LIFE SHAL[l] APPEARE.

Reverse: Dorothy, framed by a wreath and skulls, wearing a broad-brimmed hat, stiff cartwheel ruff, and damasked or brocaded gown. Inscription: WE SHAL[l] APPEARE WITH HIM IN GLORY.

Literature: Hawkins 1885, 1: no. 73; Eimer 2010, no. 98a.

This medal, a memorial to Nicholas and Dorothy Wadham, founders of Wadham College, Oxford, was created in the year of Dorothy's death. Though it was Nicholas who set aside the bulk of the funds for the endowment of a college, it was under the guidance of his capable and formidable widow that Wadham College became a reality, opening its doors a mere four years after Nicholas's death. EM

824

825

825

Thomas Rawlins (1620–1670)
SIR WILLIAM PARKHURST (d. 1667; Warden of the Mint of
England 1623–42, 1660–66)
Dated 1644
Silver, repoussé, mounted on wood backing; 80.9 mm (without
mount)
Scher Collection

Obverse: Framed by an outer border of flowers and an ornate frame
of scrolls, bouquets of flowers, and vegetal motifs, with lions' heads
above and below, Parkhurst wears a falling collar, plain buttoned
doublet, and loose cloak and holds in his hand, resting on his belly,
a portrait medal (presumably of Charles I). Inscriptions: GVILIEL[mus]
PARKHVRST EQV[es] AVRA[tus] CVSTOS CAMB[ii] ET MONET[æ] TOT[æ]
ANGL[iæ] 1623 [William Parkhurst, Gilded Knight, Warden of the
Exchange and Mint of all England, 1623]; below, RAWLINS, SCULPS[it]
[Engraved by Rawlins]; to left, OXON[ium] [Oxford]; to right, 1644.
Reverse: Wood mounting decorated with ornamental turning.
Literature: Hawkins 1885, 1: 311, no. 140.

This medal celebrates Parkhurst in his role as Warden of the Mint,
to which he had been appointed first by James I, then by Charles I.
Located in Shrewsbury at the beginning of the Civil War, the mint
was moved to Oxford in 1642, the year it was seized by Parliament
and Parkhurst, a royalist, was ousted as warden. He was returned to
his former position in 1660 under Charles II. EM, SKS

826

Thomas Rawlins (1620–1670)
CHARLES I, KING OF GREAT BRITAIN AND IRELAND
(b. 1600; r. 1625–49) and **QUEEN HENRIETTA** (1609–1669;
Queen Consort of Great Britain and Ireland 1625–49)
ca. 1649
Silver, cast; 39 x 30.2 mm
Scher Collection; Promised gift to The Frick Collection

Obverse: Charles, hair loose and curling by his neck, wearing a lace
collar, buttoned doublet, and sash. Inscription: CAROLVS D[ei] G[ratia]
MAG[næ] BRI[tanniæ] FR[anciæ] ET HIB[erniæ] R[e]X [Charles, by the
grace of God, King of Great Britain, France, and Ireland].
Reverse: Henrietta, hair held back by a small crown, and loose and
curled on the back and sides, wearing a pearl necklace and pendant,
a figured, low-cut bodice (embroidered, with a brooch in front),
and drapery. Inscriptions: HENR[i]ETTA MARIA D[ei] G[ratia] MAG[næ]
BRITAN[niæ] FRAN[ciæ] ET HIB[erniæ] REG[ina] [Henrietta Maria, by the
grace of God, Queen of Great Britain, France, and Ireland]; T[homas]
RAWLINS F[ecit] [Thomas Rawlins made it].
Literature: Hawkins 1885, 1: 354, no. 215; Eimer 2010, no. 169.

This medal was probably made to memorialize the recently
deceased Charles. Such medals were made in great numbers and
configurations to be carried or worn by royalists. EM

826

827

828

827

Thomas Rawlins (1620–1670)

CHARLES I, KING OF GREAT BRITAIN AND IRELAND

(b. 1600; r. 1625–49)

ca. 1649

Silver, cast; 44.2 x 34.5 mm

Scher Collection

Obverse: Charles wearing figured armor with lion-headed pauldrons, a lace collar, the badge of the Order of the Garter suspended from a ribbon, and his hair long, with a lovelock on his left shoulder.
Literature: Hawkins 1885, 1: 368, no. 253.

This medal probably commemorates the death of Charles, although it could have been made earlier, since such medals were worn by royalists to show their loyalty. EM

828

Thomas Rawlins (1620–1670)

CHARLES II (b. 1630; King of Scotland 1649–51; King of England, Scotland, and Ireland 1660–85)

1660

Silver, struck; 34.5 mm

The Frick Collection; Gift of Stephen K. and Janie Woo Scher, 2016 (2016.2.02)

Obverse: Charles, in armor and a broad collar, wearing a commander's sash. Inscriptions: CAROLVS II D[ei] G[ratia] MAGNÆ BRIT[anniæ] FRA[nciæ] ET HIB[erniæ] REX [Charles II, by the grace of God, King of Great Britain, France, and Ireland].
Reverse: A leafless oak tree with three branches, each of which bears a crown; the sun shining between clouds. Inscription: TANDEM REVIRESCET [It will bloom again].
Literature: Hawkins 1885, 1: 453, no. 38; Eimer 2010, no. 215.

This medal celebrates the ascension to the British throne of Charles II, who had been living in exile since the 1649 execution of his father (Charles I). The withered tree symbolizes royalty, with the inscription affirming that it will be restored to its former glory now that it can grow leaves and flourish. The three crowns could refer either to England, Scotland, and France or to England, Scotland, and Ireland. EM

829

Norbert Roettiers (1665–1727)

CHARLES I, KING OF GREAT BRITAIN AND IRELAND

(b. 1600; r. 1625–49)

Dated 1698, made ca. 1690–1700

Silver, repoussé; 93.3 x 81 mm (including rim)

Scher Collection; Promised gift to The Frick Collection

Obverse: Charles, in armor, wearing drapery over his shoulders and chest, and his hair in a lovelock on his left shoulder. Inscriptions: CAROLUS D[ei] G[ratia] MAG[næ] BRIT[anniæ] FRA[nciæ] ET HIB[erniæ] REX

829

The purpose of this medal is uncertain given that in 1662 Sir George Lane (later first Viscount Lanesborough) had been married to his second of three wives, Susan Nicholas, for almost a decade. The date of Brabazon's death is unknown but may be recorded by this medal. EM

GLORI[os]A[e] MEMO[riæ] OBIIT IA[nuarii] 30 1648 ÆTAT[is] 49 [Charles, by the grace of God, King of Great Britain, France, and Ireland, of glorious memory, died January 30, 1648, aged 49].
Literature: Hawkins 1885, 1: 347, no. 202.

Roettiers created this medal for his series of medallic portraits of English monarchs, from Charles I to William III. The date inscribed is probably meant to refer to the year of Charles's death, though Charles was executed not in 1648 but early in 1649. EM

831

Jan Roettiers (1631–1703)
CHARLES II (b. 1630; King of Scotland 1649–51; King of England, Scotland, and Ireland 1660–85)
ca. 1667
Silver, struck; 56.6 mm
Scher Collection; Promised gift to The Frick Collection

Obverse: The king wearing a laurel crown and drapery. Inscription: CAROLVS SECVNDVS DEI GRATIA MAG[næ] BRIT[anniæ] FRAN[ciæ] ET HIBER[niæ] REX [Charles II, by the grace of God, King of Great Britain, France, and Ireland].
Reverse: Personification of Britannia, seated in a rocky outcrop, one hand resting on a shield emblazoned with the flag of Great Britain and the other holding a spear, surveying her ships; above, the sun shining between the clouds. Inscriptions: FAVENTE DEO [With God's favor]; in exergue, BRITANNIA.
Edge inscription: CAROLVS SECVNDVS PACIS ET IMPERII RESTITVTOR AVGVSTVS [Charles II, august restorer of peace and of the Empire].
Literature: Hawkins 1885, 1: 535–36, no. 186 (var.); Pollard 2007, 2: no. 945; Eimer 2010, no. 241.

830

Abraham Simon (1617–1692) and Thomas Simon (1618–1665)
DORCAS BRABAZON, LADY LANE (dates unknown; m. 1644 to Sir George Lane)
Dated 1662
Silver, cast; 32.5 mm
Scher Collection

Obverse: Brabazon, with ringlets of hair falling from her braided chignon onto her shoulder, wearing a pearl tear-drop earring, pearl necklace, and a lace-trimmed or embroidered gown, with shoulders and décolletage exposed.
Reverse inscription: In six lines, DORCAS / BRABAZON / GEORGII LANE / EQ[uitis] AV[rati] DILECT[a] / CONIVX / MDCLXII [Dorcas Brabazon, the beloved wife of George Lane, Gilded Knight, 1662].
Literature: Hawkins 1885, 1: 479, no. 89.

This medal was made to commemorate Britain's extensive efforts in 1666 to expand its navy. The edge inscription was probably a later addition, referring to the peace treaty of July 31, 1667, held at Breda Castle and signed by England, the Dutch Republic, France, and Denmark (the republic's allies). The treaty brought an end to the Second Anglo-Dutch War (1665–67). EM

832

832

George Bower (d. ca. 1689)

JAMES II, KING OF ENGLAND, SCOTLAND, AND IRELAND
(1633–1701; r. 1685–88) and **QUEEN MARY** (1658–1718; Queen
Consort of England, Scotland, and Ireland 1685–88)
Dated 1687
Silver, struck; 54.6 mm
Scher Collection; Promised gift to The Frick Collection

Obverse: Jugate busts of James, with a laurel wreath in his long,
curling hair, wearing drapery over scale armor, and Mary in drapery,
with pearls in her hair. Inscriptions: IACOBVS II ET MARIA D[ei] G[ratia]
MAG[næ] BRI[tanniæ] FRAN[ciæ] ET HIB[erniæ] REX ET REGINA [James II
and Mary, by the grace of God, King and Queen of Great Britain,
France, and Ireland]; below drapery, GB [artist's initials].
Reverse: A ship, full-rigged and flying the flag of St. George, in a
sea of wreckage, the flotsam of which is being retrieved by men in
rowing boats. Inscriptions: SEMPER TIBI PENDEAT HAMUS [Always let
your hook be hanging]; in exergue, in two lines, NAVFRAGA REPERTA /
1687 [Wreck recovered 1687].
Literature: Hawkins 1885, 1: 619, no. 33; Eimer 2010, no. 285a.

This medal was created during the reign of James II to honor those
involved in the successful undertaking (the second of two efforts led
by Captain William Phipps) to recover treasure from a Spanish ship
that had been wrecked some forty-eight years earlier in the West
Indies. The legend on the reverse encourages perseverance. EM

833

Unknown artist
JOHN CHURCHILL, DUKE OF MARLBOROUGH
(1650–1722)
ca. 1706
Silver, cast; 70.3 mm
The Frick Collection; Gift of Stephen K. and Janie Woo Scher, 2016
(2016.2.79)

Obverse: Marlborough in armor, a ribbon across his breast, flanked
by supporters (Hercules and Mars), with Fame flying overhead
bearing a trumpet, laurel wreath, and pair of mural crowns; beneath
the Duke, a pile of arms, armor, mural crowns, and flags, and the
inscription, in four lines: UICTOR / SHALLEM / HOGSTET / RAMMEL
[Victorious at Schellenberg, Hochstädt, and Ramillies]; all this

833

framed by an elaborate border decorated with vegetal and floral motifs, scrolls, a club and a cornucopia, two quivers, laurel and palm branches within a mural crown, and two French scepters and a reversed mural crown. Inscriptions: innermost, IOH[annes] P[rimus] D[ux] MARLBURGIUS [John, first Duke of Marlborough]; outermost, AEQUAT MARLBURGIUS AMBOS [Marlborough Equals Both (i.e., Hercules and Mars)].
Literature: Hawkins 1885, 2: 286, no. 94.

This plaque, which may have been executed in Germany, was probably intended to be set into the cover of a box. It was created to commemorate the victories of Marlborough, a venerated English commander who led Britain and its allies to multiple successes over Louis XIV of France. By 1706, Marlborough had won crucial battles at Schellenberg, Hochstädt, and Ramillies, these triumphs being represented by the many mural crowns displayed on the obverse. EM

834

John Croker (1670–1741) and Samuel Bull (act. 1707–15)
ANNE, QUEEN OF GREAT BRITAIN AND IRELAND (b. 1665; r. 1702–14)
1707
Silver, struck; 34.6 mm
Scher Collection

Obverse: Anne, her wavy hair tied up in a knot and a curl on her shoulder, wearing a gown, loose in front and made of a light fabric, with shoulder straps, and draped. Inscriptions: ANNA D[ei] G[ratia] MAG[næ] BR[itanniæ] FRA[nciæ] ET HIB[erniæ] REG[ina] [Anne, by the grace of God, Queen of Great Britain, France, and Ireland]; IC [John Croker].
Reverse: The Royal Arms, resting on a pedestal and flanked by winged infant genii who support a crown above, and the livery collar of the Order of the Garter below; beneath the collar, a thistle

and a rose upon one stalk. Inscriptions: on pedestal, SEMPER EADEM [Always the same]; below, SB [artist's initials].
Literature: Hawkins 1885, 2: 296, no. 111; Eimer 2010, no. 425.

This medal commemorates the Acts of Union of 1707, whereby the kingdoms of England (the rose) and Scotland (the thistle) were, under the auspices of Anne, merged to form the United Kingdom of Great Britain. EM

835

Georg Wilhelm Vestner (1677–1740)
GEORGE I, KING OF GREAT BRITAIN (b. 1660; r. 1714–27)
Dated 1714
Silver, struck; 44.1 mm
Scher Collection; Promised gift to The Frick Collection

Obverse: George laureate and draped. Inscription: GEORG[ius] LVD[ovicus] D[ei] G[ratia] M[agnæ] BRIT[anniæ] FR[anciæ] ET HIB[erniæ] REX DVX B[runsvicensis] & L[uneburgensis] S[acri] R[omani] I[mperii] ELEC[tor] [George Louis, by the grace of God, King of Great Britain, France, and Ireland, Duke of Brunswick and Luneburg, Elector of the Holy Roman Empire].
Reverse: The sun, on a line bearing the symbols of the planets, in the midst of the constellation Leo (figuratively present as a lion). Inscription: REGNORVM ALBIONIS NVNC IVRA GEORGIVS INTRAT ANNO MDCCXIV D[ie] XII AVGVSTI [George now enters into the authority of the kingdoms of Albion (Britain) in the year 1714, day 12 August].
Literature: Hawkins 1885, 2: 421, no. 4; Eimer 2010, no. 464.

Created to mark the accession of George to the throne, this medal symbolically depicts the passage of George (the sun) into the kingdom of the British lion. George's accession took place in August, when the sun is in the midst of the constellation Leo. EM

834

835

836

Thomas Pingo (1692–1776)
PRINCE CHARLES EDWARD STUART (1720–1788)
Dated 1750
Silver, struck; 34.1 mm
Scher Collection

Obverse: Charles with his hair short and worn curled at the nape of his neck.
Reverse: A flourishing sapling sprouting from the root of an old, leafless oak. Inscriptions: REVIRESCIT [It flourishes anew]; in exergue, 1750.
Literature: Hawkins 1885, 2: 655, no. 359; Eimer 1998, no. 5; Eimer 2010, no. 625.

This medal was commissioned by a Jacobite society dedicated to keeping alive the cause of Prince Charles, the last serious Stuart pretender to the English throne, shortly after the failed Jacobite rebellion of 1745–46. The imagery of a sapling growing from a venerable but withered oak is symbolic of the Jacobite desire to see Charles, the youthful face of the Stuart claim to the throne, crowned king, thus restoring to power an old ruling family (allowing Stuart rule to "flourish anew"). EM

837

Thomas Pingo (1692–1776)
WILLIAM PITT THE ELDER (1708–1778; Prime Minister of Great Britain 1766–68)
1766
Silver, struck; 40.6 mm
Scher Collection

Obverse: Pitt wearing a periwig, cravat, and unbuttoned coat. Inscription: GVLIELMVS PITT [William Pitt].
Reverse inscription: In seven lines, THE MAN / WHO HAVING / SAVED THE / PARENT PLEADED / WITH SUCCESS / FOR HER / CHILDREN.
Literature: L. Brown 1980–95, 1: no. 100; Eimer 1998, no. 34; Eimer 2010, no. 713.

This medal commemorates the instrumental role played by William Pitt the Elder in the repeal of the widely disliked Stamp Act of 1765, which would have exacted money from American colonists, without the approval of their representatives, by compelling them to pay tax on papers, pamphlets, and all other printed documents. Pitt—already popular because of his opposition to corruption and his key role in

preserving, consolidating, and expanding the British Empire during and after the Seven Years' War (1756–63)—was successful in this plea for liberty on behalf of America, a "child" of the empire, by having the Stamp Act repealed. EM

838

Johann Lorenz Natter (1705–1763)
CHARLOTTE (b. 1744; Queen Consort of Great Britain and Ireland 1761–1818)
Dated 1761
Silver, struck; 34.4 mm
Scher Collection

Obverse: Charlotte, hair adorned with a fillet and pearls, in a bodice with laced-up arms and drapery pinned at the shoulder. Inscriptions: CHARLOTTA D[ei] G[ratia] M[agnæ] BR[itanniæ] FR[anciæ] ET HIB[erniæ] REGINA [Charlotte, by the grace of God, Queen of Great Britain, France, and Ireland]; L[orenz] N[atter] F[ecit] [Lorenz Natter made it].
Reverse: Fame crowning the queen before an altar with a burning flame; at her feet, a globe, garlanded. Inscriptions: QVAESITVM MERITIS [Obtained by merits]; L[orenz] N[atter]; in exergue, CORON[ata] XXII SEPT[embris] / MDCCLXI [Crowned on 22 September 1761].
Literature: L. Brown 1980–95, 1: no. 66; Pollard 2007, 2: no. 928; Eimer 2010, no. 696.

This medal commemorates the coronation of Charlotte of Mecklenburg-Strelitz as queen to George III of Great Britain (1738–1820). During the coronation, the medals were thrown to the populace. George III was declared insane in 1811, at which point his and Charlotte's son, the future King George IV, was made regent and Charlotte granted custody of her husband. EM

839

Possibly by John Kirk (ca. 1724–ca. 1778)
WILLIAM BECKFORD (1705–1770)
Dated 1770
Copper alloy, struck; 42.9 mm
The Frick Collection; Gift of Stephen K. and Janie Woo Scher, 2016
(2016.2.03)

Obverse: Beckford wearing a periwig, a small collar and cravat, an unbuttoned waistcoat over an ermine-trimmed robe, and the Livery Collar of the Lord Mayor of London; behind him, a sword and a crown. Inscription: WILL[ia]ᴹ BECKFORD ESQ[ui]ᴿ[e].
Reverse inscriptions: In six lines, THE ZEALOUS / ADVOCATE & INVA= RIABLE PROTECTOR / OF THE RIGHTS PRIV=ILEGES & LIBERTIES / OF THE PEOPLE; in exergue, in three lines, OBIIT 21 JUN[ii] 1770 / ANNO ÆTATIS / 65 [Died 21 June 1770, aged 65].
Literature: L. Brown 1980–95, 1: no. 141; Eimer 2010, no. 732.

This medal commemorates the death of William Beckford, twice Lord Mayor of London (1762–63, 1769–70). A pioneer of the Radical Movement and close political ally of William Pitt the Elder, Beckford was an outspoken critic of "pocket boroughs" (election districts "in the pocket" of an individual or family) and an advocate of political reform. He was a prominent supporter of John Wilkes, a journalist and politician who had spoken out against war with the colonies and subsequently been charged with libel. EM

840

Thomas Wyon Jr. (1792–1817)
GEORGE, PRINCE OF WALES (b. 1762; King of the United Kingdom 1820–30)
Dated 1814
Copper alloy, struck; 69 mm
Scher Collection

Obverse: George, laureate, in drapery pinned at the shoulder. Inscriptions: GEORGE PRINCE OF WALES REGENT; T[homas] WYON JUN[ior] S[culpsit] 1814 [Thomas Wyon Junior engraved it, 1814]; on truncation, RUNDELL BRIDGE & RUNDELL.
Reverse: Peace, with a caduceus at her feet and an olive branch in her hand, looking toward Liberty, who sits before a Phrygian cap on a pole and crowns herself with a floral wreath; to her left, Victory, winged and holding a palm branch in one hand and a laurel wreath in the other, with a helmet, sheathed sword, and shield emblazoned with the British flag by her feet; behind her, an ancient ship's prow; in exergue, a Hanoverian horse, flanked by a thistle and a fleur-de-lis (symbols of Britain and France, respectively) leaping over the inscription CENTENARY. Inscriptions: JUBILEE IN HONOUR OF THE PEACE 1 AUG[ust] 1814; in exergue, RUNDELL BRIDGE & RUNDELL; T[homas] WYON JUN[ior] S[culpsit] [Thomas Wyon Junior engraved it].
Literature: Schulman (Jacob) 1912, no. 781; L. Brown 1980–95, 1: no. 829; Pollard 2007, 2: no. 949; Eimer 2010, no. 1055.

The 1814 conquest of Hanover (a state that had been alternately under French and British control for a century) brought a temporary end to hostilities between France and Britain and coincided with the centenary of the Personal Union (i.e., the joint rule of Hanover and Britain by King George I, first monarch of the House of Hanover) commemorated by this medal. Because of his father's intermittent bouts of mental illness, George IV had been acting as prince regent (and thus de facto monarch) for three years by 1814, which is why his likeness (and not that of his father) is used on the medal's obverse. Rundell Bridge & Rundell was a firm of goldsmiths and jewelers that served as royal goldsmith from 1797 to 1843. EM

841

841

J. Barber (act. 1809–42) and Thomas Wyon Jr. (1792–1817)

GEORGE, PRINCE OF WALES (b. 1762; King of the United
Kingdom 1820–30)

Dated 1814

Silver, struck; 69.7 mm

Scher Collection

Obverse: George wearing a laurel wreath over his short, curled hair.
Inscriptions: GEORGIVS PRINCEPS WALLIÆ PATRIAM PRO PATRE REGENS
MDCCCXIIII [George, Prince of Wales, regent of the country for his
father, 1814]; on truncation, RUNDELL BRIDGE ET RUNDELL; J[ohn]
BARBER F[ecit] [John Barber made it].

Reverse: Winged Victory crowning Britannia, who wears a helmet
and carries a Union Jack–emblazoned shield and a spear, with a
laurel wreath, as she supports a crowned and kneeling Europa.
Inscriptions: SEIPSAM CONSTANTIÂ EUROPAM EXEMPLO [(Britain saved)
herself by her fortitude and Europe by her example]; on Europa's
cloak, EUROPA; in exergue, T[homas] WYON JUN[ior] S[culpsit] [Thomas
Wyon Junior engraved it].

Literature: L. Brown 1980–95, 1: no. 805; Eimer 2010, no. 1043.

Bearing the date of the first Treaty of Paris, this medal probably
commemorates what had seemed at the time to be the end of the
Napoleonic Wars. EM

842

Thomas Webb (act. 1797–1822) and Jean-Jacques Barre (1793–1855)

ADOLPHUS FREDERICK, DUKE OF CAMBRIDGE
(1774–1850; Viceroy of Hanover 1816–37)

Dated 1814

Silver, struck; 41 mm

Scher Collection

Obverse: Adolphus Frederick in full military uniform, wearing gold
bullion cord on his right shoulder and what appears to be the Star of
the Order of the Garter pinned to his breast. Inscriptions: H[is] R[oyal]
H[ighness] DUKE OF CAMBRIDGE; on truncation, WEBB F[ecit] [Webb
made it].

Reverse: Britannia, seated on a plinth with the British lion lying
by her side, feeding a pair of Hanoverian horses. Inscriptions: THE
ENGLISH RE-ENTER HANOVER; in exergue, MDCCCXIV [1814]; MUDIE
D[irexit] [Mudie directed/supervised it]; BARRE F[ecit] [Barre made it].

Literature: Bramsen 1977, no. 1489; L. Brown 1980–95, 1: no. 777;
Eimer 2010, no. 1058.

Part of the series of "National Medals" issued by James Mudie to
memorialize British victories in the Napoleonic wars, this medal
commemorates the conquest of Hanover, a state that had been
alternately under French and British control for a century. When
the French were finally expelled in 1814, Field Marshal Adolphus
Frederick, Duke of Cambridge (seventh son of George III and who
had served in the Hanoverian army), took command of the territory.
The reverse imagery is that of Hanoverian horses returned to the care
of Britannia. EM

842

843

843

Thomas Webb (act. 1797–1822) and George Mills (1792–1824)
PRINCESS CHARLOTTE (1796–1817)
Dated 1817
Silver, struck; 49.6 mm
Scher Collection

Obverse: Charlotte, her hair worn up and crowned with roses, wearing a fillet around her forehead, and a gown and cape with embroidered trim, clasped plainly in front. Inscriptions: H[er] R[oyal] H[ighness] PRINCESS CHARLOTTE AUGUSTA; WEBB F[ecit] [Webb made it]; W PUB [?]; in exergue, BORN IAN[uary] 7 1796 MARRIED MAY 2 1816 [Born January 7, 1796; married May 2, 1816].
Reverse: Britannia weeping, her head in her hand, holding a pole topped by a Liberty cap, seated beside the British lion; on the right, a crowned urn with oak branch and rose, on the left, a broken column and the sun's rays streaming through a cloud. Inscriptions: DIED NOV[ember] VI MDCCCXVII [Died November 6, 1817]; in exergue, in three lines, WEEP BRITAIN THOU HAST LOST / "THE EXPECTANCY AND ROSE / " OF THE FAIR STATE; MUDIE D[irexit] [Mudie directed/supervised it]; MILLS F[ecit] [Mills made it].
Literature: L. Brown 1980–95, 1: no. 940; Eimer 2010, no. 1097.

This medal memorializes Charlotte, the only child of King George IV and Caroline. The princess had been popular among those who disliked her father and wished for political reform, and her death (during childbirth) was a cause for mass mourning. EM

844

Thomas Wyon Sr. (1767–1830) after Peter Turnerelli (1774–1839)
PRINCESS CHARLOTTE (1796–1817)
1817
Copper alloy, struck; 50.6 mm
Scher Collection

Obverse: Charlotte, hair in a chignon, with curls framing her face, wearing a gown of light fabric with a lace trim beneath an ermine coat. Inscriptions: HER ROYAL HIGHNESS PRINCESS CHARLOTTE AUGUSTA &c[etera]; below, T[homas] WYON S[culpsit] [Thomas Wyon engraved it]; P[eter] TURNERELLI DES[ignavit] [Peter Turnerelli designed it].
Reverse inscriptions: In nine lines, BORN / JAN[uar]Y VII MDCCXCVI / MARRIED / TO H[is] S[erene] H[ighness] PRINCE LEOPOLD / OF SAXE COBOURG / MAY II MDCCCXVI / DIED NOV[embe]R VI / MDCCCXVII [Born January 7, 1796; married to His Serene Highness Prince Leopold of Saxe Coburg May 2, 1816; died November 6, 1817]; along border, outermost, THE VOICE OF WAILING IS HEARD; AS THE MORNING CLOUD, AS THE EARLY DEW, SHE PASSETH AWAY!; innermost, WHEN THE EAR HEARD HER IT BLESSED HER AND WHEN THE EYE SAW HER, IT GAVE WITNESS TO HER.
Literature: L. Brown 1980–95, 1: no. 943. EM

844

845

845

Peter Kempson (act. ca. 1798–ca. 1844)
CAROLINE, QUEEN OF THE UNITED KINGDOM (b. 1768; r. 1820–21)
Dated 1820
Copper alloy, struck; 41 mm
Scher Collection

Obverse: Caroline, hair curled and worn in a chignon and decorated with pearls, wearing a laurel wreath, a lace-trimmed gown of light fabric, and an ermine robe, as well as a pearl necklace and pendant (possibly a cameo portrait of her daughter, Charlotte). Inscriptions: CAROLINE D[ei] G[ratia] BRITT[onum] REGINA [Caroline, by the grace of God, Queen of the Britons]; beneath bust, K [Kempson].
Reverse: Britannia standing on the seashore before an altar, with spear and Union Jack shield, holding a laurel wreath and welcoming a ship. Inscriptions: HAIL! BRITAIN'S QUEEN! THY VIRTUES WE ACKNOWLEDGE AND LAMENT THY WRONGS; in exergue, in two lines, RETURNED TO ENGLAND / JUNE 5 1820.
Literature: L. Brown 1980–95, 1: no. 1021; Eimer 2010, no. 1130.

This medal celebrates Caroline's return from exile in 1820, six years after having left the country at the behest of her unpopular husband, King George IV, who refused to recognize her as his wife. Over the course of her life, Caroline became a powerful figurehead for the growing public desire for political reform. She is hailed here as Queen of the Britons, a title she held only nominally. The "wrongs" mentioned on the reverse are her rumored infidelities, which did not detract materially from her public support. EM

846

Alfred Joseph Stothard (1793–1864)
GEORGE GORDON, LORD BYRON (1788–1824)
Dated 1824
Copper alloy, struck; 63.6 mm
Scher Collection

Obverse: Byron, hair worn short and curled, within a thin, beadwork-like border. Inscription: ΒΥΡΩΝ [Byron].
Reverse: Leafy branches of laurel, standing upright in the ground, being struck by lightning that emanates from the clouds above. Inscription: ΑΦΘΙΤΟΝ ΑΙΕΙ [Imperishable forever].
Edge inscription: Γ ΠΙΚΕΡΙΝΓ ΚΑΙ Γ ΓΟΡΘΙΝΓΤΩΝΤΟΣ ΚΑΘΙΕΡΩΣΙΣ Α Ι ΣΤΟΘΑΡΔ ΕΠ αωχδ [A tribute from W. Pickering and W. Worthington; made by A. J. Stothard, 1824].
Literature: L. Brown 1980–95, 1: no. 1231; Eimer 2010, no. 1172; Ng 2017, 39–40.

Produced through the collaboration of the die engraver Stothard with publishers Pickering and Worthington (whose identities are not certain; see L. Brown 1980–95), this medal commemorating the hugely popular English poet's death while fighting for Greek independence was sold by subscription. The reverse evokes a passage from the narrative poem that launched Byron's fame: "For the true laurel-wreath which Glory weaves / Is of the tree no bolt of thunder cleaves" (*Childe Harolde's Pilgrimage*, canto IV, stanza XLI). AN

847

William Wyon (1795–1851)
PRINCESS VICTORIA (b. 1819; Queen of the United Kingdom 1837–1901)
Dated 1837
Silver, struck; 36.2 mm
Scher Collection

Obverse: Victoria, with hair bound up in a tightly braided bun, wearing a chaplet of roses and a pearl tear-drop earring. Inscriptions: 1837; on truncation, W[illiam] WYON ARA [William Wyon, Associate of the Royal Academy].

846

847

848

Reverse: Wreath of lilies and roses tied with a bow, surrounding an inscription. Inscription: in six lines, HER / ROYAL HIGHNESS / THE / PRINCESS VICTORIA / BORN XXIV MAY / MDCCCXIX.
Literature: Eimer 2010, no. 1294.

This medal probably commemorates the coming-of-age of the eighteen-year-old princess. EM

848

George William de Saulles (1862–1903) after Thomas Brock (1847–1922) and William Wyon (1795–1851)
VICTORIA, QUEEN OF THE UNITED KINGDOM (b. 1819; r. 1837–1901)
Dated 1897
Gold, struck; 55.6 mm
Scher Collection

Obverse: Victoria at age seventy-eight, with hair and crown half-concealed under a veil, wearing a pearl tear-drop earring, a pearl or diamond necklace with pendant, and a blouse of light material under a gown, with what appears to be the Star of the Order of the Garter pinned above her heart. Inscription: VICTORIA ANNVM REGNI SEXAGESIMVM FELICITER CLAVDIT XX IVN[ii] MDCCCXCVII [Victoria successfully completed the sixtieth year of her reign, 20 June 1897].
Reverse: The young Victoria, hair drawn back into a loose knot, with a simple fillet worn around the head; beneath her, a branch of laurels tied with a ribbon. Inscriptions: left, in six lines, LONGI=TVDO / DIERVM / IN / DEXTERA / EIVS; right, in three lines, ET IN / SINISTRA / GLORIA [Length of days is in her right hand; and in her left hand riches and honor (Proverbs III:16)]; below, 1837.
Literature: L. Brown 1980–95, 2: no. 3506; Eimer 2010, no. 1817.

For the Royal Mint, De Saulles produced the official medal commemorating Victoria's Diamond Jubilee, celebrating sixty years of rule, after designs by Brock (obv.) and Wyon (rev.). EM

849

Theodore Spicer-Simson (1871–1959)
GEORGE FREDERICK WATTS (1817–1904)
Dated 1904
Copper alloy, cast; 84.5 mm
Scher Collection

Obverse: Watts, bearded, wearing a skullcap, a shirt with a small, stiff collar, and a smock or loose-fitting over-garment. Inscriptions: G[eorge] F[rederick] WATTS; A[nno] D[omini] MCMIV [In the year of the Lord 1904]; on the sitter's shoulder, TSS [artist's initials].
Literature: Spicer-Simson 1962, 56.

Spicer-Simson created this medal of Watts, the English painter and sculptor, shortly before the artist's death. Though Watts felt he was too old to sit for his portrait, he acquiesced to Spicer-Simson's requests to study him at work. Watts's costuming, which recalls the famous self-portrait by Titian, likens him to the Renaissance artist. EM

849

850

851

850

Theodore Spicer-Simson (1871–1959)
ELLA MIELZINER (1873–1968)
Copper alloy, cast; 173 mm
Dated 1906
Scher Collection

Obverse: Mielziner seated on a bench, with hair worn pinned beneath a pillbox hat (decorated with three flowers) draped with a long veil, wearing a long dress with a lace or embroidery neck and elbow-length, leg-of-mutton sleeves (bound tight around the upper arm), holding a parasol in her lap and a pair of gloves in her hand. Inscriptions: T[heodore] S[picer]-S[imson] FEC[it] A[nno] D[omini] MCMVI [Theodore Spicer-Simson made it in the year of the Lord 1906]; ELLA MIELZINER.
Literature: Spicer-Simson 1962, 23.

Probably part of the artist's series of medallic portraits of friends, artists, and people of influence, this medallion was made at a time when Mielziner, an American friend of Spicer-Simson's, was living in Paris and working as a fashion correspondent for a Boston newspaper. She was the mother of Jo Mielziner, the famous stage set designer. EM

851

Theodore Spicer-Simson (1871–1959)
JAMES STEPHENS (1880–1950)
Dated 1913
Copper alloy, cast; 102.9 mm
Scher Collection

Obverse: Stephens, mustachioed and with short hair, wearing a jacket, soft collar, and cravat; in the upper left field, a crockpot with a serpent coiled above it. Inscriptions: on the left, in three lines, JAMES / STEPHENS / 1913; on the right, in two lines, T[heodore] S[picer]-S[imson] / FEC[it] [Theodore Spicer-Simson made it].
Literature: Spicer-Simson 1962, 149.

Like the previous medal, this medal of the Irish novelist and poet James Stephens was most likely created by Spicer-Simson for his series of medallic portraits. The medal refers specifically to Stephens's famous novel *The Crock of Gold*, published in 1912. EM

RUSSIA and SCANDINAVIA

THE TALE OF THE ELEPHANT, THE DRAGON, AND OTHER EXTINCT ANIMALS

The Early History of Medallic Art in Denmark, Sweden, and Russia

Marie-Astrid Pelsdonk

THE ELEPHANT

Because of its geographic position and cultural and dynastic connections, Denmark—for which the elephant has long been a symbol—was the first Scandinavian country to be introduced to medallic art. Christian I (b. 1426; King of Denmark 1448–81; King of Norway 1450–81; King of Sweden 1457–64, 1465–67) was the first Scandinavian king to have his portrait immortalized on a medal. The goldsmith Bartolommeo di Virgilio Melioli (1448–1514) made a very accurate portrait—a sharp profile—of the monarch, who had traveled to Rome in 1474 while visiting his brother-in-law Lodovico Gonzaga of Mantua. This medal is said to be the only authentic portrait of the Danish dynasty's forefather.[1]

The practical knowledge required for medal making was introduced to the country from abroad, often through an artist who had been invited by the neighboring royal court to visit Sweden. This is the case with the French artist Erich Parise (d. 1666), who, while staying at the Swedish court of Queen Christina, made some medals for the Danish king (no. 857).[2]

THE LION OF THE NORTH

Medallic art first came to Sweden in the mid-sixteenth century. The earliest known and documented medal is believed to have been by the Flemish artist Willem Boy (ca. 1520–1592) and was made in 1560 on the occasion of the burial of King Gustav I Vasa (ca. 1496–1560). Some versions of this medal were cast in gold, mounted on chains, and awarded to the pallbearers.[3] However, the art of the medal would not really develop in Scandinavia until the early seventeenth century. In Sweden, under the reign of King Gustavus II Adolphus (1594–1632), also known as the Lion of the North, the German *Gnadenpfennig* (known in Sweden as *klenoder*)—a portrait medal first developed in Germany during the 1580s and used until the mid-seventeenth century—was produced in large quantities (fig. 36).

The Scher Collection includes a small selection of medals from the reign of Gustavus II Adolphus (see nos. 376–379 and 854–856). One of these medals (no. 855) is a *Gnadenpfennig*, one of the most prestigious rewards a king could give a hero or government official. These portrait medals were made in precious metals, often enameled,

Fig. 36 Kilian Schenk,
Gustavus II Adolphus, 1631
Gold with green, blue, and
white enamel, one loop at the
top and one at the bottom,
49 × 40 mm
Royal Coin Cabinet, Stockholm

cut along the outline of the portrait, and adorned with pearls and precious stones. The king awarded these medals freely, mainly to his officers and confidants. Later casts of these signs of distinction were made after the death of the king (November 6, 1632) and until 1635. Sometimes a pearl or a skull, made in metal and enameled, hangs beneath the medal. These precious gems were added after the king's death and were a posthumous sign of the bearer honoring his deceased monarch. The medals had rings so they could be worn on a chain around the neck or across the chest on links of gold, as shown in a portrait of Colonel Jacob Scott (d. 1635) (fig. 37).[4]

The death of the much revered, heroic Gustavus II Adolphus at the Battle of Lützen (Germany) was commemorated in many ways. The king's arms supplier, Von Siegroth, had a copper etching printed in the Netherlands that showed the king's "triumphs in death" on two oval medal-like pictures. In one of them, the dead monarch lies on the ground in armor while his soul ascends to heaven. In the other, he sits—half skeleton—in a chariot, crushing his enemies under its wheels while two angels place a wreath of victory on his head. The inscriptions in Latin enhance the already rich symbolism: "Although dead they [the enemy] flee from him." This etching became the model for many medals, most of them of very mediocre artistic quality. However, for the king's funeral in Stockholm in June 1634 (more than a year after his death), a large medal was ordered from one of the greatest engravers of the time, the German-born Sebastian Dadler (1586–1657) (fig. 38). He had been active

Fig. 37 Unknown artist,
Colonel Jacob Scott, 1634
(medal detail shown at right)
Oil painting on canvas,
107 × 86 cm
National Museum, Stockholm
(NMGrh 2594)

Fig. 38 Detail of reverse of no. 379, showing Sebastian Dadler's initials on the wheel

in Dresden and, while the king still lived, had honored him with a few medals. Since Sweden did not possess a medal press at the time (that technology arrived in the 1640s), this particular medal was manufactured in Hamburg and then sent to Stockholm. Very few examples of the medal in gold are known: one is currently at the Royal Coin Cabinet in Stockholm, one in a coin museum in Avesta (Sweden), and another in the coin cabinet of the Kunsthistorisches Museum in Vienna. Versions of the medal in silver seem to have been given to the pallbearers during the king's funeral.[5]

To acquire quality medals, Sweden had to order them from great artists abroad, such as Sebastian Dadler and Anton Meybusch (ca. 1645–1702), or from artists trained and taught by foreign engravers, such as Johann Carl Hedlinger (1691–1771). Arvid Karlsteen (1647–1718) is considered the first Swedish-born medal artist. He came from a modest background but showed talent during his apprenticeship at the mint at Avesta. After studying abroad, he was hired to make medals for the Swedish king Charles XII (no. 860). The quality of his craftsmanship was renowned in both Sweden and Europe: the French king Louis XIV ordered medals from him.[6] After Karlsteen's death, Swiss-born Hedlinger was asked to take his place. This talented artist also worked in Russia and Germany (see no. 862).

Medals are often seen as objects that glorify a ruler, a victory in battle, or the greatness of architecture; what is frequently lost sight of is fashion. During the reign of Charles XII (b. 1682; r. 1697–1718), the fashion depicted on medals shocked the rest of Europe. Traditionally, a monarch was shown wearing a wig, an indication of status, but Charles XII found this old-fashioned—he probably hated contemporary wigs, which were hot and scratchy—and declared that he would no longer be portrayed with such headgear. Arvid Karlsteen complied with his request (see no. 860), but the European artists did not—possibly because they were unaware of it (fig. 39). Although it shocked the European courts to see these wigless portraits, more would follow: the medals had introduced a new fashion. As a result, when looking at medals with a Swedish subject from this period, it is easy to determine whether they are a Swedish design or were made elsewhere in Europe.

Fig. 39 Christian Wermuth, *Charles XII, Victory against Denmark, Poland, and Russia*, 1702
Silver, 47 mm
Royal Coin Cabinet, Stockholm

THE DRAGON

In Russia, the national mint was created in Moscow in 1534, but it was not until 1701, during the reign of Peter the Great (b. 1672; Tsar of All Russia 1682–1721; Emperor of All Russia 1721–25), that the first Russian medals were produced. As in the Scandinavian countries, foreign engravers and artists came to Russia to design and produce medals and to train local engravers. Not wanting medals inferior in quality to those of his enemies, Peter the Great made sure that the best tools and techniques were used. He did so by visiting the mint in London in the company of Isaac Newton (not only a physicist and mathematician but also Master of the Royal Mint), by studying the French engraving art at the Monnaie des Médailles at the Louvre, and by ordering the finest tools from Nuremberg. Back in Russia in 1719, he planned the construction of a new mint in Saint Petersburg. This project was, however, very quickly abandoned; instead, the Netherlands—which was aiding Russia with economic and technological development—was asked to help the mint in Moscow develop a skilled workforce.[7]

In 1709, Peter the Great had decided to immortalize his military victories in medals. Between 1713 and 1714, the German engraver Philipp Heinrich Müller (1654–1719) was asked to make a series of twenty-eight medals commemorating the greatest victories of the tsar against the Swedish enemy. The dies were then sent from Augsburg to Russia where they were used extensively, with the series given to dignitaries all across Europe. The dies started to become damaged and many broke, and the Russian artist Ossip Kalashnikov was asked to copy them. Kalashnikov was later helped by Timothei Iwanoff (1729–1802) (no. 865) and Samuel Judin (1730–1800) (no. 870) and by many anonymous hands. This extended copying of the same iconographic material is a unique phenomenon not found anywhere else in such a systematic way. This explains why, today, when studying a Russian medal collection, one can find on the reverse of medals the exact same iconography, with only minor differences in the tsar's portrait.[8]

THE TALE

Whether commemorating victory in a battle or taunting the enemy, medals were in a sense the newsflashes of the time. For the Russians, the medals of the conquest of Reval (no. 865) and of the battle at the estuary of the Neva (no. 864) are signs of pride; for the Swedes, of total humiliation. The feeling persisted for many years: in the mid-nineteenth century, while describing the Swedish medals in the collection of the Royal Coin Cabinet, the keeper of medals, Bror Emil Hildebrand (1806–1884), explained in his introduction why he had refused to describe what he called "enemy commemorating and blasphemous medals."[9]

These victory or battle medals typically show with accuracy and detail where and how the battles occurred, but sometimes the artist employed symbolism to make the enemy's humiliation even greater. This is the case for a medal on the fall of Tönning (in the territory of Holstein-Gottorp, present-day Germany) (fig. 40). No armies, generals, or kings are depicted, only animals. But are they just animals? Like the French writer Jean de la Fontaine, the medalist used animals to represent humans or countries. On the obverse, there is an elephant (Denmark), an ibex (*stenbock* in Swedish/Danish, for the name of the Danish field marshal Magnus Stenbock), a wolf (for Zacharias Wolff, the commander of Tönning), a dragon (Russia), and a leopard (Saxony-Poland). The unknown artist was

Fig. 40 Unknown artist, *The Fall of Tönning*, no date
Silver, 63 mm
Royal Coin Cabinet, Stockholm

probably Danish or German.[10] To the present-day eye, it may seem like a scene from the books of C. S. Lewis, but the eighteenth-century beholder would have seen this as a political message.

THE TAIL

Though not very large, the Scher Scandinavian/Russian collection includes some remarkable pieces. Among them is a depiction of King Christian IX of Denmark (1818–1906) (no. 863), a simple portrait in ivory with a frame carved in boxwood. Since this medal could not be found in the literature, experts at three Danish museums with renowned medal collections were consulted.[11] All three have indicated that the medal is completely unknown to them: not quite an extinct animal but an exquisite object.

The Scher medals are primarily from the seventeenth through nineteenth centuries, but medallic art in Scandinavia and Russia is by no means defunct. It has continued to evolve. In 2014, the Russian artist Irina Suvorova (b. 1965) won a prestigious international prize from the Fédération Internationale de la Médaille d'Art for her medals, which are really sculptures in miniature (fig. 41).[12] They are nothing like what Pisanello created when he began to make medals, but one wonders what he would have thought about the evolution of this art.

Notes
1 Galster 1936, 1–4; Areen 1938, 25.
2 Bildt 1908, 23–32; Rasmusson 1961, 365–66.
3 Hildebrand 1874, 10–11; Lagerqvist 2003, 34.
4 Lagerqvist 1998b; Voisin 2002, 89; Voisin 2003, 106–7; Lagerqvist 2012, 178–79.
5 Lagerqvist 1982, 3–8; Lagerqvist 1998a; Hildebrand 1874, 192–93.
6 Renqvist 1931; Stenström 1944.
7 Coullaré 2006, 29–52.
8 Ibid.
9 Ossbahr 1927, 11; Voisin 2005, 49.
10 Ossbahr 1927, 208–9.
11 The three museums were the National Museum (Royal Coin and Medal Collection), Rosenborg Castle, and the museum at Amalienborg Palace.
12 fidem-medals.org/index.html

Fig. 41 Irina Suvorova,
Noah's Ark, 2013
Glass, coagulate,
130 × 125 × 30 mm
Courtesy the artist

852

852

Unknown artist
ANSELM EPHORINUS (ca. 1498–1566) and **SOPHIA
[FOGELWEDER]** (b. ca. 1525)
Dated 1557; this example a later cast
Silver, cast; 93 mm
Scher Collection

Obverse: Ephorinus wearing a shirt with a high collar, a flat cap,
and a heavy chain around his neck; to the right, the coat of arms of
Ephorinus with the crest of a woman holding an olive branch in the
left hand and a pentagram in the right hand. Inscription: ANSELMVS
EPHORINVS MEDICVS ANNO ÆTATIS L IX AN[no] D[omini] M D L VII
[Anselm Ephorinus, physician, aged 59 in the year 1557].
Reverse: Sophia wearing a dress with a high collar, a decorated
snood holding her hair, a heavy chain around her neck and a cross
on a chain; to the right, the coat of arms of Fogelweder with the
crest of a clothed child wearing a sash charged with four stars from
the coat of arms. Inscription: SOPHIA DOCTORIS ANSELMI VXOR AN[no]
ÆTATIS XXXII AN[no] M D LVII [Sophia, Doctor Anselm's wife, aged 32
in the year 1557].
Literature: Von Zu-Rhein sale 1920, 112–13, no. 1980 (this
specimen); Brettauer 1937, no. 312; Brand 1997, 428, no. 7726 (this
specimen); Peus 2008, 41, no. 1253; M. Hirsch in Cupperi et al.
2013, no. 4728.

During extensive travels, Ephorinus, a physician and distinguished
humanist in Krakow (present-day Poland), became friendly with
Erasmus, Melancthon, Amerbach, and other leading humanists with
whom he also carried on voluminous correspondence. He amassed
a large and valuable library. MAP, SKS

853

Unknown artist
PRINCESS HEDWIG OF DENMARK (1581–1641; Electress of
Saxony 1602–11)
After 1602
Silver, cast; 33.6 × 28 mm
Scher Collection

Obverse: Hedwig wearing a cloak and dress with ruff, necklace,
and earring. Inscription: HEDWIG D[ei] G[ratia] N[ata] REG[is] DAN[iæ]
DV[cissa] SAX[onia] ELEC[trix] [Hedwig, by the grace of God, born of
the King of Denmark, Duchess and Electress of Saxony].
Reverse: Two putti holding a crown above a coat of arms of the
House of Oldenburg. Inscription: in exergue, A[lles] W[ie] E[s] G[ott]
G[efällt] E[r] W[ird] W[ohl] S[chaffen] N[ach] S[einem] W[illen] [Everything
as pleases God. He will create according to His will].
Literature: Tentzel 1714, 364.

Hedwig was the seventh child of King Frederick II of Denmark and
Sophie of Mecklenburg-Güstrow. One of her sisters was Princess
Anne of Denmark, future Queen of England and Scotland, and one
of her brothers became Christian IV of Denmark. She was married on
September 12, 1602, to Christian II, Elector of Saxony, in Dresden.
The inscription on the reverse is Hedwig's motto. MAP

853

854

855

854

Unknown artist

GUSTAVUS II ADOLPHUS, KING OF SWEDEN (b. 1594; r. 1611–32)

Dated 1629

Gilt copper alloy, cast; 46.9 × 38.1 mm

Scher Collection

Obverse: Gustavus, crowned with laurel, wearing a high tip collar and armor with a commander's sash held by a round brooch on his shoulder. Inscription: GVSTAVVS ADOLP[hus] D[ei] G[ratia] SVEC[orum] GOTH[orum] WAND[alorum] Q[ue] REX [Gustavus Adolphus, by the grace of God, King of the Swedes, Goths and Wends].

Reverse: On the left, Hope fully dressed, standing with hands joined in prayer and her left foot resting on her symbol, an anchor, and looking toward the name of God; to the right, Courage, dressed in armor and helmet, leaning on a column with her right arm and with her left hand resting on the head of a lion at her feet. Inscriptions: at top, sun rays with the inscription הדהד [Hebrew for Jehovah], ET VICTRICIBVS ARMIS [(With the help of) God and victorious arms]; in exergue, M DC XXIX [1629].

Literature: Hildebrand 1874, 146, no. 87; Lagerqvist and Åberg 2002, 38, no. 52.

This medal, of which there are several variations, is believed to have been cast before the king's participation in the Thirty Years' War (1618–48) in 1630. The reverse depicts a version of the king's motto, which is, in full: Deo et Victricibvs Armis [(With the help of) God and victorious arms]. MAP

855

Kilian Schenk (dates unknown)

GUSTAVUS II ADOLPHUS, KING OF SWEDEN (b. 1594; r. 1611–32)

Dated 1631

Gilt silver, cast; 51.1 × 44 mm (from interior of bottom loop to interior of top loop)

Scher Collection; Promised gift to The Frick Collection

Obverse: Gustavus, crowned with laurel, wearing a high, decorated tip collar and armor with a commander's sash thrown over his shoulder; broad laurel frame. Inscription: GVST[avus] ADOLP[hus] D[ei]

G[ratia] SVEC[orum] GOT[horum] WAND[alorum] REX M[agnus] P[rinceps] F[inlandiæ] D[ux] E[sthoniæ] ET C[areliæ] I[ngriæ] DO[minus] [Gustavus Adolphus, by the grace of God, King of the Swedes, Goths and Wends, Grand Duke of Finland, Duke of Estonia and Karelia, Lord of Ingria].

Reverse: A lion rampant carrying a sword and shield standing on weapons and armor belonging to the enemy. Inscriptions: DEO ET VICTRICIBVS ARMIS [(With the help of) God and victorious arms]; at beginning and end of previous inscription, 16 31; under the belly of the lion, the initials K[ilian] S[chenk]; engraved at a later date with the name of the recipient of the medal, PETER STANG.

Literature: Hildebrand 1874, 151, no. 95; Zulch 1935; Lagerqvist and Åberg 2002, 38, no. 52; Lagerqvist 2012, 180, no. 8.

Several variations of this *Gnadenpfennig* are known—some cast, others struck before or after the king's participation in the Thirty Years' War (1618–48). Awarded to soldiers for bravery in battle and others who had served the king loyally, they were meant to be carried as a token of admiration for the king and his fight for the freedom of religion of the Protestants. Some medals have a ring underneath with a pearl or a skull with two bones; these were mounted after the king's death to indicate that the bearer would continue what the king had begun. The monogram "KS" was unknown until 2012, when the probable name of the goldsmith—Kilian Schenk, from Frankfurt am Main—was found in *Frankfurter Künstler 1223–1700* by W. K. Zulch (1935). The reverse depicts the king's motto. MAP

856

Unknown artist

GUSTAVUS II ADOLPHUS, KING OF SWEDEN (b. 1594; r. 1611–32)

ca. 1630–32

Silver, embossed, from Nuremberg or Stettin (Germany), with hallmark in the field on the left of Paul Walter from Dresden; obverse 97.3 × 71.3 mm (with frame), reverse 97.3 × 73 mm (with frame)

Scher Collection

Obverse: Gustavus, standing in full armor on a shore, holding a sword in his right hand and a scepter in his left hand, and wearing a commander's sash; to his left, on a cliff surrounded by breaking

856

waves, a round column, on top of which a fire burns with the inscription VERBVM DEI [the word of God]; in the background on the horizon, a ship sailing; to the king's right, at his feet, a helmet with feathered crest. Inscriptions: above the king, GVSTAV[us] ADOLPH[us] D[ei] G[ratia] SUEC[orum] GOTH[orum] VAND[alorum] REX MAG[nus] PRIN[ceps] FINL[andiæ] DVX ETHO[niæ] CAR[eliæ] DOM[inus] ING[riæ] [Gustavus Adolphus, by the grace of God, King of the Swedes, Goths and Wends, Grand Duke of Finland, Duke of Estonia and Karelia, Lord of Ingria]; CUM DEO ET VICTRICIBUS ARMIS [With (the help of) God and victorious arms]; in exergue, in three lines, ENSEM GRADIVUS SCEPT=RUM THEMIS IPSA / GUBERNAT [Mars guides (his) sword, Themis herself guides (his) scepter].

Reverse inscription: In eleven lines, PRO VERBO FERRO [For the word of iron] / FÜR GOTTES WORTT DAS [image of a sword standing for the word "sword"] ICH FÜHR / HERR CHRISTE DIR GILTS UND NICHT MIR. / DEIN WORTT MAG NIMMER UNTERGAHN / SCHWE_R_D HAT SEIN BESTS DABEY GETHAN. / WIDER DER WELT GOTTLOS WELLEN, [ornament] / MITT GOTT SICH WAGT SELB ZU STELLEN. / HERR CHRIST THU IHM GLÜCKLICH BEISTHAN. / NIM DICH DEINS KLEINEN HEUFLEINS AN, / DAS DICH LOB EHR PREISS / JEDERMAN [(He, Gustavus Adolphus, fights) through the sword for the word (of God). For God's word I wield the (sword) / Lord Christ, I do it for you and not for me / May your word never fade. / The sword has done its best therefore. / Against the world's godless waves / he (Gustavus Adolphus) dare to stand with the help of God. / Lord Christ, stand by his side and bring him luck! / Take care of your little herd, / so that everyone will bless, honor and praise you]. At the top, within beams of heavenly light a cross; above, the inscription IN HOC SIGNO VINCES [In this sign you will conquer].
Literature: Hildebrand 1874, 129–30, no. 53; Lagerqvist and Åberg 2002, 38, no. 52; Peus 2004, no. 2358.

This medal depicts the joy of the German Protestants over the king's victory against their religious enemies. The Swedish king was seen as

a tool of God sent to save the Swedes from oppression. In the fourth line, the first word (Schwe_r_d) has a smaller sunken r, allowing it to be read either as Swede (Schwed) or sword (schwerd). The medal is believed to have been made in Nuremberg between 1630 and 1632. MAP

857

Erich Parise (d. 1666)
FREDERICK III, KING OF DENMARK AND NORWAY
(b. 1609; r. 1648–70) and **SOPHIE AMALIE OF BRUNSWICK-LÜNEBURG** (1628–1685)
Late 1650s
Silver, cast; 39.8 mm
Scher Collection

Obverse: Frederick, crowned with laurel, wearing armor all'antica and a commander's sash. Inscriptions: DOMINVS PROVIDEBIT [The Lord will provide]; beneath the portrait, EP [artist's initials].
Reverse: Sophie Amalie, crowned with laurel, a strand of pearls in her hair, wearing a dress and draped mantle fixed by diamond-shaped brooches. Inscription: SPES MEA IN DEO [My hope is in God].
Literature: Galster 1936, 58–59, no. 81; Lilja 1961, 365–66.

857

858

Erich Parise was known for having made medals of the Swedish queen Christina. In the late 1650s, he traveled with the queen to Denmark, where he made medals of the Danish king Frederick III and his wife, Queen Sophie Amalie. MAP

858

Gotfred Krüger (dates unknown)
CHRISTIAN V, KING OF DENMARK AND NORWAY (b. 1646; r. 1670–99)
ca. 1670
Silver, struck; 48.2 × 47.4 mm
Scher Collection

Obverse: Christian, crowned with laurel, wearing armor with a commander's sash, lion skin, and a ribbon with the Order of the Elephant; portrait enclosed in a laurel frame; on each side and under the portrait, three leopards under which are three hearts; above, sun rays with the inscription הדהד [Hebrew for Jehovah].
Reverse: An elephant, standing in a flowery field and guided by a seated Moor in a turban holding a goad, carries a watch tower, from which hangs the Danish flag and which contains four armed warriors; on the side of the elephant, a shabrack with the crowned monogram of the king within a circle formed by two snakes, a symbol of eternity: C[hristian] 5; in exergue, GK [artist's initials].
Literature: Forrer 1904–30, 3: 227; Galster 1936, 126, no. 200. This medal was made around the time of the coronation of Christian V. Two variations are known. One is with the initials "G K," the mark of Gotfred Krüger (mint master in Copenhagen between

1665 and 1680); the other is without initials. Officially founded in 1693 but with origins in the fifteenth century, the Order of the Elephant is the highest order of Denmark. With the establishment of constitutional monarchy in 1849, it is now bestowed almost exclusively on royalty and heads of state. MAP

859

Christopher Schneider (d. 1701)
ADMIRAL NIELS JUEL (1629–1697)
Dated 1677
Silver, struck; 69.4 mm
The Frick Collection; Gift of Stephen K. and Janie Woo Scher, 2016 (2016.2.179)

Obverse: Juel holding a baton in his right hand and wearing a lace cravat, a coat of chamois leather, a belt, a commander's sash, and the bejeweled cross of the Order of Dannebrog; on his left side, two cannons; in the background, a battle at sea. Inscriptions: D[omi]N[us] NICOL[aus] IVEL EQ[ues] R[egis] D[aniæ] ARCHITHAL[assus] [Lord Niels Juel, knight, admiral of the King of Denmark]; on truncation, CS [artist's initials].
Reverse: View of the battle scene with many ships (at least 100 took part in the battle), some sinking. Inscriptions: PRAELIVM INTER CLASSES CHRIST[iani] V ET CAR[oli] XI I IVL[ii] MDCLXXVII D[omi]N[is] NICOL[aus] IVEL ET HENR[ico] HORN DVC[ibus] [Battle between the fleets of Christian V and Charles XI under the direction of lords Niels Juel and Henrik Horn, 1 July 1677]; at the bottom, amid the waves, CS [artist's initials].
Literature: Hildebrand 1860, 60–61, no. 1; Forrer 1904–30, 5: 286, 394–95; Ossbahr 1927, 129–30, no. 71; Galster 1936, 84, no. 126; Thieme and Becker 1907–50, 30: 192.

On June 30, 1677, at the Battle of Køge Bay during the Scanian War (1675–79) between Denmark and Sweden, Admiral Juel won his greatest victory, routing the fleet of the Swedish admiral Henrik Horn. Juel was made lieutenant admiral general and a privy councilor. The medal was also struck in gold to be worn with a blue ribbon and was awarded to the officers serving under Admiral Juel at the Battle of Køge Bay. MAP

859

860

860

Arvid Karlsteen (1647–1718)
CHARLES XII, KING OF SWEDEN (b. 1682; r. 1697–1718)
1702
Silver, struck; 52.5 mm
The Frick Collection; Gift of Stephen K. and Janie Woo Scher, 2016
(2016.2.209)

Obverse: Charles wearing armor and a commander's sash.
Inscriptions: CAROLVS XII D[ei] G[ratia] REX SVECIAE [Charles XII, by the
grace of God, King of Sweden]; on truncation, AK [artist's initials].
Reverse: Two trophies composed of the armor, arms, and flags of the
enemies; each holding a shield charged with crossed swords;
on each side, small trees; above, a sun with the inscription: 9 IVLII
[9 July]. Inscriptions: LVX BINIS CLARA TRIVMPHIS [A day illuminated
by two triumphs]; in exergue, A[nn]° 1701 AD DVNAM / ET A[nn]°
1702 AD / CLISSOVAM [The year 1701 at Düna and the year 1702 at
Klissow].
Literature: Hildebrand 1874, 519, no. 73; Forrer 1904–30, 3:
118–22; Lagerqvist and Åberg 2002, 40, no. 56.

This medal commemorates the victory of the Swedes over the armies
of King August of Poland and Saxony at the Battle of Klissow on
July 9, 1702, which was also the one-year anniversary of the victory
of the Battle of Riga (Düna), both battles fought during the Great
Northern War (1700–1721). MAP

861

Anton Schultz (act. 1716–24)
CHRISTIAN VI OF OLDENBURG (b. 1699; King of
Denmark and Norway, Duke of Schleswig and Holstein, and
Count of Oldenburg and Delmenhorst 1730–46) and **SOPHIE
MAGDALENE OF HOHENZOLLERN** (b. 1700; Margravine of
Brandenburg-Kulmbach, Queen of Denmark 1730–70)
Dated 1721, made 1723
Silver, struck; 60.9 mm
Scher Collection; Promised gift to The Frick Collection

Obverse: Christian wearing a peruke, armor, a ribbon with the
Order of the Elephant, and a commander's sash, facing Sophie
Magdalene, wearing jewels, a dress with large décolleté, and a
shawl. Inscriptions: CHRISTIAN DAN[mark] NORG[e] DE WEND[ers]
OG GOTH[ers] / ARVE OG CRONPRINTZ [Christian of Denmark and
Norway, the Wends and the Goths / by heredity Crown Prince].
SOPHIE MAGDALENE CRONPRINCESSE / F[ødt] MARGGR[evinde]
AF BRANDENB[urg] [Sophie Magdalene, Crown Princess / born
Margravine of Brandenburg]; in exergue, F[ødt] 1699 30 NOV[ember]
F[ødt] 1700 28 NOV[ember] [born November 30, 1699 / born
November 28, 1700] / A[nton] SCHVLTZ F[ecit] [Anton Schultz
made it].
Reverse: Orange tree. Inscriptions: KONGENS ARVE STAMMES GREENE
VED SOPHIE MAGDALENE / MOTTE MANGE FRVGTER FAAE OG FØR
VERDEN EI FORGAAE [The succession of the King descends with the

861

862

branches of Sophie Magdalene / May many fruits fall and for the world a successor]; in the exergue, BILAGER HOLDET I PRETSCH / 1721 DEN 7 AVG [Royal wedding held in Pretzsch / the 7th of August 1721].
Literature: *Thesaurus numismatum* 1789–90, no. 361; Forrer 1904–30, 5: 407; Galster 1936, 202–3, no. 336.

This medal celebrates the marriage of Christian and Sophie Magdalene held at the Castle of Pretzsch (Duchy of Magdeburg, a province of the Kingdom of Prussia) on August 7, 1721. The reverse depicts the hope for the future security of the Danish monarchy. It was imperative that the commissioned medal be ready before the imminent birth of future King Frederick V in 1723. The royal accounts of March 19, 1723, show that Anton Schultz was asked to hurry his work. He delivered twenty medals the following day and another thirty on March 24. WAC, MAP

862

Probably Johann Carl Hedlinger (1691–1771)
FREDERICK THE GREAT, KING OF PRUSSIA (b. 1712; r. 1740–86)
ca. 1756?
Copper alloy, cast; 82.1 mm
The Frick Collection; Gift of Stephen K. and Janie Woo Scher, 2016 (2016.2.211)

Obverse: Frederick the Great wearing armor and a commander's sash; on his chest, the badge of the Order of the Black Eagle. Inscription: FRIDERICUS MAGNUS BORUSSORUM REX [Frederick the Great, King of Prussia].
Literature: Forrer 1904–30, 2: 455–67; Thieme and Becker 1907–50, 16: 218–21; Westermark 1971, 1–2; Felder 1978, 141, no. 179 (var.); 142, no. 180 (var.); 151–52, no. 236.

This medal bears no signature or initial from the artist. The three known medals of Frederick the Great are signed with the initials I. C. H., Hedlinger F., and J. C. H., respectively. Compared to the medallic portraits of the king of Prussia known to have been made by Hedlinger, this medal, which has not been found in the literature, has very close parallels. MAP

863

Olav Olavson Glosimodt (1821–1901)
CHRISTIAN IX, KING OF DENMARK (b. 1818; r. 1863–1906)
Dated 1883
Ivory, carved, frame in boxwood; 124.5 × 102.3 mm
Scher Collection

Obverse inscription: on truncation, O G 1883 [Olav Glosimodt 1883].
Reverse inscription: On paper label, KONG CHRISTIAN D[en] IX, SKAABED AF BILLEDHUGGER OLAV OLAVSON GLOSIMODT (F[ødt] I TELEMARKEN 14 JULI 1821, D[ødt] I K[ø]B[en]H[a]VN 13 DEC[em]B[e]R 1901). ELFENBEN OG BUKSBOM / F. S. [King Christian the IXth, created by the sculptor Olav Olavson Glosimodt (born in Telemark 14 July 1821, died in Copenhagen 13 December 1901). Ivory and boxwood / F. S.].

The Norwegian woodcarver and sculptor Glosimodt is known for his portraits of well-known contemporary figures, mainly in Denmark. Many of his portraits are in the form of medals, medallions, or statuettes, mainly in ivory or boxwood. MAP

863

Kong Christian d. IX, skaaret af Bil-
ledhugger Olav Olavson Glosimodt (f. i
Telemarken 14. Juli 1821, d. i Kbhvn.
13. Decbr. 1901). Elfenben og Buksbom.
F. S.

863

864

864

Fyodor Alexeyev (1753/54–1824)
PETER THE GREAT (b. 1672; Tsar of All Russia 1682–1721;
Emperor of All Russia 1721–25)
Dated 1703
Silver, struck; 55 mm
The Frick Collection; Gift of Stephen K. and Janie Woo Scher, 2016
(2016.2.178)

Obverse: Peter, crowned with laurel, wearing armor with a leonine
pauldron and a draped imperial mantle. Inscription: ПЕТРЪ А ВЖИЕЮ
МЛТИЮ ІМПЕР I САМОДЕР ВСЕРОССИЇСКИ I [Peter, son of Alexis, by
the grace of God, Emperor and Autocrat of all the Russias].
Reverse: Two frigates at sea surrounded by twenty-two small boats;
above, an arm emerging from a heavenly cloud, holding two olive
branches and a ribbon from which hangs a crown. Inscription:
НЕБЫВАЕМОЕ БЫВАЕТЬ 1703 [NEBYVAYEMOYE BYVAYET 1703]
[The impossible is possible, 1703].
Literature: Thieme and Becker 1907–50, 1: 271; Ossbahr 1927, 162,
no. 107d; Smirnov, Van Hoof, and Schoevaert 1990, 84, no. 167;
Coullaré 2006, 61–62, no. 10.

On May 8, 1703, two Swedish warships were sent on a
reconnaissance mission to the mouth of the river Neva. The
Swedish vice-admiral Gideon von Numers thought the Russians had
surrendered the fort of Retusaari on May 2. Soon, the two warships
were surrounded by a hundred Russian *ladjas* (rowing vessels with
fifty men but no cannons). The battle was furious, and the Swedes
tried to scuttle both ships rather than have them fall into the hands
of the enemy, but this succeeded with only one of the ships. The
Swedes were forced to surrender. On May 16, 1703, the city of Saint
Petersburg was founded at the mouth of the river, giving Russia direct
access to the Baltic. MAP

865

Timothei Iwanoff (1729–1802)
PETER THE GREAT (b. 1672; Tsar of All Russia 1682–1721;
Emperor of All Russia 1721–25)
Dated 1710
Silver, struck; 47.3 mm
Scher Collection

Obverse: Peter, crowned with laurel, wearing armor and an ermine-
lined cloak. Inscriptions: PETRVS ALEXEII FIL[ius] D[ei] G[ratia] RVSS[iæ]
IMP[erator] M[agnus] DVX MOSCOVIÆ [Peter, son of Alexis, by the grace
of God, Emperor of Russia, Grand Duke of Moscow]; on truncation,
TI [artist's initials].
Reverse: Plan of the fortress of Reval; above, an angel of
extermination, holding a mural crown. Inscriptions: PRAE**DOMI**NANTE
PETRI SO**LIO** RE**VALIA** C**ESSIT** [Reval bows before the pre-eminent
throne of Peter]; chronogram 1710; on the map, REVAL [today the
capital of Estonia: Tallinn]; in exergue, CAPTA 14 IVN / ST[ili] V[eteri]
[taken 14 June old style].
Literature: Forrer 1904–30, 3: 37–39; Ossbahr 1927, 200, no. 158;
Smirnov, Van Hoof, and Schoevaert 1990, 83, no. 165d; 94, no.
188r; Coullaré 2006, 72, no. 41a, 42r.

865

866

In 1710, during the Great Northern War (1700–1721), plague-stricken Reval (present-day Tallinn), along with Swedish Estonia and Livonia, capitulated to Imperial Russia, but the local governing institutions (the Magistracy of Reval and Chivalry of Estonia) retained their cultural and economic autonomy within Imperial Russia as the governorate of Estonia. MAP

866
Timothei Iwanoff (1729–1802)
ELIZABETH PETROVNA, EMPRESS OF RUSSIA (b. 1709; r. 1741–62)
Dated 1754
Copper alloy, struck; 65.1 mm
The Frick Collection; Gift of Stephen K. and Janie Woo Scher, 2016 (2016.2.212)

Obverse: Elizabeth, imperial crown on her head and hair tied with a ribbon, wearing a dress with lace and pearls, and a draped mantle decorated with imperial eagles fastened on her shoulder by an oval brooch with drop-shaped pearl. Inscriptions: D[ei] G[ratia] ELISABETA AVGVSTA OMN[is] ROSS[iæ] [By the grace of God, Elizabeth, Empress of All Russia]; under the bust, ТИМОѲЕИ ЇВАНОВЪ [Timofey Ivanov] [Timothei Iwanoff].
Reverse: Minerva, fully armed, resting her left arm on a shield with the coat of arms of Russia, shows with her right hand a monument

with the coat of arms of New Serbia, and is crowned by a double-headed eagle; in the background, a military flag, agricultural tools, and a fence. Inscriptions: NOVA SERBIA CONSTITVTA [Foundation of New Serbia]; in exergue, MDCCLIV [1754].
Literature: Thieme and Becker 1907–50, 19: 393; Smirnov, Van Hoof, and Schoevaert 1990, 120, no. 237 (rev., var.); 114, no. 226 (obv.); Coullaré 2006, 92, no. 96 (var.).

This medal relates to Elizabeth's plan to populate the desert territories along the borders of Russia by establishing communities of foreign settlers. New Serbia was created to receive the Christian immigrants from Ottoman Serbia. Under Russian-Serbian military supervision, the region between the Dniepr and Bug Rivers was colonized. MAP

867
Johann Georg Waechter (1724–1800) and Pierre Louis Vernier (act. 18th century)
CATHERINE II, EMPRESS OF RUSSIA (b. 1729; r. 1762–96)
Dated 1765
Silver, struck; 52.4 mm
The Frick Collection; Gift of Stephen K. and Janie Woo Scher, 2016 (2016.2.107)

867

868

Obverse: Catherine wearing a small crown, a string of pearls in her hair, and a dress of lace with pearls, over which is a cloak embroidered in two places with the double-headed imperial eagle and the commander's sash of the Order of St. Andrew. Inscriptions: ЕКАТЕРИНА II ПОКРОВИТЕЛЬНИЦА [Yekaterina II Pokrovitelnitsa] [Catherine II, Protectress]; beneath the bust, WÆCHTER [Vekhter].

Reverse: On a block of stone, an artist's palette with paint brushes, an overturned bust with a sculptor's mallet, and a fragment of a column. Inscriptions: ТАКО ТВЕРДЫ ПРЕБУДЕТЕ [Tako tverdy prebudete] [Thus will you become strong]; in exergue, С ПЕТЕРБУРГ IМПЕРАТОРС АКАДЕМ ТОРЖЕСТВЕН ПОСВЯЩЕНА IЮНIЯ 28 Д 1765 Г [S. Peterburg Imperators Akadem torzhestven posvyashchena iyunya 28 D 1765 Y] [Imperial Academy of Saint Petersburg solemnly inaugurated on June 28, 1765]; L[ouis] VERNIER F[ecit] [Louis Vernier made it].

Literature: Forrer 1904–30, 6: 338–39; Thieme and Becker 1907–50, 29: 287–88; Smirnov, Van Hoof, and Schoevaert 1990, 128, no. 250.

The Academy of Fine Arts, founded by Elizabeth I in 1758 (on the initiative of her favorite, Ivan Chouvalov, who directed it until 1763), was not officially inaugurated until 1765, after the publication of its final statutes on the model of the French Royal Academy of painting and sculpture in Paris. MAP

868

Johann Balthasar Gass (1730–1813)
COUNT ALEXEI GRIGORYEVICH ORLOV (1737–1808)
Dated 1770
Copper alloy, struck; 91.6 mm
Scher Collection

Obverse: Orlov wearing a cuirass, a plumed cavalry helmet with the double-headed imperial eagle and feathers, and broad commander's sash of the Order of St. Andrew over his right shoulder, and holding a commander's baton in his right hand. Inscriptions: ГР А ГР ОРЛОВЪ ПОЪЪДИТЕЛЬ И ИСТРЕБИ ТЪЛЬ ТУРЕЦКАГО ФЛОТА [Gr. A. Gr. Orlov pobeditel i istrebitel turetskago flota] [For Count A. Gr. Orlov, conqueror and destroyer of the Turkish fleet]; on truncation, I[ohann] B[althasar] GASS F[ecit] [Johann Balthasar Gass made it].

Reverse: Plan of the naval battle at Çeşme in the area between the western tip of Anatolia and the island of Chios, showing the position of the fleets and the surrounding land. The Russian fleet is sailing toward the Turkish fleet before a favorable wind issuing from the face of a wind god to the left. Inscriptions: И БЫСТЬ РОССIИ РАДОСТЬ И ВЕСЕЛIЕ [I byst Rossii radost i veselie] [And he was the joy and glee of Russia]; on the plan, НАТОЛIИ [Natolii] [Anatolia], ЛАЗАМЕНО [Lazameno] [Clamenzo], О ГОНСИ [O. Gonsi] [island of Gonsi], ЧЕСМЕ [Chesme] [(city of) Çeşme], ОСТ СПАЛМА ТОРЕ [Ost. Spalmatore] [island of Spalmatori], 3 ФИНО – СЦIО – ЛЕНА [Fino, Stsio, Lena] [Fino, Stsio, Lena], ОСТ ХIО [Ost. Khio] [island of Chios]; in exergue, ЧЕСМА IЮНЯ 24 И 26 1770 ВЪ БЛАГОДАРНОСТЬ ПОБЕ ДИТЕЛЮ ОТЬ АДМ КОЛЛ [Chesma iyunya 24 i 26 1770 v blagodarnost pobeditelyu ot Adm. Koll] [At Çeşme, June 24 and 26, 1770. As a reward to the winner from the College of the Admiralty].

869

Literature: Forrer 1904–30, 2: 205; Thieme and Becker 1907–50, 13: 232; Smirnov, Van Hoof, and Schoevaert 1990, 136, no. 264; Coullaré 2006, 107, no. 135.

In 1770, during the Russo-Turkish War (1768–74), a Russian fleet under Alexei Orlov entered the Mediterranean to destroy the Ottoman fleet and foment rebellion among the Greeks in the Morea (the Peloponnesus) against the Ottomans. The Ottoman fleet was burned, but Orlov, lacking landing forces, did not force the Straits of the Dardanelles and the Bosporus. The Ottomans suffered further setbacks on the Danube, however, and were forced to sign the humiliating Treaty of Kuchuk Kainarji (1774), which concluded the war. MAP

869

Johann Balthasar Gass (1730–1813) and Johann Georg Waechter (1724–1800)

CATHERINE II, EMPRESS OF RUSSIA (b. 1729; r. 1762–96)

Dated 1782

Silver, struck; 82.5 mm

Scher Collection

Obverse: Catherine, crowned with laurel, wearing a dress with lace and a draped mantle decorated with double-headed Imperial eagles and lined with ermine, as well as the stars of the orders of St. George and St. Andrew and also their badges hanging from a broad ribbon across her chest; in the field in front of the bust, I[ohann] B[althasar] G[ass].

Reverse: On a masonry pavement, a rock on which stands the statue of Peter the Great dressed in simple clothing and seated on a horse, the back hooves of which are treading on a snake. Inscriptions: on the rock, ПЕРУ I ЕКАТЕРИНА II [Petru I Yekaterina II] [To Peter I, Catherine II]; in exergue, ЛѢТА 1782 АВГУСТА 6 ДНЯ [Leta 1782 avgusta 6 dnya] [Summer 1782, August 6]; to the right on the pavement, I[ohann] G[eorg] W[aechter].

Literature: Forrer 1904–30, 2: 205; 6: 339; Smirnov, Van Hoof, and Schoevaert 1990, 148, no. 291a; Coullaré 2006, 115–16, no. 156.

This medal was made to celebrate the inauguration of the statue in Saint Petersburg that the French sculptor Etienne Falconet was asked to produce for the centenary of the assumption to the throne of Peter I the Great (b. 1672; Tsar of All Russia 1682–1721; Emperor of All Russia 1721–25). Falconet finished the model in 1770, but it took another four years to find a foundry that could cast it. Finally completed in 1778, the statue was not inaugurated until 1782, by which time Falconet, tired of waiting, had left the country. MAP

870

870

Samuel Judin (1730–1800) and Georg Christian Waechter (1729–ca. 1789)

CATHERINE II, EMPRESS OF RUSSIA (b. 1729; r. 1762–96)

Dated 1774

Silver, struck; 52.3 mm

The Frick Collection; Gift of Stephen K. and Janie Woo Scher, 2016 (2016.2.210)

Obverse: Catherine, crowned with laurel, wearing a scale cuirass, and a draped mantle decorated with the double-headed Imperial eagle and the Order of St. Andrew. Inscriptions: Б М ЕКАТЕРИНА II IМПЕРАТ И САМОДЕРЖ ВСЕРОССЇИС [By the grace of God, Catherine II, Empress and Autocrat of All the Russias]; below the bust, С· ЮДИНЬ [S. YUDIN] [S. Judin].

Reverse: Minerva armed with a spear and pointing with the caduceus toward a warship at sea with the Russian flag; in the background, other ships at sea; to the right a pedestal with a group of banners, armor, a sword, and a shield with the coat of arms of Russia, at the bottom of the pedestal a dismounted cannon, a quiver with arrows, a wheel, cannon balls, a drum, and three shields with the letters КЕР [Kertch] КI [Kinbourn] ЕНI [Enikalé]. Inscriptions: ТВЕРДОСТIЮ РАЗУМОМЬ И СИЛОЮ [TVERDOSTIYU RAZUMOM I SILOYU] [By firmness, intelligence, and strength]; in the exergue, in three lines, МИРЬСЬ ОТТОМА НСКОЮ ЛОРТОЮ / ЗАКЛЮЧЕНЬ 10 IЮЛЯ / 1774 ГОДА [MIR S OTTOMANSKOYU PORTOYU / ZAKLYUCHEN 10 IYULYA / 1774 GODA] [Peace with the Ottoman Porte (government of the Ottoman Empire) concluded on 10 July of the year 1774]; at left above exergue, G[eorg] C[hristian] W[aechter].

Literature: Forrer 1904–30, 3: 231; 6: 92–93, 338–39; Thieme and Becker 1926, 291; Thieme and Becker 1907–50, 35: 16; Smirnov, Van Hoof, and Schoevaert 1990, 140, no. 273c; Coullaré 2006, 111, no. 143.

The Treaty of Kuchuk Kainarji in 1774 marked the end of the Russo-Ottoman war, which began in 1768. Signed by the Sultan Abdul Hamid on July 1, 1774, the treaty allowed the sultan to remain the religious leader of the Crimean Muslims. Russia obtained much of the northern Black Sea coast and also received a large war indemnity from the Ottomans. MAP

871

871

Johann Caspar Jaeger (mid-18th century–after 1791) and Poud
Bobrovchtchikov (b. 1741)

PYOTR ALEXANDROVICH RUMYANTSEV (1725–1796)

Dated 1774

Copper alloy, struck; 93.7 mm

Scher Collection

Obverse: Rumyantsev, crowned with laurel, wearing armor with
a lion skin resting on his shoulder and draped around his body.
Inscriptions: ГРАФЪ ПЕТРЪ АЛЕКСАНДРОВИЧЬ РУМЯНЦОВЪ ГЕНЕРАЛЪ
ФЕЛДМАРШАЛЪ [Count Pyotr Alexandrovich Rumyantsev, general,
field marshal]; under truncation, I[ohann] G[aspar] IÆGER F[ecit]
[Johann Caspar Jaeger made it].

Reverse: Rumyantsev dressed as a Roman warrior, holding a lance
in his left hand and a shield and an olive branch in his right hand;
behind him, a trophy composed of flags, arms, armor, cannon and
cannon balls, drum, trumpets, and shields. Inscriptions: ПОБѢ
ДИТЕЛЮ И ПРИМИРИТЕЛЮ [To the winner and the peacemaker];
in exergue, 10 ІЮЛЯ 1774 ГОДА [10 IYULYA 1774 GODA] [10 July
of the year 1774]; on the exergue line, the initials П Б [P(oud)
B(obrovchtchikov)].

Literature: Forrer 1904–30, 3: 52–53; Thieme and Becker 1907–50,
4: 148; Smirnov, Van Hoof, and Schoevaert 1990, 142, no. 276;
Coullaré 2006, 111–12, no. 145.

In 1768, at the beginning of the war against the Turks, Count
Rumyantsev was appointed commander in chief. After several
victories, he became field marshal and was awarded the honorary
title "Zadunaisky" (meaning "Trans-Danubian"). When his forces
approached Shumla in 1774, the new Sultan Abdul Hamid I
panicked and asked for peace, which Rumyantsev signed at the
village of Kuchuk Kainarji. MAP

Leopold Sinayeff-Bernstein (1867–1944)
LEO TOLSTOY (LEV NIKOLAYEVICH TOLSTOY) (1828–1910)
1911
Copper alloy, cast; 265.2 mm
Scher Collection

Obverse inscriptions: LEON TOLSTOÏ; under the bust, L[eopold]
SINAYEFF-BERNSTEIN.
Literature: Forrer 1904–30, 1: 533.

This is a medallion cast for a commemorative medallion, possibly
intended to be smaller, made a year after the death of the great
Russian writer. The artist was living in Paris in 1944 and was sent to,
and perished at, Auschwitz. MAP

872

LEON

872
actual
size

L. Sinayeff Bernstein

SWITZERLAND, MEXICO, and the UNITED STATES

873

874

873

Jean Dassier (1676–1763)
GEORGE I, KING OF GREAT BRITAIN (b. 1660; r. 1714–27)
and **GEORGE II, KING OF GREAT BRITAIN** (b. 1683;
r. 1727–60)
Dated 1727
Bronze (partial gilt), struck; 31.7 mm
Scher Collection; Promised gift to The Frick Collection

Obverse: George, laureate, and dressed all'antica. Inscriptions:
GEORG[ius] D[ei] G[ratia] MAG[næ] BR[itanniæ] FR[anciæ] ET HIB[erniæ]
REX [George, by the grace of God, King of Great Britain, France, and
Ireland]; on the right shoulder, I.D. [artist's initials].
Reverse: Britannia personified, holding an olive branch above a
medallion of George II, inscribed GEORG[ius] II D[ei] G[ratia] M[agnæ]
B[ritanniæ] F[ranciæ] H[iberniæ] R[ex] [George II, by the grace of
God, King of Great Britain, France, and Ireland], reclining beside
the English lion and before four ships. Inscriptions: MAGNI SOLATIA
LUCTUS [The solace of a great grief]; in exergue, D[enatus] 1727 [Died
1727].
Literature: Hawkins 1885, 2: 474, no. 92; Eisler 2002–5, 1: 250, no.
A.1, 2: 380; Eimer 2010, no. 507.

This medal was made to commemorate the death of George I,
who died of a stroke on a journey to Hanover, and the peaceful
succession to the throne of his son, George II. According to Eisler,
this is the first medal produced by Dassier in this manner. EM

874

Jacques-Antoine Dassier (1715–1759)
CHARLES EMMANUEL III, DUKE OF SAVOY (b. 1701; King of
Sardinia-Piedmont 1730–73)
Dated 1739
Bronze, struck; 54.5 mm
The Frick Collection; Gift of Stephen K. and Janie Woo Scher, 2016
(2016.2.47)

Obverse: Charles Emmanuel wearing armor, the livery collar and
medal of the Supreme Order of the Most Holy Annunciation, and an
ermine-lined cloak. Inscription: CAR[olus] EM[manuel] D[ei] G[ratia] REX
SAR[diniæ] CYP[ri] ET IER[osolymæ] [Charles Emmanuel, by the grace of
God, King of Sardinia, Cyprus, and Jerusalem].
Reverse: Minerva, her shield aloft, leading by the hand Charles
Emmanuel, wearing classical armor and crowned by winged Victory.
Inscriptions: MINERVA DUX VICTORIA COMES [Minerva (is his) guide,

Victory (his) companion]; in exergue, IAC[ques] ANT[oine] DASSIER
F[ecit] [Jacques-Antoine Dassier made it]; 1739.
Literature: Norris and Weber 1976, no. 333; Eisler 2005, 1: 167,
no. 2.

This medal was made shortly after the end of the Polish War of
Succession (1733–38), from which France and Spain, allied with
Charles Emmanuel, had emerged victorious. The ensuing Treaty
of Vienna granted Novara and Tortona to Charles Emmanuel. An
excellent soldier and shrewd negotiator, the duke, who ruled
Sardinia as Charles Emmanuel I, was often sought out by other
nations for his military expertise. EM

875

Jean Dassier (1676–1763) and Jacques-Antoine Dassier (1715–1759)
GIOVANNI MARIA MAZZUCHELLI (1707–1765)
Dated 1752
Bronze, struck; 54.7 mm
Scher Collection

Obverse: Mazzuchelli, wearing a cravat and partially unbuttoned
jacket over a chemise, with drapery. Inscriptions: COMES IO[annes]
MARIA MAZZUCHELLI ÆT[atis] ANNO XLV [Count Giovanni Maria
Mazzuchelli, in his 45th year of age]; on truncation, I[ean] DAS[sier]
ET F[ils] [Jean Dassier and son].
Reverse: The winged lion of San Marco holding a sword; in the
background, a view of Venice. Inscriptions: SENATUS CONSULTO [By
decree of the Senate]; in exergue, M DCCLII [1752]; I[ean] DASSIER ET
FILS F[ecit] [Jean Dassier and son made it].
Literature: Norris and Weber 1976, no. 335; Voltolina 1998, 3: 235,
no. 1523; Eisler 2005, 1: 238–33, 337–38, no. 10.

Count Mazzuchelli was a Brescian scholar and public official of
the Venetian state whose ambitious bibliographical dictionary of
Italian men and women of letters (*Gli scrittori d'Italia*) was sadly not
completed before his death. He held several important offices; this
medal was probably struck to commemorate his appointment to the
position of governor of the Public Treasury in 1752. Mazzuchelli
was also an avid collector who accumulated a significant number
of portrait medals. These were housed in his home in Brescia (and
partially published in the *Museum Mazzuchellianum*, 1761–63) and
are now in the museum there. EM

875

876

Jacques-Antoine Dassier (1715–1759)

FRANCESCO SCIPIONE, MARQUESS OF MAFFEI

(1675–1755)

Dated 1755

Bronze, struck; 54.6 mm

Scher Collection; Promised gift to The Frick Collection

Obverse: Maffei wearing an unbuttoned jacket and a cravat beneath drapery. Inscriptions: SCIPIONI MAFFEIO MARCH[ioni] [To Marquess Scipione Maffei]; on truncation, A[ntoine] D[assier] F[ecit] [Antoine Dassier made it].

Reverse: View of the Museum of Verona. Inscriptions: MUSEI VERONENSIS CONDITORI [To the founder of the Museum of Verona]; in exergue, in three lines, ACADEMIA / PHILARMONICA / AN[no] MDCCLV [Accademia Filarmonica in the year 1755].

Literature: Norris and Weber 1976, no. 334; Voltolina 1998, 3: 248–49, no. 1534; Eisler 2005, 328–33, 338, no. 11.

Struck the year of Maffei's death, this medal was commissioned by the Accademia Filarmonica to commemorate the founding of the Museum of Verona, which had been built on the marquess's initiative between 1736 and 1746 and to which he bequeathed some antiquities. A scholar of antiquities, Maffei was also a poet known for his verse tragedy *Merope* (written as part of an effort to reform Italian theater) and his multi-volume history of Verona. He also helped found the influential literary journal *Giornale dei letterati*. EM

877

Jerónimo Antonio Gil (1731/32–1798)

CHARLES III (b. 1716; King of Spain 1759–88; King of Naples as Charles VII 1734–59)

Dated 1778

Bronze, struck; 58.6 mm

The Frick Collection; Gift of Stephen K. and Janie Woo Scher, 2016 (2016.2.176)

Obverse: Charles in a wig tied with a ribbon, wearing armor, a sash, a cravat, and the collars and orders of the Golden Fleece and of Charles III. Inscriptions: CARLOS III PADRE DE LA PATRIA Y PROTECTOR DE LAS CIENCIAS [Charles III, father of the country, and Protector of the Sciences]; G[eronimo] A[ntonio] GIL.

Reverse: On a raised platform, four figures gather around a table and crown a kneeling man; behind the table, a stag; at the table's base, the arms of Castile and Leon; in the foreground, a shepherd approaching the table, watched by another man who leans upon a tree wrapped in vines. Inscriptions: VENCE Y TRIUNFA EL MAS PRUDENTE [The most prudent one conquers and triumphs]; on a rock, G[eronimo] A[ntonio] GIL; in exergue, in three lines, REAL ACADEMIA DE DERECHO / ESPAÑOL Y PUBLICO / AÑO DE 1778 [Royal Academy of Spanish and Public Law in the year 1778]; on a rock to the left of the shepherd, M [mark of the Royal Mint of Mexico City].

Literature: Grove 1976, no. K75a; Almagro-Gorbea, Pérez Alcorta, and Moneo 2005, no. 312; Villena 2004, 240, 329, 413; Donahue-Wallace 2017, 151–52, 196.

876

877

The final commission to the artist before he left Madrid for Mexico, this commemorative medal was commissioned for the Royal Academy of Spanish and Public Law and was completed and struck in Mexico the year Gil assumed the position of principal engraver of the Royal Mint in Mexico City. The significance of the allegory has been the subject of debate. The medal type is known in gold, silver, and bronze; a variant (Grove 1976, no. K76)—struck from new dies after the first set was damaged due to the poor condition of the mint's screw press—differs only in indicating the name of the engraver as GIL. Examples (388) were sent back to Madrid in 1781 and were also available for a limited market in Mexico; the local elite purchased a total of 466 (Donahue-Wallace 2017). AN

878

Jerónimo Antonio Gil (1731/32–1798)
MARIA LUISA OF PARMA (1751–1819; Queen Consort of Spain 1788–1808)
Dated 1793
Silver, struck; 56.3 mm
The Frick Collection; Gift of Stephen K. and Janie Woo Scher, 2016 (2016.2.177)

Obverse: Maria Luisa, hair in curls and tied with ribbons, wearing a gown tied in the front with a sash. Inscriptions: MARIA LUISA REINA AUGUSTA [Maria Luisa, August Queen] [Fleur-de-lis stops]; G[eronimo] A[ntonio] GIL A[nno] 1793 [in the year 1793].

Reverse: Maria Luisa, surrounded by men and women of the court and seated beneath a canopy in a neoclassical palatial setting with a cornucopia at her feet, presenting the sash and badge of the Royal Order of Noble Ladies of Queen Maria Luisa to a woman kneeling before her; above her, winged Fame holds out another sash and badge of the order; to the left in the foreground, two nude children tending to a censer emitting perfumed clouds. Inscriptions: DISTINGUE PREMIA LA VIRTUD Y NOBLEZA DE SU SEXO [She distinguishes and rewards the virtue and nobility of her sex]; in exergue, in four lines, R[ea]ᴸ ORDEN ESPAÑOLA DE DAMAS NOBLES DE LA / REINA MARIA LUISA FUNDADA P[o]ᴿ S[u] M[ajestad] A[ugusta?] / CONSEQUENCIA DE R[ea]ᴸ DECRETO DE / 21 DE ABRIL DE 1792 [Royal Spanish Order of Noble Ladies of Queen Maria Luisa, founded by Her August(?) Majesty as a result of the royal decree of 21 April 1792]; on edge, D[oña] M[aria] GUADALUPE DE MONCADA Y BERRIO LA HIZO ACUÑAR EN MEXICO AÑO 1793 [Lady Maria Guadalupe de Moncada y Berrio had it struck in Mexico in the year 1793].
Literature: Gaillard 1852, no. 7082; Almagro-Gorbea, Pérez Alcorta, and Moneo 2005, no. 438.

On April 21, 1792, the Spanish king Charles IV and Maria Luisa of Parma founded the Royal Order of Noble Ladies of Queen Maria Luisa, a court institution that honored women for community service and extended to Spanish colonies. In Mexico the following year, the noblewoman Maria Guadalupe de Moncada y Berrio commissioned this medal from Gil to commemorate the founding of the order. AN

878

Augustus Saint-Gaudens (1848–1907)
ROBERT LOUIS STEVENSON (1850–1894)
Dated 1887, made ca. 1907
Bronze, cast; 45.5 × 46.1 cm
Scher Collection

Obverse: Stevenson reclining in bed against pillows and with a blanket on his lap, sheets of paper in his left hand and a cigarette in his right. Inscriptions: ROBERT LOUIS STEVENSON; YOUTH NOW FLEES ON FEATHERED FOOT / FAINT AND FAINTER SOUNDS THE FLUTE / RARER SONGS OF GODS AND STILL / SOMEWHERE ON THE SUNNY HILL / OR ALONG THE WINDING STREAM / THROUGH THE WILLOWS FLITS A DREAM / FLITS BUT SHOWS A SMILING FACE / FLEES BUT WITH SO QUAINT A

879

GRACE / NONE CAN CHOOSE TO STAY AT HOME / ALL MUST FOLLOW ALL MUST ROAM; THIS IS UNBORN BEAUTY SHE / NOW IN AIR FLOATS HIGH AND FREE / LATE WITH STOOPING PINION FLEW / RAKING HEDGEROW TREES AND WET / HER WING IN SILVER STREAMS AND SET / SHINING FOOT ON TEMPLE ROOF / NOW AGAIN SHE FLIES ALOOF / COASTING MOUNTAIN CLOUDS AND KISS'T / BY THE EVENING'S AMETHYST; IN WET WOOD AND MIRY LANE / STILL WE PANT AND POUND IN VAIN / STILL WITH LEADEN FOOT WE CHASE / WANING PINION FAINTING FACE / STILL WITH GREY HAIR WE STUMBLE ON / TILL BEHOLD THE VISION GONE; WHERE HATH FLEETING BEAUTY LED / TO THE DOORWAY OF THE DEAD; LIFE IS OVER LIFE WAS GAY / WE HAVE COME THE PRIMROSE WAY; MDCCCLXXXVII [1887]; BY AUGUSTUS-GAUDENS; TO HARRY DICKINSON THRASHER IN LOVING MEMORY OF AUGUSTUS SAINT-GAUDENS.

Literature: Dryfhout 1982, 174–76; Greenthal 1985, 119–21; Baxter 1987, no. 76.

Augustus Saint-Gaudens was a great admirer of the Scottish author Robert Louis Stevenson and once remarked to their mutual friend Will H. Low—to whom the Stevenson poem on the obverse is dedicated—that he would be honored to meet the writer and model his likeness. Saint-Gaudens created this relief when Stevenson, suffering greatly from tuberculosis, visited New York in 1887. It would become his most commercially successful portrait and was reproduced in both rectangular and circular form and varying sizes. This specimen, which appears to have been cast after Saint-Gaudens's death, is dedicated to the American artist Harry Dickinson Thrasher, Saint-Gaudens's long-time studio assistant. The large rectangular relief with the same image, cast in 1904, was used for Stevenson's funerary monument in St. Giles Cathedral in Edinburgh. EM

879
actual
size

... FELT · BUT SHOWS A SMILING FACE ·
FLEES · BUT WITH SO QUAINT A GRACE
NONE · CAN CHOOSE TO STAY AT HOME
ALL MUST FOLLOV ALL MUST ROAM ·

SAINT · GAUDENS

... Y · SHE ·
... ND FREE ·
... THE BLUE ·
... ON FLEW ·
... AND WET ·
... S AND SET ·
... E ROOF ·
... ALOOF ·
... OS AND KISS'T ·
... THYST ·

... LANE ·
... IN VAIN ·
... VE CHASE ·
... FACE
... UMBLE ON ·
... GONE ·

... TY LED
... DEAD ·

... AY ·
... OSE WAY

TO · HARRY ·
THRA...
IN · LOVING
AUGUSTUS

880

Augustus Saint-Gaudens (1848–1907) and Philip Martiny
(1858–1927)
GEORGE WASHINGTON (1732–1799; General and Commander-
in-Chief of the Continental Army of the United Colonies 1775–83,
President of the United States 1789–97)
Dated 1889
Bronze, cast; 112.8 mm
Scher Collection

Obverse: George Washington, hair clubbed with a ribbon, wearing
a jacket over a ruffled shirt and cravat; to the right, a fasces; all
bordered by thirteen stars. Inscriptions: GEORGE WASHINGTON; in the
field, in two lines, PATER PATRIÆ / MDCCL XXXIX [Father of his country,
1889]; beneath truncation, PHILIP MARTINY MODELER DESIGN AND
COPYRIGHT BY AVGVSTVS SAINT GAVDENS.
Reverse: A bald eagle, displayed, with the American arms bearing
the inscription E PLURIBUS UNUM [Out of many, one], grasping a
bundle of arrows wrapped in an olive branch; in the field, the arms
of New York City; border of 38 stars. Inscriptions: in thirteen lines, TO
COMMEMORATE / THE INAVGVRATION / OF GEORGE WASHINGTON /
AS FIRST PRESIDENT OF THE / VNITED STATES OF AMERICA / AT NEW
YORK APRIL XXX [30] / MDCCLXXXIX [1789]; BY AVTHORITY OF /
THE COMMITTEE / ON CELEBRATION; NEW YORK APRIL / XXX [30] /
MDCCCLXXXIX [1889].
Literature: United States Bureau of the Mint 1914, no. 279; Dryfhout
1982, 177–78; Baxter 1987, no. 77; Luftschein 1995, no. 346.

This medal was made for New York's celebration of the centennial
anniversary of George Washington's inauguration as first president
of the United States and is replete with references to the number
thirteen, for the thirteen independent states over which Washington
presided. EM

Charles Calverley (1833–1914)
JAMES RUSSELL LOWELL (1819–1891)
Dated 1896
Bronze, cast; 171.5 mm
Scher Collection

Obverse: At the top, the inscription JAMES RUSSELL LOWELL entwined
with laurels; beneath him, the seal of the Grolier Club flanked by
laurels and inscribed GROLIER CLUB NEW YORK. Inscriptions: in the
field, to the left, in seven lines, SAPIENS / HÆREDITABIT / HONOREM ET
/ NOMEN ILLIVS / ERIT VIVENS / IN ÆTERNVM / Ecclus XXXVII 26 [A wise
man shall inherit glory, and his name shall be perpetual; abbreviated
from Ecclesiasticus 37:26]; in the field, to the right on a circle, in two
lines, FEB[ruary] 22 1819 / AUG[ust] 12 1891; beneath the bust, CHA[rle]S
CALVERLEY Sc[ulpsit]; MDCCCXCV [Charles Calverley modeled this,
1895].
Reverse inscription: COPYRIGHTED 1896.
Literature: Tolles 1999, 1: no. 67.

Issued by the Grolier Club, the New York literary club founded in
1884, this medallion commemorates James Russell Lowell, the
influential American critic, writer, editor, and diplomat. The verse
from the Apocrypha on the obverse was suggested by his family.
The medallion was cast by New York founder John Williams, who
was praised and rewarded by the club for the great care he took in
casting the work. See also the commentary for no. 698. EM

881

COPYRIGHTED 1896.

881

882

Literature: American Numismatic Society 1910, no. 3470; Baxter 1987, no. 123.

882

Victor David Brenner (1871–1924)
HENRY OF PRUSSIA (b. 1862; Prince of Prussia 1862–1929, Commander-in-Chief of the High Seas Fleet 1906–9, Grand Admiral of the Imperial German Navy 1909–11, Chief of Baltic Forces 1914–18)
Dated 1902
Silver, struck; 69.6 mm
Scher Collection

Obverse: Henry in naval uniform, decorated and wearing the livery collar and medal of the Order of the Black Eagle and an Iron Cross medal; on his chest, the star of another order. Inscription: ISSVED BY THE AMERICAN NVMISMATIC AND ARCHÆOLOGICAL SOCIETY; NEW YORK FEBRVARY 1902; in the field, to the right, V[ictor] D[avid] BRENNER.
Reverse: Mercury in his winged helmet and sandals seated on a cloud, holding fruits and flowers in his right arm and the caduceus in his left; beside him, the shields of Prussia and America. Inscriptions: TO COMMEMORATE THE VISIT OF HIS ROYAL HIGHNESS PRINCE HENRY OF PRVSSIA; in the field, V[ictor] D[avid] BRENNER.

This medal was struck to commemorate the 1902 visit of Prince Henry of Prussia, brother of Kaiser Wilhelm II, to New York. A naval officer who rose to the rank of grand admiral, Henry was to become the first German naval officer to qualify as an aviator. He was made Chief of Baltic Forces for the duration of World War I. A single impression in gold was offered to the prince. EM

883

John Flanagan (1865–1952)
SCHOOL ART LEAGUE OF NEW YORK MERIT AWARD
Dated 1915
Gilt bronze, cast; 70.9 mm
Scher Collection

Obverse: A model poses for a woman drawing on a large panel beside the Belvedere torso, a bust, and a column. Inscriptions:

883

884

SCHOOL ART LEAGUE OF NEW YORK CITY; FOR MERIT; in exergue, 1915, divided by artist's monogram, JF [artist's initials].
Reverse inscription: MEDALLIC ART CO. NY.
Literature: *American Journal of Numismatics* 1915, no. 18; Baxter 1987, no. 155; Luftschein 1995, no. 154.

This medal was made as a merit award for students of the School Art League of New York. Luftschein notes that it "is also known as the John W. Alexander [1856–1915] Medal" (1995, 30). Alexander was an American painter and illustrator, and this medal was made the year of his death. EM

884
John Flanagan (1865–1952)
AUGUSTUS SAINT-GAUDENS (1848–1907)
Dated 1937
Bronze, cast; 63.2 x 45.7 mm
Scher Collection

Obverse: Saint-Gaudens in a jacket, collared shirt, and tie.
Inscriptions: AUGUSTUS SAINT-GAUDENS STATUAIRE [Augustus Saint-Gaudens, sculptor] / ÆTATIS LVI [aged 56]; in the field, to the left, below, MCMXXXIV [1934], divided by artist's monogram, J F.
Reverse inscription: In five lines, IN HONOR / OF AN AMERICAN / SCVLPTOR / AVGVSTVS SAINT / GAVDENS; below, in three lines, SCVLPTORS DINNER OF THE / MEDALLIC ART COMPANY NY / APRIL IX MCMXXXVII [April 9, 1937].
Literature: Baxter 1987, no. 164 (var.); Luftschein 1995, no. 140.

In addition to being one of America's greatest sculptors, Saint-Gaudens is remembered for his dedication to organizing professional training and institutions for sculptors. He founded the National Sculpture Society (1893), helped establish the American Academy in Rome (1905), and taught for many years at the Art Students League. This plaquette honoring Saint-Gaudens was cast for a "sculptors' dinner" at the Medallic Art Company of New York. The obverse design comes from an older plaquette. EM

Artist Biographies

Every effort has been made to provide biographical information on all of the medalists whose work is represented in the Scher Collection, but in some cases nothing more than the name is known.

Van Abeele, Pieter (1608–1684). Dutch medalist who entered the Amsterdam silversmiths' guild in 1634. His dated medals were made between 1630 and 1678. His frontal and three-quarter portraits, usually in high relief, are based on painted or graphic sources.

Abondio, Antonio (1538–1591). Italian medalist, wax modeler, and sculptor. He worked for Archduke Frederick II of Austria in 1565 and for Emperor Maximilian II in 1566. During his career, he visited the Low Countries and Spain.

Abramson, Abraham (1754–1811). Abramson studied medal engraving with his father Jacob and sculpture and modeling for four years in Italy. He produced many medals over a short career and is considered one of the finest German medal engravers of the late eighteenth century.

Adolfszoon, Christoffel (ca. 1631–1680). Dutch sculptor and medalist working in Amsterdam. Ten medals have been attributed to him, but only four bear his signature. His medals are struck in silver.

Alexander, P. (ca. 1520–1578). Dutch medalist who was probably a goldsmith of Antwerp. His signature features on a medal executed in honor of Jan Baptist Houwaert.

Alexeyev, Fyodor (1753/54–1824)

Amadei, Amadio, called Amadio da Milano (act. 1437–82; d. ca. 1483). Italian goldsmith, seal engraver, and medalist. Between 1437 and 1482, he worked as a goldsmith for the court of Ferrara, whose peculiar techniques came to be used by Gianfrancesco Enzola of Parma and by some medalists operating at the court of Pope Paul II.

Andeles, Eise (1731–1766). Dutch medalist active in Leeuwarden, who predominantly made struck medals. His works are rare.

Andrieu, Bertrand (1761–1822). French medalist, engraver, and illustrator. He studied first under André Lavau, then at the Académie de Peinture et de Sculpture in Bordeaux, after which he worked in the studio of Nicolas-Marie Gatteaux, in Paris. In the early nineteenth century, he made many medals for Denon's medallic history of Napoleon. He later received the Order of St. Michael.

ANN. Italian medalist. In all probability, he was Antonio di Desiderio of Ferrara, known as Annizatti, who trained under Domenico di Polo of Florence.

Anthony, Charles (act. 1599–1615). English medalist who was chief engraver of the Royal Mint from 1599 to 1615, a position he inherited from his father (Derick) and passed on to his son (Thomas).

Argenterio, Bartolomeo (act. 1576; d. 1591). Italian silversmith and medalist active in Rome, where he worked as supervisor of the mint. Argenterio produced medals for Gregory XIII and Francesco I de' Medici, Grand Duke of Tuscany.

Aury, Pierre (1622–1692). French seal engraver and medalist who produced several medals for the cabinet of Louis XIV.

Balugani, Filippo (1734–1780). Italian medalist who studied under Vittorio Bigari.

Barber, J. (act. 1809–42). Die engraver and medalist in London.

Barre, Jean-Jacques (1793–1855). French engraver, medalist, and draftsman who became *graveur-général* of the mints of France in 1843. He created the first French postage stamp, the seal of the French Republic, and the seal of the Assemblée Nationale.

Di Bartolommeo Savelli, Sperandio (ca. 1425/28–d. aft. 1504). Italian medalist, architect, sculptor, and painter. He worked for the court in Mantua and undertook commissions from Milan and Venice. At the court of Ferrara, he worked both as a sculptor and medalist. He is often considered the most prolific Italian medalist of the fifteenth century.

Béchot, Marc (1520–1557). French engraver and medalist for Francis I. In August 1547, King Henri II named him *graveur-général* of the mints of France, a position he held until his death.

Belli, Valerio (ca. 1468–1546). Italian medalist, gem engraver, and goldsmith. Working for Clement VII and Paul III, he became a member of the artistic and literary circles of Rome. Belli also spent time in Venice and Vicenza, where he remained until his death.

Bernard, Thomas (1650–1713). French sculptor and medalist involved with Jean Bernard on the medallic history of Louis XIV and a member of the Académie Royale. He also worked for the Paris mint.

Bernhart, Joseph (1883–1967)

Bertinetti, Francesco (d. after 1706). Italian medalist who worked in Paris for the finance minister Nicolas Fouquet. Bertinetti produced several bronze portrait medals of Louis XIV.

Bianchi, Ignazio (act. 1848–69). Italian engraver and medalist who worked in Rome at the mint. Bianchi executed medals featuring Pope Pius IX.

Bloc, Conrad (ca. 1545–after 1602). Dutch, or possibly Flemish, sculptor and medalist. Despite his being one of the most prolific medal engravers of the late sixteenth century, nothing is known of Bloc's biography except that he lived in Ghent. A document in the Antwerp archives dated 1578 notes that he came from that city, which would suggest that he is Flemish in origin.

Blum, Johann (ca. 1599–after 1668). German medalist working in Bremen, employed by the Duke of Schleswig-Holstein between 1652 and 1657, and die cutter at the Copenhagen mint between 1657 and 1662. His works are struck and follow the work of Sebastian Dadler, who may have been his master.

Bobrovchtchikov, Poud (b. 1741)

Bolsterer, Hans (act. 1540; d. 1573). Goldsmith and portrait sculptor, active primarily in Nuremberg and briefly in Frankfurt.

Bombarda (probably Giambattista Cambi) (d. 1582). Italian engraver and medalist active in Emilia in the 1550s to 1570s. Sometimes called (mistakenly, according to Attwood 2003) Andrea Cambi, the artist was appointed to the mint at Reggio in 1557 and may be the same Giambattista Cambi who worked as a sculptor and stuccoist in the 1550s and 1560s.

Bonacolsi, Pier Jacopo di Antonio Alari, called Antico (ca. 1460–1528). Italian sculptor and medalist. Among his most important patrons were Pope Alexander VI, Isabella d'Este, and the Gonzaga family, for whom he produced a pair of medals to celebrate the wedding of Gianfrancesco Gonzaga to Antonia del Balzo. He is also renowned for having restored antique marble statues.

Bonhorst, Heinrich (act. 1669–95; d. 1711). German mint master and die engraver at Clausthal. A medal of Duke Johan Friedrich of Brunswick-Lüneburg, dated 1677, bears his signature.

Bonzagni, Gian Federico (1508–after 1586). Italian medalist and goldsmith who worked in the papal mint in Rome from about 1554 to 1575. He also worked in the mint at Parma, where he engraved dies for medals featuring local prominent figures.

Bornemann, Rudolf (1650–1711). Mint master at Zallerfeld.

Bovy, Jean-François-Antoine (1795–1877). Swiss-born sculptor, medalist, and engraver who studied in Pradier's studio in Paris from 1824 to 1826, becoming a naturalized French citizen in 1835. His oeuvre consists of nearly two hundred pieces.

Bower, George (d. ca. 1689). British goldsmith, engraver, and medalist active in London. In 1664, he was made Engraver to the Royal Mint and Embosser in Ordinary.

Brachmann, Severin (act. 1564–90). Worked primarily in Prague from 1564 to 1580 and Vienna from 1581 to 1590, producing small medals of the bourgeoisie and lesser nobility.

Brandt, Henri-François (1789–1845). Medalist active in Switzerland and elsewhere who studied under Jacques-Louis David in Paris and with Antonio Canova and Bertel Thorvaldsen in Rome.

Brenet, Nicolas Guy Antoine (1773–1846). French medal designer who commemorated noteworthy individuals and major events of the Empire, the Restoration, and the July Monarchy.

Brenner, Victor David (1871–1924). American sculptor and medalist who trained as a seal engraver in his native Lithuania before moving to New York in 1890 to work as a die engraver. In 1898, he relocated to Paris to study at the Académie Julian and later became a pupil of Louis-Oscar Roty.

Breuer, Johann Georg (d. ca. 1695). Medalist, mint master, and engraver at Brunswick. He worked for the dukes of Brunswick and Saxe-Weissenfels and resided for a time in Sweden.

Briot, Nicolas (ca. 1579–1646). French medalist who also worked in England and Scotland. He became engraver general of the mints of France in 1606 and, after relocating to London in 1625, was eventually made master of the Scottish mint (1635–39).

Broccetti, Giuseppe (1684–1733). Italian medalist and sculptor, who was a pupil of goldsmith Cosimo Merlini. He executed several commissions for the churches of San Lorenzo and Santissima Annunziata in Florence.

Brock, Thomas (1847–1922). British sculptor of commemorative statues and busts who also designed coin types and six medals. He was elected a member of the Royal Academy in 1891.

Brucher, Antoine (act. 1554; d. 1568). French medalist and engraver. In December 1556, he was accepted to the Cour des Monnaies and the following month was made die engraver at the Paris mint by order of the king.

Buchheim, Johann (1624–1683). Coin engraver and medalist active in Breslau and the author of many religious medals.

Bull, Samuel (act. 1707–15). English medalist who worked as an engraver at the Royal Mint in the early eighteenth century during the reigns of Queen Anne (r. 1702–14) and George I (r. 1714–27).

Burkhart, Benedikt (act. 1496–1508). Austrian goldsmith at Innsbruck; die engraver at Hall and medalist to Duke Albrecht IV of Bavaria.

Van Bylaer (or Bijlaer), Gerard (ca. 1540–1617). Dutch medalist and die engraver for the mint of Dordrecht.

Van Bylaer (or Bijlaer), Jan (act. 1622–46). Sculptor and medalist of Utrecht who produced struck medals commemorating events of the Dutch Eighty Years' War of independence (1568–1648).

Van Bylaer (or Bijlaer), Willem (act. ca. 1580–1635). Dutch medalist and die cutter at the mint of Dordrecht.

Calverley, Charles (1833–1914). American sculptor who studied under Erastus D. Palmer in Albany before moving to New York, where, in 1875, he became a member of the National Academy of Design.

Candida, Giovanni Filangieri (ca. 1445/50–ca. 1498/99). Italian medalist and diplomat who became secretary to Charles the Bold, Duke of Burgundy, Maximilian of Austria, and Mary of Burgundy. Various diplomatic missions took him to Rome, where in 1493 the pope named him Protonotary Apostolic.

Carl, Mattaeus (ca. 1550–1609). Trained as a goldsmith in Augsburg, Carl was a medalist and goldsmith in Nuremberg and worked for various German courts.

Cattaneo, Danese (ca. 1509–1572). Italian sculptor and medalist. According to Vasari, he was one of the pupils of Sansovino, for whom he carved some figurative sculptures for the Libreria Marciana and Loggetta in Venice. He was a close friend of Bernardo Tasso.

Cavalier, Jean (act. 1684; d. 1699). French sculptor. By 1684, he was carving ivory portraits, probably in England. He was made medalist to William III of England in 1690, before moving to Copenhagen in 1694.

Da Cavino, Giovanni (1500–1570). Italian goldsmith and medalist who received his training in the workshop of Andrea Riccio. Cavino produced a pair of silver candlesticks supplied to the cathedral of Padua in 1527; nonetheless, his fame rested on his skill in carving dies for a series of struck pieces that imitated Roman *sesterces*. He also made good struck medals of contemporaries.

Cesati, Alessandro, called Il Grechetto (act. 1538–64). Italian medalist and die engraver. In 1554, he was active as *incisore e maestro delle stampe* at the papal mint until 1561. After Rome, he was summoned to Piedmont, where he produced a medal for Marguerite of France, the consort of Emanuel-Philibert of Savoy.

Chaplain, Jules-Clément (1839–1909). French medalist, sculptor, and draftsman. He was admitted to the École des Beaux-Arts in Paris in 1857, won the Prix de Rome for medal engraving in 1863, was awarded the Legion of Honor in 1877 (and promoted to *commandeur* in 1900), and in 1881 became a member of the Académie des Beaux-Arts.

Chapu, Henri-Michel-Antoine (1833–1891). French sculptor. In 1849, he began studying at the École des Beaux-Arts, Paris, and he won the Prix de Rome for sculpture in 1855. He was made *chevalier* of the Legion of Honor in 1867 and was elected to the Académie des Beaux-Arts in 1880.

Chaudet, Antoine-Denis (1763–1810). Sculptor, history painter, draftsman, illustrator, member of the Institut; professor at the École des Beaux-Arts. From 1798 to 1810, he exhibited at the Salon de Paris.

Chéron, Charles-Jean-François (1635–1698). French medalist who worked for Louis XIV on a medallic history of the king's reign. He was employed at the Paris mint for over a decade and in 1679 was admitted to the Académie Royale de Peinture et de Sculpture.

Chevalier, Nicolas (act. ca. 1677–1720). French medalist, engraver, printer, and art dealer. A Huguenot, he fled to the Netherlands after the Revocation of the Edict of Nantes in 1685. He was active in Amsterdam and Utrecht, where he assembled a notable cabinet of rarities that was open to the public.

Coudray, Marie-Alexandre-Lucien (1864–1932). French medalist who trained at the École des Beaux-Arts in Paris under Augustin-Alexandre Dumont, Gabriel-Jules Thomas, Henri-Émile Allouard, and Hubert Ponscarme. In 1893, he won the Prix de Rome for medal engraving and is remembered for his Art Nouveau medals, of which his *Orpheus at the Entrance to the Underworld* of 1900 is the best known.

Coutrier, Cornelis (before 1730–1749)

Coypel, Noël (1628–1707). French painter who studied under Poussin and Le Sueur. In 1663, he was admitted to the Académie Royale de Peinture. A favorite of Louis XIV, Coypel served as director of the French Academy in Rome for four years beginning in 1672, and in 1695 the king appointed him director of the Académie Royale in Paris.

Crocquefer, Eugène Adolphe (b. probably 1854; act. ca. 1886–ca. 1895). French sculptor and medalist who exhibited at the Salon of 1905.

Croker, John (1670–1741). English medalist of German birth. In 1697, he became assistant engraver at the Royal Mint, and chief engraver in 1705. Over the next three decades, he single-handedly produced nearly all British official medals, as well as the coinage of Anne, George I, and George II.

Dadler, Sebastian (1586–1657). One of the greatest artists of struck medals. Born in Strasbourg of German parents, Dadler received his training as a goldsmith in France but over his career worked in Augsburg, Vienna, and Dresden, settling for ten years in Gdańsk before moving to Hamburg, where he died.

Danet, Regnault (act. ca. 1529–38). French goldsmith and medalist. He sold three portrait medallions to Francis I.

Danfrie family. Philippe Danfrie I (1531/35–1606) was a French medalist who was engraver general of the mints of France from 1582 to 1598. He is the father of Philippe Danfrie II (ca. 1572–1604), who was made controller general of the mints of France in 1591 and engraver general in 1598.

Dasio, Maximilian (1865–1954). Painter and medalist who spent his entire career in Munich.

Dassier, Jacques-Antoine (1715–1759). Swiss engraver and medalist who studied in Paris and Rome. He later worked at the Royal Mint in London as an assistant engraver (1741–45) and at the Saint Petersburg mint, as well as in Geneva (from 1756). He produced a series of medallic portraits of Englishmen in the 1740s and contributed to a series commemorating the history of the Roman Republic produced by his father, Jean Dassier.

Dassier, Jean (1676–1763). Swiss medalist who studied in Paris before becoming assistant engraver at the Geneva mint in 1696. From 1720 until his death, he was chief engraver of that mint. He produced several medallic series, including Ovid's *Metamorphoses*, religious reformers, British monarchs from William I to George II, and the history of republican Rome.

Daucher, Hans (ca. 1485–1538). Augsburg sculptor and medalist who apprenticed with his uncle, the sculptor Gregor Erhart. He became a master sculptor in 1514 and was one of the most important sculptors of the early German Renaissance.

David d'Angers, Pierre-Jean (1788–1856). French sculptor, medalist, and draftsman who won the Premier Grand Prix de Rome in 1811, before going on to receive the Legion of Honor, become a member of the Académie, and accept a chair at the École des Beaux-Arts, all in 1826. He created more than five hundred portrait medals of notable contemporaries.

Delannoy, Maurice (1885–1972). French sculptor and medalist who exhibited at the 1907 Salon.

Delaune, Etienne (ca. 1518–ca. 1583). French goldsmith, medalist, draftsman, and engraver. He was briefly appointed to the Paris mint in 1552, after which he worked primarily as an engraver.

Dell, Peter, the Elder (1490–1552). Active in Würzburg and specializing in religious and portrait sculpture.

Delpech, Jean Marie (b. 1866). French medalist who studied under Gabriel-Jules Thomas, Jules-Clément Chaplain, and Alphée Dubois.

Depaulis, Alexis Joseph (ca. 1792–1867). French sculptor and medalist. At the École des Beaux-Arts, he trained under Bertrand Andrieu and Pierre Cartellier. Depaulis contributed to the medallic history of Napoleon I's reign.

Deschler, Joachim (ca. 1500/5–1571). Working primarily in Nuremberg, Deschler spent two years studying in Rome and Venice. In 1563, he entered the service of Emperor Maximilian II in Vienna as both an architect and medalist.

Van Dishoecke, Jacob (1650–1723). A little-known Dutch sculptor and medalist who produced medals of members of the House of Orange and of important historical events, as well as one for silver wedding anniversaries.

Dollin, Jean (act. 1680–1717). French medalist who worked at the Mint of France from 1714 to 1725.

Drentwett, Balduin (1545–1627). Goldsmith and medalist active in Augsburg and also working for the courts at Baden and Munich.

Dropsy, Henry (1885–1969). French sculptor and medalist who studied under Frédéric-Charles-Victor de Vernon, Jean-Antoine Injalbert, and Henri Auguste Jules Patey. He was a member of the Société des Artistes Français, *chevalier* of the Legion of Honor, and a professor at the École des Beaux-Arts.

Droz, Jean-Pierre (1746–1823). Swiss medalist trained in France, who worked at the Soho mint in England in 1788 and was later made keeper of the Mint Museum in France.

Dubois, Henri Alfred Auguste (1859–1943). Sculptor and medalist who trained with his father Alphée Dubois before studying under Chapu and Falguière. In 1878, he won a silver medal at the Grand Prix de Rome and five years later was made a member of the Société des Artistes Français at whose exhibition he won several medals. In 1900, he won a silver medal at the Exposition Universelle, and in 1903 he was made *chevalier* of the Legion of Honor.

Dubois, Joseph Eugène (1795–1863). French sculptor and medalist who studied under Droz and Bridan. He was the father of the medalist Alphée Dubois.

Dubut, Charles-Claude (ca. 1657–1742). French sculptor and stuccoist active in Berlin and possibly Dresden. He was court sculptor to Maximilian II Emanuel, Elector of Bavaria, from 1716 to 1726.

Dupré, Abraham (1604–1647). French medalist who in 1641 succeeded his father, Guillaume Dupré, as *contrôleur général* of dies and effigies for the minting of coins.

Dupré, Augustin (1748–1833). French engraver. In 1791, Dupré, supported strongly by Jacques-Louis David, won a competition for new designs for French coinage, shortly after which he was made *graveur général*. His medals commemorate the events of the French Revolution and Republic.

Dupré, Guillaume (ca. 1579–1640). French sculptor, engraver, and medalist who was made official sculptor to Henri IV in 1597 and *contrôleur général* of dies and effigies for the minting of coins in 1604.

Duvivier, Benjamin (1730–1819). French engraver and medalist who studied in the studio of his father, Jean Duvivier, before winning prizes at the Académie de Paris in 1744, 1746, and 1756 and succeeding his father as medal engraver to the king in 1764. In 1772, he was made *graveur général* of the Mint of France and, in 1776, a member of the Académie. Besides his numerous medals commemorating contemporary French figures and historical events, he also produced a series about the American War of Independence.

Duvivier, Jean (1687–1761). French painter, engraver, and medalist. About 1712, Jean-Baptiste de Valdor, ambassador of the prince of Liège, gave him the first order in medallic work: a commemoration piece of the Treaty of Baden. In 1717, Duvivier was elected to the Académie Royale de Peinture, becoming responsible for the majority of the official medals issued by the Paris mint. He exhibited at the Paris Salons of 1737, 1739, 1740, 1746, and 1750.

Engelhart, Johann (d. 1713). A die engraver and medalist, Engelhart occupied the post of mint master in Sweden before 1689 and afterward resided in Breslau.

Enzola, Gianfrancesco (act. 1455–78). Italian goldsmith and medalist. Master of the Ferrara mint in 1472–73 under Ercole d'Este, Duke of Ferrara. Among his principal patrons were Costanzo Sforza of Pesaro, Francesco Sforza, Duke of Milan, Taddeo Menfredi of Faenza, and Cecco Ordelaffi of Forlì.

Eyermann, Bruno (1888–1961). Sculptor, graphic artist, painter, die engraver, and medalist active in Leipzig.

Faccioli, Girolamo (act. ca. 1560; d. 1573). Italian goldsmith, medalist, and engraver who produced engravings in the style of Cecchino de Salviati, Correggio, and Francesco Mazzuola.

Della Fede, Matteo, called Matteo Pagano (act. 1543–62). Italian wood engraver and medalist. He produced medals for Tommaso Rangone.

Flanagan, John (1865–1952). American sculptor and medalist who studied under Paul Wayland Bartlett in Boston, Augustus Saint-Gaudens in New York, and Jean Alexandre Joseph Falguière in Paris at the École des Beaux-Arts. In 1900, he won a silver medal at the Paris Exposition Universelle, and in 1927 he was made *chevalier* of the Legion of Honor.

Flourat, Daniel G. (1928–1968). French medalist. There is evidence of his working as a medal engraver in Paris in 1958–59.

Da Foligno, Emiliano Orfini (act. 1461–84). Italian goldsmith, engraver, and medalist. In Rome, he worked at the papal mint for Pius II, Paul II, and Sixtus IV. In Foligno, his native city, he created a workshop.

Fontana, Annibale (1540–1587). Italian medalist, hardstone engraver, and sculptor mainly active in Milan, where he was a member of the Accademia della Val di Blenio. His presence is documented in Palermo in 1570, indicating a connection with the Gaggini family workshop.

Foppa, Cristoforo, called Caradosso (ca. 1452–1526/27). Italian goldsmith, jeweler, medalist, and dealer. In 1505, Caradosso moved to Rome and four years later became a founder member of the Università degli Orefici. There, he received commissions from members of the papal court. According to Cellini, Caradosso was the finest craftsman of his day.

Fortini, Giovacchino (1670–1736). Italian sculptor, architect, and medalist. Trained by Carlo Marcellini and Giuseppe Piamontini, he worked for Giovanni Battista Foggini in Florence. Chief court architect to the Medici, Fortini was also one of the masters of the Accademia del Disegno in Florence.

Di Forzore Spinelli, Niccolò, called Niccolò Fiorentino (1430–1514). Italian medalist born in Florence to a family of goldsmiths. It is reported that he worked for the dukes of Burgundy and engraved seals for Charles the Bold.

Franchi, Agostino (act. 1738–50s). Italian die sinker and medalist. Among his best-known works are two medals featuring the Venetian senator Flaminio Cornaro and Cardinal Angelo Quirini.

Francia, Francesco (1450–1517). Italian painter, engraver, and medalist, who, according to Vasari, was regarded by the people of Bologna as a god. He was a friend and colleague of Lorenzo Costa, and the two worked together on an altarpiece for the church of the Misericordia. Francia may have supplied Aldus Manutius with the first italic fonts.

Fueszl, Christoph, the Elder (d. 1561). Die engraver at Kremnitz from 1543 until 1561.

Gaci (or Caci), Rutilio (ca. 1570–1634). Italian sculptor and medalist. In 1600, he lived and worked in Spain. Caci produced wax busts and funerary monuments, including a large number of medals.

Galeotti, Pietro Paolo, called Romano (1520–1584). Italian goldsmith, sculptor, and medalist. He met Benvenuto Cellini in Rome and accompanied him to Florence and Ferrara. In Paris, Galeotti worked in Cellini's workshop with Ascanio de' Mari. About 1552, he moved to Florence, where he worked at the mint. He has been traditionally associated with medals signed "PPR," though recent scholarship has suggested those medals should be attributed instead to Pietro Paolo Tomei, also called Romano.

Galle, André (1761–1844). French medalist who worked under Augustin Dupré at the Paris mint and contributed greatly to Denon's medallic history of Napoleon's reign. He was elected to the Institut de France in 1819 and made *chevalier* of the Legion of Honor in 1825.

Gambello, Vittore, called Camelio (1455/60–1537). Italian medalist and sculptor who studied drawing under Giovanni Bellini. In 1484, he worked as *maestro delle stampe* at the Venetian mint and from 1515 to 1517 as a die engraver at the papal mint.

Gasq, Paul Jean-Baptiste (1860–1944). French sculptor who studied at the Écoles des Beaux-Arts in Dijon and Paris, respectively. In 1890, he won the Premier Prix de Rome and in 1900, a Grand Prix. He became a member of the Institut in 1935.

Gass, Johann Balthasar (1730–1813). Medalist and coin engraver in Saint Petersburg, who worked principally for Catherine the Great.

Gatteaux, Jacques-Édouard (1788–1881). French sculptor and medalist. He won the Prix de Rome in 1809, was medalist to Louis XVIII from 1814 until 1855, was made a member of the Académie des Beaux-Arts in 1845, and went on to become an influential teacher. After his death, his extensive art collection was divided between the Louvre and the École des Beaux-Arts.

Gauvain, Jacques (before 1501–after 1547). French goldsmith, engraver, and medalist. From 1521 to 1524, he worked at the Grenoble mint as die engraver. Medals he produced for the consulate of Lyon were subsequently given as presents to Queen Eleanor of Austria, second wife of Francis I.

Gayrard, Raymond (1777–1858). French sculptor, medalist, and poet. From 1814, he exhibited at the *Salon des médaillons et des bustes de personnages célèbres*. He fought for the French Republic from 1796 until 1802, worked with Denon, and was made *chevalier* of the Legion of Honor in 1825.

Gebel, Matthes (ca. 1500–1574). One of the most important and prolific of all German medalists, Gebel dominated medal production in Nuremberg for thirty years.

Di Geremia, Cristoforo (ca. 1430–1476). Italian medalist and goldsmith. He went to Rome in 1456 and was later employed by Ludovico Scarampi Mezzarota, Cardinal of San Lorenzo and Patriarch of Aquileia, for whom di Geremia may have produced a medal featuring his portrait. In 1469, he received payment for medals of Paul II to be buried in the foundations of Palazzo Venezia in Rome.

Gies, Ludwig (1887–1966). German sculptor, medalist, and professor of art active mainly in Berlin and Cologne. He produced an impressive body of medals and small plaquettes on the horrors of World War I.

Gil, Jerónimo Antonio (1731/32–1798). Spanish painter, engraver, printmaker, and medalist who studied under Tomás Prieto. He was one of the first students at the Academia de S. Fernando in Madrid, where he received the diploma of Académico de Mérito in engraving. He moved to Mexico in 1778, where he founded and directed the Real Academia de San Carlos de Nueva España and became senior engraver at the Casa de Moneda in Mexico City.

Gilbault, Ferdinand (1837–1926). French sculptor and medalist. In 1888, he became a member of the Société des Artistes Français, and he won a bronze medal in 1901.

Di Giovanni, Bertoldo (1420/30–1491). Italian sculptor and medalist. According to Vasari, Bertoldo was responsible for the completion of Donatello's late works. In charge of the academy that met in the Medici sculpture garden near the church of San Marco, he mostly worked for Lorenzo the Magnificent.

Glosimodt, Olav Olavson (1821–1901). Norwegian woodcarver and sculptor, known for his extended production of portraits of contemporary well-known figures, mainly in Denmark. Many of the portraits are done as medals, medallions, or statuettes and are in ivory or boxwood.

GO, AN (act. ca. 1568). Italian medalist and possibly sculptor. Possibly from Padua. A medal dated 1568, produced for Teodora Cosmico, features the artist's signature.

Guglielmada, Giovanni Battista (act. 1665–88; d. 1689). Italian medalist. Among his patrons were King John Sobieski of Poland and popes Clement IX and Innocent XI.

Guillemard, Anton (1747–1812). French medalist to Louis XVI before working at the Prague mint from 1769 to 1810.

Hagenauer, Friedrich (act. 1525–after 1546). Born in Strasbourg, Hagenauer was an itinerant artist, working in many German cities, especially Munich, Augsburg, and Cologne. He was among the most productive and sophisticated of German Renaissance medalists, working in an elegant, low-relief style.

Hamerani, Ermenegildo (1683–1756). Italian coin engraver and medalist who worked for popes Clement XI, Innocent XIII, and Benedict XIII. In Rome, Ermenegildo became a member of the Accademia di San Luca.

Hamerani, Giovanni (1763–1846). Italian architect and medalist who became engraver of the papal mint in 1801. His death ended the male line of the Hamerani dynasty.

Hamerani, Giovanni Martino (1646–1705). Italian medalist and master engraver of seals who worked at the papal mint where, in 1679, he became chief engraver. In 1684, Hamerani was elected to the Accademia di San Luca.

Hamerani, Ottone (1694–1761). Italian coin engraver and medalist. He worked in the papal mint, producing medals for various popes, including Clement XI, Clement XII, and Benedict XIV. Ottone also struck several medals for James Stuart, the Old Pretender of England.

Harnisch, Johann Baptist (1778–1826). Director of the School of Engraving in Vienna, where, between 1812 and 1826, he was court medalist, and, between 1808 and 1812, coin and medal engraver at the Vienna mint.

Hautsch, Georg (1664–ca. 1745). Active first in Nuremberg, his native city, from 1683 to 1712, Hautsch then settled in Vienna, where he produced both medals and coin dies.

Hedlinger, Johann Carl (1691–1771). Of Swiss origin and one of the foremost medalists and die cutters of the eighteenth century, he worked primarily for the Swedish court but also traveled and worked extensively throughout Europe.

Hendrik (Heinrik), Gerard, the Younger (act. ca. 1587; d. ca. 1616). Dutch sculptor active in Silesia and Bohemia who became a citizen of Breslau (now Wrocław, Poland) in 1587.

Hensbergen, Roelof (act. 1665–77). Dutch medalist. In 1665, he became a citizen of Amsterdam, where he was appointed die cutter in 1672.

Van Herwijk, Steven (ca. 1530–1565/67. Dutch medalist who worked in his native Utrecht, Antwerp, and England, where he produced the first medals of private individuals to be made there.

Heuberger, Leopold (1786–1839). Austrian medalist who produced many medals for the court in Vienna.

Hilliard, Nicholas (ca. 1547–1619). English miniaturist, jeweler, and painter. He worked for Elizabeth I until her death, after which, in 1603, he was made official medalist and miniaturist to James I.

Van der Hoef, Christiaan Johannes (1875–1933). Dutch medalist and sculptor. In 1928, he won a silver medal in the art competitions of the Olympic Games for his *Médailles pour les Jeux Olympiques*.

Höhn, Johann, the Elder (1607–1693). Medalist born in Strasbourg and active at the Gdańsk mint from 1636, as well as at the Danzig mint, the electoral court of Brandenburg, and various foreign courts. He produced excellent struck medals in the manner of Sebastian Dadler.

Holdermann, Georg (1585–1629). Nuremberg medalist and wax modeler.

Holtzhey, Johann George (1729–1808). Dutch medalist and engraver who became master of the mints of Guelders and Middelburg and master of the mint at Utrecht (1771–76). He received commissions from the Netherlands and from the royal houses of France and Prussia.

Injalbert, Jean-Antoine (1845–1933). French sculptor and designer who studied in Dumont's studio at the École des Beaux-Arts, Paris. He won the Prix de Rome in 1874 and the Grand Prix at the 1889 Exposition Universelle. He was made an *officier* of the Legion of Honor in 1897, a member of the Exposition Universelle *hors concours* in 1900, a member of the Institut in 1905, and a *commandeur* of the Legion of Honor in 1910.

Iwanoff, Timothei (1729–1802). Russian medalist and mint engraver who was one of the finest of the Russian medalists. He also cut most of the dies for the coinage of Catherine the Great.

Jacquet, Nicolas-Gabriel (act. 1601–26). French sculptor and medalist.

Jaeger, Johann Caspar (mid-18th century–after 1791). German medalist appointed court medalist by Catherine the Great in 1772.

Jeuffroy, Romain-Vincent (1749–1826). French gem engraver and medalist. He was director of the École de Gravure en Pierres Fines from 1805, a member of the Institut (1803) and Académie des Beaux-Arts (1816), and *chevalier* of the Legion of Honor. He contributed to Denon's medallic history of Napoleon.

Jonghelinck, Jacques (1530–1606). Flemish sculptor and medalist who trained in Milan in the studio of sculptor Leone Leoni. After his return to the Low Countries in about 1553, he worked on a number of important commissions from members of the Spanish court and royal family, and in 1572 he was made master of the Antwerp mint.

Judin, Samuel (1730–1800). Russian medalist who worked for Peter the Great in Saint Petersburg.

Kaiserswerth, Peter (act. 1765–93). Austrian medalist and coin engraver at the Vienna mint.

Karlsteen, Arvid (1647–1718). Swedish medalist and die engraver, who studied in Paris under Jean Warin and London with John Roettier. He worked in Berlin and Dresden but returned to his native land, where he was ennobled in 1692.

Kautsch, Heinrich (1859–1943). Austrian sculptor and medalist who produced many portraits and figural plaquettes in low relief.

Keller, Johann Balthasar (1638–1702). Swiss goldsmith and medalist. In France, he worked on several occasions with his brother Johann Jakob. They executed a statue of Louis XIV for the city of Lyon.

Kempson, Peter (act. ca. 1798–ca. 1844). British medalist and button maker. He entered into a die sinking partnership with Samuel Kindon in 1801 and appears to have worked with his son from 1810 to 1825/26.

Kirk, John (ca. 1724–ca. 1778). British medalist and gem engraver who studied under James Anthony Dassier.

Kleinert, Friedrich (1633–1714). Silversmith and coin dealer at Nuremberg, he produced struck medals using innovations in machinery, including a method of adding inscriptions on the edges.

Koegler, Mathias

Kornmann, Johann Jacob (d. 1649). Goldsmith, medalist, and wax modeler from Augsburg. He spent the latter part of his career in Venice and Rome.

Kounitzky, Franz (1880–1928). Austrian sculptor, medalist, and die engraver who worked for the Vienna mint.

Krüger, Gotfred (dates unknown). Mint master in Copenhagen between 1665 and 1680.

Küchler, Conrad Heinrich (act. 1763–1821). German medalist, sculptor, and portrait artist who worked under Matthew Boulton at a private mint in Soho, Birmingham.

Lafitte, Louis (1770–1828). Draftsman and painter. He won the Grand Prix de Rome, exhibited at the Salon until 1817, and was named draftsman to Louis XVIII.

Lauch, Balthasar (act. 1669–85). German goldsmith and medalist working in Leipzig.

Lauer Die-Sinking Establishment (1729–1924). Founded in 1729 and reorganized in 1860 under the name Münz-Präge Anstalt L. Chr. Lauer in Nuremberg. Ludwig Christoph Lauer (d. 1873), who became director of the firm in 1848, was its most innovative leader. He was succeeded by his wife, Betty, and three sons, Johann, Ludwig, and Wolfgang.

Lauffer, Caspar Gottlieb (act. 1660–ca. 1717). Medalist and mint master at Nuremberg from 1670 to 1690 and chief mint warden in Franconia.

Lautensack, Hanns (ca. 1520–1564/66). Medalist and die engraver from Nuremberg.

Lazari, Antonio (first half of 18th century). Italian medalist. In 1709, he worked as an engraver at the Bologna mint. Lazari signed some of his medals with ANT. LAZARI.

Le Gentil, Jean Philippe Guy, Comte de Paroy (act. ca. 1808–14). French painter, engraver, and writer. In 1785, he was made an honorary associate of the Académie Royale, and he exhibited at the Salon of 1787. He wrote several books on art, including a history of the Académie Royale de Peinture.

Lechevrel, Alphonse-Eugène (1848–1924). French medalist and gem engraver who studied under Henri François. He won a silver medal for medal engraving at the 1900 Exposition Universelle, as well as awards in several earlier expositions.

Leclerc, Nicolas (act. 1487–1507). French sculptor and publisher.

Lemot, François Frédéric (1772–1827). Sculptor; First Grand Prix de Rome, 1790; member of the Institut, 1805; professor at the École des Beaux-Arts; *officier* of the Legion of Honor. He executed many major public sculptural monuments in Paris.

Leoni, Leone (1509–1590). Italian sculptor, goldsmith, and medalist. He worked in Venice as a goldsmith, at the mints of Ferrara and Milan, and as an engraver at the papal mint in Rome. His patrons included Holy Roman emperors Charles V and Philip II and, in Genoa, Andrea Doria. Leone was also known as an art collector. He assembled paintings and sculptures, including plaster casts of both ancient and modern works.

Leoni, Ludovico (1542–1612). Italian painter, die engraver, and medalist who initially worked in Padua. In 1574, he moved to Rome, where he was an engraver at the mint. He is documented as a San Luca academician.

Leoni, Pompeo (ca. 1533–1608). Italian sculptor, son of Leone Leoni. Pompeo was trained by his father and worked with him on several projects. In Spain, thanks to Leone, Pompeo entered the service of the regent Joanna of Austria. There, he received numerous commissions for marble sepulchral effigies.

Lievens, Jan, also known as Lievens de Oude (1607–1674). Dutch painter, engraver, and draftsman. He trained under Joris van Schooten and Pieter Lastman. From 1625 to 1631, Lievens collaborated with Rembrandt, possibly sharing a studio with him. In England, he painted portraits of members of the royal family.

Linck, Johann (act. 1659–1711). Medalist and die engraver in Heidelberg.

Looff, Johannes (act. 1623–48; d. 1651). Dutch medalist and engraver who worked for the Zeeland mint.

Loos, Daniel Friedrich (1735–1819). Medalist and die engraver for the Prussian court in Berlin.

Lotello, Anteo (act. ca. 1572–ca. 1578). Italian medalist who worked in Milan, Munich, and Turin. After 1578, Lotello may have moved to France or Lorraine, producing a medal for Charles III, Duke of Lorraine.

Lutma, Johannes (or Jan), the Elder (ca. 1584–1669). Born in Emden, Germany, where he trained as a goldsmith. Established as a silversmith in Amsterdam by 1620, where he achieved considerable fame as one of the greatest Dutch silversmiths, as well as an engraver. He became master of the Amsterdam silversmiths' guild in 1643.

Lutma, Johannes (or Jan), the Younger (1624–1685/89). Dutch engraver and goldsmith and son and pupil of Jan the Elder. He is considered one of the inventors of engraving in stipple and produced portraits and prints of landscapes (after Rembrandt) and portraits.

Lysippus the Younger, also known as Hermes Flavius de Bonis (ca. 1450/55–after 1526). Italian medalist who was possibly the nephew of Cristoforo di Geremia. Lysippus was active during the reign of Pope Sixtus IV, producing many medallic portraits of papal officials.

De' Maestri of Florence, Adriano, called Adriano Fiorentino (ca. 1450/60–1499). Italian medalist and sculptor. Began his career as *staffiere* in the house of Lorenzo de' Medici. In 1493, Adriano is recorded living in the household of King Ferdinand in Naples and in 1494 in the house of the Duke of Calabria. His talent and skills as medalist are eulogized in a letter written in 1495 by Elisabetta Gonzaga, Duchess of Urbino.

Magdeburger, Hieronymus (d. 1540). Mint master and engraver at Annaberg and Freiberg in Saxony.

Malavasi, Giuseppe (d. 1855). Italian sculptor and medalist active in Modena. He produced a medal commemorating the birth of the heir apparent of Duke Francesco IV of Modena.

Maler, Christian (1578–1652). Son of the medalist Valentin Maler, he took over his father's business in Nuremberg in 1603. He worked in Vienna as an engraver at the mint (1608–9), returning to Nuremberg by the end of 1609. He was again in Vienna in 1630 but spent the remainder of his career in northern Germany. Most of his medals are struck.

Maler, Valentin (ca. 1540–1603). A prolific medalist, sculptor, and goldsmith, he was the son-in-law and pupil of the famous Nuremberg goldsmith Wenzel Jamnitzer. Maler began working in that city in 1568. Most of the subjects of his more than two hundred medals were citizens of Nuremberg, but he also worked for the courts in Vienna, Prague, and Dresden, as well as for patrons in other German cities. He was one of the first artists to use wax for his models.

Manfredini, Luigi (1771–1840). Italian metalworker active during the Napoleonic invasion in Italy. He made medallic portraits of Napoleon and a gilt-bronze ornamental table with his brother Francesco.

Marende, Jean (act. ca. 1502). French medalist and goldsmith.

Marescotti, Antonio (act. 1444–62). Italian medalist. One of his best-known medals features the profile of San Bernardino of Siena, executed after his canonization in 1450. His signature was MARE SCOTUS.

Martin, Guillaume (ca. 1520–ca. 1590). French sculptor, goldsmith, and engraver based in Paris.

Martiny, Philip (1858–1927). French sculptor born in Alsace. In 1878, he came to New York, where he worked for Augustus Saint-Gaudens. He was also a member of the Saint-Gaudens colony in Cornish, New Hampshire. He produced many works for New York but only one medal.

Master F.V. (act. 16th century). Signature of a medalist about whom nothing is known other than that he worked about 1560.

Master of the Ottheinrich of the Palatinate Group (act. 1551–59). Georg Habich gave this name to a group of medals that are among the finest German Renaissance examples. Scholars have not been able to agree definitively on the identity of the artist. The style of the medals of Ottheinrich is close to that of a remarkable alabaster bust of the elector in the Louvre attributed to Dietrich Schro, whose medals, however, are of lower quality.

Meit, Konrad (ca. 1480–ca. 1551). German sculptor, engraver, and medalist mostly active in Brabant and France. He worked for Prince Elector Frederick the Wise of Saxony, Philip of Burgundy, and Margaret of Austria. In 1536, Meit joined the guild of St. Luke. During his early career, he spent time in the workshop of Lucas Cranach the Elder.

Melone (or Melon), Giovanni Vincenzo (act. 1571–89). Italian medalist possibly related to Altobello Melone. He worked in the papal mint under popes Gregory XIII and Sixtus V.

Meynier, Charles (1768–1832). Painter, watercolorist, engraver, and draftsman. He won the Prix de Rome in 1789; exhibited at the Salon de Paris from 1795 to 1824; was a member of the Institut; an *officier* of the Legion of Honor; and painted grisailles at the Bourse and several ceiling frescoes at the Louvre.

Michel, Claude, called Clodion (1738–1814). French sculptor and draftsman who worked primarily in terracotta. He won the Prix de Rome in 1759. His work was in great demand throughout Europe.

Milicz, Nickel (act. ca. 1539–before 1575). Goldsmith, medalist, and mint engraver at Joachimsthal, Nickel was the son of Wolf Milicz and a member of a family of medalists producing for sixty-five years mostly struck medals, many of which were devoted to purely religious subjects. He was also mint engraver at Prague about 1568.

Milicz, Wolf (act. 1533–46). Founder of the Milicz family of medalists in Joachimsthal and mint engraver.

Mills, George (1792–1824). British medalist who worked at the Soho mint. He exhibited at the Royal Academy from 1816 to 1823 and won three gold medals from the Society of Arts.

Mola, Gaspare (ca. 1580–1640). Italian sculptor, goldsmith, and medalist. In 1597, he worked as a die cutter at the Florentine mint. Mola produced medals for Charles Emmanuel I, Duke of Savoy, and Ferdinando Gonzaga, 6th Duke of Mantua. In 1625, he became Master of the Mint in Rome.

Mola, Gasparo Morone (d. 1669). Italian die cutter and medalist. Working in Mantua from 1627, he produced coins and medals for Vincenzo II Gonzaga, 7th Duke of Mantua, and Carlo I Gonzaga, 8th Duke of Mantua. Mola executed medals and coins for Pope Innocent X.

Molart, Michel (1641–1713). French medalist. He worked as an ivory sculptor before becoming medalist to King Louis XIV, working on a medallic history of his reign.

Mondella, Galeazzo, called Moderno (1467–1528). Italian plaquette designer, medalist, and gem engraver. Through Cardinal Domenico Grimani of Venice, Moderno developed a considerable Venetian clientele. In 1487, he was working as a medalist in Mantua. After 1517, he may have engaged in civic affairs after the restoration of his family to the council of nobles in Verona.

Della Moneta, Antonello Grifo (act. 1454–84). Italian goldsmith, die cutter, and medalist. Active at the Venetian mint in 1454.

Monogrammist DS (act. 1560–69)

Monogrammist I.M. (Isaak Melper?) (early to mid-16th century). Swiss medalist whose initials are found on the medal of Bartholomäus Schowinger (Schubinger) dated 1561.

Muller, Wouter (1604–1673). One of the most important Dutch medalists and silversmiths. Little is known of his life other than his having been admitted to the Amsterdam guild in 1641.

Müller, Philipp Heinrich (1654–1719). Celebrated medalist and die engraver who worked in Augsburg, Nuremberg, Salzburg, and many other mints.

Natter, Johann Lorenz (1705–1763). German engraver, medalist, and art dealer who traveled across Europe, working in cities such as Venice, Florence, London, Copenhagen, and Stockholm. A frequent patron was William IV of Orange Nassau, Stadtholder of the Netherlands, after whose death in 1751 Natter moved briefly to England, where he was made an honorary member of the Society of Antiquaries. From 1756 to 1757, he worked as chief engraver at the Utrecht mint before settling in The Hague.

Neufahrer, Ludwig (ca. 1500/5–1563). Medalist, goldsmith, and mint master probably from Upper Austria and active in Vienna and Prague for the imperial court.

Nini, Giovanni Battista (1717–1786). Italian medalist and engraver. In Bologna, he studied sculpture at the Accademia Clementina. Nini worked in Spain as superintendent of a glassworks near Madrid, then as an engraver in Paris. The subjects of his portraits include Louis XV, Catherine the Great, Louis XVI, and Marie Antoinette. His medallions were made of terracotta.

Nocq, Henri Eugène (1868–1942). French sculptor, medalist, and draftsman. A pupil of Henri Chapu, he began exhibiting at the Paris Salon in 1887. He was a member of the Société Nationale des Beaux-Arts and the Société des Antiquaires de France, as well as *chevalier* of the Legion of Honor.

Olivier, Alexandre (1527–before 1607). French medalist and the second director of the Monnaie du Moulin in Paris (succeeding his father, the first director, in 1581). From 1550, he and his father produced most of the official royal commemorative medals of France.

Olivieri, Maffeo (1484–1543/44). Italian sculptor, bronze caster, and medalist. His only signed work is a pair of candlesticks for Bishop Altobello Averoldo in 1527.

Omeis (or Ohmeiss), Martin Heinrich (1651–1703). German medalist and seal and coin engraver active in the mint at Dresden.

Ortolani, Giuseppe (ca. 1674–1734). Italian medalist active in the papal court from 1689. He executed the medals of Charles III of Spain and Cardinal Henry de Noris of Verona.

Paladino, Girolamo (1647–1689). Italian seal engraver and medalist active in Rome from 1667. He created a series of restitution medals of popes from Martin V to Pius V.

Parise, Erich (d. 1666). French medalist known for having made medals of the Swedish queen Christina. Parise traveled to the Nordic countries and spent time in Denmark before settling in Sweden, where he remained in the queen's service until she abdicated in 1654. In the late 1650s, he traveled with her back to Denmark, where he made medals of the Danish king Frederick III and his wife, Queen Sophie Amalie. Parise was hired by the Swedish mint in 1661. From 1663 until his death in 1666, he worked for the Swedish nobleman Magnus Gabriel de la Gardie (1622–1686).

Pasqualigo, Martino (ca. 1524–1580). Italian sculptor, goldsmith, and medalist active in Milan and Venice. He was a student of Leone Leoni and Sansovino.

Di Pasqualino Boldù, Giovanni (act. ca. 1454–77). Italian medalist, often referred to as *maistro de nape*, Venetian for "decorator of chimneypieces." The technique used for finishing his medals suggests a background in metalworking and gem cutting.

De Passe, Simon (1595–1647). Dutch painter, draftsman, and engraver who worked in London from 1616, engraving portraits of the royal family (published either by his father, Crispijn de Passe, or in London). He moved to Copenhagen in 1624, where he became royal engraver to Christian IV. He worked in Denmark until the end of his life, returning occasionally to the Netherlands.

Passero, Bernardino (ca. 1540–1596). Italian sculptor and medalist. He worked in Rome and made medals for Pope Gregory XIII, some of which were placed in the foundations of the Jesuit College.

De' Pasti, Matteo (1420–d. aft. 1467). Italian medalist, architect, painter, and illuminator. He worked for Piero di Cosimo de' Medici in 1441 and for the Este court between 1444 and 1446. From 1449, his presence is documented in Rimini, where he became a valued artist and friend to Sigismondo Pandolfo Malatesta. Sigismondo's portrait and that of his mistress, Isotta degli Atti, are among Matteo's early medals.

De' Pastorini, Pastorino (ca. 1508–1592). Italian medalist and die engraver who trained as a glass painter under Guillaume de Marcillat. He worked in several Emilian mints. In Florence, he was *maestro di stucchi* under Grand Duke Francesco de' Medici.

Patey, Henri Auguste Jules (1855–1930). French sculptor and medalist who studied under Henri Chapu and François Jouffroy. He was made head medalist at the Paris mint in 1896 and *chevalier* of the Legion of Honor in 1898.

Pazzaglia, Antonio (ca. 1736–1815). Italian medalist and gem engraver who worked for Catherine II, Empress of Russia and Emperor Joseph II. Pazzaglia signed some of his works with his name in Greek letters: ΠΑΖΑΛΙΑΣ.

Perger, Bernhard (act. ca. 1769–98). German medalist and mint engraver in Naples, where he produced several medals of the royal house and many coin designs.

Perro, Hans Georg (act. from ca. 1629). Carinthian die cutter and medalist.

Petrecino of Florence (act. 1460). Italian medalist. Little is known about the artist, though three medals, dated 1460, bear what is believed to be his signature. They feature portraits of Pico della Mirandola, Borso d'Este, and Lorenzo Strozzi.

Pfründt, Georg (1603–1663). Sculptor, medalist, modeler in wax, and gem engraver active in Ratisbon. He appears to have resided in Lyon and possibly worked in Paris under Jean Warin, as well as in various minor courts in southern Germany.

Pilon, Germain (ca. 1525–1590). One of the most important French Renaissance sculptors. He trained in the workshop of his father André Pilon and, in 1573, was made *contrôleur général des effigies* at the Paris mint. A series of medallions with portraits of the last Valois rulers of France is attributed to him.

Pingo, Thomas (1692–1776). British medalist and engraver. He worked for the Royal Mint in London and was a successful and innovative member of a large family of medalists.

Plura, Carlo Giuseppe (1655–1737). Swiss stucco artist, sculptor, and wood carver active in England.

Poggini, Domenico (1520–1590). Italian medalist, sculptor, die engraver, goldsmith, and poet. During his early career, he worked for Cosimo I de' Medici and in 1556 was appointed die cutter for the Florentine mint. Called to Rome by the pope about 1585, he became chief engraver of the mint.

Poggini, Giampaolo (1518–ca. 1582). Italian medalist and sculptor. Brother of Domenico Poggini, with whom he worked for Cosimo de' Medici. Between 1553 and 1555, Giampaolo left Italy to work for Philip II, King of Spain, in the Netherlands and Spain.

Ponscarme, François-Joseph-Hubert (1827–1903). French medalist and sculptor who trained under Eugène Oudiné and Augustin-Alexandre Dumont at the École des Beaux-Arts. In 1871, he became a professor of medal engraving at the École, where he taught Louis-Oscar Roty and Alexandre Charpentier, among others.

Pool I, Juriaen (1618–1669). Dutch medalist and silversmith. Born in Seidlitz, Silesia, he is recorded in Amsterdam as a silversmith in 1651. All of his medals are struck and in silver.

Posch, Leonhard (1750–1831). German sculptor and medalist working in Vienna, Berlin, and Paris. He produced many works in both sculpture and medals.

Pozzo, Giovanni Battista (ca. 1670–1752). Italian medalist and engraver of ivory. He worked for Cardinal Albani and Prince Eugene of Savoy.

Pisano, Antonio di Puccio, called Pisanello (ca. 1395–1455). Italian painter, draftsman, and medalist. Early in his career, he worked under the direction of Gentile da Fabriano on a cycle of frescoes in the Great Council Hall in Venice. In 1438, Pisanello made his first portrait medal depicting Emperor John VIII on the occasion of his visit to the city of Ferrara.

Préault, Antoine-Augustin (1809–1879). An important Romantic French sculptor who studied in various ateliers and briefly with David d'Angers. He was made *chevalier* of the Legion of Honor in 1870.

Putinati, Francesco (1775–ca. 1853). Italian sculptor, engraver, and medalist who engraved several medals featuring famous contemporary figures. Among his clients was the patrician Giuseppe Archinto.

Ranghieri, Peter (d. 1624). Son of Raphael Ranghieri, Peter is described in his will as an imperial founder of "Cammerkunst." He probably moved from Prague to Vienna about 1600 and died there at the beginning of 1624.

Ranghieri, Raphael (act. ca. 1567–1587). Possibly from Verona, Ranghieri was a homeowner in Vienna between 1567 and 1587 and is recorded as a portraitist and painter. He is associated with Antonio Abondio in Vienna and at the court in Prague, where he may have died.

Rappost, Heinrich, the Younger (d. 1616). Documented in Wölfen büttel from 1599 to his death in 1616.

Rawlins, Thomas (1620–1670). British medalist, engraver, and playwright who studied under Nicolas Briot, whom he succeeded as chief engraver at the Royal Mint in London in 1646. After the execution of Charles I (1649), Rawlins fled to France, returning to England after the Restoration (1660) to serve again as chief engraver at the Royal Mint.

Regnier, Pierre (ca. 1577–after 1640). French medalist and engraver who studied under Alexandre Olivier and succeeded him after his death, in 1607, as director of the mechanized Paris mint (the Monnaie du Moulin). He resigned in 1639.

Reifenstein (or Reyffenstein), Johann Wilhelm (b. ca. 1520). Primarily an amateur medalist, recorded in letters and medals dated 1543. He studied in Wittenberg and lived in Martin Luther's house and was a close friend of Philip Melancthon.

Reinhart, Hans, the Elder (ca. 1510–1581). A sculptor and cabinetmaker, Reinhart, a resident of Leipzig, produced a series of extraordinary medals between 1535 and 1544. He was an innovator and experimented with unconventional effects, seen especially in his tour-de-force Trinity medal.

Reteke, Johann Christoph (act. 1664–1720). Medalist and die engraver at Hamburg, where he cut numerous dies for the Species-Bank. He was named mint master at Eutin in 1722.

Riccio, Andrea (ca. 1470–1532). Italian architect, sculptor, goldsmith, and medalist. Trained by Bartolomeo Bellano, Riccio worked mainly at the Scuola del Santo in Padua. About 1511, he made bronze reliefs for the church of S. Maria dei Servi in Venice.

Richard, Jean-Jacques (1792–1865). French founder who developed a number of successful alloys and founding techniques. On occasion, he worked with his brother Louis Richard.

Richard, Louis Marie Joseph (1791–1879). French founder and the favorite of his friend David d'Angers, who once referred to him as "the finest founder in all of Europe." Richard and chaser Édouard Quesnel founded Richard & Quesnel in 1826 and worked together until 1836, after which Richard joined Eck and Durand, where he worked until 1844.

Richier, Jacob (ca. 1586–ca. 1640). French architect and sculptor. After settling in the Dauphiné about 1611, he worked as a sculptor for François de Bonne, Duke of Lesdiguières.

Richter, Lucas (act. 1557; d. ca. 1590). Die engraver in the mint at Kremnitz. He produced many religious and portrait medals.

Riesing, Karl Ernst (act. until ca. 1795). German medalist and die and seal engraver in Würzburg, 1793–95.

Van Rijswijck, Dirck (1596–1679). Dutch jeweler and medalist. In the late 1620s or early 1630s, he moved from Antwerp to Amsterdam, where he produced all his known works, including his commemorative medals. He is perhaps better known as an artist of mother-of-pearl inlay.

Ringel d'Illzach, Jean-Désiré (1849–1916). French sculptor and medalist who was a member of the Salon des Artistes Français (from 1888) and the Société Nationale des Beaux-Arts (from 1904).

Rivet, Adolphe (1855–1925). French sculptor and medalist who studied under Jules Cavalier, Hubert Ponscarme, and Louis-Oscar Roty. He exhibited at the Salon des Artistes Français in Paris, where he won a second-class medal in 1908.

Roettiers, Jan (1631–1703). Flemish medalist who worked at the Antwerp mint before relocating to London, where, in 1670, he became chief engraver at the Royal Mint. He worked there until 1698.

Roettiers, Norbert (1665–1727). Flemish medalist who worked at the Royal Mint in London from 1684 to 1695, where he was responsible for, among other things, a series of medallic portraits of English monarchs from Charles I to William III. He became a naturalized French citizen in 1719 and a member of the Académie Royale in 1722.

Romano, Gian Cristoforo (ca. 1465–1512). Italian sculptor and medalist. He was probably in Urbino before 1482, working at the Palazzo Ducale with Ambrogio d'Antonio Barocci. In 1491, Romano began what is considered his major commission: the tomb of Giangaleazzo Visconti, 1st Duke of Milan, at the Certosa di Pavia.

De' Rossi, Giovanni Antonio (1513–after 1575). Italian medalist and gem engraver. He worked in Milan, Venice, Florence, and Rome, where in 1561 he became warden of the papal mint.

Rottermont, Adriaen (1579–1652). Dutch medalist and goldsmith active in The Hague, where in 1632 and 1635 he was dean of The Hague's goldsmith guild and mint master in Dordrecht in 1635.

Roty, Louis-Oscar (1846–1911). French sculptor and medalist. With the support of his mentor Jules-Clément Chaplain, Roty was elected to the Institut in 1888. In 1889, he was made an *officier* of the Legion of Honor. In 1907, he won the Salon medal of honor for sculpture, "an unprecedented award for a medalist."

Roussel, Jérôme (1663–1713). French medalist who was received into the Académie Royale de Peinture et de Sculpture in 1709. He was medal-engraver to Louis XIV and produced numerous medals for the Paris medal mint, where he started working about 1686.

Ruspagiari, Alfonso (1521–1576). Italian medalist who spent most of his life in Reggio Emilia serving as a civic official responsible for public works. In 1571, he was superintendent of the Reggio mint.

Saint-Gaudens, Augustus (1848–1907). American sculptor and painter. He initially apprenticed as a cameo cutter in New York, attending drawing classes by night under the tutelage of Daniel Huntington and Emanuel Leutze at the National Academy of Design. In 1867, he traveled to Europe, studying at the Petite École until his admission to the École des Beaux-Arts in 1868, where he studied under François Jouffroy. Saint-Gaudens founded the National Sculpture Society (1893), helped establish the American Academy in Rome (1905), and taught for many years at the Art Students League.

De Saint-Priest, Jean (act. 1490–1516). French modeler and master engraver who worked for the city of Lyon from 1487 to 1507.

De Saint-Urbain, Ferdinand (1658–1738). French architect, medalist, and engraver who became director of the papal mint in Bologna in 1673 and chief engraver to the papal mint in Rome in 1683 (a position he held until 1703). At that time, he was also architect to Innocent XI, Alexander VIII, and Innocent XII. In 1707, he was made engraver to the Nancy mint, where he produced coinage for Duke Leopold of Lorraine and a medallic series of the dukes and duchesses of Lorraine.

Salwirk, Franz Joseph (1762–1820). Swedish coin engraver and medalist. In 1782, he worked at the Milanese mint. He collaborated with Luigi Manfredini and Girolamo Vassallo.

Da Sangallo, Francesco (1494–1576). Italian sculptor and medalist. In the 1520s, he worked in Florence as an assistant to Michelangelo in the New Sacristy. After 1529, he served as the *capomaestro generale* of the fortifications of Florence, and in the 1560s he was one of the founding members of the Accademia del Disegno in Florence.

Santacroce, Girolamo (ca. 1502–1537). Italian sculptor, goldsmith, and medalist. He worked in Spain and Naples, making tombs, altars, and statues of saints for several churches.

De Saulles, George William (1862–1903). British medalist of Swiss descent who trained at the Birmingham School of Art. In 1893, he was made chief engraver at the Royal Mint, where he designed and executed the coinage of Edward VII.

Saulmon, Michelet (act. 1375–1416). French painter, miniaturist, and sculptor. From 1401 to 1416, he was court painter to the Duke of Berry.

Da Savona, Martino (act. late 16th century). Italian medalist. A medal of Girolamo Conestagio attributed to Martino da Savona is signed MART. SA. OP.

Scharff, Anton (1845–1903). Celebrated Austrian medalist who was appointed assistant engraver at the Vienna mint in 1866, engraver in 1868, and court medalist in 1887. He created a large oeuvre with refined and sensitive portraiture.

Schega, Franz Andreas (1711–1787). Mint engraver and medalist in Munich from 1738 and Bavarian court medalist from 1751 to 1774.

Schenk, Kilian

Schneider, Christopher (d. 1701). Danish medalist working in Copenhagen.

Schro, Dietrich (act. 1542/44–1572/73). Sculptor and medalist active in Mainz. He is the author of several important tomb monuments and a small group of medals signed "DS," as well as a remarkable alabaster bust of Ottheinrich von der Pfalz (Louvre, Paris).

Schultz, Anton (act. 1716–24). German medalist working in Copenhagen. He is said to have settled in Moscow during the reign of Peter II.

Schwarz, Hans (ca. 1492–after 1527). Sculptor and medalist in Augsburg, Nuremberg, and Worms. He was one of the first significant German Renaissance medalists, creating all of his models in wood, producing strong, simple portraits in high relief. Many of his portrait drawings for medals have survived, although greatly altered.

Schwergerle, Hans (1882–1950). Sculptor and medalist active in Munich, producing medals for the Bavarian government in World War I and for the Nazis during World War II.

Ségoffin, Victor Joseph Jean Ambroise (1867–1925). French sculptor who studied at the École des Beaux-Arts under sculptors Pierre-Jules Cavelier and Louis-Ernest Barrias. He won the Prix de Rome in 1897 and was made an *officier* of the Legion of Honor and member of the Salon des Artistes Français in Paris.

Seidlitz, Johann Georg (act. from 1699). Austrian cameo cutter and medalist.

Selvi, Antonio Francesco (1679–1753). Italian sculptor and medalist who worked in Florence. In collaboration with Giovanni Bartolomeo Vaggelli, he produced a series of 111 medals commemorating the Medici family.

Signoretti, Gian Antonio (act. ca. 1540–1602). Italian goldsmith and medalist who worked in Novellara as mint master. Letters dated December 1569 document Alfonso Gonzaga as patron of the artist.

Simon, Abraham (1617–1692). British medalist and modeler in wax active in London.

Simon, Thomas (1618–1665). British engraver, medalist, and draftsman who was chief engraver of the mint from 1649 to 1660.

Sinayeff-Bernstein, Leopold (1867–1944). Russian medalist and sculptor. He was born in Vilnius but spent his career in Paris. He was murdered at Auschwitz.

Smeltzing, Arent Janszoon (1639–1710). Dutch engraver and medalist who was the father of Jan and Martin Smeltzing. His initials, A.S., appear on a medal commemorating the Peace of Breda.

Smeltzing, Jan (1656–1693). Dutch medalist who produced commemorative medals, as well as medallic portraits of a number of contemporary political personalities. In the early 1690s, he lived in Paris, where he worked at the mint.

Soldani-Benzi, Massimiliano (1656–1740). Italian sculptor, medalist, and goldsmith. He studied drawing in the school of the grand-ducal Galleria in Florence. Afterward, in Rome, he studied sculpture with Ercole Ferrata and coin-making with Giovanni Pietro Travani. In Paris, through the court painter Charles Le Brun, he was brought to the attention of Louis XIV, of whom he made a portrait medal.

Spicer-Simson, Theodore (1871–1959). British sculptor and medalist. He studied at the École des Beaux-Arts in Paris from 1890 to 1894 and produced his first medals in 1903. He lived and worked in New York and became a member of the Société Nationale des Beaux-Arts in 1928.

Spinelli, Andrea (1508–1572). Italian medalist, sculptor, and dealer. A student of the goldsmith Gianfrancesco Bonzagni. In 1540, he worked as chief coin engraver at the mint in Venice. By 1543, Andrea and members of his family had started a small business in the San Giuliano district of Venice.

Stothard, Alfred Joseph (1793–1864). British sculptor and medalist who worked as engraver for Queen Victoria.

Stuckhart, Franz (1781–1857). Hungarian medalist and die engraver active in Prague, Kremnitz, Vienna, and Warsaw.

Van Swinderen, Nicolaas (1705–1760). Dutch medalist employed by the House of Orange, for which he produced several medals. These are variously signed N. V. S.; N. V. S. F.; N. V. SWINDEREN, F.; N. S.; N. V. SWINDEREN.

Symons, Jan (act. 1552–69). Sculptor and medalist active in Antwerp. He produced an important group of medals, all dated between 1552 and 1553, and significant works of sculpture for the cathedral and city hall of Antwerp.

Tadolini, Petronio (1727–1813). Italian sculptor and medalist who sculpted statues in Bologna and for the cathedrals of Faenza and Mirandola.

Ticciati, Girolamo (1671–1744). Italian sculptor, medalist, architect, and writer. He studied in Florence as a student of Giovanni Battista Foggini, and in Rome, at the Tuscan Accademia Granducale. In Vienna, he is said to have been sculptor and architect to Emperor Joseph I.

Tomei, Pietro Paolo, called Romano (ca. 1525–after 1567). Italian sculptor and medalist from Milan. He has recently been identified by Leydi and Zanuso (2015) as the artist associated with the nearly sixty medals signed, or documented as by, "PPR," which have traditionally been assocated with Pietro Paolo Galeotti, also called Romano.

Travani, Gioacchino Francesco (act. ca. 1634–75). Italian medalist and goldsmith who was one of the three consuls of the goldsmiths' guild in Rome. Employed as an assayer at the mint in about 1655–74.

Da Trezzo, Jacopo Nizzola (1519–1589). Italian sculptor, architect, goldsmith, gem cutter, and medalist who worked for Cosimo I de' Medici and Philip II of Spain. At the court of King Philip II, he was appointed a court goldsmith.

Turnerelli, Peter (1774–1839). British sculptor and medalist to the Princess of Wales, 1774–1839. He gained a medal at the Royal Academy, was an instructor to the royal family, and executed a number of busts of important people.

Ursenthaler, Ulrich (1482–1562). Austrian medalist and mint master at Hall in the Tyrol, later at Salzburg, 1521–38. He worked as mint master in various other cities and courts, especially that of the Holy Roman Emperor.

Vassallo, Girolamo (1771–1819). Italian medalist and engraver. He studied at the Academy of Fine Arts in Genoa. In 1800, he became chief engraver at the Genoa mint.

Verbeeck, Aert, the Younger (1579–1653). Dutch goldsmith, engraver, and medalist. From 1625 to 1628, he worked at the Dordrecht mint as assistant die engraver.

Vernier, Pierre Louis (act. 18th century). French medalist who worked for Catherine the Great in Saint Petersburg from 1764 to 1768.

Vestner, Georg Wilhelm (1677–1740). German medalist. He was court chamber medal maker in Bavaria in 1732 and produced several commemorative medals, many of which referenced the Peace of Passarowitz.

De' Vetri, Domenico di Polo (ca. 1480–ca. 1547). Italian medalist and gem engraver, trained by Giovanni delle Corniole and Pier Maria Serbaldi da Pescia. He spent his career as court medalist for Alessandro de' Medici, 1st Duke of Florence, and Cosimo I de' Medici, Duke of Florence and Grand Duke of Tuscany.

Van Vianen, Paulus Willemsz (1570–1614). Dutch painter, goldsmith, and metalworker. He was employed from 1596 to 1601 at the courts of William V and Maximilian I, the dukes of Bavaria, and worked from 1601 to 1603 for Wolf Dietrich von Raitenau, Archbishop of Salzburg. Most significantly, however, he was Kammergoldschmied to Emperor Rudolf II in Prague from 1603 until his death.

Vicentino, Antonio (act. 1523/24–1545). Italian medalist. His alleged signature appears on a medal of Ascanio Gabuccini from Fano.

Di Virgilio Melioli, Bartolommeo (1448–1514). Italian medalist and goldsmith who was active in Mantua. As a medalist, he was influenced by Cristoforo di Geremia's style.

Vittoria, Alessandro (1525–1608). Italian sculptor, stuccoist, and architect who worked predominantly in Vicenza and Venice. He collaborated with Jacopo Sansovino, from whom, in 1550, he received a payment for sculptures for the library of San Marco.

Voigt, Karl Friedrich (1800–1874). Highly productive sculptor, medalist, and die and gem engraver who worked in Munich and then in Rome, where he finally settled in 1859.

De Vos, Jan (ca. 1578–after 1619). Dutch goldsmith and medalist who was employed at the court of Emperor Rudolf II.

Waechter, Georg Christian (1729–ca. 1789). German medalist who worked for a time in Germany. In 1771, he was called to Saint Petersburg, where he spent the rest of his career.

Waechter, Johann Georg (1724–1800). German medalist who worked primarily in Russia during the reign of Catherine the Great.

Warin, Claude (ca. 1612–1654). French medalist who was Jean Warin's younger brother. He was active in England in the 1630s and 1640s and in Lyon from about 1647 until his death.

Warin, Jean (1606–1672). French sculptor, medalist, and goldsmith who by 1629 was engraver general of the Paris mint. He was one of the most important medalists of the seventeenth century.

Waterloos, Adrian (1600–1684). Flemish medalist and engraver who was made master general of the Brussels mint in 1663.

Webb, Thomas (act. 1797–1822). British medalist who worked in Birmingham, mostly making commemorative medals and medallic portraits of his contemporaries.

Weber, Giovanni Zanobio (ca. 1737–ca. 1806). A German or Austrian medalist working in Florence. Possibly a pupil of Anton Franz Widemann in Vienna. He engraved medals that marked the historic events of his time.

Weiditz, Christoph (ca. 1500–1559). A native of Strasbourg, Weiditz worked as a sculptor, goldsmith, and medalist in a number of German cities, including Augsburg, Nuremberg, Mainz, Cologne, and Aachen. He also served the emperor Charles V in Spain and Italy, finally working in Saxony beginning in the 1530s to 1544.

Wermuth, Christian (1661–1739). Distinguished and very prolific medalist to the Saxon court and engraver to the mint at Gotha.

Widemann, Anton Franz (1724–1792). Chief engraver at the Vienna mint from 1769 to 1778. He is known primarily for the series of medals he produced for the empress Maria Theresia and her family.

Wiener, Jacques (1815–1899). Belgian medalist. He produced commemorative medals marking the historic moments of his time, as well as medals representing the interior and exterior of famous churches. In 1866, he received the Knight's Cross of the Order of Leopold from King Leopold.

Wild, Hans (act. from 1561). Goldsmith and medalist active either at Innsbruck or Hall and possibly in Nuremberg.

Wirt (or Würth), Johann Nepomuk (1753–1811). Austrian medalist to the imperial court, chief engraver to the Viennese mint, and director of the Viennese Academy of Engraving.

Wyon, William (1795–1851). British medalist and engraver who studied under his father, Peter Wyon. He engraved British coinage from 1825 to 1850 and also produced many commemorative medals.

Wyon Jr., Thomas (1792–1817). British medalist who studied under his father, Thomas Wyon Sr., and engraved commemorative medals.

Wyon Sr., Thomas (1767–1830). British medalist who engraved seals for the London court. Early in his career, he worked with his brother, Peter Wyon.

Zirotti

Bibliography

Ackermann 1992
Ackermann, Felix. "Der Münzkasten des Basler Sammlers Basilius Amerbach (1533–1591)." *Schweizer Münzblätter* 42, no. 166 (May 1992): 47–56.

J. W. Adams and Bentley 2007
Adams, John W., and Anne E. Bentley. *Comitia Americana and Related Medals: Under-Appreciated Monuments to Our Heritage.* Crestline, Calif., 2007.

J. W. Adams and Chao 2010
Adams, John W., and Fernando Chao. *Medallic Portraits of Admiral Vernon: Medals Sometimes Lie.* Gahanna, Ohio, 2010.

N. Adams 1978
Adams, Nicholas. "New Information about the Screw Press as a Device for Minting Coins: Bramante, Cellini and Baldassare Peruzzi." *Museum Notes* (American Numismatic Society) 23 (1978): 201–6.

Adler 1929
Adler, Irene. "Die Clouet: Versuch einer Stilkritik." *Jahrbuch der kunsthistorischen Sammlungen in Wien*, n.s., 3 (1929): 201–46.

Affò 1787
Affò, Ireneo. *Memorie di tre celebri principesse della famiglia Gonzaga.* Parma, 1787.

Aign 1961
Aign, Theodor. *Die Ketzel: Ein Nürnberger Handelsherren- und Jerusalempilgergeschlecht.* Freie Schriftenfolge der Gesellschaft für Familienforschung in Franken, vol. 12. Neustadt/Aisch, 1961.

Alba 1891
Alba, Duquesa de. *Documentas escogidos del Archivo de la Casa de Alba.* Madrid, 1891.

Allgemeine deutsche Biographie 1875–1912
Allgemeine deutsche Biographie. 56 vols. Leipzig, 1875–1912. [Reprint, Berlin, 1967–71.]

Allison 1986
Allison, Ann Hersey. "Antico's Medals for the Gonzaga." Special issue, *Medal* 9 (Autumn 1986): 9–13.

Almagro-Gorbea, Pérez Alcorta, and Moneo 2005
Almagro-Gorbea, Martín, María Cruz Pérez Alcorta, and Teresa Moneo. *Medallas españolas. Real Academia de la Historia, Gabinete de Antigüedades.* Madrid, 2005.

Altdeutsche Meister 1978
Altdeutsche Meister. Catalogue of the Staatsgalerie Augsburg, vol. 1. Munich, 1978.

Alteri 2004
Alteri, Giancarlo. *Summorum Romanorum pontificum historia nomismatibus recensitis illustrata: Ab saeculo XV ad saeculum XX.* [In Italian and English.] Vatican City, 2004.

Álvarez-Ossorio 1950
Álvarez-Ossorio, Francisco. *Catálogo de las medallas de los siglos XV y XVI conservadas en el Museo Arqueológico Nacional.* Madrid, 1950.

Amadei 1955
Amadei, Federigo. *Cronaca universale della città di Mantova.* Mantua, 1955.

Amayden 1910–14
Amayden, Teodoro. *La storia delle famiglie romane.* Edited by Carlo Augusto Bertini. 2 vols. Rome, 1910–14. [Reprint, Bologna, 1979.]

Ambrosoli 1891
Ambrosoli, Solone. "Una medaglia inedita di Giacomo Jonghelinck." *Rivista italiana di numismatica* 4 (1891): 389–92.

American Journal of Numismatics 1899
American Journal of Numismatics 33, no. 3 (January 1899): 98.

American Journal of Numismatics 1915
American Journal of Numismatics 49 (1915): 204.

American Numismatic Society 1910
International Medallic Exhibition of the American Numismatic Society. Exh. cat. New York, 1910.

American Numismatic Society 1911
Catalogue of the Exhibition of Contemporary Medals. Exh. cat. New and rev. ed. New York, 1911.

Ames-Lewis 1974
Ames-Lewis, Francis. "A Portrait of Leon Battista Alberti by Uccello?" *Burlington Magazine* 116 (February 1974): 103–4.

Ames-Lewis 1984
Ames-Lewis, Francis. "Matteo de' Pasti and the Use of Powdered Gold." *Mitteilungen des Kunsthistorischen Institutes in Florenz* 28 (1984): 351–61.

Ammon 1778
Ammon, Johann Ludwig. *Sammlung berühmter Medailleurs und Münzmeister nebst ihren Zeichen.* Nuremberg, 1778.

Amorós 1958
Amorós, Josep. *Medallas de los acontecimientos instituciones y personajes españoles.* Barcelona, 1958.

Andorfer and Epstein 1907
Andorfer, Karl, and Richard Epstein. *Musica in Nummis: Beschreibendes Verzeichnis von Medailleur-arbeiten auf Musiker (Komponisten, Virtuosen, Musikschriftsteller, Instrumentmacher etc.), ferner Sänger und Sängerinnen vom XV. Jahrhundert bis auf die heutige Zeit.* Vienna, 1907.

Angerer 1984
Angerer, Martin. *Peter Flötners Entwürfe: Beiträge zum Ornament und Kunsthandwerk in Nürnberg in der 1. Hälfte des 16. Jahrhunderts.* Kiel, 1984. [PhD diss., Munich, 1983.]

Annalen der Literatur 1803–12
Annalen der Literatur und Kunst in den österreichischen Staaten. Vienna, 1803–12.

Antonetti 1991
Antonetti, Pierre. *Savonarole: Le prophète désarmé.* Paris, 1991.

Antwerpens Gouden Eeuw 1955
Antwerpens Gouden Eeuw. Exh. cat. Antwerp, 1955.

Anvers 1954
Anvers: Ville de Plantin et de Rubens. Exh. cat. Galerie Mazarine. Paris, 1954.

Areen 1938
Areen, Ernst E. *De nordiska ländernas officiella belöningsmedaljer.* Stockholm, 1938.

Argelati 1750–59
Argelati, Filippo. *De Monetis Italiæ Variorum Illustrium Virorum Dissertationes: quarum pars nunc primum in lucem prodit.* 6 vols. Milan, 1750–59.

Aretino 1957–60
Aretino, Pietro. *Lettere sull'arte.* Edited by Fidenzio Pertile and Ettore Camesasca. 3 vols. in 4. Milan, 1957–60.

Armand 1883–87
Armand, Alfred. *Les médailleurs italiens des quinzième et seizième siècles.* 3 vols. Paris, 1883–87. [Reprint, Bologna, 1966.]

Arneth 1839
Arneth, Joseph. *Catalog der kaiserlich-königlichen Medaillen-Stämpel-Sammlung.* Vienna, 1839.

Arnold 2000
Arnold, Paul. "Princely Glory: German Medallic Art in the Seventeenth Century." *Medal* 37 (Autumn 2000): 15–19.

Arnolfini 1598
Arnolfini, Pompeo. *Della vita et fatti di Andrea Doria, principe di Melfi.* Genoa, 1598.

Art of the Renaissance Craftsman 1937
The Art of the Renaissance Craftsman. Exh. cat. Fogg Art Museum, Harvard University. Cambridge, Mass., 1937.

Artola 1991
Artola, Miguel, ed. *Enciclopedia de historia de España.* Vol. 4, *Diccionario biográfico.* Madrid, 1991.

Astarte 2001
Medaglie & placchette appartenenti ad un esimio collezionista. Sale cat., no. 8. Astarte, Lugano, October 11, 2001.

Astorga 1697
Astorga, Marquis de. *Histoire de Ferdinand-Alvarez de Tolède.* Translated by J. Guignard. 2 vols. Paris, 1697.

Atil 1973
Atil, Esin. "Ottoman Miniature Painting under Sultan Mehmed II." *Ars Orientalis* 9 (1973): 103–20.

Atti della solenne incoronazione 1779
Atti della solenne incoronazione fatta in Campidoglio della insigne poetessa Donna Maria Maddalena Morelli Fernandez, pistoiese, tra gli Arcadi Corilla Olimpica. Parma, 1779.

Attwood 1992
Attwood, Philip. *Artistic Circles: The Medal in Britain, 1880–1918.* London, 1992.

Attwood 1997
Attwood, Philip. "Self-Promotion in Sixteenth-Century Florence: Baccio Bandinelli's Portrait Medal." *Medal* 30 (Spring 1997): 3–9.

Attwood 2003
Attwood, Philip. *Italian Medals, c. 1530–1600, in British Public Collections.* 2 vols. London, 2003.

Auerbach 1961
Auerbach, Erna. *Nicholas Hilliard.* London, 1961.

Augsburger Renaissance 1955
Augsburger Renaissance. Exh. cat. Augsburg, 1955.

Ausstellung für Kochkunst 1893
Katalog der Ausstellung für Kochkunst, Armeeverpflegung, Volksernährung und verwandte Fächer: Köln 1893… Exh. cat. Cologne, 1893.

Avery 1981
Avery, Charles. *Studies in European Sculpture*. London, 1981.

Avery 1985
Avery, Charles. *Plaquettes, Medals, and Reliefs from the Collection L[ederer]*. London, 1985.

Avery 2000
Avery, Charles. "Giuseppe Broccetti's Medal of the Singer Faustina Bordoni." *Medal* 36 (Spring 2000): 3–7.

Avery and Barbaglia 1981
Avery, Charles, and Susanna Barbaglia. *L'opera completa del Cellini*. Milan, 1981.

Avery and Keeble 1975
Avery, Charles, and K. Corey Keeble. *Florentine Baroque Bronzes and Other Objects of Art*. Exh. cat. Royal Ontario Museum. Toronto, 1975.

Avignone 1872
Avignone, Gaetano. *Medaglie dei Liguri e della Liguria*. Genoa, 1872.

J. Babelon 1913
Babelon, Jean. "Gianello della Torre, horloger de Charles Quint et de Philippe II." *Revue de l'Art ancien et moderne* 34 (1913): 269–78.

J. Babelon 1920
Babelon, Jean. "Le médaillon du Chancelier René de Birague par Germain Pilon à la Bibliothèque Nationale." *Gazette des beaux-arts*, 5th ser., 1 (March–April 1920): 165–72.

J. Babelon 1921
Babelon, Jean. "Un médaillon de cire du Cabinet des Médailles: Filippo Strozzi et Benedetto da Maiano." *Gazette des beaux-arts*, 5th ser., 4 (1921): 203–10.

J. Babelon 1922
Babelon, Jean. *Jacopo da Trezzo et la construction de l'Escurial*. Paris, 1922.

J. Babelon 1926
Babelon, Jean. "A propos du médaillon d'Henri II attribué à Germain Pilon." *Aréthuse* 3, no. 3 (July 1926): 111–15.

J. Babelon 1927a
Babelon, Jean. *Germain Pilon*. Paris, 1927.

J. Babelon 1927b
Babelon, Jean. *La médaille et les médailleurs*. Paris, 1927.

J. Babelon 1941
Babelon, Jean. "Sur un Médallion de cire de Louis XVI. Pl. I et II." *Revue Numismatique*, 5th ser., 6 (1941): 55–64.

J. Babelon 1946
Babelon, Jean. "Portraits en médaille." In *Encyclopédie alpina illustrée*. Paris, 1946.

J. Babelon 1948
Babelon, Jean. *La médaille en France*. Paris, 1948.

J. Babelon 1959
Babelon, Jean. *Great Coins and Medals*. London, 1959.

J. Babelon 1966
Babelon, Jean. *Das Menschenbild auf Münzen und Medaillen von der Antike bis zur Gegenwart*. Leipzig, 1966.

J. Babelon and Jacquiot 1950
Babelon, Jean, and Josèphe Jacquiot. *Histoire de Paris d'après les médailles de la renaissance au XXe siècle*. Paris, 1950.

J.-P. Babelon 1982
Babelon, J.-P. *Henri IV*. Paris, 1982.

Babinger 1953
Babinger, Franz. *Mehmed der Eroberer und seine Zeit*. Munich, 1953.

Bachtell 1974
Bachtell, Lee M. *World Dollars, 1477–1877: Pictorial Guide*. Ludowici, Ga., 1974.

Badt 1958
Badt, Kurt. "Drei plastische Arbeiten von Leone Battista Alberti." *Mitteilungen des Kunsthistorischen Institutes in Florenz* 8 (1958): 78–87.

Baert 1848–49
Baert, Philippe. "Mémoires sur les sculpteurs et architectes des Pays-Bas." *Bulletin de la Commission Royale d'Histoire* 14 (1848): 55–56, 559–62; 15 (1849): 209.

Bailey 2002
Bailey, Colin B. *Patriotic Taste: Collecting Modern Art in Pre-Revolutionary Paris*. New Haven, Conn., 2002.

Baillion 1956–57
Baillion, F. "Jacques Jongheling: Célèbre médailleur anversois, 1530–1606." *Alliance numismatique européenne*, 1956, no. 11 (November): 93–94; no. 12 (December): 101–3; 1957; no. 1 (January): 1–3; no. 3 (March): 22–24.

Baladda 2003
Baladda, Karine. "L'École des mines du Mont Blanc par Nicolas Brenet, une médaille atypique parmi les séries néo-classiques napoléoniennes." In *Essor de la médaille aus XIXe et XXe siècles*, 201–11, edited by Béatrice Coullaré and Jean-Luc Desnier. Wetteren, Belgium, 2003.

Balbi de Caro 1995
Balbi de Caro, Silvana, ed. *I Gonzaga: Moneta, arte, storia*. Exh. cat. Palazzo Te, Mantua. Milan, 1995.

Baldass 1913–14
Baldass, Ludwig von. "Die Bildnisse Kaiser Maximilians I." *Jahrbuch der kunsthistorischen Sammlungen des Allerhöchsten Kaiserhauses* 31 (1913–14): 247–334.

Balletti 1901
Balletti, Andrea. "Alfonso Ruspagiari: Medaglista del secolo XVII." *Rassegna d'arte* (1901): 107–8.

Balletti 1904
Balletti, Andrea. "Alfonso Ruspagiari e Gian Antonio Signoretti: Medaglisti del secolo XVI." *Rassegna d'arte* (1904): 44–46.

Balletti 1914
Balletti, Andrea. "Alfonso Ruspagiari e Gian Antonio Signoretti: Medaglisti del secolo XVI." *Rassegna d'arte* (1914): 46–48.

Ballico 1983
Ballico, Benedetta. *Le medaglie del Soldani per Cristina di Svezia.* Florence, 1983.

Bange 1922
Bange, Ernst Friedrich. *Die italienischen Bronzen der Renaissance und des Barock.* Vol. 2, *Reliefs und Plaketten.* Staatliche Museen zu Berlin. Berlin, 1922.

Bange 1926
Bange, Ernst Friedrich. *Peter Flötner.* Vol. 14, *Meister der Graphik.* Leipzig, 1926.

Bange 1928
Bange, Ernst Friedrich. *Die Kleinplastik der deutschen Renaissance in Holz und Stein.* Florence and Leipzig, 1928.

Bange 1933
Bange, Ernst Friedrich. "Georg Habich: Die deutschen Schaumünzen des XVI. Jahrhunderts." *Zeitschrift für Kunstgeschichte* (1933): 357–68.

Barclay and Syson 1993
Barclay, Craig, and Luke Syson. "A Medal Die Rediscovered: A New Work by Nicholas Hilliard." *Medal* 22 (Spring 1993): 3–11.

Bardon 1974
Bardon, Françoise. *Le portrait mythologique à la cour de France sous Henri IV et Louis XIII: Mythologie et politique.* Paris, 1974.

***Barock in Baden-Württemberg* 1981**
Barock in Baden-Württemberg vom Ende des Dreissigjährigen Krieges bis zur Französischen Revolution. Edited by Ernst Petrasch and Volker Himmelein. Exh. cat. Schloss Bruchsal. Karlsruhe, 1981.

Bartolotti 1967
Bartolotti, Franco. *La medaglia annuale dei romani pontefici, da Paolo V a Paolo VI (1605–1967).* Rimini, 1967.

Bartolotti 1971
Bartolotti, Franco. *Le medaglie pontifice di massimo modulo da Pio IX a Pio XI.* Rimini, 1971.

Bartolotti 1988
Bartolotti, Franco. *Medaglie e decorazioni di Pio IX (1846–1878).* Rimini, 1988.

Bartsch 1803–21
Bartsch, Adam. *Le peintre-graveur.* 22 vols. Vienna, 1803–21.

Bartsch 1978
The Illustrated Bartsch. Vol. 15 (formerly 8.2). Edited by Robert A. Koch. New York, 1978.

Bascapè 1967
Bascapè, Giacomo. "Le medaglie del Papa Pio IV." *Italia numismatica* 18, no. 3 (1967): 42–43.

Bascapè 1975
Bascapè, Giacomo. "Le medaglie del S. M. Ordine di Malta (sec. XV–XX): Note tipologiche." *Medaglia* 5, no. 9 (1975): 27–42.

Bauch 1898
Bauch, Alfred. "Der Nürnberger Medailleur M. G." *Historisches Jahrbuch* 19 (1898): 470–75.

Baumgartner 1988
Baumgartner, Frederic J. *Henry II, King of France, 1547–1559.* Durham, N.C., 1988.

Baxandall 1971
Baxandall, Michael. *Giotto and the Orators: Humanist Observers of Painting in Italy and the Discovery of Pictorial Composition, 1350–1450.* Oxford, 1971.

Baxandall 1972
Baxandall, Michael. *Painting and Experience in Fifteenth-Century Italy.* Oxford, 1972.

Baxandall 1980
Baxandall, Michael. *The Limewood Sculptors of Renaissance Germany.* New Haven, Conn., 1980.

Baxter 1987
Baxter, Barbara A. *The Beaux-Arts Medal in America.* Exh. cat. American Numismatic Society. New York, 1987.

Beaulieu 1978
Beaulieu, Michèle. *Description raisonnée des sculptures du Musée du Louvre.* Vol. 2, *Renaissance française.* Paris, 1978.

Beck and Decker 1981
Beck, Herbert, and Bernhard Decker, eds. *Dürers Verwandlung in der Skulptur zwischen Renaissance und Barock*. Exh. cat. Liebieghaus Museum Alte Plastik, 1981–82. Frankfurt am Main, 1981.

Van der Beek 2011
Van der Beek, Marcel. "De Amsterdamse dukaten van 1673." *De beeldenaar* 35 (2011): 5–11.

Begni Redona 1985
Begni Redona, Pier Virgilio. *Maffeo Olivieri e il crocifisso di Sarezzo: Comune di Sarezzo*. Brescia, 1985.

Beierlein 1848
Beierlein, J. P. "Medaillen auf ausgezeichnete und berühmte Bayern." *Oberbayerisches Archiv für vaterländische Geschichte* 10, no. 2 (1848): 163–204.

Beierlein 1851
Beierlein, J. P. "Medaillen auf ausgezeichnete und berühmte Bayern." *Oberbayerisches Archiv für vaterländische Geschichte* 12, no. 2 (1851): 115–81.

Beierlein 1897–1901
Beierlein, J. P. *Die Medaillen und Münzen des Gesammthauses Wittelsbach*. Vol. 1, *Bayerische Linie*. 2 pts. Munich, 1897–1901.

Bellesi and Visonà 2008
Bellesi, Sandro, and Mara Visonà. *Giovacchino Fortini: Scultura Architettura decorazione e Committenza a Firenze al tempo degli ultimi Medici*. 2 vols. Florence, 2008.

Bellesia 1997
Bellesia, Lorenzo. *Le monete di Francesco d'Este, marchese di Massa Lombarda*. Lugano, 1997.

Bellini 1761
Bellini, Vincenzo. *Delle monete di Ferrara: Trattato di Vincenzo Bellini*. Ferrara, 1761.

Belloni 1977
Belloni, Gian Guido. *Gabinetto numismatico*. Vol. 1. Musei e gallerie di Milano. Milan, 1977.

Beltramini et al. 2013
Beltramini, Guido, Davide Gasparotto, and Adolfo Tura, eds. *Pietro Bembo e l'invenzione del Rinascimento*. Venice, 2013.

Bemolt van Loghum Slaterus 1981
Bemolt van Loghum Slaterus, A. J. *Nederlandse familiepenningen tot 1813*. Zutphen, 1981.

Benedetti 2012
Benedetti, Simona. "La molteplice poetica di Carlo Rainaldi tra soluzioni barocche ed echi tardo-cinquecenteschi: Progetti, modelli, architetture." In *Architetture di Carlo Rainaldi nel quarto centenario della nascita*, edited by Simona Benedetti, pp. 203–58. Rome, 2012.

Bénézit 1999
Bénézit, Emmanuel. *Dictionnaire des peintres, sculpteurs, dessinateurs et graveurs*. 4th ed. 14 vols. Paris, 1999.

Bergmann 1844–57
Bergmann, Joseph. *Medaillen auf berühmte und ausgezeichnete Männer des Österreichischen Kaiserstaates vom XVI. bis zum XIX. Jahrhunderte*. 2 vols. Vienna, 1844–57.

Bernareggi 1954
Bernareggi, Ernesto. *Monete d'oro con ritratto del Rinascimento italiano, 1450–1515*. Milan, 1954.

Bernhart 1917
Bernhart, Max. *Die Münchner Medaillenkunst der Gegenwart*. Munich, 1917.

Bernhart 1919
Bernhart, Max. *Die Bildnismedaillen Karls des Fünften*. Munich, 1919.

Bernhart 1921–22
Bernhart, Max. "Judenmedaillen." *Archiv für Medaillen- und Plaketten-Kunde* 3 (1921–22): 115–23.

Bernhart 1925–26
Bernhart, Max. "Nachträge zu Armand." *Archiv für Medaillen- und Plaketten-Kunde* 5 (1925–26): 69–90.

Bernhart 1933
Bernhart, Max. "Reformatorenbildnisse auf Medaillen der Renaissance." *Numismatik* 2 (1933): 148–60.

Bernhart 1934a
Bernhart, Max. "Deutsche Medaillen aus der Frühneuzeit der Renaissance." *Pantheon* 14 (1934): 257–61.

Bernhart 1934b
Bernhart, Max. "Die Porträtzeichnungen des Hans Schwarz." *Münchner Jahrbuch der bildenden Kunst*, n.s., 11 (1934): 65–95.

Bernhart 1936
Bernhart, Max. "Kunst und Künstler der Nürnberger Schaumünze des 16. Jahrhunderts." *Mitteilungen der Bayerischen Numismatischen Gesellschaft* 54 (1936): 1–61.

Bernhart 1937
Bernhart, Max. "Augsburger Medailleure und Bildnisse Augsburger Kunsthandwerker auf Schaumünzen des 16. Jahrhunderts." *Mitteilungen der Bayerischen Numismatischen Gesellschaft* 55 (1937): 41–98.

Bernhart and Roll 1929–30
Bernhart, Max, and Karl Roll. *Die Münzen und Medaillen des Erzstiftes Salzburg*. 2 vols. Munich, 1929–30.

Berni 1950
Berni, Giulio. *Le medaglie degli anni santi*. Barcelona, 1950.

Bertolotti 1877a
Bertolotti, Antonino. "Giacomo Antonio Moro, Gaspare Mola e Gasparo Morone-Mola: Incisori nella zecca di Roma." *Archivio storico Lombardo* 4, no. 1 (1877): 295–335.

Bertolotti 1877b
Bertolotti, Antonino. "Testamento e inventarii di Gaspare Mola." *Rivista europea*, July 16, 1877.

Bertolotti 1885
Bertolotti, Antonino. *Artisti bolognesi, ferraresi ed alcuni altri del già Stato Pontificio in Roma nei secoli XV, XVI e XVII: Studi e ricerche tratte dagli archivi romani*. Rome, 1885. [Reprint, New York, 1972.]

Bertolotti 1890
Bertolotti, Antonino. *Figuli, fonditori e scultori in relazione con la corte di Mantova nel secoli XV, XVI, XVII: Notizie e documenti raccolti negli archivi mantovani*. Milan, 1890.

Berwick y de Alba 1919
Alba, Maria del Rosario Falcó y Osorio. *Contribución al estudio de la persona del III Duque de Alba*. Madrid, 1919.

Beschrijving van Nederlandsche historie-penningen 1822–69
Beschrijving van Nederlandsche historie-penningen, ten vervolge op het werk van Mr. Gerard van Loon. 10 vols. Koninklijk-Nederlandsch Instituut van Wetenschappen. Amsterdam, 1822–69.

Betts 1894
Betts, C. Wyllys. *American Colonial History Illustrated by Contemporary Medals*. New York, 1894.

Bezold 1910
Bezold, Gustav von. "Der Meister des Stabius." *Mitteilungen aus dem Germanischen Nationalmuseum* (1910): 125–26.

Bianchi 1881
Bianchi, Nicomede. *Le medaglie del terzo Risorgimento italiano: 1748–1848*. Bologna, 1881.

Bibliografia pratese 1844
Bibliografia pratese compilata per un da Prato. Prato, 1844.

Bidelli 1626
Bidelli, Giovanni Battista. *Orationi in lode di S. Carlo Borromeo, Arcivescovo di Milano*. Milan, 1626.

Biedermann 1748a
Biedermann, Johann Gottfried. *Geschlechtsregister der Reichsfrey unmittelbaren Ritterschaft Landes zu Franken Löblichen Orts an der Altmühl, welches aus denen bewährtesten Urkunden, Kauf-, Lehen- und Heyrathsbriefen gesamleten Grabschrifften und eingeholten genauen Nachrichten von innen beschriebenen Gräflich-Freyherrlich- und Edlen Häusern*. Bayreuth, 1748.

Biedermann 1748b
Biedermann, Johann Gottfried. *Geschlechtsregister des Hochadelichen Patriziats zu Nürnberg*. Bayreuth, 1748.

Bildt 1908
Bildt, Carl Nils Daniel. *Les médailles romaines de Christine de Suède*. Rome, 1908.

Billaine 1679
Billaine, Ludovicus. *Historia Summorum Pontificum a Martino V ad Jnnocentium XI, per eorum Numismata, ab anno 1417 ad annum 1678*. Vol. 2. 1679.

Biographie nationale 1866–1944
Académie Royale des Sciences, des Lettres et des Beaux-Arts de Belgique. *Biographie nationale*. 28 vols. Brussels, 1866–1944.

Biographie universelle 1870–73
Biographie universelle ancienne et moderne. 45 vols. 2nd ed. Paris, 1870–73.

Bissell 1999
Bissell, R. Ward. *Artemisia Gentileschi and the Authority of Art: Critical Reading and Catalogue Raisonné*. University Park, Pa., 1999.

Bizot 1690
Bizot [Abbé]. *Medalische historie der Republyk van Holland*. Amsterdam, 1690.

Blair 1958
Blair, Claude. *European Armour, circa 1066 to circa 1700*. London, 1958.

Blanchet 1920
Blanchet, Adrien. "Catalogue du cabinet de M. Bailly (1766)." *Revue numismatique*, 4th ser., 23 (1920): 34–36.

Blanchet 1930
Blanchet, Adrien. *Manuel de numismatique française*. Vol. 3, *Médailles, jetons, méreaux*. Paris, 1930.

Bloomfield 1952
Bloomfield, Morton. *The Seven Deadly Sins*. East Lansing, Mich., 1952.

Blühm 1997
Blühm, Andreas, ed. *Auguste Préault, 1809–1879: Romantiek in brons / Romanticism in Bronze*. Exh. cat. Van Gogh Museum, Amsterdam, 1997–98. Amsterdam and Zwolle, 1997.

Blunt 1953
Blunt, Anthony. *Art and Architecture in France, 1500 to 1700*. London, 1953.

Bober and Rubenstein 1986
Bober, Phyllis Pray, and Ruth Rubenstein. *Renaissance Artists and Antique Sculpture: A Handbook of Sources*. Oxford and London, 1986. [Rev. ed., London and New York, 1987.]

A. Bocchi 1574
Achille Bocchi. *Symbolicarum quaestionum … libri quinque*. Bologna, 1574.

F. Bocchi 1970
Bocchi, Francesca. *Il patrimonio bentivolesco alla metà del Quattrocento*. Bologna, 1970.

Boccolari 1987
Boccolari, Giorgio. *Le medaglie di Casa d'Este*. Modena, 1987.

Bode 1887
Bode, Wilhelm von. "Ein Altar in Kelheimer Stein vom Augsburger Meister Hans Daucher in den Königlichen Museen zu Berlin." *Jahrbuch der Königlich Preussischen Kunstsammlungen* 8 (1887): 3–10, 169–71.

Bode 1888
Bode, Wilhelm von. *Geschichte der deutschen Plastik*. Berlin, 1888.

Bode 1895
Bode, Wilhelm von. "Bertoldo di Giovanni und seine Bronzebildwerke." *Jahrbuch der Königlich Preussischen Kunstsammlungen* 16 (1895): 18–20.

Bode 1904
Bode, Wilhelm von. "Zur neuesten Forschung auf dem Gebiete der italienischen Medaillenkunde." *Zeitschrift für bildende Kunst*, n.s., 15 (1904): 37–42.

Bode 1922
Bode, Wilhelm von. "Caradossos Plaketten und Bramantes Anteil daran." *Zeitschrift für Numismatik* 33 (1922): 145–55.

Bode 1925
Bode, Wilhelm von. *Bertoldo und Lorenzo dei Medici: Die Kunstpolitik des Lorenzo il Magnifico im Spiegel der Werk seines Lieblingskünstlers Bertoldo di Giovanni*. Freiburg im Breisgau, 1925.

Bode and Draper 1980
Bode, Wilhelm von. *The Italian Bronze Statuettes of the Renaissance*. [1907–12.] New ed. Revised by James David Draper. New York, 1980.

Bodoni 1784–85
Bodoni, G.B. "*Prose e versi per onorare la memoria di Livia Doria Caraffa Principessa del Sacro Romano Impero della Roccella*." Parma, 1784–85.

Boissard and De Bry 1669
Boissard, Jean-Jacques, and Theodor De Bry. *Bibliotheca chalcographica, hoc est virtute et eruditione clarorum virorum imagines*. Pts. 1–5. Heidelberg, 1669.

Bolgar 1964
Bolgar, R. R. *The Classical Heritage and Its Beneficiaries: From the Carolingian Age to the End of the Renaissance*. New York, 1964.

Bolzenthal 1834
Bolzenthal, Heinrich. *Denkmünzen zur Geschichte seiner Majestät des Königs von Preussen, Friedrich Wilhelm III., in Abbildungen mit Erläuterungen und Urkunden*. Berlin, 1834.

Bolzenthal 1840
Bolzenthal, Heinrich. *Skizzen zur Kunstgeschichte der modernen Medaillen-Arbeit*. Berlin, 1840.

Bonanni 1699
Bonanni, Filippo. *Numismata pontificum Romanorum quae a tempore Martini V usque ad annum MDCXCIX*. 2 vols. Rome, 1699.

Bonsanti 1990
Bonsanti, Giorgio. "Lelio Orsi per Novellara: Linee di ricerca su affreschi e medaglie." In *Lelio Orsi e la cultura del suo tempo: Atti del Convegno Internazionale di Studi, Reggio Emilia/Novellara, 1988*, edited by J. Bentini, pp. 113–22. Reggio Emilia, 1990.

Boon 1984
Boon, Karel G., ed. *Hollstein's Dutch and Flemish Etchings, Engravings and Woodcuts, ca. 1450–1700*. Vol. 28. Blaricum, 1984.

Bora 1988
Bora, G. "Donato Bramante." In *Pinacoteca di Brera: Scuole lombarda e piemontese, 1300–1535*, edited by Federico Zeri et al., pp. 118–25. Milan, 1988.

Born 1981
Born, Robert. *Les Croy: Une grande lignée hennuyère d'hommes de guerre, de diplomates, de conseillers secrets, dans les coulisses du pouvoir, sous les ducs de Bourgogne et la Maison d'Autriche (1390–1612)*. Brussels, 1981.

Börner 1971
Börner, Lore. *Deutsche Gnadenpfennige: Ein Beitrag zur Porträt- und Kulturgeschichte der Medaillen des 16. und 17. Jahrhunderts*. Berlin, 1971.

Börner 1976
Börner, Lore. "Der Elefant als Sinnbild auf Medaillen." *Forschungen und Berichte der Staatliche Museen zu Berlin* 17 (1976): 199–200.

Börner 1981
Börner, Lore. *Deutsche Medaillenkleinode des 16. und 17. Jahrhunderts*. Leipzig, 1981.

Börner 1995
Börner, Lore. *Von Pisano bis Selvi. Vierzig Meisterwerke der italienischen Medaillenkunst der Renaissance und des Barock*. Das Kabinett 2. Berlin, 1995.

Börner 1997
Börner, Lore. *Die italienischen Medaillen der Renaissance und des Barock (1450 bis 1750)*. Berlin, 1997.

Börner and Steguweit 1990
Börner, Lore, and Wolfgang Steguweit. *Die Sprache der Medaille: Wegleitung zur Ausstellung des Münzkabinetts, Staatliche Museen zu Berlin*. Berlin, 1990.

Borromeo 2000
Borromeo, Agostino. "Clément VIII: La diplomatie pontificale et la paix de Vervins." In *Le traité de Vervins*, edited by Jean-François Labourdette, Jean-Pierre Poussou, and Marie-Catherine Vignal, pp. 323–44. Paris, 2000.

Borselli 1929
Borselli, Girolamo, ed. *Cronica gestorum ac factorum memorabilium civitatis Bononie, edita a Frate Hyeronimo de Bursellis… Rerum italicarum scriptores*, edited by L. A. Muratori, new ed., vol. 23, no. 2. Città del Castello, 1929.

Bottari and Ticozzi 1822–25
Bottari, Giovanni, and Stefano Ticozzi. *Raccolta di lettere sulla pittura, scultura ed architettura da' più celebri personaggi dei secoli XV, XVI, e XVII*. 8 vols. Milan, 1822–25.

Bouhy 1883
Bouhy, Victor. "Jacques Wiener: Graveur en médailles et son oeuvre." *Revue belge de numismatique* 39 (1883): 5–175.

Braham 1963
Braham, Allan. "Mansart Studies I: The Val-de-Grâce." *Burlington Magazine* 105 (August 1963): 351–63.

Bramsen 1977
Bramsen, Ludvig Ernst. *Médaillier Napoléon le Grand; ou, Description des médailles, clichés, repoussés et médailles-décorations relatives aux affaires de la France pendant le Consulat et l'Empire*. 3 vols. Hamburg, 1977.

Brand sale 1997
Deutsche Münzen aus Sammlung Virgil M. Brand. Pt. 5. Sale cat., no. 70. Leu numismatik, Zurich, October 20–22, 1997.

Brasseux aîné 1840
Brasseux aîné. *Catalogue des médailles de l'histoire numismatique de Napoléon*. Paris, 1840.

Braun 1921–22
Braun, Edmund Wilhelm [Braun-Troppau, Edmund Wilhelm von]. "Zwei Buchsreliefs vom Joachimsthaler Goldschmied Concz Welcz." *Archiv für Medaillen- und Plaketten-Kunde* 3 (1921–22): 128–33.

Bredekamp 2008
Bredekamp, Horst. *Der Künstler als Verbrecher: Ein Element der frühmodernen Rechts- und Staatstheorie*. Munich, 2008.

Brentano sale 1822
Catalogus eener kostbare verzameling van beeldwerken en rariteiten, prentwerken, boeken, prenten en tekeningen, nagelaten door dem wel-edelen Heer eer Josephus Augustinus Brentano; waarvan de veiling plaats zal hebben te Amsterdam … onder opzigt van de heeren Jeronimo de Vries, Albertus Brondgeest en Engelbert Michael Engelberts. Sale cat. Amsterdam, April 3, 1822.

Brenzoni 1952
Brenzoni, Raffaello. *Pisanello pittore (1395 circa–ottobre 1455)*. Florence, 1952.

***Bretagne au temps des ducs* 1991**
La Bretagne au temps des ducs. Exh. cat. Abbaye de Doulas and Musée Dobrée, Nantes, 1991–92. Doulas, 1991.

Brettauer 1937
Brettauer, Josef. *Medicina in Nummis Katalog der Sammlung Josef Brettauer Veröffentlichungen*. Vienna, 1937.

Brinton 1927
Brinton, Selwyn. *The Gonzaga: Lords of Mantua*. London, 1927.

British Museum 1888
British Museum. *Catalogue of Greek Coins: Attica, Megaris, Aegina*. London, 1888.

Brockett sale 1823
A Catalogue of the Very Valuable and Extensive Collection of Ancient and Modern Coins and Medals, Collected by … John Trotter Brockett. Sale cat. Sotheby & Co., London, June 4, 1823, and nine following days.

Brockhaus and Leinz 1994
Brockhaus, Christoph, and Gottlieb Leinz. *Die Beschwörung des Kosmos: Europäische Bronzen der Renaissance*. Exh. cat. Wilhelm Lehmbruck Museum, 1994–95. Duisburg, 1994.

Brockmann 1985–87
Brockmann, Günther. *Die Medaillen der Welfen: Die Geschichte der Welfen im Spiegel ihrer Medaillen*. 2 vols. Cologne, 1985–87.

Brockmann 1994
Brockmann, Günther. *Die medaillen der Kurfürsten und Könige von Brandenburg-Preussen*. Vol. 1, *Die Medaillen Joachim I.–Friedrich Wilhelm I., 1499–1740*. Cologne, 1994.

Van den Broek 1972
Van den Broek, R. *The Myth of the Phoenix, according to Classical and Early Christian Traditions*. Leiden, 1972.

Broglie 1971
Broglie, Raoul de. "Les Clouet de Chantilly: Catalogue illustré." *Gazette des beaux-arts*, 6th ser., 77 (1971): 258–336.

Bronzen von der Antike bis zur Gegenwart 1983
Bronzen von der Antike bis zur Gegenwart: Ex Aere Solido. Exh. cat. Westfälisches Landesmuseum für Kunst und Kulturgeschichte, Münster; Saarland-Museum, Saarbrücken; and Kestner-Museum, Hannover. Berlin, 1983.

Brooke and Hill 1924
Brooke, G. C., and George Francis Hill. *A Guide to the Exhibition of Historical Medals in the British Museum.* London, 1924.

C. M. Brown 1982
Brown, Clifford M., with Anna Maria Lorenzoni. *Isabella d'Este and Lorenzo da Pavia: Documents for the History of Art and Culture in Renaissance Mantua.* Geneva, 1982.

L. Brown 1980–95
Brown, Laurence. *A Catalogue of British Historical Medals, 1760–1960.* 3 vols. London, 1980–95.

G. Bruck 1963–64
Bruck, Guido. "Die graphische Vorlage der Medaille auf die Schlacht am Mühlberg 1547 von Nickel Milicz." *Mitteilungen der Österreichischen Numismatischen Gesellschaft*, n.s., 13 (1963–64): 27–29.

R. Bruck 1903
Bruck, Robert. *Friedrich der Weise als Förderer der Kunst.* Strassburg, 1903.

Bryden 1991
Bryden, D. J. "Medals for Funerals: Thomas Woods and the Roettiers' Medal of 1694/95." *Medal* 18 (Spring 1991): 23–28.

Buchanan 1990
Buchanan, Iain. "The Collection of Niclaes Jongelinck. I: 'Bacchus and the Planets' by Jacques Jongelinck." *Burlington Magazine* 132 (February 1990): 102–13.

Büll n.d.–1963
Büll, Reinhard. "Vom Wachs: Beiträge zur Kenntnis der Wachse." *Farbwerke Höchst A.G.* 1 (n.d.); 3 (1959); 7, no. 2 (1963).

Büll 1977
Büll, Reinhard. *Das grosse Buch vom Wachs.* Munich, 1977.

Bulla aurea 1660
Bulla aurea Caroli IV. Romanorum Imperatoris Noribergae [sic] Sancita, anno 1356. N.p. [ca. 1660].

Bulletins de la Société Archéologique de l'Orléanais 1859
Bulletins de la Société Archéologique de l'Orléanais. 2, nos. 16–1 (1859): 173.

J. Burckhardt 1951
Burckhardt, Jacob. *The Civilization of the Renaissance in Italy: An Essay.* 4th ed. New York, 1951. [Originally published as *Die Cultur der Renaissance in Italien: Ein Versuch.* Basel, 1860.]

J. Burckhardt 2000
Burckhardt, Jacob. *Das Altarbild: Das Porträt in der Malerei. Die Sammler.* Edited by Stella von Boch et al. Munich and Basel, 2000.

R. F. Burckhardt 1917
Burckhardt, Rudolf F. "Über den Arzt und Kunstsammler Ludovic Demoulin de Rochefort aus Blois, gestorben in Basel 1582." *Jahresberichte und Rechnungen* (Historisches Museum Basel) (1917): 28–60.

R. F. Burckhardt 1918
Burckhardt, Rudolf F. "Über die Medaillensammlung des Ludovic Demoulin im Historischen Museum zu Basel." *Anzeiger für Schweizerische Altertumskunde*, n.s., 20 (1918): 36–53.

Burke 1992
Burke, Peter. *The Fabrication of Louis XIV.* New Haven, Conn., 1992.

Burns, Collareta, and Gasparotto 2000
Burns, Howard, Marco Collareta, and Davide Gasparotto, eds. *Valerio Belli Vicentino, 1468c.–1546.* Vicenza, 2000.

Busignani 1970
Busignani, Alberto. *Pollaiolo.* Florence, 1970.

Cadenas y Vicent 1977
Cadenas y Vicent, Vicente de. *El Protectorado de Carlos V en Génova: La "Condotta" de Andrea Doria.* Madrid, 1977.

A. E. Cahn 1926
Sale cat. Adolph E. Cahn, Frankfurt am Main, October 26, 1926.

J. Cahn 1903
Cahn, Julius. *Frankfurter Medailleure im 16. Jahrhundert.* Frankfurt am Main, 1903.

J. Cahn 1905
Cahn, Julius. "Die Dreifaltigkeitsmedaille Hans Reinharts." *Blätter für Münzfreunde* 40 (1905), cols. 3339–43.

J. Cahn 1906
Cahn, Julius. "Die Medaillenporträts des Kardinals Albrecht von Mainz, Markgrafen von Brandenburg." In *Studienaus Kunst und Geschichte: Friedrich Schneider zum siebzigsten Geburtstag gewidmet*, pp. 159–67. Freiburg im Breisgau, 1906.

J. Cahn 1928
Cahn, Julius. "Das Vorbild zu einer Medaille Hans Reinharts." In *Georg Habich zum 60. Geburtstag*, pp. 121–22. Munich, 1928.

Callmann 1981
Callmann, Ellen. *Beyond Nobility: Art for the Private Citizen in the Early Renaissance.* Exh. cat. Allentown Art Museum. Allentown, Pa., 1981.

Calvi 1882
Calvi, Felice. "Il gran cancelliere Francesco Taverna, conte di Landriano, e il suo processo secondo nuovi documenti." *Archivio storico Lombardo* 9 (1882): 5–48.

Camesasca 1955
Camesasca, Ettore, ed. *Tutta l'opera del Cellini.* Milan, 1955.

Camozzi-Vertova 1970
Camozzi-Vertova, Giovanni Battista. "Medagliere del Risorgimento italiano: Esposizione generale italiana di Torino, 1884." *Bergomum: Bollettino della Civica Biblioteca di Bergamo* 64 (1970): 1–265.

Campbell 1990
Campbell, Lorne. *Renaissance Portraits: European Portrait-Painting in the 14th, 15th, and 16th Centuries.* New Haven, Conn., 1990.

Campbell et al. 2008
Campbell, Lorne, et al. *Renaissance Faces: Van Eyck to Titian.* Exh. cat. National Gallery. London, 2008.

Campori 1855
Campori, Giuseppe. *Gli artisti italiani e stranieri negli stati estensi.* Modena, 1855.

Campori 1864
Campori, Giuseppe. "Documents inédits sur les relations du cardinal Hippolyte d'Este et de Benvenuto Cellini." *Gazette des beaux-arts* 17 (1864): 289–97.

Campori 1866
Campori, Giuseppe, ed. *Lettere artistiche inedite.* Modena, 1866.

Cannata 2014
Cannata, Nadia. "Giorgio Vasari, Paolo Giovio, Portrait Collections and the Rhetorics of Images." In *Giorgio Vasari and the Birth of the Museum,* edited by Maia Wellington Gahtan, pp. 67–79. Farnham, Surrey, 2014.

Cano Cuesta 1994
Cano Cuesta, Marina. "Leone y Pompeo Leoni: Medallistas de la Casa de Austria." In *Los Leoni (1509–1608): Escultores del Renacimiento italiano al servicio de la corte de España,* pp. 163–201. Exh. cat. Museo Nacional del Prado. Madrid, 1994.

Cano Cuesta 2005
Cano Cuesta, Marina. *Catálogo de medallas españolas.* Museo Nacional del Prado. Madrid, 2005.

Cantelli 1979
Cantelli, Giuseppe. *Una raccolta fiorentina di medaglie tra '600 e '700.* Florence, 1979.

Cartwright 1926
Cartwright, Julia. *Isabella d'Este.* New York, 1926.

Caruana y Reig 1937
Caruana y Reig, José, Barón de San Petrillo. *Medallero valenciano o sea catálogo de medallas…* Valencia, 1937.

Casati 1884
Casati, Carlo. *Leone Leoni d'Arezzo, scultore, e Giov. Paolo Lomazzo, pittore milanese: Nuove ricerche.* Milan, 1884.

Casini 2004
Casini, Tommaso. *Ritratti parlanti: Collezionismo e biografie illustrate nei secoli XVI e XVII.* Florence, 2004.

Castiglione 1901
Castiglione, Baldassare. *The Book of the Courtier.* Edited and translated by Leonard E. Opdycke. New York, 1901.

Catalogue des Poinçons, Coins, et Médailles 1833
Catalogue des Poinçons, Coins, et Médailles. Paris, 1833.

Catalogue of the Mint of the United States 1914
Office of the Director of the Mint. *Catalogue of Coins, Tokens, and Medals in the Numismatic Collection of the Mint of the United States at Philadelphia, PA.* Washington, D.C., 1914.

Cazaux 1967
Cazaux, Yves. *Marie de Bourgogne: Témoin d'une grande entreprise à l'origine des nationalités européennes.* Paris, 1967.

Célébration du centenaire 1886
Célébration du centenaire de M. Chevreul, 31 août 1786–31 août 1886. Rouen, 1886.

Cellini 1829
Cellini, Benvenuto. *Vita di Benvenuto Cellini: Orefice e scultore fiorentino.* 3 vols. Edited by Francesco Tassi. Florence, 1829.

Cellini 1886
Cellini, Benvenuto. *La vita di Benvenuto Cellini.* Edited by Brunone Bianchi. Florence, 1886.

Cellini 1898
Cellini, Benvenuto. *The Treatises of Benvenuto Cellini on Goldsmithing and Sculpture.* Translated by C. R. Ashbee. London, 1898. [Reprint, New York, 1967.]

Cellini 1901
Cellini, Benvenuto. *La vita di Benvenuto Cellini, seguita dai trattati dell'oreficeria e della scultura e dagli scritti sull'arte.* Edited by Arturo Jahn Rusconi and Antonio Valeri. Rome, 1901.

Cellini 1949
Cellini, Benvenuto. *The Life of Benvenuto Cellini, Written by Himself.* Translated and edited by John Addington Symonds. London, 1949.

Cellini 1956
Cellini, Benvenuto. *The Autobiography of Benvenuto Cellini.* Translated by George Bull. Harmondsworth, 1956.

Centanni 2014
Centanni, Monica. "Cecilia Gonzaga come Diana nella medaglia/impresa di Pisanello (1447)." In *Il mondo e la storia: studi in onore di Claudia Villa* by Francesco Lo Monaco and Luca Carlo Rossi. Florence, 2014.

Cerboni Baiardi and Sibille 2001
Cerboni Baiardi, Anna, and Barbara Sibille. *Giovan Battista Nini, 1717–1786: Da Urbino alle rive della Loira. Paesaggi e volti europei.* Milan, 2001.

Cerro Nargánez 1998
Cerro Nargánez, Rafael. "José Carrillo de Albornoz y Montiel, conde de Montemar: Un militar andaluz entre Cataluña e Italia (1694–1725)." *Pedralbes* 18 (1998): 531–38.

Cessi 1960
Cessi, Francesco. *Alessandro Vittoria medaglista.* Trent, 1960.

Cessi 1961a
Cessi, Francesco. *Alessandro Vittoria architetto e stuccatore.* Trent, 1961.

Cessi 1961b
Cessi, Francesco. *Alessandro Vittoria bronzista.* Trent, 1961.

Cessi 1961–62
Cessi, Francesco. *Alessandro Vittoria scultore.* 2 vols. Trent, 1961–62.

Cessi 1965
Cessi, Francesco. "Pezzi editi e inediti di Giovanni da Cavino al Museo Bottacin di Padova." *Padova,* n.s., 11 (1965), no. 1: 13–18; no. 2: 13–18; no. 3: 26–32.

Cessi 1969
Cessi, Francesco, with Bruno Caon. *Giovanni da Cavino: Medaglista padovano del Cinquecento.* Padua, 1969.

Chabouillet 1875
Chabouillet, Anatole. *Notice sur une médaille inédite de Ronsard par Jacques Primavera, suivie de recherches sur la vie et les oeuvres de cet artiste.* Orléans, 1875.

Challis 1978
Challis, Christopher E. *The Tudor Coinage.* Manchester, 1978.

Challis 1992
Challis, Christopher E., ed. *A New History of the Royal Mint.* Cambridge, 1992.

Charles le Téméraire 1977
Charles le Téméraire, 1433–1477. Exh. cat. Royal Library. Brussels, 1977.

Charpentier sale 1981
Estampes, dessins, aquarelles et tableaux modernes, sculptures, art 1900, art déco; dessins, tableaux, sculptures, objets d'art et meubles. Atelier d'Alexandre Charpentier, 1856–1909. Sale cat. Hôtel Drouot, Paris, March 18, 1981.

Charvet 1907–8
Charvet, Etienne-Léon-Gabriel. "Médailles et jetons de la ville de Lyon." *Gazette numismatique française* 11 (1907): 267–426; 12 (1908): 11, 139, 387–422.

Checa Cremades 1998
Checa Cremades, Fernando, ed. *Felipe II, un monarca y su época: Un príncipe del Renacimiento.* Exh. cat. Museo Nacional del Prado, 1998–99. Madrid, 1998.

Chelminski sale 1904
Sammlung des Herrn Sigismund von Chelminski, Szarawka (Russland): Münzen und Medaillen von Polen und sonstige auf Polen bezügliche Gepräge. Sale cat. Otto Helbing, Munich, April 25, 1904.

Chiarelli 1972
Chiarelli, Renzo, ed. *L'opera completa del Pisanello.* Milan, 1972.

Chigi sale 1975
Chigi Collection. Sale cat. Sotheby's, Florence, May 14, 1975.

Chowen 1956
Chowen, Richard H. "Paduan Forgeries of Roman Coins." *Renaissance Papers* 3 (1956): 50–65.

Christiansen and Mann 2001
Christiansen, Keith, and Judith W. Mann. *Orazio and Artemisia Gentileschi.* Exh. cat. Metropolitan Museum of Art, New York; St. Louis Art Museum; and Museo del Palazzo di Venezia; 2001–2. Rome, 2001.

Christie's 1985
[*European Sculpture and Works of Art?*]. Sale cat. Christie's, London, July 3, 1985.

Ciani 1929
Monnaies françaises: Henri II à Henri IV. Pt. 3. Sale cat. M. L. Ciani, Paris, April 22, 1929.

Cicogna 1824–53
Cicogna, E. A. *Delle inscrizioni veneziane.* 7 vols. Venice, 1824–53.

Cimeliarchium 1709
Cimeliarchium seu thesaurus nummorum tam antiquissimorum quan modernorum, aureorum argenteorum et aeneorum, Serenissimi Principis ac Domini, Domini Friderici Augusti Ducis Wurtembergiae et Tecciae, Comitis Montispeligardi Dynastae Heidenheimii, etc quod prostat Neostadii ad Cocharum. Stuttgart, 1709.

Ciprut 1967
Ciprut, Edouard-Jacques. *Mathieu Jacquet: Sculpteur d'Henri IV.* Paris, 1967.

Ciprut 1969a
Ciprut, Edouard-Jacques. "Chronologie nouvelle de la vie et des oeuvres de Germain Pilon." *Gazette des beaux-arts*, 6th ser., 74 (1969): 333–44.

Ciprut 1969b
Ciprut, Edouard-Jacques. "Nouveaux documents sur Germain Pilon." *Gazette des beaux-arts*, 6th ser., 73 (1969): 257–76.

Circa 1492 1991
Circa 1492: Art in the Age of Exploration. Edited by Jay A. Levenson. Exh. cat. National Gallery of Art. Washington, D.C., 1991.

Cittadella 1864
Cittadella, Luigi Napoleone. *Notizie relative a Ferrara.* Ferrara, 1864.

Clain-Stefanelli 1965
Clain-Stefanelli, Elvira Eliza. *Numismatics: An Ancient Science. A Survey of Its History.* Contributions from the Museum of History and Technology, Paper 32. United States National Museum, Bulletin 229. Washington, D.C., 1965.

Clark 1964–65
Clark, Anthony M. "Three Roman Eighteenth-Century Portraits." *Journal of the Walters Art Gallery* 27–28 (1964–65): 48–56.

Clausse 1902
Clausse, Gustave. *Les San Gallo: Architectes, peintres, sculpteurs, médailleurs.* Vol. 3, *Florence et les derniers Sangallo.* Paris, 1902.

Clifford sale 1996
An Important Collection of Renaissance and Baroque Medals and Plaquettes. Sale cat. Collection of Timothy Clifford. Spink & Son, London, in association with Christie's, May 21, 1996.

Clouet 1970
Les Clouet & la cour des rois de France. Exh. cat. Bibliothèque Nationale. Paris, 1970.

Clough 1973
Clough, Cecil H. "Federico da Montefeltro's Patronage of the Arts, 1468–1482." *Journal of the Warburg and Courtauld Institutes* 36 (1973): 129–44.

Cloulas 1990
Cloulas, Ivan. *Jules II: Le pape terrible.* Paris, 1990.

Coch 1993
Coch, Hartmut. *Bildhauer Adolf Lehnert Leipzig und die Schule der Medailleure an der Akademie für Graphische Künste und Buchgewerbe.* Saalfeld an der Saale, 1993.

Cochran-Patrick 1884
Cochran-Patrick, Robert William. *Catalogue of the Medals of Scotland from the Earliest Period to the Present Time.* Edinburgh, 1884.

Cohen 1859
Cohen, Henry. *Description historique des monnaies frappées sous l'Empire Romain, communément appelées médailles impériales.* Vol. 1. Paris, 1859.

Cole 2004
Cole, Michael. "Münzen als Medaillen unter den ersten Medici-Herzögen." In *Die Renaissance-Medaille in Italien und Deutschland,* edited by Georg Satzinger, pp. 195–212. Münster, 2004.

Collareta 2014
Collareta, Marco. "Monete e medaglie nella decorazione." In *Le arti a dialogo: Medaglie e medaglisti tra Quattro e Settecento,* edited by Lucia Simonato, pp. 13–24. Pisa, 2014.

La collection Spitzer 1890–93
La collection Frédéric Spitzer. 6 vols. Paris, 1890–93.

Collezione di Vittorio Emanuele III 1987
Collezione di Vittorio Emanuele III: Zecca di Ferrara. Bollettino di numismatica 3. Rome, 1987.

Collin du Bocage sale 2017
Numismatique: Monnaies et Médailles en Or. Sale cat. Collin du Bocage, Paris, December 4, 2017.

Comandini 1900–42
Comandini, Alfredo. *L'Italia nei cento anni del secolo XIX (1801–1900): Giorno per giorno illustrati.* 5 vols. Milan, 1900–42.

Comba 2005
Comba, Rinaldo, ed. *Ludovico II, marchese di Saluzzo: Condottiero, uomo di stato, mecenate (1475–1504).* 2 vols. Cuneo, 2005.

"Conestaggio" 2016
"Conestaggio, Jerónimo de Franchi." In *Dicionário dos italianos estantes em Portugal.* http://www.catedra-alberto-benveniste.org/dic-italianos.asp (accessed October 10, 2016).

Coniglio 1967
Coniglio, Giuseppe. *I Gonzaga.* Varese, 1967.

Cooper 1988
Cooper, Denis R. *The Art and Craft of Coinmaking.* London, 1988.

Cora 1950
Cora, Galeazzo. "'Opus Sperandei.'" *Faenza* 36, no. 5 (1950): 108–10.

Cordellier 1996
Cordellier, Dominique. *Pisanello: Le peintre aux sept vertus.* Paris, 1996.

Corpus nummorum Italicorum 1910–43
Corpus nummorum Italicorum. 20 vols. Rome, 1910–43.

Corsi 1891
Corsi, Tommaso. *Collezione di monete e medaglie.* Florence, 1891.

Cosemans 1933
Cosemans, A. "Antoon van Stralen, burgemeester van Antwerpen, commissaris der Staten-Generaal bij den aanvang der regeering van Philips II, 1521–1568." *Verslagen en mededelingen van de Koninklijke Vlaamsche Academie voor Taal- en Letterkunde* (1933): 599–663.

Cott 1951
Cott, Perry. *Renaissance Bronzes: Statuettes, Reliefs and Plaquettes, Medals, and Coins from the Kress Collection.* National Gallery of Art. Washington, D.C., 1951.

Couderc 1894
Couderc, C. "Jean de Candida historien." *Bibliothèque de l'Ecole des Chartes* 55 (1894): 564–67.

Couderc 1924
Couderc, C. "Jean de Candida historien." *Bibliothèque de l'Ecole des Chartes* 85 (1924): 323–41.

Coullaré 2006
Coullaré, Béatrice, ed. *Médailles russes du Louvre (1672–1855).* Wetteren, 2006.

Courajod 1878–87
Courajod, Louis. *Alexandre Lenoir: Son journal et le Musée des Monuments Français.* 3 vols. Paris, 1878–87.

Coyeque 1940
Coyeque, Ernest. "Au domicile mortuaire de Pilon." *Bibliothèque d'humanisme et Renaissance* 7 (1940): 56, 80–84.

Craig 1953
Craig, John. *The Mint: A History of the London Mint from A.D. 287 to 1948.* Cambridge, 1953.

Crippa 1986
Crippa, Carlo. *Le monete di Milano da Desiderio alla chiusura della zecca.* Milan, 1986.

Crollalanza 1886–89
Crollalanza, G. B. di. *Dizionario storico-blasonico delle famiglie nobili e notabili italiane estinte e fiorenti.* 3 vols. Pisa, 1886–89. [Reprint, Bologna, 1965.]

Cucci 1968
Cucci, C. *Medaglie, placchette e monete del Risorgimento.* Bologna, 1968.

Cunnally 1984
Cunnally, John. "The Role of Greek and Roman Coins in the Art of the Italian Renaissance." PhD diss., University of Pennsylvania, 1984.

Cunnally 1999
Cunnally, John. *Images of the Illustrious: The Numismatic Presence in the Renaissance.* Princeton, N.J., 1999.

Cupperi 2002
Cupperi, Walter. "La riscoperta delle monete antiche come codice celebrativo: L'iconografia italiana dell'imperatore Carlo V d'Asburgo nelle medaglia di Alfonso Lombardi, Giovanni Bernardi, Giovanni da Cavino, 'TP,' Leone e Pompeo Leoni (1530–1558), con una nota su altre medaglie cesaree di Jacques Jonghelinck e Joachim Deschler." *Saggi e Memorie di storia dell'arte* 26 (2002): 31–85.

Cupperi 2006
Cupperi, Walter. "Le medaglie nella Milano asburgica (1535–1571): Artisti, committenti e fortuna europea." PhD diss., Scuola Normale Superiore, Pisa, 2006.

Cupperi 2013
Cupperi, Walter. "Medaillen im deutschsprachigen Raum: Ein geographischer Blickwinkel." In Cupperi et al. 2013, pp. 181–84.

Cupperi et al. 2013
Cupperi, Walter, et al. *Wettstreit in Erz: Porträtmedaillen der deutschen Renaissance.* Exh. cat. Staatliche Münzsammlung, Munich; Münzkabinett, Kunsthistorisches Museum, Vienna; and Münzkabinett, Staatliche Kunstsammlungen Dresden; 2013–15. Berlin, 2013.

Cust 1903
Cust, Lionel. *Notes on the Authentic Portraits of Mary Queen of Scots, Based on the Researches of the Late Sir George Scharf.* London, 1903.

Daniels and Baloga sale 2002
Property from the Estates of David M. Daniels and Stevan Beck Baloga. Sale cat. Sotheby's, New York, October 29, 2002.

Danielson 1990
Danielson, Cornelia. "L'iconografia storica del palazzo." In *Il Palazzo Medici Riccardi di Firenze,* edited by Giovanni Cherubini and Giovanni Fanelli, pp. 272–99. Florence, 1990.

Daninos 2008
Daninos, Andrea. "Qualche novità sulla scultura in Cera fra Cinquecento e Settecento." *Prospettiva,* no. 132 (2008): 88–99.

D'Arco 1857
D'Arco, Carlo. *Delle arti e degli artefici di Mantova.* Mantua, 1857.

Darr and Bonsanti 1986
Darr, Alan P., and Giorgio Bonsanti, eds. *Donatello e i suoi: Scultura fiorentina del primo Rinascimento*. Exh. cat. Forte di Belvedere, Florence. Detroit and Milan, 1986. [Revised edition of *Italian Renaissance Sculpture in the Time of Donatello*. Exh. cat. Detroit Institute of Arts. Detroit, 1985.]

Darr and Roisman 1987
Darr, Alan P., and Rona Roisman. "Francesco da Sangallo: A Rediscovered Early Donatellesque 'Magdalen' and Two Wills from 1574 and 1576." *Burlington Magazine* 129 (December 1987): 784–93.

Darras 1933
Darras, Eugène. "La famille Bergeret de l'Isle-Adam et de Frouville (Seine-et-Oise)." *Mémoires de la Société Historique et Archéologique de l'Arrondissement de Pontoise et du Vexin* 42 (1933): 65–92.

J. S. Davenport 1979
Davenport, John S. *German Talers, 1500–1600*. Frankfurt am Main, 1979.

M. Davenport 1948
Davenport, Millia. *The Book of Costume*. New York, 1948.

David Daniels Collection 1979
Sculpture from the David Daniels Collection. Edited by Louise Lincoln. Exh. cat. Minneapolis, 1979.

Davids sale 2005
Creative Encounters: Portraits of Writers, Artists and Musicians, the Roy Davids Collection. Sale cat. Bonhams, London, October 3, 2005.

Davis 1978
Davis, Charles. "Aspects of Imitation in Cavino's Medals." *Journal of the Warburg and Courtauld Institutes* 41 (1978): 331–34.

De Bie 1634
De Bie, Jacques. *Les familles de la France, illustrées par les monuments, des médailles anciennes et modernes*. Paris, 1634.

De Bie 1635
De Bie, Jacques. *La France métallique*. Paris, 1635.

De Chantelou 1981
De Chantelou, Fréart. *Journal de voyage du Cavalier Bernin en France*. Aix en Provence, 1981.

De Coo 1969
De Coo, Jozef. *Beeldhouwkunst, plaketten, antiek*. Catalogus 2. Museum Mayer van den Bergh. Antwerp, 1969.

De Dompierre de Chaufepié 1903–6
De Dompierre de Chaufepié, Henri Jean. *Catalogus der Nederlandsche en op Nederland betrekking hebbende Gedenkpenningen*. 2 vols. Koninklijk Kabinet van Munten, Penningen en Gesneden Steenen. The Hague, 1903–6.

De Lorenzi 1983
De Lorenzi, Giovanna. *Medaglie di Pisanello e della sua cerchia*. Exh. cat. Museo Nazionale del Bargello. Florence, 1983.

De Vinne 1905
De Vinne, Theodore L. "Samuel Putnam Avery." In *The New York Genealogical and Biographical Record* 36, no. 1 (January 1905), pp. 1–4. [Reprinted in *Editorials and Resolutions in Memory of Samuel Putnam Avery: Born March 17th, 1822; Died August 11th, 1904*. New York, 1905.]

Dean 1988
Dean, Trevor. *Land and Power in Late Medieval Ferrara: The Rule of the Este, 1350–1450*. Cambridge, 1988.

Degenhart 1940
Degenhart, Bernhard. *Antonio Pisanello*. Vienna, 1940.

Degenhart 1945
Degenhart, Bernhard. *Pisanello*. Turin, 1945.

Dekker 1986
Dekker, Alfred M. M. *Janus Secundus (1511–1536): De tekstoverlevering van het tijdens zijn leven gepubliceerde werk*. Nieuwkoop, 1986.

Delisle 1890
Delisle, L. "Le médailleur Jean de Candida." *Bibliothèque de l'Ecole des Chartes* 51 (1890): 310–12.

Delitala 1973
Delitala, Francesco. "Medaglie medicee di Granduchi e Granduchesse." *Medaglia* 3 (1973): 35–48.

Dennistoun 1909
Dennistoun, James. *Memoirs of the Dukes of Urbino*. 3 vols. New ed. Edited by Edward Hutton. London, 1909.

Deonna 1930
Deonna, W. "Le groupe des Trois Graces nues et sa descendance." *Revue archéologique*, 5th ser., 31 (1930): 274–332.

Di Dio 2011
Di Dio, Kelley Hemstutler. *Leone Leoni and the Status of the Artist at the End of the Renaissance*. Farnham, Surrey, 2011.

Di Rauso 2008
Di Rauso, Francesco. "La straordinaria medaglia napoletana del 1735 in omaggio a Giuseppe Carillo de Albornoz y Monteil [*sic*], duca di Montemar." *Panorama numismatico*, no. 229 (2008): 44–47.

Dictionnaire de biographie française 1939
Dictionnaire de biographie française. Vol. 3. Paris, 1939.

Diemer 2008
Diemer, Peter. "Zum Schicksal der Münzsammlung Herzog Albrechts V." In *Die Münchner Kunstkammer*, vol. 3, *Aufsätze und Anhänge*, edited by Willibald Sauerländer, pp. 253–60. Bayerische Akademie der Wissenschaften, Philosophisch-Historische Klasse, Abhandlungen, n.s., 129. Munich, 2008.

Van Dillen 1974
Van Dillen, J. G. *Bronnen tot de geschiedenis van het bedrijfsleven en het gildewezen van Amsterdam*. Vol. 3, *1633–1672*. Rijks geschiedkundige publicatiën, Grote serie, 144. The Hague, 1974.

***Dizionario biografico degli italiani* 1960–**
Dizionario biografico degli italiani. 85 vols. to date. Rome, 1960–.

Docci 2006
Docci, Marina. *San Paolo fuori le Mura: Dalle origini alla basilica delle origini*. Rome, 2006.

Dolfi 1670
Dolfi, Pompeo Scipione. *Cronologia delle famiglie nobili di Bologna*. Bologna, 1670.

Domanig 1892
Domanig, Karl. "Die deutsche Privatmedaille der älteren Zeit." *Numismatische Zeitschrift* 24 (1892): 77–118.

Domanig 1893
Domanig, Karl. "Älteste Medailleure in Österreich." *Jahrbuch der kunsthistorischen Sammlungen des Allerhöchsten Kaiserhauses* 14 (1893): 11–36.

Domanig 1895
Domanig, Karl. *Anton Scharff, K. und K. Kammer-Medailleur (1845–1895): Sein Bildungsgang und sein Schaffen*. Vienna, 1895.

Domanig 1896
Domanig, Karl. *Porträtmedaillen des Erzhauses Österreich von Kaiser Friedrich III. bis Kaiser Franz II. aus der Medaillensammlung des Allerhöchsten Kaiserhauses*. Vienna, 1896.

Domanig 1907
Domanig, Karl. *Die deutsche Medaille in kunst- und kultur-historischer Hinsicht: Nach des Beständen der Medaillen-sammlung des Allerhöchsten Kaiserhauses*. Vienna, 1907.

Domanig 1913
Domanig, Karl. "Die Hans Reinhart'sche Dreifaltigkeitsmedaille." *Mitteilungen der Österreichischen Gesellschaft für Münz- und Medaillenkunde in Wien* 24, n.s., 9 (1913): 69–73.

Donahue-Wallace 2017
Donahue-Wallace, Kelly. *Jerónimo Antonio Gil and the Idea of the Spanish Enlightenment*. Albuquerque, 2017.

Donebauer sale 1889
Catalog der nachgelassenen Sammlung des sel. Herren Max Donebauer zu Prag: Münzen und Medaillen des Königreichs Böhmen. Pt. 1, *Die Regierungs-Münzen*. Sale cat. Adolph Hess, Frankfurt am Main, May 22, 1889, and following days.

Van Dorsten 1969
Van Dorsten, Jan. "Steven van Herwyck's Elizabeth (1565): A Franco-Flemish Political Medal." *Burlington Magazine* 111 (March 1969): 143–47.

Doty 1982
Doty, Richard G. *Encyclopedic Dictionary of Numismatics*. London, 1982.

Draper 1992
Draper, James David. *Bertoldo di Giovanni: Sculptor of the Medici Household*. Columbia, Mo., 1992.

Dressel 1973
Dressel, Heinrich. *Die römischen Medaillone des Münzkabinetts der Staatlichen Museen zu Berlin*. 2 vols. Dublin, 1973.

Dryfhout 1982
Dryfhout, John H. *The Work of Augustus Saint-Gaudens*. Hanover, N.H., 1982.

Du Chesne 1680
Du Chesne, François. *Histoire des chancelliers de France et des gardes de sceaux de France*. Paris, 1680.

Du Molinet 1679
Du Molinet, Claude. *Historia summorum pontificum a Martino V. ad Innocentium VI. per eorum numismata, ab anno MCCCCXVII ad annum MDCLXXVIII*. Paris, 1679.

Du Molinet 1692
Du Molinet, Claude. *Le cabinet de la Bibliothèque de Sainte Geneviève*. Paris, 1692.

Duisburg 1862
Duisburg, Carl Ludwig von. *C. A. Rudolphi recentioris aevi numismata virorum de rebus medicis et physicis meritorum memoriam servantia*. Danzig, 1862.

Duisburg 1869
Verzeichnis der Medaillensammlung des Dr. C. L. von Duisburg. Danzig, 1869.

Dumolin 1930
Dumolin, Maurice. "La construction du Val-de-Grâce." *Bulletin de la Société de l'Histoire de Paris* (1930): 106–7.

Durand 1865
Durand, Anthony. *Médailles et jetons des numismates*. Geneva, 1865.

Dürer 1969
Dürer, Albrecht. *Dürers Schriftlicher Nachlass*. Edited by Hans Rupprich. Berlin, 1969.

Dworschak 1925–26
Dworschak, Fritz. "Der Manierismus in der deutschen Medaille." *Archiv für Medaillen- und Platten-Kunde* 5 (1925–26): 61ff.

Dworschak 1926
Dworschak, Fritz. "Die Renaissance Medaille in Österreich." *Jahrbuch der kunsthistorischen Sammlungen in Wien,* n.s., 1 (1926): 213–44.

Dworschak 1927
Dworschak, Fritz. "Wiener Porträtmedaillen des XVI. Jahrhunderts." *Mitteilungen des Vereins für Geschichte der Stadt Wien* 7 (1927): 91–104.

Dworschak 1958
Dworschak, Fritz. *Antonio Abondio: Medaglista e ceroplasta (1538–1591)*. Trento, 1958.

***Early German Art* 1906**
Exhibition of Early German Art. Exh. cat. Burlington Fine Arts Club. London, 1906.

Ebner 1908–9
Ebner, Julius. "Zum Werk des Hans Kels." *Mitteilungen der Bayerischen Numismatischen Gesellschaft* 26–27 (1908–9): 101–4.

Ebner 1909
Ebner, Julius. "Peter Flötner oder Matthes Gebel?" *Frankfurter Münzzeitung* 9 (1909): 472–79.

Eden 1988
Tom Eden. "A Recent Sale of Renaissance Medals." *Medal* 13 (Autumn 1988): 8–11.

Edmond 1983
Edmond, Mary. *Hilliard and Oliver: The Lives and Works of Two Great Miniaturists*. London, 1983.

Egg 1971
Egg, Erich. *Die Münzen Kaiser Maximilians I*. Innsbruck, 1971.

Eidlitz 1927
Eidlitz, R. J. *Medals of Architects*. New York, 1927.

Eimer 1987
Eimer, Christopher. *British Commemorative Medals and Their Values*. London, 1987.

Eimer 1989
Eimer, Christopher. *An Introduction to Commemorative Medals*. London, 1989.

Eimer 1994
Eimer, Christopher. *Medallic Portraits of the Duke of Wellington*. London, 1994.

Eimer 1998
Eimer, Christopher. *The Pingo Family and Medal Making in 18th-Century Britain*. London, 1998.

Eimer 2010
Eimer, Christopher. *British Commemorative Medals and Their Values*. New ed. London, 2010.

Eisler 1983
Eisler, William Lawrence. "The Impact of Charles V upon the Visual Arts." PhD diss., Pennsylvania State University, 1983.

Eisler 2002–5
Eisler, William Lawrence. *The Dassiers of Geneva: 18th Century European Medallists*. 2 vols. Lausanne, 2002–5.

Elliott 1986
Elliott, John Huxtable. *The Count-Duke of Olivares: The Statesman in an Age of Decline*. New Haven, Conn., 1986.

Emison 2004
Emison, Patricia A. *Creating the "Divine" Artist: From Dante to Michelangelo*. Leiden, 2004.

***Enciclopedia cattolica* 1948–54**
Enciclopedia cattolica. 12 vols. Vatican City, 1948–54.

***Enciclopedia italiana* 1929–39**
Enciclopedia italiana di scienze, lettere ed arti. 36 vols. Rome, 1929–39.

***Enciclopedia universale dell'arte* 1963**
Enciclopedia universale dell'arte. Vol. 9. Rome, 1963.

***Encyclopedia of World Art* 1959–87**
Encyclopedia of World Art. 18 vols. New York, 1959–87.

***Encyclopedie van Zeeland* 1984**
Encyclopedie van Zeeland. Vol. 3. Middelburg, 1984.

Engl 1906
Engl, Johann Evangelist. *Katalog des Mozart-Museums im Geburts- und Wohnzimmer Mozarts zu Salzburg*. 4th ed. Salzburg, 1906.

Ephrussi 1883
Ephrussi, Charles. "Les médailleurs de la Renaissance." *L'art* 34 (1883): 243–52.

***Erasme et la Belgique* 1969**
Erasme et la Belgique. Exh. cat. Bibliothèque Royale Albert Ier, Brussels, and Musée de la Ville, Louvain. Brussels, 1969.

Erasmus von Rotterdam 1986
Erasmus von Rotterdam. Exh. cat. Historisches Museum. Basel, 1986.

J. Erbstein and A. Erbstein 1888–96
Erbstein, Julius, and Albert Erbstein. *Erörterungen auf dem Gebiete der sächsischen Münz- und Medaillen-Geschichte: Bei Verzeichnung der Hofrath Engelhardt'schen Sammlung veröffentlicht.* Dresden, 1888–96.

Erbstein sale 1908
Hess, Adolph Nachfolger. *Sammlung Erbstein, Nachlass Des Herrn Geh. Hofraths Dr. Richard Julius.* (Part 1: Italian and German Renaissance Medals.) Dealer's cat. Frankfurt am Main, May 19, 1908.

Eredità del Magnifico 1992
Eredità del Magnifico. Exh. cat. Museo Nazionale del Bargello. Florence, 1992.

Erlanger 1965
Erlanger, Herbert J. "The Medallic Portrait of Albrecht Dürer." *Museum Notes* (American Numismatic Society) 10 (1965): 145–72.

Erman 1884
Erman, Adolf. *Deutsche Medailleure des sechzehnten und siebzehnten Jahrhunderts.* Berlin, 1884.

Erman 1885
Erman, Adolf. "Deutsche Medailleure des sechzehnten und siebzehnten Jahrhunderts." *Zeitschrift für Numismatik* 12 (1885): 14–102.

Ernsting 1995
Ernsting, Bernd. *Ludwig Gies, Meister des Kleinreliefs, mit Werkverzeichnis der Medaillen und Plaketten, Münzen und Münzenentwürfe, Siegel und Trockenstempel.* Cologne, 1995.

Erwerbungsbericht 1924–26
Erwerbungsbericht (Staatliche Münzsammlung, Munich), 1924–26.

Eser 1991
Eser, Thomas. "Augsburger Kalksteinreliefs des frühen 16. Jahrhunderts. Hans Daucher: Ein Zeitgenosse Dürers." *Weltkunst* 61 (1991): 1770–73.

Espezel 1925
Espezel, Pierre d'. "Sur un médaillon de Louise de Savoie, mère de François Ier." *Aréthuse* 2, no. 1 (January 1925): 1–10.

Ettlinger 1988
Ettlinger, Helen S. *The Image of a Renaissance Prince: Sigismondo Malatesta and the Arts of Power.* Berkeley, Calif., 1988.

Evans 2004
Evans, Helen, ed. *Byzantium: Faith and Power (1261–1577).* Exh. cat. Metropolitan Museum of Art. New York, 2004.

Evelyn 1697
Evelyn, John. *A Discourse of Medals.* London, 1697.

Évrard de Fayolle 1902
Évrard de Fayolle, Alexis. "Medailles et jetons municipaux de Bordeaux." *Gazette numismatique française* 6 (1902): 295–306.

Exter 1759–75
Exter, Friedrich. *Versuch einer Sammlung von Pfälzischen Münzen und Medaillen.* 2 vols. with supplement. Zweybrücken, 1759–75. [Reprint, *Pfälzische Münzen und Medaillen.* Munich, 1988.]

Fabriczy 1897
Fabriczy, Cornelius von. "Toscanische und oberitalienische Künstler in Diensten der Aragonesen Neapel." *Repertorium für Kunstwissenschaft* 20 (1897): 85–120.

Fabriczy 1903a
Fabriczy, Cornelius von. "Adriano Fiorentino." *Jahrbuch der Königlich Preussischen Kunstsammlungen* 24 (1903): 71–98.

Fabriczy 1903b
Fabriczy, Cornelius von. *Medaillen der italienischen Renaissance.* Leipzig, 1903.

Fabriczy 1904
Fabriczy, Cornelius von. *Italian Medals.* London, 1904.

Fach-Katalog der Musikhistorischen Abtheilung 1892
Fach-Katalog der Musikhistorischen Abtheilung von Deutschland und Oesterreich-Ungarn. Vienna, 1892.

Farbaky et al. 2008
Farbaky, Péter, et al. *Matthias I, King of Hungary, 1443–1490.* Exh. cat. Budapest History Múzeum. Budapest, 2008.

Farina 2015
Farina, Ferruccio. "Il volto e la fama: le medaglie di Pisanello e di Matteo de'Pasti per Sigismondo Pandolfo Malatesta nei repertori iconografici tra XVI e XVII secolo." *Romagna arte e storia*, Anno 54, 103 (January–April, 2015): 15–46.

Farquhar 1907
Farquhar, Helen. "Portraiture of Our Tudor Monarchs on Their Coins and Medals." *British Numismatic Journal* 4 (1907): 79–143.

Farquhar 1908
Farquhar, Helen. "Nicholas Hilliard: 'Embosser of Medals in Gold.'" *Numismatic Chronicle*, 4th ser., 8 (1908): 324–56.

Fasanelli 1965
Fasanelli, James A. "Some Notes on Pisanello and the Council of Florence." *Master Drawings* 3, no. 1 (1965): 36–47.

Fauver Collections 2006
The Benj Fauver Collections. Presidential Coin & Antiques Co. Exonumia Auction no. 75, July 15, 2006.

Felder 1978
Felder, Peter. *Medailleur Johann Carl Hedlinger, 1691–1771: Leben und Werk*. Aarau, 1978.

Felipe II 1998
Felipe II, un monarca y su época: Las tierras y los hombres del rey. Exh. cat. Museo Nacional de Escultura, Palacio de Villena, 1998–99. Valladolid, 1998.

Felix sale 1886
Die Kunstsammlung des Herrn Eugen Felix in Leipzig. Sale cat. J. M. Heberle, Cologne, October 25, 1886.

Felix sale 1895
Sammlung Eugen Felix: Kunstmedaillen hauptsächlich aus der Periode der deutschen Renaissance. Sale cat. Adolf Hess Nachfolger, Frankfurt am Main, September 23, 1895.

Fenichel 2016
Fenichel, Emily A. "Penance and Proselytizing in Michelangelo's Portrait Medal." *Artibus et Historiae* 37, no. 73 (2016): 125–38.

Ferino-Pagden 1997
Ferino-Pagden, Sylvia. *Vittoria Colonna: Dichterin und Muse Michelangelos*. Exh. cat. Kunsthistorisches Museum. Vienna, 1997.

M. Ferrara 1952
Ferrara, Mario. *Savonarola*. 2 vols. Florence, 1952.

Fiala 1904
Fiala, Eduard. *Münzen und Medaillen der Welfischen Lande*. Vienna, 1904.

Fiala 1906
Fiala, Eduard. *Das mittlere Haus Braunschweig, Linie zu Wolfenbüttel*. Vienna, 1906.

Fiala 1909
Fiala, Eduard. *Antonio Abondio*. Prague, 1909.

Ficker 1924
Ficker, Johannes. "Neue alte Bilder Luthers." *Luther: Mitteilungen der Luther-Gesellschaft* 6, nos. 4–5 (1924): 54–76.

Ficker 1934
Ficker, Johannes. "Die Bildnisse Luthers aus der Zeit seines Lebens." *Luther-Jahrbuch* 16 (1934): 103–61.

Filangieri 1883–97
Filangieri, Gaetano. *Documenti per la storia, le arti e le industrie nelle provincie napoletane*. 6 vols. Naples, 1883–97.

Filarete 1965
Filarete. *Treatise on Architecture; Being the Treatise by Antonio di Piero Averlino, Known as Filarete*. Translated and edited by John R. Spencer. 2 vols. New Haven, Conn., 1965.

Firenze e la Toscana dei Medici 1980
Firenze e la Toscana dei Medici nell'Europa del Cinquecento. Exh. cat. Palazzo Vecchio. Florence, 1980.

Flaten 2012
Flaten, Arne R. *Medals and Plaquettes in the Ulrich Middeldorf Collection at the Indiana University Art Museum, 15th to 20th Centuries*. Bloomington, Ind., 2012.

Fleury 1969
Fleury, Marie-Antoinette. *Documents du Minutier Central concernant les peintres, les sculpteurs et les graveurs au XVIIe siècle (1600–1650)*. Paris, 1969.

Flohil 1953
Flohil, M. "Het penning- en muntportret van Willem van Oranje." *Jaarboek voor Munt- en Penningkunde* 40 (1953): 49–70.

Flohil 1968
Flohil, M. "Eerste en tweede staat van Coenraad Bloc's portretpenning van Willem van Oranje." *Jaarboek voor Munt- en Penningkunde* 48 (1968): 65–70.

Fontana 2009
Fontana, Federica Missere. *Testimoni parlanti: Le monete antiche a Roma tra Cinquecento e Seicento*. Modena, 2009.

Fornari Schianchi and Spinosa 1995
Fornari Schianchi, Lucia, and Nicola Spinosa, eds. *I Farnese: Arte e collezionismo*. Exh. cat. Palazzo Ducale di Colorno, Parma; Galleria Nazionale di Capodimonte, Naples; and Haus der Kunst, Munich. Milan, 1995.

Forrer 1904–30
Forrer, Leonard. *Biographical Dictionary of Medallists: Coin-, Gem-, and Seal-Engravers, Mint-Masters, &c., Ancient and Modern, with References to Their Works, B.C. 500–A.D. 1900*. 8 vols. London, 1904–30. [Reprint, London and Maastricht, 1979–80.]

Forschler-Tarrasch 2002
Forschler-Tarrasch, Anne. *Leonhard Posch: Porträtmodelleur und Bildhauer, 1750–1831*. Berlin, 2002.

Fortnum 1875
Fortnum, C. D. E. "On the Original Portrait of Michel Angelo by Leo Leone, 'Il Cavaliére Aretino.'" *Archaeological Journal* 32 (1875): 1–15.

Fossi Todorow 1966
Fossi Todorow, Maria. *I disegni del Pisanello e della sua cerchia*. Florence, 1966.

Foville 1908
Foville, Jean de. "Le médailleur 'à l'Amour Captif.'" *Gazette des beaux-arts*, 3rd ser., 39 (1908): 385–93.

Foville 1910
Foville, Jean de. *Sperandio: Sculpteur et médailleur mantouan*. Paris, 1910.

Foville 1913
Foville, Jean de. "Les premières oeuvres de Jean Varin en France." *Revue de l'art* 34 (1913): 149–58.

Foville 1913–14
Foville, Jean de. "L'élève vénitien de Riccio." In *Archiv für Medaillen- und Plaketten-Kunde* 1 (1913–14).

Foville 1914
Foville, Jean de. "Notes sur le médailleur Sperandio de Mantova." *Revue numismatique*, 4th ser., 16 (1914): 432–33.

Foville 1915
Foville, Jean de. "La médaille française au temps de Henri IV et de Louis XIII." In *Histoire de l'art*, edited by André Michel, vol. 5, pt. 2. Paris, 1915.

Fox 1988
Fox, Stephen Paul. "Medaglie medicee di Domenico di Polo." *Bollettino di numismatica* 19 (1988): 189–219.

Franceschini 1970
Franceschini, Gino. *I Montefeltro*. Varese, 1970.

Frank zu Dëfering 1936
Frank zu Dëfering, Karl Friedrich von. *Die Kressen: Eine Familiengeschichte*. Schloss Senftenegg, 1936.

Frankfurter Münzhandlung 1992
Gold- und Silbermünzen Braunschweig Süddeutschland. Sale cat, no. 139. Frankfurter Münzhandlung, Frankfurt am Main, November 24–26, 1992.

Franz 1969
Franz, Rosemarie. *Der Kachelofen: Entstehung und kunstgeschichtliche Entwicklung vom Mittelalter bis zum Ausgang des Klassizismus*. Graz, 1969.

Frapiccini 2013
Frapiccini, David. *L'età aurea di Giulio II: Arti, cantieri e maestranze prima di Raffaello*. Rome, 2013.

Frederiks 1943
Frederiks. J. W. *De meesters der plaquette-penningen*. The Hague, 1943.

French Bronze 1968
The French Bronze, 1500 to 1800. Exh. cat. M. Knoedler & Co. New York, 1968.

Frese and Datow 1983
Frese, Inge, and Joachim Datow. *Martin Luther und seine Zeit auf Münzen und Medaillen*. Schwetzingen, 1983.

Frick Collection 2003
The Frick Collection: Drawings, Prints, and Later Acquisitions. New York, 2003.

Friedenberg 1963
Friedenberg, Daniel M., ed. *Great Jewish Portraits in Metal*. New York, 1963.

Friedenberg 1970
Friedenberg, Daniel M. *Jewish Medals*. New York, 1970.

Friedlaender 1882a
Friedlaender, Julius. "Die italienischen Schaumünzen des fünfzehnten Jahrhunderts." Pt. 8, "Florenz, Fortsetzung." *Jahrbuch der Königlich Preussischen Kunstsammlungen* 3 (1882): 29–46.

Friedlaender 1882b
Friedlaender, Julius. *Die italienischen Schaumünzen des fünfzehnten Jahrhunderts (1430–1530): Ein Beitrag zur Kunstgeschichte*. Berlin, 1882.

Fries 1919
Fries, Walter. "Hans Daucher." PhD diss., Universität Freiburg im Breisgau, 1919.

Frize 2013
Frize, Monique. *Laura Bassi and Science in 18th Century Europe: The Extraordinary Life and Role of Italy's Pioneering Female Professor*. Berlin, 2013.

Furse 1885
Furse, Edouard Henri. *Mémoires numismatiques de l'Ordre Souverain de Saint Jean de Jérusalem*. Rome, 1885.

Gabel 1959
Gabel, Leona C., ed. *Memoirs of a Renaissance Pope: The Commentaries of Pius II*. Translated by Florence A. Gregg. New York, 1959.

Gabrielli 1974
Gabrielli, Noemi, ed. *Arte nell'antico Marchesato di Saluzzo*. Turin, 1974.

Gaedechens 1850–76
Gaedechens, Otto Christian. *Hamburgische Münzen und Medaillen*. 3 vols. Hamburg, 1850–76.

Gaehtgens 1967
Gaehtgens, Thomas W. *Zum frühen und reifen Werk des Germain Pilon: Stilkritische Studien zur französischen Skulptur um die Mitte des 16. Jahrhunderts*. Bonn, 1967.

F. M. E. Gaetani 1754
Gaetani, Francesco Maria Emanuele. *Della Sicilia nobile*. Vol. 1. Palermo, 1754.

P. A. Gaetani 1761–63
Gaetani, Pietro Antonio. *Museum Mazzuchellianum, seu numismata virorum doctrina praestantium*. 2 vols. Venice, 1761–63.

Gaettens 1951–58
Gaettens, Richard. "Der Konterfetter Hans Schwarz auf dem Reichstag zu Worms 1521." *Der Wormsgau* 3 (1951–58): 8–17.

Gaettens 1954–56
Gaettens, Richard. "Die Dürer-Medaillen." *Blätter für Münzfreunde und Münzforschung* 781–83 (1954–56): 557–64.

Gaettens 1956
Gaettens, Richard. "Das Bildnis des Pfalzgrafen und Kurfürsten im Spiegel der Medaille und Grossplastik." In *Ottheinrich: Gedenkschrift zur vierhundertjährigen Wiederkehr seiner Kurfürstenzeit in der Pfalz (1556–1559)*, edited by Georg Poensgen, pp. 62–85. Heidelberg, 1956.

Gaettens 1958
Gaettens, Richard. *Zur Ikonographie Albrecht Dürers*. Heidelberg, 1958.

Gaettens sale 1966
Kunstmedaillen und Plaketten, 1400–1837: Sammlung Dr. Richard Gaettens. Sale cat, no. 21. Münzhandlung Richard Gaettens Jr., Heidelberg, April 1, 1966.

Gaillard 1852
Gaillard, Joseph. *Description des monnaies espagnoles et des monnaies étrangères qui ont eu course en Espagne*. Madrid, 1852.

Gale 1964
Gale, Robert L. *Thomas Crawford: American Sculptor*. Pittsburgh, 1964.

Galeotti 1930
Galeotti, Arrigo. *Le monete del Granducato di Toscana*. Livorno, 1930.

Galster 1936
Galster, Georg. *Danske og norske Medailler og Jetons, ca. 1533–ca. 1788*. Copenhagen, 1936.

Gans 1969
Gans, Edward. *Goethe's Italian Medals*. San Diego, 1969.

García Carraffa (Alberto) and García Carraffa (Arturo) 1920
García Carraffa, Alberto, and Arturo García Carraffa. *Enciclopedia heraldica y genealogica hispano-americana*. Madrid, 1920.

García de la Fuente 1927
García de la Fuente, Arturo. *La Numismática Española en el reinado de Felipe II. Discurso, etc*. Real Monasterio de El Escorial, 1927.

García y López 1905
García y López, Juan Catalina. "Inventario de las medallas españolas que posee la Real Academia de la Historia." *Boletín de la Real Academia de la Historia* 47 (1905): 152–229.

Garfagnini 1983
Garfagnini, Gian Carlo, ed. *Firenze e la Toscana dei Medici nell'Europa del 500*. 3 vols. Proceedings of a conference held in Florence, June 9–14, 1980. Florence, 1983.

***Garrett Collection* 1985**
The Garrett Collection. Pt. 3, *Ancient, Medieval, and Modern Coins, Commemorative Medals, Orders, and Decorations*. By order of Johns Hopkins University. Sale cat. Numismatic Fine Arts, Beverly Hills, Calif., and Bank Leu, Zurich. Unreserved mail bid auction, closing date, March 29, 1985.

Gasparotto 2000
Gasparotto, Davide. "Le medaglie di Valerio Belli nella descrizione di Pirro Ligorio." In Burns, Collareta, and Gasparotto 2000, pp. 456–62.

Gatterer 1767
Gatterer, Johann Christoph. "Beyträge zu einer Theorie der Medaillen." In *Allgemeine historische Bibliothek von Mitgliedern des Königlichen Instituts der Historischen Wissenschaften zu Göttingen*, vol. 1, pp. 97–158. Halle an der Saale, 1767.

Gaye 1839–40
Gaye, Giovanni. *Carteggio inedito d'artisti dei secoli XIV, XV, XVI*. 3 vols. Florence, 1839–40.

Gebhart 1932
Gebhart, Hans. *Der Münchner Medailleur Josef Bernhart*. Halle an der Saale, 1932.

Génard 1865
Génard, Pieter. "Inventaire des biens saisis dans la maison du bourgmestre Antoine van Stralen, 1567." *Antwerpsch archievenblad* 2 (1865): 256–70.

Génard 1871
Génard, Pieter. "Actes concernant le bourgmestre Antoine van Stralen." *Antwerpsch archievenblad* 7 (1871): 1–321.

Gerlo 1944
Gerlo, Aloïs. "Erasmus en Quenten Metsijs." *Revue belge d'archéologie et d'histoire de l'art* 14 (1944): 33–45.

Gerlo 1950
Gerlo, Aloïs. *Erasme et ses portraitistes: Metsijs, Dürer, Holbein*. Brussels, 1950.

Gersdorf 1872
Gersdorf, Ernst Gotthelf. "Zur Medaillenkunde: Der Meister H. R., 1535–1547." *Blätter für Münzfreunde* 8 (1872): cols. 221–23.

Gessert 1921–22
Gessert, Oskar. "Augustin Adelmann und andere Heidelberger Meister." *Archiv für Medaillen- und Plaketten-Kunde* 3 (1921–22): 53–62.

Gibert 1882
Gibert, Honoré. *Le Musée d'Aix (Bouches-du-Rhône), Première partie*. Aix, 1882.

Gierach 1926
Gierach, Erich. "Stefan Schlick." *Sudetendeutsche Lebensbilder* 1 (1926): 80–86.

Gilbert 1980
Gilbert, Creighton. *Italian Art, 1400–1500: Sources and Documents*. Englewood Cliffs, N.J., 1980.

Gill 1959
Gill, Joseph. *The Council of Florence*. Cambridge, 1959.

Gimeno 1987
Gimeno, Javier. "Thèmes américains de la médaille espagnole." *Médailles* (1987): 35–40.

Gimeno Rúa 1976
Gimeno Rúa, Fernando. "Los artistas italianos y los comienzos de la medalla en España." In *L'influenza della medaglia italiana nell'Europa dei sec. XVᵒ e XVIᵒ: Atti del IIᵒ* Convegno *Internazionale di Studio, Udine, 6/9 ottobre 1973*, pp. 59–86. Udine, 1976.

***Giorgio Vasari* 1981**
Giorgio Vasari: Principi, letterati e artisti nelle carte di Giorgio Vasari; pittura vasariana dal 1532 al 1554. La Toscana nel '500. Exh. cat. Casa Vasari and Sottochiesa di S. Francesco, Arezzo. Florence, 1981.

Giovannoni and Giovetti 1992
Giovannoni, Giannino, and Paola Giovetti. *Medaglisti nell'età di Mantegna e il Trionfo di Cesare*. Exh. cat. Casa del Mantegna. Mantua, 1992.

Giovio 1561
Giovio, Paolo. *Lettere volgari raccolte per messer Lodovico Domenichi*. Venice, 1561.

***Glaube & Macht* 2004**
Glaube & Macht: Sachsen im Europa der Reformationszeit. Vol. 1, *Katalog*. Edited by Harald Marx and Eckhard Kluth. Exh. cat. Schloss Hartenfels, Torgau. Dresden, 2004.

Glinsman 1997
Glinsman, Lisha Deming. "Renaissance portrait medals by Matteo de'Pasti: a study of their casting materials." In *Conservation Research 1996/1997*, pp. 93–107. Studies in the History of Art, vol. 57. Center for Advanced Study in the Visual Arts, National Gallery of Art, Monograph Series 2. Washington, D.C., 1997.

Glockner 1963–64
Glockner, M. "Lorenz Stauber (1486–1539): Nürnberger Kaufmann, Ritter und Agent König Heinrichs VIII. von England." In *Mitteilungen des Vereins für Geschichte der Stadt Nürnberg* Bd. 52. 1963–64.

F. Gnecchi and E. Gnecchi 1884
Gnecchi, Francesco, and Ercole Gnecchi. *Le monete di Milano da Carlo Magno a Vittorio Emanuele II*. Milan, 1884.

Goffen 1989
Goffen, Rona. *Giovanni Bellini*. London, 1989.

Goldenberg 1967
Goldenberg, Yvonne. *La médaille en France, de Ponscarme à la fin de la Belle Epoque*. Exh. cat. Hôtel de la Monnaie. Paris, 1967.

Goldschneider 1952
Goldschneider, Ludwig. *Unknown Renaissance Portraits: Medals of Famous Men and Women of the XV and XVI Centuries*. New York, 1952.

Gomes Ferreira and Pereira Coutinho 1979
Gomes Ferreira, Maria Teresa, and Maria Isabel Pereira Coutinho. *Medalhas do Renascimento: Catalogue of the Colecçao Calouste Gulbenkian*. Lisbon, 1979.

Gonzaga 1875–82
Gonzaga, Berardo Candida, conte. *Memorie delle famiglie nobili delle province meridionali d'Italia*. 6 vols. Naples, 1875–82.

***Gonzaga* 1996–2002**
Monete e medaglie di Mantova e dei Gonzaga dal XII al XIX secolo: la collezione della Banca Agricola Mantovana. 7 vols. Milan, 1996–2002.

González-Palacios 1981
González-Palacios, Alvar. *Objects for a "Wunderkammer."* Exh. cat. P. D. Colnaghi & Co. London, 1981.

Gorini 1973
Gorini, Giovanni. "Appunti su Giovanni da Cavino." In *La medaglia d'arte: Atti del Primo Convegno Internazionale di Studio, Udine, 10–12 ottobre 1970*, pp. 110–30. Udine, 1973.

Gorini 1987
Gorini, Giovanni. "New Studies on Giovanni da Cavino." In *Italian Medals*, edited by J. Graham Pollard, pp. 45–54. Studies in the History of Art, vol. 21. Center for Advanced Study in the Visual Arts, National Gallery of Art, Symposium Papers 8. Washington, D.C., 1987.

Gosman, MacDonald, and Vanderjagt 2005
Gosman, Martin, Alasdair MacDonald, and Arjo Vanderjagt, eds. *Princes and Princely Culture, 1450–1650*. Vol. 2. Leiden, 2005.

Gotti 1875
Gotti, Aurelio. *Vita di Michelangelo Buonarroti: Narrata con l'aiuto di nuovi documenti*. 2 vols. Florence, 1875.

Gray 1932
Gray, Basil. "Two Portraits of Mehmet II." *Burlington Magazine* 61 (July 1932): 4–6.

Grayson 1972
Grayson, Cecil. "Appendix: Alberti's Work in Painting and Sculpture." In Leon Battista Alberti, *On Painting and On Sculpture: The Latin Texts of* De Pictura *and* De Statua, edited and translated by Cecil Grayson, pp. 143–54. London, 1972.

Greene 1883
Greene, T. Whitcombe. "The Medallion of Philibert the Fair of Savoy and Margaret of Austria." *Numismatic Chronicle*, 3rd ser., 3 (1883): 288–96.

Greene 1885
Greene, T. Whitcombe. "Medals of the Hanna Family." *Numismatic Chronicle*, 3rd ser., 5 (1885): 148–52.

Greene 1913
Greene, T. Whitcombe. "Notes on Some Italian Medals." *Numismatic Chronicle*, 4th ser., 13 (1913): 413–21.

Greene sale 1898
Sammlung des Herrn T. Whitcombe Greene B.C.L., Winchester: Kunstmedaillen hauptsächlich aus der Periode der deutschen Renaissance; Modelle in Holz, Wachs und Kelheimer Stein. Sale cat. Adolf Hess Nachfolger, Frankfurt am Main, February 14, 1898.

Greenthal 1985
Greenthal, Kathryn. *Augustus Saint-Gaudens: Master Sculptor*. Exh. cat. Metropolitan Museum of Art, 1985–86. New York, 1985.

Grendler 1989
Grendler, Paul F. *Schooling in Renaissance Italy: Literacy and Learning, 1300–1600*. Baltimore, 1989.

Gretzschel and Mai 1993
Gretzschel, Mathias, and Hartmut Mai. *Kirchen in Leipzig*. Beucha, 1993.

Grierson 1959
Grierson, Philip. "Ercole d'Este and Leonardo da Vinci's Equestrian Statue of Francesco Sforza." *Italian Studies* 14 (1959): 40–48.

Griffet 1770
Griffet, Henri. *Histoire des hosties miraculeuses, qu'on nomme le très-saint Sacrement de Miracle*. Brussels, 1770.

Griffiths 1989
Griffiths, Antony. "Advertisements for Medals in the London Gazette." *Medal* 15 (Autumn 1989): 4–6.

Griffiths 1990a
Griffiths, Antony. "The Origins of Napoleon's Histoire Métallique." Pt. 1. *Medal* 16 (Spring 1990): 16–30.

Griffiths 1990b
Griffiths, Antony. "The Origins of Napoleon's Histoire Métallique." Pt. 2. *Medal* 17 (Autumn 1990): 28–38.

Grimm 1957
Grimm, Heinrich. "Cochlaeus, Johannes." In *Neue deutsche Biographie* 1953–, vol. 3 (1957), pp. 304–6.

Grodecki 1981
Grodecki, Catherine. "Les marchés de Germain Pilon pour la chapelle funéraire et les tombeaux des Birague en l'église Sainte-Catherine du Val des Ecoliers." *Revue de l'art* 54 (1981): 61–78.

Groen van Prinsterer 1839
Groen van Prinsterer, Guillaume. *Archives ou correspondance inédite de la Maison d'Orange-Nassau: 1e série, 6, 1577–1579*. Leiden, 1839.

Gröning 1705
Gröning, Johann. *Historia numismatico-critica: Das ist Neueröfnete Historie der Modern Medaillen. Worin Besonders von dero Würde und vielfältigen Nutzen, wie auch von denen Medailleurs gehandelt wird*. Hamburg, 1705.

Grössing 1968
Grössing, Helmut. "Johannes Stabius: Ein Oberösterreicher im Kreis der Humanisten um Kaiser Maximilian I." *Mitteilungen des Oberösterreichischen Landesarchivs* 9 (1968): 239–64.

Grotemeyer 1937
Grotemeyer, Paul. "Führer durch die Staatliche Münzsammlung in München." Pt. 2. *Mitteilungen der Bayerischen Numismatischen Gesellschaft* 55 (1937): 1–40.

Grotemeyer 1953
Grotemeyer, Paul. "Gussformen deutscher Medaillen des 16. Jahrhunderts." *Neue Beiträge zur süddeutschen Münzgeschichte* (1953): 103–16.

Grotemeyer 1957
Grotemeyer, Paul. *Da ich het die Gestalt: Deutsche Bildnismedaillen des 16. Jahrhunderts*. Munich, 1957.

Grotemeyer 1958
Grotemeyer, Paul. "Eine Medaille des Andrea Doria von Christoph Weiditz." In *Centennial Publication of the American Numismatic Society*, pp. 317–27. New York, 1958.

Grotemeyer 1970
Grotemeyer, Paul. "Die Statthaltermedaillen des Kurfürsten Friedrich des Weisen von Sachsen." *Münchner Jahrbuch der bildenden Kunst*, 3rd ser., 21 (1970): 143–66.

Grotemeyer 1971
Grotemeyer, Paul. *Franz Andreas Schega, 1711–1787: Münzstempelschneider und Medailleur an der kurfürstlichen Münze zu München*. Munich, 1971.

Grove 1976
Grove, Frank W. *Medals of Mexico. Vol. 1: Medals of the Spanish Kinds*. Ontario, Calif., 1976.

Grün 2012
Münz-Auktion. Sale cat., no. 60. Heidelberger Münzhandlung Herbert Grün, Heidelberg, November 12–14, 2012. [Sale held at the hotel Europäischer Hof, Heidelberg.]

Gruyer 1897
Gruyer, Gustave. *L'art ferrarais à l'époque des princes d'Este*. 2 vols. Paris, 1897.

Gualandi 1842
Gualandi, Michelangelo. "Medaglia e ricordi dell'antico reggimento in lode di Laura Bassi, ed incisione." *Almanacco statistico bolognese dedicato alle donne gentili* 13 (1842): 65–77.

Guenée and Lehoux 1968
Guenée, Bernard, and Françoise Lehoux. *Les entrées royales françaises de 1328 à 1515*. Vol. 5, *Sources d'histoire médiévale*. Paris, 1968.

Guiffrey 1876
Guiffrey, J. J. "Guillaume Dupré: Sculpteur et médalliste." *Nouvelles archives de l'art française* (1876): 172–224.

Guiffrey 1894–96
Guiffrey, J. J. *Inventaires de Jean, duc de Berry (1401–1416)*. 2 vols. Paris, 1894–96.

Gundersheimer 1973
Gundersheimer, Werner L. *Ferrara: The Style of a Renaissance Despotism*. Princeton, N.J., 1973.

Gurlitt 1897
Gurlitt, Cornelius. *Die Kunst unter Friedrich dem Weisen*. Dresden, 1897.

Guthrie 2009
Guthrie, Neil. "Of Princes and Perukes: Jacobite Medals from 1731 to 1741." *Medal* 55 (2009): 24–34.

Haag 2017–18
Haag, Sabine. *Zuhanden Ihrer Majestät: Medaillen Maria Theresias*. Exh. cat. Kunsthistorisches Museum. Vienna, 2017–18.

Habich 1903
Habich, Georg. "Beiträge zu Hans Daucher." *Monatsberichte über Kunst und Kunstwissenschaft* 3 (1903): 53–76.

Habich 1906
Habich, Georg. "Studien zur deutschen Renaissancemedaille. II: Hans Schwarz." *Jahrbuch der Königlich Preussischen Kunstsammlungen* 27 (1906): 30–69.

Habich 1907
Habich, Georg. "Studien zur deutschen Renaissancemedaille. III: Friedrich Hagenauer." *Jahrbuch der Königlich Preussischen Kunstsammlungen* 28 (1907): 181–98, 230–72.

Habich 1911
Habich, Georg. "Hans Schwarz in Frankreich." *Mitteilungen der Bayerischen Numismatischen Gesellschaft* 29 (1911): 52–57.

Habich 1913
Habich, Georg. "Studien zur deutschen Renaissancemedaille. IV: Christoph Weiditz." *Jahrbuch der Königlich Preussischen Kunstsammlungen* 34 (1913): 1–35.

Habich 1914–15
Habich, Georg. "Über zwei Bildnisse des Kurfürsten Otto Heinrich von der Pfalz." *Münchner Jahrbuch der bildenden Kunst*, n.s., 9 (1914–15): 67–86, 212–23.

Habich 1916
Habich, Georg. *Die deutschen Medailleure des XVI. Jahrhunderts*. Halle an der Saale, 1916.

Habich 1920–21
Habich, Georg. "Dietrich Schro, der Monogrammist D S." *Archiv für Medaillen- und Plaketten-Kunde* 2 (1920–21): 29–33.

Habich 1922
Habich, Georg. *Die Medaillen der italienischen Renaissance*. Stuttgart, 1922.

Habich 1923–24
Habich, Georg. "Die Erasmus-Medaille." *Archiv für Medaillen- und Plaketten-Kunde* 4 (1923–24): 119–22.

Habich 1925–26
Habich, Georg. "Peter Flötner oder Hieronymus Magdeburger." *Archiv für Medaillen- und Plaketten-Kunde* 5 (1925–26): 26–45.

Habich 1927
Habich, Georg. "Jan de Vos oder Paulus von Vianen." *Das schwäbische Museum* (1927): 124–35.

Habich 1929–34
Habich, Georg. *Die deutschen Schaumünzen des XVI. Jahrhunderts*. 3 vols. in 5. Munich, 1929–34.

Hall 1979
Hall, James. *Dictionary of Subjects and Symbols in Art*. Rev. ed. London, 1979. [First ed., 1974.]

Hall sale 2010
The Michael Hall Collection: Medallic Portraits from the Renaissance to the Nineteenth Century. Pt. 3. Sale cat, no. 67. Baldwin's Auctions, London, *Official Coinex Auction,* September 28, 2010.

Haller 1780
Haller, Gottlieb Emanuel von. *Schweizerisches Münz- und Medaillenkabinet*. Bern, 1780.

Halm 1920
Halm, Philipp Maria. "Studien zur Augsburger Bildnerei der Frührenaissance. II: Hans Daucher." *Jahrbuch der Preussischen Kunstsammlungen* 41 (1920): 283–343.

J. Hamburger 1908
Hamburger, Joseph. *Münzen- und Medaillen-Sammlung des Herrn Dr. Antoine-Feill, Hamburg*. Pt. 2, *Deutschland und Oesterreich*. Hamburg, 1908.

L. Hamburger 1924
Kunstmedaillen. Sale cat. Leo Hamburger, Frankfurt am Main, November 4, 1924.

Hamilton 1991
Hamilton, Duke of. *Maria R., Mary Queen of Scots: The Crucial Years*. Edinburgh, 1991.

Hampe 1902
Hampe, Theodor. *Matthes Gebel*. Nuremberg, 1902.

Hampe 1904
Hampe, Theodor. *Nürnberger Ratsverlässe über Kunst und Künstler im Zeitalter der Spätgotik und Renaissance (1449) 1474–1618 (1633)*. Vienna and Leipzig, 1904.

Hampe 1918–19
Hampe, Theodor. "Allgäuer Studien zur Kunst und Kultur der Renaissance." In "Festschrift für Gustav von Bezold … zu seinem 70. Geburtstage (17. Juli 1918)." *Mitteilungen aus dem Germanischen Nationalmuseum Nürnberg,* 1918–19, pp. 3–105.

Hargreaves-Mawdsley 1963
Hargreaves-Mawdsley, W. N. *A History of Academical Dress in Europe until the End of the Eighteenth Century*. Oxford, 1963.

Hartop 2005
Hartop, Christopher. *Royal Goldsmiths: The Art of Rundell & Bridge, 1797–1843*. Exh. cat. Koopman Rare Art, London. Cambridge, 2005.

Haskell and Penny 1981
Haskell, Francis, and Nicholas Penny. *Taste and the Antique: The Lure of Classical Sculpture, 1500–1900*. New Haven, Conn., 1981.

Hasselmann 2000
Hasselmann, Wolfgang, with Johanna Schwegerle and Philomena Schwegerle. *Hans Schwegerle: Medaillen und Plaketten*. Vol. 1. Regenstauf, 2000.

Hauck & Aufhäuser 2000
Versteigerung von Münzen und Medaillen: Antike, Mittelalter, Neuzeit. Sale cat., no. 15. Hauck & Aufhäuser Privatbankiers Numismatik, Munich, March 21–22, 2000.

Hauschild 1805
Hauschild, Johann Friedrich. *Beytrag zur neyern Münz- und Medaillen-Geschichte vom XVten Jahrhundert bis jetzt, nebst einem raisonnirenden Verzeichniss einer beträchtlichen Sammlung von Medaillen in allen Classen und von allem Metall*. Dresden, 1805.

Hauser 2006
Hauser, Peter. *Katalog meiner Sammlung von Medaillen, Plaketten und Jetons aus der Regierungszeit der Kaiser Ferdinand I. und Franz Josef I.* 2 vols. Horn, 2006.

Hawkins 1885
Hawkins, Edward. *Medallic Illustrations of the History of Great Britain and Ireland*. Edited by Augustus W. Franks and Herbert A. Grueber. 2 vols. London, 1885. [Reprint, London, 1978.]

Head 1977
Head, Constance. *Imperial Twilight: The Paliologos Dynasty and the Decline of Byzantium*. Chicago, 1977.

Hegener 2008
Hegener, Nicole. *Divi Iacobi Eques: Selbstdarstellung im Werk des Florentiner Bildhauers Baccio Bandinelli*. Munich, 2008.

Van der Heijden 1948
Van der Heijden, M. J. M. "Het godsdienstig element in de iconographie van de Nederlandsche historiepenningen uit den Tachtigjarigen Oorlog." *Jaarboek voor Munt- en Penningkunde* 35 (1948): 1–15.

Heiss 1881–92
Heiss, Aloïss. *Les médailleurs de la Renaissance*. 9 vols. Paris, 1881–92.

Heiss 1890
Heiss, Aloïss. "Jean de Candida: Médailleur et diplomate sous Louis XI, Charles VIII et Louis XII." *Revue numismatique*, 3rd ser., 8 (1890): 453–79.

Helas 2007
Helas, Philine. "Michelangelo pellegrino: Zur Bildnismedaille von Leone Leoni für Michelangelo Buonarroti." In *Curiosa Poliphili: Festgabe für Horst Bredekamp zum 60. Geburtstag,* edited by Nicole Hegener, Claudia Lichte, and Bettina Marten, pp. 70–77. Leipzig, 2007.

Heller 1997
Heller, Karl. *Antonio Vivaldi: The Red Priest of Venice*. Translated by David Marinelli. Portland, Ore., 1997.

K. Helmschrott and R. Helmschrott 1977
Helmschrott, Klaus, and Rosemarie Helmschrott. *Würzburger Münzen und Medaillen von 1500–1800*. Kleinrinderfeld, 1977.

Henkel and Schöne 1978
Henkel, Arthur, and Albrecht Schöne. *Emblemata: Handbuch zur Sinnbildkunst des XVI. und XVII. Jahrhunderts*. Stuttgart, 1978.

Hennin 1826
Hennin, Michel. *Histoire numismatique de la Révolution Française; ou, Description raisonnée des médailles, monnaies, et autres monumens numismatiques relatifs aux affaires de la France*. Paris, 1826. [Reprint, 2 vols. Maastricht, 1970.]

Heraeus 1780
Heraeus, Carl Gustav. *Bildnisse der regierenden Fürsten und berühmter Männer, &c.* Vienna, 1780.

Heraeus 1828
Heraeus, Carl Gustav. *Bildnisse der regierenden Fürsten und berühmter Männer...* Vienna, 1828.

Herald 1981
Herald, Jacqueline. *Renaissance Dress in Italy, 1400–1500*. London, 1981.

Hermann 1909–10
Hermann, Hermann Julius. "Pier Jacopo Alari-Bonacolsi, genannt Antico." *Jahrbuch der kunsthistorischen Sammlungen des Allerhöchsten Kaiserhauses* 28 (1909–10): 201–30.

Herrera 1882
Herrera, Adolfo. *Medallas de proclamaciones y juras e los reyes de España*. Madrid, 1882.

Herrera 1905
Herrera, Adolfo. "Rutilio Gaci." *Boletín de la Sociedad Española de Excursiones* 13, no. 146 (1905): 57–70.

Herrgott 1752–53
Herrgott, Marquard. *Nummotheca principum Austriae*. 2 vols. Freiburg im Breisgau, 1752–53.

Hersey 1969
Hersey, George L. *Alfonso II and the Artistic Renewal of Naples, 1485–1495*. New Haven, Conn., 1969.

Hess 1929
Hess, Adolph Nachfolger. *Münzen von Bayern, Goldmünzen u. Medaillen: Universalsammlung*. Dealer's cat. Frankfurt am Main, October 29, 1929, and following days.

Hildebrand 1860
Hildebrand, Bror Emil. *Minnespenningar öfver enskilda svenska män och qvinnor*. Stockholm, 1860.

Hildebrand 1874
Hildebrand, Bror Emil. *Sveriges och svenska konungahusets minnespenningar praktmynt och belöningsmedaljer*. Vol. 1. Stockholm, 1874.

Hill 1905
Hill, George Francis. *Pisanello*. London, 1905.

Hill 1906
Hill, George Francis. "Some Medals by Pastorino da Siena." *Burlington Magazine* 9 (September 1906): 408–12.

Hill 1907
Hill, George Francis. "Some Italian Medals in the British Museum." *Burlington Magazine* 10 (March 1907): 384–87.

Hill 1908a
Hill, George Francis. "The Medallist Lysippus." *Burlington Magazine* 13 (August 1908): 274–86.

Hill 1908b
Hill, George Francis. "Stephen H.: Medallist and Painter." *Burlington Magazine* 12 (March 1908): 355–63.

Hill 1909a
Hill, George Francis. "Notes on Italian Medals. VI: Three Wax Models." *Burlington Magazine* 15 (April 1909): 31–35.

Hill 1909b
Hill, George Francis. "Notes on Italian Medals. VIII: Three Pen-Studies by Sperandio of Mantua." *Burlington Magazine* 16 (October 1909): 24–25.

Hill 1910a
Hill, George Francis. "Note on the Mediaeval Medals of Constantine and Heraclius." *Numismatic Chronicle*, 4th ser., 10 (1910): 110–16.

Hill 1910b
Hill, George Francis. "Notes on Italian Medals. X." *Burlington Magazine* 18 (October 1910): 13–21.

Hill 1911
Hill, George Francis. "Classical Influence on the Renaissance Medal." *Burlington Magazine* 18 (February 1911): 259–68.

Hill 1912a
Hill, George Francis. "Notes on Italian Medals. XIII: Some Florentine Medals." *Burlington Magazine* 22 (December 1912): 131–38.

Hill 1912b
Hill, George Francis. *Portrait Medals of Italian Artists of the Renaissance*. London, 1912.

Hill 1913a

Hill, George Francis. "Medals." In *Catalogue of a Collection of Italian Sculpture and Other Plastic Art of the Renaissance*, pp. 87–117. Exh. cat. Burlington Fine Arts Club. London, 1913.

Hill 1913b

Hill, George Francis. "Notes on Italian Medals. XIV." *Burlington Magazine* 23 (April 1913): 17–22.

Hill 1914

Hill, George Francis. "Notes on Italian Medals. XVI." *Burlington Magazine* 24 (January 1914): 211–17.

Hill 1915

Hill, George Francis. *Select Italian Medals of the Renaissance in the British Museum*. London, 1915.

Hill 1916

Hill, George Francis. "Notes on Italian Medals. XXI." *Burlington Magazine* 29 (May 1916): 56–59.

Hill 1917

Hill, George Francis. "Notes on Italian Medals. XXV: On the Technique of the Renaissance Medal." *Burlington Magazine* 31 (November 1917): 178–83.

Hill 1918

Hill, George Francis. "Recent Acquisitions for Public Collections. IV: Steven H.—The British Museum." *Burlington Magazine* 33 (August 1918): 54–59.

Hill 1920a

Hill, George Francis. *The Medallic Portraits of Christ*. Oxford, 1920.

Hill 1920b

Hill, George Francis. *Medals of the Renaissance*. Oxford, 1920.

Hill 1920–21

Hill, George Francis. "Not in Armand." *Archiv für Medaillen- und Plaketten-Kunde* 2 (1920–21): 10–28, 45–53.

Hill 1921

Hill, George Francis. Review of Bernhart 1919. *Numismatic Chronicle*, 5th ser., 1 (1921): 159–60.

Hill 1922

Hill, George Francis. *A Guide to the Department of Coins and Medals in the British Museum*. London, 1922.

Hill 1923a

Hill, George Francis. "L'école des médailleurs de Mantoue à la fin du XVe siècle." *Aréthuse* 1, no. 1 (October 1923): 12–21.

Hill 1923b

Hill, George Francis. *A Guide to the Exhibition of Medals of the Renaissance in the British Museum*. London, 1923.

Hill 1923c

Hill, George Francis. "Notes on Italian Medals. XXVII." *Burlington Magazine* 42 (January 1923): 38–47.

Hill 1926

Hill, George Francis. "Medals of Turkish Sultans." *Numismatic Chronicle*, 5th ser., 6 (1926): 287–98.

Hill 1927

Hill, George Francis. "Gold Medal of Queen Mary Tudor." *British Museum Quarterly* 2 (1927): 37–38.

Hill 1928

Hill, George Francis. "Some Italian Medals of the Renaissance." In *Georg Habich zum 60. Geburtstag,* pp. 11–12. Munich, 1928.

Hill 1929

Hill, George Francis. "Andrea and Gianettino Doria." *Pantheon* 4 (1929): 500–501.

Hill 1930

Hill, George Francis. *A Corpus of Italian Medals of the Renaissance before Cellini*. 2 vols. London, 1930.

Hill 1931a

Hill, George Francis. *The Gustave Dreyfus Collection of Renaissance Medals*. Oxford, 1931.

Hill 1931b

Hill, George Francis. "A Lost Medal by Pisanello." *Pantheon* 8 (1931): 487–88.

Hill and Bell 1913

Hill, George Francis, and C. F. Bell. "Medals, Plaquettes, Wax Models, Gems etc." In *Catalogue of a Collection of Italian Sculpture and Other Plastic Art of the Renaissance*, pp. 87–141. Exh. cat. Burlington Fine Arts Club. London, 1913.

Hill and Brooke 1924

Hill, George Francis, and G. C. Brooke. *A Guide to the Exhibition of Historical Medals in the British Museum*. London, 1924.

Hill and Pollard 1967

Hill, George Francis. *Renaissance Medals from the Samuel H. Kress Collection at the National Gallery of Art*. Revised and enlarged by Graham Pollard. London, 1967.

Hill and Pollard 1978

Hill, George Francis. *Medals of the Renaissance*. Revised and enlarged by Graham Pollard. London, 1978.

Hillerbrand 1996

Hillerbrand, Hans J., ed. *The Oxford Encyclopedia of the Reformation*. 4 vols. New York, 1996.

Hinterstoisser sale 1926
Sammlung des †Regierungsrats Dr. Josef Hinterstoisser, Salzburg: Münzen u. Medaillen… Sale cat. Otto Helbing Nachfolger, Munich, October 12, 1926.

G. Hirsch 1969
Münzen- u. Medaillen-Auktion. Sale cat., no. 63. Gerhard Hirsch, Munich, July 1–4, 1969.

G. Hirsch 2013
Münzen- u. Medaillen-Auktion. Sale cat., no. 288. Gerhard Hirsch, Munich, February 8–9, 2013.

J. Hirsch 1910
Sammlung Commerzienrat H. G. Gutekunst, Stuttgart: Kunstmedaillen und Plaketten des XV. bis XVIII. Jahrhunderts. Sale cat. Jacob Hirsch, Munich, November 7–8, 1910.

M. Hirsch 2012
Hirsch, Martin. "Heuberger, Leupold." In Saur 1992–, vol. 72 (2012), pp. 531–32.

M. Hirsch 2013a
Hirsch, Martin. "Anlässe und Funktionen." In Cupperi et al. 2013, pp. 129–31.

M. Hirsch 2013b
Hirsch, Martin. "Weite Perspektiven: Die Beziehung von Medaille und Kleinplastik." In Cupperi et al. 2013, pp. 47–57.

His Majesties Declaration 1672
His Majesties Declaration against the States General of the United Provinces of the Low Countries. [London] 1672.

Hobson 1975
Hobson, Anthony. *Apollo and Pegasus: An Enquiry into the Formation and Dispersal of a Renaissance Library.* Amsterdam, 1975.

Hoerschelmann 1991
Hoerschelmann, Suzanne von. "Basilius Amerbach als Sammler und Kenner von antiken Münzen." In Elisabeth Landolt et al., *Das Amerbach-Kabinett: Beiträge zu Basilius Amerbach*, pp. 29–50. Exh. cat. Kunstmuseum. Basel, 1991.

Hollstein 1954–2014
Hollstein, F. W. H. *German Engravings, Etchings, and Woodcuts, ca. 1400–1700.* 82 vols. Amsterdam, Rotterdam, Blaricum, and Ouderkerk aan den IJssel, 1954–2014.

Holzmair 1937
Holzmair, Eduard. *Katalog der Sammlung Dr. Josef Brettauer: Medicina in nummis.* Vienna, 1937.

Hommel 1951
Hommel, Luc. *Marie de Bourgogne; ou, Le grand héritage.* 4th ed. Brussels, 1951.

Hook 1984
Hook, Judith. *Lorenzo de' Medici.* London, 1984.

Horsky sale 1910
Sammlung Horsky: Münzen und Medaillen der österreichisch-ungarischen Monarchie. Sale cat. Adolph Hess Nachfolger, Frankfurt am Main, November 7, 1910, and following days.

Huffschmid 1916
Huffschmid, Maximilian. "Aufzeichnungen des Benjamin v. Münchingen." *Mannheimer Geschichtsblätter* 17 (1916): cols. 77–87.

Humphris 1993
Cyril Humphris. *Pisanello to Soldani: Commemorative Medallions, 1446–1710.* Dealer's cat. London, 1993.

Huszár and Procopius 1932
Huszár, Lajos, and Béla Procopius. *Medaillen- und Plakettenkunst in Ungarn.* Budapest, 1932.

Hutten-Czapski 1871–1916
Hutten-Czapski, Emeryk. *Catalogue de la collection des médailles et monnaies polonaises.* Graz, 1871–1916. [Reprint, Graz, 1957.]

Hyckert 1892
Hyckert, Bror Edvard. *Sveriges och svenska konungahusets minnespenningar, praktmynt och belöningsmedaljer efter 1874, jämte några från äldre tider.* Stockholm, 1892.

Ilg 1887
Ilg, Albert. "Die Werke Leone Leoni's in den Kaiserlichen Kunstsammlungen." *Jahrbuch der kunsthistorischen Sammlungen des Allerhochsten Kaiserhauses* 5 (1887): 65–88.

Imhof 1780–82
Imhof, Christoph Andreas. *Sammlung eines Nürnbergischen Münz-Cabinets…* Nuremberg, 1780–82.

"Inventaire des médailles" ca. 1685
"Inventaire des médailles des rois de France, pour le Cabinet du roi." ca. 1685. MS 59. Cabinet des Médailles, Bibliothèque Nationale de France, Paris.

"Inventario … Riccardi" 1752
"Inventario in morte di Francesco Riccardi." 1752. Riccardi 276.1 ins. B: 1-446. Archivio di Stato di Firenze.

Iongh 1965
Iongh, Jane de. *Madama: Margaretha van Oostenrijk, hertogin van Parma en Piacenza, 1522–1586. Regentessen der Nederlanden 3.* Amsterdam, 1965.

Italian Medals 1920
Select Italian Medals. Exh. cat. British Museum. London, 1920.

Italian Renaissance Sculpture 1985
Italian Renaissance Sculpture in the Time of Donatello. Exh. cat. Detroit Institute of Arts. Detroit, 1985.

Jacobi 1982
Jacobi, Hans. "De mechanisatie van het Zeeuwse muntbedrijf in 1671." *Archief: Mededelingen van het Koninklijk Zeeuwsch Genootschap der Wetenschappen* (1982): 150–76.

Jacobs 1927
Jacobs, Emil. "Die Mehemmed-Medaille von Bertoldo." *Jahrbuch der königlich preussischen Sammlungen* 48 (1927): 1–17.

Jacobus de Voragine 1941
Jacobus de Voragine. *The Golden Legend of Jacobus de Voragine.* Edited and translated by Granger Ryan and Helmut Ripperger. New York, 1941.

Jacquiot 1970
Jacquiot, Josèphe. *La médaille au temps de Louis XIV.* Exh. cat. Hôtel de la Monnaie. Paris, 1970.

Janson 1937
Janson, Horst W. "The Putto with the Death's Head." *Art Bulletin* 19, no. 3 (September 1937): 423–49.

Jintes and Pol-Tyskiewicz 1994
Jintes, L. F., and Jadwiga T. Pol-Tyskiewicz. *Chris van der Hoef, 1875–1933.* Exh. cat. Rijksmuseum Het Koninklijk Penningkabinet, Leiden; Drents Museum, Assen; and Museum voor Sierkunst, Ghent. Assen, 1994.

C. Johnson 1973
Johnson, Cesare. "Tre medaglie e tre donne 'colte' nell'Italia settecentesca." *Medaglia* 6 (1973): 29–39.

C. Johnson 1975
Johnson, Cesare. "Due medaglie barocche nella storia del teatro lirico del secolo XVIII." *Medaglia* 10 (1975): 120–25.

C. Johnson 1976
Johnson, Cesare. "Cosimo I de' Medici e la sua 'Storia metallica' nelle medaglie di Pietro Paolo Galeotti." *Medaglia* 12 (1976): 14–46.

C. Johnson 1981
Johnson, Cesare. "Avvenimenti e personaggi nella vita di Antonio Canova in medaglie." *Medaglia* 16 (1981): 22–55.

C. Johnson 1990
Johnson, Cesare. *Collezione Johnson di medaglie.* 3 vols. Milan, 1990.

C. Johnson and Martini 1986–95
Johnson, Cesare, and Rodolfo Martini. *Catalogo delle medaglie.* Milan, 1986–95.

V. Johnson 1974
Johnson, Velia. "La nascita della medaglia italiana." *Medaglia* 5 (1974): 7–25.

V. Johnson 1975a
Johnson, Velia. "La medaglia barocca in Toscana." *Medaglia* 10 (1975): 11–74.

V. Johnson 1975b
Johnson, Velia. "La medaglia italiana in Europa durante i secoli XV e XVI." *Medaglia* 8 (1975): 7–22.

V. Johnson 1979
Johnson, Velia. *Dieci anni di studi di medaglistica, 1968–78.* Milan, 1979.

Jones sale 2011
The Dr. Christian C. Jones Collection of Napoleonic Coins and Medals. Sale cat. Baldwin's of St. James's, London, October 3, 2011.

J. R. Jones 1965
Jones, J. R. "Cavino's Imitations of Roman Coins." *Numismatic Circular* (Spink & Son) 73, no. 11 (November 1965): 232–33.

M. Jones 1977
Jones, Mark. *Medals of the French Revolution.* London, 1977.

M. Jones 1979a
Jones, Mark. *The Art of the Medal.* London, 1979.

M. Jones 1979b
Jones, Mark. "The First Cast Medals and the Limbourgs: The Iconography and Attribution of the Constantine and Heraclius Medals." *Art History* 2, no. 1 (March 1979): 35–44.

M. Jones 1979c
Jones, Mark. *Medals of the Sun King.* London, 1979.

M. Jones 1982
Jones, Mark. "The Medal as an Instrument of Propaganda in Late 17th and Early 18th-Century Europe: Part 1." *Numismatic Chronicle* 142 (1982): 117–26.

M. Jones 1982–88
Jones, Mark. *A Catalogue of the French Medals in the British Museum.* 2 vols. London, 1982–88.

M. Jones 1986
Jones, Mark. "Guillaume Dupré." Special issue, *Medal* 9 (Autumn 1986): 23–47.

M. Jones 1987
Jones, Mark. "Medal-Making in France, 1400–1650: The Italian Dimension." In *Italian Medals*, edited by J. Graham Pollard, pp. 57–71. Studies in the History of Art, vol. 21. Center for Advanced Study in the Visual Arts, National Gallery of Art, Symposium Papers 8. Washington, D.C., 1987.

M. Jones 2015
Jones, Mark. "Un compte public de toutes leurs actions à tout l'univers et à tous les siècles." In *The King and His Public: Dilemmas around the Representation of Louis XIV in the Medallic History of His Reign. Revue numismatique*, 6th ser., 172 (2015): 161–76.

M. Jones 2016
Jones, Mark. "Museums and Their collections." In *Ancient Lives: Object, People and Place in Early Scotland. Essays for David V Clarke on His 70th Birthday*, edited by Fraser Hunter and Alison Sheridan. Leiden, 2016.

P. J. Jones 1974
Jones, Philip J. *The Malatesta of Rimini and the Papal State*. London, 1974.

T. L. Jones 2005
Jones, Tanja L. "Crusader Ideology and Chivalric Tradition: Pisanello's Portrait Medal of Cecilia Gonzaga." *Athanor* 23 (2005): 15–23.

T. L. Jones 2010
Jones, Tanja L. "The Constantine and Heraclius Medallions: Pendants between East and West." *Medal* 56 (Spring 2010): 5–13.

José 1956
José, Marie. *La maison de Savoie*. Vol. 1, *Les origines, le Comte Vert, le Comte Rouge*. Preface by Benedetto Croce. Paris, 1956.

Josephi 1910
Josephi, Walter. *Die Werke plastischer Kunst*. Kataloge des Germanischen Nationalmuseums. Nuremberg, 1910.

Jouin 1899
Jouin, Henry. "Jean-Baptiste Nini et le médaillon de Franklin." *Monthly Numismatic Circular* (Spink & Son) 8 (February 1899): col. 3203.

Jourda 1930
Jourda, Pierre. *Marguerite d'Angoulême, duchesse d'Alençon, reine de Navarre (1492–1549): Etude biographique et littéraire*. 2 vols. *Bibliothèque littéraire de la Renaissance*, n.s., 19. Paris, 1930.

Julius sale 1932
Sammlung Dr. P. Julius, Heidelberg: Französische Revolution, Napoleon I. und seine Zeit. Medaillen, Orden und Ehrenzeichen, Münzen. Sale cat., no. 66. Otto Helbing, Munich, January 11, 1932.

Julius sale 1958
Sammlung Julius: Krieg und Frieden in der Medaille und in der Gedenkmünze. Pt. 1. Sale cat. Münzhandlung Richard Gaettens Jr., Heidelberg, July 7–8, 1958.

Julius sale 1959
Sammlung Julius: Französische Revolution, Napoleon I. und seine Zeit. Medaillen, Orden und Ehrenzeichen, Münzen. Pt. 2. Sale cat. Münzhandlung Richard Gaettens Jr., Heidelberg, September 14–16, 1959.

Juncker 1706
Juncker, Christian. *Das goldene und silberne Ehrengedächtnis D. Martini Lutheri*. Frankfurt am Main, 1706.

Jungk 1875
Jungk, Hermann. *Die bremischen Münzen: Münzen und Medaillen des Erzbisthums und der Stadt Bremen mit deschichtlicher einleitung*. Bremen, 1875.

Jürgensmeier 1991
Jürgensmeier, Friedhelm, ed. *Erzbischof Albrecht von Brandenburg (1490–1545): Ein Kirchen- und Reichsfürst der frühen Neuzeit*. Beiträge zur Mainzer Kirchengeschichte, vol. 3. Frankfurt am Main, 1991.

Kagan 1999
Kagan, Jonathan. "The Origin of Contemporary Medallic History on Paper." In *La tradizione classica nella medaglia d'arte dal Rinascimento al Neoclassico: Atti del Convegno Internazionale, Castello di Udine, 23–24 ottobre 1997*, edited by Maurizio Buora, pp. 53–63. Trieste, 1999.

Kahane 1928
Kahane, S. B. *Die Münze im Dienste der Liebe und Ehe*. 3rd ed. Braunschweig, 1928.

***Kaiser Ferdinand I* 2003**
Kaiser Ferdinand I, 1503–1564: Das Werden der Habsburgermonarchie. Edited by Wilfried Seipel and Georg Johannes Kugler. Exh. cat. Kunsthistorisches Museum. Vienna, 2003.

Kamen 2000
Kamen, Henry. *Who's Who in Europe, 1450–1750*. London, 2000.

Karabacek 1918
Karabacek, J. von. *Abendländische Künstler zu Konstantinopel im XV. und XVI. Jahrhundert*. Vol. 1, *Italienische Künstler am Hofe Muhammeds II. des Eroberers, 1451–1481*. Vienna, 1918.

Kastenholz 2006
Kastenholz, Richard. *Hans Schwarz: Ein Augsburger Bildhauer und Medailleur der Renaissance*. Munich, 2006.

***Katalog … aus dem Nachlass Professor C. Fieweger* 1885**
Katalog satyrischer Medaillen und Münzen aus dem Nachlass Professor C. Fieweger. Berlin, 1885.

Katz 1926
Katz, Viktor. "Wolf Milicz, Nickel Milicz a Zachariáš Kempf." *Numismatický časopis československý* 2 (1926): 85–114.

Katz 1927–29
Katz, Viktor. "Der Monogrammist H+ (Michael Hohenauer oder Hieronymus Magdeburger?)." *Berliner Münzblätter* 9 (1927–29): 340–42, 357–59.

Katz 1932
Katz, Viktor. *Die erzgebirgische Prägemedaille des XVI. Jahrhunderts.* Prague, 1932.

Kauffmann 1970
Kauffmann, Georg. *Die Kunst des 16. Jahrhunderts.* With contributions by Josef Benzing et al. Berlin, 1970.

Keary 1881
Keary, C. F. *A Guide to the Italian Medals Exhibited in the King's Library.* London, 1881. [2nd ed., 1893.]

Kemmerich 1910
Kemmerich, Max. *Die deutschen Kaiser und Könige im Bild.* Leipzig, 1910.

Kenner 1891
Kenner, Friedrich. "Bildnismedaillen der Spätrenaissance." *Jahrbuch der kunsthistorischen Sammlungen des Allerhöchsten Kaiserhauses* 12 (1891): 84–164.

Kenner 1892
Kenner, Friedrich. "Leone Leoni's Medaillen für den Kaiserlichen Hof." *Jahrbuch der kunsthistorischen Sammlungen des Allerhöchsten Kaiserhauses* 13 (1892): 55–93.

Van Kerkwijk 1929
Van Kerkwijk, A. O. "Portretpenningen van Prins Willem van Oranje en Charlotte de Bourbon." *Jaarboek voor Munt- en Penningkunde* 16 (1929): 103–4.

Kirch 2017
Kirch, Miriam. "The Princess and the Portrait Medal: A Sixteenth-Century Sampling." In "Die andere Seite. Funktionen und Wissensformen der frühen Medaille Numismatische Zeitschrift," edited by Martin Hirsch and Ulrich Pfisterer, with Michael Alram and Walter Cupperi, special issue, *Mitteilungen der Österreichischen Numismatische Zeitschrift* 122/123 (2017): 107–19.

Kirchner 1968
Kirchner, Walther. *Alva.* Translated by W. Jappe Alberts. The Hague, 1968.

Klauss 2000
Klauss, Jochen. *Die Medaillensammlung Goethes.* 2 vols. Berlin, 2000.

Klawans 1977
Klawans, Zander H. *Imitations and Inventions of Roman Coins: Renaissance Medals of Julius Caesar and the Roman Empire.* Santa Monica, Calif., 1977.

Klein 1976
Klein, Ulrich. "Eine juristisch-numismatische Tübinger Dissertation aus dem Jahre 1755: Ein Beitrag zu den sogenannten Judenmedaillen." In *Beiträge zur süddeutschen Münzgeschichte: Festschrift zum 75-jährigen Bestehen des Württembergischen Vereins für Münzkunde e.V.,* pp. 210–44. Stuttgart, 1976.

Klein and Raff 1995
Klein, Ulrich, and Albert Raff. *Die württembergischen Medaillen von 1496–1797 (einschließlich der Münzen und Medaillen der weiblichen Angehörigen).* Stuttgart, 1995.

Klein and Raff 2003
Klein, Ulrich, and Albert Raff. *Die württembergischen Medaillen von 1797–1864 (einschließlich der Orden- und Ehrenzeichen).* Stuttgart, 2003.

Klinger 1998
Klinger, Linda. "Images of Identity: Italian Portrait Collections of the Fifteenth and Sixteenth Centuries." In *The Image of the Individual: Portraits in the Renaissance,* edited by Nicholas Mann and Luke Syson, pp. 67–79. London, 1998.

Knecht 1982
Knecht, R. J. *Francis I.* Cambridge, 1982.

Knyphausen 1872–77
Knyphausen, K. Graf zu Inn. *Münz- und Medaillen-Kabinett.* 2 vols. Hannover, 1872–77.

Kohl 1988
Kohl, Benjamin G. "Humanism and Education." In *Renaissance Humanism: Foundations, Forms, and Legacy,* edited by Albert Rabil Jr. Vol. 3, *Humanism and the Disciplines,* pp. 5–22. Philadelphia, 1988.

Köhler 1729–50
Köhler, Johann David. *Der wöchentlichen historischen Münz-Belustigung.* 22 vols. Nuremberg, 1729–50.

Köhler 1745
Köhler, Johann David. *Des Nvmophylacii Bvrckhardiani anderer Theil von nevern Mvntznen.* Göttingen, 1745.

Kohlhaussen 1968
Kohlhaussen, Heinrich. *Nürnberger Goldschmiedekunst des Mittelalters und der Dürerzeit, 1240 bis 1540.* Berlin, 1968.

Koldeweij 2014
Koldeweij, Anna C. "Stempelsnijder en zilversmid Jurriaan Pool (ca. 1618–1669): Een Poolse immigrant in een Amsterdams zilversmedennetwerk." *Jaarboek voor Munt- en Penningkunde* 101 (2014): 124–91.

König 1914
König, Erich. *Peutingerstudien.* Studien und Darstellungen aus dem Gebiete der Geschichte 9. Freiburg im Breisgau, 1914.

Konigson 1975
Konigson, Elie. "La cité et le prince: Premières entrées de Charles VIII (1484–1486)." In *Les fêtes de la Renaissance: 3, Quinzième Colloque International d'Etudes Humanistes, Tours, 10–22 juillet 1972*, pp. 55–69. Paris, 1975.

Kranz 2004
Kranz, Annette. "Zur Porträtmedaille in Augsburg im 16. Jahrhundert." In *Die Renaissance-Medaille in Italien und Deutschland*, edited by Georg Satzinger, pp. 301–42. Münster, 2004.

Kranz 2013
Kranz, Annette. "Die Reichstage: Eine ephemere Geographie." In Cupperi et al. 2013, pp. 185–87.

Kratzsch 1972
Kratzsch, Klaus. *Bergstädte des Erzgebirges: Städtebau und Kunst zur Zeit der Reformation*. Munich, 1972.

Krautheimer 1970
Krautheimer, Richard. *Lorenzo Ghiberti*. 2 vols. 2nd ed. Princeton, N.J., 1970.

Kress ca. 1640
Kress, Johann Wilhelm. "Geschlechterbuch, begonnen 1640: Die Kressen samt derselben verschwägerte adelige Stammlinien Beschreibung." MS. Signature FA Kress no. 140. Germanisches Nationalmuseum Nürnberg.

Kress von Kressenstein 1985
Kress von Kressenstein, Hans Karl. *Die Kressen: Eine Familiengeschichte*. 2 vols. Aalen, 1985.

Kris 1929
Kris, Ernst. *Meister und Meisterwerke der Steinschneidekunst*. Vienna, 1929.

Kris 1931
Kris, Ernst. "Zum Werk Peter Flötners und zur Geschichte der Nürnberger Goldschmiedekunst. I: Ein Kokosnussbecher." *Pantheon* 8 (1931): 496–99.

Kubler 1964
Kubler, George. "A Medal by G. P. Poggini Depicting Peru and Predicting Australia." *Mitteilungen des Kunsthistorischen Institutes in Florenz* 5 (1964): 149–52.

H. Kuhn 1941
Kuhn, Hermann. "Hans Reinhart: Ein Meister der mitteldeutschen Renaissance-Medaille." *Blätter für Münzfreunde* 76 (1941): 169–84.

Kundmann 1738
Kundmann, Johann Christian. *Silesii in nummis, oder, Berühmte Schlesier in Münzen*. Breslau, 1738.

Künker sale 2005
Auktion Munzen und Medaillen aus Mittelalter und Neuzeit. Sale cat, no. 98. Fritz-Rudolf Künker, Osnabrück, March 8–10, 2005.

Kunst der Reformationszeit 1983
Kunst der Reformationszeit. Exh. cat. Altes Museum. Berlin, 1983.

Kunsthandwerk der Dürerzeit 1971
Kunsthandwerk der Dürerzeit und der deutschen Renaissance. Exh. cat. Berlin, 1971.

Küthmann et al. 1973
Küthmann, Harald, Berhard Overbeck, Dirk Steinhilber, and Ingrid [S.] Weber. *Bauten Roms auf Münzen und Medaillen*. Exh. cat. Staatliche Münzsammlung. Munich, 1973.

La Tour 1893
La Tour, Henri de. "Giovanni Paolo." *Revue numismatique*, 3rd. ser., 11 (1893): 259–78.

La Tour 1895
La Tour, Henri de. *Jean de Candida: Médailleur, sculpteur, diplomate, historien*. Paris, 1895.

La Tour 1900
La Tour, Henri de. "Domenico di Polo: Médailleur et des pierres fines du duc Alexandre de Médicis." In *Congrès International de Numismatique, réuni a Paris, en 1900: Procès-verbaux & mémoires*, pp. 382–99. Paris, 1900.

La Tour 1910
La Tour, Henri de. *Bibliothèque Nationale: Catalogue de la collection Rouyer léguée en 1897 au Département des Médailles et Antiques*. Pt. 2, *Jetons et méreaux de la Renaissance et des temps modernes*. Paris, 1910.

Labus 1837
Labus, Giovanni. *Museo della Reale Accademia di Mantova*. Mantua, 1837.

Lafaurie and Prieur 1951–56
Lafaurie, Jean, and Pierre Prieur. *Les monnaies des rois de France*. 2 vols. Paris, 1951–56.

Lagerqvist 1982
Lagerqvist, Lars O. *Efter Lützen: Gustav II Adolfs minne på mynt och medaljer*. Edited by Ulla Westermark. *Kungligla Myntkabinettet* no. 22. Stockholm, 1982.

Lagerqvist 1998a
Lagerqvist, Lars O. "The Funeral of Gustav II Adolf." In *Quadra: Klenoder i Kungl. Myntkabinettet / Treasures in the Royal Coin Cabinet*, pp. 106–9. Stockholm, 1998.

Lagerqvist 1998b
Lagerqvist, Lars O. "A Portrait of the Lion of the North." In *Quadra: Klenoder i Kungl. Myntkabinettet / Treasures in the Royal Coin Cabinet*, pp. 99–101. Stockholm, 1998.

Lagerqvist 2003
Lagerqvist, Lars O. "La médaille en Suède comme communication: Les premiers cent ans, 1560–1660." *Médailles*, no. 60 (2003): 34–43.

Lagerqvist 2012
Lagerqvist, Lars O. "Det var en gång ett telefonsamtal." *Svensk numismatisk tidskrift*, no. 8 (2012).

Lagerqvist and Åberg 2002
Lagerqvist, Lars O., and Nils Åberg. *Kings and Rulers of Sweden: A Pocket Encyclopaedia*. Fagernes, 2002.

Lami 1910–11
Lami, Stanislas. *Dictionnaire des sculpteurs de l'école française au dix-huitième siècle*. 2 vols. Paris, 1910–11.

***Land im Mittelpunkt der Mächte* 1984**
Land im Mittelpunkt der Mächte: Die Herzogtümer Jülich, Kleve, Berg. Exh. cat. Städtisches Museum Hans Koekkoek Kleve and Stadtmuseum Düsseldorf; 1984–85. Kleve, 1984.

Landolt and Ackermann 1991
Landolt, Elisabeth, and Felix Ackermann. *Das Amerbach-Kabinett: Die Objekte im Historischen Museum Basel*. Exh. cat. Historisches Museum. Basel, 1991.

A. Lang 1906
Lang, Andrew. *Portraits and Jewels of Mary Stuart*. Glasgow, 1906.

K. H. von Lang 1825
Lang, Karl Heinrich von, ed. *Regesta; sive, Rerum Boicarum autographa*. Vol. 3. Munich, 1825.

Langdon 2006
Langdon, Gabrielle. *Medici Women: Portraits of Power, Love, and Betrayal from the Court of Duke Cosimo I*. Toronto, 2006.

Langedijk 1981–87
Langedijk, Karla. *The Portraits of the Medici, 15th to 18th Century*. 3 vols. Florence, 1981–87.

Lankheit 1962
Lankheit, Klaus. *Florentinische Barockplastik: Die Kunst am Hofe der letzten Medici, 1670–1743*. Munich, 1962.

Lanna sale 1911a
Sammlung des Freiherrn Adalbert von Lanna. Pt. 2. Sale cat. Rudolph Lepke's Kunst-Auctions-Haus, Berlin, March 21–28, 1911.

Lanna sale 1911b
Sammlung des Freiherrn Adalbert von Lanna. Pt 3. *Medaillen und Münzen*. Sale cat. Rudolph Lepke's Kunst-Auctions-Haus, Berlin, May 13–19, 1911.

G. Lanzoni 1898
Lanzoni, Giuseppe. *Sulle nozze di Federigo I Gonzaga con Margherita di Wittelsbach (1463)*. Milan, 1898.

K. H. Lanzoni 2010
Lanzoni, Kristin Huffman. "New Light on Renaissance Faces: Alessandro Vittoria, Portrait Medals and Fashioning Images." *Medal* 56 (Spring 2010): 37–46.

Lauffer 1742
Lauffer, Caspar Gottlieb. *Das Laufferische Medaillen-Cabinet: oder, Verzeichniß aller Medaillen, welche sowohl die historischen Begebenheiten von A. 1679 biß A. 1742 als auch andere christlich- und moralische Betrachtungen nebst der vollkommenen Reise der Römischen Päbste enthalten…* [Nuremberg] 1742.

Laverrenz 1885–87
Laverrenz, C. *Die Medaillen und Gedächtiszeichen der deutschen Hochschulen*. 2 vols. Berlin, 1885–87.

I. Lavin 1970
Lavin, Irving. "On the Sources and Meaning of the Renaissance Portrait Bust." *Art Quarterly* 33, no. 3 (1970): 207–26.

I. Lavin 1993
Lavin, Irvin. "David's Sling and Michelangelo's Bow: A Sign of Freedom." In *Past—Present: Essays on Historicism in Art from Donatello to Picasso*, pp. 29–61, 268–74. Berkeley, Calif., 1993.

M. A. Lavin 1974
Lavin, Marilyn Aronberg. "Piero della Francesca's Fresco of Sigismondo Pandolfo Malatesta before St. Sigismond: ΘΕΩΙ ΑΘΑΝΑΤΩΙ ΚΑΙ ΤΗΙ ΠΟΛΕΙ." *Art Bulletin* 56, no. 3 (September 1974): 345–74.

Lawe 1990
Lawe, Kari. "La medaglia dell'Amorino bendato." In *La corte di Ferrara & il suo mecenatismo, 1441–1598: Atti del Convegno Internazionale, Copenghagen, maggio 1987*, edited by Marianne Pade, Lene Waage Petersen, and Daniela Quarta, pp. 233–45. Copenhagen and Modena, 1990.

Lawrence 1883
Lawrence, Richard Hoe. *Medals by Giovanni Cavino, the "Paduan."* New York, 1883.

Lawrence 1996
Lawrence, Sarah E. "Imitation and Emulation in the Numismatic Fantasies of Valerio Belli." *The Medal* 29 (1996): 18–29.

Leberecht sale 1833–35
Numophylacii Ampachiani … Verzeichniss der von dem verstorbenen Domdechant zu Wurzen und Domkapitular zu Naumburg an der Saale Herrn Stifts-Regierungsrath Christian Leberecht von Ampach hinterlassenen Münz- und Medaillensammlung… Sale cat. 3 pts. Leipzig and Naumburg an der Saale, 1833–35.

Lebon 2008
Lebon, Élisabeth. "Les Frères Richard, fondeurs de David d'Angers." In *La sculpture au XIXe siècle: mélanges pour Anne Pingeot*, edited by Catherine Chevillot and Laure de Margerie, 24–29. Paris, 2008.

Lecoq 1987
Lecoq, Anne-Marie. *François Ier imaginaire: Symbolique et politique à l'aube de la Renaissance française.* Paris, 1987.

Lefevre 1986
Lefevre, Renato. *"Madama" Margarita d'Austria (1522–1586).* Rome, 1986.

Lehmann 1702
Lehmann, Peter A. *Der Historischen Remarques über neuesten Sachen in Europa, Vierdter Theil, auf das M.D.CCII Jahr.* Hamburg [1702].

Leithe-Jasper 1986
Leithe-Jasper, Manfred. *Renaissance Master Bronzes from the Collection of the Kunsthistorisches Museum, Vienna.* Exh. cat. National Gallery of Art. Washington, D.C., 1986.

Leitschuh 1912
Leitschuh, Franz Friedrich. "Der Augsburger Medailleur Hans Schwarz in seinen Beziehungen zu Johannes Secundus." In *Studien und Quellen zur deutschen Kunstgeschichte des XV.–XVI. Jahrhunderts.* Freiburg (Switzerland), 1912.

Lembright 1974
Lembright, Robert L. "Louise of Savoy and Marguerite d'Angoulême: Renaissance Patronage and Religious Reform." PhD diss., Ohio State University, 1974.

Lenger 1967
Lenger, Eike Eberhard. *Die Fugger in Hall i. T.* Tübingen, 1967.

Leonardo da Vinci 1970
Leonardo da Vinci. *The Literary Works of Leonardo da Vinci.* Compiled and edited by Jean Paul Richter. 3rd ed. London, 1970.

Lepage 1875
Lepage, Henri. *Notes et documents sur les graveurs des monnaies et médailles et la fabrication des monnaies des ducs de Lorraine, depuis la fin du XVe siècle.* Nancy, 1875.

Lepke 1913
Münzen und Medaillen aus dem Besitz des Herrn F. von Parpart; Englische Sammlung von Medaillen und Plaketten des 15. bis 17. Jahrhunderts. Sale cat. Rudolph Lepke's Kunst-Auctions-Haus, Berlin, April 22–23, 1913.

Leschhorn 2010
Leschhorn, Wolfgang. *Braunschweigische Münzen und Medaillen: 1000 Jahre Münzkunst und Geldgeschichte in Stadt und Land Braunschweig.* Braunschweig, 2010.

Levin 1975
Levin, William R. *Images of Love and Death in Late Medieval and Renaissance Art.* Exh. cat. University of Michigan Museum of Art. Ann Arbor, Mich., 1975.

Levy Pisetzky 1964–69
Levy Pisetzky, Rosita. *Storia del costume in Italia.* 5 vols. Milan, 1964–69.

Lewis 1987
Lewis, Douglas. "The Medallic Oeuvre of 'Moderno': His Development at Mantua in the Circle of 'Antico.'" In *Italian Medals*, edited by J. Graham Pollard, pp. 77–97. Studies in the History of Art, vol. 21. Center for Advanced Study in the Visual Arts, National Gallery of Art, Symposium Papers 8. Washington, D.C., 1987.

Lewis 1989
Lewis, Douglas. "The Plaquettes of 'Moderno' and His Followers." In *Italian Plaquettes,* edited by Alison Luchs, pp. 105–41. Studies in the History of Art, vol. 22. Center for Advanced Study in the Visual Arts, National Gallery of Art, Symposium Papers 9. Washington, D.C., 1989.

***Lexikon für Theologie und Kirche* 1930–38**
Lexikon für Theologie und Kirche. Edited by Konrad Hofmann. 2nd ed. 10 vols. Freiburg im Breisgau, 1930–38.

Leydi and Zanuso 2015
Leydi, Silvio, and Susanna Zanuso. "Pietro Paolo Tomei detto Romano: la ritrovita identità del medaglista 'PPR.'" *Bollettino d'Arte* 25 (January–March 2015): 35–76.

Lieb 1952–58
Lieb, Norbert. *Die Fugger und die Kunst im Zeitalter der Spätgotik und frühen Renaissance.* 2 vols. Munich, 1952–58.

Lietzmann 1989–90
Lietzmann, Hilda. "Unbekannte Nachrichten zur Biographie von Antonio Abondio und Carlo Pallago." *Jahrbuch des Zentralinstituts für Kunstgeschichte* 5–6 (1989–90): 327–49.

Lilja 1961
Lilja, Gösta. *Svenskt konstnärslexikon: tiotusen svenska konstnärers liv och verk.* Vol. 4, *Lundgren–Sallberg.* Allhems, 1961.

Lincoln 1890
W. S. Lincoln and Son. *A Descriptive Catalogue of Papal Medals to which Is Added Papal Bullae and Medals of Cardinals and Other Church Dignitaries*. London, 1890.

Lingua 1984
Lingua, Paolo. *Andrea Doria*. Milan, 1984.

Litta 1819
Litta, Pompeo. *Famiglie celebri di Italia*. Vol. 3. Milan, 1819.

Lloyd 1987
Lloyd, Christopher. "Reconsidering Sperandio." In *Italian Medals*, edited by J. Graham Pollard, pp. 99–113. Studies in the History of Art, vol. 21. Center for Advanced Study in the Visual Arts, National Gallery of Art, Symposium Papers 8. Washington, D.C., 1987.

Löbbecke sale 1908
Sammlung Arthur Löbbecke, Braunschweig: Kunstmedaillen und Plaketten des XV. bis XVII. Jahrhunderts. Sale cat. Jacob Hirsch, Munich, November 26, 1908, and following days.

Löbbecke sale 1925
Sammlung Arthur Löbbecke: Kunstmedaillen und Plaketten des XV.– XVII. Jahrhunderts. Sale cat., no. 32. A. Riechmann & Co., Halle an der Saale, February 5, 1925.

Löbbecke sale 1929
Médailles et plaquettes artistiques des XV–XVIIme siècles. Sale cat. Collection of Arthur Löbbecke. Jacques Schulman, Amsterdam, June 17, 1929.

Lochner 1737–44
Lochner, Johann Hieronymus. *Sammlung Merkwürdiger Medaillen*. 8 vols. Nuremberg, 1737–44.

Locker 2015
Locker, Jesse M. *Artemisia Gentileschi: The Language of Painting*. New Haven, Conn., 2015.

Loehr 1899
Loehr, August, Ritter von. *Wiener Medailleure*. Vienna, 1899.

Loehr 1904
Loehr, August, Ritter von. *Anton Scharff: Katalog seiner Medaillen und Plaketten*. Vienna, 1904.

Van Loon 1723–31
Van Loon, Gerard. *Beschryving der Nederlandsche historipenningen; of, Beknopt verhaal van 't gene sedert de overdracht der heerschappye van keyzer Karel den Vyfden op koning Philips zynen zoon, tot het sluyten van den Uytrechtschen vreede, in de zeventien Nederlandsche gewesten is voorgevallen*. 4 vols. The Hague, 1723–31.

Van Loon 1732–37
Van Loon, Gerard. *Histoire métallique des XVII provinces des Pays-Bas depuis l'abdication de Charles-Quint, jusqu'à la paix de Bade en MDCCXV*. 5 vols. The Hague, 1732–37. [Reprint, Leipzig, 1969.]

Loskoutoff 2016
Loskoutoff, Yvan, ed. *Les médailles de Louis XIV et leur livre*. Mont-Saint-Aignan, 2016.

Loubet 1967
Loubet, Christian. *Savonarole: Prophète assassiné?* Paris, 1967.

Louis XV 1975
Louis XV: Un moment de la perfection dans l'art français. Exh. cat. Hôtel de la Monnaie. Paris, 1975.

Louise de Savoie 1851
Louise de Savoie. "Journal de Louise de Savoye, duchesse d'Angoulesme, d'Anjou et de Valois, mère du grand roi François Premier." In *Nouvelle collection des mémoires pour servir à l'histoire de France depuis le XIIIe siècle jusqu'à la fin du XVIIIe*, 1st ser., vol. 5, pp. 83–93. Lyon and Paris, 1851.

Lucinge 2000
Lucinge, René de. *Les occurrences de la Paix de Lyon (1601)*. Edited by Alain Dufour. Geneva, 2000.

Luckius 1620
Luckius, Johann Jakob. *Sylloge numismatum elegantiorum…* Strassburg, 1620.

Luftschein 1995
Luftschein, Susan. *One Hundred Years of American Medallic Art, 1845–1945: The John E. Marqusee Collection*. Ithaca, N.Y., 1995.

Lugli 1982
Lugli, A. "Le 'Symbolicae quaestiones' di Achille Bocchi e la cultura dell'emblema in Emilia." In *Le arti a Bologna e in Emilia dal XVI al XVII secolo*, edited by Andrea Emiliani, pp. 87–96. Atti del XXIV Congresso Internazionale di Storia dell'Arte, Bologna, 1979. Bologna, 1982.

Lühmann-Schmid 1976–77
Lühmann-Schmid, Irnfriede. "Peter Schro: Ein Mainzer Bildhauer und Backoffenschüler. 2." *Mainzer Zeitschrift* 71–72 (1976–77): 57–100.

Luijt 2013
Luijt, Janjaap. "'La librairie s'accorde assez bien avec mon autre négoces [sic]': Nicolas Chevalier—Verzamelaar, boekdrukker en penningmaker." *De Vrede van Utrecht: Jaarboek Oud-Utrecht* (2013): 95–116.

Van Luttervelt 1955
Van Luttervelt, Remmet. "Bij een penning van Jacques Jonghelinck." *Jaarboek voor Munt- en Penningkunde* 42 (1955): 99–102.

Luzzati 1943
Luzzati, Ivo. *Andrea Doria*. Milan, 1943.

Mackowsky 1898
Mackowsky, Hans. "Sperandio Mantovano." *Jahrbuch der Königlich Preussischen Kunstsammlungen* 19 (1898): 171–82.

Madden 1852
Madden, F. "Portrait Painters of Queen Elizabeth." *Notes and Queries* 6 (September 11, 1852): 237–39.

Maffei 1731–32
Maffei, Scipione. *Verona illustrata*. 4 vols. Verona, 1731–32.

Magagnato 1958
Magagnato, Licisco, ed. *Da Altichiero a Pisanello*. Exh. cat. Museo di Castelvecchio, Verona. Venice, 1958.

Magnaguti 1918
Magnaguti, Alessandro. "L'Evento del Seicento." *Rivista italiana di numismatica*, 2nd ser., 31, no. 1 (1918): 101–6.

Magnaguti 1921
Magnaguti, Alessandro. *Edizione de 200 Esemplari Numerati*. Vol. 148. *Le medaglie mantovane*. Mantua, 1921.

Magnaguti 1965
Magnaguti, Alessandro. *Ex nummis historia*. Vol. 9, *Le medaglie dei Gonzaga*. Rome, 1965.

Mai 1970
Mai, Ekkehard. *Medaillen und Plaketten*. Bildhefte des Kunstmuseums Düsseldorf, vol. 7. Düsseldorf, 1970.

Maier 2010
Maier, Nicolas. *French Medallic Art, 1870–1940*. Munich, 2010.

Majer 1929
Majer, Giovannina. *Le medaglie di magistrati veneti nell'Istria e nella Dalmazia e Albania*. Rome, 1929.

Majkowski 1937
Majkowski, E. "Steven van Herwijck's serie der Jagellonen-medaillons en zijn vermeend verblijf in Polen, 1561–1562." *Jaarboek voor Munt- en Penningkunde* 24 (1937): 1–37.

Malagola 1882–83
Malagola, Carlo. "Di Sperindio e delle cartiere, dei carrozzieri, armaioli, librai fabbricatori e pittori di vetri in Faenza sotto Carlo e Galeotto Manfredi (1468–1488)." *Atti e memorie della R. Deputazione di Storia Patria per le Provincie di Romagna*, ser. 3, 1 (1882–83): 377–411.

Malatesta e il suo tempo 1970
Sigismondo Pandolfo Malatesta e il suo tempo. Exh. cat. Palazzo dell'Arengo, Rimini. Vicenza, 1970.

Mâle 1984
Mâle, Emile. *Religious Art in France, the Thirteenth Century: A Study of Medieval Iconography and Its Sources*. Edited by Harry Bober. Princeton, N.J., 1984.

Mallett 1974
Mallett, Michael. *Mercenaries and Their Masters: Warfare in Renaissance Italy*. Totowa, N.J., 1974.

Maltby 1983
Maltby, William S. *Alba: A Biography of Fernando Alvarez de Toledo, Third Duke of Alba, 1507–1582*. Berkeley, Calif., 1983.

Manca 1989
Manca, Joseph. "The Presentation of a Renaissance Lord: Portraiture of Ercole I d'Este, Duke of Ferrara (1471–1505)." *Zeitschrift für Kunstgeschichte* 52, no. 4 (1989): 522–38.

Mann 1931
Mann, James G. *Wallace Collection Catalogues. Sculpture: Marbles, Terra-Cottas and Bronzes…* London, 1931.

Manteuffel 1909
Manteuffel, K. Zoege von. *Die Gemälde und Zeichnungen des Antonio Pisano aus Verona*. Halle an der Saale, 1909.

Marchal 1895
Marchal, Edmond. *La sculpture et les chefs-d'oeuvre de l'orfèvrerie belges*. Brussels, 1895.

Maresti 1681
Maresti, Alfonso. *Teatro geneologico et istorico dell'antiche et illustri famiglie di Ferrara*. Ferrara, 1681.

Margolis 2015
Margolis, Richard. *Benjamin Franklin in Terra Cotta: Portrait Medallions by Jean-Baptiste Nini at the Chateau of Chaumont*. Gahanna, Ohio, 2015.

***Maria van Hongarije* 1993**
Maria van Hongarije, 1508–1558: Koningin tussen keizers en kunstenaars. Exh. cat. Edited by Bob van den Boogert and Jacqueline Kerkhoff. Rijksmuseum het Catharijneconvent, Utrecht, and Noordbrabants Museum, Hertogenbosch. Zwolle, 1993.

Marincola, Poulet, and Scher 1986
Marincola, Michele D., Anne L. Poulet, and Stephen K. Scher. "Gothic, Renaissance, and Baroque Medals from the Museum of Fine Arts, Boston." Special issue, *Medal* 9 (Autumn 1986): 79–105.

Marini 1914
Marini, Riccardo Adalgisio. "Motti ed imprese della Real Casa di Savoia." *Rivista italiana di numismatica e scienze affini* 27 (1914): 67–120.

Marrow 1982
Marrow, Deborah. *The Art Patronage of Maria de' Medici*. Ann Arbor, Mich., 1982.

F. R. Martin 1910
Martin, F. R. "New Originals and Oriental Copies of Gentile Bellini Found in the East." *Burlington Magazine* 17 (1910): 5–7.

Martin Luther 1983
Martin Luther und die Reformation in Deutschland. Exh. cat. Germanisches Nationalmuseum Nürnberg. Frankfurt am Main, 1983.

A. J. Martini 1646
Martini, Adam Jacob. *Kurtze Beschreibung und Entwurff alles dessen, was bye der … Prinzessin und Frewlein Frewlein Ludovicae Mariae Gonzagae … Einzüge in die königl. Stadt Danzig sich denckwürdiges begeben*. Gdańsk, 1646.

R. Martini and Turricchia 1999
Martini, Rodolfo, and Arnaldo Turricchia. *Catalogo delle medaglie delle Civiche Raccolte Numismatiche di Milano.* Vol. 5, *Secoli XVIII–XIX*. Pt. 3, *Stati italiani (1815–1860)*. Milan, 1999.

Martinori 1917–22
Martinori, Edoardo. *Annali della zecca di Roma*. 24 vols. Rome, 1917–22.

Mateu y Llopis 1975
Mateu y Llopis, Felipe. "Los medallistas del Renacimiento italiano y los orígenes de la medalla española." *Gaceta numismática,* no. 36 (1975): 59–72.

Mateu y Llopis 1977
Mateu y Llopis, Felipe. "Medaglie di governatori di Milano sotto i regni di Carlo V e Filippo II (1528–1598)." *Medaglia* 14 (1977): 29–38.

Matthias Corvinus 1982
Matthias Corvinus und die Renaissance in Ungarn, 1458–1541. Exh. cat. Edited by Gottfried Stangler. Schloss Schallaburg. Vienna, 1982.

Matzke 2013
Matzke, Michael. "Das Münzkabinett des Historischen Museums Basel." *INC / CIN* (International Numismatic Council / Conseil International de Numismatique) *Compte rendue* 60 (2013): 50–64.

Maué 1982
Maué, Hermann. "Die Münze als Objekt des Sammeleifers und der numismatischen Forschung." In *Münzen in Brauch und Aberglauben: Schmuck und Dekor—Votiv und Amulett—Politische und religiöse Selbstdarstellung; zur 100-Jahrfeier des Vereins für Münzkunde Nürnberg*, edited by Hermann Maué, with Ludwig Veit, pp. 196–205. Mainz, 1982.

Maué 1985
Maué, Hermann. "Nürnberger Medaillen, 1500–1700." In *Wenzel Jamnitzer und die Nürnberger Goldschmiedekunst, 1500–1700*, pp. 151–59. Exh. cat. Germanisches Nationalmuseum Nürnberg. Munich, 1985.

Maué 1986
Maué, Hermann. "Die Anfänge der deutschen Renaissancemedaille." In *Nürnberg 1986*, pp. 105–8.

Maué 1987
Maué, Hermann. "Die Dedikationsmedaille der Stadt Nürnberg für Kaiser Karl V. von 1521." *Anzeiger des Germanischen Nationalmuseums* (1987): 227–44.

Maué 1988
Maué, Hermann. "Hans Schwarz in Nürnberg, 1519–1520." *Medal* 13 (Autumn 1988): 12–17.

Maué 1989
Maué, Hermann. "Nürnberger Medaillenkunst zur Zeit Albrecht Dürers." In *Medailles & Antiques*, pp. 23–29. Trésors monétaires, suppl. 2. Bibliothèque Nationale. Paris, 1989.

Maué 1991
Maué, Hermann. Review of Trusted 1990. *Medal* 18 (Spring 1991): 108.

Maué 1992
Maué, Hermann. "Die Medaille des Matthes Gebel auf den Tod des Georg Ploed aus dem Jahre 1532: Antikenrezeption; oder, Übernahme eines Motivs der italienischen Renaissance?" In *ΜΟΥΣΙΚΟΣ ΑΝΗΡ: Festschrift für Max Wegner zum 90. Geburtstag*, edited by Oliver Brehm und Sascha Klie. *Antiquitas*, ser. 3, vol. 32. Bonn, 1992.

Maué 1994
Maué, Hermann. "Die Münzsammlung im Praunschen Kabinett." In *Die Kunstsammlung des Paulus Praun: Die Inventare von 1616 und 1719*, edited by Katrin Achilles-Syndram, pp. 85–94. Nuremberg, 1994.

Maué 1997
Maué, Hermann. "Europäische Ereignismedaillen aus Nürnberg im 17. und 18. Jahrhundert: Venedig kämpft gegen die Türken." In *Medaillenkunst in Deutschland von der Renaissance bis zur Gegenwart: Vorträge zum Kolloquium im Schlossmuseum Gotha am 4. mai 1996*, edited by Rainer Grund, pp. 51–69. Dresden, 1997.

Maué 2000
Maué, Hermann. "The Renaissance Medal in Germany." *Medal* 37 (Autumn 2000): 3–14.

Maué 2005
Maué, Hermann. "Medaillen auf Albrecht von Brandenburg." In *Kintinuität und Zäsur: Ernst von Wettin und Albrecht von Brandenburg*, edited by Herausgegeben von Andreas Tacke, pp. 350–79. Göttingen, 2005.

Maué 2008
Maué, Hermann. *Sebastian Dadler, 1586–1657: Medaillen im Dreissigjährigen Krieg*. Wissenschaftliche Beibände zum Anzeiger des Germanischen Nationalmuseums 2. Nuremberg, 2008.

Maué 2013
Maué, Hermann. "Jenseits der Porträtmedaille: Vom Spott bis zur Belohnung." In Cupperi et al. 2013, pp. 69–79.

Maulde la Clavière 1895
Maulde la Clavière, R. de. *Louise de Savoie et François Ier: Trente ans de jeunesse (1485–1515)*. Paris, 1895.

Maumené 1935
Maumené, Charles. "Le visage royale d'Henri IV, des médailles de Guillaume Dupré aux peintures de Rubens." *Demareteion* (1935): 28–39.

Maumené and Harcourt 1929
Maumené, Charles, and Louis d'Harcourt. *Iconographie des rois de France*. Archives de l'art français, n.s., 15, no. 1. Paris, 1929.

Maximilian I 1959
Maximilian I, 1459–1519. Exh. cat. Nationalbibliothek. Vienna, 1959.

Maximilian I 1969
Maximilian I. Exh. cat. Innsbrucker Zeughaus. Innsbruck, 1969.

D. M. Mayer 1966
Mayer, Dorothy Moulton. *The Great Regent: Louise of Savoy, 1476–1531*. London, 1966.

Mayr 1843
Mayr, G. *Monete e medaglie onorarie ferraresi illustrate da Giuseppe Mayr*. Ferrara, 1843.

Mazerolle 1897a
Mazerolle, Fernand. "Catalogue de l'Oeuvre de M. J.-C. Chaplain." *Gazette numismatique française* 1 (1897): 6–41.

Mazerolle 1897b
Mazerolle, Fernand. "Catalogue de l'Oeuvre de M. L.-O. Roty." *Gazette numismatique française* 1 (1897): 451–72.

Mazerolle 1902–4
Mazerolle, Fernand. *Les médailleurs français du XVe siècle au milieu du XVIIe*. 3 vols. Paris, 1902–4.

Mazerolle 1927
Mazerolle, Fernand. "Coins de médailles de Conrad Bloc." *Revue belge de numismatique* 79 (1927): 95–98.

Mazerolle 1932
Mazerolle, Fernand. *Jean Varin: Conducteur de la monnaie du Moulin, tailleur général des monnaies, controleur général des poinçons et effigies. Sa vie, sa famille, son oeuvre (1596–1672)*. Paris, 1932.

Mazio 1824
Mazio, Francesco. *Serie dei conj di medaglie pontificie da Martino V. fino a tutto il pontificato di Pio VII. esistenti nella Pontificia zecca di Roma*. Rome, 1824.

Mazio 1884
Mazio, Francesco. *Supplemento al catalogo della serie dei conj di medaglie pontificie da Martino V. a Pio VII*. N.p., 1884.

McCrory 1987
McCrory, Martha A. "Domenico Compagni: Roman Medalist and Antiquities Dealer of the Cinquecento." In *Italian Medals*, edited by J. Graham Pollard, pp. 115–29. Studies in the History of Art, vol. 21. Center for Advanced Study in the Visual Arts, National Gallery of Art, Symposium Papers 8. Washington, D.C., 1987.

McCrory 1999
McCrory, Martha A. "Medaglie, monete e gemme: Etimologia e simbolismo nella cultura del tardo rinascimento italiano." In *La tradizione classica nella medaglia d'arte dal Rinascimento al Neoclassico: Atti del Convegno Internazionale, Castello di Udine, 23–24 ottobre 1997*, edited by Maurizio Buora, pp. 39–52. Trieste, 1999.

McKeown 2001
McKeown, Simon. "The King Struck Down: Sebastian Dadler's Medallic Images of Gustavus Adolphus, King of Sweden." *The Medal* 38 (Spring 2001): 7–22.

McKeown 2004
McKeown, Simon. "Literary Tradition and the Medal: Sebastian Dadler and the Emblem Genre." *The Medal* 45 (Autumn 2004): 44–59.

McQueen 2011
McQueen, Alison. *Empress Eugénie and the Arts: Politics and Visual Culture in the Nineteenth Century*. Surrey, 2011.

Medaglie del Rinascimento 1960
Medaglie del Rinascimento: Catalogo. Museo Civico. Bologna, 1960.

Médailles des anciens Pays-Bas 1956
Médailles des anciens Pays-Bas: Contribution numismatique à l'histoire du protestantisme. Exh. cat. Hôtel des Monnaies. Paris, 1956.

Medal: Mirror of History 1979
The Medal: Mirror of History. Exh. cat. British Museum. London, 1979.

Medaljen genom tiderna 1942
Medaljen genom tiderna. Exh. cat. Stockholm, 1942.

Van der Meer 1975
Van der Meer, Gay. "Spotpenningen gericht tegen Willem III." *De geuzenpenning* 25, no. 1 (1975): 3–6.

Van der Meer 1991
Van der Meer, Gay. "Spotpenningen." *De beeldenaar* 5 (1991): 350–55.

Van der Meer 2007
Van der Meer, Gay. "Problemen bij de toeschrijving van penningen aan Nicolas Chevalier." *De beeldenaar* 31 (2007): 65–73.

Meijer 1979
Meijer, Bert W. "The Re-emergence of a Sculptor: Eight Lifesize Bronzes by Jacques Jonghelinck." *Oud-Holland* 93 (1979): 116–35.

Meister & Sonntag 2004
Auktion 2. Sale cat. Auktionen Meister & Sonntag, Stuttgart, September 21–22, 2004.

Meloni Trkulja 1980
Meloni Trkulja, Silvia. *Al servizio del Granduca: Ricognizione di cento immagini della gente di corte*. Exh. cat. Palazzo Pitti. Florence, 1980.

Mende 1983
Mende, Matthias. *Dürer-Medaillen: Münzen, Medaillen, Plaketten von Dürer, auf Dürer, nach Dürer*. Nuremberg, 1983.

Menestrier 1691
Menestrier, Claude François. *Histoire du roy Louis le Grand, par les medailles, emblêmes, deuises, jettons, inscriptions, armoiries, et autres monumens publics*. Paris, 1691.

Merseburger sale 1894
Sammlung Otto Merseburger umfassend Münzen und Medaillen von Sachsen, albertinische und ernestinische Linie. Sale cat. Münzhandlung Zschiesche & Koder. Leipzig, 1894. [Reprint, Berlin, 1983; Gütersloh, 1999.]

Merzbacher 1900
Kunst-Medaillen-Katalog: Hauptsächlich aus den Sammlungen zweier süddeutscher Kunstfreunde. Sale cat. Eugen Merzbacher, Munich, May 1–2, 1900.

Metman 1977
Metman, Yves. "Sceau de Charles le Téméraire, duc de Bourgogne, 1433–1467–1477." *Bulletin* (Le Club Français de la Médaille) 55–56 (1977): 172–75.

Michaelson 1900
Michaelson, H. "Cranach des Älteren Beziehungen zur Plastik." *Jahrbuch der Königlich Preussischen Kunstsammlungen* 21 (1900): 271–84.

Middeldorf 1938
Middeldorf, Ulrich. "Portraits by Francesco da Sangallo." *Art Quarterly* 1 (1938): 109–38.

Middeldorf 1977
Middeldorf, Ulrich. "Glosses on Thieme-Becker." In *Festschrift für Otto von Simson zum 65. Geburtstag*, edited by Lucius Grisebach and Konrad Renger, pp. 289–94. Frankfurt am Main, 1977.

Middeldorf 1979
Middeldorf, Ulrich. "Medals in Clay and Other Odd Materials." *Faenza* 65, no. 6 (1979): 269–78.

Middeldorf Collection 1995
Medals and Plaquettes from the Middeldorf Collection. Exh. cat. Indiana University Art Museum, Bloomington, Ind., 1995.

Middeldorf and Goetz 1944
Middeldorf, Ulrich, and Oswald Goetz. *Medals and Plaquettes from the Sigmund Morgenroth Collection*. Chicago, 1944.

Middeldorf and Kriegbaum 1928
Middeldorf, Ulrich, and Friedrich Kriegbaum. "Forgotten Sculpture by Domenico Poggini." *Burlington Magazine* 53 (July 1928): 9–17.

Middeldorf and Stiebral 1983
Middeldorf, Ulrich, and Dagmar Stiebral. *Renaissance Medals and Plaquettes*. Florence, 1983.

Van Mieris 1732–35
Van Mieris, Frans. *Historie der Nederlandsche vorsten*. 3 vols. The Hague, 1732–35.

Migeon 1904
Migeon, Gaston. *Catalogue des bronzes & cuivres du Moyen Age, de la Renaissance et des temps modernes*. Musée National du Louvre. Paris, 1904.

Migeon 1908
Migeon, Gaston. "La collection de M. Gustave Dreyfus. IV: Les médailles." *Les arts* 7 (August 1908): 1–32.

Millin 1819
Millin, Aubin Louis. *Medallic History of Napoleon: A Collection of All the Medals, Coins and Jettons, Relating to His Actions and Reign, from the Year 1796 to 1815*. Translated by James V. Millingen. London, 1819.

Minor and Bonner 1968
Minor, Andrew C., and Bonner Mitchell, eds. *A Renaissance Entertainment: Festivities for the Marriage of Cosimo I, Duke of Florence, in 1539. An Edition of the Music, Poetry, Comedy, and Descriptive Account*. Columbia, Mo., 1968.

Mirnik 1994
Mirnik, Ivan. "Livio Odescalchi on Medals." *Medal* 24 (Spring 1994): 50–55.

Missirini 1825
Missirini, Melchior. *Della vita di Antonio Canova: Libri quattro*. Milan, 1825.

Mitchell 1978
Mitchell, Charles. "Il Tempio Malatestiano." In *Studi Malatestiani*, pp. 71–103. Studi storici (Istituto Storico Italiano per il Medio Evo), fasc. 110–11. Rome, 1978.

Modesti 1988
Modesti, Adolfo. "La serie papale di restituzione di Girolamo Paladino." *Medaglia* 23 (1988): 7–57.

Modesti 2002–4
Modesti, Adolfo. *Corpus numismatum omnium Romanorum pontificum (C.N.O.R.P.)*. 3 vols. Rome, 2002–4.

Molinier 1886
Molinier, Émile. *Les bronzes de la Renaissance: Les plaquettes*. Catalogue raisonné. 2 vols. Paris, 1886.

Montenuovo sale 1885
Verzeichnis verkäuflicher Münzen aus der fürstlich Montenuovo'schen Münzsammlung. Dealer's cat. Vol. 1, Österreich. Adolph Hess Nachfolger, Frankfurt am Main, 1885.

Montigny 1842
Montigny, C. de. "Des Faussaires: Jean Cavino et Alex. Bassiano, Padouans." *Le cabinet de l'amateur et de l'antiquité* 1 (1842): 385–414.

Morbio sale 1882
Catalog einer Sammlung italienischer Münzen aller Zeiten aus dem Nachlasse des Cavaliere Carlo Morbio in Maitland. Sale cat. F. J. Wesener, Munich, October 16, 1882.

Moreau-Nélaton 1908
Moreau-Nélaton, Etienne. *Les Clouets: Peintres officiels des rois de France*. Paris, 1908.

Moreau-Nélaton 1924
Moreau-Nélaton, Etienne. *Les Clouets et leurs émulés*. 3 vols. Paris, 1924.

Morscheck 1978
Morscheck, Charles R., Jr. *Relief Sculpture for the Façade of the Certosa di Pavia, 1473–1499*. New York, 1978.

Morton & Eden 2003
Ancient, Islamic, British and World Coins, War Medals and Decoration, Historical Medals and Banknotes. Sale cat. Morton & Eden, in association with Sotheby's, London, May 20–21, 2003.

Morton & Eden 2005
Ancient, British, Islamic and World Coins, Historical Medals and Banknotes. Sale cat. Morton & Eden, in association with Sotheby's, London, December 13–14, 2005.

Moser and Tursky 1977
Moser, Heinz, and Heinz Tursky. *Die Münzstätte Hall in Tirol*. Vol. 1. Innsbruck, 1977.

Motta 1908
Motta, E. "Giacomo Jonghelinck e Leone Leoni in Milano (nuovi documenti)." *Rivista italiana di numismatica* 21 (1908): 75–76.

Mueller-Lebanon sale 1925
Sammlung Hans Mueller-Lebanon (Kentucky, U.S.A.): Kunstmedaillen der Renaissancezeit, besonders hervorragende Arbeiten der besten deutschen Meister sowie künstlerische und interessante Münzen und Medaillen des XVI. bis XIX. Jahrhunderts. Sale cat. Adolph E. Cahn, Frankfurt am Main, September 7, 1925, and following days.

Mula 2000
Mula, Charles. *The Princes of Malta: The Grand Masters of the Order of St. John in Malta, 1530–1798*. Malta, 2000.

S. Muller 1911
Muller, S. "De medailleur Ste. H. te Utrecht." *Tijdschrift voor van het Koninklijk Nederlandsch Genootschap Munt- en Penningkunde* 19 (1911): 175–80.

S. Muller 1922a
Muller, S. "De medailleur Steven van Herwijck te Utrecht." *Oud Holland* 40 (1922): 24–31.

S. Muller 1922b
Muller, S. "De penningen der Utrechtsche bisschoppen." *Oud Holland* 40 (1922): 86–91.

T. Müller 1950–51
Müller, Theodor. "Hans Schwarz als Bildhauer." *Phoebus* 3 (1950–51): 25–30.

T. Müller 1959
Müller, Theodor. *Die Bildwerke in Holz, Ton und Stein von der Mitte des XV. bis gegen Mitte des XVI. Jahrhunderts*. Kataloge des Bayerischen Nationalmuseums München, vol. 13, pt. 2. Munich, 1959.

***Municipio di Cuneo* 1873**
Cenno intorno alle lapidi decretate dal Municipio di Cuneo ai cittadini illustri e ai soldati morti combattendo per la patria solennemente inaugurate il X agosto MDCCCLXXIII. Cuneo, 1873.

Müntz 1884
Müntz, Eugène. "L'atelier monetaire de Rome." *Revue numismatique*, 3rd ser., 2 (1884): 220–332.

Müntz 1887
Müntz, Eugène. *Histoire de l'art pendant la Renaissance*. Paris, 1887.

***Münzen- und Medaillen Auktion* 1961–62**
Münzen- und Medaillen Auktion: Münzenhandlung Egon Beckenbauer, vorm. J. Jenke. Munich, 1961–62.

***Münzen und Medaillen … Heldenzeitalters* 1987**
Münzen und Medaillen des österreichischen Heldenzeitalters, 1683–1794. Exh. cat. Belgische Nationalbank, Charleroi, and Bruges. Brussels, 1987.

***Münzsammlung des … Johann Michael von Stubenrauch* 1803**
Verzeichniß einer auserlesenen Münzsammlung des sel. Herrn Reichshofraths-Agenten Johann Michael von Stubenrauch, welche im Monate April 1803 zu Wien im Strauchgässel Nro 253 im 3ten Stocke durch öffentliche Verrsteigerung gegen baare Bezahlung wird hindau gegeben werden. Vienna, 1803.

Murdoch sale 1904
Catalogue of the Valuable Collection of Coins and Medals, the Property of the Late John O. Murdoch, Esq., Member of the Numismatic Society of London. Sale cat. Sotheby, Wilkinson & Hodge, London, June 2–6, 1904.

***Muse e il principe* 1991**
Le Muse e il principe: Arte di corte nel Rinascimento padano. 2 vols. Exh. cat. Museo Poldi Pezzoli, Milan. Modena, 1991.

***Musée de Toulouse* 1865**
Musée de Toulouse. *Catalogue des antiquités et des objets d'art.* Toulouse, 1865.

"Musei Bonamiciani" 1748
"Musei Bonamiciani Pratensis brevis descriptio." In *Symbolae letterariae opuscula varia*, vol. 2, edited by Antonio Francesco Gori, pp. 209–23. Florence, 1748.

Müseler 1983
Müseler, Karl. *Bergbaugepräge: dargestellt auf Grund der Sammlung der Preussag Aktiengesellschaft.* 2 vols. Hannover, 1983.

Museo Correr 1898
Museo Correr. *Catalogo delle monete, medaglie, tessere … nel Museo Civico Correr.* Venice, 1898.

***Museum … Milano-Viscontianum* 1786**
Museum numarium [*sic*] *Milano-Viscontianum, hoc est, quod vir illustris atque nobilissimus Gisbertus Franco de Milan-Visconti … id vero nunc Museum sigillatim plus licentiatibus vendetur die I. Maii, & subsequentibus diebus.* Utrecht, 1786.

***Napoléon et son temps* 1914**
Napoléon et son temps: Collection historique et artistique, J.-J. Gayet de Félissent. Sale cat. Milan, April 27, 1914.

Nash 1996
Nash, Ralph. "Chronological Table." In Jacopo Sannazaro, *The Major Latin Poems of Jacopo Sannazaro*, translated and edited by Ralph Nash, pp. 7–8. Detroit, 1996.

***Natur und Antike in der Renaissance* 1985**
Natur und Antike in der Renaissance. Exh. cat. Liebieghaus Museum Alte Plastik, 1985–86. Frankfurt am Main, 1985.

***Négotiations … du Président Jeannin* 1819**
Négotiations diplomatiques et politiques du Président Jeannin, ambassadeur et ministre de France. 2nd ed. Paris, 1819.

Neuburg sale 1938
Catalogue d'un cabinet renommé de médailles artistiques des XVe et XVIe siècles. Neuburg Collection. Sale cat. Jacques Schulman, Amsterdam, December 19, 1938.

Neudörfer 1875
Neudörfer, Johann. *Nachrichten von Künstlern und Werkleuten daselbst* [in Nuremberg] *aus dem Jahre 1547.* Edited by G. W. K. Lochner. Vienna, 1875.

***Neue deutsche Biographie* 1953–**
Neue deutsche Biographie. Edited by the Historische Kommission, Bayerische Akademie der Wissenschaften. 26 vols. to date. Berlin, 1953–.

Neugebauer 1619
Neugebauer, Salomon. *Selectorum symbolum heroicorum.* Frankfurt am Main, 1619.

***New Catholic Encyclopedia* 1967**
New Catholic Encyclopedia. 15 vols. Washington, D.C., 1967.

Newton 1988
Newton, Stella Mary. *The Dress of the Venetians, 1495–1525.* Aldershot, 1988.

Ng 2017
Ng, Aimee. *The Pursuit of Immortality: Masterpieces from the Scher Collection of Portrait Medals.* New York and London, 2017.

Nicolini 1925
Nicolini, Fausto. *L'arte Napoletana del Rinascimento e la lettera di Pietro Summonte a Marcantonio Michiel.* Naples, 1925.

Niggl 1965
Niggl, Paul. *Musiker Medaillen.* Hofheim am Tanus, 1965.

Nigrisoli Wärnhjelm 2008
Nigrisoli Wärnhjelm, Vera. "Apollonio Menabeni: Protomedico di Giovanni III di Svezia, e il suo trattato sull'alce." In *Atti della XXXVII tornata degli studi storici dell'arte medica e della scienza: Congresso Internazionale "In memoriam Mario Santoro" … Fermo, Centro Congressi San Martino, 18–20 settembre 2003*, edited by Fabiola Zurlini, pp. 94–107. Fermo, 2008.

Noè 1984
Noè, Enrico. "Profilo della medaglia bolognese del Settecento." *Medaglia* 19 (1984): 65–110.

Noè 1989
Noè, Enrico. "Le medaglie di Livio Odescalchi." *Medaglia* 24 (1989): 79–96.

Nohejlová 1938–39
Nohejlová, Emanuela. "Ceské medaile Severina Brachmanna." *Sborník Národního Musea v Praze* 1 (1938–39): 61–119.

Norris 1987
Norris, Andrea. "Gian Cristoforo Romano: The Courtier as Medalist." In *Italian Medals*, edited by J. Graham Pollard, pp. 131–41. Studies in the History of Art, vol. 21. Center for Advanced Study in the Visual Arts, National Gallery of Art, Symposium Papers 8. Washington, D.C., 1987.

Norris and Weber 1976
Norris, Andrea S., and Ingrid [S.] Weber. *Medals and Plaquettes from the Molinari Collection at Bowdoin College*. Brunswick, Maine, 1976.

Northumberland sale 1981
European Historical Medals from the Collection of His Grace the Duke of Northumberland, Removed from Alnick Castle. Sale cat. Sotheby's, London, June 17, 1981.

Nudelman 2013
Münz-Auktion: Ungarn und Siebenbürgen. Sale cat, no. 13. Nudelman Numismatica, Budapest, September 29, 2013. [Sale held at Kempinski Hotel Corvinus, Budapest.]

Numismatic Circular 1977
Spink & Son. *Numismatic Circular* 85, no. 1 (1977).

Nürnberg 1986
Nürnberg, 1300–1550: Kunst der Gotik und Renaissance. Edited by Rainer Kahsnitz and William D. Wixom. Exh. cat. Germanisches Nationalmuseum Nürnberg and Metropolitan Museum of Art, New York. Munich, 1986.

Nussbaum 1934
Vente nomisa: Spezialsammlung von Münzen der südlichen Niederlande und von historischen niederländischen Medaillen, sowie solchen des Hauses Habsburg; numismatische Bibliothek. Sale cat. Hans Nussbaum, Zurich, February 26, 1934, and following days.

Olding 1987
Olding, Manfred. *Die Münzen Friedrichs des grossen: Katalog der preussischen Münzen von 1740–1786*. Osnabrück, 1987.

Olding 2003
Olding, Manfred. *Die Medaillen auf Friedrich den Grossen von Preussen 1712 bis 1786*. Regenstauf, 2003.

Olszewski 2004
Olszewski, Edward J. *Cardinal Pietro Ottoboni (1667–1740) and the Vatican Tomb of Pope Alexander VIII*. Philadelphia, 2004.

Oppenheimer sale 1936
Catalogue of the Important Collection of Medals … Formed by the Late Henry Oppenheimer. Sale cat. Christie, Manson & Woods, London, July 27, 1936.

Oranje Nassau-boekerij 1898
De Oranje Nassau-boekerij en de Oranje-penningen in the Koninklijke Bibliotheek in het Koninklijk Penning-Kabinet te 's Gravenhage. Haarlem, 1898.

Ossbahr 1927
Ossbahr, Carl Axel. *Mynt och medaljer slagna för främmande makter i anledning av krig mot Sverige*. Uppsala, 1927.

Van der Osten and Vey 1969
Van der Osten, Gert, and Horst Vey. *Painting and Sculpture in Germany and the Netherlands, 1500–1600*. Middlesex, 1969.

Ostermann 1888
Ostermann, Valentino. "Le medaglie friulane del secolo XV e XVI: Aggiunte ai *Médailleurs italiens* de A. Armand." *Rivista italiana di numismatica* 1 (1888): 195–210.

Österreichisches biographisches Lexikon 1954–
Österreichische Akademie der Wissenschaften. *Österreichisches biographisches Lexikon, 1815–1950*. 14 vols. to date. Graz, 1954–.

Ovid 1975
Ovid [Publius Ovidius Naso]. *Metamorphoses*. Translated by Mary M. Innes. London, 1975.

Paccagnini 1972
Paccagnini, Giovanni. *Pisanello alla corte dei Gonzaga*. Exh. cat. Palazzo Ducale, Mantua. Milan, 1972.

Paccagnini 1973
Paccagnini, Giovanni. *Pisanello*. London, 1973.

Pace Gravina 2013
Pace Gravina, Giacomo. "Un diplomatico siciliano tra guerre di religione e impegno pastorale: Bonaventura Secusio." *Rivista di storia del diritto italiano* 86 (2013): 23–37.

Palazzi 1687–90
Palazzi, Giovanni. *Gesta pontificum Romanorum a Sancto Petro Apostolorum principe vsque ad Innocentium 11. P.O.M. Additis pontificum imaginibus ad viuum aere excvlptis, cum hieroglyphicis, numismatibus, signis, sigillis, &c. Auctore Io. Palatio*. Venice, 1687–90.

Palizzolo Gravina 1871–75
Palizzolo Gravina, Vincenzo. *Il blasone in Sicilia; ossia, Raccolta araldica*. Palermo, 1871–75.

Palliser 1870
Palliser, Bury. *Historic Devices, Badges, and War-Cries*. London, 1870.

Paltroni 1966
Paltroni, Pierantonio. *Commentari della vita et gesti dell'illustrissimo Federico Duca d'Urbino*. Edited by Walter Tommasoli. Urbino, 1966.

Pannuti 1996
Pannuti, Michele. "L'arte e la ritrattistica nelle medaglie della collezione Farnese." In *La collezione Farnese*, [vol. 3], *Le arti decorative*, pp. 253–303. Museo Nazionale di Capodimonte. Naples, 1996.

Panofsky 1962
Panofsky, Erwin. *Studies in Iconology: Humanistic Themes in the Art of the Renaissance*. New York, 1962.

Panvini Rosati 1968
Panvini Rosati, Franco. *Medaglie e placchette italiane dal Rinascimento al XVIII secolo*. Exh. cat. Rome, 1968.

Panvini Rosati 1973
Panvini Rosati, Franco. "Ricordo di S. L. Cesano." *Annali dell'Istituto Italiano di Numismatica* 20 (1973).

Paolucci 1988
Paolucci, Antonio. *I Gonzaga e L'Antico Percorso di Palazzo Ducale a Mantova*. Rome, 1988.

***Papers of Benjamin Franklin* 1986**
The Papers of Benjamin Franklin. Vol. 25. Edited by William B. Willcox. New Haven, Conn., 1986.

***Papers of Benjamin Franklin* 2001**
The Papers of Benjamin Franklin. Vol. 36. Edited by Ellen R. Cohn. New Haven, Conn., 2001.

***Papers of Benjamin Franklin* 2006**
The Papers of Benjamin Franklin. Vol. 38. Edited by Ellen R. Cohn. New Haven, Conn., 2006.

Parise and Saccocci 1988
Parise, Roberta, and Andrea Saccocci. *Duemila anni di storia della moneta al Museo Bottacin*. Padua, 1988.

Parker 1977
Parker, Geoffrey. *The Dutch Revolt*. London, 1977.

Pasini 1983
Pasini, Pier Giorgio. *I Malatesti e l'arte*. Bologna, 1983.

Pasini 1987
Pasini, Pier Giorgio. "Matteo de'Pasti, Problems of Style and Chronology." In *Italian Medals*, edited by J. Graham Pollard, pp. 143–59. Studies in the History of Art, vol. 21. Center for Advanced Study in the Visual Arts, National Gallery of Art, Symposium Papers 8. Washington, D.C., 1987.

Pasini 1992
Pasini, Pier Giorgio. *Cortesia e geometria: Arte malatestiana fra Pisanello e Piero della Francesca*. Exh. cat. Museo della Città. Rimini, 1992.

Pasini 2009
Pasini, Pier Giorgio. *Il Tesoro di Sigismondo e le medaglie di Matteo de'Pasti*. Bologna, 2009.

Pastor 1959
Pastor, Ludwig von. *Storia dei Papi dalla fine del Medio Evo*. Vol. 3. *Storia dei papi nel periodo del Rinascimento dall'elezione di Innocenzo VIII alla morte di Giulio II*. Rev. ed. Rome, 1959.

Pastoureau 1982
Pastoureau, Michel. "La naissance de la médaille: Le problème emblématique." *Revue numismatique*, 6th ser., 24 (1982): 205–21.

Pastoureau 1986
Pastoureau, Michel. "Une image nouvelle: La médaille du XVe siècle." Special issue, *Medal* 9 (Autumn 1986): 5–8.

Pastoureau 1988
Pastoureau, Michel. "La naissance de la médaille: Des impasses historiographiques à la théorie de l'image." *Revue numismatique*, 6th ser., 30 (1988): 227–47.

Pastoureau 1990
Pastoureau, Michel. *Couleurs, images, symboles: Etudes d'histoire et d'anthropologie*. Paris, 1990.

Patrignani 1947
Patrignani, Antonio. "Le medaglie di Pio IX." *Bollettino del circolo numismatico napoletano* 23 (1947): 65–95.

Patrignani 1951
Patrignani, Antonio. *Il corpus delle medaglie pontificie (1404–1939)*. Naples, 1951.

***Paulys Realencyclopädie* 1901**
Paulys Realencyclopädie der classischen Altertumswissenschaft. Vol. 4, pt. 8. New ed. Stuttgart, 1901.

Pearce 1957
Pearce, Mary. "Costumi tedeschi e borgognoni in Italia nel 1452." *Commentari* 8 (1957): 244–47.

Pechstein 1971
Pechstein, Klaus. *Goldschmiedewerke der Renaissance*. Kataloge des Kunstgewerbemuseums Berlin 5. Berlin, 1971.

Pechstein 1984
Pechstein, Klaus. "Peter Flötner (um 1495–1546)." In *Fränkische Lebensbilder*, pp. 91–100. Veröffentlichungen der Gesellschaft für fränkische Geschichte, ser. VII A, vol. 11. Neustadt/Aisch, 1984.

Pelc 2002
Pelc, Milan. *Illustrium Imagines: Das Porträtbuch der Renaissance.* Leiden, 2002.

Pelsdonk 2012
Pelsdonk, Jan. "De geschiedenis op orde: Collectioneurs, netwerken en verzamelingen in de Gouden Eeuw." In Pelsdonk and Plomp 2012, pp. 51–77.

Pelsdonk 2013
Pelsdonk, Jan. "Van Pool tot Valckenaer: De stadhuispenning van 1655." *De beeldenaar* 37 (2013): 111–17.

Pelsdonk and Plomp 2012
Pelsdonk, Jan, and Michiel Plomp, eds. *Hulde! Penningkunst in de Gouden Eeuw.* Exh. cat. Teylers Museum, Haarlem. Zwolle and Haarlem, 2012.

Pény 1947
Pény, Frédéric. *Jean Varin de Liège, 1607–1672.* Liège, 1947.

"Per Sperandio da Mantova" 1911
"Per Sperandio da Mantova." *Rivista italiana di numismatica e scienze affini* 24 (1911): 143–44.

Pérez de Tudela Gabaldón 1998
Pérez de Tudela Gabaldón, Almudena. "Algunas precisiones sobre la imagen de Felipe II en las medallas." *Madrid*, no. 1 (1998): 241–71.

Peter Flötner 1947
Peter Flötner und die Renaissance in Deutschland. Exh. cat. Fränkische Galerie am Marientor. Nuremberg, 1947.

Petz 1889
Petz, Hans. "Urkunden und Regesten aus dem königlichen Kreisarchiv zu Nürnberg." *Jahrbuch der kunsthistorischen Sammlungen des Allerhöchsten Kaiserhauses* 10 (1889): XX–LXII.

Peus 1975
Schaumünzen der Renaissance. Sale cat., no. 286. Dr. Busso Peus Nachfolger, Frankfurt am Main, March 17, 1975.

Peus 1989
Sale cat., no. 326. Dr. Busso Peus Nachfolger, Frankfurt am Main, November 1–3, 1989.

Peus 2004
Mittelalter, Neuzeit. Slg. Prof. Dr. Karl-Wolfgang Mundry: Medaillen der Renaissance und des Barock. Slg. s.D. Ernst Diether Prinz zu Ysenburg und Büdingen: Das Haus Ysenburg; Slg. Habsburg. Pt. 2, *Reichsmünzen, Lots, Literatur.* Sale cat., no. 379. Dr. Busso Peus Nachfolger, Frankfurt am Main, April 29–30, 2004.

Peus 2007
Mittelalter, Neuzeit. Sale cat., no. 391. Dr. Busso Peus Nachfolger, Frankfurt am Main, May 2–4, 2007.

Peus 2008
Sale cat., no. 397. Dr. Busso Peus Nachfolger, Frankfurt am Main, November 5–7, 2008.

Peus 2013
Sammlung Dr. Günther Brockmann u. a.: Medaillen; Sammlung Judaica. Sale cat., no. 411. Dr. Busso Peus Nachfolger, Frankfurt am Main, October 31, 2013.

Pfisterer 2008
Pfisterer, Ulrich. *Lysippus und seine Freunde: Liebesgaben und Gedächtnis im Rom der Renaissance, oder: Das erste Jahrhundert der Medaille.* Berlin, 2008.

Pfisterer 2013a
Pfisterer, Ulrich. "'Sinnes-Wissen': Jean Siméon Chardin und die Numismatik zwischen Kunst und Wissenschaft." In *Translatio Nummorum: Römische Kaiser in der Renaissance; Akten des Internationalen Symposiums, Berlin, 16.–18. November 2011*, edited by Ulrike Peter and Bernhard Weisser, pp. 17–37. Ruhpolding, 2013.

Pfisterer 2013b
Pfisterer, Ulrich. "Wissensordnungen der Medaille: Sammlungswesen, visuelle Kompetenzen, Deutungskontexte." In Cupperi et al. 2013, pp. 297–300.

Pfisterer 2017
Pfisterer, Ulrich. "'Mobile Medailleure': Pierre II. Woeiriot de Bouzey porträtiert Francesco und Clara Taverna in Mailand 1558/59." In *Die andere Seite: Funktionen und Wissensformen der frühen Medaille.* Proceedings of conference in Munich, February 7–8, 2014. *Numismatische Zeitschrift* 122/23 (2017): 133–47.

Phillips 1936
Phillips, John Goldsmith. "Medals from the Oppenheimer Collection." *Metropolitan Museum of Art Bulletin* 31, no. 12 (December 1936): 271–74.

Pialorsi 1982
Pialorsi, Vincenzo. "Le medaglie dei Musei civici di Brescia." *Medaglia* 17 (1982): 6–30.

Pialorsi 1989
Pialorsi, Vincenzo. "Medaglie relative a personaggi, avvenimenti e istituzioni di Brescia provincia." Pt. 1, "Sec. XV–XVI." *Medaglia* 17 (1989): 7–34.

Pialorsi 1991
Pialorsi, Vincenzo. "Le medaglie per Altobello Averoldo." In *Il polittico Averoldi di Tiziano restaurato,* edited by Elena Lucchesi Ragni and Giovanni Agosti, pp. 81–86. Exh. cat. Monastero di Santa Giulia. Brescia, 1991.

Piantanida 1807
Piantanida, Luigi. *Della Giurisprudenta marittima—commerciale antica e moderna.* Milan, 1807.

Piazzo 1956
Piazzo, Marcello del. *Protocolli del carteggio di Lorenzo il Magnifico per gli anni 1473–1474, 1477–1492*. Florence, 1956.

Pick 1905
Pick, Behrendt. "Die Medaillen." In Oscar Doering and Georg Voss, *Meisterwerke der Kunst aus Sachsen u. Thüringen*, pp. 33–36. Magdeburg [1905].

Picqué 1882
Picqué, Camille. "Médaillons & médailles des anciennes provinces belges." In *L'art ancien à l'Exposition Nationale belge*, pp. 103–28. Brussels and Paris, 1882.

Pinchart 1854
Pinchart, Alexandre. "Jacques Jonghelinck." *Revue belge de numismatique* 2, no. 4 (1854): 209–39. [Reprinted in *Recherches sur la vie et les travaux des graveurs de médailles, de sceaux et de monnaies des Pays-Bas*, vol. 1, pp. 312–42. Brussels, 1858.]

Pinchart 1868
Pinchart, Alexandre. *Histoire de la gravure des médailles en Belgique, depuis le XVIe siècle jusqu'en 1794*. Mémoires de l'Académie Royale de Belgique, Classe des beaux-arts, 34. Brussels, 1868.

Pinchart 1870
Pinchart, Alexandre. *Histoire de la gravure des médailles en Belgique, depuis le XVme siècle jusqu'en 1794*. Brussels, 1870.

Pinchart 1871
Pinchart, Alexandre. "Médailles relatives à l'histoire des Pays-Bas." *Revue belge de numismatique*, 5th ser., 3 (1871): 75.

Pini 1869
Pini, Carlo, ed. *La scrittura di artisti italiani*. Florence, 1869.

Piromalli 1975
Piromalli, Antonio. *La cultura a Ferrara al tempo di Ludovico Ariosto*. Rome, 1975.

***Pisanello* 1988**
Da Pisanello alla nascita dei Musei Capitolini: L'antico a Roma alla vigilia del Rinascimento. Exh. cat. Musei Capitolini, Rome. Milan and Rome, 1988.

Planiscig 1927a
Planiscig, Leo. *Andrea Riccio*. Vienna, 1927.

Planiscig 1927b
Planiscig, Leo. "Bronzi minori di Leone Leoni." *Dedalo* 7 (1927): 544–67.

Planiscig 1932
Planiscig, Leo. "Maffeo Olivieri." *Dedalo* 12 (1932): 34–55.

Pliny 1855–57
Pliny [Gaius Plinius Secundus]. *The Natural History of Pliny*. 6 vols. Translated and edited by John Bostock and H. T. Riley. London, 1855–57.

Pliny 1940
Pliny [Gaius Plinius Secundus]. *Natural History*. Translated by H. Rackham. Vol. 3. Loeb Classical Library. London, 1940.

Plon 1883
Plon, Eugène. *Benvenuto Cellini: Orfèvre, médailleur, sculpteur. Recherches sur sa vie, sur son oeuvre et sur les pièces qui lui sont attribuées*. Paris, 1883.

Plon 1884
Plon, Eugène. *Benvenuto Cellini: Nouvel appendice aux recherches sur son oeuvre et sur les pièces qui lui sont attribuées*. Paris, 1884.

Plon 1887
Plon, Eugène. *Leone Leoni, sculpteur de Charles-Quint, et Pompeo Leoni, sculpteur de Philippe II. Les maîtres italiens au service de la Maison d'Autriche*. Paris, 1887.

Poey d'Avant 1858–62
Poey d'Avant, Faustin. *Monnaies feodales de France*. 3 vols. Paris, 1858–62. [Reprint, Paris, 1961.]

Poilleux 1842
Poilleux, Antony. *Le Duché de Valois pendant les quinzième et seizième siècles*. Paris, 1842.

Poliziano 1958
Poliziano, Angelo. *Della congiura dei Pazzi (Coniurationis commentarium)*. Edited by Alessandro Perosa. Padua, 1958.

Pollard 1970
Pollard, J. Graham. "Matthew Boulton and Conrad Heinrich Küchler." *Numismatic Chronicle*, 7th ser., 10 (1970): 259–318.

Pollard 1984–85
Pollard, J. Graham. *Medaglie italiane del Rinascimento nel Museo Nazionale del Bargello*. 3 vols. Florence, 1984–85.

Pollard 1990
Pollard, J. Graham. "England and the Italian Medal." In *England and the Continental Renaissance: Essays in Honour of J. B. Trapp*, edited by Edward Chaney and Peter Mack, pp. 191–201. Woodbridge, Suffolk, 1990.

Pollard 2007
Pollard, J. Graham. *Renaissance Medals*. 2 vols. Washington, D.C., and New York, 2007.

Pontieri 1969
Pontieri, Ernesto. *Per la storia del regno di Ferrante I d'Aragona, re di Napoli: Studi e ricerche*. 2nd ed. Naples, 1969.

Pope-Hennessy 1965
Pope-Hennessy, John. *Renaissance Bronzes from the Samuel H. Kress Collection: Reliefs, Plaquettes, Statuettes, Utensils and Mortars.* London, 1965.

Pope-Hennessy 1966
Pope-Hennessy, John. *The Portrait in the Renaissance.* London, 1966.

Pope-Hennessy 1985a
Pope-Hennessy, John. *Cellini.* London, 1985.

Pope-Hennessy 1985b
Pope-Hennessy, John. *Italian High Renaissance and Baroque Sculpture.* New York, 1985.

Pope-Hennessy 1985c
Pope-Hennessy, John. *Italian Renaissance Sculpture.* 3rd ed. New York, 1985.

Pope-Hennessy 1985d
Pope-Hennessy, John. Review of Hill 1930 (reprint, edited by J. Graham Pollard). *Medal* 7 (Autumn 1985): 55.

Pope-Hennessy and Hodgkinson 1970
Pope-Hennessy, John, and Terence W. I. Hodgkinson. *The Frick Collection: An Illustrated Catalogue.* Vol. 4, *German, Netherlandish, French and British Sculpture.* New York, 1970.

Popken sale 2014
Gold- und Silberprägungen, und andere Raritäten aus der Sammlung Friedrich Popken. Russische Münzen und Medaillen. Sale cat., no. 244. Fritz-Rudolf Künker, Osnabrück, February 6, 2014. [Sale held in Berlin.]

Popp 2015
Popp, Nathan Alan. "Expressions of Power: Queen Christina of Sweden and Patronage in Baroque Europe." PhD diss., University of Iowa, 2015.

Porcher 1921–22
Porcher, Jean. "Jean de Candida et le Cardinal de Saint-Denis." *Mélanges d'archéologie et d'histoire* 39 (1921–22): 319–26.

Porée 1891
Porée, Adolphe André. *François Bertinet: Modeleur et fondeur en médailles.* Paris, 1891.

Pötzl-Malíková 1969
Pötzl-Malíková, Maria. "Sochy na fasáde Primaciálného paláca v Bratislave." *Vlastivedný časopis* 18 (1969): 83–87.

Pötzl-Malíková 2009
Pötzl-Malíková, Maria. "Das Programm der Fassade des Primatialpalais in Pressburg (Bratislava): Ein kirchenpolitisches Manifest aus der Zeit des Josephinismus." In *Orbis Artium: K Jubileu Lubomíra Slavíčka*, edited by Jiří Kroupa, Michaela Šeferisová Loudová, and Lubomír Konečný, pp. 591–612. Brno, 2009.

Poulet and Scherf 1992
Poulet, Anne L., and Guilhem Scherf. *Clodion 1738–1814.* Exh. cat. Musée du Louvre. Paris, 1992.

Pradel 1963
Pradel, Pierre. *Henri Dropsy: Cinquante ans de médaille.* Monnaie de Paris, 1963.

Prag um 1600 1988
Prag um 1600: Kunst und Kultur am Hofe Kaiser Rudolfs II. 2 vols. Exh. cat. Kunsthistorisches Museum. Vienna, 1988.

Praun 1747
Praun, Georg. *Vollständiges Braunschweig-Lüneburgisches Münz- und Medaillen-Cabinett.* Helmstedt, 1747.

Probszt 1928
Probszt, Günther. *Die geprägten Schaumünzen Innerösterreichs (Steiermark, Kärnten, Krain).* Die geprägten österreichischen Schaumünzen. Zurich, 1928.

Probszt 1960
Probszt, Günther. *Ludwig Neufahrer: Ein Linzer Medailleur des 16. Jahrhunderts.* Vienna, 1960.

Probszt 1964
Probszt, Günther [Probszt-Ohstorff, Günther]. *Die Kärntner Medaillen, Abzeichen und Ehrenzeichen.* Klagenfurt, 1964.

Probszt 1975
Probszt, Günther. *Die Münzen Salzburgs.* 2nd ed. Basel and Graz, 1975.

Promis 1858
Promis, Domenico. *Monete dei Paleologi, marchesi di Monferrato.* Turin, 1858.

Promis 1873
Promis, Domenico. "Monete e medaglie italiane." In *Miscellanea di storia italiana*, vol. 13, pp. 697–717. Turin, 1873.

Proske 1943
Proske, Beatrice Gilman. "Leone Leoni's Medallic Types." *Notes Hispanic* 3 (1943): 48–57.

Puaux 1987
Puaux, Anne. *Madama, fille de Charles Quint: Régente des Pays-Bas.* Paris, 1987.

Puppi 1996
Puppi, Lionello, ed. *Pisanello: Una poetica dell'inatteso.* Cinisello Balsamo, 1996.

Pyke 1973
Pyke, Edward J. *A Biographical Dictionary of Wax Modellers.* Oxford, 1973.

Quynn 1941
Quynn, Dorothy MacKay. "Philipp von Stosch: Collector, Bibliophile, Spy, Thief (1611–1757)." *Catholic Historical Review* 27, no. 3 (1941): 332–44.

Raby 1980
Raby, Julian. "El Gran Turco: Mehmed the Conqueror as a Patron of the Arts of Christendom." PhD diss., University of Oxford, 1980.

Raby 1987
Raby, Julian. "Pride and Prejudice: Mehmed the Conqueror and the Italian Portrait Medal." In *Italian Medals*, edited by J. Graham Pollard, pp. 171–94. Studies in the History of Art, vol. 21. Center for Advanced Study in the Visual Arts, National Gallery of Art, Symposium Papers 8. Washington, D.C., 1987.

Rachfahl 1898
Rachfahl, Felix. *Margaretha von Parma, Statthalter der Niederlande (1559–1567)*. Munich, 1898.

Rady 1988
Rady, Martyn. *The Emperor Charles V*. London, 1988.

J. Rasmussen 1975
Rasmussen, Jörg. *Deutsche Kleinplastik der Renaissance und des Barock*. Bildhefte des Museums für Kunst und Gewerbe Hamburg, vol. 12. Hamburg, 1975.

J. Rasmussen 1976
Rasmussen, Jörg. "Untersuchungen zum Halleschen Heiltum des Kardinals Albrecht von Brandenburg. I." *Münchner Jahrbuch der bildenden Kunst*, 3rd ser., 27 (1976): 59–118.

J. Rasmussen 1983
Rasmussen, Jörg. "Kleinplastik unter Dürers Namen: Das New Yorker Rückenakt-Relief." *Städel-Jahrbuch*, n.s., 9 (1983): 131–44.

N. Rasmusson 1961
Rasmusson, Nils Ludvig. "Parise, Erich." In *Svenskt konstnärslexikon*, vol. 4, pp. 365–66. Malmö, 1961.

N. Rasmusson 1966
Rasmusson, Nils Ludwig. "Medaillen auf Christina: Eine Skizze." In *Queen Christina of Sweden: Documents and Studies*, edited by Magnus von Platen, pp. 296–321. Stockholm, 1966.

Rath 1993
Rath, Elisabeth. "Caroline Auguste (1792–1873): Kaiserliche Wohltäterin in Salzburg." In Karl Ehrenfellner, Elisabeth Rath, and Hubert Winkler, *Caroline Auguste (1792–1873), Namenspatronin des Salzburger Museums: Kaiserliche Wohltäterin in Salzburg*, pp. 15–161. Exh. cat. Salzburger Museum. Salzburg, 1993.

Rauch 2014
95. Münzenauktion, Katalog III: Medaillen und Römisch Deutsches Reich, in unserem Auktionssaal… Sale cat. H. D. Rauch, Vienna, September 30–October 2, 2014.

Rausch 1880
Rausch, Karl. *Der burgundische Heirat Maximilians I.* Vienna, 1880.

Ravegnani Morosini 1984
Ravegnani Morosini, Mario. *Signorie e principati: Monete italiane con ritratto, 1450–1796.* 3 vols. [San Marino] 1984.

Reallexikon zur deutschen Kunstgeschichte 1973
Reallexikon zur deutschen Kunstgeschichte. Vol. 6. Munich, 1973.

Reber 1990
Reber, Horst. *Albrecht von Brandenburg: Kurfürst, Erzhanzler, Kardinal, 1490–1545.* Exh. cat. Landesmuseum Mainz. Mainz, 1990.

"Receuil des médailles" ca. 1685
"Receuil des médailles." Ca. 1685. Manuscripts of the Royal Collection, Cabinet des Médailles, Paris.

Regling 1928
Regling, Kurt. "Medaillenstudien. II: Eine Fürstensuite von Valentin Maler, 1575." *Jahrbuch der Preussischen Kunstsammlungen* 49 (1928): 93–101.

Reilly 1953
Reilly, D. R. *Portrait Waxes: An Introduction for Collectors*. London, 1953.

Reinis 1999
Reinis, J. G. *The Portrait Medallions of David d'Angers: An Illustrated Catalogue of David's Contemporary and Retrospective Portraits in Bronze.* New York, 1999.

Reinis 2007
Reinis, J. G. *The Founders and Editors of the Barye Bronzes.* New York, 2007.

"Renaissance Bronze Portrait" 1933
"A Renaissance Bronze Portrait." *Bulletin of the Minneapolis Institute of Arts* 22, no. 18 (1933): 86–87.

Renaissance im deutschen Südwesten 1986
Die Renaissance im deutschen Südwesten. 2 vols. Exh. cat. Badisches Landesmuseum Karlsruhe. Karlsruhe, 1986.

Renaissance in Österreich 1974
Renaissance in Österreich. Exh. cat. Schloss Schallaburg. Vienna, 1974.

Renesse-Breidbach 1836
Renesse-Breidbach, Clément Wenceslas de. *Mes loisirs, amusemens numismatiques: Ouvrage posthume … publié par son fils.* Vol. 2, *Médailles et monnaies des empereurs, rois, électeurs, papes et personnes ecclesiastiques, comtes d'Anhalt, ducs de Bade et de Bavière.* Antwerp, 1836.

Renqvist 1931
Renqvist, Alvar. *Arvid Karlsteen: En medaljgravör och konstnär från karlarnes tid.* Helsinki, 1931.

Rentzmann 1865
Rentzmann, Wilhelm. *Numismatisches Legenden-Lexicon des Mittelalters und der Neuzeit.* Vol. 2. Berlin, 1865.

Reposati 1772
Reposati, Rinaldo. *Della zecca di Gubbio e delle gesta de' conti e duchi di Urbino.* Bologna, 1772.

Resch 1901
Resch, Adolf. *Siebenbürgische Münzen und Medaillen von 1538 bis zur Gegenwart.* Hermannstadt, 1901.

Reusner 1581
Reusner, Nicholas. *Emblemata.* Frankfurt am Main, 1581.

Reusner 1587
Reusner, Nikolaus. *Icones; sive, Imagines virorum literis illustrium, quorum fide et doctrina religionis et bonarum literarum studia nostra patrumque memoria, in Germania praesertim, in integrum sunt restituta.* Strasbourg, 1587.

Reusner 1589
Reusner, Nikolaus. *Icones; sive, Imagines viuoe, literis Cl. Virorum Italiae, Graeciae, Germaniae, Galliae, Angliae, Ungariae.* Basel, 1589.

Reynolds 1952–54
Reynolds, Graham. "Portraits by Nicholas Hilliard and His Assistants of King James I and His Family." *Walpole Society* 34 (1952–54): 14–26.

C. Ricci 1924
Ricci, Corrado. *Il Tempio Malatestiano.* Milan [1924]. [Reprint, with appendix by Pier Giorgio Pasini. Rimini, 1974.]

S. Ricci 1931
Ricci, Seymour de. *The Gustave Dreyfus Collection: Reliefs and Plaquettes.* Oxford, 1931.

Riechmann 1921
Kunstmedaillen des XVI. bis XX. Jahrhunderts von Deutschland, Niederlande, Frankreich, England. Sale cat. Foreword by Richard Gaettens. A. Riechmann & Co., Halle an der Saale, July 5–6, 1921.

Reimmann 1892
Reimmann, Johann Friedrich Christian. *Münzen- und medaillen-cabinet des justizraths.* Pt. 3. Frankfurt am Main, 1892.

Rietstap 1884–87
Rietstap, J. B. *Armorial général.* 2nd ed. 2 vols. Gouda, 1884–87. [Reprint, London, 1965.]

Rigoni 1970
Rigoni, Erice. *L'arte rinascimentale in Padova: Studi e documenti.* Padua, 1970.

Rinaldis 1913
Rinaldis, Aldo de. *Medaglie dei secoli XV e XVI nel Museo Nazionale di Napoli.* Naples, 1913.

Ripa 1618
Ripa, Cesare. *Iconologia.* Padua, 1618. [Reprint, edited by Piero Buscaroli. Milan, 1992.]

Rizzini 1892
Rizzini, Prospero. *Illustrazione dei civici musei di Brescia.* Vol. 2. *Medaglie: Serie Italiane.* 2 pts. Brescia, 1892.

Rizzoli 1902
Rizzoli, Luigi. "Due bassorilievi in bronzo di Giovanni da Cavino." *Bollettino del Museo Civico di Padova* 5 (1902): 69–76.

Rizzoli 1905
Rizzoli, Luigi. "Una medaglia del Bembo che non è opera di Benvenuto Cellini." *L'arte* 4 (1905): 276–80.

Rizzolli 1993
Rizzolli, Helmut. "I Madruzzo e le medaglie." In *I Madruzzo e l'Europa, 1539–1658: I principi vescovi di Trento tra Papato e Impero,* edited by Laura Dal Prà, pp. 437–53. Exh. cat. Castello del Buonconsiglio, Trento, and Chiesa dell'Inviolata, Riva del Garda. Milan, 1993.

Robinson 1856
Robinson, J. C. *Catalogue of the Soulages Collection; Being a Descriptive Inventory of a Collection of Works of Decorative Art, Formerly in the Possession of M. Jules Soulages of Toulouse …* London, 1856.

Rodríguez G. de Ceballos 1994
Rodríguez G. de Ceballos, Alfonso. "Forma, clientela e iconografía en las medallas de Leone y Pompeo Leoni." In *Los Leoni (1509–1608): Escultores del Renacimiento italiano al servicio de la corte de España.* Madrid, 1994.

Rodríguez G. de Ceballos 2000
Rodríguez G. de Ceballos, Alfonso. "El cardenal Granvela: Gestor y menor artístico de Felipe II." In *Felipe II y las artes: Actas del Congreso Internacional, 9–12 de diciembre de 1998,* pp. 149–60. Departamento de Historia del Arte II (Moderno), Facultad de Geografía e Historia, Universidad Complutense de Madrid. Madrid, 2000.

Roethlisberger 1985
Roethlisberger, Marcel. "The Drawing Collection of Prince Livio Odescalchi." *Master Drawings* 23–24, no. 1 (1985): 5–30.

Roggiero 1901
Roggiero, Orazio. *La zecca dei Marchesi di Saluzzo.* Pinerolo, 1901.

Rolas du Rosey sale 1863
Die numismatischen Sammlungen an Medaillen und Münzen nebst numismatischer Bibliothek, nachgelassen durch weiland Freiherrn Carl Rolas du Rosey… Sale cat. Auctioneer, A. G. Oehlschlägel. Dresden, September 1, 1863, and following days.

Ronchini 1865

Ronchini, A. "Leone Leoni d'Arezzo." *Atti e memorie delle RR. Deputazioni di Storia Patria per le Provincie Modenesi e Parmensi* 3 (1865): 9–41.

Ronchini 1870

Ronchini, A. "Il Pastorino da Siena." *Atti e memorie delle RR. Deputazioni di Storia Patria per le Provincie Modenesi e Parmensi* 5 (1870): 39–44.

Rondot 1883

Rondot, Natalis. *Jean Marende et la médaille de Philibert le Beau et de Marguerite d'Autriche.* Lyon, 1883.

Rondot 1884

Rondot, Natalis. *Les sculpteurs de Lyon, du quatorzième au dix huitième siècle.* Lyon and Paris, 1884.

Rondot 1885a

Rondot, Natalis. *Jacob Richier: Sculpteur et médailleur.* Lyon, 1885.

Rondot 1885b

Rondot, Natalis. *La médaille d'Anne de Bretagne et ses auteurs Louis Lepère, Nicolas de Florence et Jean Lepère, 1494.* Lyon and Paris, 1885.

Rondot 1887

Rondot, Natalis. *Jacques Gauvain: Orfèvre, graveur et médailleur à Lyon au seizième siècle.* Lyon, 1887.

Rondot 1888

Rondot, Natalis. *Claude Warin: Graveur et médailleur (1653–1654).* Paris, 1888.

Rondot 1902

Rondot, Natalis. "Pierre Woeiriot (1532–1587)." In *L'art et les artistes à Lyon du XIVe au XVIIIe siècle: Etudes posthumes…*, edited by Alfred Cartier and Léon Galle, pp. 273–87. Lyon, 1902.

Rondot 1904

Rondot, Natalis. *Les médailleurs et les graveurs de monnaies, jetons et médailles en France.* Paris, 1904.

Rosenheim and Hill 1907

Rosenheim, Max, and George Francis. "Notes on Some Italian Medals." *Burlington Magazine* 12 (December 1907): 141–54.

Rosenheim sale 1923

Rosenheim Collections: Catalogue of the Collection of Medals, Plaquettes and Coins; Chiefly of the Renaissance, Formed by the Late Max Rosenheim, Esq., F.S.A. and Maurice Rosenheim, Esq., F.S.A. Sale cat. Sotheby, Wilkinson & Hodge, London, April 30–May 4, 1923.

E. Rosenthal 1971

Rosenthal, Earl. "Plus ultra, Non plus ultra, and the Columnar Device of Emperor Charles V." *Journal of the Warburg and Courtauld Institutes* 34 (1971): 204–28.

Ross 1943

Ross, Marvin Chauncey. "An Iron Plaque of Filippo Strozzi." *Art in America* 31, no. 3 (July 1943): 151–53.

F. Rossi 1974

Rossi, Francesco. *Plachette, sec. XV–XIX: Catalogo.* Musei civici di Brescia. Cat. 1. Vicenza, 1974.

F. Rossi 1977

Rossi, Francesco. "Maffeo Olivieri e la bronzistica bresciana del '500." *Arte lombarda*, n.s., nos. 47–48 (1977): 115–34.

M. Rossi 2000

Rossi, Massimo. "Le medaglie." In *Monete e medaglie di Mantova e dei Gonzaga dal XII al XIX secolo: La collezione della Banca Agricola Mantovana*, vol. 8, *Le medaglie dei Gonzaga*, pp. 35–144. Milan, 2000.

U. Rossi 1886

Rossi, Umberto. "Ludovico e Giannantonio da Foligno: Orefici e medaglisti ferraresi." *Gazzetta numismatica* 6 (1886): 65–90.

U. Rossi 1888a

Rossi, Umberto. "Francesco Marchi e le medaglie di Marguerita d'Austria." *Rivista italiana di numismatica* 1 (1888): 333–50.

U. Rossi 1888b

Rossi, Umberto. "I medaglisti del Rinascimento alla corte di Mantova. II: Pier Jacopo Alari-Bonacolsi, detto l'Antico." *Rivista italiana di numismatica* 1 (1888): 161–94, 433–38.

U. Rossi 1888c

Rossi, Umberto. "Nuovi documenti: Pastorino a Reggio d'Emilia." *Archivio storico dell'arte* 1 (1888): 229–30.

U. Rossi 1890

Rossi, Umberto. "La collezione Carrand nel Museo Nazionale di Firenze. II." *Archivio storico dell'arte* 3 (1890): 30–31.

Rossmann 1956

Rossmann, Kurt. "Der Ottheinrichsbau." In *Ottheinrich: Gedenkschrift zur vierhundertjährigen Wiederkehr seiner Kurfürstenzeit in der Pfalz (1556–1559)*, edited by Georg Poensgen, pp. 261–73. Heidelberg, 1956.

Rosso 2015

Rosso, Paolo. "Processi di ridefinizione di un culto locale: Il martire 'tebeo' Costanzo nel quattrocentesco Sermo ad laudem marchionis Saluciarum del giurista e umanista Giacomo Falco." *Bollettino della Società per gli Studi Storici, Archeologici ed Artistici della Provincia di Cuneo* 152, no. 1 (2015): 65–99.

H. Rott 1905

Rott, Hans. *Ottheinrich und die Kunst.* Heidelberg, 1905.

H. Rott 1912
Rott, Hans. "Die Schriften des Pfalzgrafen Ott Heinrich." *Mitteilungen zur Geschichte des Heidelberger Schlosses* 6 (1912): 21–191.

H. Rott 1936
Rott, Hans. *Quellen und Forschungen zur südwestdeutschen und schweizerischen Kunstgeschichte im XV. und XVI. Jahrhundert.* Vol. 3, *Der Oberrhein.* Stuttgart, 1936.

Rouhette and Tuzio 2008
Rouhette, Thierry, and Francesco Tuzio. *Médailles françaises des XVe, XVIe et XVIIe siècles.* Musée des Beaux-Arts de Lyon, 2008.

Rowlands 1977
Rowlands, John. *Rubens Drawings and Sketches.* Exh. cat. British Museum. London, 1977.

Rowlands 1985
Rowlands, John. *Holbein: The Paintings of Hans Holbein the Younger.* Oxford, 1985.

Ruffert 2009
Ruffert, Lutz. *Medaillen Hamburg, 1549–2009: Katalog mit Preisen.* [Regenstauf] 2009.

Ruhmer 1960
Ruhmer, Eberhard. "Reliefs des Sperandio." *Pantheon* 18 (1960): 20–24.

Ruscelli 1566
Ruscelli, Girolamo. *Le imprese illustri con espositioni, et discorsi.* Venice, 1566.

Ryder 1976
Ryder, Alan. *The Kingdom of Naples under Alfonso the Magnanimous.* Oxford, 1976.

Ryder 1990
Ryder, Alan. *Alfonso the Magnanimous: King of Aragon, Naples, and Sicily, 1396–1458.* Oxford, 1990.

Sabbadini 1896
Sabbadini, Remigio. *La scuola e gli studi di Guarino Guarini Veronese.* Catania, 1896. [Summarized in *Enciclopedia italiana*, vol. 18, pp. 27–28. Milan, 1933.]

Sabbadini 1919
Sabbadini, Remigio, ed. *Epistolario di Guarino Veronese.* 3 vols. Venice, 1919.

Sakisian 1939
Sakisian, Armenag. "The Portraits of Mehmet II." *Burlington Magazine* 74 (April 1939): 172–81.

Sallet 1875
Sallet, Alfred von. "Medaillen Albrecht Dürers." *Zeitschrift für Numismatik* 2 (1875): 362–67.

Sallet 1884
Sallet, Alfred von. "Deutsche Gussmedaillen aus dem 16. und dem Beginn des 17. Jahrhunderts." *Zeitschrift für Numismatik* 11 (1884): 123–51.

Salmi 1957
Salmi, M. "Riflessioni sul Pisanello medaglista." *Annali dell'Istituto Italiano di Numismatica* 4 (1957): 13–23.

Salton Collection 1969
The Salton Collection: Renaissance and Baroque Medals and Plaquettes. Bowdoin College Museum of Art. Rev. ed. Brunswick, Maine, 1969.

Samaran 1944
Samaran, Charles. "Un exemplaire de luxe de l' 'Histoire de France abrégée' de Jean de Candida." *Bibliothèque de l'Ecole des Chartes* 105 (1944): 185–89.

Sambon sale 1914
Sammlung Dr. Arthur Sambon, Paris: Medaillen und Plaketten der Renaissance. Sale cat. Jacob Hirsch, Munich, May 9, 1914.

Sammlung … Otto Bally 1896–1911
Beschreibung von Münzen und Medaillen des Fürstenhauses und Landes Baden in chronologischer Reihenfolge aus der Sammlung des großherzoglich badischen Kommerzienraths Otto Bally in Säckingen. Aarau, 1896–1911.

Sanders 2013
Sanders, George. *Het present van Staat: De gouden ketens, kettingen en medailles verleend door de Staten-Generaal, 1588–1795.* Hilversum, 2013.

Sargentson and Bennett 2008
Sargentson, C., and S. Bennett, eds. *French Art of the Eighteenth Century at the Huntington.* New Haven, Conn., and London, 2008.

Sartori 1976
Sartori, Antonio. *Documenti per la storia dell'arte a Padova.* Vicenza, 1976.

Sauerländer 2008
Sauerländer, Willibald, ed. "Auszüge aus Samuel Quiccebergs Inscriptiones, 1565." In *Die Münchner Kunstkammer*, vol. 3, *Aufsätze und Anhänge*, edited by Willibald Sauerländer, pp. 346–61. Bayerische Akademie der Wissenschaften, Philosophisch-Historische Klasse, Abhandlungen, n.s., 129. Munich, 2008.

Saulcy 1841
Saulcy, Félicien de. *Recherches sur les monnaies des ducs héréditaires de Lorraine.* Metz, 1841.

Saumaise 1623
Saumaise, Pierre. *Eloge sur la vie de Pierre Janin*. Dijon, 1623.

Saur 1992–
Saur, K. G. *Allgemeines Künstler-Lexikon: Die bildenden Künstler aller Zeiten und Völker*. 92 vols. to date. Munich and Berlin, 1992–.

Scardeone 1560
Scardeone, Bernardino. *De antiquitate urbis Patavii et claris civibus Patavinis libri tres*. Basel, 1560.

Schadler 1987
Schadler, Alfred. "Zur Kleinplastik von Christoph Weiditz." *Münchner Jahrbuch der bildenden Kunst*, 3rd ser., 38 (1987): 161–84.

Schaeper 1995
Schaeper, Thomas J. *France and America in the Revolutionary Era: The Life of Jacques-Donatien Leray de Chaumont, 1725–1803*. Providence, 1995.

Schärli 1986
Schärli, Beatrice. *Erasmus von Rotterdam*. Exh. cat. Historisches Museum. Basel, 1986.

Scharloo 2012
Scharloo, Marjan. "Majesteitsschennis in metaal?" In Pelsdonk and Plomp 2012, pp. 25–39.

***Schaumünzen des Hauses Hohenzollern* 1901**
Schaumünzen des Hauses Hohenzollern. Exh. cat. Königliche Museen zu Berlin. Berlin, 1901.

Schembri 1908
Schembri, H. Calleja. *Coins and Medals of the Knights of Malta*. London, 1908. [Reprint, London, 1966.]

Scher 1961a
Scher, Stephen K. "Doppeltaler of Johann Friedrich I, Elector of Saxony." *Coat of Arms* 6, no. 48 (October 1961): 332–34.

Scher 1961b
Scher, Stephen K. "The Medals in the Collection of the Duke of Berry." Master's thesis, Institute of Fine Arts, New York University, 1961.

Scher 1986
Scher, Stephen K. "A Sixteenth Century Wax Model." Special issue, *Medal* 9 (Autumn 1986): 15–21.

Scher 1989a
Scher, Stephen K. "Immortalitas in Nummis: The Origins of the Italian Renaissance Medal." In *Trésors monétaires*, suppl. 2, pp. 1–19 and pls. I–IX. Paris, 1989.

Scher 1989b
Scher, Stephen K. "Veritas Odium Parit: Comments on a Medal of Pietro Aretino." *Medal* 14 (Spring 1989): 4–11.

Scher 1993a
Scher, Stephen K. "Connoisseurship of the Medal: A Supplement to the Exhibition Catalogue *The Currency of Fame: Portrait Medals of the Renaissance*." *Medal* 23 (Autumn 1993): 3–11.

Scher 1993b
Scher, Stephen K. "Germain Pilon et l'art de la médaille." In *Germain Pilon et les sculpteurs français de la Renaissance: Actes du colloque organisé au Musée du Louvre par le Service Culturel, les 26 et 27 octobre 1990*, pp. 131–59. Paris, 1993.

Scher 1994
Scher, Stephen K. *The Currency of Fame: Portrait Medals of the Renaissance*. Exh. cat. National Gallery of Art, Washington, D.C.; Frick Collection, New York; and National Gallery of Scotland, Edinburgh. New York, 1994.

Scher 1997
Scher, Stephen K. *The Proud Republic: Dutch Medals of the Golden Age*. Exh. cat. Frick Collection. New York, 1997.

Scher 2000
Scher, Stephen K., ed. *Perspectives on the Renaissance Medal*. New York, 2000. [Papers from two symposia held in conjunction with the exhibition *The Currency of Fame: Portrait Medals of the Renaissance*, at the National Gallery of Art, Washington, D.C., Frick Collection, New York, and National Gallery of Scotland, Edinburgh, in 1994 (see Scher 1994).]

Schindler 1985
Schindler, Herbert. *Augsburger Renaissance: Hans Daucher und die Bildhauer der Fuggerkapelle bei Sankt Anna*. Munich, 1985.

Schivenoglia 1857
Schivenoglia, Andrea. "Cronaca di Mantova dal 1445 al 1484." Edited by Carlo D'Arco. In *Raccolta di cronisti e documenti storici lombardi inediti*, vol. 2, pp. 119–94. Milan, 1857.

Schlosser 1910
Schlosser, Julius von. *Werke der Kleinplastik in der Skulpturensammlung des A. H. Kaiserhauses*. Vol. 2. Vienna, 1910.

Schlosser 1910–11
Schlosser, Julius von. "Geschichte der Porträtbildnerei in Wachs: Ein Versuch." *Jahrbuch der kunsthistorischen Sammlungen des Allerhöchsten Kaiserhauses* 29 (1910–11): 171–258.

S. Schmidt 1983
Schmidt, Siegfrid. "Numismatiker-Medaillen." *Berichte der Münzen- und Medaillensammler* 23 (1983): 1815–38, 1853–71.

Schneider 1990
Schneider, Laurie. "Leon Battista Alberti: Some Biographical Implications of the Winged Eye." *Art Bulletin* 72, no. 2 (June 1990): 261–70.

Schnell 1983

Schnell, Hugo. *Martin Luther und die Reformation auf Münzen und Medaillen*. Munich, 1983.

Scholten 1938

Scholten, C. "De medailleur Pool en eenige penningversjes." *Vondelkroniek* 9 (1938): 169–75.

Schönherr 1884

Schönherr, David: "Urkunden und Regesten aus dem k. k. Statthalterei-Archiv in Innsbruck." *Jahrbuch der kunsthistorischen Sammlungen des Allerhöchsten Kaiserhauses* 2 (1884): I–CLXXII.

Schulman (Jacob) 1912

Schulman, Jacob. *Collection Le Maistre. Pax in nummis; médailles, jetons et monnaies ayant rapport aux divers traités de paix conclus depuis le XVIe siècle jusqu' à nos jours*. Amsterdam, 1912.

Schulman (Jacques) 1956

Coins and Medals. [In Dutch and English.] Sale cat., no. 226. Jacques Schulman, Amsterdam, January 30–February 1, 1956.

Schulz 1988

Schulz, Karl. *Antonio Abondio und seine Zeit*. Exh. cat. Münzkabinett, Kunsthistorisches Museum. Vienna, 1988.

Schulz 1989–90

Schulz, Karl. "Bemerkungen zu Antonio Abondio." *Jahrbuch der kunsthistorischen Sammlungen in Wien* 85–86 (1989–90): 155–61.

A. Schumacher 2004

Schumacher, Andreas. "Leone Leonis Michelangelo-Medaille: Porträt und Glaubensbekenntnis des alten Buonarroti." In *Die Renaissance-Medaille in Italien und Deutschland*, edited by Georg Satzinger, pp. 169–94. Münster, 2004.

H. Schumacher 2007

Schumacher, Hans. *Medaillen der Stadt Bielefeld*. Regenstauf, 2007.

Schüssler 1998

Schüssler, Gosbert. "Marc Aurel als Knabe auf einer Medaille des Quattrocento." In *Gedenkschrift für Richard Harpath*, edited by Wolfgang Liebenwein and Anchise Tempestini, pp. 247–34. Munich/Berlin, 1998.

Schweizerisches Künstler-Lexikon 1908

Schweizerisches Künstler-Lexikon. Vol. 2. Edited by Carl Brun. Frauenfeld, 1908.

Sculpture in Miniature 1969

Sculpture in Miniature: The Andrew S. Ciechanowiecki Collection of Gilt and Gold Medals and Plaquettes. Catalogue of medals and plaquettes by Jacques Fischer, with Gay Seagrim. Exh. cat. J. B. Speed Art Museum, Louisville, Ky., and Museum of Fine Arts, Houston; 1969–70. Houston, 1969.

Scultura 1994–96

La scultura: Studi in onore di Andrew S. Ciechanowiecki. With contributions by Francis Haskell et al. 2 vols. *Antologia de belli arti*, nos. 48–51, 52–55. Turin, 1994–96.

Selbstbildnisse und Künstlerporträts 1980

Selbstbildnisse und Künstlerporträts von Lucas van Leyden bis Anton Raphael Mengs. Edited by Bodo Hedergott. Exh. cat. Herzog Anton Ulrich-Museum. Braunschweig, 1980.

Sellers 1962

Sellers, Charles Coleman. *Benjamin Franklin in Portraiture*. New Haven, Conn., 1962.

Sereno 2002

Sereno, Paola. "'Se volesti descrivere il Piemonte': Giovan Francesco Peverone e la cartografia come arte liberale." In *Rappresentare uno stato: Carte e cartografi degli stati sabaudi dal XVI al XVIII secolo*, vol. 1, pp. 33–46. Turin, 2002.

C.-A. Serrure 1881–82

Serrure, C.-A. "Deux médailles de Stephanus Hollander." *Bulletin mensuel de numismatique & d'archéologie* 1 (1881–82): 3–6.

Seward 1973

Seward, Desmond. *Prince of the Renaissance: The Life of François I*. London, 1973.

Seymour 1949

Seymour, Charles, Jr. *Masterpieces of Sculpture from the National Gallery of Art*. New York, 1949.

Seznec 1937

Seznec, Jean. "Youth, Innocence and Death: Some Notes on a Medallion on the Certosa of Pavia." *Journal of the Warburg Institute* 1, no. 4 (April 1937): 298–303.

Sheard 1978

Sheard, Wendy Stedman. *Antiquity in the Renaissance*. Exh. cat. Smith College Museum of Art. Northampton, Mass., 1978.

Sibille 2002

Sibille, Barbara. "Portraits sculptés des Lumières au Romantisme, autour de Jean-Baptiste Nini (1717–1786)." *Revue de la Société des Amis du Musée National de Céramique* 11 (2002): 9–20.

Siciliano 1956

Siciliano, Tommaso. "Memorie metalliche delle Due Sicilie 1600–1735." *Bollettino del circolo numismatico napoletano* 41 (1956): 3–97.

Siebmacher 1885–1904

Siebmacher, Johann. *Grosses und allgemeines Wappenbuch*. Nuremberg, 1885–1904.

Silver 1985
Silver, Larry. "Shining Armor: Maximilian I as Holy Roman Emperor." *Art Institute of Chicago Museum Studies* 12 (1985): 9–29.

Simon 1988
Simon, Kate. *A Renaissance Tapestry: The Gonzaga of Mantua*. New York, 1988.

Simonato 2008
Simonato, Lucia. *Impronta di Sua Santità: Urbano VIII e le medaglie*. Pisa, 2008.

Simonis 1900
Simonis, Julien. *L'art du médailleur en Belgique: Contributions à l'étude de son histoire*. Brussels, 1900.

Simonis 1904
Simonis, Julien. *L'art du médailleur en Belgique: Nouvelles contributions à l'étude de son histoire*. Jemeppe-sur-Meuse, 1904.

Sindona 1961
Sindona, Enio. *Pisanello*. Milan, 1961.

"Sitzungsberichte der Numismatischen Gesellschaft zu Berlin" 1898
"Sitzungsberichte der Numismatischen Gesellschaft zu Berlin." Supplement, *Zeitschrift für Numismatik* 21 (1898): 3–31.

Smirnov, Van Hoof, and Schoevaert 1990
Smirnov, V. P., François van Hoof, and André Schoevaert. *Description de médailles russes, 862–1908*. Alexandria, Va., 1990.

J. C. Smith 1983
Smith, Jeffrey Chipps. *Nuremberg: A Renaissance City, 1500–1618*. Exh. cat. Archer M. Huntington Art Gallery at the University of Texas at Austin. Austin, 1983.

J. C. Smith 1994
Smith, Jeffrey Chipps. *German Sculpture of the Later Renaissance, c. 1520–1580: Art in an Age of Uncertainty*. Princeton, N.J., 1994.

P. Smith 1964
Smith, Peter. "Mansart Studies II: The Val de Grâce." *Burlington Magazine* 106 (March 1964): 106–15.

Smolderen 1968
Smolderen, Luc. "Deux médailles à l'effigie de l'armateur anversois Gilles Hooftman." *Revue belge de numismatique* 114 (1968): 95–109.

Smolderen 1969a
Smolderen, Luc. "Jacques Jonghelinck: Waradin de la Monnaie d'Anvers de 1572 à 1606." *Revue belge de numismatique* 115 (1969): 83–247.

Smolderen 1969b
Smolderen, Luc. "Quentin Metsys: Médailleur d'Erasme." In *Scrinium Erasmianum*, edited by J. Coppens, vol. 2, pp. 513–25. Leiden, 1969.

Smolderen 1972
Smolderen, Luc. *La statue du duc d'Albe à Anvers par Jacques Jonghelinck, 1571*. Mémoires de l'Académie Royale de Belgique, Classe des beaux-arts, 2nd ser., 14, no. 1. Brussels, 1972.

Smolderen 1980–81
Smolderen, Luc. "Le tombeau de Charles le Téméraire." *Revue belge d'archéologie et d'histoire de l'art* 49–50 (1980–81): 21–53.

Smolderen 1984
Smolderen, Luc. "Jonghelinck en Italie." *Revue belge de numismatique* 130 (1984): 119–39.

Smolderen 1986
Smolderen, Luc. "Jean Second médailleur." *Handelingen van de Koninklijke Kring voor Oudheidkunden, Letteren en Kunst van Mechelen* 90 (1986): 61–86.

Smolderen 1990
Smolderen, Luc. "A propos de Guillaume Dupré." *Revue numismatique*, 6th ser., 32 (1990): 232–53.

Smolderen 1991
Smolderen, Luc. "Le séjour à Vienne de Conrad Bloc." *Revue belge de numismatique* 137 (1991): 159–64.

Smolderen 1996
Smolderen, Luc. *Jacques Jonghelinck: Sculpteur, médailleur et graveur de sceaux (1530–1606)*. Louvain-la-Neuve, 1996.

Smolderen 2009
Smolderen, Luc. *La médaille en Belgique des origines à nos jours*. Wetteren, 2009.

Sokol 1992
Sokol, Stanley S., with Sharon F. Mrotek Kissane. *The Polish Biographical Dictionary*. Wauconda, Ill., 1992.

Solms 1956
Solms, Ernstotto, Count zu. *Solmser Medaillen des 16. Jahrhunderts*. Solms-Laubach, 1956.

Sommer 1981
Sommer, Klaus. *Die Medaillen des königlich preussischen Hof-Medailleurs Daniel Friedrich Loos und seines Ateliers*. Osnabrück, 1981.

Sonntag 1989
Sonntag, Stefan. *Sammlung Herbert J. Erlanger: Nürnberg; Münzen, Marken und Medaillen von Nürnberg…* Zürich, 1989.

Sotheby's 1980
Sale cat. Sotheby Parke Bernet, Monaco, May 26–27, 1980.

Sotheby's 1988a
European Works of Art, Arms and Armour, Furniture and Tapestries. Sale cat. Sotheby's, New York, November 22–23, 1988.

Sotheby's 1988b
Renaissance Medals, Coins and Paper Money. Sale cat. Sotheby's, London, May 23–24, 1988.

South Kensington Museum 1868
"Inventory of Art Objects Acquired in the Year 1860." In South Kensington Museum, *Inventory of the Objects in the Art Division of the Museum at South Kensington, Arranged according to the Dates of Their Acquisition.* Vol. 1, *For the Years 1852 to the End of 1867.* London, 1868.

Spalatin 1851
Spalatin, Georg. *Friedrich des Weisen Leben und Zeitgeschichte.* Edited by Christian Gotthold Neudecker and Ludwig Preller. Jena, 1851.

Spätgotik am Oberrhein 1970
Spätgotik am Oberrhein: Meisterwerke der Plastik und des Kunsthandwerks, 1450–1530. Exh. cat. Badisches Landesmuseum Karlsruhe. Karlsruhe, 1970.

Specchio e il doppio 1987
Lo specchio e il doppio: Dallo stagno di Narciso allo schermo televisivo. Edited by Giulio Macchi and Maria Vitale. Exh. cat. Mole Antonelliana, Turin. Milan, 1987.

Spencer 1979
Spencer, John R. "Filarete: The Medallist of the Roman Emperors." *Art Bulletin* 61, no. 4 (December 1979): 551–61.

Spencer 1987
Spencer, John R. "Speculations on the Origins of the Italian Renaissance Medal." In *Italian Medals*, edited by J. Graham Pollard, pp. 197–203. Studies in the History of Art, vol. 21. Center for Advanced Study in the Visual Arts, National Gallery of Art, Symposium Papers 8. Washington, D.C., 1987.

Spicer-Simson 1962
Spicer-Simson, Theodore. *A Collector of Characters: Reminiscences of Theodore Spicer-Simson.* Miami, 1962.

Spitzer sale 1893
Catalogue des objets d'art et de haute curiosité: Antiques, du Moyen-Age & de la Renaissance; composant l'importante et précieuse Collection Spitzer. Sale cat. Paris, April 17–June 16, 1893.

Splendours of the Gonzaga 1981
Splendours of the Gonzaga. Edited by David Chambers and Jane Martineau. Exh. cat. Victoria & Albert Museum. London, 1981.

Sponsel 1927
Sponsel, Jean Louis. "Peter Flötner, nicht Hieronymus Magdeburger." *Zeitschrift für Numismatik* 37, nos. 1–4 (1927): 139–83.

Stahl 2009
Stahl, Alan M., ed. *The Rebirth of Antiquity: Numismatics, Archaeology, and Classical Studies in the Culture of the Renaissance.* Princeton, N.J., 2009.

Stahl and Waldman 1993–94
Stahl, Alan M., and Louis Waldman. "The Earliest Known Medalists: The Sesto Brothers of Venice." *American Journal of Numismatics*, 2nd ser., 5–6 (1993–94; pub. 1995): 167–88.

Stahr 1990
Stahr, Maria. *Medale Wazów w Polsce, 1587–1668.* Wrocław, 1990.

Stam 2016
Stam, David H., ed. *International Dictionary of Library Histories.* London, 2016.

Steguweit 2012
Steguweit, Wolfgang. "Die Dreifaltigkeitsmedaille von Hans Reinhart d. Ä. (um 1510–1581)." *MünzenRevue* 12 (2012): 141–47.

Steguweit 2015
Steguweit, Wolfgang. "Das `Numismatische Porträtarchiv Peter Berghaus' im Münzkabinett der Staatlichen Museen zu Berlin." *Numismatische Zeitschrift* 120/121 (2015): 415–59.

Steguweit 2017
Steguweit, Wolfgang. "'Meister der goldenen Medaillensuite um 1600': Untersuchungen zu Ihrer Entstehung und Verbreitung." In "Die andere Seite: Funktionen und Wissensformen der frühen Medaille," edited by Martin Hirsch and Ulrich Pfisterer, with Michael Alram and Walter Cupperi, special issue, *Numismatische Zeitschrift* 122/23 (2017): 147–60.

Steguweit and Kluge 2008
Steguweit, Wolfgang, and Bernd Kluge. *Suum Cuique: Medaillenkunst und Münzprägung in Brandenburg-Preussen.* Berlin, 2008.

Stein 1928
Stein, Henri. "Nouveaux documents sur Jean de Candida diplomate." *Bibliothèque de l'Ecole des Chartes* 89 (1928): 235–39.

Steinmann 1913
Steinmann, Ernst. *Die Porträtdarstellungen des Michelangelo.* Leipzig, 1913.

Stemper 1997
Stemper, Annelise. *Die Medaillen der Pfalzgrafen und Kurfürsten bei Rhein: Pfälzische Geschichte im Spiegel der Medaille.* Vol. 1. Worms, 1997.

Stenström 1944

Stenström, Stig. *Arvid Karlsteen: Hans liv och verk*. Göteborg, 1944.

Sterling 1963

Sterling, Charles. "Une peinture certaine de Perréal enfin retrouvée." *L'oeil* 103–4 (1963): 2–15, 64–65.

Stetten 1779

Stetten, Paul von. *Kunst-, Gewerb-, und Handwerks-Geschichte der Reichs-Stadt Augsburg*. Augsburg, 1779.

Van der Stock and Leesberg 2004

Van der Stock, Jan, and Marjolein Leesberg, eds. *Hollstein's Dutch & Flemish Etchings, Engravings and Woodcuts 1450–1700*. Vols. 65 and 68: The Wierix Family, Pts. 9 and 10. Rotterdam 2004.

Storelli 1896

Storelli, André. *Jean-Baptiste Nini: Sa vie, son oeuvre, 1717–1786*. Tours, 1896.

Storer 1923

Storer, Malcolm. *Numismatics of Massachusetts*. Boston, 1923. [Reprint, Lawrence, Mass., 1981.]

Storia di Milano 1953–66

Storia di Milano. Fondazione Treccani degli Alfieri per la Storia di Milano. Milan, 1953–66.

Stroehlin sale 1910

Catalogue of the Stroehlin Collection of Coins and Medals… Sale cat. Sotheby, Wilkinson & Hodge, London, May 30–June 8, 1910.

Strong 1969

Strong, Roy. *National Portrait Gallery: Tudor and Jacobean Portraits*. London, 1969.

Strong 1983

Strong, Roy, with V. J. Murrell. *Artists of the Tudor Court: The Portrait Miniature Rediscovered, 1520–1620*. Exh. cat. Victoria and Albert Museum. London, 1983.

Stübel 1706

Stübel, Andreas. *Der neu-bestellte Agent von Haus aus, mit allerhand curieusen; Missiven, Brieffen, Memorialien, Staffeten, Correspondencen und Commissionen, nach Erforderung der heutigen Staats- und gelehrten Welt*. Fonction 2, Depêche 6. Freyburg, 1706.

Suhle 1950

Suhle, Arthur. *Die deutsche Renaissance-Medaille*. Leipzig, 1950. [2nd ed., 1952.]

Summonte 1675

Summonte, Gio. Antonio. *Historia della città e regno di Napoli*. 2nd ed. Naples, 1675.

Supino 1899

Supino, I. B. *Il medagliere Mediceo nel R. Museo Nazionale di Firenze (secoli XV–XVI)*. Florence, 1899.

Syllabus 1822

Syllabus praesulum Jaurinensium ex diversis auctoribus secundum seriem documentorum publicorum et authenticorum conquisitus, novissime revisus ac supplemento auctus ab R. P. Romano a S. Venantio. Győr, 1822.

H. Symonds 1913

Symonds, Henry. "English Mint Engravers of the Tudor and Stuart Periods, 1485 to 1688." *Numismatic Chronicle*, 4th ser., 13 (1913): 349–77.

J. A. Symonds 1935

Symonds, John Addington. *The Renaissance in Italy*. 2 vols. New York, 1935.

Syson 1994

Syson, Luke. "The Circulation of Drawings for Medals in Fifteenth Century Italy." In *Designs on Posterity: Drawings for Medals*, edited by Mark Jones, pp. 10–26. London, 1994.

Syson 2004

Syson, Luke. "Bertoldo di Giovanni: Republican Court Artist." In *Artistic Exchange and Cultural Translation in the Italian Renaissance City*, edited by Stephen J. Campbell and Stephen J. Milner, pp. 96–133. Cambridge, 2004.

Syson and Thornton 2001

Syson, Luke, and Dora Thornton. *Objects of Virtue: Art in Renaissance Italy*. London, 2001.

Taylor 1983

Taylor, Lou. *Mourning Dress: A Costume and Social History*. London, 1983.

Telesko 2017–18

Telesko, Werner. *Aeternitas Augustae: zur Ikonographie Maria Theresias, in Zuhanden Ihrer Majestät: Medaillen Maria Theresias*, edited by Sabine Haag, pp. 37–43. Exh. cat. Kunsthistorisches Museum. Vienna, 2017–18.

Tentzel 1697

Tentzel, Wilhelm Ernst. *Die Medaillen und Müntzen derer durchlauchtigsten Chur- und Fürstinnen zu Sachsen bey dem höchst-erfreulichen Gebuhrts-Tage der durchlauchtigsten Fürstin und Frauen, Frauen Magdalenen Augusten Hertzogin zu Sachsen, Jülich, Cleve und Berg … den 12. Octobr. 1697. kürtzlich beschrieben*. N.p., 1697.

Tentzel 1699

Tentzel, Wilhelm Ernst. *Gedächtnißmüntzen auf Antritt der Regierung und Huldigungen bey dem Chur- und Fürstl. Hause Sachsen, als … Joh. Wilhelm Hertzog zu Sachsen … die Erbhuldigung zu Eisenach … eingenommen, … mit etlichen neuen Medaillen vermehret*. 1699.

Tentzel 1705
Tentzel, Wilhelm Ernst. *Saxonia numismatica … lineae Albertinae.* Dresden, 1705. [Reprint, 1982.]

Tentzel 1714
Tentzel, Wilhelm Ernst. *Sächsisches Medaillen-Cabinet von Gedächtnüss-Müntzen und Schau-Pfennigen…* Vol. 1. Frankfurt, 1714.

Terrasse 1930
Terrasse, Charles. *Germain Pilon.* Paris, 1930.

Terrasse 1943–70
Terrasse, Charles. *François I: Le roi et le règne.* 3 vols. Paris, 1943–70.

Tervarent 1958–64
Tervarent, Guy de. *Attributs et symboles dans l'art profane, 1450– 1600: Dictionnaire d'un langage perdu.* 3 vols. Geneva, 1958–64.

Teulet 1864
Teulet, Alexandre. *Liste chronologique et alphabétique des chevaliers et des officiers de l'Ordre du Saint-Esprit.* Paris, 1864.

***Thesaurus* 1723**
Thesaurus antiquitatem et historiarum Italiae. Vol. 9. Leiden, 1723.

***Thesaurus numismatum* 1789–90**
Thesaurus numismatum ex auro, argento et aere Graecorum et Romanorum, nec non Medii et recentioris Aevi, quae, dum vixit, collegit illustrissimus atq. excellentissimus dominus Dominus Otto Comes de Thott… Copenhagen, 1789–90.

Theuerkauff 1986
Theuerkauff, Christian. *Nachmittelalterliche Elfenbeine.* Berlin, 1986.

Thiel 2014
Thiel, Ursula B. *Der Bildhauer und Medaillenschneider Dietrich Schro und seine Werkstatt in Mainz (1542/44 –1572/73). Grabdenkmäler, Porträtmedaillen, Alabasterskulptur und Wappentafeln.* Vol. 134, *Quellen und Abhandlungen zur mittelrheinischen Kirchengeschichte.* Mainz, 2014.

Thieme and Becker 1907–50
Thieme, Ulrich, and Felix Becker, eds. *Allgemeines Lexikon der bildenden Künstler von der Antike bis zur Gegenwart.* 37 vols. Leipzig, 1907–50.

Tietjen 1991
Auktion: Münzen und Medaillen. Sale cat., no. 63. Tietjen + Co., Hamburg, October 17, 1991.

Tietjen 1992
Auktion: Münzen und Medaillen. Sale cat., no. 65. Tietjen + Co., Hamburg, May 11, 1992.

Tilley 1932
Tilley, Arthur. "The Literary Circle of Margaret of Navarre." In *A Miscellany of Studies of Romance Languages and Literatures Presented to Leon E. Kastner,* edited by Mary Williams and James A. de Rothschild, pp. 519–31. Cambridge, 1932.

Timann 1990
Timann, Ursula. "Zum Lebenslauf von Georg Pencz." *Anzeiger des Germanischen Nationalmuseums* (1990): 97–112.

Tiraboschi 1832
Tiraboschi, Girolamo. *Storia della letteratura italiana nel secolo XVIII.* Vol. 6. Venice, 1832.

Toderi and Vannel 1990
Toderi, Giuseppe, and Fiorenza Vannel. *Medaglie italiane barocche e neoclassiche.* Exh. cat. Museo Nazionale del Bargello. Florence, 1990.

Toderi and Vannel 2000
Toderi, Giuseppe, and Fiorenza Vannel. *Le medaglie italiane del XVI secolo.* 3 vols. Florence, 2000.

Tolles 1999
Tolles, Thayer, ed. *American Sculpture in the Metropolitan Museum of Art: A Catalogue of Works by Artists Born before 1865.* Vol. 1. New York, 1999.

Tomasini Pietramellara and Turchini 1985
Tomasini Pietramellara, Carla, and Angelo Turchini, eds. *Castel Sismondo e Sigismondo Pandolfo Malatesta.* Rimini, 1985.

Tommasoli 1978
Tommasoli, Walter. *La vita di Federico da Montefeltro (1422–1482).* Urbino, 1978.

Torre 2014
Torre, Simona. "Studio antropologico dei resti umani appartenenti alla famiglia principesca degli Aragona Tagliavia di Castelvetrano: L'importanza delle ossa nell'analisi storica in contesto archeologico-funerario." PhD diss., Università di Bologna, 2014.

Tourneur 1914
Tourneur, Victor. "Jehan de Candida: Diplomate et médailleur au service de la Maison de Bourgogne, 1472–1480." *Revue belge de numismatique* 70 (1914): 381–411.

Tourneur 1919a
Tourneur, Victor. "Jehan de Candida: Diplomate et médailleur au service de la Maison de Bourgogne, 1472–1480." *Revue belge de numismatique* 71 (1919): 7–48, 251–300.

Tourneur 1919b
Tourneur, Victor. "Société Royale de Numismatique: Extraits des Procès Verbaux." *Revue belge de numismatique* 71 (1919): 355–72.

Tourneur 1920
Tourneur, Victor. "La maison de Jacques Jongheling à Bruxelles." *Annales de la Société Royale d'Archéologie de Bruxelles* 29 (1920): 209–13.

Tourneur 1921
Tourneur, Victor. "Le médailleur anversois Steven van Herwijck (1557–1565)." *Revue belge de numismatique* 73 (1921): 27–55.

Tourneur 1922a
Tourneur, Victor. "Le médailleur Steven van Herwijck." *Revue belge de numismatique* 74 (1922): 209–11.

Tourneur 1922b
Tourneur, Victor. "Steven van Herwijck: Médailleur anversois (1557–1565)." *Numismatic Chronicle*, 5th ser., 2 (1922): 91–132.

Tourneur 1925a
Tourneur, Victor. "Conrad Bloc: Médailleur anversois." *Revue belge de numismatique* 77 (1925): 199–211.

Tourneur 1925b
Tourneur, Victor. "Jan Symons: Médailleur anversois." *Revue belge de numismatique* 77 (1925): 45–55.

Tourneur 1927
Tourneur, Victor. "Le médailleur Jacques Jongheling et le Cardinal Granvelle, 1564–1578." *Revue belge de numismatique* 79 (1927): 79–93.

Tourneur 1947
Tourneur, Victor. "Steven van Herwijck et les baillis de l'Ordre de Malte à Utrecht." *Revue belge de numismatique* 93 (1947): 59–66.

Toynbee 1944
Toynbee, Jocelyn M. C. *Roman Medallions*. New York, 1944. [Reprint, with an introduction by William E. Metcalf, New York, 1986.]

Trampitsch sale 1988
Collection Armand Trampitsch. Sale cat. Pt. 2. Hôtel George V, Paris. May 31–June 1, 1988.

Trau sale 1904
Auctions-Catalog der Sammlung des Herrn Franz Trau in Wien. Münzen und Medaillen fast aller Länder, vorzüglich von Oesterreich, der geistlichen und weltlichen Herren, griechische und römische Münzen… Sale cat. Brüder Egger, Vienna, January 11, 1904.

Traunfellner sale 1841
Verzeichniss der Münzen- und Medaillen-Sammlung des seel. Herrn Aloys Traunfellner in Klagenfurt, welche den 11. April 1842 und die folgende Tage … durch das Bücher- und Kunstsachen-Auctions-Institut gegen gleich baare Bezahlung in Conventions-Münze wird veräussert werden. Sale cat. Vienna, 1841. [Sale held April 11, 1842, and following days.]

Trautmann 1869
Trautmann, Franz. *Kunst und Kunstgewerbe vom frühesten Mittelalter bis Ende des achtzehnten Jahrhunderts: Ein Hand- und Nachschlagebuch…* Nördlingen, 1869.

Trease 1971
Trease, Geoffrey. *The Condottieri*. New York, 1971.

Trento 1984
Trento, Daria. *Benvenuto Cellini: Opere non esposte e documenti notarili*. Florence, 1984.

Trésor de numismatique 1834–58
Trésor de numismatique et de glyptique; ou, Recueil général de médailles, monnaies, pierres gravées, bas-reliefs, etc. tant anciens que modernes, les plus intéressants sous le rapport de l'art et de l'histoire. Edited by Achille Collas, Paul Delaroche, Louis Pierre Henriquel-Dupont, and Charles Lenormant. 20 vols. Paris, 1834–58.

Treu 1959
Treu, Erwin. *Die Bildnisse des Erasmus von Rotterdam*. Basel, 1959.

Trevor-Roper 1976
Trevor-Roper, Hugh. *Princes and Artists: Patronage and Ideology at Four Hapsburg Courts, 1517–1633*. London, 1976.

Tribolati 1955
Tribolati, Pietro. "Due grandi incisori di conii della zecca 'cesarea' Milanese: Leone Leoni da Arezzo, Iacopo da Trezzo." *Rivista italiana di numismatica e scienze affini* 57 (1955): 94–102.

Tricou 1953
Tricou, Jean. "Quelques médailles rares du Musée de Lyon, XVI–XVIIIe." In *Exposition internationale de numismatique*. Exh. cat. Monnaie de Paris. Paris, 1953.

Tricou 1958
Tricou, Jean. *Médailles lyonnaises du XVe siècle au XVIIIe siècle*. Paris, 1958.

Trogan and Sorel 2000
Trogan, Rosine, and Philippe Sorel. *Augustin Dupré (1748–1833): Graveur général des Monnaies de France: Collections du musée Carnavalet*. Paris, 2000.

Trusted 1990
Trusted, Marjorie. *German Renaissance Medals: A Catalogue of the Collection in the Victoria & Albert Museum*. London, 1990.

Trusted 2007
Trusted, Marjorie, ed. *The Making of Sculpture: The Materials and Techniques of European Sculpture*. London, 2007.

P. Tuttle 1987
Tuttle, Patricia. "An Investigation of the Renaissance Casting Techniques of Incuse-Reverse and Double-Sided Medals." In *Italian Medals*, edited by J. Graham Pollard, pp. 205–12. Studies in the History of Art, vol. 21. Center for Advanced Study in the Visual Arts, National Gallery of Art, Symposium Papers 8. Washington, D.C., 1987.

R. Tuttle 1987
Tuttle, Richard J. "*Bononia Resurgens*: A Medallic History by Pier Donato Cesi." In *Italian Medals*, edited by J. Graham Pollard, pp. 215–46. Studies in the History of Art, vol. 21. Center for Advanced Study in the Visual Arts, National Gallery of Art, Symposium Papers 8. Washington, D.C., 1987.

Typotius 1601–3
Typotius, Jacob. *Symbola divina et humana*. 2 vols. Prague, 1601–3.

UBS 2001
Gold- und Silbermünzen. Sale cat, no. 52. UBS AG Gold & Numismatik, Hotel Savoy-Baur en Ville, Zurich, September 11–13, 2001.

UBS 2006
Gold- und Silbermünzen. Sale cat, no. 67. UBS AG Gold & Numismatik, Hotel Savoy-Baur en Ville, Zurich, September 6–8, 2006.

***Ultimi Medici* 1974**
Gli ultimi Medici: Il tardo barocco a Firenze, 1670–1743. Exh. cat. Detroit Institute of Arts and Palazzo Pitti. Florence, 1974.

Umberto di Savoia 1980
U. di S. [Umberto di Savoia]. *Le medaglie della Casa di Savoia*. Rome, 1980.

Valerianus 1556
Johannes Pierius Valerianus. *Hieroglyphica; sive, De sacris Aegyptiorum literis commentarii*. Basel, 1556.

Vannel and Toderi 1987
Vannel, Fiorenza, and Giuseppe Toderi. *La Medaglia Barocca in Toscana*. Florence, 1987.

Vannel and Toderi 1998
Vannel, Fiorenza, and Giuseppe Toderi. *Medaglie e placchette del Museo Bardini di Firenze*. Florence, 1998.

Vannel and Toderi 2001
Vannel, Fiorenza, and Giuseppe Toderi. "Alcune medaglie inedite del Pastorino in Le Stagioni." In *Le stagioni della medaglia italiana: Atti del Sesto Convegno Internazionale di Studio sulla Storia della Medaglia, 17–19 dicembre 1998, Salone della Fondazione CRUP, Cassa di Risparmio di Udine e Pordenone, Sala Consigliare del Municipio di Buia,* edited by Giovanni Gorini, pp. 87–94. Padua, 2001.

Vannel and Toderi 2003–7
Vannel, Fiorenza, and Giuseppe Toderi. *Medaglie italiane del Museo Nazionale del Bargello*. 4 vols. Florence, 2003–7.

Varesi 1998–2011
Varesi, A. Iberto, et al. *Monete italiane regionali*. Pavia, 1998–2011.

Varriano 1987
Varriano, John. "Alexander VII, Bernini, and the Baroque Papal Medal." In *Italian Medals*, edited by J. Graham Pollard, pp. 249–60. Studies in the History of Art, vol. 21. Center for Advanced Study in the Visual Arts, National Gallery of Art, Symposium Papers 8. Washington, D.C., 1987.

Vasari 1878–85
Vasari, Giorgio. *Le vite de' più eccellenti pittori, scultori ed architettori*. Edited by Gaetano Milanese. 8 vols. Florence, 1878–85. [2nd ed., 1906.]

Vasari 1896
Vasari, Giorgio. *Le vite dei più eccellenti pittori, scultori e architettori, scritte da M. Giorgio Vasari, pittore et architetto Aretino*. Vol. 1, *Gentile da Fabriano e il Pisanello*. Edited by Adolfo Venturi. Florence, 1896.

Vasari 1960
Vasari, Giorgio. *Vasari on Technique*. Translated by Louisa S. Maclehose. New York, 1960.

Vasari 1962
Vasari, Giorgio. *La vita di Michelangelo, nelle redazioni del 1550 e del 1568*. Edited by Paola Barocchi. 5 vols. Milan, 1962.

Vasari 1966–87
Vasari, Giorgio. *Le vite de' più eccellenti pittori, scultori e architettori, nelle redazioni del 1550 e 1568*. Edited by Paola Barocchi and Rosanna Bettarini. 8 vols. Florence, 1966–87.

Vaudoyer 1925
Vaudoyer, Jean-Louis. "La collection Gustave Dreyfus." *L'amour de l'art* (1925): 245–64.

Veit 1976
Veit, Ludwig. "Der Einfluss der italienischen Renaissance-Medaille auf die deut[s]che Renaissance-Medaille." In *L'influenza della medaglia italiana nell'Europa dei sec. XV° e XVI°: Atti del Convegno II° Internazionale di Studio, Udine 6/9 ottobre 1973*, pp. 97–117. Udine, 1976.

Van de Ven 1959
Van de Ven, A. J. "De zestien kwartieren van George van Egmond, bisschop van Utrecht." *Jaarboekje van Oud-Utrecht* (1959): 87–99.

Venturi 1885
Venturi, Adolfo. "Ein Brief des Sperandio." *Der Kunstfreund* 1 (1885): 278–79.

Venturi 1888a
Venturi, Adolfo. "Leone Leoni incisore della zecca del duca di Ferrara." *Archivio storico dell'arte* 1 (1888): 327–28.

Venturi 1888b
Venturi, Adolfo."Sperandio da Mantova." *Archivio storico dell'arte* 1 (1888): 385–97.

Venturi 1889
Venturi, Adolfo. "Sperandio da Mantova (appendice)." *Archivio storico dell'arte* 2 (1889): 229–34.

Venturi 1891
Venturi, Adolfo. "Costanzo: Medaglista e pittore." *Archivio storico dell'arte* 4 (1891): 374–75.

Venturi 1901–40
Venturi, Adolfo. *Storia dell'arte italiana*. 11 vols. Milan, 1901–40. [Reprint, Nendeln, Liechtenstein, 1967. Index, edited by Jacqueline D. Sisson, 2 vols. Nendeln, 1975.]

Venturi 1935a
Venturi, Adolfo. *Storia dell'arte italiana*. Vol. 10, *La scultura del Cinquecento*. Pt. 1. Milan, 1935.

Venturi 1935b
Venturi, Adolfo. "Su alcune medaglie di Pisanello." *L'arte* 38, no. 6 (1935): 30–38.

Venturi 1939
Venturi, Adolfo. *Pisanello*. Rome, 1939.

Venuti 1744
Venuti, Ridolfino. *Numismata Romanorum pontificum praestantiora a Martino V ad Benedictum XIV*. Rome, 1744.

Verlet 1987
Verlet, Pierre. *Les bronzes dorés français du XVIIIe siècle*. Paris, 1987.

Verly 1860
Verly, Charles-Narcisse. *Catalogue du musée archéologique et numismatique de la ville de Lille*. Lille, 1860.

Vermeule 1952
Vermeule, Cornelius C. "An Imperial Medallion of Leone Leoni and Giovanni Bologna's Statue of the Flying Mercury." *Numismatic Circular* (Spink & Son) (1952): 509–10.

Vermeule 1987
Vermeule, Cornelius C. "Graeco-Roman Asia Minor to Renaissance Italy: Medallic and Related Arts." In *Italian Medals*, edited by J. Graham Pollard, pp. 263–81. Studies in the History of Art, vol. 21. Center for Advanced Study in the Visual Arts, National Gallery of Art, Symposium Papers 8. Washington, D.C., 1987.

Vermeylen 1902
Vermeylen, Frantz. "Quelques mots sur François Bertinet, à propos d'un médaillon de Louis XIV." *Revue belge de numismatique* 58 (1902): 343–54.

***Vernon Hall Collection* 1978**
Catalogue of the Vernon Hall Collection of European Medals. Elvehjem Museum of Art, University of Wisconsin. Madison, Wisc., 1978.

Vesco 2010
Vesco, Maurizio. "Carlo d'Aragona e la politica urbanistica del Senato palermitano: Alcuni progetti per il rinnovamento della città." In *Manierismo siciliano: Antonino Ferraro da Giuliana e l'età di Filippo II di Spagna; Atti del Convegno di Studi di Giuliana, Castello Federiciano, 18–20 ottobre 2009*, edited by Antonino Giuseppe Marchese, pp. 227–52. Palermo, 2010.

Vespasiano da Bisticci 1951
Vespasiano da Bisticci. *Vite di uomini illustri del secolo XV*. Edited by P. d'Ancona and E. Aeschlimann. Milan, 1951.

Vespasiano da Bisticci 1963
Vespasiano da Bisticci. *Renaissance Princes, Popes and Prelates: The Vespasiano Memoirs. Lives of Illustrious Men of the XVth Century*. Introduction by Myron P. Gilmore. Translated by William George Waters and Emily Waters. New York, 1963.

Vickers 1978
Vickers, Michael. "Some Preparatory Drawings for Pisanello's Medallion of John VIII Paleologus." *Art Bulletin* 60, no. 3 (September 1978): 417–24.

Vico 1555
Vico, Enea. *Discorsi sopra le medaglie degli antichi*. Venice, 1555.

Vidal Quadras y Ramón 1892
Vidal Quadras y Ramón, Manuel. *Catálogo de la colección de monedas y medallas de Manuel Vidal Quadras y Ramón de Barcelona*. 4 vols. Barcelona, 1892. [Reprint, Barcelona, 1975.]

Viljoen 2003
Viljoen, Madeleine. "Paper Value: Marcantonio Raimondi's *Medaglie contraffatte*." *Memoirs of the American Academy in Rome* 48 (2003): 203–26.

Villari 1888
Villari, Pasquale. *Life and Times of Girolamo Savonarola*. London, 1888.

Villena 2004
Villena, Elvira. *El arte de la medalla en la España illustrada*. Exh. cat. Centro cultural Conde Duque. Madrid, 2004.

Villers 1862
Villers, Alfred. *Jean-Baptiste Nini: Ses terres cuites*. Blois, 1862.

Visschers 1853
Visschers, P. *Iets over Jacob Jonghelinck, metaelgieter en penningsnijder, Octavio van Veen … en de gebroeders Collyns de Nole…* Antwerp, 1853.

***Vite e ritratti* 1812–20**
Vite e ritratti d'illustri italiani. 2 vols. Padua, 1812–20.

Vives 1916
Vives, Antonio. *Medallas de la Casa de Borbón, de d. Amadeo I, del gobierno provisional y de la República Española*. Madrid, 1916.

Vöge 1910
Vöge, Wilhelm. *Beschreibung der Bildwerke der christlichen Epochen*. Vol. 4, *Die deutschen Bildwerke und die der anderen cisalpinen Länder*. 2nd ed. Königliche Museen zu Berlin. Berlin, 1910.

Vogel sale 1924
Sammlung †Geheimrat Hermann Vogel, Chemnitz. Pt. 1, *Kunstmedaillen*. Sale cat. Leo Hamburger, Frankfurt am Main, November 4, 1924.

Vogel sale 1928
Sammlung Vogel: Schweiz, Sachsen; ernestinische Linie, albertinische Linie, Hamburg, Lübeck, Bremen. Sale cat. Adolph Hess Nachfolger, Frankfurt am Main, October 8, 1928, and following days.

Voglhuber 1971
Voglhuber, Rudolf. *Taler und Schautaler des Erzhauses Habsburg von Erzherzog Sigismund von Tirol 1484 bis Kaiser Franz Josef I. 1896*. [Reprint, Frankfurt, 1971.]

Voigtmann 2012
Voigtmann, Carolien. "Joost van den Vondels penningpoëzie." In Pelsdonk and Plomp 2012, pp. 41–49.

Voisin 2002
Voisin, Marie-Astrid [Marie-Astrid Pelsdonk]. "Aspekter på svenskt barocksilver: Klenoder och nådetecken." In *Silverskatter från svensk stormaktstid*, pp. 89, 102–3. Exh. cat. Nationalmuseum, Stockholm. Nationalmusei utställningskatalog, no. 596. Stockholm, 2002.

Voisin 2003
Voisin, Marie-Astrid [Marie-Astrid Pelsdonk]. "Aspekter på svenskt barocksilver: Klenoder och nådetecken." In *Silver: Makt och prakt i barockens Sverige*, pp. 106–7, 217–19. Exh. cat. Nationalmuseum, Stockholm. Nationalmusei utställningskatalog, no. 633. Stockholm, 2003.

Voisin 2005
Voisin, Marie-Astrid [Marie-Astrid Pelsdonk]. "Le Cabinet Royal des Monnaies et Médailles de Stockholm: Son histoire dans le domaine de l'art de la médaille." *Medal* 46 (Spring 2005): 44–55.

Vollenweider 1966
Vollenweider, Marie-Louise. *Die Steinschneidekunst*. Stuttgart, 1966.

Voltolina 1998
Voltolina, Piero. *La storia di Venezia attraverso le medaglie*. 3 vols. Milan, 1998.

Volz 1972
Volz, Peter. "Conrad Peutinger und das Entstehen der deutschen Medaillensitte zu Augsburg 1518." PhD diss., Universität Heidelberg, 1972.

Volz 1981–82
Volz, Peter. "Unbekannte deutsche Schaumünzen des 16. Jahrhunderts." *Jahrbuch für Numismatik und Geldgeschichte* 31–32 (1981–82): 141–47.

Volz 1992–93
Volz, Peter. "Unbekannte deutsche Schaumünzen des 16. Jahrhunderts." *Jahrbuch für Numismatik und Geldgeschichte* 42–43 (1982–83): 249–50.

Volz 2013
Volz, Peter. *Medaillen und Plaketten der Renaissance aus einer Schweizer Privatsammlung*. Munich, 2013.

Volz and Jokisch 2008
Volz, Peter, and Hans Christoph Jokisch. *Emblems of Eminence: German Renaissance Portrait Medals—The Age of Albrecht Dürer. The Collection of an Art Connoisseur*. Munich, 2008.

***Vom Taler zum Dollar* 1986**
Vom Taler zum Dollar, 1486–1986. Exh. cat. Staatliche Münzsammlung. Munich, 1986.

Voogt 1867
Voogt, W. J., de. "Deux médailles du graveur Etienne de Hollande: Cesilia Veeselar—Floris Allewijn." *Revue belge de numismatique*, 4th ser., 5 (1867): 347–49.

Vossberg 1844
Vossberg [Friedrich August]. "Danziger Denkmünzen des sechzehnten Jahrhunderts." *Zeitschrift für Münz-, Siegel- und Wappenkunde* 4 (1844): 227–32.

Vossberg 1852
Vossberg, Friedrich August. *Münzgeschichte der Stadt Danzig*. Berlin, 1852.

Waddington 1989a
Waddington, Raymond B. "Before Arcimboldo: Composite Portraits on Italian Medals." *Medal* 14 (Spring 1989): 13–23.

Waddington 1989b
Waddington, Raymond B. "A Satirist's Impresa: The Medals of Pietro Aretino." *Renaissance Quarterly* 42 (1989): 655–81.

Waddington 2004
Waddington, Raymond B. *Aretino's Satyr: Sexuality, Satire and Self-Projection in Sixteenth-Century Literature and Art*. Toronto, 2004.

Waldman 1991
Waldman, Louis. "A Rare Sixteenth-Century Jugate Medal of the Hapsburgs." *Medal* 19 (Autumn 1991): 3–19.

Waldman 1992
Waldman, Louis. "Varrone d'Agniolo Belferdino's Commemorative Medal of an Unknown Lady." *American Journal of Numismatics*, 2nd ser., 3–4 (1992): 105–16.

Waldman 1994
Waldman, Louis. "The Genesis of Pompeo Leoni's 'Patience.'" In *Designs on Posterity: Drawings for Medals*, edited by Mark Jones, pp. 52–63. Papers read at the 23rd Congress of the Fédération Internationale de la Médaille, London, September 16–19, 1992. London, 1994.

Walker 1983
Walker, John. *Portraits: 5000 Years*. New York, 1983.

Wallenstein 2012
Wallenstein, Uta. "Die Sammlungsbereiche des Gothaer Münzkabinetts." In *Gothas Gold: 330 Jahre Münzkabinett*, edited by Martin Eberle, pp. 23–146. Gotha, 2012.

Walther 1983
Walther, Hans. *Carmina Medii Aevi posterioris Latina*. Vol. 2, pt. 8, *Lateinische Sprichwörter und Sentenzen des Mittelalters und der frühen Neuzeit in alphabetischer Anordnung*. New series. Göttingen, 1983.

Watkins 1960
Watkins, Renée. "L. B. Alberti's Emblem, the Winged Eye, and His Name, Leo." *Mitteilungen des Kunsthistorischen Institutes in Florenz* 9 (November 1960): 256–58.

F. P. Weber 1910
Weber, F. Parkes. *Aspects of Death in Art*. London, 1910.

I. S. Weber 1975
Weber, Ingrid [S.]. *Deutsche, Niederländische und Französische Renaissanceplaketten, 1500–1650*. 2 vols. Munich, 1975.

I. S. Weber 1985
Weber, Ingrid S. *Maximilian Dasio, 1865–1954: Münchner Maler, Medailleur und Ministerialrat*. Exh. cat. Neue Pinakothek. Munich, 1985.

I. S. Weber 1989
Weber, Ingrid S. "Prägeanstalt Carl Poellath Schrobenhausen: Ausgangspunkt und langjähriges Zentrum der Münchner Medaillenkunst des 20. Jahrhunderts." *Jahrbuch für Numismatik und Geldgeschichte* 39 (1989; pub. 1991): 57–98.

Weihrauch 1967
Weihrauch, Hans Robert. *Europäische Bronzestatuetten, 15.–18. Jahrhundert*. Braunschweig, 1967.

Weiler 1970–81
Weiler, Hanno. *Kölnische Medaillen, Plaketten, Schautaler, Jetons, Marken und Zeichen*. 2 vols. Krefeld, 1970–81.

Weiler 1977–79
Weiler, Hanno. *Kölner Dom-Medaillen*. 3 vols. Krefeld-Hüls, 1977–79.

Weiller 1979
Weiller, Raymond. *Les médailles dans l'histoire du pays de Luxembourg*. Institut Supérieur d'Archéologie et d'Histoire de l'Art de l'Université Catholique de Louvain. Louvain-la-Neuve, 1979.

Weinberger 1930
Weinberger, M. "Sperandio und die Frage der Francia-Skulpturen." *Münchner Jahrbuch der bildenden Kunst*, n.s., 7 (1930): 293–318.

Weinkopf 1875
Weinkopf, Anton von. *Anton Weinkopf's Beschreibung der k. k. Akademie der bildenden Künste in Wien, 1783 und 1790*. Vienna, 1875.

Weinstein 1971
Weinstein, Donald. *Savonarola and Florence: Prophecy and Patriotism in the Renaissance*. Princeton, N.J., 1971.

D. J. Weiss 1991
Weiss, Dieter J. "Melchior Pfinzing (1481–1535)." In *Fränkische Lebensbilder* 14, pp. 14–29. Veröffentlichungen der Gesellschaft für fränkische Geschichte, ser. VII A. Neustadt/Aisch, 1991.

R. Weiss 1960
Weiss, Roberto. "Une médaille à demi connue de Lysippus le jeune." *Schweizer Münzblätter* 10, no. 37 (May 1960): 7–10.

R. Weiss 1965
Weiss, Roberto. "The Medals of Pope Julius II (1503–1513)." *Journal of the Warburg and Courtauld Institutes* 28 (1965): 163–82.

R. Weiss 1966
Weiss, Roberto. *Pisanello's Medallion of the Emperor John VIII Paleologus*. London, 1966.

R. Weiss 1969
Weiss, Roberto. *The Renaissance Discovery of Classical Antiquity*. Oxford, 1969.

Wellenheim sale 1844
Verzeichniss der Münz- und Medaillen-Sammlung des kaiserl. königl. Hofrathes und Mitgliedes mehrerer gelehrten Gesellschaften, Herrn Leopold Welzl von Wellenheim. Vol. 2, pt. 1, *Die öffentliche Versteigerung beginnt am 10. Februar 1845*. Vienna, 1844.

Wellens-de Donder 1959a
Wellens-de Donder, Liliane. "La médaille 'Venus et l'Amour' de Steven van Herwijck." *Revue belge de numismatique* 105 (1959): 165–70.

Wellens-de Donder 1959b
Wellens-de Donder, Liliane. *Médailleurs et numismates de la Renaissance aux Pays-Bas.* Exh. cat. Bibliothèque Royale de Belgique. Brussels, 1959.

Wellens-de Donder 1960
Wellens-de Donder, Liliane. "Documents inédits relatifs à Jacques Jonghelinck." *Revue belge de numismatique* 106 (1960): 295–305.

Wellington 2015
Wellington, Robert. *Antiquarianism and the Visual Histories of Louis XIV: Artifacts for a Future Past.* Burlington, Vt., 2015.

Welt im Umbruch 1980
Welt im Umbruch: Augsburg zwischen Renaissance und Barock. 2 vols. Exh. cat. Rathaus and Zeughaus. Augsburg, 1980.

Wenzel Jamnitzer 1985
Wenzel Jamnitzer und die Nürnberger Goldschmiedekunst, 1500–1700. Exh. cat. Germanisches Nationalmuseum Nürnberg. Munich, 1985.

Werd 1977
Werd, G. de. "Porträts des Herzogs Johann Wilhelm von Kleve." *Kalender für das Kleverland* (1977): 49–51.

Wermuth 1714
Wermuth, Christian. *Specificatio Wermuthischer-Medaillen, allen curieusen Medaillen-Freunden zu dienstlicher Nachricht.* N.p., 1714.

Westermark 1971
Westermark, Ulla. *Johann Carl Hedlinger, 1691–1771: En schweizare i Sverige.* Stockholm, 1971.

Westfälische Auktionsgesellschaft 1998a
Medaillenkunst aus fünf Jahrhunderten. Sale cat, no. 11. Westfälische Auktionsgesellschaft für Münzen und Medaillen, Udo Gans, Heinz-Günther Hild, Manfred Olding, Dortmund, March 23, 1998.

Westfälische Auktionsgesellschaft 1998b
Brandenburg, Preußen: Mittelalter Sachsen, Medaillen… Sale cat, no. 12. Westfälische Auktionsgesellschaft für Münzen und Medaillen, Udo Gans, Heinz-Günther Hild, Manfred Olding, Dortmund, March 23–24, 1998.

Westfälische Auktionsgesellschaft 2012
Altdeutsche Münzen und Medaillen, RDR, Kaiserreich, Ausland, Baltikum, Adlerschillinge, Löwentaler Kunstmedaillen u.a. von Bosselt, Gies, Goetz, Scharff und Schwegerle Musikermedaillen. Sale cat, nos. 59 and 60. Westfälische Auktionsgesellschaft für Münzen und Medaillen, Udo Gans, Heinz-Günther Hild, Arnberg, February 13–14, 2012.

Westphal 2012
Westphal, Sina. "Degenhardt Pfeffinger: Spätmittelalterliches Weltverständnis im Spiegel einer Münzsammlung." In *"Es geht um Menschen": Beiträge zur Wirtschafts- und Sozialgeschichte des Mittelalters für Gerhard Fouquet zum 60. Geburtstag,* edited by Harm von Seggern and Gabriel Zeilinger, pp. 225–43. Frankfurt am Main, 2012.

Weyl 1876–77
Weyl, Adolph. *Die Paul Henckelsche Sammlung Brandenburg-preußischer Münzen und Medaillen, mit einem Nachtrag.* Berlin, 1876–77.

Whitman 1983
Whitman, Nathan T., with John L. Varriano. *Roma Resurgens: Papal Medals from the Age of the Baroque.* Exh. cat. Mount Holyoke College Museum of Art, South Hadley, Mass.; David and Alfred Smart Gallery, University of Chicago; and University of Michigan Museum of Art, Ann Arbor. Ann Arbor, Mich., 1983.

Więcek 1962
Więcek, Adam. *Sebastian Dadler: Medalier gdański SVII wieku.* Gdańsk, 1962.

Wielandt 1969
Wielandt, Friedrich. *Medaillen der Renaissance und des Barock.* Badisches Landesmuseum Karlsruhe. Karlsruhe, 1969.

Wielandt and Zeitz 1980
Wielandt, Friedrich, and Joachim Zeitz. *Die Medaillen des Hauses Baden: Denkmünzen zur Geschichte des zähringen-badischen Fürstenhauses aus der Zeit von 1499–1871.* Karlsruhe, 1980.

Wiesfiecker 1986
Wiesfiecker, Hermann. *Kaiser Maximilian I.* Vol. 5, *Der Kaiser und seine Umwelt: Hof, Staat, Wirtschaft, Gesellschaft und Kultur.* Munich, 1986.

Wiesfiecker 1991
Wiesfiecker, Hermann. *Maximilian I: Die Fundamente des habsburgischen Weltreiches.* Vienna, 1991.

Will 1764–67
Will, Georg Andreas. *Der Nürnbergischen Münz-Belustigungen.* 4 vols. Altdorf, 1764–67.

Willem van Oranje 1984
Willem van Oranje, om vrijheid van geweten. Exh. cat. Rijksmuseum. Amsterdam, 1984.

Wilson 1983
Wilson, Carolyn C. *Renaissance Small Bronze Sculpture and Associated Decorative Arts at the National Gallery of Art.* Washington, D.C., 1983.

Wind 1937
Wind, Edgar. "Aenigma Termini." *Journal of the Warburg Institute* 1, no. 1 (July 1937): 66–69.

Wind 1958
Wind, Edgar. *Pagan Mysteries in the Renaissance*. New Haven, Conn., 1958. [2nd ed., New York and London, 1968.]

Winter (Heinrich) 1996
Deutschland, Ausland: Münzen, Medaillen, Plaketten. Sale cat, no. 71. Heinrich Winter Münzenhandlung, Düsseldorf, June 22, 1996.

Winter (Heinrich) 1999
Deutschland, Ausland: Münzen, Medaillen, Plaketten. Sale cat, no. 81. Heinrich Winter Münzenhandlung, Düsseldorf, beginning July 10, 1999.

Winter (Heinz) 2009
Winter, Heinz. *Glanz des Hauses Habsburg: Die Habsburgische Medaille im Münzkabinett des Kunsthistorischen Museums*. Sammlungskataloge des Kunsthistorischen Museums, edited by Wilfried Seipel, 5. Vienna, 2009.

Winter (Heinz) 2011
Winter, Heinz. "Die 'Prager Judenmedaillen' des Wiener Münzkabinetts: Eine Medaillensuite aus dem ersten Drittel des 17. Jahrhunderts." *Mitteilungen der Österreichischen Numismatischen Gesellschaft* 51 (2011): 1–33.

Winter (Heinz) 2013
Winter, Heinz. *Die Medaillen und Schaumünzen der Kaiser und Könige aus dem Haus Habsburg im Münzkabinett des Kunsthistorischen Museums Wien*. Vol. I, *Suiten, Rudolf I. (König 1273–1291), Friedrich III. (Kaiser 1452–1493), Maximilian I. (Kaiser 1508–1519) und dessen Nachkommen Philipp I. und Margarethe von Österreich*. Vienna, 2013.

Witte 1912
Witte, Alphonse de. *Catalogue des poinçons et matrices du Musée de l'Hôtel des Monnaies de Bruxelles*. Brussels, 1912.

Wittkower 1977
Wittkower, Rudolf. *Allegory and the Migration of Symbols*. London, 1977.

Wixom 1975
Wixom, William D. *Renaissance Bronzes from Ohio Collections*. Exh. cat. Cleveland Museum of Art. Cleveland, 1975.

Wohlfahrt 1992
Wohlfahrt, Cordula. *Christian Wermuth: Ein deutscher Medailleur der Barockzeit / A German Medallist of the Baroque Age*. London, 1992.

Wolff-Metternich 1975
Wolff-Metternich, Franz, Graf. *Bramante und St. Peter*. Collectanea Artis Historiae 2. Munich, 1975.

Wolff-Metternich and Thoenes 1987
Wolff-Metternich, Franz, Graf, and Christof Thoenes. *Die Frühen St.-Peter-Entwürfe, 1505–1514*. Veröffentlichungen der Bibliotheca Herziana (Max Planck-Institut) 25. Tübingen, 1987.

Wolfgang and Lochner 1875
Wolfgang, Georg, and Karl Lochner. *Des Johann Neudörfer Schreib- und Rechenmeisters zu Nürnberg Stadtnachrichten von Künstlern und Werkleuten aus dem Jahre 1547: Nebst der Fortsetzung des Andreas Gulden*. Quellenschrift für Kunstgeschichte und Kunsttechnik des Mittelalters und der Renaissance 10. Vienna, 1875.

Wolfsgruber 1893
Wolfsgruber, Cölestin. *Carolina Auguste: Die "Kaiserin-Mutter."* Vienna, 1893.

Woods-Marsden 1988
Woods-Marsden, Joanna. *The Gonzaga of Mantua and Pisanello's Arthurian Frescoes*. Princeton, N.J., 1988.

Woods-Marsden 1989
Woods-Marsden, Joanna. "How Quattrocento Princes Used Art: Sigismondo Pandolfo Malatesta of Rimini and *cose militari*." *Renaissance Studies* 3, no. 4 (December 1989): 387–414.

Woods-Marsden 1994
Woods-Marsden, Joanna. "Toward a History of Art Patronage in the Renaissance: The Case of Pietro Aretino." *Journal of Medieval and Renaissance Studies* 24, no. 2 (Spring 1994): 275–99.

Woodward 1897
Woodward, William Harrison. *Vittorino da Feltre and Other Humanist Educators*. Cambridge, 1897. [Reprint, New York, 1963.]

Woolf 1988
Woolf, Noel. *The Medallic Record of the Jacobite Movement*. London, 1988.

Wormser 1914
Wormser, Mauritz. "Coins and Medals of Transylvania in New York Collections." *American Journal of Numismatics* 48 (1914): 182.

Woyke 2010
Woyke, Saskia Maria. *Faustina Bordoni: Biographie, Vokalprofil, Rezeption*. Frankfurt am Main, 2010.

Wurzbach 1856–91
Wurzbach, Constant von. *Biographisches Lexikon des Kaiserthums Oesterreich*. 60 vols. Vienna, 1856–91.

Wurzbach-Tannenberg 1943
Wurzbach-Tannenberg, Wolfgang, Ritter von. *Katalog meiner Sammlung von Medaillen, Plaketten und Jetons*. 2 vols. Zurich, 1943. [Reprint, Hamburg, 1978.]

Yatsevich 1925
Yatsevich, A. G. *Antichniye motiviy u italyanskikh medalyerov Bozmzhdeniya*. New York, 1925.

Yriarte 1882
Yriarte, Charles. *Un condottiere au XVe siècle: Rimini. Etudes sur les lettres et les arts à la cour des Malatesta d'après les papiers d'état des archives d'Italie*. Paris, 1882.

Zaccariotto 2010
Zaccariotto, Giulia. "'A misser Piero Mateo Jordano amico suo': una lettera autografa del Camelio." *Prospettiva* 139/140 (July–October 2010): 131–34.

Zaccariotto 2014
Zaccariotto, Giulia. "'Lavora in zecha di conio': Camelio, le oselle e la circolazione di temi e stili dentro e fuori la serenissima nel primo Cinquecento." In *Le arti a dialogo. Medaglie e medaglisti tra Quattro e Settecento*, edited by Lucia Simonato, pp. 63–80. Pisa, 2014.

Zanetti 1779
Zanetti, Guido Antonio. "Indice delle monete d'Italia raccolte, ed illustrate dal fu Mons. Gianagostino Gradenigo Vescovo di Ceneda, che si conservano presso sua Eccellenza il sig. senatore Jacopo di lui fratello." In *Nuova raccolta delle monete e zecche d'Italia*. Vol. 2, pp. 57–208. Bologna, 1779.

Zanoli 1973
Zanoli, Anna. "Sugli affreschi di Pisanello nel Palazzo Ducale di Mantova." *Paragone* 24 (1973): 23–44.

Zeitler 1951
Zeitler, Rudolf. "Frühe deutsche Medaillen, 1518–1527. 1: Studien zur Entstehung des Stiles der Medaillenmeister Hans Schwarz, Christoph Weiditz und Friedrich Hagenauer." *Figura* (Uppsala) 1 (1951): 77–119.

L. Zeitz and J. Zeitz 2003
Zeitz, Lisa, and Joachim Zeitz. *Napoleons Medaillen*. Petersberg, Germany, 2003.

Ziegler 2010
Ziegler, Hendrik. *Der Sonnenkönig und seine Feinde: Die Bildpropaganda Ludwigs XIV. in der Kritik*. Studien zur internationalen Architektur- und Kunstgeschichte 79. Petersberg, Germany, 2010.

Zimerman 1883
Zimerman, Heinrich, ed. "Urkunden und Regesten aus dem K. u. K. Haus-, Hof-, und Staats-Archiv in Wien." *Jahrbuch der kunsthistorischen Sammlungen des Allerhöchsten Kaiserhauses* 1 (1883): I–LXXVIII.

Zimmermann 1995
Zimmermann, T. C. Price. *Paolo Giovio: The Historian and the Crisis of Sixteenth-Century Italy*. Princeton, N.J., 1995.

Zograf 1923
Zograf, A. N. *Stroganovskiyi dvoretz-muzei: Italyanskiye medali*. Petersburg, 1923.

Zorzi 1962
Zorzi, Elda. "Un antiquario padovano del secolo XVI: Alessandro Maggi da Bassano." *Bollettino del Museo Civico di Padova* 51 (1962): 41–98.

Zöttl 2014
Zöttl, Helmut. *Salzburg: Münzen und Medaillen, 1500–1810*. 2nd ed. Salzburg, 2014.

Van Zuiden 1913
Van Zuiden, D. S. "Testament van Frederick Alewijn." *Tijdschrift van het Koninklijk Nederlandsch Genootschap voor Munt- en Penningkunde* 21 (1913): 160.

Zulch 1935
Zulch, W. K. *Frankfurter Künstler, 1223–1700*. Frankfurt am Main, 1935.

Von Zu-Rhein sale 1920
Sammlung Freiherr von Zu-Rhein, Würzburg. Sale cat. Otto Helbing Nachfolger, Munich, June 28, 1920.

Index

B

C

D

H

T

Y

Z

Photograph Credits

Photographs of the Scher Collection medals are by Michael Bodycomb.
Comparative photographs have been provided by the owners or custodians of the works.
The following list applies to those photographs for which a separate credit is due.

Figs. 11, 12 © Collections artistiques de l'Université de Liège
Fig. 17 © Musée d'Unterlinden, Dist. RMN-Grand Palais / Art Resource, NY
Figs. 32–35 Photo Christopher Eimer
Figs. 36, 39, 40 Photo Ola Myrin
Fig. 41 Photo Bogomil Nikolov